THE
HISTORY·OF
ART

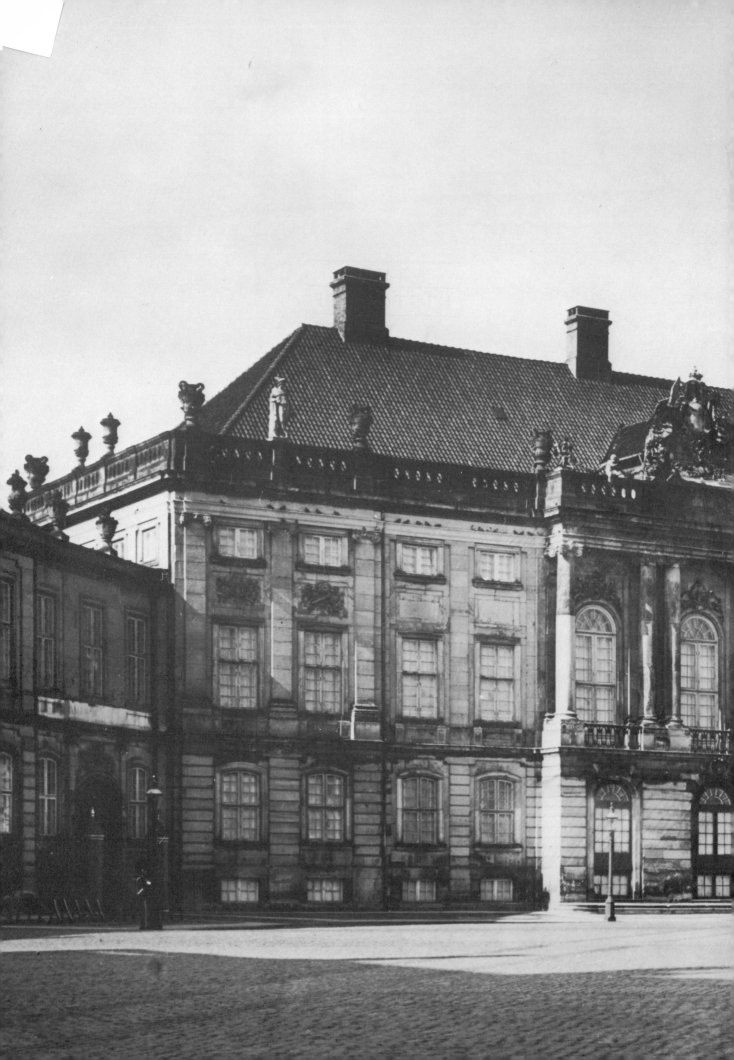

THE · HISTORY · OF
ART

ARCHITECTURE · PAINTING
SCULPTURE

HAMLYN

General Editors

Bernard S. Myers
New York

Trewin Copplestone
London

Contributors

Introduction
Edward Lucie-Smith, art critic, poet and broadcaster.

The Classical World
Dr Donald Strong, formerly Assistant Keeper, Department of Greek
and Roman Antiquities, British Museum, London.

The Early Christian and Byzantine World
Professor Jean Lassus, formerly of the Institute of Art and
Archaeology, Sorbonne, Paris.

The Medieval World
Dr Peter Kidson, Reader in the History of Art, London University.

Man and the Renaissance
Professor Andrew Martindale, School of Fine Arts and Music,
University of East Anglia, England.

The Age of Baroque
Professor Michael Kitson, formerly Deputy Director of the Courtauld
Institute of Art, London; Director of Studies, Paul Mellon Centre
for Studies in British Art, London.

The Modern World
Professor Norbert Lynton, Department of History of Art,
University of Sussex, England.

Title spread illustration: The Baroque palace
of the Amalienborg, Copenhagen, Denmark, built in 1754
by N. Eigtved for Christian VII. Newnes Books

This edition first published in 1985 by
The Hamlyn Publishing Group Limited
Michelin House, 81 Fulham Road, London SW3 6RB

Original text
© copyright The Hamlyn Publishing Group Limited
1965, 1966, 1967
Revised and updated edition
© copyright The Hamlyn Publishing Group Limited 1985

Fifth impression 1990

ISBN 0 600 35803 8
Printed in Yugoslavia

CONTENTS

INTRODUCTION

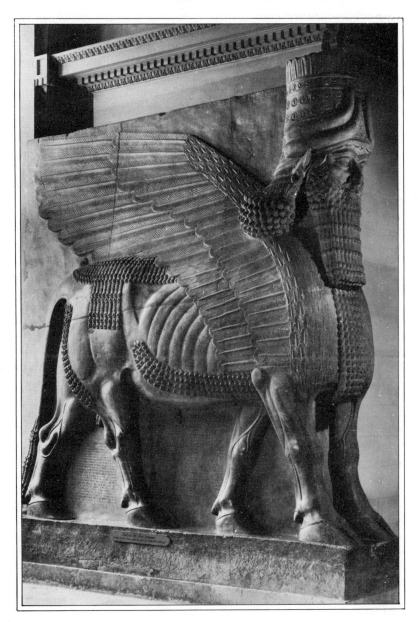

Introduction

The figures in the margin of the Introduction refer to the colour plates in the various sections of this book: Cl– the Classical World; EC – The Early Christian and Byzantine World; Me – The Medieval World; Re – Man and the Renaissance; Ba – The Age of Baroque; Mo – The Modern World.

THE EARLIEST ART

The earliest art now known to us goes back to the very dawn of the history of mankind—indeed, it is fair to say that making art is one of the earliest human activities of which we now have a record. The painting and sculpture of the Old Stone Age provably antedates the majority of the basic crafts, even weaving or making pottery. It is far older than metalworking, and belongs to a level of society which we now find almost unimaginably primitive.

The chief subject of Palaeolithic art was animals, drawn, painted and engraved on the walls of caves and rock shelters. These animals include deer, wild cattle, horses, mammoth and buffalo—the usual quarry of the hunters of the period. The distribution of subject-matter in Palaeolithic painting varies according to the location of the sites where paintings have been found. Usually there is a marked preponderance of a single species at each site, something which most likely reflects the ecology of the immediate neighbourhood at the time the work was done, though it may also suggest that each cave was a sanctuary, dedicated to a particular animal cult.

The Palaeolithic artist did not confine himself to animals alone, though these take by far the largest place. The repertoire of subjects in cave-painting also includes human beings, monsters, abstract symbols, and positive and negative imprints of hands. There are also a number of Palaeolithic sculptures and reliefs. The sculptures are usually small. Some seem to be independent cult-objects, such as the steatopygous female figures which apparently represent some kind of Mother Goddess, while others serve as carved decoration for what are apparently useful objects. I say 'apparently' because experts differ as to the role of a number of these carvings—what one scholar sees as an arrow-straightener another may describe as a *bâton de commandment* or ceremonial sceptre.

The purpose of the cave-paintings—the most spectacular products of Palaeolithic man—is also in dispute. One feature of Palaeolithic art is that the paintings are often found in caves so deep and so difficult of access that it is hard to think of them as having possessed any public, ceremonial purpose. Another, even more disconcerting, is the fact that the artists seem to have felt no respect for their own creations, to the point where they frequently put one design on top of another. Many explanations have been offered for this practice, ranging from the idea that painting and drawing were purely ritual activities, and that it was the making of them that counted, rather than the finished result; to the claim that, since suitable surfaces for painting were comparatively rare, the artists tended to use those available to them over and over again. The first of these theories is supported by an eyewitness account of a hunting ritual once in use among South African Bushmen. Their custom was to draw the animal to be hunted on the bare earth, to wound it ritually before the hunt, and then to efface the drawing after the kill had been made, so as to offer no refuge to the dead animal's spirit, which might seek to take revenge.

Palaeolithic art was re-discovered comparatively recently—art-historians have only had just over a century to get used to the fact of its existence. Though Palaeolithic artefacts had already begun to attract the attention of antiquarians in the 1860s, the first major discovery of paintings dates from 1879, when the Spanish archaeologist Don Marcelino de Satuola announced the discovery of the painted cave at Altamira. His findings were published the next year, and were met with widespread scepticism, especially in France, which was then the centre for Palaeolithic studies. This scepticism was based on what seemed the extreme fluency and naturalism of Altamiran style, as well as on the fine preservation of the work. The first paintings of Palaeolithic date in France were found nearly two decades later, in 1895, in a sealed cave at La Mouthe, but these too were dismissed as forgeries. It was only in 1902 that a turning point was reached, when Émile Carthaillac, the leading French scholar in the field, published a full retraction of his previous doubts. In this sense, the earliest painting known to man is also scarcely older than the birth of Modernism. Carthaillac's book, *The Mea Culpa of a Sceptic*, preceded the explosive group manifestation of the Fauves at the Paris Salon d'Automne of 1905 by a bare three years.

As Palaeolithic art has become more familiar, chiefly through illustrations in books, so it has acquired a much sharper stylistic identity. The painters and draughtsmen relied primarily on the power of outline, and they tended to present the animals they depicted in their 'completest' form—that is, viewed sideways on, so that all important physical features could be apparent. A closer glance reveals that the naturalism of the portrayal is often illusory—in Palaeolithic art we find a number of recurrent conventions, though these are so inconsistently applied that no general rule can be deduced. For example, there are many instances of what the Abbé Breuil, one of the leading authorities on the subject, describes as 'twisted perspective'. If an animal is shown, then its horns and ears, and also its hooves, if these are cloven, will be shown frontally, so as to present them to the viewer in their most typical and immediately recognisable guise.

In addition to painting or drawing one representation on top of another, the Palaeolithic artist sometimes chose to show his subject-matter in incomplete or abbreviated form. With animals, the legs in particular are often left unfinished. More rarely, a particular beast will be indicated by little more than the characteristic curve of back or belly. Human beings can be shown as mere torsos, with both head and legs omitted. **Cl**

Far more puzzling than this inconsistent use of stylisation is the matter of Palaeolithic attitudes towards pictorial composition—if, indeed, 'composition', in the sense in which we now understand the word, can be said to exist at all in cave-painting. Very occasionally it *is* possible to sense that certain things have been deliberately grouped together, and are meant to be read as a whole unit. This is the case with five reindeer apparently swimming a river at Lascaux. But even here the exact nature of the action represented is not absolutely clear. One has to recall not only the Palaeolithic habit of abbreviating representations, and particularly legs, but the consistent absence of a ground line

1. (above). **Outlines of human hands superimposed on a bison and other animals.** Abbé Breuil's copy of an Aurignacian rock painting in red, c. 25,000 BC. Cueva del Castillo, Puente Viesgo (Santander). The French priest, Henri Breuil (1877–1961), was one of the world's greatest pioneers in the study and popularisation of the art of our Ice Age ancestors. His copies testify to his sympathy with their prehistoric masterpieces.

2. (above left). **Rock engraving of men, a woman and a fallow deer.** Palaeolithic. h. (of central figure) 9½ in. (24 cm.). Grotta di Addaura, Monte Pellegrino, Palermo, Sicily.

3. (left). **A stag and other figures with abstract signs superimposed.** Second Hunter style, c. 6000–2000 BC. Copy of a rock, painting. Cueva de Tajo de las Figuras, Casas Viejas (Cadiz). The well-drawn incised outlines of sprightly men and women in conjunction with animals in traditional style at Monte Pellegrino represents a revolution in Old Stone Age art.

in this kind of art. Palaeolithic artists seem ready to accept a ground line, if this is provided by an already existing natural feature such as a fissure in the rock, but they never deliberately draw one. When an animal is shown at an unexpected angle, it can simply be that the fissure on which it stands is tilted away from the expected horizontal.

Students of Palaeolithic art have repeatedly tried to find evidence not only of deliberate grouping (whose existence seems more or less certain) but of actual narrative. Proof that a genuine narrative impulse existed in cave-painting has been difficult to discover, though occasional juxtapositions seem more than accidental, and suggest that some kind of story is being told. A famous example comes from Lascaux. **Cl 2** An ithypallic man is seen lying on his back between a bison and a rhinoceros. Near him, and also between the two

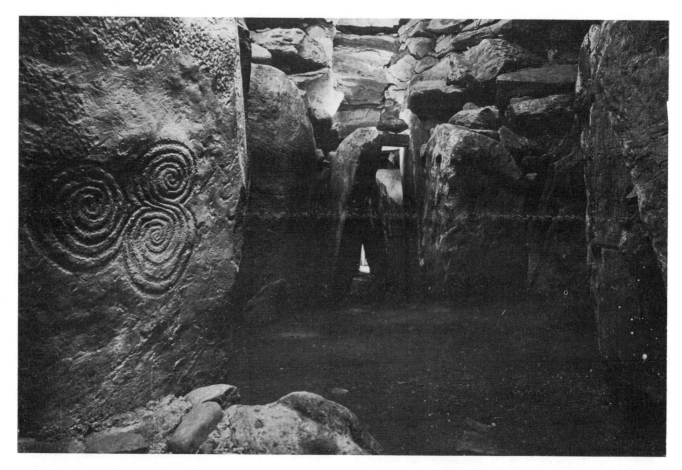

4. **Passage Grave at New Grange**, on the River Boyne, Co. Meath, Ireland. c. 3000 BC. This tumulus covers 1 acre (0.4 hectare) and has an entrance passage 60 feet (18 m.) long leading to a main chamber with a corbelled roof and containing recesses for graves. Spiral patterns decorate the chamber, the passage, and a large stone guarding the entrance.

animals, is a bird-headed stick. The bison's entrails are apparently pulling out of its belly. The Abbé Breuil interpreted the group as a complete scene in which a dead man was shown lying between the rhinoceros which had killed him and the bison which he himself had just wounded. On the basis of a comparison with certain modern tribal customs, Breuil saw the bird-headed stick as a funerary post. Other interpreters argue that the rhinoceros is not really part of the scene, which consists of the man and the bison; while others still consider the rhinoceros to be essential and the bison to be irrelevant. If the artist meant to tell a story he was not very good at making his meaning clear; and in fact we have no guarantee that only one artist was involved, or even that the scene was all done at one time. Breuil's little tragedy may be the work of several different artists, working at widespread intervals and independently of one another.

THE LESSONS OF PALAEOLITHIC ART

Both because it is so remote from us in time, and because it has re-entered our consciousness so recently, after dropping out of sight (in the most literal sense) for many millennia,

it is difficult to make useful direct comparisons between the art of the caves and the rest of the western European art discussed in this book. We know little which is truly solid about the social context. Though the main outline is clear, we are ignorant of most of the details of the way in which settled societies grew from the life led by these small, scattered, vulnerable tribes of hunter-gatherers, struggling to exist in circumstances unimaginably different from our own. We know nothing at all about the position of Palaeolithic artists within the tribe—whether they were men or women, or both; whether everyone made art, or whether making art was a function assigned to certain especially gifted individuals. We do not know if it was a prestigious thing to be recognised as a gifted artist, or even if there was something sacred about this occupation.

Certain things are clear, however, because they can be found in the art itself. We observe that from the very beginning, the artist was subject to conflicting impulses. On the one hand, he wanted to provide an accurate reflection of what he saw. The bulk of Palaeolithic art is founded on acute observation of nature. Yet it also seems to have suffered from certain inhibitions. Human figures are always considerably more stylised and distorted that those of animals. Two reasons have been put forward for this. One is that men were not hunters of men, and that the artists did not therefore scrutinise the human form with the special keenness they reserved for what was quarry. The second is that they were wary of depicting any man too precisely, since

in that way they might seem to steal a portion of his spirit and make the individual who was depicted vulnerable to enemies who might injure him by attacking his image. This second reason prompts the thought that the struggle to make art has always been a struggle against inner inhibitions, as well as being sometimes a struggle against lack of skill and adverse material circumstances.

While the bulk of Palaeolithic art is founded on the observation of nature, even if the artist sometimes drew back in fear and shyness from what he had observed, it also contains a conceptual element. This is represented not only by the various abstract signs which recur in cave painting, but more subtly by the use of various conventions, chief among them the Abbé Breuil's 'twisted perspective'. This is something which re-appears, used in a more systematic and also a more schematic way in Ancient Egyptian art, where the head and legs of a figure will be shown in profile, while the torso is shown frontally. In addition to making us see what he has seen, the artist wants to tell us all the facts, everything he knows about the visual appearance of what he is depicting. His work thus responds to a general conceptual idea, that of providing a particular sort of information, even at the expense of the immediate illusion of life. This is also a conflict which recurs throughout the history of western European art, especially in painting, where the artist has to reduce three dimensions to two. The battle was still being fought in Cubism.

Palaeolithic painting carries tantalising echoes of concerns which have interested artists and their patrons throughout the ages, yet in other respects remains almost impenetrably ambiguous, as the controversy over narrative demonstrates. This suggests that it may be necessary to issue a general warning concerning the interpretation of all works of art. Our own reactions to Palaeolithic artworks are governed by an interaction of three different forces. The first of these is the immediate impact made by the image itself. But this is modified by what we know, or think we know, about its background—its cultural context and the artist's intention in making it. The third factor is what we bring to the work from our own time—the whole clutter of unquestioned assumptions and prejudices which we share with other twentieth-century observers. It is easy to appreciate the skill of the Palaeolithic artist, yet it is at the same time very difficult to imagine the context within which his art was created. Its meaning for us thus obviously differs from, and in all likelihood falls short of, its meaning for him.

EGYPT AND THE ANCIENT NEAR EAST

Though they take us outside the geographical boundaries of Europe, the great civilizations of Ancient Egypt and even more so of the ancient Near East, are the direct ancestors of our own, and hence have a firm connection with us which is difficult to prove in the case of Palaeolithic hunter-gatherers. Nevertheless, artworks from these civilisations invite us to look at the business of making art in a focus quite different from the one we are accustomed to. Art emerges, not as the work of individuals, but as a form of collective expression. The Great Sphinx at Gizeh, carved from the

5. (below). **The pyramid of Chephren**. Fourth Dynasty. c. 2600 BC. Gizeh. The pyramids of Gizeh were built of limestone quarried on the spot, with finer blocks for facing brought from across the Nile. Unlike the Mesopotamian ziggurat, the Egyptian pyramid was intended to house the dead, not to serve as a sanctuary (see figure 14).

6. (bottom). **The avenue of rams leading to the Temple of Amon at Karnak, Egypt.** The New Kingdom temple of Luxor was connected with the temple at Karnak by this paved avenue; a similar avenue lead to the temple of Mut.

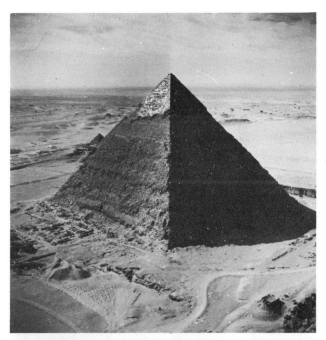

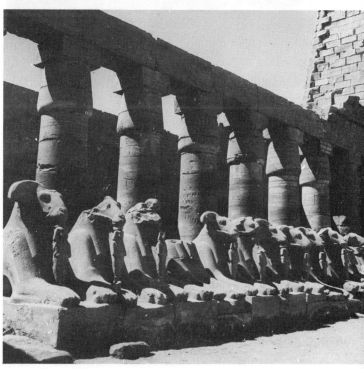

7. (below). **Head of a seated figure of Amenemhet III**.
Middle Kingdom, Twelfth Dynasty, *c.* 1840–1792. Hard
yellow limestone. Full height of figure 63 in. (160 cm.).
Egyptian Museum, Cairo. This magnificent figure of
Amenemhet III executed in the Memphite tradition has a
serene, but almost sorrowful expression.

8. (bottom). **Relief from the tomb of Ti at Saqqara**. Old
Kingdom, Fifth Dynasty, *c.* 2480–2350 BC. Limestone,
painted. This is one of many brilliantly executed scenes in the
tomb of Ti illustrating episodes from everyday life. The
figures begin to overlap and the gestures are more lifelike than
in earlier reliefs.

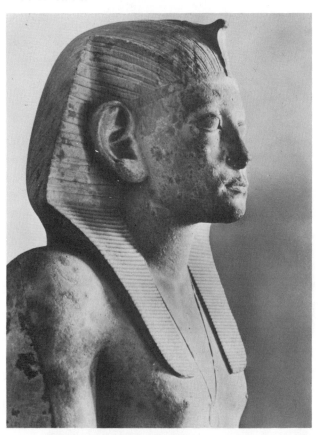

natural rock c. 2500 BC has long been the symbol of everything
which is mysterious and enigmatic. Yet its mystery is less
than that of the art of the caves. The figure with the body
of a lion and the head of a man, wearing a royal headdress,
is clearly a guardian of some kind. Like the nearby pyramids,
it is also an emblem of overwhelming royal power—it
immediately brings to mind the sheer amount of labour
which must have been necessary to create it, and we think
of it as the creation, not of the man who designed it, but of
the ruler who commissioned it.

The image of the sphinx, invented in Egypt, and typical
of the Egyptian tendency to combine human and animal
components in the effort to portray divine beings, became
widely disseminated. There are paired sphinxes, female
rather than male, guarding the gates of the Hittite city at
Alaca Hüyük in Anatolia. They date from over a thousand
years later than the great Sphinx at Gizeh, and it is likely
that the idea reached this region via Syria, and not directly
from Egypt. The guardian sphinxes of Alaca Hüyük provide
an early instance of the way in which certain motifs are
transmitted from culture to culture, usually being somewhat
changed in the process. The sphinx was also inherited from
the Egyptians by the ancient Greeks, and was transmitted
by the Greeks to the Etruscans and Romans, though the
latter were also influenced directly by Egypt itself. It
remained part of the decorative repertoire during the Middle
ages, and was revived in more authentic form by the artists
of the Renaissance. The playful sphinxes which served as
eighteenth-century garden ornaments have an unbroken
pedigree which stretches back to the original model, though
its brooding spirit has now been completely transformed.
But they are still emblematic of the continuity as well as the
diversity of art.

Palaeolithic man left nothing that we can call architecture
behind him. The walls he painted on were those he found
readymade. With the civilisations of Egypt and the Near
East, architecture became the dominant mode of architec-
tural expression. Many of the artworks which have survived
from these civilisations were originally intended as architec-
tural decoration. Occasionally the medium chosen has

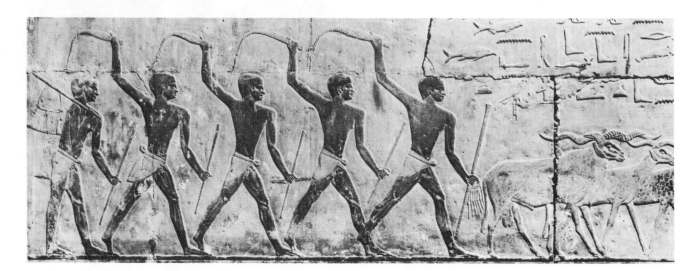

resisted time well enough to allow us to understand how magnificent the buildings themselves must have been when they were in their original state. A case in point is the glazed brick decoration favoured by the ancient Babylonians. The moulded reliefs of lions and other animals have survived with their bright colours sufficiently well preserved to give us a good idea of the intended effect. In other places, particularly in Egypt, it is the sheer bulk of these ancient constructions which overwhelms us. This, too, speaks of art as a communal rather than an individual expression.

Yet there are two other points which ancient buildings bring to mind, and they are confirmed by the numerous small and luxurious objects which have also come down to us. The first is that there was little or no differentiation in the ancient world between art and craft. The glazed polychrome murals of the Babylonians were made in what would now be thought of (that is, if it were applied to a contemporary building) as an artisan technique. The continuing unity of art and craft persisted until the philosophers of the Renaissance started to make distinctions between the one sphere and the other.

The second point is that power made itself manifest in the ancient world not only through the ability to control large amounts of labour, of the kind required to build the Gizeh pyramids, but through access to precious materials and a monopoly of the reservoir of skill. Royal graves in many places have yielded objects of astonishing magnificence. Among the earliest are the finds made by Sir Leonard Woolley in excavations in the royal cemetery at Ur, where the graves date from *c.* 2600–2400 BC. Among the objects found was a lyre, its soundbox decorated with inlay of mother-of-pearl and lapis lazuli, and ornamented with the head of a bull in beaten gold. Though still an object of practical use, this nevertheless clearly proclaims the standing of the individual who possessed it. In aesthetic terms, it is certainly on a par with any 'independent' artwork which has come down to us from Ur.

Each ancient civilisation is marked by its own clearly distinguishable style, though it is also possible to see how one style grows out of another as one culture succeeds another. Sometimes, a single culture will seem to show us two very different aesthetic approaches, existing side by side. The fiercely war-like civilization of Assyria produced superbly carved shallow reliefs, which were used to decorate the palaces of the Assyrian kings. The majority of these celebrate military triumphs, such as the relief showing the capture of Susa, which comes from the palace of Assurbanipal at Nineveh. This carefully inventories all the events of the siege, arranging the scenes in narrow registers one above the other. But there are also reliefs from the same palace which show a very different spirit—they celebrate, not the king's campaigns, but his exploits as a hunter. One scene shows wild asses being hunted with mastiffs—the animals float freely in the available space very much as they do in Palaeolithic cave-painting. The spirit in which they are observed has not in fact changed so very much, though the narrative element is of course unambiguous. There is a strong empathy with animals, but no equivalence is

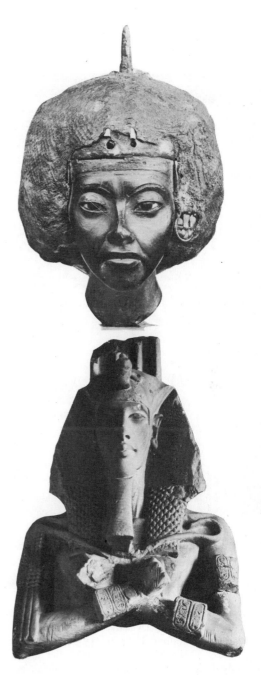

9. (top). **Head of Queen Tiy.** New Kingdom, Eighteenth Dynasty. *c.* 1440 BC. Painted yew-tree wood, gold and inlays. h. 4¼ in. (10.7 cm.). From Medinet Gurob in the Faiyum. Now in the Staatliche Museen zu Berlin. This royal face has a disdainful, almost contemptuous expression. The eyes are inlaid, the earring is of gold and lapis lazuli, and the headcloth was covered by plaster and linen set with small blue heads.

10. (above). **Amenhotep IV, later known as King Akhenaton.** New Kingdom, Eighteenth Dynasty, *c.* 1375 BC. Sandstone. More than twice life size. Original site, Karnak. Now in the Egyptian Museum, Cairo. This fragment from a colossal statue was found in the temple of Aton, near the temple of Amon at Karnak. Still bearing the name Amenhotep, it depicts the ruler during the years before he moved his capital to Amarna. The almost decadent stylisation of the features are typical of the sculpture of Akhenaton's reign. Akhenaton was the son of Amenhotep III and Queen Tiy.

16

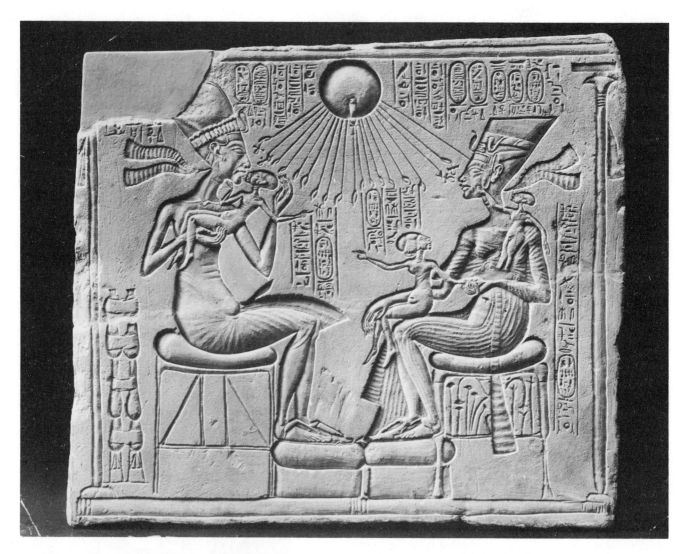

11. **Akhenaton, Nefertiti and three of their daughters**.
New Kingdom, Eighteenth Dynasty. Amarna period.
c. 1370–1350 BC. Limestone. h. 17 in. (43.5 cm.). Egyptian
Museum, Cairo. This stele, carved in sunk relief and painted,
was probably designed as a private altar. An unconventional
subject, the informal portrayal of the royal family shows
them beneath the extended rays of the sun disk, the Aton.

suggested between human and animal feelings even at this
moment of fear and flight.

Ancient Egyptian artists were also fond of hunting scenes,
and their portrayals of animals and birds show a similar
dispassionate keenness of observation, plus a concentration
on essential outlines which seems to echo the methods of the
very earliest artists. An 18th-Dynasty mural from a Theban
tomb belonging to a private individual shows marsh-birds
caught in a clap net. The victims—some agitated, some
already acquiescent to their fate—are drawn with great
authority, and the naturalism of the portrayal makes a
striking contrast with the figure of a fowler standing nearby
half-hidden by papyrus rushes.

Perhaps the subtlest works of art produced before the
Greeks are certain Egyptian portraits. The Egyptian way of

depicting animals may seem, through its freshness and
innocence as well as its actual concision, to reach back into
the remote past of humankind. Portraiture, from the Old
Kingdom onwards, is something quite new, more especially
when the portrait is carved in three dimensions, rather than
being done in relief or painted. For the Egyptians, the
portrait could serve as the repository for a man's soul,
especially if his mummified body was destroyed—either
maliciously, or through some natural catastrophe. The
portrait statues of the Fourth and Fifth Dynasties already
have great individuality. A famous example is the corpulent
figure known as the 'Sheikh-el-Beled', which comes from
Saqqara. This, though it is monumental in form, sacrifices
idealization in the effort to produce a completely lifelike and
convincing portrayal of a particular individual. It stands at
the beginning of a long sequence of magnificent portrait
statues, most of them, however, of kings and queens rather
than the likenesses of private individuals. Particularly noble
in style are some portraits of Middle Kingdom rulers, such
as the limestone statue of Amenemhet III, of c. 1840–1792
BC., now in the Cairo Museum. This, with its sorrowful
expression, seems to reach out beyond mere fidelity to
appearances, and to attempt a portrayal of man's soul.

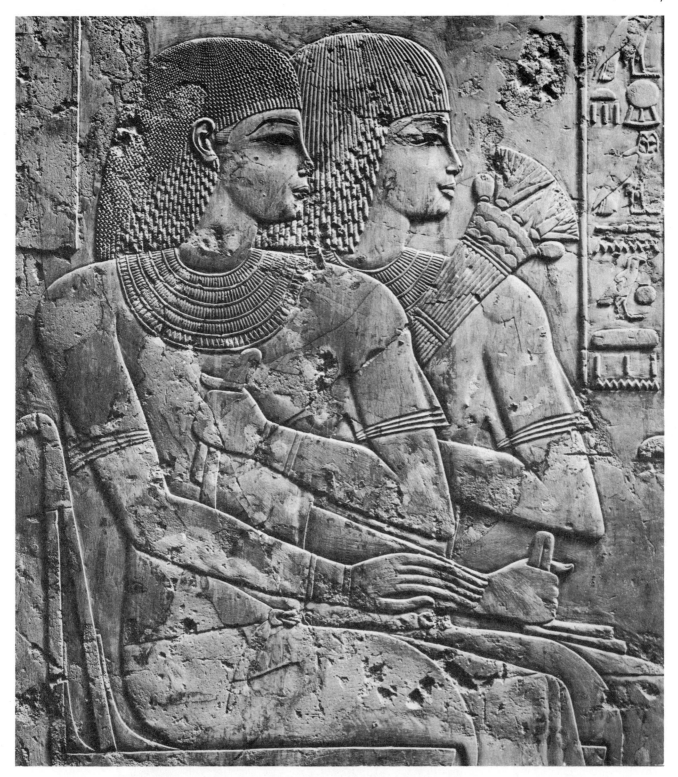

At the end of the 18th Dynasty, Egypt was the scene of a religious upheaval, led by the so-called 'heretic pharaoh', Amenhotep IV, who later renamed himself Akhenaton. Akhenaton seems to have been rather strange in appearance, with an exaggeratedly long skull and pendulous lips. His body, if we are to believe his official portraits, was androgynous, with broad hips and stick-like arms. In the earlier part of his reign, these characteristics were deliberately exaggerated by the official sculptors, who produced images of their unorthodox ruler which are simultaneously expressionist and strangely decadent.

Later in the reign, after the royal capital had been moved from Thebes to a new site at Amarna, the new style

12. **Detail of a relief carving from the tomb of Rameses III**. Twentieth Dynasty, 1190–1160 BC. An elegant combination of stylisation with sculptural subtlety.

modulated into a delicate naturalism, which had already been foreshadowed in certain artworks produced in the reign of Akhenaton's father, Amenhotep III. One of the most striking of these is a small yew-wood head of Queen Tiy, Amenhotep III's wife and Akhenaton's mother, showing her as a handsome middle-aged woman with a coldly scornful expression. Even this masterpiece, however, is eclipsed by the famous bust of Akhenaton's own consort, Nefertiti. This is simultaneously one of the most alluring and

18

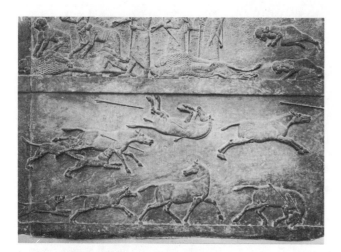

13. **Wild asses hunted with mastiffs**. Detail of a relief from the North Palace of Assurbanipal at Nineveh. 686–626 BC. h. 21 in. (53 cm.). British Museum, London. This poignant rendering of animals in flight suggests a sympathy on the part of the sculptor with the fate of the wild asses. The animals are carved with an extraordinary subtlety. This is one of many hunting scenes which decorated the walls of Assurbanipal's palace.

Cl 9 the most enigmatic of all ancient works of art. Because the portrait is a true bust, and not a fragment, and busts are otherwise unknown in Ancient Egyptian art, it has been conjectured that the work was meant to serve as a sculptor's model for other portraits of the queen. Ths hypothesis is supported by the fact that it is apparently unfinished—it is fully polychromed, except for one eye (another conjecture is that Nefertiti suffered from some kind of eye-disease). Whatever his intentions, the unknown sculptor has succeeded in creating a totally individual portrait which is, at the same time, a statement about a particular ideal of beauty.

Long before the discovery of the portrait of Nefertiti, which only took place during the past hundred years, Egyptian portraiture was admired, both for its liveliness and for the extreme technical skill shown for the artists in

handling often extremely recalcitrant materials such as granite. It has not, however, been given a central place in the story of art despite the obvious derivation of the Greek *kouros* from the Egyptian standing portrait statue. Some of the reasons for this are obvious. Egyptian portraits, despite their connection with Greek *kouroi*, do not seem to lead directly onwards to the portraiture of later Greek and Roman times, which, in turn, is of great significance for the whole history of western art. In addition to this, recent art history has been prejudiced against these portraits precisely because of their realism. It must often have seemed to twentieth-century art historians that the effort to present the continuing development of art in a truthful and convincing way was hampered by expectations created during the Renaissance and never since completely discarded. Chief among these is the idea that art progresses in a rational 'scientific' way, as evidenced by its increasing naturalism.

The importance of the best ancient Egyptian portraits is that they turn our attention towards a very different question. They are revolutionary because they overcome the fear felt by Palaeolithic artists about the portrayal of men rather than animals. Instead, they are able to concentrate on the search for the essence of a particular man or woman—for the first time, the concept of individuality is introduced into art. Even when drawing or painting animals, Palaeolithic artists seem to have looked for something else—for what was most typical of the species, rather than for what most clearly distinguished one particular specimen from the herd.

14. **The Ziggurat at Ur.** Ur III period. *c.* 2150–2050 BC. The imposing ziggurat at Ur owes its fine state of preservation to the fact that the entire staged tower was given a brick facing. It was built in the reign of Ur-Nammu, founder of the Third Dynasty of Ur, and was probably surmounted by a temple dedicated to the moon god Nanna, but no traces of this remain. Approached by three staircases, its sloping walls are broken with shallow articulations. In this view the holes in the brick casing can be seen. These must have been incorporated to stop the mud-brick core from cracking during the rainy season.

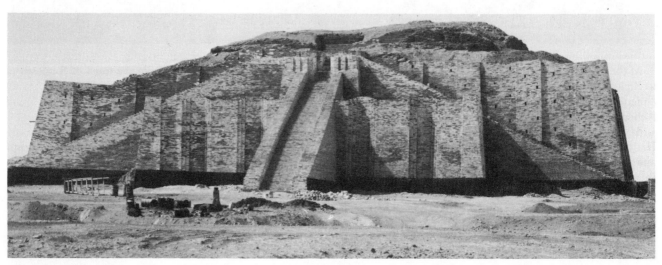

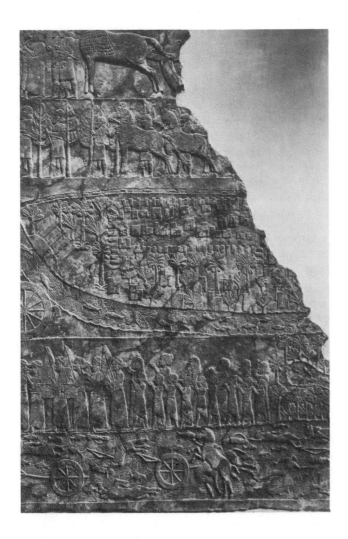

15. **The capture of Susa**. Relief from the palace of Assurbanipal at Nineveh. 668–626 BC. British Museum, London. In the centre the sculptor has shown the city on the banks of a river almost as if it were a plan. Its houses and streets, and the palm trees can be clearly distinguished.

works are now entirely lost to us, but those of sculptors, and architects, such as Polykleitos, Pheidias, Scopas and Praxiteles, where we possess both rare examples of original work, and also Roman copies faithful enough to give a good idea of the originals. The story, up to the beginning of the fourth century BC, and perhaps even until the age of Alexander the Great, is one of coherent development, where technical and stylistic advances go hand in hand. The Hellenistic age, when Greek influence spread almost throughout the known world, carried to its remotest frontiers by Alexander himself and the rulers who succeeded to the various parts of his empire, presents us with a break in this pattern. Art to some extent becomes stylistically plural. For the first time, for example, we see artists deliberately reviving antiquated styles—dabbling in archaism to give additional spice to the work. We also see art beginning to divide itself into genres—the grotesque against the heroic.

Perhaps the most significant moment in the history of Roman art is when artists begin to rebel both against Greek classicism and Hellenistic deviations into rhetoric or aggressive realism. There came a moment at the beginning of the third century AD, when Roman art grew more schematic, and at the same time began to aspire towards the otherworldly. Many explanations have been given for this change—the rise of Christianity (and of other, rival mystery religions such as Mithraism), and the struggle the empire had to undergo against enemies within and without. The art of late antiquity clearly prepares for the appearance of that of Byzantiun—and the Byzantines in any case spoke of themselves as 'East Romans', and acknowledged no moment of division between their own empire and that founded by Augustus. The Byzantines also inherited many things from even older empires, and it is tempting to see their formal, hieratic art as the direct successor of what had been produced by the old kingdoms of the Near East. Yet there is one very important difference, which is that Byzantine art, however powerful and sumptuous, still remains an art of struggle and aspiration, yearning towards some beyond, which mortals may glimpse but can never hope to attain.

One of the most typical of all Byzantine images is that of Christ Pantocrator, occupying the centre of the dome or alternatively the main apse of a church. Christ the judge and mediator threatens the worshipper with hellfire at the same moment as he promises salvation. The hints of spiritual unease which exist in embryo in certain Egyptian portraits of Amenemhet III here cease to be hints, and become the whole subject of the work. It is not going too far to say that this is the moment at which art for the first time fully exercises its power to portray a condition of mind—where the image is deliberately shaped to make the subjective manifest.

It is of course true that the Egyptian artist still seems to have been indifferent to the notion of expressing his own individuality, rather than that of the subject before him. It has in fact long been fashionable to talk of the impersonality of Ancient Egyptian sculpture—something justified by the loftily impassive air of so many Egyptian statues. Yet, though aloof, the best of the portraits are unmistakably individualised, and it does not take much reasoning to see that the artist who seeks to express the inner essence of others, must at last stumble upon the idea that whatever he makes is also inevitably personal—but personal to himself.

THE PATTERN OF DEVELOPMENT

The way in which art-historians tell the story of art is inevitably predicated, not only on what we know about the work produced in a particular place at a particular period, but on our knowledge of the circumstances in which it was produced. The art of the Greek city states is not only superbly beautiful in itself, but its development echoes that of Greek literature and Greek philosophy, which have exercised such a profound influence upon the whole of European thought.

One of the things we notice about the story of Greek art is the way in which artists' names begin to emerge—not only those of painters, such as Polygnotus and Zeuxis, whose

EC 52

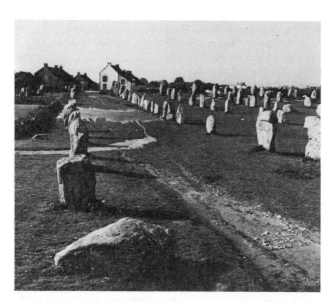

16. **An alignment of menhirs or standing stones at Carnac, Brittany.** *c.* 3000 BC. The largest and most complex surviving arrangement of standing stones in Europe, its architectural similarities to the plan of a cathedral have suggested that this site had a religious or astronomical function.

THE EUROPEAN MIDDLE AGES

The image of Christ in the art of the European Middle Ages presents him as a more human and more suffering figure, and here, too, there is a change in the relationship between the work of art and the spectator. The viewer, instead of viewing suffering passively, or even rejoicing in it (as is the case with the savage Assyrian battle-scenes) is now asked to empathise with it. This interpretation of the Passion of Christ emerges very early, as can be seen from the pre-Romanesque Gero Crucifix now in Cologne cathedral, which dates from the middle of the tenth century.

Me 15

The greatest fascination of the medieval world, however, is to be found not in the development of any single image, but in the completeness of the relationship between art and society—art then penetrated to every corner of human experience. The ruler used it to stress his power, just as the Church used it to convey the Christian message. But the great cathedrals and churches of the time made it available even to the humblest. Collective patronage was often as important as that of temporal and spiritual rulers. The great stained glass windows at Chartres, some of the finest achievements of medieval art, were many of them commissioned and paid for by members of various guilds.

Me 35

The men who made these windows also belonged to a guild, as indeed did all artists. The social organisation of the medieval world required this—or began to require it as soon as artistic activity emerged from the rural isolation of the great monasteries and once again settled in towns, which were now growing rapidly after the period of chaos which followed the dissolution of the Roman Empire. The guild-system put the creative artist on a level with all the other practitioners of a particular craft 'mystery'. His training followed the same general pattern: he learned through apprenticeship to a particular master for a period of time fixed by guild regulations; he then became a journeyman—that is, fully qualified in his trade but working by the day or hour for someone else; and finally, if he was lucky, he attained the mastership, and ran his own business. Businesses were often transmitted from one set of hands to another by marriage. The journeyman would marry his master's widow or daughter, and through this become entitled to take over his shop.

Naturally this created a particular frame of mind. There was no objection to division of labour, with several artists, often of varying levels of skill, labouring on a single artwork. There was, on the other hand, a strong emphasis on skill itself—on things being well executed according to existing standards. The surprising thing, perhaps, is how much personality nevertheless emerges from major medieval artworks. In each we sense the presence of a particular guiding intelligence, which is that, evidently, of the master responsible for the enterprise. At the same time we notice distinctive tricks of execution, peculiar to the workshop in question and quite obviously founded on the master's own practice.

Medieval art was certainly not wedded to the idea of anonymity—this is a fiction later ages have sometimes tried to impose on it. Medieval artists often signed their work—one of the best-known examples is the Romanesque west tympanum of Autun cathedral, signed by the sculptor Giselbertus. But in northern Europe at least the social status of the artist remained fairly low. It was not for him to assert that he belonged to a different category from the rest of humanity, nor to seek in any way to disturb the social structure.

THE RENAISSANCE

The place where the situation first began to change was Italy. Here the control of the guilds seems always to have been fairly weak, so that artists enjoyed a freedom to experiment not always available to them elsewhere. Indeed, they were encouraged to seek for new ways of doing things by the intellectual curiosity which early began to characterise the Italian city states, just as it had been typical of their predecessors in classical Greece.

A key figure in the revolution which overtook Italian art was Giotto (c. 1267–1337). It is not the least significant thing about him that he is mentioned with respect in Dante's *Divina Commedia*, written at the same epoch. As the reference indicates, the professional painter was beginning to emerge from the shadows, and to assert himself as an innovator capable of altering men's perception of the world. What Giotto did, in a technical sense, was to find the means of translating the already grand and classical work of contemporary Italian sculptors, such as Nino and Giovanni Pisano and Arnolfo di Cambio, from three dimensions into two. He created convincing pictorial spaces, inhabited by figures which have their own solidity. But Giotto did more than this; he also made art into a more efficient instrument of communication, especially in terms of narrative, than it had ever been previously. His personages move like **Me 8**

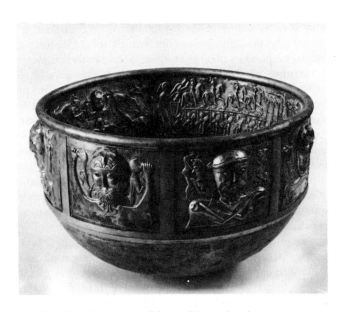

17. **The Gundestrup cauldron**. Silver-plated copper. 1st century BC. This bowl was discovered in a bog in Denmark in 1891, and is richly decorated with scenes and figures relating to Iron Age Celtic mythology. It is a fine example of the metalworking skills flourishing in ancient Europe.

actors on a stage. Their expressions and gestures convey unmistakable meaning. We have come a long way from the narrative impotence of Palaeolithic art.

The change which Giotto initiated did not, however, complete itself until the 15th century. In order to understand its full consequences, we must look at the life and work of another great artist, but this time one from the north—Albrecht Dürer (1471–1528), whose life marks more clearly than that of any other individual the transition from the Middle Ages to a way of thinking which resembles our own. He was the son of a goldsmith, and after studying with his father was apprenticed in the traditional fashion to Michael Wolgemut, then the leading painter in the city of Nürnberg where he was born. After completing his apprenticeship, he set out on the travels which were then customary for a young journeyman, and which were undertaken both to allay the restlessness of youth and as a means of broadening his experience as a craftsman. Dürer acquired a taste for travel which he never afterwards lost. Though he continued to base himself at Nürnberg, his travels took him twice to Italy, where he came into contact with some of the leading Italian artists of the time, and later to the Netherlands. His travels endowed him with a keen awareness of the natural world, and also with a changed conception of the artist's role within it. He began to feel that the creative power of art was an aspect of divine creativity and that the artist, in consequence, belonged to a different order of being. Yet this proud assertion of the rights and status of the artist was increasingly shaken by doubts which were prompted by the religious crisis which engulfed Europe during Dürer's lifetime. Dürer became preoccupied with the new religious doctrines associated with the name of Martin Luther, and eventually became a whole-hearted convert to

Lutheranism. This conversion had direct practical consequences—Dürer, like the other artists of his epoch, had been accustomed to earn his living as a religious painter. Now he was cut adrift from traditional formats and the career framework which traditional patronage supplied. But there was more to it than this. Lutheranism on the one hand, and intimate contact with Italian humanism on the other, had the effect of pushing Dürer towards ever greater self-consciousness concerning the artist's role. He separated himself from the world of craft in which he had (quite literally) grown up, and was forced to reconsider the fundamental basis of his own activity.

The next stage in the process initiated by Dürer is represented by the career of Michelangelo (1475–1564). Though only four years younger than Dürer, Michelangelo seems to belong to a later generation because he was so long-lived. In old age he was revered by a circle of contemporaries which included Giorgio Vasari as a being who possessed powers which seemed to pass well beyond what normal men were capable of. In Vasari's phrase, Michelangelo was 'acclaimed as divine'. The fact that Michelangelo often failed to complete the ambitious enterprises he undertook was sometimes due to adverse circumstances beyond his own control, but it also had something to do with his own temperament: something he had in common with his Florentine contemporary, Leonardo da Vinci (1452–1519). This failure to reach a conclusion became part of the artist's legend in each case, and tended to redirect attention away from the finished work of art and towards the process of making it, which was increasingly envisaged as a struggle undertaken by the creative artist not only against outside circumstances, but against adverse forces within himself. 'Michelangelo used to say,' Vasari reports admiringly, 'that if he had had to be satisfied with what he did, then he would have sent out very few statues, or rather none at all.'

The four centuries from the sixteenth to the nineteenth saw a gradual change in the social status of the artist. Some exceptional individuals, such as Titian (c. 1490–1576) who was ennobled by the Emperor Charles V, and Rubens (1577–1640), knighted by James I of England, provide striking examples of the upward mobility which was now conferred by exceptional artistic talent especially when, as in Ruben's case, this was accompanied by exceptional gifts as a courtier and diplomat. But the upward movement was not universal, and ambitious artists had to struggle hard to achieve the secure position as members of the upper reaches of the professional class which was at long last achieved by great Victorian Academicians such as Lord Leighton (1830–96) who in the last year of his life became the first English-born artist to be accorded a hereditary title. Only as this late date can the artist be seen as having finally made his escape from the artisan condition to which medieval society had implicitly consigned him.

There was also, however, another way in which attitudes towards the artist altered—a change which encompassed both society's attitudes and the artist's own judgement of himself. Certain Renaissance painters are reported as having displayed strongly neurotic symptoms. Among

Re 62

Re 49

them were Uccello (1396/7–1475) who, after the sculptor Donatello had condemned one of his paintings, 'shut himself up in his house and devoted all his time to perspective, which kept him poor and secluded till the day he died,' (Vasari) and the Florentine Mannerist Jacopo Pontormo (1494–1556), whose surviving diary documents his timorous and introspective temperament. It was not, however, until the beginning of the seventeenth century that there appeared the *artiste maudit*, totally at odds with the society who surrounded him. The most famous example is Caravaggio (1571–1610), forced to flee from Rome in 1606 after killing his opponent in a brawl—the last of a long series of incidents involving quarrels and violent assaults; and another is Salvator Rosa (1615–1673), whose self-consciously farouche demeanour contributed no little to his reputation with contemporaries. These were among the first artists to put themselves deliberately at odds with the society in which they lived.

At about the same time there appeared the first group of artists whom we should now recognise as 'bohemians'—that is, as the inhabitants of a society, within a society, obedient to its own unconventional rules. These were the Dutch and the Flemish artists who flocked to Italy at this period, and particularly to Rome, where they formed a community quite separate from the rest of the population of the city. They set up a *Schildersbent* (fraternal organisation) as a focus for their activities, and initiation into this was marked by riotous ceremonies, involving a mock baptism which eventually attracted the condemnation of the Church. These Netherlanders were the direct forerunners of the '*vie de Bohème*' which was later to be immortalised, first by Mürger's novel, and later still by Puccini's opera, which between them fixed once and for all a certain image of the way in which artists choose to behave.

ART IN A SECULAR SOCIETY

It is no accident that the rise of self-consciousness in art coincided with the onset of the Reformation. As Dürer's case demonstrates, this did not merely bring with it a change of religious belief—a change important enough in itself because of the emphasis it put on a man's responsibility for finding his own salvation. It also heralded an ever-increasing secularism. The appearance of the cult of the genius (which of course extended to practitioners of all the creative arts) is significant not merely for its own sake, but because it represents an attempt to find within man himself powers which had previously been thought of as purely external, as part of a divine will which commanded all men without exception. We can perhaps define the difference by reaching back beyond Christianity and considering the case of the Greek philosopher Socrates. Socrates did not see himself as a genius in the modern sense—that would have been alien to his whole framework of ideas. He did acknowledge, however, the occasional prompting of some external power, a genius or tutelary spirit, whose purpose was to protect him against wrong actions. Asked, when he had been condemned to drink hemlock by an Athenian court, whether this tutelary spirit had not misled him in

some way by failing to warn him that if he continued to pursue a certain course of action his life would be forfeit, Socrates replied in effect that, since he had in fact received no warning, his death must be for some higher good.

Genius as it was defined by the Romantic movement in the arts has active, not passive connotations. It regards the arts as providing proof that man can sometimes, on some occasions, reach out beyond the limits set for him both by reason and by the physical laws of the universe. Works of art therefore become certificates of these powers and take on a numinous aura on that account. The numinous spirit with an early medieval artwork such as the Gero Crucifix is not inherent in the object itself, but arises from the way in which it both expresses and embodies a whole system of belief. The mysticism we may discover within a painting by Mark Rothko (1903–1970) arises only from the object itself and our knowledge of the man who painted it. Nevertheless it is legitimate to regard a modern painting of this sort as being in its own way an icon—a point of focus for a new and very different kind of transcendental belief. In that sense, the development of the secular spirit has finally tended to bring the wheel full circle.

Rothko's mystic abstractions are only one expression of the contemporary spirit. One of the ways in which the art of recent decades differs from everything which has preceded it is in its pluralism both of sources and of aims, which goes a long way beyond anything we might recognise among the Hellenistic Greeks. As this volume demonstrates, western European art, for all its variety, seems to flow along a single broad current of development until it reaches the closing years of the nineteenth century. It was only then that certain disturbances began to make themselves felt, finally erupting in the huge psychic explosion which we call Modernism. A contributory factor to this explosion was the input from exotic and primitive cultures which is clearly manifest in the Tahitian paintings of Gauguin (1848–93). Before this, when European culture absorbed influences from elsewhere, as it did for example during the eighteenth-century vogue for chinoiserie, it did so in a spirit of playful self-confidence.

Increasingly, since Gauguin's day, the European consciousness has expanded to encompass kinds of art quite alien to the European spirit, which ask to be judged by their own standards. At the same time, there has been a huge expansion of our historical consciousness—the rediscovery of Palaeolithic art provides an especially striking example, but in fact this whole volume is a monument to a process which has completely altered our attitude towards art. No one rigid system of aesthetics or philosophy is wholly adequate to explain the mass of information we now possess about man's activity as an artist, even if we confine our studies to Europe alone. And it is here, perhaps, that one finds the real value of an omnibus volume of this kind—in the challenge which it necessarily offers to rigid attitudes, and in the opportunity it affords to make comparisons between many different kinds of object, created for many different reasons, but all still to be described by the single syllable 'art'. The modulations and fluctuations of meaning within that word are the true subject of this book.

THE CLASSICAL WORLD

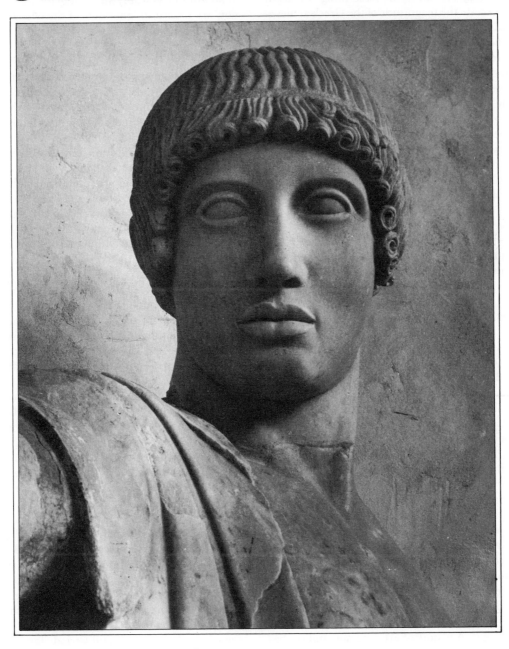

Introduction

The numbers in the margins refer to the illustrations to The Classical World: heavy type for colour plates, italics for black and white illustrations.

It takes less effort of the imagination to picture a Greek statue, or a Greek temple, than works of art of any other period, and the very familiarity of these things makes it difficult to appreciate the magnitude of the Greek achievement. We need to remind ourselves constantly that it was the Greeks who discovered the methods of representing man and nature in sculpture and painting which we accept as natural, and that very often when we observe in the history of Greek art some vital step towards the understanding of the human body, of the rules of perspective, of modelling in colour and so on, we are observing something which is happening for the first time.

'Classical' is a word that has many meanings. In the present context it means, broadly speaking, Greek and Roman, one of its most widely accepted senses. But when we speak of 'Classical' art we mean much more than the artistic output of the Greeks and Romans. We imply an ideal. The Greeks of the 5th century believed that the highest aspirations of the spirit could be expressed in a perfection of human form based upon harmony and proportion; that perfect humanity implies the perfection of a universal order. The classical spirit and the classical tradition in art survived as long as something of this ideal, this fundamental belief in humanity, remained the source of inspiration, and all subsequent classical revivals have tried to recapture it.

This Part is concerned with a very long period of time; three thousand years from the 3rd millennium BC to the 4th century AD. Its theme is the origin and development of Greek art and the spread of the Greek tradition. Every part of this long period has its own contribution to make. There are of course periods when the creative stimulus was strongest, but, from the point of view of western art and indeed of western civilisation, the whole development of the classical tradition from its beginnings right through to late Roman times is of vital importance to us. This Part ends in the 4th century AD, not because the classical tradition was dead but because the Christian faith, while continuing to draw inspiration from pagan artistic traditions, introduced into art fundamentally different conceptions of truth and beauty.

The aim here is to provide an outline account of classical art in terms of the history of the time and, by explaining the circumstances in which the art was produced, give a basis for understanding it. A history of art need not, and probably had better not, attempt to pass judgement upon it. Nor does it offer objective standards of judgement. It can, however, discourage false standards by stressing the different aims and ideals of different periods and the circumstances in which the works of art were produced. The art of the Greeks from the 8th century BC seems, at first sight, to show an apparently simple, logical, and, indeed, inevitable development towards naturalism. It seems easy to divide into periods of preparation, high achievement and decline; some think of an archaic statue as less developed and therefore inferior to a 5th-century figure. The sculptures

7
24

of the great temple of Zeus at Olympia have been called crude, the Laocoon group judged the greatest sculpture of all antiquity. Many such judgements, whether valid or not, are passed in ignorance of the whole development of classical art.

15
42

OUR KNOWLEDGE OF CLASSICAL ART

In fact, it is only since the 19th century that a reasonably complete picture of classical art has been possible. With the collapse of the ancient world, most of the great masterpieces of painting and sculpture were lost and they will never be recovered. Bronzes were melted down, paintings destroyed, marble sculpture burnt for lime; the great buildings survived only because they could be put to new practical uses. A thousand years later the Italian Renaissance found inspiration in antique art and began to study it. Artists and writers found everything in antiquity excellent and perfect, but the classical art they knew was a very little part of the whole, and without the Greek background they could hardly judge the merit, and certainly not the originality, of the Roman works they did see. In the 18th century the scientific study of classical art was inspired by the great Winckelmann, but he knew no original Greek masterpiece, no single work of the archaic period, and could not yet master the chronological sequence of the surviving pieces. Few today would share the unqualified praise he gave to the first statues recovered from the buried town of Herculaneum in 1711, or accept the judgement of his contemporary, the Marchese Venuti, on a painting of Theseus and the Minotaur from Pompeii as 'the loveliest thing in the world, much more beautiful than the work of Raphael'. The marbles, as we now know, were mechanical copies of Greek works, and the wall-paintings made by artisans inspired by masterpieces of the past. We cannot share with the 18th century this wholehearted admiration for the 'Greco-Roman' schools, because since the 19th century the excavation of Greek sites has given us a more thorough picture of the development of art and architecture in classical lands. And yet it must be remembered that this picture remains a very partial one. The position is still that we have only two or three works by sculptors who were famous in antiquity, and that we cannot enjoy a single famous painting. It is true that we know something of them from copies made in Roman times, but the copy is no real substitute for the original. There are still periods for which our knowledge of artistic development is slight, and for which the evidence is likely to remain poor. After Pompeii, for example, the surviving examples of Roman decorative painting are meagre. New discoveries, of course, continue to be made for all periods, and will improve the knowledge we have at present.

The Character of Greek Art

The place of art in the life of the Greeks, at least until the Hellenistic period, was very different from our own. Early Greek art always had a practical purpose, whether to adorn the temples of the gods or to decorate a pot. At all levels of activity, the artist was looked upon as a useful member of society who was respected for his skill as a craftsman. Art was a completely professional activity in the best sense of the word, and because it maintained a generally high level of craftsmanship, Greek art seems to throw up masterpieces, and certainly works of immense skill, at a comparatively humble level—a superbly drawn picture on a vase, an exquisite figure on a bronze mirror. The craftsman underwent a long training in the workshop of his master, and this, no doubt, does much to explain the strongly conservative character of Greek art as a whole, and the fact that a limited number of themes in sculpture, painting and architecture underwent comparatively little change over a long period.

But although, as we are often reminded, the Greeks had no word for *art* as opposed to *craft*, they recognised that great art is much more than a distinguished example of technical skill, and that it owes its greatness to the creative power of the artist. The sculptor Pheidias, in his statues of the Olympian gods, was held to have added something to the Olympian region; Polykleitos to have incorporated art itself in his statues of men. In the 5th century BC it was believed that the purpose of art was to edify, to create perfect forms of men and gods, and to illustrate the noble themes that expressed the triumph of Greek civilisation over barbarism. The ancient world believed that Greek ideals, based on the concept of perfect form, had been completely achieved in the second half of the 5th century BC. The Parthenon was surely the greatest of Doric temples; the work of the 5th-century sculptors showed the perfect harmony of ideal form and nature in the representation of the human figure.

The 4th century, and the Hellenistic period that followed, changed the whole character of Greek art. While recognising the unapproachable perfection of the 5th-century ideal, it turned its attention to aspects of art that had been neglected. If it criticised earlier art, it was for its lack of variety, and it ranged for inspiration over the whole field of nature and humanity, and began to treat themes which had either been deliberately ignored or never approached in the earlier period. The rise of portraiture is the most obvious example of this new development, but the period also gave rise to all the *genres* of painting and sculpture which are now part of western artistic tradition, and to the full development of techniques. The conditions of the time, whereby the artist could travel widely and find employment with rich patrons over the vastly enlarged Greek world, gave new opportunities for the spread of ideas and techniques. The respect for the past also gave rise to our modern conception of a 'work of art', that is to say, of a work which is respected not for any practical reasons but solely for its beauty and fame. We find the Hellenistic kings

building up art collections as such; the kings of Pergamon in the 2nd century BC had copies made of famous 'masterpieces', and paid enormous sums for Greek paintings. Two distinct traditions began to form; a living tradition, which carries on the story of classical art, tackling new problems and subjects and developing new techniques, and a 'classicising' tradition, which looks back to the art of the 5th and 4th centuries as a direct source of inspiration.

GREEK ART AND THE ROMANS

The Romans in the 2nd century BC inherited the artistic patronage of the Hellenistic kings. As their enthusiasm for Greek art developed, the two traditions became clearly and firmly established. On the one hand, as 'connoisseurs' of the antique they collected originals of the famous masterpieces and encouraged new and flourishing schools of copyists; in this direction they called for almost nothing new, except eclectic works which combined the most popular features of a number of favoured schools. On the other hand, they, like the Hellenistic kings, gave their patronage to Greek artists and craftsmen who were to carve statues, paint pictures and erect buildings in Rome and Italy. At first their patronage was given with a sense of guilt, which gets its positive expression in the attitude of such Romans of the old school as Marcus Porcius Cato the censor, who led the attack on luxury and the taste for things Greek. But under the Emperor Augustus came the full rapprochement between the traditionally Roman ideas and Greek art. Just as Virgil's *Aeneid* is a Roman epic for all that much of its inspiration is Greek, so the *Ara Pacis* is a Roman monument though it sculptors and much of its style was Greek.

The choice of the philhellene Romans ensured the survival of the Greek artistic tradition through the period of the Empire. Nor indeed should we underestimate the power of the Romans to develop and add to that tradition. We have to acknowledge that it is to the Romans that we owe not only a great part of our knowledge of Greek art, but the creation of a 'classical tradition' in art. The buildings and the sculptured monuments of the Empire are far different from those of the Greeks, but they make creative use of Greek motifs and, at least until the end of the 2nd century AD, the Romans maintained a wholehearted respect for Greek form in sculpture and painting. From the first we see important differences of taste between Greek and Roman, and as the Empire progresses, there appear new ideas, religious and artistic, which are directly opposed to the classical. The conflict between classical and anti-classical modes of representational art in the late Empire forms a fascinating study. The anti-classical triumphs in the Byzantine style, but the classical survives as a source of inspiration and triumphs again in the civilisation of the Renaissance in Italy.

Historical Outline

BRONZE AGE CRETE

The first flowering of civilisation in Greek lands took place in Minoan Crete, the Crete of the legendary King Minos, whose rediscovery is the achievement of our own century. The understanding of metals, reaching the Aegean from the Near East, made this civilisation possible, and it flourished from the 3rd millennium BC until about 1400 BC. About 2000 BC, the lords of the Minoan cities built large palaces in several places on the island, the best known being the great palace of Minos at Knossos. Their wealth and prosperity provided the resources for monumental building and creative artistic achievement, which finds its best expression in colourful decorative painting, lively and naturalistic sculpture on a small scale, exquisite work in gem-engraving and precious metalwork.

THE MYCENAEAN GREEKS

About the same time that the palaces were built in Crete, the first Greek-speaking people arrived on the mainland of Greece. By about 1600 they, too, had become powerful and wealthy; the first manifestation of what we call Mycenaean culture is seen in the lordly burials of the so-called Shaft Graves of Mycenae, excavated by Schliemann in the late 19th century. Mycenaean civilisation was far different from Cretan. Mycenaean sites are strongly fortified citadels ruled over by feudal lords. Their architecture had little in common with that of their Cretan neighbours, but for the arts of painting and sculpture the Mycenaeans turned to Crete. Cretan artists decorated the halls of their palaces, made vases and other objects of luxury. By 1400, it seems, the Mycenaeans had conquered Crete, usurped its power in the Aegean, and asserted their influence over the whole Mediterranean world. During the most flourishing period of Mycenaean power, from 1400–1200 BC, tendencies in their art and certain specific art-forms seem to have an unequivocal connection with Greek art in its later phases. There are definite connections between later Mycenaean architectural designs and the buildings of classical Greece, and perhaps some positive signs of the emergence of new artistic ideas in painting and sculpture. But all this was cut short by the collapse of the Mycenaean world in the 12th century, and there followed a period of poverty and obscurity that is known as the Greek Dark Ages.

THE DEVELOPMENT OF GREEK CIVILISATION

During the period of obscurity the historical Greek world took shape. The destruction of the Mycenaean towns and citadels is associated with an invasion from the north—the Dorian invasion—of further Greek-speaking people. This invasion, which destroyed Mycenaean culture, also produced large-scale migration of Greeks from the mainland across the Aegean Sea to found the later Greek cities on the coast of Asia Minor and establish the pattern of settlement there in historical times. Although all the luxury arts ceased in the Dark Ages, there was a continuous tradition of decorated pottery which is also our principal historical docu-

ment for the period. The 'proto-geometric' style of pottery-decoration seems to have originated in Athens around 1000 BC, and is characterised by abstract ornament, consisting of carefully organised geometric patterns, which forms the basis of the subsequent development of Greek art.

When the feudal system of the Mycenaean world came to an end, the geographical divisions of the Greek mainland asserted themselves, and gave rise to the kind of community we call the city-state and the Greeks themselves called *polis*, an urban centre controlling a surrounding countryside enclosed in the mountains and high hills that divide the country. Royal government gave way to aristocracy, and by the time the Greeks re-emerge into history all the essential conditions of Greek life are there. The links with the Mycenaean world are strong. The Greek epic, which was to be a main source of inspiration for Greek art, had descended through the centuries, and the Olympian religion had taken shape as the communal religion of the city-states.

By the 8th century BC the Greek city-states, ruled over by hereditary aristocracies, had recovered much of their prosperity, and began a period of expansion by trade and colonisation in the Mediterranean. With increased wealth and prosperity came the first attempts at monumental art; the enormous funerary vases of the developed geometric style in Athens, the movement towards temple-building, and very soon the making of large cult-images of the gods. In the late-geometric style the human figure again became part of the repertory of representational art, and there are narrative scenes which seem to be inspired by Homeric epic, themes which run right through the history of classical art. From this time onwards the development of classical art is clear and continuous.

THE GREEK EXPANSION

This development is strongly conditioned by historical circumstances. In the 7th century Greek trade and colonisation brought the city-states into close contact with the civilisations of the ancient east. In Egypt, Greeks saw the gigantic temples and cult-images of the Pharaohs, and their earliest large-scale statues made about the middle of the century were chiefly inspired by what they saw. So thoroughgoing is the influence of oriental art in this period, that the phase of Greek art which follows the geometric of the 9th and 8th centuries is normally called the 'orientalising'. But oriental themes were not merely adopted into Greek art; they were adapted into a living and developing tradition.

Commercial prosperity created problems for the governing aristocracies of the Greek cities. It produced a class of rich merchants important to the well-being of the state, but lacking a major voice in its government; the peasant-farmer, too, was often discontented. Conditions were thus created for revolutionary activity which, in fact, happened in most of the city-states during the 6th century. Throughout the early archaic period the wealthy aristocrats were the chief patrons of the arts; in the revolutionary period

their place was often taken by the 'tyrant', a man, generally from the ranks of the rich merchants, who rose to power by championing the discontented elements in the city-states. The Athens of Pisistratus, one of the most famous of these tyrants, was rich and colourful; a tremendous stimulus to artistic achievement was given by the court of this tyrant, producing conditions which we do not meet again until the court patronage of the Hellenistic kings.

THE CITY-STATES

Tyranny was succeeded in many city-states by a form of democracy, such as that which ruled Athens during her period of greatness in the 5th century. The Athenian democracy was established at the end of the 6th century, and it was under this form of government that she made her contribution to the combined effort of the city-states against the invasions of the Persians. The result enormously increased her prestige and gave her the leadership of the alliance designed to protect the Greek cities, especially those of the Asiatic coast and the islands, against Persian power. The Persian wars also provided the complete break with the traditions of archaic art. There is no greater contrast than that between the decorative prettiness of the figures of maidens dedicated on the Acropolis in the last years of the 6th century, and the severity of the sculptured female figure of the years that followed the war. The self-confident ideals of the city-states, now the chief patrons of the arts, find their greatest expression in Pericles' ambitious building projects on the Acropolis at Athens.

The Peloponnesian War destroyed the city-states, breaking their political vigour, undermining the faith in the old gods, encouraging individualism and private luxury. Whereas the art of the 5th century seems an expression of the whole society in which it was created, and the artist a willing servant of its religious and social life, the aims and ideals of the 4th century are less clearly defined. The limited perfection of ideal form achieved in the 5th century fails to satisfy, the Olympian religion ceases to inspire. The gods of Praxiteles shed their majesty and become elegant and human creatures. Increasing individualism is reflected in the rise of portraiture. The economic decline of the city-states persuaded more Greek artists to find work abroad among the wealthy barbarians on the fringes of their world. The artist no longer worked for the small communities of Greece, but travelled widely. His independent status was increasingly recognised by the patrons of the day. Although major works of art were still largely financed by the state, few large building schemes were carried out in Greece itself.

THE HELLENISTIC WORLD

From the middle of the 4th century, the kingdom of Macedon under Philip and his son Alexander became the centre of Greek culture. Macedon emerged as the champion of the city-states, against the will of most of them, and Alexander's conquests in the east opened up a new world to Greek civilisation. Alexander's dreams of a cosmopolitan Greek culture were never achieved, but the world of his successors was vastly more cosmopolitan than that of the classical Greeks. The new kingdoms of the Seleucids in Syria and the Ptolemies in Egypt were founded in eastern countries and the semi-Hellenised rulers held sway as far afield as India. Hellenistic art takes much of its character from this new situation. Art is again placed at the service of private patronage, and in the process becomes largely divorced from religious and political life. Great political events can still inspire grandiose artistic schemes, but, in the main, the artists' themes are secular and often personal, they go their own way, developing new techniques and searching for themes among all races and ages and from the whole range of human emotions.

THE RISE OF ROME

By the 2nd century BC Rome had asserted her rule over most of the Italian peninsula. The defeat of Carthage in the Second Punic War brought her into increasingly close contact with the Hellenistic kingdoms and, one by one, they succumbed to her power. By the time of Augustus the Romans had built up an empire stretching from Spain to Syria, controlled by a uniform system of government which survived for 300 years. In the history of art, Rome's enthusiastic adoption of Greek art is an event of the utmost importance. The Greek colonies in South Italy and Sicily and the philhellene tastes of the Etruscans had already laid the basis for the spread of Greek culture; and the Roman Empire, backed by a strong system of government, further extended it over large parts of Europe previously untouched by its influence. It brought the civilised world very close to the dream of cosmopolitan Greek culture conceived by Alexander the Great. The Romans ensured the survival of the Greek tradition, and it is the measure of the strength of that tradition that Christianity, originating among the Jews of Roman Palestine, developing under the influence of oriental mysticism, and violently protesting against pagan ideals, yet continued to draw inspiration from pagan art.

The Bronze Age

THE BRONZE AGE AND HISTORICAL GREECE

Books on Greek art do not always include the Bronze Age, and some still deliberately and firmly refuse to take it into account. The art of Minoan Crete seems at first sight so alien to that of the historical Greeks that the recently expressed view that 'European pictorial art begins with the Minoans' seems completely indefensible. For the moment we may leave this question aside. Nowadays, the study of the Bronze Age as a prelude to classical art seems, in any case, inevitable. Since Schliemann excavated at Mycenae at the end of the 19th century, the historical basis of the heroic age of Greece has been accepted as fact, and that heroic age provided the subject-matter for a great part of Greek art and literature. Since the 1950s, when Michael Ventris deciphered the script known as Linear B found in Crete and Mycenaean Greece, and established that the language is an early form of Greek, the student of classical Greece has to take his studies back at least to that time when it is believed that the Greek speakers first entered Greece, say about 1900 BC. And since archaeological discoveries in the Aegean area have shown the close connections between the art and civilisation of ancient Crete and that of the Mycenaean Greeks, we are almost forced to take up the story at that point when the civilisation of ancient Crete began to flourish.

THE ORIGINS OF CRETAN ART

Before the introduction of metals into Crete, the island was inhabited by people at the neolithic level of civilisation, living in agricultural communities. Art of a simple kind already had its place; pottery in everyday use was decorated with incised patterns, clay figures of humans and animals were being modelled by primitive artists. The introduction of metals about the middle of the 3rd millennium BC, began to transform the agricultural communities. Crete lies in a favoured position for trade with the eastern Mediterranean, from which the knowledge of working metals came. Egyptian influence is apparent in Crete from an early period and there are contacts, too, with the islands of the Cyclades and with Anatolia. Ivory scarabs and figures closely modelled on Egyptian prototypes have been found on the island, and some of the pottery forms seem to derive from Anatolia. Cycladic imports include the marble idols characteristic of the early Bronze Age in the Aegean. These idols reduce the human figure to a simple formula which makes a striking contrast with the spontaneous attempts at naturalism in neolithic figures, and it is surely significant that they are confined to the Aegean area, where many years later Greek art was to find its basis in a similar approach to the problems of representing the human figure.

Despite the strong foreign influences, Cretan art in this early period begins to show its own individual character. Decorative motifs, such as running spirals and meanders, increase the repertory of neolithic ornament on the early painted pottery, and one begins to appreciate the keen decorative sense of Cretan artists and their imaginative synthesis of form and decoration. The early figurines of clay and other materials are simple in form and structure, but already show a strong interest in movement and gesture. The favourite subjects for small-scale terracottas are animals and worshippers, male and female; the humans are already dressed like the Cretans we know from the later paintings and sculptures.

THE PALACES OF CRETE

By about 2000 BC the pattern of developed Cretan civilisation had taken shape. At this time the country seems to have been controlled by a number of powerful rulers, who built themselves the palaces which have become known to us as the result of excavations in this century. The Palace of Knossos was first built in this period, those of Mallia and Phaistos are not much later. Sir Arthur Evans, who first excavated and recreated Knossos, called the Bronze Age civilisation of Crete Minoan, after the legendary King Minos who ruled there. The Minoan palaces went through a long history of building and reconstruction from 2000 BC onwards, and their earliest form is not well known to us. But it seems that from the first they were planned on a fairly grand scale, and that the big central courtyard around which the buildings were grouped, at first perhaps in isolated blocks, is an original feature. They were well built of solid masonry, and probably made use of columnar architecture to support the roofs.

There is no major art of painting and sculpture associated with the palaces in their earliest form. The Minoan pottery of this period, however, is some of the most attractive that has survived from the ancient world, and the most imaginative in design. A variety of colours—orange, red, yellow and white—are used on the dark body of the vessel; the motifs are either patterns of purely abstract character or are based upon plant life. These versions of plant life, although they do not imitate nature, imply a keen understanding of its forms and they are applied quite brilliantly to the shapes they decorate. The big jar illustrated in plate 10 is exceptional in that a representation of a fish is used as a principal decorative motif; the strange bubble-like motif that seems to issue from the mouth of the fish has been variously interpreted in terms of nature, but it illustrates best of all the rich imagination of the Minoan decorative sense in this period. As time goes on there is a tendency to imitate nature more closely, and some of the seal-engravings, which are among the finest survivals of Minoan art, begin to show the lively naturalistic style that is associated with the great period of Minoan art.

THE LATER PALACES

Major rebuilding of most of the Cretan palaces around 1650 BC, after a catastrophe on the island, gave them the form in which we seem them today. At Knossos, Sir Arthur Evans made a brave attempt to recreate the appearance of certain parts of the palace, replacing lost wooden columns with concrete ones, rebuilding rooms, staircases and light

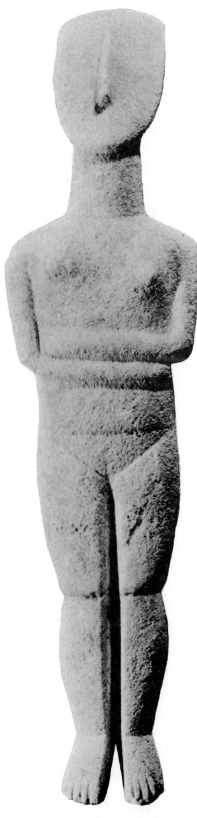

1. **Cycladic idol**. 3rd millennium BC.
Marble. h. 19 ¼ in. (49 cm.). British
Museum, London. One of a large number of standing nude female figures made
in the islands of the Cyclades.

wells. Fragments of paintings found in the excavations were used to reconstruct the schemes of decoration on the walls; the total effect now is of a ruin which seems to be both ancient and modern at the same time. If you visit Knossos today it is an unforgettable but perplexing experience. You wander along corridors and from room to room without seeming to recall a stopping point; everywhere you see signs of comfortable, even luxurious, living, and relics of a courtly and religious life that is still hardly understood. The grand rooms of the state apartments on the west side of the courtyard have largely disappeared, except for some of the ground plan reconstructed by Evans; it is only on the east side, in what is believed to be the private apartments of the palace, that the pillared halls, the columned staircases, the light wells have been completely reconstructed. It is all a very far cry from the Greek world; only occasionally does the student of classical architecture feel at home with the reconstructed wooden columns, with their crowning members that seem to have something in common with the classical Doric. The wall paintings that decorated the rooms of the palace are our closest contact with the people who lived there. In the so-called Throne Room attempts have been made to reconstruct a complete decorative scheme from surviving fragments; similar attempts were made by Evans in other parts of the palace. These paintings give us some insight into the courtly life, the games and rituals of the people but they have come down to us in a tantalisingly fragmentary state.

CRETAN WALL-PAINTING

The techniques of wall-painting became known in Crete from Egypt and the eastern Mediterranean, but the Cretan paintings, most of which date from the period between 1600 and 1400 BC, are very different from Egyptian work. The techniques in use include painted stucco relief and true fresco-painting, that is, the application of colour to the plaster surface of the wall while it is still damp. The colours used have a limited range; strong reds, blues, greens and yellows are favoured. In scale the pictures range from the monumental to the miniature.

Among the earliest paintings, dating from about 1600 BC, is part of a room decorated with garden scenes in a villa **11** at Amnisos on the coast, not far from Knossos. Three white lily flowers growing from a calyx of leaves are combined into an attractively simple design, that shows the same keen sense of decorative stylisation based upon natural forms that we have seen in earlier Cretan pottery. The most remarkable achievements of Cretan painters at this time are their attempts at vivid illustration of the world of men and nature. Their technique is limited, their range of colour small, their art lacks understanding of the principles of illusionistic painting. Their conventions are simple: man is red, woman is white. Figures, drawn with hard outlines and coloured with flat washes, are shown in profile, or awkwardly combining profile head and frontal body with profile legs. Yet, when they want

A. Plan of the Palace at Knossos.

1 West Porch

2 Corridor of the Procession

3 South Propylon

4 Central Court

5 North Propylon

6 Pillar Hall

7 Throne Room

8 Grand Staircase

9 Hall of the Colonnade

10 Hall of the Double Axes

11 Rooms of the Queen's Megaron

to show action, the artists can do it with a spontaneous liveliness that is wholly convincing. Their studies of nature are keenly observed. It is an art which seems to be trying to run before it can walk, yet nothing seems to be beyond it. The fragments of a bull's head, over life size, from a painted relief that once decorated a loggia by the north entrance to the palace at Knossos is a brilliant study of the charging animal. In a scene from a painting in the miniature style, groups of spectators in an olive orchard are watching a festival of dancing, and here the artist adopts a racy, almost impressionistic use of colour to suggest the massed spectators. The achievement of Minoan painters during this period can be best appreciated if we compare their work with the representational art of the Greeks in the 6th century BC.

CRETAN SCULPTURE

The sculpture contemporary with these wall-paintings shows the same fine command of naturalistic detail and movement. The bull's head vase, or *rhyton*, of black steatite from Knossos is carved with absolutely confident three-dimensional plasticity; an ivory figure of an acrobat from Knossos gives a wonderful portrayal of vigorous movement. On the well-known Harvester Vase from Hagia Triada, we find a clever study of the faces of the singing harvesters and a keen understanding of movement. Some of the most remarkable Cretan relief-work is to be seen on the two gold cups decorated with repoussé, which were found in a Tholos Tomb at Vaphio, in the Peloponnese, but are certainly Cretan work of the 15th century BC. A detail of one of these cups shows a striking scene where a bull has charged a hunter and a huntress, hurling one of them into the air. We shall not find a more effective rendering

of violent action in the whole history of classical art. Figures like the faience Snake Goddess from Knossos adopt a more simple representational formula, but the artist brings the same keen observation of nature and love of precise detail into his work.

LATER CRETAN PAINTING

The 'naturalistic' phase of Cretan art was short-lived, perhaps inevitably so. The potters of this period tried to apply the varied forms of nature to the decoration of the vessels, and were most brilliantly effective in the so-called 'marine style' illustrated by the Octopus Vase. By about 1450 there are strong signs of new artistic influences in the pottery of Knossos. Vessels of the 'Palace Style' show a renewed attempt to reduce the world of nature to order and decorative symmetry, and, although the technique is different, the effect brings us back to something much closer to the early styles of Cretan pottery. The influence of Egyptian representational art shows more strongly in the later fresco-paintings, especially the processional scenes. There is a stiff formalism in the ritual scenes painted on the famous alabaster sarcophagus from Hagia Triada, which belongs to the 14th century BC. The artists were clearly giving up their attempts at free imitation of nature; the age of Cretan naturalism was over.

The appearance of new artistic tendencies in Knossos around 1450 BC has been associated by some archaeologists with the arrival of Greeks from the mainland. Archaeological discoveries lend their support to this view, and in the graves of the period there is evidence for the presence of a more warlike people, such as we know the Mycenaean Greeks to have been. On one of the well-known vases of the 'Palace Style' there appears one of those boar's tusk helmets that are characteristic of the armour of the Myce-

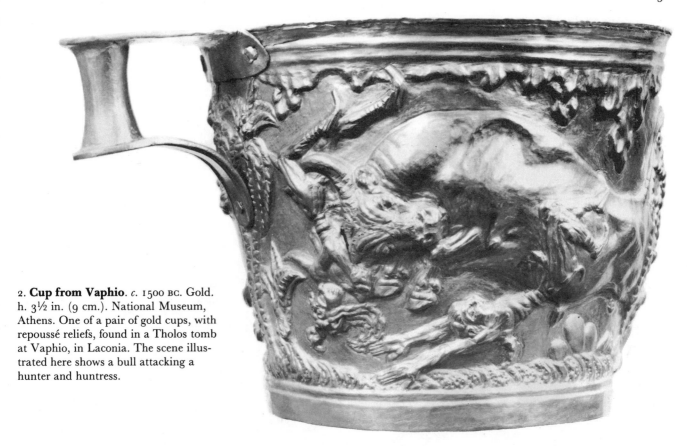

2. **Cup from Vaphio**. *c.* 1500 BC. Gold. h. 3½ in. (9 cm.). National Museum, Athens. One of a pair of gold cups, with repoussé reliefs, found in a Tholos tomb at Vaphio, in Laconia. The scene illustrated here shows a bull attacking a hunter and huntress.

naeans. Not long after the supposed appearance of the Mycenaeans, the palace of Knossos was destroyed—according to the still prevailing view, around 1400 BC. At this point we must turn from Crete to the mainland of Greece and consider the earlier development of the people of the mainland who, it seems, had usurped the power of the Minoans in the Aegean world.

THE EARLY BRONZE AGE IN GREECE

The Early Bronze Age on the mainland of Greece is known as Early Helladic, and it began rather later than the Bronze Age in Crete. Its character, too, is quite different, the closest affinities being with the Greek islands and the Bronze Age in Anatolia. The characteristic pottery shapes associated with the phase, the 'sauceboat' and the two-handled goblet, are also found at Troy and other Anatolian sites, and probably originated there. There are close connections, too, between the architecture of the two areas. The *megaron* house, which was to be the most important single unit of the later Mycenaean palace, is found in both areas. The Middle Helladic phase, which begins early in the second millennium, is associated with an invasion of new peoples who are now generally believed to be the first Greek speakers to arrive in the Greek peninsula. The Middle Helladic invaders introduced new architectural forms, though some of the old were still retained, new burial customs and new types of pottery. They built on the same sites as those which were later to be important as Mycenaean citadels. The general level of prosperity seems to have been lower than that of the Early Helladic phase but, by 1600, a general accession of wealth created the early Mycenaean culture which is known to us chiefly from the remarkable finds made by Schliemann in the Shaft Graves of the famous Grave Circle at Mycenae, and

from those in the more recently discovered second Grave Circle at the same place.

THE SHAFT GRAVES OF MYCENAE

The Shaft Graves are a series of rectangular burials cut in the rock, with walls of rubble masonry and roofs of timber and stone slabs. When, later, the massive 14th-century walls of Mycenae were built, the burials were enclosed by circles of close-set upright stone slabs. The burials, especially those in Schliemann's Circle, were accompanied by rich possessions, which suggest that they must have been the burials of the Royal House of Mycenae. We know little of the citadel in which these Mycenaeans lived, since the walls and palace of Mycenae belong to a later phase, but they themselves come before us with a remarkable immediacy in the series of forbiddingly regal death masks of gold plate, which were laid upon the faces of the men; even if, as we now know, these men lived long before the Achaean lords of Homer's epic, we feel much more at home with them than with the Minoans. Their warlike character, their love of hunting, so clearly reflected in the contents of the tombs, put us in mind of Homer's heroes.

The objects found in the Shaft Graves are the personal possessions of the dead. The men are buried with their richly decorated weapons and vessels of precious metal; the women wore extravagant jewellery and had vessels of gold and silver for their own use. Because the decoration of these objects is predominantly Minoan in character, it was once thought that they represented loot taken by the Mycenaean lords from Crete, but a closer analysis of the finds has shown that while many of the objects are obviously the work of Minoan craftsmen, they are made to Mycenaean usage and taste. Shaft Grave art can be considered Minoan in the same sense that Roman art is Greek; the Mycenaeans em-

32

3. **The grave circle at Mycenae.**
14th century BC. diam. 90 ft. (27.5 m.).
The double ring of upright slabs was put
up to enclose the Shaft Graves of a dynasty
of Mycenaean kings, buried between 1600
and 1500 BC.

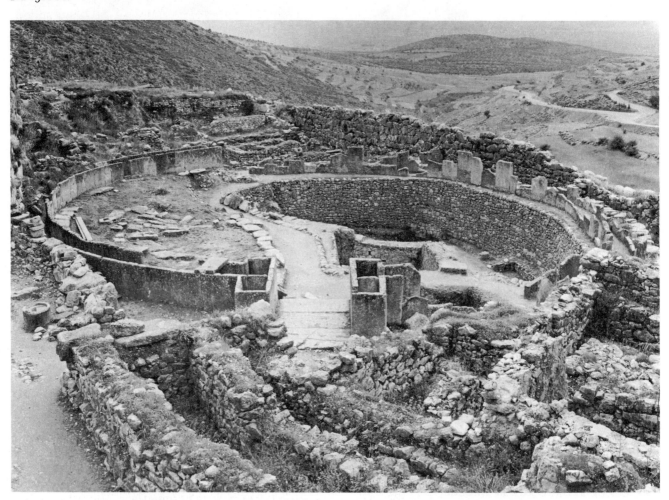

ployed Cretan artists, but they asked them to illustrate themes and decorate objects that suited a different taste. We must suppose that an artist from Crete came to the mainland to decorate the superb inlaid dagger illustrated in plate 19. The scene, which is inlaid with gold, silver and niello on a copper sheet fixed to the dagger, shows an episode in a lion hunt in which four soldiers and an archer are in combat with the lion, who has already struck down one of them. It is a wonderfully vigorous, if exaggerated, scene of action that must be the work of a fine Cretan craftsman. Prosperity gave the Mycenaean lords the opportunity to employ the best Cretan skill in all branches of the arts, and so to satisfy their admiration for the arts and crafts of a superior civilisation.

THE CITADELS OF THE MYCENAEAN WORLD

The great period of the Mycenaean world begins about 1400, at just the time when it is believed that the palace of Knossos was finally destroyed. By this time the Mycenaeans had become the principal power in the Aegean, they had trading contacts not only with the eastern and western Mediterranean, but also with central Europe, and they colonised widely in their sphere of influence. The great

citadels at Mycenae, Tiryns and elsewhere, took the shape in which we know them today during the 14th century. The sites are characterised by massive defensive walls built to enclose the palace of the king, and to be a place of refuge in time of trouble. These walls are built either of large squared blocks of regular masonry, or of rough hewn blocks of enormous size carefully fitted together so as to give the appearance of a level surface; the classical Greeks believed that the giant Cyclops built the walls, and justifiably. At Tiryns, 'the most Cyclopean walls in all Greece' were as much as 17½ metres thick at one point in their circuit. The great Lion Gate at Mycenae which forms the main entrance to the citadel provides us with the first example from the Greek world of monumental sculpture allied to architecture. As we have seen, there was no monumental sculpture in the Minoan world, but here the massive entrance, with its enormous stone lintel, is surmounted by a relief that shows two lions heraldically flanking a column and entablature, which symbolise the palace of Mycenae. The lions and the column are Minoan in character, but the scale of the architectural conception is Mycenaean.

(Continued on page 49)

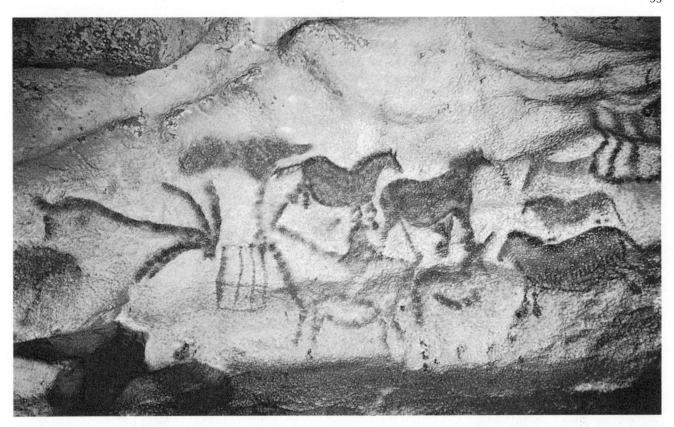

1 (above). **Horses and ibexes**.
c. 15,000–10,000 BC. Cave painting.
h. *c.* 31½ in. (80 cm.). Lascaux, France.
The prominently drawn 'traps' here may
not have been intended literally but as
magical objects with which to trap the
animals' souls.

2. (below). **Man in a bird's-head mask
attacked by a wounded bison.**
c. 15,000–10,000 BC. Cave painting. h. 55
in. (140 cm.). Lascaux, France. This vivid
and gory scene can be explained with the
help of shamanist legends that survived
in Siberia until modern times. Battle is
joined between two rival shamans, one

in the guise of a bison and the other with
a bird's head. The wand with the figure
of a bird on top suggests that the
prostrate shaman's 'spirit-helper'
appeared in bird form. A spear seems to
have pierced the bison's flank and its
bowels may be seen gushing from the
wound.

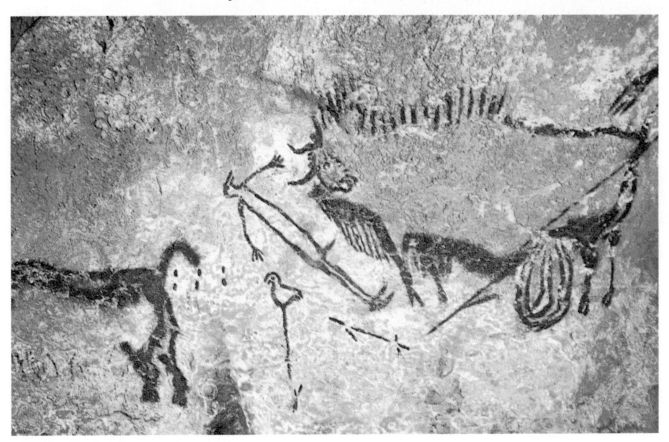

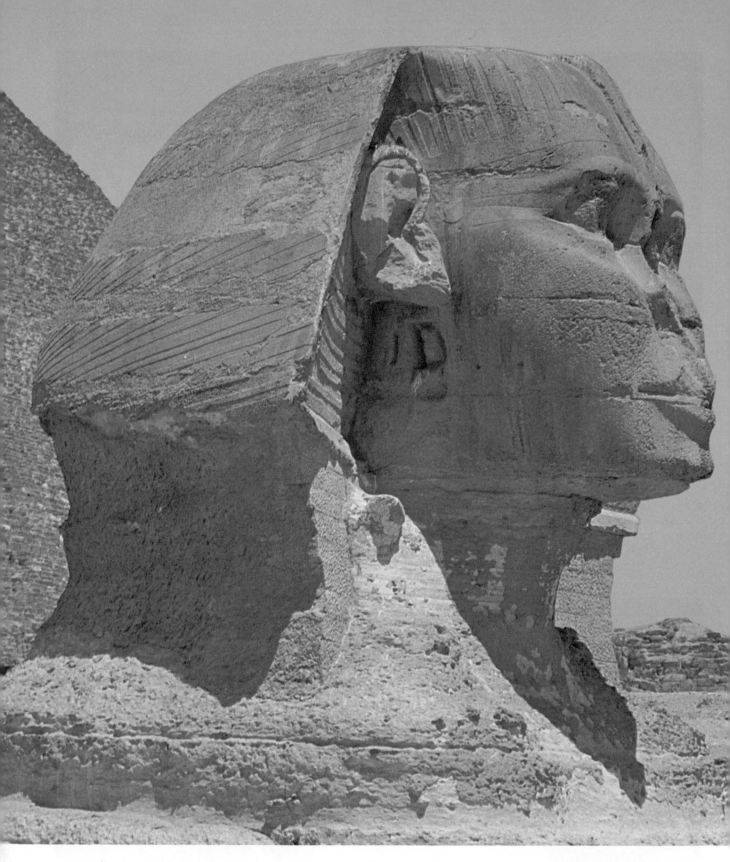

3 (above). **The Sphinx of Chephren**
(detail). Fourth Dynasty. Approximately
2500 BC. width of face 13½ ft. (4·10 m.).
The guardian Sphinx was fashioned out
of a knoll of rock left in the quarry where
the blocks were hewn for the Chephren
pyramid. It has the body of a lion and
the head of a human being in royal
headdress. Despite signs of weathering,
recalling that it has stood guard over the
burial places for many thousands of

years, it still retains the fascination it
had for the Greeks who took it as
symbolic of everything mysterious and
enigmatic.

4 (opposite). **Golden head of a bull
decorating the front of a lyre from Ur**.
Early Dynastic II Period. 2600–2400 BC.
Gold on a wood core. h. 11⅝ in. (29·5
cm.). Iraq Museum, Baghdad. Stringed
instruments such as harps and lyres are

frequently illustrated in feasting scenes on
Early Dynastic seals, and several
examples were unearthed from the Royal
Cemetery at Ur. The soundboxes are
decorated with an inlay of mother-of-pearl
and lapis lazuli. The bull's head
demonstrates the high standards that the
art of the metal-worker achieved at this
period, together with an obvious delight in
inlay work.

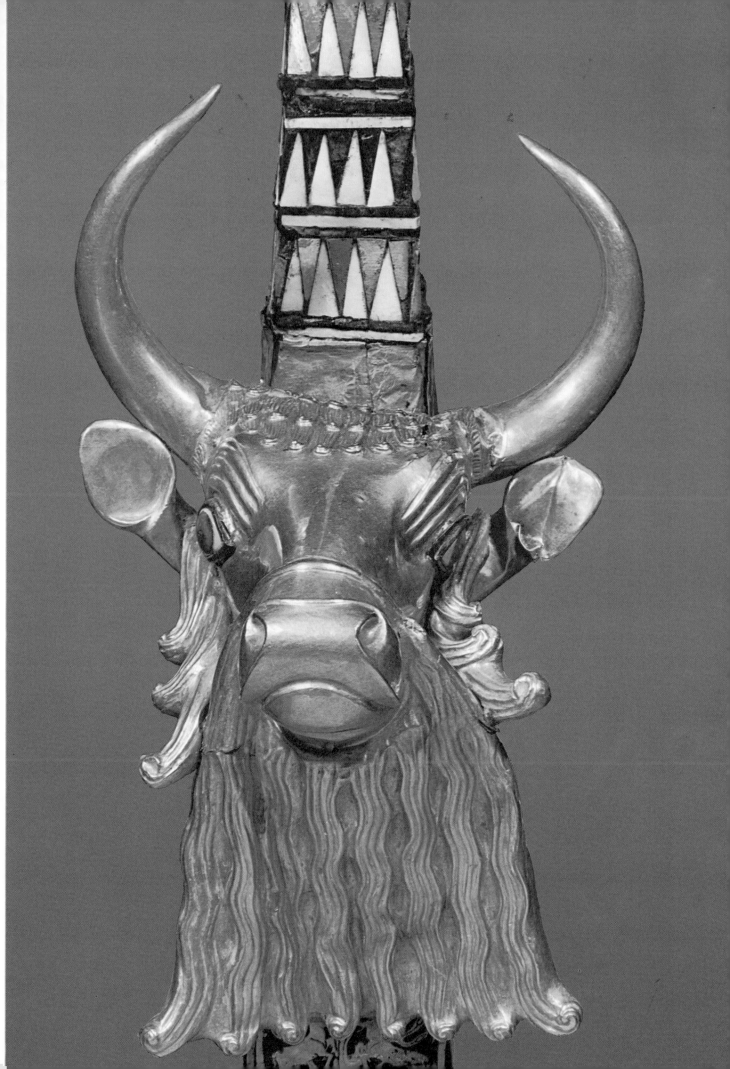

5, 6 (left and below left). **Sphinx from the Sphinx Gate at Alaca Hüyük**. Hittite Imperial Period. Middle of the 14th century BC. The Sphinx Gate, like the Lion Gate at Hattusas, guarded the entrance to the city. The sphinx motif probably reached Anatolia from Egypt via Syria, but it is transformed from a male symbol into a female one. If the idea of guardian creatures originated in Mesopotamia, it was developed by the Hittites in a monumental way which was to find echoes in Assyria centuries later.

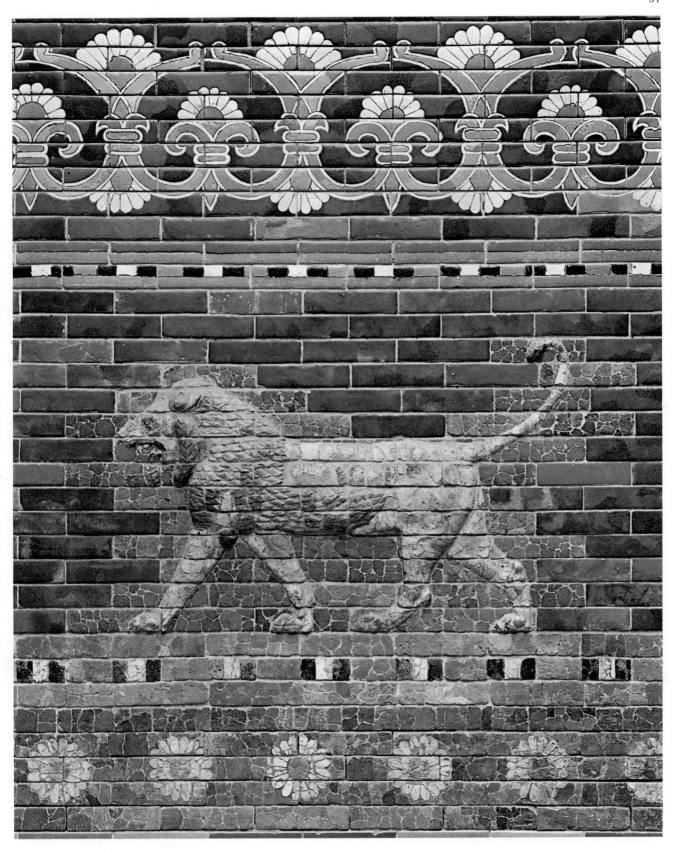

7 (above). **Detail from the façade of the throne room at the palace of Babylon: polychrome lion**. Reign of Nebuchadnezzar II, (604–562 BC). Staatliche Museen zu Berlin. The main gates into Babylon and the side walls of the Processional Way were faced with glazed bricks in rich colours. The heraldic animals were first modelled on a rectangular panel of clay. While still soft, the panel was cut up into separate small bricks, which were glazed, fired and then reassembled on the façade. The great crenellated walls must have presented a dazzling sight; the technique so impressed the Achaemenians that they imported Babylonian craftsmen to produce similar effects on the walls of Susa.

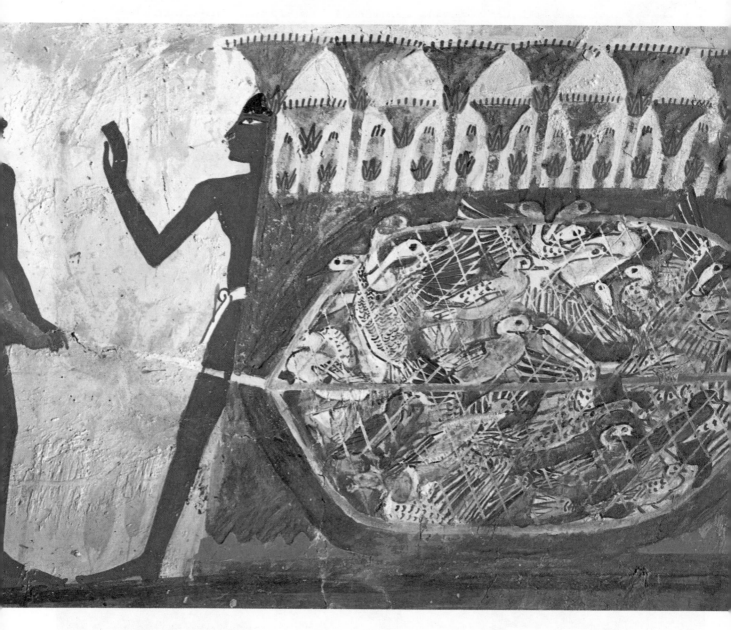

8. **Birds caught in a net**. To nb of Nakht,
Sheikh-abd-el-Qrnah. Thebes. Mid-
eighteenth Dynasty. Painting on plaster.
This detail from a fowling scene shows
birds caught in a clap-net in the marshes.
The water is indicated by a line of blue
around the net, and the catch is being
drawn to the bank by a group of servants.
The ducks, heaped one upon the other in
convincing disarray are observed with an
impressionistic freedom.

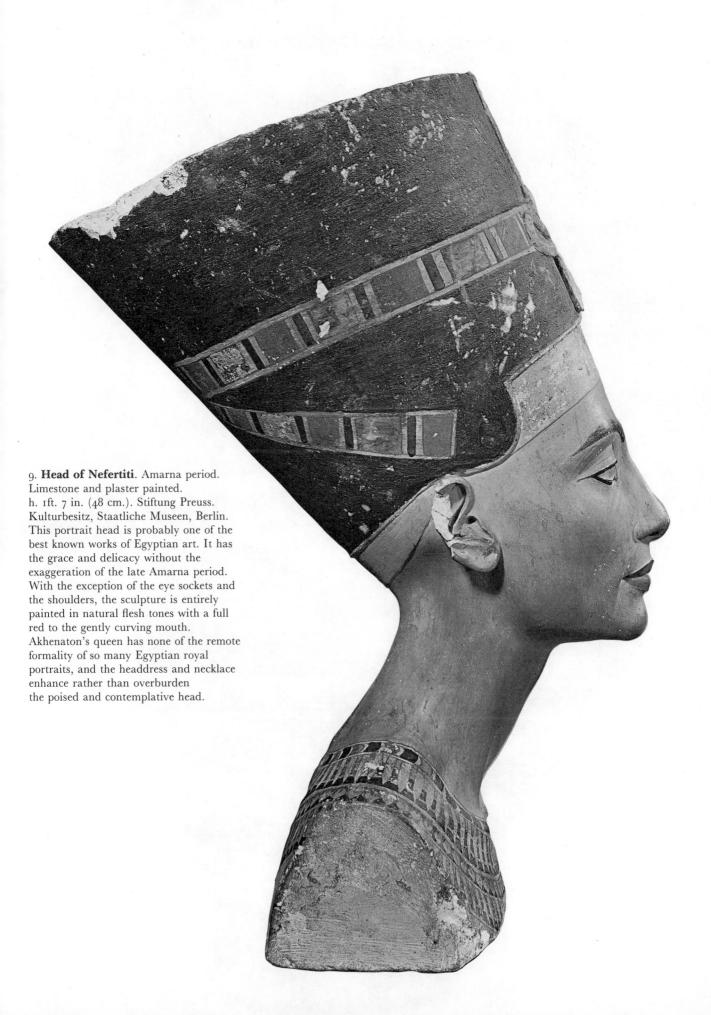

9. **Head of Nefertiti**. Amarna period.
Limestone and plaster painted.
h. 1ft. 7 in. (48 cm.). Stiftung Preuss.
Kulturbesitz, Staatliche Museen, Berlin.
This portrait head is probably one of the
best known works of Egyptian art. It has
the grace and delicacy without the
exaggeration of the late Amarna period.
With the exception of the eye sockets and
the shoulders, the sculpture is entirely
painted in natural flesh tones with a full
red to the gently curving mouth.
Akhenaton's queen has none of the remote
formality of so many Egyptian royal
portraits, and the headdress and necklace
enhance rather than overburden
the poised and contemplative head.

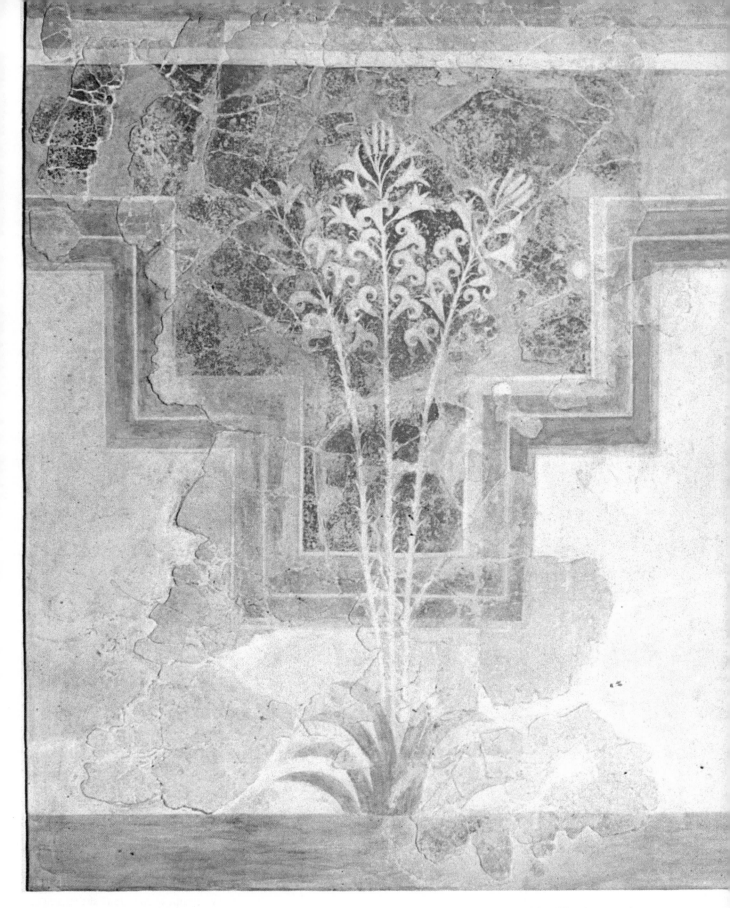

10 (opposite). **Jar from Phaistos**. 1900–1700 BC. Pottery. h. 20 in. (50 cm.). Heraklion Museum, Crete. The design, based on curvilinear patterns, incorporates a representation of a fish shown with what looks like an enormous bubble issuing from its mouth; the hatching may be intended for the mesh of a net. In this early Cretan style of pottery decoration, representations of the animal world are rare, though many of the decorative motifs are based upon natural forms. The spiral patterns are typical of Cretan decorative art.

11 (above). **White lilies in a garden**. c. 1600 BC. Fresco. h. 6 ft. 3 in. (1.89 m.). Heraklion Museum, Crete. Wall painting from a Villa at Amnisos near Knossos. The design consists of three white lilies growing from a calyx of leaves. This painting is one of the earliest examples of Minoan fresco painting.

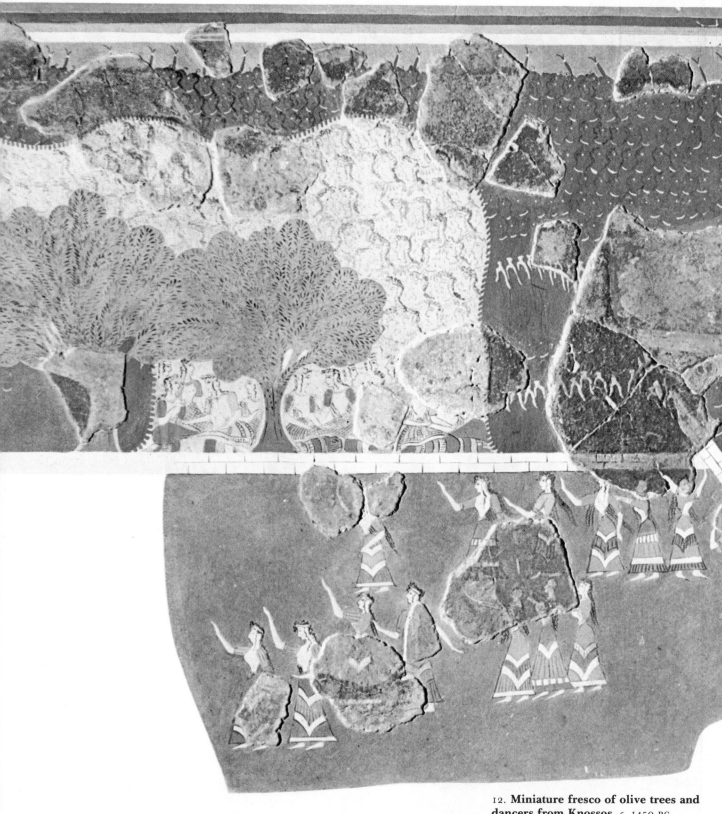

12. **Miniature fresco of olive trees and dancers from Knossos**. *c.* 1450 BC. Fresco, approx. h. 14 in. (35 cm.). Heraklion Museum, Crete. The scene shows groups of spectators sitting among olive trees and watching women perform a ritual dance. The 'impressionistic' method of suggesting a crowd is interesting: for the men, patches of reddish-brown colour with a series of heads roughly painted; for the women, patches of white with similar sketchy drawing of the heads.

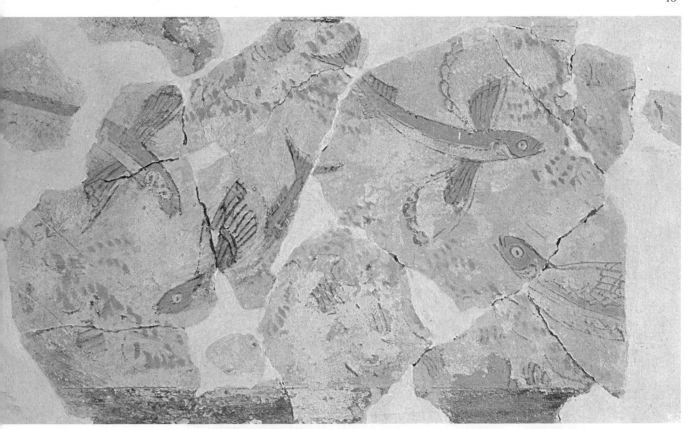

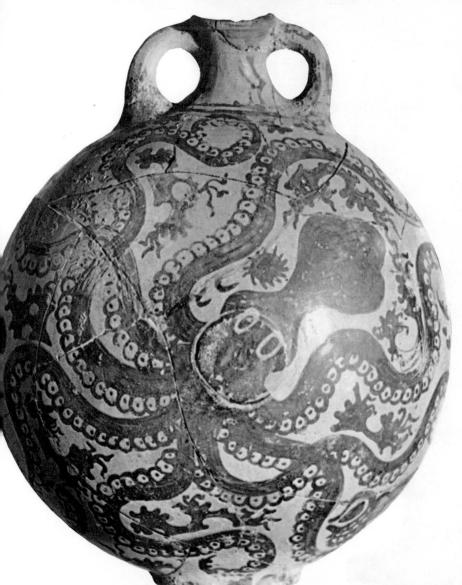

13 (above). **Painting of flying fish from Melos**. 15th century BC. Fresco. h. 9 in. (23 cm.). National Museum, Athens. This fresco was found in the palace of Phylakopi on the island of Melos. The painting, which is certainly the work of a Cretan artist, is a fine example of the combination of keen observation of nature and strong decorative sense that characterises all the best Cretan painting.

14 (left). **Octopus vase**. *c.* 1500 BC. Pottery. h. 11¼ in. (28 cm.). Heraklion Museum, Crete. This little flask, of a type normally called a 'stirrup jar', was found at Palaikastro in eastern Crete. It is a fine example of the 'marine-style' of Cretan pot-painting. The surface of the vase is painted with a representation of an octopus swimming amid seaweed, coral and shells: a lively naturalism is combined with a superb decorative sense.

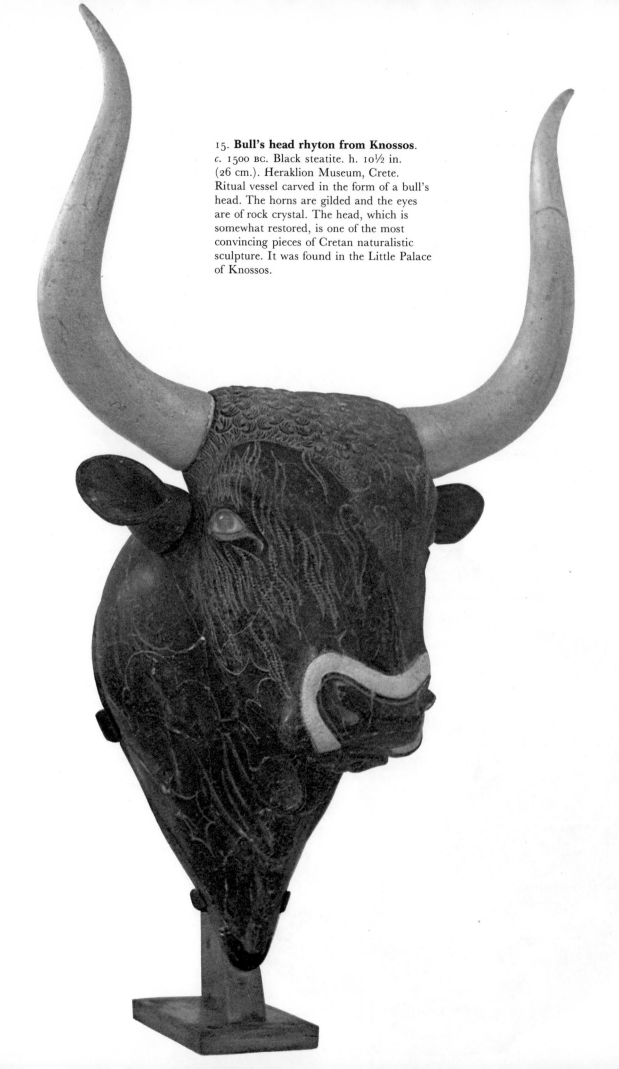

15. **Bull's head rhyton from Knossos**.
c. 1500 BC. Black steatite. h. 10½ in.
(26 cm.). Heraklion Museum, Crete.
Ritual vessel carved in the form of a bull's
head. The horns are gilded and the eyes
are of rock crystal. The head, which is
somewhat restored, is one of the most
convincing pieces of Cretan naturalistic
sculpture. It was found in the Little Palace
of Knossos.

16 (right). **Snake Goddess**. *c.* 1600 BC.
Faience. h. 17½ in. (29.5 cm.). Heraklion
Museum, Crete. This statuette of a
female figure holding snakes in both
hands was found in the palace at Knossos.
It is disputed whether she
represents a goddess, queen or priestess.
She wears the characteristic costume of
Cretan women of the court, with breasts
exposed, a tight waist, and long flounced
skirt.

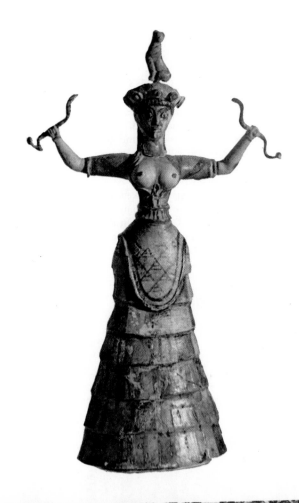

17 (below). **The frescoes of boxing
children and antelopes from Thira**. The
palace civilisation of Thira, on the island
of Santorini, flourished until it was
destroyed by a massive volcanic explosion
in about 1500 BC. Its art was surprisingly
naturalistic and lively, often dealing with
informal subjects. Thira remained
forgotten until excavations began there in
1967.

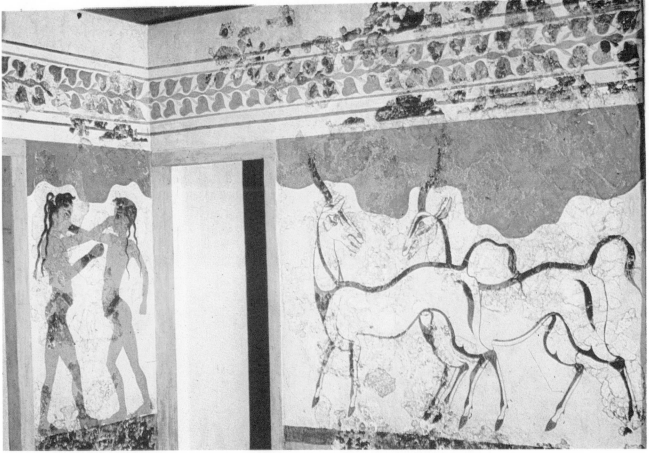

18 (below). **Sarcophagus from Hagia
Triada**. *c.* 1400 BC. Alabaster. l. 4 ft. 6 in.
(1.37m.). National Museum, Athens. A
small sarcophagus of alabaster with
painted scenes on all four sides found at
Hagia Triada, the royal villa not far from
Phaistos. On the side illustrated here, the
scene on the left shows two women
bringing libations to a shrine marked by
two double axes. They are accompanied
by a man playing a lyre. On the right three
men are bringing offerings to an image
standing in front of a building.

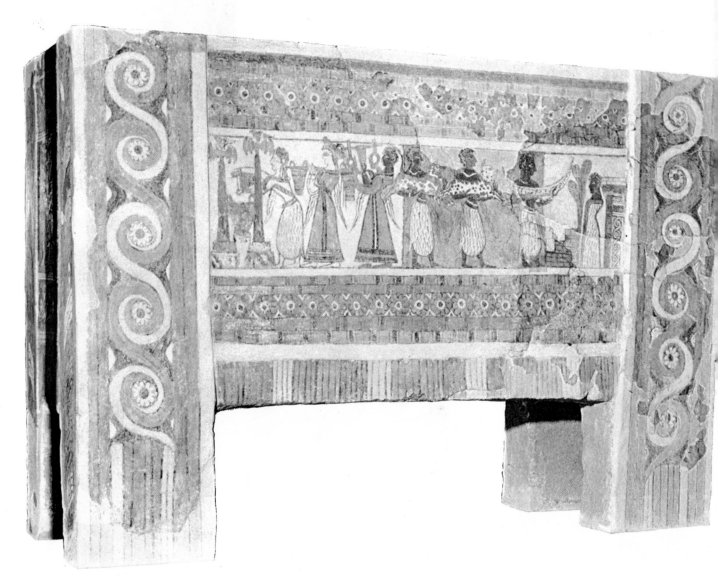

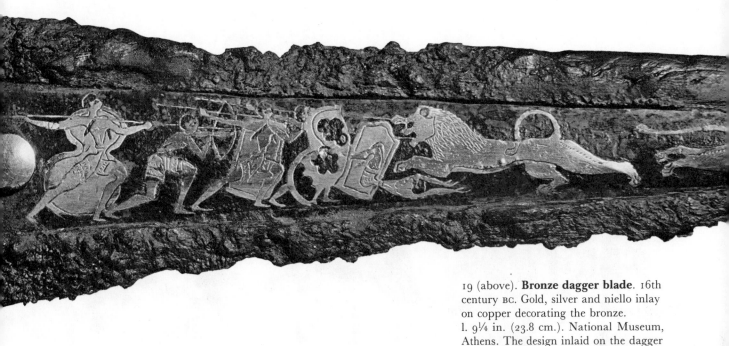

19 (above). **Bronze dagger blade**. 16th century BC. Gold, silver and niello inlay on copper decorating the bronze. l. 9¼ in. (23.8 cm.). National Museum, Athens. The design inlaid on the dagger blade shows four soldiers and an archer fighting with a lion. One of the soldiers has been struck down by the lion which is already wounded by a spear. The style is Minoan and the dagger is probably the work of a Minoan craftsman. Found in the Fourth Shaft Grave at Mycenae.

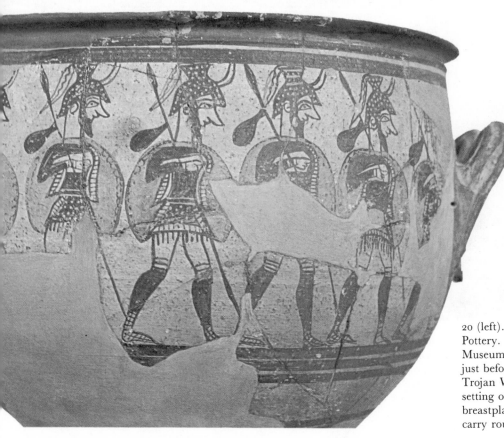

20 (left). **The Warrior Vase**. c. 1200 BC. Pottery. h. 12 in. (30 cm.). National Museum, Athens. This vessel dates from just before the traditional date of the Trojan War. Six warriors are shown setting out. They are wearing breastplates, helmets and greaves, and carry round shields.

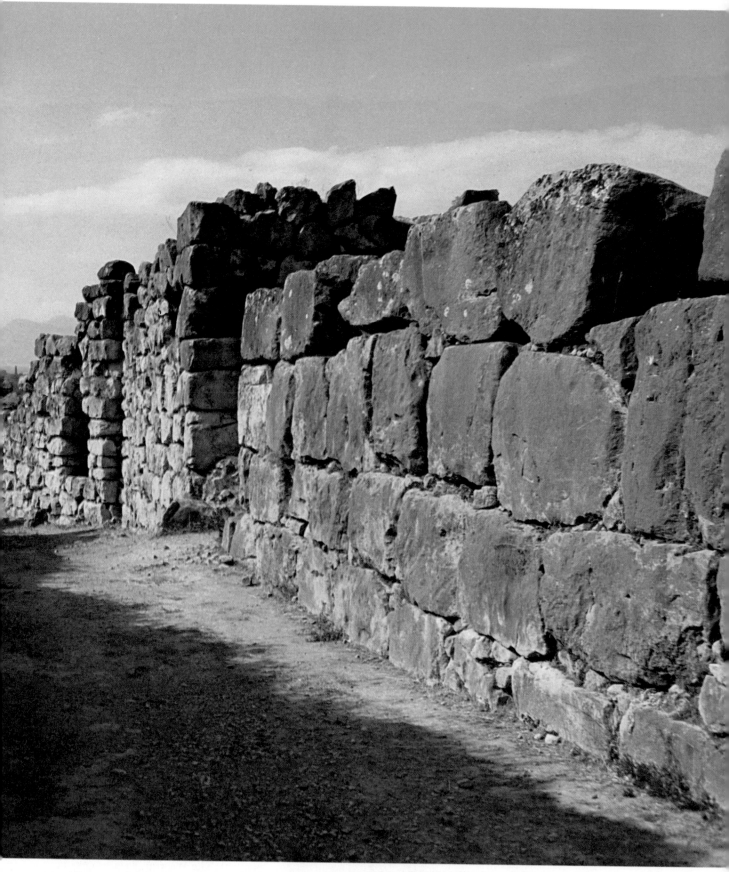

21. **The walls of Tiryns**. 13th century BC.
The Mycenaean citadel of Tiryns was
built on a long narrow ridge rising from
the plain of Argos, not far from Mycenae.
The walls enclose the palace of the ruler
and an area that served as a place of
refuge in time of trouble; they were built
during the most flourishing period of
Mycenaean civilisation and were described
by Pausanias as 'the most Cyclopean walls
in Greece'. Some of the blocks used in the
masonry are as much as 9 ft. long.

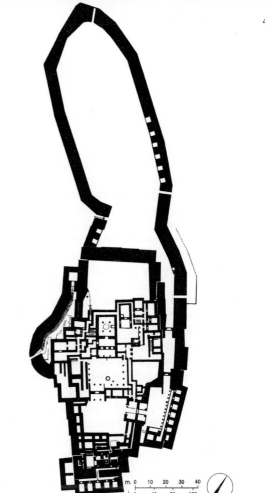

PALACES AND TOMBS

These grand architectural schemes are the chief Mycenaean contribution to the history of art. At first sight, the remains of the palaces themselves are disappointing. Tiryns is the best preserved, and here only the ground plan can be seen by the visitor today. The main characteristic feature is the *megaron*, a house form which had a long history on the Greek mainland and in Anatolia. A megaron generally consists of three elements—an open porch with columns supporting the entrance, an ante-chamber, and a main rectangular hall with a central hearth, which was both the reception and living room of the king; the roof of the megaron was supported by four columns. At Tiryns the megaron was approached through a series of courtyards and columned entrances, or *propylaea*; the main courtyard was surrounded by colonnades. The whole plan is much more closely related to classical Greek practice than anything we have seen at Knossos, and other sites in Crete.

The palace buildings were richly decorated with frescoes in Minoan technique, but often with a subject-matter that is Mycenaean. The megaron of Mycenae had frescoes showing battle subjects; at Pylos, scenes of peace and war were apparently combined. In the palace of Tiryns the paintings included purely decorative themes, among them a frieze of enormous figure-of-eight shields, and a processional frieze of woman clad, apparently, in Minoan court dress. The studied simplicity and clarity of outline seems to take us away from the spontaneous naturalism of Cretan painting and much closer to archaic Greek art; and it is remarkable how like an archaic Greek woman this Mycenaean looks.

The great chamber tombs at Mycenae and elsewhere are the most striking achievements of Mycenaean architecture. The use of corbelled vaulting, which we see in the galleries of the citadel of Tiryns, was applied with masterly effect to create a domed chamber on a circular plan. The so-called Treasurey of Atreus, the most famous of these tombs at Mycenae, is 14.5 metres in diameter and the pointed dome rises to a height of 13.2 metres. The corbels are cut so as to give the effect of a continuous vault. The entrance to the tomb, which clearly served as a communal burial place for the rulers of Mycenae in the 14th century, is approached by a long passage cut in the rock; the entrance itself was decorated with applied architecture of coloured stones consisting of richly ornamented columns, on either side of the door, supporting an elaborate entablature. Fragments of the architecture can now be seen in the British Museum.

CRETAN AND MYCENAEAN ART

Throughout the period of Mycenaean power, the influence of Cretan art and technique dominates the courtly art, not only of painting but of precious metalwork and jewellery. It is in the more humble products of the potter's craft that fundamental changes of artistic outlook can best be seen, and they are changes which many people think show us the

B. Plan of the Citadel of Tiryns.

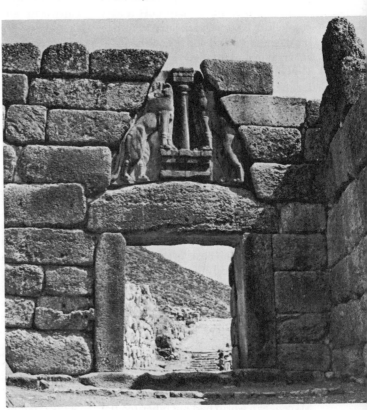

4. **The Lion Gate, Mycenae**. 14th century BC. The main entrance to the citadel of Mycenae, with the famous relief over the lintel showing two lions flanking a column.

emergent Greek artistic spirit. The abandonment of natural forms in favour of a more stylised kind of ornament has already been seen in the pottery of the so-called Palace Style at Knossos, and in later Mycenaean times this tendency develops until we find decorative motifs whose naturalistic basis is scarcely recognisable, and those which are frankly based on abstract geometric patterns. Some of the latter look remarkably like the geometric decoration that characterises the pottery decoration of post-Mycenaean times, until one realises that they lack the rigid symmetry and precise execution of the later style.

Another striking anticipation of later Greek art is the appearance on late Mycenaean vases, of figure scenes arranged in a frieze zone round the body of the vessel. The well-known warrior vase from Mycenae shows a column of soldiers setting out; on the extreme left is the figure of a woman who bids them farewell. This vase, which was made about 1200 BC, seems to bring us very near to our image of the Achaeans who fought the Trojan War. The vases of the so-called Levanto-Helladic class, made in the 13th century BC, illustrate similar themes; some, such as the example from Cyprus in the British Museum show the kind of decadent naturalism that seems to be leading inevitably to that complete extinction of representational art which, in fact, took place in the final collapse of the Mycenaean world. The conflicting tendencies in later Mycenaean art make it very hard to understand. On the one hand, we see the precarious survival of a naturalistic art based on the achievements of Cretan artists, and on the other, the emergence of a new taste for the order and simplicity of abstract forms.

THE END OF THE MYCENAEAN WORLD

The Mycenaean world came to an end about 1100 BC. The great palaces were destroyed, overseas connections were broken, and the whole system of Mycenaean rule collapsed. We have to consider in the next chapter what happened afterwards, but here we must consider the significance of the Bronze Age world in terms of the history of Greek art. The Cretans, we know, were not Greeks, and this surely is clear in their art. The Greeks began their search for ideal form in art on the basis of a severely ordered sense of form to which the study of nature was secondary. The Minoans, on the other hand, drew their first inspiration from nature and, although they did not always imitate it, they were always acutely aware of it. The contrast between the Minoan and the Greek spirit goes deep. Nothing could be further from the ordered symmetry of Greek architecture than the informal, apparently haphazard, planning of the Minoan palaces. Indeed, we should not find it necessary to preface an account of 'classical art' with a Minoan chapter, if the Mycenaean world had not inherited the art of the Cretans, and applied it to their own purposes.

The Mycenaeans, as we know, were Greeks and, for all that, much of their art is Minoan in inspiration, they are very close to the Greeks of history. They created a monumental architecture that has much in common with Greek architecture. No one can look at the ground plan of the palace of Tiryns, with its ordered succession of courtyards and entrances leading to the megaron, without thinking of classical planning. The megaron form, itself, is connected with that of the later Greek temple; perhaps this is because many of the Acropolis sites were quickly converted into sanctuaries of the gods, as happened in the case of the palace at Tiryns. Much of the Mycenaean world did not survive, and only a memory of it, often false in detail, is preserved in the poems of Homer; Mycenaean writing disappeared completely. But if the art whose origins we are going to discuss in the next chapter is the product of a new creative spirit, it is nevertheless true that some of its inspiration is drawn directly from the Bronze Age World.

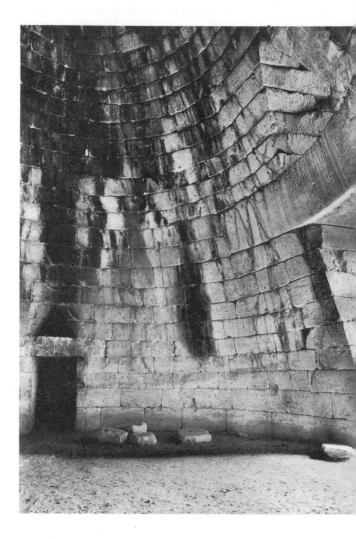

5. **The interior of the so-called Treasury of Atreus, Mycenae.** *c.* 1400 BC. diam. 48 ft. (14.6 m.). × h. 44 ft. (13.4 m.). This is the largest and best preserved of the Tholos tombs of Mycenae.

The Beginnings of Greek Art

THE DARK AGES

The Greek Dark Ages are now not so dark. There is no history, it is true; only a vague memory in later times of the catastrophes that brought about the end of the Mycenaean world. But archaeology, in so far as it can, is slowly bridging the gap between the downfall of the Mycenaean world and the emergence into history of the Greek city-states in the 7th century BC. Greek tradition associated the collapse of the Mycenaeans with an invasion of new Greek-speaking people, the Dorians, who settled in and dominated several of the Mycenaean centres, bringing with them, it seems, the use of iron, different burial customs, and a different way of life. The Dorian invasion not only established the historical pattern of settlement in mainland Greece, but had as one of its effects the migration of Greek settlers to the islands and the Asiatic coast of Turkey, which is the basis of the eastern Greek world. The evidence of archaeology now throws light on the course of this migration, and the slow recovery of prosperity that made possible the achievements of the historical Greeks.

THE EMERGENCE OF A NEW ART

The Dorian invasion does not seem to have provided any new artistic stimulus, and it was in Athens, which claimed to have been untouched by the invasion, that the emergence of a new artistic spirit in the 11th century can be most clearly seen. It comes as a great surprise to those who think of Greek art in the terms of its 5th-century achievements, that it begins with a completely abstract phase in which the human figure and the world of nature have no place. In this age of poverty and obscurity, the only documents for the history of art are the painted pots which served both domestic and funerary purposes. The style of painting that succeeded the sub-Mycenaean is known as the proto-geometric, the earliest phase of a tradition of ornament based upon geometric patterns that prevailed until the end of the 8th century BC.

There is a world of difference between a sub-Mycenaean and a proto-geometric pot, between the decadent naturalism of the one and the strict formalism of the other. The difference is seen in the shapes of the pots, which are much more precise in outline and have the various parts more clearly defined, in the symmetrical arrangement of the ornamental bands, and the accuracy with which the ornamental motifs—the compass-drawn concentric circles, the precise chequer patterns—are carried out. Certain Mycenaean elements survive in the pottery, but nevertheless, with the proto-geometric, art in Greece takes on a new direction and a completely new discipline. It is at first sight surprising that this non-representational phase should form the basis for the development of Greek art; but even in these humble beginnings the virtues of proportion, symmetry, clarity and precision, on which all its greatest achievements were founded, are clearly present.

THE GEOMETRIC STYLE

The proto-geometric style of pot-painting seems to have originated in Athens about 1000 BC, and Athens led the Greek world in art throughout the geometric phase. The development of the geometric style shows an increasing repertory of motifs—zigzags, lozenges, meanders—until in the late geometric of the 8th century BC the pot was covered overall with bands of ornament. Figures of any kind were slow to appear. There is a little horse, rather casually placed, on a proto-geometric pot of the 10th century, but it is not until the 8th century that humans and animals have a place of any importance in the pot-painters' scheme of things. When the human figure does appear he is a strange creature, painted as a silhouette with the head shown in profile, and distinguished by a reserved area with a blob in it for the eye; the body is shown frontal in the form of a triangle; the arms are like match-sticks; and the legs appear in profile with rounded buttocks and strong calves. It hardly needs saying that the geometric painter is not attempting to represent what he sees, but he hardly ever leaves us in doubt as to what he means. He will draw all four wheels of a chariot seen in profile, because he knows that his chariot has four wheels whether they can be seen from his chosen viewpoint or not, and, on this basis, he can tackle quite complicated scenes, and make them understandable.

The vases of the so-called Dipylon style made in Athens in about 750 are the high water mark of geometric art. The biggest Dipylon vases—the one from which our detail on plate 23 is taken stands over 5 feet high—were placed above ground to mark the positions of tombs in the Dipylon cemetery at Athens, and they may be considered as the first real attempts at monumental art in early Greece. The figure compositions, though comparatively small in scale, have pride of place. The scene illustrated here is a typical one showing the dead man laid out on a bier surrounded by his family and mourners; an enormous chequered canopy frames the scene. Other vases of the same class have secondary friezes with processions of chariots and armed warriors, and some contemporary vases depict battle scenes of various kinds, inspired probably by the subject matter of Greek epic poetry. If so, they stand at the head of the tradition of mythological representation in Greek art, which was to be its main source of inspiration, and they bring us out of the Dark Ages into the realm of Greek history.

THE ORIGINS OF GREEK SCULPTURE

The documents for the history of sculpture during this period are much more scanty than those for painting. Clearly, there was no monumental sculpture of any kind during the Dark Ages, but there was a considerable output of small-scale work in bronze and terracotta in many places. In Crete, human and animal bronzes were made in a decadent Minoan style long after the collapse of Minoan

22

civilisation. Elsewhere primitive figures with hardly a definable style continued to be made. By the 8th century a figure style corresponding closely to the geometric formula seen on pottery became fairly widespread. Little bronze horses with short cylindrical bodies, almost cylindrical heads, long legs and strongly developed fore- and hindquarters are the three-dimensional counterparts of the painted figures. Human beings were also represented in the clear-cut geometric formula. The bronze group of a man

24 and a centaur, perhaps Herakles and Nessos, in the Metropolitan Museum, New York, was made about 750 BC.

29 The bronze figure of Apollo in Boston, which seems to be a Boeotian work of about 700, shows the fully developed geometric scheme for the human figure with long triangular face and large eyes, long neck, triangular body and strongly developed thighs. The inscription reveals that the statuette was dedicated to the god Apollo, by a certain Mantiklos. In these minor works of sculpture Greek artists found their first simple, straightforward formula for the representation of human and animal figures, which could serve as the basis for future development.

EARLY GREEK BUILDINGS

As in painting and sculpture, so in architecture, the basis of the Greek styles was laid in the Dark Ages. We have much less to go on here than in the other arts. 'The surviving buildings of the Dark Age', says A. W. Lawrence, 'are few in number and of deplorable quality'. It is possible, however, to follow some of the steps by which the most characteristic of Greek buildings, the temple, took on the shape it was to have in later times. There had been no temples in the Bronze Age, and we do not know when they began to be built. The Olympian religion of the Greeks, which contains both Bronze Age and later elements, conceived its gods in human form. Very early on they must have been represented by cult-images of some kind, and these cult-images required to be properly housed; so it was natural that the earliest temples should take the form of houses. In the Dark Ages houses might be circular, elliptical or rectangular and, no doubt, many of the earliest temples assumed these various forms. But the rectangular shape soon predominated. One of the earliest surviving temples, at Thermon in Aetolia, is designed on the plan of a Mycenaean megaron; it would have been built of mud-bricks with a ridged timber roof. A model of a simple temple with a porch and high-pitched roof has survived from the end of the geometric period. A vital development took place when colonnades were put round the main temple building, thus creating the essential form of later Greek temples, and this may have happened as early as 750 BC; the first temple of Hera at Samos, which belongs to this period, is the earliest known example. Certainly, by the early 7th century the Greek temple, constructed of mud brick and wood, had assumed its essential form, and the way was open for the development of the Greek orders of stone architecture.

THE GREEKS AND THE EAST

In architecture, painting and sculpture the Dark Ages, which saw the slow revival of prosperity in Greece, laid the foundations of the development of Greek art. By 750, when the geometric style reached its acme in Athens, the Greek city-states were beginning to plant their first colonies abroad, trade with the eastern Mediterranean was reopened, and Greek art was open to new ideas derived from imitation of imported objects and things seen by the Greeks abroad. At the same time, renewed prosperity made possible big projects in architecture and sculpture. The new ideas came predominantly from the eastern Mediterranean through a variety of different sources; from the neighbours of the Greeks in Anatolia, through Phoenician traders, from direct Greek contacts in Egypt and in many other ways. These ideas did not change the fundamental character of Greek art; the reception of foreign ideas was accompanied by a flair, amounting to genius, for adapting them into the living and developing tradition.

The oriental influence is first seen in pottery with the introduction of new decorative elements, a new repertory of formal and naturalistic patterns and a whole new world of strange animals, real and fantastic. There is no sharp **26** break with the geometric figure-style; what we see is a slow relaxing of the strict principles of geometric painting with the severe silhouette giving place to some outline drawing and the bodily forms becoming more rounded. On the Athenian vase, illustrated in plate 27, which dates from around 700 BC, the lions are inspired by oriental sources, but the chief interest lies in the treatment of the chariot scene above; the horses move more naturally than geometric horses, and instead of the odd combinations of frontal view and profile that characterise the pure geometric figure style, the figures are shown consistently in profile. On this vase the prominence given to the figure scenes is evidence of the general development of the taste for figure painting during the period.

In the 7th century, many centres of the Greek world were making fine pottery influenced by the newly discovered oriental repertory. On the mainland, at Corinth, the leader of the commercial states of Greece, which had already been producing a refined type of geometric pottery without figures, there was developed a style which at first adopted horizontal bands of real and imaginary animals, **25** and soon added figure compositions, including mythological scenes, to its sources of inspiration. It was the Corinthian painters who developed the black-figure technique which was to dominate Greek pot-painting until the late 6th century. In this technique the figures are painted in dark silhouette on the natural colour of the clay; details of the anatomy, which increasingly interest the painter, are shown by engraved lines, and pure silhouette is also relieved by a few added colours, among them white and purple. The most famous of 7th-century Corinthian vases is the so-called Chigi Jug in the Villa Giulia Museum, Rome, which was found in Etruria. The body of this vessel

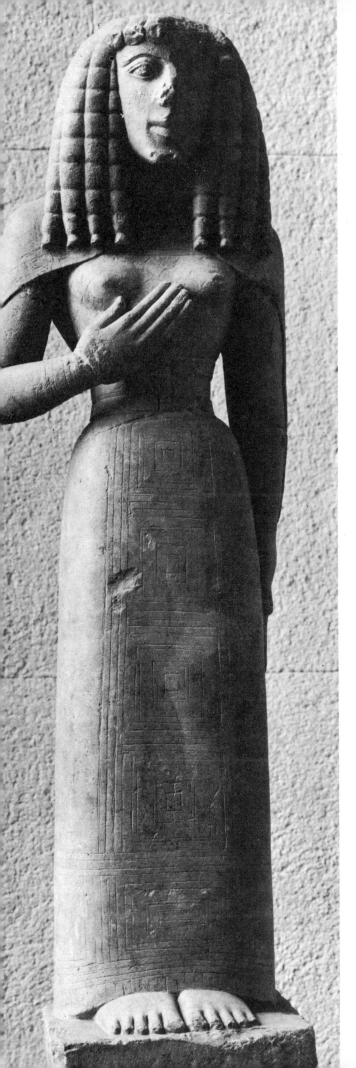

6. **The Kore of Auxerre**. *c.* 640 BC.
Limestone. h. 25½ in. (65 cm.).
Louvre, Paris. Small figure of a young
woman, in the so-called Daedalic style,
probably made as a votive offering.

is decorated with horizontal bands of figured ornament showing battle and hunting scenes, a procession of chariots, and a mythological subject—the Judgement of Paris. The painted pots made at this time in the eastern Greek cities are often attractively colourful. One of the best known groups, which was made in Rhodes, is generally decorated with bands of animal figures and ornament over a white slip that covers the body of the vessel.

THE BEGINNINGS OF MONUMENTAL SCULPTURE

The problem of the origins of monumental sculpture in Greece is a very vexed one. The only works of sculpture surviving from the Dark Ages are small bronzes and terracottas. There is some evidence from later Greek tradition that the earliest cult-images were of wood, but of their appearance there is very little to be said. The historical reasons for the rise of monumental sculpture in the 7th century are clear enough; prosperity gave the opportunity for expensive projects, and in Egypt, and elsewhere in the Orient, the Greeks saw temples and statues of men and gods which could serve as models to imitate. By the middle of the 7th century, certainly, the Greeks were making use of their fine local sources of stone and marble to carve big figures, both cult-images and statues of men.

Greek art, beginning from a purely non-representational approach, had, by the 8th century, developed the geometric formulae for human and animal figures. The search for an ideal scheme of human, and divine, form now found inspiration in the achievements of Egyptian art. Greek sculpture of the 7th century is associated with the name of the mythical Daedalus of Crete, who in legend was the first Greek sculptor. The 'Daedalic' style is widespread in the 7th century on the Greek mainland and in the islands. The narrow-waisted broad shouldered form of the male figure still owes something to the geometric 'canon', but the oriental elements are clear in the coiffure which is often a version of an Egyptian wig, and in the poses of the figures. The figure of a girl illustrated on the left is a 'Daedalic' work of about 640 BC. Her long triangular face and wig-like headdress, the simplicity of the forms beneath her long garment, are typical of the style. Her dress is decorated with engraving, and was once richly coloured, as was all archaic sculpture.

By the end of the 7th century, Greek artists had developed a form of standing male figure which is completely free of geometric conventions, and, although strongly influenced by oriental models, is properly their own. Figure 7 represents an over life-size marble statue dedicated at the sanctuary of Poseidon on Cape Sunium, at the southeastern tip of Attica. It illustrates perfectly the simple archaic 'canon' of male figure sculpture. The figure stands erect and strictly frontal with his left leg advanced, his arms tense at his sides with fists clenched. Details are represented with strength and simplicity. The eyes are big and almond-shaped, the ears large and so carved as to form a kind of decorative adjunct; the essential parts of the body are

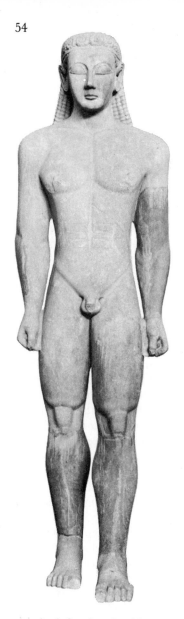

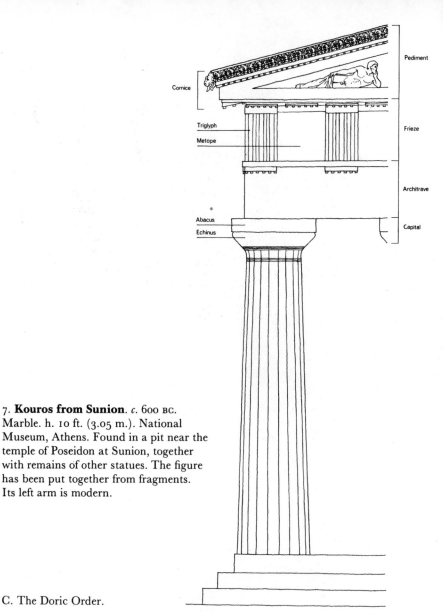

7. **Kouros from Sunion**. *c.* 600 BC. Marble. h. 10 ft. (3.05 m.). National Museum, Athens. Found in a pit near the temple of Poseidon at Sunion, together with remains of other statues. The figure has been put together from fragments. Its left arm is modern.

C. The Doric Order.

clearly defined and subject to an established canon of proportions, while muscles and bones form surface patterns on the marble. The work already has those qualities of grandeur and proportion which characterise all the best Greek sculpture throughout its history. Female figures of the same period are always represented clothed, and are not subjected to a single rigid scheme. In early female statues the lower part of the body beneath the clothes may be shown flat and board-like, or cylindrical, with the folds of the garment indicated by vertical lines, but there is the same simplicity and monumental quality, and the same attempt to find a clear and direct formula.

EARLY HISTORY OF GREEK ARCHITECTURE

The development of architecture during the 7th century was rapid. The basic Greek temple form, as has been seen, had been created during the 'Dark Ages', but it was not until the 7th century that the Greek 'Orders of Architecture' began to take shape. Nothing illustrates better the characteristic Greek search for an ideal form to refine and perfect, than the Doric style of architecture. Its origins lie in the wooden forms of the earliest Greek architecture, as a brief look at its essential elements will show. The columns rise without a base from the floor of the building, and are vertically fluted throughout their length; the capitals which surmount them consist of a spreading convex

moulding (the *echinus*), and a low square block (the *abacus*). The plain *architrave* is made up of a series of rectangular lintel blocks spanning between the columns; above that comes the frieze, which is divided up into a series of panels (*metopes*) by projecting blocks, each having three vertical bands separated by grooves (*triglyphs*). The crowning member is the cornice, a continuous projecting stone eave, downward tilting on its underside and adorned with rectangular slabs carrying projecting pegs. Many of these features have a direct origin in wooden prototypes. The triglyphs of the frieze derive from decorative treatment of the ends of the structural roof beams, and there is a similar explanation for the detail on the underside of the cornice; the column and its capital must have been based on wooden originals.

The Doric order was firmly established by about 600 BC, and thereafter undergoes remarkably little change except in the direction of increasing refinement. The shape of the capitals, the proportions of the various parts, develop and change, but the essential form remains the same. The Temple of Hera at Olympia, built about 600 BC, has a fully developed temple plan with a rectangular *cella*, colonnaded porches at either end, a surrounding colonnade, a pitched roof creating the triangular space (*pediment*) between the horizontal and raking cornices, and a standard classical arrangement of six columns along the

D. Plan of the Temple of Hera, Olympia.

m. 0 2 4 6 8
f. 0 10 20 30

8. **Medusa and her son Chrysaor**.
Early 6th century BC. Marble. h. 10¼ ft.
(3.15 m.). Museum of Corfu, Greece.
The central group of the east pediment
of the Temple of Artemis at Corcyra.

front. This particular temple was originally built of wood, but there were already stone temples in the middle of the 7th century.

In contrast with the Doric, the second of the two great orders of Greek architecture, the Ionic, which was especially favoured by the city-states of Asiatic Greece, did not achieve a canonical form at this period, not, indeed, until the later part of the 5th century BC. Its origins are more obscure; the early forms of the Ionic capital, with its characteristic volutes, admit of considerable variations, and the details of the superstructure are different from place to place. But from the very beginning, the two orders are clearly distinguished; the columns of the Ionic have profiled bases, and the system of fluting is quite different. The architrave is stepped not plain, and the cornice is marked by a range of close-set projecting blocks (*dentils*) below the main projection. Sometimes a plain continuous frieze is introduced, but not at first in association with dentils. The early Ionic temples of Asiatic Greece are more ambitious and grander in scale than the Doric; we see this most clearly in the plans of the 6th-century temple at Samos, and of the enormous temple of Artemis at Ephesus put up about 560 BC. In both there was a double row of huge columns surrounding the main building, and in scale these early Ionic temples were hardly ever surpassed in later Greek building.

THE DECORATION OF BUILDINGS

The development of the standard forms of Greek temples in the 7th century give rise to new classes of sculpture and painting concerned with their decoration. Some fragments of sculpture in the Daedalic style of about 640, found on the site of a temple on the Acropolis of Mycenae, seem to be the earliest examples of sculpture serving to decorate the metopes of a Doric frieze. If an early temple was built of wood the metopes would be made of painted terracotta, and there are fragments of terracotta metopes, dating from the second half of the 7th century, from a temple dedicated to Apollo at Thermon in Aetolia. They are, in fact, the earliest examples of monumental painting that have survivedfrom archaic Greece; their style is Corinthian, closely related to that of contemporary vases. One of the finest fragments shows a seated woman, a fine outline drawing with washes of colour—white for face and arms, black for hair, and purple for the dress. Essentially the same technique as that of the vase-painters is used for this work on a larger scale.

The triangular space of the temple pediment cried out for some decorative treatment. The earliest surviving example of pedimental sculpture, dating from the early 6th century BC, comes from the temple of Artemis in the Corinthian colony of Corcyra (Corfu). The solution of the difficult problem of the slope of the pediment is not particularly

E. Reconstruction of the pediment of the Temple of Artemis at Corcyra.

successful, but the giant Gorgon in the centre of the pedi-
8 ment is a magnificent creation. She is depicted in the
kneeling pose which serves to represent a running action,
and she is flanked by two heraldic lion-panthers; the
rest of the triangular space is taken up with smaller fig-
ures: her sons Chrysaor and Pegasus beside her and figure
groups near the corners. Some fine fragments of early
pedimental compositions have also been found in the
debris of the Persian sack of the Acropolis of Athens; the
group of frightening scale and character, showing a lioness
31 attacking a bull, was made about 600 BC, and belongs
to a world where monsters and exotic creatures still have
power to terrify men. This sculpture associated with
buildings posed difficult problems in the grouping of
figures, which gave a great impetus to the development of
Greek figure-sculpture.

THE ART OF THE SIXTH CENTURY

By 600 BC the subject-matter of Greek painting and sculp-
ture, and the standard forms of temple architecture, were
fully established. The period of oriental influences was
over, and Greek art began to go its own way. Although
there are almost no surviving examples of monumental
painting from the 6th century, many painted vases, some
of the highest quality, have come down to us; there is a
body of original sculpture much larger than for any other
period of Greek art. Temples and other buildings have
either survived to the present day or are well-known from
the results of excavations. The 6th century is an age of great
achievement in art, as in almost every other branch of life.
Artists were always searching for new ideas and increasing
their understanding of the problems of representational art.
Ignorance is not shortcoming, and what they do, they do
superlatively well; some of their work has a clarity and a
nobility that is scarcely ever surpassed in the history of art.

ATHENIAN VASE-PAINTING

We may begin to consider the last phase of archaic Greek
art with the paintings on pottery made in Athens. The pots
of this time are decorated in the black-figure technique,
black painted silhouette against the rich red of the fired
clay, with internal details of the figures drawn with incised
line and a few added colours, especially white and purple.
It is a technique that is exclusive to the pot-painter; on
wall-paintings or panel pictures made in the same period
we should probably find that, though the same principles
of outline drawing filled with colour prevailed there too,
the artist's palette was a much larger one, comparable to
that used in the colouring of sculpture during the time. But
the vases give a good idea of the advances made in represen-
tational art during the 6th century.

The *Running Gorgon* vase is one of the latest examples 28
of enormous funerary vases in the tradition of the Dipy-
lon vase, the work of a pot-painter who was active in 23
Athens around 600 BC, and who painted in a big style ap-
propriate to the scale of the pots. On the neck of the ves-
sel, in a panel, appears the episode of the hero Herakles
killing the Centaur Nessos, a favourite scene from legend;
our detail shows one of the two hideous sisters of Medusa, 28
who appear on the body of the vase, rushing from the
scene of her decapitation. The kneeling pose, with the
legs in profile, which is the early convention for running
figures, is still used here, and the painter has swung the
enormous heads and the upper parts of the bodies frontally,
to reveal their terrifying appearance. The Nessos painter,
so named after the scene he painted on this vase, is, within
the limits of his technique, a brilliant and powerful illus-
trator.

The black-figure style in Athens comes to full fruition
around 560 BC, when the tyrant Pisistratus was in power in
the city. His patronage of the arts inspired great achieve-

ments in architecture, sculpture and painting. We see evidence for a building programme on the Acropolis comparable to that under Pericles in the 5th century. The Athens of Pisistratus was a cosmopolitan place; artists from all over the Greek world, including the Ionian cities, came to work there. The great advances in the art of painting are reflected in the vase pictures. The painters who made these luxury vessels often signed their works; others are not known by name, but their work on different vases can be recognised. Exekias, who painted the vase in the British Museum illustrated on plate 37, is perhaps the greatest black-figure vase painter of Athens. He has chosen for his subject here the popular episode of Achilles slaying Penthesilea, the queen of the Amazons, and he represents it at the moment when the hero has plunged his sword into the Amazon's body, as she desperately defends herself on one knee. The painter achieves the effect of life and movement by drawing without any of the tricks of foreshortening, and shows a remarkable ability to illustrate so dramatic a moment simply and directly. There are many other fine black-figure painters whose work is admired, but this painting by Exekias may justly stand for their achievements, for the exquisite quality of their draughtsmanship, and the powerful simplicity of their work.

BLACK-FIGURE AND RED-FIGURE

In the last quarter of the 6th century BC, the black-figure style gave way to a new technique, that of red-figure. Red-figure is, in simple terms, a reversal of black-figure. The pot-painter instead of painting his figures in black silhouette against the red clay, paints the background in black and leaves the figures in the natural colour of the clay. The advantages of the new technique are obvious; the black-figure painter has to incise the internal details of his figures. The red-figure painter can draw or paint them in line, and by this means has much greater opportunity to convey natural movement. The new technique appears at a time when the painters were becoming more and more concerned with the problems involved in creating an illusion of three-dimensionality in representing the human figure; whereas the black-figure painter generally showed his figures either strictly frontal or in profile, or awkwardly combined the two viewpoints, the red-figure painter wants to show twists of the body, suggest subtle movements, and introduce unusual views. Another technique of vase-painting, which was becoming increasingly popular in the late 6th century, allowed the use of a wider range of colours. This is the white-ground technique, in which the body of the vase is covered with a white slip, the design is drawn in outline and filled in with washes of colour—red, purple, brown and yellow, a range of colours that probably gives an idea of the palette of contemporary wall-painting.

At first, red-figure and black-figure were practised together, sometimes on the same vase. The vase by the Andokides painter illustrated opposite has the same scene on both sides, one in red-figure and one in black-figure.

Very soon the more progressive artists have all turned to red-figure. In the last two decades of the 6th century the best red-figure painters delight in showing the human figure in different, complicated poses, and they begin to master the principles of foreshortening and anatomy in action. The work of Oltos on cups, and Euphronios on big vases, shows remarkable ability to suggest the solidity of three-dimensional form by pure line drawing.

SIXTH-CENTURY SCULPTURE

The development of Greek painting in the 6th century can only be studied with the aid of the vases, which, however fine their quality, are secondary sources; the major art of painting is almost unknown. In the case of sculpture, the primary documents themselves have survived. In 480 BC, when the Persians under Xerxes sacked the Acropolis of Athens, buildings and sculpture were destroyed, and, when Athens was reoccupied, these fragments were not restored but were used as rubble-filling in new walls and foundations; many of them have been excavated in a condition which, though fragmentary, is almost as fresh as the day they were cast down. Excavations in other parts of the Greek world have yielded many fine archaic sculptures and we can now appreciate the styles of the eastern cities and other centres of the Greek mainland. Apart from major works, small bronzes and work in other materials fill out the picture of archaic sculpture in the 6th century.

9. **Sphinx**. *c.* 550 BC. Marble. h. 21⁵/₈ in. (55 cm.). Acropolis Museum, Athens. This figure of a sphinx, found on the Acropolis at Athens, was part of a votive offering.

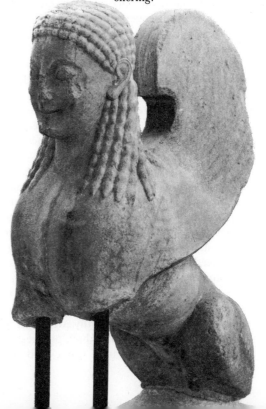

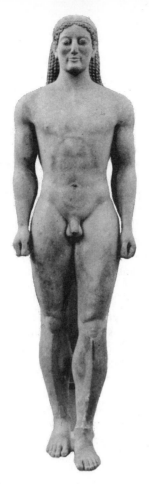

10. **Kouros**. *c.* 520 BC. h. 6 ft. 4 in. (1.94 m.). National Museum, Athens. Statue of a young man, whose name, according to an inscription, was Kroisos. Found at Anavyssos in Attica, in 1936.

personal representation of a man, superbly modelled and subtle in detail. It is, indeed, remarkable how 6th century **40** sculptors can portray the individual; we see their ability most clearly in the series of archaic maidens in the Acropolis Museum, one of the finest of which is the figure illustrated in plate 33, a work of wonderful individuality and charm. She wears a Doric garment, the *peplos*, and is called the *Peplos Kore*. Most of her sisters on the Acropolis wear Ionian dress, on which the sculptor exercised his skill in rendering the contrast between the heavier folds of the cloak (*himation*), and the soft material of the undergarment (*chiton*). The sculptors of the 6th century were also tackling many new poses and compositions in the round. The *Rampin Horseman* figure is part of an equestrian **36** statue dedicated on the Acropolis in about 540 BC; the remains of the horse and body of the rider are in the Acropolis Museum at Athens, and the head, of which a cast is shown in the picture, is in the Louvre. It seems to be a work of the same sculptor who carved the *Peplos Kore*.

The little bronze figure of a reclining banqueter, in the British Museum, is an exquisite piece, which illustrates **35** the high standard of craftsmanship in small-scale work. On a similar scale we may compare with it the superb detail of the procession of chariots on the well-known crater of Vix, a big bronze vase found in a chieftain's tomb in central France, and dating from the late 6th century BC. **41** By this time Greek sculptors have acquired a wonderful mastery in representing the essential forms of human and animal alike. The marble figure of a horse in the Acropolis Museum at Athens may stand for their skill in rendering animal forms; the piece is archaic in its firmness and simplification of anatomical detail, but we shall not have again in Greek art a more convincing representation of the animal.

IONIAN GREECE

In this brief discussion of archaic sculpture the examples have been mostly drawn from Attica, but there are other important regional styles which must not be entirely ignored here. The statue of a man from Samos may per- **11** haps serve to illustrate some of the more obvious differences between the sculpture of the mainland and that of Ionia. The draped male figure is very rare in mainland Greece, but seems to have been common in Ionia. It also seems that the more fleshy type of male was respected, or at least frequently represented, by the sculptors; the man from Samos provides a marked contrast with the more compact ideal of Attic sculptors and those of the mainland in general.

ARCHITECTURAL SCULPTURE IN THE SIXTH CENTURY

We shall not deal in this chapter with the further development of architectural forms, except in so far as it affects the development of sculpture. We have already seen that in the 7th century a rich sculptural decoration began to be ap-

THE 'KOUROS' AND 'KORE'

The development of sculpture in this period is a comparatively simple story. In figure-sculpture the ideal schemes of the nude *kouros* and the draped female (*kore*) hold the field until the early years of the 5th century. Decoration on buildings—pedimental sculpture, metopes, and friezes—provides the main inspiration for experiments with the posing and grouping of figures which, by the end of the century, have achieved such freedom, that they seem about to break with conventions and achieve a completely free range of expression. A major influence on the development of Greek sculpture was the discovery, in the first half of the century, of the technique of hollow-casting large bronze figures; the only surviving archaic bronze figure, the *kouros* found at the Piraeus and now in Athens, has the same hard transitions as the marble figures of the period, as though the model from which it was cast had been carved **34** in hard material. Modelling in clay, which is the basis of the bronze worker's technique, allowed greater freedom in composition, and bronze became the favourite medium of the great sculptors of the 5th century.

The sculptors of the 6th century were keenly interested in the problems of rendering the anatomy of the human figure, and although the archaic scheme and its conventions were not abandoned, the statues become more lifelike in face and figure. A work of the later 6th century (figure 10) shows how the four-square structure of the earlier figures has been relaxed, the forms are more rounded, less abrupt, the anatomical details represented more nearly as they are in nature. If we look at the fine grave relief of Aristion in the National Museum at Athens, one of the series of superb gravestones made for wealthy Athenians of the period, we can see how far the sculptors have progressed in this direction by the end of the century. It is a vivid and

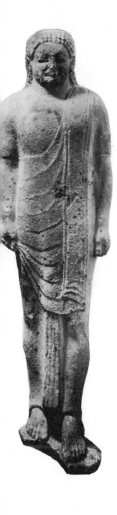

11. **Man from Samos**. *c.* 550 BC. Marble. h. 6¼ ft. (1.90 m.). Vathy Museum, Samos. Statues of draped male figures were very rare in mainland Greece, but more common in the cities of Ionia.

12. **Herakles**. *c.* 490 BC. Marble. h. 3 ft. 3 in. (1 m.). Antikensammlungen, Munich. Figure of Herakles drawing his bow, from the east pediment of the so-called Temple of Aphaia, at Aegina, was part of a composition depicting a battle in the Trojan War. (see below). This and other figures of the pediment were restored by the sculptor Thorwaldsen.

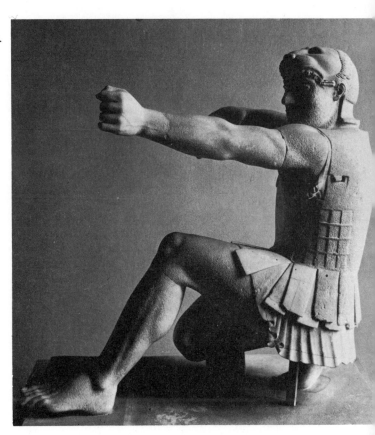

plied to buildings, and in the following century this decoration provided one of the most important fields for the development of sculptural styles. Fragments of 6th-century buildings from the Acropolis at Athens illustrate the progress in solving the problems of pedimental composition. Part of the famous 'bluebeard' pediment from a building of about 560 BC is illustrated in plate 32; here the sculptor has chosen a subject particularly appropriate to the difficult shape of the pediment, a weird and wonderful creation of a three-headed monster with a serpent's body filling the corner. A group depicting Herakles fighting Triton occupied the corresponding place on the other side of the pediment. There is a fine decorative use of colour, dark blue for the creature's beard and hair, deep red for the snakes and reddy-yellow on the skin. He is hardly a fierce beast but a friendly, almost amiable monster.

By the end of the century sculptors had mastered the problems of combining figures on the same scale into a single pedimental composition. The figure of Herakles illustrated above comes from the east pediment of the Temple of Aphaia at Aegina, designed about 490 BC. The subject was a battle before Troy, in which mythical Aeginetan heroes took part; the centre of the pediment was dominated by the standing figure of the goddess Athena, while the fighting figures—striding forwards and backwards, kneeling, falling and fallen—are skilfully arranged in different poses to fill the triangular space. There is a fine freedom and variety in the representation of the figures. An example of early metope composition (below) comes from a temple at Selinus, in Sicily, one of the Greek colonial cities which saw a great deal of important building activity in the 6th century. This composition of Perseus killing Medusa is stiff and somewhat retarded in style for its period, but it shows well the kind of composition that the

12

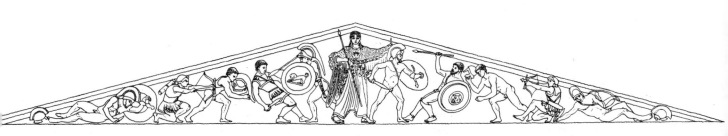

F. Reconstruction of the east pediment of the Temple of Aphaia at Aegina.

13. **Perseus and Medusa**. *c.* 550–540 BC. Marble. h. 4 ft. 10 in. (1.47 m.). Museo Nazionale, Palermo. Perseus, with Athena in attendance, is cutting off the head of Medusa; one of the metopes from the temple, known as temple C, at Selinus, in Sicily.

Greeks found appropriate for the metopes of the Doric frieze. The Ionic order included the continuous sculptured frieze. We have no examples of the period from large buildings, but one of the finest works of archaic relief sculpture comes from an exquisite little Ionic building at Delphi erected by the wealthy Cycladic island of Siphnos about 525 BC. This building, one of the Treasuries put up by Greek cities at the main pan-Hellenic sanctuaries, was a little rectangular structure with two standing figures of maidens (*caryatids*) taking the place of columns to support the entablature of the porch. A continuous frieze ran all round the building representing various subjects, including battles of gods and giants. In the battle frieze on the north side, the goddess Cybele appears in her chariot drawn by lions, one of whom is attacking a hel-

39

meted giant. The background of the frieze was painted in blue and the figures in bright colours. The sculptor shows a remarkable skill in rendering the most minute detail and the subtleties of texture and form, and he makes a convincing attempt to create an illusion of spatial depth by means of relief height, the overlapping of figures, and the clever use of foreshortenings.

THE ACHIEVEMENT OF ARCHAIC GREEK ART

We may now attempt to summarise the achievements of Greek artists in the long period from the end of the Mycenaean world to the beginning of the 5th century. When the Greek artist, after the first purely non-representational phase of art, begins to be interested in the human figure, he looks for and finds a simple, almost childlike, formula. Almost as soon as it is devised, the formula is used for representing quite complicated narrative scenes derived from a rich mythology, which continues to be the subject-matter of much of classical art throughout its history. At the same time the Greeks begin their search for ideal form to represent gods and men. In the period of oriental influences they found an ideal for monumental sculpture in Egyptian art, not because it was the only art available as a model, but because it was sympathetic to their own aims and ideals. But the Greeks, and herein lies the difference between their art and what had gone before, were not content to accept this form as absolute, but developed it by constant reference to what they saw in nature. It is dangerous to look too closely into the causes of this development—why it should have been made in Greece and not elsewhere—but two factors are certainly of prime importance. Firstly the Greeks wished to represent their vivid mythological and epic tradition by an equally vivid narrative art; secondly, they, more than other peoples, found the inspiration for their ideals in human nature in which they fervently believed.

By the beginning of the 5th century, neither sculptors nor painters had achieved the complete break with archaic conventions. Painting, in so far as we can judge from the vases, was still outline drawing with flat washes in a limited range of colour, shading was not attempted, nor was the painter yet able to show a figure with absolute consistency

14. **Young men playing a ball-game**. *c.* 510 BC. Marble. h. 13 in. (32 cm.). National Museum, Athens. One side of a marble statue base found in the Dipylon cemetery at Athens, with reliefs showing a group of athletes playing a ball-game.

from his chosen viewpoint. A frontal eye appears in a profile head; the principles of foreshortening are not yet fully understood. Sculpture, especially relief-sculpture, is rather more ambitious; the ball-players on one side of the well-known statue base in the National Museum at Athens show how close artists, inspired by the cult of athletics, were getting to a complete understanding of human anatomy in action. In architecture, the forms which were to be still further refined and perfected in the 5th century had been brought into being, and already have some outstanding achievements behind them. In all branches of art the scene is set for what the Greeks are to achieve in the great period of their history.

14

The Art of the City-States

In 490, and again in 480 BC, the Persians, who had subdued the Greek cities of Asia Minor, attempted to bring those of mainland Greece under their sway. The defeat of the Persian invasions inaugurated the greatest period in the history of the Greek city-states; it brought economic prosperity, self-confidence in their institutions and way of life, rich achievement in every branch of the arts. In the years that followed, Athens emerged as the leader of the Greek states against the Persian threat. She converted a league of defence into an empire and, under the leadership of Pericles, made herself great. The power of Athens, achieved against strong opposition from Sparta and other states of Greece, lasted until the Peloponnesian War. That war did more than destroy the power of Athens: it undermined the whole system of city-state organisation, weakening their strength and breaking down their faith in themselves and their way of life. After it, they maintained their independence until the middle of the 4th century, when they succumbed at last to the power of Macedon under Philip and his son, Alexander the Great. Throughout this period, painters, sculptors and architects laid the foundation of European art.

THE REVOLUTION IN GREEK ART

It is customary to speak of a revolution in Greek art as having taken place in the early years of the 5th century, but it is not easy to understand its character and importance. We have seen how the archaic *kouros* type had been brought increasingly close to nature, how sculptors, especially those working on reliefs and the decoration of buildings, had made successful attempts to convey difficult action poses with accuracy and vitality. This steady development might be thought to lead on inevitably to the complete abandonment of the archaic formulae. But there is, nevertheless, a vital step to be taken and, so far as we know, it was not taken until the early years of the 5th century, when the sculptors, with their thorough understanding of the human form, felt able to abandon completely the traditional, almost magical, statuary-types of the standing male and female figures which had long served to represent both gods and humans.

It is difficult to fix this revolutionary step in time. There is a hint of change in the well-known bronze *Apollo of Piombino* in the Louvre, a work of about 490 BC, but the slight relaxing of the frontal pose is not fully expressed in the forms of the body. The complete break has been made by **46** the sculptor of the so-called *Kritian Boy*, a statue found in the Persian debris on the Acropolis, which was probably made just before 480 BC. This figure, 'the first beautiful nude in art', as Sir Kenneth Clark has called it, belongs to a different world from the archaic *kouros*. He no longer stands four-square and frontal with the weight of the body distributed evenly on two stiff legs; instead the weight is taken on the left leg while the right is drawn back and bent at the knee. There is movement in the body, with one hip raised above the other, and the head is turned gently to the right. The face, too, is different, not only in structure but in expression; the keen, smiling archaic face has given place to a gently pensive and serious look that we associate with the artists of the 5th century. The *Kritian Boy* seems to set Greek sculpture on a new path: the search for an ideal of human and divine beauty, grounded in nature but disciplined by perfection of symmetry, proportion and balance. To this ideal Polykleitos, the great Argive sculptor, was to devote the greater part of his life and work in the second half of the 5th century.

THE GREAT ARTIST OF THE FIFTH CENTURY

If the fundamental break with the archaic world had already taken place before the Persian Wars, the Greek victories undoubtedly set the seal upon it and created the opportunity for the rapid development of the new tradition. It is not easy to follow this development in what has survived. The 5th century is an age of great names in sculpture and painting, but very little of their work has come down to us. The great sculptors of the period, such as My- **47** ron and Polykleitos, worked mainly in bronze, and we know their masterpieces primarily from the copies that were made in Roman times. The work of the great painters, such as Polygnotus, is completely lost, and there are no copies; all we have are reflections of their styles and technique in the work of contemporary vase-painters, and some information about them from second-hand literary sources. The monuments of architecture are better known, and the surviving buildings also provide a body of sculpture which is not only primary material for the development of the art, but sometimes gives evidence for the style of the great sculptors who were concerned with their decoration.

THE TEMPLE OF ZEUS AT OLYMPIA

The sculptures from the great temple of Zeus at Olympia, begun about 470 and finished in 456 BC, give a starting point for the study of Greek sculpture in the years following the Persian Wars. Both pediments of this Doric temple were filled with sculptural compositions—on the west, a wild scene of fighting between the Lapiths and the Centaurs at the wedding feast of Peirithoos, and, on the east, a scene of absolute stillness showing the preparations for the chariot race between Pelops and Oinomaos. Twelve metopes, six at the eastern and six at the western end of the building, represented the Labours of Herakles. The sculptures, though found in a very fragmentary state, have been reconstructed to give a good idea of the design and style. Grandeur of conception and depth of feeling, qualities which the ancient critics attributed to the great sculptors and painters of the period, are the outstanding characteristics of these magnificent sculptures. In the centre of the west pediment stands Apollo, magnificent in scale, **15** commanding in gesture, remote in expression, dominating a wild scene of fighting. On the east pediment the figures are still and frontal, their stillness conveying a powerful feeling of impending drama. No artists of any other period of Greek art would have attempted a scene so dramatically still as that of the east pediment; no artist for

15. **Pediment of the Temple of Zeus at Olympia**. 470–456 BC. Marble. Olympia Museum, Greece. Central part of the west pediment of the temple of Zeus, at Olympia, showing the figure of Apollo and groups of a Lapith and Centaur in combat.

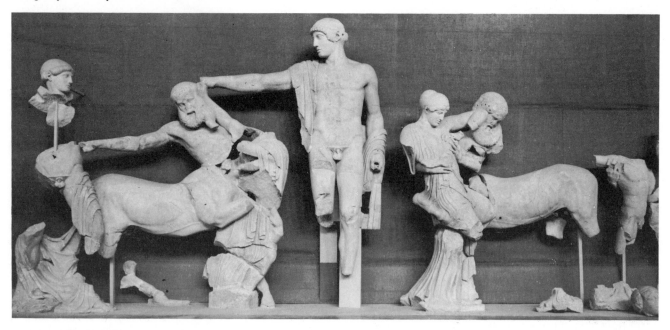

16. **Fore-part of a horse**. 490–480 BC. Marble. h. 44½ in. (1.13 m.). Acropolis Museum, Athens. The figure was found in the debris of the Persian sack of the Acropolis.

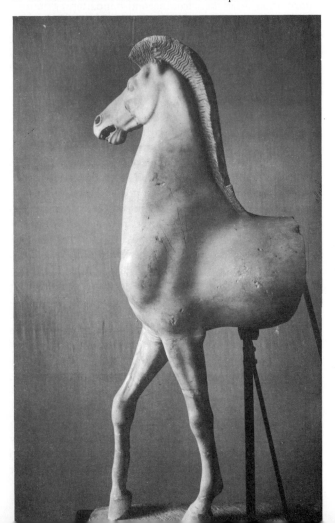

another hundred years would achieve so powerful a piece of illustration as did the creator of the west pediment.

The sculpture of the early 5th century is full of the same kind of contrasts as we see in the pediments of Olympia. On the one hand, artists are striving to perfect new ideals of human and divine beauty. The decorative prettiness of drapery styles, the smiling faces of the archaic period, have disappeared. The figures of Zeus, Hippodameia, Pelops and Sterope, standing in the east pediment, represent that severe ideal of the human figure at which the artists of the period were aiming, an ideal that still lacks the harmonious balance achieved in the later part of the century. On the other hand, sculptors pursue a restless enquiry into the actions and emotions of men. The tortured struggle of the Centaurs is expressed in their faces; old age is brilliantly captured in the figure of the seer on the east pediment.

One of the few large-scale Greek bronzes that has come down to us, the statue of Zeus from the sea off Cape Artemision is the work of an unknown master sculptor, made **51** between 470 and 460 BC. Zeus is in the act of hurling a thunderbolt, a pose in which the sculptor has tried to combine a monumental stillness and a momentary action. Myron's famous discus-thrower, a work of about the *18* same period, which is known only from copies, is a wonderful attempt to produce a perfect athletic action figure, an attempt that the later 5th-century sculptors were to renounce in favour of an ideal figure at rest. They were to abandon, temporarily at least, the study of human emotions, and concentrate on achieving that limited perfection of symmetry and proportion which is the essence of Greek art. Pheidias, in his figures of gods and goddesses, raised humanity to a new position of dignity; Polykleitos, with devotion and supreme earnestness, created physical types that best exemplify man's power to possess the world.

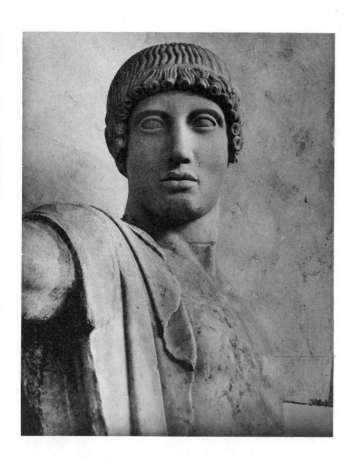

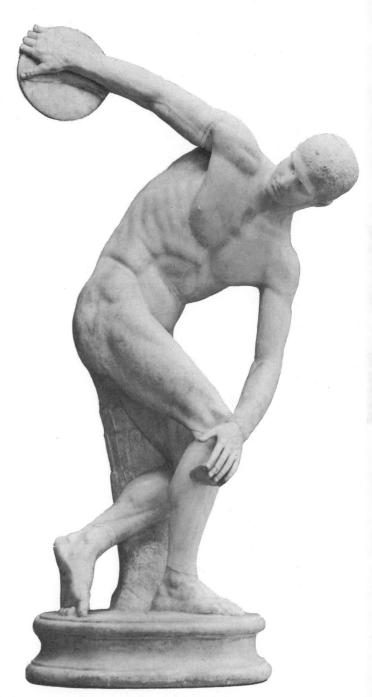

17.**Head of Apollo**. Olympia Museum, Greece. A detail of the head of Apollo, in the centre of the west pediment at Olympia.

ATHENS UNDER PERICLES

It was the greatness of Athens in the time of Pericles, that has given us the most vivid realisation of the Greek achievement. In the middle of the century, the Athenians, prompted by Pericles, decided to devote some of the surplus funds accumulated in the treasury of the league of defence against Persia to the rebuilding of the Acropolis at Athens. They inaugurated a building programme which resulted in some of the finest buildings of the ancient world: the Parthenon, chief temple of the patron goddess Athena, the Propylaea, a monumental entrance to the sacred enclosure of the Acropolis, the Erechtheum and other famous buildings. The programme included the erection of statues in bronze, marble and in the gold-and-ivory technique that was used for the most splendid cult-statues of the day. The great names in the sculpture of this period are Pheidias, the friend of Pericles and, according to Plutarch, the director of all his building projects, creator of the gold and ivory cult images of Zeus at Olympia, and Athena Parthenos at Athens, and the Argive Polykleitos, the perfector of the ideal athletic statue. Nothing survives of Pheidias' work, but he must have been concerned in the design of the sculptures of the Parthenon, and it is quite likely that he had a hand in some of the work. No original by Polykleitos has come down to us, but his great athletic figures were much copied in later antiquity.

The Parthenon, built between 447 and 432 BC, was the most grandly conceived Doric temple of antiquity. Most of its sculptures are in the British Museum, brought to England by Lord Elgin in the early 19th century. Inside the temple stood Pheidias' gold and ivory image of Athena; on the building the groups of sculpture consisted of the two pedimental compositions, a complete series of sculptured metopes in the Doric frieze, and a continuous frieze round

18. **The Lancellotti Discobolus**. Roman period. Marble. h. 4 ft. 1 in. (1.25 m.). Terme Museum, Rome. A Roman copy of the famous bronze figure of an athlete throwing a discus, made by the Athenian sculptor, Myron, about 450 BC.

19. **The Temple of Hephaestos, Athens**. 450–440 BC. This Doric temple stands on high ground near the Agora of Athens. Of all Greek temples, it is the best preserved.

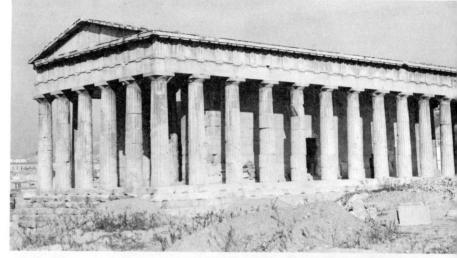

20. **The Parthenon**. 447–432 BC. Marble. The temple of Athena Parthenos, on the Acropolis at Athens, was designed by two architects, Iktinos and Kallikrates.
It housed the colossal gold and ivory image of Athena, patron goddess of the city.

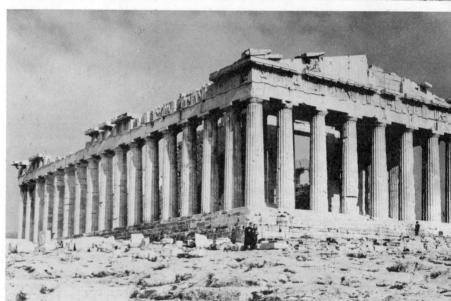

21. **Dionysos**. 440–432 BC. Marble. h. 4ft. 7 in. (1.40 m.). British Museum, London. The so-called 'Dionysos', a god or hero, is one of the surviving figures from the east pediment of the Parthenon at Athens.

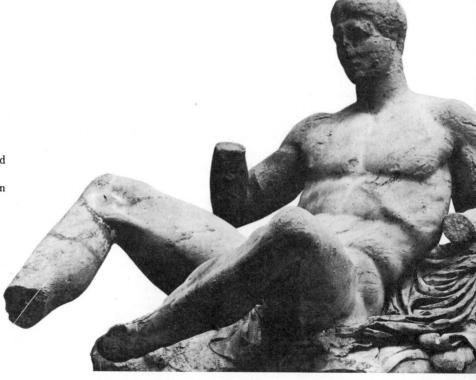

22. **Proto-geometric vase**. *c.* 1000 BC.
Pottery. h. 13¾ in. (34 cm.). British
Museum, London. The vase is very simply
decorated in the style apparently created
in Athens during the 11th century BC.
The chequer pattern on the upper part of
the body is a typical motif; the wavy band
on the main frieze is perhaps a survival
from the Mycenaean decorative tradition.

23. (left). **A funeral scene**. 8th century BC. Pottery. h. (of vase) 5 ft. 1 in. (1.55 m.). National Museum, Athens. This detail is from a very large painted vase found in the Dipylon cemetery at Athens, where it served to mark a tomb. The scene shows the dead man on a bier, lying in state beneath a chequered canopy, attended by mourners. It is one of the finest surviving examples of geometric vase-painting.

24. (below). **Man and Centaur**. 8th century BC. Bronze. h. 4½ in. (11.4 cm.). Metropolitan Museum of Art, New York. Gift of J. Pierpont Morgan, 1917. This little group has been interpreted as Herakles killing the Centaur Nessos. The man apparently held a sword in his right hand but there is little suggestion of any violent action in the composition. The forms of man and beast are typical of geometric sculpture in Greece during the 8th century—triangular body, narrow waist, bulging thighs and a flat face. There was no large-scale sculpture in this period but many such figures of men and animals and a few groups like this.

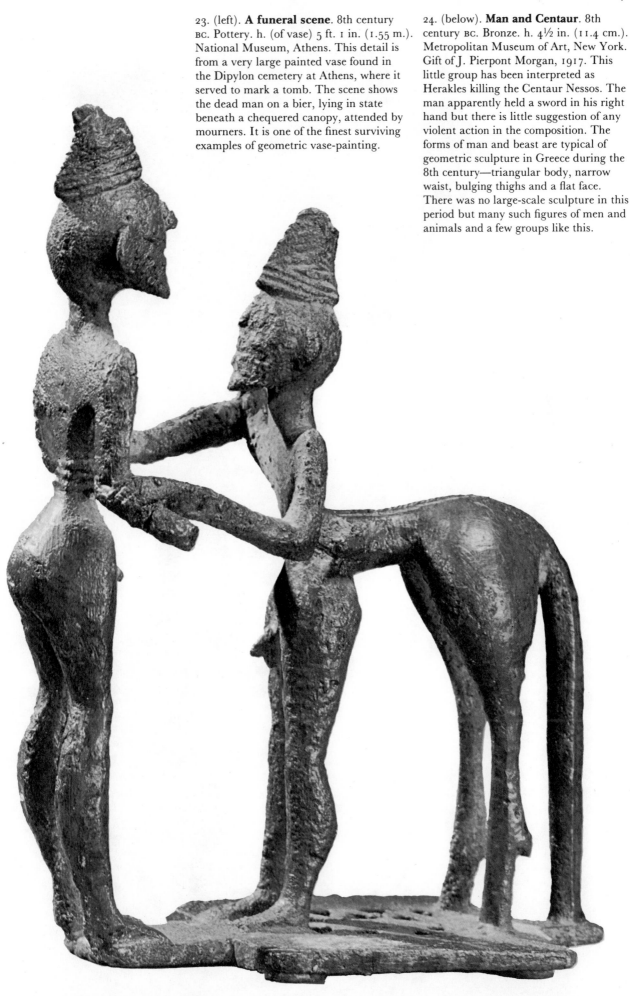

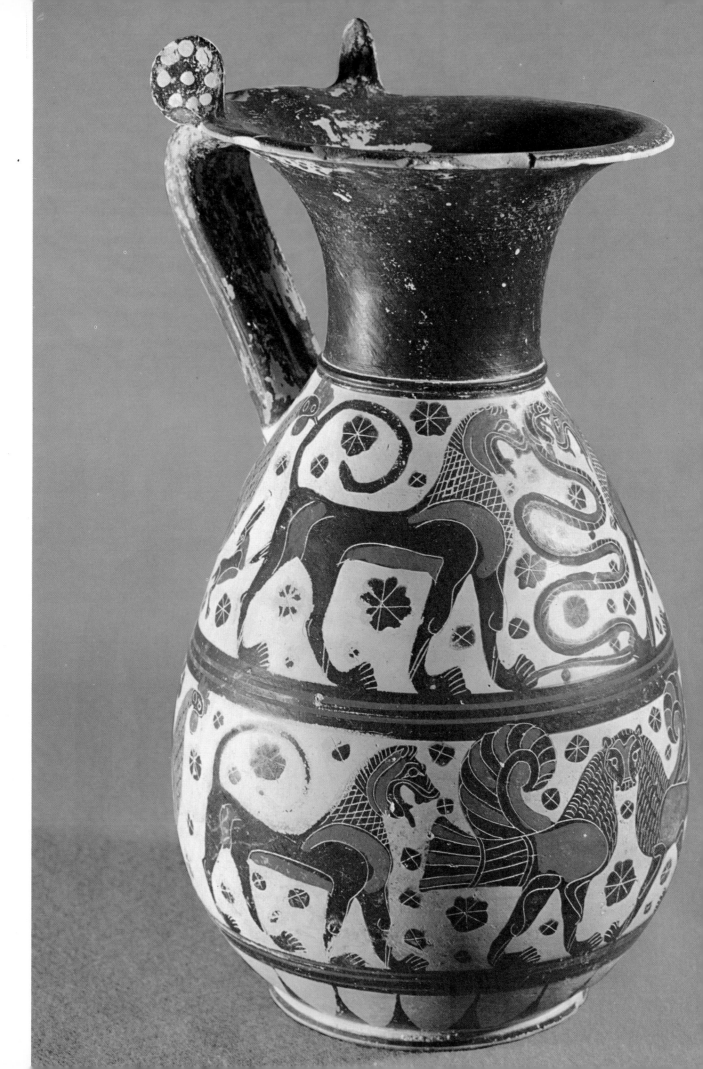

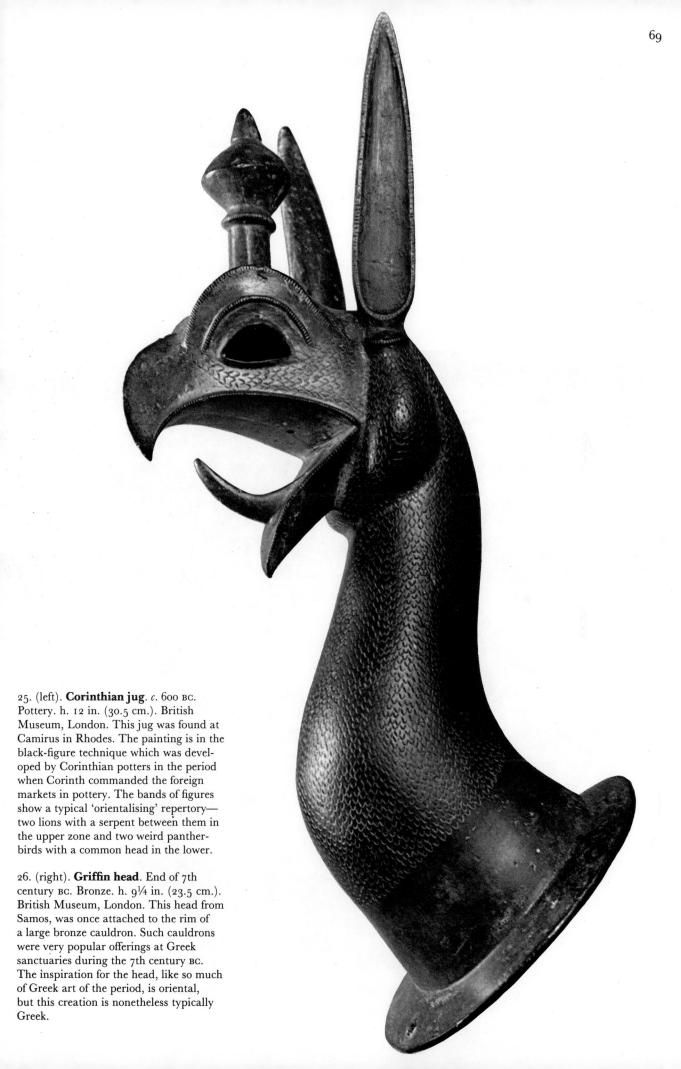

25. (left). **Corinthian jug**. *c.* 600 BC. Pottery. h. 12 in. (30.5 cm.). British Museum, London. This jug was found at Camirus in Rhodes. The painting is in the black-figure technique which was developed by Corinthian potters in the period when Corinth commanded the foreign markets in pottery. The bands of figures show a typical 'orientalising' repertory— two lions with a serpent between them in the upper zone and two weird pantherbirds with a common head in the lower.

26. (right). **Griffin head**. End of 7th century BC. Bronze. h. 9¼ in. (23.5 cm.). British Museum, London. This head from Samos, was once attached to the rim of a large bronze cauldron. Such cauldrons were very popular offerings at Greek sanctuaries during the 7th century BC. The inspiration for the head, like so much of Greek art of the period, is oriental, but this creation is nonetheless typically Greek.

70

27. (below). **Mixing Bowl (crater)**.
Early 7th century BC. Pottery h. 15¾ in.
(40 cm.). Antikensammlungen, Munich.
This bowl of the late-geometric period
was made in Athens. The figures are no
longer painted in pure silhouette; there is
more use of outline drawing and a more
effective rendering of natural movement.
The lions of the main frieze show the
influence of oriental art on the Greek
world of the 7th century.

28 (right). **The Nessos Painter.
Running Gorgon**. *c.* 600 BC. Pottery.
h. (of vase) 4 ft. (1.22 m). National
Museum, Athens. This detail shows part
of the scene painted on the body of the
vase found in the Dipylon cemetery at
Athens. The two sisters of Medusa, slain
by Perseus, are rushing in pursuit of the
hero. The Nessos painter takes his name
from the scene of Herakles killing the
Centaur Nessos, which appears on the
neck of the vase.

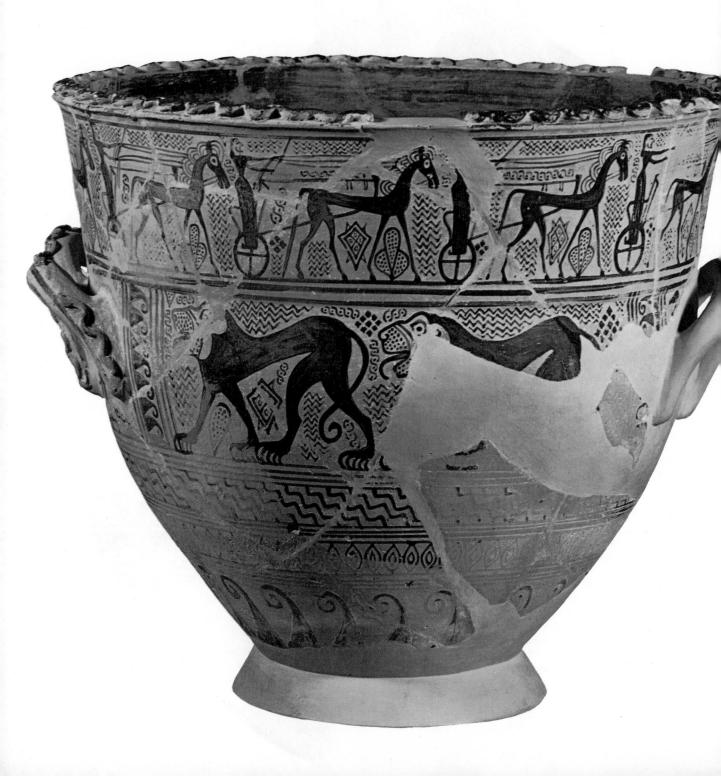

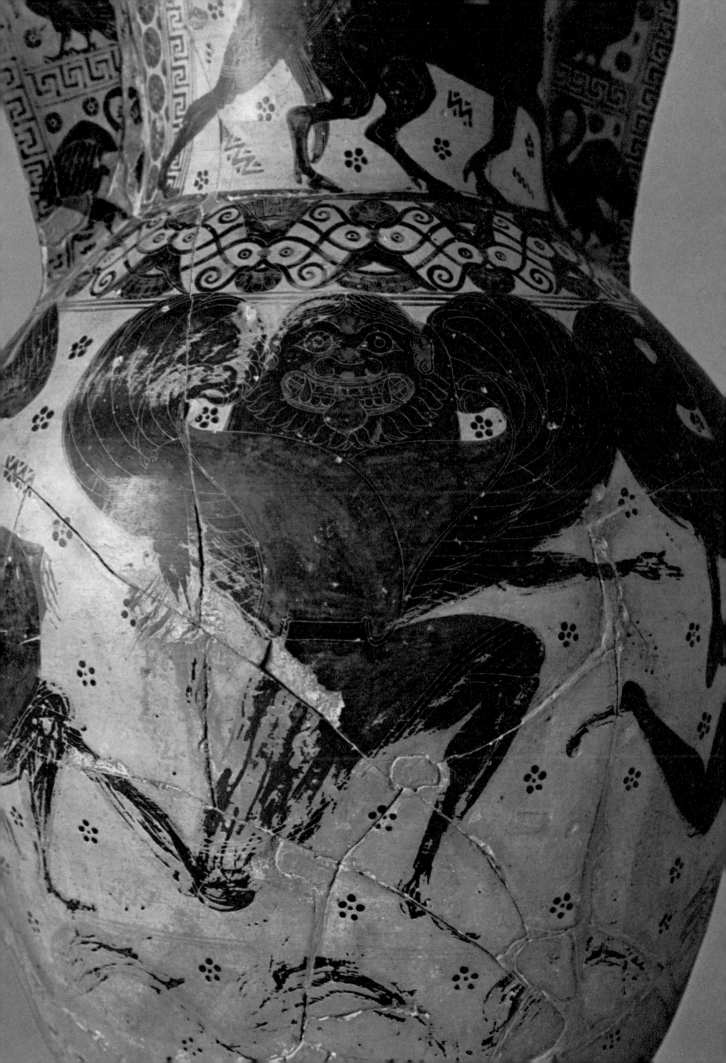

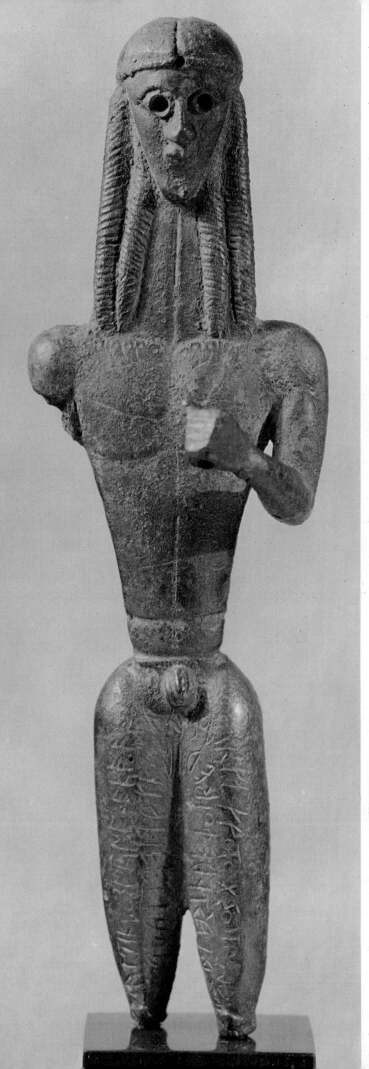

29. (left). **The Mantiklos Apollo**. Early
7th century. Bronze. h. 8 in. (20 cm.).
Museum of Fine Arts, Boston. Statuette
of the god Apollo from Thebes in Boeotia.
The forms of the body are those estab-
lished during the geometric period for the
representation of the human form. The
god wore a headdress and probably car-
ried a bow in his left hand. On the thighs
is an inscription saying that Mantiklos
dedicated the figure to the god Apollo.

30. (right). **Detail of storage jar from
Thebes**. *c.* 700 BC. Pottery. h. (of vase)
4 ft. 1¼ in. (1.25 m.). National Museum,
Athens. Detail of a big amphora decorated
with relief-ornament found in a tomb near
Thebes. The detail shows the figure of a
goddess, the Potnia Theron or Mistress
of the Animals, who is accompanied here
by two smaller human figures and flanked
by two standing lions.

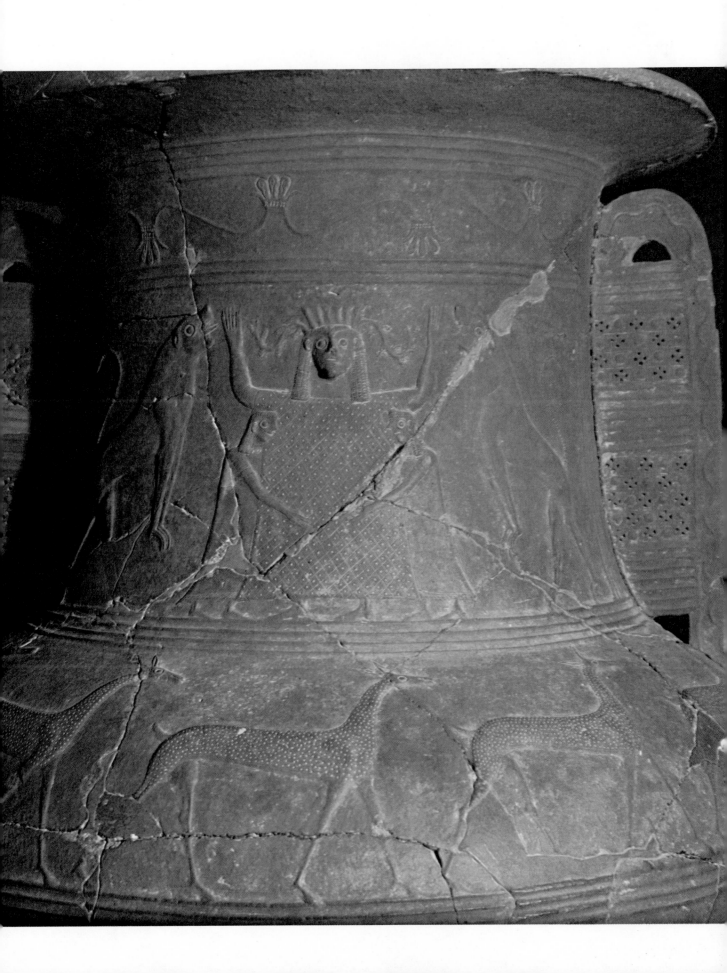

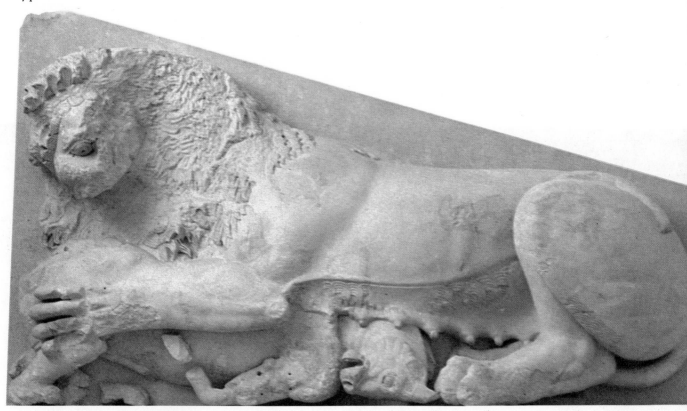

31. (above). **Lioness attacking a bull**. *c*. 600 BC. Painted limestone. approx. h. 5 ft. 7 in. (1.70 m.). Acropolis Museum, Athens. This powerful sculpture comes from the pediment of a building on the Acropolis. The complete group probably showed two lions, one on either side of the pediment, and a bull in the centre. The figures have been restored from many small fragments found in excavations.

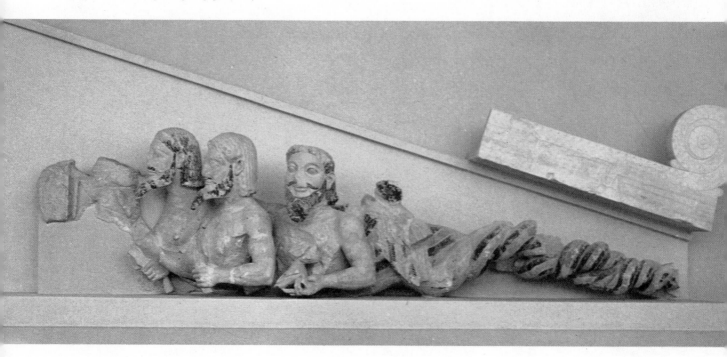

32. **The three-bodied Monster**. *c*. 570 BC. Limestone. l. 11 ft. 4 in. (3.40 m.). Acropolis Museum, Athens. Part of a pediment from a temple on the Acropolis at Athens, destroyed in the Persian sack of 480 BC. The left half of the pediment showed Herakles wrestling with Triton and the right, illustrated here, a weird three-bodied monster with a tail in the form of twisted snakes. Much of the ancient paint still survives on the carving. The pediment is often called the 'Blue-beard pediment' because hair and beards of the creature are painted dark blue.

33. (left). **Kore No. 679**. *c.* 530 BC. Marble. h. 4 ft. (1.21 m.). Acropolis Museum, Athens. The 'Peplos Kore' is one of the best-known of the series of figures of maidens (*korai*) dedicated on the Acropolis of Athens in the 6th century and destroyed by the Persians. The painting on this figure, as on others of the series, is fairly well preserved. The clothes she wears are the sleeveless Doric *peplos* of heavy material over a lighter garment with sleeves (*chiton*). Her gently smiling face, typical of archaic sculpture in Greece, has wonderful life and charm and, for all the apparent simplicity of the figure, the forms of the body beneath the drapery are suggested with consummate skill.

34. (right). **Bronze Kouros from Piraeus**. *c.* 530 BC. Bronze. h. 6 ft. 3 in. (1.90 m.). National Museum, Athens. This statue was found by workmen digging a drain in 1959 at Piraeus, the port of Athens. It is the earliest large hollow cast bronze figure which has survived from the Greek world and belongs to a period when the technique had not long been discovered. It probably represents the god Apollo, who was shown holding a bow in his left hand.

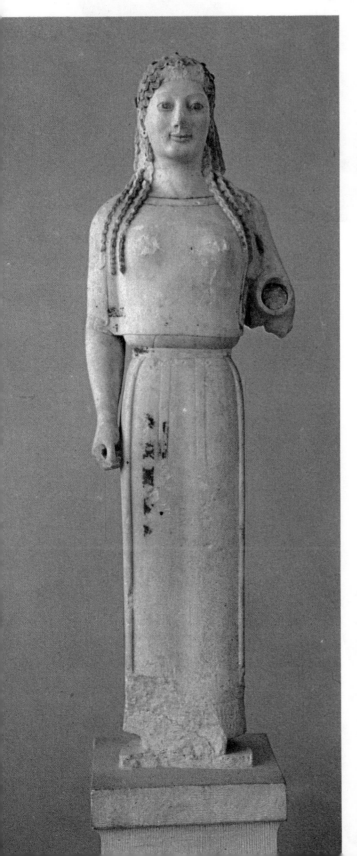

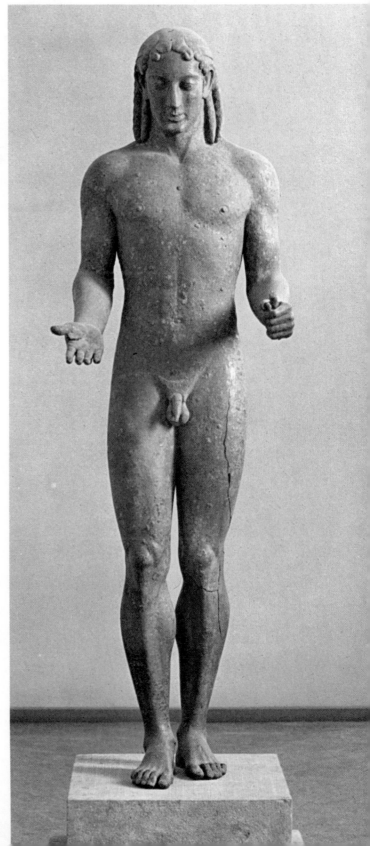

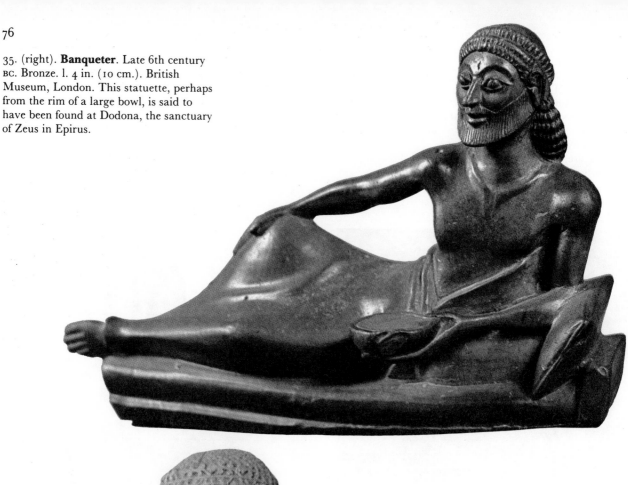

35. (right). **Banqueter**. Late 6th century
BC. Bronze. l. 4 in. (10 cm.). British
Museum, London. This statuette, perhaps
from the rim of a large bowl, is said to
have been found at Dodona, the sanctuary
of Zeus in Epirus.

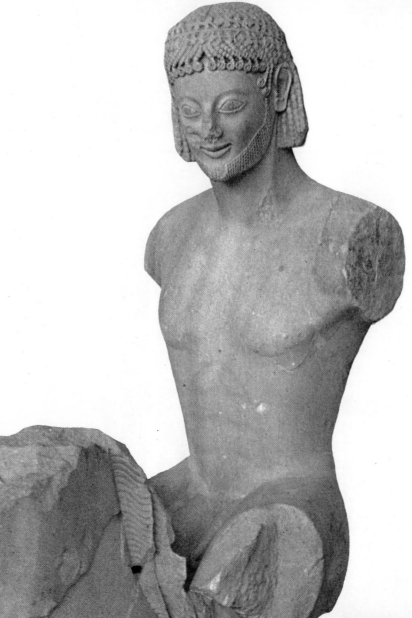

36. (left). **The Rampin Horseman**.
c. 550 BC. Marble. h. 3 ft. 7½ in. (1.10 m.).
Acropolis Museum, Athens. This statue of
a horse and rider was one of the dedica-
tions on the Acropolis of Athens destroyed
by the Persians under Xerxes in 480 BC.
To judge from the oak wreath he wears,
the rider was the victor of a horse race.
It is believed to be an earlier work of the
sculptor who carved the 'Peplos Kore'
(plate 33). The head is a cast of the so-
called Rampin head in the Louvre, which
gives its name to the whole group.

37. (right). **Exekias. Attic black-figure
vase**. *c.* 530 BC. Pottery. h. 16¼ in. (41 cm.).
British Museum, London. This amphora,
by one of the finest black-figure painters
of Athens, showing Achilles slaying
Penthesilea, is a perfect example of the
technique consisting of black silhouette
with engraved detail and white and
purple paint added for some details.
On the other side of the vase Dionysos
appears with his son Oinopion.

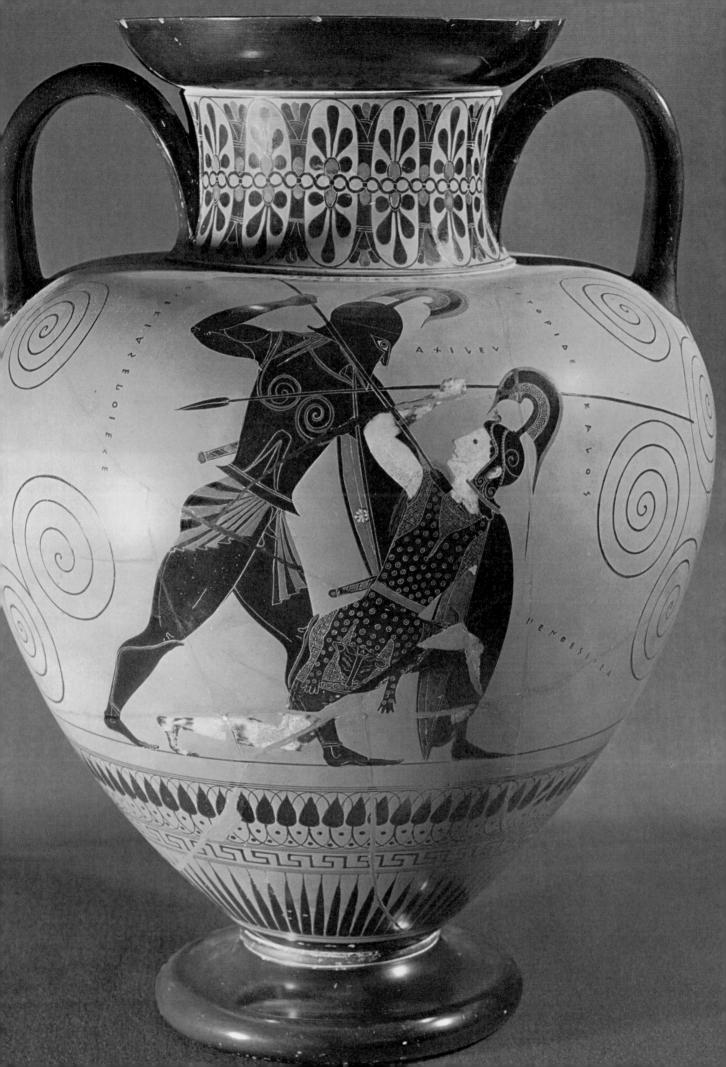

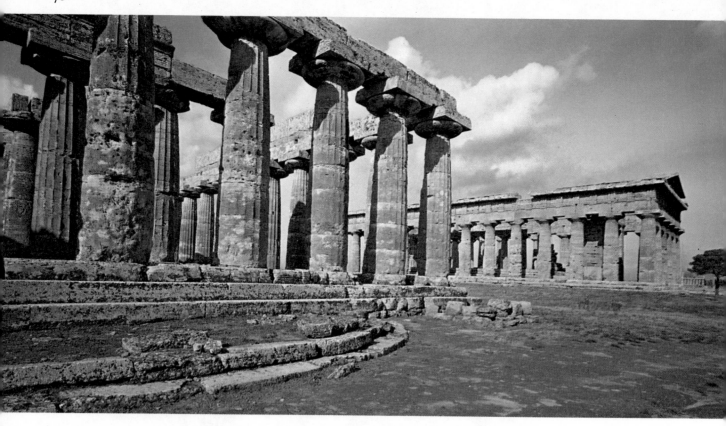

38. (above). **The 'Temple of Neptune' at Paestum** (mid-5th century BC) and part of the so-called Basilica (mid-6th century) in the foreground. The view of these two temples shows something of the development of Doric architecture from the archaic to the classical period. The columns of the earlier building taper more markedly towards the top and the *echinus* of the capital is flatter and more spreading.

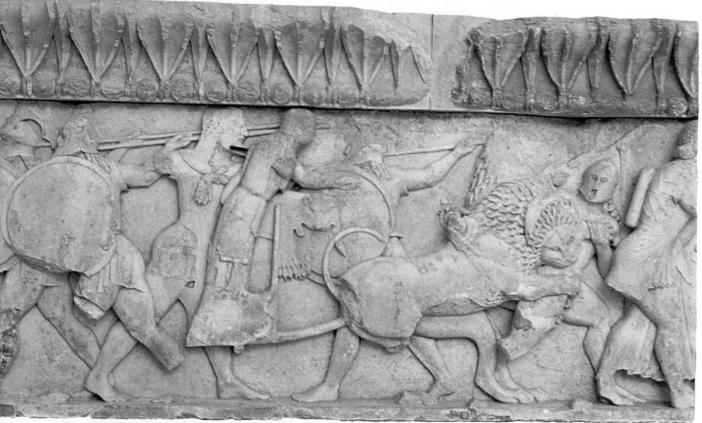

39. **Part of the frieze of the Siphnian Treasury, Delphi**. Archaeological Museum, Delphi. *c.* 525 BC. Marble. h. 2 ft. 2 in. (66 cm.). The frieze ran round the whole building, and more than half of it still survives. The subjects on the west and south sides were the Judgement of Paris and the Rape of the Leucippids; on the east and north, scenes from the Trojan War and Battle of Gods and Giants. The detail shown here is part of the Gods and Giants frieze; Cybele is in her chariot drawn by lions, Herakles in the background fights with a giant.

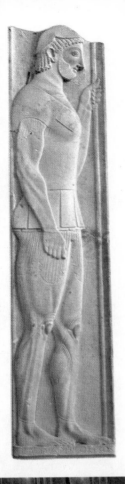

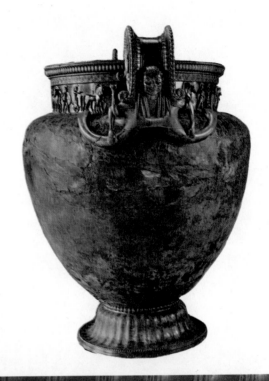

40. (left). **Aristokles. The Stele of Aristion**. Late 6th century BC. Marble. h. 8 ft. (2.4 m.). National Museum, Athens. Aristion appears in military dress, wearing breastplate, greaves and helmet; the top of the gravestone was once crowned by a palmette. The figure is carved in low relief; of the rich painting the red on the hair and beard is best preserved. Found near Velanidesa in Attica. An inscription gives the name of the sculptor.

41, 42. (right and below). **The crater of Vix and detail showing freize.** *c.* 525 BC. Bronze. h. 5 ft. 4 in. (1.64 m.). Museum at Châtillon-sur-Seine. This fine mixing-bowl was found in 1953 at Vix near Châtillon-sur-Seine (Côte d'Or) in a rich chariot burial of the late Hallstatt period. The vessel is made of hammered bronze decorated with cast appliqué figures on the neck and equipped with elaborate cast handles. The frieze on the neck, of which a detail is shown here, depicts four-horse chariots and soldiers (*hoplites*). This is one of the finest surviving Greek bronze vessels and its presence at Vix illustrates the wide extent of Greek trade north of the Alps.

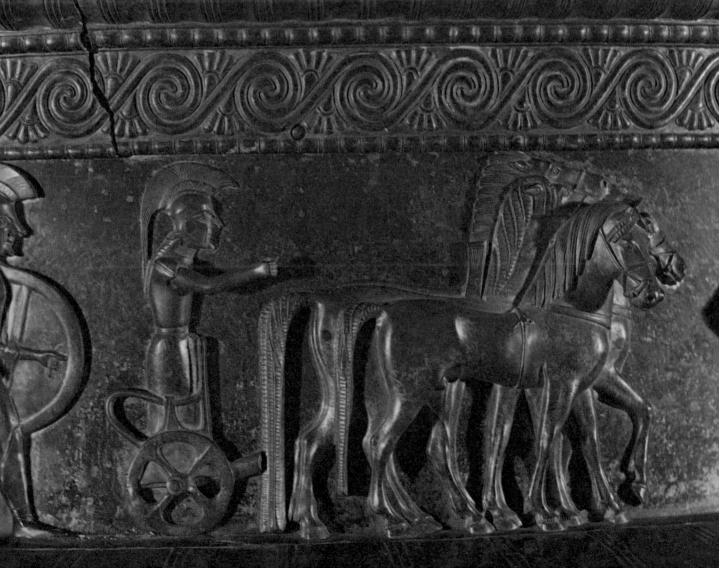

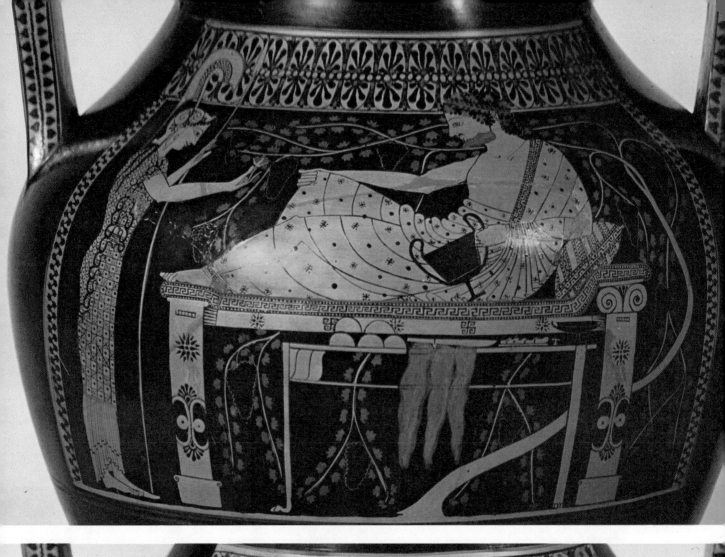

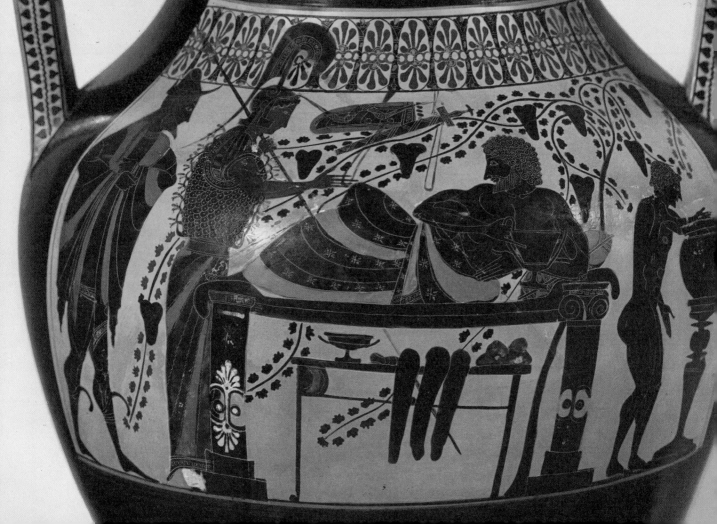

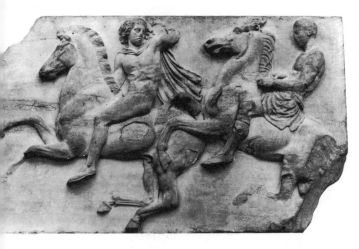

22. **Two horsemen**. *c.* 440–432 BC. Marble. h. 3 ft. 3 in. (1 m.). British Museum, London. Two young horsemen riding in the Great Panathenaic procession in honour of Athena; part of the west frieze of the Parthenon.

the upper part of the cella wall, an Ionic feature introduced into a number of Doric buildings during the period. The pedimental compositions represent, on the east, the birth of Athena, and, on the west, her contest with Poseidon to decide which of them should be the patron deity of Athens. The metopes show battles of Lapiths and Centaurs, gods and giants, Greeks and Amazons, Greeks and Trojans, all themes chosen to symbolise the triumph of Greek civilisation over barbarism, appropriate to a building which, in some sense, was thought of as a victory monument over the Persians. The frieze portrays the procession of the Great Panathenaia, held every four years by the people of Athens, the purpose of which was to present a new robe to a venerable image of Athena on the Acropolis. The procession began on the west side of the building, ran along the north and south in two separate streams, and converged on the ceremony of the robe that took place in the centre of the east front.

THE SCULPTURE OF THE PARTHENON

It is the business of great artists to reveal the ideals of an age, and in what has survived of the pedimental compositions the sculptural ideals of the 5th-century Greeks seem to stand fully revealed. The 'Dionysos' of the east pediment, one of the assembled company of gods to whom the birth of the goddess is announced, is one of the most grandly conceived nude figures in the whole history of art; he sits relaxed, pensive, a perfect blend of naturalism and ideal form, awe-inspiring in his grandeur. The river god ('Ilissos') from the west pediment raises himself on his left arm from a reclining position, a gentle movement that provides the artist with an opportunity to show the powerful forms of the body in a harmony of rest and tension. In the group of three goddesses from the other side of the same pediment, the majestic ideal of the female figure is embodied, with the massive forms of the body offset by a rich

43, 44 (opposite). **The Andokides Painter. Bilingual amphora** (both sides). Late 6th century BC., Pottery. h. 21 in. (53.5 cm). Antikensammlungen, Munich. The same scene (with variations) of Herakles banqueting on Olympus appears on both sides of the vase, once in the red-figure technique and once in black-figure. In the late 6th century, when the red-figure technique was coming into fashion, a number of vases were painted making use of both techniques.

and subtle handling of the drapery. The stiffness, the flatness, the uncertainties of scale that one sees at Olympia, have now given place to a full three-dimensionality backed by superb technique. Comparatively few of the high relief metopes are well-preserved, and they, of all the sculptures from the Parthenon, are the least satisfying. Perhaps it is inherent in the nature of Greek art at this moment that they should be so; that the wild scenes of combat between Lapiths and Centaurs lack conviction, because perfection of form cannot be reconciled with violent action. It may be, as some people have thought, that less able sculptors worked on this particular part of the building. The same criticism is certainly not applicable to the low-relief of the frieze, which conveys the movement of the procession in a wholly convincing way—the bustle of the preparations, the gathering momentum of the horsemen, the handling of the sacrificial victims, the rush of the chariots, the quiet solemnity of the votive scene. Idealising it certainly is, but idealising in a way that seems to give a keener understanding of the reality of the events that lie behind it.

POLYKLEITOS AND ATHLETIC SCULPTURE

The Argive sculptor, Polykleitos, was held in antiquity to have achieved the Greek ideal of athletic beauty. We know his most famous work, the athlete carrying a lance, from many copies made in Roman times, when it was probably the most copied of Greek statues. Polykleitos himself wrote a book explaining the principles of symmetry and proportion on which it was based. Since the abandonment of the *kouros* figure, the standing nude male figure had shifted its pose from one leg to the other, without achieving a position of perfect balance at rest. Some of the sculptors of the early 5th century had attempted to reconcile perfect pose and vigorous action, but Polykleitos goes back uncompromisingly to the position of rest. He chooses a pose with the left leg drawn back and touching the ground with the toes only—neither walking nor standing but partaking of both. The forms of the body are strongly knit and clearly differentiated, and a subtle opposition of tenseness and relaxation creates the perfect balance of the pose. Polykleitos, an intellectual among artists, was obsessed with rules of mathematical proportion in creating his figures, and was criticised in antiquity for a lack of versatility. His style is easily distinguishable, and copies of several of his famous

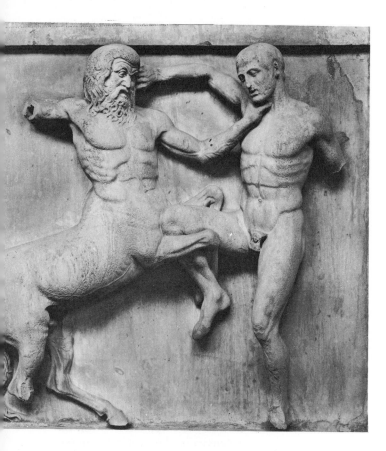

23. **Lapith and Centaur**. *c.* 440 BC.
Marble. h. 4 ft. 8 in. (1.42 m.). British
Museum, London. A metope from the
south side of the Parthenon, showing a
Lapith and a Centaur in combat.

works including the statue of a boy binding a fillet round
his head and a figure of an Amazon, have been recognised.

A Roman copy of one of Pheidias' masterpieces may
serve to conclude this brief account of sculpture in Greece
down to the time of the Peloponnesian Wars. The head
illustrated opposite is a marble copy of the head of a
bronze Athena by Pheidias, dedicated on the Acropolis of
Athens about 440 BC by the Athenian colonists of Lemnos.
The Roman writer, Lucian, chose the details of this head
to grace his perfect woman, and indeed, it does seem to
express to perfection the idea of Greek beauty, a beauty un-
touched by human emotion and existing nowhere in na-
ture, yet raising the human face itself into a realm of super-
human reality.

THE DEVELOPMENT OF PAINTING

The 5th century was an age of great painters as of great
sculptors, but of their work we know little. Polygnotus of
Thasos, the most famous name in the period after the Per-
sian wars, painted historical and mythological pictures at
Athens and elsewhere, and ancient descriptions of some of
them still survive. From what we hear of him he was a rest-
lessly inventive genius, struggling, like the great innovators
in sculpture, with problems of spatial representation, and
a powerfully dramatic illustrator able to depict character as
well as action in his work. We can only catch glimpses of the
work of such masters in the surviving vase paintings of the
time, but many of these are richly deserving of study in
themselves. The best vases are superbly drawn, with their
subjects taken from every branch of mythology, religion and
everyday life.

In vase-painting, as in sculpture, the steps of the artistic
revolution in the early 5th century can be followed fairly
closely. The red-figure painters of the last two decades of
the 6th century had delighted in showing the human figure
in many different and complicated poses, but had not yet
freed themselves from some of the awkwardness and incon-
sistency in archaic conventions. The best painters of the
next generation, from 500–480 BC, have caught the spirit of
a new age. By about 480 BC, the vase painters have achieved
a consistent representation of figures at rest, or in move-
ment, from a single viewpoint; the archaic face has made
way for the 5th-century profile. On a *hydria*, now in Naples,
the Kleophrades painter paints a scene showing the Sack
of Troy, and with a fine command of gesture and expres-
sion, depicts the despair and horror of the victims. In a
scene on one vase, now in the British Museum, by the
same painter, we see something of his powers as an illustra-
tor. With wonderful economy of line, a clear understanding
of anatomy in action, and a skilful use of foreshortening he
gives a powerful rendering of his theme. The Berlin painter,
a contemporary of the Kleophrades painter, stands for the
severity of the early 5th-century idea of beauty; he likes to
decorate his vases with single figures, slender long-limbed
and grandly conceived, striving for a formal perfection
that can stand alone.

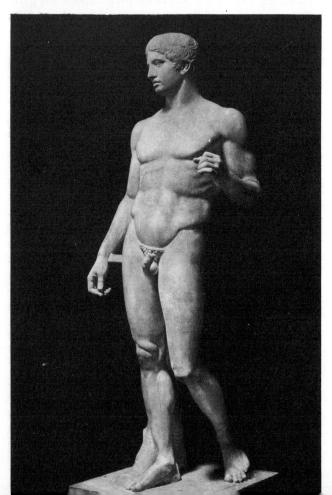

24. **The Doryphoros**. Roman period.
Marble. h. 7 ft. (2.12 m.). National
Museum, Naples. A Roman copy of the
famous bronze statue of an athlete carry-
ing a lance, made by Polykleitos of
Argos about 440 BC.

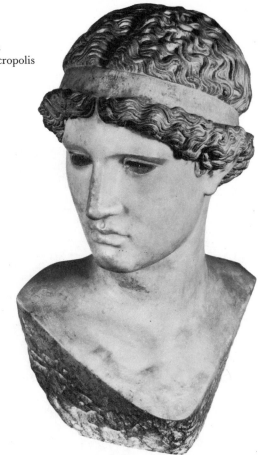

25. Head of Athena. Roman period. Marble. Museo Civico Archeologico, Bologna. This head of Athena is believed to be a Roman copy from a bronze statue by Pheidias, known as the Lemnian Athena, which was set up on the Acropolis at Athens in about 440 BC.

The Niobid painter, who was one of the chief vase painters in the generation between 480 and 460 BC, gives us, in his famous calyx crater in the Louvre, some idea of the methods used by the great masters of the early 5th century in their big compositions. The picture shows a scene apparently from the story of the Argonauts, a still scene like the composition of the east pediment at Olympia. The figures stand in easy poses, some skilfully shown in three-quarter view. The arrangement of the figures on different levels, with a very simple background of rocks as the only landscape detail, reflects the early attempts of the big-picture painters to suggest the third dimension. One figure is partly concealed by the rock behind which he is standing. The bigger white-ground vases of this period give us some idea of the palette and the technique of the panel painters. The technique is outline drawing filled in with washes of red, yellow and black in various tones, and still with no suggestion of attempts to shade or model the forms of the body in tones of colour. The grand manner of the master painters is captured by the Penthesilea painter in his scene on the inside of a cup, now in Munich, which shows Achilles in the act of slaying Penthesilea. Although the composition, which may, in fact, be copied from one of the big pictures of the day, is ill-suited to the shape of the cup, the artist contrives to give a powerful impression of the pathos of the moment. It is instructive to compare Exekias' version of the same episode made some fifty years earlier. From such pictures as these we get some idea of the style and technique of the great painters. Although their painting was still purely linear, they could, by their skill in conveying movement and expression, stimulate the imagination without recourse to the tricks of illusionist art.

The Pistoxenos painter, in his exquisite white-ground cup of Aphrodite riding on a goose, now in the British Museum, seems to have achieved the perfection of the classical Greek ideal; but the painter who tells us most about the lost masterpieces contemporary with the sculptures of Pheidias and Polykleitos is the Achilles painter. A pupil of the Berlin painter, he devotes his skill to the creation of single figures which have all the beauty of formal perfection for which the great artists strove. He is famous for his paintings on white-ground *lekythoi*, a type of vase made in the latter half of the 5th century to be placed in tombs. The quiet scenes, corresponding with those seen on the grave reliefs of the period, suited the simplicity of his style.

ARCHITECTURE IN THE CITY-STATES

In architecture, as in other branches of the arts, the period down to the Peloponnesian Wars is one of the greatest achievement. After the Persian Wars, the city-states made great advances in civic and religious building but it is well to remember that there was still a great contrast between the splendours of their religious buildings and their civic architecture. Town planning and attention to the amenities of life were rudimentary. No stone theatre had yet been built; the Athenians of the 5th century watched the plays of Aeschylus, Sophocles and Euripides from wooden benches arranged on the south slope of the Acropolis, and, when they were over, they returned along narrow winding streets to homes built of humble materials and with no great pretensions to comfort. The buildings they used in their capacity as officials of the state were grander, and there were already public meeting places with shady colonnades.

THE ACROPOLIS OF ATHENS

The wealth of the city-states was lavished not on improving the private amenities of the citizens, but on beautifying the sanctuaries of the gods. The progress of temple building in the 5th century culminated in Pericles' great scheme for the rebuilding of the Acropolis. No other city-state commanded both the resources of Athens and the artists and architects capable of executing so grand a plan. One approaches the Acropolis rock from its western end, and enters the sacred enclosure through the Propylaea, a monumental gateway built by the architect Mnesikles between 437 and 432 BC. The main architecture of the porches on either side of the gateway is massive Doric, but combined, in the outer porch, with Ionic columns. The gateway and its porches are flanked on the north and south by projecting halls, one of which, the southern, was never completed. The whole design of this complex building was brilliantly adapted to the difficult nature of the ground.

When you pass through the inner porch of the Propylaea, you get your first view of the Parthenon, which stands on the highest part of the rock. It is the greatest of the Doric temples and the ultimate achievement of the Doric style. The development of the Doric order can be followed through the early 5th century in the buildings of the Greek colonies and the mainland. The little temple of Hephaestos by the Agora at Athens, the most perfectly preserved of Doric temples, had been built in the forties, and almost

26. The Propylaea. 437–432 BC. The Propylaea, the monumental entrance to the Acropolis, was erected under the administration of Pericles. The architect was Mnesikles.

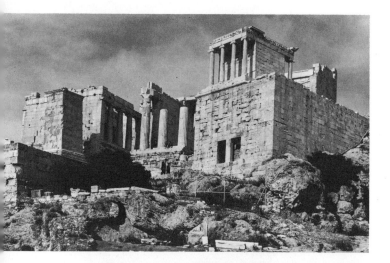

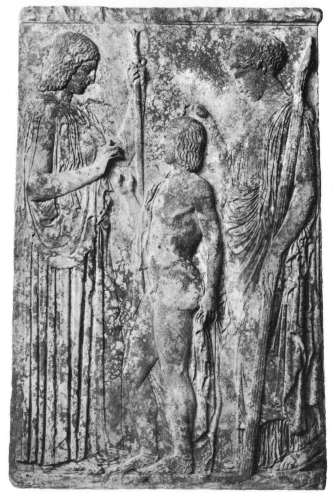

27. Demeter, Persephone and Triptolemos. *c.* 440 BC. Marble. h. 7 ft. 11 in. (2.40 m.). National Museum, Athens. A votive relief found at Eleusis, in 1859, showing Demeter giving the ears of corn to her son, Triptolemos, while Persephone, her daughter, places a wreath on his head.

achieves the perfection, though it lacks the grandeur, of the Parthenon. Of the Parthenon itself, there is almost nothing left to be said; the subtle curvatures and refinements, introduced by the architects Iktinos and Kallikrates, give so solid and massive a structure a lightness and life which would seem to be denied to the Doric style by its very nature.

The Parthenon is the ultimate achievement of the Doric order, from which no further progress seems possible. From this time onwards we shall see architects experimenting with different orders and combinations. The Ionic order, which had been mainly confined to the cities of Ionian Greece, was becoming increasingly popular in the Greek cities of the mainland. It is used for two famous buildings on the Acropolis rock, the little temple of the Wingless Victory that stands isolated on a bastion to your right as you go up to the Propylaea, and the temple of Poseidon-Erechtheus, the Erechtheum, across from the Parthenon. The temple of Victory was apparently planned before the Parthenon, but the work was not begun until after 432; the Erechtheum was built between 421 and 409 BC. The plan of the Erechtheum is complicated, but basically consists of a rectangular temple building with porches at different levels on three sides; its architectural detail is exquisitely pretty and superbly carved. The entablature of the south porch is supported by six figures of maidens, admirably suited by their classical severity to the role they perform. The Ionic order was, to some extent, still experimental; it did not achieve its canonical form until the next century. The Corinthian has not yet appeared at all in external architecture.

THE ACHIEVEMENTS OF THE FIFTH CENTURY

It is perhaps foolish even to attempt a summary assessment of the achievement of the Greeks in the arts up to the time of the Peloponnesian War. It is the period to which all antiquity, and we today, look back as the one of greatest achievement. Yet we should not be blinded to the limitations of the achievement. The restless enquiry of Greek artistic spirits in the late 6th century, and early 5th century, was, to some extent, halted in the achievement of its 'classical moment' in the second half of the 5th century. The architecture and sculpture of Periclean Athens seem to be the perfect expression of the aims and ideals of Greek culture, and it is a temptation to look on anything that follows it as a decline. But the history of European art would have been far different had progress been halted at this point. Painters had made only limited progress in the problems of their art, sculptors had achieved a limited ideal without a complete mastery of three-dimensional form, architects had brought a few traditional types of building to perfection, but had hardly begun to apply their art to wider uses.

THE PELOPONNESIAN WAR

When the Peloponnesian War began in 431 BC, the Parthenon had just been completed. The war dragged on until

28. Victory undoing her sandal.
c. 410 BC. Marble. h. 3 ft. 6 in. (1.06 m.).
Acropolis Museum, Athens. Relief from
the balustrade of the Temple of Athena
Nike, on the Acropolis at Athens.

29. Stele of Hegeso. *c.* 400 BC. Marble.
h. 4 ft. 11 in. (1.49 m.). National Museum,
Athens. Grave relief of a young woman,
Hegeso, daughter of Proxenos. Hegeso is
shown seated. Her maid hands her a jewel box.

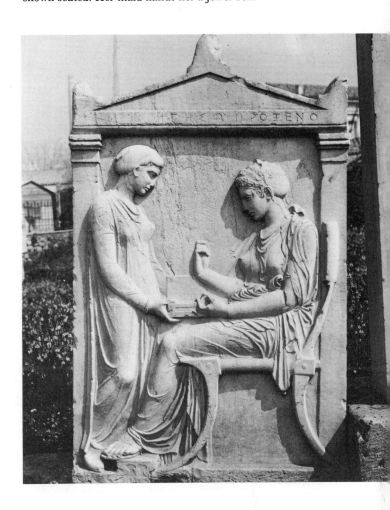

404 BC, ending in ultimate victory for Sparta and her allies.
The Greek city-states would never again be able to tackle
artistic projects of such grandeur as the Periclean scheme
for the Acropolis. The state, it is true, continued to be the
chief patron of the arts, but the whole artistic atmosphere
began to change. Artists, who had devoted their lives to the
small communities in which they lived, now found it neces-
sary to work abroad, for foreign rulers or for private citi-
zens. The great sculptors and painters of the 4th century
emerge as individuals no longer devoted to the ideals of the
state and of the state religion, but free to experiment, even
to create, for themselves. They now saw much more of the
possibilities of subjects that had not been considered worthy
of study in the 5th century, and began to renew their en-
quiry into the problems of representational art.

There is a period in the art of the Greek city-states which
we may call the 'aftermath of the classical'; it covers the
years of the Peloponnesian War and the early years of the
4th century. In Athens the style of the Parthenon, reduced
to human proportions, continued to prevail, shorn of its
grandeur, and sometimes lapsing into a kind of decorative
prettiness and mannerism seen in some of the sculptures,
especially the relief sculptures, of the time. The charming
figures of Victories on the parapet put round the bastion
of the temple of Wingless Victory about 415 BC, show

the exquisite skill of the sculptors in handling the con-
ventions of classical drapery—the clinging *chiton*, the
sweeping folds—in a purely decorative context. This
elegant late 5th-century style of relief sculpture was much
copied in later antiquity.

ATHENIAN GRAVE-RELIEFS

The Athenian grave-reliefs of the later 5th century repre-
sent the dead with the same ideal detachment that is used
to portray the people of Athens on the Parthenon frieze.
The *Stele of Hegeso* made about 420 BC, which is perhaps 29
the most famous of the long series of Athenian funerary
monuments, has that atmosphere of quiet resignation
which is common to them all. The dead girl is seated on
a chair, holding a necklace which her maidservant has
handed to her; there is no attempt at a portrait which
would break the harmony of this almost overpowering
scene of resignation in death. The grave-relief of Dexileos,
which commemorates a young man who fell at Corinth in
394 BC, shows the cavalryman, in the heat of battle, rid- 30
ing down an enemy.

THE SCULPTURE OF THE FOURTH CENTURY

It was inevitable that the grand manner, whose fundamen-
tal inspiration was the Olympian religion and the greatness

30. **Stele of Dexileos**. *c.* 394 BC. Marble.
h. 5 ft. 8 in. (1.72 m.). Kerameikos
Museum, Athens. Dexileos, who is shown
here riding down an enemy, fell at
Corinth in 394 BC, aged 20.

31. **Dancing Maenad**. Roman period.
Marble. h. 18 in. (45 cm.). Skulpturen-
sammlung, Dresden. This figure of a
maenad dancing in ecstasy may be a copy
of a famous work by the Greek sculptor,
Scopas of Paros of the 4th century BC.

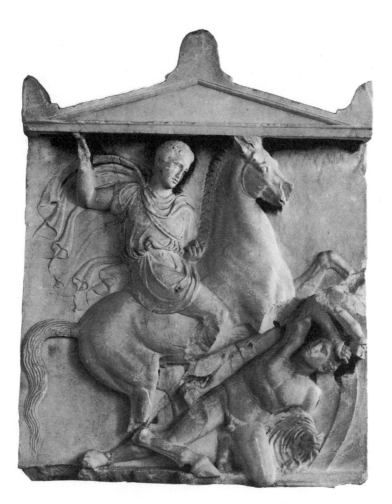

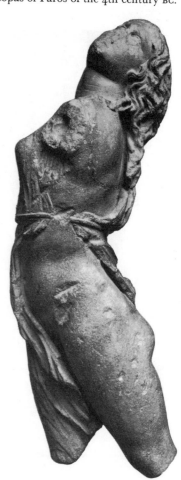

of Athens, should not survive the Peloponnesian War. The
gods began to lose their mystery and frightening power.
The famous statue called the *Venus Genetrix*, which is prob-
ably copied from a famous sculpture of the last decades of
the 5th century, perhaps by a pupil of Pheidias, already
gives us a much more human conception of divinity. She
represents, too, a new interest in the beauty of woman,
paving the way for the studies of the female nude, a subject
that was to be the concern of Praxiteles and his contempo-
raries in the 4th century. Around 375 BC, Kephisodotos of
Athens, father of Praxiteles, made a statue, *Peace holding the
infant Wealth*, one of the earliest of such allegorical composi-
tions in the history of art. His figure of Peace is conceived
in severe drapery, like the figures of Pheidias, but there
is a new gentleness and softness in the head inclining to
gaze at the little child she holds in her arms.

The great figures of the new generation of 4th-century
sculptors are Scopas, Praxiteles, Timotheus and Bryaxis.
We know something about the work of these sculptors from
direct Greek sources, as well as from Roman copies of their
work. Timotheus was concerned in the decoration of
the Temple of Asclepius at Epidaurus, and some fragments
of the architectural sculpture still survive. Scopas is said
to have been the architect of the Temple of Athena Alea
at Tegea, and may be supposed to have worked on its

sculpture as well. We know Praxiteles from Roman
copies of many of his sculptures. One statue, the *Hermes of
Olympia*, is believed by many to be an original from his
hand. Bryaxis is a less clearly defined personality, but
copies of some of his famous works survive. All four of these
men were said, according to one ancient tradition, to
have worked together in the decoration of the tomb of
Mausolus of Caria, the celebrated Mausoleum, in the
middle of the 4th century BC, and attempts have been made
to recognise their work in the sculptures that have survived
from the building.

SCOPAS AND PRAXITELES

Scopas was clearly an artist of genius. He was famous for
his attempts to express strongly emotional themes. He made
a group depicting Love, Yearning and Desire, at Megara,
and his figure of a maenad dancing in ecstasy was one of
his most admired pieces. The art of the second half of the
5th century had, as we have seen, halted the Greek urge to
portray violent feelings and emotions; the 4th-century
sculptors revived and developed it. The head illustrated in
plate 60 comes from one of the scenes decorating the pedi-
ments of the temple designed by Scopas at Tegea; the
heavy features and deep-set haunted eyes are something
new in the history of Greek art, and should probably be

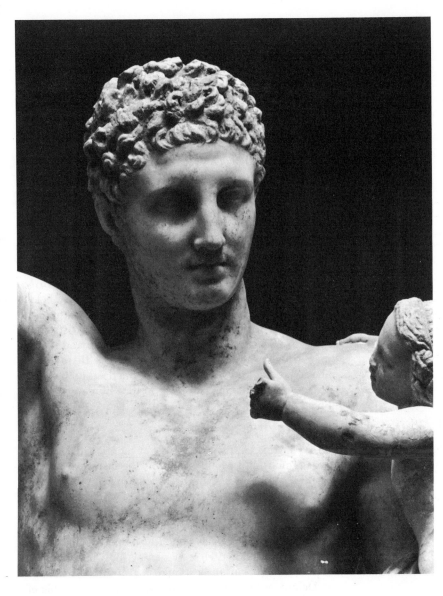

32. **Head of Hermes**. *c.* 340 BC. Marble.
h. (of statue) 7 ft. (2.13 m.). Olympia
Museum, Greece. Head of the statue of
Hermes carrying the child Dionysos
found in the Temple of Hera at Olympia
in 1877. It is probably the work of the
sculptor Praxiteles.

attributed to the influence of Scopas. There is a tradition
that Scopas was the sculptor of one of the column-bases in
the new temple of Artemis at Ephesus, rebuilt after a fire
in 356. The best preserved of these bases has a solid Poly-
kleitan figure of Hermes, seen standing and looking up-
wards between the figures of two goddesses. It has been
attributed to Scopas, and perhaps there is something of his
style in the yearning face and deep-set eyes.

Scopas is a world apart from Pheidias and Polykleitos,
and so is his contemporary Praxiteles who worked both in
bronze and marble, but seems to have preferred the latter.
The painter Nikias used to colour his statues. No statue il-
lustrates better the contrast between his work and the art
of the 5th century, than that of *Hermes carrying the infant
Dionysos*, which was found in the Temple of Hera at Olym-
pia in 1877, and is probably an original by his hand. The
god, in a leaning pose, rests his left elbow in the trunk of a
tree and holds the child in the crook of his arm. In his miss-
ing right hand he held a bunch of grapes, or some other
object, for the child to play with. The figure represents a
completely new ideal of male beauty, the 'climax', Sir Ken-
neth Clark calls it, 'of passion for physical beauty'. The
forms of the body are softer and slimmer, the transitions
less sharply defined, firm, but without athletic strength.
The perfection of the finish gives to the surface the texture

of real flesh, just as the drapery, to the casual glance, looks
like real drapery.

The temperament of Praxiteles was delicate, refined and
graceful, and found its best expression in studies of beauti-
ful women. The female nude had not been a subject for 5th-
century art, though the way in which post-Pheidian sculp-
tors force the flimsy drapery to reveal the forms of the nude
seems to herald its appearance. From the time of Praxiteles
the female nude becomes a chief subject for art. We illus-
trate a Roman copy of one of the famous Aphrodites
of the time, the so-called *Capitoline Venus*, now in the
Capitoline Museum, Rome. Praxiteles' most famous statue
was his nude *Aphrodite in Cnidos*, for which he is said to have
used his mistress, Phryne, as a model. The tradition is re-
vealing; the classical vision of a glorious but impossible
humanity has now given place to an ideal much closer to
actuality, and Praxiteles was certainly one of the chief in-
novators who led Greek art in this new direction.

PORTRAITURE IN THE FOURTH CENTURY

A closer study of the individual, and the rapid development
of the art of portraiture, is a characteristic of the art of the
4th century. In the early 5th century there had already
been some notable attempts at individual portraiture; we
have copies of 5th-century generals, including those of

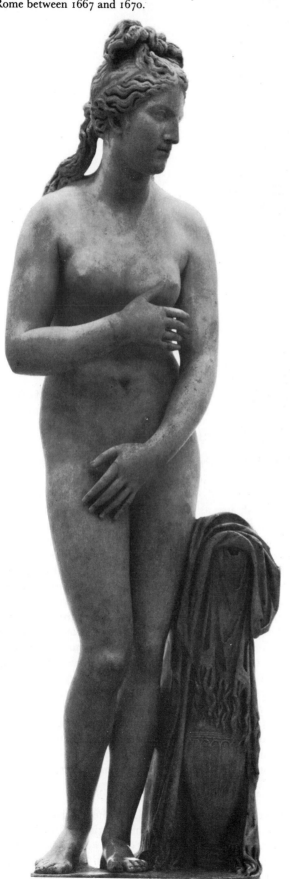

33. **The Capitoline Venus**. Roman
period. Marble. h. 6 ft. 4 in. (1.93 m.).
Capitoline Museum, Rome. A Roman
copy of a Greek original made about the
middle of the 4th century BC; found in
Rome between 1667 and 1670.

Themistocles and Pericles, which are convincing attempts
at characterisation made with a careful study of the features
of the individual. But the search for ideal form, with its
implied perfection of mind and spirit, led artists away from
attempts at true realistic portraiture. In the 4th century,
on the other hand, the individual bulks much larger in the
Greek scheme of things, and careful observation of distinc-
tive features forms the basis of the characterisation. The
statue, usually identified as Mausolus himself, from the
ruins of the Mausoleum at Halicarnassus, is a fine study
of a man of obvious strength of character, made by a
Greek sculptor about 350 BC. The bronze *Head of a Berber*,
from Cyrene, in the British Museum, which may belong
to this period, combines a detailed study of nature with
almost classical regularity of features. The artists of the
4th century extended their studies to all ages and types of
man. In the famous grave-relief from the Ilissos, made
about 340 BC, the weeping child at the dead man's feet is
portrayed with loving care, and in the old man we have a
fine study of old age.

LYSIPPUS OF SICYON

So far in this chapter we have not mentioned Lysippus.
This famous and prolific sculptor, the last great name in
the history of Greek sculpture, seems in fact to have had a
remarkably long career, the last part of which was spent as
court sculptor to Alexander the Great. The best creative
part of his career probably fell in his later years. Perhaps he
should be looked upon as a slightly younger contemporary
of Scopas and Praxiteles. We know his work only from
copies, though, curiously enough, a group of figures, found
at Delphi, seem to be contemporary copies in marble of a
bronze group he made at Pharsalus in northern Greece.
The best-preserved of these figures is the statue of Agias, a
boxer. His most famous figure, *The Apoxyomenos*, an athlete
scraping himself with a strigil, is known from Roman
copies. He also made the portrait of Alexander the Great,
from which the *Azara Herm* is taken.

One important aspect of Lysippus' work as a sculptor
seems to have been his attempt to introduce a new canon
of proportions for the male figure. Scopas and Praxiteles
had been content with adapting the Polykleitan propor-
tions to the new types of figure they chose; Lysippus favours
a taller and slimmer figure with a smaller head. In the
Apoxyomenos, he also goes a good deal further than the
masters of the 5th century towards achieving a figure that
can be looked at with equal satisfaction from all angles; the
arms of his athlete stretch out towards the spectator, and
even in the inferior Roman copy there is a fine sense of im-
minent movement. Lysippus, the last great athletic sculp-
tor of antiquity, restored firmness to the forms of the body,
but introduced a lightness and movement, and a three-
dimensionality, that were to serve as powerful new influ-
ences on the art of the Hellenistic world. A fine original,
contemporary with the later work of Lysippus, is the Anti-
kythera bronze youth, a figure of an athlete holding a ball,

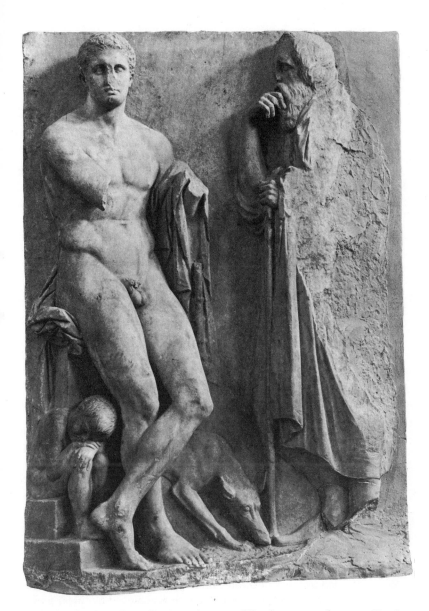

34. Grave relief from the Ilissos.
c.. 340 BC. Marble. h. 5 ft. 6 in. (1.67 m.).
National Museum, Athens. Grave relief
of a young man found on the bed of the
river Ilissos at Athens. To the right of the
young man stands his mourning father;
by his feet are his young brother or
servant, and his dog.

found in the sea off Antikythera in 1900. The figure, made perhaps about 340 BC, follows the Polykleitan canon of proportions but, like Lysippus, the sculptor has chosen a simple action of the arm to give life and movement to the static figure.

THE DEVELOPMENT OF ILLUSIONISTIC PAINTING

There was a statement in one of the elder Pliny's Greek sources that painting began about 420 BC. To Apollodorus, a painter of Athens in the last quarter of the 5th century, is given the credit for having 'opened the door of art' by first using shades of colour to model his figures, and so give them 'real substance'. The ancient critics, in other words, distinguished the art of painting from that of coloured drawing, which had prevailed down to that time. The period that followed Apollodorus was one of rapid advances in the solution of problems of modelling in colour, and the creation of pictorial space. These advances were the work of the great painters of the 4th century, of whose work we have scarcely an inkling. We cannot even follow the progress of the art of painting by means of first-class vase-paintings; at the end of the 5th century, vase-painting goes into decline and, in any case, the traditional red-figured technique can give us very little idea of what the big painters were achieving in the direction of illusionist art. Just occasionally there are

still echoes of the big pictures in the vases of Athens, and of the south Italian Greek cities, which also provide a vast mass of red-figured vases during the 4th century.

The vase illustrated in plate 55 is contemporary with the Peloponnesian Wars; the painter shows his principal figure in three-quarter view, and has gone as far as a draughtsman can go to give his picture depth and three-dimensionality without the aid of shading. This is just the time when Apollodorus was taking the first steps towards modelling his figures in colour, and in a few of the vases of the time a limited use of shading and a more skilful application of thin glaze washes in drapery folds, and other details, seem to reflect his work. The 'grisaille' painting on a marble slab, found at Herculaneum, which is generally believed to be a copy of a late 5th-century picture, makes use of a good deal of shading on drapery and skin. The Meidias painter **54** of the last quarter of the 5th century is a mannered and affected draughtsman, whose style corresponds with the charming decorative sculpture of the late 5th century. He makes much use of foreshortening, but has not advanced beyond the early 5th century in his method of showing depth by distributing figures over the vase surface at different levels. There is no trace of linear perspective **57** in his work, or in the work of his contemporary, the Pronomos painter, who uses the same scheme in one or two ambitious

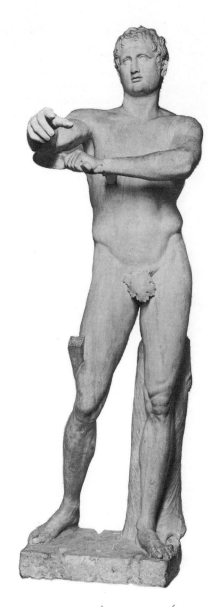

35. The Apoxyomenos of Lysippus.
Roman period. Marble. h. 6ft. 9 in.
(2.05 m.). Vatican Museums. A copy of
a bronze original by Lysippus of Sicyon,
showing an athlete scraping himself with
a strigil. Second half of the 4th century BC.

mythological pictures. These often show a rather more developed use of landscape, and seem to be modelled on contemporary wall paintings.

The first inkling of major advances in the problems of linear perspective is to be seen in some of the south Italian vases of the 4th century. The fragment, illustrated in plate 58, from a Tarentine vase of about 350 BC, shows an attempt to depict a building receding in depth. It is effective, without suggesting any clear understanding of the theory of perspective. Experiments in this kind of illusion are associated with the work of stage-designers in the theatre, and it seems to have been in stage painting that the Greeks of the Hellenistic period ultimately worked out the basic knowledge of consistent linear perspective. The fragment also shows that flat washes and outline drawing are giving place to modelling in colour, and there is a subtle use of colour tones in the rendering of the architecture.

THE ALEXANDER MOSAIC

Despite these few indications of rapid advances in the art of painting during the 4th century, it nevertheless comes as a great surprise to realise that the famous Alexander Mosaic found at Pompeii is almost certainly a copy of a painting **66** of the late 4th century. Here the artist, perhaps a certain Philoxenos of Eretria, working in a limited four-colour scheme, depicts the dramatic moment in the victory of Issus, when Alexander and Darius come face to face in battle. The bodies of men and animals are skilfully modelled in tones of colour; highlights and shadows play on the figures, and recession in depth is achieved by linear and a suggestion of aerial perspective. All these had been devices completely unknown to painters of the time of Pericles.

It has been suggested that several of the large figure compositions used in Pompeian wall decorations, are copies of well-known masterpieces of the period. These pictures are usually mythological scenes, in which the figures are arranged in the foreground against a setting of buildings or landscape. The setting, though secondary to the figures, is skilfully handled, using illusionistic techniques, and displays a fair understanding of linear and aerial perspective. The Hellenistic painted tombstones from Pagasai in Greece, though poorly preserved, show similar relations of figures to setting and similar attempts to create spatial depth, and it is likely that such pictures as the Perseus and Andromeda **11** scene even though they cannot be taken as accurate copies of 4th-century pictures, give us some idea of how the painters of the period composed their pictures.

NEW FORMS IN ARCHITECTURE

The architecture of the late 5th and 4th centuries may seem to be anti-climax after the achievements of the 5th century. Yet the period is one of great importance in the history of architecture. The development of town-planning, and a greater variety of specifically designed civic buildings, are two features of the age. New towns, laid out to the regular

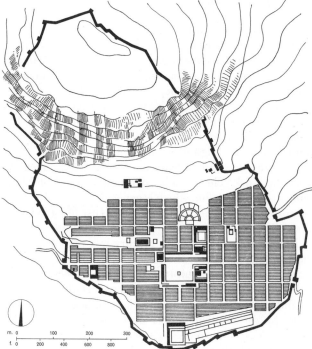

plan associated with the name of Hippodamus of Miletus, would be equipped with a regularly planned market place surrounded by colonnades, and meeting places for the assembly and council. Much greater attention was now paid to the amenities of life; well paved streets with efficient drainage became a normal feature of Greek towns. The first stone theatres, which are such familiar monuments of the Greek scene, were built in this period; the theatre at Epidaurus which, even today, is still well preserved, was designed by a famous architect, Polykleitos the Younger, in the second half of the 4th century. Pausanias, who wrote his guide book to Greece in the 2nd century AD, calls it the most beautiful theatre of the ancient world. There was rapid development, too, in the handling of the classical orders of architecture. The greatest achievements of the Ionic order belong to this century. The temple of Artemis at Ephesus, destroyed by fire in 356, was rebuilt on an even grander scale in the years that followed, and was counted in later antiquity among the Seven Wonders of the World. Another of the Seven was the famous tomb of Mausolus at Halicarnassus, a building of outlandish design, with an Ionic colonnade surmounted by a stepped pyramid built by a Greek architect for the Carian dynasty. The Corinthian order began to be used for external architecture. The Corinthian capital had made its first tentative appearance in the interior of the temple of Apollo at Bassae, in the Peloponnese. Its popularity increased during the 4th century. A Corinthian 'order', combining the Corinthian column with an Ionic entablature, was used on the little round monument, put up in Athens in 334 BC by Lysicrates, the successful patron of a chorus in the theatre.

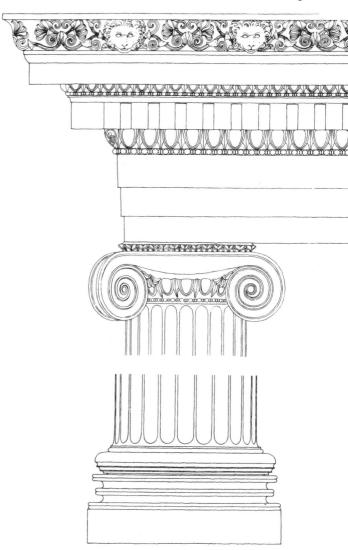

G. Reconstructed drawing of the Ionic Order.

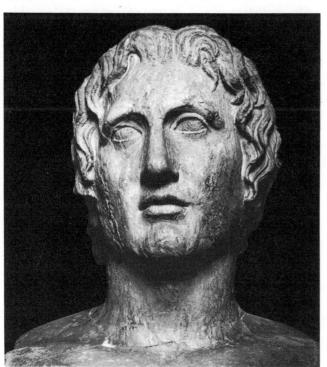

36. **Herm of Alexander the Great**.
c.. 330 BC. Marble. h. 2 ft. 3 in. (68 cm.). Louvre, Paris. Roman copy of the head of the famous portrait statue of Alexander with a lance by the sculptor Lysippus.

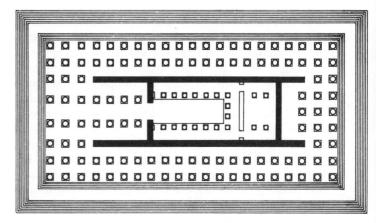

H. Plan of the later Temple of Artemis at Ephesus.

The Hellenistic World

Down to the time of Alexander the Great (356–323 BC), the small independent communities which we call city-states had been the basis of Greek life. With Alexander's conquests, the Greek world was transformed and its area vastly expanded. The new kingdoms founded by Alexander's successors, and not the old city-states, now dictated the course of Greek history. The period from Alexander down to 31 BC, when the last of the successor-kingdoms, that of the Ptolemies in Egypt, was absorbed by Rome, is called Hellenistic to describe the process by which a large part of the previously non-Greek world was 'Hellenised'. Greek influence now reached as far east as India; 'Hellenised' kingdoms were set up in the eastern possessions of the Persian Empire. In Egypt the Ptolemies ruled over Greeks and Egyptians; the Seleucids of Syria controlled a kingdom that included peoples of many different racial stocks. The extent to which Greek mixed with non-Greek varied from place to place, and Alexander's ideal of brotherhood between Greeks and Orientals was never fully realised. But everywhere there was a mingling of Greek and oriental ideas, which served as the basis for the unified rule later imposed on the Hellenistic world by the Romans.

COMPLEX CHARACTER OF HELLENISTIC ART

The art of the Hellenistic world is difficult to understand; it lacks the clear simple lines that dictate the development of the Greek tradition. We can only understand it, if we grasp the fact that the whole conception of art now changes. I think it is true to say that the Greeks, for all they had achieved, had not yet discovered the pleasure of art; the Greeks of the Hellenistic period gave us a new conception of art as something to please and amuse, not simple to educate and instruct. We must abandon the idea of the Greek artist as the respected craftsman working for a small community, the servant of its ideals and way of life. Artists now moved freely about the Greek world; they worked as court artists for the new rulers, for city-communities, and for private individuals. They were honoured for their talents, their products admired as 'works of art'. They were called upon to exercise their talents on a much wider range of subjects, for the Hellenistic age is characterised by a spirit of restless enquiry into every branch of art and science. The development of the exact sciences inspires the desire to portray things as they are, encourages the representation of men and nature in all their aspects. The desire produces the means for achieving the illusion of reality in sculpture and painting; the most admired works are those which are nearest to complete illusion. The ideals of the art of the city-states seem very remote from all this.

In the sense that it introduces a vast new range of themes into art, the Hellenistic period is greatly creative, and has left us some of the most admired works of ancient sculpture and painting; in the sense that it makes use of established types, copies or adapts them to new purposes, it lacks the highest kind of artistic creativity. The restless search for variety and new techniques among contemporary artists inevitably produced this harking back to the directness and simplicity of earlier ideals. Hellenistic rulers and wealthy private individuals wanted copies of old masters; the kings of Pergamon sent artists to Greece to copy famous pictures, and a copy in marble of the *Athena Parthenos* has been found in their capital. When art, as it so often did, served purely decorative purposes, and was backed by a supreme mastery of technique, it was bound to lack the certainty of taste that characterised the work of the classical masters. Hellenistic art can be all things—bombastic and rhetorical, pretty and decorative, vulgar or restrained—and in the end one tires of its variety and virtuosity.

OUR KNOWLEDGE OF HELLENISTIC ART

There is an embarrassing mass of surviving sculpture, both originals and copies, from the Hellenistic period, and almost no original painting. The sculpture is very difficult to classify into regions and styles, and we shall make very little attempt to do so here. It is easy to over-emphasise the importance of particular centres, and to attribute a particular 'style' to them on very little evidence; Alexandria, for example, has been associated with the development of the Praxitelean style towards greater softness, but whether this tendency is purely Alexandrian we cannot say. We know the art of Pergamon in the 2nd century BC comparatively well, but the 'schools' of other important centres are hardly known at all. In a period of art which is characterised by its variety of aims, it is dangerous to apply modern artistic labels, such as 'baroque' and 'rococo', especially if these are given any close chronological or regional significance in the period. Ease of communication throughout the Hellenistic world produces, in many different places, works of similar style: the 'baroque' and the 'rococo' can exist side by side. Only in architecture, where local conditions produce their own solutions to problems of building, can we recognise regional styles clearly, and here, too, new fashions spread quickly to other areas.

HELLENISTIC ART AND THE ROMANS

Before concluding this introduction, there is one further problem to be mentioned. Hellenistic art is not sharply divided from Roman art; in many aspects the two merge with one another. In the final chapter of this book an attempt is made to explain the various influences that give rise to the development of a specifically Roman tradition in art and architecture. Here we must stress that the Romans have a large part to play in the later development of Hellenistic art itself. From the 2nd century onwards, the Romans were increasingly involved in the affairs of the Hellenistic kingdoms which, one by one, succumbed to their power. The Roman attitude to art was very similar to that of the Hellenistic kings and wealthy citizens, whom they began to displace as its chief patrons. Like the kings of Pergamon, they needed artists to carve commemorative monuments and paint triumphal pictures, they admired the decorative qualities of contemporary art, and used it to

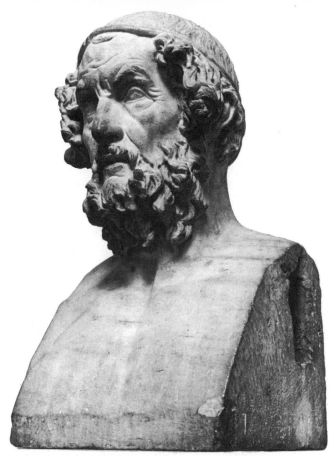

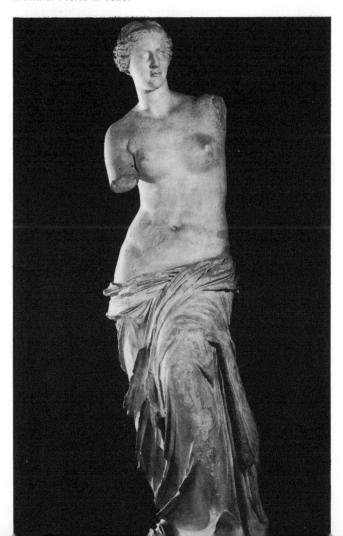

38. The Venus de Milo. *c.* 100 BC. Marble. h. 6 ft. 8 in. (2.03 m.). The Louvre, Paris. This famous statue of the goddess Aphrodite was found on the island of Melos in 1820.

37. **Homer**. Roman period. Marble. h. 20½ in. (52 cm.). British Museum, London. This herm is a Roman copy of an ideal portrait of the Hellenistic period, showing the poet as a blind old man.

decorate their houses and public buildings. Like the Pergamene kings, they also admired the work of the 5th- and 4th-century artists, collected their masterpieces and encouraged the rapid development of copying and adaptation, both in painting and sculpture. There is a word, Greco-Roman, which has rather gone out of fashion, but it serves well to describe the lastest phase of Hellenistic art, especially the 1st century BC, because it clearly implies this intimate relationship between Greek art and Roman patronage, in the century before the foundation of the Roman Empire by Augustus.

HELLENISTIC FIGURE-SCULPTURE

The career of Lysippus of Sicyon extended from the earlier part of the 4th century down to the time of Alexander of Macedon, whose court sculptor he was. He is, therefore, the first of the Hellenistic sculptors: he is also the last of the great names, and this, in itself, is a very significant fact. The artists of the early Hellenistic period carry on the traditions of the masters of the 4th century without winning great reputations for themselves. It was a pupil of Lysippus who, in the 3rd century, made for the city of Rhodes the bronze colossus of the sun god, which was counted among the Seven Wonders of the World. His own name, however, is not among the truly famous. The followers of Praxiteles could add little to the master's ideal of the female nude, because, in truth, there was nothing to add; the blend between ideal form and reality was perfect. The famous statue, the *Venus de Milo*, in the Louvre, is a work of about 100 BC; the style is still essentially that of Praxiteles, *38* only the more complicated pose of the body, which lacks the simplicity of the Praxitelean ideal, distinguishes it from the work of the master, and makes it typical of the age to which it belongs. Hellenistic sculptors did try to get away from the traditional poses, to develop the momentary stance that was brought in by Lysippus, and to render convincing action figures, but the result tends to be unnatural and exaggerated, even theatrical. There is a very delicate balance between a figure that seems about to move and one that is artificially frozen into immobility, and only the greatest artists can achieve the one and avoid the other.

In the later Hellenistic period, there seems to have been some attempt to create ideal figures based on the best available human models, instead of an ideal conception of the human form. The models do not often appeal. A leaning Herakles of Lysippus, translated into a heavy muscular, even muscle-bound athlete, achieved some popularity. The well-known bronze, called *The Hellenistic Ruler*, in the Terme Museum, Rome, has a heaviness and lack of proportion in which one recognizes a human model. The attempt at realism in the rendering of the nude was short-lived, and when it was abandoned, artists resorted instead to a kind of eclecticism, which sometimes takes details and forms from a number of different statues, and sometimes adapts traditional figures by altering the forms of the head and

94

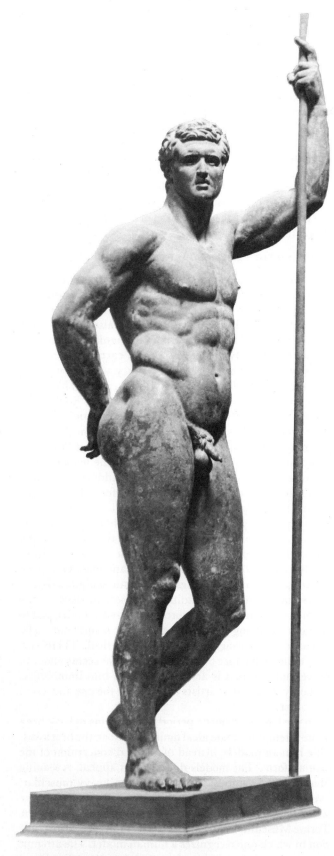

body. A small bronze figure of Marsyas in the British Museum is a typical Hellenistic adaptation, based on the figure in a group of Athena and Marsyas by the 5th-century sculptor, Myron. The artist has completely transformed the head to suit modern taste, has given the figure a more strongly modelled muscular form, and preserves only the pose of Myron's original masterpiece. The eclectic tendencies in late Hellenistic figure-sculpture culminate in the work of Pasiteles, a south Italian Greek from Naples, who worked mainly for rich Roman patrons in the early 1st century BC, and founded a school that copied and adapted classical masterpieces. A Pasitelean figure may combine the styles of a number of different periods of Greek art—a body in the severe style, a head of the 4th century, a Polykleitan pose. Such work implies the same deep knowledge of the development of Greek art that we find in contemporary art-critics and historians of art, a little of whose work is preserved to us in the pages of Roman writers.

It is only very rarely that Hellenistic art achieves greatness in single-figure sculpture, but none can deny this quality to the figure of Victory, from the island of Samothrace, which was made about 200 BC to commemorate a naval victory. The goddess is represented alighting on the prow 40 of a vessel. The pose of the figure is superb, but perhaps the most most remarkable quality of the piece is the brilliant synthesis of movement and drapery, something which had never been done quite so well before. In an age when most sculptors had abandoned earlier attempts to use the drapery of the female figure as a powerful means of expression, and had resorted to technical tricks to show their virtuosity, this work stands out as an immense achievement.

HELLENISTIC SCULPTURED GROUPS

A very important development in the art of sculpture during Hellenistic times lies in the handling of figure-groups in the round. As we have seen, free figure sculpture achieved something approaching full three- dimensionality in the work of Lysippus, and this new knowledge was applied in the succeeding period to complicated groups of a kind that had previously been attempted only in relief sculpture. The technical problems involved in the design and execution of such groups were now well within the scope of the artists, and their work has produced some remarkable examples of artistic virtuosity. These groups illustrate the vast range of Hellenistic sculpture; they range from the noble 'baroque' conceptions of the Pergamene Gaulish groups to playful combinations of satyrs and maenads. Among the best known groups in the grand manner are those deriving from the monuments put up by the Attalid kings of Pergamon in Athens and Pergamon, to commemorate the victories over the Gaulish invaders in the 3rd century BC. The famous group of a Gaulish chieftain who has slain his wife and is on the point of plunging his sword into his own breast, is a magnificent piece of theatre; for all its exag- 41 geration, it makes a powerful appeal to the emotions.

39.**The Hellenistic Ruler**. 2nd century BC. Bronze. h. 7ft. 9 in. (2.36 m.). Terme Museum, Rome. This well-known bronze has a heaviness and lack of proportion in which one recognises a human model.

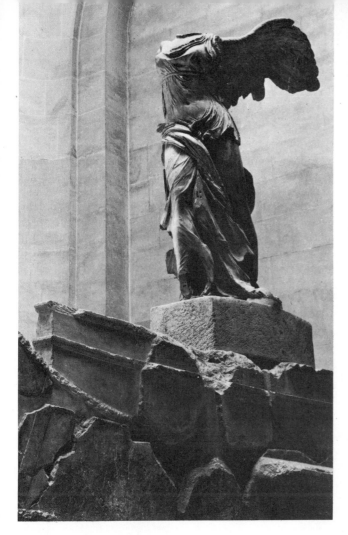

40. The Victory of Samothrace.
Early 2nd century BC. Marble. h. 8 ft.
(2.45 m.). Louvre, Paris, Statue of
victory alighting on the prow of a ship.
Found on the island of Samothrace in
1863, it was originally made to com-
memorate a naval victory.

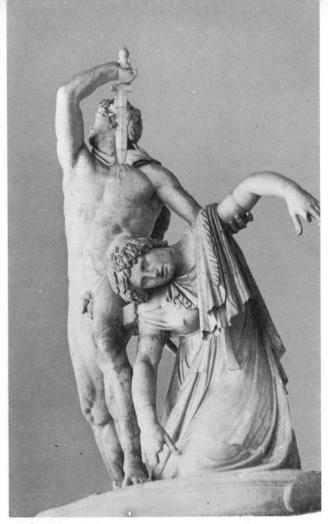

41. Gaulish chieftain and his wife.
Marble. h. 50 in. (1.8 m.). Terme
Museum, Rome. The Gaul has killed
his wife and is about to kill himself.
A Roman copy of a group set up in the
late 3rd century BC, to commemorate the
Gaulish victories of the Pergamene kings.

So, indeed, does the even more famous group *Laocoon
and his two Sons*. Pliny the Elder thought that this
group, the work of Rhodian sculptors, was the finest sculp-
ture of antiquity and many, since Renaissance times, have
held the same view; we today do not give it quite the same
unqualified praise, but we can admire its strong emotional
power expressed through the bodies and the faces, and the
brilliance of its composition and technique. There is much
to admire, too, in the more frivolous groups of figures in
which Hellenistic artists and their patrons so obviously de-
lighted. A typical example is the group, *Aphrodite, Pan and
Eros*, now in the National Museum at Athens. The goddess
Aphrodite is warding off Pan with her slipper,
while Eros, his tormentor, is also in attendance. The group,
which was made, perhaps about 100 BC for a rich merchant
on the island of Delos, typifies the lighter, playful side of
Hellenistic art, which delights in humanised gods and mon-
sters, and allegories of the ordinary human emotions.

REALISM AND PORTRAITURE

We have already stressed the range of human themes that
becomes the subject-matter for Hellenistic art, and the rest-
less enquiry and pitiless realism with which they are por-
trayed. The sculptors now model with convincing skill the

plump bodies of children, the withered flesh of old women,
and their skill and virtuosity were greatly admired. In one
of Herondas' mimes, there is a quotation about a well-
known group of a child strangling a goose: 'If the marble
were not before your eyes,' says the poet, 'you would swear
he was about to speak'. In the search for variety, sculptors
did not shrink from the portrayal of physiological and
pathological defects, such as we see in the little Hellenistic
ivory figure of a hunchback.

The desire to see and represent things as they are in
reality is shown best in the developments that took place
in the art of portraiture during the Hellenistic period. Por-
trait sculptors of the 5th century BC had indeed paid some
attention to an individual's features; one feels it is probable
that we would recognise Pericles from the portrait of him
by Kresilas, which exists in marble copies, but the head is
simplified in detail and obviously idealised. In the 4th cen-
tury the same idealising tendencies survive in the portrait-
statue of Sophocles, one of a series of retrospective statues
of 5th-century dramatists set up in Athens between 340 and
330 BC. But the urge towards realism is clear enough.
The portraits of contemporary 4th-century celebrities
attempt to get close to the character of the man through
a careful study of his features. The copies of por-

traits of Alexander the Great, which seem to go back to originals by Lysippus, his court sculptor, are 'idealised', but their idealism is achieved within the frame of a realistic likeness, by expression and set of the head, and not by simplification of the individual's face.

The ancient judgement on the portraits by Lysistratus, Lysippus' brother, stresses this essential difference from earlier work by saying that he made them lifelike, whereas previous artists had striven to make them as beautiful as possible. But no court portraiture can be too frank, and portraits of Hellenistic rulers are never realistic. Ideal physical form still implied the perfection of mind and spirit, and portrait figures continued to be ideal types, often based upon traditional figures, even when the faces try to express the personality of the men with a remarkable vividness. The coin portrait of Antimachus, the marble head of Euthydemus, both kings of the remarkable dynasty that ruled the Greco-Bactrian kingdom, and the fine portraits of Ptolemy I and his successors in Egypt, show what the best portrait sculptors of the Hellenistic courts could achieve. In the last centuries BC, the traditions of Hellenistic court-portraiture served the new masters of the Greek

world, the Romans; an interesting series of late Hellenistic portraits mainly of wealthy businessmen living on the commercial island of Delos, are the work of Greek portraitists for rich private individuals, many of them Romans, whose own traditions demanded the same kind of realistic portraiture, which did not ignore the irregularities and blemishes of the individual face, and could convey a powerful impression of the character of the man.

RELIEF-SCULPTURE

The art of relief-sculpture made great advances in the Hellenistic period. The tendency towards realism, and the invention of new illusionistic techniques in other branches of the arts, shows its influence in the treatment of reliefs. The scene from the Amazon frieze of the Mausoleum at Halicarnassus makes clear the principles of earlier relief-sculpture. Groups of figures are arranged against a plain background in simple, balanced compositions, there is very little overlapping of figures and hardly any attempt to suggest space. The syntax is simple and disciplined; the idea of the struggle is conveyed entirely by means of power-

(Continued on page 113)

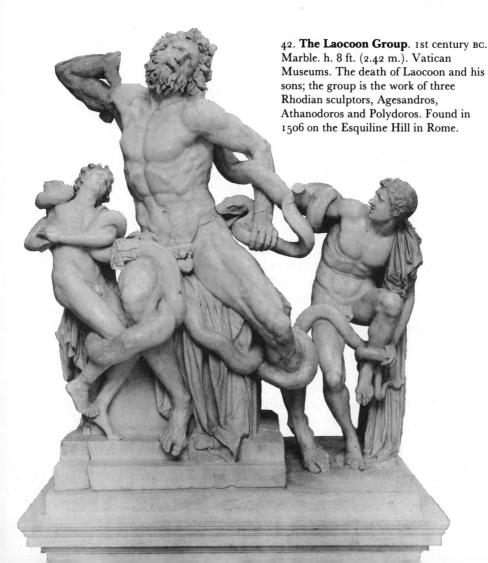

42. **The Laocoon Group**. 1st century BC. Marble. h. 8 ft. (2.42 m.). Vatican Museums. The death of Laocoon and his sons; the group is the work of three Rhodian sculptors, Agesandros, Athanodoros and Polydoros. Found in 1506 on the Esquiline Hill in Rome.

43. **Grotesque figure**. Late Hellenistic. Ivory. h. 4 in. (10.5 cm.). British Museum, London. Statuette of a hunchback with the symptoms of Pott's disease.

45. (above) **Relief from the Palace at Persepolis**. 1 ft. 8 in. (50 cm.). British Museum, London. This fragment of a processional frieze comes from the eastern façade of the palace built by Darius I. It shows a group of royal guards in procession. The kings of Persia employed many Greek artists from the cities of Ionia and the mainland, and their influence can be clearly seen in the treatment of the drapery on these figures, though the spirit of the frieze is completely un-Greek.

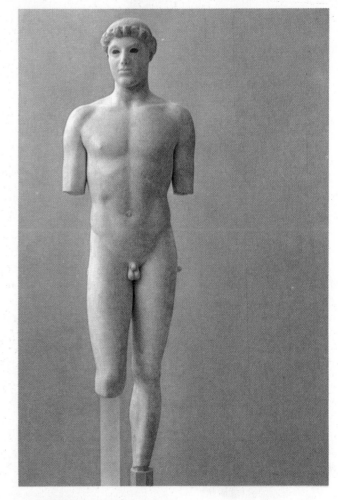

46. (right). **The Kritian Boy**. *c.* 480 BC. Marble. h. 2 ft. 9 in. (84 cm.). Acropolis Museum, Athens. This statue of a youth was found on the Acropolis at Athens, and is believed to be one of the sculptures cast down by the Persians in 480 BC. It was probably carved shortly before that date. The figure has departed from the strict canon of the 6th century *kouroi*, and looks forward towards the balance, rhythm and mastery of structure that characterise the art of the 5th century. It is called the Kritian boy, because its style is similar to the figure of Harmodius in the famous group of the tyrant slayers by the sculptors Kritios and Nesiotes, which is known to us from Roman copies.

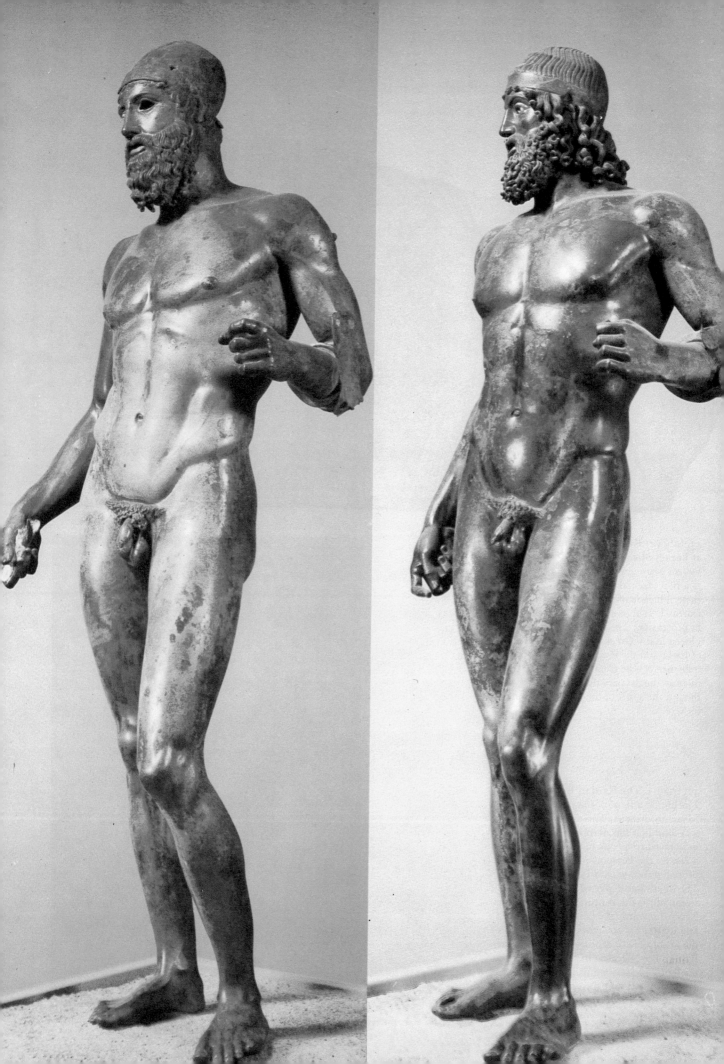

47. (left). **Standing figures from Riace.**
Bronze. 5th century BC. Museum of Reggio
Calabria, Sicily, These two lifesize statues
were found in the sea of Riace, Sicily, in 1972
Representing soldiers, though with their
spears and shields missing, they are very
rare examples of original sculpture of this
period.

48 (below). **The Penthesilea Painter.
The death of Penthesilea.** *c.* 460 BC.
Vase painting. diam. 18 in.(46 cm.).
Antikensammlungen, Munich. The scene
is painted on the inside of a red-figure cup.
It is thought that the scene was copied
from a large scale painting, perhaps one
of the big panel pictures of the day. The

fallen Amazon, whose body follows the
curve of the cup, must be thought of as
lying on the ground below the main
figures. Considerable use is made of
additional colours in the picture: blue,
red, brown, yellow and some gilding. The
scene is painted with a fine dramatic
feeling.

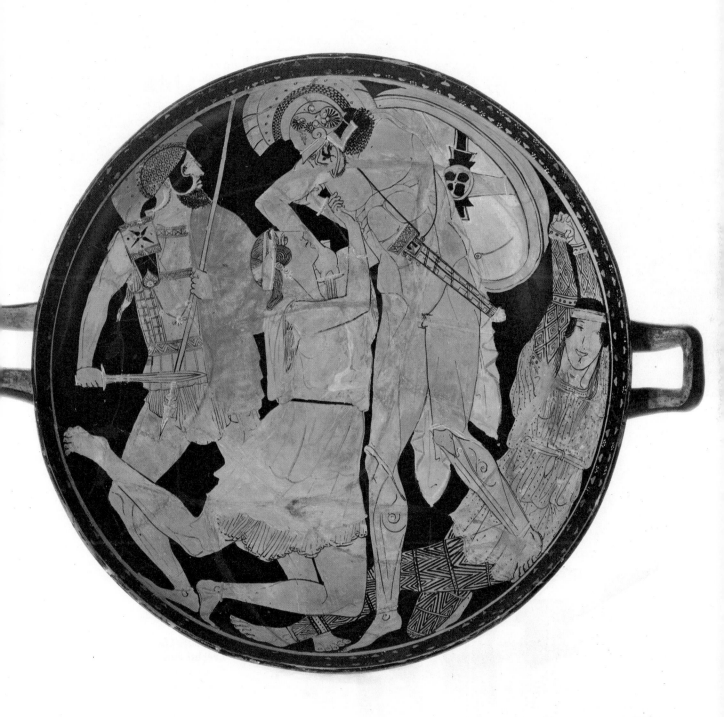

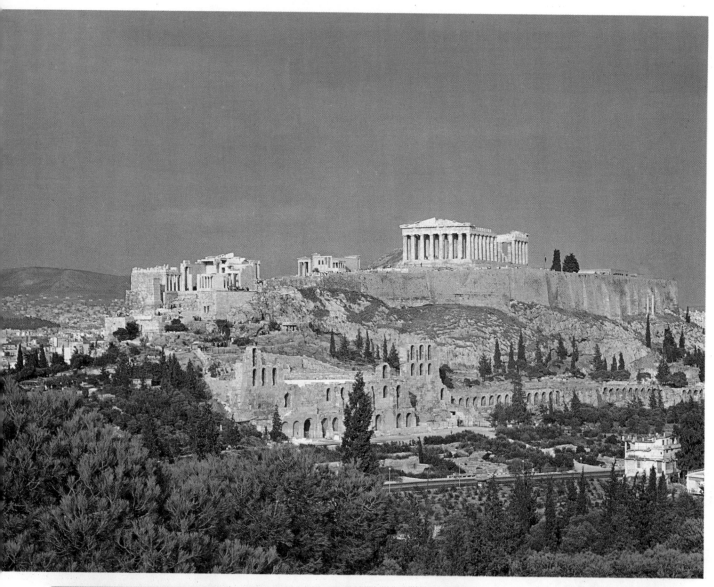

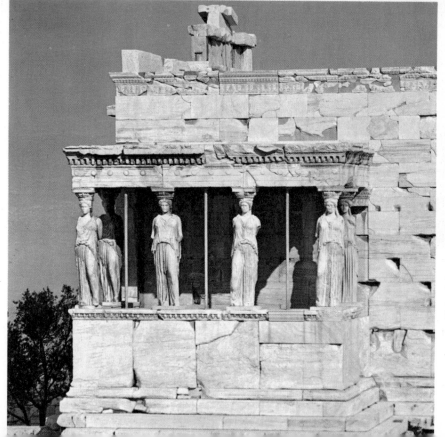

49. (above). **The Acropolis of Athens, from the South-West**. The Acropolis, which had been the citadel of Mycenaean times, became the chief sanctuary of the city-state. The buildings that may be seen in this view are, on the left, the monumental entrance, the *Propylaea*, with the temple of Athena Nike on the bastion to the right of it, the Parthenon, chief temple of the patron goddess Athena, and the Erechtheum.

50. (left). **The Caryatid Porch of the Erechtheum**. 421–409 BC. Marble. The Erechtheum, temple of Athena Polias and Poseidon-Erechtheus, was begun in 421 BC, and completed some time after 409 BC. In the south porch of the temple the place of columns is taken by standing figures of maidens, called Caryatids; the second figure from the left in this picture is a portland cement cast of the one in the British Museum, which was removed from the building by Lord Elgin.

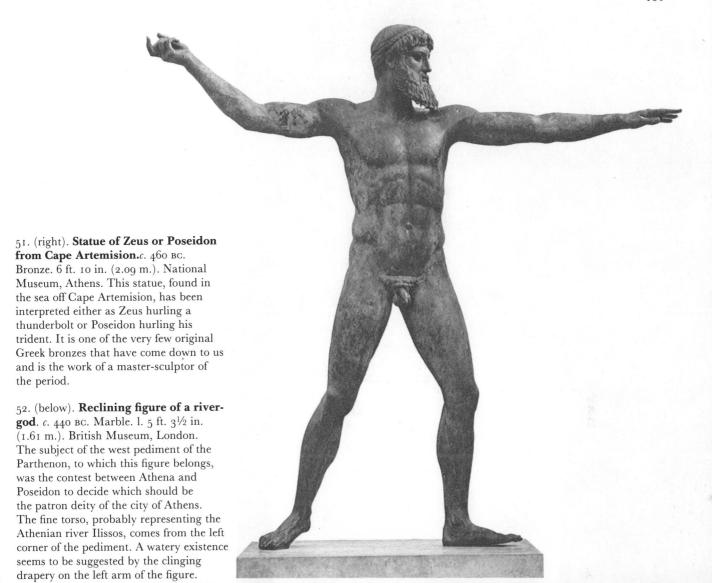

51. (right). **Statue of Zeus or Poseidon from Cape Artemision.** *c.* 460 BC. Bronze. 6 ft. 10 in. (2.09 m.). National Museum, Athens. This statue, found in the sea off Cape Artemision, has been interpreted either as Zeus hurling a thunderbolt or Poseidon hurling his trident. It is one of the very few original Greek bronzes that have come down to us and is the work of a master-sculptor of the period.

52. (below). **Reclining figure of a river-god**. *c.* 440 BC. Marble. l. 5 ft. 3½ in. (1.61 m.). British Museum, London. The subject of the west pediment of the Parthenon, to which this figure belongs, was the contest between Athena and Poseidon to decide which should be the patron deity of the city of Athens. The fine torso, probably representing the Athenian river Ilissos, comes from the left corner of the pediment. A watery existence seems to be suggested by the clinging drapery on the left arm of the figure.

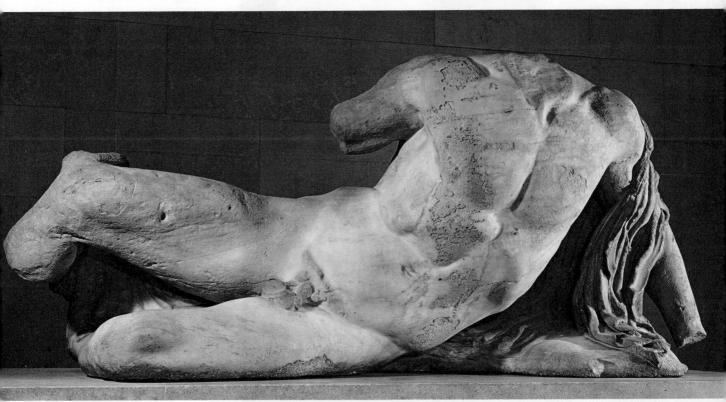

53. (left). **The Achilles Painter. White-ground lekythos**. *c.* 440 BC. Pottery. h. 15½ in. (39 cm.). British Museum, London. This type of vase was a common grave-offering in 5th-century Athens, and the painted subjects are often related to this funerary use. On this vase a woman is shown handing a soldier his helmet. The figures are painted in brown, black and red on a white slip, which covers the body of the vase.

55. (right). **The Peleus Painter. The Muse Terpsichore**. *c.* 440 BC. Pottery. h. (of vase) 23 in. (58 cm.). British Museum, London. This detail is from an Attic red-figure vase found at Vulci in Etruria. The figure seated in the centre is the muse Terpsichore; the youth in front of her is Mousaios, while behind her stands Melousa. The picture belongs to the time of the Parthenon. The use of the three-quarter view for the principal figure shows the painter's interest in creating an impression of depth in his picture.

54. (right). **Alexander of Athens.
The Knucklebone Players**. Painting
on marble. National Museum, Naples.
Found at Herculaneum, this work, which
belongs to the Roman period is generally
believed to be copied from a painting of
the 5th century BC. There is a skilful use
of shading to render the drapery folds.
The figures, which are named, are char-
acters from Greek mythology: Leto,
Niobe and Phoebe are standing, while
two girls, Aglaia and Ileaira, play.

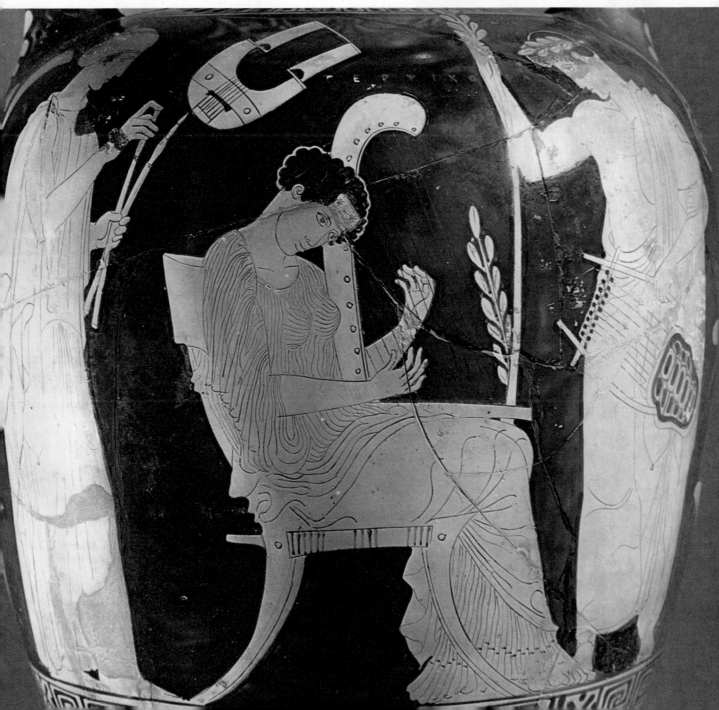

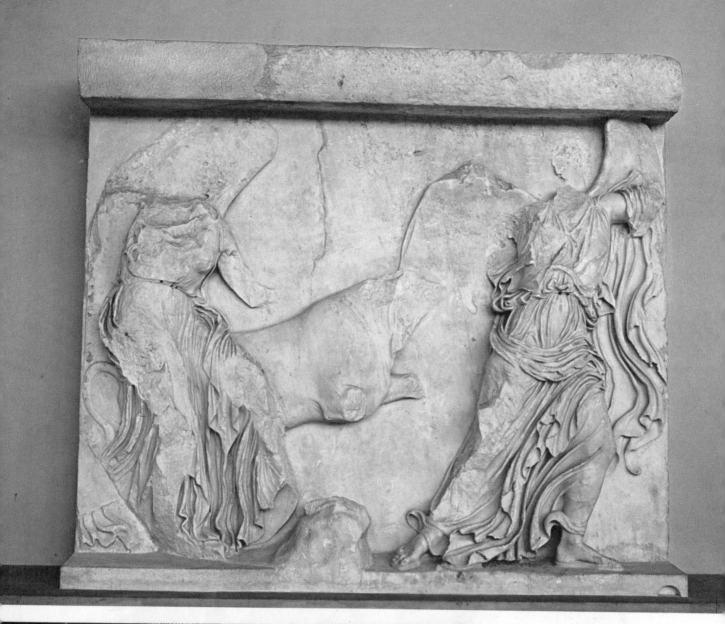

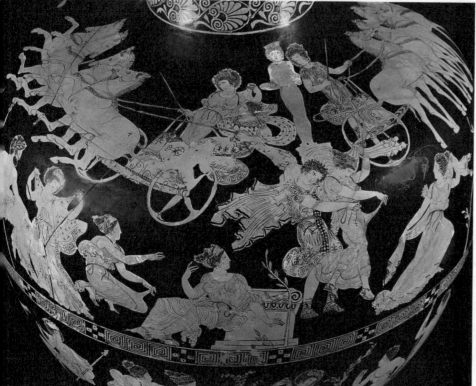

56. (above). **Scene from the frieze of Nike Temple parapet**. 421–415 BC. Marble. h. 3 ft. 5 in. (1.04 m.). Acropolis Museum, Athens. This sculptured slab comes from the parapet of the temple of the Wingless Victory on the Acropolis at Athens. The Victory, on the left, is trying to control a sacrificial bull while the one on the right takes evasive action. The sculptor here makes decorative, but rather artificial use of the discoveries made in the treatment of female drapery. Decorative work of this period was much copied in Roman times.

57. (left). **The Meidias Painter. The Rape of the Leucippids**. Late 5th century BC. Vase painting. h. (of vase) 20½ in. (52 cm.). British Museum, London. This scene appears on a red-figure hydria by the Meidias painter. The subject is the rape of the daughters of Leucippus by the Dioscuri, Castor and Pollux. The Meidias painter who worked in the late years of the 5th century BC is noted for the same kind of decorative prettiness and charm that we see in the sculptures of the period.

58. (right). **Scene on a Tarentine vase**. *c.* 350 BC. Pottery. h. 9 in. (22.5 cm.). Martin von Wagner Museum, Würzburg. This fragment of a bowl, made in the south Italian Greek city of Tarentum, shows a scene from a tragedy enacted before a palace setting. The painter makes a successful, though not consistent, attempt to show the building in perspective.

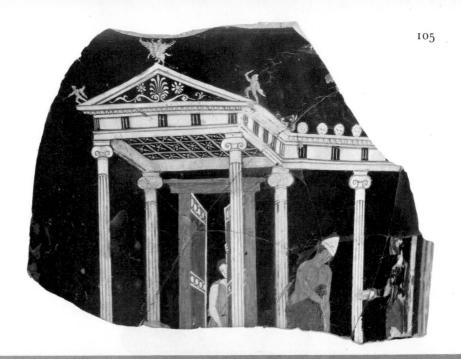

59. (below). **The Cyclops Painter. Early Lucanian calyx crater**. *c.* 425 BC. Pottery. diam. 18 in. (45 cm.). British Museum, London. Red-figure bowl made in one of the Greek colonies of southern Italy (Lucania). The picture shows the companions of Odysseus preparing to blind Polyphemus. The arrangement of the figures shows the painter's interest in the problem of rendering spatial depth.

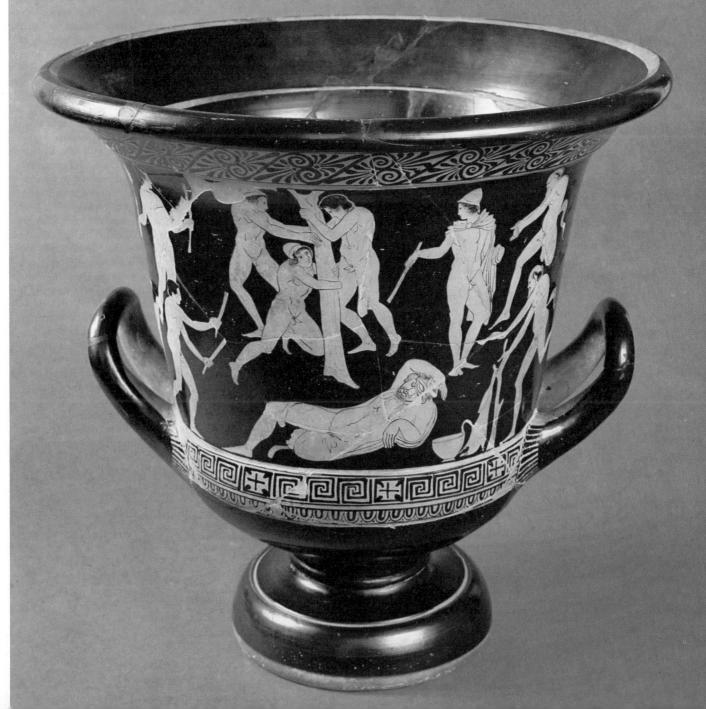

60. (left). **Helmeted head from Tegea**. 4th century BC. Marble. h. 7 in. (17.5 cm.). National Museum, Athens. The temple of Athena Alea at Tegea was rebuilt after a disaster in 394 BC; the architect is said to have been Scopas of Paros, the famous sculptor. This head of a warrior comes from one of the pedimental compositions of the temple, the subjects of which were the Calydonian boar hunt and the battle of Telephos and Achilles on the plain of the *Käikos*. The style of the head is a very individual one, which suggests the influence of a great sculptor, and it has been taken as evidence for the work of Scopas.

61. (left). **Base of a column from the temple of Artemis at Ephesus**. *c.* 325 BC. Marble. 5 ft. 11 in. (1.8 m.). British Museum, London. The Old Temple of Artemis was burnt down in 356 BC and rebuilt on an equally grand scale in the second half of the 4th century. The new building was reckoned one of the Seven Wonders of the World. The best preserved of the massive sculptured column bases from the temple is illustrated here. The figures are, in the centre, Hermes, with female draped figures on either side of him.

62. (right). **Statue of a young man from Antikythera**. *c.* 340 BC. Bronze. 6ft. 5 in. (1.94 m.). National Museum, Athens. Statue of a young man found in the sea near Antikythera, an island off the Peloponnese. The action of the figure seems to suggest throwing; he may have held a ball in his right hand. The statue has been restored from many fragments. The eyes are inlaid with coloured glass.

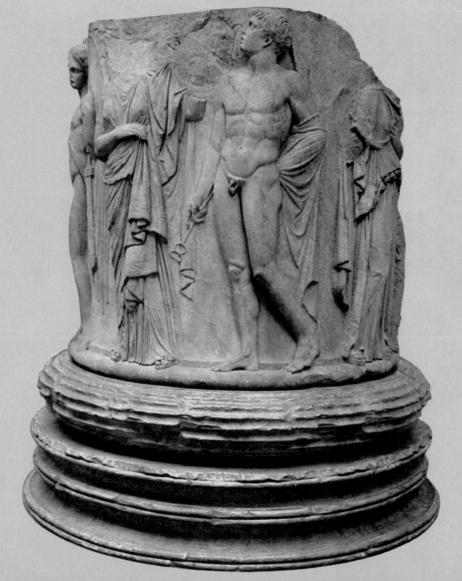

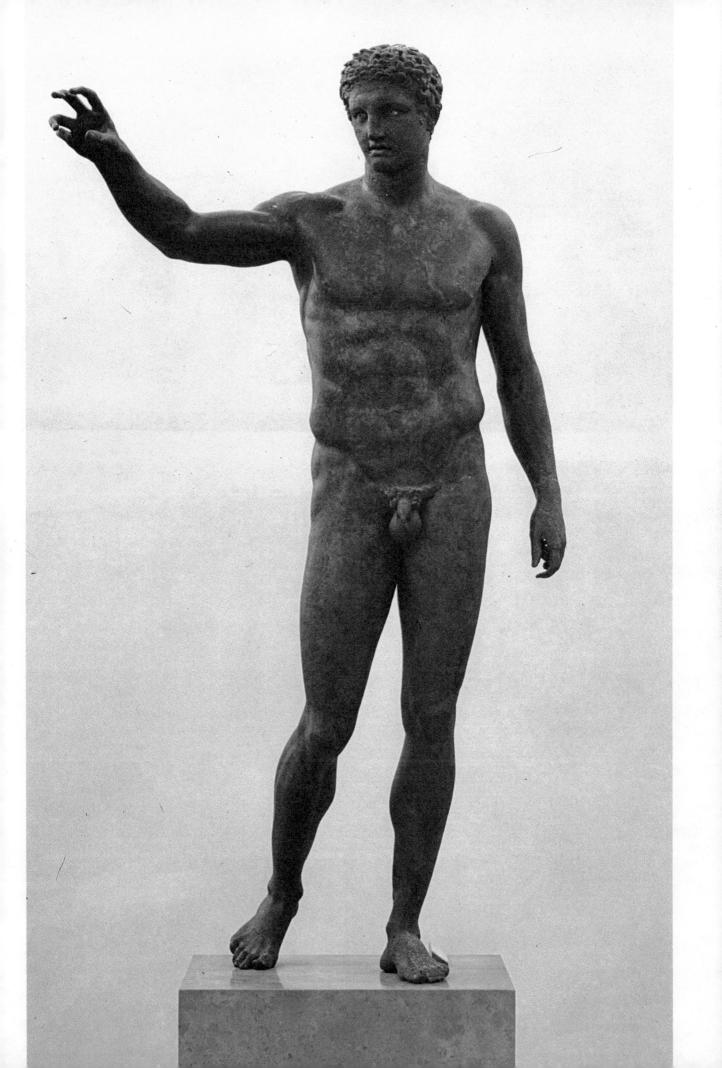

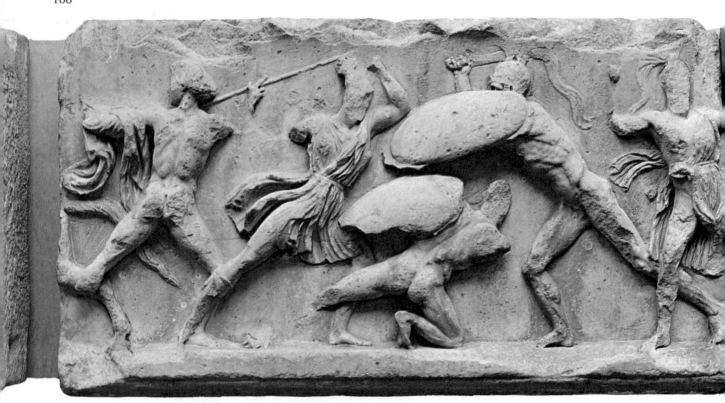

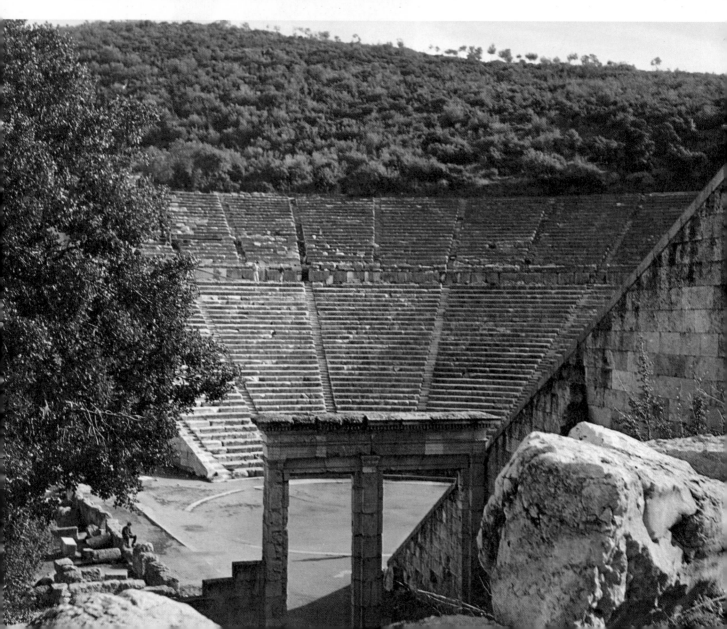

63. (left). **Slab of the Amazon frieze
from the Mausoleum**. Marble. h. 2 ft.
11 in. (89 cm.). British Museum, London.
A battle between Greeks and Amazons
is the subject of this best preserved of three
sculptured friezes from the Mausoleum
at Halicarnassus. The powerful triangular
composition in the centre of the slab,
consisting of an Amazon and a Greek
fighting over a fallen warrior, is a recur-
rent motif in the design. On the left of the
central group a young man is hurling a
spear; on the right is a helmeted Amazon.

64. (left). **The theatre of Epidaurus**.
c. 350 BC. A view of the best preserved
of Greek theatres built, according to
Pausanias, by the architect Polykleitos
the younger. The auditorium is well pre-
served, the stage building ruinous. It is
estimated that the theatre would hold
13,000 people; its remarkable acoustics
are still a source of wonder to visitors.

65. (right). **Statue of Mausolus**.
c. 350 BC. Marble. 9 ft. 4 in. (3 m.). British
Museum, London. This colossal statue,
found in the excavations of the Mauso-
leum of Halicarnassus, is generally identi-
fied as a portrait of Mausolus, prince of
Caria, for whom the famous tomb was
built. The figure wears Greek dress, but
is characterised as an oriental by his
long hair and beard.

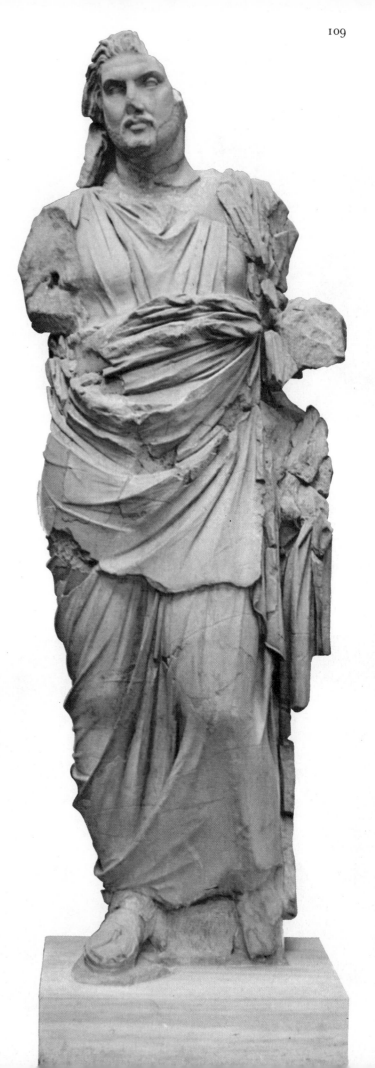

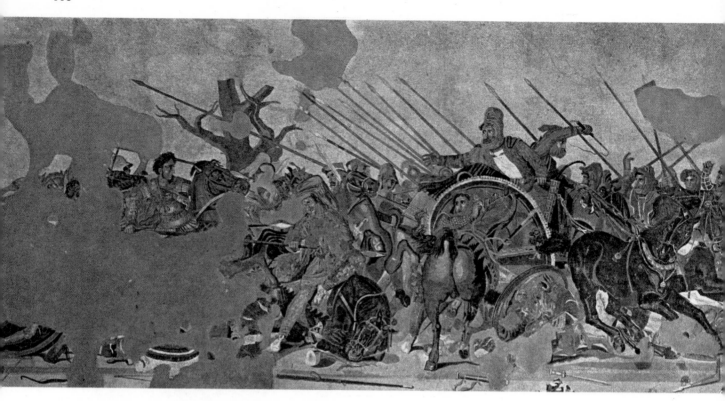

67. (below). **Pebble Mosaic from Pella**. *c.* 300 BC. Mosaic. l. 5 ft. 4¼ in. (163 cm.). This mosaic depicts a lion hunt. Floor mosaics appear in the Greek world in the later 5th century BC, the earliest examples being made of water-worn pebbles. A fine series of pebble-mosaics has been found recently at Pella, the birthplace of Alexander of Macedon, dating from the late 4th century BC. The use of cut pieces of coloured stone (*tesserae*) for making floor-mosaics seems to have come in during the 3rd century BC, and superseded the pebble technique.

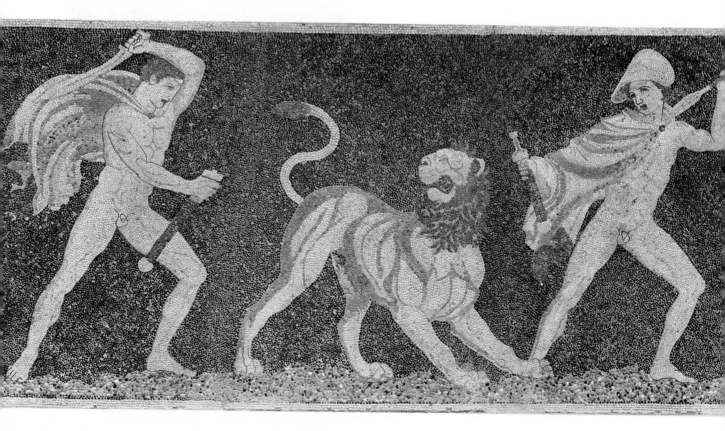

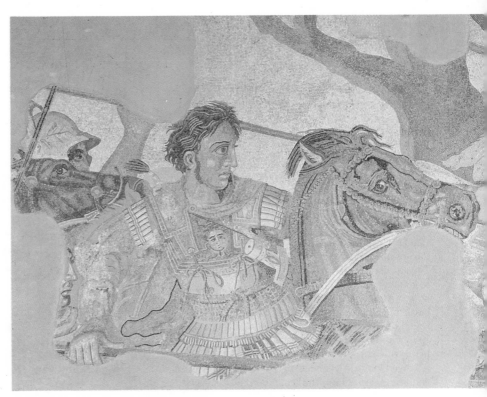

66, 68. (left and right). **The Alexander Mosaic, with detail**. 1st century BC. Mosaic. h. 11 ft. 3 in. (3.42 m.). National Museum, Naples. This mosaic was found in the House of the Faun at Pompeii in 1831. The subject is the Battle of Issus (near Iskenderun), in which Alexander defeated the great King Darius of Persia. It is believed to be an accurate copy of a 4th century painting. The artist has chosen the moment when Alexander and Darius are face to face in battle. The painting is carried out in a basically four-colour scheme of red, brown, black and white applied in various tones, and shows a masterly use of foreshortening, perspective effects, and highlights. A single tree is the only landscape element in the picture. The detail on the right shows the figure of Alexander.

69. (right). **Head of a Berber**. Early Hellenistic. Bronze. h. 1 ft. (30.5 cm.). British Museum, London. This life-size head of a berber was found in the temple of Apollo at Cyrene. It may have belonged to a statue. The eyes were inset with glass. The date is uncertain, but the combination of accurate rendering of physical characteristics and a fine simplicity of form suggests the early Hellenistic period.

70. (right). **The Stoa of Attalos, Athens**.
2nd century BC. The rebuilt Stoa of Attalos
in the Agora (Market Place) at Athens.
The two storey colonnade, which closed
the east side of the main square of the
Agora, was the gift of Attalos II, King of
Pergamon (159–138 BC). Its main purpose
was to provide a sheltered promenade;
each of its two stories is backed by a row
of rooms which served as shops. The com-
bination of Doric and Ionic architecture
is typical of the Hellenistic period.

71. (below). **The Athena Group from
the frieze of the Great Altar at
Pergamon**. *c.* 180 BC. Marble. 7 ft. 6 in.
(2.28 m.). Staatliche Museen, East Berlin.
Part of the east frieze from the Altar of
Zeus at Pergamon, erected by Eumenes II
to commemorate the victories of his
father, Attalos I. The frieze, showing a
battle of gods and giants, was carved
round the base on which the altar stood.
In one of the best known scenes, illustrated
here, Athena is engaged in combat with
a winged giant, Alcyoneus; the earth
goddess emerges from the ground on the
right and above her is a figure of Victory
crowning Athena.

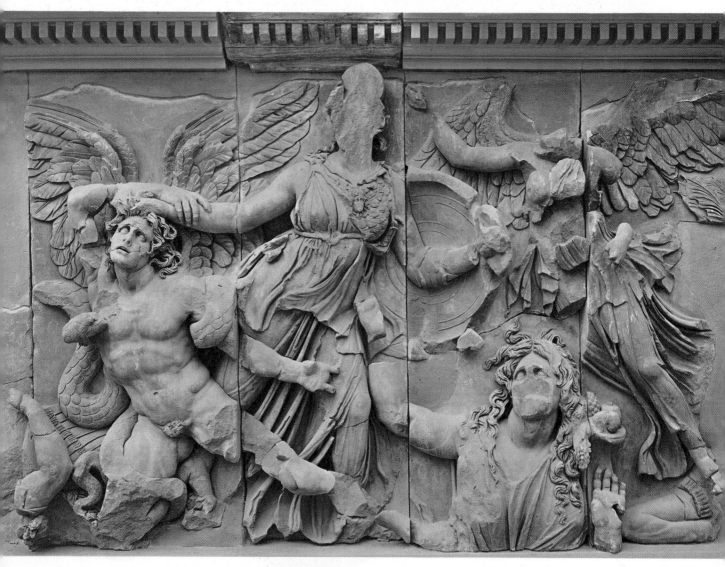

44. **Sophocles**. Roman period. Marble. h. 6 ft. 4 in. (1.93 m.). Lateran Museum, Rome. A copy of a bronze portrait statue of the great poet set up in Athens between 340 and 330 BC.

ful renderings of the human form in action. The faces show almost no expression. There is a marked contrast between the Amazon frieze and the scenes depicted on the Alexander sarcophagus, which is latest in the series made by Greek craftsmen for the kings of Sidon, and dates from about 300 BC. The scenes of lion hunting and battle have much more of the appearance of real events. Violence and action in the bodies is accompanied by powerful expression in the faces. The figures are arranged to overlap one another, so as to give a greater impression of depth, and a skilful and realistic use of colour enhances the effect of the carving. Of course, nothing so ambitious in pictorial realism as we have seen in the Alexander mosaic, could be attempted in sculpture but, throughout the period, new discoveries in illusionistic painting were exerting strong influence on the sculptor's art. The development of the use of landscape in painting during this time resulted in a greater use of landscape elements in the reliefs. This may be seen in the reliefs from the smaller frieze, the Telephos frieze, from the Great Altar of Zeus, built by Eumenes II at Pergamon between 180 and 160 BC. There are also a number of little reliefs with rustic scenes in landscape settings, which seem to belong to later Hellenistic times, and look very much like sculptural counterparts of panel pictures.

THE GIGANTOMACHY FRIEZE FROM PERGAMON

The battle of gods and giants, on the great frieze that decorated the Altar of Zeus at Pergamon, is in many ways the most revealing document of Hellenistic art. It is one of the few monuments of the period inspired by stirring historical events, the victories of the Pergamene kings over the Gaulish invaders of Asia Minor, and it adopts the same allegorical method as the sculpture of 5th-century Athens to convey the triumph of Greek civilisation over barbarism. But nothing could be further from the 5th century than this highly theatrical art. The composition is a closely interwoven mass of writhing bodies, heroic and dynamic in feeling, exaggerated in gesture and expression. It is a work of immense skill and, indeed, of immense erudition. One admires these qualities without reserve, but here, as in so much of the art of the period, one senses the yearning for the grand and magnificent which leads to an overstraining of effects, and which comes from the sculptors' desire to impress with their range and skill. One longs for the simplicity and clarity of 5th-century sculpture, and it seems inevitable that this inflated and pompous art should produce, as it did, a reaction towards the more restrained styles of the 5th and 4th centuries.

THE NEO-ATTIC SCHOOL

This reaction is best exemplified by the work of the so-called Neo-Attic school, which developed in Athens during the last century BC, under the strong influence of Roman patronage. Throughout the Hellenistic period there had been a big demand for purely decorative sculpture, and this de-

45. **Ptolemy I**. c. 280 BC. Marble. h. 10¼ in. (26 cm.). Ny Carlsberg Glyptotek, Copenhagen. Ptolemy I, one of Alexander the Great's most trusted generals, was the founder of the dynasty of kings who ruled Egypt from 323–30 BC.

mand increased when, in the last two centuries BC, the Roman patricians became enthusiastic collectors of Greek art. There had always been a tendency to copy masterpieces of past ages, and now the Neo-Attics decided to capitalise on this aspect of contemporary taste, and produce decorative pieces in marble and other materials, making use of classical figures and themes almost purely as ornamental motifs. There is, for example, a series of relief-panels, found in the Piraeus, with scenes of Greeks and Amazons copied from the reliefs of the golden shield of Pheidias' Athena Parthenos; there is a well-head in Madrid, which seems to copy the central group representing the Birth of Athena on the east pediment of the Parthenon; there are innumerable examples of marble furniture and garden ornaments with figures based on classical and archaic models. This Neo-Attic school exerted considerable influence on the development of art during the period of the Roman Empire; the high quality of its craftsmanship and the simplicity and clarity of its style, appealed both to the Roman patricians of the late Republic, and to those who were responsible for the decoration of public buildings in the early years of the Empire.

48

HELLENISTIC 'OBJETS D'ART'

As we have seen, there was not in ancient times a clear-cut distinction between the 'major' and the 'minor' arts, and in the Hellenistic period, especially, the versatile artist-craftsman was prepared to meet the demands of his patrons by working in many different media. Pasiteles of Naples, whom we have already mentioned, worked in marble, ivory, bronze, gold and silver and was famous, among other things, for his silver mirrors. Goldsmiths and silversmiths, particularly, won high reputations for their products, and both rulers and private individuals built up big

collections of precious metalwork. Gem-engravers produced cameos and intaglios in semi-precious stones, which were as much admired as any artistic products of the period. The *Tazza Farnese*, a sardonyx cup decorated with an elaborate Egyptian allegory, is one of the finest examples of Hellenistic gem carving that has come down to us, the work perhaps of an Egyptian artist at the court of the Ptolemies. The output of the silversmiths included bowls ornamented with portrait medallions, cups decorated with elaborate figured scenes, and ornaments of different kinds, all of which were the products of educated and highly skilled craftsmanship. As in all other branches of art, the Romans inherited this Hellenistic taste for 'objets d'art', and paid enormous prices for them in the last century BC.

7

6

THE DEVELOPMENT OF PAINTING

There is very little direct evidence for the development of painting in Hellenistic times. The art of vase-painting declined during the 4th century and had practically ceased by the end of it, and there are almost no surviving wall paintings or panel pictures. In the earlier chapters we have tried to trace the general lines of the development of illusionistic painting. By the late 4th century, painters, if we may judge from the written record and the evidence of the Alexander mosaic, while still using a comparatively limited palette, had mastered the techniques of modelling in colour, and had made great advances in the handling of pictorial space and in the understanding of linear and aerial perspective. The Hellenistic age further developed these techniques, and vastly extended the subject matter of the art of painting. The admiration for illusionistic tricks in the work of 4th-century painters leads Hellenistic painters to experiment with new methods of 'trompe l'oeil'. Experiments in per-

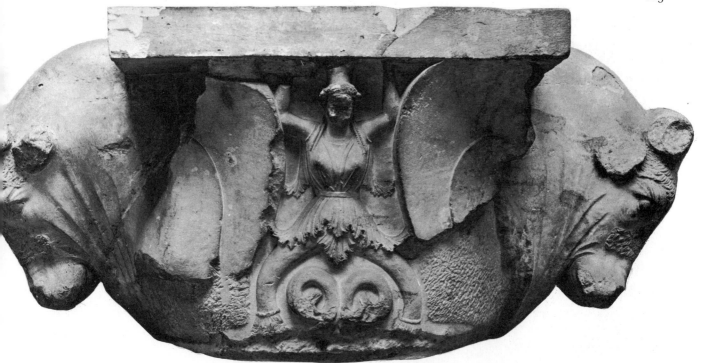

46. **The Alexander Sarcophagus**. Late 4th century BC. Marble. h. 6 ft. 4¾ in. (1.95 cm.). Archaeological Museum, Istanbul. One of a series of sculptured marble coffins by Greek artists, found in the royal necropolis of Sidon in Syria. The scene shows Alexander out hunting. The reliefs were richly painted.

47. **Bull's head capital**. 3rd century BC. Marble. h. 3 ft. 3 in. (1 m.). British Museum, London. Capital decorated with bulls' heads, found at Salamis in Cyprus. The design combines Greek and Persian elements.

spective inspired a scientific enquiry into its principles, and in late Hellenistic times, Greek painting seems to have achieved something very close to a consistent theory of linear perspective.

The pebble floor mosaics recently discovered at Pella, the birthplace of Alexander the Great, date from the late 4th century BC. Like all early Greek mosaics, they are composed of natural pebbles of a comparatively small range of colours. The lion-hunt scene shows a limited use of chiaroscuro in the modelling of the bodies and drapery, but probably gives very little idea of what had already been achieved in painting. In the series of painted tombstones from Pagasai in North Greece, there is evidence of further advances in technique, especially in the wider use of mixed colours and in the treatment of depth. The figures in the background are shown in small scale, and there is even some suggestion of aerial perspective in the colour-tones used for more distant features. But apart from very few examples such as these, our evidence for the great advances in painting made during the Hellenistic period is drawn from surviving works of the 1st century BC and the 1st century AD. With few exceptions, these paintings derive from the interior decoration of Roman houses, especially at Pompeii and the other towns of the Bay of Naples which were buried by the eruption of Vesuvius in AD 79.

ROMAN COPIES OF HELLENISTIC PAINTINGS

The use of these paintings as evidence for the development of Hellenistic art requires some explanation. By the 2nd century BC, the interior decoration of Greek private houses had become quite luxurious. Furnishings were more elaborate, the walls were decorated with paintings and the floors with mosaics. The latter were now carried out in a new

technique—the use of small cut stones of many colours instead of the natural pebbles. The new technique made possible rich polychrome effects, such as we see in 2nd- and 1st-century floors at Delos, and mosaics could be closely copied from paintings.

HELLENISTIC WALL-DECORATION

The earliest style of Hellenistic painted wall-decoration is a simple one, imitating the use of facings of coloured marble, which apparently decorated the interior of the palaces and houses of the very wealthy. This style of interior decoration is widespread in the Hellenistic world, and it reached Italy in the late 2nd century BC; at Pompeii, where it is known as the 'First Style', it prevailed down to about 80 BC. The walls are divided up into three zones—a dado, a wide central zone, and a crowning entablature. Painting is combined with stucco relief, to give the impression of real masonry construction. The style which superseded this relies entirely on the use of paint to create illusionistic effects; it still retains the basically triple division of the wall, but the central section is much more elaborately decorated. The basic element of design is usually a row of widely spaced columns or pilasters in the foreground, painted to look like real architectural features; behind these columns the artist tries to give an impression of an architectural vista, or a landscape, or a scene with figures. These schemes owe their success to a fine command of the principles of illusionistic painting. Although almost all the surviving examples of the 'Second Style' are from Italy, there are one or two from other parts of the Hellenistic world, and it seems clear that the style was invented in Greece and brought to Italy by Greek artists and craftsmen.

The Second Style wall-decorations in Italy, and those of the subsequent Pompeian styles which are discussed in the

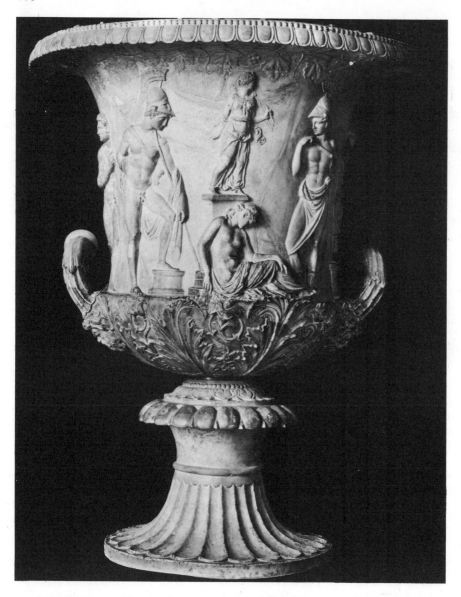

48. **The Medici Vase**. 1st century BC. Marble. h. 5 ft. 8 in. (1.73 m.). Uffizi Gallery, Florence. A typical product of the Neo-Attic school, this vase is decorated with reliefs depicting a scene from Greek mythology, perhaps the sacrifice of Iphigeneia.

last chapter, introduce us to almost every *genre* of painting. There is still life, portraiture, landscape with figures, nature-painting, scenes of everyday life, apart from the traditional mythological figure-scenes that had long been part of the repertoire of Greek painting. It seems certain that the techniques and range of subjects employed by the interior decorators of Pompeii, and elsewhere in Italy, were discovered in the Hellenistic period. The literary sources make it fairly clear that all these *genres* were practised by Hellenistic painters, and it is a fair assumption that in many cases we are seeing copies of their work. Some of the big pictures incorporated in decorative schemes are probably close copies of famous masterpieces of the 4th century and later; others are free adaptations.

THE ODYSSEY LANDSCAPES

Three famous Second Style wall-paintings are illustrated here in plates 79–81. The first of these, the *Odyssey Landscape*, **80** which once decorated the wall of a house on the Esquiline Hill in Rome, illustrates a scene from the adventures of

Odysseus as told in Homer's poem, and was painted about 50 BC. Landscape, as we have seen, had played little part in classical painting; the setting for the scene was indicated by a few 'symbolic' rocks and trees, which are dominated by the figures. In the 4th century there is evidence for an increasingly significant use of landscape detail, but its role remains strictly subordinate. In the Odyssey picture, on the other hand, the landscape dominates the figures, and the painter shows his delight in portraying the world of nature for itself. This development of the art of nature painting belongs to the Hellenistic world, and we can judge from this example how far Hellenistic artists had advanced. They have not completely succeeded in creating a unified landscape illumined by a single source of light and seen from a single viewpoint. There is no suggestion of a single perspective system in the picture, but it is remarkable how skilfully the artist contrives to show atmospheric effects, how cleverly he relates the figures to the landscape, and suggests the effect of distance by subtle modifications in the colours of the distant objects.

ARCHITECTURAL PAINTING

The second of the pictures shows an architectural wall from a villa at Boscoreale. Behind the foreground columns, the painter opens up a vista of elaborate architecture receding into the background. The advances made by Greek artists in showing buildings and other objects in recession were, so far as we can judge from our sources, associated with scene-painting for the theatre. A view of the king's palace commonly formed the backcloth for tragic plays, private houses for comedy, a country scene for satyr-plays, and it was natural that the scene-painters should attempt to make this background as realistic as possible. Our picture probably shows such a theatrical stage-setting, and we can see how closely the painter has come to giving the picture a consistent linear perspective, in which all the parallel lines recede to a single vanishing point. There seems little doubt that Hellenistic artists had developed, by experiment and study, a system of perspective. In the Second-Style paintings from Pompeii, and elsewhere, one sees evidence for this Hellenistic discovery but, curiously, its use is short-lived. Later Roman wall-paintings ignore it, reverting to a multiplicity of vanishing points within the same composition, where each object has its own foreshortening unrelated to that of neighbouring objects. Nor are individual objects consistently foreshortened. It was not until the Renaissance that the principles of perspective were again understood completely by painters.

THE VILLA OF THE MYSTERIES

The third of our pictures illustrates part of the famous Dionysiac initiation scenes on a Second-Style wall in the so-called Villa of the Mysteries, at Pompeii. The central portion of the wall shows a continuous frieze of figures against a background of pilasters, the subject of which is the initiation of a young woman into the mystery-rites of the Dionysiac cult. There is no attempt here at elaborate illusionistic effects; the scenes are represented against a red background, the interest entirely concentrated on the movement and expression of the figures. But in the treatment of the bodies and faces there is remarkable skill in modelling with colour, which enables the painter to give a very convincing rendering of this dramatic subject. There are paintings in very similar style, from a villa found at Boscoreale, with portraits of philosophers and famous figures which are believed to be copied from court-paintings of the 3rd century BC.

MOSAICS OF THE FIRST CENTURY BC

The wide range of subjects in Hellenistic painting is illustrated by some of the mosaic panels from 2nd- and 1st-century floors at Pompeii. These panels are among the finest examples of mosaic work that have survived from the ancient world; the technique of using very small pieces of coloured stone, with a wide range of colours, enables the mosaicist to imitate the effects of painting fairly closely. One of these mosaics, the *Alexander Mosaic* from the House of the Faun at Pompeii, has already been mentioned as giving a good idea of a lost masterpiece of the 4th century BC. Other subjects are landscape scenes, compositions of marine life and *genre* scenes, like the well-known mosaic of the street musicians from Herculaneum, signed by a Greek craftsman Dioscourides. Other popular subjects go back to the work of Sosus, an artist of the Pergamene school, who seems to have specialised in 'trompe l'oeil'. One of these shows doves drinking from a bowl of water, and was admired clearly for the remarkable illusion of reality that the artist managed to convey. His most famous piece of 'trompe l'oeil', was the picture of the 'unswept floor' which had as its theme the remnants of food cast on the floor by diners at a banquet. A copy of this work has been found in Rome.

HELLENISTIC ARCHITECTURE AND TOWN-PLANNING

These Roman paintings and mosaics compensate, to some extent, for the almost complete lack of original works of Hellenistic painting. The conclusions drawn from the study of them are similar to those we have observed in the account of Hellenistic sculpture—a search for new themes and rapid development of new techniques and methods. The third of the major arts, that of architecture, illustrates perhaps best of all the chief contribution of the Hellenistic period to the history of art. As we have seen, Greek architecture of the classical period had achieved perfection in a few traditional forms of building. The perfect Doric temple was the Parthenon, and no Doric temple thereafter could surpass it, or even compare with it. The Hellenistic world was not concerned with perfection, though it produced its crop of academic architects, who laid down precise and unchangeable rules of architectural form, which they tried to follow in their buildings. This academic 'classicism' is a very small part of the Hellenistic achievement. The Greek world after Alexander saw the foundation of many new towns and cities over a wide area, and all the varied aspects of city life were now the concern of the architects and planners. The cities were laid out in regular plans in accordance with rules of town-planning developed in the 5th century BC. We have already drawn attention to the contrast between the splendour of the temples of the gods in the old city-states and the haphazard and even squalid domestic quarters. The contrasts were far less marked in Hellenistic cities; houses were laid out in regularly planned areas defined by crossing streets; attention was paid to public hygiene and the comforts of private life. Hellenistic homes were often large and spacious, and richly decorated inside; the palaces of rulers were incomparably grand in planning and architecture. The varied activities of public life were catered for by well-designed buildings of permanent character. There had been no stone theatre in the Greek world until the 4th century, but in the Hellenistic period every Greek city had its permanent theatre, and many had concert halls and other places of public entertainment. Stone-built *stadia* for athletic events were associ-

ated with the gymnasium which was the city's centre for athletic exercise and, indeed, the hub of the whole educational system. Around the market-place, which was the political as well as the commercial centre of city-life, there were shady colonnades where people could meet and talk, as well as the permanent buildings of the city's political life—the council chamber and the assembly hall. The temples of the gods were still built on a grand scale, and still dominated the layout of the cities; some were designed on a scale that completely overshadowed the great buildings of the city-states.

PERGAMON UNDER THE ATTALIDS

The buildings of the main capitals of the Hellenistic world are not well-known to us. The only Hellenistic city that gives us a good picture of the magnificence of public building is Pergamon where, as we have seen, during the 3rd and 2nd centuries the Attalid dynasty spent lavishly on buildings and works of art, to adorn their capital. The Acropolis of Pergamon is still a monument to their ostentation. Of the sculptures of the Great Altar of Zeus, with its enormous columned enclosure built round the altar of the god, we have already spoken. Only the foundations of the altar remain today, but we can still get a good impression of the great scale of the other buildings on the Acropolis, of the palace of the kings, the library, the porticos, and the enormous theatre built against the slope of the rock. It is significant that the legacy of the last of the Attalid kings, by which he bequeathed his kingdom to the Romans in 133 BC, gave the new world conquerors their first permanent foothold in Asia, and that new conceptions of monumental building on a grand scale came very shortly afterwards to Italy.

NEW METHODS OF CONSTRUCTION

Generally speaking, the traditional methods of building and forms of decoration continued to be practised in Hellenistic times. There was no revolution in techniques, such as we find at the beginning of the Roman period, but a number of new building methods began to make their appearance. The most important is the arch, constructed of a series of wedge-shaped stones, called voussoirs, which was to become a basic constructional form of Roman architecture. In Hellenistic times the arch did not replace the column and lintel method of spanning a space, but there were already a number of very assured examples of its use in the last two centuries BC, and the probability is that the arch was an invention of Hellenistic architects.

THE TREATMENT OF THE 'ORDERS'

The development of the classical 'orders' of architecture during Hellenistic times, is typical of the character of the age. As we have seen, only the Doric order had achieved its complete 'canonical' form by the middle of the 5th century; the details of the Ionic still varied from place to place, and the Corinthian had scarcely made its appearance. In the hands of Hellenistic architects the Doric began to lose its uncompromising rigidity of form. The precise rules for fluting the column, for forming the capitals, for spacing the triglyphs of the frieze, are often ignored; the proportions became more slender and light. The Ionic comes more and more into favour, and acquires an established form combining frieze and dentils on the cornice; different varieties of capital are used in different places, a developed form with volutes at the corners being especially popular in the Greek colonies of southern Italy. The Corinthian, admired as it was for its richer decorative qualities, comes into its own. In Athens about 170 BC, Antiochus IV of Syria resumed the building of the enormous Temple of Olympian Zeus, and gave us the earliest example of Corinthian architecture on a grand scale. No new form of entablature was invented for this new order; Corinthian capitals were combined with the developed version of the Ionic.

Combinations of the orders, which would surely have shocked the taste of classical architects, came into fashion. In the colonnade or *stoa* of Attalos II, which has now been reconstructed in the Agora at Athens, the architecture of the ground floor is Doric, that of the upper floor is Ionic, and a very unorthodox Ionic at that. Hellenistic unorthodoxy went even further by combining elements of the different orders into a single scheme; Ionic columns are found with Doric superstructure, Corinthian columns with Doric and Ionic. More significant perhaps for the future history of architecture, is the increasing tendency towards the purely decorative use of architectural forms that have an essentially structural origin. Engaged columns and pilasters, serving purely as decoration of a wall-surface, pave the way for the Roman use of applied order in conjunction with arch and concrete construction, such as we see in the great buildings of the Roman Empire.

HELLENISTIC ART

The Hellenistic period is a vital stage in the history of European art. The basic discoveries of the Greeks of the 5th and 4th centuries were developed and extended, artistic techniques were fully worked out and applied. The age gave to the world a new conception of art as a manifestation of human life in all its varied aspects; art descends from its Olympian heights into everyday life. In so doing it loses much; the great periods of art have been inspired by limited ideals, and by its very range Hellenistic art falls short of greatness. Hellenistic art can be pretty and eloquent by turns; it can be pleasing and winning, but when it tries to be grand it is usually grandiose. But the gains surely outweigh the losses; for the first time in history men saw clearly that art does have a role to play in every part of life.

Greek artists outside the Greek World and the Art of the Etruscans

The chapter of this book which discusses the origins of Greek art, stressed the foreign contribution to the tradition. Here we are concerned with the influence of Greek art among the non-Greek peoples who were their neighbours. In one special case, that of the Etruscans in central Italy, to whom most of this chapter is mainly devoted, we are dealing with a subject which is central to our theme—the development of the Greek tradition—because Etruscan art forms the background to the art of the Romans. Before the latter came to a position of power, which eventually enabled them to create a great empire, Greek art had won enthusiastic acceptance in the cities of Etruria; without this background of Hellenised Etruscan art, it is doubtful whether Rome would ever have adopted Greek art as she did, and it is certain that the character of Roman art would have been far different.

GREEK EXPORTS

From the 7th century BC onwards, Greek works of art were widely exported outside the Greek world. Geometric and 'orientalising' pottery was traded over the Mediterranean, and came into the hands of barbarians. In the 6th century the volume of trade was vastly increased, and the peoples of central Europe began to know and value Greek pottery and metalwork. We have already mentioned the famous crater of Vix, perhaps the finest Greek bronze vessel that has come down to us. This was found in a chieftain's grave at Vix, in central France. The Thracian tribes on the northern frontier of the Greek world were using Greek metal vessels from the middle of the 6th century BC, as were the Scythian neighbours of the Greek colonies on the Black Sea. The Iron Age peoples of Italy were ardent collectors of Greek objects. By means of archaeological discoveries Greek commerce can be followed from Marseilles up the Rhône valley and into the heart of Switzerland.

GREEK ARTISTS ABROAD

From the early 6th century, Greek artists and craftsmen seem to have lent their services to their non-Greek neighbours. As we shall see, in the middle of the 6th century immigrant craftsmen from Ionia set up workshops to produce pottery in Etruria. Greeks were making objects to the local taste of Scythians and Thracians in the same period. Wall paintings in pure Greek style of the late 6th century have been found at Gordion, in Phrygia. The Persians called for Greek artists to work on the grandiose building-schemes of Darius and Xerxes at Persepolis, and elsewhere; the stone friezes from the palace of Persepolis show us an art which is non-Greek in spirit, yet adopts many of the conventions of Greek art in the treatment of drapery, hair and other details. We hear, in fact, of a certain Greek artist, by name Telephanes, who spent his entire career in the employ of Darius and Xerxes. The ruling house of Sidon, from the early 5th century onwards, certainly had Greek artists to carve the sarcophagi in which they were buried; the earliest examples have the anthropoid form traditional in Egyptian coffins, but the heads are often carved in purely Greek style. Overleaf is one of the 'Greek' anthropoid sarcophagi from Sidon, side by side with one in Egyptian style. The Persian satraps in Asia Minor employed Greek artists throughout the 5th century and in the 4th. The Nereid monument at Xanthus, erected in the early 4th century, is one of many grand funerary monuments made by Greeks for foreign dynasts; the grandest of all was the famous Mausoleum, the tomb of Mausolus, prince of Caria around 350 BC, a building in which all the most famous sculptors of the day were said to have worked, and which was counted among the Seven Wonders of the World.

THE INFLUENCE OF GREEK ART ABROAD

Thus, long before Alexander's conquests hellenised the entire known world, Greek artists and Greek works of art had reached far afield. From our point of view, the chief interest in this penetration lies in its permanent effects upon the arts of the areas it affected. These effects range from poor imitation of imported works to the creative adaptation of Greek ideas into an independent living tradition. It is not possible yet to assess fully all the effects, because of the difficulties in dating much of the material that has come down to us. It is easy to see similarities, some perhaps fortuitous, between early Indian sculptures and 6th-century *kouroi*, between seated Buddhas and Ionian figures, between Celto-Ligurian sculptures from Provence and late archaic Greek sculpture, but we are still far from understanding the precise relationship between them. In some cases we are on firmer ground. We can follow the influence of Greek art on the essentially non-representational artistic traditions of the Scythians and the Celts. We can see how the early Iberian bronze sculptures in Spain derive from a mixed tradition of local, oriental and Greek elements. The influence of Greek 5th-century sculpture is very strong in the stone sculptures from Iberian sites as, for example, in the well-known figure of the 'High Priestess' from Cerro de los Santos, or the famous Elche bust, both of which owe much to Greek art, although the ideas that inspired them are non-Greek.

GREEK ART AND THE ETRUSCANS

These early influences of Greek art outside the Greek world paved the way for the progressive 'Hellenisation' of the European world after Alexander. In all these cases, Greek ideals, imperfectly understood, are seen working on and modifying local traditions; in some cases, they provide the main stimulus for the creation of a representational art where none had existed before. Etruria provides us with

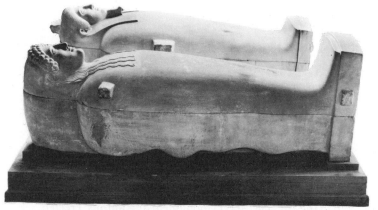

49. **Anthropoid Sarcophagi**. *c.* 460 BC. Archaeological Museum, Istanbul. Two anthropoid sarcophagi found in the royal necropolis at Sidon in Syria. The form of the coffins is Egyptian, but the heads are carved in Greek style and by Greek artists.

50. **Lycian Sarcophagus**. Late 5th century BC. h. 9 ft. 8¾ in. (2.96 m.). Archaeological Museum, Istanbul. The sarcophagus from the royal necropolis at Sidon with its high, pyramidal cover, is in the form of a Lycian tomb. The reliefs, which show hunting scenes, are in Greek style.

the special case of an area where, from a very early period, we can follow out the development of an artistic tradition heavily indebted to Greek inspiration, yet showing at all times a certain independence. Many have held the view that Etruscan art is no more than inferior imitation of Greek art, and there is, indeed, some truth in this view. The Etruscans coveted the products of Greek artists and craftsmen, and imported them in enormous quantities. In the early 19th century, Greek red-figured vases were commonly known as Etruscan, because so many of them had been found in the tombs of wealthy Etruscans. From the late 7th century onwards, Greek art provided the main stimulus for art in Etruria, and almost all the products of Etruscan art may be recognised as more or less derivative from the art of the Greeks. And yet there are qualities in the best Etruscan art which raise it far above a purely 'provincial' status, making it a subject worthy of study for itself. Furthermore, as we have already mentioned, the art of the Etruscans provides a vital link in the chain of historical continuity between Greek and Roman art, without which it is impossible to understand the development of the classical tradition in the Roman world. Finally, it should be said that there are those who see in the character of Etruscan representational art, clearly from a very early period, the same anti-classical elements that came to modify and eventually transform the classical tradition in the late Roman Empire.

ETRUSCAN ART AND THE PROBLEM OF THEIR ORIGINS

We are not here concerned with the vexed question of the origins of the Etruscans, except in so far as it affects the character of their art. The Etruscan problem has been argued out in terms of the two conflicting ancient accounts of their origins, the more widely accepted view being that they were an immigrant people from Asia Minor arriving in Italy some time after the period of the Trojan War. A later view, still held by many today, is that they were a people indigenous to Italy. In their art and architecture we shall find evidence that seems to support now the one, now the other hypothesis, but it is dangerous evidence to handle. In the case of a people so receptive to foreign art as the Etruscans, a new artistic influence has no bearing on the problem of their ethnic formation. It is now generally agreed, for example, that the strongly orientalising phase of Etruscan art in the 7th century BC is no more evidence for the oriental origin of the people than is the similar orientalising phase we have observed in Greek art. This is not to say that a deeper understanding of Etruscan art will not, in the end, throw light upon their origins, but we shall find the evidence, if anywhere, in the differences between their art and its oriental and Greek models rather than in its similarities. One factor which comes out clearly in their art is a strongly indigenous element; there seems to be a

clear, unbroken line of development from the 'canopic' jars of northern Etruria, where a carefully modelled head dominates a summarily rendered body, to the late Etruscan portrait effigies on stone and terracotta sarcophagi. There is a continuity of ideas from the clay hut-urns of the Villanovans in southern Etruria and Latium to the most elaborate house-tomb structures of the Etruscans. There are perhaps more subtle implications to be drawn from the obvious Etruscan delight in representing the world of nature, a delight that seems to bring us closer to the Minoans, and the Egyptians, among the peoples of the Mediterranean, and from their essential failure to understand the ideals of Greek art and culture.

THE DEVELOPMENT OF ETRUSCAN POWER

Leaving aside the problems of the Etruscans as a people, and the contribution that the study of their art may make to these problems, we must attempt a brief archaeological and historical survey of Etruria as a prelude to considering their art. In the 8th century BC there are clear signs of the development in the Etruscan area of a culture distinct from the rest of Iron Age Italy, a development which is accompanied by a considerable accession of wealth and new burial customs. There are inscriptions in the Etruscan language, a language which has no basic affinity with the Indo-European languages of Italy, as early as the middle of the 7th century. In southern Etruria a very rich orientalising phase, represented by the lordly burials in the Regolini-Galassi tomb at Caere and elsewhere, characterises the 7th century. A rapid development of art and civilisation, though not everywhere on the same pattern, may be observed in all the centres which later became famous as Etruscan cities—Veii, Tarquinia, Vulci, Chiusi and the rest. By about 500 BC Etruria had come to the height of her power. A federation of the principal city-states of Etruria had expanded Etruscan power northwards into the Po valley, and southwards into Campania. The Etruscans were trading widely in the Mediterranean and in central Europe, their commercial interests protected by alliance with the Carthaginians against the Greeks. The Greeks themselves had established a trading colony at Spina on the mouth of the Po, and many Greeks had emigrated into Etruria. In the 5th century, following the defeat at the Battle of Cumae in 474 BC, Etruscan power began to decline, her rule in Campania came to an end, and the Gauls began undermining her power in the north. In the 3rd century Etruria eventually succumbed to the rising power of Rome, and thereafter most of the famous Etruscan cities have no important part to play in history.

ROME AND ETRURIA

It is worthwhile stressing again that although Etruscan art is richly deserving of study for itself our main purpose in dealing with it in this book is to understand the background

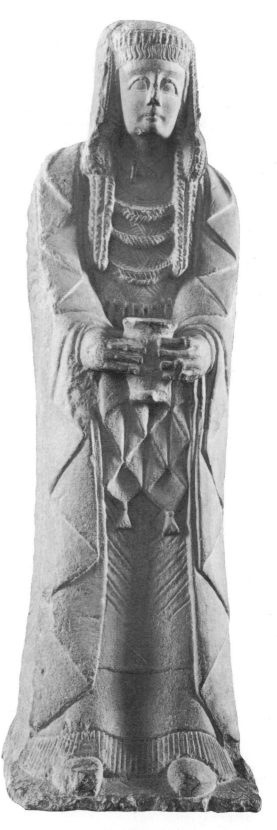

51. **The 'High Priestess'.** Probably 5th century BC. Limestone. h. 4 ft. 5 in. (1.35 m.). Archaeological Museum, Madrid. Iberian statue from the Cerro de Los Santos representing a priestess, or votary, wearing ceremonial dress and jewellery.

of Roman art. Rome, in the 6th century BC, was an Etruscan city ruled, according to tradition, by Etruscan kings, and what has survived of the architecture and sculpture of this period in the city, shows a complete dependence on the art of her Etruscan neighbours. When the Romans eventually overcame the Etruscans, most of the Etruscan cities were ruthlessly looted for works of art, especially bronze and stone sculptures, which went to adorn the public and private buildings of Rome. After the collapse of Etruria, it is hard to detect any basic change in the artistic tradition of central Italy until the 1st century BC. The same Etruscan techniques in architecture and the arts continued to be practised, although Rome was now the dominant power in central Italy. And so the Etruscan merges with the Roman.

THE 'VILLANOVANS'

The 'Villanovan' culture of Etruria in the 8th century is closely related to the other Iron Age cultures of Italy. The principal burial rite is cremation, the ashes of the dead being interred in a characteristic ossuary, the biconical urn, which is covered either with a small cup or by a bronze helmet. The Villanovans were skilled bronze-workers, making and decorating bronze armour and *fibulae*, and domestic vessels; their pottery was wheel-made in a grey-black fabric known as *impasto*. In the 8th century both pottery and metalwork were decorated in a geometric style, with incised meanders, zigzags, lines and so on, which is obviously related to the geometric style in Greece, but lacks its precision and strong sense of order. The human figure does not appear at all in the earliest stage.

The Greeks established their first colony in southern Italy, at Cumae, about 750 BC and the Villanovan geometric style probably derives from imitation of Greek pottery, which was certainly being imported into Etruria at a very early period. By about 700 BC, or perhaps a little later, we find painted pottery being made in the Etruscan area, which provides us with the first clear-cut imitation of Greek work; a well-known vase from Bisenzio, in the Villa Giulia Museum, Rome, is decorated with geometric ornament and a narrow frieze of dancing figures in characteristic geometric silhouette. The earliest figure-sculpture, too, is closely inspired by Greek geometric art. Like Greek work, it is all on a small scale; animal figures serve as supports for metal vessels, or are attached to clay vases. There is, for example, a clay vase decorated in Villanovan style from Bologna, which has a bull's head spout and is surmounted by the figure of a little geometric horse with helmeted rider.

THE 'ORIENTALISING' PHASE

The 7th century sees the rapid development of prosperity in Etruria. Members of the Etruscan ruling class were buried in elaborate chamber tombs, and these tombs were richly furnished with pottery, bronzes and objects of precious metal. In a family burial, called the Regolini-Galassi tomb, at Caere, the dead were buried with magnificent

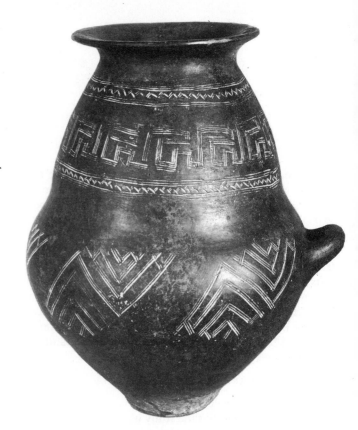

52. **Funerary Urn**. 7th century BC. Terracotta. h. 14¼ in. (36 cm.). British Museum, London. Biconical urn of Villanovan type decorated with incised geometric ornament.

jewellery, handsome vessels of gold and silver, objects of ivory and amber, and other luxury materials. In this period the wealth of Etruria attracted trade from all over the Mediterranean world. There were imports from Greece, Egypt, northern Syria and Phoenicia, and imitations of imported work in Greek and orientalising styles. The lavish gold jewellery, typical of the Etruscan taste of the time, is overloaded with ornamental detail, mostly of oriental inspiration. Much of it is carried out in the granulation technique—the use of tiny gold granules to make ornamental patterns—in which the Etruscans achieved a high degree of mastery. The gold cup from the Bernardini Tomb at Praeneste has a Greek shape; the un-Greek feature is the presence of little oriental sphinxes on top of the handles, a feature reminiscent of the famous Cup of Nestor from the Fourth Shaft Grave at Mycenae.

The first attempts at a monumental sculpture are found in the 7th century. There are some early stone sculptures from Vetulonia based on oriental models, and oriental influence shows very strongly in the face of the seated statuette of a woman from Caere. The 7th-century Canopic jars from Chiusi have heads whose primitive character is modified by Greek and oriental models. According to tradition, it was the Corinthians who first introduced to Etruria the arts of modelling in terracotta, at which the Etruscans were to excel, and it was a Greek, Aristonothos, who signed a painted vase of the later 7th century, found at Tarquinia. It is very likely that native Etruscan craftsmen were responsible for some of the products, especially those

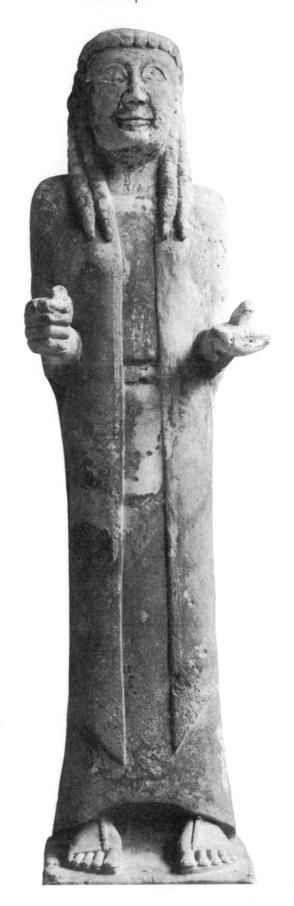

53. **Statuette of a Woman**. *c.* 600 BC. Alabaster. h. 2 ft. 9½ in. (85 cm.). British Museum, London. This statuette, found in the Isis Tomb near Vulci in 1839, is closely related in style to 7th-century Greek sculpture.

which show an obvious mingling of Villanovan and foreign elements, but there is little doubt that the best work was done by foreigners. The result is that the 7th century does not see the creation of a firm Etruscan artistic tradition, comparable to that which developed in Greece following its orientalising phase. Instead, at the end of the 7th century, new Greek influences begin to assert themselves in Etruria, and, from then on, successive waves of Greek influence dictating the general development of Etruscan art.

EARLY ETRUSCAN SCULPTURE

Let us look first at Etruscan sculpture. Etruria lacks the rich resources of statuary marble that are readily available in Greece, and the quarries of Carrara, which produce a good marble, were not exploited until the 1st century BC. The chief materials of sculpture were terracotta, bronze and the local stones, including the alabaster of the Volterra region. Terracotta was used both for making large statues, and for protective facings and architectural decoration of wooden temples and other buildings. Stone was used for free-standing figures, sarcophagi and funerary urns. Bronze was the principal material for statuary, but, as in the case of Greece, comparatively little full-size bronzework has survived. The Etruscans were also famous for high-class bronze utensils, which made considerable use of small-scale figures to decorate them; tripods, candelabra, bronze vessels with figure-attachments were made at many Etruscan centres.

The alabaster figure of a woman (right) comes from the Isis Tomb at Vulci, and is now in the British Museum. This half life-sized figure was made around 600 BC, and in style it is closely related to 'Daedalic' sculptures in Greece, at the period when more rounded forms had begun to replace the sharpness and angularity of the earlier Daedalic style. It is difficult to say whether this is in fact the work of a Greek or an Etruscan, and perhaps it does not matter, because there is so little to distinguish it from Greek work. The same is true of a stone statue of a centaur from Vulci, another work of the same period, whose big eyes, square face, narrow waist and broad shoulders, are strongly reminiscent of the 7th-century Peloponnesian 'canon' for the human figure. What these sculptures lack is the polish and refinement of the best Greek work.

Vulci, where both these figures were made, was the leading sculptural centre in central Etruria; Veii and Caere led in the south. In the 6th century the influence of the Greek colonies of Campania, where Greek and Etruscan lived side by side for over a hundred years, became very strong in Etruria. Artists at Caere seem to have learnt from Campania the art of revetting their wooden buildings with terracotta plaques, and Campanian bronzework was much prized in Etruria. During the 7th century, Corinthian painting and sculpture had dominated the art of Etruria, but by the 6th century Corinthian influence was being replaced by stronger influences from Ionian Greece, and this can be seen particularly clearly in painting.

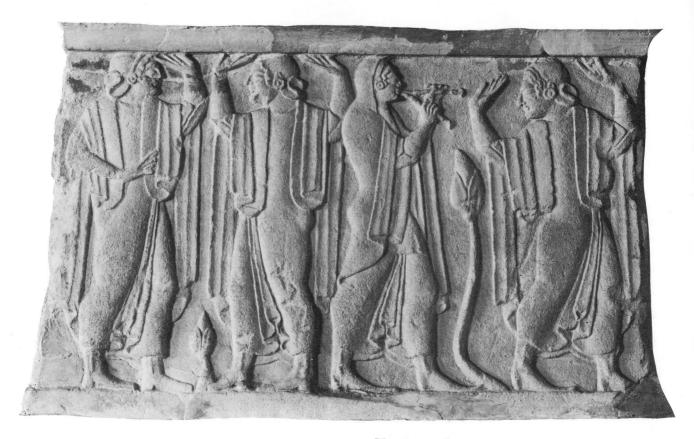

54. **Woman revellers**. *c.* 500 BC.
Limestone. h. 1 ft. 6½ in. (47 cm.).
British Museum, London. This scene is
carved on a funerary stone (*cippus*) made
at Chiusi, in Etruria. These *cippi* held
cremation burials.

TERRACOTTA SCULPTURES FROM SOUTHERN ETRURIA

The school of terracotta sculpture that flourished in southern Etruria towards the end of the 6th century, has been associated with the name of Vulca of Veii, the famous Etruscan who was called in by the Romans to decorate the temple of Capitoline Jupiter. The school of Veii stands out from the mass of derivative Etruscan art. In the 6th century, the Etruscans had adopted the Greek archaic figure types, the *kouros* and *kore*, and had learnt the Greek conventions of drapery and the rendering of the human form. More important, they had adopted the Greek anthropomorphic conception of the gods, and conflated Greek divinities with their own. Yet nothing could be further from the Greek conception of Apollo than the figure from Veii, which once formed part of a group apparently decorating the ridge of a temple roof. The subject of the group was the struggle between Apollo and Herakles, who has tried to steal the holy hind of the god. The god is shown advancing swiftly against his opponent, with his drapery clinging tightly to his body in a pattern of regular folds. The strength and power of the figure has nothing of the aloofness of the Greek ideal. The terracotta sarcophagus from Caere, now in the Villa Giulia Museum, with a man and his wife shown reclining on the lid, was made about the same period as the Apollo. Here the Etruscan sculptor has captured the tenderness of the scene by a subtle use of gesture and expression in the faces; he has devoted much more attention to the movements of the hands, and the look on the faces, than to the forms of the body. His approach seems fundamentally different from the contemporary Greek.

The differences between late archaic sculpture in Greece and Etruria come out well in a comparison of the Greek banqueter and the Etruscan satyr-banqueter. In the one all is delicacy and refinement, with a strong sense of the bodily forms underlying the contours of the drapery; in the other the head is made more vividly expressive by exaggerating its scale, while the elongated body is lost below the rich patterning and flowing lines of the drapery.

FIFTH- AND FOURTH-CENTURY ETRUSCAN SCULPTURE

The development of the Greek ideal in the 5th century BC corresponds with the beginnings of decline in the fortunes of the Etruscans, and there is nothing corresponding to the process of artistic revolution that we observe in Greece. The Tyskiewicz head, in the British Museum, made perhaps about 480–470 BC, shows how the archaic style lingers on into the 5th century and the head has a hardness that could never be mistaken for contemporary Greek work. It is not until late in the 5th century that we see some reflection of the 5th-century Greek achievement in the local sculpture of Etruria. A group of sculptors working on a temple at Orvieto (Via S. Leonardo), seem to have been inspired by late 5th-century Athenian sculpture. They aim at the same quiet dignity of expression and the same rich effects of drapery and strength of form. The well-known figure of Mars from Todi, an almost life-size

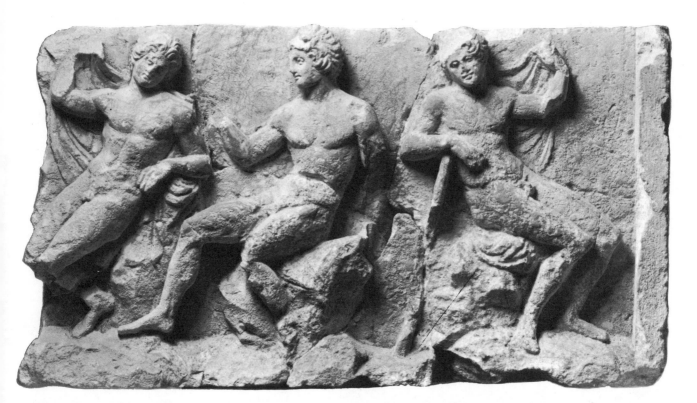

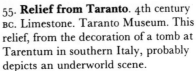

55. **Relief from Taranto**. 4th century
BC. Limestone. Taranto Museum. This
relief, from the decoration of a tomb at
Tarentum in southern Italy, probably
depicts an underworld scene.

56. **Head of a young man**. Early 5th
century BC. Bronze. h. 6 in. (15.5 cm.).
British Museum, London. The head is
a good example of late archaic Etruscan
work under Greek influence.

bronze made in the early 4th century, has something of the
grandeur and simplicity of a Greek divinity, but the head
is disproportionately large and the balance of the figure
lacks the Greek sense of symmetry. The bronze Chimaera
from Arezzo, which probably belongs to the same period,
is one of the finest examples of animal sculpture that has
survived from the ancient world.

HELLENISTIC SCULPTURE IN CENTRAL ITALY

The revival of Etruscan art in the 3rd century BC should
probably be looked upon as a revival of central Italian art
under the guidance of Rome. New Greek influences from
the southern Italian colonies now reached central Italy,
largely as a result of Roman expansion. But because the
traditional materials continued to be used together with
traditional techniques, this revived art still has the look of
being Etruscan, although Etruria had in fact ceased to be
a power. The sculptures from the Temple of Lo Scasato, at
Città Castellana, were made about the middle of the 3rd
century BC. The magnificent head of Apollo, from the pedi-
ment of the temple, is modelled in a style related to the
work of Lysippus' pupils. A remarkable head from Arezzo
is very like the strangely intense Scopaic heads from the
Temple at Tegea, with the same square contours of the **60**
upthrust face and the 'pathetic' expression in the deep-
set eyes. It was probably made about 200 BC.

The realism of Hellenistic art, and the interest in por-
traiture, found a ready response in central Italy, where a
strong interest in the details of the individual face had been
apparent from the first. The head had stood for the man

57. **Ulysses and the Sirens**. 2nd century BC. Alabaster. h. 1 ft. 3½ in. (39 cm.). British Museum, London. This scene appears on an Etruscan funerary urn made in Volterra.

on the Canopic jars of Chiusi, and the practice of dedicating votive heads at tombs and sanctuaries seems to have gone on throughout the Etruscan period, a practice which must have had its influence on the Roman tradition of ancestral portraiture. A rich series of funerary sculptures, from *57, 58* sarcophagi to ash-urns, provides the principal source for the development of portraiture in central Italy, but there are also fine bronze portrait heads and figures of the last two centuries BC. In the terracotta votive-heads the individual is portrayed with a down-to-earth simplicity, which is generally free of any idealisation. The *100* bronze portrait head of a boy from Fiesole, now in the Louvre, is a masterpiece of direct and vivid portraiture, of the kind which the Roman patricians of the last century BC demanded of the sculptors who worked for them. The most famous of all the late Etruscan portraits is *98* the so-called *Arringatore*, the statue of an orator, which bears an inscription in Etruscan, but portrays a Roman citizen, Aulus Metellus. It is the first of the long line of portrait statues of Romans, which form so important a part of Roman art throughout the Empire.

In late Etruscan relief-sculpture on buildings, sarcophagi and urns, we can follow both the developments in Hellenistic relief and the appearance of distinctively Italian themes. The subjects are taken mainly from Greek mythol-ogy and history, but local history and religious practices also appear. All the styles of later Greek relief-sculpture are reflected in the funerary reliefs, from the balanced action of battle scenes like the Amazon frieze on the Mausoleum at Halicarnassus, to the dynamic style of the massed compositions on the frieze of the Pergamene Altar. The heroic emotionalism of the latter seems to have appealed particularly to central Italian taste. A 2nd-century terracotta frieze from Città Alba represents the attack by the Gauls on Delphi in 279. It seems to provide a link between the Greek representations of history and the Roman idea of the historical frieze, since it treats of a specific event and introduces a good deal of precise detail, in contrast with the more generalised or completely allegorical commemoration of history that we find in Greece. Some of the Volterran urns show ritual scenes, in a straightforward factual style that has much in common with Roman commemorative art. A group of terracotta pedimental sculptures from Via S. Gregorio, Rome, reminds us that temples were still being built in Etruscan style at Rome during the last century BC. The subject is a sacrificial scene of the kind which became common in Imperial relief-sculpture.

ETRUSCAN TOMB-PAINTING

The almost complete loss of monumental painting in

58. **Sarcophagus of the Magnate**.
3rd century BC. h. 6 ft. 9½ in. (2.07 m.).
Tarquinia Museum. Etruscan stone
sarcophagus, with reclining figure of the
dead man on the lid. The reliefs depict a
battle between Greeks and Amazons.

Greece has been stressed in the earlier chapters of this book. In Etruria, on the other hand, a rich legacy of large-scale paintings inspired by Greek sources, decorate the walls of chamber tombs at Tarquinia, and elsewhere. The paintings are carried out on a layer of lime plaster in the fresco technique; the earliest examples belong to the 6th century BC, and the series extends right down to the 1st century BC. The Etruscan idea, that the tomb is a place where the dead live on, lies behind the subject-matter of the paintings. Scenes in the earlier period are taken from daily life—banqueting, games, hunting and so on. In the later tombs, underworld scenes peopled by frightening demons show what seems to be a complete change in the Etruscan attitude to death; even the banquet scenes take on a melancholy air.

THE EARLIEST PAINTING

Before the development of monumental painting in Etruria, the Etruscans were already imitating Greek painted pottery. We have already mentioned some examples of the geometric style, and in the 7th century the products of Corinthian potters, which commanded the foreign markets in the period, were copied in the so-called Italo-Corinthian vases. During the 6th century, Ionian Greek influence dominated the local painted pottery of Etruria. A group of black-figured vases, the so-called Caeretan *hydriae* (water-pots), seem to have been made about the middle of the 6th century BC, by immigrant Ionian craftsmen in Caere. The style is Ionian, the subjects lively and sometimes humorous versions of Greek mythology. The earliest monumental tomb-paintings belong to about the same period. In the scene from the Tomb of the Bulls, one of the earliest of the archaic painted tombs of Etruria, Achilles is waiting in a thicket behind a fountain to ambush the Trojan prince Troilus. The inspiration comes from vase-painting, but despite the Greek models there is much that seems characteristically Etruscan, especially the introduction of trees and plants into the scene, the powerfully dramatic rendering of the ambush, and the strange incongruities of scale. There is something too, of the same spirit of irony that we see in the Caeretan hydriae.

THE EARLY TOMBS OF TARQUINIA

In the archaic tombs of Tarquinia, the technique is outline drawing with flat washes of colour—reds, greens, blues and yellows. There are conventions of brown for the skin of the men, and a paler wash for the women; trees and shrubs appear as filling ornaments in the most unexpected contexts. Within the conventions of archaic art, the artists paint with a liveliness that delights in exaggerated gesture

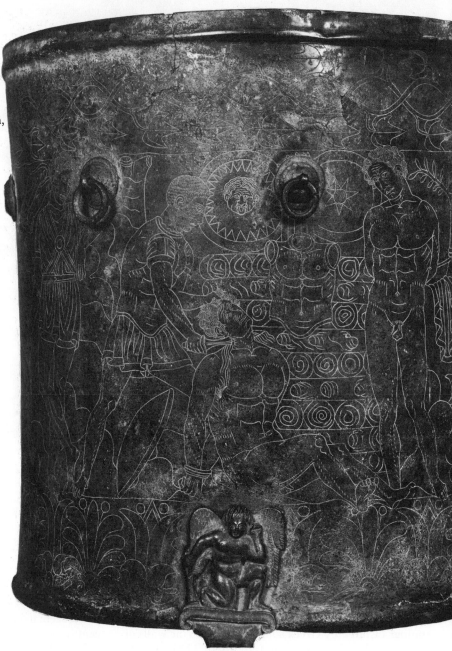

59. **Trojan Captives**. *c*. 300 BC. Bronze.
h. 1 ft. 2½ in. (36.5 cm.). British Museum,
London. Detail of the engraving on a
bronze *cista* from Palestrina, showing the
sacrifice of Trojan captives at the funeral
of Patroclus.

and violent movement. Even though the essence of the style
is Greek, the artists often seem to be indulging a taste for
realistic detail, and an interest in nature which is wholly
un-Greek. It is in the *Tomb of Hunting and Fishing* that the
contrast beween the Greek and Etruscan approach comes
out best. Here are scenes which show a genuine delight in
the world of nature; in the fishing scene the landscape is
painted with loving care and the figures do not dominate
the scene. 'Man is a feature of the landscape', says one
critic. One is reminded strongly of the wall paintings of
Knossos, where nature inspires the same colourful decora-
tive art. But it would be wrong to contrast the lively colour-
ful painting of Etruria with the monotonous black-and-red
world of the Greeks that we see in their vase-painting.
Etruscan paintings show the same palette that must have
been used in the lost mural paintings of Greece, and may be
taken as some evidence for it.

The archaic series of Etruscan tomb-paintings extends to
about the middle of the 5th century BC. The most famous
are those of the *Tomb of the Augurs*, the *Tomb of the Triclinium*,
with perhaps the finest of the whole series, and the *Tomb of
the Leopards*. Etruscan painting shows little of the develop-
ments and experiments in foreshortening, and the ren-
dering of the human figure that characterise late archaic
art in Greece; there is hardly a trace of the Greek revolution
of the early 5th century, and the paintings as late as the
mid-5th century are still predominantly archaic.

LATER PAINTINGS

As in sculpture, so in painting there is a big gap between
the archaic tombs and those of the 4th century, when Greek
inspiration finds a new creative response in Etruria. When
the series begins again, we see evidence for developments in
representational art that have taken place in the inter-
vening period. One of the finest examples of ancient paint-
ing that has come down to us may be seen on the painted

(Continued on page 145)

72. (above). **Decorated diadem**. 3rd century BC. Gold. 1½ in. (4.2 cm.). British Museum, London. Diadem found at St. Eufemia del Golfo near Monteleone in south Italy. The diadem is decorated with tendrils and flowers of filigree work; near the apex of the triangle is a little embossed head. The floral ornament is typical of south Italian decorative work in the Hellenistic period.

73. (below). **Conversation piece.** c. 200 BC. Terracotta. h. 8 in. (20 cm.). British Museum, London. This little painted terracotta group shows two women sitting on a couch talking to one another; the elder woman on the right is perhaps giving advice to the younger. A pleasant everyday theme of a kind that the makers of terracotta figures liked to portray in Hellenistic times. The group probably comes from Myrina in Asia Minor.

74. (right). **Aphrodite, Pan and Eros**.
c. 100 BC. Marble. 4 ft. 4 in. (1.32 m.).
National Museum, Athens. A group made
for a Syrian merchant on the island of
Delos. Aphrodite is warding off Pan's
attack with a sandal, while Eros grabs
Pan's horn in order to push him away.
The group is a good example of a large
series of light-hearted groups of satyrs,
Pans, centaurs and so on, which were
made to satisfy a taste for decorative
sculpture in Hellenistic times.

75. (below). **Head vase**. *c.* 100 BC. Bronze.
h. 4 in. (10 cm.). British Museum, London.
Little jug cast in the form of a negress's
head. Silver inlay is used for the whites of
the eyes. The negroid features are closely
observed but not exaggerated; the fashion
for corkscrew curls still prevails among
some African tribes today. The vase was
probably made in the late Hellenistic period.

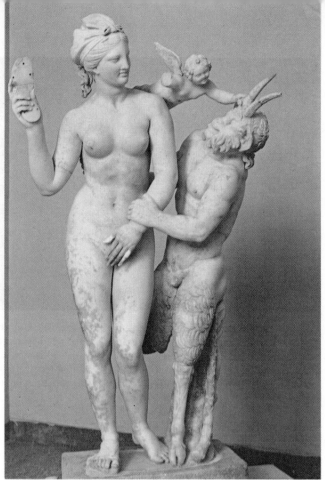

76. (below). **Tetradrachm of Anti-
machus of Bactria**. *c.* 175 BC. Silver.
d. 1¼ in. (3 cm.). British Museum, London.
The kingdom of Bactria declared its in-
dependence from the Seleucids in Syria
in 208 BC, and flourished for over 100
years. The portrait heads of the kings of
the dynasty on their coinage are the work
of first-class Greek artists.

77. (right). **Portrait head of a man
from Delos**. *c.* 100 BC. Bronze. 13 in.
(33 cm.). National Museum, Athens.
It is one of the best examples in the series
of portraits, in marble and bronze, of
merchants and officials made in the last
two centuries BC on the commercial island
of Delos. The eyes are of glass inlay.

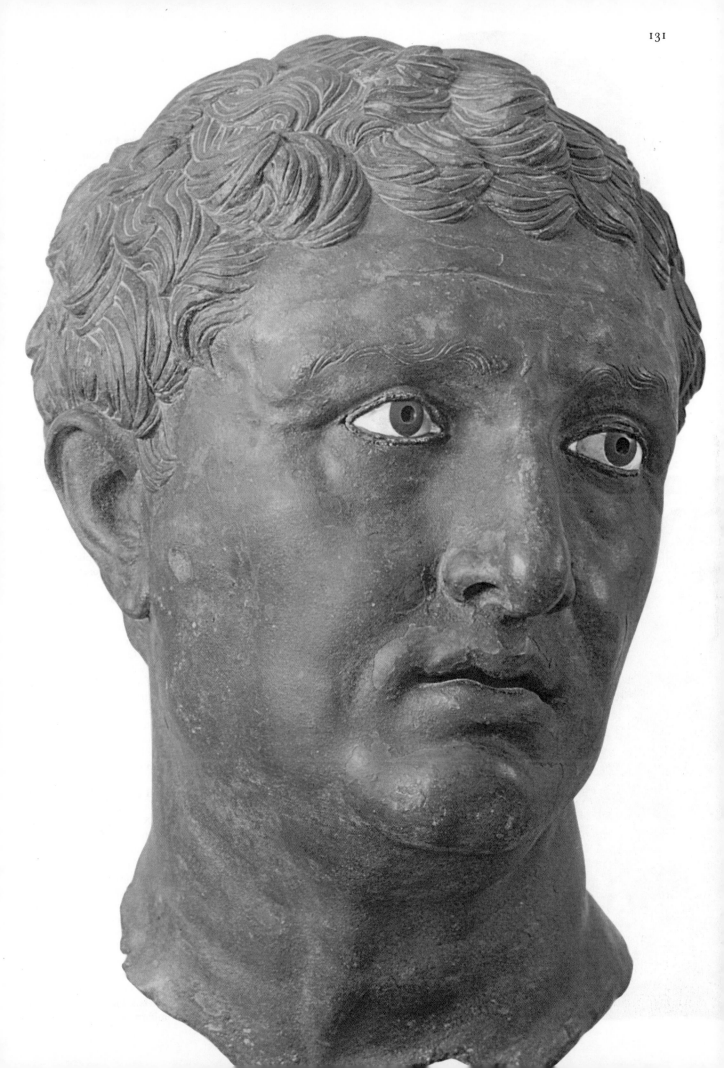

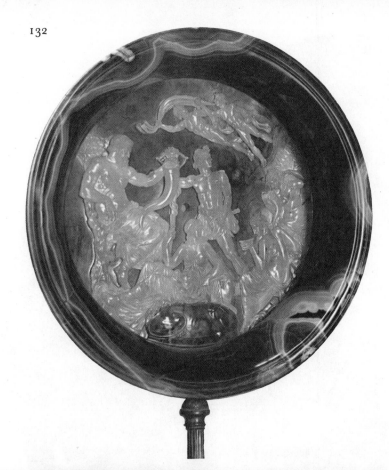

78. (left). **The Tazza Farnese**. 2nd or
1st century BC. Sardonyx. diam. 8 in.
(20 cm.). National Museum, Naples.
The scene on the inside of this shallow cup
is an allegory of the fertility of Egypt.
A figure representing the Nile is seated
on the left; below him is Euthenia, goddess
of prosperity, resting against a sphinx.
Triptolemus, bringer of fertility, is in the
centre; to the right are two graceful
female figures, and two youthful wind-
gods float across the scene above. On the
outside of the cup is a superbly carved
Medusa head. The cup was probably
made in Ptolemaic Egypt in the 2nd or
1st century BC.

79. (left). **Pompeian wall painting**.
c. 50 BC. Fresco. Villa of the Mysteries,
Pompeii. Detail from the famous painted
frieze showing the initiation rites of the
Bacchic mystery. Silenus, the attendant
of Bacchus, appears with two other satyrs;
on the back wall to the left a woman, her
veil caught by the wind, is moving rapidly
away. The painting belongs to the so-
called Second Style.

80. (right). **The Odyssey landscape**.
50–30 BC. Fresco. 4 ft. 11 in. (1.50 m.).
The Vatican Library. This picture is one
of a series of paintings decorating a
'Second Style' wall scheme, found in a
Roman house on the Esquiline Hill,
Rome, and now in the Vatican. It illus-
trates one of Odysseus' adventures in the
land of the Laestrygonians; the men who
have been sent by Odysseus meet the
king's daughter, who is coming down
to draw water at a spring. The artist has
conjured up a fairy tale landscape of cliffs
and rocks and trees. The skilful handling
of light, shade and colour, and the way
in which the figures are fitted into the
landscape, show how far Hellenistic artists
had advanced in illusionistic painting.

81. (right). **Wall painting from a Villa
at Boscoreale**. *c.* 50 BC. Fresco. l. 4 ft.
9 in. (1.45 m.). National Museum, Naples.
painted wall of the so-called 'Second-
Style' from the dining-room of a villa at
Boscoreale in the Bay of Naples. The
architectural vista may be based upon the
design of a Greek stage set of the Hellenistic
period. It is noteworthy that in general
the parallel lines of the composition recede
to a single vanishing point suggesting that
the painter understood the essentials of
a theory of perspective. It is only in these
'Second Style' paintings that this kind of
consistency is achieved. The lighting of
the architecture is arbitrary, that is, there
is no single uniform source of light.

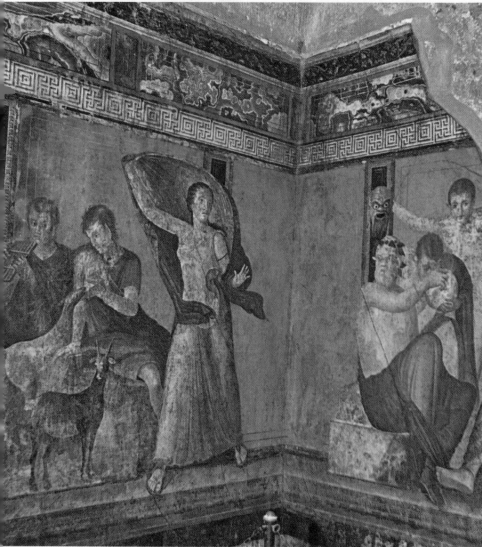

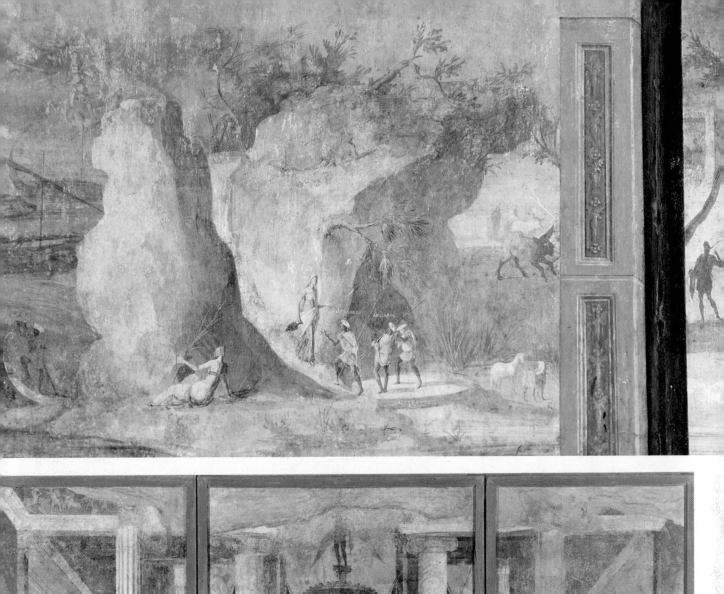

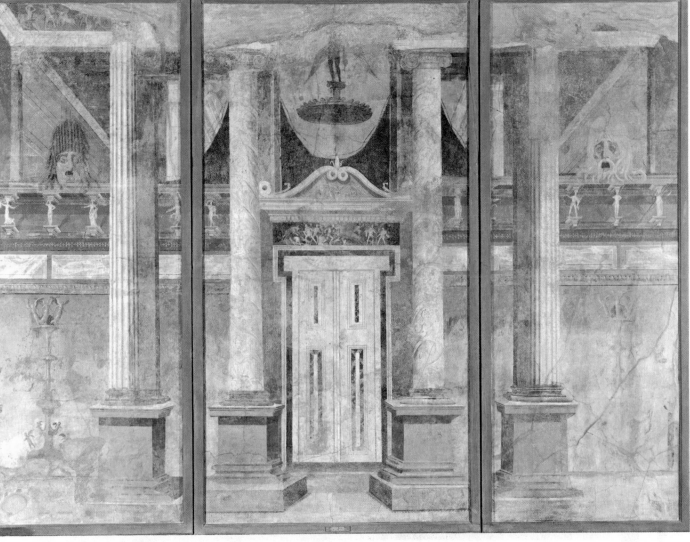

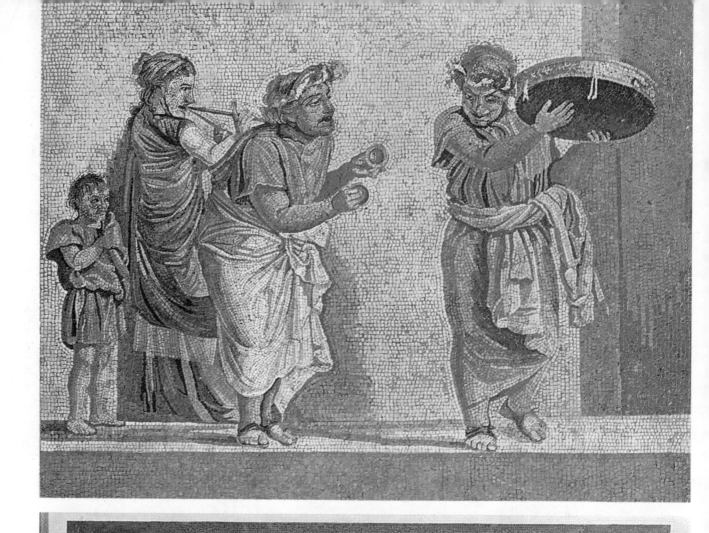

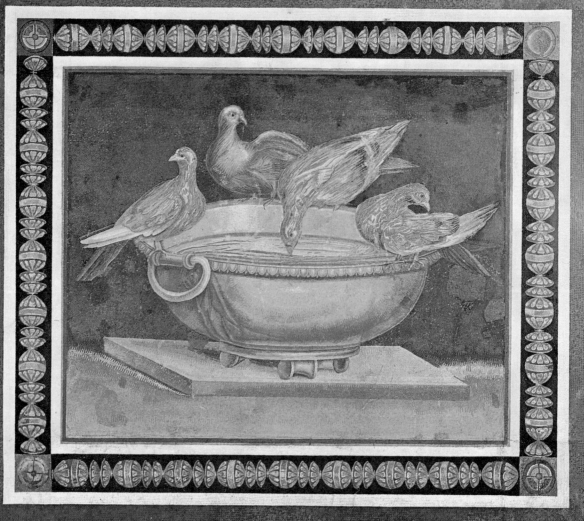

82. (left). **Dioscourides of Samos. Musicians**. *c.* 3rd century BC. Mosaic. h. 16 in. (41 cm.). National Museum, Naples. This mosaic, from the so-called Villa of Cicero at Pompeii, is signed by the artist, who also signed a second mosaic in the house showing a scene from the Greek New Comedy. This one is a fine example of the mosaicist's skill in handling minute pieces of coloured stone to imitate the effects of painting; it was probably copied from a Hellenistic painting, perhaps of the 3rd century BC.

83. (left). **Doves around a bowl**. 2nd century AD. Mosaic. h. 2 ft. 9½ in. (85 cm.). Capitoline Museum, Rome. This mosaic, from the Villa of Hadrian at Tivoli, is probably a copy of a mosaic by Sosus of Pergamon (2nd century BC), which is described by Pliny the Elder as showing a dove drinking from a vessel while other doves are perched on the rim. There is another version of the same theme in Naples.

84. (right). **Figure of seated woman from Cerveteri**. 7th century BC. Terracotta. h. 21½ in. (54 cm.). British Museum, London. Figure of a seated figure from Caere (Cerveteri). This figure, together with another similar one and a seated figure of a man, was found in a chamber tomb and probably represented the family of the dead. The right hand is held out to receive an offering. The cloak is pinned to the right shoulder with one of those elaborate *fibulae*, of which examples survive in gold and other materials. The figure was made in the 7th century, when there was strong oriental influence on the art of Etruria.

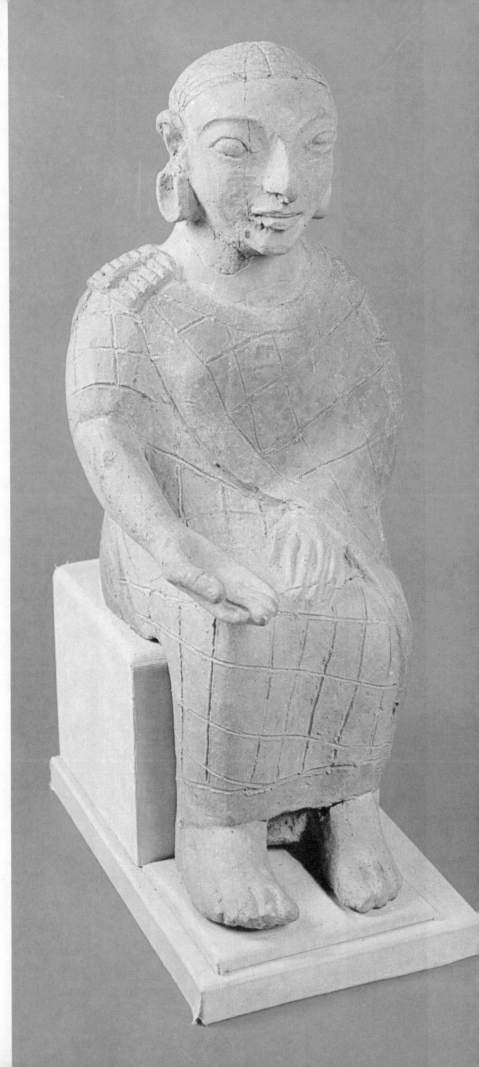

85. (left). **Bracelet from Praeneste**. Gold. l. 7¼ in. (18.3 cm.). British Museum, London. This bracelet is made from a sheet of gold decorated with repoussé figures, to which details are added in the granulation technique. The figures belong to an 'orientalising' repertory; there are winged lions, male figures and rows of female figures. Clasps and hooks are fitted to the ends of the bracelet.

87. (right). **Cup with sphinxes from the Bernardini tomb, Praeneste**. 7th century BC. Gold. 3 in. (7.9 cm.). Villa Giulia Museum, Rome. The Etruscan goldsmith has placed two little sphinxes made of sheet gold decorated with gold granulation, on each of the handles of the cup which is a typical 7th century Greek shape.

86. (below). **Etruscan ornament from the Barberini tomb, Praeneste**. Gold. 9½ in. (24.3 cm.). Villa Giulia Museum, Rome. The 7th century tombs of Etruria and Latium testify to the great wealth of the Etruscan lords of the period. Gold jewellery and vessels of precious metal are among the richest that have come down to us from the ancient world. This gold ornament has little figures of lions, sphinxes, and griffins soldered on to gold sheet. The figures are embossed and decorated with lines of minute gold granules, a technique which is characteristic of the jewellery of the period.

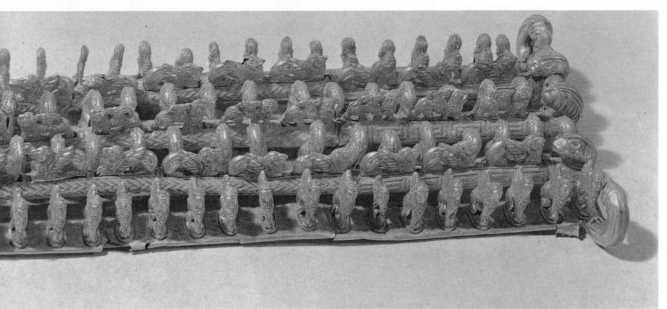

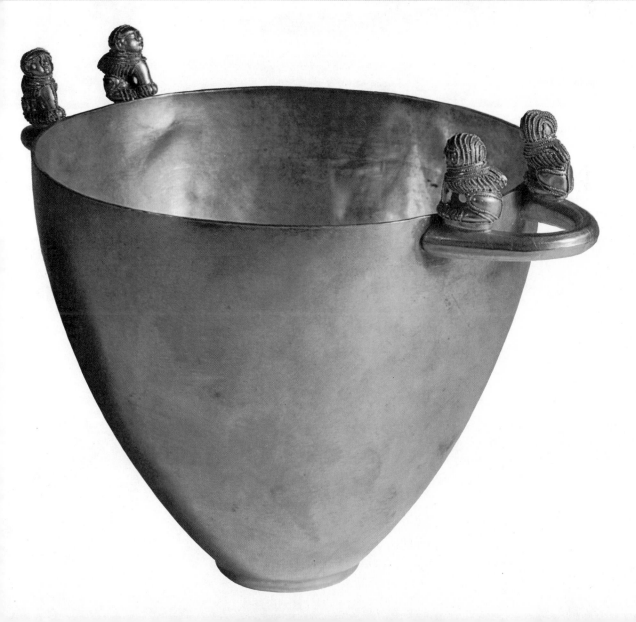

88. (above). **The ambush of Troilus**. *c.* 540 BC. Fresco. w. 4 ft. 2 in. (127 cm.). Tomb of the Bulls, Tarquinia. The Trojan prince Troilus, son of Priam, whose horse can just be seen on the right of this detail, is coming down to a well to water his horse. Achilles is just about to sally forth from hiding and kill him. This picture is one of the oldest in the series of tomb paintings from Tarquinia. The inspiration is drawn from Greek vases, but the use of trees and bushes suggesting a landscape setting is in Etruscan taste.

89. (below). **A chariot race**. *c.* 450 BC. Fresco. w. 4 ft. 10 in. (148 cm.). Tomb of the Colle Casuccini, Chiusi. Scenes connected with the games are among the most popular subjects in early Etruscan tomb paintings. This picture is one of the liveliest examples that has survived.

90. (below). **The blinding of Polyphemus**. *c.* 530–510 BC. Pottery. h. 17½ in. (44 cm.). Villa Giulia Museum, Rome. The blinding of Polyphemus by Odysseus and his companions is the subject of the painting on this hydria found at Caere. Three men are driving the stake into the Cyclops' eye, while a fourth urges them on. The vase is one of the so-called Caeretan hydriae (water pots), a group of some thirty black-figure vessels, most of which have been found at Caere in Etruria. They were probably made in a single workshop at Caere by a Greek immigrant from Ionia.

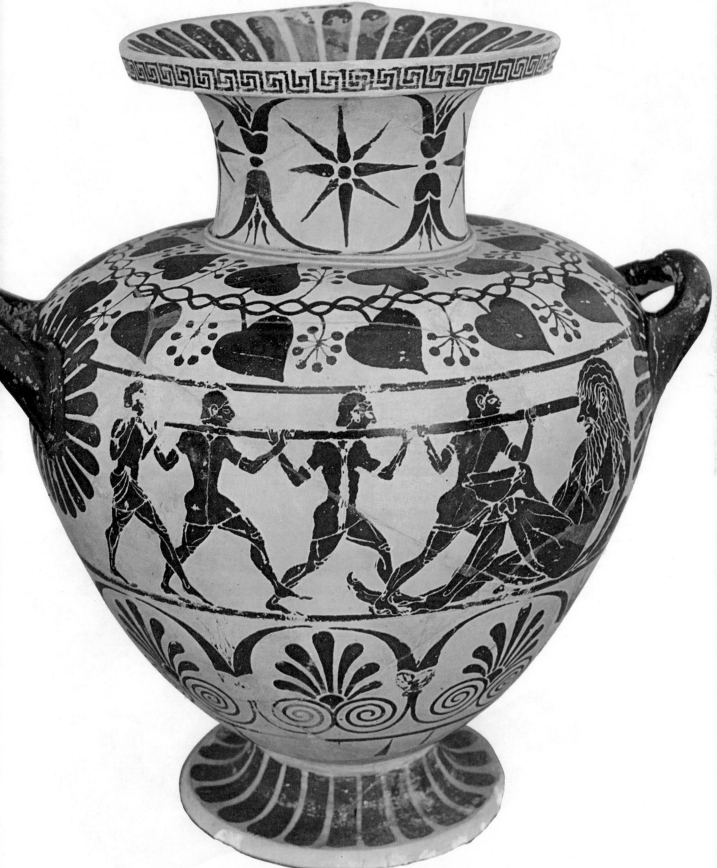

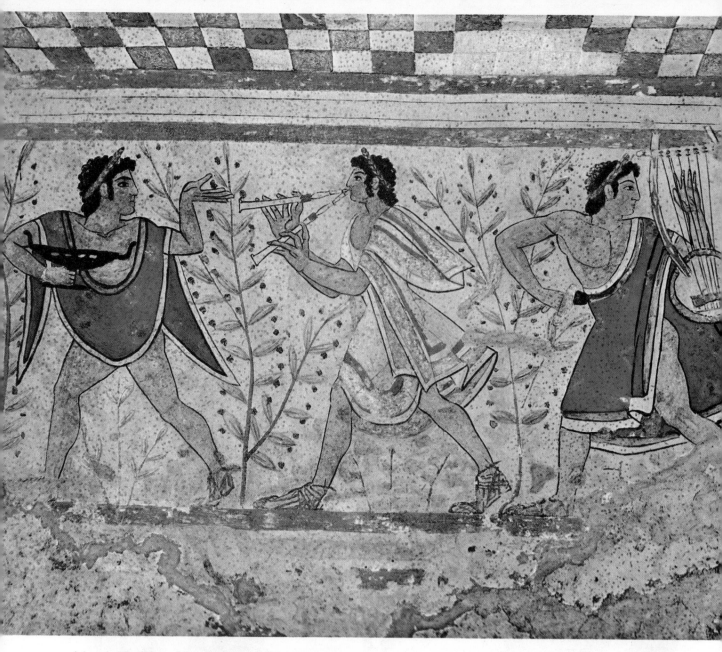

91. (above). **Musicians from the Tomb of the Leopards.**
*c.*480–470 BC. Fresco. h. 3 ft. 6 in. (106 cm.). Etruscan Necropolis,
Tarquinia. Painted scene from the Tomb of the Leopards at
Tarquinia. On the left a young man holding a cup, in the centre
a man playing a double pipe, and on the right a man playing
a lyre. The scene is typical of the gay, colourful paintings of the
early tombs at Tarquinia in a style which is basically archaic
Greek. Laurel bushes are set between the figures.

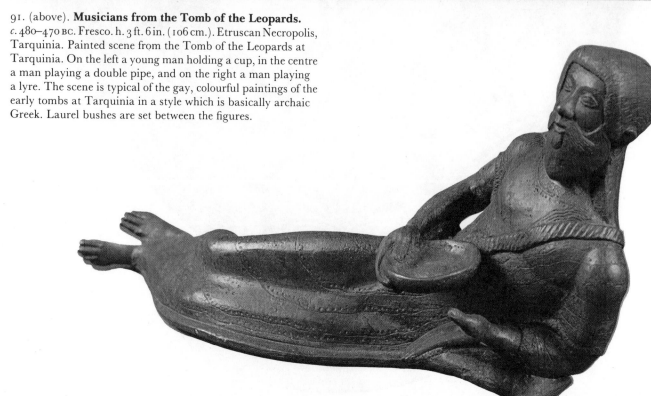

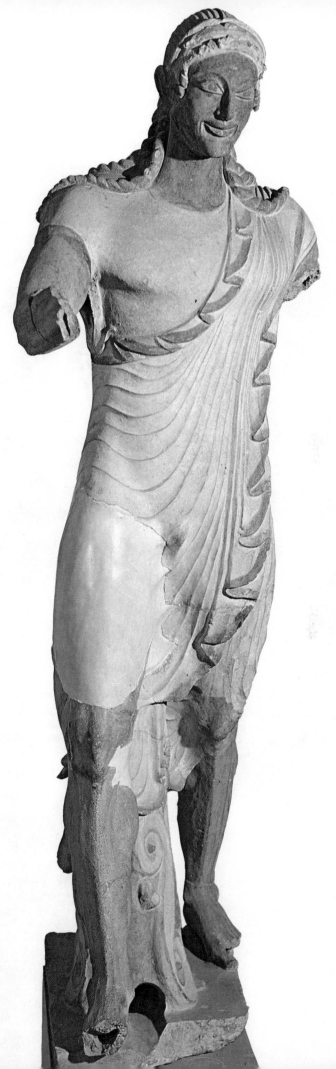

92. (left). **Etruscan Banqueter**. *c.* 500
BC. Bronze. l. 13¼ in. (33 cm.). British
Museum, London. The figure, perhaps a
satyr, is reclining on a wineskin (?).
He holds a dish in his right hand. The
forms of the body are strangely elongated.

93. (right). **The Apollo of Veii**. *c.* 500 BC.
Terracotta. 5 ft. 9 in. (1.75 m.). Villa
Giulia Museum, Rome. This figure is
perhaps the most famous of all Etruscan
sculptures. It belongs to a group repre-
senting Hercules' theft of the holy hind
of the god Apollo at Delphi, which deco-
rated an Etruscan Temple at Veii.
Though based on Greek models the figure
has an individual character that is un-
mistakably Etruscan.

94. (below). **The Nazzano Painter. Calyx crater**. *c*. 400–350 BC. Pottery. h. 22½ in. (51 cm.). Villa Giulia Museum, Rome. This red-figure vase, depicting the sack of Troy, was made at Falerii (Città Castellana). The scene has the lively con-fusion of a burlesque, perhaps an inten-tional one. King Priam lies on the ground with a warrior standing threateningly over him; on the left Aphrodite is protecting Helen from the wrath of Menelaus. Neoptolemus is brandishing the boy Astyanax by the leg.

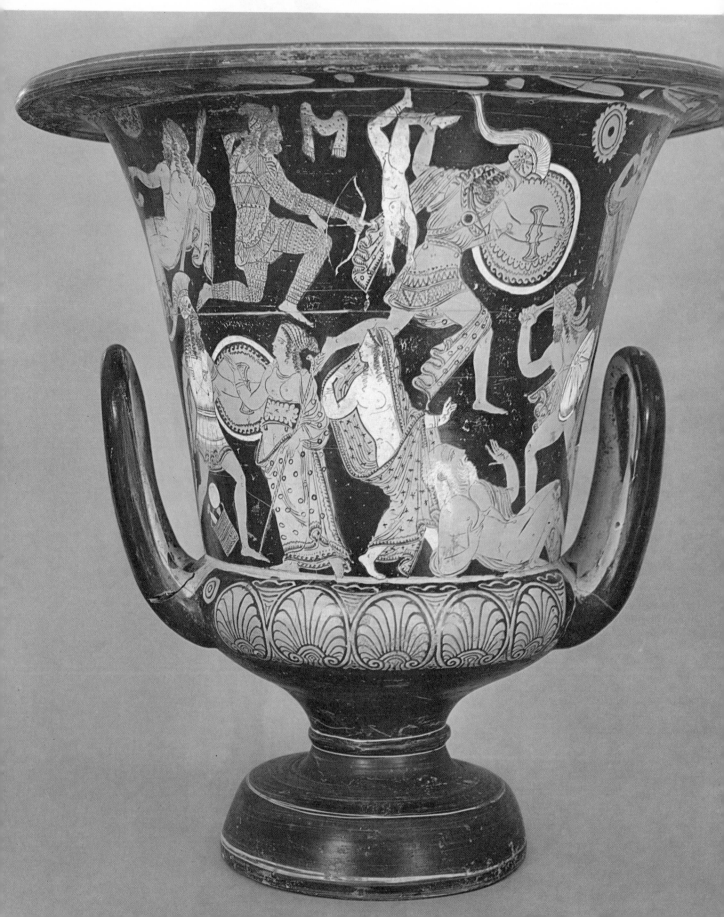

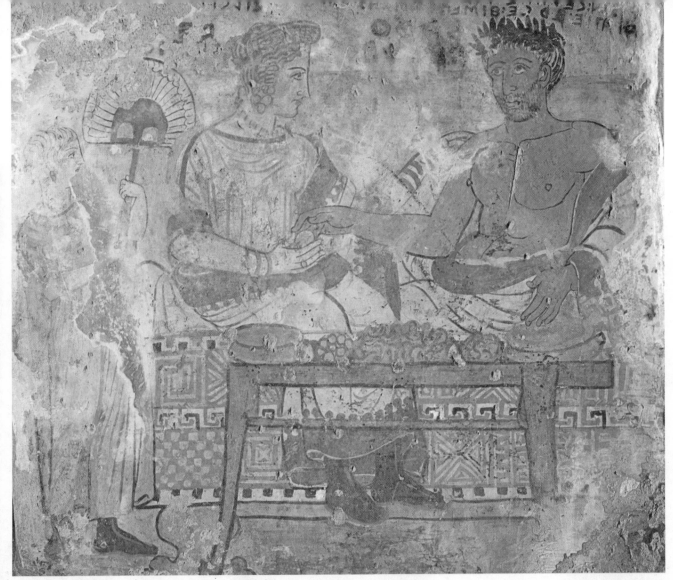

95. (above). **An Etruscan funeral banquet**. 3rd century BC. Fresco. h. 4 ft. 8 in. (142 cm.). Tomb of the Shields, Tarquinia. In this scene the dead man, Larth Velcha, is shown with his wife, Velia Seitithi, in a melancholy scene that contrasts strongly with the festive gaiety of earlier Etruscan tomb paintings. Larth Velcha lived in the 3rd century BC, and held high rank in the priesthood. His head suggests a convincing portrait, and the intensity of his expression has something in common with Roman portraits of the 3rd century AD.

96. (below). **Sarcophagus of the Amazons from Tarquinia**. *c.* 350 BC. Alabaster, h. 20¼ in. (51 cm.). Archaeological Museum, Florence. This scene, on a painted sarcophagus in Florence, shows a chariot driven by Amazons. The figures are drawn in outline, with a clever use of shading to give an impression of three-dimensional form. Different tones of colour are used for effects of light and shade on the chariot. Perspective and foreshortening are skilfully handled. The sarcophagus was found at Tarquinia, but it is suggested that it was painted by a south Italian Greek.

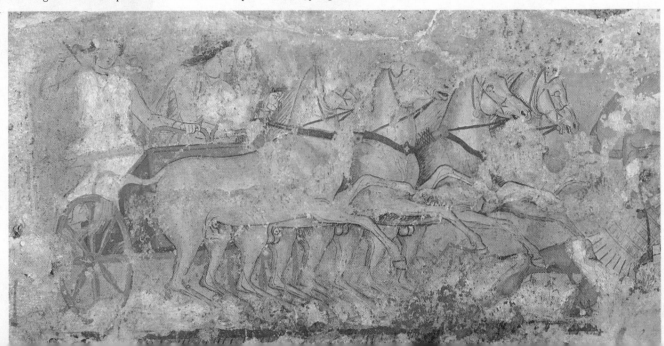

97. **Portrait of Velia**. Late 4th century BC. Fresco. h. 16 in. (41 cm.). Etruscan Necropolis, Tarquinia. This head of Velia, wife of Arnth Velcha comes from the Tomb of Orcus at Tarquinia. She wears a wreath of leaves and rich jewellery. The head is closely inspired by Greek art of the 4th century BC. The profile is beautifully drawn, and there is a subtle use of colour tones in the modelling of the face.

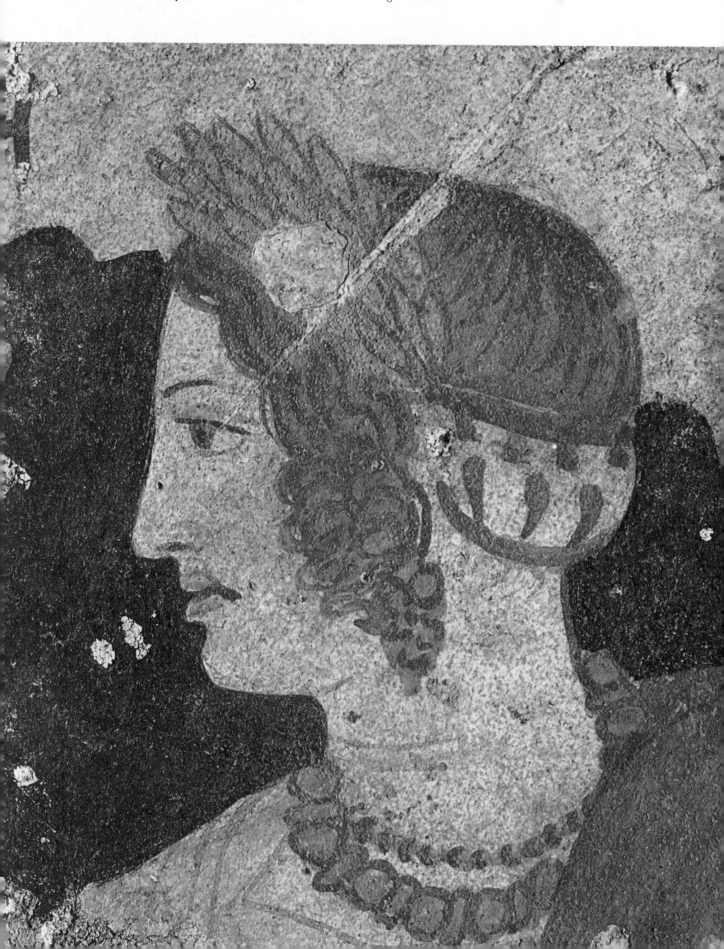

sarcophagus from Tarquinia in Florence; one scene, of a chariot driven by Amazons, is painted in a style which shows a mastery of chiaroscuro effects and a skilful handling of foreshortening. The painting is purely Greek in spirit, and one suspects that the artist was a Greek of southern Italy. The head of Arnth Velcha's wife, from the Tomba dell'Orco at Tarquinia, is painted in a fine Greek style, with a subtle use of shading on the face. The hideous demons who people the underworld of later Etruscan painting, are utterly un-Greek in spirit. Greek art had rid itself of its legacy of monsters, but those of the Etrucans are painted with a morbid love of horrifying colour and detail. The banquet scenes of the later period introduce portraits of the dead, painted with close attention to facial likeness, especially in the men. The François tomb from Vulci combines painted scenes, taken from Greek mythology, with scenes of local history. It seems to be one of the latest in the series of Etruscan tomb-paintings and by its choice of subjects brings us near to the tradition of Roman commemorative painting.

VASE-PAINTING AND DRAWING FROM THE FOURTH CENTURY

Local imitation of Greek vases went on throughout the Etruscan period, but it is not until the 4th century that we find in central Italy a style of vase-painting with really independent characteristics. The big red-figured vases produced in Falerii (Cività Castellana), in the 4th century, are painted in a lively and distinctive style. The scene on a big crater by the Nazzano painter, illustrated in plate 94, shows the sack of Troy; it is drawn in a rich style, vivid in detail and attractively different from the mass of southern Italian vase-painting of the same period. The compositional technique is still that of the 5th-century painters in Greece, though there is some suggestion of smaller scale for the more distant figures. The same representational method is used on some of the engraved bronze vessels produced, in a typically Etruscan technique, during the 4th century. The finest surviving example is the so-called *Ficoroni Cista*, in the Villa Giulia Museum, Rome, which is signed by a Latin artist who states that he made it in Rome; the scene is taken from the story of the Argonauts. The engraving shows a mastery of the principles of foreshortening, skilfully introduces landscape details into the scene, and makes the more distant figures smaller than those of the foreground. The figures on the handle and feet of this vessel are exquisite examples of Etruscan bronzework, but with just that slight harshness of detail, carelessness in proportions, oddity of pose, that distinguish Etruscan from Greek work of the same period.

ETRUSCAN ARCHITECTURE AND THE ROMANS

We cannot deal in detail with the architecture of the Etruscan area; our chief interest in Etruscan art comes from the fact that it provides the background to Roman art, and it is from that point of view that we shall treat briefly the history of Etruscan architecture. We know, in fact, very little about the principal Etruscan cities, and, in general, it is one of the main difficulties in understanding Etruscan culture that our sources of evidence come from funerary monuments. None of the famous Etruscan cities has been thoroughly excavated, and we can only generalise about the character of the buildings and layout. The Etruscan cities were built on easily defensible sites, and were not given elaborate circuits of defensive walls until a later period. It seems fairly clear that the cities grew up haphazardly from Villanovan beginnings, without the regular layout which was associated in later times with Etruscan town-planning. But the small Etruscan town of Marzabotto, founded near Bologna in the early 5th century, has a strictly formal plan, with principal streets crossed by narrower subsidiary streets, creating rectangular building plots such as we find in the regular layouts of later Greek and Roman town-plans. The streets were well paved and efficiently drained; the houses were of brick, stone and timber. The basic form of the Etruscan house was rectangular, consisting of a single room partitioned in various ways. The more elaborate plans are known to us from Etruscan tombs, which, as we have seen, often imitated the houses of the living. In these more ambitious plans, we see a form of house which is preserved in the domestic architecture of the Roman Empire; the main feature is a central chamber, the *atrium*, which has three rooms opening off it at one end, and is approached on the opposite side by a passage with flanking rooms. The Romans, indeed, specifically attributed to Etruria one form of atrium, the so-called *atrium tuscanicum*, in which the roof has a downward tilt in all directions towards a central opening. Some of the internal details of the Etruscan house are also known from tombs; ceiling joists, doors, windows and furniture are carved in stone in some of the richer tombs.

TEMPLE DESIGN AND DECORATION

Etruscan towns were dominated by the temples of the gods, and Etruscan temple-architecture provides us with the most important evidence for the influence of Etruria on Rome. As we have seen, the Etruscan temple was built predominantly of wood, with the wooden members protected by facings of terracotta slabs. It developed under Greek influence, but like all branches of Etruscan art retained its own essential characteristics and traditional materials. Unlike the Greek temple, it was not transformed from wooden origins into monumental stone forms. The Etruscan temple, unlike the Greek, was raised up on a high podium approached by steps at the front. The basic plan seems to have consisted of a single chamber, fronted by a row of wooden columns of wide span supporting the porch, but a number of variant and more elaborate plans are found. Vitruvius specifically attributes to Etruscan invention the triple division of the main chamber of the temple, which later becomes characteristic of Roman temples dedicated to Jupiter, Juno and Minerva, the deities of the Capi-

toline Triad. The arrangement of the temple columns varied; there was never, so far as we know, a complete peristyle or colonnade all round the *cella*, but the columns might run along the sides, or there might be a double row along the front. Many of these details continued into the architecture of the Empire. The Roman temple always has a high podium, and the columns are generally related to the Etruscan arrangement rather than the Greek. It was surely the Etruscan taste for richness of detail in the brightly painted terracotta facings, that lay behind the Roman taste for elaborately carved ornamental detail on the buildings of the Empire. Apart from the terracotta facings, the structural elements of Etruscan temples are derived from Greek architecture. The typical Etruscan column is a simplified form of Doric with a plain shaft and a torus base. The pure Doric also makes its appearance, but without any of the refinement of detail that we find in Greek work. The 'Aeolic' capital, prototype, it seems, of the Greek Ionic, is also found in Etruria, and from the 4th century onwards, under the influence of south Italian art, Ionic and Corinthian come in together with various special forms of capital, such as capitals with figures and busts as decoration, but these elements are part of a general central Italian Hellenistic tradition, rather than a pure Etruscan one. The 'Tuscan Order' of Vitruvius seems to be a Roman 'rationalisation' of various Etruscan elements.

BUILDING METHODS

Etruscan methods of building are basically similar to those of the Greeks. Polygonal and ashlar wall building is found in the Etruscan cities, none of which seem to have been walled before about 400 BC. The early tombs are often vaulted in a technique similar to that used for the Mycenaean chamber tombs, where overlapping horizontal courses are used to cover passages and domed structures. There has been much discussion about the origins of the true arch and vault, and the invention has been attributed to the Etruscans. In fact, it is very difficult to make a special claim for its origin in Etruria, but it does seem that the development of the arch as a vital architectural form took place in Italy in the last centuries BC. By about 100 BC, in central Italy, we find it used in conjunction with engaged columns and pilasters, for example, in the city-gates of the Etruscan city of Perugia; but this use belongs to the period of 'Italic-Hellenistic' architecture in Italy, which is not a pure Etruscan tradition. At this time the arch was already being used in a similar way in the eastern Greek world, though it had not perhaps achieved the same popularity.

By about 80 BC, as we shall see, the big monuments of Rome and Latium were making use of the arch, and of the concrete vault, in conjunction with the Greek orders of architecture, in a way which leads on directly to the great achievements of Roman Imperial building. Although we cannot attribute the invention of the arch and vault to Etruria, we can claim that it found popularity in the Etruscan area, because of the deficiencies of the local supplies of fine building stone, and because one of the main characteristics of Etruscan art in general was its enthusiastic acceptance of new ideas from Greece.

ROME AND ETRURIA AGAIN

At the beginning of this chapter, we stressed that our main interest in the art of the Etruscans was as an essential element in the development of the Roman tradition. The danger is of underestimating, rather than overestimating, the Etruscan contribution. Everyone can recognise in the developed Roman temple elements which are certainly derived from Etruria, but it is perhaps not so readily understood that the Etruscan tradition of Hellenised art lies behind Rome's enthusiastic acceptance of Greek art in the 1st century BC, which we shall discuss in the last chapter. The Romans had already become acquainted with Greek themes and methods of representation, long before their foreign contacts brought them direct knowledge of the Greek world, and it was through Etruria that they made their acquaintance. It is clear, too, that much of the independent character of Roman art has its origins in the Etrusco-Italic tradition—the enthusiasm for realistic portraiture, especially for the portrait-bust, the love of rich decoration, the delight in the world of nature. Like the Etruscans, the Romans never understood the aims and ideals of Greek art, but they used its achievements to their own purposes in very much the same way.

I. Plan of an Etruscan temple.

The Roman Empire

This chapter is concerned with Rome and her empire, the last phase of the classical world. From a small city-state community, for long under the power of the Etruscans, Rome had, by the end of the 3rd century BC, achieved domination of the whole of Italy, and laid the foundations of an empire abroad. In the 2nd century, Rome's influence began to assert itself over the whole Hellenistic world, and by the end of the 1st century all the Hellenistic kingdoms had succumbed to her power. She had also acquired rich possessions in the west; Spain had fallen to her after the Second Punic War, Gaul had been conquered by Caesar, parts of North Africa were under her control, even Britain had seen Roman troops in Caesar's two invasions. Under her old city-state form of government, Rome's foreign possessions were amateurishly, and often inefficiently, organised. The need for stronger rule was expressed in the struggle between the leading statesmen during the last century of the Roman Republic, which continued until 31 BC when Caesar's heir, Octavian, defeated Mark Antony at the Battle of Actium, and established the Roman Empire.

THE ROMAN TASTE FOR GREEK ART

The Roman contribution to the history of art lies in the new stimulus given to the continuation of the Greek tradition, and the spread of a 'Greco-Roman' art over the whole area of the Roman Empire. To understand the art of the Roman age, we must first understand how the marriage of Roman imperialism and Greek artistic traditions came about. But it would be wrong to ignore the independent characteristics of Roman art, and the very great influence that those independent characteristics have had upon the subsequent development of art in Europe.

By the 3rd century BC, Rome had become the dominant power in central Italy, and was coming increasingly into contact with the Greek cities of southern Italy and of Greece itself. The triumphs of Roman generals in the 2nd century and later, were adorned with vast booty of works of art—sculpture, paintings, gold and silver—taken from conquered cities. The Etruscan background of Roman art, and the work of Greek artists from southern Italy, had created a sympathy and understanding for Greek art, which developed into a positive mania for collecting Greek art treasures. The acquisition of Pergamon in 133 BC, brought to Italy the hoarded wealth of the Attalid kings whose tastes in many ways coincided with those of the new world conquerors. The demand for Greek works of art among the Roman upper classes of the last century BC, was enormous; it was met by an influx of artists from all over the Hellenistic world, and also by the revival of artistic schools in many of the Greek cities. The bulk of their output was concerned with copying and adapting earlier work to decorate the interiors of houses with statuary, furniture and painting. The versatile school of Pasiteles in southern Italy, and that of the neo-Attics in Athens, which satisfied this aspect of Roman taste, have already been mentioned. But towards the end of the Republic, Greek artists were also commissioned to produce work for their Roman patrons, which was inspired by Roman traditions, and it is this work which is of far greater significance for the future history of art. Roman patricians wanted portraits of themselves and their ancestors, buildings and sculpture to commemorate historical events, and paintings to adorn their temples, and it was natural that they should turn to the superior skill of Greek artists and craftsmen to satisfy these demands.

THE TRADITIONS OF THE ROMAN REPUBLIC

The complex character of the art of the Roman Republic is best illustrated in the study of its portraiture. Rome had her own traditions of portraiture, among them that of preserving the likenesses of ancestors in the form of wax and clay masks, which were kept in the *atria* of their houses, and used on the occasion of family funerals. In some way connected with this custom was the practice of taking death-masks, and this practice must explain the presence of death-features in some of the funerary portraits of the last century BC. Rome had also inherited the Etruscan tradition of commemorative portraiture—a tradition of strongly individualised likenesses, based on careful study of the features of the model, and not lacking the ability to express character. In the last century BC the final element in the creation of the Roman tradition of portraiture, the technical skill of Greek sculptors, was added; the portraits of the last great men of the Republic, of Caesar, Pompey, and the rest, show us this blend of Roman taste and Greek ability. Hellenistic influence gave more than refinement and the ability to give the features the stamp of fine portraiture. The Roman patricians also inherited some of the ideals of Hellenistic court-portraiture. Throughout the Empire the ideal of physical beauty expressed in the nude portrait figure, and the ideal of military prowess in the cuirassed warrior, run side by side with the traditional representation of the Roman citizen in the toga of domestic life.

THE ROMAN COMMEMORATIVE RELIEF

The origins of the Roman tradition of commemorative relief sculpture also go back to the last centuries of the Republic. Here again, the tradition is compounded of Roman, Italic and Greek elements. There seems to have been a fairly old tradition in Rome of commemorating historical events in painting, and we get some evidence for it in late Etruscan tomb-paintings, engravings and funerary reliefs. There is also one surviving fragment of a tomb-painting, showing scenes from a military campaign, which perhaps belongs to the tradition of commemorative paintings exhibited on the occasion of military triumphs; it was found in a tomb on the Esquiline Hill, in Rome, and probably dates from the 1st century BC. On the coinage of the last century BC, the reverse types show an interest in the direct commemoration of historical and political events. The earliest example of historical relief-sculpture inspired by an event of Roman history, is the frieze from the monument

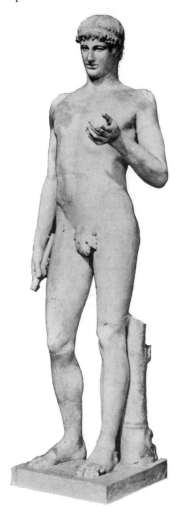

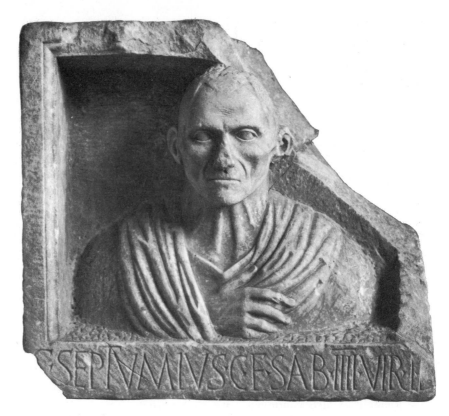

60. **Stephanos. An Athlete**. 1st century BC. Marble. h. 4 ft. 7 in. (1.40 m.). Villa Albani, Rome. This statue is signed by Stephanos, who belonged to the school of Pasiteles. The style is eclectic, combining elements of a number of different periods in the history of Greek art.

61. **Tombstone of Gaius Septumius**. 1st century BC. h. 20½ in. (57 cm.). Ny Carlsberg Glyptotek, Copenhagen. The portrait of the dead man is one of a number of Roman portraits of the period which seem to show the influence of death masks.

62 put up by the general, Aemilius Paullus, in 168 BC, to commemorate his victory at the Battle of Pydna. The sculptor was certainly a Greek, and his work is in many ways a typical Hellenistic battle scene. It is interesting, however, that a specific moment of significance in the battle, the episode of the runaway horse, has been chosen as the subject of the scene. There is an inkling here of the Roman liking for direct, straightforward representation of historical events, which is a leading characteristic of the finest achievements of Roman historical relief. In the last century BC, particularly towards its end, we find events of Roman history represented in a direct factual style by highly skilled Greek sculptors brought to Rome to work on the monuments of the capital.

REPUBLICAN ARCHITECTURE

In architecture, as in relief-sculpture and portraiture, the late Republic was the formative period of the specifically Roman tradition. The erection of buildings, in the traditional central Italian materials, continued right down to the time of the Empire, but in the last century new methods of construction and the use of new materials, were rapidly developed. There are a number of buildings in Rome and Latium, put up in the first half of the last century BC, which seem to show all the developed characteristics of Roman architecture in embryo. The most impressive is the Sanctuary of Fortuna Primigenia, at Palestrina, a vast complex

of buildings built in the form of a series of terraces against the natural slope of a hill and supported by means of concrete vaults and arches (figure K). Combined with the use of concrete construction is a decorative, and partly structural, use of classical columnar architecture. Pilasters and half-columns may serve to decorate the spaces between arches; columns give support to one side of a concrete vaulted passage. By the middle of the 1st century BC, Roman architects were using the same methods to build the permanent theatres that were to become so characteristic a part of Roman architecture. The combination of concrete vault construction, and the decorative use of the Greek orders, gave rise to an entirely new kind of building. Whereas the Greek theatre had made use of a natural slope to create the auditorium, and conceived the stage-building as a separate structure, the Romans were able to raise the auditorium from level ground on radial vaulting, and to integrate its design with that of the stage. The Greek inspiration for the general form of the Roman theatre is clear enough, but the differences are great.

Differences are no less apparent in other kinds of building. In Rome during the last century BC, there were a few temples built in pure Greek form and style, generally by Greek architects, but the typical late Republican temple is a mixture of Etruscan, Italic, and Greek elements. One of the best examples is the little 'Temple of Fortuna Virilis', by the Tiber in Rome, put up in the last years of the Re-

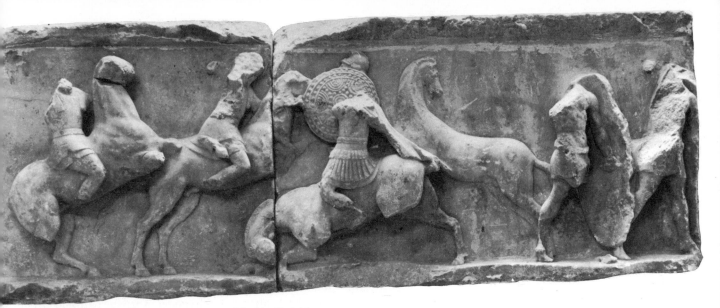

62. **The Battle of Pydna**. 2nd century BC. Marble. Delphi Museum. Part of the sculptured frieze from a pillar erected at Delphi to commemorate the battle of Pydna (168 BC), at which L. Aemilius Paullus defeated Perseus, king of Macedon.

J. Reconstruction of the central part of the Sanctuary of Fortuna Primigenia at Praeneste (Palestrina).

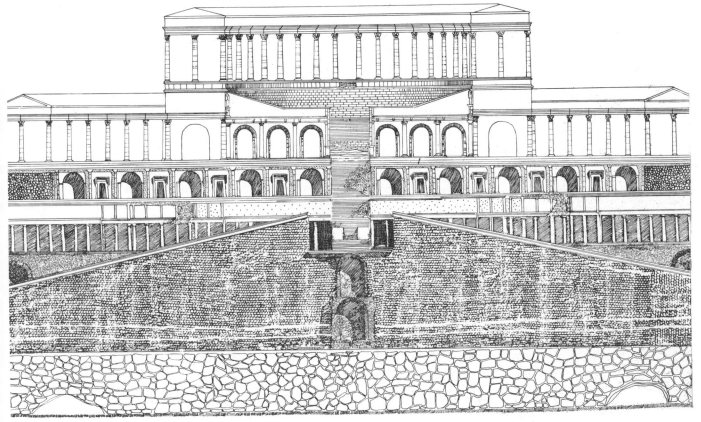

public. Like the traditional Etruscan temple it stands on a high base or podium which is approached only by steps at the front. The architectural detail is a fairly pure version of Greek Ionic, but unlike a Greek temple the columns do not run all round the main chamber of the temple, but continue in the form of half-columns against the sides and back of the chamber. Here again we see a reflection of the typically Etruscan plan, with columns only at the front, and the whole design illustrates that mixture of conservatism and new ideas which characterises the art of the period. These essential forms were to survive right through the period of the Empire.

The purity of the classical tradition in ornament is completely alien to the taste of Roman architects. At Palestrina,

the forms of the Ionic and Corinthian capitals are not those of the eastern Hellenistic world where, to some extent, the purity of the Greek orders was still admired, especially by the more academic architects; the Romans used instead local versions inspired by southern Italian models. In the course of the 1st century BC, new and direct influence from the Hellenistic world led to the general adoption of more orthodox forms of the orders, but the essentially non-Greek background of Roman architecture was always likely to inspire a frivolous disregard for purity, and a liking for over-elaboration of ornamental detail. The Corinthian order was adopted as the Roman order par excellence because of its richer decorative possibilities, and combinations of the orders, which seem to have appealed especially to the

K. The Roman Corinthian Order.

L. Roman composite capital.

M. Reconstruction of the *Ara Pacis*, Rome.

Roman taste, led to the creation of the composite capital, a mixture of Ionic and Corinthian. The severe Doric order was almost completely rejected for large scale building. As in constructional method and design, so in ornament, the Roman taste differs very greatly from the Greek.

THE FOUNDATION OF THE EMPIRE

The foundation of the Roman Empire by Augustus did not fundamentally change the character of Roman art, but it completely altered the character of artistic patronage. The Roman State now became the chief patron of the arts, and the best talents were organised to work on an inspired propaganda programme, devised by Augustus and his circle of advisers. The building of new towns throughout Italy, and the provinces, gave a new stimulus to architecture and the arts. The Roman government continued to employ Greek artists and craftsmen to achieve their purposes, but their work was given a specifically Roman character by Roman aims and ideals. It is an age of anonymity in the arts; the artist declined to the level of the craftsman, whose work was admired for its skill. We know the names of very few painters and sculptors, and almost all of them are Greeks; their work satisfied every aspect of Roman taste—for grand buildings and commemorative monuments, for portraiture, for copies of Greek masterpieces, for decorative sculpture and painting, and it kept the classical tradition alive throughout the Empire. Only towards the end of the Empire, from the early 3rd century AD onwards, do we see evidence of tendencies in art which are opposed to classical ideals. They are the product of many different conditions of the time—the general decline of the Empire, the changes in religious beliefs, and many others—and, in many ways, they lead us on to a fundamentally different conception of the purpose and character of art in Byzantine and medieval times.

THE ARA PACIS IN ROME

The first great sculptured monument of the Imperial Age, is the *Ara Pacis*, in Rome, a monumental altar contained in a richly decorated rectangular enclosure, put up between 13 and 9 BC to commemorate the establishment of peace in the Roman world. The best available craftsmanship worked on its sculpture; there are exquisite arabesques of floral ornament in low relief carved in fine Hellenistic style, figured panels with allegorical compositions and scenes from Roman mythology, garlands of fruit and flowers, and a processional frieze commemorating the act of dedication of the altar in 13 BC. The whole decoration is a superb illustration of the way in which Greek talent was put to the service of imperial ideas; the processional frieze deserves our closest attention, for in it we see Greek and Roman ideas in the most harmonious combination. There is something of the Athenian ideal in the severe, noble conception of Roman citizenship contained in the figures, and the clarity of the 'Neo-Attic' style reminds us of the Parthenon frieze, but here the principal figures are not the ideal citi-

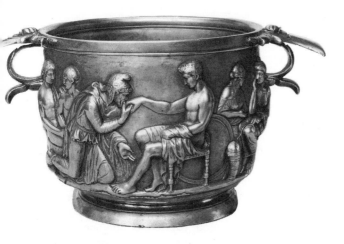

63. **Cup from Hoby**. Augustan period. Silver. h. 4¼ in. (10.9 cm.). Danish National Museum, Copenhagen. This scene on one of a pair of silver cups found in a rich man's grave at Hoby on the island of Laaland shows Priam appealing to Achilles for the return of Hector's body.

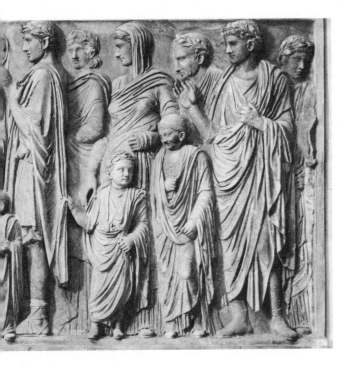

64. **A Roman procession**. *c.* 9 BC. Marble. h. 5 ft. 2 in. (1.57 m.). Part of the frieze from the *Ara Pacis* (Altar of Peace) in Rome, showing members of the Imperial family and officials in procession. The altar was built between 13 and 9 BC to commemorate Augustus' return from the western provinces of the Empire.

zens of 5th-century Greece, but portraits of distinguished Romans of the day. Their presence gives to the frieze the sense of a real event, of a moment of history.

THE DEVELOPMENT OF HISTORICAL RELIEF

The *Ara Pacis* laid the foundations of Imperial commemorative and decorative relief-sculpture, and the commemoration of historical events gives us some of the finest, and most typically Roman, achievements in sculpture. The two sculptured panels from the passage-way of the Arch of Titus are among the most famous; one of these shows us part of the triumphal procession of Vespasian and Titus, with the loot from the Temple of Jerusalem, brought to Rome after the Jewish War; in the other we see Titus, drawn in his chariot, and crowned by Victory. The processional panel makes a most subtle use of the different planes of relief 65 to give an effective rendering of mass and movement, a development which takes us beyond the later achievements of Greek relief-sculpture into something which we may think of as specifically Roman. The strength of the Greek tradition is nowhere better seen than in the companion panel, where the allegorical figures, symbolising the various elements of the Roman people, are conceived in the tradition of Greek art. Indeed, throughout the early Empire we can see the Roman desire for factual, straightforward representation of events competing with an allegorical manner largely inspired by Greek models. In the magnificent spiral frieze on Trajan's column, which depicts 66 the Dacian campaigns of the Emperor, the factual style, with a wealth of accurate detail, prevails; in the time of Hadrian and the early Antonines the grand allegorical manner tends to assert itself in a rather pompous and overconfident expression of imperial ideas, which does much to inspire the strong reaction to classicism that we shall discuss in a later part of this chapter.

PORTRAITURE AND PROPAGANDA

The portraiture of the Emperor was one of the most important vehicles of imperial propaganda. The generals of the late Republic had already followed Hellenistic practice, and put their portraits on their coins, and they had gone to Greek artists to have busts and statues made of themselves. The creation of a satisfactory public image for the Emperor was a complex and subtle problem. Augustus' artistic advisers provided him with brilliant solutions. They preserved for us the features of the Emperor, but they treated them with an almost classical purity of style, that could give his lean ascetic countenance an almost divine majesty. 102 He could be all things to all men; now the devout, dedicated toga-clad Roman citizen, a great man among his fellows, now the forbidding symbol of imperial power that he presents in the famous statue from Prima Porta, in the Vatican where he stands clad in military costume, 67 and in classical pose, making a simple but immensely expressive gesture of authority. Not all Emperors submit to these ideals in their portraits. Vespasian, proud of the

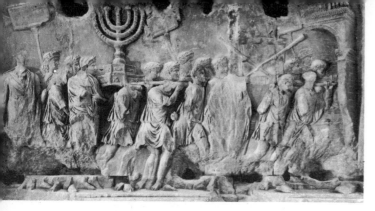

65. The Spoils of Jerusalem. *c.* AD 80.
Marble. The Arch of Titus, Rome. The
relief from the passage of the arch shows
part of the triumphal procession of Titus
in AD 71, after the conquest of Judea.
The booty from the Temple of Jerusalem
includes the table of shew-bread, trumpets
and seven-branched candle stick.

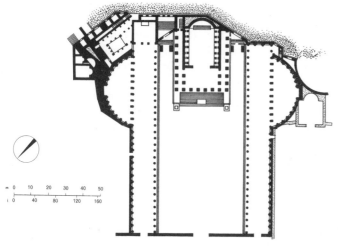

N. Plan of the Forum of Augustus, Rome.

66. Trajan's Column. Rome. *c.* AD 113.
Detail of the reliefs of the spiral frieze
on the marble column set up in Trajan's
Forum to commemorate the Emperor's
victories over the Dacians. The column
is 38 metres high, including its base and
column, and the frieze is over 50 metres
long.

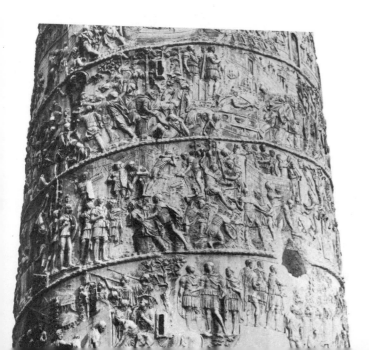

simple Italic stock from which he had sprung, favours a
down-to-earth likeness, that reminds one of the portraiture
of Romans of the time of the Republic, and in the hands
of the best artists conveys a power of personality and a
strength of purpose. One cannot imagine Vespasian sub-
mitting to so comic a piece of portraiture as the statue
of Claudius as the god Jupiter, or anyone wishing to
portray him so. Trajan, 'best of Emperors', projects, in
the portraits that have come down to us, a wonderful image
of benevolent rule, and the bearded Hadrian, lover of
things Greek, emerges almost as a Greek hero. The por-
traits of his favourite, Antinous, combine the classical
purity of his features and the ideals of Greek sculpture in
his body, making him a divinity almost on the level of
the great creations of the past. The Antonine emperors
suffer from the technical preoccupations of the sculptors of
the time, who love the striking effects of contrast between
the high finish on the features and the deeply drilled unruly
mass of hair, but some of the portraits of private individuals
of this time are among the finest studies of character that are
preserved from the Roman period.

THE ACHIEVEMENTS OF ROMAN ARCHITECTURE

Architecture takes its full place in the propaganda pro-
gramme of the Roman Empire. The rebuilding of Rome as
a worthy capital of a world Empire had been begun by
Julius Caesar, and his policy was extended by his successor,
Augustus, who boasted that he had found the city of Rome
built of brick and left it of marble. Buildings on the Roman
pattern were erected everywhere in the Empire—*fora* and
basilicas, triumphal arches, theatres and amphitheatres,
temples and sanctuaries. As we have seen, the basic forms
of most of these buildings had been created in the late Re-
public, but they now rose with a new magnificence, making
lavish use of plain and coloured marbles. Complexes of
buildings were planned on a grand scale, and the develop-
ment of brick-faced concrete as a building technique in the
early Empire gave Roman buildings a completely different
character. The Forum of Augustus, in Rome, was built
by the emperor to extend the administrative area
of the city, and to be a monument of imperial prestige.
The Forum consists of an open area flanked on two sides by
colonnades and semicircular exedras, and dominated by the
massive temple of Mars Ultor at one end. The design of the
temple and the whole forum area are characteristically
Roman, but the architectural detail is very largely Greek in
spirit. The influence of 5th-century Athens is particularly
strong, and may be seen in the copies of the Caryatids from
the porch of the Erechtheum, at Athens, which served to
decorate the upper order of the flanking colonnades, and in
the carved ornament on the decorated mouldings. The
classical simplicity and restraint of the Forum of Augustus
later gave way to a much more elaborate style of decoration,

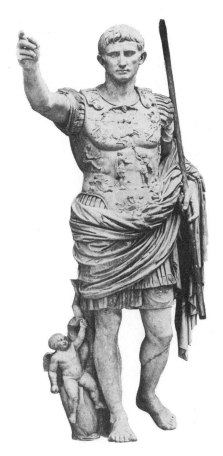

which we think of as typically Roman, and which is exemplified by the Temple of the deified Vespasian, in the Forum.

The period of the Flavian Emperors saw a further ambitious programme of building in Rome; the erection of the Imperial Palace on the Palatine Hill, the construction of new baths, imperial fora, temples and other public buildings. The most famous monument of Flavian architecture is the Colosseum in Rome, the most massive of Roman amphitheatres, and one of the finest examples of Roman constructional technique. Here is the characteristic Roman blend of Greek detail and Roman construction. The external walls of this immense building rise in four storeys of arches, decorated with engaged architecture of the Greek orders; on plan the oval of the auditorium, which is supported on massive concrete vaults, measures about 617 × 512 feet, and it is estimated that it would hold about 45,000 people. Theatres and amphitheatres constructed on these principles were put up everywhere during the first two centuries of the Empire; one of the finest and best preserved of the theatres is at Orange, in Provence, an area where the surviving Roman buildings are a striking memorial of the grandeur of the Roman Empire.

The Pantheon, built in the time of Hadrian, has long been one of the most admired of all Roman buildings; it has had a continuous history since classical antiquity, and is still in use as a Christian church. The great, circular, domed hall of the temple, lit by a circular opening at the top, encloses a space 142 feet in diameter and height; the walls were elaborately decorated with niches and coloured marble facings. In front of the rotunda is a colonnaded porch of six Corinthian columns supporting a pediment. By this time, the Romans had so perfected the techniques of building in concrete, that they were able to enclose enormous spaces with concrete vaults and domes, and they used the same methods in the construction of those vast complexes of buildings, which served the various purposes of the public bathing establishments. Throughout the Empire, they continued to give to their architecture the veneer of traditional Greek detail. The combination has given us the Roman triumphal arches, which were usually erected to commemorate military triumphs. They consist of an arched opening, or openings, flanked by engaged or detached columns, and surmounted by an entablature, above which is an attic usually serving as a base for a chariot group. Triumphal arches were erected from the late Republic to the late Empire.

ROMAN PRIVATE TASTE UNDER THE EMPIRE

We have dwelt on the public monuments of the early Empire, because so much of what is characteristically Roman is to be found on them. But, in the long run, it was the private taste of the Romans that did most to keep alive the Greek tradition throughout the Empire. It was the whole-

67. **The Emperor Augustus**. 27 BC–AD 14. Marble. h. 6 ft. 7 in. (2.01 m.). Vatican Museums. This statue was found in the Villa of Livia at Prima Porta near Rome. The reliefs on the breastplate represent the return, in 20 BC, of the Roman standards captured from Crassus at the Battle of Carrhae.

68. **Head of Vespasian**. AD 69–79. Marble. h. 1 ft. 4 in. (41 cm.). British Museum, London. This portrait head of the Emperor Vespasian was found during excavations at Carthage in 1835–36.

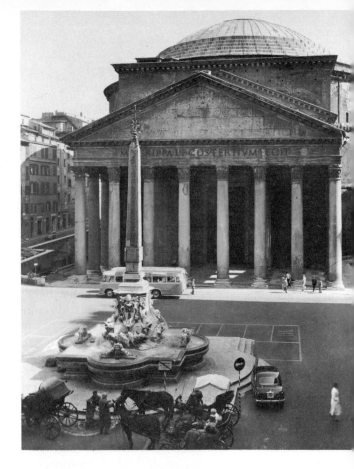

69. **Claudius as Jupiter**. AD 41–54.
Marble. h. 8 ft. 4 in. (2.54 m.). Vatican
Museums. This statue of the Emperor
Claudius as Jupiter, with eagle and oak-
wreath, was found at Città Lavinia
in 1865.

70. **Head of Trajan**. AD 98–117. Marble.
h. 2 ft. 5¼ in. (74.5 cm.). British Museum,
London. This portrait bust of the Emperor
Trajan was found in the Roman Cam-
pagna in 1776.

71. **The Pantheon**. *c.* AD 126. Exterior
view of the Pantheon in Rome, built early
in the reign of Hadrian. A classical portico
fronts the brick rotunda which was once
faced with marble and stucco.

72. **The Pantheon. Interior view**.
The decoration of the building, which
has remained in continuous use since
Roman times, has been much altered.
A reconstructed section of the original
marble facing may be seen in this view.

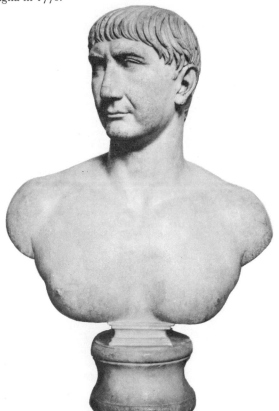

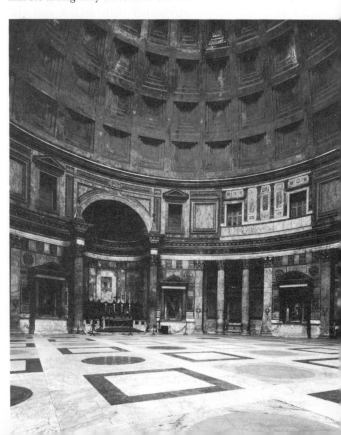

73. **Figure of Egypt**. *c.* AD 145. Marble. h. (of figure) 5 ft. (1.51 m.). Palazzo dei Conservatori, Rome. A personification of the province of Egypt, one of a series of province-figures from the Temple of the deified Hadrian, dedicated in AD 145.

hearted adoption of Greek art by the wealthy patricians of the late Republic that did most to Hellenise the Roman tradition, and, in the early Empire, there was no falling off in the taste for things Greek. The Romans continued to give employment to the copyists of Greek sculpture and painting. In sculpture the Roman period involved scarcely a single new figure-type, if we except new divinities in Greek guise, and personifications of imperial ideas. Only very rarely do we see aspects of a different taste, such as the increasing popularity of coloured marbles for statuary. The private taste of the Romans of the Empire comes out best in the interiors of their private houses, which we know from Pompeii and Herculaneum. Copies of Greek sculpture and furniture in Greek style were used in gardens and rooms; Greek painting was the main inspiration of the interior decorators, who painted the frescoes on the walls. The epitome of philhellenic taste was to be found in the 'Villa', built by the Emperor Hadrian at Tivoli, near Rome. Here Hadrian laid out a great complex of buildings, many of them copied from, or inspired by, what he had seen during his travels in the provinces; he filled them with copies of Greek sculpture, paintings and mosaics. Though certainly the most philhellene of Emperors, he was no exception among Romans in his tastes.

ROMAN DECORATIVE PAINTING

We may consider here two aspects of Roman private taste: the painted interiors of their houses and the stone sarcophagi in which they were buried. Roman fresco-painting has already been mentioned for the light it throws upon the later history of Greek painting. We are not concerned here with the later schemes of Roman wall-decoration, except in so far as they illustrate the general lines of development of ancient painting, but something must be said about them in general terms. The earlier Second Style aimed at creating the illusion of space, whether with architectural vistas, landscape, or figure compositions, within the limits of a unified architectural scheme. In the later Second Style, which prevailed in the time of Augustus, the unity of the architecture was broken up by the introduction of large panel compositions, and, later on, the attempt at illusion was abandoned by many painters in favour of flat surfaces, with ornament based on architectural forms, but treated as arabesques, purely decorative in intention. Delicate columns and candelabra served to frame panel-compositions, which stood out against the brightly coloured flat background. Later still, in the so-called Fourth Style of Pompeii, there is compromise between flat decoration and architectural vista, and throughout its later history, which, after AD 79, is poorly documented, Roman wall-decoration continued to make use of architectural elements or architectural divisions as the basis of its schemes. The pictures incorporated in the various Roman schemes of decoration continue to be closely inspired by the repertoire of Greek painting; the painters continued to paint epic scenes, land-

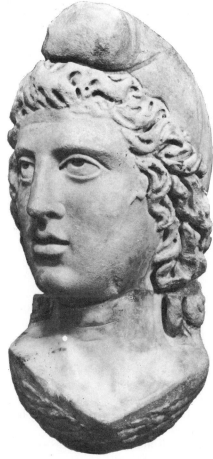

74. **Head of Mithras**. *c.*. AD 200. Marble. h. 14½ in. (37 cm.). Guildhall Museum, London. Head of the god Mithras found in the excavation of the Walbrook Mithraeum, London, in 1954. It was made in Italy and imported into Britain.

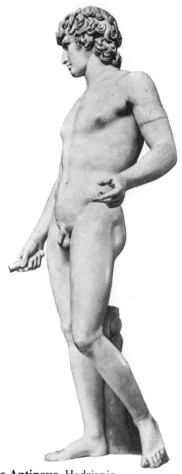

75. **The Farnese Antinous**. Hadrianic period. Marble. h. 6 ft. 6 in. (2 m.). National Museum, Naples. Statue of Antinous, the young Bithynian favourite of the Emperor Hadrian. Antinous, who was drowned in AD 130, is here represented as Hermes.

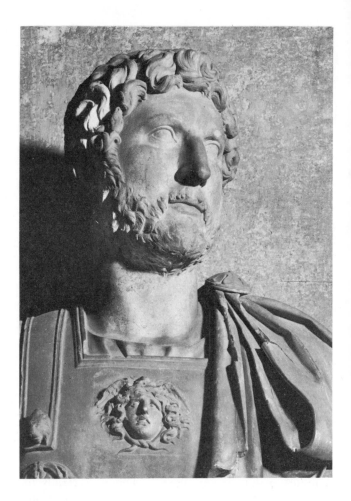

76. **Head of Hadrian**. AD 117–138. Marble. h. 2 ft. 11½ in. (90 cm.). Palazzo dei Conservatori, Rome. Hadrian was the first Roman Emperor to wear a beard, a feature which enhances the Greek idealism of his portraits.

scapes, still life, scenes from everyday life, in the techniques and styles invented by later Greek artists. It is very difficult to say how much the Romans added to the repertoire. In the time of Augustus there was a fashion for garden painting which gave the illusion of opening up the wall with a view into a garden; a room in the Villa of Livia at Prima Porta was completely decorated in this manner, and in a style which contrives to give convincing effects of light and atmosphere and vivid naturalistic detail. The big panel pictures are generally inspired by Greek models of different periods with scenes from Greek mythology and epic being especially popular. Pictures, such as the scene which shows the rescue of Andromeda by Perseus, are probably adaptations of later Greek masterpieces, and they show how the techniques of modelling in colour and of rendering light effects could now be skilfully handled even by painters of moderate talent.

The Roman age had little to add to the development of technique, but the appearance, in later Second-Style pictures, of what may be called an 'impressionistic' technique, is something which has been claimed for the Romans. The technique is used especially, and with especial success, in the fantasy landscapes—views of imaginary countryside with buildings, houses, harbour scenes. It abandons the precise modelling of the Greek tradition in favour of colour

impressions, obtained with rapid strokes of the brush, by which the painter can achieve powerful effects of light and shade. One of the most striking examples of the use of this technique is the picture which shows the introduction, by night, of the Wooden Horse into the city of Troy; a ghostly light pervades the whole picture, and the slashing highlights on the foreground figures give the scene a fine sense of drama. It is one of the most vivid pieces of narration that has come down to us from the ancient world. The impressionistic technique appears first as an experiment in the treatment of light and colour, not as a deliberate reaction to 'classicism'. In the later Roman Empire, however, when a more positive and widespread reaction to the principles of pagan painting did exist, it found a ready acceptance among artists, and became a powerful influence in the development of painting.

ROMAN SARCOPHAGI

The early Roman sarcophagi illustrate, perhaps best of all, the thoroughly Greek inspiration of the Roman decorative arts. In the time of Hadrian the use of stone coffins for burial became widespread among the wealthier classes in Rome, and largely superseded the earlier practice of cremation, where the ashes were placed in stone urns and funeral altars. These sarcophagi were richly decorated with relief

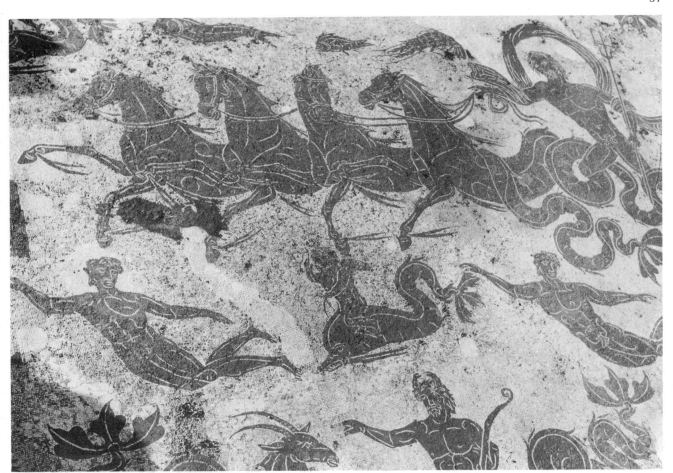

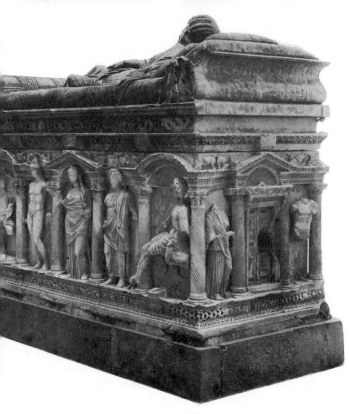

77. **Neptune in his Chariot**. Late 2nd century AD. Mosaic. Baths of Neptune, Ostia. The mosaic, composed of black and white stones, shows Neptune being carried across the sea in a chariot drawn by sea-horses.

78. **The Melfi Sarcophagus**. Late 2nd century AD. Marble. h. 5 ft. 5 in. (1.65 m.). Melfi. Richly decorated column-sarcophagus made in Asia Minor and found at Melfi, in Italy. Figures of gods and heroes stand in the intercolumniations.

ornament, sometimes with purely decorative motifs, but most commonly with scenes taken from Greek mythology. The subjects are clearly based upon originals of Greek sculpture and painting, and the sarcophagi provide us with some of the liveliest and technically skilful sculpture that has come down to us from Roman times. The compositions, like those of the *Gigantomachy Sarcophagus*, in the Vatican, and the *Orestes Sarcophagus*, in the Lateran Museum, make up tapestries of figures in violent poses and movement that remind one of scenes on the Pergamene Altar. As the sarcophagi became taller, the complication of the groupings is increased, and the sculptors achieve remarkable feats in the massing of figures. The importance of the sarcophagi in the history of Roman art cannot be over-emphasised; not only did the production of them give permanent employment to sculptors in Italy, but the demand was so great and so widespread that workshops were soon set up in the eastern provinces of the Empire to satisfy it. Sarcophagi made in Asia Minor, and Athens, show the techniques and style of those centres, and in the 3rd century the sarcophagi became a principal source of knowledge for the history of Roman sculpture in general.

78, 79

ROMAN ART IN THE PROVINCES AND BEYOND

In the first two centuries of the Empire, the Roman styles

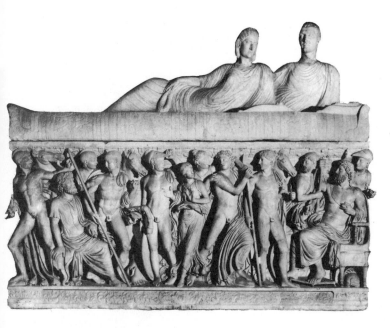

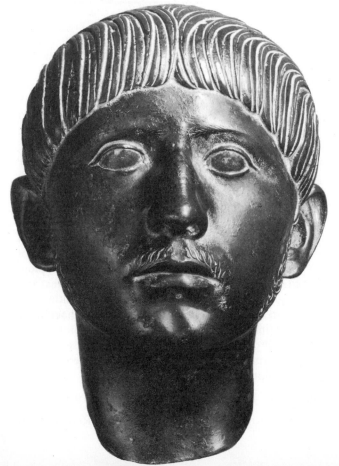

79. **The Achilles Sarcophagus**. 3rd
century AD. Marble. h. 4 ft 3½ in.
(1.31 m.). Capitoline Museum, Rome.
The reliefs depict the discovery of Achilles
among the daughters of Lycomedes.
Figures of the dead man and his wife
recline on the lid. The sarcophagus was
made in Greece.

80. **Head of a Helvetian chief**. 1st cen-
tury AD. Bronze. h. 10¼ in. (26 cm.).
Historical Museum, Berne. A portrait
probably of a young prince of the Helvetii,
modelled in a fine Roman style. The head
comes from Prilly (Vaud).

of art and architecture spread to all the provinces, and their
influence was felt beyond the frontiers. It is interesting to
contrast the character of art in the Greek and eastern prov-
inces, with that of the western provinces, which lacked the
background of Hellenistic art. The Greek provinces, by
providing artists trained in the techniques of Greek art, did
most to keep alive the Greek tradition. In the west, the
mixing of Greco-Roman with native traditions may pro-
duce a debased 'classicism', uncertain in proportion and
ugly in detail or, where the local elements have a positive
role to play, a genuinely fruitful union, as in the vigorous
portrait of a Helvetian prince, or in the well-known sculp-
tured pediment from the Temple of Sulis-Minerva, at Bath.

Beyond the eastern frontiers of the Empire, was the
meeting place of classical and oriental art. The caravan ci-
ties of Dura Europos and Palmyra have provided us with
sculptures and painting which, although they show strong
Roman influence, are predominantly oriental in feeling.
Imported Roman works of art show their influence in
Indian sculpture during the first centuries of the Empire.
The problem of provincial and foreign influences on the
development of Roman art in general is an extremely
complex one. The role of the eastern provinces, as creator
of new techniques and transmitter of oriental ideas, is clear
enough, but who can say to what extent the western
provinces influence the progressive debasement of the
classical tradition in the late Empire. But leaving aside these
problems, the dominating impression of the art of the Roman
Empire, as a whole, is of its uniformity. Everywhere in the
days of its prosperity the Romanised provincials aspired to
live like Romans, to adorn their houses with Roman
sculpture, paintings and mosaics. The public monuments
were built to standard patterns in all the principal towns.
Even if, with the collapse of the Roman world, native
traditions began to reassert themselves against classical
representational art, the Roman influences went deep
enough to have a place of importance in the future develop-
ment of art in all the countries they touched.

THE DECLINE OF THE CLASSICAL TRADITION

The last part of this chapter deals with the decline of
the Roman Empire, and of the classical tradition in art.
There is, however, a danger of overstressing the aspect of
decline, and failing to see the beginnings of a powerful new
tradition inspired by new ideals which rejected the old. If
we look at the art of Rome in the 3rd and 4th centuries AD
solely in terms of the classical tradition, then we may see
nothing but decline. We shall find painting and sculpture
falling away from the standards set in the early Empire, we
shall see the technical ability of the sculptors clearly infe-
rior, we shall see painters losing the ability to handle line
and colour in the old way. We may explain these in terms
of the economic and political decline of the Roman Empire.
We may even think that we have solved the problems of the
decline of the classical tradition in art. But we shall be far

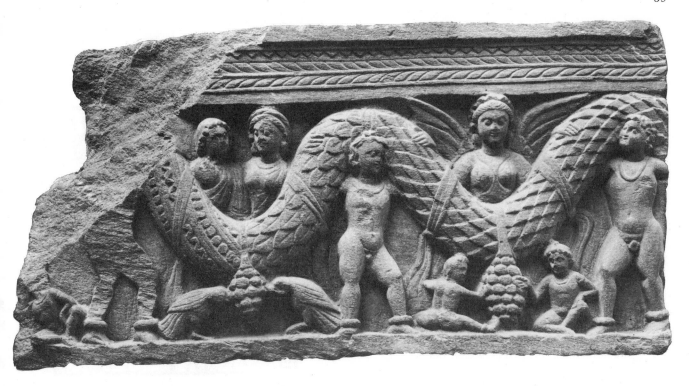

81. **Relief from Taxila, Punjab**. 2nd century AD. (?). Stone. l. 15 in. (38 cm.). The design of the frieze, showing garlands of leaves supported by *putti* and with busts in the loops, is basically classical but the carving is the work of an Indian sculptor.

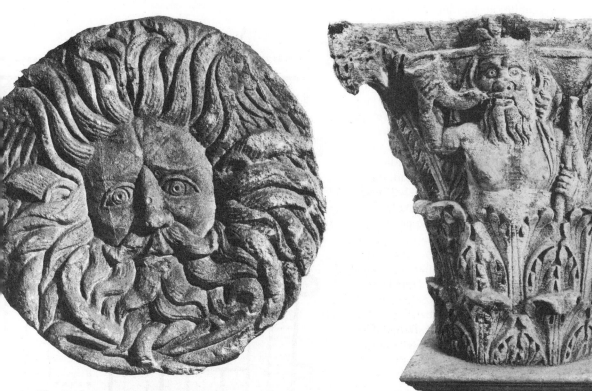

82. **The Bath Gorgon**. 2nd century AD. Bath Stone. h. 8 ft. 2½ in. (2.50 m.). Bath Museum, England. Central part of the pedimental relief from the temple of Sulis-Minerva at Bath. The central feature is a carved shield decorated with a head of a Gorgon and supported by winged victories.

83. **Corinthian capital**. 1st century AD. Stone. h. 3 ft. 3 in. (1.00 m.). Cirencester Museum, England. Corinthian capital decorated with busts on four sides found at Cirencester. The wild Silenus-like figure shown here probably represents a Celtic fertility god.

from the truth if we fail to see that the rejection of much of what is essential in the classical tradition springs from a deliberate reaction to the ideals and aims of pagan culture. In fact, the causes of the breakdown of the classical tradition is one of the most complex problems in the whole history of ancient art. Our evidence comes mainly from an imperial tradition which tries hard to preserve the old values, and the elements of significant change are often hard to recognise. They manifest themselves in so many different ways; they may be differences of technique or they may be totally different methods of expression. We may find the picture confused from time to time by deliberate revivals of older styles, by seeing new ideas expressed in a symbolic language derived from pagan art. But one thing is certain, that from the time of the Antonines onwards, the old ideals of classical art failed to satisfy the aspirations of men, and this is the fundamental lesson of late Roman art.

LATE ROMAN ARCHITECTURE

Let us look first at the most obvious evidence of change in architecture, since here there is less obvious evidence of decline. It is true that the economic conditions of the late Empire produced periods when little public building was carried out, and the prosperity of the provincial cities was running down; but until the time of Constantine, when our survey ends, many very ambitious building projects were undertaken throughout the Roman world, especially under the Tetrarchy, and in the reign of Constantine himself.

Roman architecture had always been what has been called, 'a compromise between actual and apparent structure', that is, between Roman methods of buidling in concrete, and a decorative use of the classical orders. In the late Empire the Roman methods of building assert themselves even more strongly, and the use of the classical orders becomes more and more decorative and decadent; in some cases the latter are abandoned altogether. The buildings of the 3rd and 4th centuries AD, show increasingly ambitious planning of space and volume. The massive main hall of the Baths of Caracalla (figure P), measures 170 × 82 feet; its roof is carried on eight colossal piers, which supported the cross-vaulting. Arched openings between the piers gave access to side chambers, and other rooms of the Baths complex. The main hall of the Baths of Diocletian was even larger in scale. When, in AD 306, Maxentius designed a new administrative basilica near the Forum, he rejected the traditional columnar hall used in earlier basilicas, and adopted the design of the great halls of the Baths. The basilica had a nave built in three bays, each roofed with an intersecting barrel-vault, communicating side halls forming the aisles.

126

Most of these late Roman buildings make extremely elaborate use of interior architectural decoration, but the use is rarely structural, and the detail becomes more and more unorthodox by classical standards. Architectural forms and styles of ornament developed in the eastern Roman provinces became more widespread. The carved fa-

(Continued on page 177)

O. Plan of the baths of Caracalla, Rome.

P. Plan of Diocletian's Palace at Split.

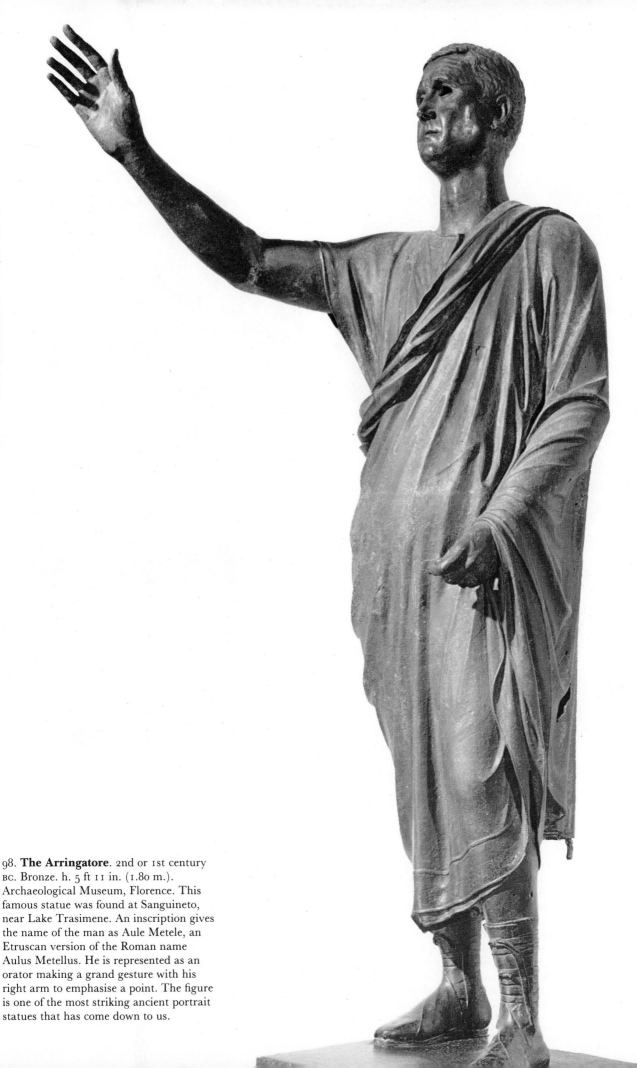

98. **The Arringatore**. 2nd or 1st century
BC. Bronze. h. 5 ft 11 in. (1.80 m.).
Archaeological Museum, Florence. This
famous statue was found at Sanguineto,
near Lake Trasimene. An inscription gives
the name of the man as Aule Metele, an
Etruscan version of the Roman name
Aulus Metellus. He is represented as an
orator making a grand gesture with his
right arm to emphasise a point. The figure
is one of the most striking ancient portrait
statues that has come down to us.

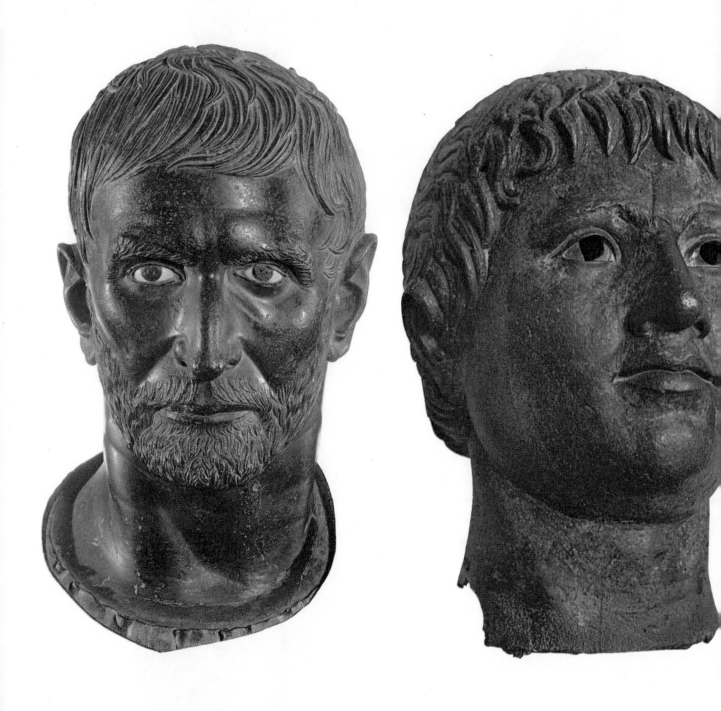

99. (above). **Portrait of a bearded man**.
c. 2nd century BC. Bronze h. 12⁵/₈ in.
(32 cm.). Conservatori Museum, Rome.
This head has been identified, but without
good reason, as L. Junius Brutus, the
founder of the Roman Republic. The
hard structure of the head and the flat
treatment of beard and hair suggest that
it belongs to the late Etruscan tradition
of portraiture. The eyes were inlaid with
enamel, brown for the iris and white
for the eyeballs.

100. (above). **Head of a young man
from Fiesole**. Bronze. h. 11⁵/₈ in.
(29.6 cm.). Louvre, Paris. Head of a
young man, found in the environs of
Fiesole, not far from Florence. This por-
trait of a fleshy-faced youth is a lively
piece in the late Etruscan tradition of
portrait sculpture, with a fine momentary
expression and a clear individual
characterisation.

101. (right). **Head of a Roman of the
early Empire**. Bronze. Palazzo Barberini,
Rome. The figure, from which this detail
is taken, holds in his hands two busts of
his ancestors, probably those of his father
and grandfather. Though carved in the
Augustan period, the portrait still shows
something of the hard, dry style of the
late Republic.

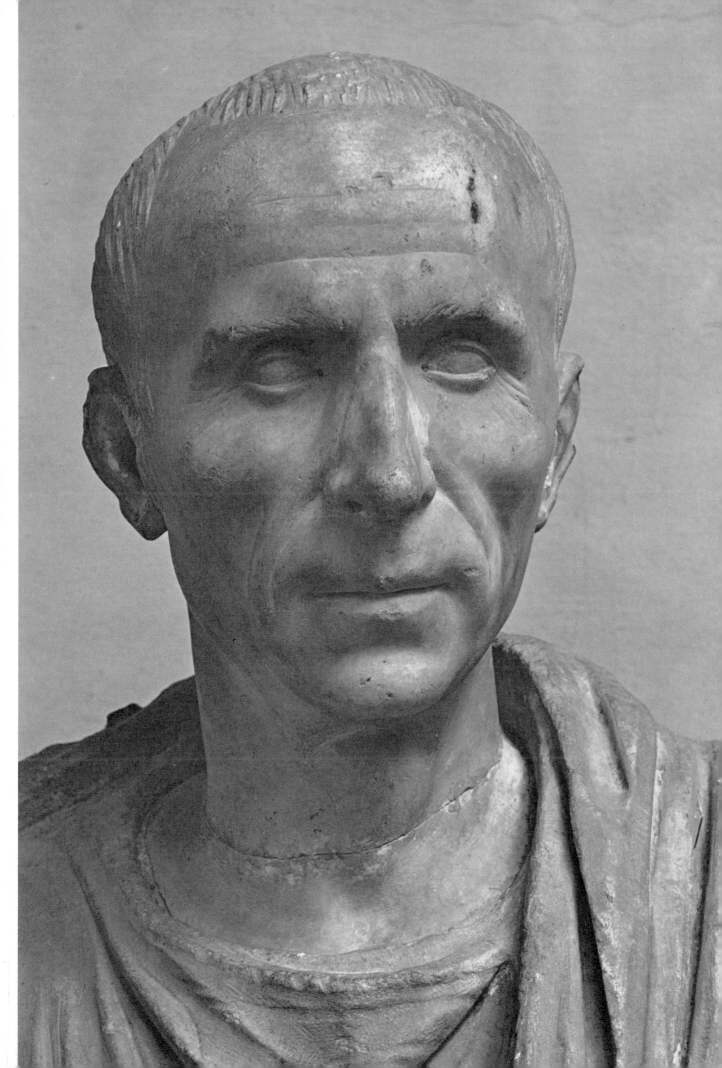

102. (right). **The Emperor Augustus**.
1st century AD. Sardonyx. h. 5 in.
(12.8 cm.). British Museum, London.
The Emperor wears an *aegis* and *gorgo-
neion*, symbols of his invincible power.
The diadem of gold and gems is a medi-
eval addition to the cameo. This is one of
a series of fine cameo portraits of members
of the Roman Imperial house and has been
attributed to Dioscorides, who was court
gem-engraver to the emperor.

103. (below). **The Maison Carrée at
Nîmes**. Early 1st century AD. The Maison
Carrée at Nîmes (Nemausus), in Provence,
is one of the most famous and best-
preserved temples of the Roman Empire.
Like most Roman temples it stands on a
high base (*podium*), with access to the
temple chamber by means of steps at the
front. The columns do not form a peristyle
all round the chamber, but are continued
as half-columns engaged against the
chamber wall, a scheme which is known
as 'pseudo-peripteral'. The temple was
built during the reign of the Emperor
Augustus.

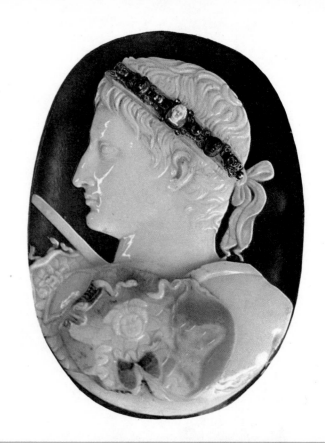

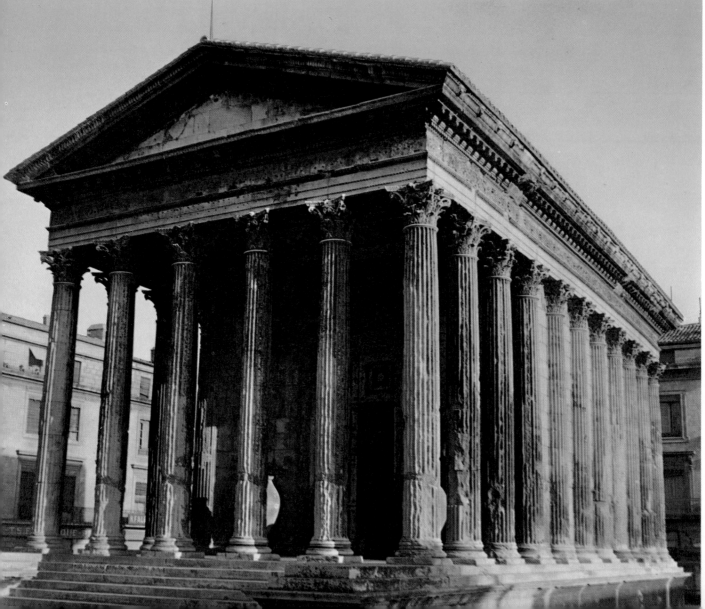

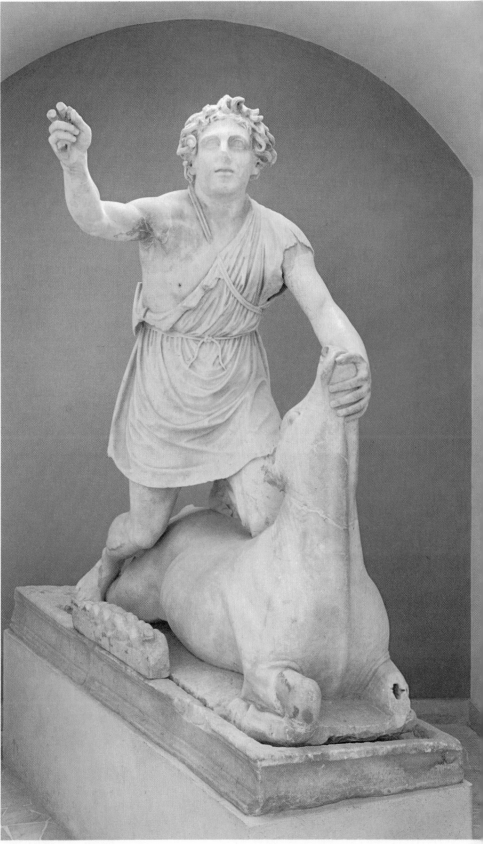

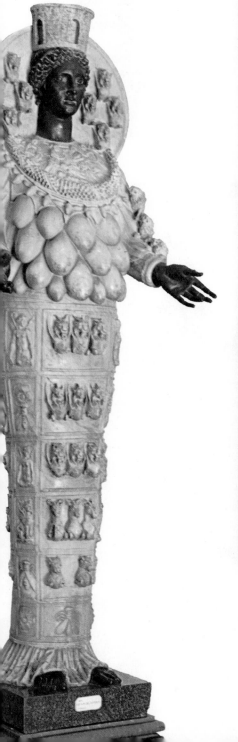

104. (below). **The Ephesian Artemis**.
1st century AD. Alabaster and bronze.
h. 6 ft. 8 in. (2.03 m.). National Museum,
Naples. The cult statue of the goddess
Artemis, 'Diana of the Ephesians', multi-
breasted, wearing a turretted crown, and
with the lower part of her body richly
decorated with symbolic reliefs, is one of
the strangest figures that has come down
to us from classical antiquity. This Roman
copy illustrates the Roman taste for poly-
chromy in statuary and architecture.

105. (above). **Kritios of Athens.
Mithras slaying the bull**. *c.* 2nd century
AD. Marble. h. 5 ft. 7 in. (1.70 m.). Ostia
Museum, Rome. The central event of
Mithraic mythology was represented
either in relief or in the round in all
Mithraic shrines. This group was found
in the underground Mithraeum in the
Baths of Mithras at Ostia, the port of
Rome. It is unusual in that it does not
represent the god as he usually appears
in Persian dress, but in Greek dress.
It is the work of an Athenian sculptor.

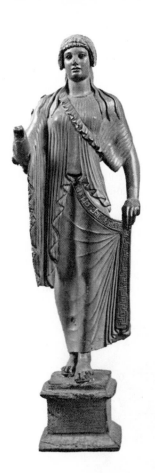

106. (left). **Polychrome Jug**. 3rd century BC. Glass. h. 5½ in. (14 cm.). British Museum, London. A multi-coloured vessel made by a process of winding strips of glass in a viscous state over a sand core. Moulded glass was also made in Hellenistic times, and glass-blowing, invented towards the end of the Hellenistic period, was practised throughout the Roman period.

107. (right). **Statuette of a girl**. 1st century AD. Bronze. h. 6 in. (15 cm.). British Museum, London. This small figure of a girl is said to come from Verona. The style imitates, but not consistently, archaic sculpture in Greece; such archaising works were very popular in Italy in the 1st century BC and the 1st century AD.

108. (below). **Wall painting from the Villa of Livia**. Early 1st century AD. h. 6 ft. 6¾ in. (2 m.). Museo Nazionale delle Terme, Rome. Livia was the wife of the Emperor Augustus, whom she outlived; the Emperor Tiberius was her son by a previous marriage. Garden scenes like this one taken from her villa at Prima Porta, near Rome, were very popular in the interior decoration of Roman houses during the early Empire.

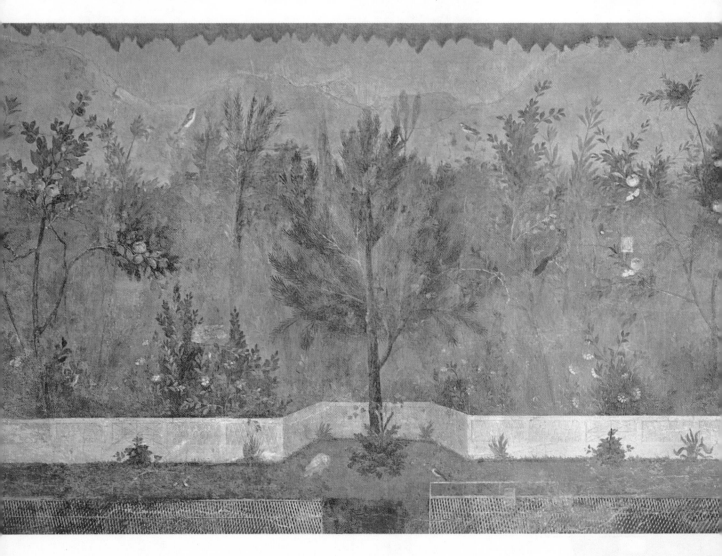

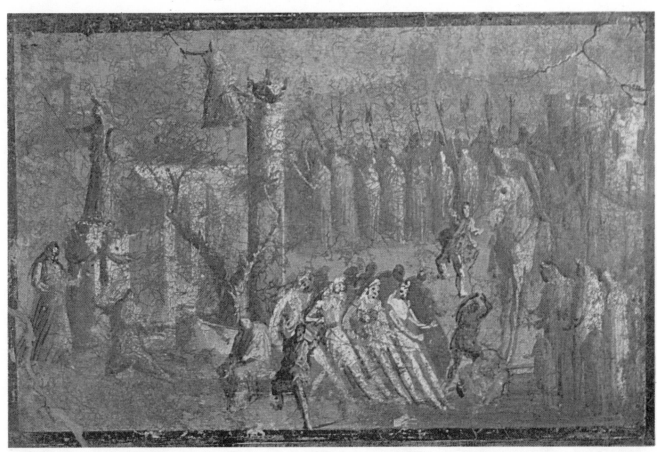

109. (above). **The Trojan Horse**. 1st
century AD. h. 1 ft. 4 in. (39 cm.). Fresco.
National Museum, Naples. In the fore-
ground of this picture the horse is being
dragged into the city by a group of men.
They are caught in a ghostly glow of light.
The towers and walls of the city can be
seen dimly in the background. The clever
effects of light, painted in a rapid impres-
sionistic technique, give an eerie atmos-
phere to the scene and a powerful sense
of drama. From a house at Pompeii.

110. (below, left). **Theseus triumphant**.
1st century AD. Fresco. h. 3 ft. (92 cm.).
National Museum, Naples. In this picture,
from the wall of a house at Pompeii,
Theseus, who has slain the Minotaur, is
greeted by the Athenian children, whose
lives he has saved. On the right are a
group of spectators. A number of similar
versions of this subject have been found
at Pompeii, and they were probably
inspired by a famous Greek picture.
The original was probably painted in
the 4th or 3rd century BC.

111. (below, right). **Perseus rescuing
Andromeda**. 1st century AD. Fresco.
h. 4 ft. (122 cm.). National Museum,
Naples. There are a number of versions
of this subject among the wall paintings
from Pompeii, and it seems likely that the
inspiration comes from a famous picture
of the 4th century BC or the Hellenistic
period. The painting shows considerable
skill in modelling with colour, and in the
handling of light and shade.

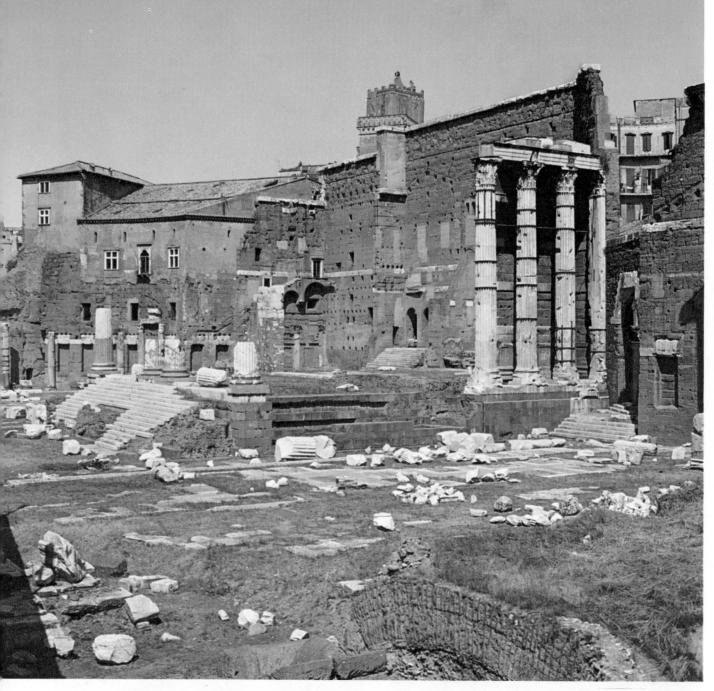

112. (above). **The Forum of Augustus**. Completed 2 BC. This view from the south shows the massive back-wall of the Forum, and the base and three standing columns of the Temple of Mars Ultor, which was the principal building. In front of the temple was an open space flanked by colonnades built in two storeys; the upper storey was adorned with figures of Caryatids copied from the Erechtheum at Athens. The series of imperial *fora* was built by the Emperors to extend the administrative centre of the capital.

113. (above, right). **The Colosseum, Rome**. AD 70–80. The great amphitheatre built under the Flavian Emperors on the site of the lake of Nero's Golden House in Rome. The massive elliptical building served for gladiatorial shows and other spectacles; it is estimated to have held 45,000 people. The building is the finest example of the skill of Roman architects in supporting a massive auditorium on arches and vaults. The classical orders of architecture are used to decorate the exterior of the building.

114. (below, right). **Wall painting from the House of the Vettii, Pompeii**. *c.* AD 70. Fresco. The wall is decorated in what is called the 'Fourth Style' of Pompeian wall-painting, combining blank areas of wall, on which are painted imitation panel pictures, with views into distant architecture. This scheme belongs to the later years of Pompeii, not long before its destruction in AD 79.

115. (far right). **The Theatre at Orange**. 1st century AD. The interior of the Roman theatre at Orange (Arausio), in Provence, one of the best preserved theatres in the Roman Empire. The massive back wall of the stage, which is a characteristic feature of Roman theatres, has turret-like projections, and was originally decorated with elaborate marble architecture. The external wall of this stage building was described by Louis XIV as 'the finest wall in my kingdom'.

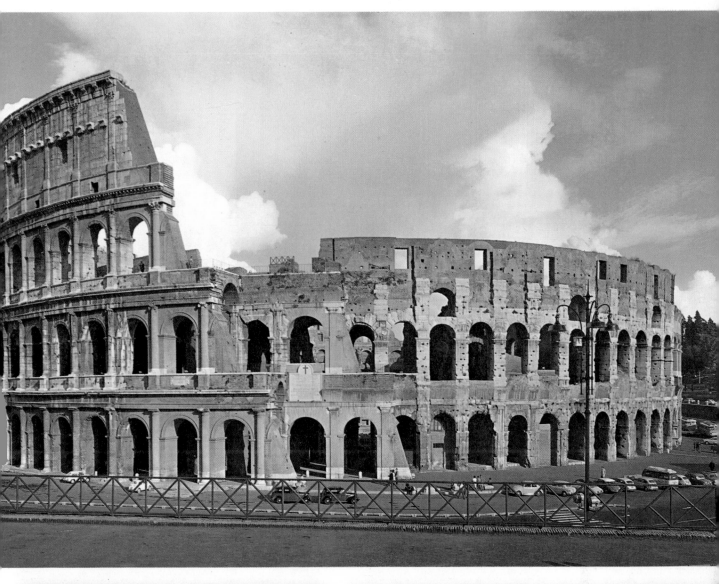

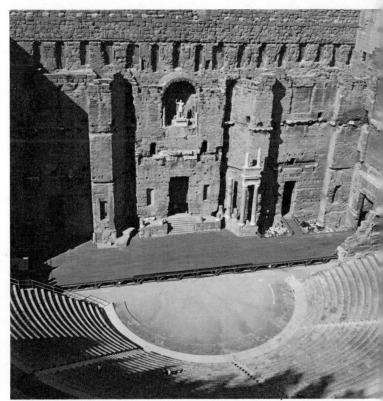

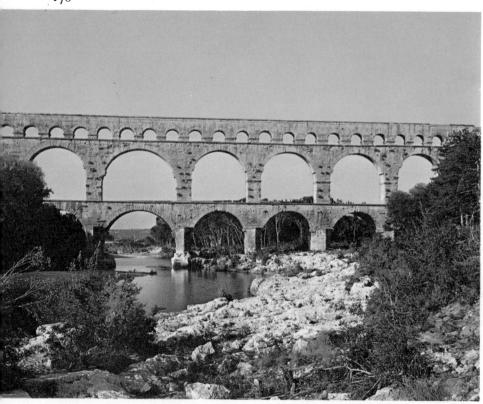

116. (above). **The aqueduct at Nîmes**.
1st century AD. l. 885 ft. (270 m.), h. 160 ft.
(49 m.). The 'Pont du Gard', an aqueduct
carrying water from Uzès to Nîmes in
Provence, is one of the finest surviving
examples of the magnificent engineering
works carried out everywhere in the
Roman Empire. It has three storeys of
arches, six at the bottom, ten in the
middle, and a series of smaller arches in
the top storey carrying the actual conduit.

117. (below). **The Forum Romanum**.
A view of the central area of the Roman
Forum from the west, looking towards the
Temple of Antoninus and Faustina,
which was converted into a Christian
church in medieval times. The three
columns on the right of the picture belong
to the temple of Castor and Pollux. The
Basilica of Constantine and the Colosseum
can be seen in the distance.

118. (above). **Bust of a Roman citizen**.
c. AD 160. Bronze. h. 7½ in. (19 cm.).
British Museum, London. Hollow cast,
the eyes are inlaid with silver and garnets.
The head was made about AD 160.

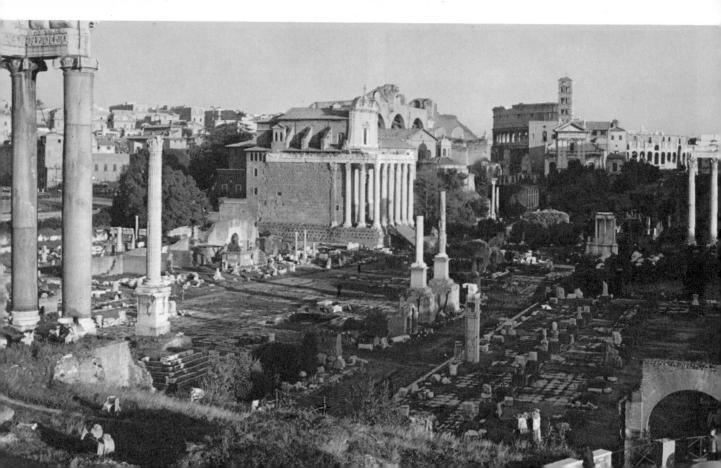

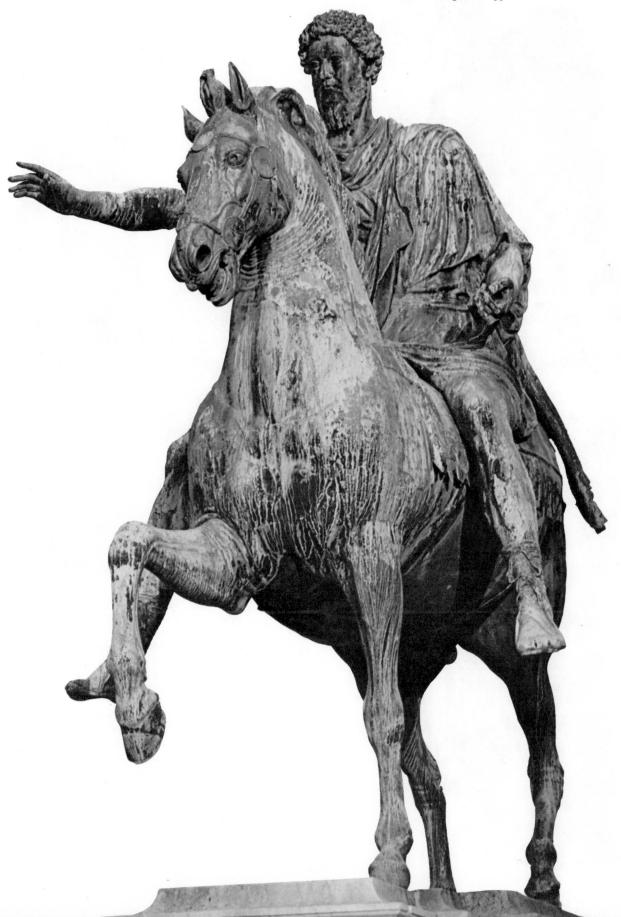

119. **Equestrian statue of Marcus Aurelius**. AD 161–180. Bronze. h. 16 ft. 8 in. (5.08 m.). Rome. This statue of the Emperor now stands in the Piazza del Campidoglio, at Rome. It may once have stood above a triumphal arch erected to commemorate the Emperor's victories. In the Middle Ages the statue, which is the finest imperial bronze group surviving, was taken to represent Constantine the Great, a fact to which it owes its preservation. It was put in its present position by Michelangelo in 1538.

120. (left). **Bodhisattva of the Gandhara School, India**. 1st or 2nd century AD. Bronze. h. 3 ft. (91 cm.). British Museum, London. Gandhara sculpture seems to show strong influence from the Greco-Roman world, which may be recognised here in the treatment of the hair and drapery, especially the lower folds.

121. (above). **Bust of a woman from Palmyra**. 2nd century AD. Marble. h. 1 ft. 7½ in. (49.5 cm.). British Museum, London. Palmyrene funerary sculpture illustrates the mingling of Greco-Roman and oriental elements in the art of frontier lands of the Empire.

122. (right). **Roman mummy-portrait of a man**. 2nd century AD. h. 1 ft. 4 in. (40.6 cm.). British Museum, London. (Reproduced by courtesy of the Trustees of the National Gallery, London). This portrait, painted in coloured wax on wood, was found at Hawara in Egypt. Portraits of this kind were inserted into the wrappings of mummies from the 1st to the 4th century AD, and include some of the finest examples of painted portraiture that have survived from the ancient world.

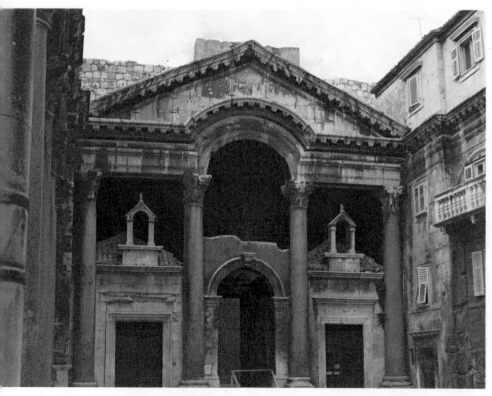

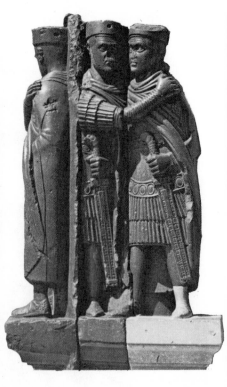

123. (above). **The entrance to Diocletian's palace at Split**. *c.* AD 300. The Emperor Diocletian built this palace near Salona in Dalmatia for his retirement. It is protected by strong towered walls, and laid out like a military camp. The porch giving access to the palace proper consists of four massive granite columns with an architrave that breaks out into an arch over the two centre columns. Above is a pediment. The porch stands at the end of the main colonnaded street.

124. (below). **The Baths of Caracalla, Rome**. AD 211–217. Part of the *frigidarium* of the Baths. The arch on the left gave access to the great hall, which was the principal room of the bath building and was roofed by a series of three concrete cross-vaults supported upon huge piers. Massive columns of granite stood against the piers and the whole brick and concrete structure was given a rich veneer of classical architecture. The baths remained in operation until the 6th century AD, when the Roman aqueducts were finally broken down.

125. (above). **The Tetrarchs of St. Mark's, Venice**. *c.* AD 284–305. Porphyry. 4 ft. 6 in. (1.30 m.). These two pairs of imperial portraits now stand at the south-west corner of the Treasury of St. Mark's, Venice. The portraits are of Diocletian and his colleagues in the tetrarchy, Maximianus Herculius, Constantius I and Galerius, wearing military dress. The figures were brought from Palestine during the Middle Ages.

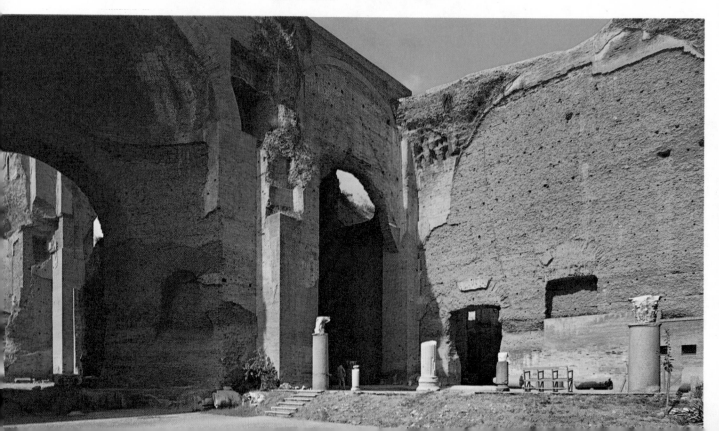

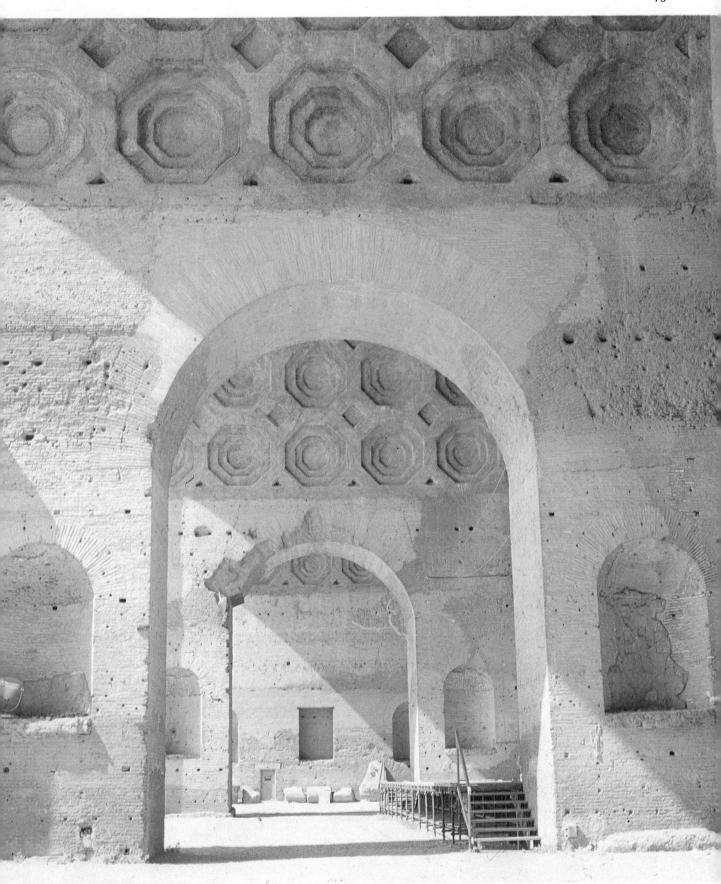

126. **The Basilica of Constantine, Rome**. This building was begun by Maxentius between AD 306 and 310 and completed by Constantine. It is one of the most impressive examples of late Roman architecture. The basilica stands by the *Via Sacra* in Rome, and was modelled on the great halls of Roman bath buildings. The main entrance was at the east, and at the west end there was an apse, originally intended for a tribunal, but later used for a colossal figure of Constantine, fragments of which still survive. This view looks westwards along the northern side-aisle, the best preserved part of the building.

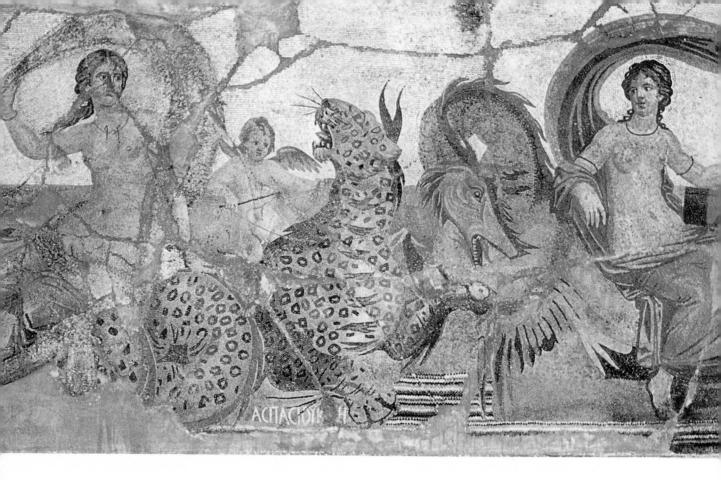

127. (above). **Nereïds and Sea-Monsters**. Late 3rd century AD. Mosaic. This theme, of sea-maidens and sea-monsters was one of the most popular in the repertory of Roman decorative art. These rich polychrome mosaics of the late Roman period in Africa are among the finest that have come down to us. This example was found at Lambaesis in Algeria.

128. (below). **Vault mosaic from Santa Costanza.** 4th century AD. Santa Costanza in Rome was built as a mausoleum, probably in the time of Constantine the Great. The mosaics decorating the vault of the ambulatory combine Christian and pagan subjects. In this detail *putti* are shown gathering grapes among the vine tendrils, treading the vintage and bringing in the grapes. These mosaics are the earliest surviving examples of the large-scale use of mosaic decoration on walls and vaulting in the Roman world.

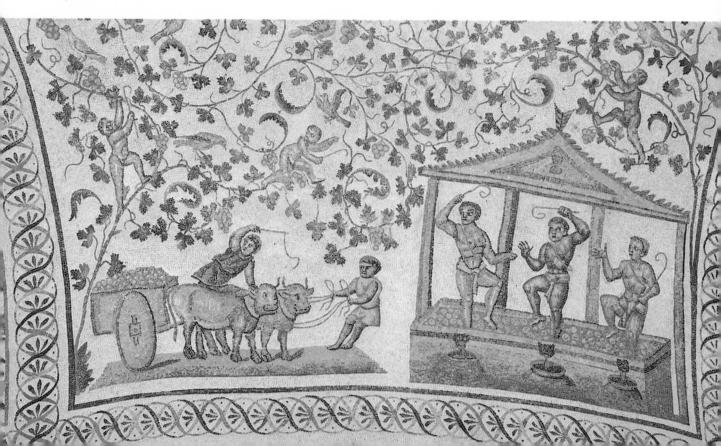

84. **The Treasury at Petra**. *c.* 2nd century AD. h. 132 ft. (40 m). Rock-cut tomb known as the 'Treasury', at Petra, in Jordan. Behind the elaborate architectural façade are several tomb-chambers.

çade of the so-called Treasury at Petra shows how daring some of the eastern versions of·classical architecture were as early as the time of Hadrian; above a fairly orthodox colonnade we see a circular *aedicula*, flanked by curious half-pediments. The interiors of temples at Baalbek are sumptuously ornate, and show similar unorthodoxy of detail, and in the late Empire similar features begin to make a more obvious appearance in the west. We find arcades, with the arches springing directly off the columns, an arch interrupting a horizontal architrave, an arch within a pediment. The architectural ornament is carved to produce formal patterns with strong black-and-white effects, and shows very little connection with the classical motifs on which it is based.

Many of these new features in late Roman architecture illustrate the transition from the late Roman to the Byzantine style; they are decadent only in terms of the classical tradition. The late Roman styles of ornament, which we see so well, for example, in Diocletian's Palace at Split, lead naturally to the Byzantine. The latest Roman experiments in the construction of dome and vault, and the discovery of the spherical pendentive, making possible the transition from vertical wall to domed roof, were to make possible such masterpieces as Santa Sophia. The brick arched exterior of the Basilica of Trier, which gains its effect without any resort to classical decoration, has the promise

of a totally different approach to architectural design. Late Roman architecture almost everywhere provides such evidence of creative change. A contrast is provided by a number of buildings which attempt to prolong the classical tradition, and in these the evidence of decline seems to dominate. The classic example is provided by the Arch of Constantine, put up by that Emperor in AD 312, to commemorate his victories. It is undeniably a most successful building, perhaps the finest of Roman triumphal arches, but its success is achieved by recourse to methods which imply a sense of inferiority. Most of the architectural detail and much of the sculpture, is taken from earlier buildings; the contemporary sculpture, when it attempts to imitate the old, is far inferior in technique and totally different in style. The Arch of Constantine illustrates the decline of classical form, and was taken as the object lesson of this theme by Bernard Berenson. The Arch of Constantine illustrates only one aspect of late-Roman architecture, probably its least significant.

NEW TRENDS IN RELIEF-SCULPTURE

It is more difficult to recognise the new trends in sculpture and painting than in architecture, because they manifest themselves in many different ways on established traditions. The commemorative sculpture of the early Antonine

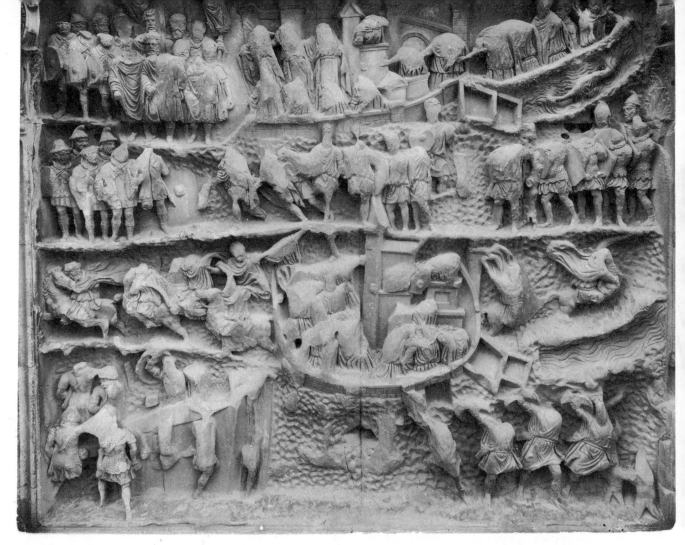

85. **Panel from the Arch of Septimius Severus**, Rome. AD 203. Marble. The panel illustrates events in the Emperor's eastern campaigns.

period is still firmly founded on the classical tradition, but, in the time of Marcus Aurelius, the signs of change are already clear. The contrast between the reliefs on the Column of Trajan, and those on the column erected to commemorate the victories of Marcus Aurelius at the end of the 2nd century, brings them clearly before us. The design of the later column is based on the earlier, but the differences in style and technique are very marked. Most obvious of all, perhaps, is the decline in the modelling of the human figure and in the carving of drapery where black and white effects replace the rounded forms of the classical tradition. There is uncertainty in proportions, and the sculptor tends to concentrate his attention on the head at the expense of the body. He makes much more effort to express feelings, to portray the sufferings of war instead of giving a cold factual record of events. He tries to involve us in events, and to do this he abandons many of the stock conventions of the Greco-Roman tradition. He tends to reject the traditional profile view of a scene, and turns the figures to face the spectator, almost as though they were posing for him; this tendency towards frontality becomes more and more marked in late Roman sculpture, until in the long frieze of the Arch of Constantine it has assumed the authority of a law. The decline of classical form, in favour of a more expressive style, is accompanied by an abandonment of any

attempt to create an illusion of reality and depth, by means of subtle carving on many planes. The conventions become more naive and, because more naive, also more direct. Two rows of figures, one behind the other, are simply shown one above the other, the background figures appearing in the form of a series of heads. A bird's eye perspective is sometimes used to give the setting for action. The interpretation of these new elements of technique, design, and expression is not always clear. Some appear as a deliberate reaction to classicism, some seem to express unconsciously new aims and notions. But all of them show unequivocally a new approach to the problems of representational art, and an increasing tendency to reject the old.

THE LATER SARCOPHAGI

The later Roman sarcophagi provide a clear record of the changing attitudes of mind in the late Roman Empire. As we have seen, classical themes carved in the classical manner satisfied the taste of the Roman upper class in Hadrian's reign; in the Antonine period specifically Roman themes became more common. A fine series of Battle sarcophagi begins at this time, and there are sarcophagi with scenes from Roman military and civil life. But mythological scenes continue to predominate; Bacchanalian subjects were especially popular. The demand for these sarcophagi was

86. **A Triumphal Procession**. *c*. AD 200.
Marble. h. 5 ft. 7 in. (1.70 m.). Lepcis
Magna. Part of the triumphal procession
of Septimius Severus on a panel from the
Arch of Septimius at Lepcis in Tripoli-
tania. The Emperor stands in his chariot
with his sons Caracalla and Geta.

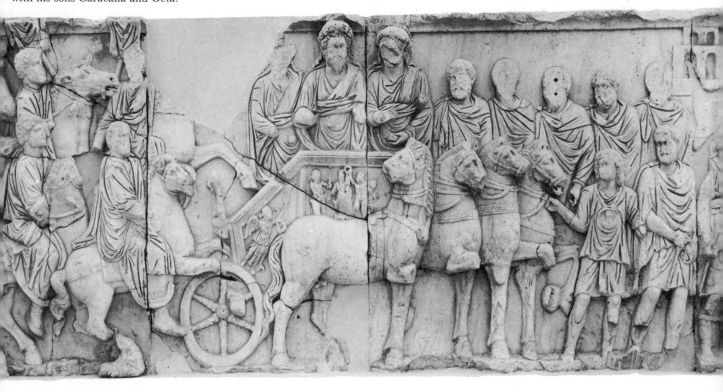

87. **The Ludovisi Battle Sarcophagus**.
c. AD 250. Marble. h. 5 ft. (1.53 m.).
Museo delle Terme, Rome. Battle be-
tween Romans and barbarians, probably
Dacians. The figure of the dead man,
a Roman general, dominates the scene.

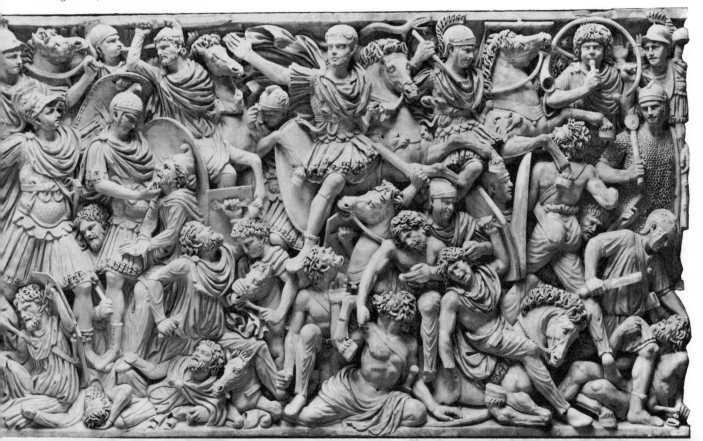

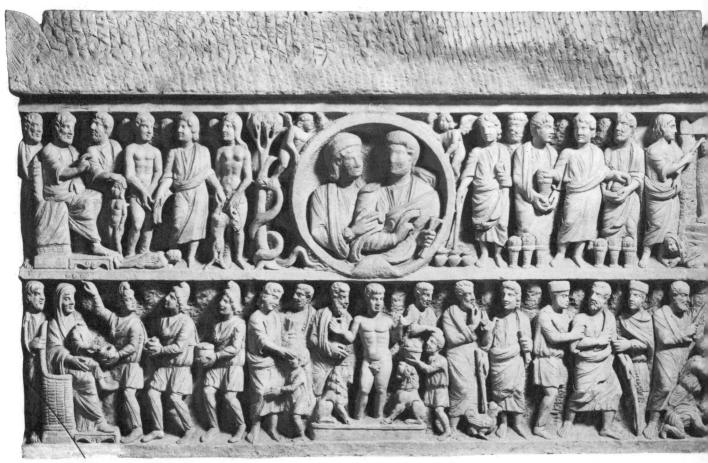

88. **A Christian sarcophagus**. Constantinian period. Marble. Lateran Museum, Rome. The sarcophagus is decorated with scenes from the Old and New Testaments. The central roundel encloses half-figures of the dead man and his wife; the heads were never finished.

met by workshops all over the Roman world; some of the finest and most elaborate were produced in Asia Minor and in Greece. The Asiatic sarcophagi show the typically eastern style of carving ornament, with deep cutting and strong black and white effects; those of Greece try to preserve the classical figure-styles and classical techniques of modelling. In the Roman workshops of the 3rd century, ugly faces and ill-proportioned bodies became more common. In contrast with the cool classicism of the *Achilles Sarcophagus*, from Greece, a contemporary sarcophagus in Rome shows less attention to the forms of the body and concentrates the interest in the faces which are often disproportionately large.

The symbolism, too, is different. The popular lion-hunt theme symbolises the triumph of life over death; other themes express the ideals of virtue, bravery, of philosophic contemplation of the after-life, to which the thoughts of the Romans in the troubled times of the late Empire were increasingly turning. One of the most magnificent of all Roman sarcophagi is the Ludovisi *Battle Sarcophagus* of about 250 AD; the battle theme is a traditional one but the whole conception is utterly different from the cold impersonal battle scenes of the earlier period. Here the struggles and sufferings of the barbarians seem to symbolise the struggles of life, and the triumphant gesture of the general suggests

his escape from earthly sufferings to a better life.

Some Christian themes begin to take their place on the sarcophagi; the sarcophagus of the Constantinian period, now in the Lateran Museum, with scenes from the Old and New Testaments arranged in two tiers, cultivates a deliberate ugliness in the figure style, which seems a complete negation of classical ideals. In this particular example, anti-classical feeling is very strong, much stronger than in many other works of the period, but it serves well to bring to our notice the fact that we have to do not simply with decline, but with a definite reaction to all the pagan values of the classical world. Ugliness is deliberately cultivated to show how far man has fallen from God's image. If we were to follow Christian sculpture further, we should find that it begins to compromise with classical art and to draw fresh inspiration from pagan themes. There is Greek beauty in the 4th-century figure of Christ, a reminder that the classical tradition is not dead, but could be transformed to express the new ideals of the age.

PORTRAITS OF THE LATE EMPIRE

The portraits of the late Empire change the whole conception of portraiture. As we have seen, the combination of Greek and Roman taste and techniques gave early Roman portraiture the same fundamental characteristics as that of

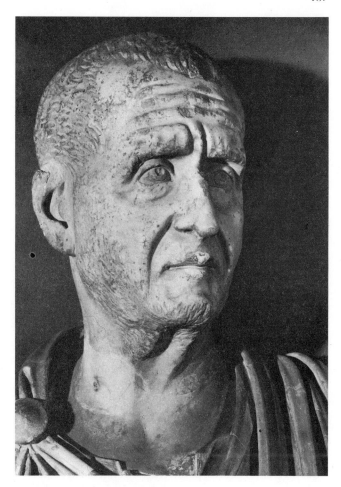

90. **Head of Trajan Decius**. *c.* AD 250.
Marble. h. 13 in. (33 cm.). Capitoline
Museum, Rome. Portrait of an Emperor
who reigned briefly from AD 249–51 and
died fighting against the Goths.

89. **Christ**. 4th century AD. Marble.
h. 2 ft. 4 in. (71 cm.). Museo delle Terme,
Rome. This statuette is believed to repre-
sent Christ, youthful and beardless,
as he was first portrayed in ancient times.

·the Hellenistic world. The Greco-Roman portrait is a care-
ful record of a man's features, plastically modelled, and at-
tempting to express his personality and character; one em-
peror may prefer the cold, remote expression of the face,
another the intensity of a momentary glance, but none of
the portraits give away the subject's feelings, aspirations,
and sufferings. The man is kept at a distance. This concep-
tion of the portrait lasts until the time of the Antonines;
thereafter, striking changes begin to take place. The por-
traits of 3rd-century emperors and private persons try to
penetrate the very soul of the man. The artist concentrates
on the essentials of expression; he may pay little attention
to the details of the hair and beard, but devote immense
care to the expression of the eyes, the lines of the face, the
set of the mouth. One of the finest of these 3rd-century por-
traits is the head of Trajan Decius, carved about AD 250;
in it we seem to see not only the struggles and perplexi-
ties of the man, but of the whole age in which he lived.
He seems to symbolise an age. These powerful forms
of expression, which bring these men of the 3rd century so
much nearer to our understanding, can also be used to
make them more remote from us. Once the artists, in order
to get beyond a man's features, begin to remodel and even
distort them, the way is open for the kind of symbolic ren-
dering of the human face which we associate with the art of

90

Byzantium. We see it already in the colossal head of the Emperor Constantine broken from the statue which once stood in the Basilica of Constantine; this is no portrait, but an impersonal, symbolic image of imperial majesty, which has drawn the man away from us into the realm of the superhuman and divine.

CATACOMB PAINTINGS

After we lose the guiding thread of Pompeian painting, the history of Roman painting is hard to follow. Much of what has come down to us is second-rate. The paintings from the catacombs, which begin in the 3rd century AD, provide a body of painting with a completely new source of inspiration, but much of the work is at a very poor level of craftsmanship and technique. The mosaics become increasingly important as a source of understanding the new trends in representational art; wall mosaic increases in popularity, heralding its supremacy in the decorative art of the Byzantine period. The general tendencies in late Roman painting and decoration are clear enough. As in sculpture, the painters lose interest in the problems of representing space and of modelling in colour; they show a preference for frontal figures, painted against flat backgrounds in a sketchily impressionistic style, opposed to the modelling of classical painting. Sometimes this impressionistic style is combined with hard outline drawing, which gives the figures a rigidity and conventionalism which has a very Byzantine look. Though they lose in subtlety, these pictures gain in directness and simplicity of representation, and, by the time of Constantine, we get pictures, like the Christ in Majesty from the catacomb of Domitilla, that give us a completely new vision of art. The splendours of Byzantine mosaic are heralded in the rich use of colour, to be seen in the mosaics of Santa Costanza, probably the Mausoleum of Constantina, daughter of Constantine the Great, who died in 354. The subjects are traditional pagan themes, but handled with a freshness and brightness which few pagan mosaics can equal.

PAGAN AND CHRISTIAN ART

The last section of this chapter is inevitably inconclusive. The great achievements of early Christian art belong to a period covered in the next section of this volume. Here we see only the beginnings of a new tradition, working uncertainly on an old tradition, that of the classical world. The early Christians were frightened of pagan art, in much the same way that Roman patricians of the old school in the last century of the Republic had been frightened of Hellenistic art. In the end, both the Romans and the early Christians had to compromise, but the early Christians rejected the ideals of classical culture, and introduced fundamentally different sources of inspiration, so changing the whole character and purpose of art. But if we follow the history of art beyond its late Roman phase, we shall find many examples where the classical spirit and classical techniques live on, until their triumphant revival at the Renaissance.

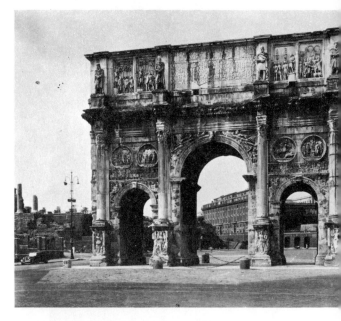

91. **The Arch of Constantine**. AD 312. This arch was erected in Rome to commemorate the Emperor's victories. The sculpture with which it is decorated was largely taken from earlier buildings, but the long, narrow panels (see figure 92) are contemporary work.

92. **The Emperor Constantine on the Rostra**. This relief from the north side of the Arch of Constantine shows the Emperor addressing the people from the Rostra in the Roman forum. The Rostra are flanked by seated statues of past Emperors.

THE EARLY CHRISTIAN
AND
BYZANTINE WORLD

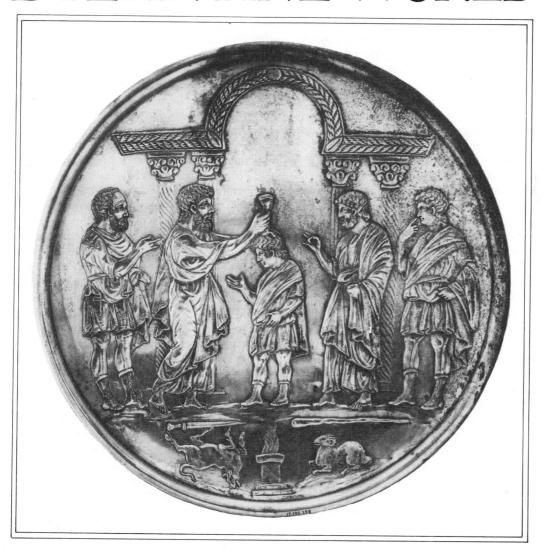

Introduction

The numbers in the margins refer to the illustrations of the Early Christian and Byzantine World: heavy type for colour plates, italics for black and white illustrations.

Works of art may be classified in various ways. They may be grouped according to their country of origin, as in 'Egyptian Art', according to period, which may take the name of one man, as in 'The Age of Augustus', or according to style, as in 'Gothic Art'. It is also possible, and just as legitimate, to study together all the works that have been inspired by the same religion.

It is obviously this last method that lies behind a work on Christian art. So, at the start, we should stop to consider the astonishing way in which this art flourished. Because twelve workers from Palestine travelled the world, the world was changed, spiritually changed, since men found a new purpose in life, but outwardly changed as well. To this day villages are grouped round their church towers and cities around their cathedrals. And the greatest artists, whatever their philosophical outlook may be, almost always turn, at some time or another, to the creation of a work inspired by Christianity. The modest texts of the Gospels constantly give rise to new pictorial interpretations, the Apocalypse again illuminates the heavens, again the tortured body is nailed to the cross.

All this is inextricably linked with our own lives. But it had to begin somewhere: the first church had to be built, the first symbols created, and the first Bible illustrated. There was a first 'Virgin and Child', a first 'Crucifix'. The spread of evangelism, the forms of the hierarchy, the relations between Church and State, the development of theology, the rise of devotion to the saints or of monachism —every aspect of Christian history is depicted in its art. It is reflected not only in what might be called ecclesiastical art, which serves the immediate requirements of worship and enhances the glory of the church itself, but also in popular art, where one can trace the hold of faith on the lives and souls of the people. The present author is attempting to describe the process by which Christian art originated, developed and spread during its first thousand years.

Religious art is subject to all the usual limitations imposed upon artistic creation. The first limitation is financial: the architect and painter must work within a budget, whether small, as with the primitive communities, or large, as when a converted state overwhelms the bishops with its generosity. Then scope is limited: religious art is utilitarian. It is obvious that church architecture, which has to conform to the rules laid down by the liturgy, must take into account the numbers of those participating in the ceremonies. A Christian church is not a pagan temple. An effort of imagination is required that will work within the accepted forms, that will be aware of the different kinds of building, past and present, which have fulfilled similar needs, and which in any case will be rigorously controlled by the client, whether the donor or the head of the community. Christian building reflects the development of the Church: a desire for glory soon became apparent which, because of historical circumstances,

made Christian art a triumphal art parallel to that of Imperial Rome.

Painting similarly found new subjects. Events which marked the origins of the Church were depicted for the instruction and edification of the devout and the great mysteries of the faith were represented. The painter was obviously not given a free hand, but was submitted to other limitations than those of the text he had been asked to illustrate.

The use of a work of art, defined in the commissioning by the customer, is little more than a given subject matter, a point of departure. In Christian art, the demands of the clergy were obviously more rigorous. A concern for orthodoxy, particularly in the East, led to the notion of iconography; the representation of each subject was fixed once and for all and was considered valid only in this form.

There was a traditional way, which was almost obligatory, of representing the Adoration of the Magi or Christ's entry into Jerusalem, and the subject took on a theological value when it was the Baptism of Christ, the Transfiguration or the Descent into Hell—scenes that have trinitarian or eschatological implications. Again, the 'portraits' of Christ or of the Virgin—said to derive from St Luke, who is supposed to have been a painter—or even from miracles, the veil of Veronica or heaven-sent images, had a mystical reality which must not be overlooked. The images of saints were soon given the power that the relics had had; the painters gave life and immediacy to the intercessors both in everyday circumstances and in the spiritual life. Their portraits had a power over the faithful similar to that formerly exercised by the statues of gods. From the idol to the icon, art was not only a means of expressing supernatural power, but made it live among men. This sacred nature of Christian art and the respect accorded to it contributed to its splendour but prevented innovations.

Furthermore consciously or unconsciously, each artist followed what his master had taught him; he was not even free on a technical level, he bore the imprint of a school or the influence of some famous predecessor. He could seldom escape from the general movement that determined the traditions and methods of each period, each region, sometimes of each town. Yet even in the anonymity that almost completely cloaks the art of primitive Christianity, we can see the emergence of individual personalities who establish themselves through the originality, the purity and the splendour of their work.

It is tempting no doubt to regard Christian art, particularly in its earlier stages, as a collection of archaeological documents, which provide evidence concerning the content of the teaching, the form of the liturgy, the expansion of missionary activity and the everyday life of the Church. But we must go further and seek the individual personality of each work as it expresses the spiritual life of the artist and also his ideal of beauty.

The Awakening

THE EARLY CHURCH

'Render . . . unto Caesar the things which are Caesar's, and unto God the things that are God's.' When these perfectly reasonable words were first spoken they were quite revolutionary. The Emperor Augustus, who had been dead some years, had become the object of a cult that was growing throughout the Roman world. During his own reign, Augustus had deified Caesar, but had tried to keep popular adulation within manageable proportions. In Rome, former citizens of the Republic still had reservations; but in the East, Hellenistic traditions helped to perpetuate a politically effective confusion; and in Africa, the Berber King Juba II had shown his gratitude by building a temple to the friend to whom he owed his throne.

Christianity was to be born and to develop in a world in which religion, the Empire and patriotism were closely linked. Temples were built to 'Augustus and Rome'. Venus, Caesar's mother, was the goddess of the Julia *gens*. or family, and protected the dynasty accordingly. At different times and under different dynasties, other gods were called upon to fulfil this role—Apollo, for example, or Jupiter and Hercules, or even Heliogabalus the sun-god who was worshipped at Emese in Syria. It was at the heart of this imperial paganism, this State religion, this ceremonial expression of loyalty to the imperial throne that Christianity was to develop.

There is no need to emphasise the restrictions that surrounded it. A Roman city was the physical embodiment of a monolithic system. In Rome the Capitol dominated the Forum, and the Forum was surrounded by temples. On the public squares of every provincial town were temples and statues of the gods and deified emperors—idols. The theatre was still a Dionysiac ceremony; the games that took place in the amphitheatre had a propitiatory value. Every army officer was bound by oaths to the gods; every imperial or municipal official was a priest in some way or other. A Christian would have had to stand aside from the public life of his time.

Yet the Christian communities flourished because they offered a more satisfying expression of the need both for brotherhood and a spiritual life of hope than did the mystery religions that came from the East at the same period. Gradually and unobtrusively, those communities grew. At first, they were composed entirely of ordinary people—Jewish and Syrian tradesmen grouped together in certain districts of Greek or Roman cities and a few pagan neighbours who had been attracted by the novelty of their religious witness. Slaves and artisans seem to be the first to be drawn to the new religion, and women. Only later, and much more slowly, did conversions take place in the wealthier or more intellectual classes. So, at the beginning, there was scarcely enough money to create a Christian art.

1. **The Good Shepherd.** 4th century. Mosaic. Basilica Theodoriana, Aquileia, Italy. Symbolic motifs already traditional in the Christian Church are set into the geometrical mosaic which paves the entire basilica. The familiar stance of the figure of the Good Shepherd carrying his sheep and Pan-pipes is found in catacomb paintings and sarcophagi of the same period.

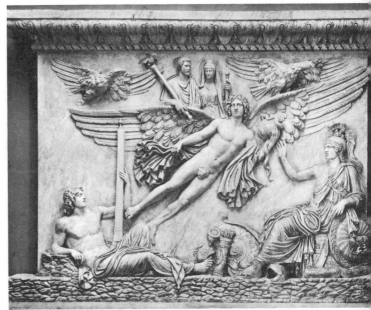

2. **The Apotheosis of the Emperor Antoninus and his wife Faustina.** 161–169 AD. Marble. Cortile della Pigna, Vatican, Rome. This relief is from the base of the column of Antoninus Pius. The imperial couple are carried skywards by a winged spirit, in the presence of the goddess Rome and a personification of the river Tiber. Dead emperors were deified, even during their lifetime they became the object of a cult; there was a temple of Antoninus and Faustina on the forum.

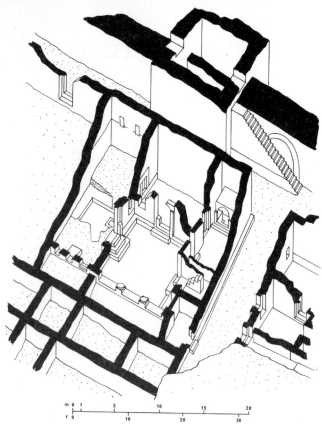

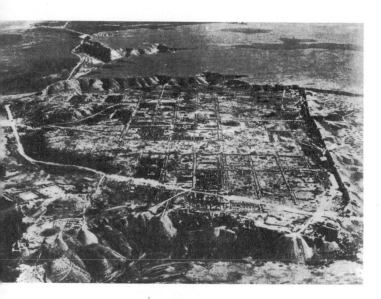

3. **Aerial view of Dura-Europos.** This fortified town, built
in a loop of the Euphrates by one of Alexander's generals, has
revealed in excavation precious evidence of the religious art
of the Eastern world in the first centuries of our era. The town
was captured and destroyed by the Parthians in 265, but a
synagogue and a Christian church have been found,
figure 4, plates 1, 2.

4. **Christian community house.** *c.* 230. Dura-Europos,
Syria. The Christian community was housed in a dwelling
which differed from all the others only in the baptistery
(top right) where a large bath was installed under a canopy
and the walls decorated with paintings recalling scenes of the
Old and New Testaments.

Perhaps the need for such an art was barely felt, especially
with the heritage of Jewish prejudices. When the com-
munities began to include rich and influential citizens
among their members the problem emerged of adapting
the new faith to a world from which until then it had been
kept apart. It was the duty of the clergy, the hierarchy that
had now formed, to preserve the distinction between the
Church and the world but in order to live each Christian
had to accept compromises within it.

In a world in which art was official, imperial, and pagan,
Christian art could only begin in a very small way. And,
anyway, was it not in itself a compromise with the world?
The pagan statues were for their worshippers the dwellings
of the gods, while the Christians, in their turn, were con-
vinced that they were inhabited by demons. How, there-
fore, should Christian statues be conceived? As images of
the true God? The Jewish elements in the Church would
abhor the idea. But there were other factors to consider.
Prevented by poverty and then by prudence from erecting
special buildings for their meetings—which, in any case,
should never resemble temples—Christians met in houses
that had been lent or given to the community by a rich
convert. These houses would be altered a little—a few
walls might be knocked down to provide a larger room.
Very often the Hellensitic or Roman decoration of the
house was left unchanged. In a period of expansion, and
conversion in Christian as in Mithraic practices, the
initiation ceremony—here adult baptism—had obviously

to be given its full significance. On Easter night, in a spe-
cially arranged room, the catachumens were plunged
three times in a decorated bath.

These early churches were so modest that for a long
time archaeologists were unable to discover any of them.
Sometimes they were destroyed by persecutions, particu-
larly the last, that of Diocletian in 305. More often, after
the triumph of Christianity, they were effaced by the in-
creasingly ambitious buildings that replaced them—this
is what happened to the parishes of ancient Rome—the
'titular churches'. The basilicas of the 11th, 13th and 18th
centuries were built on the sites of the meeting-places that
had been given to the community in the 3rd century by
Equitius, Vizans or Aemiliana.

The identification as primitive churches of buildings of
very varying form which have been excavated beneath later
churches has given rise to controversy—as in the case
of the Christian community house, called 'titulus Equitii',
which certain scholars believe they have recognised beside
the basilica of S. Martino ai Monti. Elsewhere, it seems
that the rooms used by the communities for their meetings
were situated on the first floor, above a row of shops, as at
Sta Anastasia, or over large, dark warehouses, as at S.
Clemente. Even if, as in the second case, a very large room
had been opened out, the building had no distinctive
appearance from the outside. Its nearest neighbour, on
the other side of an alley, was a sanctuary of Mithras. At
SS. Giovanni e Paolo the community owned the whole

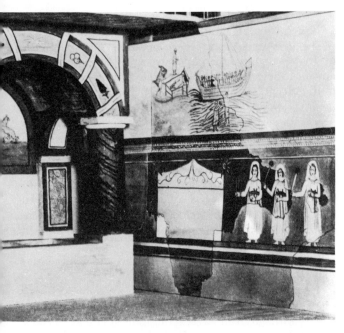

5. **Wall-painting from the baptistery at Dura-Europos.**
3rd century. Paint on plaster. Syria. The restored paintings
from the walls of the baptistery depict scenes from the Old
and New Testaments. In the top register of the right wall are
the *Healing of the paralytic and Christ walking on the Sea of
Galilee*. Below are the *Three Maries at the sepulchre*.

building: in a room on the ground floor, paintings have
been found of the martyrdom—apocryphal, as it happens
—of two saints, while the church itself was on the first
floor. However vague these results may be, they show that
the early Roman churches were unobtrusive, set up in
quite simple households and were not noticeable among
the buildings of the capital and probably of any large town.

DURA-EUROPOS

It was in Dura-Europos a small fortified town on the
banks of the Euphrates, that a Roman garrison was besieg-
ed by the Parthians in 265. The Romans, fearing for the
safety of a wall that the enemy was undermining, built a
high embankment of soil and rubble behind the ramparts,
thus overrunning the nearby houses, and preserving a
church of the 3rd century recently rediscovered.

Dura was built by one of the generals of Alexander the
Great and was full of temples. In them the gods of Greece
and Rome were worshipped, of course, but also those of
Mesopotamia, Iran and Syria, the gods of the caravans of
Palmyra and the camel-rider's gods of the Arabs. There was
a Jewish community and a splendid synagogue covered
with paintings, a sort of illustrated Bible, revealing the exis-
tence of a Jewish art and a Jewish iconography that were
nevertheless forbidden by the law. And, on one street
corner, there was a house exactly like the others with a
baffle-type door and a square courtyard. There was a
room that had been enlarged, where a small platform had

been built, a dining room, and, in the corner—the only
notable alteration—a baptistery, with a bath surmounted
by a canopy and a few fragments of frescoes. The priest
probably lived on the upper floor.

Painted on the walls of the baptistery, in a very simple
style, similar to that of the paintings in the temple of the
town, were Adam and Eve, the Good Shepherd. Christ
walking on the waters, David and Goliath and a procession
of women carrying candles moving towards a lighted sarco-
phagus. In the large room—which was used for the meet-
ings of the community—a frieze belonging to the former-
owner, decorated with Pan-pipes and theatrical masks, had
been left untouched.

We have no reason to believe that the Christian com-
munity at Dura was at this time particulrly small, or
particularly poor and timid. On the contrary, it seems
more likely that it was a missionary church, in which the
community grew more from adult conversions than from
its own children. It is a strange stroke of chance that has
thus allowed us to enter one of those churches of Mesopo-
tamia, related to the synagogues of the *diaspora*, and to see
the problems of the Christian community house and of its
decoration in a setting that, at that date, was as oriental as
possible. The art of Dura has revived our knowledge of
what has been called 'Parthian' art, which was probably
the Alexandrine art of Asia. One can recognise at first
glance the conventions and ideas that were to constitute
certain of the characteristics of Byzantine art—the use of
'frontality', the absence of relief and the spirituality of the
faces. From the beginning Christian art had origins out-
side the Mediterranean world as well as within it.

In the larger cities, the churches may have been set up
in more satisfactory conditions and decorated more richly.
But it is certain that the Christian community houses were
generally of this humble kind, probably the house of one
of the faithful, and indistinguishable from the others. As
there were different types of house throughout the Roman
world, so the churches had no consistent architectural
style of their own. Thus, at the beginning of the 4th cen-
tury, the church at Qirkbizé, in northern Syria, with its
enclosed courtyard, its colonnade on the south side and all
the detail of its building, looked very like the fine house
next door to it—as it still does, despite the alterations of
subsequent centuries.

Perhaps there already existed a certain choice of themes
that were represented on the walls—and perhaps definite
ways of representing them. The very existence of decora-
tion of such a rich and assured iconography in the syn-
agogue at Dura leads one to believe that the primitive
Church had access to the same kind of model books that
resulted in pagan mosaic floors at the same time being
executed in a comparable form throughout the Roman
world. In any case, even if the paintings of the church in
Dura did belong to local art, they are not as exotic as
might be imagined, but are conceived in the same way as
the paintings in the Roman catacombs.

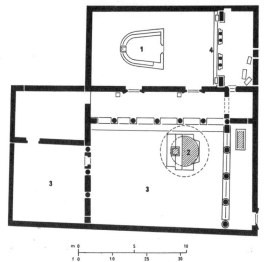

7. **The Christian cemetery.** 6th century. Timgad, Algeria. A southern view of the cemetery which consisted of very simple tombs made of large tiles sunk into the earth. They are unembellished with funerary equipment.

8. **Catacomb of S. Panfilo, Rome.** 3rd or 4th century. The narrow corridors were hollowed out of the rock bed, *loculi* were carved in the walls of them thus permitting large numbers of bodies to be buried in a piece of land of restricted surface area.

6. **The church of Qirkbizé.** 4th century. Northern Syria. The church is of a form very close to that of the neighbouring house. The development of the liturgy in the 4th and 5th centuries imposed certain modifications in its interior and exterior arrangements—1, Bema, 2, the cistern, 3, courtyards, 4, iconostasis.

EARLY CHRISTIAN BURIAL

One of the fundamental articles of the Christian faith was the belief in the Second Coming of Christ. The apocalypse of John—among other apocalypses—had described in advance the terrible day when the Lord would appear from the clouds in all his glory and judge the living and the dead. At the sound of the trumpet the dead would rise up. The bodies would return to life and be joined to their souls and men would be called to account for their sins. This theme of the resurrection of the body, as seen in the story of the prophet Ezekiel, had been depicted on the wall of the synagogue at Dura. For the first Christians, this return of Christ, victorious over death, was imminent—and even after the beginning of the 2nd century, it was expected to occur from one day to the next. In the end, they anticipated that the prophecy would take place in an indefinite future, but the hope of resurrection nevertheless remained central to Christian thought.

This is probably why Christians were forbidden to cremate the dead, a practice which alternates in human history with burial and was, at this time, almost universally accepted. The Romans used cremation; their ashes were put into urns, and these urns were either buried or placed in niches in the *columbaria*. There was a marked return in the 2nd century to the practice of burial, perhaps under the influence of Christianity. As a result, new problems were created for the cemeteries. Space was needed, especially for the Christians, who insisted on preserving something of the individuality of their dead.

The Christian communities began to help families to solve this problem. It was of course more difficult in the case of the poor than of the rich—and most of the faithful were poor. Moreover, they wished to be buried together, among their brothers. So from the middle of the 2nd century Christian cemeteries were created. Usually these consisted of reserved areas in the open air outside the city walls, *7* where, as with pagan burial, the bodies were placed between two rows of tiles forming a roof. Above ground there was an inscribed stele or a plain monument. Sometimes, however, the bodies were placed in stone sarcophagi, juxtaposed. Sometimes vaults were dug in hillsides or in rock faces—where sarcophagi were often carved out of the rock itself, often under arches, hence their name *arcosolia*. *3* It was particularly in Rome that Christians adopted a form of cemetery that had previously but infrequently been used by pagans: these consisted of a network of subterranean tunnels known as catacombs. Because it was important to make the best possible use of the land available the *8* tunnels were very narrow. Moreover when in one tunnel all the *loculi* were full, the height and depth of it were increased in order to add more. Then new tunnels would be dug out at a lower level and further tunnels branched off it in different directions. All this resulted in those impressive labyrinths around Rome which are so extensive that new ones are still being discovered.

At first, like the 'houses of the Christians', these ceme-

teries were on private land, which had been put at the disposal of the community by individual members. However, by the 3rd century it appears that the right of association recognised by the Romans enabled them to be regarded as Church property and to be maintained by the Church. This, of course, implies that the imperial administration and the police knew of both the churches and cemeteries and tolerated them, unless some special event —a local crisis or an imperial decision—set off a wave of persecution.

In these cemeteries the bodies of the martyrs were laid beside those of their fellow-Christians. At first both received visits, honours and gifts, as was the custom in Roman society. To these were soon added prayers for the repose of the dead and prayers to the martyrs requesting their intercession. But the catacombs were not intended to be places of worship, nor to be used as underground refuges for the persecuted. They played exactly the same role as the 'open-air' cemeteries in the provinces of the empire.

CATACOMB PAINTINGS

Funerary art is, in our day as well, essentially a matter of simple craftsmanship, when it is created for families of modest means. It would be excessive to regard as great works of art the paintings with which the Christians decorated the galleries and *cubicula* of the catacombs. They derive from that sketchy, but charming decorative art that, after Pompeii, was used in most Roman houses—and which could be adapted without effort to new subjects. This Christian decoration is strongly reminiscent of the paintings in private houses. Often, the traditional motifs —cupids, the seasons, animals—are intermingled with the themes created by the Christians.

These themes were very simple and, at first, purely symbolic—anchors, fish, baskets full of loaves, and vines with birds pecking at them. There was the Good Shepherd, borrowed from the pagan art of the time, and represented sometimes as a shepherd, surrounded by his flock and playing on a bucolic pipe, and sometimes carrying a sheep on his shoulders. There is the *orans*, the figure of the woman praying, with her arms raised, who represents the soul of the dead person—whether a man or a woman— rather than an actual dead woman. This theme is treated either as a symbolic motif or, on the contrary, as a figure surrounded with flowers representing the gardens of Paradise. If we recall the Shepherd of Hermas and the visions of St Perpetua, both these pastoral and floral scenes may be seen as visions of the place of light and peace.

A certain number of scenes taken from the Old and New Testaments are also to be found on the walls of the catacombs, but they are treated in so schematic and elementary a way that only the faithful could recognise the subject. They suggest rather than represent, and were not a method of pictorial instruction for those who could not read the Bible as later Christian frescoes were to be. Prior knowledge is needed to recognise the man cured of the palsy in

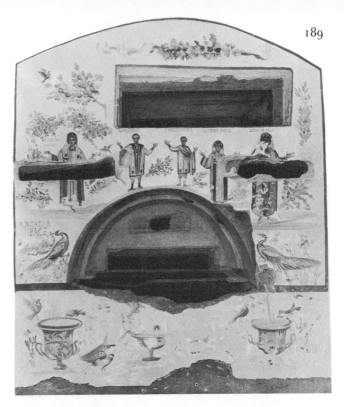

9. **Evocation of Paradise.** Wall-painting from the catacomb of Callixtus, (after Rossi). The decoration of the catacombs stresses the salvation of souls which is evoked by symbols, or by sketchily drawn scenes.

10a, b. **The miracle of the loaves and fishes.** (a) Painting from the crypt of Lucina, Catacomb of Callixtus, Rome. (b) Pavement mosaic from et-Tagbah (Heptapegon), Israel, in the Church of the Multiplication of the Loaves and Fishes. Mid-5th century. The representation is almost the same in Rome as the one in the place where the miracle occurred.

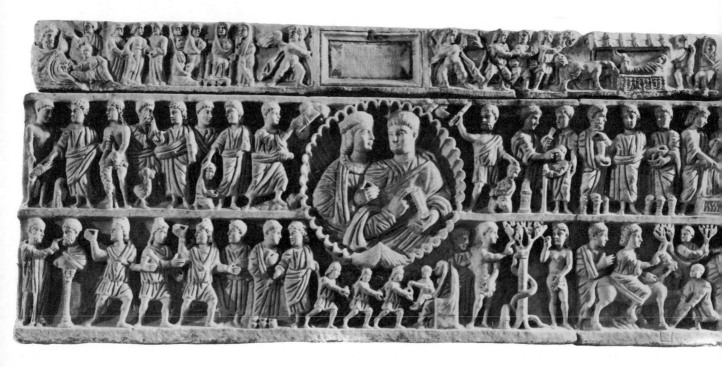

11. **Sarcophagus of Adelphia.** 4th century. Marble. Syracuse. The two registers of the sarcophagus are broken by a shell with busts of the deceased. On the cover can be distinguished scenes from the life of the Virgin, then to the right the shepherds at the crib. In the top register among other biblical scenes are *Christ foretelling Peter's denial*, and the *Healing of the woman with an issue of blood*; to the right *Moses receiving the law*, the

Sacrifice of Abraham, the *Healing of the blind man*, the *Multiplication of the loaves and fishes* and the *Raising of the widow's son from the dead*. Below: *The young Hebrews before Nebuchadnezzar*, the *Miracle at Cana*, the *Adoration of the Magi*, *Adam and Eve* and the *Entry into Jerusalem*. It is a good example of the complex iconography of the early sarcophagi.

the figure of a man carrying his bed upon his back; or
11 Noah in another figure whose bust emerges from a four-legged coffer (*arca*, in Latin) and whose hand reaches out
10 to hold a bird; or Jonah in the handsome young man asleep under a trailing gourd; Daniel in the lion's den looks more like an ancient Gilgamesh—an *orans* standing between two crouching animals. And the feeding of the five thousand, a prefiguration of the Eucharist, is sym-
10a, b bolised by a basket filled with loaves and fishes. It has often been thought that the choice of such methods of representation was a result of the enforcement of secrecy. But even when the scene represented involves several figures, decorative elements and exotic costumes, they are not necessarily any more explicit for the uninitiated. Three
9 young men standing in the middle of flames, full face and with their arms outstretched, what could this signify to someone who did not know of the punishment inflicted by Nebuchadnezzar on three young Hebrew blasphemers? And how can the man striking a rock with a stick and causing a spring to flow be recognised as Moses, if one does not know that Moses miraculously gave drink to his people in this way. More elaborate images appear later, the adoration of the Magi, for example, or banqueting scenes, representing perhaps a funeral ceremony, the eucharistic
9 meal or an episode in the heavenly life of the blessed.

The range of subjects is limited, but there are a great many repetitions and variations. This is not from a lack of imagination, but out of choice. The scenes of Paradise provide a clue to the explanation of other subjects. These **12** are the promises that the dead take with them into the next life, where they must observe their realisation, because the miraculous aid that the god of the Old Testament so often gave his people and the help given by Christ to those he met as he travelled were guarantees of future salvation.

Representations of daily life also occur in the catacombs, as in pagan funerary art: there are scenes, for example, of masons building a house, tradesmen in their shops and, above all, grave-diggers, who found themselves at home in these labyrinths that they had dug.

The style of all these paintings is flowing and relaxed; the colours are bright and gay, and light touches were necessary if the paintings were to be seen by lamplight. The attitudes and movements of the figures are boldly conceived, the faces are usually only sketched in—except, sometimes, in the case of praying women, when they may have been portraits. These paintings are rarely framed, but are generally placed against a light background, or sometimes among more complex decorative compositions. These ancient works are rather more religious and his-

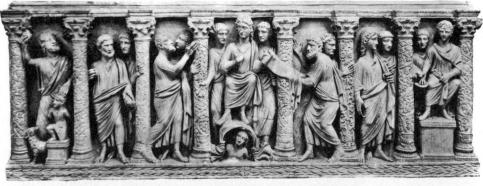

12. Columnar sarcophagus.
4th century. Marble. Lateran Museum, Rome. The richly decorated columns separate the figures but give rhythm and elegance to the composition. The scenes represented follow the traditional iconography; to the left is the *Sacrifice of Abraham*, followed by Peter's arrest, then in the centre *Christ triumphant hands the law to Peter*, and on the right the *Judgment of Pilate*. The lack of order in the scenes is typical of the sarcophagi.

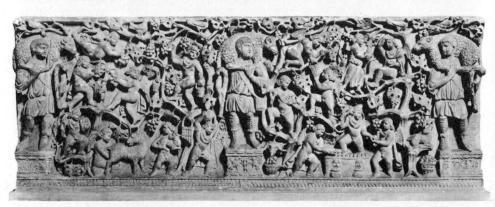

13. Symbolic sarcophagus. 4th century. Marble. Lateran Museum, Rome. The entire front of the sarcophagus is covered with vine-trails peopled with *putti*, like some pagan Bacchic scene. Only the three statues of the Good Shepherd, standing on ornamental pedestals, indicate the transposition to Christian symbolism (see plate 6).

torical in import than properly artistic. The baptistery at Dura has shown that the houses of the Christians, like the subterranean cemeteries, were decorated with paintings based on similar themes and treated in the same spirit; consequently they may only be reflections. It would be unwise to judge primitive Christian art simply by the examples of it that have survived. It is possible that art of a quite different order flourished in the early churches, despite the restrictions imposed on them. Certain paintings discovered in Egypt, which are generally of a later period, may date nonetheless from before the *Pax Ecclesiae*. It may well be that archaeology has not yet said its final word.

EARLY CHRISTIAN SARCOPHAGI

The sarcophagus is a luxurious coffin—a long vessel hollowed out of stone, often marble, to fit the body which it protects and contains beneath a heavy monolithic lid. Sarcophagi can obviously be grouped together either in a subterranean tomb or in a built mausoleum, or simply placed on the ground in an open-air cemetery. They were often decorated, a custom the Romans—and the Christians in their turn—inherited from the Etruscans and the Greeks. A continuous development may be traced from the pagan sarcophagi of the 2nd century to the finest Christian coffins of the 4th. There is no break: the marble masons used the same tools, the same techniques and the same traditions. Only some motifs were new, and even then they sometimes kept the same subjects. There are Christian sarcophagi on which, as in the previous century, the seasons are represented by *putti*. There are lions mounting guard —not to mention the decorative background, the strigils, for example, or the colonnades. In the details of the figures and drapery, for instance, the tradition developed in exactly the same way as in official bas-reliefs. Occasionally, a mythological character or scene has been borrowed and incorporated in a Biblical scene; so Jonah lying under

the gourd has the appearance of the sleeping Endymion. The dead are still represented as busts in medallions.

So it is in the subjects, first of all, that Christianity expresses itself. The same motifs are to be found in sarcophagi as in the catacombs—particularly the use of symbolic figures, the Good Shepherd carrying the sheep on his shoulders and the *orans*. But they are blended with a traditional background of architecture or foliage.

The traditions of the workshops died hard, so that the Christian character of certain sarcophagi is dubious because of the difficulty in deciphering the symbolism of some of the motifs. But before long Biblical scenes are introduced and treated, as in the catacombs, in the most economic way. The most characteristic sarcophagi are like collections of pictures, sometimes juxtaposed and framed, sometimes even overlapping each other, so that the subjects can be recognised only by an experienced and attentive eye.

These subjects are curiously mixed. The Old Testament is well represented: Adam and Eve in the temptation scene, the sacrifice of Abraham, Jonah, the young Hebrews and Nebuchadnezzar. Moses receiving the Law, or striking water from the rock, Daniel among the lions, Job, and a great many others. The New Testament is represented first by the Gospel stories of Christ's childhood—the crib, the Magi—then by the miracles—the miracle of the loaves and fishes, the marriage-feast at Cana—and the miraculous cures—of the man born blind, of the man sick of the palsy, of the woman with an issue of blood, the raising of Lazarus, and of the daughter of Jairus. Finally, there are the scenes of the Passion—the entry into Jerusalem, the Arrest, the judgment of Pilate, and sometimes, but in a symbolic form, the Crucifixion and the Resurrection. These pictures always seem to be assembled by chance, as if there was no logical or chronological link between the episodes. Their choice of scene has long been explained by

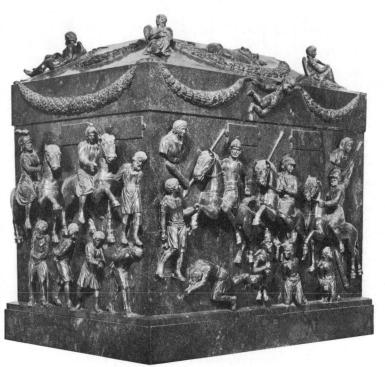

14. **Sarcophagus of the Empress Helena.** 4th century. Porphyry. 95 × 91¾ × 61 in. (225 × 233 × 155 cm.). Vatican Museum, Rome. Carved out of an enormous block of Egyptian porphyry the sarcophagus of St Helena, the mother of Constantine, was formerly in her tomb on the Via Appia. It is decorated with sculptures in high relief of Roman horsemen and barbarian prisoners. The motifs are treated separately probably because of the hard stone. The *putti* and garlands emphasise the purely triumphal character of the decoration.

the fact that they are a commentary on the prayers of the liturgy for the repose of the souls of the dead. They are references to the helping action of God—'protect him O Lord, as thou hast protected Daniel among the lions'. It is also possible that the texts, on which the scenes were based, were later forgotten by the sculptors who re-arranged the scenes according to their own needs—balancing their decorative band by putting the tomb of Lazarus on the left edge, for example, and Pilate's dais on the right.

In fact, amidst the pious intentions of these works, their artistic requirements are not lost sight of. Certain friezes possess an astonishing pictorial overcrowding such as was previously to be found on pagan sarcophagi; others are arranged in bands placed one on top of another—increasing the number of intercessions. A feeling for architectural form often makes its appearance: the friezes are then arranged on one or two storeys, like façades, and interspersed vertically with columns supporting architraves or arches. Some of these arrangements are highly successful —but these more beautiful sarcophagi usually date from the second half of the 4th century.

This period also sees the appearance of new subjects which are important enough in themselves to take up the whole decoration of a frieze. Such a subject might be a high-

ly graphic scene like the crossing of the Red Sea, treated in the same style as the victory of Constantine at the bridge of Milvius on his triumphal arch in Rome; or they might be compositions similar to those that were to be found in the apses of the basilicas—and which sometimes appear in the same period in the later catacomb paintings—such as Christ teaching the twelve apostles in a terrestrial scene or in paradise.

The richness, variety and fantasy of the Christian sarcophagi of Rome or Provence, for example, provide one of the most delightful aspects of primitive Christian art. Sometimes the execution is a little clumsy—it is, after all, the work of simple craftsmen—but the development of relief in this period must be taken into account. The short figures, with large heads full of movement and expression, are to be found not only on the sarcophagi but also on other bas-reliefs of the 4th century and in the painting of this period. The intention is one of dramatic evocation rather than pictorial composition. But these works do have great linear rhythm, the planes being divided up by columns or simply by the figure of Christ being endlessly repeated in the miracle scenes. He is taller than the other figures and has great presence and authority, which with the sobriety of his gestures, which never alter, is strongly reminiscent of the invocations of the funeral liturgy.

Before the *Pax Ecclesiae*, Christian funeral art was entirely the work of ordinary craftsmen; and as it was intended for private individuals, it did not undergo any dramatic change when the triumph of Christianity was finally confirmed. Paintings and sarcophagi followed an uninterrupted development, which explains the difficulties experienced by specialists when trying to pass from a relative chronology to an absolute chronology. There were developments in the style as well as in the choice of the subjects which would probably have occurred whether or not profound changes had taken place in the status of the Christian church of the 4th century.

The greatest effect on monumental Christian art was its link with the imperial State. It will be seen how Christian art became not only free, but official. The bishops had formerly been poor and suspect: they could now request and obtain generous help from the Emperor. This resulted, of course, in a quite different and much richer art.

But however lacking the first communities had been in materials and money, often persecuted, and suspicious, too, of any kind of ostentation or of any tendency to towards anthropomorphism, the works of their artists and craftsmen have retained their value—what might be called their sociological value, since they express as fully as the texts certain of the most original characteristics of the Christian communities; their spiritual value, since they represent an attempt to find an expression for the new faith, an incarnation in art of a religion of the spirit and of truth, and their artistic value, too, since the traditional forms were infused with a new spirit which affected even the hand of the sculptor and the painter.

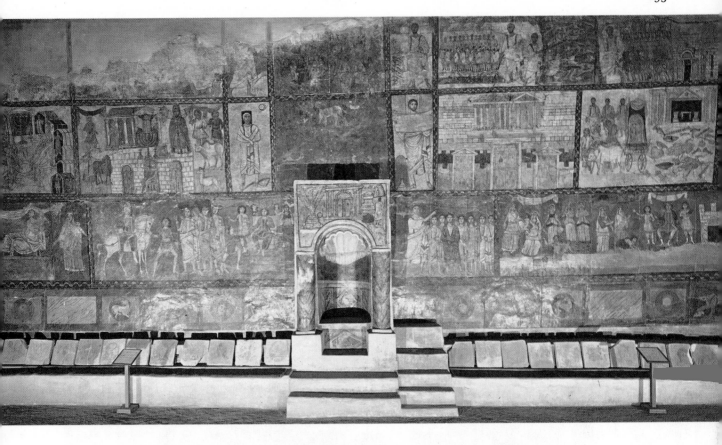

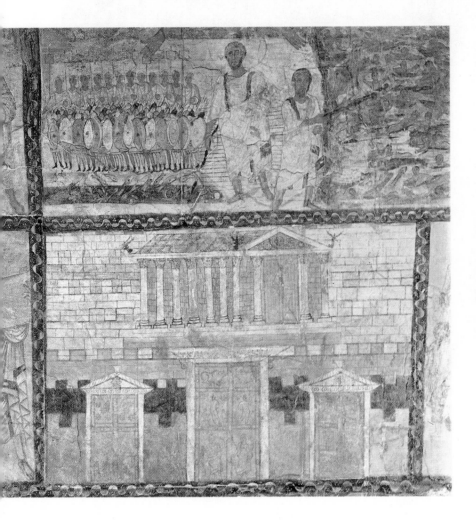

1 (above). **West wall of the synagogue at Dura-Europos,** Northern Syria. First half of the 3rd century. Fresco transferred to Damascus Museum. The discovery of these paintings in the synagogue has revealed the existence of an Israelite iconography of the Bible. In the centre of the wall is the niche for the Book, surmounted by a painting of the Torah shrine, the Temple of Jerusalem and the seven-branched candlestick. To the right of this is the Elder's seat and around the walls the benches for the faithful. Among the biblical scenes are, below right, the *Anointing of David* and *Moses rescued from the waters of the Nile.* The last one clearly shows how the successive episodes in a story are incorporated in a single scene.

2 (left). Detail showing the Temple at Jerusalem, a prophet to the left, and above *Moses and the burning bush* and part of a scene depicting the *Crossing of the Red Sea.*

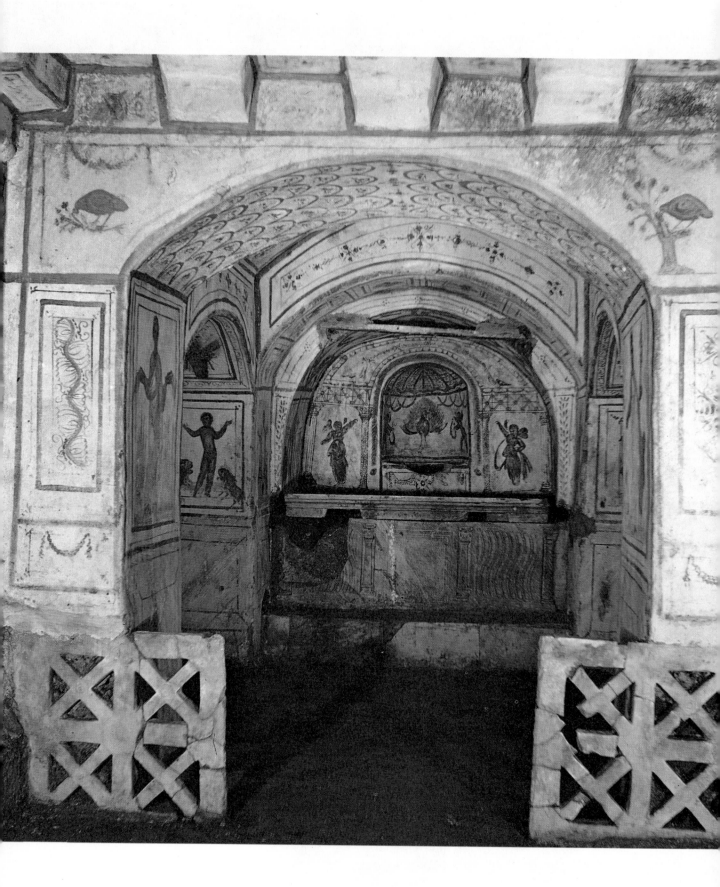

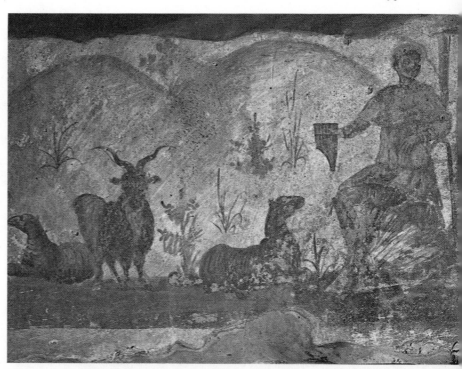

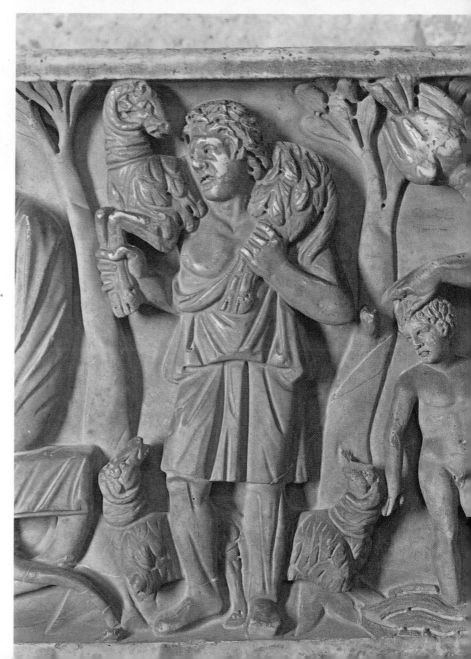

3 (opposite). **Cubiculum 'O'.** Mid-4th century. Paint on plaster. New Catacomb of the Via Latina, Rome. The overall effect of catacomb-painting in its more elaborate parts is clearly demonstrated in this view, with the individual motifs isolated against a plain background within a painted frame. Garlands, birds and geometrical decoration surround scenes from the Gospels and from everyday life. The niches to the right and left are the *loculi*, or graves, and in the *arcosolium* at the back is a sarcophagus beneath an arch hollowed out of the rock.

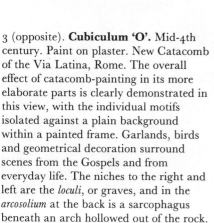

4 (above left). **The Good Shepherd.** Mid-3rd century. Paint on plaster. 31 in. (78 cm.) diameter. Ceiling of the Chamber of the Velatio, Catacomb of Priscilla, Rome. The theme of the Good Shepherd carrying a sheep is one of the most recurrent in Early Christian art.

5 (above right). **Pastoral scene.** 3rd century. Paint on plaster. 20 × 36 in. (50 × 91 cm.). Painting from the Catacomb of Domitilla, Rome. The Good Shepherd was often depicted surrounded by his flock in a pastoral scene, which might represent Paradise. Here he holds Pan-pipes, reminiscent of Orpheus, reflecting the way in which classical subjects were adapted by the Christians to their own meaning.

6. **Detail from a sarcophagus.** *c.* 270. Marble. Sta Maria Antiqua, Rome. The Good Shepherd carrying a sheep on his shoulders is depicted in the same way as in the catacomb painting. The trees from divisions between one subject and the next, and to the right can be seen part of the *Baptism of Christ*.

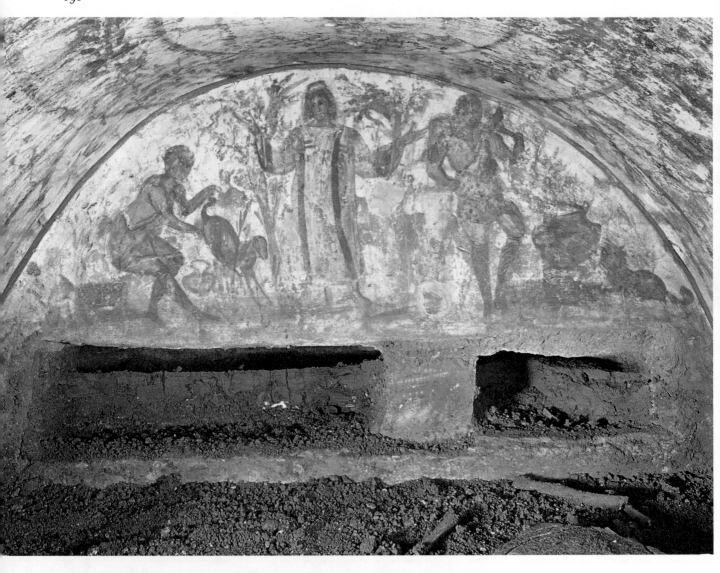

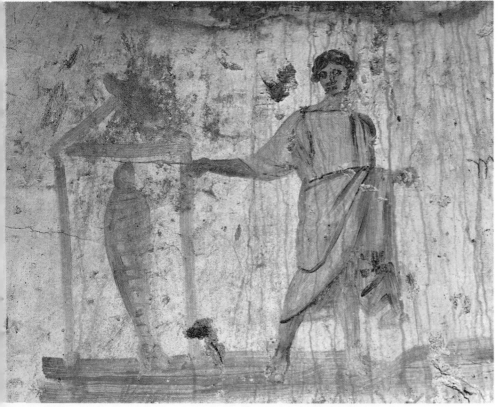

7. **Orans.** Late 3rd century. Paint on plaster. 27 × 80 in. (68 × 203 cm.). Painting in an *arcosolium* in the Ceometerium Maius, Rome, which depicts a woman with her arms raised in supplication and prayer. She stands in surroundings suggesting an earthly Paradise, flanked by two shepherds, one of them milking one of the flock, the other bringing a stray to the fold, under the watchful eyes of a dog. Beneath the painting are the *loculi* or graves roughly hewn out of the rock wall.

8 (left). **The Raising of Lazarus.** Late 3rd century. Paint on plaster. 32 × 44 in. (*c.* 81 × 111 cm.). Painting from the Catacomb of St Peter and St Marcellinus, chamber XIII, Rome. The extreme simplification of the Gospel scene, with Lazarus swathed like a mummy, prevented interpretation by the pagans. Like the scenes from the Old Testament opposite this expresses a hope of salvation.

9 (right). **The three Hebrews in the fiery furnace.** Mid-3rd century. 20 × 34½ in. (50 × 87 cm.). Painting in the Chamber of the Velatio, Catacomb of Priscilla, Rome. The story of the three young Jews cast into the flames by Nebuchadnezzar, and saved from death by the intervention of an angel illustrates another invocation for salvation.

10 (centre). **Jonah thrown to the whale.** Late 3rd century. 16 × 23 in. (c. 40 × 58 cm.). Vault of a crypt, Catacomb of St Peter and St Marcellinus, Rome. The story of Jonah was both an allegory of baptism and an invocation for salvation. The realistic portrayal of the bent body of Jonah and the high prow of the boat contrast with the weird conception of the whale.

11 (right). **Noah in the Ark.** 3rd century. Catacomb of St Peter and St Marcellinus, Rome. Once more this scene is symbolic of salvation with the dove bearing an olive branch in its beak. Noah is represented in the posture of an *orans*, the ark is an open coffer, *arca* in Latin.

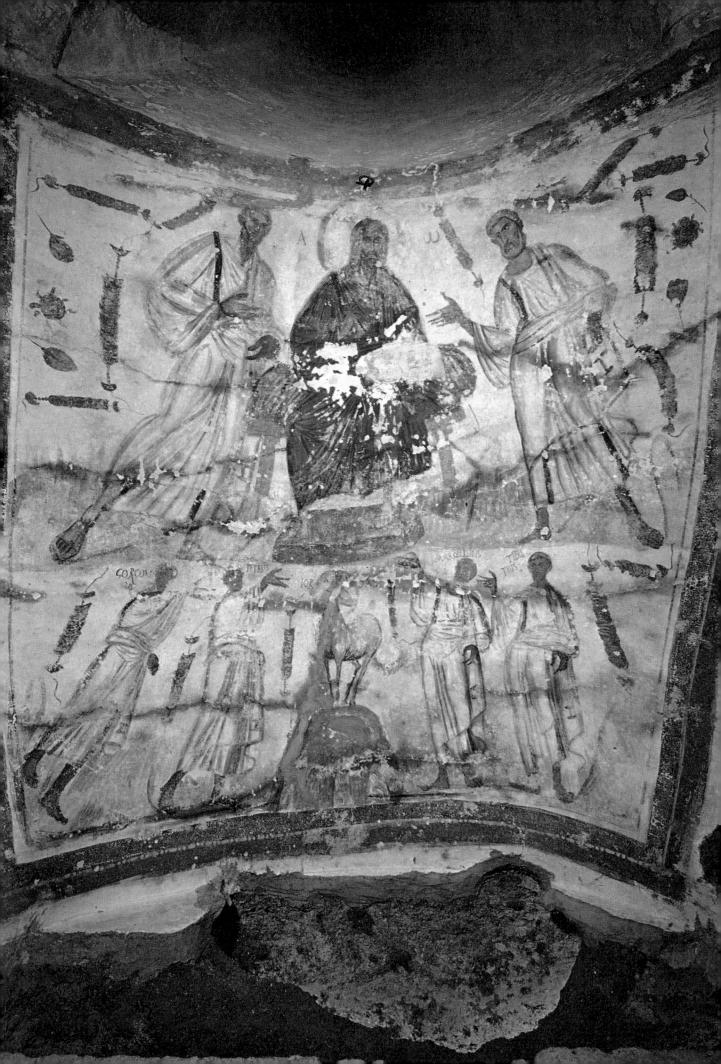

12 (opposite). **Christ between Peter
and Paul.** Late 4th century. 88 × 96 in.
(213 × 243 cm.). Crypt of the Saints,
Catacomb of St Peter and St Marcellinus,
Rome. This later painting openly depicts a
Christian subject—Christ between the two
apostles above the Divine Lamb,
standing on a knoll from which the four
heavenly rivers flow. To the left are
SS. Gorgonius and Peter, and to the
right SS. Marcellus and Tiburtius. Such
a decoration has monumental character.

13. **Christ Helios**. Early 4th century.
Mosaic. Ceiling of a chamber from the
Pre-Constantinian necropolis under the
Basilica of St Peter. Here Christ appears in
his glorious role—as the sun in his
chariot, the Apollo of the ancients.

14 (left). **Vault mosaic.** 4th century. Sta Costanza, Rome. These are the earliest surviving vault mosaics on a large scale; they combine Christian and pagan subjects, and are enclosed in a geometric border. This detail shows a Bacchi scene, with *bacchi* gathering grapes and oxen bringing in the harvest.

15 (below). **Detail of the mosaic decoration** in the adjoining section or the ambulatory, showing the fruit and foliage and the peacock. Similar mosaics adorned contemporary pagan buildings.

16 (opposite above). **Interior of Sta Costanza, Rome.** 4th century. The magnificent mausoleum of Constantina, one of the daughters of Constantine, became a church. The vaults of the ambulatory and the apses of the beautiful circular monument are decorated with mosaics.

17 (opposite below). **The apse mosaic** in the north ambulatory shows Christ standing on a rock from which flow the four streams of Paradise. He gives the law, '*traditio legis*', to St Peter, with St Paul to his left; the sheep at his feet represent saved souls.

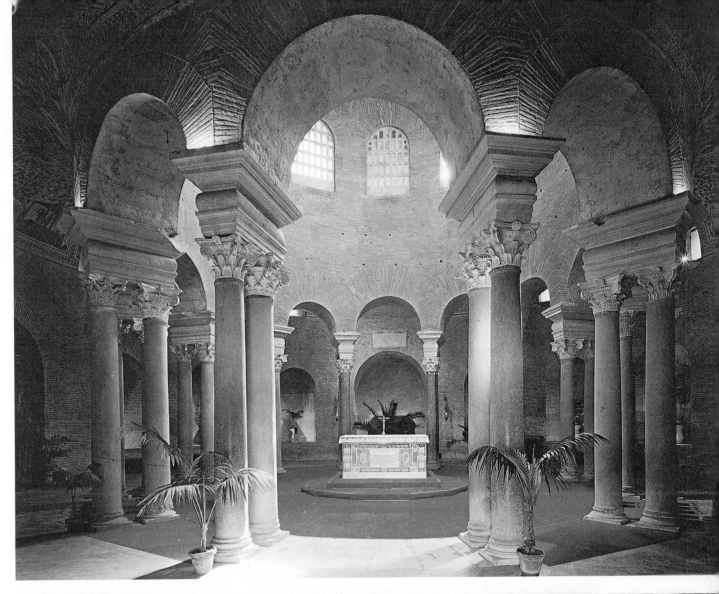

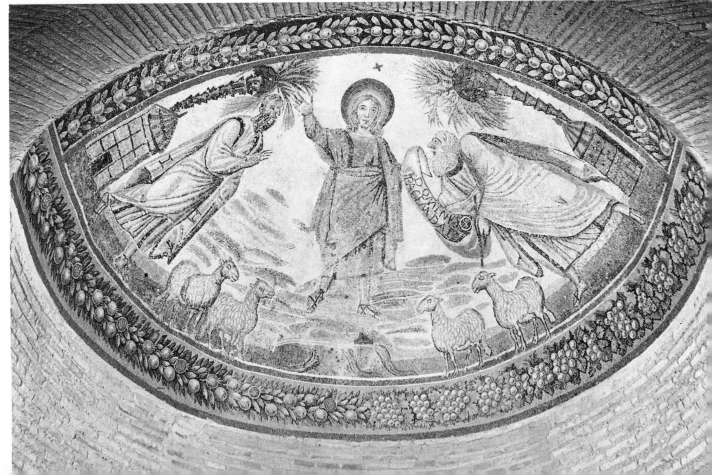

18 (above). **The story of Jonah.** 4th
century. Detail of a floor mosaic from the
basilica at Aquileia. The two scenes from
the story of the prophet, his escape from
the sea monster and his sleep beneath the
gourd, are set against an extensive
background similar to many pagan
mosaics of the same time. The sea is full of
realistically depicted fishes of all kinds.
19 (left). **The detail of the cupids
fishing** shows how the pagan motifs were
still employed side by side with Christian
subjects. The octopus and swimming
ducks are delightfully imaginative.

20. **Christ teaching the Apostles.**
c. 400. Mosaic. Sta Pudenziana, Rome.
This detail from the apse mosaic (see
figure 22) shows the haloed Christ,
'Lord the Preserver of the church of
Pudentiana', seated on his throne in full
glory. Behind him is the rock of Golgotha
on which is a representation of the
jewelled cross which was erected there by
Constantine or Theodosius.

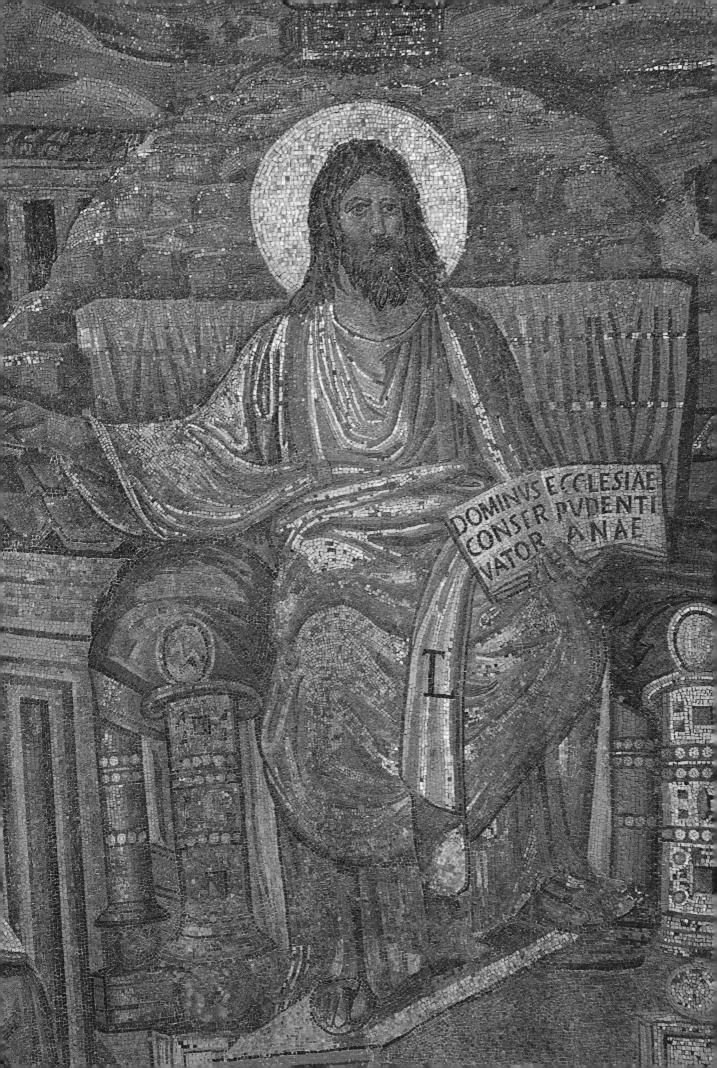

DOMINVS ECCLESIAE
CONSER PVDENTI
VATOR ANAE

21 (opposite). **The nave of Sta Maria Maggiore.** 432–40 (ceiling *c.* 1500). Rome. Built during the 'classical revival' under Sixtus III, the wide, majestic nave of the basilica is flanked by two aisles. The Ionic columns support a 'classical' entablature and a clerestory and lead towards the triumphal arch which used to continue into the original apse vault. Mosaics on the arch celebrate the Virgin as the Mother of God; on the left wall of the nave are scenes from the life of Abraham and Jacob (plate 22, 23), and on the right wall, of Moses and Joshua (plates 24, 25).

22 (right). **Abraham and Lot.** Early 5th century. Mosaic. Sta Maria Maggiore, Rome. These mosaic scenes are enclosed in frames under the windows of the clerestory. This scenes shows the parting of the two brothers, leading the wandering Hebrews. Abraham with his son departs to the left and Lot with his daughters to the right. Both the setting and the costumes are borrowed from classical art and there is no attempt at local colour.

23 (right). **Abraham and the angels.** Early 5th century. Mosaic. Sta Maria Maggiore, Rome. The story of Abraham with his heavenly visitors is divided into two registers: above, the patriarch greets his visitors, and below he tells his wife Sarah to make 'cakes upon the hearth', and offers them a 'calf tender and good'. It is the story of God's promise of a son to the father of his people.

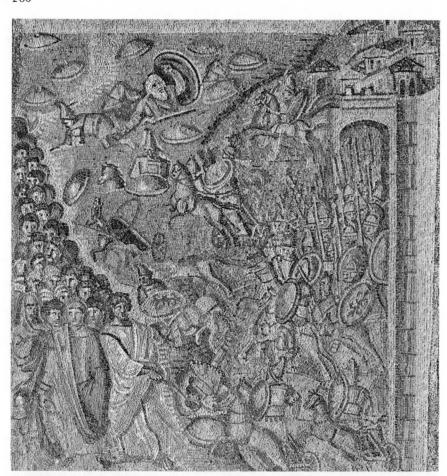

24. **The passage of the Red Sea.** Early 5th century. Mosaic. Sta Maria Maggiore, Rome. This is a magnificent composition despite the limitations of the frame. To the left stand the Children of Israel led safely across the Red Sea by Moses. The Egyptian army and their chariots, leaving the citadel on the right, are engulfed in the returning waters of the sea.

25. **The capture of Jericho.** Early 5th century. Mosaic. Sta Maria Maggiore, Rome. Joshua's army march round Jericho and the walls topple; the figure within the city may be identified with the harlot Rahab who was saved because she hid the messengers who had been sent by Joshua to spy on the city. This is the upper register of a panel; below there is a procession with the trumpeters.

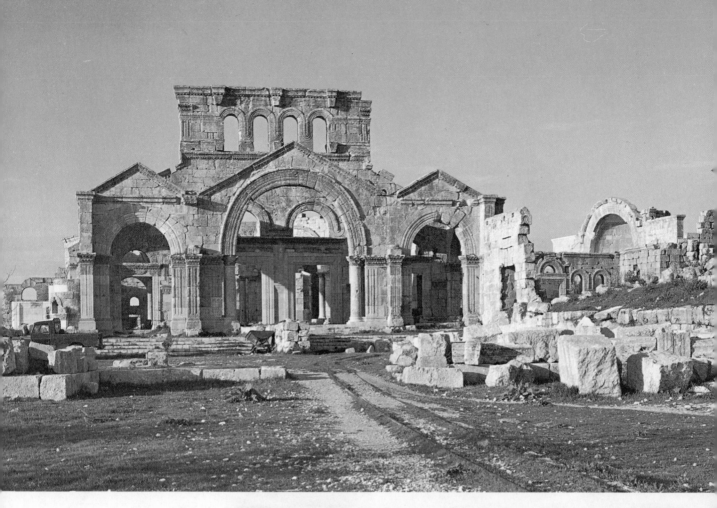

26. **Qalat Siman.** *c.* 470. Syria. This view
shows the porch of the southern basilica
of the cruciform sanctuary of St Simeon
Stylites. Round the column, on the top of
which the saint had spent thirty years of
his life, an octagon was built, and from
this radiated four basilicas each with a
nave and two aisles (see figure 32). The
narthex can be seen behind the arches of
the porch, with typical Syrian
mouldings. To the right appears the top
of the central apse at the end of the
eastern basilica.

27 (right). **detail of the façade
decoration** showing the fluted pilasters
of the entrance porch and the magnificent
capitals of spiky acanthus leaves.

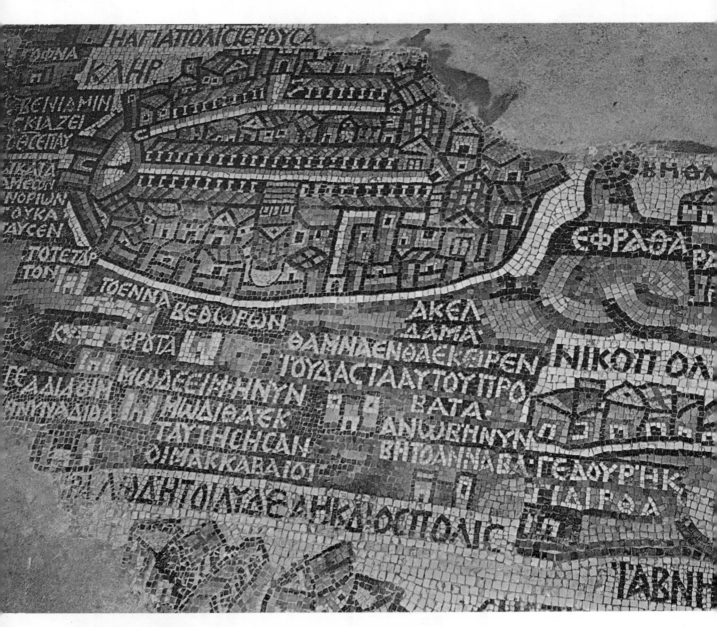

28. **Plan of Jerusalem.** *c.* 560. Mosaic.
Madaba, Jordan. The best preserved part
of the floor mosaic map of the Holy Land
is the area depicting Jerusalem, seen at the
top of this picture. Some streets and
buildings can be recognised; on the left is
the city gate, with its obelisk. From here
run two streets lined with porticoes and
in the middle of the lower of these two can
be seen the Church of the Holy Sepulchre
(figure 15).

Constantine

THE CHURCH TRIUMPHANT

Despite the ponderous but often rhetorical account given by Eusebius of Caesarea, and despite the vengeful clamour of Lactantius, it is difficult to imagine the upheaval that was caused in the Roman world by the triumph of Christianity. Our own time has made us familiar with revolutionaries emerging from underground, with condemned men suddenly set free, and exiles returning home to occupy the highest posts in the State—their ideas, only a short time before subversive, suddenly becoming the law of the land. In 305, Diocletian had burned the Scriptures, destroyed the churches and executed the bishops in a vain attempt to preserve at all costs the unity of the empire around the emperors, who modelled themselves on Jupiter and Hercules. Suddenly full civic rights had to be granted to this community which had previously been illegal. It was even granted a kind of primacy. And to assure the unity of the empire, it was also necessary, unfortunately, to tighten the unity of the Christians themselves. In 325, at Nicaea, Constantine presided over the first Ecumenical Council—amidst the very bishops who had survived the repression of his predecessor. He himself, victorious through a miracle of Christ, found himself engaged for political, but perhaps also for intellectual and emotional reasons, in a theological debate. Previously, he had hesitated between paganism and Christianity; now he heistated between the views of his advisers—orthodoxy and Arianism. Even on his death bed he was not baptised in the faith that he had proclaimed at Nicaea. The affairs of the Church had become the affairs of the State; theological disputes became a question of conscience for the emperor.

At first the Christian emperors did not indulge in persecution against paganism; they attacked neither the gods they had abandoned, nor their believers. In the middle of the 4th century there was even a revival of hope on the part of the pagans when Julian, a nephew of Constantine and a Greek philosopher, became emperor. Until the end of the century there were senators in Rome, led by Symmachus, who kept the statue of Victory in the assembly rooms—against the wishes of the Emperor Theodosius and of Ambrose, the formidable Bishop of Milan. But from the beginning the die was cast. Nothing shows this better than the building programme that is associated with Constantine. There were, it is true, the civil basilica of Maxentius

40

15. **The Constantinian Holy Sepulchre.** 4th century. Jerusalem. This plan of the first building of the Holy Sepulchre as reconstructed by R.P. H. Vincent is an intepretation of the description given by Eusebius, bearing in mind the few walls which have been preserved. The Holy Sepulchre was surrounded with a rotunda before the end of the century. The *propylaeum* gives access to an *atrium* before the basilica with a western apse, a nave and four aisles. A second atrium or courtyard, of which the rock of Calvary formed a corner, was in front of the vast rotunda with its internal colonnade.

in the Forum in Rome and Constantine's *thermae*. There was the new capital, Constantinople, built on the site of Byzantium, which was to be a new Rome—but the centre of Constantinople was the Emperor's tomb and this tomb was a church, dedicated to the twelve apostles and intended to contain their relics. Throughout the world Constantine constructed Christian sanctuaries.

Of course some of these, such as the Lateran basilica, the cathedral of the Bishop of Rome, or the octagonal church at Antioch, which was probably a Palatine chapel, do no more than represent the new alliance—the help that the empire gave the hierarchy and the help that, in turn, the empire expected from God. But a great many of these buildings take on a quite different character, expressive of Constantine's attitude to the truth of Christianity.

In Jerusalem, in answer to an appeal from Bishop Macarius and on the advice of his counsellor, Eusebius, Bishop of Caesarea of Palestine, Constantine gave permission for archaeological excavations to begin. The aim was to discover the tomb of Christ—not in order to weep over the death of the Saviour, but to glorify his Resurrection. The monument built on the spot would be called the *Anastasis*, the Resurrection; and the basilica adjoining it would be called the *Martyrion*, the Witness. The Church Triumphant and the Emperor both sought the historical evidence of the Resurrection—the Resurrection without which, according to St Paul, our faith would be in vain. It was during a second stage that the True Cross was discovered in excavations attributed to Helena, the mother of the Emperor, so Calvary was included in a secondary position in the group of buildings. The Passion found its value in the Resurrection. In Bethlehem the birthplace of Jesus was sought and found in a cave in a quarry. *17, 18*

At the summit of the Mount of Olives, a monument was built around a rock in which footprints were found that had been left by Christ before the Ascension. Other episodes in the earthly life of the Saviour were illustrated by the founding of sanctuaries; archaeologists have recently found, on the banks of Lake Tiberias, the sanctuary built to commemorate the miracle of the loaves and fishes. *10b*

In Rome searches were made in three places to discover traces of St Peter and St Paul. The result, *ad catacumbas*, was a basilica, now dedicated to St Sebastian, which has retained signs of a local cult of the two apostles centred around what was probably in the 3rd century a funerary

16. **Plan of the Anastasis.** 4th century. The commemorative Sanctuary of the Ascension on the Mount of Olives at Jerusalem was an octagon surrounding a rock where it was said that Christ, ascending to heaven, had left the imprint of his feet.

17. **Plan of the Sanctuary of the Nativity**. 4th century. Bethlehem. The grotto of the Nativity was covered by an octagon, and could be seen by the pilgrims through an open 'oculus' in the centre of the building. The building was completed by a large basilica which has been preserved. In the 6th century the octagon was replaced by a choir with three apses in trefoil shape.

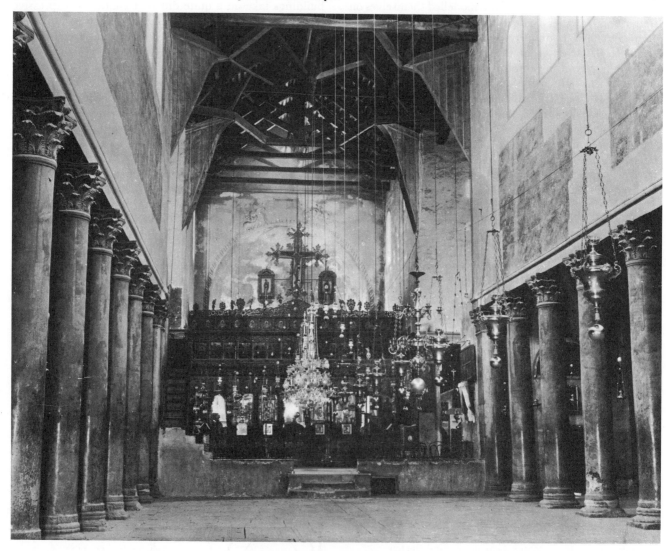

18. **The Sanctuary of the Nativity.** 4th century. Bethlehem. Dating from the time of Constantine the colonnade of the basilica of the sanctuary is one of the earliest surviving examples of Christian architecture. Note the architraves carried by the columns.

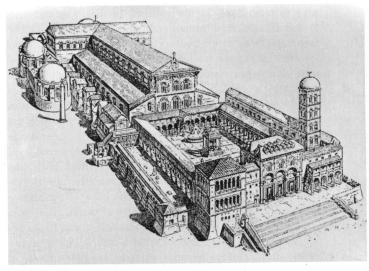

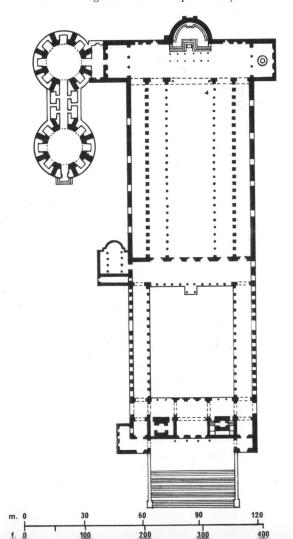

aediculum. On the Vatican hill, after considerable levelling
of the ground, a vast basilica was built around a simple
monument that has just been discovered in the altar of St
Peter's. S. Paolo fuori le mura is a similar case.

The authenticity of these discoveries is of little impor-
tance here. Scientific scrutiny comparable to that of our
time cannot be expected of this early period and a dream
held to have been inspired, provided the best minds with
a guarantee that may be, for us, worthless. The Holy
Sepulchre, as we know from a reference made by Eusebius,
owed its discovery to a dream and St Ambrose found
through a dream the tomb of St Gervase and St Protase.
These monuments illustrate the great work of Eusebius,
the first history of the Church. What is important here is
that the Christian Emperor and his advisers sought to
place in time and space the earthly life of Christ and to
verify and glorify the origins of Christianity.

CONSTANTINIAN CHURCH BUILDING

The help of the Emperor was indispensable to any such
programme—first of all, because of the land question. In
the small towns of Africa—and elsewhere—it was ex-
tremely difficult to erect a vast new basilica in the midst of
a concentrated mass of urban building—the Christian
community houses did not cover a large enough area of
ground and were not necessarily in the town centres. The
churches of the 4th century are near the outskirts of their
towns. This was the price they paid for being able to devel-
op without undue hindrance, with all the ancillary activi-
ties that the community life entailed. Similarly in Rome
the monuments to the apostles—and also the martyria of
other cities—were built over the cemeteries where they
were buried, which were naturally outside the walls. The
Lateran cathedral was built on a large estate bordered by
Aurelian's wall which was given to the Bishop by Constan-
tine, and nearby, was the church of Sta Croce in Gerusa-
lemme. In the East the churches were more determined
to give expression to their triumph. In Constantinople the
church of the Holy Apostles, the church of Divine Wisdom
(H. Sophia), and the church of Divine Peace, (H. Irene's)
were all built within the new city; but this, of course, was
an easy thing to do since they could be included in the
original plans. At Antioch or Jerusalem, such a privilege
involved considerable demolition. Yet a site has been dis-
covered in the Syrian capital very near the imperial palace
rebuilt by Diocletian, on the island that formed part of the
monumental centre of the city. In Jerusalem, the tomb of
Christ was discovered under the pagan temples in the cen-
tre of Aelia Capitolina, the city Hadrian had built on the
site of Jerusalem after its destruction; it was near the tetra-
pyle that marked the principal crossroads.

A major difficulty was the levelling of the ground
necessitated by the proposed building. The tomb of
Christ was of a subterranean type well known in the East
at the time and was closed by means of a heavy, circular
stone (which the holy women feared they would not be

19 *a, b.* **St Peter's, Rome.** 4th century. This monument, erected
by Constantine and his son, was a basilica with a nave and four
aisles and a transept. The dedicatory inscription consecrates
the basilica to Christ, who had allowed the Emperor to triumph
over his enemies. The drawing (*a*) of the 16th century shows
the basilica with all the later additions while the plan (*b*)
shows the building as it was in the 4th century.

m. 0 30 60 90 120

f. 0 100 200 300 400

able to push back on the morning of the Resurrection). It was transformed into an aediculum, around which the sanctuary was to be built. The level of the ground was lowered by at least twelve feet, which was a major operation involving considerable excavation. The rock of Calvary, which now looks like a cube-shaped block, was three hundred feet south-east of the tomb and was included in the sanctuary complex. The top of this rock, in which the Cross had been fixed, was preserved, but the sides and surrounding area were cut straight down to the lowered level of the ground, and a courtyard was formed with this outcrop in the angle; even so the complex remained at a higher level than the street. At Bethleham, fewer altera-

17, 18

tions were needed because the Grotto of the Nativity was kept in its natural form. A hole was made in the rock ceiling and this circular *oculus*, or small window, occupied the centre of the commemorative octagon: the pilgrims stood on a raised surround to look down, over a circular railing, into the natural crypt, where the incarnation had taken place.

19a, b

In St Peter's, Rome, excavations have shown that the Constantinian monument had been organised around an early, very simple, aediculum—two small columns and a horizontal stone slab placed in front of a niche hollowed out of the wall. This structure which was similar to certain funerary monuments in Rome and Ostia was situated over a rich pagan cemetery of a much later period than the saint himself. In order to build the basilica, this cemetery had to be filled in. Moreover, the summit of the hill (now the Vatican hill) on the slopes of which it was built, had to be levelled off. All this involved an enormous amount of work among the splendid mausoleums of the necropolis, including the building of stone substructures to support each of the columns of the sanctuary. The extent of this work shows how the builders submitted the entire construction of a sanctuary to the monument it commemorated. The results of archaeological research limited the architect, and the glorification of the relics imposed expense on the client which could not be avoided. Whether in Jerusalem or Rome, the holy relics were enclosed in marble and surrounded by columns, railings and lamps.

In view of the expense involved in the preparation of these sites, the buildings themselves might have been constructed more solidly. But it has been observed that Christian architectural forms were established at a time when other types of buildings were constructed with elaborate technical methods such as in the basilica of Maxentius in the Forum. These methods were first used in the *thermae*, or public baths—a very large hall, covered by three concrete groined vaults, supported on both sides by lower vaults sustaining the pillars. It was much more like a *frigidarium* than like the pillared, wood-covered buildings that formed the basilicas of the original Forum or even those of Trajan. Confronted with the needs of the Christian church, the architects were unable to exploit these innovations, so they returned to the traditional methods, adopting styles

that were less complex, perhaps because they were cheaper. Constantine was building a capital which was to take up a considerable proportion of the funds available; and the rebuilding churches that had been destroyed in the persecution, together with the enlargements and improvements that were found necessary, required an enormous financial programme. Even when the Emperor asked Bishop Macarius to make plans for as magnificent a sanctuary as possible for Jerusalem, it is probable that the money given for the work was somewhat limited. The destruction caused at Constantinople by the Nika revolt at the beginning of the reign of Justinian does not provide an adequate explanation for the total disappearance of Constantine's capital—perhaps it was just not built solidly enough. In Rome St Paul's was destroyed by fire; the ancient St Peter's had to be razed to the ground before Michelangelo could build a new church; the Lateran basilica was enlarged and altered several times. No trace has been found of the octagon at Antioch; and with great difficulty attempts are being made to find pieces of the walls of the original Holy Sepulchre beneath the plasterwork and rebuilding of the Crusaders. Hardly anything remains except the fine colonnade of the sanctuary at Bethlehem—the octagon that was constructed over the grotto was replaced, under Justinian, by a *trefoil*, a treble apse, and the mausoleum at Rome of one of the Emperor's daughters, Constantina, became the church of Sta Costanza. The discussion about these vanished monuments is never-ending and controversy is increased rather than diminished by the most methodical excavations.

André Grabar has shown that although these commemorative monuments were of very different types, the intention was the same: to serve as a shrine for some holy place, to enable the masses to come as pilgrims and contemplate it without harming it and to assemble nearby for communal prayer. The spectators used to arrange themselves in concentric circles around a single point. The monuments were therefore either circular or polygonal and resembled the imperial mausoleums, which had a similar purpose. This was why the mausoleum of Constantina, which was classified as one of the imperial tombs, could also be classified among the Constantinian *martyria*. It includes an internal circular portico, as later did the sanctuary of the Ascension and the rotunda of the Holy Sepulchre. There is a development here from the round mausoleum to the concentric sanctuary. But this type of building could not be developed indefinitely: in fact, even with its internal colonnade, the diameter of the rotunda of the Holy Sepulchre is no larger than the unbroken diameter of the dome of the Pantheon in Rome. The architects were therefore led to combine the circular structures with the great colonnaded rectangular halls. The two forms could be juxtaposed, linked only by porticos which integrated them into a single composition, as in the churches of the Holy Sepulchre and of the Holy Apostles at Constantinople. They could also be combined,

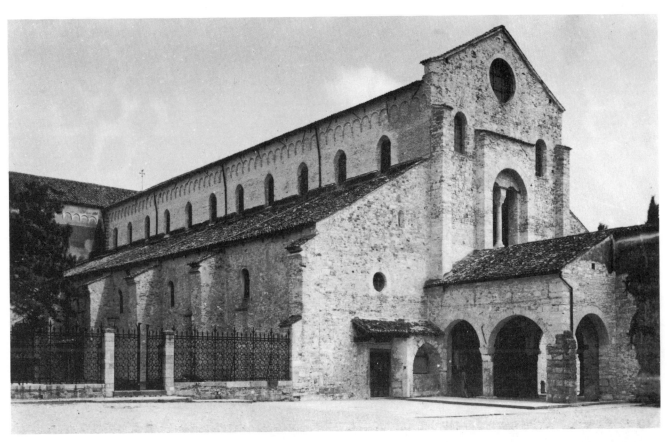

20. **Aquileia cathedral.** 4th century. Veneto, Italy. At the same time as vast monuments were erected with the help of the emperor to celebrate the great souvenirs of Christianity, cathedrals were being built everywhere to replace the more modest churches destroyed in the persecution of Diocletian. The earlier double church of Aquileia was replaced by a basilica with nave and two aisles with a clerestorey.

17 as was the case at Bethlehem, where the colonnades opened directly on to the octagon.

b The ecclesiastical needs that determined the design of St Peter's, Rome, were the same: a monument in which a crowd could be assembled around the tomb of the apostle and which would glorify Christ, whose first witness in Rome he had been. But the architect went further; he added to the basilica a transept, separating it from the apse, in front of which the monument of the apostle was placed at the centre of the three huge radiating areas. The basilica with transept was to have a long future, especially after the second half of the 6th century, when an altar was erected by St Gregory the Great over the tomb of St Peter —that is to say, when the difference finally disappeared between the church as community house and the commemorative monument. Several Greek basilicas and most of the churches in the West were then to become basilicas with transepts. Later the fusion of the two types of buildings chosen by the Constantinian architects, the rotunda and basilica, was to result in the basilica with dome, which became the accepted type of church in the East.

It might be said that as early as the first half of the 4th century, the first architects to deal with the requirements of the Christian church chose or created definitive solutions or prepared the elements of them, the basilica, the rotunda, and the basilica with transept. The influence of the plan of the Holy Sepulchre, or that of St Peter's was to *15, 19a, b* be perpetuated because of the fame of the sanctuaries and the artistic prestige of the architectural solutions. Throughout history, they were to serve as models. Constantine himself may not have played much part in their choice, but it was he who initiated the commissions and set the artists to work. Things really begin with him.

DECORATIVE MOTIFS

The almost total disappearance of these monuments means that there is little trace of their extremely rich decoration. Here, too, the traditions of the Roman artists were adopted without reservation and their motifs used with no concern for the symbolic interpretations that they might have had for the pagans. The decoration of the vaults of Sta Costanza is typical in this respect. They contain *14, 15* complicated geometrical patterns such as can be found in earlier or contemporary mosaic pavements. At Sousse, for example, or at Cherchel, in North Africa, there are many examples of these combinations of circles and polygons with rounded sides enclosing birds, animals, cupids or dancing-girls. Similarly, those scenes of the wine-harvest

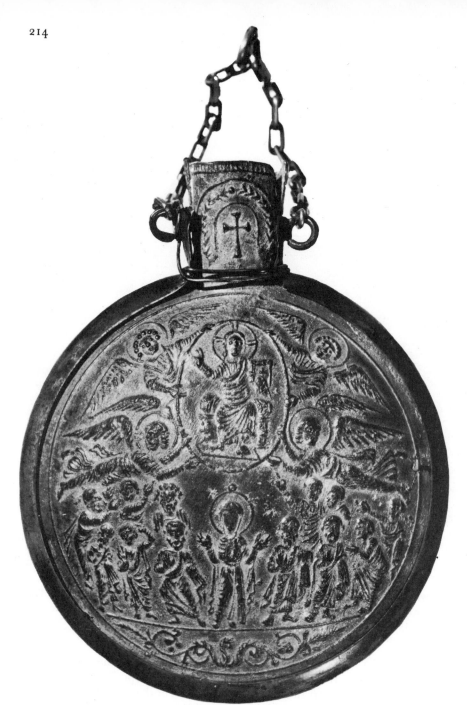

21. **Ampulla.** 6th century. Chase silver.
Cathedral treasury, Monza, Italy.
Bottles such as this were brought back
from Jerusalem by pilgrims, and would
have contained oil of the wood of the
Cross. According to tradition this one
belongs to a collection offered to the
Lombard queen Theodelinda in 625.
It represents the scene of the Ascension of
Christ, borne in a medallion by angels.
Below the Virgin prays among the
Apostles.

that add grace and life to a large vine scroll—the loading
of the ox-carts and naked peasants treading the grapes—
are found throughout pagan art. The vine scrolls depict
the same frolicking *putti* as before. The motif seems to have
slipped without transition from its Dionysiac meaning to
symbolise the Eucharist, and similar motifs can be seen in
the catacombs.

Similarly, in the great mosaic of the church of Aquileia,
which dates from the beginning of the 4th century, animals
quite foreign to Christian symbolism are arranged in
geometrical compositions. These form a framework round
birds and human busts, as well as fish, the Good Shepherd
and scenes that are difficult to interpret, such as the twice-
repeated fight between a cock and a tortoise—the cock,
we are told, symbolises Christ and the tortoise Arianism.
Another section of the pavement represents a sea filled
with fish, which is typical of so many Alexandrian mosaics.
Here, among the traditional fishing scenes in which winged
cupids hold out their lines or throw out the nets from their
barges, one suddenly finds Jonah being thrown from his

ship and swallowed by a sea monster. In another corner of
the pavement, one can make out the prophet asleep under
the gourd. The Christian subject is here treated in the same
style as in the catacombs, but is more intimately linked with
the traditional decorative themes with which it is inter-
spersed.

At the same time a truly Christian iconography seems to
have developed, as can be seen at Sta Costanza, in the
conches of the apsidal chapel, in which Christ is seen in the
sky sitting on the globe, or standing on the rock from which
the four rivers of Paradise flow, giving the Law to the
apostles Peter and Paul. Larger scenes of the same period
are found in the catacomb paintings and on the sides of
sarcophagi, depicting similar subjects, but in which the
whole apostolic college participates. The monuments in
Jerusalem, however, seem to have had a greater variety
of themes judging by some small chased silver *ampullae*,
which came from the Holy Land in the 7th century and
used to contain oil sanctified by contact with the wood of
the Cross, or the soil of the Holy Places. They depict a

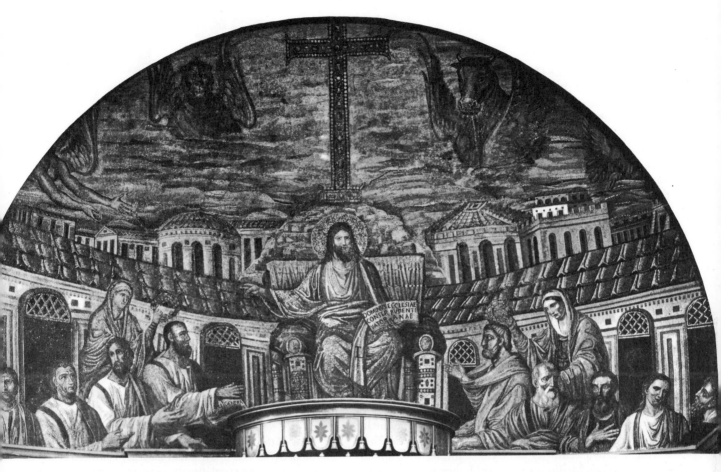

22. **Apse mosaic, Sta Pudenziana.** End of the 4th century.
Rome. Despite a great many repairs, this mosaic is an example
of the decoration of a Roman apse of the late 4th century.
Christ (see plate 20) is enthroned among his Apostles,
accompanied by personifications of the church of the
Circumcision and the church of the Gentiles. In the background
is Golgotha, with the cross planted by Cosntantine or
Theodosius and the symbols of the Evangelists. The view of
Jerusalem evokes the celestial city and it has been suggested
that the rotunda to the left recalls the Sanctuary of the Holy
Sepulchre.

whole series of scenes, either singly or in groups. The icon-
ography is sufficiently stable for one to be able to assert the
existence of well-known models, probably the paintings
and mosaics that decorated the Holy Places themselves.
These scenes include the Resurrection, with the holy women
arriving at the tomb and being met by the angel. The tomb,
as was often the case, was represented in the form of the
aediculum erected by the Constantinian architects around
the Holy Sepulchre. There is the Ascension, the Crucifixion,
the Annunciation, the Visitation, the Nativity and the Bap-
tism of Christ. Some of these pictures were probably intro-
duced into the monuments of the Holy Land at a later date;
but it is nonetheless possible, to recognise in some of them
at least a reflection of their original decoration.

The late 4th-century mosaic in the apse of Sta Puden-
ziana helps us to interpret the images of the *ampullae*.
Christ is enthroned in the centre, surrounded by the
apostles and two female figures, which are interpreted as
allegories. Behind the throne is a rock—the rock of Calvary
—surmounted by a cross, either the one planted there by

Constantine or that of Theodosius II, if the latter the
mosaic is of a slightly later date. Behind this are the monu-
ments of Jerusalem—the sanctuaries built around the
Holy Places mentioned earlier, which here suggest the
celestial Jerusalem. In the sky appear the apocalyptic
symbols of the Evangelists.

Such a work, which is related to the simpler works in
Sta Costanza and to the scenes depicted on the sarco-
phagi and in the catacombs, reveals an established icono-
graphy in which scenes from the earthly and the heavenly
lives of Christ are intermingled, as if to emphasise the two
natures he unites within his person. The second person
of the Blessed Trinity lived in Palestine under the reign of
the Emperor Tiberius. His earthly life was soon to be de-
scribed, as well as the history of the patriarchs on the walls
of Sta Maria Maggiore, Rome. From now on his sovereign-
ty was recognised, was shown in pictures where the Saviour
is enthroned in the midst of his apostles like an emperor in
his court. And the cross of suffering became, through the
emperors, the very sign of his triumph.

Basilicas and Sanctuaries

THE CHRISTIAN BASILICA

The recognition of the Christian Church by the State obviously reassured those who hesitated and the number of conversions increased. The communities already in existence expanded and new ones were rapidly created. Sooner or later all those who could afford to do so built their own churches, many of which have disappeared; but enough have survived to give an idea of their form and development. Thus in certain provinces of the Roman Empire there are numerous well-preserved basilicas which give a better idea of the architecture of the time than the churches in the countries which remained Christian. The latter were usually enlarged and altered according to the changing demands of the liturgy or of taste, and seldom give such a complete and unadulterated picture. Places like Ravenna are important exceptions. The later Muslim invasion of Syria, for example, created a frontier over the Taurus, ruining the peasants of northern Syria, who lived solely from the cultivation of olives, by cutting them off from the buyers of their oil. They were forced to go down into the plains, abandoning their villages and churches, in order to be able to sow corn. As a result the buildings are almost the same as they were in the 7th century, apart from earthquake damage.

In examining all those buildings erected to serve the liturgical requirements of the community, one realises that during the two centuries after Constantine, throughout the whole of the Mediterranean world, they were unexpectedly similar—at least at first sight. Looking more closely at the plans of these buildings, the numerous important differences become obvious, but the resemblances dominate. All these churches are basilicas, or to be more precise, they are basilicas with three aisles, facing east, with a raised apse at the east end. The central nave is nearly always broader and higher, and is lit by a clerestory above the colonnades. In the first half of the 4th century there are a small number of basilicas in which, as in the Constantinian buildings, the columns support architraves. After some hesitation, due to reasons of economy rather than of symbolism—for the high shafts needed for architraves were very costly—arcades supported by columns were soon adopted almost everywhere.

This is a much more precise definition than that given of the Roman civil basilica, which was a rectangular pillared hall, with clerestory, often with an apse at the end of one of the smaller sides. More often, however, the building was surrounded by the colonnade on the four sides and there were many variations of it not to be found in the churches. The Christians adopted one particular type of civil basilica, perhaps influenced by the basilical halls that were to be found in the imperial palaces, or perhaps because this plan had already been thought suitable for the religious meetings of other cults, as in the famous 'Pythagorean basilica' of the Porta Maggiore, certain Mithraea, or particularly in some synagogues. It was a convenient formula and it is quite probable that it was

23. **Plan of the basilica at Kharab Shems.** 5th century. Northern Syria. It is in Syria that the early Christian churches have best been preserved, usually in small village parishes; they are modest but carefully built in chipped stone and timber. This church has a nave and two aisles with an eastern apse and two eastern chapels.

recommended, officially or unofficially, by imperial example—Mr Ward Perkins has shown that the cathedral at Rome, the Constantinian basilica of the Lateran, did not originally have the transept with which it was later provided in imitation of St Peter's. It could therefore have served as a prototype.

In any case, the model was adopted everywhere—often for centuries. Churches of every period, despite changes in methods of roofing, answer the same description. In the West the general appearance was to be somewhat modified by the spread of the transept, first created at St Peter's, and in the East by the introduction of the cupola and vaulting. In Syria there were façades with two towers—the ancestors of the Romanesque and Gothic façades—from the end of the 5th century.

We are not concerned here simply with architectural tradition. Once a particular type of basilica was adopted it became canonical—and was preserved even when new building techniques made some of its formulae entirely obsolete. So even in our time columns or pillars are retained in churches built of reinforced concrete which could easily be covered with a single span. It is difficult for religions and for ecclesiastical hierarchies not to regard as sacred—whether consciously or unconsciously—whatever tradition has handed down from the past.

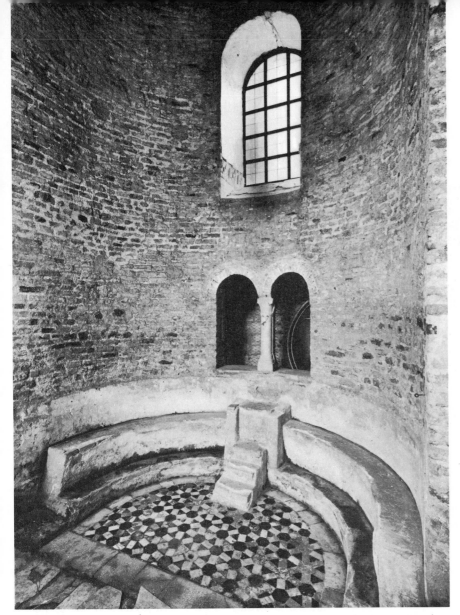

29a

24. The Bishop's chair in the apse.
Church of Sta Maria delle Grazie, Grado,
Italy. The apse of the 5th-century church
showing the floor mosaic which was found
almost intact under a later floor, has
preserved the circular bench (*synthronon*)
for the clergy, and the bishop's chair.
The altar used not to be in the apse.

This fidelity to tradition was all the more curious in that the basilical form was not, even from the very beginning, necessary for the performance of the liturgy. The mass was not presented as a spectacle that took place in the apse, attended by the congregation seated in the nave and two aisles. The apse was more like a presidential tribune, with the bishop's throne placed in the centre, surrounded by a semicircular bench intended for the clergy. According to region, and sometimes in the same region, the altar occupied different places in the building. In Syria it is sometimes found against the rear wall of the apse—in which case there was obviously no *synthronon*. At other times it is placed at the front of the apse, just above the steps. In North Africa, or in Greece, it is often found in the nave immediately before the steps of the apse, or even in the middle of the central nave. The placing of the railings (chancels) which mark off the area reserved for the clergy, provides further evidence of these differences. The *ambo*, intended for readings and sermons, had various forms: sometimes it was attached to the chancel, and sometimes it was placed further into the nave. In Syria, it was replaced by a *bema*— a semicircular dais, forming a counter-apse in the middle of the nave, on which the clergy sat around a lectern for the first part of the *synaxis*. In the East, the apse, occasionally open to the nave, was usually shut off by a curtain before being permanently cut off by the introduction of the partition known as the *iconostasis*.

In view of these variations, the congregation occupied different parts of the basilica—especially in the East where the Semitic custom of keeping the men and the women separate in the synagogue was maintained. Sometimes, as at Philippi in Macedonia, the whole nave was reserved for the movements of the clergy; they even went so far as to build galleries over the side aisles, the *matroneum*, to keep the women apart.

The apse was often isolated, projecting beyond the east end, but frequently it was completely enclosed by the eastern wall of the church. At this point two rectangular rooms were created on the right and left sides, which served as sacristies. In Syria, from the beginning of the 5th century, the one on the south side became a chapel dedicated to the relics of the martyrs. Later, in the Byzantine liturgy, they came to be called the *prothesis* and the *diaconicon* and played a necessary part in the performance of the eucharistic *synaxis*.

At a time in which the liturgy had no strict form—even within each province—the building was adapted to different needs, concurrently and successively. The basilica was not the mould which decided the form the ceremonies would take, but an adaptable hall, which the clergy

25. The Ambo. 5th century. Leptis Magna, Homs, Tripolitania. The ambo of the Christian basilica of Leptis Magna was constructed of capitals and marble slabs from pagan monuments. It was built on the axis of the nave of the

26. The 'Bêma'. 5th century. Western church at Behyo, northern Syria. Clearly seen in the centre of the nave the bêma is a semi-circular chancel which, in the Syrian liturgy, was used by the clergy during the first part of the mass for reading and preaching.

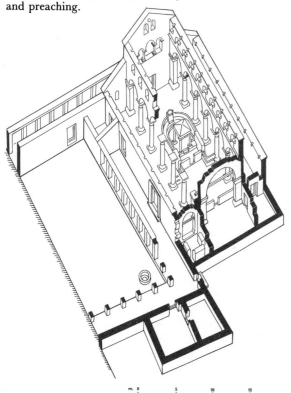

civilian basilica, which was erected by the Emperor Septimius Severus, in the town of his birthplace, and was transformed into a church under Justinian.

altered according to their own needs and tastes. This is still the case; following the recent Vatican Council for example the old basilicas are once more undergoing changes that are liturgical in origin.

It should be added that the basilica did not become the whole church all at once. For too long the Christian community had been using a house containing many different rooms. The basilica only replaced the meeting-hall and was usually surrounded by a number of other buildings, arranged around a courtyard, sometimes in front of the west façade and treated as a decorative element—the *atrium*—and sometimes on the south side, treated simply as a utilitarian addition. Among these buildings devoted to the various episcopal services were the baptistery, the catechism room (the *cathecumeneum*), chapels dedicated to the martyrs, funerary chapels and rooms which might have been used as a school, as offices and as accommodation for the bishop, the clergy and guests. Here again, there was a great deal of variation; sometimes the plans seem to have been conceived as a whole by an architect, at others one feels that the building has grown with the needs and the means of the community.

The form of the basilica was a beautiful one, on the outside and inside. It allowed interpretations such as the majestic colonnades of Sta Maria Maggiore in Rome and the church of the Nativity in Bethlehem, or the more graceful and delicate colonnades of Sta Sabina in Rome and of S. Apollinare at Ravenna. There is the complex of buil-

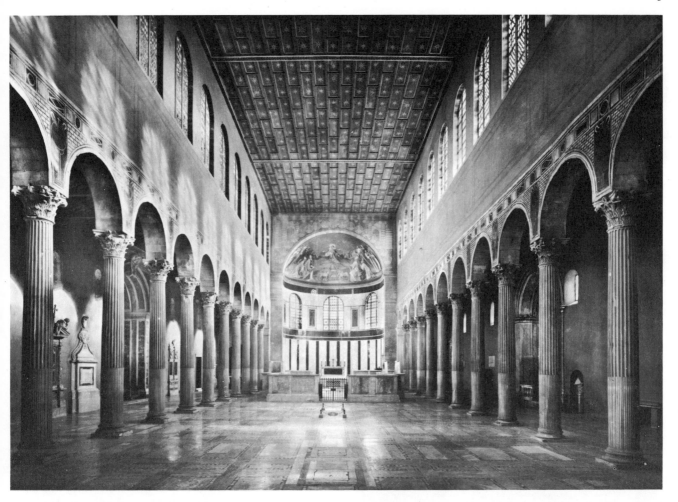

27. **The nave of Sta Sabina.** 422–32. Rome. The basilica is typical of the plan of the Roman basilicas of the 5th century.

The beautiful columns and capitals, perhaps from an older building, contribute to the grace and elegance of the church.

28. **Aerial view of Hippo Regius,** Algeria. The aerial view of the Christian quarter shows the basilica with its nave ending in an apse, and two aisles, surrounded by numerous dependent buildings—baptistery, chapels, courtyard, library, *triclinium* and dwellings. This was very probably where St Augustine spent his years as bishop.

dings at Jerash, in Jordan, with its *propylaea*, its two churches one after another, separated by the courtyard in which, on the feast day, the miracle of the marriage-feast at Cana was enacted and wine flowed from the fountain. The picturesque austerity of the basilicas of southern Syria was due to a special building method whereby the roofs were covered solely by lava cut into long slabs— which necessitated a series of transverse arches. Or one may prefer the charm of the small churches of northern Syria, built, like their villages, in limestone from the hills on which they stood, and in which there is a proliferation of carved decoration that covers the capitals, lintels and arcades, enriched with mouldings which run like garlands from window to window along the façades.

The Christian basilicas of the 4th and 5th centuries vary so much, both in their architectural outline and in their decoration, from Istria to Tripolitania, from Spain to Macedonia, as to make the Christian art of each province worthy of separate study.

Among these provinces, there were some that followed different paths, probably because of different architectural traditions. In Asia Minor, for example, there appeared, at Binbirkilisse, the Thousand and One Churches, the first vaulted basilicas. They were of limited dimensions, with narrow aisles of almost equal size, filled with heavy pillars, which were very dark, because the builders did not dare to make a clerestory beneath the vaults. They are scarcely

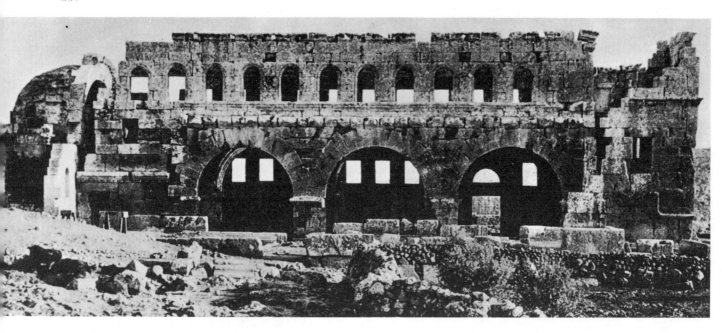

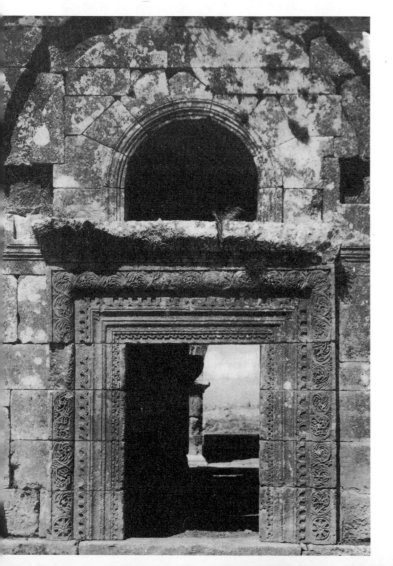

29 *a, b*. **Qalb Louzeh.** *c.* 500. Syria. The exterior of the church from the north (*a*) shows the sturdy construction of the standing wall between the nave and side aisle, the regular arches of the clerestorey windows, and the rounded apse to the east. The south-west door, seen through the arch to the extreme right, is illustrated here (*b*) to show the typical elaborately carved decoration of the portal (see plate 27).

more than curiosities, but they pose the problem that was shortly to alter Christian architecture.

THE SANCTUARIES OF THE MARTYRS

It was also because of the frequent presence of vaults, and, here, of domes, that the monuments built to the glory of the martyrs have a particular architectural importance. Before the *Pax Ecclesiae*, the rites with which they had been honoured in the cemeteries had been of a discreet kind; the community honoured their martyrs in the same way as the families honoured their dead. But with the triumph of the Church, things became quite different. Each church was proud of its martyrs, and believing with some justification that the list was now complete, a liturgical calendar was drawn up, and each saint was celebrated on the anniversary of his death. The Church also began to honour them with sanctuaries which grew in size and wealth in order to receive the crowds who came on pilgrimage.

At Salona particularly, but also at Trier in Gaul, or Tipasa in Mauretania, the development of the monuments may be traced from the simple tomb, more or less decorated and enlarged, to the mausoleum and sanctuary. Even in Rome, on the spot said to be '*ad catacumbas*', there existed in the 3rd century only a very simple monument surrounded by a courtyard onto which opened a hall intended for funeral feasts. We know from graffiti that this group of buildings was connected with the cult of St Peter and St Paul. After the *Pax Ecclesiae*, these buildings were filled up and over them was built a vast basilica, in the form of a Roman circus, with a nave that was possibly not covered. In Rome, basilicas were built over the catacombs to allow the crowds to honour the martyr buried in the gallery beneath. At Salona one can see the development of basilicas, either covered or not, from an *exedra*-shaped mausoleum. Other vaulted, two-storeyed tombs provide a hall for devotion over the funerary hall. But also at Salona a cruciform church soon developed, built according to the usual methods used in basilicas.

Here and there other forms appeared, sometimes linked, as in the time of Constantine, with basilicas: the same

30. **Plan of martyria, cemetery of Marusinac.** 5th century. Salona, Dalmatia. The tombs of the martyrs were covered with a large mausoleum or even a basilica, sometimes preceded by porticos. Several sanctuaries were grouped together in a cemetery with a courtyard and a few tombs of devout Christians.

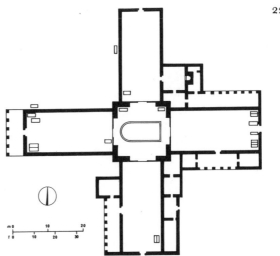

31. **Martyrion of St Babylas.** 381. Antioch-Kaoussié, southern Turkey. The cruciform monument was erected round the tomb of the martyr-bishop Babylas. It has no apse; the focal point of worship was in the central square, where a platform for the clergy was placed next to the sarcophagus of the saint. Bishop Meletios, who built the church, also wished to be buried there.

lateral treble apse is to be found at Corinth and Tebessa; isolated, in Jerusalem, it forms the *martyrion* of St John the Baptist. At Mount Nebo we find it over the 'Tomb of Moses'; in the White Monastery at Sohag, in Egypt, it replaces the apse. In Armenia, the *quatrefoil* (with four apses) is found in several places, at Bagaran and Vagarshapat, modern Echmiadzin, but there is also one at Tsaritchingrad, in Serbia.

The quatrefoil can also become an open baldachin or canopy, with pillars and columns surrounding the apses. On the outside the monument containing it might reproduce its shape, or keep to a more simple outline, a rotunda, for example. Trefoil monuments are to be found in Syria, at Seleucia Pieria, Apamea, Bosra and later at St Sergius' at R'safah. But there was also one in Athens, in Hadrian's *stoa* and another at Perustica, in Bulgaria. Perhaps the oldest example of the series is to be found in Milan, at S.Lorenzo. It is also the most monumental, the most faithful to Roman building methods—the one in which the derivation from the mausoleums of imperial Rome is most apparent, despite the new developments of the plans. But all these buildings had to face the very delicate problems of the joining of the vaults – though in different terms according to the form of the exterior shell. Even more than the balance of the cupola, which was sometimes quite light, or was even replaced by a pyramidal or circular wooden roof, it was the work of these complex collaterals, often repeated on a higher storey, that forced the architects to innovate.

The development of more simple forms is also apparent. In 381, at Kaoussié, on the outskirts of Antioch, Bishop Meletios had a great cruciform *martyrion* built in honour of his predecessor, St Babylas, martyred under the Emperor Decius. It was a square with sides fifty feet long formed by four arches, a *tetrapyle*, similar to those that were built at crossroads. Backing on to these arches were four halls each eighty feet long, forming a free cross, the branches orientated to north, south, east and west. This monument was not vaulted—unlike the mausoleum of Galla Placidia at Ravenna, which has an analogous scheme

in miniature. This plan was to be developed elsewhere, first at Ephesus, where, over the tomb of St John, around a square monument, with four arches similar to the one at Antioch-Kaoussié, four basilicas were built to form a cross. The monument, orientated, looked somewhat like a basilica with projecting transept. On the other hand, at Qalat Siman, in northern Syria, around the column at the top of which St Simeon Stylites had lived for thirty years, an eight-arched octagon was erected and, on this octagon, four radiating basilicas each with a nave and two aisles were built. It is not known whether the octagon was covered or not: it has even been suggested that there was a quatrefoil. Around this vast, complex and cleverly constructed monument some fine monastic buildings were erected, a baptistery and adjoining churches. At the foot of a triumphal way, leading from the valley and punctuated at intervals by arches, was an entire pilgrimage town with monasteries and hostelries. This magnificent group of buildings, still remarkably well preserved, was the most ambitious and the most successful example of Christian architecture before H. Sophia, Constantinople. St Simeon Stylites had died in 459 and the construction of the sanctuary was started soon afterwards. Such a building is indicative of the honour which was paid to the ascetics, who were now accorded in part the veneration formerly given to the martyrs by the masses. The body of St Simeon had been brought back to Antioch to protect the city, whose walls had been destroyed by an earthquake in 458. It is possible that the Emperor Zeno encouraged the building of a sanctuary around the column in an attempt to re-establish union between the Christians which he sought at the same time through his *Henotikon*, or Edict of Peace.

BAPTISTERIES

Apart from the *martyria*, a study of those buildings with a centralised plan should include the baptisteries, which were never developed in so monumental a way. The baptistery remained the centre of one of the fundamental ceremonies of an expanding and converting Church. On Easter night the adult catachumens gave proof of their

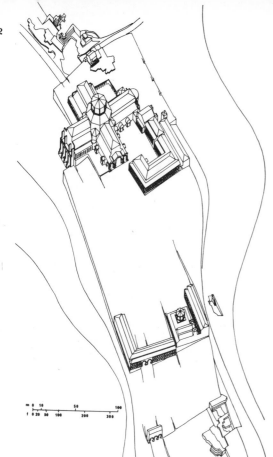

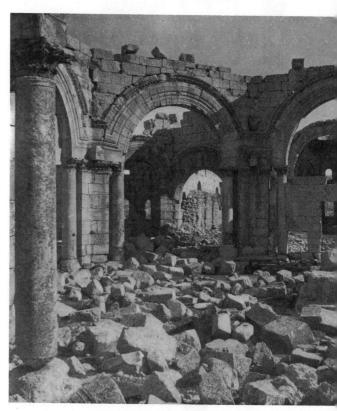

32. *a, b*. **Qalat-Siman.** 459–480. The sanctuary and the convent of St Simeon Stylites. (*a*) The reconstructed view of the complex in about 500 is after a drawing by Georges Tchalenko. Above are the stone quarries, then the great cruciform monument radiating from the octagon (*b*) erected round the column where the saint lived for thirty years. To the

right the porticoed buildings of the monastery. Below, the dome of the baptistery is flanked by a side basilica, and other guest buildings. The monumental gates mark the beginning of the sacred way which descends the valley, where a pilgrimage town developed with convents and hostelries (plates 26, 27).

religious preparation, recited the symbol of the faith and were brought before the bishop for the initiation ceremony. They were plunged naked into the bath three times, were then anointed and, dressed in white, admitted to the eucharistic office. Around the bath used for the immersion, which was often covered by a stone canopy, the baptisteries were square or circular, with a trefoil or cruciform plan. Like the *martyria*, they introduced the use of domes, which, as can be seen at Djemila in Algeria or at Salona in Dalmatia, break the linear uniformity of the roofs of the basilicas, porticos and outbuildings. Within a definite programme and with traditional forms that were to be found everywhere, the early Christian architects were still able to express their own personalities.

It should be noted that in all these monuments, the dome and a centralised plan on the one hand, or basilica, on the other, are juxtaposed, or combined, but never mixed. Each element retains its own system of construction. Even in the basilicas with transept, the existence of perpendicular aisles does not present the problem of covering a central square: the rectilinear roof of the transept is perpendicular to that of the nave which rests against it.

Two non-architectural factors were to compel the architects of the end of the 5th century to face the problem of the dome.

The first of these was the introduction of the cult of the martyrs into the parish church, and even into the cathedral. For a long time, mass had been said in the *martyria* of the cemeteries. The merging of the two cults resulted in the

disappearance of the differences between the two types of building, which, in any case, had never been completely divorced. The church became a *martyrion* and the *martyrion* became a church and the two tended to become similar. At Antioch-Kaoussié there is no east apse, whereas both Ephesus and Qalat Siman have one.

The second factor was the discovery of the cruciform plan. Sanctuaries had always been built in the form of a cross, whether the branches appeared outside or merely inside the building. The branches naturally resulted from the buttresses which were necessary to pillars supporting a dome. Similarly, the transept of St Peter's formed a cross. But one cannot be at all sure that this fact was conscious. In pagan architecture there had been many buildings, *thermae* or mausoleums, based on a cruciform plan, to which no one had dreamed of giving a symbolic value. It was at the end of the 4th century that the bishops—St Ambrose was perhaps the first—thought of the symbol: *Forma Crucis templum est*. The temple is in the form of a cross; the temple is the Sign of the Cross.

Thus the expansion of the transept, and the introduction of the dome at the centre of the basilica were given a religious reason and value. The basilica was retained, but it now ended not in the apse, but in a square, preceding the apse, with projecting perpendicular arms to the north and south and that square was ready to receive the Byzantine dome. And it was the Byzantine dome, with its weight and thrust, that was to alter entirely the methods and forms of Christian architecture in the East.

Ravenna and Mosaics

In order to get a first-hand understanding of the Christian art of the 5th and 6th centuries, one can do no better than go to Ravenna. This refuge city in the marshes bordering the Adriatic, owed its fortune to Augustus, who made its port Classis the base of the Adriatic fleet. At the beginning of the 5th century, the Emperor Honorius settled there and it was his sister, Galla Placidia, who, governing the state for her son, Valentinian III, from 425 to 450, gave the city the appearance of a capital. Theodoric, the Gothic chieftain, who, with the agreement of Constantinople, became king of Italy, also took up residence there and continued to embellish it. At the time of the Justinian conquest, Belisarius made Ravenna the capital of the exarchate that represented the Byzantine State in the West. The local development of architecture and of the art of mosaic shows the mixture of Italian traditions and eastern influences. The relative importance of one or the other in a particular work, or in Ravenna as a whole, will always be open to discussion. It is at all events one of the most successful and easily studied examples of Christian art.

For ten centuries mosaic was to be the decoration of the eastern churches. At Ravenna, the mosaicists had to solve all their problems—technical, decorative, figurative and iconographical. Little is known of the extent to which mural mosaics were used before the 4th century, though extraordinarily rich and magnificent collections of pavement mosaics have survived. The development of this art can be traced from its origins in Greece, whence it became so extraordinarily popular throughout the Roman empire. Recent discoveries have enabled the study of the pavement mosaics of the 4th century—in Syria, in Africa and, above all, at Piazza Armerina, the great Sicilian villa, where the Emperor Maximian, the partner of Diocletian, is said by some to have retired after the voluntary dissolution of the tetrarchy in 305. We know nothing of the walls of this building, nor of many African villas of the same period, yet it seems that the fresco was still the normal method of mural decoration. However, surprises are always possible —at Pompeii, for example, mosaic was used only in the decoration of fountains. In the 4th century it is sometimes used in funerary monuments, as in the Christ-Helios or Sun Christ, in one of the mausoleums discovered beneath St Peter's in Rome and, also, this time in a really monumental way, in the mosaics of the vaults of Sta Costanza.

There does not appear to have been any break: the decorative motifs of Sta Costanza as we have seen are directly related to the composition of the floor mosaics of the time. Later the first difference was in the increased use of glass cubes. The mosaicists obviously limited the use of these for floors for reasons of permanence—golden cubes for jewels, red or blue cubes for the plumage of certain birds, and sometimes blue and green cubes for the sea. As might be expected, these cubes proved too fragile and have generally disappeared.

This limitation was no longer necessary in mural mosaic.

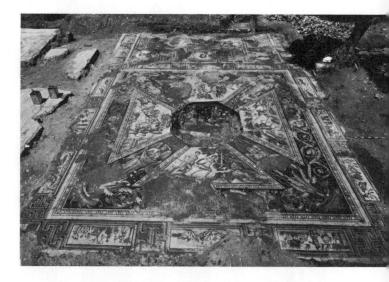

33. **Floor mosaic of the seasons.** 4th century. Antioch, Turkey. This typical composition of scenes radiating round a central portion was later adopted in mosaic decoration of vaults. This shows the tradition of floor mosaics which, used in the time of Constantine was influenced by classical models and in turn influenced later Christian mosaicists.

34. **Decoration of the vault of the Pantheon.** c. 120. Rome. The panelled relief decoration is typical of the Roman solution to the problem of decorating the vault.

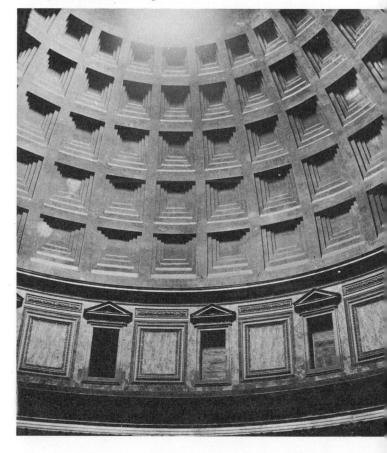

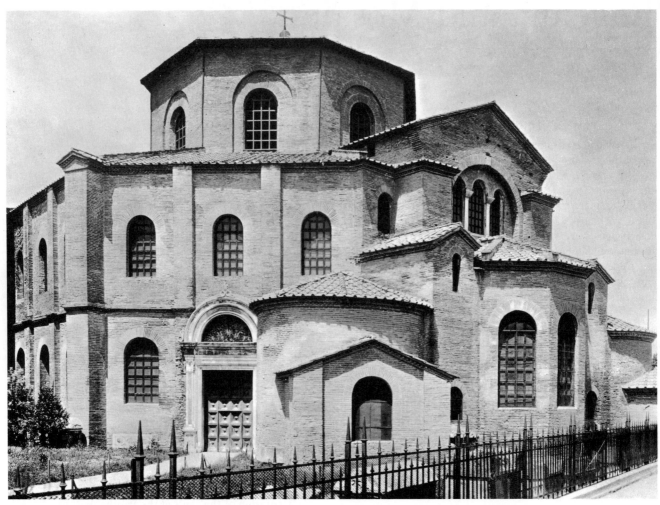

35. **Exterior of S. Vitale.** 546–548. Ravenna. The outer octagon is clearly distinguished in this view, and rising above it the central octagon which surrounds the dome. On the right the aisle is broken by the perpendicular roof of the presbyterium. The triple-arched window rises above the apse surrounded by its complex symmetrical dependent chapels. There is no external embellishment, the brick walls being divided only by light buttresses (see plate 33).

White backgrounds made of limestone or marble were replaced first by blue then by gold, giving a splendid brilliance, the quality of light found in the interiors of Byzantine churches, and first found at Ravenna. The blue effect of the mausoleum of Galla Placidia, enriched by the golden glow from the alabaster plaques of the windows, reveals a new sensitivity and feeling for colour. Surely the Roman monuments, with their plastic panelled decoration, enclosing painted motifs in deep mouldings, could not have produced anything like these mosaics. We are now in an architecture of bricks and plaster and it is almost always strips of mosaic and not mouldings that are used to accentuate the structure of the buildings.

The mosaicists were now confronted with surfaces to decorate—or rather with all the solid areas of the interior, in the midst of which the spectator stands. Already in Ravenna they seemed to delight in varying these surfaces and masses. There were Christian basilicas of the normal type, with columns, clerestory, beamed roofs and vaulted apse in the form of a half-dome, and monuments with a centralised plan—the domed polygonal baptisteries and the cruciform mausoleum of Galla Placidia, with groined and barrel vaults. The culmination of this, the fully Byzantine monument, is the octagon of S. Vitale, which is incomparably light and still has intact, in its *presbyterian*, all its mosaic decoration. So there were not only expanses of wall to decorate but also walls broken up by windows and blind arcades, semicircular tympana and hemispherical apses, vaults and domes all posing complicated, but exciting problems for the imagination of the decorators.

Of course, the basic solutions to the different problems were not necessarily discovered in the workshops at Ravenna. Many of them had already been found and the corresponding motifs chosen—in the Christian catacomb paintings or sarcophagi, in monumental Roman art and even in earlier times. Ever since the Assyrians, if not before, the motif of the procession had been adapted by artists into a rectangular composition where figures of equal height followed each other in a direction determined by the axis of the monument. The motif of the military procession was followed by that of a triumphal procession moving towards a god or a king seated on his throne, surrounded perhaps by dignitaries. The frieze of the Parthenon was a free variation of this theme—the gods, on the west side, received the procession of the Panathenaeas, the two columns of worshippers who, after regrouping in the east, had advanced towards them through the north and south. This traditional theme was used to magnificent effect at St Apollinare Nuovo where, setting out from the two towns of Ravenna and Classis, the martyrs and saints

(Continued on page 241)

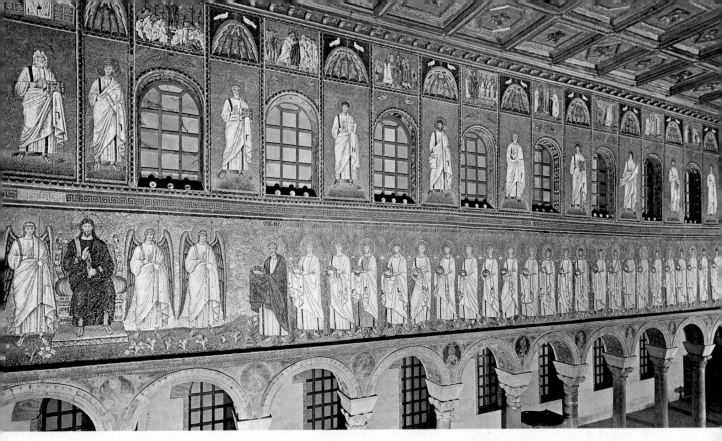

29 (above). **The Procession of Martyrs.** 5th–6th centuries. Mosaic. St Apollinare Nuovo, Ravenna. This view shows the decoration of the south wall. Over the arches is a mosaic frieze of the procession of the martyrs, leading to the enthroned Christ at the east end. Above, between the windows of the clerestorey, are figures of saints represented like statues in niches; over each window is a mosaic from the narrative cycle of Passion scenes.

30 (below left). **The healing of the paralytic**. Early 6th century. Mosaic. St Apollinare Nuovo, Ravenna. The narrative scenes above the north clerestorey windows depict Christ's early miracles. The healing of the paralytic follows the scheme of the original iconography of the sarcophagi, with Christ and an apostle to the right and to the left the miraculously healed man, carrying his bed on his back.

31 (below right). **The Last Supper**. This iconography was to be of long duration. Christ, with Peter beside him, Judas opposite and the other apostles recline round a semicircular table, of the sort that used to seat thirteen Romans.

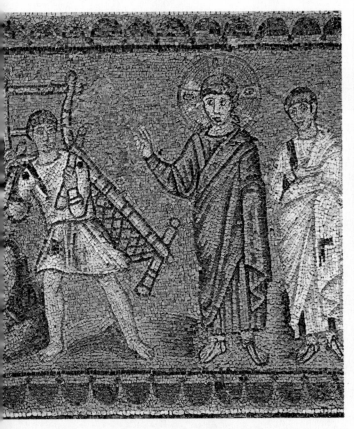

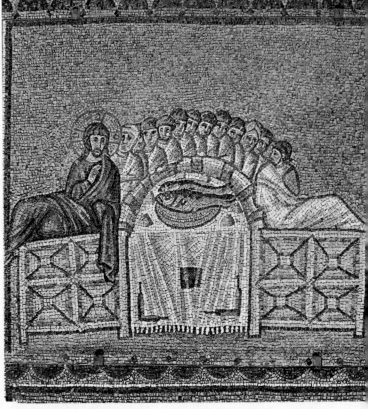

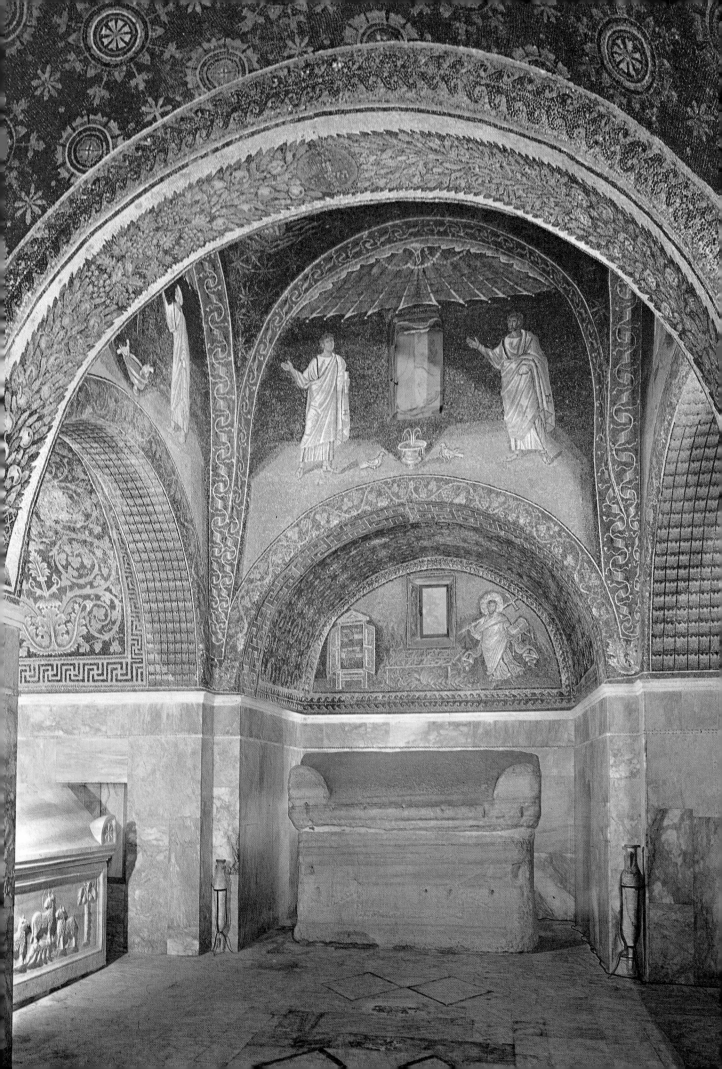

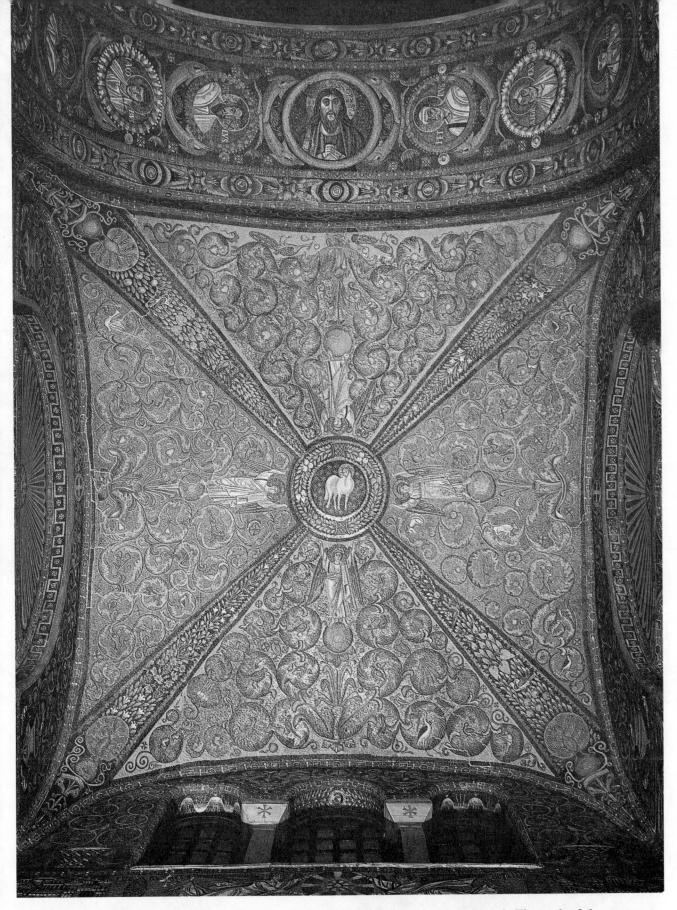

32 (opposite). **The Mausoleum of Galla Placidia.** Mid 5th century. Ravenna. The mosaic decoration of the cross-shaped mausoleum continues uninterrupted over the whole of the upper surface. The architectural divisions are indicated by borders of mosaic garlands and geometric patterns. Dedicated to St Lawrence it contained the sarcophagi of Honorius, Galla Placidia and her husband Constantius III. Grey marble revets the lower part of the walls.

33 (above). **The vault of the presbyterium of S. Vitale.** 546–548. Ravenna. Four arches, one decorated with medallions of Christ and the apostles, support a groined vault; the angels standing amidst the foliated decoration bear in triumph the central wreath of the Blessed Lamb.

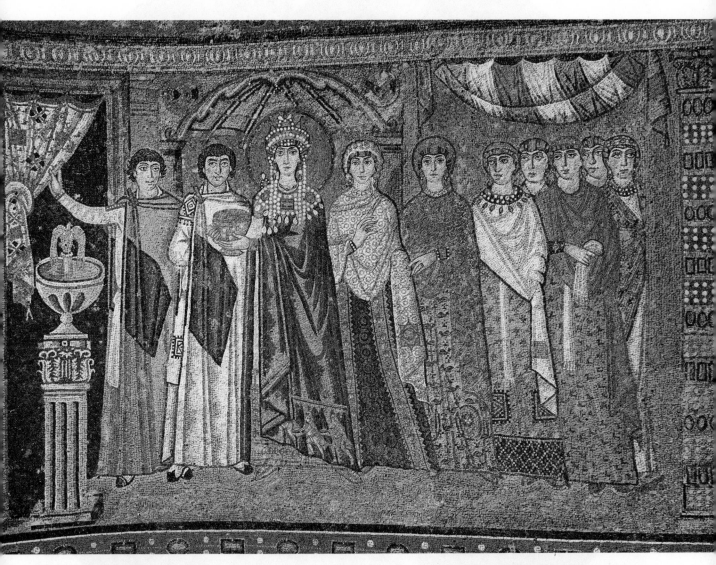

34 (opposite). **Detail of the robes of Theodora's attendant.** 546–548. Mosaic. South-west wall of the presbyterium of S. Vitale, Ravenna. The mantle is woven with a geometric pattern, and the plain dress beneath has borders embroidered with flowers. The colours and the skilful placing of the *tesserae* can here be seen to full effect.

35. **The Empress Theodora and her suite.** 546–548. Mosaic. South-west wall of the presbyterium of S. Vitale, Ravenna. Theodora and her attendants advance in stately procession towards the Christ represented in the apse. She carries a jewelled chalice and is surrounded by stately regalia. Two dignitaries precede her into the church in front of which stands an elaborate fountain. The noble, huge-eyed faces and magnificent colours are the essence of the glorious art of Byzantium.

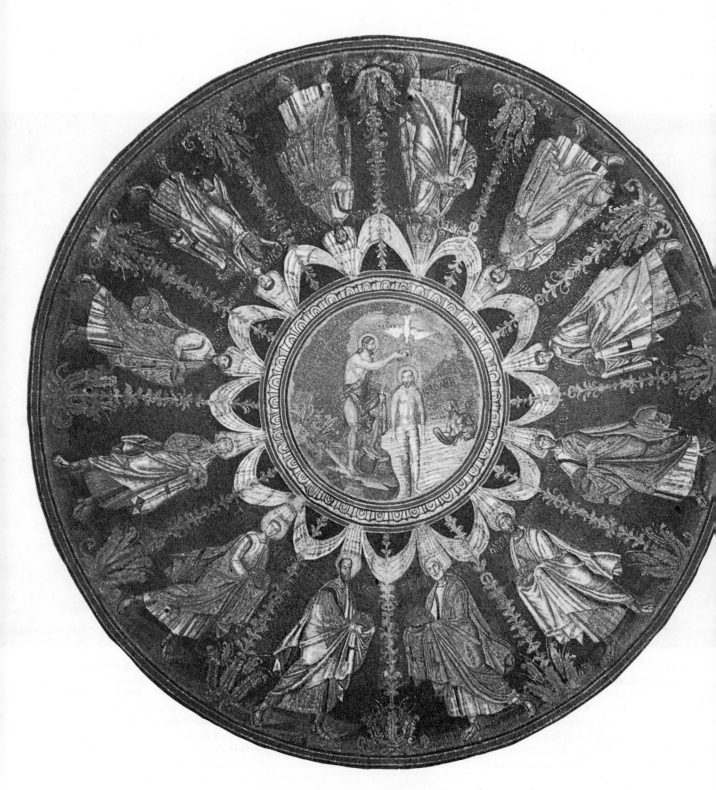

36. **Part of the vault mosaic
of the Baptistery of the Orthodox.**
5th century. Mosaic. Ravenna. This
central portion of the vault mosaic shows
the *Baptism of Christ* in the central
medallion, with the surrounding
procession of the apostles. The frontal
faces belie the movement of the robes and
the placing of the apostles' feet.

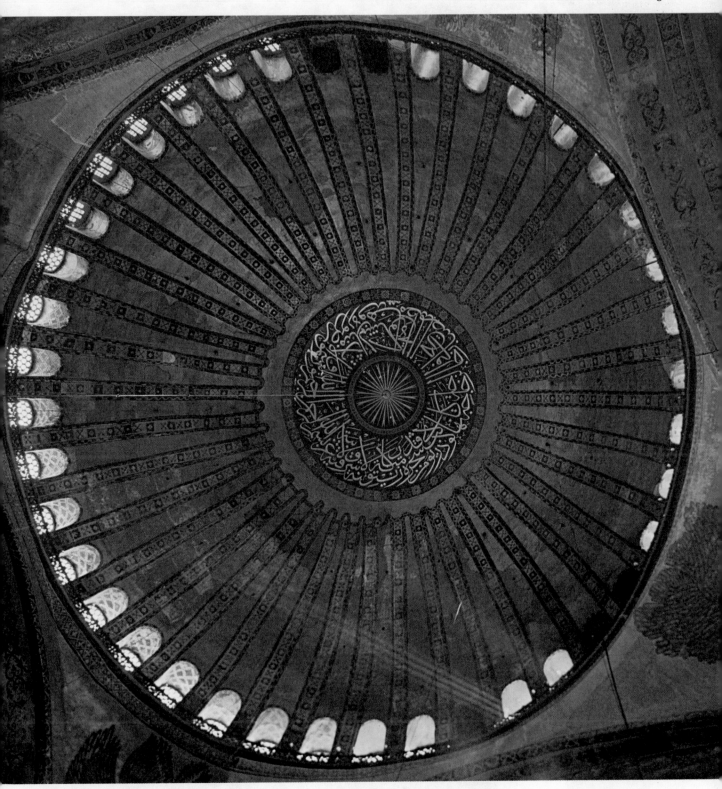

37. **View of the golden dome of Hagia
Sophia.** *c.* 563. Mosaic. Constantinople.
The magnificent mosaic dome of the
basilica was first constructed in 537. It
collapsed in 558, and was replaced by the
present dome, which suffered damage in
939 and 1346. Despite these misfortunes
the glorious vault which soars above the
majestic spaces of the nave remains
superbly impressive.

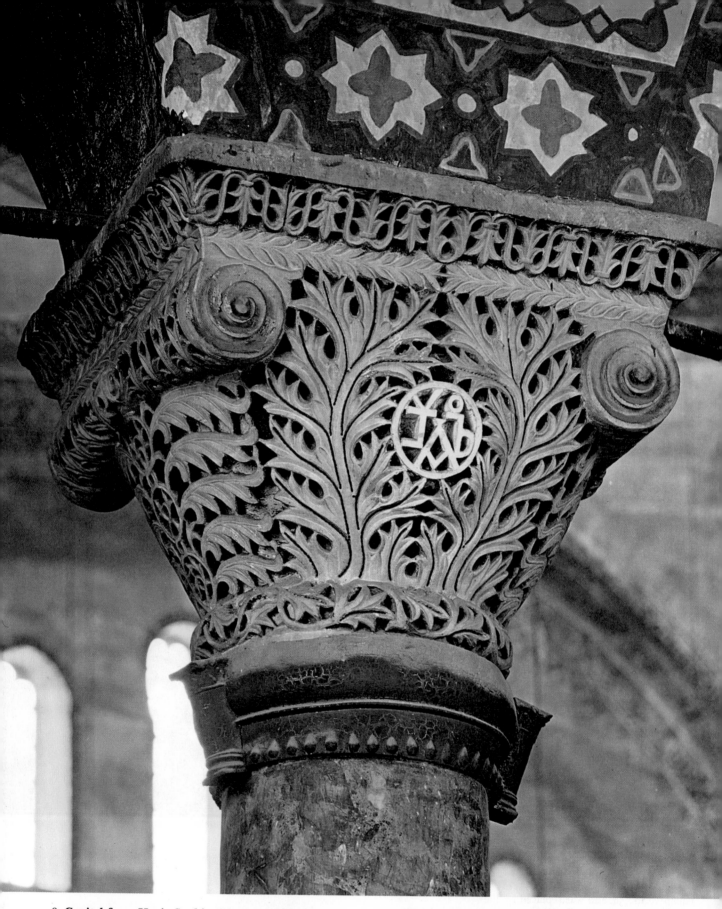

38. **Capital from Hagia Sophia.** 6th century. Marble.
Constantinople. This beautiful example of a Byzantine capital,
with the monogram of Justinian, the lacy, openwork design
of acanthus leaves, the scrolls, and the floral motif of the
abacus, is an exquisite detail typical of the magnificence of
the whole basilica. The marble probably came from the
quarries of the Marmara islands, as did that for the capitals
and columns of S. Vitale, Ravenna (plate 33).

39. **Interior of S. Lorenzo, Milan.** *c.* 370. The huge
quatrefoil structure of S. Lorenzo is of double shell design, the
interior being surrounded by ambulatories and galleries, as
can be seen in this view of the eastern apse. Although much
has been changed in later remodellings, the grandeur of the
original plan and construction gives an idea of the importance
of Milan in Early Christian architecture in the West.

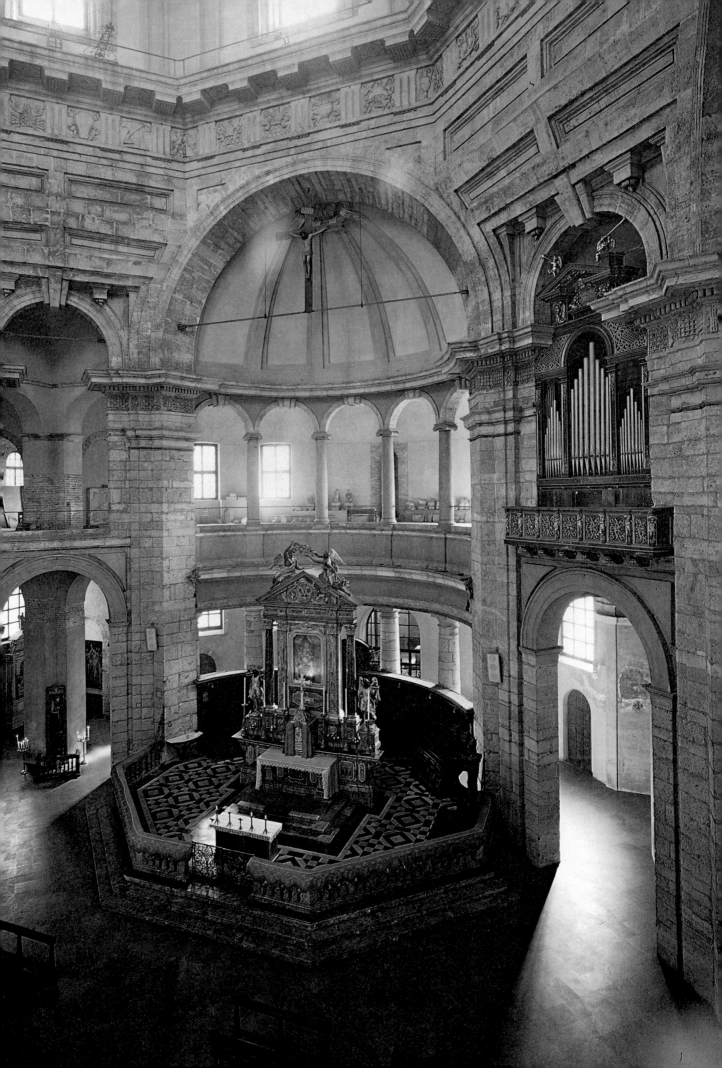

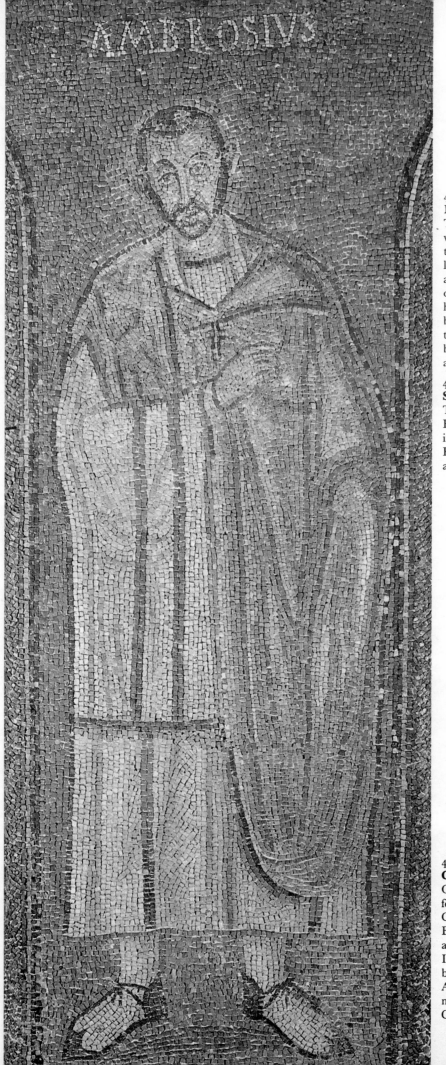

40 (left). **St Ambrose.** 5th century.
Mosaic. Church of St Ambrogio, Milan.
The figure of the saint has a humanity
which comes from classical art, in spite of
the Oriental influence which explains the
lack of relief. St Ambrose is numbered
among the four great Latin doctors of the
church; while still a catechumen in 374
he was elected by the people to the
bishopric of Milan. His influence extended
throughout the Christian world, not only
by his teaching but in church architecture
and matters of state.

41 (opposite, above). **Baptistery of
St Jean.** 7th century. Poitiers, France.
The elements of pre-Carolingian
Frankish architecture can be seen here as
in no other building above ground in
France: supporting arches, blind arcades,
and capitals of Pyrenean marble.

42 (opposite below). **The Ark of the
Convenant.** 799–818. Mosaic. Aspe of the
Oratory at Germigny des Prés. One of the
few mosaics surviving from the time of
Charlemagne, there are traces of
Byzantine feeling, especially in the larger
angels, which may be a result of
Italian influence. The little oratory was
built by Theodulf, Bishop of Orléans and
Abbot of St Benoît sur Loire, one of the
most distinguished figures at
Charlemagne's court.

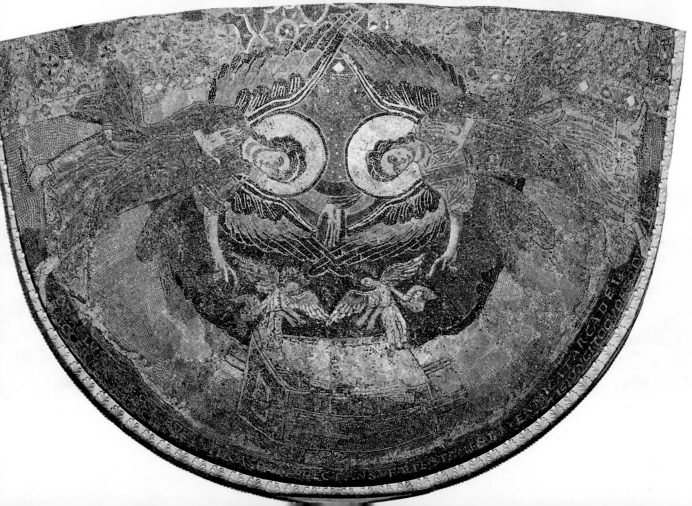

43 (left). **Book of Durrow.** 7th century. 9½ × 6½ in. (24 × 16.5 cm.). Trinity College Library, Dublin. This spiral page (fo. 3v.-Codex Durmachensis) shows how much this favourite motif of the Irish miniaturist can be interwoven and developed. Here the development is highly original and shows links with Celtic art in Ireland of the pre-Roman period.

44 (below). **Detail from the Book of Durrow.** 7th century. Trinity College Library, Dublin. The detail of elaborate interlacing pattern from a page full of similar decorative areas shows the intricate weaving of the forms with the animal heads and tails, and the glowing colours so distinctive of the Irish manuscripts.

45 (right). **Title page of the Book of Kells.** End of 8th, early 9th century. Trinity College Library, Dublin. The beginning of the Gospel of St Matthew: *Christi generatio* (fo. 34 r.) shows how unbounded was the graphic imagination and sense of colour of the artist. The letter takes up the whole page, enriched with carefully balanced whirls and patterns, each different from the next.

Xpi generatio

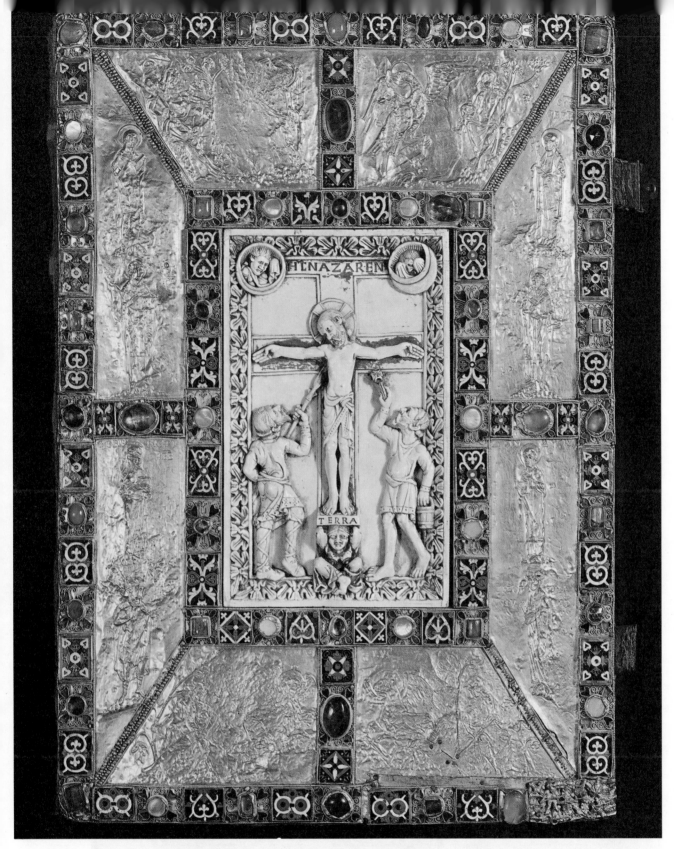

46 (opposite). **St Matthew.** End of 8th, early 9th century. 13 × 9½ in. (33 × 24 cm.). Book of Kells (fo. 28v), Trinity College Library, Dublin. The figure of the apostle seems to be standing, but is in fact seated in an armchair which blends with the decorative frame. In the same way the folds of the drapery form part of the design which is enlivened by the typical Irish interlacing pattern, and the animal forms spiralling round the border.

47 (above). **Cover of the Echternach Gospels.** c. 990. Ivory, beaten gold, enamel and precious stones. Germanisches Nationalmuseum, Nuremberg. The manuscripts of this and earlier periods (see figure 53) usually had covers of magnificent workmanship. The example shown was probably made on the orders of the dowager Queen Theophanu who is depicted below right. Her son Otto III faces her, and the other panels represent the symbols of the Evangelists and several saints. The exquisitely carved ivory panel depicts the crucifixion, with the cross supported by the crouching figure of Earth, while above the sun and moon mourn the crucified Christ.

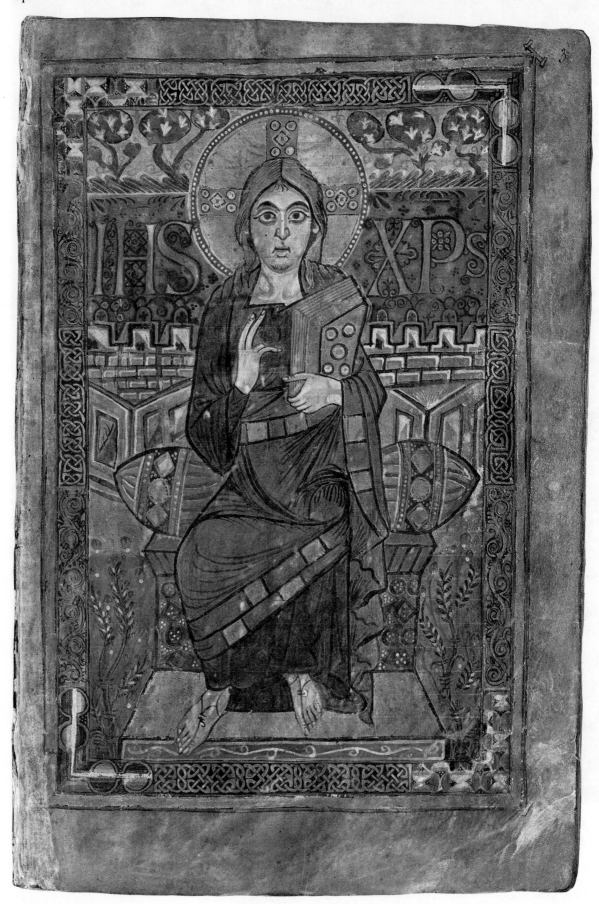

48 (above). **Christ Blessing.** *c.* 781. Bibliothèque Nationale, Paris. From an Evangelistary commissioned from the scribe Godescale at the court school of Charlemagne. This page contains elements deriving from the early Roman Christian (see plate 12) and Byzantine traditions, and the interlace pattern from Irish art.

move from the porch to the apse to offer their crowns to Christ and to the Virgin. It is curious that the Byzantine artist in the 6th century should have rediscovered the taste for strict repetition and colour that is so apparent in the procession of archers at Persepolis. His technique is certainly his own and the effect he produces, but the basic theme is inherited. The circular processions of the Egyptian zodiacs seem to be the forerunners of the procession of apostles arranged round the central medallion of the baptistery dome.

Again at St Apollinare Nuovo historical pictures were placed in panels above the clerestory. Similarly at Sta Maria Maggiore half a century earlier; perhaps the Christians may have been reviving the tradition of basilical decoration where the architectural form determined the decorative scheme. The apostles and prophets between the windows, with magnificent red and gold conches over their heads are reminiscent of the classical arrangement of statues in niches. The whole of this arrangement seems to be an attempt to reproduce a relief decoration in two dimensions. The decoration of the apses, too, was already outlined as can be seen at Sta Pudenziana, and for which there may be evidence in Palestine. At S. Vitale and at St Apollinare in Classe it consists of a triumphal scene taking place in the sky—the triumph of Christ or of a saint in a symbolic or figurative sense of Paradise. This type of representation, involving a frontal view of the principal figure, and the symmetry of the supporting figures and of the decoration, has the advantage, at the end of the church, of presenting a devotional image with remarkable dramatic effect. It is found throughout Byzantine art and even when the painting depicts a definite scene, the Transfiguration in the apse of the church of the monastery on Mount Sinai for example, the frontality and symmetry are retained.

THE DECORATION OF THE VAULT

The composition of the basilica with the distribution of spaces and masses and the existence of a roof independent of the decorative scheme means that the decoration is usually rather fragmentary. But with the rise of the vault, mosaic takes over and the building gains a new unity. Whether at Galla Placidia, in the archiepiscopal chapel, in the baptisteries or in the presbyterium of S. Vitale, we are now confronted with an overall decoration which seems to have a greater unity as all the demarcations are integrated into the whole, the bands round the arches and the windows with their columns and mouldings. Individually treated figures now tend to disappear. Certain figures, integrated into gilt foliage, as at Galla Placidia, have lost any identity they ever had. Others, whose visual traits were fixed by tradition are only noticed and recognised at second glance; they look at first sight like patches of colour, whose value is dependent on the overall scheme. The side walls of the presbyterium of S. Vitale are decorated almost entirely with a background of stylised rocks, foliage,

flowers and animals, all exquisitely drawn. Into this are set the figures of prophets, which are so well integrated into the lavish decoration that they are hardly noticeable despite their representing specific episodes, such as Moses tying his sandals. In the same way on the vault the angels, bearing the wreath which encircles the triumphant Lamb of Christ, become focal elements of the decorative foliage around them. The architecture itself is not merely accentuated by the colours covering it, but seems to have been interpreted anew. **33**

FACES AND FORMS IN MOSAICS

Yet as soon as one pauses to look at them, the figures assume their real importance once again. The period covered by the Ravenna monuments is particularly instructive in the development of the representation of the human figure. Comparing two groups of apostles or the two medallions representing the baptism of Christ in the baptisteries of the Orthodox and of the Arians, and comparing the prophets between the windows and the procession of martyrs in St Apollinare Nuovo, one is confronted with the same profound change. Ever since the 5th century, the stylisation of draperies had been very accentuated, but the faces were still treated as if they were painted portraits, with extreme subtlety in the shape and arrangement of the *tesserae*, in the tones, the shading and the placing of highlights. **34** **36**

Far from there being a tendency to simplification or decadent clumsiness in the 6th century, there was a new style, better adapted to monumental decoration, and which proceeded from a new spirit. In the drapery, for example, there is practically no attempt at modelling or colour shading; they are purely indicated by a play of lines that is intended to suggest both the movement of the material and the muscles it covers. In fact, this use of the contrast of black motifs against a light background is a colour effect. This is seen even more clearly when the toga is replaced by the *chlamys* and plain white material by brightly coloured trimmings and brocades. The indication of folds becomes increasingly sketchy; otherwise they would detract from the harmony and continuity of the splendid, faithfully reproduced motifs of Byzantine fabrics. It is this, at Ravenna, that makes the astonishing contrast between the two processions of St Apollinare Nuovo in which the magnificent robes of the saints' court dress are presented as red surfaces, whereas the martyrs retain a certain relief, despite the simplicity with which the folds in their white togas are drawn. It is to this that the two famous pictures in S. Vitale depicting Justinian and Theodora bringing their gifts to the church owe their strangeness and magnificence. However characteristic the faces of the Emperor, the Empress, the bishop and their followers may be, what strikes one first is the incomparable brilliance of the coloured surface in which the splendour of the ecclesiastical vestments and the richness of the court costumes blend in a kind of marvellous tapestry. **34, 35**

But this is not all. Contrary to appearances, the subjects of these two pictures are not static. They are not groups of motionless figures who have posed for the artist, but here again processions, groups of walking figures, who, in different settings, move towards the triumphant Christ at the end of the apse, although this movement almost disappears in the stiffness of the costumes and the frontality of the figures. This is an artistic tradition which is quite foreign to the Roman West and which originated in the Hellenised East where the traditions Alexander took with him as far as the frontiers of India had developed according to their own rules and resulted in artistic forms that are quite different from their European sources. These forms —which are more familiar to us since the excavations at Dura in Mesopotamia—have since been recognised and analysed. They form what Michael Rostovtzeff called Parthian art and they had a decisive influence on Byzantine painting.

Of course, the faces are transformed—and it is this that makes the strongest impression. The frontality often creates a total symmetry in the figures: the head, seen completely in full face, is divided into two by a nose that is still sometimes given side shadow but is more often shaded equally on either side. The nose tends to disappear altogether and the face is no longer seen in relief which is no more important. The eyes now play the essential role; enlarged, symmetrical, gazing fixedly and accentuated by the thick arch of the dark shaded eyebrows, they stare pitilessly at the spectator, creating the impression of a living, supernatural presence. It is easy to understand how such figures became objects of devotion and icons. Perhaps at first this was simply the result of a technique of representation, as in the funeral portraits of the Faiyum which in the second century AD replaced the relief masks on mummies. But the effect produced is one that was later to be much sought after—and of which Byzantine spirituality was to make full use.

However, these staring faces, with their enlarged eyes, have lost nothing of their character. The eastern mode of representation certainly captures their personality in a different way and to some extent idealises them. The round, ruddy, unhandsome face of Justinian takes on a certain majesty, but nonetheless remains of this world. And the difference between the portraits of Bishop Maximianus and of the figure whom some scholars have tried to recognise as Julius Argentarius, who had been in charge of the building of the church, and the more anonymous faces of the women and guards is a good indication of the degrees of stylisation that were still possible. It is not only in the cut and colour of their beards that St Peter and St Paul stand out from among the other apostles and from each other. The Byzantine mosaicist can still portray individuals within the limitations of the stylised type.

There are also many occasions when the figures are not fixed in a frontal position for the sake of symmetry, whether in the processions or in one of the more active scenes. Some of the faces are, of course, entirely in profile, but even before the 6th century there was a tendency towards a frontal attitude in many of the faces. The martyrs of St Apollinare Nuovo, for example, whose walking movement is subtly indicated by the slant in the hems of their cloaks or by the dissymmetry of their veils, are shown almost full face with their haloes giving the effect of so many medallions, so that the inflection of the eyes is what gives the movement to the head and even to the body.

Nevertheless, with the triumph of these tendencies we enter a new aesthetic, in which realism and respect for volumes and forms gives place to colour and vision. It is a two-dimensional world, suitable for expression and symbolism. These hieratic figures surround the worshippers, whose eyes are caught by theirs, with supernatural presences.

At Ravenna the eastern contribution did not arrive on virgin soil, but was superimposed on and modified by western traditions to which Christian art had already adapted. This is what gave the art of Ravenna its particular flavour—under the auspices of the Imperial State and of the needs of the Church.

The Architecture of the Dome

THE PROBLEM OF THE DOME

Byzantine architecture was born from the introduction of the dome into the structure of the churches—a correct, if inadequate definition. After all, there were domed monuments before Justinian, some of them very large indeed, the Pantheon at Rome for example, which dates from the time of Augustus. There were even certain Christian sanctuaries which, as we have seen, adopted the form of the imperial mausoleum, the first being the rotunda built over Christ's tomb in Jerusalem. But the domes were still lids placed upon cylinders, on thick walls that had no difficulty in supporting their weight. The concrete vaults invented by the Romans for their *thermae*, had been rounded into domes over *caldaria*, monolithic domes, which they later tried to lighten by mixing volcanic stone or even cylindrical pottery chains with the cement. The half-domes of the basilicas too had given the masons some training. Some of those in Syria were made of carved stone, but elsewhere they were usually made of more or less lightened concrete. It was easy as long as the supporting wall was round.

The real problem appeared when the dome had to be placed on a square base. This is still quite an easy matter when the monument is small, like those innumerable *marabouts*, or tombs of saints, covered with a dome, that add so much charm to Islamic landscapes. A stone placed across each corner of the square was enough to form an octagonal base on which the circular base of the dome could be placed. This overhanging stone may be replaced by an arch; link this arch to the corner by a piece of vaulting, and you have a squinch; and the dome supported by *36* squinches was to have a long history both in the Christian art of Mesopotamia and in the Romanesque art of the West.

The difficulty increases, however, when the dome must be placed, not on a cube of walls, but on four great arches, like those of the *martyrion* of St Babylas at Antioch Kaoussié. *31* These supported a pyramidal wooden roof. If one wishes to replace this roof by a dome, even the lightest possible one, one must first solve the problem of the thrusts. A dome does not just squash the pillars supporting it, but tends rather to force them outwards and collapse.

Byzantine Asia used brick as its building material. The Romans knew about bricks and used them for facing walls and for coursed work. They seldom used them in the building of whole walls or for supporting arches and never for domes. Brick is a cheap material, easy to make, lay and align—and easy, by means of divergent cement joints, to form into an arch on a frame. The engineers of the 5th century had perfected the techniques of the barrel vault, the groined vault and, finally, the dome: so it became easy to make the covering joints that an architect's audacious ideas might necessitate. We know very little of the preparatory developments that led up to these technical exploits. The Byzantine masterpieces sprang up almost simultaneously in the first thirty years of the 6th century. They did not develop out of Roman architecture, nor from the ancient architecture of Mesopotamia, where bricks had

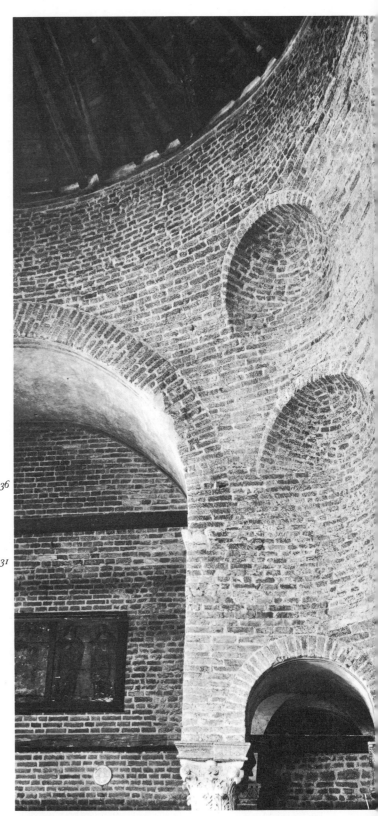

36. **The squinch.** This view of the 11th century church of Sta Fosca, Torcello, clearly shows the use of two squinches, one placed above the other, to progress from the vertical walls of the arches to the round drum supporting the dome in this case replaced by a circular timber roof.

been used to build extremely thick walls, but because of an innovation. This was the brilliant invention of the pendentive, replacing the squinch at the corners of the square intended to support the dome. The pendentive is a spherical triangle. It is a section of dome which starts at the corner of the square from the capital of the pillar and then rises between the two perpendicular arches until it reaches the top of them. The four pendentives meet forming a circle poised at the top of the canopy formed by the pillars and arches; this circle therefore rests at four points on the keystones of the arches and also on the successive courses of the pendentives. It is from this circle that the dome rises—whether directly or on a drum of the height desired; before long the drum was pierced with windows. The thrust of the dome is thus distributed over the whole *extrados*, or outer curve, of the arches and descends, through the arches and the pendentives, to the four pillars of the baldachin. So it is these pillars and arches that had to be reinforced in order to prevent them from splaying out. There were a limited number of solutions and it was from a combination of these solutions that the basic principles of Byzantine architecture were to emerge.

The first and simplest of these was to regard each pillar of the baldachin as the angle of two walls: there would thus be four naves, in the form of a cross, proceeding from the central square. Naturally, they would be vaulted: the walls would strengthen the piles and the vaults the arches, so controlling the thrusts of the dome. These vaulted naves could be replaced by apses, whose openings would merge into the arches of the dome and throw their weight on to the walls that supported them, and a vault could be placed between the arch and the apse. Lastly, the arches of the central dome could be juxtaposed with four secondary domes, of similar or different character, which would buttress the first. They, in turn, would have to be reinforced on the outside. We therefore have three schemes which automatically produce cruciform plans—either as a free cross, if the supporting elements are left separate, or as a cross inscribed within a square, if the basic structure is enclosed within four walls. In the latter case, there would be halls at each of the four corners, which could be connected to the large cruciform hall if necessary by openings of any size desired and whose vaults would contribute to the balance of the whole building. These theoretical schemes are in fact real plans, which were used in churches with the addition perhaps of an apse at the east end and a vestibule—a *narthex*—at the west.

It is equally possible, according to the sides of the square, to provide for different kinds of buttressing, which, both in plan and in elevation, would create dissymmetries. For example, there could be one apse and three barrel vaults, three apses and one barrel vault or one apse, two barrel vaults and a second dome.

These complex solutions were to be particularly popular on account of the pre-eminence originally accorded to the church of basilical plan. This plan consists of a rectangle, which has one dominant axis and not four

or even eight, as in a building based on the square. In order to extend this west-east axis, various subterfuges could be resorted to: simple additions—an apse at the east end, a longer nave at the west. But the structures themselves could also be adapted. Thus from apparently rigid technical principles several distinct schemes were developed, from which sprang some entirely original buildings. It is these exceptional buildings which usually represent Byzantine art in books: like all styles, it is represented by its masterpieces. But it is more useful, it seems, to look first at the plan that was used most commonly from the normal application of basic principles.

The plan of the inscribed cross, with central dome and internal buttressing vaults, was to become after the early period the typical plan of the Byzantine church and played the same role as the basilica with a nave and two aisles and a sloping roof in the previous period.

SAN VITALE AND HAGIA SOPHIA

S. Vitale, like H. Sergius and Bacchus in Constantinople, is a special case. In fact the dome is supported not by a square but by an octagon, marked by eight corner pillars, parallel to the outside walls, which carry eight lofty arches. These eight arches are in fact the openings of eight half-domes, which thus support the central dome. They in turn are not formed by solid walls, but by two tiers of very slender columns and very light arches, which give the whole structure a transparent, airy appearance. These half-domes are necessarily buttressed by vaults, on two tiers, which join them to the strong outside walls. In the circular side aisle thus formed, the placing of the columns is so complex that the whole plan seems to be hidden; and picturesque perspectives are created which add a quite unexpected charm to what is a purely logical structure. The difference between S. Vitale and H. Sergius and Bacchus shows how much the architect has gained by his accentuation of height and by replacing a horizontal moulding by arcades to support the gallery and by making his modules more slender. Even within a demanding and highly technical scheme individual talent can bring something new.

The problem facing Anthemius of Tralles and Isidorus of Miletus, the architects of H. Sophia, was of a much greater order. The task that the Emperor Justinian had entrusted to them was of the greatest importance for him. During the Nika revolt which had followed his accession, several buildings constructed by Constantine in his new capital had been burnt down by the rioters and among them were several churches, those of the Divine Wisdom, H. Sophia and the Divine Peace, H. Irene. H. Sophia in particular, was both the cathedral and the church of the palace, which was situated between the church and the hippodrome. It was imperative that the emperor should declare his power and his glory with a monument that would be more dazzling than any ever seen or heard of by man. Legend has it that as he entered the finally completed cathedral he cried: 'Solomon, I have triumphed over you.'

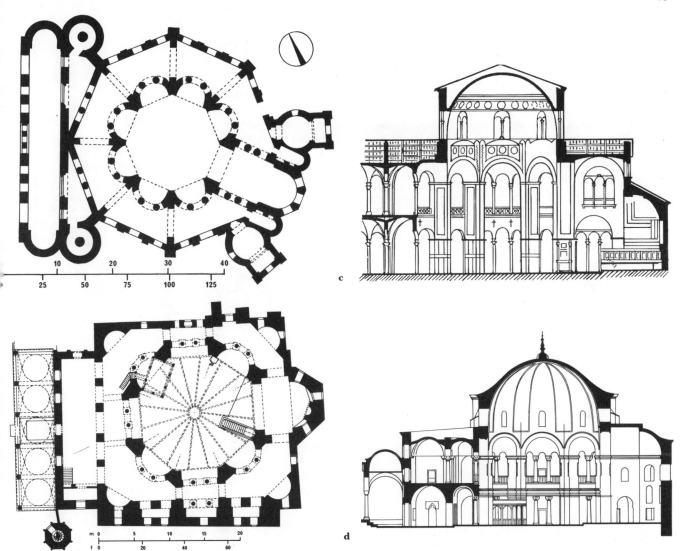

c

d

37. *a, b, c, d.* **The plan of** (*a*) **S. Vitale,** Ravenna, is practically identical to the contemporary building of **H. Sergius and Bacchus** (*b*) (5th century). The sections show how the architect of S. Vitale (*c*) has given his monument an elegance and lightness in the height of the openings of the octagon not found in the church of H. Sergius and Bacchus (*d*).

The technical problem that faced the builders was on a similar scale. They had to raise a dome 75 feet in diameter (the same size as the dome of the Pantheon in Rome) 75 feet in the air and place it on four arches. This was to become the summit of a series of vaults, which in all would cover an area four or five times larger.

They decided to adopt a plan of simple symmetry. They wanted to build a rectangular basilica, of which the length would be twice its width. In the length therefore it was sufficient to stabilise the dome by half-domes fitted between the side arches and consequently having the same diameter as the main dome. Each of these half-domes was buttressed by three others, whereas at S. Vitale there are four. Two of these were supported by two tiers of small columns. The eastern one was closed to form the apse of the basilica. At the west end, it was replaced by an internal porch. Thus the main axis of the building was *c.* 250 feet long.

Now the arches on the left and right of the dome had to be buttressed too. They were filled by a side wall of a basilica, made of a row of five porphyry columns, bearing a gallery with five more columns which supported a cornice above bearing a semicircular wall pierced with windows.

This pierced wall, strong as it was, did not fully bear the thrusts of the huge dome, so enormous interior buttresses were placed against the wall behind the pillars. This was merely static resistance, and when later the dome collapsed the weight had to be increased and continually so throughout history. Superimposed groined vaults between the sturdy arches covered the two-tiered side aisles.

As at S. Vitale the perspectives are wonderful with the golden vaults appearing between the columns like sky through trees. But the main impression is of the nave itself when, as one moves from the narthex through the central door, one sees above the magnificent east apse, the main dome brilliant with so many windows. One indeed wonders, with Paul the Silentiary, in the inaugural sermon, if it was not suspended from the skies by a golden chain.

Unlike the cathedrals of the West this vast hall is not apparently interrupted by bays, nor by side aisles, nor does the amazing height of the vaults seem to detract from the width. The side annexes seem to disappear. The width is preserved completely all the way up the building, the dome and two half-domes seem to push the walls apart rather than bring them closer to each other. It is a single space, undivided by the succession of curves in the upper areas. As the light flooded into the splendid interior the magnificent marble of the walls, the porphyry of the columns and the gold of the mosaics, enhanced its majesty.

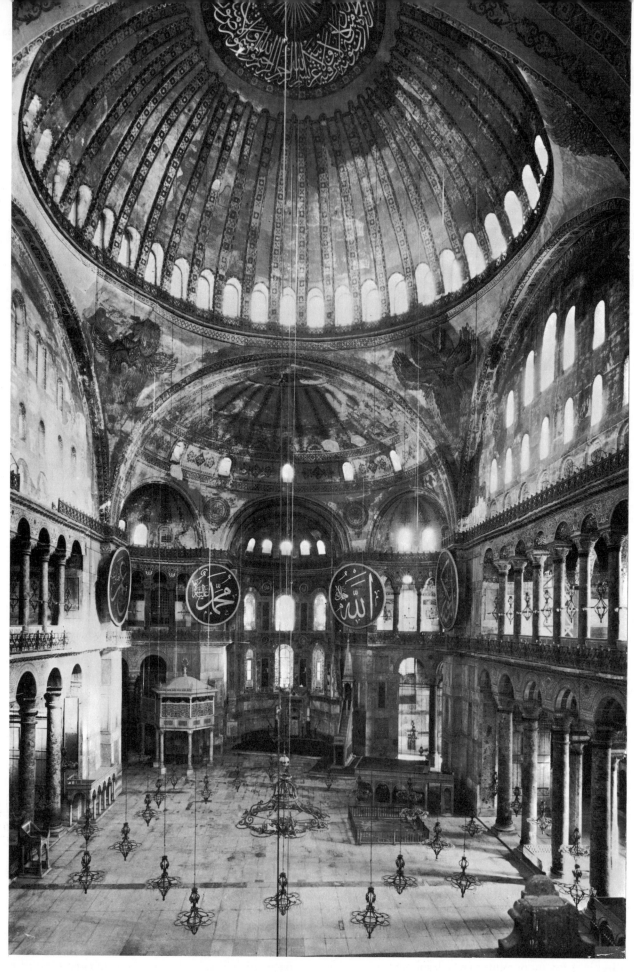

38. Interior of Hagia Sophia. 532–537. Constantinople. The soaring dome and spacious apse of the great Byzantine masterpiece seem poised on a succession of arches. The pendentives supporting the dome and the arcades and perforated wall of the side arches are clearly seen in this view. The Arab medallions date from the time the building was used as a mosque.

The West

39. **Sarcophagus of Pyrenean marble.** 7th century.
Toulouse Museum. The existence of these workshops where
craftsmen continued to work the marble in motifs freely adapted
from classical art, shows the continuity of artistic pursuits in the
Merovingian period.

'MORE ANTIQUORUM'

Throughout the Roman empire—with the differences
which were created by the unequal spread of Christianity
throughout the provinces, architects and decorators were
faced with the same problems, which they approached
from the same fundamental principles. At the end of the
3rd century and during the 4th, imperial art did not vary
enough between regions to lead us to expect very deep
differences. There were the same basic concepts, the same
techniques and precedents: the variations of style to be
discovered, which are sometimes quite delightful, do not
detract from the religious and aesthetic unity of Christian
art.

It is therefore natural to find no fundamental contrasts
between Western and Eastern buildings. It was on a basis
of Roman art that Christian art developed in Gaul: the
sarcophagi of Provence are directly related to those of
Rome and the basilicas and baptisteries of the 4th century
were built according to universally accepted principles. It
is occasionally possible to find, apart from directly Roman
influences, a certain Syrian inspiration, perhaps in the
form of a baptistery or in the drawing of a foliated scroll.
This is because Christianity was first introduced among the
Gallo-Romans in the Syrian colonies of the Rhône valley.
But it is only a question of minor differences.

Gaul was later to prove more conservative than the East.
This was largely because of the impoverishment that was
to afflict the whole of the West as a result of successive
invasions. Insecurity is no more favourable to architecture
than the economic crises that are inevitably produced by

deep changes in the political system and in social relations.
And this was the case in the 5th and 6th centuries. How-
ever the Barbarian chiefs had shown an immediate desire
to build; for them this was undoubtedly a sign that they
had at last achieved stability and abandoned their nomadic
past. Even if they did not all manage to do what Theodoric,
who had been educated in Byzantium, realised at Ravenna,
they all wanted to have palaces and to provide their sub-
jects, conquerors or conquered, with vast, elaborately
decorated churches. At Toulouse, the cathedral—the
Daurade—proclaims even in its name the splendour of its
gold ceilings, and at Auxerre and in Paris, the Gothic and
Frankish princes competed with each other. Clovis built a
basilica dedicated to the apostles which was later given
the name of Ste Geneviève; and Childebert, again in Paris,
built a church called Ste Croix at St Vincent and a cathe-
dral dedicated to St Etienne.

The Lombards at Pavia, Monza or Como and the Saxons
in Kent or Northumbria made an effort comparable with
that of the Franks and Goths. But what models could their
builders have used? What were their traditions? Who were
they, and who their workers? It is quite obvious that at the
time when these nomadic tribes finally settled they had
neither architects nor masons. The buildings that have
been discovered in various parts of Germany, made of
wooden stakes and mud, could hardly have had a greater
influence than the tents of the Arab nomads in countries
where the Romans had introduced or developed a magnifi-
cent architecture of stone and concrete. The Barbarians
hastened into the empire probably because they had been

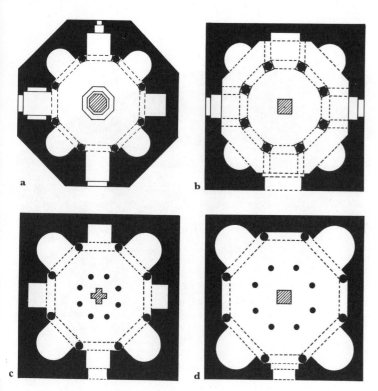

40 a, b, c, d. Plans of early Christian baptisteries
5th century (*a*) Albenga had an octagonal plan with internal
niches, as was sometimes seen in the *caldaria* of Roman baths.
(*b*) Riez had a square ground-plan with corner niches and an
interior octagonal arcade. (*c*) Frejus is also a square plan
with alternate rectangular and horseshoe arched niches. (*d*)
Marseille was a square plan with an interior octagon and corner
niches and colonnades.

driven out of their previous territories resulting from a
chain of upheavals in the depths of Asia; but they were also
drawn by the attraction of a legendary civilisation based on
agriculture and the city. They were seeking cultivated
land, which their tenants were to continue to work for
them, and houses to live in. The archaeological discoveries
made on the territories that they passed through show the
attraction that an object from the Roman empire had for
them—whether they had obtained it by barter, by
diplomatic exchange or by the looting of a foray. Once
they had settled, they set themselves up on the Romans'
lands, in their farms, in their houses and in their churches.
And they had new ones built by the conquered natives who
had changed neither their taste nor their traditional tech-
niques. In Italy, Gaul, Spain and Africa, Roman archi-
tecture continued, in its provincial forms, sometimes
declining during times of battle and crisis, sometimes re-
discovering something of its former vigour when a chief
established his power and fortune.

If the migrants did not bring with them new architec-
tural methods, at least they had developed, like the Celts
before them, their own techniques for the minor arts,
chasing and enamelling, which they may have borrowed
in part from the Persians or the Greeks of the Black Sea
while they were still in Asia or southern Russia. They had
their weapons and trappings, their drinking vessels and
jewellery, and probably also, though nothing remains of
them, their fabrics and carpets. They were all decorated in
the same style which seems to owe nothing to Mediter-
ranean art. It is not representational but decorative, geo-
metrical and stylised, sometimes covering the surface with
a linear pattern; sometimes introducing motifs recognis-
able as originating from plants like foliated scrolls, but it
has nothing of the realism, even in the most abstract trans-
position, of Greco-Roman art. Everything is subjected to
the complex rhythm, to the proliferation of curving lines;
and even when animals are introduced into the decorative
scheme they are forced to undergo all the transformations
the continuity of the pattern demands.

Such an art could pass from bronze to the velum of
manuscripts. It was more difficult to transmit on to stone
and few attempts were made to do so, except in the British
Isles. And in any case Christianity would have difficulty in
introducing its iconography into a graphic system that was
so foreign to all representation. It is thought that Daniel
among the lions can be recognised on a belt buckle found
in Switzerland; but these lions are heraldic and the prophet

41. **Bronze decoration for a moneybag.** 7th century.
Found at Wingles (Pas de Calais, France). Musées Royaux d'Art
et d'Histoire, Brussels. In the angular motifs one can decipher
interlacing patterns and birdheads. The central piece is
composed of eight S-shaped animals intertwined round a cross.

himself is rigidly stylised—much closer to the *Gilgamesh* of the Mesopotamian seals than to the prophet of the catacombs. In fact, throughout the whole of this period architects and masons claimed to be continuing to obey the Vitruvian rules: they worked '*more antiquorum*', or 'in the manner of the ancients'.

One proof of the activity of the builders, apart from the texts, is that there were workshops in the Pyrenees where marble was quarried and sarcophagi, columns and capitals were made which, with the re-opening of the ways of communication, spread throughout Gaul. The capitals, which are based on Corinthian models, are often charming in their originality and exquisitely carved. But even when they depart from the ancient canons, the acanthus leaves still curve away from the *calathos* with great suppleness to support projecting scrolls at the corners of the abacus. In the ancient manner they are surmounted by parts of an architrave: but they develop along their own lines quite differently from those followed by the Byzantine marble-masons—reducing the flat, pointed acanthus-leaves to an alternation of black and white triangles.

A building like the baptistery of St Jean, Poitiers, one of the few surviving examples from this period, with its interior decoration of blind arcades completing the line of the supporting arches, has a style very much its own which is accentuated by the solid Pyrenean capitals and the heavy mouldings they support. In the crypt at Jouarre, which was probably profoundly altered in character by a Romanesque rebuilding of the vaults, there are Pyrenean columns and capitals, sometimes almost classical in style, at others delightfully original. They surround some very different sarcophagi, among which that of Abbess Theodochilde (662) derives its sober decoration from a double row of shells, separated by bands of writing which are decorative in themselves.

The transition is not abrupt from these buildings to those of the next period—the crypt of St Laurent at Grenoble (8th century) or the oratory of Germigny des Prés, built by a bishop of Charlemagne's time. Even if little is known about the basilicas of the 7th century, or, for that matter, of the 8th or 9th centuries they were definitely firmly attached to Roman traditions. At St Denis, the monastery church, where the tomb of the apostle of Gaul was situated, was built in the Merovingian period, and restyled by Abbot Fulrad under Pepin the Short. Before being completed by Charlemagne in 775, it had a plan based on that of St Peter's, Rome, a basilica with a nave and two aisles, a transept and a projecting apse. The chapel

42. **Daniel and the lions.** 7th century. Bronze. Length ½in. (10 cm.). Fribourg museum, Switzerland. This belt buckle found in a tomb at Tronche-Belon, near Fribourg, is an adaptation of the art of the migratory peoples to a Christian motif. Both the technique and the stylisation of the theme are characteristic.

43. **The Crypt of St Laurent, Grenoble.** 8th century. Grenoble, France. This vaulted quatrefoil building is decorated with blind arcades and small columns carrying Pyrenean capitals.

44. **Celtic scabbard.** Lisnacroghera
(Antrim), Ireland. Numerous Celtic
bronze objects have been found in
Ireland dating from before the Roman
conquest of Britain in which one finds
motifs which were taken up again later
in Irish Christian art.

45. **The Ardagh Chalice.** 8th century
Bronze and enamel. National Museum,
Dublin, Ireland. The Irish strapwork
is found in metalwork as in the stone
crosses and in the miniatures of
manuscripts.

of the abbey of Fulda has a similar plan, but with a coun-
ter-apse, and the shrine of St Boniface, the apostle of the
Germans, played the same national role. The introduction
of monasticism by St Martin in the 5th century was to
create a demand for more complicated schemes, which
were to be treated according to traditional methods.

As far as this architecture is concerned, it does not
seem that the 'Carolingian Renaissance' represented a new
departure, but rather a flowering of traditions.

'INSULAR' ART

In the 7th century the art of the British Isles was to bring
a new repertoire of forms and a new concept of decoration
to the whole of western Europe, which was to reach its
zenith in the illumination of manuscripts which had the
greatest influence abroad. St Columba, born in Ireland in
c 521, was the founder of a Christian movement of great
spiritual intensity. He grouped his disciples in monasteries
or hermitages, consisting of a cluster of huts around a poor
chapel, at Derry and at Durrow, and tried to extend their
knowledge as well as deepen their piety. He copied
manuscripts himself—and one of those that have survived
46a, b, c is probably his work, the Cathach, a fragment of a psalter,
written in an archaic Irish form of capital letters.

St Columba created other monasteries in Ireland before
settling in Iona, an island off the coast of a part of Scotland
that had been colonised by the Irish in the 5th century.
This seems to have been the result of a desire to break with
everything he held dear, and the Irish monks were to con-
tinue in the same spirit, emigrating in groups to distant
and often desolate parts. In 590 a monk called Columban
from the abbey at Bangor set out with twelve companions
for Gaul and finally settled at Luxeuil, in the Vosges. After
many attempts, and after leaving in Switzerland one of his

disciples, Gall (whose tomb was to be the site of the famous
abbey), he settled south of Milan, at Bobbio, where the died
in 615. Shortly afterwards, another of his disciples, St
Aidan, was to set out from Iona and settle at Lindisfarne,
to the north of Northumbria on the east coast, and found
communities as far south as Essex.

Irish monasticism thus seems to have spread rapidly
across western Europe. It had its own particularly severe
rules, and theological tendencies of its own which were
regarded by Roman Christendom as archaic and were to
lead to various conflicts. It represented a considerable
intellectual achievement; Latin as well as Irish manuscripts
were copied and among the monks there were poets, his-
torians and chroniclers. They soon began to write the lives
of their saints—beginning with St Columba.

These Irishmen were to tackle the conversion of Saxon
England from their base at Lindisfarne. They then met
with competition from missionaries sent from Rome. First,
in the 6th century, Augustine who had been sent by
Gregory the Great and had settled at Canterbury, then, in
the 7th century an Asiatic, Theodorus of Tarsus, intro-
duced Mediterranean culture to Britain. To them we owe
the building of the first stone churches in England and,
with the second mission, a whole flowering of Roman art,
unparalleled in the Germanic world, or even, at that time,
in the Frankish kingdom. It was particularly apparent in *4*
the decoration of certain stone crosses, and in the copying
of Italian-inspired manuscripts, such as the Codex
Amiatinus.

The conflict between the two missions, which came to a
head over the fixing of the date of Easter, was to end with
the victory of the Roman organisation. But the evangelistic
activity of the Irish monks was to lose neither its strength
nor its originality. Thus in 678 Wilfred of York undertook

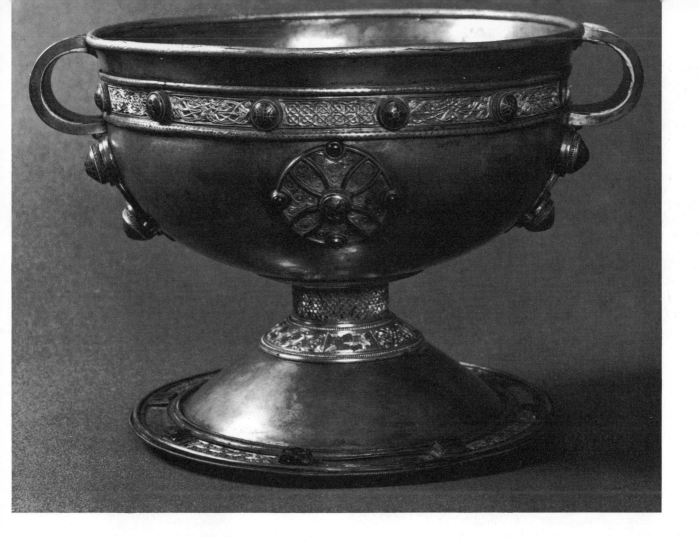

the conversion of Friesland and was followed by Willibrord who founded the abbey of Echternach in Luxemburg. And it was from Friesland that Wynfrith Boniface set out as the papal legate to convert the Germans.

In Great Britain at the end of the 8th century, the Viking invasions had forced the monks to abandon first Lindisfarne, then Iona, and after terrible massacres, the order retreated to Kells; but the Irish monasteries themselves were soon to be threatened and destroyed one after another.

This monastic movement had diffused over western Europe an art of the highest quality and one which is quite unlike any other. Its origin is a matter of dispute. It would seem natural enough that Irish monks should have taken with them an Irish art. Certain scholars, however, have tried to show that the first manuscripts to originate from Ireland—the first being St Columba's Cathach—are not highly decorated. There are only a few initial capital letters, which lead to quite simple graphic developments. They believe that the austerity of the saint was opposed to the luxury of decoration as he was to any other form of luxury and that it was only at Lindisfarne, when they came into contact with the art introduced by the Roman mission into Northumbria, that the Irish and their Northumbrian disciples returned to Celtic themes in order to oppose one art with another.

It is certain that this 'insular' art (using the term intentionally in order to avoid controversy) is connected, despite a long gap, with primitive Celtic art. Various attempts have been made to close the gap. Nils Aberg and François Henry have enumerated sculptures or religious objects made of gold, which have been found in Ireland and which are of the 7th, 6th or even 5th century—and whose motifs form part of the decorative vocabulary of the weapons and jewels of the La Tène period, that is, prior to the arrival of the Romans on the northern coast of the Channel. These include the Battersea shield, or the scabbards found at Lisnacroghera Grannog. The spirals with which these are 44 decorated are also to be found on the Arkakillen Grannog brooch or on the very fine Ardagh chalice of the 8th cen- 45 tury. Curiously combined with others related to Coptic art, these motifs form the very basis of 'insular' illumination. It seems remarkable that they are already to be found in an embryonic form around certain of the initials in the Cathach. What is most striking in the more deco- 46a, b, c rated manuscripts is that, in spite of allusions to the Christian art of Egypt, there is an absence of the Roman tradition itself. This was an art conceived outside the influence of the Romanised communities of Great Britain, and it decorates a great many manuscripts written in Irish; and even if it did not originate entirely in Ireland, it was the art of Irish monasticism.

IRISH MANUSCRIPTS

This art is made up of geometrical elements and non-figurative themes—geometrical decoration did exist in the Mediterranean art of both the Roman and the Christian periods, but it was a decoration which might frame figures, scenes or be part of a floor mosaic. It was never treated for its own sake. In 'insular' art, on the other hand, the motif dominates a whole page: as proof of this, one has only to look at the first page of the Book of Durrow, which is of an

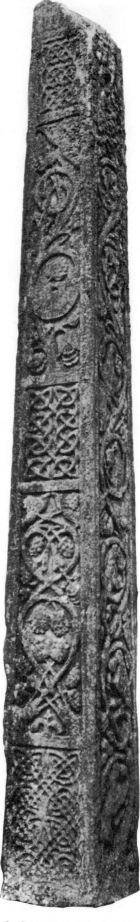

46a, b, c. **Initials from the Catach of St Columba.**
6th century. Royal Irish Academy, Ireland. The initials of
this manuscript are of a magnificent graphic quality. They
come from Celtic traditions and herald the Irish miniatures.

47. **The Bewcastle Cross.** 7th–8th centuries. The fusion of
barbaric ornament figure subjects and the vine scroll theme can
be seen in this early Northumbrian cross. Similar motifs are
found in the Irish manuscripts.

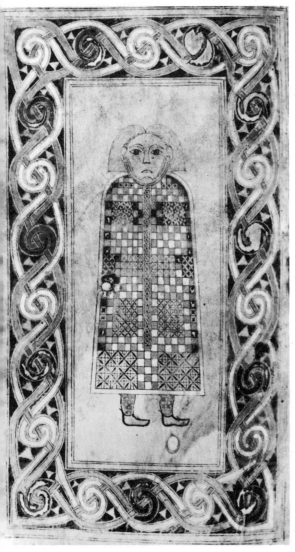

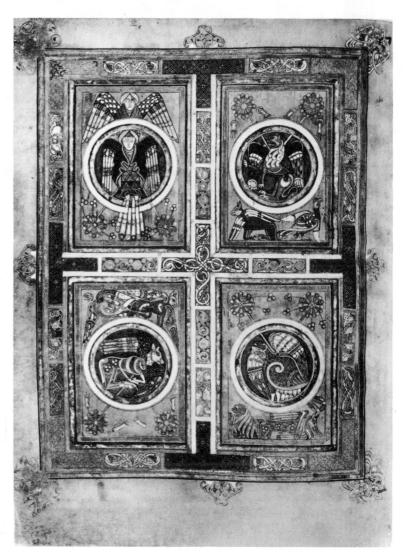

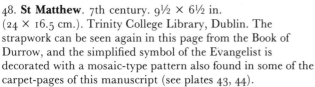

48. **St Matthew**. 7th century. 9½ × 6½ in.
(24 × 16.5 cm.). Trinity College Library, Dublin. The
strapwork can be seen again in this page from the Book of
Durrow, and the simplified symbol of the Evangelist is
decorated with a mosaic-type pattern also found in some of the
carpet-pages of this manuscript (see plates 43, 44).

49. **The four Evangelists**. End of the 8th century.
12 × 9½ in. (32 × 24 cm.). Book of Kells. Trinity
College Library, Dublin. The symbols of the Evangelists are
treated like heraldic motifs in a completely free graphic
interpretation. The frame is divided into bands allowing for a
variation of spiral and interlacing patterns. The patterns are
not always exact repeats.

elaborate intricacy quite foreign to Mediterranean art.
The almost total suppression of the straight line and right-
angle within the motifs gives the strips and borders the ap-
pearance of ribbons which tend to invade the whole of the
available space. This can be seen at once in the large
initials.

Quite naturally, when motifs taken from the animal
world are introduced into this decoration, they seem to be
taken up in the general movement. As we have seen, such
tendencies existed in the art of the migrant peoples; they
had also appeared in Italian initials. In a page of the Book
of Durrow, one can scarcely recognise the heads at the ends
of the volutes or the paws at the beginning. And even the
human face, so unexpressive, so enclosed within its frame,
that symbolises St Matthew in the Durrow Gospel-book,
was to be taken up in the movement of pattern in the Book
of Kells. Not only is there a rejection of space, but graphic
design replaces external form.

One should also emphasise that these manuscript pages,
though all dominated by these volutes, are in fact extreme-
ly varied. The form of the initial capitals, the importance

given to the lines of writing, the frames that suddenly
break across the decoration, the sometimes symmetrical,
sometimes spontaneous forms of the decoration, the magnif-
icence of the colours, which are both rich and arbitrary
as in enamels, all this contributes to an impression of exu-
berant imagination—somewhat too vertiginous for a Me-
diterranean head. This art of Ireland, which only fifty years
ago was dismissed as the work of barbarians is now appre-
ciated as an astonishing expression of the Christian faith.

THE CAROLINGIAN RENAISSANCE

The Carolingian Renaissance is no longer regarded as a
sudden illumination that came about through Charle-
magne's own intelligence and authority. Yet it was a tempt-
ing idea to attribute to the Frankish emperor a role in the
West comparable to that of Constantine or Justinian.
Charlemagne had gone to Ravenna in 786 and to Rome in
800, and was thinking of precedents such as Rome, Byzan-
tium and Ravenna when he decided to create a permanent
residence for himself at Aachen, a small watering place in
agricultural country. He was surrounded by Germans who

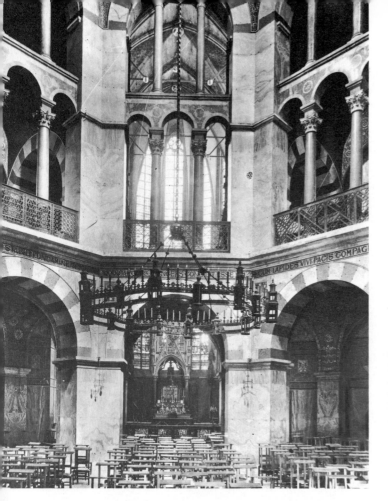

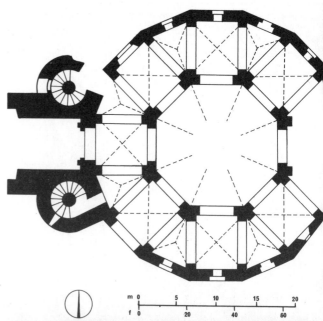

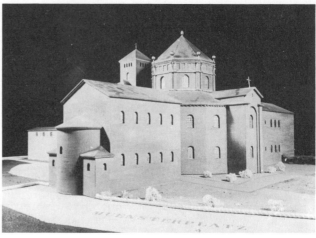

50*a, b, c.* **The Palace Chapel.** Aachen. Late 8th century.
(*a*) The interior view of the cathedral at Aachen shows the
three-storeyed arrangement of the arches of the central
octagon, seen in plan in (*b*). The model (*c*) shows the
exterior of the church.

always occupied the posts of military command or, like
Eginhard, were in charge of the administration, but there
were also foreigners. Alcuin, born in Yorkshire in 786, had
acquired such a reputation for his knowledge that the
emperor invited him to Aachen and entrusted to him the
task of reviving art and the sciences. His role in the organi-
sation of the schools, the Academy and the palace chapel,
where manuscripts were copied, was of crucial importance;
and through his impetus 'insular' artistic influences were
kept alive in the court. They remained strangely sub-
ordinate, because at Aachen there were also Provençals,
Lombards, Romans, Sicilian Greeks and Byzantine
Greeks—not to mention Jews and Arabs. In this cosmo-
politan court, to which the monarch entrusted the care of
culture, art and education, certain men were given the
task of transcribing the sacred and liturgical texts into a
new style of writing, Carolingian minuscule, and of
illustrating them. There were goldsmiths and builders—
and all the different traditions had to merge together.

 Quite apart from its own beauty, the palace chapel at
Aachen is especially important because of the problem of
the origin of its plan. It is a very high octagon, with an
50a ambulatory. Because of its octagonal plan and also be-
cause of superimposed columns, it reminds one of S.
Vitale at Ravenna. But one must look closer. The plan is
basically simple and like its large-stoned construction, it
50b is Roman. What is particularly striking is the sturdiness,
space and height of the interior octagon—and not the

clever articulation of a complex and subtle pillared build-
ing. It is a question of strength, not lightness: overhead,
the arches have a short span, the capitals look Roman and
are surmounted not by a Byzantine *impost*—a very char-
acteristic pyramidal cushion—but by parts of an archi-
trave in the Roman style. The interplay of the vaults looks
like a series of improvisations, particularly the plunging
barrel vaults of the gallery. On a basis of Roman traditions,
with perhaps some idea of Byzantine compartmentation,
the architect had to invent his own formulas whenever his
experience did not provide him with a solution. And he
liked to give his building a considerable height, which is
somewhat concealed on the outside by the gallery roof
broadening out beneath the lantern, but which looks sur-
prisingly majestic on the inside.

 It is rather of S. Lorenzo at Milan—and of the more
strictly western developments of the Christian architecture
of the 4th century—than of the Ravenna churches that the
palace chapel at Aachen reminds the author. There too one
finds space and a certain majestic austerity, which are due
to the height, to the sturdiness of the bonding, and to the
decorative rather than constructional character of the
interior colonnade. At Aachen there is no definite exterior
support, but an original development based on traditional
forms that were well known in the West. We have only to
think of the Dome of the Rock, built in Jerusalem in 691 by
caliph Abd al-Malik, and based on a similar plan that had
been borrowed from that of the church of the Ascension on

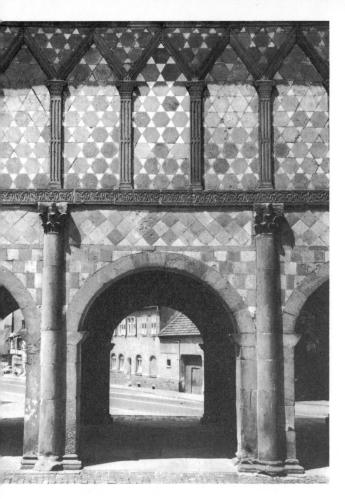

51. The Entry Pavilion to the monastery at Lorsch.
c. 830. Germany. This delightful decoration is composed of a series of colonnades one on top of the other, and polychrome facing.

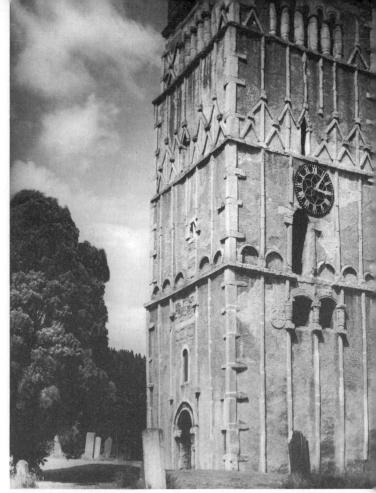

52. The Tower of Earl's Barton Parish Church.
10th century. Northamptonshire. This is an unusual type of decoration, with the local traditions interpreting Carolingian art in an original way.

the Mount of Olives, to feel the gulf that separated the two worlds—the difference between a kiosk—all airiness, colour and light—and this tall, ambitious, sombre tower.

In no other Carolingian building is the same audacity to be found; but their architects were to show the same mastery. Jean Hubert worked out the simple geometrical rules on which their work is based: the equilateral triangle. Charlemagne's palace at Aachen, or monasteries like St Gall (820) or St Riquier (890) provided opportunities for vast, ordered architectural conceptions, in which there was scope to develop new forms and techniques. When models were required, they turned to Rome. After the great church of the abbey at Fulda, the plan of St Peter's in Rome lost nothing of its prestige. It reappears, with variations, at Hersfeld (980), Tours (995) and St Remi at Rheims (1000). The buildings of the 9th and 10th centuries that have survived are certainly very different from each other. The astonishing façade of the abbey of Corvey, in Germany (822), slender, flat, enlivened by its towers and high, narrow veneered galleries; the exquisite polychrome façade of the monastery portal at Lorsch (early 8th century); the square tower of Earl's Barton, with its decoration of angular arches—these examples show that as far as elevations and façades were concerned there were architects with vigorous imaginations and their work can be seen reflected in buildings in Vignory in Champagne and at Tarrasa or at Oviedo in Spain.

WALL-PAINTINGS AND MOSAICS

Western buildings of the 5th century, like those of the 9th, had been decorated in colour—by frescoes and mosaics. Unfortunately, these have suffered even more than the buildings and the few authenticated fragments which have survived in each province are all the more valuable. One notices with some surprise that these belong to different traditions, so much so that it is sometimes difficult to believe that they belong to the same period. In Italy, of course, the Roman tradition was still dominant. Its iconographical tendencies and pictorial technique may be derived from the mosaics of Sta Maria Maggiore, which **22, 23** date from 432–40. These tendencies and techniques re- **24, 25** appear later, about 470, at Milan, in the chapels attached to S. Lorenzo or S. Ambrogio. A taste for movement, for large numbers of figures and complicated scenes give these **39, 40** pictures a certain amusing, almost popular vitality. The individual figures have lost their weight and relief, but contrary to what often happens in Byzantine art there is in their attitudes and facial features a freedom of expression that gives them personality. These tendencies remain dominant from the 6th to the 8th centuries in small Roman sanctuaries.

Yet, in a little 9th-century chapel, at Castelseprio in Lombardy, one finds frescoes that are truly Byzantine. They show great charm in the way in which they bring to life, through colour, the characters of iconographical

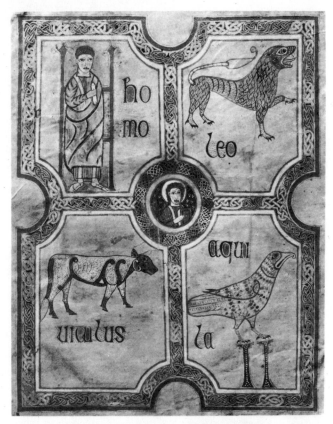

53. Christt and the Symbols of the Evangelists. 7th century. The Echternach gospels, (Cod. 61, fo. IV.) Cathedral Treasury, Trier, Germany. The strapwork motifs of Irish manuscripts are evident in this miniature from the famous 7th-century Gospel book brought to the abbey at Echternach by monks from Ireland. The symbols are painted in a stylised and simplified manner.

54. St Matthew. 750. 15 × 12 in. (c. 39 × 32 cm.). Codex Aureus (Gospel) fo. 9v, Kungl-Biblioteka Stockholm. This miniature is a masterpiece of Anglo-Saxon monastic art of classical inspirations. In other pages from the manuscript, painted in Canterbury, there is an array of strapwork of a typically 'insular' style.

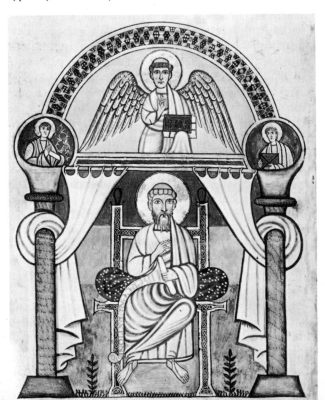

tradition. They may have been painted by a westerner, but certainly by someone who had been taught directly in the East. Byzantine influences are also to be found at Cividale; but further north, between Milan and the Tyrol, once again one meets Roman traditions: the astonishing cycle that covers the walls of the chapel at Mustair, in the Grisons, with a series of Old and New Testament scenes and a Last Judgement, retains the appearance of a Western work both in its colouring (pink and ochre) and in its scenic composition. The two decorations at Mustair and at Castelseprio are almost contemporary and date from immediately after the 'Carolingian Renaissance'.

Among the works produced by this renaissance one finds the same disparities, either from one region to another, or, within a particular region, from one building to another. As in the East, there was a trend of hostility to icons among the Frankish clergy of the 8th and 9th centuries, which resulted in architectural decoration, at Lorsch in Germany and at Oviedo in Spain, for example, in which walls were divided into geometric panels, or painted with scenes of fantastic architecture. Behind these works was the strong Roman tradition of carved marble mural decoration.

Elsewhere mosaics remain figurative: in the dome of the chapel at Aachen the old men of the Apocalypse walk in procession around the triumphant Christ—a motif created in the 4th century in S. Paolo fuori le Mura, in Rome. At Germigny des Prés, not far from his abbey of St Benoît sur Loire, Théodulf, the Bishop of Orléans, and a friend of Charlemagne, chose a complicated decoration in a classical tradition. We know from the texts that it depicted personifications of the seven liberal arts and the four seasons. There remain only a few fragments of floral decoration—palms and foliated scrolls—that seem to have been affected by Islamic influences, perhaps from the Ummayad palaces in Spain. There are also two winged angels over an arch decorated with cherubim. The whole group was perhaps intended to represent paradise.

The frescoes of St Germain d'Auxerre depict in an astonishingly animated way the Stoning of St Stephen and other scenes taken from the Acts of the Apostles. There were also standing figures placed on pedestals, of bishops and popes. On the one hand, we are in the midst of Roman traditions and, on the other in contact with Carolingian miniature painting.

(Continued on page 273)

49 (opposite). The Emperor Nicephorus III Botaniates. c. 1078. (MS. Coislin 79. fo. 2v.) Bibliothèque Nationale, Paris. The miniature is from a famous manuscipt of the Homilies of St John Chrysostom. The Emperor is shown standing between St John and the Archangel Michael. The glittering costumes and rather flat pattern of the imperial figure can be compared to the mosaic panel of Zoe and Constantine in H. Sophia (figure 55); they are official portraits. The attitudes of the figures and the excellence of the execution witness the supremacy of the court workshops and the definitive influence that their products had in the Byzantine empire.

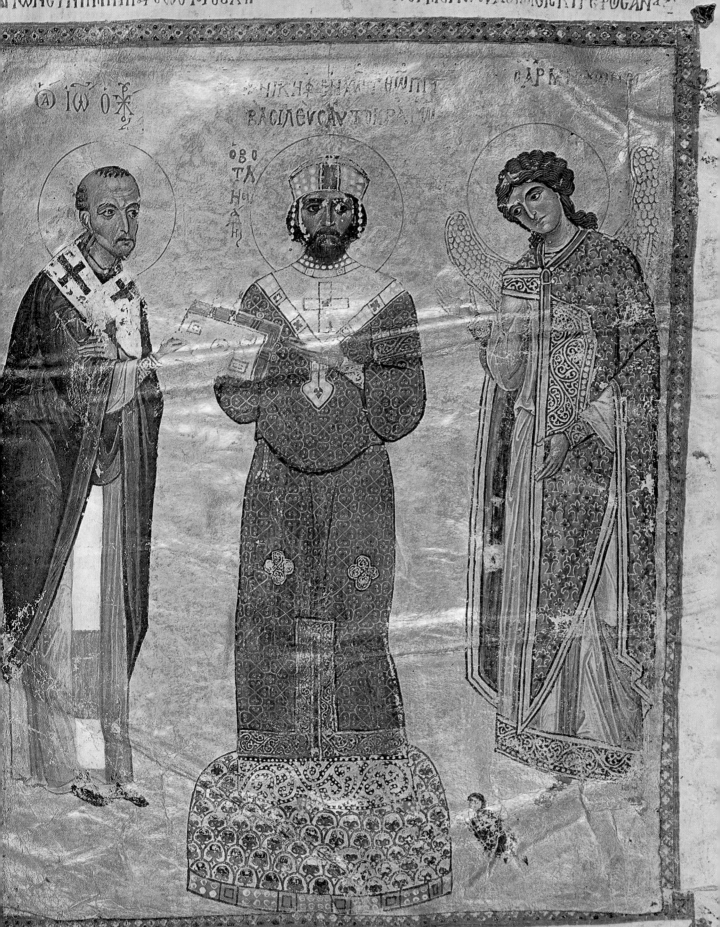

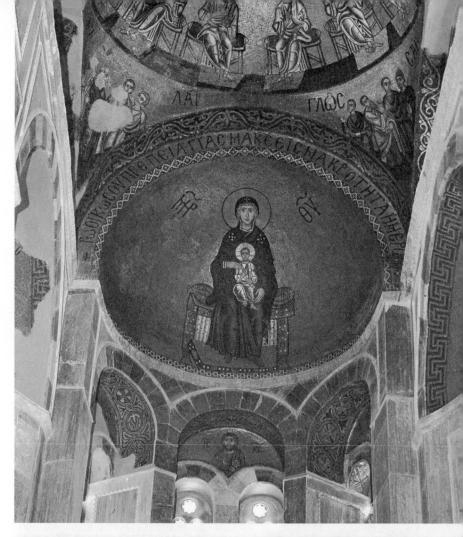

50. Interior of the Katholikon, Hosios Lukas. *c.* 1020. Phocis, Greece. The spacious interior of the domed octagon and the cross-in-square is decorated on every available surface. The Virgin and Child are in the apses, in the dome is the scene of the Pentecost, with the apostles, partly visible, receiving the Holy Ghost from a central symbolic throne. The figures on the pendentives are the nations they evangelised.

51. The Crucifixion. *c.* 1020. Mosaic. Katholikon, Hosios Lukas in Phocis, Greece. The mosaics in the narthex of the church are by a different hand from those in the main body of the church. The stylisation of the figures and the way in which they stand isolated from sach other by glittering gold areas seem related to the style of court workshops. The *Resurrection* (represented by the *Descent into Limbo*), the *Washing of the Feet* and *Thomas's Disbelief* are other scenes in the narthex, and in the vaults are medallions and figures of martyrs and bishops.

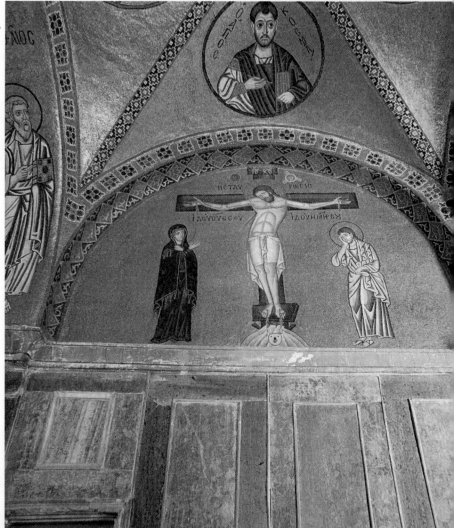

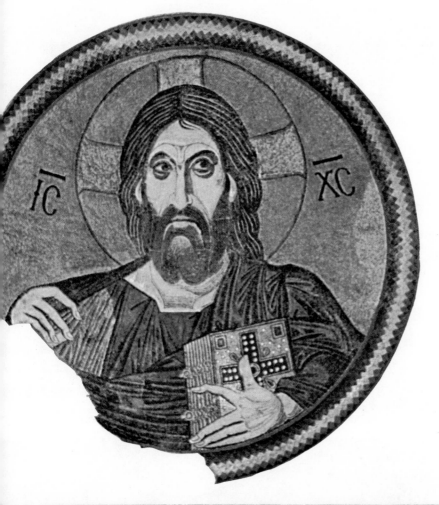

52 (left). **Christ Pantocrator.** 1100. Mosaic. Daphni, Greece. This representation usually occupies the central dome or the main apse of Byzantine churches. The awesome figure of Christ Almighty is a more Eastern concept than the suffering mortal of late Western churches. The second person of the Holy Trinity mediates between God and mankind, whom he has saved and will judge in the end.

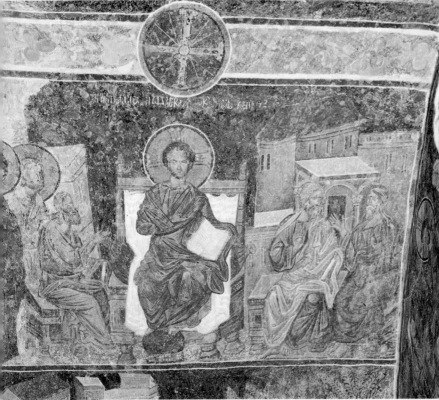

53. **Wall-paintings in Sta Sophia, Trebizond.** *c.* 1260. Paint on plaster. Eastern end of the Black Sea, Turkey. During the period when the workshops at Constantinople were comparatively inactive after the capture of the city by the Crusaders the far-flung outposts of the Empire were carrying on the artistic traditions. These fine paintings at Sta Sophia show distinct similarities with paintings in Macedonia and Serbia. The common derivation from court models can be seen in both the attitudes and the execution of these and the Christ Pantocrator above. **Christ among the doctors** shows the beardless young Christ in the same position as in plate 12. To the left are Joseph and Mary, and to the right the architectural detail so typical of late Byzantine frescoes and mosaics, especially those in Kahrie Cami.

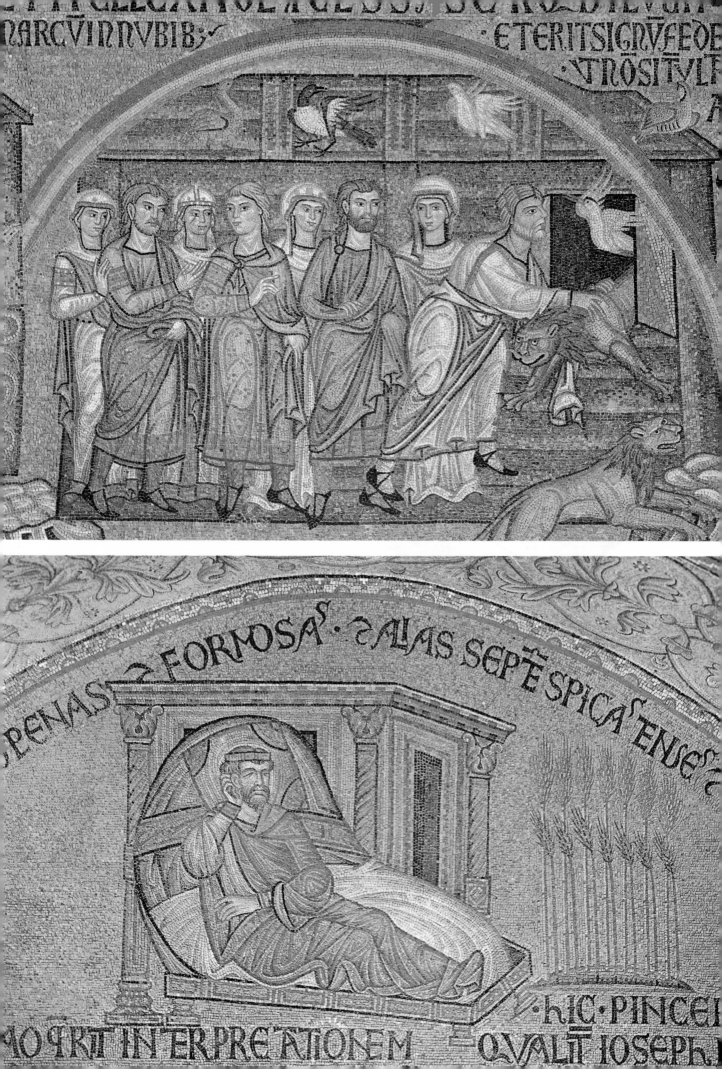

NARCUI NNUBIB; ET ERIT SIGNU FEDE
TROSITUL

PENAS FORMOSAS ALIAS SEPTE SPICA ENSES

OPRT INTERPRETATIONEM QUALI IOSEPH

HIC PINCER

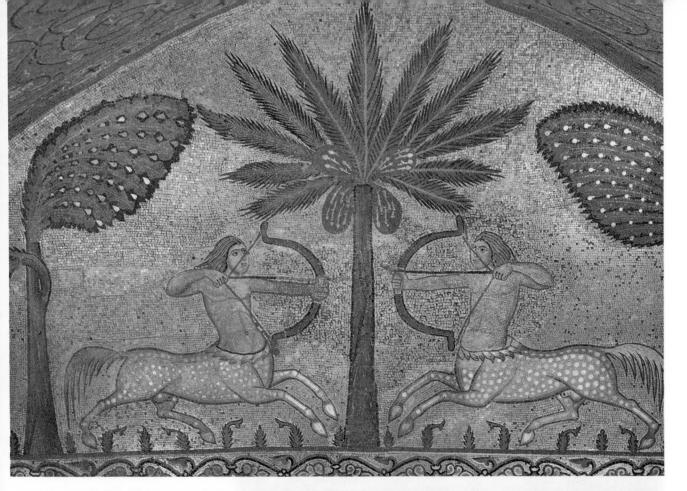

54, 55 (opposite). **Noah leaves the ark.**
13th century. Mosaic. S. Marco, Venice.
The heritage of Byzantine traditions died
hard in Venice—these mosaics of the
Genesis in the cupolas of the narthex show
how a more 'conversational' religious art
developed here from the miniatures of a
6th-century Bible. Noah (above), his wife,
his sons and daughters-in-law have left
the ark beneath the protection of the
rainbow, a sign of their alliance with
God, they have released the animals
from their long captivity. Below the
scene representing **Pharaoh's dream**
shows how the architectural elements of
the later mosaics and of the Hellenistic
frescoes have influenced the Venetian
craftsmen. Pharaoh reclines while the
seven fat and seven shrivelled ears of corn
appear before him. His bed is in a
classical setting with the perspective
reversed.

56, 57. **Decorative mosaics in the
Palazzo Reale.** c. 1160–70. Palermo,
Sicily. In complete contrast to the
religious scenes of the Byzantine mosaics
in Sicilian churches the decoration of the
Norman *stanze* in the palace at Palermo
shows the presence of Muslim influences
in this island which had only just been
liberated from the Arabs. The stylised
animals, trees and hunting scenes are
typical of motifs in Persian textiles. They
had for a long time infiltrated into
Byzantine art and the Sicilian mosaicists
could easily mix the traditions.

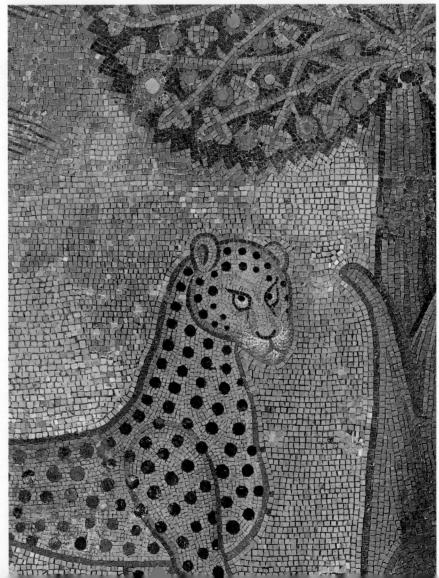

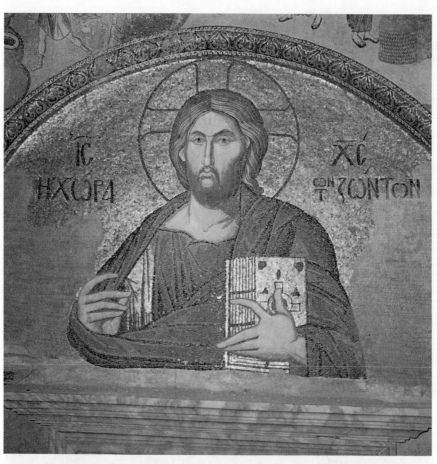

58. **Christ Emmanuel.** *c.* 1300–20.
Mosaic. Kahrie Cami (Chora Church),
Constantinople. This church was rebuilt
in the 11th century as it now stands and
decorated during the two hundred years
which followed. Most of the mosaic
decoration was executed at the same
time, including two panels above the
doors of the narthex representing Christ
and the Virgin. Although the attitude of
Christ is traditional, his features are less
severe, no longer the dreaded
Pantocrator, but the refuge of mankind.

59 (below). **Detail of the Birth of the
Virgin.** *c.* 1300–20. Mosaic. Kahrie
Cami (Chora Church), Constantinople.
The story of the Virgin is one of the main
themes of the mosaic decoration preserved
at Kahrie Cami. The wealth of
architectural details, the furniture and the
activity of the figures gives a dramatic
effect to the scenes. This detail is
particularly realistic with the cradle
prepared to the left, the anxious father
peeping to the right and the preparation
for the washing of the Virgin to the
extreme right.

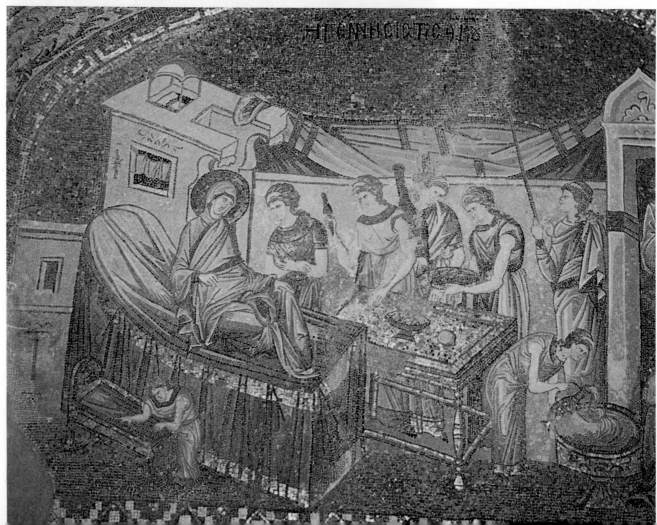

60 (above). **Eliezer and Rebecca.**
6th century. Purple parchment.
National Library, Vienna. Known as the
Vienna Genesis this famous manuscript is
one of the rare examples of early
Byzantine illumination and is of uncertain
date and provenance. But even if there is
nothing definite with which to compare it
the taste for anecdote and landscape is
Alexandrian. Rebecca leaves the town,
approaching the spring, and gives water
to Jacob's messenger before watering her
camels. The text is illustrated with an
uninterrupted movement, in a charming
and informal way.

61 (left). **Christ before Pilate.** 6th
century. Purple parchment. 12 × 10½ in.
(30.7 × 26 cm.). Cathedral Treasure,
Rossano, Italy. The Rossano Codex has
the same continuity of imagery as in the
Vienna Genesis. In this instance the
scenes appear more detached from each
other. Pilate in the upper register hears
the case of the chief priests. Below, to the
left, Judas is overcome with remorse and
hands back the thirty silver pieces; on the
right he has hanged himself. The solemn
symmetry of the judgement scene is
followed by others in a more intimate
style.

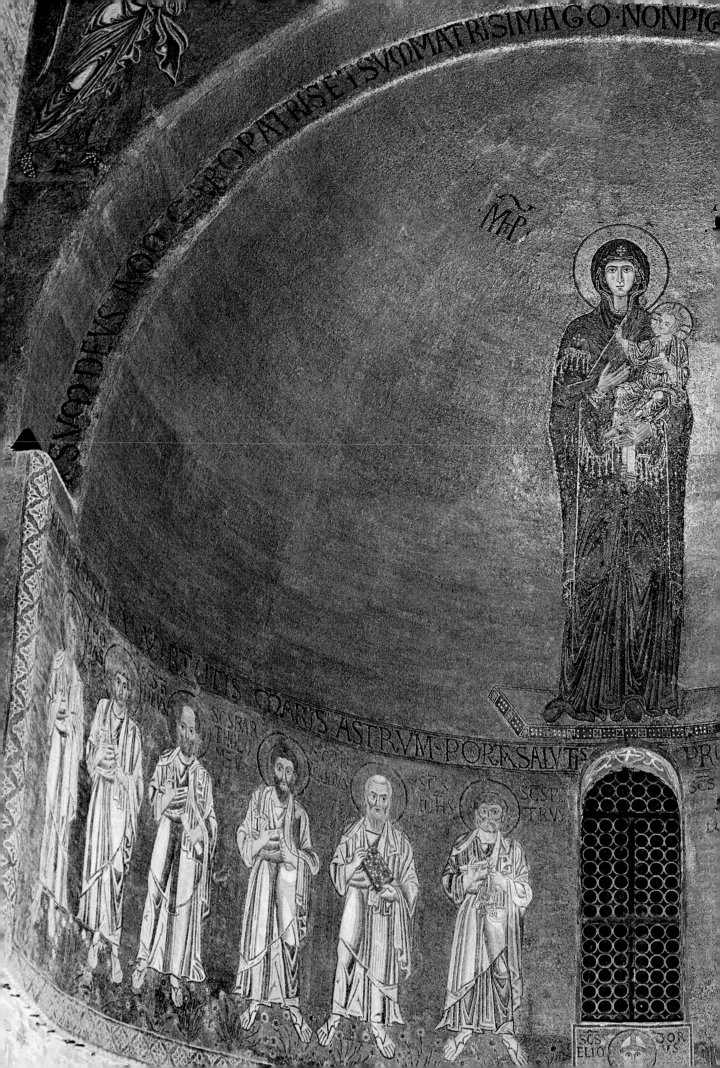

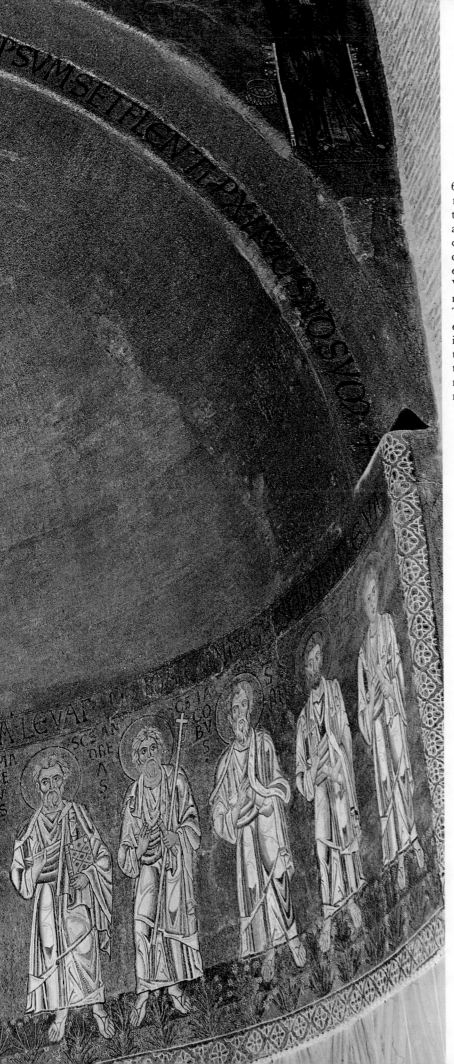

62. **Apse mosaic, Torcello cathedral.**
12th century. Torcello, Venice. The
theme of the Virgin standing in a golden
apse, known from earlier examples in
churches at Nicaea and Salonika (now
destroyed), is used here with magnificent
effect. The tall elegant figure of the
Virgin dominates the apse and stands out
majestically from the gold around her.
The apostle below probably date from
earlier in the 12th century. The direct
influence of Ravenna and of Constan-
tinople is noticeable here, as in some of
the mosaics in S. Marco, Venice. The
motif of the Virgin standing in the apse
recurs in the nearby church of Murano.

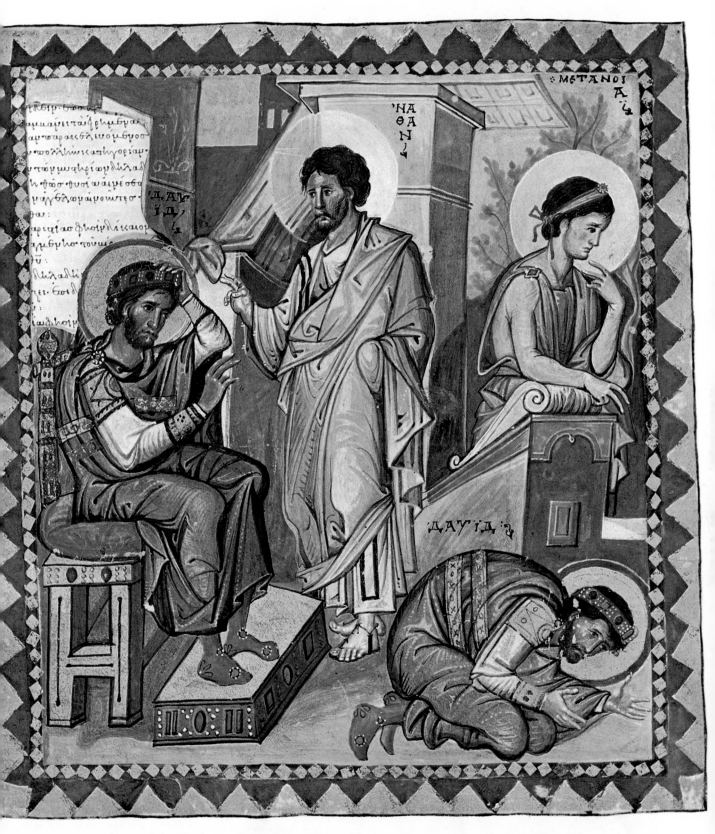

63 (opposite). **Sermons of the Monk
James Kokkinobaphos.** 12th century.
9 × 6 in. (23 × 16.5 cm.).
Bibliothèque Nationale, Paris (MS. Grec.
1208 fo. 47). The expulsion of Adam and
Eve from Paradise is here depicted in a
delightfully original way. The *Sermons on
the Virgin* by James Kokkinobaphos is a
series of discussions taken from the
Gospels and the Apocrypha. All the

illustrations are treated in the same
spontaneous and masterly way. Their
importance lies in the complete
originality of the iconography.

64 (above). **The Penitence of David.**
10th century. Manuscript. 14⅛ × 10¼
in. (36 × 26 cm.). Bibliothèque Nationale,
Paris (MS. Grec. 139). The miniatures
of the famous Paris Psalter which came

from the imperial workshops at
Constantinople were evidently copied
from an earlier manuscript and as with
many manuscripts of the same period
seemed a direct continuation of classical
art. In this scene David, reproached by
the prophet Nathan, repents at having
abducted Bathsheba. On the right is a
personification of penitence, an
Alexandrian tradition.

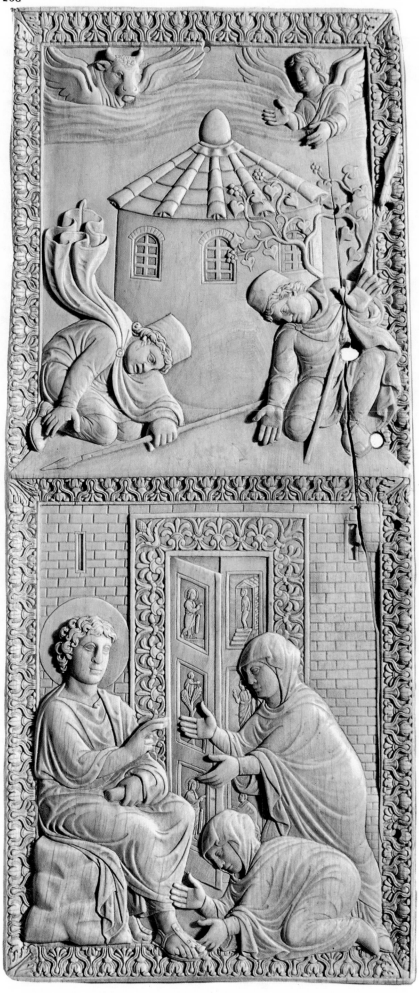

65 (left). **The Holy Women at the Sepulchre.** 5th century. Ivory. 12⅛ × 5¼ in. (31 × 13.5 cm.). Trivulzio Collection, Castello Sforzesco, Milan. The simple beauty of this early carving on the leaf of a diptych is characteristic of the passage from classical to Christian art. The two scenes, one above the other, represent two moments in the action, the sleeping guards, then the angel greeting the Holy Women at the entrance to the tomb. The risen Christ is not featured— Christian art proceeds by allusions. The tomb recalls the *aediculum* built over the Holy Sepulchre in the 4th century. Note the Christian scenes on the doors.

66 (opposite). **Pala d'Oro.** 10th–14th centuries. Enamels mounted in gold and silver Gothic framework, set with precious stones. Basilica of S. Marco, Venice. This detail from the glorious altarpiece of S. Marco shows the centre of the elaborate panel, and the magnificent late Byzantine plaque of Christ, enthroned in the familiar attitude of the Lawgiver. The roundels surrounding it contain the four Evangelists; above are scenes of the *Baptism*, the *Last Supper*, the *Crucifixion* and the *Resurrection*, and the symbol of the Holy Ghost. Saints and martyrs occupy the surrounding niches. The enamels were brought from Constantinople in the 10th century and again at the beginning of the 13th after the capture of the city. The present setting dates from 1345 and includes much earlier elements in its Gothic frame. It conforms to the taste for magnificence that the Venetians acquired from the Byzantines.

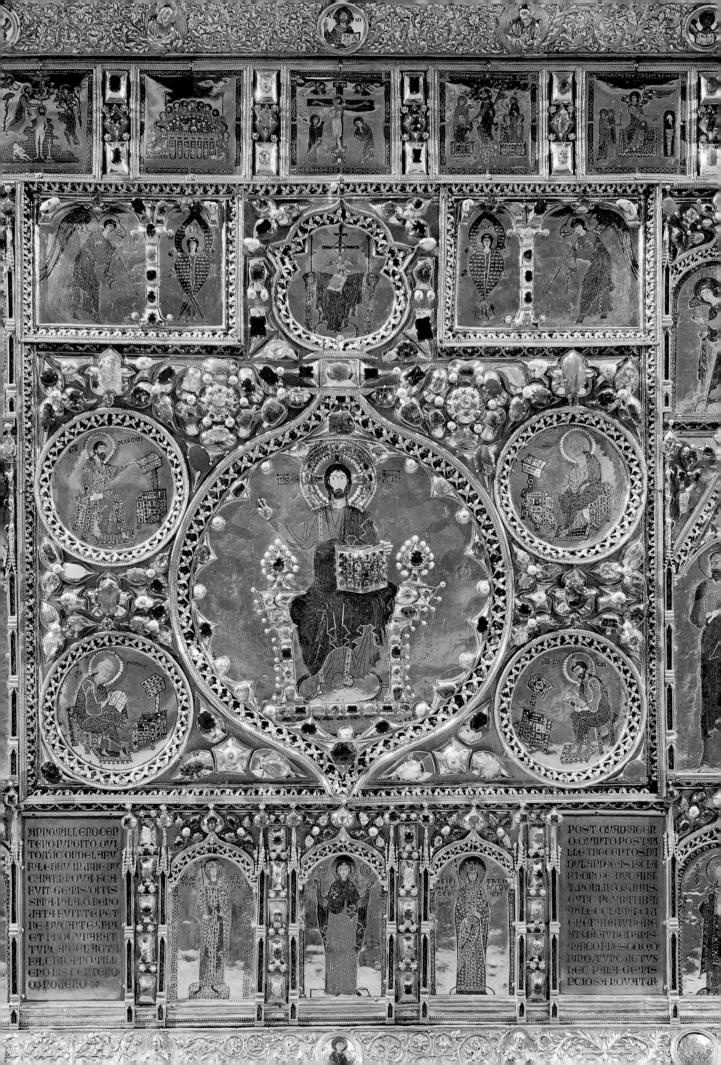

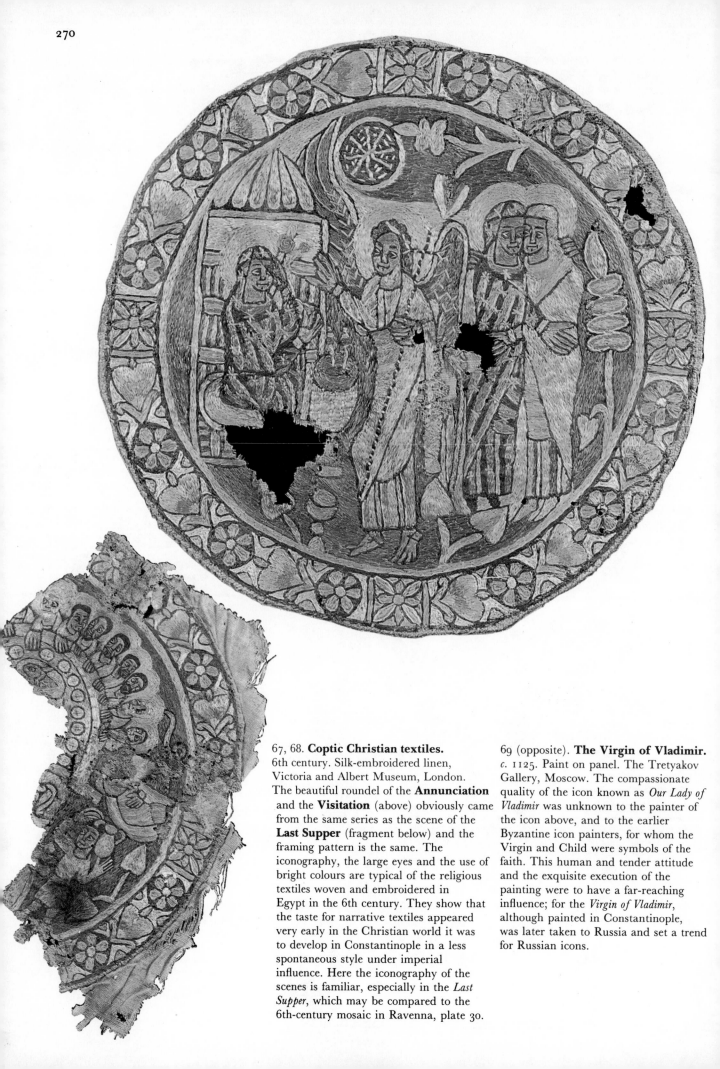

67, 68. Coptic Christian textiles.
6th century. Silk-embroidered linen,
Victoria and Albert Museum, London.
The beautiful roundel of the **Annunciation**
and the **Visitation** (above) obviously came
from the same series as the scene of the
Last Supper (fragment below) and the
framing pattern is the same. The
iconography, the large eyes and the use of
bright colours are typical of the religious
textiles woven and embroidered in
Egypt in the 6th century. They show that
the taste for narrative textiles appeared
very early in the Christian world it was
to develop in Constantinople in a less
spontaneous style under imperial
influence. Here the iconography of the
scenes is familiar, especially in the *Last
Supper*, which may be compared to the
6th-century mosaic in Ravenna, plate 30.

69 (opposite). **The Virgin of Vladimir.**
c. 1125. Paint on panel. The Tretyakov
Gallery, Moscow. The compassionate
quality of the icon known as *Our Lady of
Vladimir* was unknown to the painter of
the icon above, and to the earlier
Byzantine icon painters, for whom the
Virgin and Child were symbols of the
faith. This human and tender attitude
and the exquisite execution of the
painting were to have a far-reaching
influence; for the *Virgin of Vladimir*,
although painted in Constantinople,
was later taken to Russia and set a trend
for Russian icons.

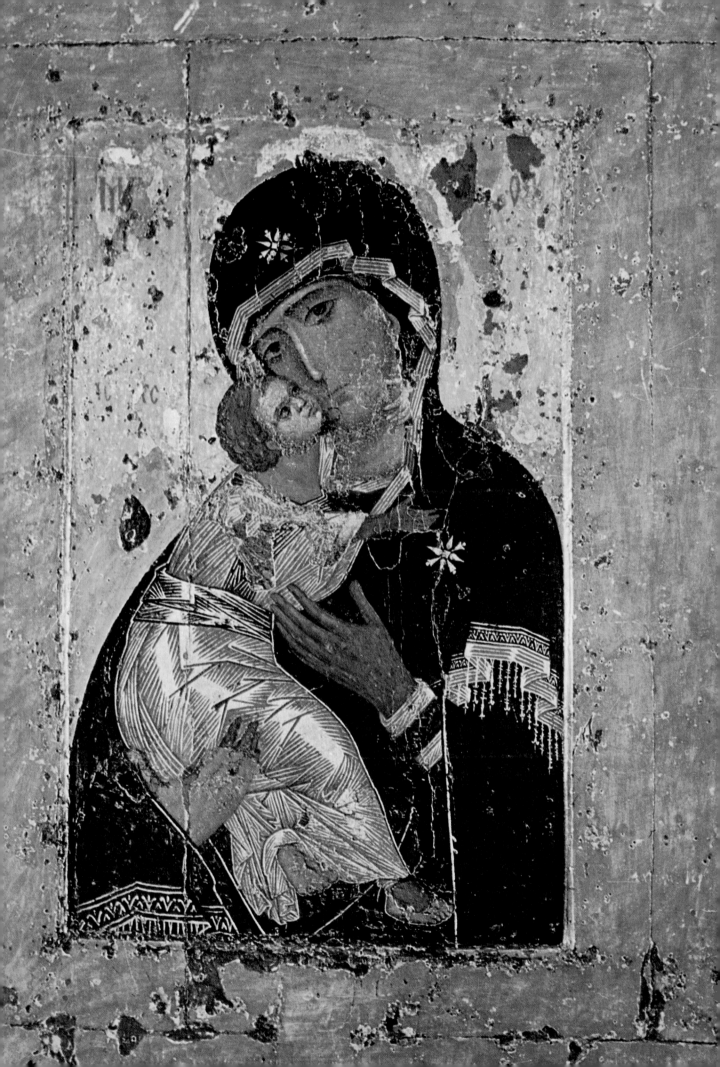

These diverse tendencies were to continue without a break through into Romanesque art, which with its power of expression brought them together and transformed them into a vigorous new style.

MINIATURES AND MANUSCRIPTS

Even if the western mosaicists and mural painters did possess a certain originality, they never had the disconcerting power of their contemporary miniaturists. It is rare to find such violent contrasts between two arts of the same period. The reason is that from the 8th century the miniature had undergone the influence of Ireland which had not touched monumental art.

The so-called 'Echternach' Gospel-book, which was painted about 690 in Ireland or in an Irish abbey in England, was brought by the monks to the abbey founded by Willibrord in 698 at Echternach. More even than the Durrow Book, it subordinates the human figure to an interplay of curls and volutes. Many other original documents, just as characteristic, arrived in the Frankish kingdom in this way.

There are few works as intellectually stimulating as these miniatures, in which this 'insular' art confronts Mediterranean art on its own ground. This convergence is already apparent in works of English origin, like the *Codex Aureus* of Stockholm, painted at Canterbury about 750, in which there are portraits of the Evangelists, sitting quietly beneath arcatures decorated with motifs taken from ornamental mosaics like the wavy ribbons and in others where the 'insular' decoration is applied to a heavily framed text. Also in works like the Gospel-book of Trier (Trèves) cathedral, painted at Echternach about 730, the 'insular' decoration is more disciplined and arranged so as to leave room for animals—the symbols of the four Evangelists—enclosed in frames. In the way they are drawn, these animals remind one of their predecessors, which were incorporated into the design. It is not surprising therefore to find basic motifs of Irish origin on metal or ivory reliquaries made in the Frankish empire.

When Charlemagne decided to create an official workshop at court for the reproduction of manuscripts, his painters were also to find themselves confronted by these different tendencies—and each of them was affected in his own way. It was the Gospel-book of Godescalc, commanded by Charlemagne returning from Rome in 781,

after the baptism of his son Pepin, that marked the opening of the royal workshop. Like the great imperial manuscripts of Constantinople, it is written in gold and silver on purple parchment. It contains Christ in Majesty and the four Evangelists. The composition is traditional, but the execution is Italian-influenced, using a great range of colours, which contrasts vividly with both previous western illustration and Byzantine miniature painting.

A whole series of masterpieces was to emerge from the palace chapel, among which are admirable portraits of the Evangelists, sitting diagonally on a seat that seems to be part of the architecture, and which have an intense vitality of their own; they are shown in magnificent arcades, with their symbolic animals (the Gospel-book of St Médard de Soissons). There are also portraits of enthroned emperors, surrounded by officials and ecclesiastics, which are reminiscent of classical art. Some years later, a new palace school was to rediscover even older techniques as in the so-called Coronation Gospels which was almost a return to classical painting; there are several manuscripts that revived this technique.

Curiously enough, these highly graphic works seem to have brought about a revival in draughtsmanship. The Ebbo Gospel-book, at Reims, marks the flowering of a new sensibility—a desire on the part of the artists not to stylise, as they drew them, the folds that they had just learnt to paint. This resulted in the Utrecht Psalter, drawn at Reims about 820, which represents a complete revolution in artistic habits. The psalms are illustrated not according to their general meaning, nor according to the historical events of their composition, but by seizing upon every allusion as it occurs in each verse. As a result, the pages are covered by a mass of strangely realistic figures depicted against a background of mountains or dream architecture, side by side with cleverly dramatised allegorical interpretations. Some scholars believe that the miniaturist had recourse to early Christian models, and one is constantly reminded of earlier works, but everything has been assimilated. It is the astonishing draughtsmanship which gives unity to the illustrations of the volume and they are executed in such an original way that one is tempted to abandon any attempt at trying to discover its origin. (*see* The Medieval World, figure 22).

Each of these series of paintings turned back to ancient sources, but all of them go beyond those sources: we are no longer in early Christian art but in the Middle Ages.

70 (opposite). **The Annunciation.** Early 14th century. 36¼ × 26¾ in. (92 × 68 cm.). Macedonian State Collections, Skopje, Macedonia. Although this double-sided icon is from the Church of St Clement at Ochrid, it is probably the work of a master from Constantinople. A processional icon, it would be carried on a pole. The other side shows the *Virgin and Child*, but the graceful beauty of this *Annunciation* has made it one of the most famous of Byzantine paintings. The traditional reserve in the expression of feeling is maintained here, but other icons, while keeping the same composition, are imbued with a new emotion.

The Byzantine Expansion

IMPERIAL ART IN CONSTANTINOPLE

In the East a magnificent revival of Byzantine power in the 9th century almost coincided with the end of the iconoclastic dispute. Michael III and his uncle, Bardas, intensified the policy of converting the Slavs, to whom Cyril and Methodius brought not only the Gospel but also an alphabet created specially for them. He then helped his new favourite, Basil, to eliminate Bardas; Basil in his turn became so powerful that he was able to rid himself of his protector and found the Macedonian dynasty. This dynasty was to enjoy a brilliant reign from the end of the 9th century to the middle of the 11th. In 80, Byzantium regained the positions it had lost in Italy. Basil II rid the Balkans of the threats from Bulgarians and Russians. Nicephorus II drove out the Arabs, reconquering first Cilicia, then Syria. Armenia and Cyprus were reoccupied. A powerful empire was thus reconstituted and its glory was to increase, and its art spread accordingly. Even in regions like Sicily, where the Normans had established a kingdom that was strong enough to hold both Arabs and Byzantines in awe, basilical churches of an almost western type were decorated with Byzantine mosaics by Greek artists.

The starting point of this new expansion was obviously Constantinople and above all H. Sophia, which was given a new imperial decoration. Mosaics covered the walls of the narthex and gallery, celebrating the accession of emperors and empresses like the imperial statues in the forums of earlier times: once again the icon replaced the idol and painting—or in this case mosaic—replaced sculpture in the round. At the west gate, Leo VI (886–912) is represented prostrated before Christ in majesty, seated on a golden throne, between medallions in which the Virgin and an angel enact the scene of the Annunciation. At the south gate where the Virgin is shown between Constantine and Justinian, the two former emperors look like brothers, dressed alike in purple tunics and long, cleverly draped, golden stoles. Leo VI is given a beard and represents a transition from the imaginary portrait to the real one.

In 1030, the Emperor Romanos III and the Empress Zoe were represented, in the south gallery, on either side of Christ. After the death of her second husband, Zoe married Constantine Monomachus, who, in turn, became emperor; as with the statues of the Roman emperors, whose marble heads were removable, all that was necessary was for the face of the emperor to be changed.

The Comneni followed the example of the Macedonians: as did John II Comnenus and the Empress Irene in 1118. Adding to these the splendid frontispieces of books painted in the court studios, we have a rich series of imperial portraits, including those of Basil II in the Venice psalter and of Nicephorus Botaniates (1078) in the Homilies of St John Chrysostom. All these pictures are static and utterly imperial; and the art of the court totally overshadows the religious art.

Basil II had a new church built at Constantinople—the Nea—which was later destroyed. It is thought to have provided the model for another church, the Assumption

55. **The Emperor Constantine II and the Empress Zoe.** 1030. Mosaic. South Gallery, H. Sophia, Constantinople. The mosaic originally portrayed Romanos III who was already Zoe's second husband. It was enough just to change the head to portray her third. The sovereigns present Christ with a bag of gold and a donation—for God's protection of the imperial family.

at Nicaea, which was destroyed in 1922, but of which photographs have been preserved. These show a group of archangels and a particularly fine picture of the Virgin, standing on a plinth and holding the Christ Child in front of her, in a vast golden dome. This simple composition was used later at Murano and at Torcello—and produces an astonishing effect of grandeur.

BYZANTINE MOSAICS IN GREECE

Three Greek churches also provide evidence of the splendour of the 'Macedonian Renaissance'. All three are monastery churches: Hosios Lukas in Phocis (early 11th century), the Nea Moni at Chios (about 1050) and the monastery of Daphni on the road from Athens to Eleusis. Such monastic enterprises may be regarded as being independent on the art of the court, they may have been realised by Greek artists foreign to the capital. It is all the more remarkable to find in them touches that are peculiar to the early Byzantine inspiration of this period.

The church of the monastery of St Luke—Hosios Lukas—has a central dome, dominated by a medallion of the Christ Pantocrator, surrounded by archangels and prophets. In the apse, is a seated *Virgin*. Above her, in a dome, the apostles, sitting in a circle, are receiving the illumination of the Holy Ghost. In the niches placed beneath the dome are represented the Annunciation, the Nativity, the

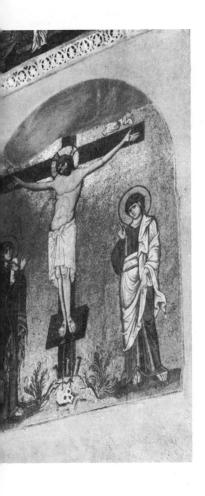

56a, b. **Daphni.** second half of the 11th century. Greece. The golden walls of the monastery church of Daphni (b) surrounded by pines and cypress trees, stand out against the barren hillside. (a) The magnificent mosaics inside are ablaze with gold (see plate 52). The crucifixion is most expressive in its restrained treatment.

Presentation in the Temple and the Baptism in the Jordan. In the narthex, opposite the entrance, is the Crucifixion—Christ on the cross, with the Virgin and St John, the Resurrection, represented by the descent into limbo and, at the ends of the gallery, the Washing of the Feet and Thomas's Disbelief. This series of historical scenes is complemented by a whole army of saints and bishops—intercessors and witnesses—on the vaults, on the arches and at the tops of the walls.

In the Gospel scenes, there is an added dignity. This is apparent in the attitude of Christ in Limbo: he is shown full-face, yet, despite the effort he is making to pull Adam from his grave, there is no loss of balance. His gesture is that of the conquering emperor—the spear being replaced by the cross—standing over his defeated enemy, represented here by the gaping jaws of hell. On the other hand, the Nativity is narrative and picturesque, with connecting motifs on a different scale.

The monastery at Daphni, like many in the West, but like even more in the East, looks like an oasis. The dome rises over gold and white walls, between tall pines and cypresses, and the mosaics greet the visitor in a blaze of light, although they themselves are grave, somewhat cold —one might almost say classical. The Crucifixion, for example, is surprisingly sober. As at Hosios Lukas, the Crucifix, the Virgin and St John are each treated in isola-

tion. St John is presented like a statue—which suggests antecedents beyond Christian art, in ancient Greek sculpture. The attitude of the Virgin is traditional but the face, shown in semi-profile raised towards the cross, is charged with controlled suffering. The Christ on the cross is also treated with restraint—the body curves only slightly to one side, the musculature hardly visible, and his eyes are closed in an almost serene expression. This beautiful picture is full of respectful adoration.

It is rather surprising to find the same discretion—in this case perhaps as a result of a certain lack of feeling—in scenes like Thomas's disbelief, in which the risen Christ, so much taller than his apostles, offers himself impassively, for verification, while the apostles stand around looking detached and distinguished. The Anastasis, which is more dramatic in plan, manages to create emotion only on the face of Eve. In the Entry into Jerusalem, the handsome face of Christ has a faraway look and there is a frozen quality about the enthusiastic gestures and noble faces of the onlookers. There is no stiffness here: the technique is faultless but the feeling is always controlled. At Daphni, Byzantine art is revealed as the expression of an accomplished civilisation.

All these monuments, whether imperial or monastic, give an impression of dignity, discretion and nobility. The influence of a courtly art can be felt even in monasteries

far away. It is the same impression that one gets when turning the pages of the great imperial manuscripts of the time, the Paris psalter 139, the Venice psalter or the Homilies of Gregory Nazianzus—all works in which the religious emotion is contained within the purity of style. Classical echoes crop up constantly, not only when the personified figure of the Jordan appears in the river, or that of Night participates in the prophet's vision. It is difficult not to be affected by this charm—even if one prefers more powerful works, less dependent on Hellenistic tradition.

ITALY

Under the Macedonians, Italy knew two episodes in her relations with the Byzantine Empire that were to be of great importance in her history.

The Byzantines witnessed first the formation, then the expansion of the power of Venice. The empire still held Dalmatia and its presence was a break on Venetian expansion. But the Carolingians and their successors represented a much more immediate danger: so much so that the Doges usually preferred an alliance with Byzantium, which opened up trading routes to the East. In every episode in the struggles of the Macedonians and the Comneni against the Bulgarians, the Arabs and the Normans, Venice played a role that was often a determining one. But whether protected, in alliance, or hostile, Venice was nonetheless affected by her relations with Constantinople.

This explains how there began, around 1100, the building of the cathedral of S. Marco and the first stages of its mosaic decoration.

S. Marco in Venice is a church with five domes arranged in the form of a cross. It is encircled by a side-aisle, with columns between the pillars. At the east end this side-aisle is transformed into side chapels, so the church thus has three apses. An exterior portico, covered by a series of small domes, surrounds the west arm to create five doorways very deep in the façade, covered with small columns: in the ground-plan they form the *scenae frons* of a Roman theatre —alternate square and semi-circular niches. This structure, of which the general arrangement is taken from the church of the Holy Apostles at Constantinople, as rebuilt

by Justinian, creates a fine effect in itself. This is enhanced on the outside by the later superelevation of the lead domes and on the inside, as in the narthex, by the brilliance of the mosaics.

Of course the mosaics were laid at different times, and added to, repaired and re-arranged. Here and there one might find a baroque saint, with billowing clothes, but the gold backgrounds were left untouched and the effect remains. The domes, 'shining with their own, unearthly light' (Marcel Proust) are best seen from the interior galleries. Questions of iconography and chronology are then forgotten; Byzantine architecture is balance, but it is also colour.

There is little doubt that Byzantine tradition, represented for the *Genesis* in the narthex for example by the 6th-century Cotton Bible, was, from the 12th century, interpreted by the Venetians in their own way; however they wished to remain faithful to it. But it would be better to say that there is a Venetian School of Byzantine mosaic.

The scenes which are definitely old inside the church were distributed between different studios. In the Temptation of Christ or the Entry into Jerusalem, the style is full of simplicity and nobility; whereas in the Ascension of the central dome, it revives with vigour and movement the theme illustrated at Sta Sophia of Salonika—the apostles run about gesticulating as they watch their Master rise into the sky and, below them, between the windows, the Virtues and Beatitudes remind one of dancers, while the calm evangelists, in the pendentives, are by another hand.

The 13th-century Genesis in the domes of the narthex is still a delightful series despite its having been considerably retouched. The Creation, the Fall and the Flood have an apparently naive, but effective expression, owing to the precision of the drawing and the technique of the placing of the cubes: the animals in the ark, the rain falling on the drowned and the spires sticking up out of the water as Noah releases the dove are quite unforgettable.

The Venetian School was also active at Torcello, on an island in the lagoon, where two masterpieces face each other: the golden apse dating from the 12th century, in which stands a slender, blue Virgin presenting the Child,

57. **S. Marco**, Venice. 10-12th centuries. The aerial view shows the five domes of the basilica forming the Greek cross. The tall lanterns of the dome are pierced with windows. The basilica was modelled on the church of the Holy Apostles, built by Justinian in Constantinople.

above a row of apostles faces the inside wall of the façade, which is taken up by an extraordinary Last Judgement, with five registers of increasing height, dominated by the traditional scene of the Resurrection—Christ's descent into Limbo, flanked by two angels dressed as imperial dignitaries. Above, Christ is enthroned among his apostles; below, angels separate the saved from the damned—an arrangement of scenes already treated, but linked together for the first time in an impressive whole.

SICILY

The second event of great importance to Italy was the conquest of Sicily, first by the Arabs, then by the Normans. It was in 827, while the Muslims of Egypt were occupying Crete, that the Muslims of Africa made a victorious attack on Sicily. In spite of successive counter-attacks the Byzantine positions were gradually eroded. The Normans, who were first brought into this struggle as mercenaries, soon established their power both in Apulia and Sicily. The Comneni were forced to negotiate with them in 1073, and in 1172 to offer them Porphyrogenetes in marriage. Roger II, king of the two Sicilies from 1130 to 1154, negotiated on an equal level with both the Byzantine emperor and the empire of the West.

The contacts that had been created by such a succession of crises had given birth in Sicily to a very complex art. Its architecture is sometimes of a western type as in the basilicas at Cefalù and Monreale. On the other hand, the Martorana at Palermo, a delightful domed church, is very

58. **Christ crowning Roger II.** 1143-1151. Mosaic. Church of the Martorana, Palermo. Roger II was the Norman king of Sicily. The scene of investiture was borrowed from the official court art of Constantinople (see figure 55) while the picture itself may have been executed by a Greek mosaicist.

Byzantine inside but takes on Islamic forms on the outside.

A great many of the mosaics around Palermo have been preserved. This is partly due to the Byzantine artists who were followed by Sicilian mosaicists on the spot. As a result there are disparities and inequalities of style, which are apparent on close examination, but which detract very little from the overall effect. The cathedral at Cefalù is the oldest of these buildings—it was begun in 1131. In the apse, a calm-faced Christ Pantocrator holds out a Bible to the faithful, on which the text 'I am the light of the world' is written, on one side in Latin and on the other in Greek. But there is nothing Latin about his features or his attitude. Below him is the Virgin enthroned among the archangels, then the bishops and saints—a traditional arrangement. In the cathedral at Monreale, built about 1190, we find the Pantocrator in the apse, then the Virgin, surrounded by angels and saints. But the nave, the transept above the arches, between the windows of the clerestory, the walls of the side aisles and, finally, the façade wall are covered with historical mosaic pictures recounting in detail the Old and New Testaments. The iconography is traditional; the execution is robust and retains a character of narrative imagery, with no striving after expression. The backgrounds of architecture and landscape, the attitudes of the figures and the costumes all seem to conform to the norms. The colour is bright, and occasionally a more interesting figure or a livelier scene appears.

The mosaics of the Martorana at Palermo are of a finer quality, and their position in the structure of a Byzantine church allows them more variety and charm. The Palatine Chapel, the jewel of Roger II's palace, is decorated beneath Moorish ceilings and a dome supported by squinches, with evangelists, rows of saints with faces resembling the originals of Constantinople and scenes along the walls. They have a freshness which is more appealing than those at Monreale. The Byzantine Christ is shown crowning Roger II in the narthex of the Martorana, and 84 William II at Monreale. The Norman kings are wearing the same costume as the emperors in the coronation scenes in Constantinople. They showed their greatness by borrowing not only the emperors' clothes, but also their artists.

Thay also borrowed extensively from the Arabs: in a hall of the palace at Palermo one is surprised to encounter whole series of hunting and animal scenes, set among trees, 56, 57 which recall certain pavement compositions in Antioch, borrowed from the Sassanians under Justinian, but in their Islamic version. The taste of the Norman princes for rich fabrics which resulted in the establishing of weaving-shops, was no doubt also responsible for their importing silks not only from Byzantium, but also from Persia.

THE PALAEOLOGUES: THE LAST REVIVAL

Before leaving Byzantine art, we should return to Constantinople. Michael Palaeologus, who was at Nicaea, and who seized power at the death of Theodotus II Lascaris, succeeded, with the help of the Genoese, in driving the Franks from Constantinople (1261) and founding a dynasty that proved strong enough to resist all attacks until the

fall of 1453. From the beginning, it was a much smaller empire than before, with the Seljuks in Anatolia, the Armenians in Cilicia, the Bulgarians an Serbs independent in the Balkans, while the empire of Trebizond and the Despotate of Epirus maintained their independence and the Peloponnese, despite the conquest of a few citadels, remained in the hands of the Franks. During this difficult period, Byzantine painting was to revive once more, first in Constantinople, then in the empire itself, in particular in its Peloponnesian citadel of Mistra.

The church of the Saviour at Chora, now Kahrie Cami, has a whole cycle of mosaics dating from the beginning of the 14th century. The church is very small—82 feet by 82 feet in all, or without the additions 27 feet 6 inches. The walls are entirely covered with astonishingly animated mosaics recounting the lives of the Virgin and of Christ and adding to the traditional episodes allusions to hymns that had just been introduced into the liturgy. The scenes take on a new development thanks to the attention paid to the details of the event, the subsidiary characters, the decorative background and the accessories. The mosaic of the Birth of the Virgin becomes the occasion for a great scene with serving women carrying torches and preparing food for the mother while the midwives stand in a corner preparing the bath for the new-born child under the indiscreet eye of the father peeping from a doorway.

59

The apocryphal Gospel of St James supplied other picturesque and moving motifs like the Annunciation to Elizabeth, or the scene in which the Virgin is learning to walk and stumbles towards her mother. In the life of Christ the Gospel accounts of his childhood are interpreted in a similar way as in the census of Quirinus, in which Joseph presents his wife to the governor and registrar, or again the Flight into Egypt, preceded by Joseph's premonitory dream. Christ's miracles also allow the arrangement of a picturesque group of beggars and cripples opposite the majestic, somewhat aloof apostles. It represents, in fact, a quite new vitality in the portrayal of the familiar Gospel stories.

Overhead extends a representation of the Last Judgement, in which Christ is enthroned, surrounded by a *synthronon* of apostles and a host of angels standing over the tiny figures of the damned. And in the mosaic dedication scenes, one with Theodorus Metochetes, the founder of the church, the other with Prince Isaac Porphyrogenetes and his sister Maria at his feet, the Christ, accompanied on the second occasion by a Virgin of intercession, has the same solemn majesty that was present everywhere in the previous period. Nevertheless the humanity of the group scenes is a new departure and shows that once more Byzantine art was trying to revitalise its conventions with more daring than ever before.

This is to be found with even greater freedom in the frescoes of the churches of Mistra in the Peloponnese. In the 14th century the city was dependent on Constantinople; it was governed by one of the emperor's sons, who brought with him the latest artistic inspiration from the capital, which itself was enjoying a really intellectual life. In spite of its connections with western culture—it was surrounded by Frankish principalities and several of its princes had married Italian princesses—it was very little affected in its architecture and decoration by foreign influences. The architecture is Byzantine and the painting was dependent on Constantinople.

59. **The Ascension.** Paint on plaster. Pantanassa church, Mistra, Peloponnese, Greece. The frescoes of the vault of the sanctuary include this beautiful detail of the Ascension. The grace and realism of the expressions and the draperies are quite outstanding. The Virgin, and here the Apostles, stand among the trees, witnessing the miracle of the Ascension depicted on the vault.

A good way of appreciating the transformation in Byzantine painting is by means of a theatrical comparison. Usually the figures are traditionally placed on a narrow stage, before a plain wall. The acting is solemn and conventional. The scene is set by the arrangement of a few 'props' on the stage. In the 13th century, the plain backdrop is replaced by changing backdrops depicting various, complicated architectural scenes; but the characters remain isolated from these settings by a wall that confines them to their narrow platform and which enables them to stand out against a plain, bright surface. In the 14th century, the backdrop is replaced by 'flats'. The wall is broken and arranged at various depths; the stage becomes deeper and is filled up. The actors, too, are placed at different depths, separated by architectural elements or by rocks in country scenes. At the same time the actors move and gesticulate more freely and the 'walkers-on', until then a few figures standing motionless at the sides of the stage, now increase in number and take a more animated part in the action. The two-dimensional surface has been broken. The action now unfolds within complex, clashing structures, with contradictory perspectives: this may not be western space, organised in perspective, but it is space.

As can be seen we are now a long way from the definition with which we began. It would be interesting to take the comparison further, to study side by side, page by page, the simultaneous achievements of painters in the East and in the West, beginning with Giotto and the mosaicist of Kahrie Cami. The great collections of works on the history of art are forced to preserve geographical as well as chronological classifications. But it would be intriguing to see what place would be occupied by the painters of Mistra if they were suddenly confronted in the same book with their contemporaries in Siena, Florence or Padua. It is likely that they would appear as free, as imaginative, and as profoundly human.

THE
MEDIEVAL WORLD

Introduction

The numbers in the margins refer to the illustrations to The Medieval World section: heavy type for colour plates, italics for black and white illustrations.

Late in the 2nd century BC two German tribes known to Latin historians as the Cimbri and Teutones left their homelands in Jutland and began a long march southward, which by 113 BC had brought them to the confines of Italy. There, as much to their own surprise as to the consternation of their enemies, they contrived to defeat one Roman army after another, and for a period of some twelve years it seemed to the Italians as though the terrible invasions of Hannibal and the Gauls were about to be repeated. Eventually, the danger was averted by the military genius of Caius Marius, and a superficial observer might easily have concluded that a transitory episode was at an end. But in fact this first recorded encounter between Romans and Germans was fraught with immense consequences for the future. The totally unexpected renewal of danger from the north, after a century of unbroken victories in the coastlands of the Mediterranean, touched the pride, the complacency and fear of the Romans in a spot that was inordinately sensitive. Accordingly in due course they embarked on a policy of conquest in north-western Europe that was designed to put an end once and for all to any further threat to their security from that quarter.

With the partial implementation of this northern policy of Rome, which began with Caesar's invasion of Gaul in 58 BC and ended with the destruction of Varus' legions in the Teutoburg Forest in AD 9, a new situation was created. Within the Roman world a new balance was established between East and West, and a whole new set of relations were formed with peoples beyond the Roman frontiers. Although the occupation of Gaul was primarily a military affair, it had the effect of extending the frontiers of the classical world beyond the limits of the Mediterranean, to include the greater part of north-western Europe. The Latin language and pockets of Latin culture took root throughout the region. In Burgundy, the Rhône valley, on the Mosel and the left bank of the Rhine below Mainz, buildings were erected which, if modest by the standard of Rome itself, were sufficient even in ruin to evoke for later generations who saw them images of surpassing splendour. Not least, a system of roads was devised which presupposed that nearly everyone who travelled wished to travel to Italy; and this characteristic orientation survived the military and political links that gave it sense. The stamp of all this has proved indelible. In spite of the upheavals of the centuries that followed, north-western Europe was never quite able to forget that it had once been Roman.

Nevertheless, granted that there would have been no Europe as we understand it if the legions had not marched northward, it is necessary to make two very important reservations. The first is that in creating an Empire beyond the Alps, the Romans took the forms and features of Mediterranean life into regions whose climate, landscapes and peoples were utterly different from those of the Mediterranean itself. As the Greeks before them had found when they tried to transplant their own way of life abroad after the conquests of Alexander the Great, classicism apparently could not flourish too far from its native sea. The further north the frontier went, the more superficial, diluted and compromised were the authentic patterns of Roman life. North of the Loire, except on the frontiers themselves, traces of the occupation are slight compared with those in the south. No doubt much has been effaced in the northern provinces; but at least part of the explanation for the effacement lies in the fact that this was relatively easy to accomplish.

The consequences of these inequalities of emphasis in the inheritance that Europe received from classical antiquity were no less important than the inheritance itself, for the distribution of Barbarian settlements after the collapse of Roman government in western Europe had the effect of accentuating the differences. France in particular was deeply affected by the ambiguities inherent in this situation. All through the Middle Ages and beyond, her Janus-faced position at the centre of the cultural life of Europe stemmed ultimately from the fact that she had once belonged, yet never wholly belonged, to the Mediterranean world.

The second reservation is even more important. The Roman conquests were partial and incomplete. Presumably on the grounds that the danger did not justify the effort, an outer Celtic fringe was left unsubdued in Scotland and Ireland. In the event this turned out to be a miscalculation. By the 4th century the Picts from Scotland were proving a serious menace to the province of Britain. Moreover the Irish, after centuries of docile obscurity beyond the horizons of the Empire, responded to its dissolution by taking it upon themselves to preserve and transmit whatever garbled fragments of Christian and classical learning had come their way. This presumptuous intervention of the un-Romanised Irish in the cultural life of early medieval Europe proved an episode of considerable importance for the dissemination, if not the actual creation, of some of the weirder forms of Barbarian art.

1,

But the really decisive failure of the Romans was against the Germans. If the conquest of Gaul was undertaken to provide Rome with inviolable frontiers, it is unlikely that the Rhine was chosen for this purpose in the first instance. Caesar's own punitive forays into Britain and Germany foreshadowed developments of Imperial policy. During the 1st century AD the campaigns of Claudius and Agricola brought the greater part of Britain under Roman control; and for some years at the turn of the era Augustus clearly entertained the far more important project of subduing the Germans. But the latter after their success against Varus managed to elude a similar fate. With surprising meekness the Romans seemed to have accepted the verdict of the Teutoburg Forest, and henceforth their frontier stopped short at the Rhine. So the Germans, unlike most of the Celts, remained free and outside the Empire.

2

It would be anachronistic to gild this victory with the lurid colours of 19th-century nationalism. At the time the Germans do not seem to have been unduly impressed by

1. **Cross at Ahenny, County Clare,** Ireland. 8th century. The elaborate carving of the high crosses that were popular in Ireland between the 8th and 12th centuries contasts with the simplicity of the churches of the same period. This early example is covered with interlace comparable to that found in contemporary metalwork and manuscripts (figures 11, 12).

2. **The Aula Regia, Trier.** Early 4th century. The Imperial hall at Trier, in the Roman frontier region east of the Rhine, one of the most impressive reminders in northern Europe of the architectural achievements of the classical world, was a source of inspiration throughout the early Middle Ages. It was the model for Charlemagne's hall at Aachen (p. 313) and almost certainly inspired the giant wall arcades found in the Imperial cathedrals of the 11th and 12th centuries.

their success. It left no mark on their legends or folk memory. Many centuries were needed for the full implications of the Roman failure to become evident. The first thing to realise is that the defeat in no way put an end to dealings between Romans and Germans. It merely altered the terms on which these were destined to be conducted. Instead of having Roman civilisation imposed upon them from above in one sudden and overwhelming dose, as happened to the Gauls, the Germans slowed the whole process down to their own pace, and took what they wanted from their neighbours only when they were ready. We know almost nothing in detail about these early transactions. But if we compare what Tacitus wrote about the Germans in about 100 AD with Caesar's remarks 150 years before, it is clear that they had already learnt much, especially about agriculture, commerce and war. Three hundred years later, when at last they emerged into the light of history, many of them no longer deserved to be called 'Barbarians' —at least in the pejorative sense of the word.

In material and technological respects, they were probably not far behind the Romans. By assimilating the elementary forms of civilised life in this piecemeal way, the Germans did not cease to be German. Above all, their independence allowed them to remain formidable—unlike the Gauls who, once they had become Roman provincials, more or less ceased to take an active part in shaping the events of history. In fact, the Germans became more and more formidable, so that from the middle of the 3rd century AD it was no longer a question of Romans conquering the Germans, but of Germans conquering the Romans.

This is no place to recount the long and complicated story of how the various German kingdoms were established among the ruins of the western provinces of the Roman Empire. For us what matters is that these events brought the Germans, or at least some of them, face to face with the more sophisticated aspects of Roman life, such as religion, law, literature, architecture and the figurative arts. Until this happened their initiation into the higher mysteries of civilisation could hardly proceed. But here we encounter one of those great paradoxes, about which historians have never ceased to wrangle: for it would seem that in order to become civilised themselves in this more profound sense the Germans had to destroy the only civilisation from which they could learn.

THE IDEA OF A 'MIDDLE AGE'

The extent to which the German invasions were responsible for the fall of the Roman Empire has been assessed in many different ways ever since the Renaissance. It is perhaps no accident that the first people to blame them outright for the catastrophe were the earliest Italian humanists, archaeologists and art historians, whose picture of events is neatly summarised in the terminology which they invented and which we still use for the epochs of history, i.e. ancient, medieval and modern. The idea of a 'Middle Age' could only occur to men for whom the past was, so to speak, split in two. On the one hand there was a past that was both precious and remote—something that was infinitely worth recovering, but which could be recovered or recreated now only because it had ceased to be long ago.

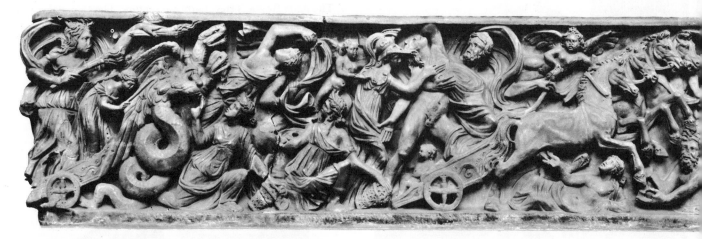

3. **Proserpina sarcophagus.** 2nd-3rd centuries. St Michael's chapel, Aachen minster. This sarcophagus, according to tradition, was reused for the tomb of Charlemagne, and with its elaborate composition of animated figures is an example of the type of classical sculpture that must have been known throughout the Middle Ages, although it was only at times a direct source of inspiration to medieval sculptors.

4 (opposite). **Front panel of a reliquary.** 8th-9th centuries. Oak. Abbey church, Werden. The crude representation of Christ on this reliquary, possibly of Irish or Anglo-Saxon origin, illustrates the lack of interest in a naturalistic figure style that was a legacy of the pre-Christian artistic traditions of northern Europe.

On the other hand there was a more recent past, stretching like a gulf of time between the present and the past that really mattered. So far as literature and the arts were concerned this was precisely how many learned and influential Italians felt, from Petrarch in the 14th century to Flavio Biondo in the 15th and Vasari in the 16th. Between them these and other men of like mind successfully launched the mutually complementary concepts of the decline and fall of classical antiquity and the Renaissance. The intervening Middle Age, devoid of all merit, was ushered in by the German invaders, among whom the Goths were singled out for special notoriety, by reason of their alleged part in the destruction of Rome itself. (Hence the term 'Gothic', which has remained part of the vocabulary of art history ever since, although its meaning has changed much since the days when it was a term of abuse, synonymous with both barbaric and medieval. The name of the Vandals, another German tribe, whose qualifications for the part were probably better than those of the Goths, still has this Renaissance connotation.)

It may be said at once that this attitude toward medieval history, as beginning with the overthrow of Rome and ending with the recovery of Roman civilisation, has long been recognised as inadequate, especially by historians (as apposed to art historians). But it does not follow that this is a point of view wholly devoid of insight or truth. So far as the arts are concerned, even if we manage to avoid the emotional attitudes and value judgements of the Renaissance, it is abundantly clear that for many centuries German societies in the west had little or no use for the achieve-

ments of classical antiquity and, whether through ignorance, neglect or wilful perversity, they did in fact destroy far more than they preserved. If the Renaissance picture of the Middle Ages is wrong, it is not because it does excessive violence to the evidence, but because it is essentially too simple. What these earliest historians failed to realise were the complications that arose partly from the different circumstances in which different groups of Germans found themselves when they began to adjust to their Roman environment, partly from the discordant elements embedded in the civilisation they inherited, and partly from the attitudes of the Germans toward their inheritance. When allowances have been made for these aspects of the matter, the Middle Ages are apt to appear in a somewhat different light.

If we stand far enough back and regard the thousand years of European history between 400 and 1400 as a whole, with antiquity at one end and the Renaissance world at the other, the negative aspect of German indifference toward Rome becomes less important than German attempts to come to terms with Rome and all that it implied. For Rome was synonymous with civilisation itself, and unless the Germans were to thwart their urge to civilise themselves, they had no option but to model themselves on the Romans, and indeed in a manner of speaking to become Romans. From this point of view, the Renaissance began when the Germans arrived on the scene, and took a thousand years to work itself out.

One reason why the process of assimilation took so long is that it was not political. At the outset, while Rome re-

mained great, the Germans had grown used to the status of exclusion—Romans were Romans and Germans were Germans. Strange as it may seem, this sense of separate identity was heightened rather than lessened by the German conquests. Whereas before they had wanted nothing better than to break into the Empire, afterwards they turned in on themselves and became conscious once more of the fact that they were racially and socially apart. To some extent no doubt this was due to the disdain of the conquerors for the conquered. But the crux of the matter was their total inability to comprehend the literary culture that confronted them. In a sense we may think of the culture of the ancient world as part of the plunder which fell to the Barbarians by right of conquest. But precisely because they took possession of it by force, they were never in the position of being directly taught by the Romans and consequently had no idea what to do with it. Apart from a few farsighted Romans such as Boethius and Cassiodorus in the 6th century, who saw that the future lay with the Barbarians and thought it was their duty to educate the new masters, there was no one to show them how. So in the event, there was no alternative but for them to teach themselves, and make what use of it they could. Being under no pressure to learn they did so in leisurely, perverse and fitful ways. They made endless mistakes and got things confused. In the manner of children they often seemed to have been performing some ludicrous masquerade or elaborate caricature of their elders and betters. But if we think of them in this way we must also remember that the only elders and betters in the world for most of the time in question were far away in

Byzantium and the Muslim world, and that like children they took themselves absolutely seriously. Moreover it was a continuous process. We tend to speak of a Carolingian renaissance, or the renaissance of the 12th century as though they were isolated spurts of energy separated by intervals of stagnation. But although this habit has a value of convenience, it is apt to conceal a crucial feature of the matter, namely that there was seldom any considerable period of time during the Middle Ages when somebody's attention somewhere in Europe was not concentrated on some aspect or other of the inheritance from antiquity. Instead of arranging the phenomena of renaissance chronologically, it is perhaps more illuminating to classify them according to their content. In the first place it was religion. However providential we may be disposed to regard the conversion of the Barbarians, the fact remains that for them Christianity was the religion of the Romans. Indeed, apart from the army, it was the first department of Roman life which they were actually invited to share. By becoming Christian the Barbarians established a kind of fraternity with the Romans over against the rest of the world, and this in effect opened all other doors to them.

In the wake of religion came the political theory of the later Roman Empire. Charlemagne in the 8th century, the Ottonian and Salian rulers of Germany in the 10th and 11th centuries, Frederick Barbarossa in the 12th century, and Frederick II of Sicily in the 13th were all deeply concerned with the implications of the Imperial title, and in their respective reigns it often seemed as though medieval Europe was on the point of entering into the political

heritage of Rome. Much early medieval art is in fact Imperial propaganda. But whereas the consequences of the Barbarian conversion to Christianity were both endless and permanent, the medieval Empire was never wholeheartedly accepted as the right and proper framework for the development of European society. Responsibility for these inhibitions rests ultimately with the Church, or more precisely with the Pope. For the medieval Papacy no less than the medieval Empire was grounded in Roman concepts of law and government, and in the event the antipathy of the Popes to the implications of Imperial power brought about the downfall of the Empire.

What it came to is that the Popes eventually saw themselves as the true successors of the Caesars, and the Church whether by design or accident found itself from the turn of the millennium onwards the guardian and promoter of classical learning. At the outset only a few remarkable individuals were involved. Men like Gerbert of Aurillac (Pope Sylvester II) and Fulbert of Chartres were inspired by much the same attitude toward antiquity as their more numerous successors in the 12th century; and if their renaissance was more superficial than that of their successors this was because they operated more or less singlehanded. It took time for the processes of scholarship to acquire momentum. The more difficult and delicate achievements of antiquity in the fields of philosophy, literature and natural science were only fully appreciated towards the end of the Middle Ages, and only slowly disentangled from the more familiar preoccupation of medieval people with religion. The same is true of the arts. As the rest of this book is devoted to them as a special case, there is no need at this point to anticipate what follows. All that concerns us here is the overall picture, and it is sufficient to indicate that the arts in no way depart from the general pattern of development. However improbable it may seem at first sight, nearly every important change that occurred in the history of medieval art took place under the catalytic auspices of some aspect of what had been handed down from the ancient world.

From this point of view it is tempting to regard the Italian Renaissance, the Renaissance proper, as nothing more than the last and most sophisticated stage of a process that had begun before the Roman Empire in western Europe had even disappeared. Up to a point this is true. Nevertheless, it would be a mistake to think of the Middle Ages as a period wholly given up to the systematic and painstaking exploration of what survived from antiquity. In the first place no one thought of it as an inheritance, and no one thought of the ancient world as we do. There were simply books and buildings, ideas and precedents, for which uses could be found when the occasion arose. This idea that the symptoms of antiquity which we encounter throughout medieval history were connected with practical problems and contemporary situations, that antiquity was so to speak used rather than revived, is vital. Thus it was the military and political clarification which followed the conquests of

Charlemagne that invited the generation of AD 800 to regard him as a veritable Roman Emperor—not the other way round. Again, in the 12th century when Europe was avid for knowledge, any source of learning would do. In a sense there was ultimately no alternative to antiquity, but what came via the Arabs was just as eagerly accepted. Perhaps not until Aristotle obtruded on the attention of 13th-century theologians did a really critical test case arise. By then it was possible for the words of an ancient writer to strike a note that was both too important to be ignored and at the same time recognisably discordant. It is highly illuminating to observe the effects of this shocking realisation on sensitive medieval minds like that of St Thomas Aquinas, and the incredible efforts that were made to reconcile the ostensibly irreconcilable factors in the case, and co-opt Aristotle into what was essentially a contemporary debate.

In this long and complex encounter between the Middle Ages and antiquity, the latter was essentially passive and pliable. Not until the Italian Renaissance, when the concept of classical antiquity was clearly formulated for the

first time, was the past completely disentangled from the present and in a position actively to impose its own forms and attitudes on living men. This is the crucial sense in which the Italian Renaissance can be distinguished from the Middle Ages. It is not so much a question of the Italians being more closely concerned with antiquity than with the Middle Ages, but of them thinking about the past in a different way. The Italian humanists made an ideal out of antiquity. It provided them with a new yardstick of excellence whereby they could judge men, literature and art. But this vision could be apprehended only by the exercise of new intellectual skills. In effect it was a kind of archaeological reconstruction—if somewhat too rosy by modern scientific standards. Together with their new consciousness of temporal distance, it introduced them to something recognisable as history. There was nothing corresponding to this in the Middle Ages. Not only was medieval chronology both rudimentary and vague, but in so far as it can be said to have existed at all everything was related to a single event—the Incarnation. Taken literally, as of course it

was, this intrusion of an eternal God into a transitory world had the effect of enveloping time in timelessness; and instead of the historical sense of everything receding away from the present into an ever more remote past, there were so to speak two absolute moments set over and against one another in an abrupt and static antithesis—before and after, then and now, BC and AD.

PAGAN AND CHRISTIAN

The consequences of this medieval way of thinking about time were almost endless. For our purposes, however, we may single out its obvious relevance to the distinction between pagan and Christian. Not every pagan lived before Christ, but everyone who had done so was *a fortiori* pagan, and this of course included all classical antiquity.

Medieval attitudes toward the pre-Christian past varied so much that it is reckless to generalise. Nevertheless they seem to have gravitated in two opposite directions. On the one hand there was the feeling, already widespread in antiquity itself, that pagan culture was a snare and delusion

5 (opposite). **Ascension of Christ.** 4th-5th centuries. Ivory. Bayerisches Nationalmuseum, Munich. Easily portable Early Christian works such as this ivory were frequently copied in Carolingian times. The form of the Holy Sepulchre seen here derives from pagan Roman tombs (compare it with the towers of St Riquier, figure 20).

6 (right). **St Augustine.** Page from St Augustine's *De Civitate Dei* (MS. Plut. XII, 17, f. 3v). Early 12th century. 13¾ × 9¾ in. (35 × 25 cm.). Biblioteca Laurenziana, Florence. The ideas in St Augustine's *City of God* were of fundamental importance to medieval thought (see p. 286). This page showing St Augustine, which comes from a copy made at St Augustine's abbey, Canterbury, demonstrates how English illumination of the early 12th century combines Anglo-Saxon artistic traditions (figures 23, 24) with new continental elements (compare plates 47, 48).

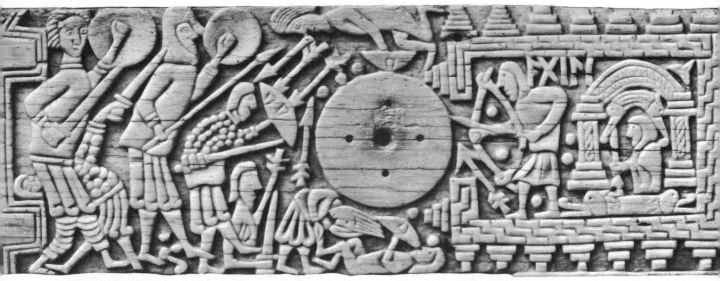

7. **The Franks casket.** Late 7th century. Whalebone.
1. 9 in. (23 cm.). British Museum, London. This casket is
decorated with both pagan and Christian subjects—a
confused mixture typical of this period of English culture
(compare plate 1). Note how the details of this vigorous
narrative scene from Norse mythology cover the entire surface.

for the prudent Christian soul. As Tertullian put it in his
famous rhetorical question: 'What has Athens to do with
Jerusalem?' It was a position congenial to men of strong
will and austere temperament, and a point of view that
was always liable to receive expression from powerful puri-
tans such as St Bernard in the 12th century, or humble con-
templatives like St Thomas à Kempis in the 15th.

But it was equally possible to think of Christianity as the
consummation rather than the antithesis of classical cul-
ture. This was the approach of a number of learned and
cultivated writers of the early Christian period, such as
Clement of Alexandria and the Cappadocian Fathers. In
his *Civitas Dei (The City of God)* St Augustine presented the
presuppositions of this view of history so plausibly that it
was a thousand years before any real alternative was
worked out. From this standpoint the ancient philosophers
and even poets like Virgil could be regarded in much the
same way as the Old Testament prophets; and the study of
ancient letters could be justified or excused on the grounds
that it was conducive to 'the better understanding of the
mysteries of the divine scriptures', to use a formula which
Alcuin wrote into one of Charlemagne's capitularies.
Being in possession of the true faith, medieval Christians
consulted the classics, if not actually in a spirit of condes-
cension, at least with a consoling smugness that came of
knowing higher truths than any accessible to pagan authors.
On the other hand, especially after the tidying up of
Church doctrine and the extension of papal control down
to the lower echelons of the ecclesiastical hierarchy which
followed the great reform of the 11th century, the Church
tended to become increasingly sensitive to the dangers of
heresy, and there was seldom a shortage of zealous church-
men who were prepared to recognise, not always tacitly,
that a line had to be drawn somewhere. Pagan literature
was never formally proscribed, but after the suppression

of the Albigensians in the south of France during the first
half of the 13th century ecclesiastical indulgence was tem-
pered by a good deal of moral circumspection. There was
always a danger that if people read the classics they would
read Ovid; and for those who were prepared to penetrate
its more seductive and less edifying aspects, like Tann-
häuser, antiquity could be regarded as a temptation either
to be risked or resisted.

It is very important for us to realise that this fundamen-
tal antithesis between what was pagan and what was Chris-
tian was itself part of the Barbarian inheritance from anti-
quity. It is relatively easy for us to disentangle what was
distinctly classical in origin from what came to the Middle
Ages chiefly through the agency of Christianity from the
East. But the German Barbarians were not in this same for-
tunate position, and in fact it was only in terms of the dis-
tinction between pagan and Christian that they were able
to apprehend the classical past until quite late in the
Middle Ages. They were not to know that the culture of the
world upon which they burst, the later Roman Empire, was
itself undergoing fundamental changes at the very moment
of their arrival on the scene. The Romanisation of the
Barbarians was accompanied by another, quite distinct
but contemporary process, the Orientalisation of Rome.

This provides us with a quite different position from
which to contemplate the fall of the Roman Empire. If we
think of the Empire primarily as a political and military
institution, then its collapse in the West must inevitably to
some extent have been due to the external pressures of the
Barbarian invasion. But if we think of Rome as the last
guardian of the classical tradition which had been fash-
ioned in Greece during the 6th and 5th centuries BC, then
the breakdown began long before the appearance of the
Barbarians. No doubt it is tempting to connect the break-
down of civilisation with the onslaughts of enemies whose

condition was admittedly barbarous. This is precisely what the historians of the Renaissance did. But the contribution of the Germans to the destruction of classical civilisation, though real enough up to a point, was both belated and superficial. The real spiritual crisis in which the traditional values of the classical world were put on trial and in great measure rejected occurred during the 2nd and 3rd centuries AD. From this point of view Gibbon's celebrated contention that Christianity had much to do with the fall of the Empire is valid. But it is not enough merely to lament the passing of the classical world. The plain fact of the matter is that by 200 AD classical culture had become little more than a literary affectation. The last resuscitation, which took place in the time of the Emperor Hadrian (see *The Classical World*), was itself oddly reminiscent of the Italian Renaissance. In so far as Christianity was responsible for exposing the bankruptcy of classicism, it also provided a genuine alternative, the superior attractions of which for the vast majority of men it is impossible to deny, and to whose more profound insights into the needs and status of human individuals classical learning had no answer.

The impeachment of the classical way of life which was conducted by pagan and Christian Emperors alike as well as the Doctors of the Church was extended to include classical art. For much the same reasons the classical tradition in art gradually lost any significance it might once have had for ordinary men, and it ended up as the rhetorical instrument of official propaganda. Even this function was taken away from it after 300 AD and from then on classical forms appear in art either as selfconscious revivals or disguised under heavy stylisation. In their place more often than not are to be found forms and styles whose purpose, affiliations and bias were deliberately anti-classical.

There is no doubt that the Church was largely responsible for this revolution in taste. After the conversion the Church was in a position to have the art it wanted; and the truth is that it had little use for the classical kind. No doubt Pheidias, Polykleitos and the rest had perfected the classical style in the 5th and 4th centuries BC with the purpose of making the divinity of the gods visible to human eyes. But it required some very special metaphysical assumptions to imagine the gods in the ideal likeness of men, and the style easily degenerated into a vapid humanism. For most people, not trained in the discipline of Greek philosophy, it was easier and more satisfactory to think of the gods as being different from men rather than like them, and they instinctively accepted the corollary that contact with a god transfigured or even deformed those who underwent the experience. These were the fundamental assumptions behind the transcendental stylised art of the ancient East, and for many Christians they were equally valid for any art destined to serve the needs of the Church. What the Church wanted was not perhaps the crude daubs of the catacombs, but the kind of art we encounter in the Early Christian mosaics of Ravenna and Rome (see *The Early Christian and Byzantine World*). It is worth remembering, however, that

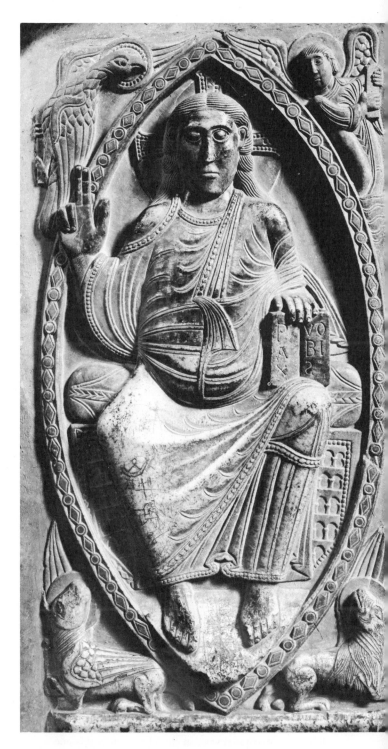

8. **Christ in Majesty.** Late 11th century. Marble.
St Sernin, Toulouse. While the apostles in this series of reliefs at St Sernin (plate 36) reflect the influence of late antique sculpture, this stylised figure of Christ, with its highly finished marble surface, appears closer in style to low relief works on a smaller scale in ivory or metal.

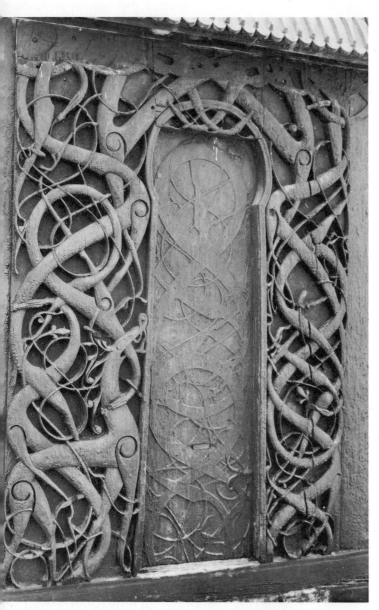

9. **Wooden door of the stave church at Urnes.**
Mid-11th century. The woodcarving at Ornes has
given its name to the style of Scandinavian sculpture
characterised by this particular type of decorative
animal carving—a motif which, however, goes back to the
traditions of pagan secular art (compare figures 11, 12).
The lack of building stone in Scandinavia accounts for
elaborately decorated wooden churches such as this one.

the range of Early Christian art was as wide as the intel-
lectual attitudes of the time. At one extreme there were
styles of which Tertullian might have approved—so sat-
urated with other-worldliness as to involve a repudiation
of the classical tradition. At the other we find a measure
of synthesis between classical naturalism and formal
abstractions which not unfairly reflects the outlook of cul-
tivated Christians like Clement of Alexandria. This even-
tually matured into the stylised classicism of Byzantine art.

This was the state of affairs when the Barbarians ap-
peared on the scene. In a sense the Middle Ages traversed
in art much the same range of experience as the ancient
Greeks. Like them they started from an almost exclusive
concern for abstract ornament, and ended up with the
kind of naturalism that springs from man's preoccupation
with man. But unlike the Greeks they did not have to
break new ground. At every turn they were liable to find a
suitable precedent, and their progress therefore takes the
form of penetrating back through varying degress of styl-
isation to a position from which they could appreciate
classical naturalism for its own sake. Thus medieval art is
apt to seem almost unduly obsessed with what already
existed. At the crudest level this took the form of mere copy-
ing. But even imitation required a measure of insight and
understanding, and in certain circumstances it also re-
quired the selection of some models and the rejection of
others. Hence the interest of medieval art historians in
identifying sources. All the really important changes, how-
ever, arose from the recognition of new needs, which in
turn required the consultation of new precedents. For it
was not the medieval way to invent where there was an
example to follow. Apart from Viking and Muslim orna-
ment these precedents were nearly always found in the in-
heritance from antiquity. And so it came about that uses
were gradually found for more and more aspects of ancient
art. Whenever this happened on a large scale we encounter
the symptoms of a renaissance. But in every case these situa-
tions arose from contemporary problems, not from a special
desire to recreate antiquity for its own sake. That is why
none of the so-called medieval renaissances endured for
long, and why they made hardly any impression on the
fundamental presuppositions of society.

It is impossible here to deal equally with all the problems
presented by such a vast period. No doubt there is a certain
injustice in focusing attention on the period after the turn
of the millennium rather than before. On the other hand to
reverse the stress would be even more unjust. It should not
be necessary to add that this somewhat old-fashioned
distribution of emphasis does not entail the view that
medieval art was nothing more than a preparation for the
Italian Renaissance, or that it can be regarded as having a
life cycle of its own. It is simply a question of a series of
historical changes from which the overtones of biology
that cling to our habitual terminology must be rigorously
excluded.

(Continued on page 305)

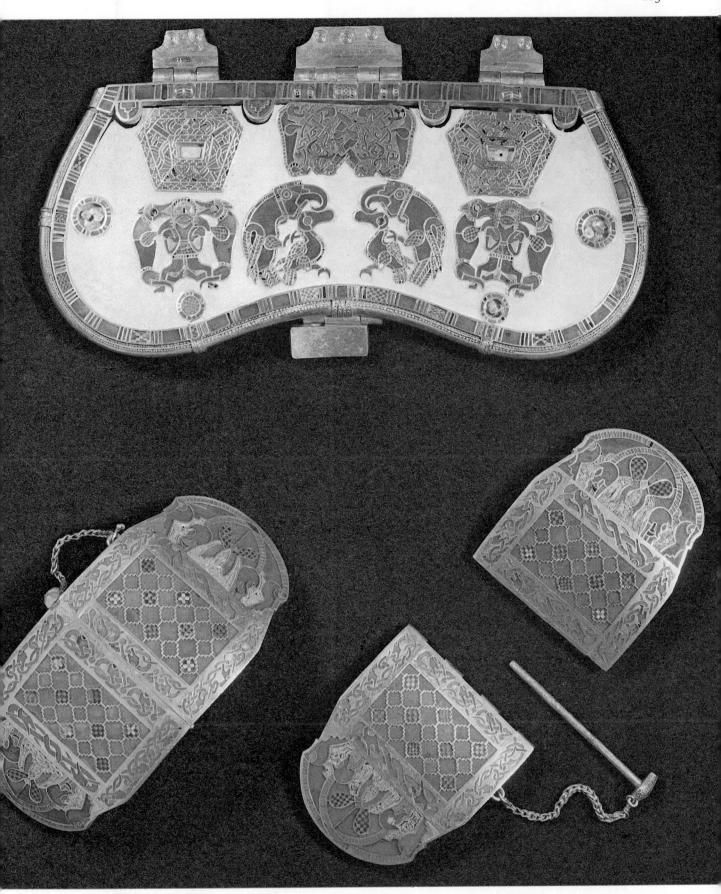

1. Purse lid and clasps from Sutton Hoo, Suffolk. Before *c.* 655. Gold, garnets and mosaic glass. Purse lid 7½ × 3 in. (19 × 8 cm.). British Museum, London. The Sutton Hoo ship burial, containing a rich collection of pagan grave goods together with objects probably of Christian significance, stands at the borderline between pagan and Christian. The skilled workmanship and elaborate designs found in these small portable personal adornments soon came to be applied to objects for the Church. Compare the interlaced animals on the clasps with the carpet page from the St Chad Gospels (figure 12).

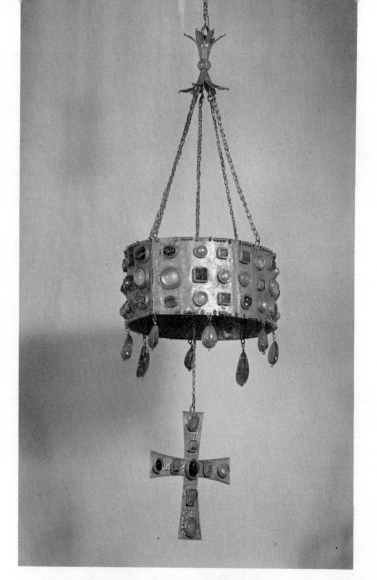

2. **Visigothic votive crown.** 7th century. Gold with precious stones. Cluny Museum, Paris. In 1858 a collection of eight votive crowns was discovered at Guarrazar, near Toledo in Spain. They are now divided between the National Museum, Madrid, and the Cluny Museum, Paris. From the name of Recceswinth, a 7th-century Visigothic king, that appears on all of them, and from the similarity of style, they can be dated to the last century of Visigothic rule in Spain.

3. **Frankish jugs.** 4th-6th centuries. Glass. Landesmuseum, Bonn. The Roman glass industry on the Rhine was one of several organised for industrial production to serve the needs of the army. When the Franks occupied the territories on the west bank these did not disappear at once, indicating that the change was not cataclysmic nor wholly destructive.

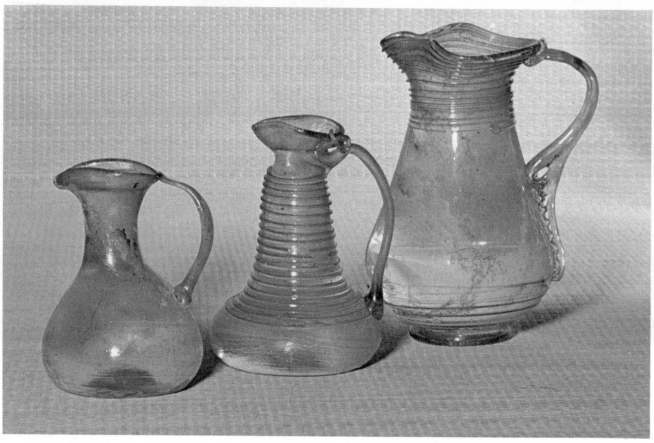

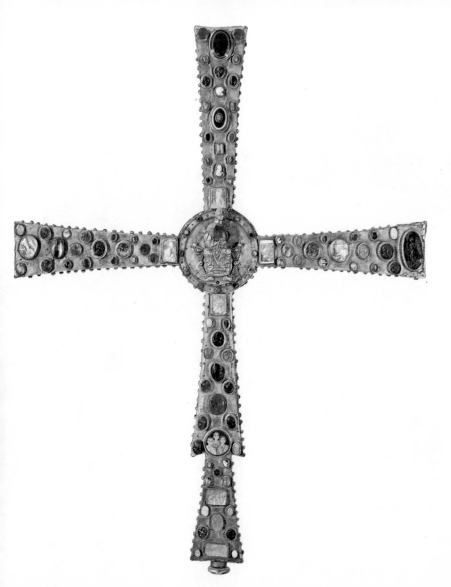

4. **Processional cross.** 7th century with 4th-century portrait medallion. Silver with gems and inset miniatures, etc. h. *c.* 43¼ in. (110 cm.). Museo Civico dell' Eta Cristiana, Brescia. Often known as the Desiderius Cross. The embellishment of spectacular objects like this was often arbitrary, depending on what was available when it was made, and what was added later. The portrait may be of Galla Placidia with her children.

5 **Theodelinda's crown.** Early 7th century. Gold and precious stones. Cathedral Treasury, Monza. Theodelinda, the Christian wife of two successive Lombard rulers, took an active part in establishing peace between the Pope, the Eastern Empire and the new secular powers in northern Italy. This votive crown, which remains with other of her treasures at Monza, displays expensive materials rather than elaborate craftmanship. (Compare plates 1 and 2.)

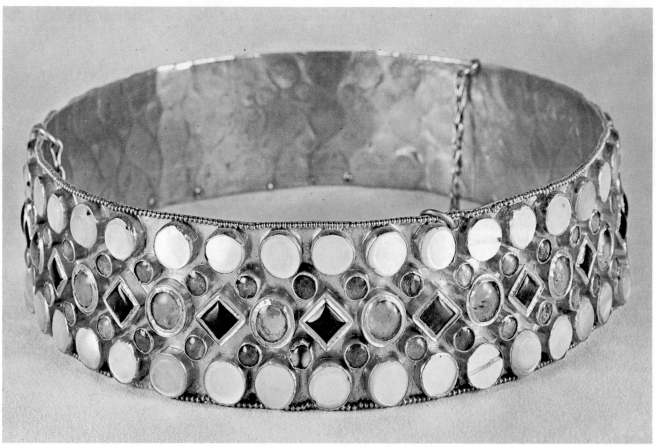

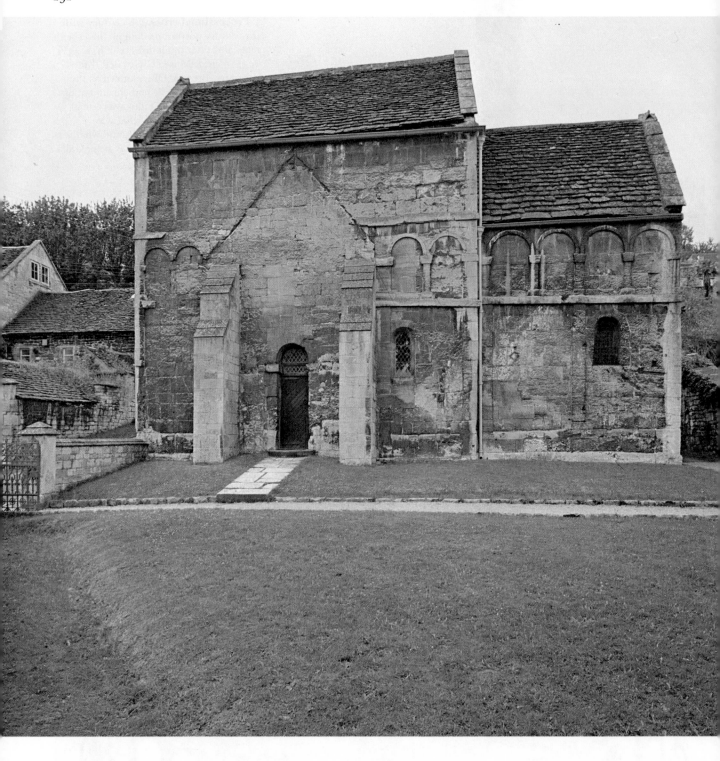

6. **St Lawrence, Bradford on Avon.**
8th century or late 10th century. The
church is constructed of ashlar of quite
exceptional quality which may be reused
Roman masonry. William of Malmesbury
mentions a church at Bradford built by
St Aldhelm (8th century), which was still
there in his time (c. 1125). St Lawrence
has been identified as Aldhelm's church
on this testimony; but most of the detail is
usually regarded as belonging to the
period c. 1000. This kind of confusion is
typical of Anglo-Saxon architecture.

7 (opposite). **The scribe Ezra rewriting
the sacred records.** Early 8th century.
13¾ × 9¾ in. (35 × 25 cm.). From the
Codex Amiatinus (f. 5r). Biblioteca
Laurenziana, Florence. This
Northumbrian copy of an early Christian
manuscript succeeds to some extent in

reproducing the three-dimensional sense
of space found in the original, although
perspective, human form, light and shade
are copied without any real
understanding. Note the positions of the
left leg and foot, and the conflicting
perspectives of the cupboard.

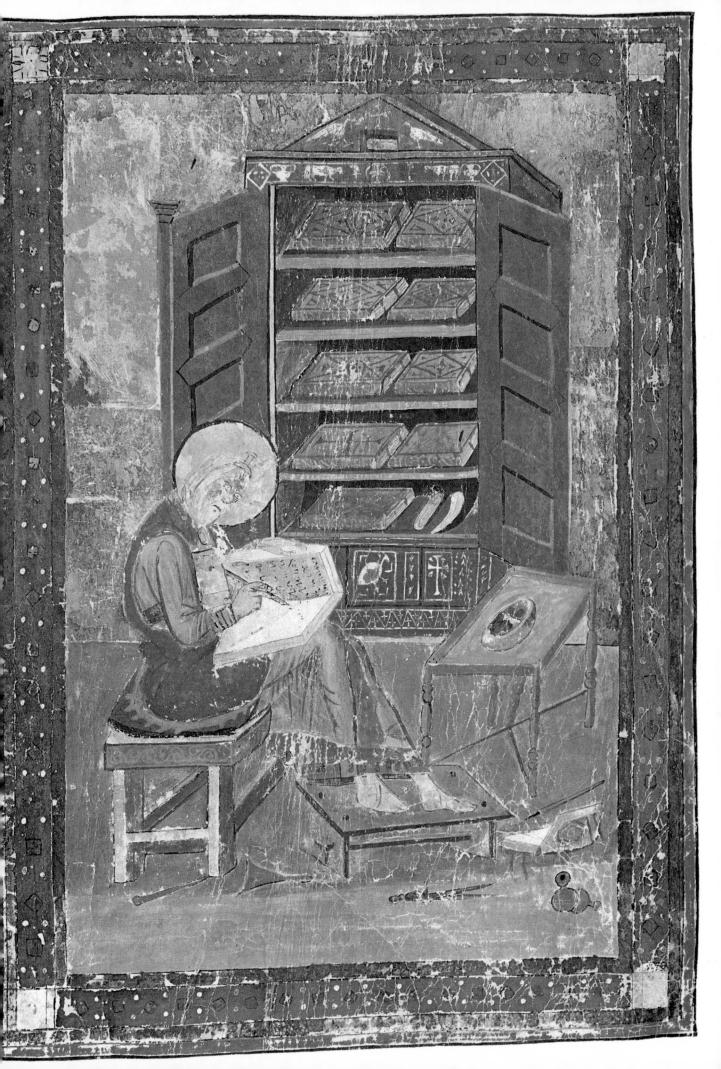

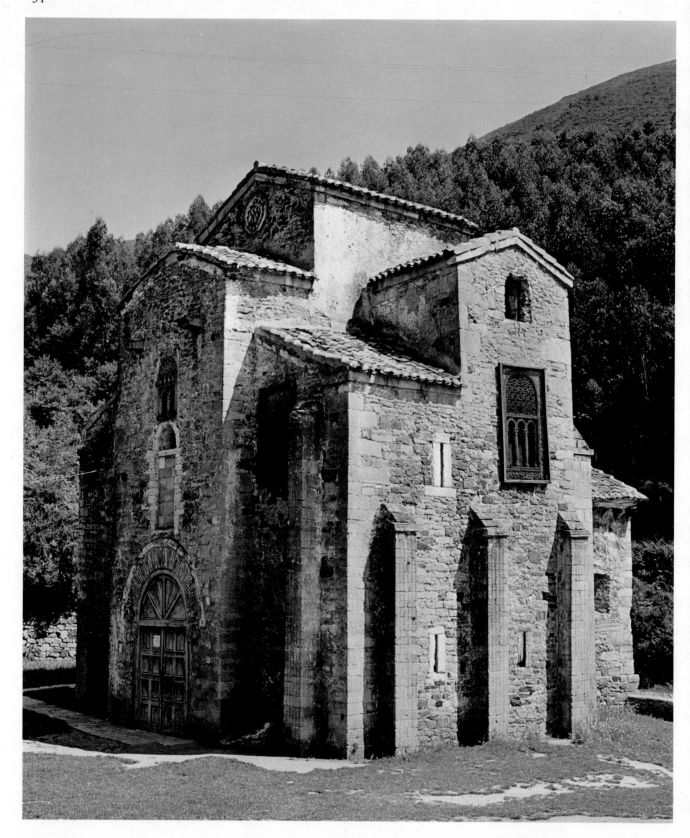

8. **Exterior of the church of S. Miguel de Liño, Oviedo,** from the south-west. 9th century. After the Muslim invasion in the 8th century, the only part of Spain under Christian rule was the isolated kingdom of the Asturias on the north coast. S. Miguel de Liño, of which only the narthex and west part of the nave now survive, was one of the churches founded by Ramiro I (842–50).

9 (opposite). **St Matthew.** Before 823. From the gospel book of Ebbo. 6¾ × 5½ in. (17 × 14 cm.). Bibliothèque Municipale, Epernay. Written at Hautvillers abbey for Ebbo, Archbishop of Reims, probably before his conversion of the Danes in 823 (as there is no reference to it in the dedication), this gospel book is illustrated in a style which, although clearly dependent on late

classical impressionism, also shows the Carolingian artist's interest in conveying spiritual intensity through dynamic calligraphy. Compare the Utrecht Psalter (figure 22).

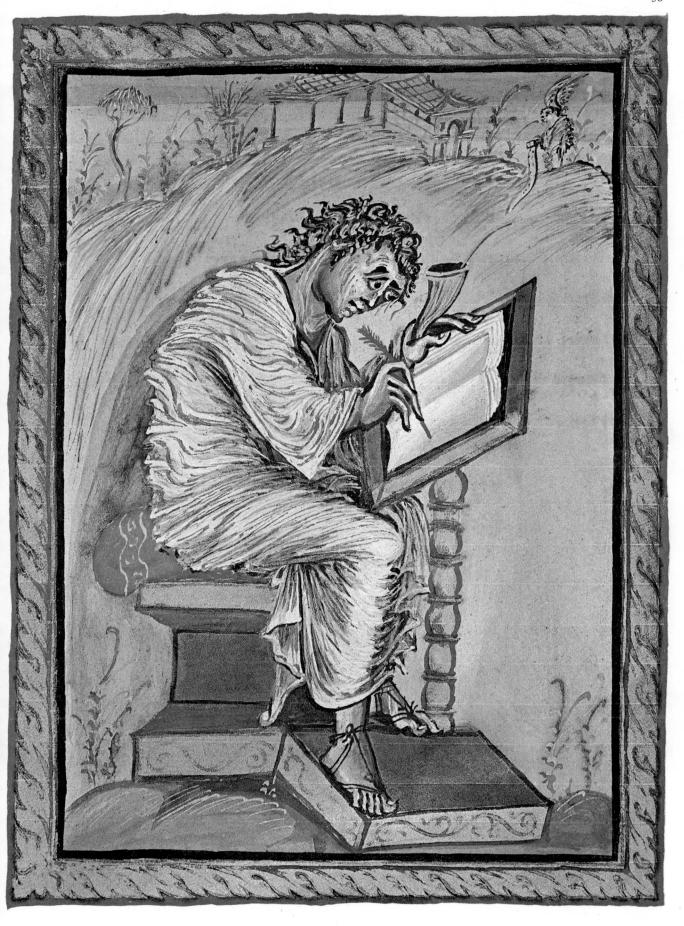

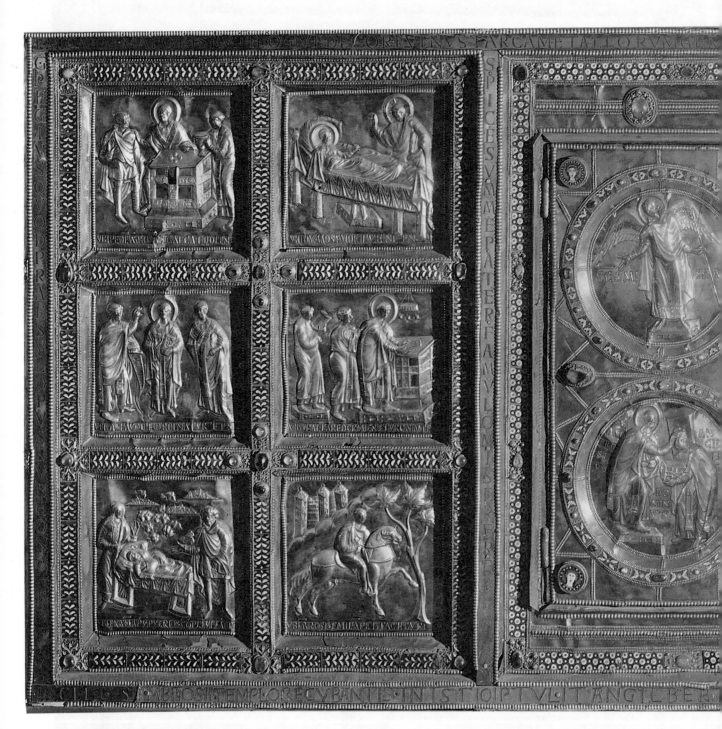

10. **Back of altar antependium.** 835.
Gold and silver gilt, precious stones,
enamel and filigree. S. Ambrogio, Milan.
Master Volvinius, the artist of this
remarkable work (dated by the inscription
to 835), is shown with the donor, Bishop
Angilbert II, in the central roundels,
flanked by twelve scenes from the life of
St Ambrose. The arrangement of this
Carolingian altar, consisting of separate
panels with naturalistic figure scenes,
should be contrasted with the hieratic
architectural composition of the later
Basle altar (plate 22).

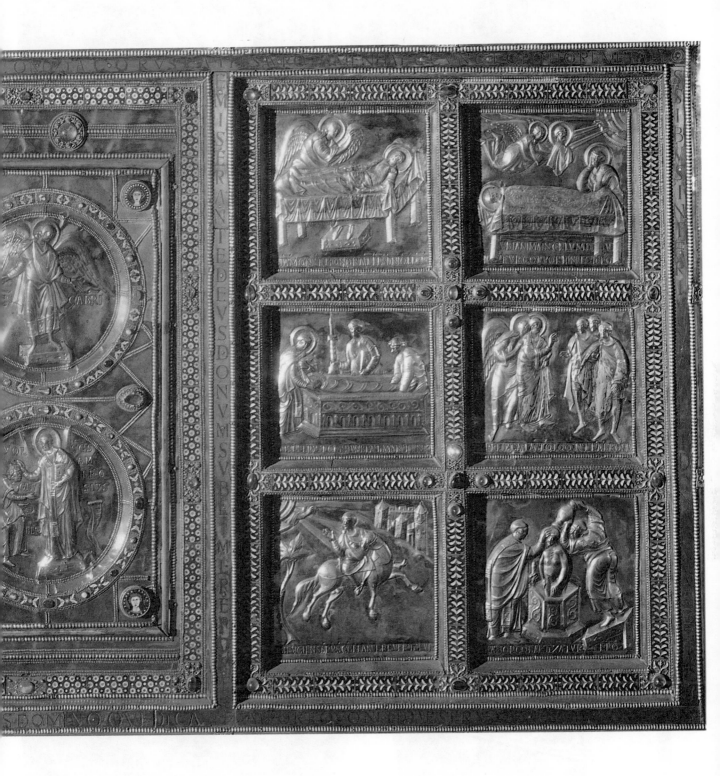

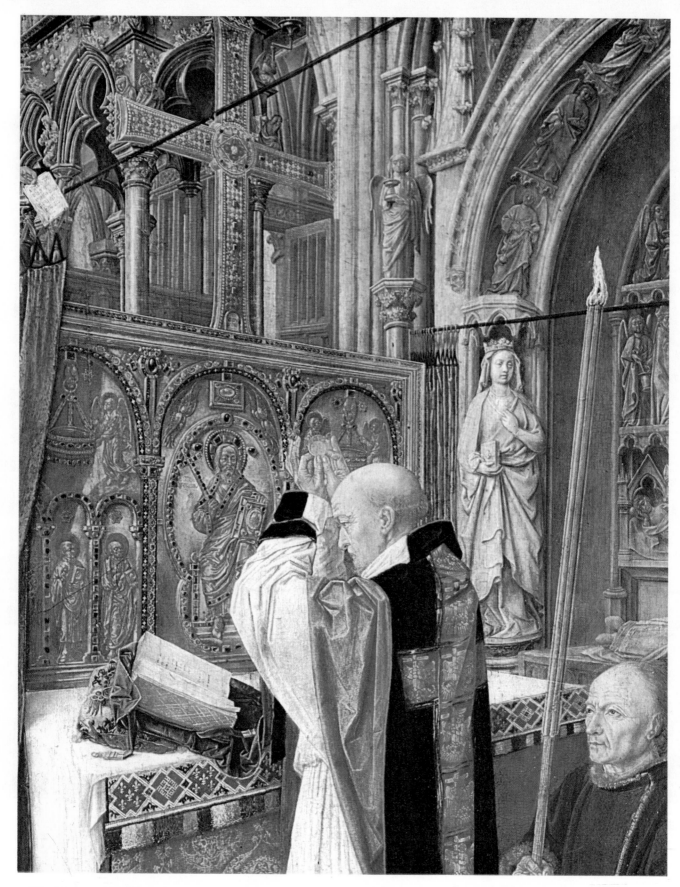

11 **The Master of St Giles.** *The Mass of St Giles* (detail). Late 15th century. Oil on panel. 24¼ × 18 in. (62 × 46 cm.). National Gallery, London. The picture shows St Giles celebrating Mass at the high altar of St Denis, on which are displayed the altar frontal of Charles the Bald, and the Cross of St Eloi. The latter, made for the Bishop of Noyon who died in 663, must have been one of the masterpieces of Merovingian metalwork (compare the Desiderius Cross, plate 4). The altar frontal was made late in the 9th century, probably at St Denis itself.

12 (opposite). **Cover of the Gospels of Gauzelin of Toul.** Late 10th century. Gold and precious stones, pearls, enamels. 12¼ × 8¾ in. (31 × 22 cm.). Nancy cathedral. Often as much care was lavished on the covers of religious books as on the illuminations inside them. Gospel books, being displayed and read during the celebration of the Mass, received a treatment comparable to other liturgical objects (compare plates 11 and 18).

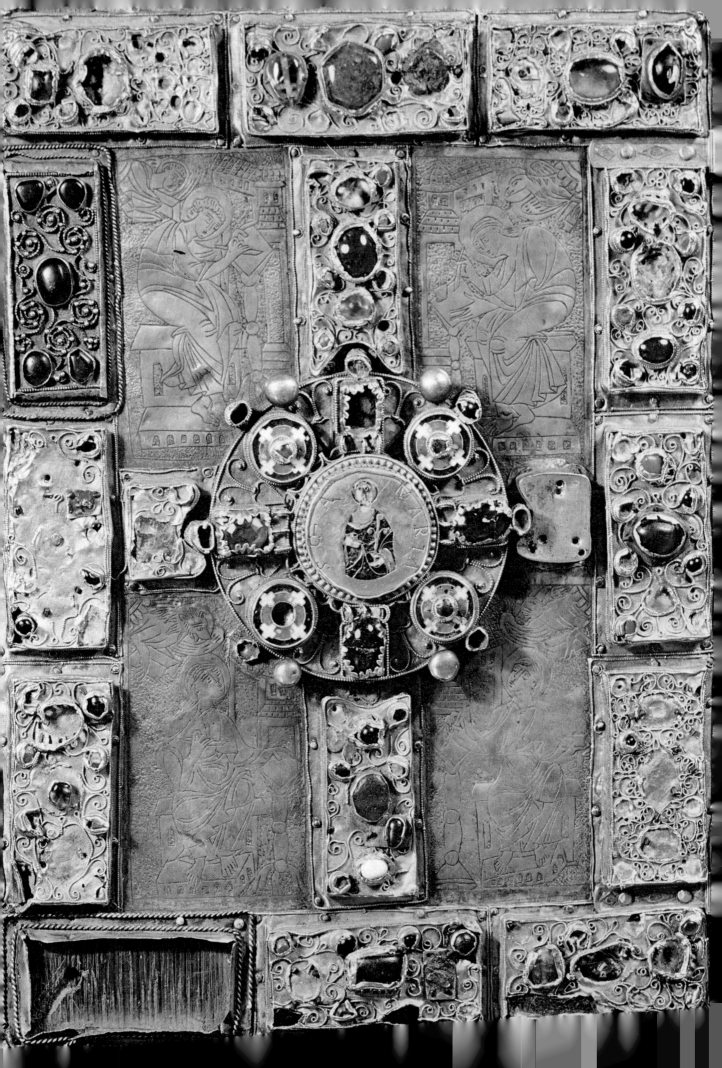

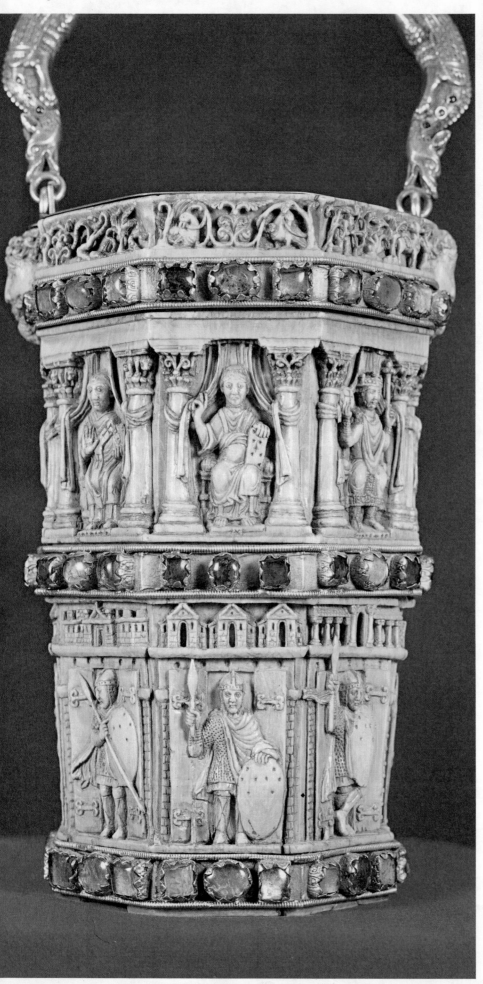

13. **Holy water bucket.** c. 1000. Ivory, gold and precious stones. h. 7 in. (18 cm.). Aachen cathedral. This unique holy water bucket decorated with figures of Pope, Emperor and various ecclesiastics, with a row of guards underneath, may perhaps have been made for an Imperial coronation. It reflects the pomp and ritual of the Ottonian court, whose patronage was influential in all branches of art (compare plates 14 and 16). The jewelled bands are later additions.

14 (opposite). **Coronation of the Emperor.** 1002–1114. From the Bamberg Sacramentary (Cod. Lat. 4456, f. 11r). 11½ × 9½ in. (29 × 24 cm.). Staatsbibliothek, Munich. This illustration in the sacramentary given by Henry II to Bamberg cathedral shows the symbolic coronation of the Emperor, stressing his quasi-priestly function as *Servus Dei*. While the modelling of the faces reflects some contact with Byzantine art (compare plate 16), the stiff symmetrically arranged figures placed against flat ornamental frames and panels reminiscent of metalwork (compare plates 14 and 44) foreshadow many aspects of Romanesque art (compare plates 48 and 49).

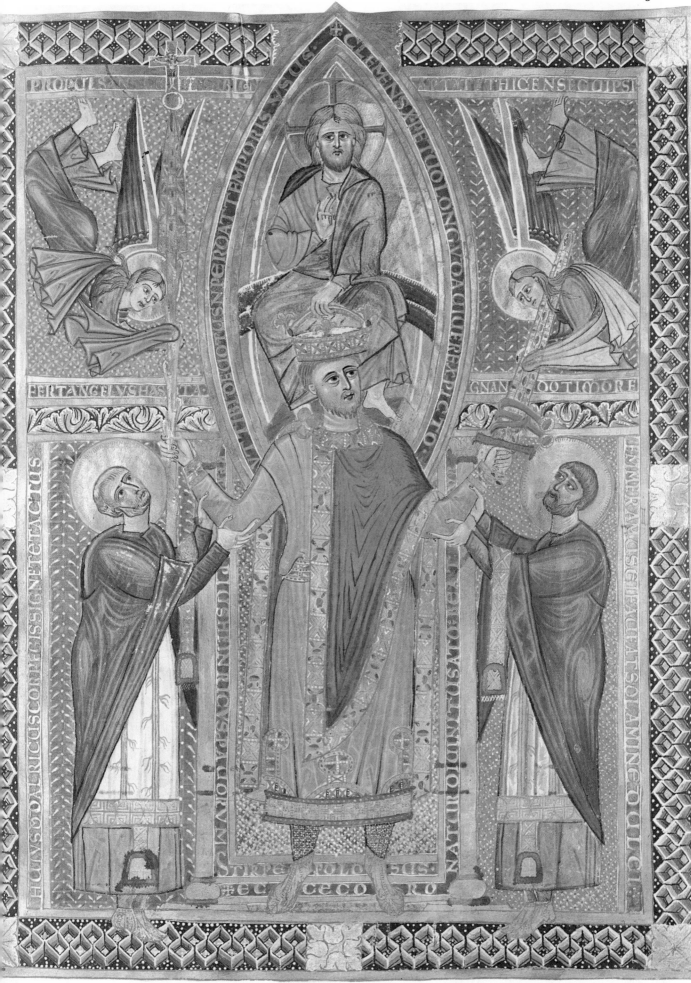

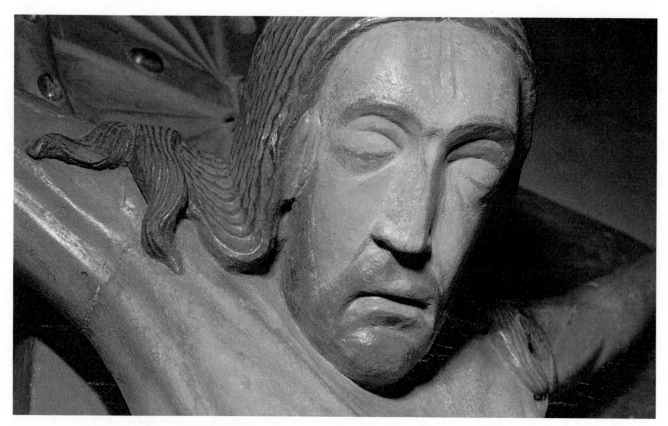

15 (above). **Detail of crucifix** probably carved for Archbishop Gero (969–976). Wood with traces of pigmentation. h. 74 in. (188 cm.). Cologne cathedral. Once dated to the 12th century, but now generally accepted as Ottonian. Large-scale figures in wood and metal (compare plate 22) lead the way to Romanesque stone sculpture (see figures 46, 94).

16 (below left). **Master of the Registrum Gregorii.** *Otto II receiving the homage of the nations.* c. 983. From the Registrum Gregorii. 10½ × 8 in (27 × 20 cm.). Musée Condé, Chantilly. This artist displays in his sense of pictorial space and the delicate

modelling of his figures a perceptive understanding of Early Christian prototypes that marks a new departure in Ottonian art.

17 (below right). **Christ the Saviour in the Tree of Life.** Page from Gospel book (Cod. Lat. 4454, f. 20v). Early 11th century. 12¼ × 9 in. (31 × 23 cm.). Staatsbibliothek, Munich. This book, compared with plates 14 and 16 and with figure 25, demonstrates the diversity of style which flourished under the patronage of the Ottonian Emperors. Through their contacts with Italy and the East, new artistic influences reached northern Europe.

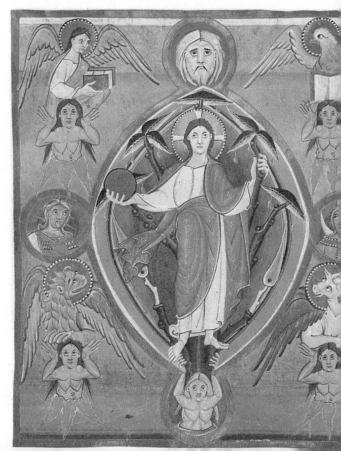

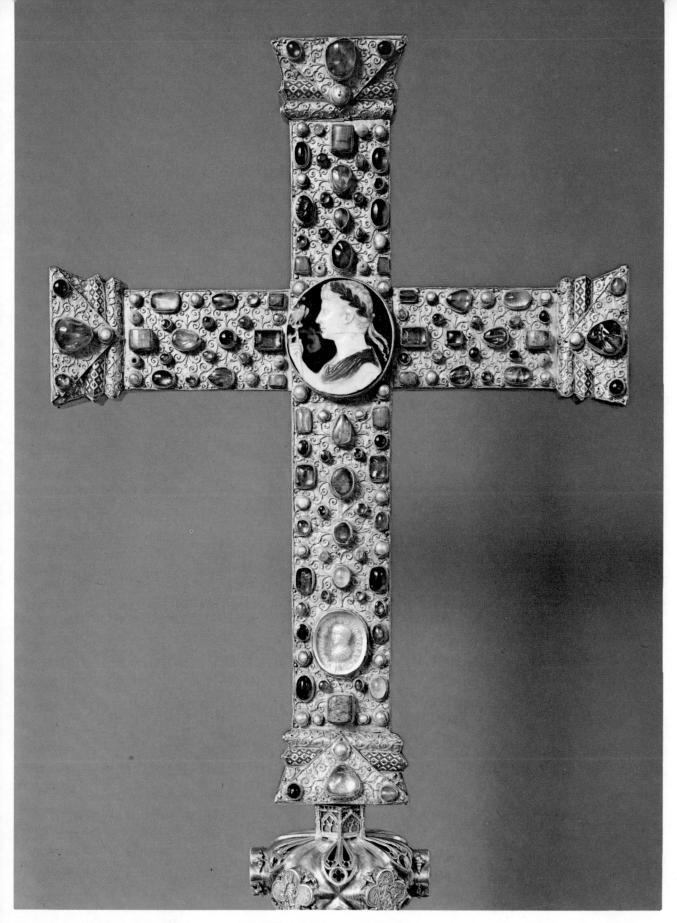

18. **The Lothar Cross.** 10th century. Wood covered with gold, filigree, precious stones, pearls, enamel. h. 19¾ in. (50 cm.). Aachen cathedral. Included in the carefully arranged composition of precious stones is a rock crystal seal of Lothar II from which the cross derives its name. Both the reused cameo of Augustus (perhaps meant to represent Christ) and the moulded capital-like terminals give this work a classical feeling comparable to that found in some Ottonian painting (see plate 16).

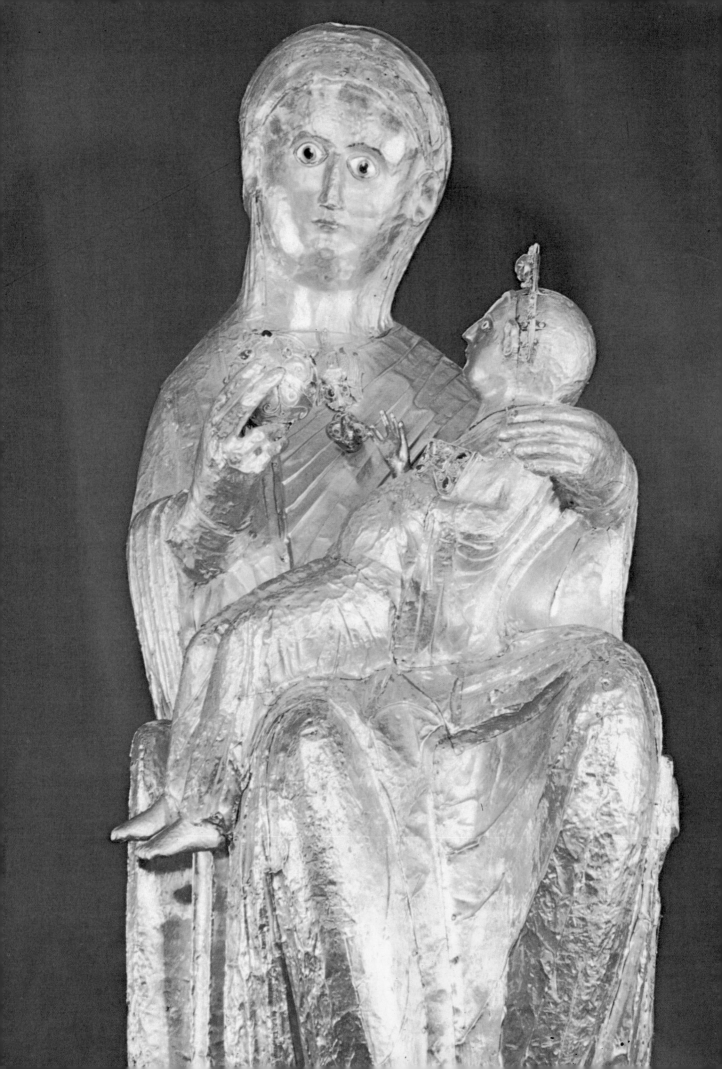

Pre-Romanesque Art

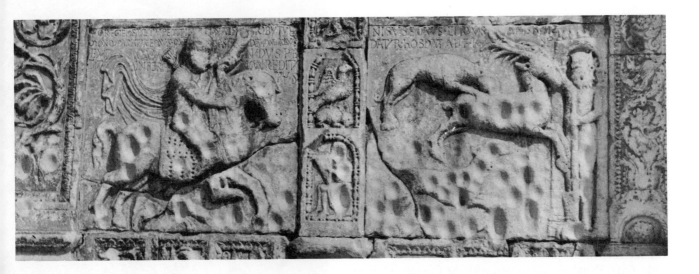

10. **King Theodoric pursuing a Stag into Hell.** 12th century. Stone. West portal, S. Zeno, Verona. In the *Nibelungenlied* the historical king of the Ostrogoths, Theodoric, was remembered as the legendary Dietrich von Bern. This is a very rare and early example of a secular theme from the German heroic age making its appearance in the predominantly religious art of the Romanesque period.

It is almost impossible to say anything about the art of the Barbarians before they encountered the Romans. Nothing whatever has survived from the first millennium BC, and by the time of the migration period (300–600) contacts were already numerous and well established. From the time of Septimius Severus onwards (c. 200) the industries which supplied the needs of the Roman armies on the frontiers became progressively more indifferent to the classical tradition; and as the number of German recruits increased it is almost possible to postulate an 'army style' to bridge the transition from late classical to Barbarian art. In any case Imperial diplomacy was largely conducted in terms of bribes and gifts, the forms of which were no doubt shrewdly adjusted to Barbarian taste. The earliest objects of Barbarian art come from hoards and graves extending from East Prussia to Rumania and the Crimea, and they betray a highly developed sense of pattern combined with an almost total indifference to the figure arts. Most of them were personal effects. Warriors were buried with swords, helmets and shields, women with brooches and trinkets. These were the prestige symbols of a primitive society, and their splendour was measured partly by the art, i.e. the

cunning, that went into their making, and partly by the intrinsic brilliance of the materials from which they were fashioned. This love of ornament was the one positive asset which they brought with them to their great encounter with the accumulated inheritance of Mediterranean art, and virtuosity in the working of metals or the construction of patterns out of jewellery outlasted the paganism with which it was originally associated. The treasures of the ship burial at Sutton Hoo (c. 655) which coincide with the end of pagan burial customs in East Anglia reveal the incredible sophistication of long-practised techniques which Christianity deflected rather than destroyed.

The character of Barbarian art after the migration period was largely determined by the numbers of the Barbarians themselves and the places in which they settled. The Goths who occupied Italy and Spain were not particularly numerous and they found themselves in the most intensely Romanised parts of western Europe. Their reaction is not unfairly reflected in the frank and famous remarks of one of their leaders, Athoulf, after his marriage to a Roman princess, Galla Placidia, in 414: 'At first I wanted to eradicate the very name of Rome, turn all the Roman lands into an Empire of the Goths, and to be myself what Caesar Augustus was. But I have learnt by experience that the Goths are too unruly to submit themselves to the law, and without law there can be no state. I have therefore chosen a more prudent way to glory by devoting Gothic energies to the increase of the name of Rome and I hope to be remembered by posterity as one who restored Rome because it was impossible for me to destroy it.' By and large the Goths lived up to this declaration of policy, more successfully perhaps in Italy than in Spain. So did the Lombards. Together they inherited the Early Christian

19 (opposite). **Golden Madonna.** Late 10th century. Wood covered in gold, filigree, precious stones, enamel. h. 29 in. (74 cm.). Essen minster. This work, the earliest surviving cult image of the Virgin and Child conceived as free-standing sculpture, reveals a striking understanding of three-dimensional form (compare the awkward figure of Ste Foi, plate 20). These new developments in Ottonian sculpture (compare plates 15 and 22), and also in painting (plate 16), must reflect increased contact with classical and Byzantine art.

culture of the Mediterranean which they modified only by debasement. Perhaps their most conspicuous contributions to the art of their time was in the form of sumptuous votive crowns with which the 7th-century kings of Visigothic Spain and Lombardy sought to emulate the gorgeous ceremonial and the mystery of consecrated kingship implied by the theory of Imperial government.

At the other end of the scale were the Anglo-Saxons. These were real Barbarians who moved from one peripheral area outside the Roman world to another within it. They ought thereby to have ensured for themselves a future tinged with mediocrity, but from this they were rescued by the ecclesiastical policy of Pope Gregory the Great (590–604). Papal dissatisfaction with the Caesaro-papism (control of the Church by the state) of Imperial Constantinople culminated in the resolve to reunite western Europe, not politically but ecclesiastically around the concept of orthodox Catholic Christendom with the Pope at its head. For a variety of reasons Britain offered a suitable base, and whether or not events transpired as Gregory planned, the Anglo-Saxon mission eventually completed the conversion of the residual German heathens and was instrumental in regenerating the established Church on the mainland of northern Europe.

One might have expected that the Roman mission to Britain would have imported Early Christian art into that country. On the contrary, however, we find an extraordinary willingness on the part of the Church to let Christian art there 'go native'. Only to a very limited extent can this be explained as tolerance of Barbarian ineptitude. A large element of deliberate policy was involved, and the outcome was important for the whole future development of Christian art, for the mere fact that henceforth there was an alternative to the Early Christian art of the Mediterranean introduced an element of polarity which in turn gave rise to stylistic tensions and the possibilities of interaction.

ANGLO-SAXON ARCHITECTURE

The two principal spheres of activity in which the implications of this far-reaching concession on the part of the Church may still be studied were church building and illuminated manuscripts. Whether or not any basilican churches were constructed in England after the arrival of St Augustine's mission in 597, the surviving traces of Anglo-Saxon architecture make it clear that they must have been exceptional. We know that the first Canterbury cathedral was a patched up Roman building, and that at the end of the 7th century Wilfrid built imposing churches at Ripon and Hexham, which may have reflected current Roman fashions. But the vast majority of Anglo-Saxon churches were of a different type altogether. Stripped of their accretions, they consisted essentially of boxes of masonry. The size, arrangement and proportions of these boxes varied, and the uses to which they were put are by no means all certain. Escomb in County Durham may be

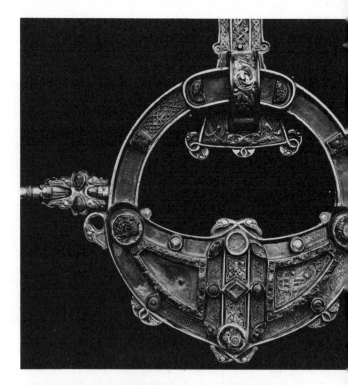

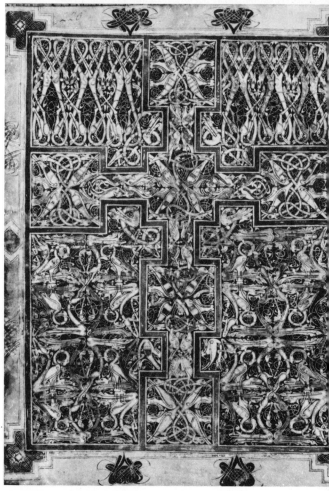

12 (above). **Carpet page.** St Chad Gospels. 8th century. 9¾ × 7¼ in. (25 × 18 cm.). Lichfield cathedral library. Like the Lindisfarne Gospels, this book includes pages of pure ornament doubtless inspired by the decorative traditions of pagan art of the migration period (compare plate 1, figure 7). Writhing beasts like these remained popular, particularly in Viking art, until the 12th century (see figure 9).

11 (opposite). **The Tara brooch.** 8th-9th centuries. Gilt bronze, silver, glass, filigree, amber, enamel. National Museum of Ireland, Dublin. The so-called 'Tara' brooch, which was carried off in a Viking raid in the 9th century and discovered with Scandinavian objects near the mouth of the River Boyne, is the finest surviving example of the exquisite Irish brooches that date from this period. The intricate patterns that were applied to this type of secular object were also used in the decoration of religious objects (compare figures 1, 12).

used to illustrate the simplest type of plan with only two boxes, one for the nave and one for the chancel, while Reculver in Kent (669) shows a more complicated form. While it would be necessary to know much more than we do to explain these churches satisfactorily, it is evident that, in spite of occasional allusions to Mediterranean architecture, they have no counterparts in the Mediterranean world, and they can never have carried the same meaning as Early Christian basilicas. The main difference is in the architectural setting of congregation and altar. Instead of a unified hall with no more than an apse at the east end to house the altar, the little northern churches often tended to stress the contrast by making nave and chancel in effect separate if contiguous buildings.

It is tempting to relate this arrangement to the legal position of the Church in the Barbarian societies of northern Europe. Among the Germans the idea of an abstract corporation owning property was unfamiliar, and when they endowed churches they did so in a form which made no clear provision for the outright transfer of ownership. It is unlikely that their generosity towards the Church would have been as reckless as it appears to have been if it had entailed giving up all rights over the property in question. In effect what happened is that founders entered into a kind of treaty with the saint to whom the church was dedicated. The actual church buildings and the appointment of priests remained very much under the control of the founder and, although the saint enjoyed indirectly the yield of the endowments, the only thing he could be said to own was the altar, in which his presence was represented by a relic. This was the reason for the growing importance of relics, and helps to explain the widespread use of portable altars before relics became plentiful. This state of affairs, which persisted until the reform movement of the 10th and 11th centuries, meant that the lay influence was liable to be considerable and at times excessive. It also meant from an ecclesiastical point of view that the focus of attention shrank to a particular part of the church, the part which housed the altar. In fact in the last resort the altar itself became the only real object of religious devotion. The symbolic overtones of Early Christian architecture were either jettisoned outright or else drastically watered down.

A sense of contrast between nave and chancel, east end and west end, clergy and laity, was something towards which the practice of the Church had been moving for a long time. But this was the first overt architectural expression of the antithesis and, once established, in one form or another the idea was to go on affecting church architecture right through the Middle Ages. Furthermore, when architectural symbolism became an important factor in church design again, i.e. in Carolingian and Romanesque times, it was from the altar and the need to stress its meaning that the necessary imagery was largely drawn. So, in spite of their modesty, Anglo-Saxon churches represent a momentous new beginning.

ANGLO-SAXON MANUSCRIPT ILLUMINATION

Anglo-Saxon illuminated manuscripts indicate a similar point of view. From the end of the 7th century to the end of the 10th this particular kind of painting was perhaps more important than at any other time. Not that sumptuous manuscripts were more admired in the Dark Ages or that they ceased to be made later. But in the perhaps fortuitous absence of competition from the other arts, manuscript illumination assumes for a while a position at the centre of Christian art. During this period northern painting was heir to two very different traditions: on the one hand the decorative arts of the pagan Barbarians, with which must be included a problematic contribution from the already Christian Celtic fringe; and on the other the Early Christian art of the Mediterranean. In a sense the history of European painting during these three centuries is concerned with the interaction of these opposed strands, and with the gradual subordination of the former to the latter. During the first phase, however, before the so-called Carolingian renaissance, the Barbarian elements were very much in the ascendant.

The events that touched off the great outburst of artistic energy in northern England at the end of the 7th century are largely connected with the end of the independent history of the Celtic Church, and its submission to Rome at the Synod of Whitby (664). Christianity had penetrated to Ireland from England and Gaul in the 5th century, and it survived there more or less cut off from the rest of Christian Europe after the conquest of Britain by the pagan Anglo-Saxons. Some Christian literature seems to have found its

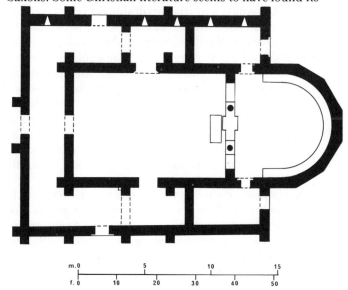

13. **Plan of Reculver,** Kent. 7th and 8th centuries. The church at Reculver was founded in 667. The original plan, as revealed in excavations, consisted of a chancel and nave separated by three arches resting on columns, with two flanking chambers to north and south. Later chambers were added further west.

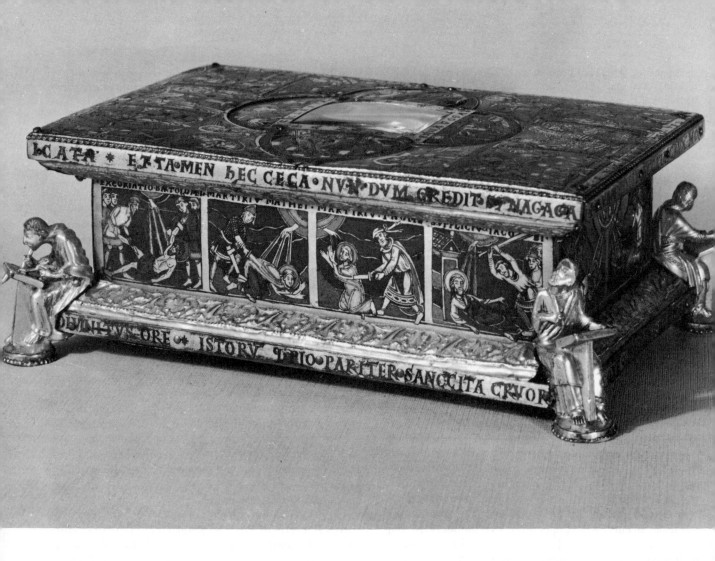

way to Ireland, but if any Early Christian art did likewise, the traces were soon obliterated. The only links with the Mediterranean area that are observable in later Irish art seem to have been with Coptic Egypt. Such affinities are not so far-fetched as they might seem at first, because the form of Christianity which most deeply impressed the Irish was eremitic monasticism, whose original home was the Egyptian desert. But the early history of so-called Irish art is incredibly difficult to unravel. On the whole it is perhaps safer to think of the Dark Age Celts on either side of the Irish Sea as sharing a common way of life, the residue of a widespread culture which had been only superficially altered by the Roman conquest of north-western Europe. And it was probably the surviving Celtic societies on the western side of Britain, rather than the Irish themselves, who contributed most to the amalgam now generally called Hiberno-Saxon art.

Nevertheless the style itself seems to have been formed in Northumbria, and since the discovery of the Sutton Hoo treasure it has been acknowledged that the Anglo-Saxons contributed far more than the unduly publicised Celtic elements. Moreover it was only in Northumbria that books from the Mediterranean world were available to be copied. A special effort seems to have been made during the 7th century to supply Northumbria with outstanding Italian manuscripts. Some of these have in fact been traced to the Vivarium of Cassiodorus, a famous monastery in Calabria. One of the earliest copies made in Northumbria was the Codex Amiatinus now in the Laurentian Library at Florence. The famous Ezra miniature in this manuscript

must have been a passable rendering of its Early Christian original, and the fact that the book was immediately sent to Rome may account for the style of its illuminations. For home consumption, however, little or no attempt was made to reproduce either the colours or the spatial aspects of the model. This becomes obvious if the Codex Amiatinus is compared with the Lindisfarne Gospels (c. 700), the recognised masterpiece of the style. The Lindisfarne Gospels are one of those rare works of art, like the van Eycks' *Adoration of the Lamb*, for the perfection of which we are totally unprepared by its meagre precedents. It was a labour of love in honour of St Cuthbert, undertaken by his successor at Lindisfarne who wrote it, and by a goldsmith who covered the binding, now lost, with gold and gems. Each of the four Gospels was introduced by a portrait of the evangelist, a complete page of pure decoration and an incredibly elaborate initial for the first word of the text. The interest of the evangelists arises partly from their place in the gradual reduction of these images to the quality of playing-cards, partly from the destruction of their respective pictorial settings. There are still one or two suggestions of space around the Lindisfarne figures. A hundred years later, in the Book of Kells, everything had become two-dimensional outlines on the surface of the page. But it is the pages of abstract ornament and the initials that command our deepest respect. Celtic spirals, Roman key patterns and animal interlaces of Teutonic origin are disposed within their curious frames with a virtuosity that almost defies analysis. Apart from the rudimentary outlines of crosses, there are no traces of traditional Christian symbolism. The

14 (opposite). **Portable altar from Stavelot.** Mid-12th century. Silver gilt, champlevé enamel, bronze gilt. 4 × 6 × 9¾ in. (10 × 15 × 25 cm.). Musées Royaux d'Art et d'Histoire, Brussels. This fine example of a Mosan portable altar includes scenes of saints' martyrdoms in enamel, and bronze figures of evangelists at the corners. The increasing use made in the 12th century of virtually free-standing cast figures in metalwork (compare figures 53, 62) can be compared to the development of stone sculpture (see p. 350).

15. **St Luke.** St Chad Gospels. 9th century. 9¾ × 7¼ in. (25 × 18 cm.). Lichfield cathedral library. Although the idea of an 'author portrait' derives from late classical manuscripts, this version of the evangelist shows how, to an even greater extent than in the Lindisfarne Gospels, the human figure has almost dissolved into abstract patterns under the influence of the traditions of non-representational art (compare figure 12).

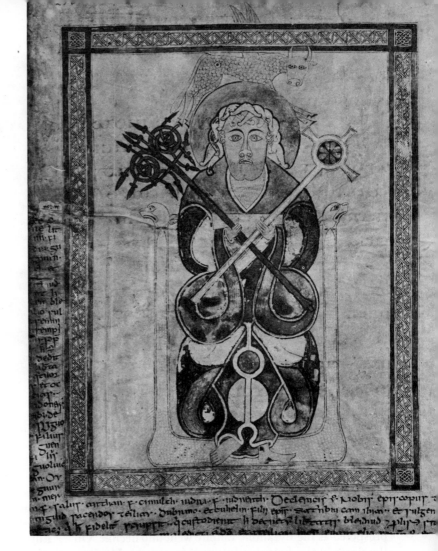

patterns themselves have taken charge, and acquired a meaning that perhaps verged on magic.

It is both baffling and salutary to realise that this outlandish style was meant to serve the interests of religion, and that it flourished side by side with the active study of Christian and classical literature. The term 'renaissance' has been applied to these Northumbrian phenomena, but Hiberno-Saxon art brings out very forcibly just how selective the Barbarians could be in the uses they made of what the Mediterranean had to offer. At that stage even the relatively stylised forms of Early Christian art were beyond their grasp, and accordingly repudiated in favour of even more ruthless abstractions.

In a more restricted way Anglo-Saxon monumental sculpture deserves mention if only because it was practised at a time when scarcely anyone else in Europe had any use for this art form. A series of great stone crosses starting from the latter part of the 7th century show a typological development analogous to that of the manuscripts. When their decorative patterns, e.g. the vine scroll, are recognisably late antique, it is logical to presume that these come at the beginning of the series, and that when the vegetable forms are transmuted into abstract patterns they belong to its later stages. Whether such a tidy conceptual scheme provides a clue to chronology is another matter. But two of the earlier examples at Ruthwell and Bewcastle include figure sculpture which is remarkable for both its quality and its rarity. Later the Anglo-Saxons applied sculpture to the decoration of churches as well, and in this respect anticipated the tastes if not the methods of the Romanesque.

In a long-term estimate of the achievements of Anglo-Saxon art, there is much to be said for regarding them as did Vasari. If we think of European art during the first millennium as moving away from the norm of the classical ideal, this was as far as the process went (unless the Scandinavian animal styles are considered more outlandish). From the 8th century onwards there are symptoms of a movement in the opposite direction. Nevertheless it must be recognised that the 7th and 8th centuries were the crucial period in which the Barbarians acquired their fundamental grounding in the basic art forms of Mediterranean civilisation. In this sense their significant achievements have nothing to do with style at all. What mattered is that they built churches of stone or painted illuminated manuscripts or occasionally carved monumental reliefs. Otherwise the refinements of style had no context.

It was not the Anglo-Saxons but the Franks who took the decisive step of bringing northern art into permanent contact with the Mediterranean tradition. Of all the German tribes who crossed the Rhine in the 4th and 5th centuries the Franks were probably the most numerous and they did not move very far. They settled in a compact mass between the Rhine and the English Channel, including what had been the most highly developed part of the Roman Empire north of the Alps, i.e. the hinterland of the Rhine frontier. It was no accident that this area was to become the most highly industrial part of medieval Europe, and that the Roman skills of making glass, enamelling, and working metals were first relearnt here, if ever they had been entirely forgotten.

16. **Vine scroll.** Detail of frieze. 9th century. St Mary, Breedon on the Hill, Leicestershire. The Anglo-Saxon church at Breedon was originally decorated with sculptured friezes (now incorporated in a later building) which included this classically-inspired vine scroll motif, with birds pecking grapes.

The special contribution of the Franks to the development of Europe arose from historical circumstances that can only be briefly mentioned here. In a sense they prospered as the Byzantine Empire went into decline. On the death of the Emperor Justinian in 565 the Mediterranean seemed on the point of being reunited under the Imperial government of Constantinople, and it must have been a shock when the concealed weakness of the Empire was almost immediately exposed by the belated arrival in Italy of another tribe of Germans, the Lombards, who occupied large parts of that country. Nothing could be done to dislodge them, and henceforth, although the Exarch at Ravenna and the Pope at Rome in their respective capacities either embodied or acknowledged the formal claims of the Eastern Empire to rule Italy, in practice links between Italy and the East gradually assumed the status of fictions. In the 7th century the fortunes of the Byzantine Empire went from bad to worse. A ruinous bout of wars with Sassanid Persia was followed almost at once (c. 640) by the totally unexpected irruption of Mohammadan fanatics from Arabia. Neither Byzantium nor Persia was able to contain this avalanche. Persia succumbed altogether, while the Byzantine Empire in Asia shrank abruptly to the confines of Anatolia. Twice, in 681 and 717, it seemed as though the capital itself might fall to the Arabs. In the event this did not happen, but it was two hundred years before the Eastern Empire was in a position to carry the war back to this formidable enemy. Yet another line of attack threatened to take Europe in the rear. Along the south coast of the Mediterranean the Mohammadan tide proved irresistible. In 704 the Arabs took Gibraltar and in 732 they crossed the Pyrenees. Then at last at Poitiers in the heart of France they were stopped, decisively as it turned out, by the Franks under Charles Martel. If that verdict had gone the other way, it is conceivable that Christendom might have collapsed altogether. As it was, the two Christian successes, at Constantinople in 717 and at Poitiers in 732, ensured that Europe, both Eastern and Western, should survive, and they mark the point at which the fortunes of war began to even out.

Whether the internal life of Christian Europe was as deeply affected by the Muslim conquests as has sometimes been claimed, there is no doubt that they established the basic framework of medieval political geography. With the destruction of its age-long unity, the Mediterranean ceased to be a highway and became a frontier, Italy relapsed into a peripheral region and the centre of gravity shifted northwards. This was when Europe became Europe as we now know it. Moreover, instead of being drawn together by the gravity of their beleaguered situation, the components of Christendom tended to fall further and further apart. The European predominance of 6th-century Byzantium was never restored or replaced. In the West the vacuum was partially filled by the Frankish kingdom, the largest and most powerful of the Barbarian states. Around this polarity of power there imperceptibly developed a political antithesis between East and West which coincided with and underlined the ecclesiastical differences which had emerged in the century after Gregory the Great. This was the state of affairs in the middle of the 8th century when the Roman church decided to break its residual connections with Constantinople and seek the more effective protection of Frankish arms in the face of imminent Lombard hostility.

By 750 everything conspired to select the ruler of the Franks as the only conceivable candidate for the vacant title of Emperor of the West. However, an ambiguous situation had developed which not only inhibited practical thinking in that direction, but also sheds curious light on the superstitions which surrounded kingship during the

early Middle Ages. By the 7th century the patrimony of the ruling family, the Merovingians, had been dissipated to such an extent that the kings themselves were reduced to a state of political impotence. Effective power passed into the hands of aristocratic families near the throne who, like Japanese *shoguns*, disputed among themselves for control over puppet kings. By 687 the issue had been decided in favour of Pepin, the so-called Mayor of the Palace of Austrasia, i.e. the eastern and more German part of the Frankish kingdom. Pepin's descendants are known to history as the Carolingian dynasty. Their family estates were chiefly located in the vicinity of Liège and Aachen, the old Roman frontier region. It was not until 751 that papal sanction gave them an opportunity to retire the last of the Merovingians to a monastery (the only recognised method of deposition) and to assume the vacant crown. For only the Church controlled supernatural powers sufficient to abrogate the accumulated sentiment that surrounded one dynasty by shedding the aura of its approval on another. This was part of the price which Pepin exacted from the Pope in return for his armed intervention against the Lombards.

CHARLEMAGNE

What had been done once could be done again. In 800 Pepin's son Charlemagne (king 768–814) was formally crowned Emperor by the Pope in old St Peter's at Rome. For several hundred years afterwards ideas about Rome and the Roman Empire became a constant preoccupation with medieval publicists and artists. What they achieved, however, was saturated with all manner of ambiguities, and although in the final analysis the result was to attach Teutonic Europe more firmly than ever to its Mediterranean inheritance, the medieval Empire as such was largely self-deception. If many of the people concerned with its inception really took it seriously, this was due to Charlemagne himself. His personality must have been quite exceptionally overpowering. In an age when communications were bad and political cohesion depended almost entirely on the ability of a ruler to establish personal ascendancy over his vassals, Charlemagne appears to have had no difficulty at all in commanding obedience from Thuringia to the Pyrenees. He was a natural ruler, and when his biographer Einhard thought fit to borrow the Latin of Seutonius and flatter his subject by, so to speak, adding another to the *Lives of the Twelve Caesars*, more was involved than a literary conceit. As a conqueror, Charlemagne's reputation rests somewhat equivocally on push-over victories against the Lombards and Avars, and a very hard-won compaign against the Saxons, who were reluctantly though in the end effectively incorporated into the Frankish Empire by the expedient of enforced conversion (the alternative being massacre). To these may be added some posthumous and entirely fictitious successes against the Muslims in Spain which, however, in the literature of later ages gave him the lustre of an archetypal Crusader.

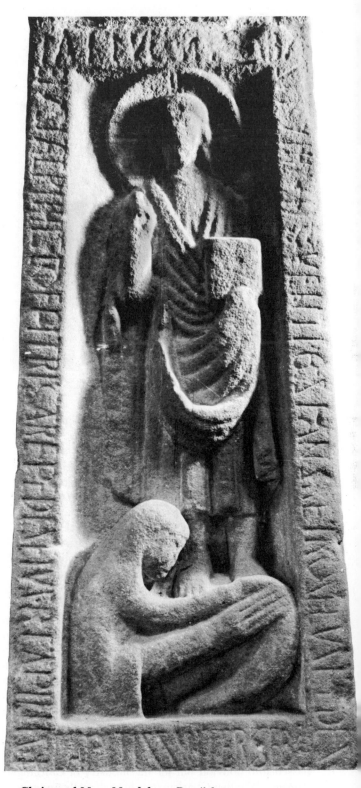

17. **Christ and Mary Magdalene.** Detail from a stone cross at Ruthwell. Late 7th century. h. 15 ft. (457 cm.). The remarkable quality of the figure carving on this cross must reflect the close contacts with classical culture that existed in Northumbria at the time of the adoption of the practices of the Roman Church after the Synod of Whitby.

18. **Aachen minster.** 9th century. Charlemagne built a palace and chapel at Aachen, one of his favourite residences. The chapel with its Italian-inspired circular plan and innovating and influential feature of a massive westwork still survives to the west of the Gothic choir.

19 (opposite, left). **The Symbolic Crowning of Otto II and Theophanu.** 982–3. Ivory. 7 × 4 in. (18 × 10 cm.). Cluny Museum, Paris. This ivory plaque showing Christ crowning the German Emperor Otto II and his Greek wife Theophanu is inspired by the kind of art produced by the Byzantine court. This is an important witness of artistic links with Byzantium, which help to explain the new developments in Ottonian art of this period (see plates 13–19).

20 (opposite, right). **St Riquier before 1090.** 17-th century engraving. This engraving after a drawing which is now lost, even if not entirely accurate, provides valuable evidence for the appearance of the exterior of this important Carolingian building where, as at Aachen (figure 18), particular attention was paid to the west as well as to the east end—a departure from the traditions of the Early Christian basilica.

Nevertheless he managed to bring together under one government all the continental Germans except the remnants of the Spanish Visigoths, and for a time there were only two powers in Christendom—the Greeks in the East and the Franks in the West. If the Franks thought of reviving the ancient Roman Empire in the West, this was partly because they were confronted by Imperial Byzantium. They looked sideways as well as backwards. The elevation of Charlemagne was one way of making plain that henceforth the West was on an equal footing with the East, and the Greeks had to concede that in spite of their inferior civilisation the Germans could no longer be excluded from a part in the political heritage of Rome.

But granted the great man, and the attitude of an age whose propaganda was habitually conducted in terms of symbols, the Carolingian Empire still seems like a literary charade mounted and stagemanaged by the scholars of the time. They alone had any idea of what Rome had been like in the days of its greatness, and they were the only people in a position to advice Charlemagne as to the form the renaissance should take. Not unfairly, perhaps, in the last resort the literary achievements were the ones that mattered most. Not a few ancient authors would have passed into oblivion but for the industry of Carolingian *scriptoria*. Whether Charlemagne himself really understood all that was done in his name and by his authority is another matter. No doubt he was content to bask in the reflected glory as a patron of art and letters. But it is difficult for us to see him now except through the eyes of his creatures, and therefore to disentangle the old Germanic warrior-hero with disgusting personal habits from the glowing image of scholarly wishful thinking.

The whole enterprise was inspired by the theory of the Christian Empire. But during the Middle Ages two very different interpretations of Imperial authority were current. One was that of the Byzantine Emperors, who saw themselves as God's viceroys on earth, a role which they chose to interpret as including the right to interfere in matters of Church doctrine. The other was that of the Roman Church, for which the Pope alone held God's commission to govern, and which was therefore inclined whenever possible to stress the indispensable contribution of the Pope to the making of an Emperor. It was not until the 11th century that the potential antagonism of these points of view came to the surface. During the Carolingian period the Church was not sufficiently organised as an international body to make an issue of its own claims, while the Carolingians themselves had too much need of the Church's cooperation to indulge in the hypothetical delights of Caesaro-papism. Nevertheless, precisely because each of these two positions was extreme, logically consistent and incompatible with the other, they define the limits within which all medieval Imperial art, not just Carolingian, was conceived. Any Western Emperor who took a high view of his office was liable to emulate the style of his Byzantine peers, and to recognise at Constantinople the kind of art that was most to his liking. Conversely those for whom the title was little more than an embellishment to the real substance of their power tended to make do with straightforward forms of Church art.

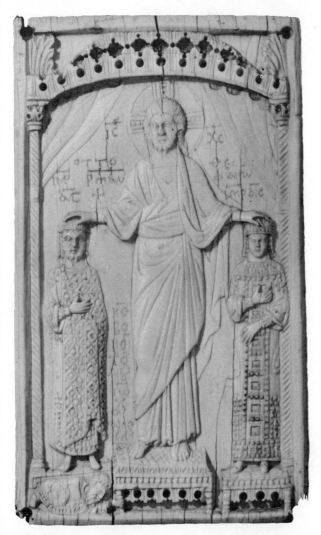

CAROLINGIAN ART

Charlemagne himself was probably the only Carolingian in a position to 'go Byzantine' if he had so wished. That he does not appear to have done so is largely due to the fortuitous circumstance that at the time the Byzantine world was still convulsed with controversy over iconoclasm. In the absence of contemporary inducements to copy the art forms of the Eastern Empire, and no doubt with papal approval, the Carolingians turned back to the past. In so far as they promoted a renaissance at all, it was fundamentally a renaissance of Early Christian art. In a sense they achieved what the Northumbrians had failed to do, namely to establish in northern Europe types of building and styles of painting whose ultimate place of origin was the Mediterranean. From this point of view Italy played a crucial role; and as the core of Carolingian power was in the north, artistic ideas and craftsmen began to flow from the south, from Italy to Aachen, fanning out from there to Tours and St Denis in France, and to the Rhineland and newly conquered Saxony in Germany. This traffic was to remain a fundamental feature of medieval art history until the development of the Gothic style.

But Carolingian art and architecture were more than just a renaissance. If the main impetus came from Italy, the 'minister of culture' himself, Alcuin, came from York, and with him the considerable strand of Saxon ornament that survives in Carolingian works. There was no conscious repudiation of Barbarian art, or official endorsement of Mediterranean styles. On the contrary we often get the impression that an effort was made to adapt the old forms to contemporary needs. This is perhaps most obvious in the palaces and churches. So much fuss has been made of the Roman features of Aachen and Ingelheim that it is as well to remember that they never lost the basic features of the traditional Teutonic *Hof*, the dwelling of a great man and his household. The basic formula was transformed, not replaced. The great hall at Aachen became a public building modelled on the Aula Regia at Trier, the most impressive Roman building north of the Alps. Likewise Carolingian churches were not so much Early Christian imports as the conflation of selected Early Christian forms with buildings whose function perhaps corresponded more closely to the Anglo-Saxon type. We know very little about northern Frankish churches before the Carolingian period; but it seems clear that few of them were simple Roman basilicas. The most important Carolingian contribution to the development of church architecture was perhaps a new conception of scale. From this time onwards we have evidence to sustain the distinction between great churches and small halls. Our knowledge of great Carolingian churches is fragmentary, and the best indications are provided by two drawings, one of the plan of an ideal monastery at St Gall in Switzerland (*c.* 820) and the other a drawing of the exterior of St Riquier (late 8th century). The St Gall plan provides our first evidence of the traditional Benedictine monastery of later times with the principal monastic buildings, including the church, set around a cloister. Although this general arrangement was reminiscent of a Mediterranean house-plan, the church itself had apses at both ends. This double-ended conception of a

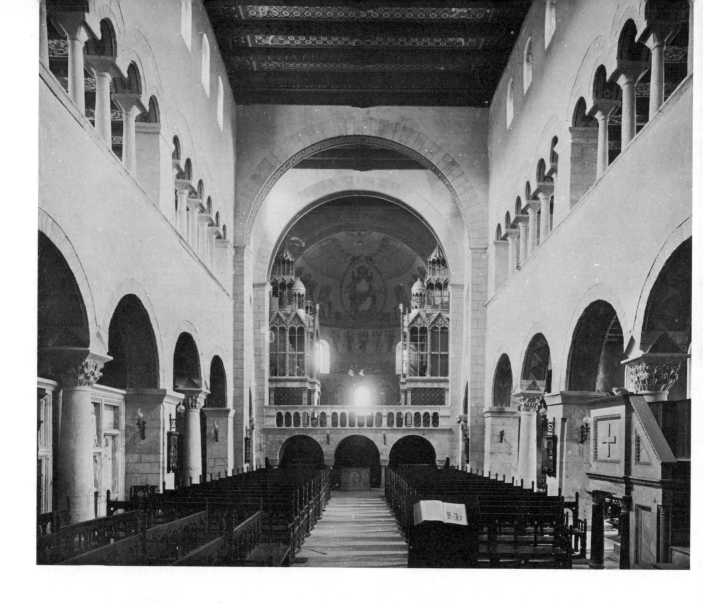

great church was something of a Carolingian speciality, although it more often took the form of contrasting groups of towers or eastern and western transepts. Our earliest indication of what these churches looked like is provided by the St Riquier drawing in which a western block culminating in a staged tower was deliberately matched against a similar group at the crossing. Western blocks of this type had a long history in the following three centuries
86 before they finally turned into the two-tower façade of the Gothic cathedrals. Towers as such seem to have played little part in Early Christian architecture and, although the St Riquier towers remind us of Roman tower tombs and
5 representations of the Holy Sepulchre in Early Christian ivories, their incorporation into great church designs was a significant development of the new kind of medieval church iconography mentioned above.

The one really exceptional Carolingian building was the
18 palace chapel at Aachen. The connection of this with S. Vitale at Ravenna is well known, and nothing betrays the Imperial aspirations of Charlemagne better than this attempt to emulate his illustrious Imperial predecessors, from Constantine to Justinian, who had built centrally planned churches as part of or in close proximity to their palaces. Nothing like the Aachen chapel had existed in the north before and its influence was as widespread as that of the Sainte Chapelle centuries later.

When we turn to the decorative and figure arts, the Carolingian compromise between past and present becomes a straightforward confrontation of Early Christian and Barbarian art. The Barbarian contributions, which came from both Anglo-Saxon and Lombard traditions, was chiefly felt in the field of ornament, while the impact of Early Christian forms was paramount in figure drawing. Our knowledge of Carolingian painting is entirely confined to illuminated manuscripts, although we know that the cupola of Aachen was covered with mosaics, and if the extant mosaics of Germigny des Prés are any clue it is likely that Byzantine craftsmen were employed. The range of style represented in surviving Carolingian manuscripts is surprisingly wide and suggests that any model would do providing it reached a sufficient standard of magnificence. So we find a fairly severe and not conspicuously classical figure style in the Godescalc Gospels at one extremity, and the ultra pictorial, impressionistic style of late antiquity represented by the Schatzkammer Gospels at Vienna on the other. The illuminations of the latter book were perhaps as close as Carolingian painting ever came to reviving a truly classical style, and it is interesting to observe the rapid transformation which this particular style underwent at the hands of its later practitioners. In the Ebbo Gospels 9 of the early 9th century calligraphy is already more important than paint, while in the Utrecht Psalter there is 2 nothing but outline drawing. It was in this last form that Carolingian art exerted its most far-reaching influence

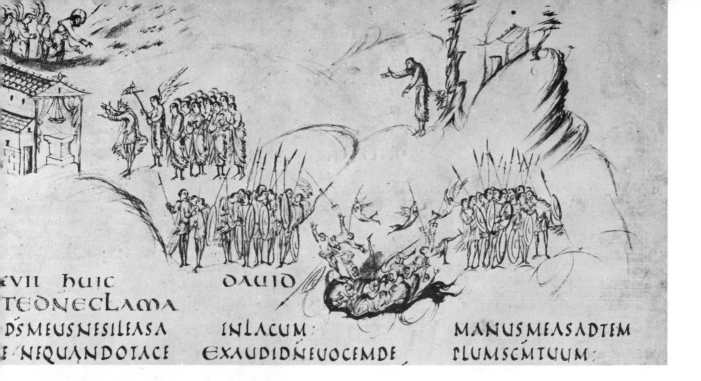

VII huic
TEONECLAMA
DSMEUSNESILEASA INLACUM MANUSMEASADTEM
E NEQUANDOTACE EXAUDIDNEUOCEMDE PLUMSCMTUUM;

21 (opposite). **Interior of St Cyriakus, Gernrode,** looking west. 10th, 11th and 12th centuries. The emphasis on the west end of a church (see figures 18, 20) often took the form in Germany of a western choir with its own apse, an alternative solution to a complex of chapels at the east end (figures 32, 33). Note the typically German features of alternating piers and columns, and the lack of vertical articulation (compare plate 21, figure 26).

22. **'Unto thee will I cry, O Lord.'** Detail of a page from the Utrecht Psalter (MS. 32, Psalm 28, f. 15v). 12¾ × 9¾ in. (33 × 25 cm.). University Library, Utrecht.

23. **Crucifixion.** From Anglo-Saxon Psalter (B. L. Harley 2904, f. 3v). Late 10th century. Drawing 9¼ × 7¼ in.

(23 × 18 cm.). British Library, London. The Utrecht Psalter is illustrated with animated scenes which literally portray the words of each psalm, in a style that derives from the narrative illusionism of late classical painting. Its influence can be seen in the Crucifixion page from the 10th-century Anglo-Saxon manuscript, where however the agitated outline drawing is used not to convey movement, but to emphasise the emotions of the figures (compare plate 9, figure 24).

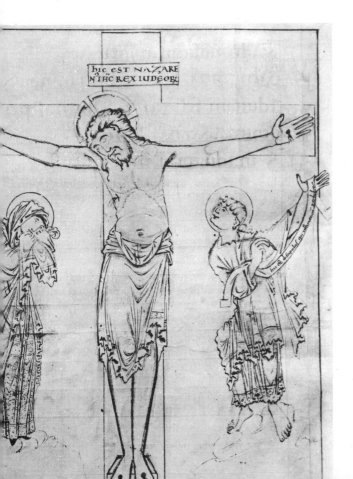

hic est nazare
nIHC REX IUDEOR

on the later Middle Ages, particularly on Anglo-Saxon 23 manuscripts. The Utrecht Psalter had found its way to England by the 10th century, and a whole tradition of outline drawing there was derived from it. Moreover this abstract drawing style can be detected in later Carolingian metalwork, such as the altar frontal which Charles the 11, 14 Bald gave to St Denis.

It is important to realise the extent to which Early Christian styles were transformed to suit Carolingian tastes. From one point of view the process was not fundamentally different from that which we observe earlier in the British Isles. It may be unfair to attach undue importance to this trend, but it is necessary to bear in mind that technical progress in architecture and the greater interest in pictorial art which were the permanent achievements of the renaissance, were not in themselves sufficient to sustain the impetus of regeneration. During the 9th century there was a perceptible *rallentando* in which the high Imperial aspirations of the court of Aachen became progressively more isolated and deprived of their significance. Here we encounter the ultimate ambiguity of Carolingian art. Although it was a new beginning, it was too precarious and in a sense artificial to mature into a strong living tradition. And it is therefore perhaps nearer the mark to see it as the latest if also the most curious and hybrid of the sources from which medieval art drew its inspiration rather than as an integral part of medieval art itself.

Romanesque Art

In 910 and 911 three events took place which in a long-term view did much to shape the history of Europe during the next three hundred years. At Forchheim the leading dynasts of the eastern half of the Carolingian Empire met to elect a new king from among themselves. As a result, the bonds between Germany and the Carolingian dynasty were broken for ever, and Germany cautiously embarked upon the most brilliant period of her medieval history. During the hundred years that elapsed between the battle of the Lechfeld (955) when Otto I put an end once and for all to the Magyar menace in central Europe, and the premature death of Henry III in 1056, it must have seemed as though the future of Europe lay with the Germans, not with the French. In 962 Otto I was crowned Emperor at Rome, and the idea of the medieval Empire recovered some of the substance which it had lacked since the death of the Carolingian Lothar in 855. German art under the Ottonians and the Salians who followed them was inevitably coloured by these Imperial associations. In one respect it was a deliberate revival or even a continuation of 9th-century Carolingian art, although the emphasis differed somewhat in that Byzantine influence was now more overt. The reign of Basil II (976–1025) saw the high-water mark of the military fortunes of the Eastern Empire and the Germans consciously sought to associate themselves with its prestige through the marriage of Otto II with a Byzantine princess Theophanu (972) which was accompanied by the traditional exchange of works of art. But it would be a mistake to think of German art during this period as pursuing a course wholly different from that of the rest of western Europe. It was simply that Germany was the first part of Europe to emerge from the crisis of what has been aptly called the darkest part of the Dark Ages (c. 900) and, thanks to a strong central government and an enlightened clergy dedicated to the royal service, she got away to a flying start, both politically and in respect of artistic patronage. If this early promise was never quite fulfilled, it was largely due to entirely unforeseen circumstances after 1056. But in spite of the chronological accident that seems to separate Ottonian art from Romanesque, there is much to be said for seeing them as earlier and later phases of the same complex cultural phenomenon. and it is perhaps worth adding here that the other precocious artistic revival which took place in the 10th century, i.e. in Anglo-Saxon England, had a similar equivocal relationship with Romanesque art, being both a contributing source and an antithetical foil.

In France there was no counterpart of Forchheim until 987, when the throne passed to the Capetian dynasty. Nevertheless two events did occur in France in 910 and 911 which however inauspicious they may have seemed at the time were destined to mark an equally important turning point in the history of western Europe. The first was the establishment by Duke William of Aquitaine of a new kind of monastery at Cluny in French Burgundy not far from Macon. The other was an agreement, often dignified by

24. **Initial B.** Detail of a page from Anglo-Saxon Psalter (B. L. Harley 2904 f. 4r). Late 10th century. Initial 6¾ × 5½ in. (17 × 14 cm.). British Library, London. Richly coloured frames and initials composed of forms inspired by classical acanthus foliage were popular features of late Anglo-Saxon illumination, which flourished side by side with figure drawing in the tradition of the Utrecht Psalter (see figures 22, 23). While the style of the latter gave way to new ideas in the 12th century, this kind of decorative initial influenced the development of Romanesque ornament.

the name of treaty, made at St Clair sur Epte between Charles the Simple and the leader of a marauding band of Northmen whereby the latter were allowed to settle in the lower valley of the Seine. In their very different ways these two foundations, Cluny and Normandy, serve to illustrate two of the more important aspects of life in western Europe that determined the formation of Romanesque art. They are the reform movement in the Church and the remodelling of society on feudal lines.

It would be wrong to suppose that the depredations of the Northmen came abruptly to an end after 911 or that the Northmen themselves became docile. What happened was that their taste for violence was gradually deflected in a different direction—away from sheer plunder to the wider end of carving out for themselves large estates. At first sight this change hardly seems to constitute a constructive development. Feudal warfare in the 10th and 11th centuries must often have been cruel and savage, especially for the non-combatants. But although there was a great deal of wanton destruction the more enterprising protagonists

always kept in mind the primary aims of creating enclaves of wealth and power. At a time when land was the only form of capital, and its yield the only sort of wealth that could be consumed or exchanged, the game of acquiring control over land was played with the same kind of ruthless zest that we find today in the commercial world of private enterprise, only with far fewer curbs and restrictions on their equivalents of our take-over bids. Every device was used—oaths of loyalty, guarantees of protection, marriages, blackmail, sheer blatant dispossession, and in the last resort killing. But out of the turmoil there eventually emerged throughout western Europe a landed aristocracy numbering at most ten thousand families, and with real power concentrated in the hands of a few hundred among them. By acquiring a stake in the land of France the Northmen qualified for co-option into this feudal aristocracy. They were to prove perhaps the most successful exponents of its techniques of aggrandisement; and by the 11th century they were outstanding among its members for their energy, intelligence and, not least, the range of their activities, which extended from Scotland to Sicily and the Balkans.

In the feudal world, no less than now, respectability was one of the rewards or penalties of success. In the 11th century respectability was equated with a certain kind of piety, which demonstrated itself by the endowment of religious foundations. These endowments seldom took the form of outright acts of alienation. For the most part they were regarded as investments whose value was twofold. On a purely mundane level, they functioned rather like trust funds, which left the benefactor an influence in the temporal affairs of the religious institution concerned, usually a monastery, often not far removed from total control. This was one way of making provision for the younger sons of the family, and it is not surprising to find during the 11th and 12th centuries that the upper echelons of the ecclesiastical hierarchy were recruited from the secular Establishment. The second advantage which these foundations represented brings us close to the heart of medieval religiosity. Granted that there were always individuals with insight into the spiritual character of Christianity, it remains true that for the vast majority of people, including the lay aristocracy, the operations of the Faith could only be conceived in terms of temporal and material analogies. From this point of view the establishment of a monastery was like taking out an insurance policy. The church became the family mausoleum, and special masses were said there for the benefit of the founder's soul. The benefactor entered into a special relationship with the saint to whom his foundation was dedicated, and whose presence was represented by the relics contained in the altar of the church. Given the habit of thinking of human society as a hierarchy of feudal obligations, the saint in question was expected, in return for the dedication, to guard the interests of his mortal client in the world to come and at the Day of Judgement.

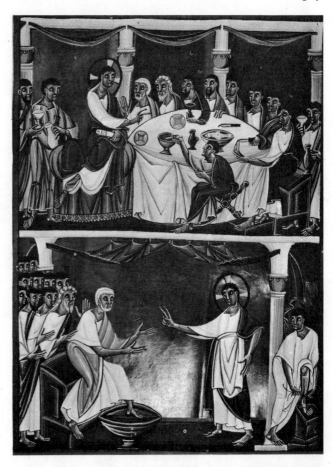

25. **The Last Supper,** and **The Washing of the Feet.** From the Perikope Book of Henry II (Clm. 4452). Early 11th century. 10¼ × 7½ in. (26 × 19 cm.). Staatsbibliothek, Munich. This book of extracts from the Bible, given by Henry II to Bamberg cathedral, is an example, like the contemporary but very different Sacramentary (plate 14), of an aspect of Ottonian art that was to be of importance in the development of 12th-century Romanesque painting. Compare the way in which the actions of the solid figures are emphasised here by the contrasting simple background, with the narrative style of the Albani Psalter (plate 48).

Not everyone was in a position to promote his eternal prospects by the expedient of founding a monastery. For lesser men there remained the consolations afforded by the holy places and the relics of the saints. In the curiously practical way in which medieval men regarded their religion, some of the spiritual merit of holy men was held to have rubbed off on the localities in which they lived their lives and on their possessions, and in particular to have survived their deaths in the sense of adhering to their mortal remains. From these merit was given off almost like a gas, strong near the source, and weaker at a distance. To get the full benefit of relics it was therefore necessary to enter their physical proximity. This was done either by bringing the relics to those who wished to venerate them, or by sending the latter to the relics. Both were practised during the 10th, 11th and 12th centuries. In the nature of the case the acquisition of relics was liable to involve unedifying transactions. Claims to ownership were often disputed and ended in prolonged litigation. On the other hand pilgrimages as penitential exercises were popular with both

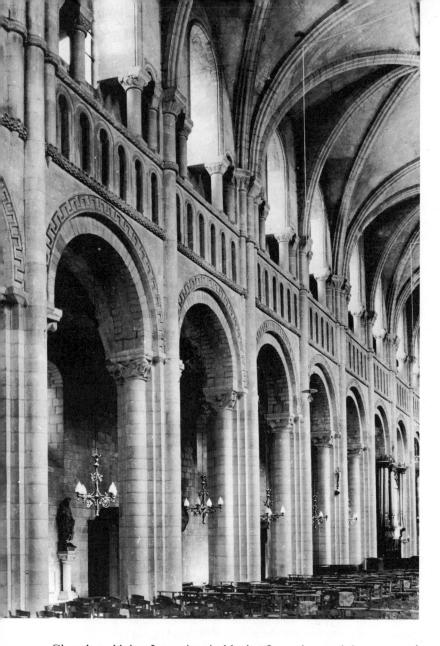

26. **Nave of La Trinité, Caen.** Second half of the 11th century and early 12th century. William the Conqueror and his wife founded the monastery of St Etienne and the nunnery of La Trinité at Caen to atone for their marriage as cousins. This early example of 'thick-wall' construction (see p. 372) was built with a vaulted choir, but the nave was only given its sexpartite vault (one of the earliest examples of this kind of rib vault) in about 1120, when the clearstorey windows received their present form.

Church and laity. It was inevitable that Jerusalem and the Holy Land should hold a unique place in the estimation of pilgrims. But the hazards and the length of the journey were sufficient to deter all but the most determined, and accordingly suitable alternatives were recognised at Rome or Monte Gargano in Italy, at Santiago de Compostela in north-western Spain and at several places in France, of which some at least were en route to Rome or Santiago.

The gross superstition of these attitudes was compatible with prodigious displays of fervour. A truly awe-inspiring feudal gangster, Fulk Nerra (Count of Anjou 987–1040), founded two abbeys himself, was closely connected with the origins of two more, and when he died, presumably in the odour of sanctity, was on the way back from his third pilgrimage to Jerusalem. Nor was this kind of piety at all feigned. If it made little difference to the conduct of their lives, it nevertheless betrayed a lively awareness of God's presence in the world and the dues that were owed to him by men of substance and position. The revenue necessary to maintain a community of monks, canons or nuns in the manner of life to which by 1050 they had become accustomed represented no small proportion of the total wealth at the disposal of society. Pilgrimages were less costly, but even so not everyone could incur the expense.

All this represented on the part of secular society a

growing respect for the Church. That this was so was due in the last resort to the efforts which the Church itself made at the time to live up to its own pretensions. This brings us to the second great preoccupation of the 10th and 11th centuries—the reform movement in the Church. First and foremost, there was the recognition of abuses and corruption. Primitive societies, among which catastrophe is always imminent and frequently experienced, never fail to attribute their misfortunes to the wrath of God and presume that this animosity has been aroused against them by their own sins and shortcomings. The endless onslaughts of Vikings, Hungarians and Saracens from outside Europe, and the ever present chaos of feudal warfare within, provided plenty of scope for this kind of reflection, especially during the first part of the 10th century. The secular priesthood in particular came in for criticism. Too often it was tarnished by the sins of simony and incontinence, and a worried laity was apt to enquire whether the sacraments themselves were compromised by the shortcomings of the men through whom they were administered. The Church was unanimous in pronouncing that this was not so, but prudent men betook themselves to the discipline of monastic life just in case. The numbers, social importance and wealth of the postulants made monasticism for a time a major factor in European life. For two hundred years

27. **West tower of La Charité sur Loire.** 12th century. The single surviving west tower of La Charité sur Loire, one of the daughter monasteries of Cluny, is covered with a profusion of ornament typically Burgundian in detail (compare Autun, figure 40). Mature Romanesque architecture often concentrated on elaborate surface decoration applied to basically simple architectural forms. Compare the ealier tower at Cluny (figure 28) and the early Gothic towers of Laon (figure 86).

28. **Ruins of the abbey church of Cluny.** Late 11th and early 12th centuries. This tower and transept are all that remain of the great abbey church begun in 1088, the third to be built at Cluny. The vast building originally included towers above both its crossings and over the double transepts, as well as at the west end. The idea of multiple towers goes back to Carolingian buildings and continued into early Gothic architecture (see figures 20, 86).

(c. 950–1150) monks were a sort of spiritual *corps d'élite*, responsible by the purity of their lives and the rigour of their observance for procuring the goodwill of God toward Christians in general and specific benefactors in particular.

Between the interests of the laity, often anxious to control monasteries for their own purposes, and monks anxious to escape the contagions of worldliness, frictions and disagreements were always possible. Already in the 10th century the desirability from a spiritual point of view of emancipating monasteries from excessive interference by secular benefactors was recognised. Cluny was one of the first fruits of this more enlightened outlook. Duke William's foundation charter formally eschewed all rights and reservations on the part of the founder and his family, and the only external authority which Cluny was obliged to recognise was that of the Pope himself. In the course of the 10th century, under a succession of distinguished abbots, Cluny rose to a position of eminence among the monasteries of Europe. If the modes of observance practised there were not exactly those envisaged by the rule of St Benedict or the Desert Fathers, the pomp, dignity and elaboration of its liturgies set an exacting standard which its neighbours found expedient to emulate. Cluniac monks were invited to reform the customs of other Benedictine foundations. At first these benefits were gratuitous, but by the time of the

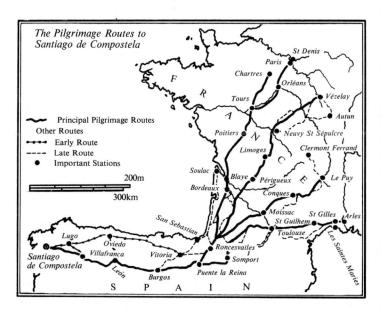

29. **The main routes used by pilgrims** to the shrine of St James at Santiago are known from a 12th-century 'guide book', but it would appear that the routes were already well established by the second half of the 11th century, when most of the great pilgrimage churches were begun. (See plate 21, figures 32, 33.)

fourth abbot, Odilo (994–1049), Cluny was in a position to embark on a policy of direct annexation. Gradually a kind of monastic empire was built up—an ecclesiastical counterpart to the secular immunities of the feudal dynasts. This vast congregation created a precedent which other religious orders such as the Cistercians followed in the 12th century. And to some extent the Church as a whole did likewise, especially in its dealing with secular governments; it tended to behave like a privileged organisation exempt from the normal obligations of political obedience.

As a corporate embodiment of ecclesiastical power Cluny was certainly exceptional, but as an instrument of Church reform it was only one among several contemporary movements. In the Low Countries and what was then called Lotharingia, similar efforts were made to restore the life of the Church in accordance with its pristine standards; and under the influence of Cluny and Lotharingia monastic life was revived in southern England during the late 10th century by St Dunstan, St Ethelwold and St Oswald. The Lotharingian movement, unlike Cluny, was concerned with the secular clergy. Moreover its point of view was to a much greater extent determined by the doctrines of early canon law, in which the status of the Church as a divinely instituted body was set forth with admirable clarity, undimmed by any serious consideration of what was likely to happen if these high-flown claims were actually implemented. This was the intellectual background of the men who purged the Church of its abuses and set it in what they conceived to be its rightful position, beyond all secular control at the apex of human society. The culmination of the movement was the reform of the Papacy itself during the middle years of the 11th century. The success of this operation led to a head-on collision between the Church and the secular powers, involving what the latter regarded as vested interests hallowed by tradition. The issue really turned on who should control the assets of the Church—the ecclesiastics themselves or their lay patrons. There were political overtones as well. But overall the Church made a determined and fairly successful bid to take charge of its own resources; and in spite of bitterness and the conflicts which arose, there is little doubt that society was persuaded to accept the Church as its own ideal aspect.

It is necessary to dwell at some length on these matters, and to stress the variety—even the inconsistency—of the attitudes involved, for without them it is impossible to understand what the Romanesque revolution was about. The great churches, monumental sculpture, metalwork and the new styles of painting were part of a vast effort in which the whole of Christendom tried to get its values sorted out. What began in the 10th and 11th centuries was one of those deep-rooted and spontaneous urges on the part of society as a whole to come to terms with the higher aspects of human life, which up to then it had been content to neglect. Unlike the Carolingian renaissance, which had been the precarious achievement of a few high-minded scholars, inspired by an almost ludicrously unreal vision, this movement was broadly based on the genuine aspirations of Christian folk. Whether they realised it or not, they were setting out to become civilised, and in this respect Romanesque Europe resembled nothing so much as archaic Greece.

The fact that from the end of the 11th century Romanesque art and architecture were designed almost exclusively as propaganda to project their own exalted image on the world was not inconsistent with these wide and vague implications. On the contrary, in order to construct prestige buildings here on earth worthy of the Church Triumphant architects were called upon to tackle structural problems that had not been faced since late antiquity and, to find solutions, they were forced to look far beyond the horizons of their previous experience. In the same way, as men thought more deeply about the symbolism of the Church, new decorative ideas came into vogue, and new problems arose in the representations of the human form, which launched the more adventurous artists on courses that opened their eyes to the achievements of classical figure art.

ROMANESQUE ARCHITECTURE

To begin with the architecture. In any precise sense of the word, there is no such thing as a Romanesque style of architecture. Thanks to the combination of feudal patronage and the aspirations of the reformed Church, more churches were built, and more of them were bigger churches. Moreover the bigger churches tended to become more elaborate in both plan and structure. But given the local character of feudal life, church building was largely conducted on a regional basis. Neighbours took their standards of economy or magnificence from one another. The same group of masons could therefore spend their whole working lives producing similar buildings all within a hundred miles. So the Romanesque architecture of Burgundy is different from that of Normandy, and it is possible to identify distinctive Romanesque schools in Provence, Auvergne, Alsace and western France, not to speak of the local differences that occur in England, Spain and Italy. It is true that special circumstances such as Imperial patronage in Germany or the promotion of

(Continued on page 337)

20 (opposite). **Statue-reliquary of Ste Foi.** Head, 5th century; statue, last quarter of the 9th century, modified during the last quarter of the 10th century. Plates of gold and silver gilt over a wooden core, with precious stones, cameos, enamels, etc. h. 33½ in. (85 cm.). Church of Ste Foi, Conques. The statue was originally made to house the relics of Ste Foi, which were brought to Conques between 864 and 875. From 985 onwards the relics became celebrated for their miracles, and many additions were made to its ornamentation in the subsequent centuries. (See p. 337.)

27

21, 26, 41, 40, 44

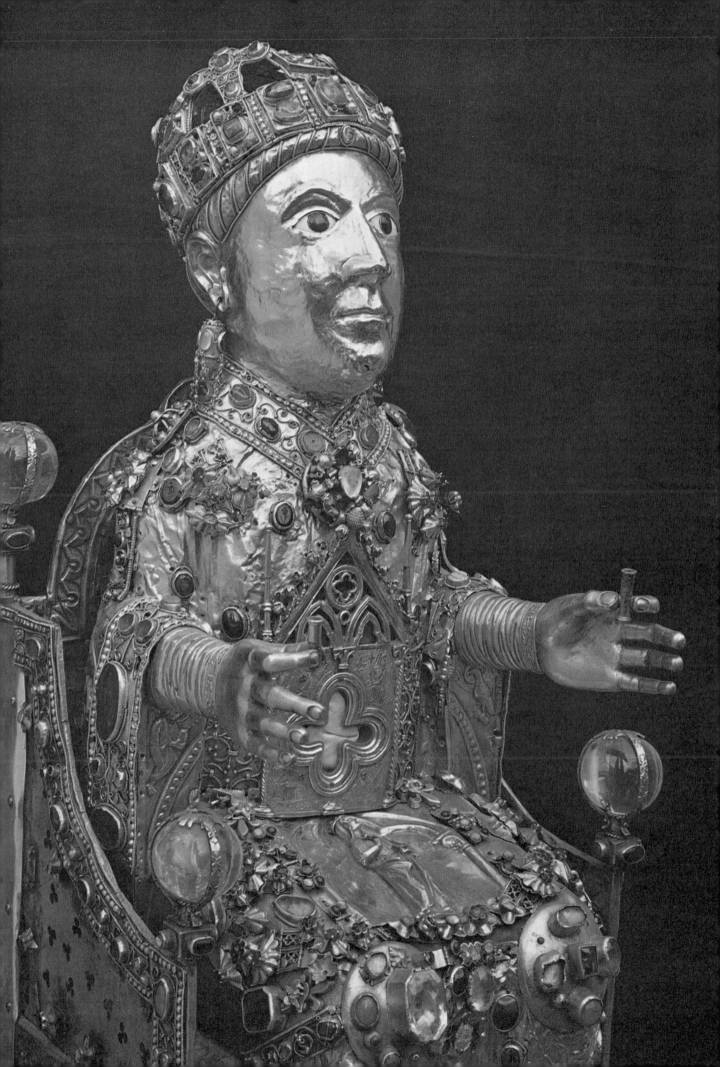

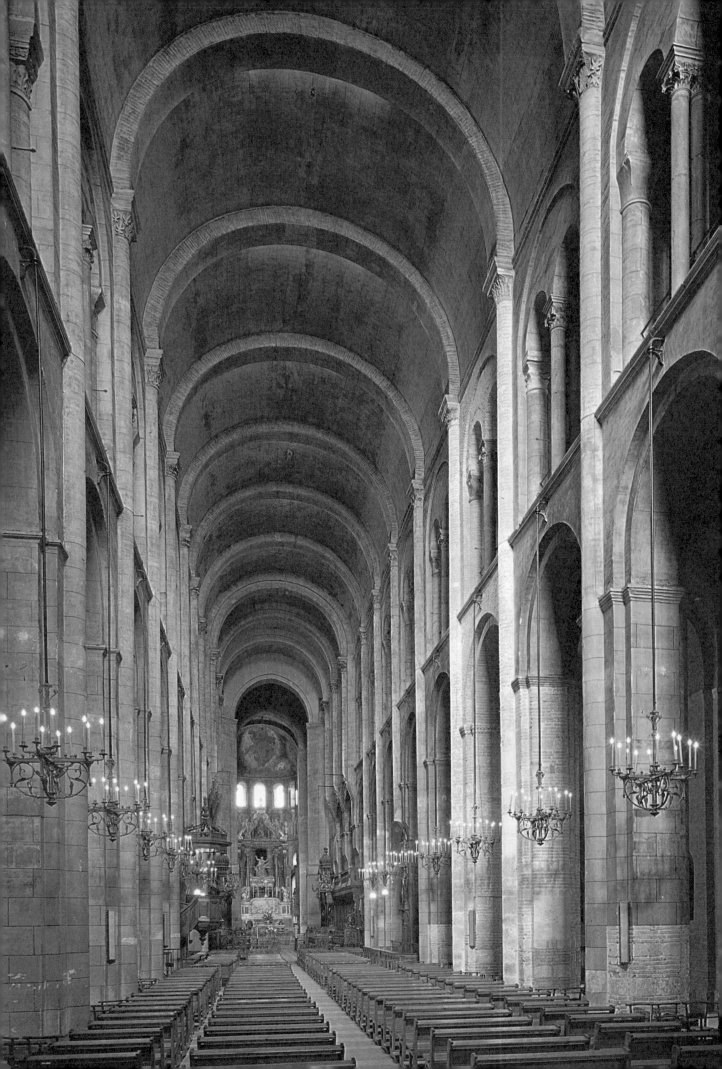

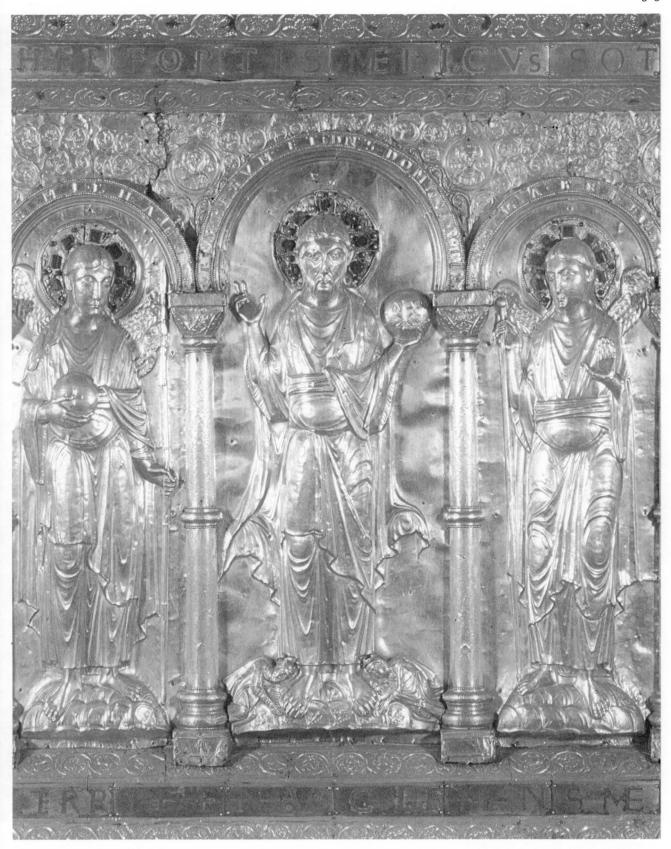

21 (opposite). **Nave of St Sernin, Toulouse,** looking east. Late 11th-12th century. St Sernin at Toulouse, one of the main centres on the road to Santiago, has the long barrel-vaulted nave, tall arcades and spacious galleries typical of French and Spanish pilgrimage churches (see p. 337). The east end was consecrated in 1076 but the plainer nave was completed in brick only during the course of the 12th century.

22 (above). **Golden altar from Basle** (detail). Before 1019. Gold, precious stones, pearls. 47¼ × 69¼ in. (120 × 177 cm.). Cluny Museum, Paris. Given by Henry II to Basle cathedral, this splendid altar frontal with its figures in high relief standing beneath arches (an arrangement which goes back to Early Christian sarcophagi) reflects a growing interest in the use of the arch—not only in architecture (see p. 340) but also as a frame for figure sculpture (compare plates 36, 43, and figure 39).

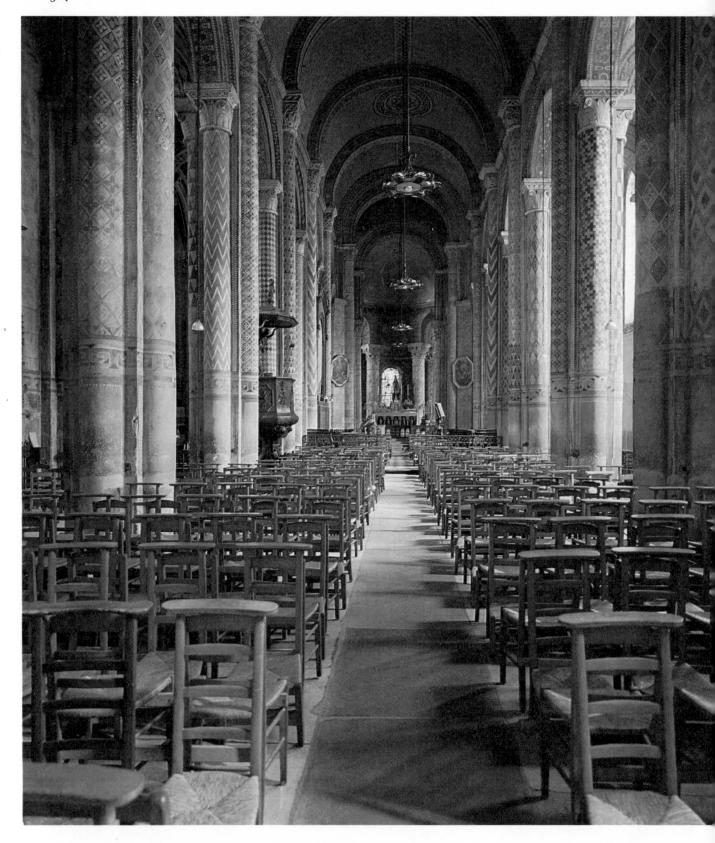

23. **Nave of Notre Dame la Grande, Poitiers,** looking east. First half of the 12th century. This 'hall church' type of building, with aisles and nave of equal height, lit only by windows in the aisle walls, is characteristic of west French Romanesque architecture, but also became internationally popular in the Gothic period (see St Sebaldus, Nürnberg, figure 84). The painted decoration is 19th-century but probably gives some impression of the wealth of colour intended by the Romanesque builders.

24 (opposite). **Nave of S. Miniato, Florence,** looking east. 12th century. This splendid interior displays the Italian love of richly coloured building materials (see p. 345). An interest in surface decoration rather than in structural innovation is typical of Tuscan Romanesque architecture: this building is basically a wooden-roofed basilica in the Early Christian tradition, though with the innovation of a choir raised above a spacious crypt, the Italian alternative to the east end with subsidiary chapels (see figure 32 and p. 338).

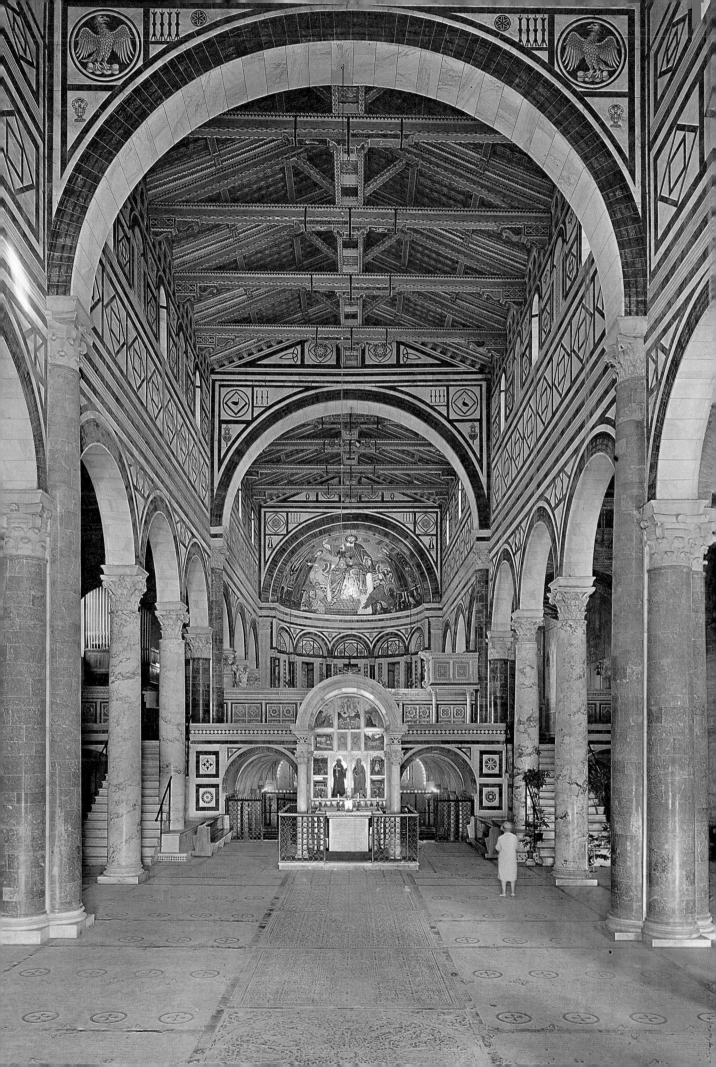

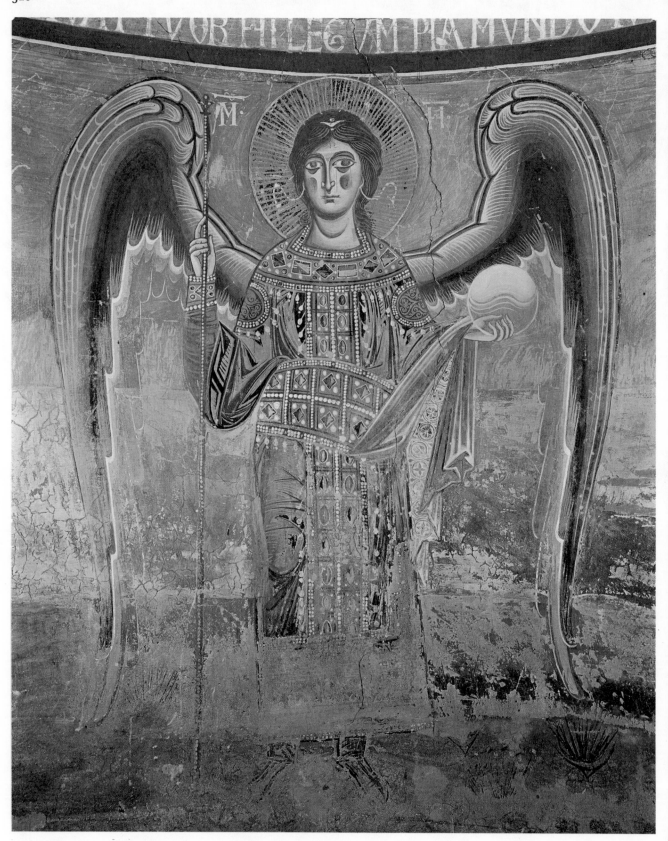

25. **Detail of wall-painting in the church of S. Angelo in Formis.** Late 11th or early 12th century. Precise links between the art of the East and Western Europe are surprisingly difficult to determine. This painting may reflect the style that flourished nearby at Monte Cassino, where Abbot Desiderius had many contacts with the East. But whether the Byzantine elements in this work, which appear less transmuted than in other Romanesque painting (compare plates 31 and 49), derive directly from contemporary metropolitan Byzantine art or from lost Italian intermediaries remains uncertain.

26 (opposite). **Christ in Majesty.** Detail of painting in the apse of the chapel at Berzé la Ville, Burgundy. Early 12th century. The chapel at Berzé la Ville belonged to St Hugh, abbot of Cluny. It seems likely that it was decorated before his death in 1109 by artists from the great abbey, and thus gives some impression of the kind of monumental painting that existed at Cluny itself. (See also plate 28.)

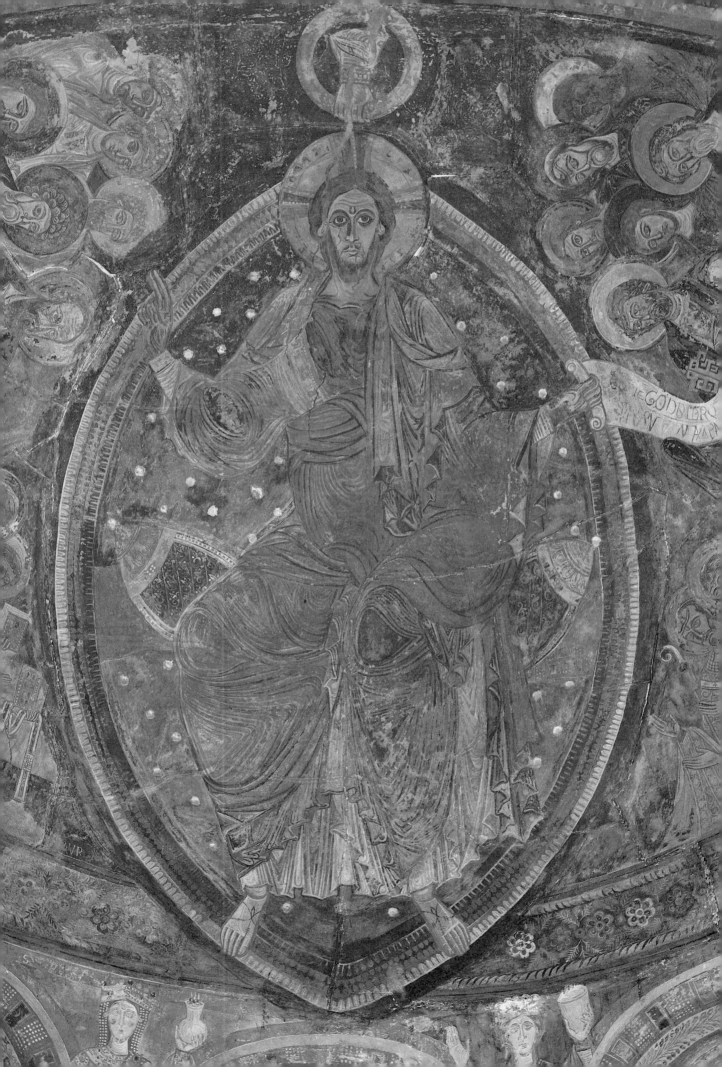

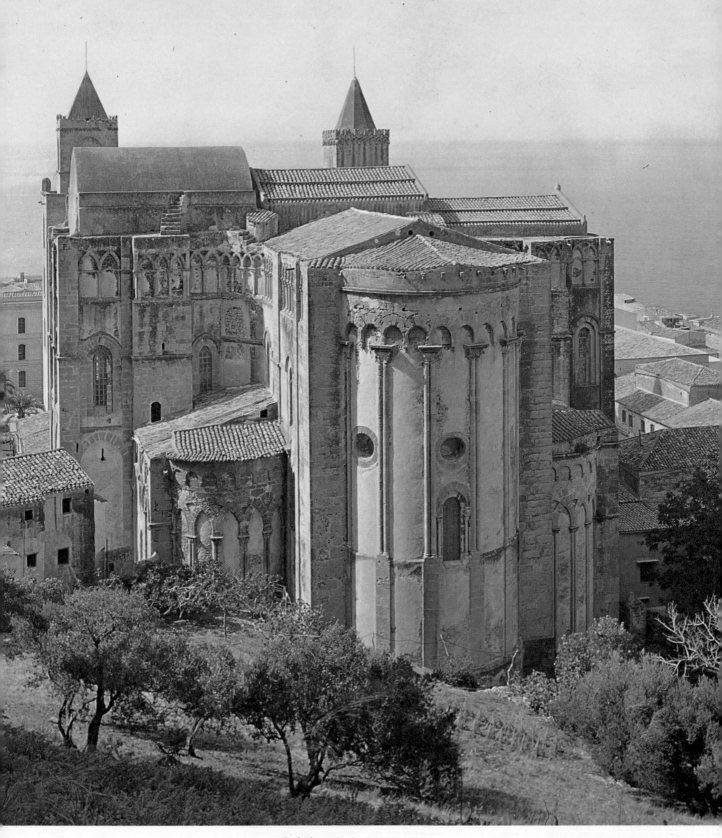

27. **Cefalù cathedral,** Sicily, from the
south-east. Begun 1131. The Norman
conquest of Sicily resulted in the
absorption of some architectural ideas
from northern Europe into a country with
an already mixed culture. While the
interior of this building contains pointed
arches of Muslim type, and has mosaics in
the Byzantine tradition, the general plan
and the use of decorative intersecting
arches can be paralleled in earlier
examples of Anglo-Norman architecture.

28 (opposite). **Apse of the chapel at
Berzé la Ville,** Burgundy (reconstruction
in the Palais de Chaillot, Paris). Early
12th century. Berzé la Ville (see also
plate 26) is one of the few surviving
examples of an apse still completely
covered with Romanesque painting of
high quality. The vault shows *Christ in
Majesty* surrounded by the apostles, with
figures of saints below, depicted in a
wealth of colour not often found in
Romanesque wall-painting. (Compare
plates 29 and 31.)

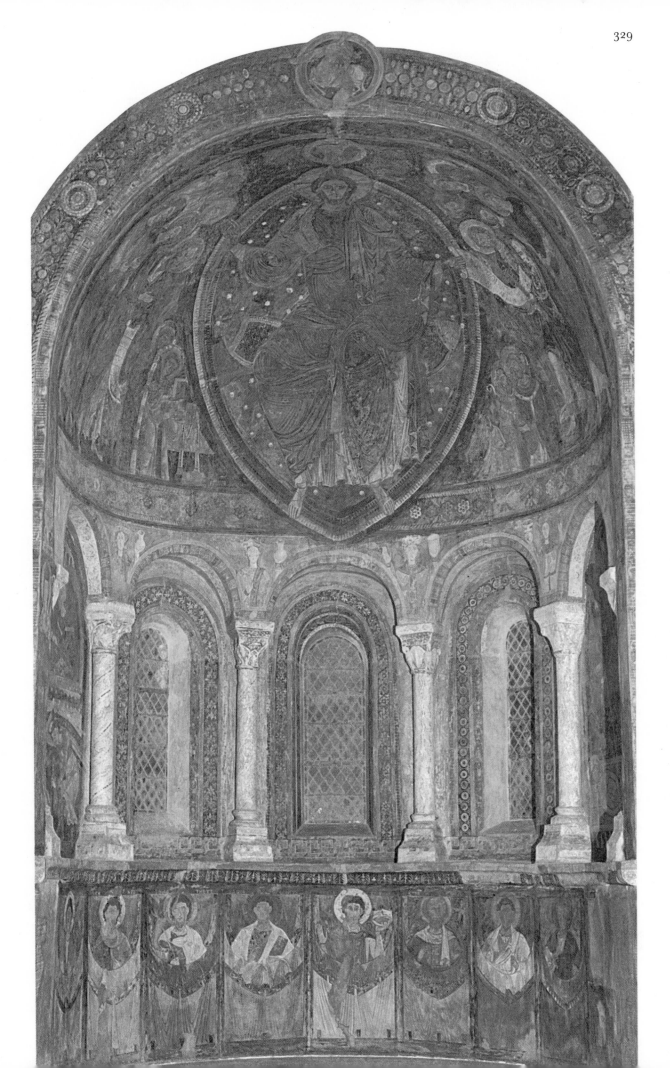

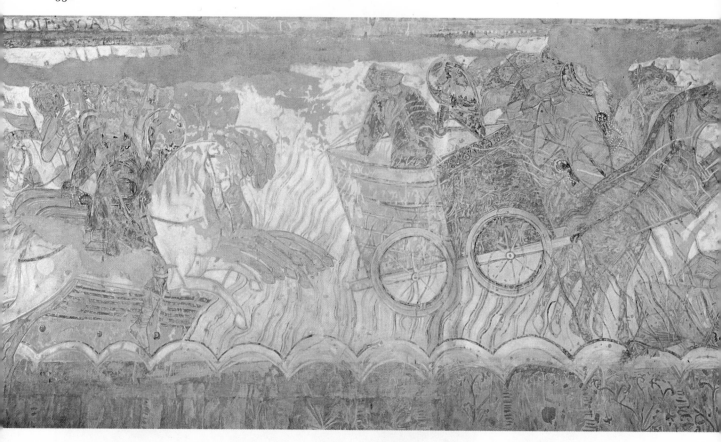

29 (opposite, above). **The Crossing of the Red Sea** (detail). Wall-painting in church of St Savin sur Gartempe. *c.* 1100.

30 (opposite, below left). **St Paul and the Viper** (detail). Wall-painting in chapel of St Anselm, Canterbury cathedral. Late 12th century.

31 (opposite, below right). **St Michael.** Wall-painting in Le Puy cathedral. Late 11th century or early 12th century. The fragmentary survival of Romanesque wall-painting makes it very difficult to understand the stylistic and iconographic development of this type of art. The monumental figure shows in its rather crude detail some echo of the stylistic conventions of Byzantine art (compare plate 25), while the detail from the extensive cycle of Old Testament scenes at St Savin (plate 29) perhaps has more in common with Carolingian and Ottonian traditions of narrative painting (compare figure 25). The much later painting of *St Paul* at Canterbury illustrates the close connections that can exist between wall-painting and book illumination—compare the treatment of the drapery with that in the Bury Bible, plate 49. (See p. 352).

32 (right). **A Prophet.** Stained glass window in Augsburg cathedral. Early 12th century. This window with the figure of a prophet, one of five in the west end of Augsburg cathedral, is one of the earliest surviving examples of a complete stained glass window, and shows that the art was already highly developed. Theophilus, writing in the early 12th century, refers to the practice of placing brightly coloured figures on a ground of white glass. (See p. 346.)

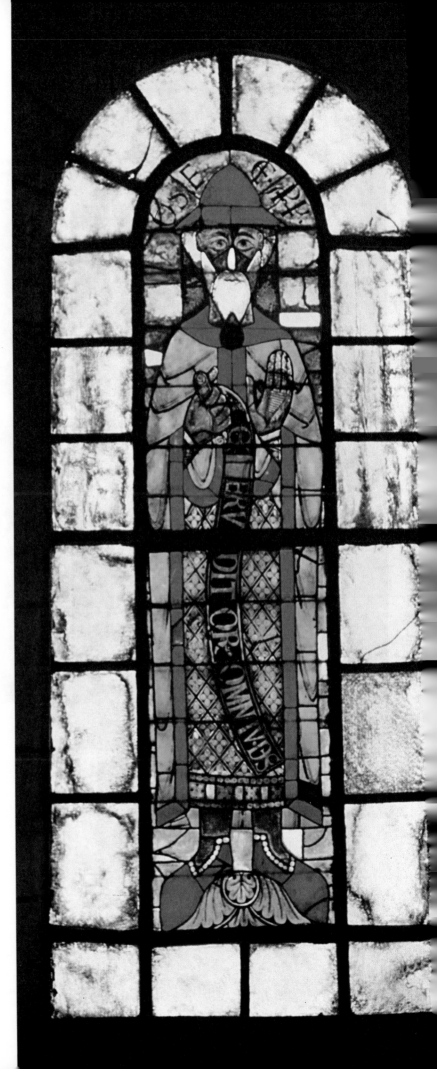

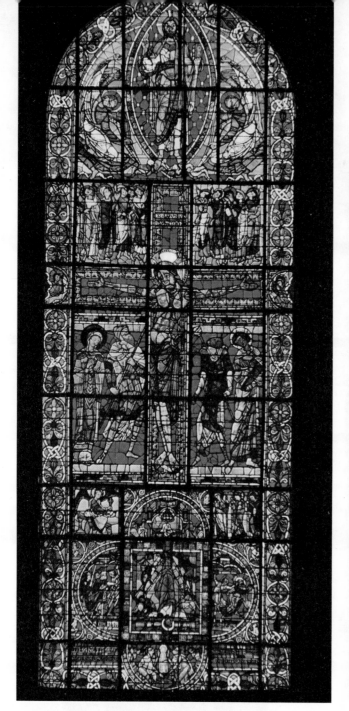

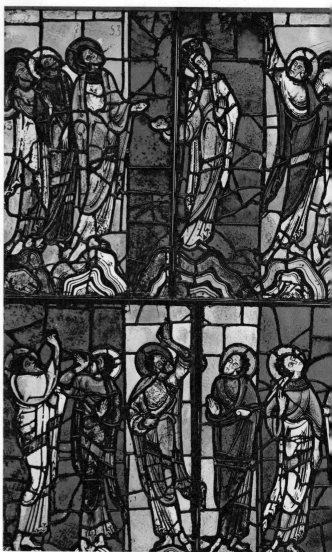

33 (above left). **The Crucifixion.** Stained glass window in Poitiers cathedral. Mid-12th century.

34 (above right). **The Ascension.** Stained glass window in Le Mans cathedral. Mid-12th century. As windows became larger during the 12th century, elaborate stained glass compositions tended to replace single figures (compare plate 32). These two examples from west France, with their stylised gesticulating figures, belong to the traditions of late Romanesque painting and metalwork (compare plates 49, 51) which continued side by side with the development of early Gothic architecture.

35 (opposite). **The Virgin and Child.** Stained glass window in Chartres cathedral. Late 12th century. The reused glass of this magnificent window in the ambulatory at Chartres, traditionally called the 'Belle Verrière', is of an earlier date than the 13th-century medallions that fill most of the other windows. The glowing reds and blues that dominate the composition are typical of stained glass of the early Gothic period.

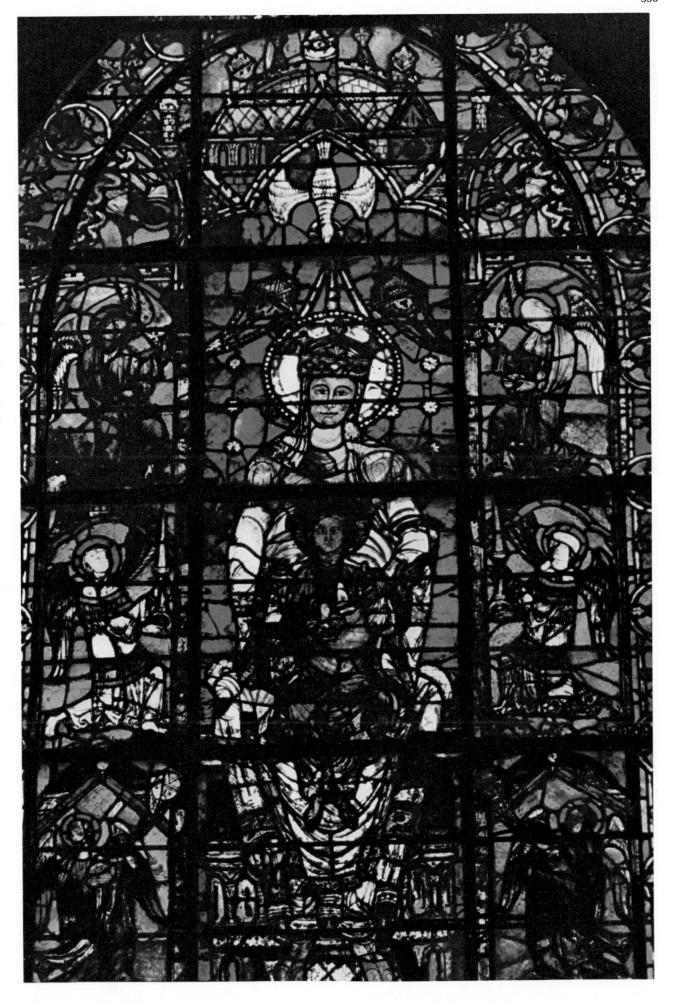

36 (left). **Detail of carved slab from St Sernin, Toulouse.** Late 11th century. Marble. The original function of this figure carved in high relief, one of a series (see also figure 8) now in the ambulatory of St Sernin, Toulouse, is uncertain. It illustrates the revival of interest in large-scale stone sculpture in late 11th-century France; its style shows a close dependence on late antique work, still commonly found in southern France.

37 (below). **Four apostles.** Wall-painting in S. Clemente, Rome. 12th century. This frieze decorates the apse of the upper church of S. Clemente, Rome, which was built above the Early Christian basilica. Like the sculpture at Toulouse, it is in a style strongly reminiscent of the art of the Early Christian period.

38 (opposite). **West front of Verona cathedral.** Mid-12th century. The projecting porch and lion supports are characteristic of the developed Italian Romanesque west front. The small figures placed against the angles of the jambs show the increasing desire to integrate figure sculpture with its architectural setting, which led ultimately to the fully developed 'column figure' (see p. 350, figure 52).

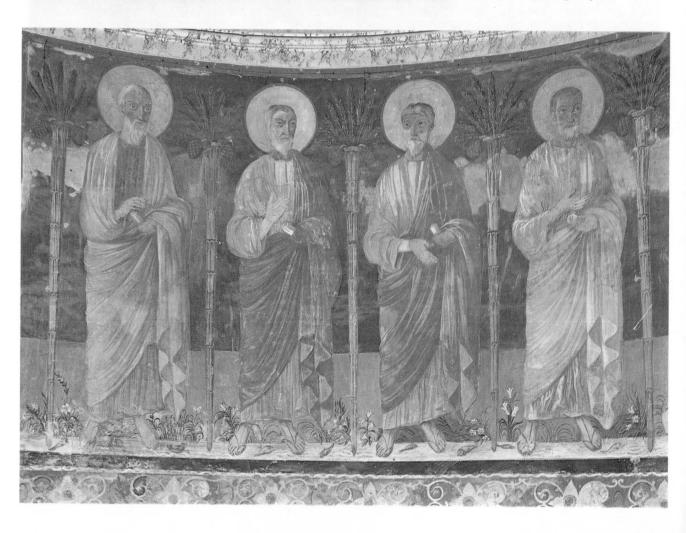

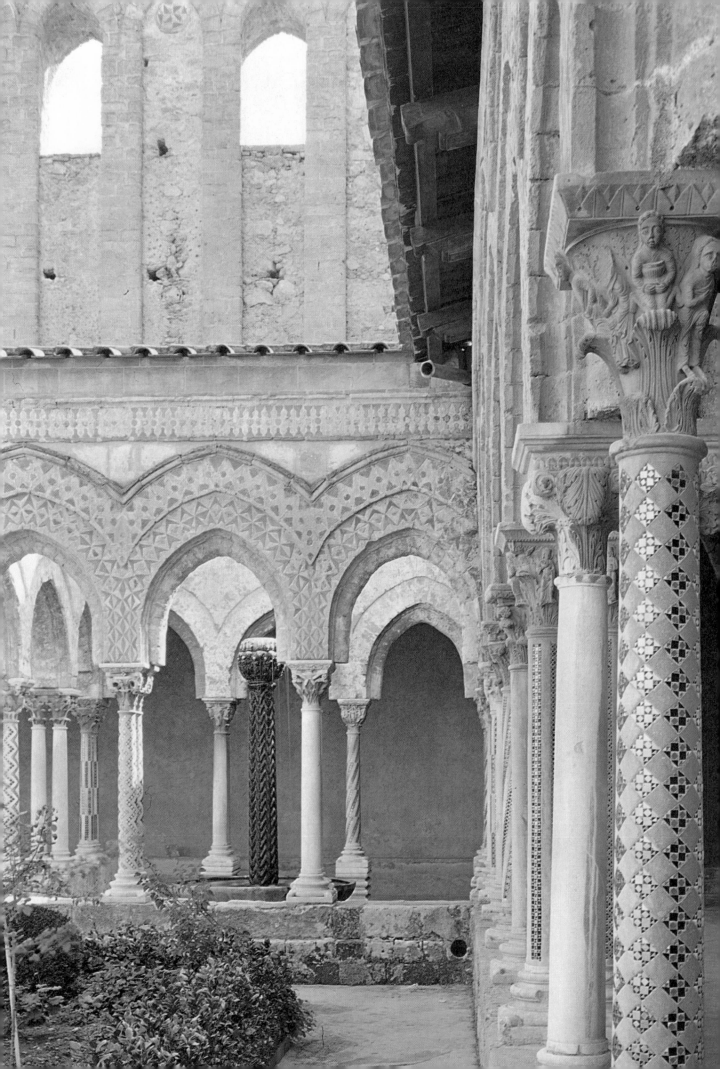

30. Interior of Notre Dame du Port, Clermont Ferrand, looking east. 12th century. The decoration of the interior of this building with local stone, and the plan, similar to that of the pilgrimage churches but with four instead of five radiating chapels, are features typical of Auvergne Romanesque. A central octagonal tower surmounting a lofty crossing which is abutted by the raised inner bays of the transepts is also a design peculiar to this region.

31 (below). **Crypt of Worcester cathedral.** Begun 1186. Worcester was one of several English churches built soon after the Conquest with a crypt of considerable size. Note the typically 11th-century groin vaults and undecorated cushion capitals. The popularity of both cushion capitals and large crypts in post-Conquest architecture suggests connections with the Empire as well as with Normandy, where these features are less common.

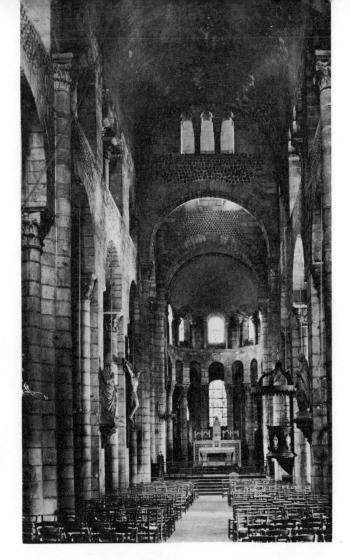

international pilgrimages could result in the wider diffusion of more ambitious types of building. Essentially, however, the architects of the 11th century were concerned with the appropriate form for a great church, and it is this preoccupation rather than any particular solution that gives unity to Romanesque architecture.

In the treasury of the church of Ste Foi at Conques in Auvergne, the principal attraction is a little jewelled statuette purporting to represent the lady to whom the church is dedicated. This image was made about 980, and for such an early date it is an exceptional object. It is a kind of reliquary, and one may guess that it acquired a human form because a late Roman bronze head was fortuitously available. This gruesome little figure is hardly a work of art, but it conveniently displayed the things of real value at Conques, which drew pilgrims from hundreds of miles away—the relics of Ste Foi. These were responsible for the miracles which in turn were the source of a considerable part of the abbey's income. Together with benefactions, they made it possible by the middle of the 11th century for the abbey church to be rebuilt on the scale that we see today.

This church at Conques was one of a group which share the same basic design. Others are at Toulouse (St Sernin) and Santiago de Compostela in Spain. Two more, at Limoges and Tours, were destroyed after the French Revolution. Although they were exceptional buildings and are not to be thought of as 'typical' Romanesque churches, they illustrate several important and characteristic trends. First and foremost, as they were all concerned with the display of relics to pilgrims, special care was lavished on the part of the building in which these were housed, the east end. Formerly it was the practice in churches which possessed valuable relics to conceal them underground in crypts, and to make access to them as difficult and in-

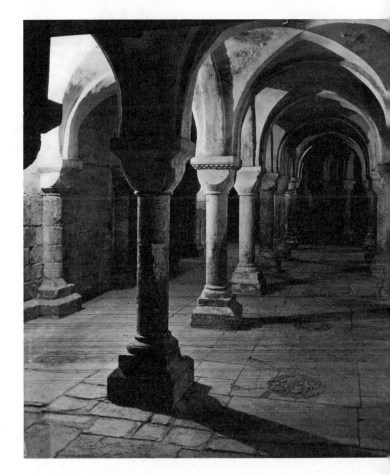

39 (opposite). **Cloister of Monreale cathedral.** Late 12th century. Stone with mosaic glass. While the cloister of Monreale cathedral, built by the Norman William II, has pointed arches with flat geometric inlaid decoration reflecting Muslim influence, the style of the capitals, like so much Mediterranean Romanesque sculpture (compare plate 24, figure 50), shows the strong influence of classical prototypes, a mixture typical of Sicily (compare plate 27).

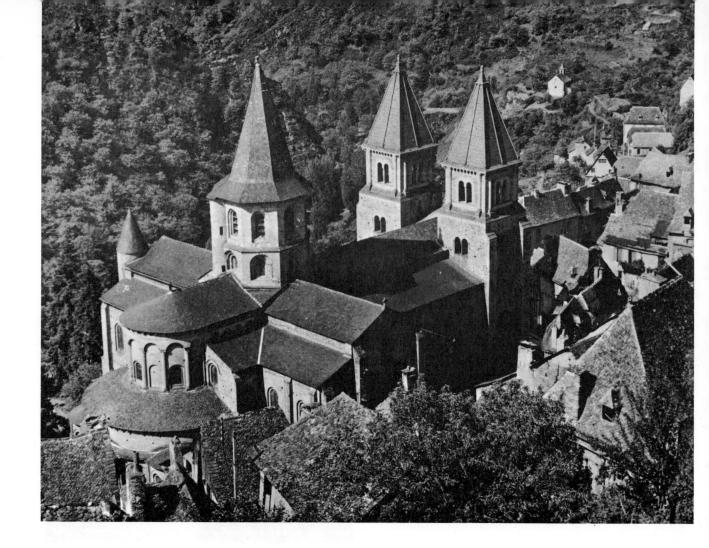

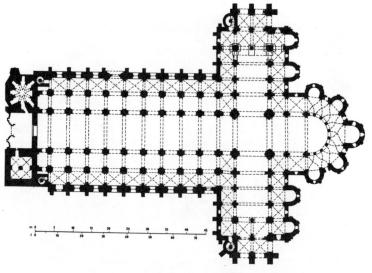

32. **Exterior of Conques abbey.** 11th century.

33. **Plan of St Martin, Tours.** 11th and 12th centuries.
The 11th-century church of St Martin at Tours was possibly the prototype for the developed 'pilgrimage church'—no two of which, however, are quite identical. The ambulatory and ring of chapels became a standard feature, but the completely aisled transept and towers of Tours were not always copied. Conques, begun before 1065, is less ambitious than the larger later churches at Toulouse and Santiago (see plate 21).

convenient as possible. Relics were treated as a kind of buried treasure. This was no doubt prudent when danger threatened. But with the reorientation of the Church's relations with the secular world, relics were so to speak brought out into the open, and presented to the world at large. Where there was no crypt, the reliquary was displayed on the altar. Otherwise the crypts themselves were enlarged so that instead of dark and narrow passages they became veritable halls spread under the choirs and transepts of churches. This solution was favoured in Italy and the Rhineland. But either way the change involved a radical departure from the traditional types of church design. At Conques and kindred buildings the east end is particularly elaborate. It is often said that the semicircular ambulatory around the apse of the choir, and the series of chapels opening radially from it, which we find there, were designed to solve problems arising from processions, etc. This may well be true. But the significance of the ambulatory was not exhausted by considerations of convenience. In Early Christian times it had been the practice to construct special churches, usually centrally planned, for relics and the services devoted to their veneration. These were usually adjacent to but separate from the great halls, or basilicas. In the pilgrimage churches these two early types of church were combined into a single unified design.

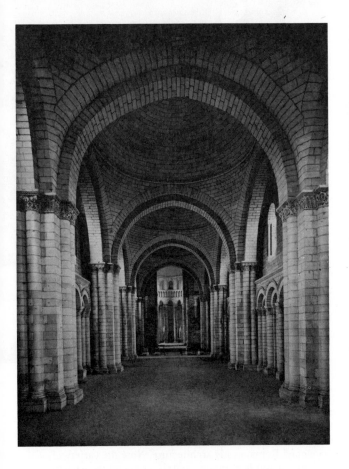

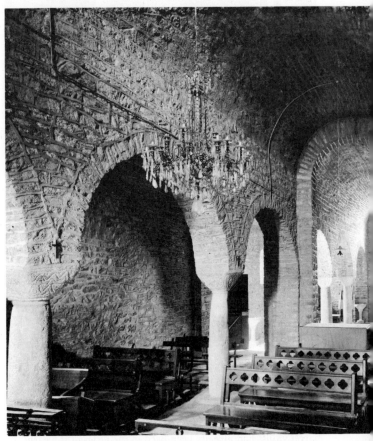

34. **Interior of Fontevrault abbey,** looking east. Early
12th century. A number of large west French Romanesque
churches in the area of Angoulême and Périgueux are vaulted
with a series of domes—an idea that must be inspired by
domed buildings of the East. Fontevrault, a northern outlier
of this group, was the burial place of the Plantagenet kings
of England, who ruled so much of western France.

35. **Interior of St Martin du Canigou,** looking west.
11th century. This small church in the Pyrenees is an example
of one of the early completely barrel-vaulted buildings that
are to be found particularly in Italy, Spain and southern
France, where so many examples of Roman vaulted buildings
survive.

The tendency to merge two historically distinct types of
church was a special case of another, more widely spread
practice, namely that of stressing the contrast between the
two ends of the church. Although the Church was an
organisation that embraced both clergy and laity, and
although both frequented the same buildings, nevertheless
the reform movement tended to accentuate the gulf
between them, and the parts of church buildings which
they respectively used often received different architectural
emphasis. Thus the east end which was reserved for the
clergy, and which contained the principal altars and
reliquaries, was now habitually more elaborate than the
nave. The ambulatory and radiating chapel plan was one
way of stressing the importance of the east end. It was
particularly effective from the outside, where the various
roof levels could be made to ascend stage by stage to reach
their climax in a central tower. It is unlikely that the sense
of hierarchy which we still detect in the east ends of these
churches was unintentional. Another method was to put a
vault over the choir. The introduction of stone vaulting was
partly encouraged by the need to protect altars and
reliquaries from the dangers of fire from a wooden roof; but,
like central planning, vaults had iconographical overtones
which contributed to the symbolism of church architecture.
All vaults could symbolise the vault of heaven, and had

done so long before Christianity adopted the idea for its
own purposes. From this point of view the vault *par excel-
lence* was the dome, which in so far as it approximated to
part of a sphere could claim to participate in the perfections
of that most perfect of all Platonic shapes. Domes were
habitually used in Byzantine churches and for a time also in
certain parts of France. The difficulty with domes, however,
was that they did not readily lend themselves to use in
longitudinal churches (nor in aisled churches) which by
tradition most Western churches were. These difficulties
could be overcome, and the results were often strikingly
effective. But by and large other solutions were preferred.

VAULTS AND ARCHES

So far as the Middle Ages were concerned, all vaults came
from Rome, and apart from domes the other Roman types
available were the barrel vault and the groined vault.
Barrel vaults were easier to construct and accordingly the
first to be tried. They were first used over choirs, as at
Agliate near Monza in Lombardy. Then they were
extended to the whole church, which is what happened
at Conques. A whole tradition of Romanesque church
building developed around the barrel vault. The surviving
monuments are to be found from northern Italy to the
Atlantic coast of France and Spain. We have only to put,

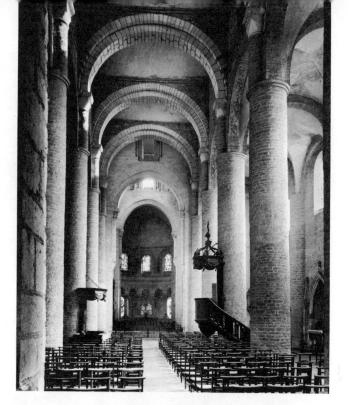

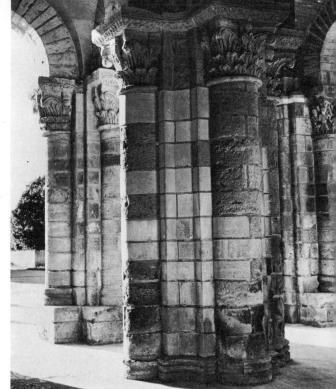

36. Interior of St Philibert, Tournus, looking east. 11th and 12th centuries. This impressive 11th-century nave was vaulted in the 12th century in an unusual fashion with a series of barrel vaults supported on transverse arches set at right angles to the main direction of the building. Transverse barrel vaults had already been used in the aisles of the early 11th-century narthex.

37. Detail of the narthex, St Benoît sur Loire.
11th century. St Benoît sur Loire has an 11th-century narthex with groin vaults separated by arches, which spring from piers with attached half columns—an early example of the compound pier, which becomes a basic feature in developed Romanesque architecture. Note the variety of Corinthian and historiated capitals—some of the earliest French examples of elaborately carved capitals.

for example, Notre Dame la Grande at Poitiers or S. Martín at Frómista near Burgos alongside the ruins of the classical Roman nymphaeum at Nîmes to realise how direct was the descent of southern Romanesque architecture from the traditions of antiquity.

Medieval groined vaults also seem to have started from Italy. Presumably there were still examples of late Roman vaults of this kind in cities such as Milan or Ravenna which had Imperial associations. There were certainly some to be seen in Rome itself. It was, however, in the north of Europe that the possibilities of this kind of vaulting were most thoroughly explored. Groined vaults are really only suited *31,37* for use over square or nearly square compartments; and a whole series of 11th- and 12th-century churches in Lombardy and the Rhineland seem to betray in their planning care to make provision for this necessity. Even so, the geometry of their construction was liable to seem complicated and almost from the start we find a tendency among the designers of vaults to simplify their procedures by substituting straightforward arches for the more *38* sophisticated curves of true groins. Once this step had been taken it required little further imagination to stress these by making them visually conspicuous. The result was the *62,55,57* kind of vaulting which is called the ribbed vault.

Because ribbed vaults became an essential feature of Gothic architecture, some historians have had a strong inclination to distinguish this kind of vaulting from the use of groins. However, one is only a refinement of the other, and both developed in the context of Romanesque architecture. Enough has been said elsewhere about the struc-

tural convenience which ribbed vaults offered, but other factors were involved as well. However else they were regarded, ribs soon came to be considered as arches, or parts of arches. One of the most widespread features of Romanesque churches, in every part of Europe, was the part that arches came to play in their general articulation. In Early Christian and Carolingian churches the only arches worthy of the name were to be found in the main arcades between the nave and aisles, where they were supported by columns or piers. Windows and doorways were often no more than holes, left unmoulded and undecorated. It is the application of colonnettes, capitals and moulded arch forms to these apertures which most commonly distinguishes a Romanesque church from its predecessors. During the 11th century we find the same form applied wherever possible to the articulation of the interiors of churches, so that by about 1100 a great church was well on the way to becoming an organised system of interrelated arches. The introduction of arches into the vaults of these churches was therefore just another instance of something that had already been going on for some time. It happened to require greater audacity, and the resulting effects were more conspicuous, providing as they did a certain vertical accent in the space that they covered.

What was the purpose of all these arches? Clearly the majority of them, especially those around windows and doorways, were primarily decorative. But we can go further than this. Arches like vaults had a symbolic significance for the Middle Ages. Set over or around the figures of saints, as for instance on the golden altar frontal

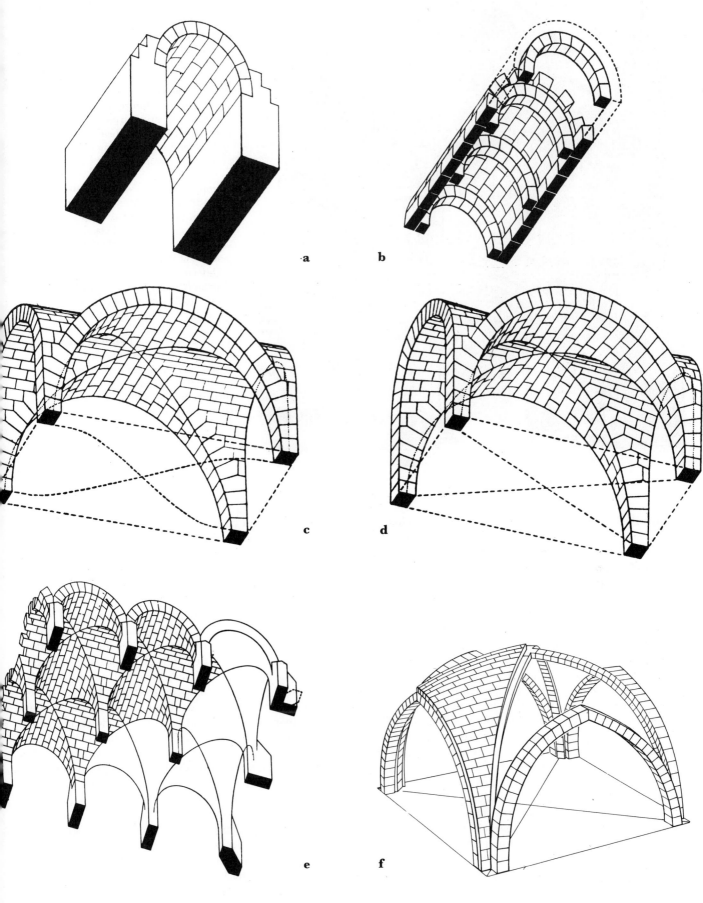

a

b

c

d

e

f

38. **Vaults**. The simplest kind of longitudinal vault is that represented in figure (a), i.e. a long barrel vault. In Romanesque churches this was usually combined with transverse arches as in (b); a groined vault started from the intersection of two barrel vaults (c). Unless both barrel vaults were identical in span (e), the groins themselves tended to undulate and the next step was to 'straighten' the groins into simple curves (d). The final step was the substitution of arches, i.e. ribs, for the straightened groins. (f).

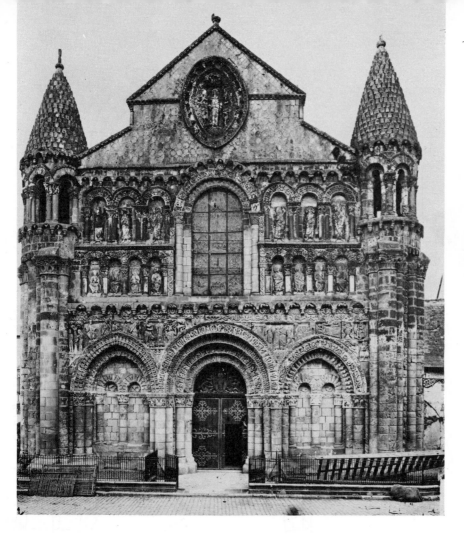

39 **West front of Notre Dame la Grande, Poitiers.** Mid-12th century. The application of sculpture to the whole façade is a feature typical of Romanesque architecture of west France, as is the absence of west towers. In this region figure sculpture is often used for entirely decorative purposes, particularly for the embellishment of arches, but in this building it is unusually prominent.

40 (opposite, left). **Nave of Autun cathedral.** Second quarter of the 12th century. Autun has the pointed arches, barrel vault and classical details such as fluted pilasters that are typical features of Burgundian Romanesque architecture, probably inspired by Roman remains. The main features of this building derive from the slightly earlier great abbey church at Cluny.

41 (opposite right). **Detail of the west front of St Gilles du Gard.** 12th century. With its rather disorganised wealth of classically-inspired sculpture, this façade is a striking contrast to contemporary developments in northern France.

22 from Basle cathedral (now in the Cluny Museum in Paris), they conveyed the idea of victory in much the same way as Roman triumphal arches, and by an easy extension they came to represent the architectural abode of the Church 90 Triumphant, i.e. St Augustine's *City of God* or the Heavenly Jerusalem. All through the Middle Ages churches, that is the actual physical masonry, evoked thoughts and images along these lines. But with the construction of the great churches of the Romanesque period, the imagery became particularly rich and vivid. Everything connected with these buildings was designed not just to impress people with the irresistible majesty of the contemporary Church Militant here on earth, but to bring about a direct confrontation between the faithful and the illustrious Christians of the past. To go into church was meant to be a foretaste of Paradise, where the distinction between the living and the dead was for a moment obliterated and men could really believe that they were participating in the Communion of Saints. The proliferation of arches in church buildings irrespective of whether they served a structural or a decorative purpose, was part of a process whereby the church became a more comprehensive and satisfactory image of the heavenly mansions. Other aspects of the same 39 process were the intensification of surface ornament, and the practice of inhabiting selected parts of great churches, such as the doorways and windows, with figures of saints, etc., and narrative scenes, to which we return later. But it is perhaps worth mentioning here that from this point of view there was no essential line of demarcation between the Romanesque and Gothic versions of the con-

cept of the great church. Both were preoccupied with the same fundamental symbols, and Gothic was only a more thorough-going and systematic presentation of the Romanesque iconographical programme.

Churches with articulated walls, arcades, doorways and windows, not to mention vaults, required masonry of a higher quality than had sufficed in earlier times. The 11th century saw the introduction of ashlar for church architecture all over Europe. (In certain places the need for stone castles intensified the demands on the quarries. Some of them, e.g. those near Caen, acquired an international reputation.) At first, cut stone tended to be used to augment rubble masonry at those crucial points where mouldings were required, around windows and doorways; but gradually ashlar either replaced rubble altogether, or else formed a kind of skin on either side of a rubble core. The latter method was particularly popular in Normandy and in England after the Conquest, and the walls so built tended to be very thick, and to require more extravagant articulation than walls elsewhere. This in turn led to a host of interesting developments that spread over into the Gothic period. But either way, the mere fact that great churches were henceforth built of stone forced architects to study the techniques of stonemasonry wherever these could be found.

First and foremost this meant referring back once again to antiquity. Vaults were not the only forms that the Romanesque Middle Ages derived from Roman architecture. Piers and elevations were likewise inspired. Several Carolingian buildings are known to have made specific

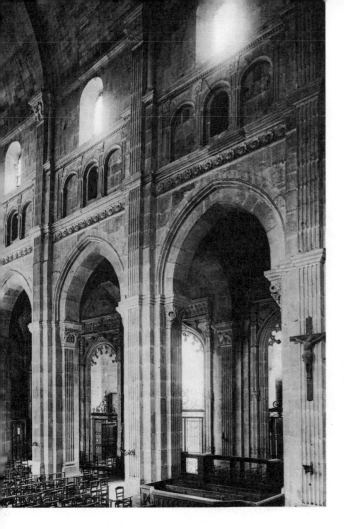

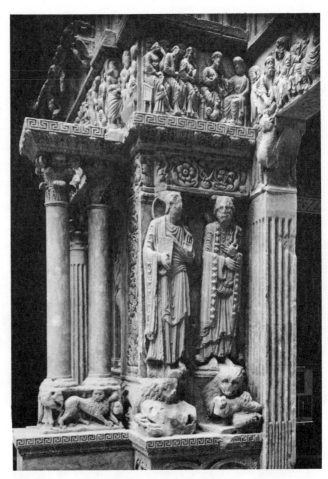

allusions to one Roman prototype or another, and in the Ottonian period the same thing happened. For Otto the Great's own cathedral at Magdeburg (*c.* 968) marble shafts were brought from Italy, as for the chapel at Aachen. The giant arcades of the basilica at Trier again exerted their influence—on the nave of St Pantaleon at Cologne (*c.* 955), and later on the cathedral of Speyer (*c.* 1030). The climax of this trend was reached at the end of the 11th century, when Speyer was drastically remodelled for Henry IV. This time Lombard vaults were added to the transepts and nave, and a series of remarkable Corinthian capitals gave the church a strong Imperial flavour. Outside Germany Roman forms seldom carried precisely the same significance. The most curious instance was the third abbey at Cluny, started about 1088. Here, when the building was complete, a visitor entered the precincts of the monastery through an imitation of one of the Roman gates at Autun, and the abbey church itself through a doorway decorated with sculpture that was set in a way recalling Roman or early Byzantine usage. The interior vistas vied both in size and actual arrangement with the largest of the Early Christian basilicas in Rome, old St Peter's and S. Paolo fuori le Mura, and the piers and upper walls were covered with fluted pilasters or half-columns, surmounted by Corinthian capitals. The allusions to Rome, whether classical or Christian, were too numerous to be explained as general symptoms of the age. Cluny seems to have been a deliberate retort to the classicism of Speyer. Some Church leaders clearly felt that the Pope was the true Emperor and that if there was to be any revival of classical forms it should

be conducted under the auspices of the Church. On the whole, however, this attitude was not widespread. It is true that in Burgundy itself and the Rhône valley a whole school of Romanesque grew up under the influence of Cluny; and near the mouth of the Rhône the west façade of St Gilles du Gard, ostensibly based on the *scaena* of a classical theatre, perhaps reflects similar sympathies. But it may be suspected that its fondness for classical details was one of the aspects of Cluniac art of which St Bernard so loudly disapproved, and under his influence the unsuitability for Christian churches of what soon came to be regarded as pagan forms was widely admitted. Nevertheless it was impossible for the building industry to proceed at all without making some references to Roman practice. Mathematical rules of thumb are a case in point. And at the visual level itself it would seem that, providing the allusions were unobtrusive enough, no objections were raised. For instance, if the nave of Tournai cathedral calls to mind the Pont du Gard, this is because Roman aqueducts in general suggested an appropriate method of procedure for constructing elevations in tiers of arches, not because one particular monument of this kind was endowed with special meanings for Church patrons. Many other allusions to aqueduct architecture can be detected in Romanesque churches, but elsewhere they are usually less obvious than at Tournai.

It is the same with compound piers. Square piers with engaged half-columns are liable to occur almost everywhere in Romanesque churches. Ultimately they must be derived from classical Roman prototypes which may be

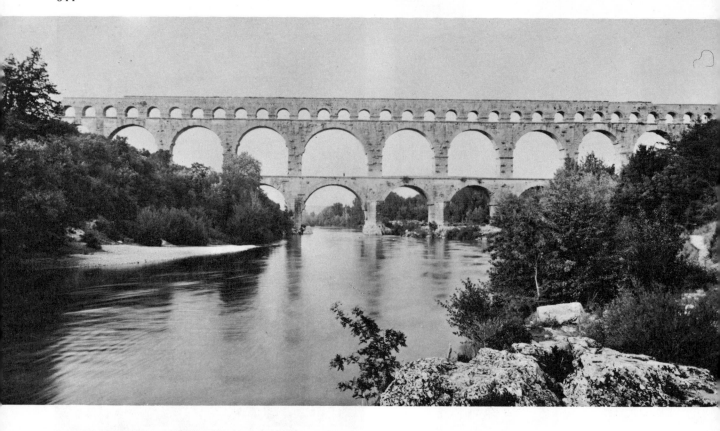

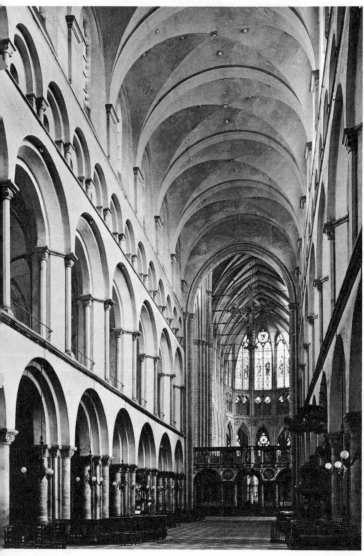

represented by the piers of the Colosseum. This derivation
is particularly apparent when the medieval examples
include Corinthian capitals, whether newly cut or reused.
Nevertheless Romanesque compound piers always make
sense in terms of the visual logic of the design of which they
form a part. There was no antiquarianism for its own sake.
On the contrary, contemporary problems were being
solved by the intelligent use of an antique convention; and
if, as often happened, this required the original to be
modified, even drastically, no one appears to have la-
mented the ensuing deformities. The same practical con-
sideration which made it necessary to refer to antiquity in
the first place nearly always tempered respect for what was
found there.

LINKS WITH THE EAST

On occasion, in fact, Romanesque architects were prepared
to look beyond Rome, and even beyond Byzantium, for the
inspiration they required. It is becoming increasingly ap-
parent that there were great numbers of disconcerting
links (mainly dating from the 11th century) between the
Romanesque architecture of western Europe and the
Christian architecture of Armenia and Georgia. Just why
there should be these links between the two extremities of
Christendom is something of an historical puzzle. They
were certainly already there before the Crusades began,
and it is doubtful whether the journeys of individuals
(mainly religious) could account for the surprisingly
technical similarities that we encounter. On the whole we
are forced back to quite general reflections. The only
considerable part of the Early Christian world which
developed a church architecture in stone was around the
eastern Mediterranean, more especially in syria. After the
loss of Syria to the Muslims in the 7th century this particular
architectural tradition seems to have survived in the moun-

42 (opposite, above). **The Pont du Gard,** near Orange.
1st century AD. This is the most outstanding surviving example
of Roman aqueduct construction, consisting of superimposed
tiers of arches. Compare this technique of building with the
cathedral of Tournai (figure 43).

43 (opposite, below). **Nave of Tournai cathedral.** First
half of the 12th century. Tournai cathedral is one of the few
surviving examples of a number of influential churches built
in the 12th century in the wealthy towns of this border area
of the Empire. The use of coloured marble and the
reduction of the wall surfaces by four storeys of arches were
ideas taken up in the early Gothic architecture of northern
France (see figure 42).

44. **Nave of Salisbury cathedral.** Second quarter of the
13th century. Salisbury cathedral was begun on a new site in
1220. The use of Purbeck marble, the lancet windows and the
relatively low height in comparison with contemporary
French buildings, are typical of the 'Early English' period of
English Gothic, which lasted until the rebuilding of
Westminster abbey in the mid 13th century introduced
England to the latest French ideas.

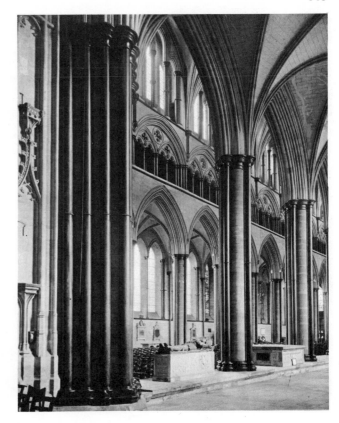

tainous regions of eastern Anatolia, and as soon as the West
began to develop a stone architecture of its own, the ob-
stacles evidently were not of an order to prevent the flow
of ideas from East to West.

One of the circumstances that may have favoured this
improbable traffic was the power and prestige of the
Byzantine Empire. At the turn of the millennium, the real
centre of civilisation was still the Middle East where, in
spite of the religious conflict between Christian and
Muslim, some sort of cultural continuity—and in the case
of Constantinople policial continuity as well—had been
preserved with the classical past. One way of regarding the
Romanesque period in western Europe is as a gigantic
effort to catch up with the Greeks and Arabs; and although
relations were bedevilled by suspicion, prejudice and
ignorance on both sides, it was to the Mediterranean, and
the lands beyond the Mediterranean, that the northerners
constantly turned for instruction and guidance.

It was this orientation toward the south and south-east
that gave Italy its unique status in the Romanesque world.
Not only did it contain in Rome the religious capital of
Latin Christendom, but it was the only country of the West
which still retained considerable traces of its classical past,
both in art and in learning. Moreover it pointed like a
finger toward those regions where higher standards of
civilisation were recognised, and although Italy was no
longer the political centre of gravity in the West, ideas and
forms passed through that county as through a funnel, on
their way to north-west Europe.

The Italians made their greatest impact on the north in
the field of decoration rather than in the construction of
churches. Apart from vaults, which for iconographical
reasons were of interest to everybody, and where the
Italians got a head start thanks to the particular richness of
their inheritance from Rome, their views on how churches
should look were too much determined by local considera-
tions to have any close bearing on northern problems. The
Early Christian churches of Italy exercised a constant if not
easily specified influence over later medieval architecture
there. The great basilicas, with their long rows of fine
marble columns, represented a norm from which patrons
were always reluctant to move away. In the cathedral of
Pisa, in S. Miniato at Florence and more or less everywhere
south of Rome there seems to have been an incredibly
plentiful supply of antique columns waiting to be used in
11th- and 12th-century churches. Abbot Desiderio had
some brought to Monte Cassino, and sets of them, not
always matching, are to be found in nearly every Roman-
esque church in Sicily and Apulia. This Italian predilection
for marble columns did occasionally penetrate into the
north. Abbot Suger at St Denis wished to follow Desiderio's
example in his new choir (1140); and the much extolled
beauties of the choir of Canterbury in the 12th century
must also have included some coloured marble shafts. The
northern centre from which this taste disseminated was the
Low Countries, where a suitable supply of dark marble
was discovered early in the 12th century near Tournai. But
it lasted longest in England, where Purbeck marble shafts
continued in use until the 14th century.

COLOUR IN BUILDING

The use of coloured marble slabs as revetments for brick
or concrete was an Imperial Roman practice, continued
through the most expensive strain of Early Christian and
Byzantine churches. In conjunction with mosaics on the
upper walls and vaults, it produced effects of the utmost
splendour. The basic idea behind this kind of church was
that of the audience chamber of an Imperial palace, over
which Christ himself, the Pantocrator, presided like an
Emperor on his tribunal. Very few Western churches ever

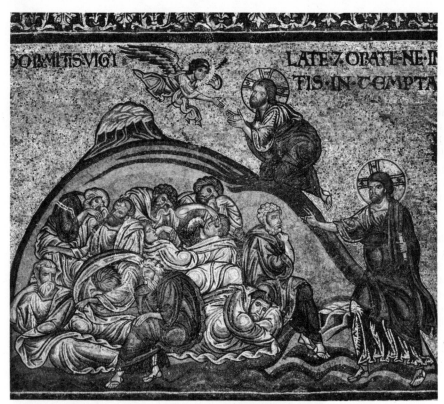

45. **The Agony in the Garden.** Mosaic in Monreale cathedral. Last quarter of the 12th century. Monreale, founded by William II in 1174, was, like other Sicilian churches, decorated in the Eastern fashion with mosaics. These represent the type of artistic style derived from Byzantium which may have been familiar to northern artists such as Villard d'Honnecourt, possibly through the medium of pattern books. (Compare plate 53, figure 62.)

commanded the resources necessary for this sort of decoration, and the mere fact that Latin churches were designed in a totally different way from the Greek type made it impossible for the complicated schemes of Greek iconography to be transferred to the West without being drastically modified in the process. The Royal Chapel at *45* Palermo, the cathedral of Monreale, and St Mark's in Venice, the three outstanding instances where serious attempts were made to carry out the Greek programme, were all the result of direct contact with Constantinople itself (see *The Early Christian and Byzantine World*). Nevertheless, the palatial and sumptuous interiors of the Early Christian and Byzantine tradition acted as a kind of yardstick against which Romanesque ingenuity measured *28* itself in emulation.

The normal counterparts of mosaic in the West were painting and stained glass. Not one of the great original schemes of Romanesque monumental painting has sur- *29* vived intact, unless the Genesis cycle at St Savin is placed in this category; the interest of that, however, is more iconographical than stylistic. Occasionally, as at S. *25, 26, 28* Angelo in Formis not far from Naples, or at Berzé la Ville near Cluny, we have fairly extensive cycles which may be presumed to follow closely in both form and content the examples of their more illustrious neighbours (in these cases, respectively, Monte Cassino and Cluny itself). But by far the greater part of the Romanesque wall-painting known to us has survived for reasons that have little or nothing to do with its quality. Some, notably in England, has been protected by later paint, plaster or whitewash, and some in out of the way places like the valleys of Catalonia have remained untouched because money has never since been available to improve on them. Painting was so easy, cheap and convenient that it must have been the most universal form of embellishment in Romanesque

churches. Yet one cannot escape the feeling that it occupied the lowest place in the decorative hierarchy, and that wherever possible more expensive media would have been preferred. If churches could have had mosaic, they would most certainly have done so. The materialism of the Middle Ages is nowhere more apparent than in its rating of the arts according to the costliness of their ingredients. Compared with gold, ivory or marble, even the rarest pigments were outclassed. To be fair, however, this attitude must not be confused with the vulgar venality of the traditional bourgeoisie of later times. Substances had symbolic, even mystical, properties not far removed from magic. Moreover, colours were seldom at their most intense when spread over the vast surfaces of church walls. This aspect of Romanesque art—its love of deep, strong or strident colours—found its most authentic expression in stained glass and enamels, rather than in painting, *3* propely so-called. And when painting did achieve something like the brilliance of jewellery or enamels this was usually in the field of manuscript illumination. Occasionally, however, we encounter fragments of wall-paintings such as the monumental *St Michael* at Le Puy, *3* or the exquisite *St Paul* at Canterbury, whose outstanding quality compels us to wonder what riches have been lost.

Stained glass is an art form so closely associated with Gothic architecture that we are apt to forget the extent to which it must have been exploited in Romanesque times. Yet it is evident that Theophilus, the author of the treatise *De Diversis Artibus* written in Germany during the first half of the 12th century, knew recipes for coloured glass that went back long before his own time, and claims have recently been made that Carolingian fragments still exist. So perhaps the secrets of the late Roman glass-makers of the Rhineland were never entirely fogotten by their Frankish successors. Be that as it may, when Abbot Suger *3*

wanted glass-painters to make new windows for St Denis in about 1140, he was able to recruit them '*de diversis nationibus*' ('from various peoples')—which implies that skill in the art was already widespread. One place where stained glass may have been used before St Denis is Canterbury, which was extolled by William of Malmesbury for, among other things, 'the light of its glass windows'. The frames of some of these still survive and are curiously uneven as though they were deliberately designed for the glass they contained, and this would hardly have happened if the subject-matter had not been important. As with so many other aspects of Romanesque art, one is tempted to locate the centre from which glass-painting spread across Europe in the Mosan area, although apart from Augsburg most of the early windows that have actually survived are in France, at St Denis itself, at Chartres, Le Mans and Poitiers.

ROMANESQUE SCULPTURE

Whatever innovations are to be found in the Romanesque handling of colour, these were at least accomplished within the context of a living tradition. Monumental sculpture, however, had to be more or less recreated. For this reason it has perhaps come to be regarded as the Romanesque art form *par excellence*. Certainly it is the one that conforms most readily to modern notions of what art should be. Historically speaking, however, the contemporary vogue for Romanesque sculpture is apt to be misleading. What we tend to like about it now has very little to do with the purposes and aspirations that it set out to fulfil. In the wider context of medieval art as a whole, Romanesque sculpture betrays the uncertainties of men who had no clear idea of what could be done with their new medium. Local schools were formed, each with their own pattern-books and stylistic formulas, but these gave way to one another with bewildering rapidity. For some, impossible movements conveyed the violence of divine inspiration—as for instance the *Isaiah* at Souillac. Others, like Gislebertus of Autun, contrived to evoke the pathetic helplessness of humanity, caught up in the toils of an inexorable fate. Within three generations of its inception the art had already changed out of all recognition, and within two more (at least in France) it had entirely ceased to have any connections with its Romanesque origins.

In many ways, the progress of Romanesque sculpture from the late 11th century to the point in the middle of the 13th when it had become completely Gothic resembled that of archaic sculpture in Greece. Whatever else is involved, sculpture is concerned with the third dimension, and for medieval Europe, as for ancient Greece, the ultimate significance of the third dimension lay in the greater realism with which it allowed images to be endowed. At the end of the process, in both cases, we are left with what purported to be imitation human beings. In retrospect we are therefore entitled to say that the revival of monumental sculpture in the 11th century was the first step in the direction of a truly representational art, and that all the

46. **Isaiah.** Second quarter of the 12th century. Abbey church of Souillac. This expressive figure from a doorway is now reset with other fragments on the inside of the west door of the church. The style of this example of south-west French Romanesque sculpture derives from the important works at Toulouse and Moissac dating from the early 12th century.

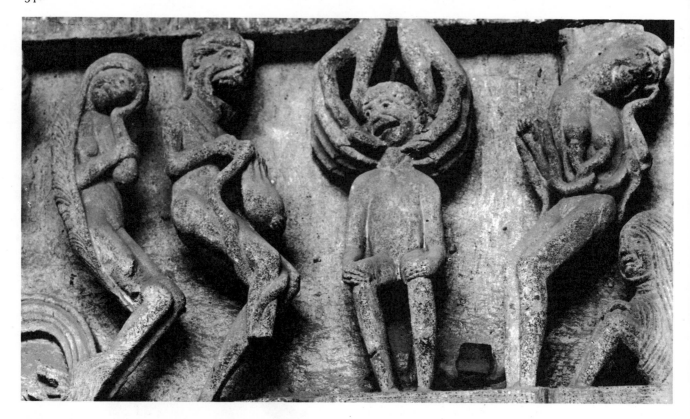

marvellous patterns and stylisations that we admire so much and so rightly in Romanesque sculpture were blind alleys that led nowhere.

From this point of view the history of Romanesque sculpture was a quest for emancipation from the residual enchantments of older conventions that really belonged to the world of two-dimensional art. In one respect, however, Romanesque sculptors were in a different position from their Greek predecessors. Whereas the latter had to work out the formulas of ideal naturalism for themselves, the Romanesque had some of the achievements of classical antiquity to guide them. For them the problem was basically one of insight, sympathy and understanding—the finding of new uses for what already existed, rather than the invention from scratch of a new conception of art.

From among the cat's-cradle of interwoven themes which make up what we know of Romanesque sculpture, we may select two threads for guidance. In Italy, Provence and northern Spain, where classical Roman reliefs and statues were still to be seen in profusion, it is evident that Romanesque sculptors came under the influence of antiquity almost from the start. Thus recognisable references to late antique works that still survive are to be found at Toulouse before 1100. The outstanding figure in these early stages, however, was Wiligelmo, whose reliefs on the west front of the cathedral of Modena already show considerable awareness of what could be done with classical draperies. Even more unmistakably classical are the decorative reliefs on the main doorway of Modena cathedral which show little naked figures climbing through luxurious vine scrolls. The best classical instances of this particular motif are to be found at Leptis Magna in North Africa, but the same kind of thing must have been plentifully represented in Italy, perhaps even at Modena itself. In the north of Europe, on the other hand, classical

remains were far fewer in number and far less inspiring in quality. Here it seems to have been a general practice for would-be sculptors to take their patterns and subjects from the nearest available paintings. These were usually, though not always, to be found in the illuminated manuscripts in the library of the church that was being decorated. Thus it is clear that the men who carved the capitals in the crypt of Canterbury cathedral were familiar with the ornamented initials that were painted in the adjacent scriptorium. And the patterns that we find carved on the jambs and arches of Romanesque doorways like those at Paray le Monial and Chartres were taken from the painted columns and arches that framed the canon tables of early gospel books. One can imagine that before there was any carving at all in northern churches some forms had simply been painted on the surface of the masonry and, when carving began, its purpose was simply to throw these patterns into greater relief.

But sculptors very soon found themselves confronted with problems peculiar to their own art. In the first place the surfaces that were destined for sculpture, namely capitals, and the tympana and recessed jambs of doorways, were uncongenial in shape and placed at inconvenient angles. The virtuosity with which sculptors applied themselves to the solution of these problems evokes our admiration. Nearly all the well-known works of Romanesque sculpture are reliefs, superbly adjusted to the overriding conditions of the parts of the buildings to which they were assigned. It is from this that we derive our vivid sense of integration between architecture and sculpture. The figures are not just added; they seem to grow out of the masonry. It is not a question of their inhabiting so much as animating the structure. And this, fundamentally, is what they were intended to do—to turn a mere building into a living image of the Church. Through their iconography they were in

47 (opposite). **Gislebertus.** *The Damned..* Detail from the west tympanum, Autun cathedral. Second quarter of the 12th century. Some of the most impressive Burgundian Romanesque sculpture is to be found at Autun (see figure 40) where the splendid Last Judgment tympanum is signed by the sculptor Gislebertus—an unusual feature for this century when most art is anonymous.

48. **The Apocalyptic Vision.** Tympanum of the abbey church at Moissac. First third of the 12th century. The relatively few Romanesque tympana which are on this exceptional scale are mostly to be found in Burgundy and south-west France. This awe-inspiring vision of Christ surrounded by the evangelists' symbols and the elders of the Apocalypse skilfully fills the entire available space. Compare the contorted figures and the agitated crowding of forms with Chartres west front, only a few decades later (figure 51, 60).

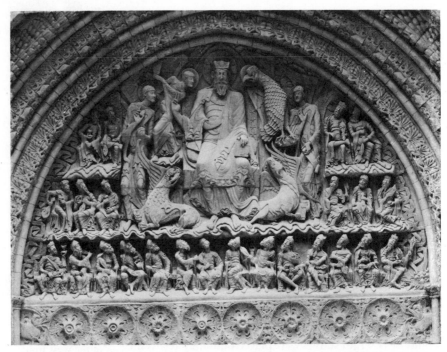

49. **Lintel at St Genis des Fontaines.** 11th century. The lintel of this Pyrenean church is carved in low relief with figures beneath arches whose horseshoe shape suggests the influence of the Muslim art of Spain. An inscription gives the date of 1020–1. A carved lintel was one of the simplest forms of architectural decoration; later Romanesque doorways became increasingly elaborate (see figure 51).

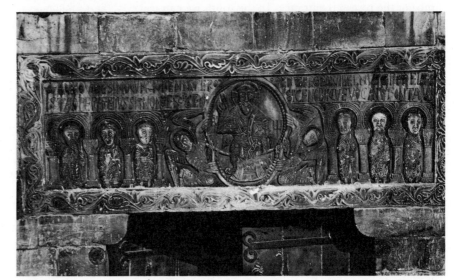

50. **Capital from Toulouse.** Late 12th century. Musée des Augustins, Toulouse. This double capital, probably from a cloister (compare plate 39), is carved with motifs directly inspired by antique art, although the way they are skilfully arranged to fit the form of the capitals is typical of the Romanesque style. It was this kind of subject-matter that inspired the polemics of St Bernard (see p. 370).

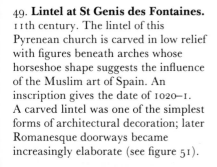

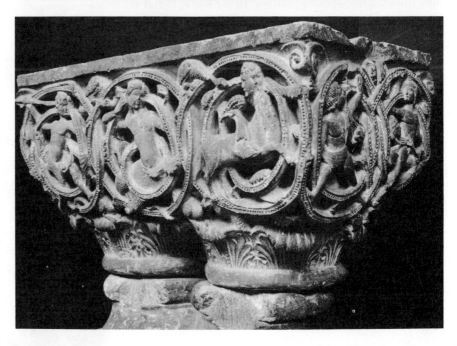

fact able to do more. By carefully matching themes from the Old Testament against the Nativity, the Passion of Christ, the life of the Virgin and the prophesied events at the end of time, they contrived to present both the Church's view of world history and its own role in world history.

But it was precisely this purpose that impelled the sculptors to explore the possibilities of the third dimension, and their really outstanding achievement lay in their ability to conceive their figures more and more in the round. From this point of view the presence of so many shafts and arches in northern Romanesque churches was to prove decisive. By and large, the idea of applying monumental sculpture to buildings spread from south to north. One of the places where it developed most rapidly was in doorways, where for instance in the chapter house of the cathedral of Toulouse (c. 1130) statues were placed obliquely across the jambs of the recessed entrance. In the south we can trace this development typologically if not chronologically from flat reliefs like those on the piers of the cloister at Moissac (c. 1100) to what we find in the cloister piers at St Trophime, Arles (c. 1170), where statues are placed across the corners. From this sort of thing, which was no doubt done on many occasions before Arles, it is but a short step to the Toulouse doorway; and if intermediaries are required, they may be found in the small jamb figures of the doorways of the

38 cathedrals of Verona and Ferrara in Italy (c. 1135–40).

When these ideas reached the north the practice of articulating doorways and windows with engaged or even free-standing shafts was already well established. The problem of applying figure sculpture to doorways therefore resolved itself into the improbable task of carving a figure in relief on a column. In the nature of the case such reliefs tended to become figures in the round, and it is fascinating to trace the gradual metamorphosis of these figures into fully rounded free-standing statues. In the Royal Portal at Chartres (c. 1150) we can see how in the early stages incredible efforts were made to preserve the architectonic character of the column. Later at Senlis (1170s) the figures

52 began to move; at Chartres again (after 1200) they began to turn; and by the time we get to the north transept of

63 Reims (c. 1220) they have vitually detached themselves from the building altogether. Smaller figures were applied in much the same way to the roll mouldings that framed the

52 arches over the doorways, and they likewise gradually emerged into fully three-dimensional forms.

63 At Reims the statues have already acquired something more than a superficial classicism. It would be wrong to suppose, however, that the stone carvers had found their own way back to antiquity unaided. During the last quarter of the 12th century spectacular steps in this direction had been taken by a celebrated Mosan metalworker

64 called Nicholas of Verdun. In the great enamelled altarpiece that he made for the abbey of Klosterneubug near

65 Vienna (c. 1180), and even more obviously in the Three Kings shrine of Cologne cathedral (c. 1200), Nicholas reveals a deep understanding of the conventions of classical

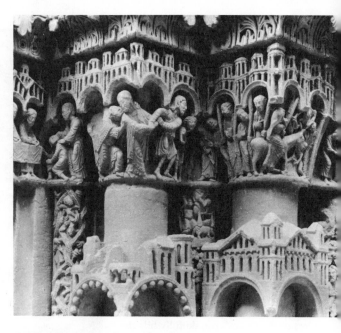

51. **The Entry into Jerusalem.** Capitals on the west front of Chartres cathedral. Mid-12th century. On the doorways of the west front of Chartres (which are earlier than the rest of the building) the sculpture is spread over all available areas—lintels, tympana, voussoirs, jambs, columns and capitals—to form an elaborate iconographic programme (see also figure 60). Note how the capitals form a frieze which can depict a whole biblical narrative.

52. **Melchizedek, Abraham, Moses, Samuel, David.** Column figures on the east side of the central porch of the north transept of Chartres cathedral. First quarter of the 13th century. When Chartres cathedral was rebuilt, the west front was retained, but elaborate new portals were constructed at the end of each transept. These monumental Old Testament figures, in spite of their relative naturalism in comparison with Romanesque versions of the same theme (see figure 46), appear, however, stiff and elongated when compared with the roughly contemporary sculpture of Reims (figure 63).

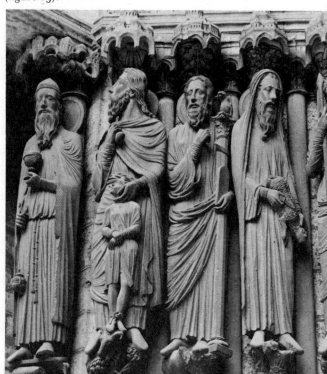

53. **Roger of Helmarshausen.** *Portable altar from Paderborn.* 1100. Silver, precious stones, pearls. 6¾ × 13¾ × 8¼ in. (17 × 35 × 21 cm.). Cathedral Treasury, Paderborn. This altar was made at Helmarshausen for Bishop Henry of Werl by an artist named Roger in 1100.

The linear modelling of the lively apostles is a remarkably early example of an artistic technique that recurs throughout the 12th century in painting and metalwork and even occasionally in sculpture (compare plates 49, 51).

drapery, and even to some extent the relation between drapery and the underlying physical anatomy. His faces also remind us of classical as well as Byzantine types. No doubt Nicholas was a remarkable innovator, but it is no accident that these developments should have taken place in the context of metalwork rather than stone sculpture. The whole order of procedure was different. Once the practice of beating strips of metal over wooden cores had been left behind, and casting became prevalent (after 1150), the formative stages in figure design were done by modelling as opposed to carving. As was the case in antiquity itself, this particular method of creation always seems to have allowed greater scope for movement and gesture, and the miniature scale on which they habitually worked also encouraged the more uninhibited metalworkers to show off their talents. Long before Nicholas of Verdun these symptoms had shown themselves in other virtuosi such as Rainer of Huy or Godefroid of Claire. When Theophilus wrote his treatise on the arts, he assumed that the same craftsman would be called upon to draw and paint illuminated manuscripts, to make glass and enamels and to work precious metals. Stone carvers were odd men out in this company, offshots of the totally different trade of masonry. In one sense what happened during the 12th century is that the sculptors in stone broke away from their parent body, the masons, and moved over into the camp of the image-makers. But the latter themselves did not remain static. Until not long before the time of Theophilus the arts of which he wrote were either two-dimensional or else conceived in low relief. They consisted essentially of the application of colour or a little modelling to preliminary drawings, and the drawing styles in question were still derived from the great continuous tradition of medieval drawing going back to late antiquity, which is most fully represented for us in manuscript illumination. By the end of the 12th century, however, emphasis had shifted in an entirely different direction. If painters and metalworkers still shared a common drawing style in 1200, this was now derived from another source altogether, namely the drapery conventions of classical sculpture. In other words, at some point in the 12th century, initiative in drawing seems to have passed from a two-dimensional art to a three-dimensional one. From this moment on, the various forms of painting fell more and more under the influence of metalwork and sculpture. This is not to say that painting at once set out to imitate the three-dimensional effects that were natural to sculpture, although in the long run this is exactly what happened. To begin with, it was more a question of painters producing two-dimensional abstracts of figures meant to be seen in the round—as though painters actually used drawings intended for the preparation of sculpture. We can see this perhaps most clearly if we compare the Ingeborg Psalter at Chantilly with the drawings by Villard de Honnecourt who was a mason, and the statues in the north transept portals at Reims.

53
62
89

DRAWING AND PAINTING

But the process must have begun long before this. One of the ways in which we distinguish a Romanesque manuscript from its predecessors is by the firm smooth lines of the drawing. There is all the difference in the world between the feathery calligraphy of Anglo-Saxon outline drawings and, say, the great *Christ in Glory* of the Stavelot Bible, or the solemn hieratic figures of the St Albans Psalter. No doubt this is making the point in the crudest possible way, but it seems obvious that a fundamentally new concept of the function of drawing is part of what we mean when we talk about the Romanesque style in manuscript illumination. This new drawing style uses line in much the same way as a glass-painter or an enameller would—to indicate precisely

22, 23
47
48

and clearly the boundaries of colours, not to hint vaguely at an impression of movement, or to convey the agitation of feeling. It represents in fact just those affinities which Theophilus postulates in his treatise. Let us take another case. In all the great English bibles of the middle years of the 12th century, Bury St Edmunds, Lambeth and Winchester, there is to be found a very characteristic drapery convention known as the 'damp-fold' style. This consists essentially of double sinuous lines that run over limbs in a way that suggests their corporeality. It is, however, not confined to manuscript illumination. It occurs in the *St Paul* at Canterbury, and on metal objects like the Warwick ciborium. And in fact it would seem to have originated in metalwork before it was taken up by the painters. There is a famous portable altar at Paderborn which was made at the very beginning of the 12th century, in which the damp-fold is present, or at least distinctly anticipated. The author of this work was Roger of Helmarshausen, who may well have known Theophilus, or may even have been Theophilus.

When we turn from drawing to colour, the same sort of conclusion is forced upon us. It is perhaps ridiculous to generalise, but if there is any characteristic Romanesque taste in colour, it is for the deep, rich tones. The light washes that tint Anglo-Saxon outline drawings eventually go the same way as the drawing style itself (although not without putting up a tremendous resistance). We can see the process at work very clearly in the succession of copies that were made in England of the Utrecht Psalter. In the Anglo-Saxon version (Harley MS. 603, British Museum) all the fundamental characteristics of the original are preserved. In the mid 12th-century version, the so-called Eadwine Psalter at Trinity College, Cambridge, the kinship can still be recognised, although there is a perceptible ossification in the outlines. In the last version, however, the Paris Psalter, dating from the end of the 12th century, everything has changed. Both drawing and colour have hardened, and if it were not for the more or less identical iconography we would scarcely admit that the manuscript belonged to the same family. In the case of manuscripts the fact that alternative styles were available allowed considerations of expense and economy to come into play, and for this reason alone purely stylistic trends are more difficult to trace. Nevertheless, where cost was no object, as for instance in the Winchester Bible, a definite predilection may be observed for strong and vivid colours which approximate, as far as the medium will allow, to the brilliance of stained glass or enamel. These latter, of all the arts concerned with colour, were the ones most dear to the hearts of Romanesque patrons. Enamelling was in fact more or less perfected during this period. The addition of a translucent glaze to an intensely coloured piece of metal, however small, epitomises what was perhaps the most deeply felt of all the aesthetic urges of the High Middle Ages in the West—the sense of almost mystic awe in the presence of jewellery. From this point of view enamelling

was in a way the nearest they came to Byzantine mosaics. This is probably the basic reason for their great preoccupation with Byzantine forms during the middle years of the 12th century, although the mere fact that the Middle Ages approached classical antiquity from a background of abstract and heavily stylised art would make Byzantium an almost ideal intermediary.

The upshot of this survey of the relations between the various arts of western Europe during the 12th century is that metalwork occupied a central position of crucial importance. We talk of metalwork as an art, but for the Middle Ages what gave metalwork its significance were the purposes it served, i.e. the objects it made. Of all the arts it was the one physically most closely associated with the things that really mattered—the altars and reliquaries of the great churches. The relationship was reciprocal. Some of the holiness of the contents passed to the containers and, to be worthy of what they held, the sacred vessels had to be made of the most precious materials. Given the distinctive mood of Romanesque religiosity, its superstition and its sense of pomp and hierarchy, this distribution of emphasis within the arts was inevitable. Only architecture, which in Romanesque terms served exactly the same purpose, namely that of housing relics, albeit on a different scale, could sustain an equal status. All the rest, however beautiful and expensive they may have been, were ancillary.

The realisation that churches and reliquaries were fundamentally the same thing was one of the great Romanesque discoveries, and it continued to be one of the cornerstones of the Gothic art which followed. Very few of the great reliquary caskets which were made in the 12th century have survived; and, of those that do, not one can truly be said to have the form of a building (except the little domed structures either brought from or made under the direct influence of Byzantium). But just as churches themselves became more and more elaborate systems of arches, and were increasingly possessed by visible reminders of sacred events, analogies and personalities, so also were the reliquaries. The two forms gradually grew towards one another; and if the final identification did not take place until Gothic times, this is yet one more pointer to the conclusion that there was no real break or line of demarcation between the two styles. Until we really get down to details, Romanesque is in many ways simply incomplete Gothic.

(Continued on page 369)

40 (opposite). **The Gloucester Candlestick.** 1104–1113. Bell metal. h. 23 in. (58 cm.). Victoria and Albert Museum, London. Identified by an insciption as having been made for Gloucester abbey at the instigation of Abbot Peter, whose rule therefore dates the candlestick. It has recently been assigned to a workshop closely associated with the Canterbury manuscripts.

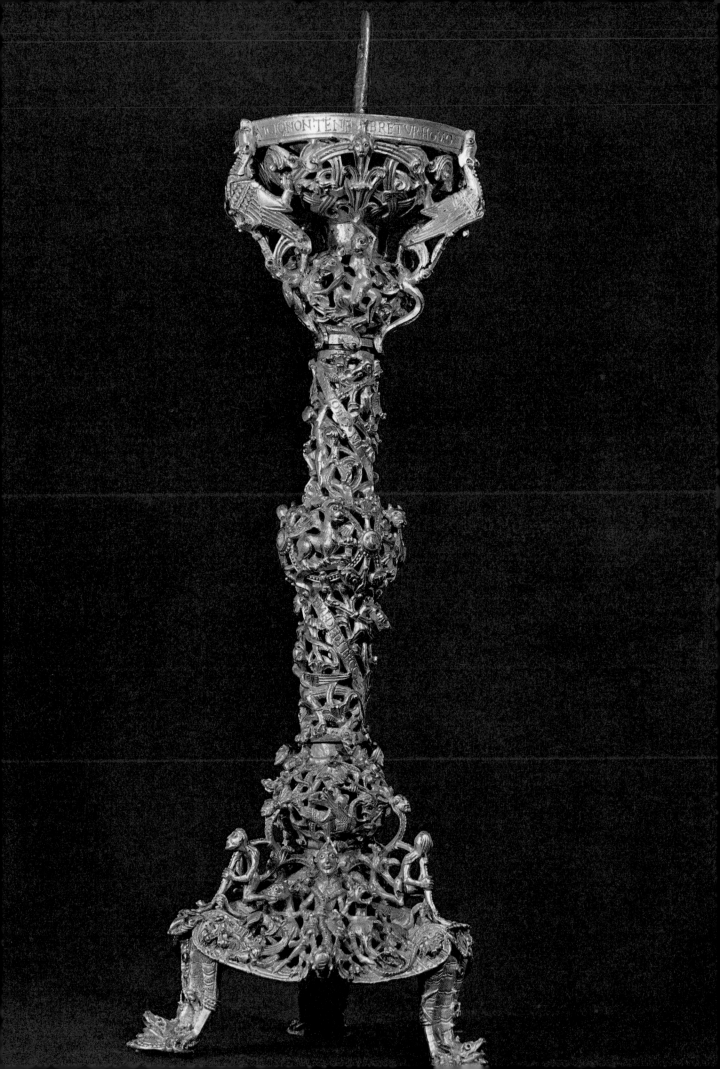

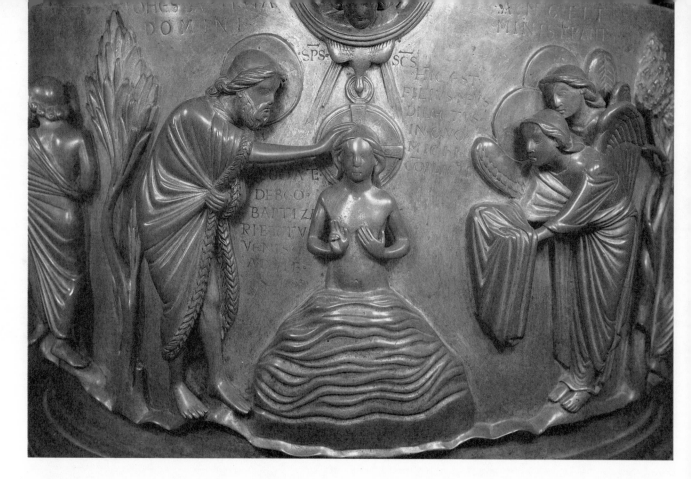

41. Rainer of Huy. Baptismal font (detail). 1107–1118. Cast bronze. h. 25 in. (64 cm.). Church of St Barthélemy, Liège. Commissioned by Hellinus, whose presence at Liège was first mentioned in 1107, the font itself was described in 1118. Rainer of Huy was the first of the great 12th-century Mosan metalworkers whose names have come down to us. The font is remarkable for the classical quality of its figures, a characteristic of the Mosan school which becomes even more obvious in the work of Nicholas of Verdun.

42. Workshop of Egbert of Trier. Reliquary shrine of the foot of St Andrew. 977–93. Gold, ivory, enamel, precious stones, etc. h. 12¼ in. (31 cm.). Trier cathedral. This reliquary belongs to a widespread group in which a piece of a real arm or foot is kept in an imitation arm or foot. This practice may be ultimately of Irish origin.

43. **Gable end of the Shrine of Heribert.** Third quarter of the 12th century. Copper gilt, silver gilt, enamel, filigree, precious stones, rock crystal. 26¾ × 16½ in. (68 × 42 cm.). Heribert church, Deutz, Cologne. The elaborate decoration of this large coffin-sized reliquary in all kinds of metalwork techniques demonstrates the important role of the shrine in the medieval church (see p. 352). In all types of metalwork (as in churches) in the 12th century, an increasing use is made of figures in relief (see also figures 39, 75).

356

44 (opposite). **Plaque from the tomb of Geoffrey Plantagenet.** Third quarter of the 12th century. Champlevé enamel. 24¾ × 13 in. (63 × 33 cm.). Musée Tessé, Le Mans. This plaque with a prince in ceremonial vestments from the tomb of Geoffrey Plantagenet, originally in the church of St Julien at Le Mans, is an unusually large example of the type of richly coloured enamel-work produced in the Limoges region in western France. Limoges enamels became very popular, especially in the 13th century, when they were widely exported.

45 (right). **Enamelled cross.** Mid-12th century. Copper gilt, precious stones, enamel. Musées Royaux d'Art et d'Histoire, Brussels. The champlevé enamels on this cross, typical examples of 12th-century Mosan work, depict Old Testament events prefiguring the Passion of Christ—for example (lower scene) the cross-like mark made with the blood of the Passover Lamb (Exodus 12). This use of Old Testament 'types', very common in the decoration of liturgical objects, also occurs in paintings, sculpture and glass (see plate 57).

46 (below). **Charlemagne dedicates Aachen minster to the Virgin.** Relief from the Charlemagne shrine, Aachen. Early 13th century. Silver gilt, copper gilt, enamel, filigree, precious stones. Aachen minster. The ceremonial translation of the relics of Charlemagne to this shrine, in the presence of Frederick II in 1215, was not simply a religious gesture, but a deliberate political move by the German ruler to counter the growing cult of Charlemagne as the founder of the French monarchy.

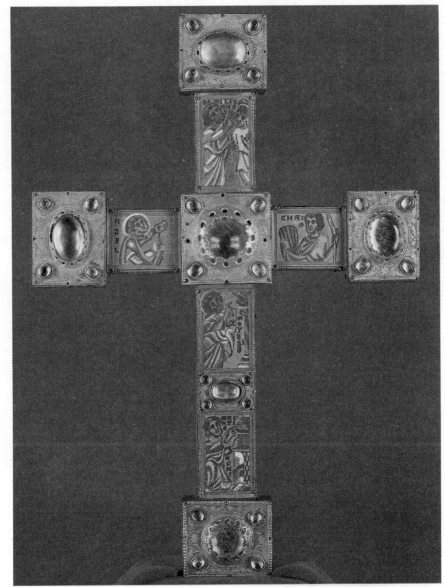

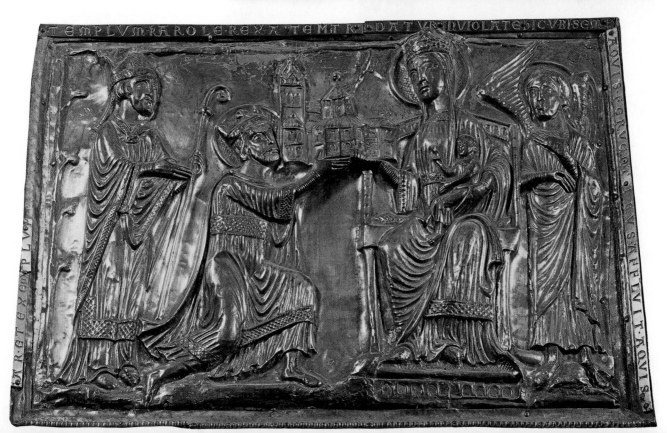

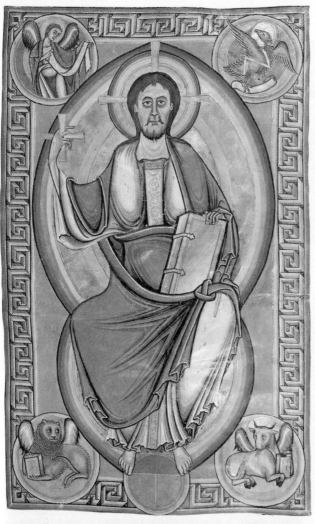

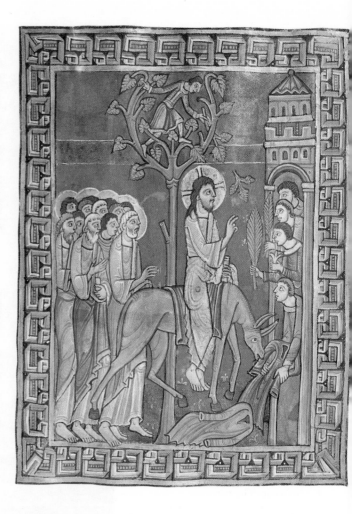

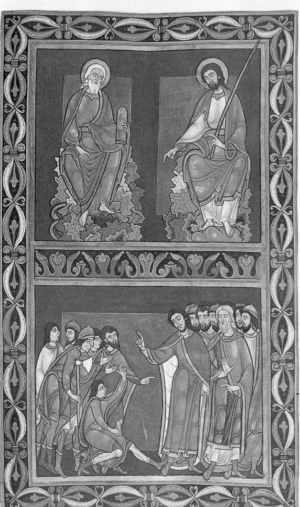

47 (above left). **The Master of the Majesty of Christ.** *Christ in Majesty.* 1093–7. From the Stavelot Bible (B. L. MS. Add. 28106–7, f. 136r). 17¼ × 10¾ in. (44 × 27 cm.). British Library, London. The Master of the Majesty of Christ was one of the decisive contributors to the formation of the Mosan style, which emerged in the period about 1100 at Liège and the group of important abbeys in the vicinity. The plasticity at which the miniaturist aims has a close analogy with metalwork (see the font of Rainer of Huy, plate 41).

48 (above right). *Entry into Jerusalem.* First half of the 12th century. From the Albani Psalter (f. 19f). 11 × 7¼ in. (28 × 18 cm.). St Godehard, Hildesheim.

49 (left). **Master Hugo.** *Moses and Aaron,* and *Moses and Aaron numbering the People..* Mid-12th century. From the Bury Bible (frontispiece to the Book of Numbers, f. 70r). 20½ × 14 in. (52 × 36 cm.). Corpus Christi college, Cambridge. The Albani Psalter (so called from its supposed connections with St Albans, though in fact it belonged to the nearby nunnery of Markyate) is prefaced by a series of full-page illustrations of the life of Christ in a style which, with its monumental, solidly modelled figures set against a simple coloured background, suggests links with both Ottonian narrative traditions (figure 25) and the new developments in Mosan art (plate 47). The profound influence of the Albani master on English painting, hitherto dominated by the delicate drawing style in the tradition of the Utrecht Psalter (figures 22, 23), can be seen in the slightly later great Bible from Bury St Edmunds, but here the rather subtler modelling becomes in places almost abstract patterning. (Compare plates 30, 34, 50 and see p. 352.)

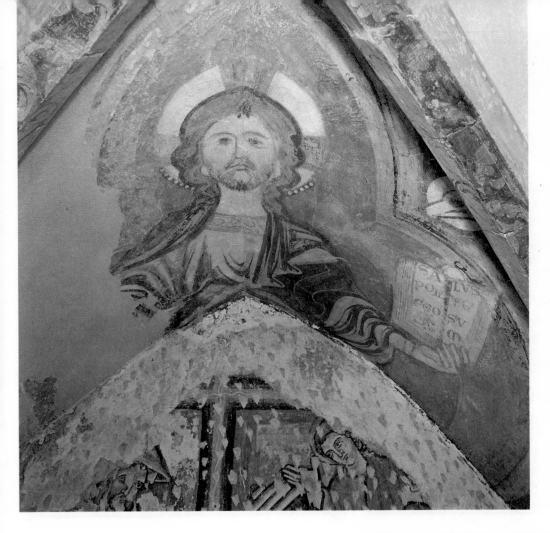

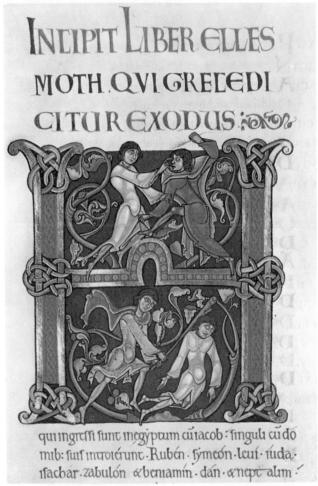

50. **Wall-painting in St Sepulchre chapel, Winchester cathedral.** 12th and 13th centuries. Beneath this early 13th-century Gothic wall-painting of Christ lie the remains of some late 12th-century work close in style to one of the artists of the Winchester Bible. The difference between the two works, probably only a few decades apart, exemplifies the rapid changes of style that took place at this period.

51. **The Master of the Leaping Figures.** *The Egyptian smiting the Hebrew* and *Moses slaying the Egyptian.* Second half of the 12th century. From the Winchester Bible (historiated initial at the beginning of the Book of Exodus). Winchester cathedral. The Winchester Bible, one of the large illuminated Bibles made in England in the 12th century, was illustrated by several artists, probably for St Swithin's priory, Winchester. The way in which the work of the Master of the Leaping Figures, so called because of his love of agitated movement, contrasts with the mentality found in the Bury Bible (plate 49), despite the similarity of drapery conventions, illustrates the diversity of mature Romanesque style.

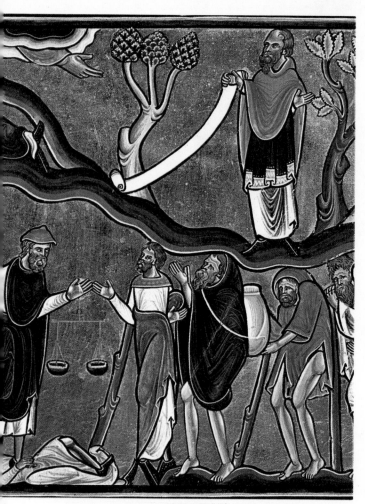

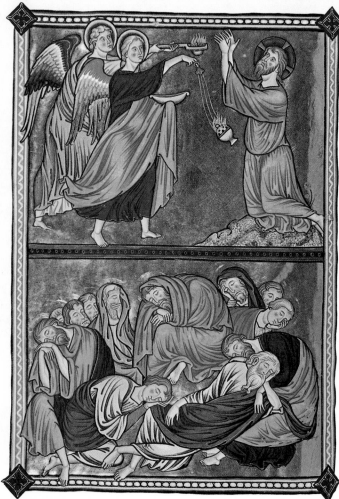

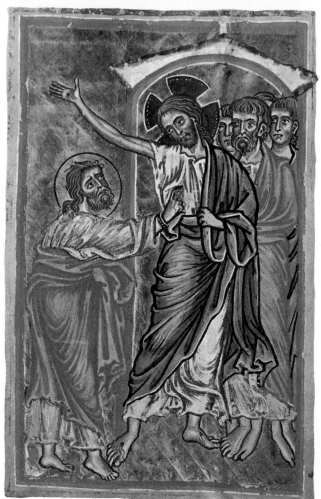

52 (above left). **'He that walketh uprightly, and worketh righteousness . . .'** *c.* 1200. Detail of a page from Paris Psalter (MS. Lat. 8846, Psalm 15, f. 23r). Bibliothèque Nationale, Paris.

53 (above right). **The Agony in the Garden.** *c.* 1200. From the Psalter of Queen Ingeborg (MS. 1695, f. 24v). Musée Condé, Chantilly.

54 (left). **Doubting Thomas.** From the Gospels from St Martin, Cologne (MS. 9222, f. 98v). First quarter of the 13th century. Bibliothèque Royale, Brussels. These three illustrations exemplify the crucial departure from the traditions of Romanesque painting (compare plates 49 and 51) that took place around 1200, and must reflect the influence of the metalwork of Nicholas of Verdun (figures 64, 65). The Psalter made for Queen Ingeborg (plate 53), like the drawings by Villard d'Honnecourt (see figure 62), shows particularly clearly the preoccupation with a figure style deriving its inspiration from antique sculpture, which is also to be seen in contemporary work in both stone and metal (plate 70, figure 63). The later, rather more fluid and dramatic style of the Gospels from Cologne (plate 54) shows the interpretation of these ideas in Germany (compare it with the Gothic sculpture at Bamberg and Naumburg, plates 71 and 73). The radical nature of the change from Romanesque to Gothic can hardly be better illustrated than by the Paris Psalter (plate 52) which, though following the iconography of the Utrecht Psalter (figure 22), is in a style completely different both from the latter and from its 12th-century copy.

55 (opposite). **Chalice.** *c.* 1140. Sardonyx, and other precious stones, metals, etc. h. 7½ in. (19 cm.). Widener Collection, National Gallery of Art, Washington. One of Abbot Suger's principal treasures. It was lost in 1804, but reappeared in 1922. The sardonyx cup is made from a single stone, which impressed Suger very much. The base is much restored.

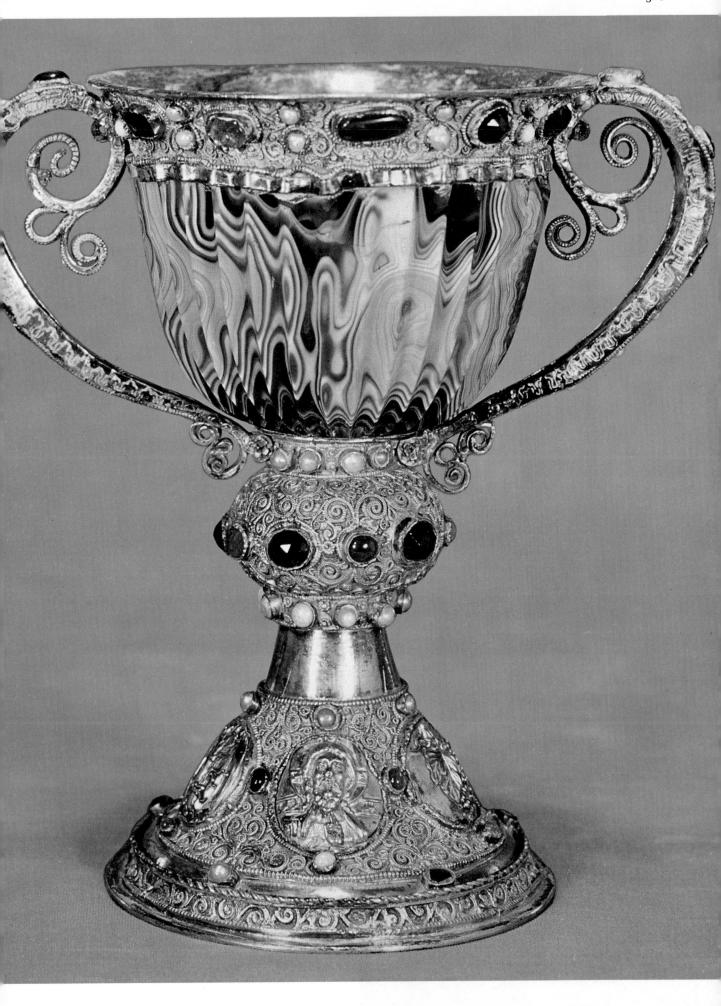

56 (left) **South transept of Noyon
cathedral.**Third quarter of the 12th
century. Noyon cathedral, begun slightly
earlier than Laon (compare figure 61), is
constructed with a basically 'thick' wall
(see p. 372) which is hollowed away by a
series of openings and passages,
particularly apparent in this south
transept end where there are no chapels
or galleries to block the light. This concern
with lightening the mass of the wall is one
of the driving forces behind the
development of early Gothic architecture.

57 (opposite). **'William the English-
man'.** Ambulatory of the Trinity chapel,
Canterbury cathedral, looking east. Late 12th
century. The east end of Canterbury
cathedral was rebuilt after a fire in 1174,
in order to provide a lavish setting for the
shrine of St Thomas à Becket. With its use
of coloured marble shafts and columns, its
large stained glass windows (see also
plates 63 and 64) and its foliage capitals,
it is one of the earliest examples of the
influence of early Gothic ideas outside
France. (Compare figures 59, 71.)

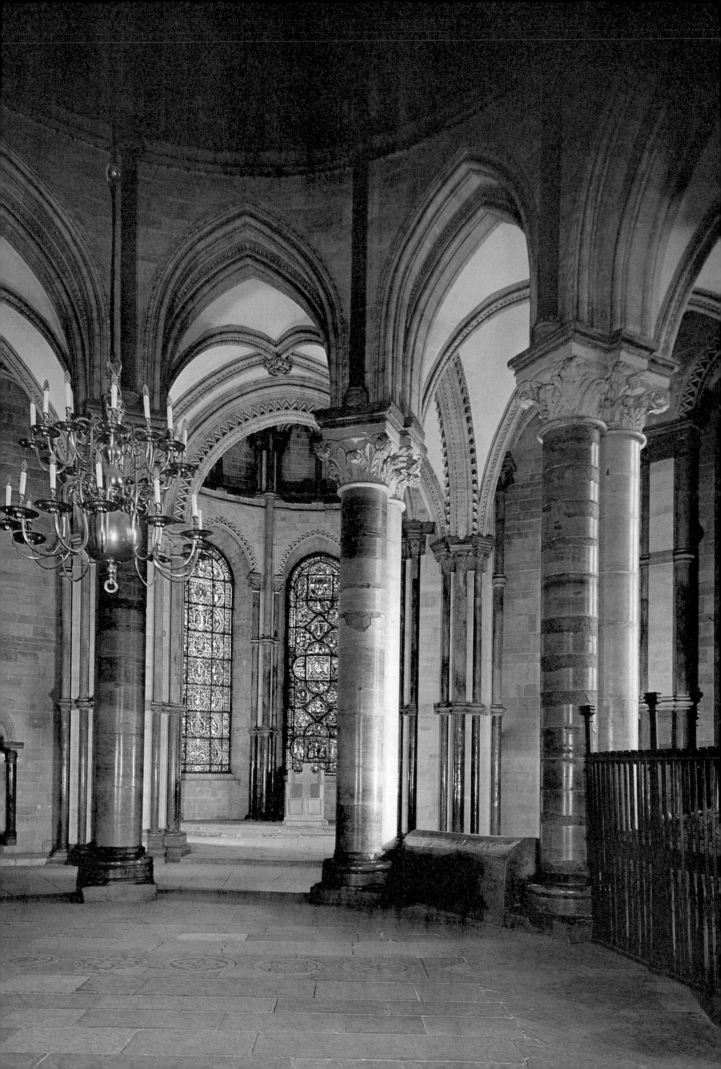

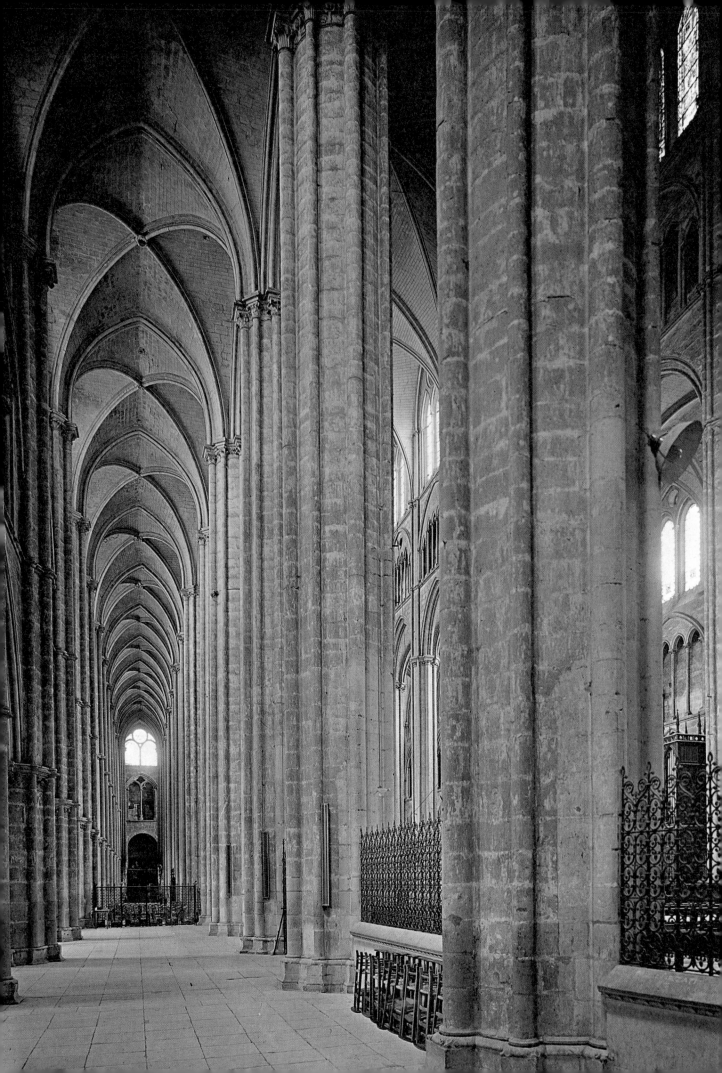

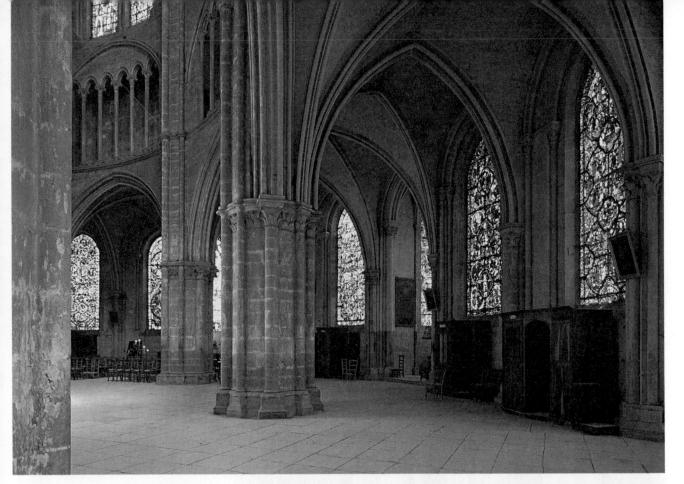

58 (opposite). **Inner aisle of Bourges cathedral.** End of the 12th and early 13th centuries. The 'échelon' arrangement of the elevation of Bourges cathedral makes it possible for the main nave, the tall inner aisles and the lower outer aisles all to be lit directly. This complicated system was not widely imitated. (See also plate 59, p. 383.)

59 (above). **Ambulatory of Bourges cathedral,** looking east. Late 12th and early 13th centuries. The spacious ambulatory of Bourges is still lit by its original stained glass. The sequence of the ambulatory windows is only broken briefly by the very small projecting chapels, which themselves each have three windows. The way in which the Bourges architect achieved his lighting effect (see also plate 58) was quite different from the contemporary solution of Chartres (see p. 381). It was the latter, however, which became the classic formula for the High Gothic cathedral (compare figures 73, 77).

60 (right). **Interior of León cathedral,** looking east. Third quarter of the 13th century. León cathedral, with its walls almost entirely filled with tracery windows, is a direct transplantation to Spain of French Gothic ideals of the mid 13th century (see plate 61). Compare the lighter effect of the glass here with the deep colours of the earlier glass at Bourges.

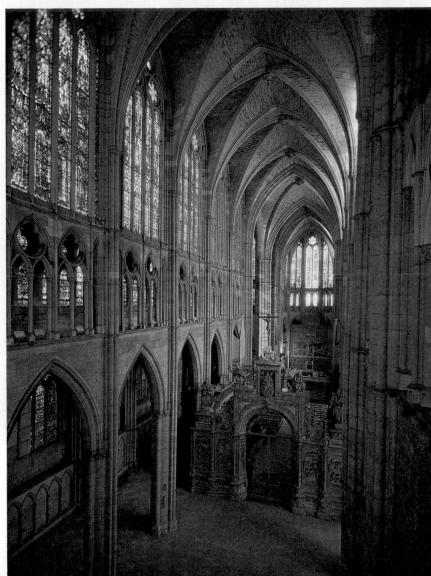

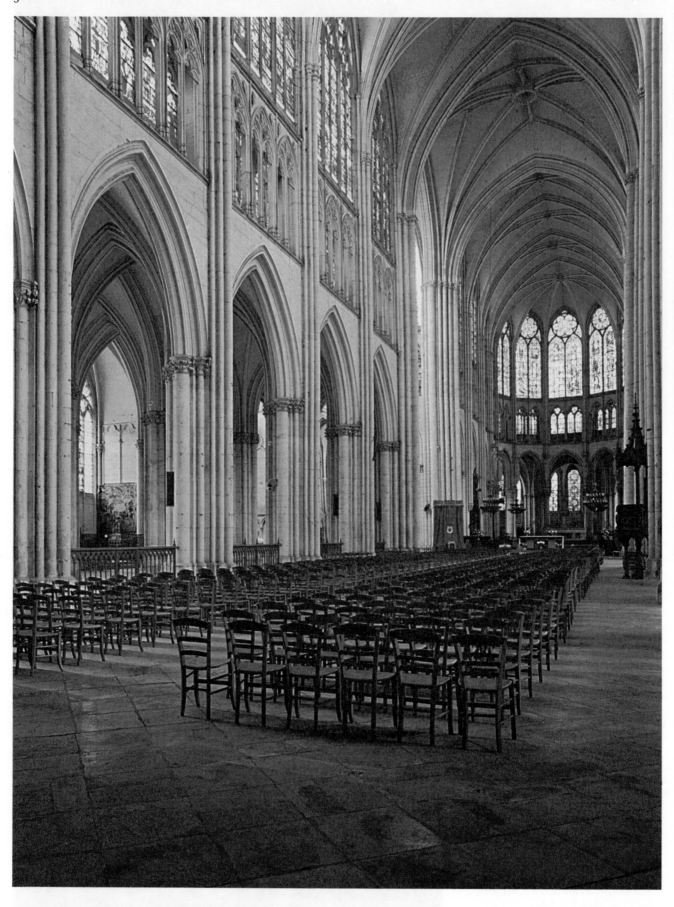

61. **Nave of Troyes cathedral,** looking east. Mostly 13th century. Begun in the early 13th century but completed rather later, Troyes cathedral, with its delicate tracery windows and glazed triforium, reflects the influence of the 13th-century work at St Denis (see figure 77). The uninterrupted vaulting and the similar subdivision of triforium and clearstorey give the nave walls the screen-like unity that becomes a typical feature of late Gothic architecture (see figures 78, 81).

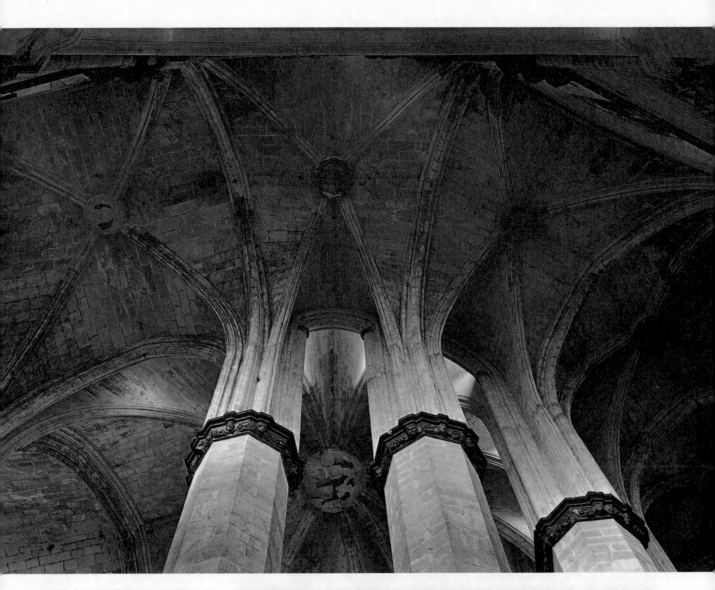

62. **Vaulting in the ambulatory of
Sta Maria del Mar, Barcelona.** Begun
1328. This building, perhaps the greatest
achievement of Catalan Gothic, was
substantially completed by 1384 when the
first Mass was held at the new altar. The
spacious dimly lit interior is in complete
contrast to León (plate 60) and its French
preoccupation with light.

63. **Samuel,** and **Noah.** Stained glass in
Canterbury cathedral. Late 12th century.
The clearstorey windows of the new choir
of Canterbury (see plate 57) were
originally each filled with an Old
Testament figure, illustrating the
genealogy of Christ, while some of the
ambulatory windows had related Old and
New Testament subjects. Many churches
must have had similarly elaborate
iconographic programmes, which have
been lost because of the fragmentary
survival and frequent resetting of so much
medieval glass.

Gothic Art

In or about 1135 Abbot Suger started to replace the decayed Carolingian fabric of his abbey church at St Denis, outside Paris. The fame of this new building rests perhaps more firmly on the reiterated publicity that Suger himself gave it, rather than on the actual innovations that were incorporated into its design. Clearly, however, no expense was spared, and we may therefore be certain that it was both as resplendent and as up-to-date as it could be made. The work fell into two quite separate campaigns—one beyond the west end of the old church, and the other beyond its east end. It was not until the middle of the 13th century that the resulting fragments were joined together, and then it was on a scale and in a style quite different from anything Suger had envisaged.

At the west end Suger planned a monumental façade with two towers and three doorways. There is a considerable body of evidence to suggest that these doorways were among the first in northern France to have the sculptured jambs and voussoirs that subsequently became obligatory for all churches with any pretensions to be considered important. So one might have expected that Suger would at least have mentioned the sculpture. In fact he passes it over in unwonted silence, and this has led some writers to suppose that the sculpture was added after his time. Be that as it may, he does think fit to draw our attention to other features of the doorways, namely that some, if not all, of the doors were made of bronze, and one of the tympana above them was filled with mosaics. The bronze doors of St Denis anticipated by a decade those of Bury St Edmunds in England; and both sets must be regarded as remote representatives of a practice whose home was Italy even if the craftsmen who made them came from the Low Countries. Moreover the precedent for bronze doors in the West was set by no less a building than old St Peter's at Rome. So in this respect Suger's intentions seem to have been retrospective rather than forward-looking. In the case of the mosaics he admits that their use was 'contrary to the modern custom', and the same inferences can be made.

That Suger's aim was—in some sense of the word—to create an Italian church in France is most clearly revealed by his admission that at one stage during the rebuilding of the choir he actually contemplated having marble columns shipped to St Denis from Rome, just like Desiderio for Monte Cassino, and it was only the providential discovery of a quarry near Pontoise, where suitable alternatives could be got more cheaply, which deflected him from this purpose. It is in fact possible that some of Suger's sculptors came from Italy. There are reliefs on the doorways at St Denis which have a remarkable resemblance to similar works at Modena. But it is an open question as to whether they came direct, or via the Low Countries, along with Suger's metalworkers and (as seems eminently probable) his glass-painters as well. In view of the state of the evidence, this is a question which it is perhaps better to ask than to answer, but the implications are important and far-reaching. For what it is worth, we may recall that there was at least one church in the Low Countries, St Maria at Utrecht, which inside and outside was closely modelled on Italian designs, and it was built at almost exactly the same time as St Denis. It would of course be ridiculous to attribute everything in Suger's church to this one overriding consideration, but in so far as Italy and the Low Countries played a part in determining his views on the appropriate appearance and furnishing of a great church, St Denis falls into line with Canterbury, Bury and Lincoln in England, and reflects what in retrospect seems to have been the mainstream of Romanesque taste, rather than a new beginning.

It is necessary to state all this at the outset because there is a persistent and by now no doubt inextinguishable tradition that St Denis was the first Gothic church. In point of fact, there is nothing inconsistent about this claim if we are prepared to accept the view that Gothic was simply the continuation and fulfilment of certain tendencies already present in Romanesque art and architecture. When allowances have been made for what was orthodox and conventional about Suger's patronage, two features are left outstanding which call for comment. One is his attitude towards symbolism; the other is his architecture.

It used to be thought that Suger was one of the great

54. **Plan of the abbey church of St Denis.** Mid-12th century. Suger rebuilt the west end and the choir of the abbey church of St Denis, leaving the Carolingian nave and transept, which were not rebuilt until the mid-13th century. The east end was begun in 1140, after the west end was ready, and was consecrated in 1144. (See figures 55, 77.)

64 (opposite). **Stained glass in the Trinity chapel, Canterbury cathedral.** Early 13th century. Before the invention of tracery, large windows were subdivided by iron bars to support the glass, which was frequently arranged in a pattern of roundels, squares or lozenges. The Trinity chapel, Canterbury (see plate 57) containing the shrine of Thomas à Becket, was filled with glass illustrating his miracles; the reset roundel here depicts an unidentified figure calling on the saint for aid.

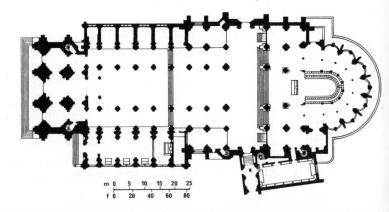

m 0 5 10 15 20 25
f 0 20 40 60 80

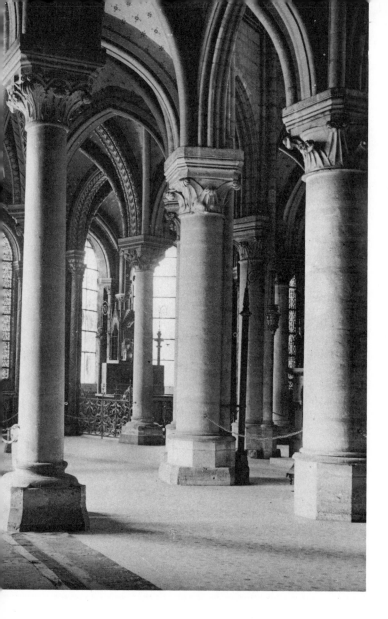

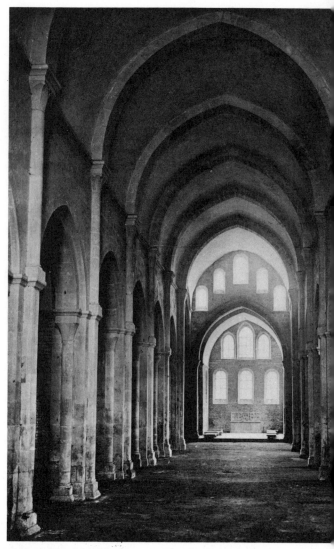

innovators in the realm of iconography—for instance, that he invented the Tree of Jesse. We now realise that this was not so—indeed, that nearly everything which seems new in medieval imagery arose from more thoughtful reflection on perennial Christian themes. Nevertheless Suger broke new ground in the reasoned account—one is almost tempted to say defence—of symbolism that appears in his writings on St Denis. In this he was undoubtedly responding to the prevailing moods of his generation, to the intellectual as represented by Abelard, no less than to the puritanical as represented by St Bernard. Abelard was not directly concerned with the arts, although it is perhaps not entirely fanciful to detect an echo of his stringent standards in the careful visual logic of early Gothic architecture. But the formidable personality of St Bernard loomed large in Suger's affairs, and at one stage the two men virtually confronted one another over questions to which art was indirectly relevant. It is tempting nowadays to dismiss St Bernard as an insufferable bigot who disapproved of almost everything that everyone else liked, and with a flair for hectoring rhetoric which no one knew how to rebut. But by shifting the focus of Christian attention away from the material pomp of altars, reliquaries and church buildings to the spiritual condition of the individual soul, he gave a new depth to medieval religion at a time when it was an open

question in many parts of Europe whether the tremendous enrichment of human experience which the 12th century made possible would be kept within the traditional framework of Christianity. Though he was certainly no humanist himself, St Bernard's insight into what Christianity was really about played no small part in preparing the way for the humanism that was to come. From this point of view, his attacks on the indiscriminate ornament and visual seductiveness of contemporary Romanesque churches were entirely justified. With the scandalous behaviour of Pons de Melgueil known to everybody, it was very difficult to meet St Bernard's charges that Cluniac magnificence was born of the sin of pride and that it nourished pride in those who were surrounded by it. (Pons was abbot of Cluny from 1109 to 1122, and he had to be deposed for his excesses. On the death of his successor, he tried to recover Cluny by force. He failed, and ended his days in a Roman prison.) But the standpoint from which St Bernard mounted his attack on Cluny was a new one. He looked at church ornaments solely in terms of their effect on men, and from this point of view they could be regarded simply as distractions. No one made out a case in defence of the Cluniac position, but if they had done so it would probably have been along the lines that the right and proper way to honour God was to offer him the best that was available, that is the most expen-

55 (opposite, left). **Ambulatory of St Denis.** Before 1144. The skilful use of the rib vault over the awkwardly shaped bays of the double ambulatory, the slender monolithic columns and the large number of windows give this interior a light and spacious atmosphere that is strikingly different from earlier Romanesque buildings.

56 (opposite, right). **Interior of Fontenay abbey,** looking east. 1139–47. Early Cistercian architecture in France, of which this is one of the few surviving examples, took over the pointed arch and barrel vault from Burgundian Romanesque, but without the complicated plan, the towers and the elaborate decoration (compare figures 27, 28, 40) that were considered irrelevant to the principles of the new order.

sive and the most skilfully wrought things. The assumption that God would share their own delight in gold, jewellery and bright colours was no doubt primitive and naive. But the anthropomorphism was unconscious, and as an expression of religious feeling it was touchingly genuine, until questioned. Things were never quite the same after St Bernard and, although Suger's sympathies were all with the old-fashioned point of view, he realised that some sort of theological justification was henceforth needed for ecclesiastical iconography, and some degree of order and discipline to control its ramifications. Not that he set out to state his case systematically in the manner of the later scholastics. He found what he wanted in the writings of a Greek neo-Platonist, known as Dionysius the Areopagite, or Pseudo-Dionysius, who, though he lived in Syria in about 500 AD, was nevertheless confused or identified with the Dionysius who followed St Paul, and with the Dionysius, or Denis, who was the evangelist of the Paris region and titular saint of Suger's abbey. Between these writings and the predominantly Augustinian outlook of contemporary theologians there was a fundamental kinship which guaranteed their respectability, while the special emphasis which they placed on the mystic role of light in human experience seemed to provide precisely the argument that was needed to allay the suspicions of St Bernard. In the event, Suger tightened up the discipline at St Denis, and he was allowed to carry out his artistic programme there unmolested. St Bernard turned his attentions to what he considered the infinitely greater danger of Abelard's rationalism.

Although it does not seem to have been an important part of Suger's case, it was inevitable that his more serious approach to church symbolism should carry didactic overtones, and from this point of view it is perhaps legitimate to place him at the beginning of a fruitful development. He was not, however, unique in his generation on this account. His contemporary Peter the Venerable, the abbot of Cluny who succeeded Pons, was very much of the same mind. In the last resort, Suger's claim to be regarded as the father of Gothic rests on the somewhat fortuitous circumstance that

he happened to employ an architect of genius.

It was once remarked with considerable insight that in its early stages Gothic was the Romanesque of the Ile de France. During the 11th century, when great experiments in architecture were being made elsewhere in France, the region around Paris, though not wholly quiescent, played a relatively insignificant part. This was the one area of France ruled directly by the king, and perhaps nothing reveals more clearly the comparative weakness of the French crown at this stage of its history than its poor showing in the field of patronage when measured against the record of the feudal aristocracy elsewhere. With the rebuilding of St Denis all this was changed. A veritable flood of great buildings followed and, although few of them were the result of direct royal patronage, they faithfully reflect a momentous change in the fortunes and prestige of the French monarchy, a change for which Suger himself was in some measure responsible, in so far as he was the first of that distinguished line of French ecclesiastical statesmen who served their king perhaps even more zealously than their Church. Up to this moment, the Ile de France was a kind of vacuum, and the works at St Denis drew architects and craftsmen from all the regions around into a kind of melting pot. It is hardly surprising that a new style should have emerged from the fusion. But in order that it should do so, a masterful imagination was needed, and this was provided by the architect of St Denis.

It is probable that Suger's views about architecture were of a fairly general nature—that is, he wanted a sumptuous building and one that contained a large number of stained glass windows, prominently displayed, and beyond that he was prepared to leave the design to his architect. Clearly, great masses of masonry were inconsistent with these conditions, and if slender columns of marble were to be used they would not have to carry any great load. The clue to the solution of the problem was found in the ribbed vault. As we have seen, this was a structural device that had been developed in northern Italy at the end of the 11th century along with other varieties of vaulting, and from there it had passed, in ways that are not altogether clearly understood, to the Anglo-Norman kingdom that straddled the English Channel. The outstanding instance of their use in that part of the world was at the cathedral of Durham (1093–1133). It was suggested on p. 340 that the ribs themselves eventually came to be regarded as arches, different in function but not different in character from those which were placed around doorways and windows. Almost from the start this idea seems to have been present in Italy, but at Durham there are several features in the masonry which make it clear that the ribs were not conceived in an organic relation with their supports. They were simply arcs of stone, inserted where necessary to carry the broad surfaces of the vault. The great masses of masonry at Durham, i.e. the piers and walls, were still the primary structural elements and, although there were plenty of arches in the building, they were not related to one another in a systematic way.

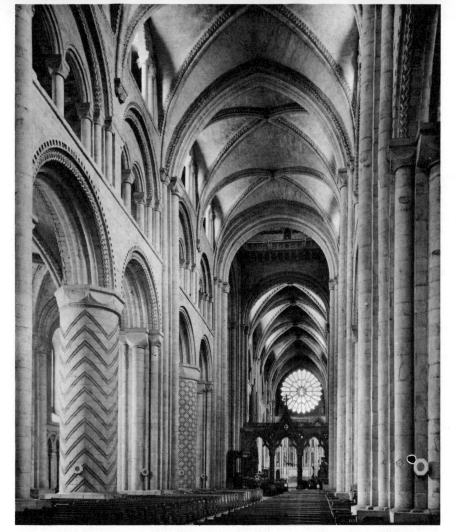

57. **Nave of Durham cathedral,** looking east. Late 11th and early 12th centuries. The east end of Durham cathedral, begun in 1093, was designed with a vault, but the nave appears to have received its rib vault only after a change of plan. Note the great thickness of the walls, a typical feature of Anglo-Norman buildings (compare figure 26), and the chevron ornament which became a hallmark of English Romanesque decoration.

58 (opposite). **Galilee chapel, Durham cathedral.** Late 12th century. The Galilee chapel built on to the west end of the cathedral, with its richly ornamented arches resting on slender columns (before restoration there were two, not four columns, in each group), demonstrates the attenuation of mass associated with early Gothic architecture, but which is here found applied to purely Romanesque forms.

In this respect St Denis is perhaps closer to its Italian precursors; but the application of arch forms to masonry was such an Anglo-Norman speciality, and St Denis was in several other ways so closely connected with the architecture of Normandy and the Norman border, that it is perhaps easier to see it as a development from the Anglo-Norman tradition.

THICK-WALL AND THIN-WALL CHURCHES

The really crucial difference between St Denis and the great buildings of the Normans lay in the thickness of their respective walls. Moulded arches applied to masses eight feet thick could never be more than a special kind of surface decoration. But to the east and south-east of Normandy there appears to have been during the 11th century no decisive change in the traditional Carolingian method of building churches with much thinner walls. One way of looking at the origins of Gothic architecture is to see it as a union of the Anglo-Norman method of using arches for the articulation of church interiors with a 'thin-wall' technique of construction. The essential feature of such a union would be that the arches could henceforth play a structural as well as a decorative role in the design. But in order to do so, they had to form themselves into a system—in fact, into a sort of skeleton—that could take the place of the great masses of the 'thick-wall' churches. When this happened, the walls would lose their structural primacy and assume a function rather like that of vault surfaces, namely that of enclosing space. In the skeleton of arches ribs performed an essential role, both as carrying members for whatever

superstructure was required, and visually as devices that conveyed a sense of connection and recession. Spaces covered by ribs (the French term '*croisée d'ogives*' is much more comprehensive than the English) became in effect identifiable compartments. And at this point architectural technicalities would begin to acquire iconographical significance. For if arches as such could define the spiritual ambiance of the Heavenly Jerusalem symbolically for two-dimensional images, the *croisée d'ogives* did so in a much more specified way for real or imitation people. In a sense, the original *croisé d'ogives* was the open ciborium over the altar and tomb of St Peter in the basilica at Rome. Long before the 12th century, that famous and venerable structure had been vaulted over; but we may be certain that something of its meaning had passed into the wider sphere of structural vaults, if only from the presence of something remarkably similar to it in the mosaic of the groined vault over the choir of S. Vitale at Ravenna. No doubt it is a long way from the 6th century to the 12th, and none of the surviving groined vaults over choirs belonging to the period have kept their original decoration. But there is nothing intrinsically improbable in the notion that the St Peter's idea was handed down as a convention for indicating that the particular space beneath was sacred. If this were so, then there is some justification for supposing that, for its own time as well as for the exponents of the Gothic Revival, Gothic as a style of architecture based on the *croisée d'ogives* was peculiarly suited for religious purposes.

It is not necessary to suppose that all the implications of Gothic architecture were at once apparent to the master of

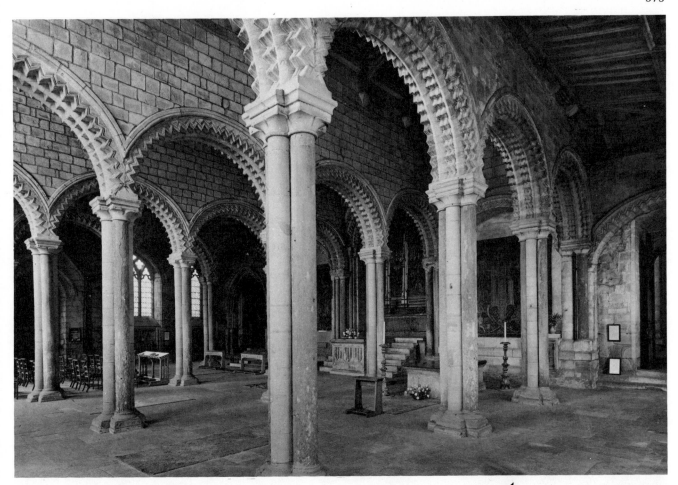

St Denis. But a great many of them were. The delicacy of
the masonry in the new choir ran counter to the trend of
almost every great building in northern Europe of the pre-
vious half century. Instead of deep self-contained chapels,
the latter were more or less merged into an undulating
ripple on the exterior wall, while internally the removal of
all solid masonry allowed the windows that were their prin-
cipal features to flood the whole choir with their coloured
light. Nothing of the superstructure has survived, but we
can infer from the incredibly slender dimensions of the
original columns that its elevation cannot have been very
great. Yet what there was must have been carried not on
the columns alone, but on the structural units of the com-
partments of the aisles and ambulatories. Most of these
features were to appear in the Ile de France cathedrals of
the next decade (the choir of St Denis was dedicated in
1144), and it is clear, whether or not we call St Denis itself
Gothic, that as a piece of architecture it stands more or less
at the head of a development which was to lead directly to
the Gothic cathedrals of the 13th century.

When we read the list of the prelates who attended the
consecration of St Denis, it is like a roll-call of churches
from the history books of architecture: Reims, Rouen, Sens,
Canterbury, Chartres, Soissons, Noyon, Orléans, Beau-
vais, Auxerre, Arras, Châlons, Coutances, Evreux, Thé-
rouanne, Meaux, Senlis. The only notable omissions from
the list are Cambrai, Laon, Amiens and Paris. With the
exception of Canterbury and the three from Normandy,
all of them came from the ecclesiastical provinces of Sens
and Reims; and although it would be wrong to think of the

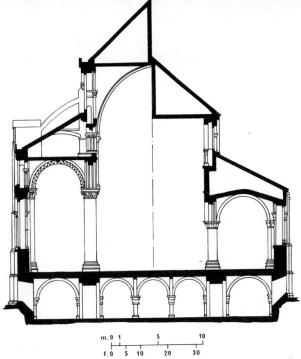

59. Section through the choir of Canterbury cathedral.
This section shows the rebuilt choir at Canterbury (plate 57)
in comparison with a reconstruction of the earlier building
burnt in 1174. Although the vault is supported by some of the
earliest examples of flying buttresses, which were eventually
to enable all the upper walls of a church to be of glass
(see figure 74) it also rests on thick walls, which
demonstrates how Anglo-Norman building techniques
continued into the early Gothic period.

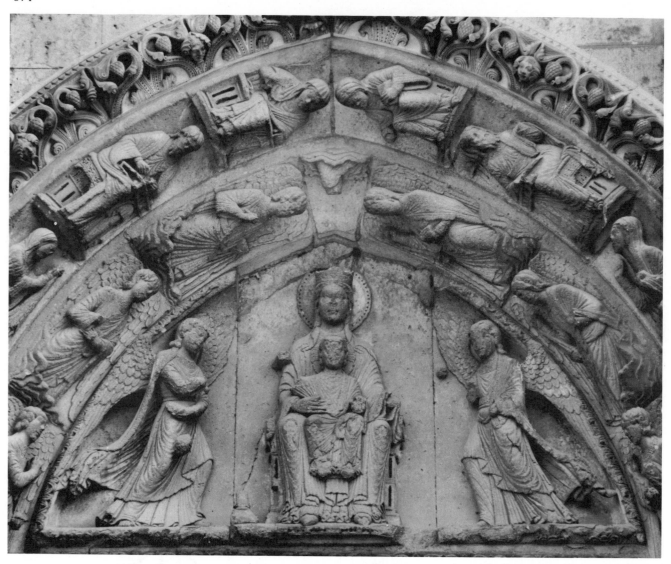

respective bishops as returning home and straight away setting about rebuilding their own cathedrals along the lines of what they had seen at St Denis, it is clear that they were in the habit of meeting together often and exchanging ideas about all manner of things, which no doubt included architecture. Their ecclesiastical connections reinforced the political links that bound them all to the affairs of the king of France. This was the basis on which the new style spread.

Although, to begin with, Gothic was very much a local style, the part of the world where it originated was already by the middle of the 12th century of more than local importance. To call this area the Ile de France is to connect it with the growing power and fortunes of the kingdom of France, and it is true that in the 13th century Gothic became an international style largely as a result of the prestige of France and her ruling dynasty. But in the 12th century these symptoms were not yet evident. It would be nearer the mark, perhaps, to describe the early Gothic zone as being on the French side of the old Mosan-Low Countries region, which ever since Carolingian times had been the real core of the political, cultural and industrial life of north-west Europe. In a sense the new style reflects a shift in the centre of gravity toward the west, and although the first manifestations were of a cultural order they cannot be explained wholly without reference to the upheavals of the so-called Investiture Contest. One of the permanent repercussions of that crisis was to break for ever the links which Carolingian, Ottonian and Salian Emperors had successively forged between their predominantly German states and the Church of Rome. But the successful effort which the Papacy made during the second half of the 11th century to emancipate itself from this particular instance of lay control only gave a new twist to the question as to what form relations between the Church and the world should take in the future. It very soon became apparent that the new international Papacy could not survive without some kind of secular support, and in practice, however long it was before the fact was overtly acknowledged, this support was sought from the western powers, England and France, but more especially from France. Throughout the 12th and 13th centuries a special relationship grew up between France and the Papacy, which culminated, if that is the right word, in the long succession of French popes and the 'Babylonian captivity' of the Papacy at Avignon in the 14th century. By that time, however, the international importance of the Church had dwindled and, deplorable as it must have seemed for the highest spiritual office in the world to be used as an asset in a game of power-politics, the degradation was of moral rather than practical significance.

60 (opposite). **The Liberal Arts.** South doorway on the west front of Chartres cathedral. Mid 12th century. The interests of the school of Chartres are shown by the appearance of the Liberal Arts on the voussoirs of this doorway, each personified by a woman, and represented by a classical philosopher. Note how these practically three-dimensional figures are fitted into the shape of the arch without the contortions found so often in earlier Romanesque sculpture.

61. **Nave of Laon cathedral,** looking west. Third quarter of the 12th century. The four-storeyed elevation, the sexpartite vault and the prolific use of slender monolithic columns and shafts are typical of this stage in the rapid development of the Gothic architecture of northern France. Compare the earlier cathedral of Tournai (figure 73, plate 58).

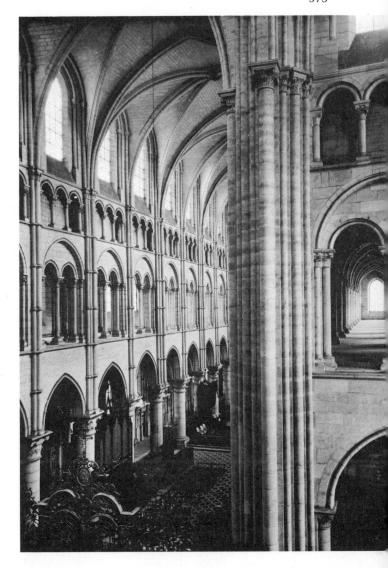

In the 12th century things were different. Then the relationship was not so one-sided. In fact, if anything France stood to gain most. This was the period when northern France suddenly emerged as the centre of higher learning for the whole of Europe. What is known as the renaissance of the 12th century was an international phenomenon, and there was perhaps something indiscriminate about the voracious and seemingly insatiable way in which whatever there was to read, in whatever language, Greek, Arabic and Hebrew as well as Latin, and on whatever subject, was consumed at the behest of one of the most prodigious outbursts of curiosity the world has ever seen. It would be misleading to say that this movement was conducted by the Church for its own ends. Indeed, when the Church tried to control it, in the middle years of the 13th century, it was with the avowed purpose of preventing everything getting out of hand. But in the early stages, only churchmen had access to the literature that was available, and only they could read it. And before the dangers of heresy and paganism were fully realised, there was a widespread if somewhat touching assumption that everything that was written must in some way redound to the glory of God. So while the exuberant mood lasted, Church reform carried in its wake consequences of immense importance for European education. In the schools of northern France, and especially at Chartres, Reims, Laon and Paris, the traditional curriculum of the seven liberal arts came to be taught with a much enlarged reading list that included mathematicians like Euclid, as well as Plato and, later, Aristotle. If the Greek philosophers were ultimately responsible for provoking acute scholastic minds into the creation of the medieval science *par excellence*—theology—it is hardly claiming too much for Euclid to say that Gothic architecture was the child of 12th-century geometry.

While it is necessary to insist on the organic links between early Gothic architecture and its Romanesque antecedents, it is no less true that the style soon began to develop its own distinctive characteristics. One of the most pervasive of these was the amount of sheer geometry that was involved in a Gothic design. Take a cathedral like Laon which was started about 1160. Its interior presents to the beholder a multitude of columns, shafts and arches of varying size. In spite of the complexity, it can be shown that there is nothing haphazard about the distribution of its many components. The whole interior is composed around a carefully worked out and surprisingly well integrated space frame, the mathematics of which were derived, knowingly or unknowingly, from the architectural traditions of classical antiquity. But quite apart from this, it is obvious on a cursory inspection that the arches and mouldings of such a building required stone cutting of a higher degree of precision than anything we find from the 11th century, and in the last resort all this was based on the application of geometry. Another way in which geometry was used was in the design of pointed arches. The days are long since passed when the presence of pointed arches could be regarded as one of the infallible signs that a building was Gothic. We have only to think of Cluny and Durham, two emphatically Romanesque buildings which nevertheless contained pointed arches, to realise the truth of this. But there is still a tendency to think of arches as either round or pointed, as though there were only two types. In fact, however, it is gradually becoming apparent that a great many arch forms were used in medieval architecture—elliptical, horseshoe, stilted, even perhaps something like catenary, as well as pointed and semicircular. And if in the end the pointed arch came into almost universal use, this was probably because it was the simplest and easiest to handle of all the arches whose height was not directly controlled by their span. Looked at in this way all the non-semicircular arches

62. **Villard d'Honnecourt.** *Page from a sketch-book* (MS. Fr. 19093, f. 17). 1230s. Bibliothèque Nationale, Paris. The use of pattern-books or sketch-books was widespread in the Middle Ages and of great importance in the diffusion of stylistic ideas. This figure is possibly derived from a mosaic at Monreale (figure 45) and analogies for the drapery style can be found at Reims, and in the work of Nicholas of Verdun.

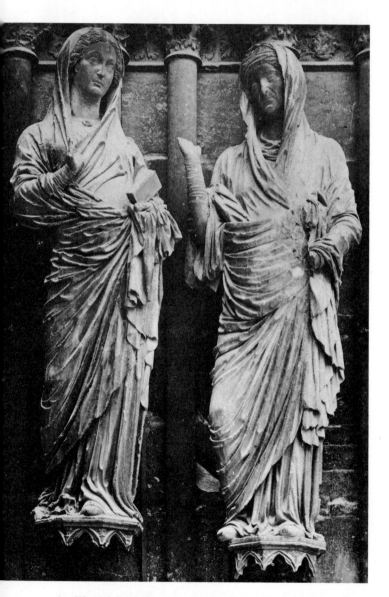

63. **The Visitation.** c. 1220. Central porch on the west front of Reims cathedral. The overt classicism of this group, both in facial type and drapery style, suggests that the sculptor had knowledge of classical works. Compared with Chartres north transept (figure 52) these figures have, to a greater extent, broken away from the rigidity of earlier column figures.

go together, and it is possible to trace their history back beyond Gothic and Romanesque in western Europe to the architecture of Georgia, Byzantium and even the late Roman world of the eastern Mediterranean, where they connect up with a still more remote ancestry. But all this is by the way. What matters is that the pointed arches of Laon, and other Gothic churches as well, were constructed according to definite formulas, with the centre placed in preordained positions, and the radii of the arcs calculated in terms of the overall geometry of the design. In fact, the wholesale use of geometry came by the end of the 12th century to be perhaps the most characteristic feature of the mason's trade, the thing which marked him off from the virtuosi of the profession who produced what were in effect the cadenzas—the foliage capitals and perhaps even the stone figures of the portals.

GOTHIC VERSUS CLASSICAL

It may seem paradoxical to stress unduly the affinities, such as they are, between Gothic architecture and antiquity. If any style seems to embody all that distinguishes the Middle Ages from the classical world of Greece and Rome, it is surely Gothic. This was certainly how it seemed to the exponents of classical culture in Renaissance Italy. Brunelleschi could take the Romanesque Baptistery at Florence for an Early Christian or late antique building, but no one ever made the same mistake over a Gothic church. And even in the late Gothic north it was customary to convey the difference between the Old Testament and the New by using Romanesque forms to symbolise the former and Gothic the latter. Nevertheless, we must remember that unless there were watertight compartments of extraordinary efficiency early Gothic was, in some sense of the word, the architecture of the 12th-century renaissance and that, during precisely the same decades as it was developing in north-eastern France, the figure arts were undergoing a parallel transformation just to the east, but in a direction that was openly and frankly classical. This antinomy reaches a kind of climax at Reims in the early 13th century, where one of the most spectacular of the High Gothic cathedrals was provided with figure sculpture by one who, in default of his name, is significantly called 'the Master of the Antique Figures'. By 1220 it is unlikely that the sculp-

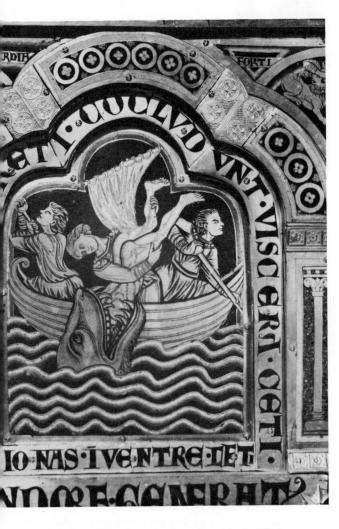

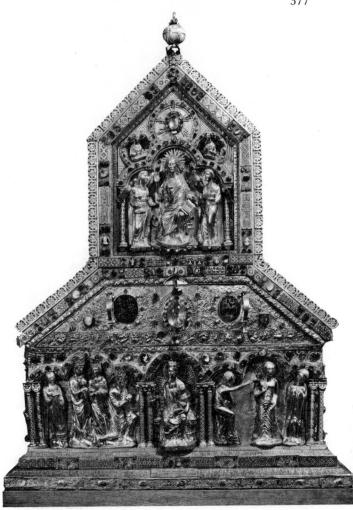

64. **Nicholas of Verdun.** *Jonah swallowed by the Whale* Detail of the Klosterneuburg altar. 1181. h. of centre panel 5½ in. (14 cm.). Klosterneuburg, Austria.
65. **Three Kings shrine** (detail). c. 1200. Cathedral Treasury, Cologne. This Jonah scene, believed to prefigure the *Entombment of Christ* (compare plate 45), is one of a series flanking scenes of New Testament events on the altar (originally a pulpit) at Klosterneuburg, which is dated 1181 and signed by Nicholas of Verdun. On analogy with this,

and his other known work, a shrine at Tournai of 1205, part of the Three Kings shrine at Cologne is also ascribed to him. The relatively naturalistic figure style and distinctive drapery with its mass of fine folds, found in both his enamelwork and his cast figures, contrast strikingly with late Romanesque traditions, and make Nicholas' work a precocious example of a style which slightly later became popular in painting and sculpture (plate 53, figures 52, 62, 63).

tor and master mason were the same man. But they must have known one another well, and there can hardly have been any serious disagreement between them as to the limits beyond which it was improper to pursue classical prototypes. Or even if there were, then we have in the sketchbook of Villard d' Honnecourt, who came from the same milieu, indisputable indications that a classical drapery style, if nothing else, was thought compatible with Gothic architectural forms at that time. Up to a point, therefore, there is good reason to think that when we encounter evidence of Gothic architects doing things in a classical way they knew what they were doing, and we are therefore entitled to ask why they stopped short. Why did they not go further and produce buildings that really did look classical, in the way that 12th-century churches like Cluny and Autun, Pisa and Monreale, had tried to do. It is of course true that all these buildings belonged, culturally speaking, to the south, and that the enormous influence of

France, or more specifically northern France, during the 13th and 14th centuries (when it was every bit as overwhelming as in the time of Louis XIV) tended to act like a brake on instinctive southern tendencies. But in sculpture, in spite of the advantages of inheritance at the disposal of 12th-century Italians like Wiligelmo, Niccolò or Antelami, it was the northerners, Nicholas of Verdun and the Master of the Antique Figures at Reims, who were the first to grasp what could be done with classical sculpture. No doubt there were few classical buildings left in the north to serve as models and, given the somewhat bizarre standards by which the Middle Ages were prepared to recognise a copy of something, it is just possible that architects really did think they were building in the antique fashion when they used antique proportions. But on the whole this is not likely. It is far more probable that if they had wanted to make Gothic classical they would have found ways of doing so and that by refraining they had other ends in view.

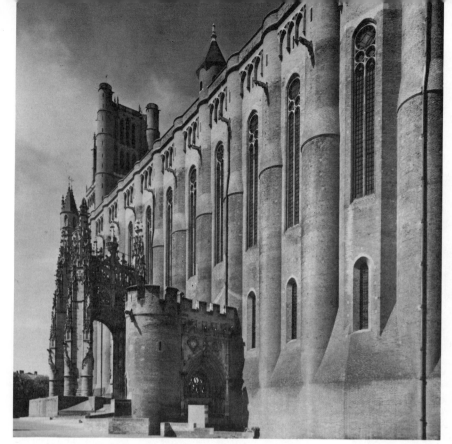

66. **Albi cathedral.** Begun 1282. the fortress-like appearance of this vast cathedral, built in one of the former centres of the Albigensian heresy, has the austere simplicity typical of the southern French version of Gothic architecture. The fantastic elaboration of the late Gothic portal is a striking contrast.

67 (opposite). **Interior of La Chaise Dieu,** looking east. 1342–75. The establishment of the Popes at Avignon in the 14th century led to the creation of an important centre of artistic patronage in southern France. The abbey of La Chaise Dieu, built by Pope Clement VII, has, like Albi, a simple interior consisting of an aisleless nave with lateral chapels, a popular southern Gothic design.

This brings us face to face with what is, or ought to be, the central problem of Gothic, namely why there should have been such a style at all. In a very long-term view it is apt to seem decidedly odd that after all the tentative but impressive advances toward the recovery of classical techniques and styles, which, whatever qualifications and refinements we have recently seen fit to introduce, still provide our only justification for using a word like 'Romanesque', there should have been this long meander extending over some three hundred years before the next steps were taken toward the accomplishment of a genuine 'Renaissance'. If a brief answer has to be given, it can only be in terms of the attitude of the Church.

During the 13th century, that curious ambivalence in the Church's response to the legacy of the classical past, which ran like a thread from Tertullian in the 3rd century to the papal patrons of Michelangelo in the 16th, came to a head on numerous occasions. Generally speaking the Church has always been disposed to look favourably on classical scholarship in periods of tolerance, when the temperature of great issues was running low, and individuals could be safely allowed to do (more or less) what they liked. During the early Gothic period, however, the Church enjoyed, for the first and last time in its history, temporal power roughly commensurate with its own view of its own importance, and the responsibilities of power caused drastic reappraisals in many fields where laxity had hitherto prevailed. To use a somewhat unseemly metaphor, the Church behaved like a balloon, into which new ideas were constantly pumped. So long as there were few of these, they could be accommodated with little discomfort; but once the pressure was on, it became an open question whether the container could continue to expand, or whether it would burst. Up to a point the Church tried bravely to absorb the flood of strange thoughts that were dredged up

from the ancient books. Perhaps the most heroic of these efforts was that made by the theologians to square Aristotle with the doctrines of the Church, which occupied them for the greater part of the 13th century. But the spectacular condemnation in 1277 of 219 propositions taught at the university of Paris (mostly blamed on the infidel commentator Averroes, although they included a number held by St Thomas Aquinas himself) may be taken to mark the point at which this effort stopped. The momentous decision to call a halt to unfettered speculation at the highest or deepest level of medieval experience epitomises a predicament into which the Church gradually, and perhaps reluctantly, found itself forced at all levels. The situation was always in principle the same. There were aspects of ancient life and thought that were beyond question wrong if what the Church taught was right. Limits, therefore, had to be drawn somewhere. The idea of paganism was intimately connected with the idea of heresy. In this respect, long before the rarefied intellectual wrangle at Paris, a far more dangerous crisis had arisen in the south-west of France, where there had come to flourish an entire way of life that was inconsistent with the precepts of the Church. By 1200 this scandal could no longer be ignored. It had to be either condoned or proscribed. The bloody glee with which the proscription was executed, in what is known as the Albigensian Crusade during the first decades of the 13th century, already betrays the mood of the Inquisition, which was established shortly afterwards to prevent the same kind of thing happening again elsewhere.

The fundamental sin of the Albigeois, even if it was not mentioned, was their tendency to regard the orthodox Catholic priesthood as superfluous. This was, of course, to cut at the very root of the Church's grip on the secular world, and it is conceivable that, if the rather precocious civilisation which flourished at the higher levels of this

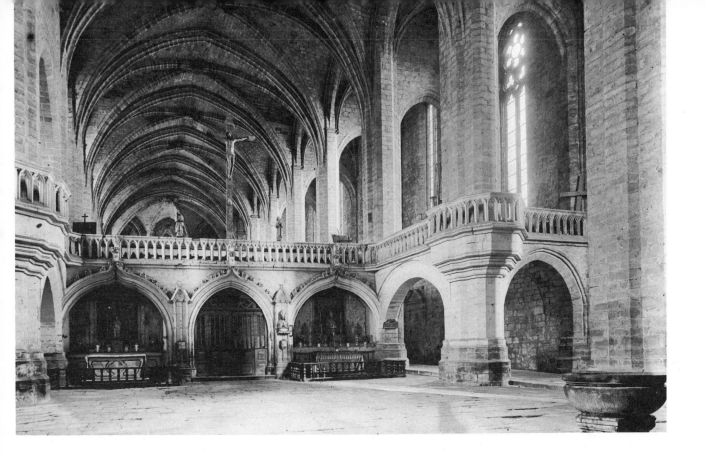

heretical society had been allowed to grow unhindered, it might eventually have reached a secular position and point of view similar to that of the 14th-century Italian humanists. As it was, however, the whole of the western Mediterranean coastlands were affected by the zealotry which followed the Albigensian Crusade, and any Renaissance symptoms there were set back by at least two hundred years.

CHURCH VERSUS STATE

But of all the enemies who threatened danger to the Church's position, it was perhaps inevitable after the Investiture Contest that the one to evoke the most acute apprehension should have been the medieval Empire. Although in the end it was the national governments that grew out of the feudal monarchies of western Europe which reduced the Papacy to a level of resounding impotence, all the arguments and propaganda of the great debates of the 11th and 12th centuries saw the Emperor as the Pope's natural antagonist. Each inherited the same theory of government, the only difference being the identity of the keystone that should crown the whole edifice of human society, under God. In the nature of the case no compromise was possible, and in practice solutions were only reached by the surrender, tacit or otherwise, of important claims by one or other of the contenders. Ultimately the whole of the Church's attitude toward classical art and architecture turned on the degree to which these were contaminated by their inevitable association with the very idea of the Empire.

It was the essence of the papal case that the Pope was placed 'as mediator between God and man—less than God, but more than man,' as Innocent III put it. In Imperial language he was indeed more truly emperor than the Emperor, and from this point of view there was some jus-

tification for the Church taking over all the trappings of Empire, including Imperial art. Ideas such as these seem to have lain behind the numerous classical allusions at Cluny, though they were carefully mixed with others derived from Early Christian sources. On the whole, however, the Church preferred to think of itself as something beyond and above the Empire, and in so far as it pondered seriously on the implications of its patronage of art and architecture the advantages of having so to speak its own style, free from all embarrassing associations with the other side, must have seemed overwhelming. But in any case too much classicism, and especially overt classicism, was undesirable in a Christian Church. It was yet another case of a line having to be drawn in the interests of ecclesiastical prudence. As the feud between successive Popes and the Hohenstaufen Emperor Frederick II moved toward its hysterical and unedifying climax in the middle years of the 13th century, the position of the Church in this matter must have seemed by implication to have shifted still further, to one of uncompromising hostility. Although the Emperor did not exactly preach anti-sacerdotalism, he appears to have practised it on a sufficiently repugnant scale to make himself the focus of all the heresies, and these, added to the sins of his office and his person, qualified him in the eyes of the Church for the unenviable role of Antichrist. So long as the animosities that were generated in this quarrel lasted, a lingering stigma seems to have attached itself to the study of classical art. Even when the literary Renaissance had begun, one of the most interesting things about it from a medieval point of view was the extraordinary lapse of time before artists followed suit, and genuine antiquities were *96* copied in an uninhibited way; and another was the tenacity of Gothic traditions, even in the heart of Italy. In fact, *98* the whole Gothic episode, so far as the south was concerned, stemmed in large measure from the Church's dread of

heresy, whether in its Albigensian or Hohenstaufen forms. Gothic was never truly at home in the Mediterranean world, and its presence there calls for something more by way of explanation than the pseudo-biological operations of the spirit of the times. Historically the answer is that it was there because the Church wanted it to be there. In short, Gothic was in a sense the Church's own style. Precisely because it was an interloper in the south, this conclusion may be grasped more readily there than in the north, where Gothic was at home.

60, 62, 67

Just when the Church decided to adopt Gothic, or indeed, whether any conscious decision along these lines was ever taken at all, is uncertain. But if we have to pick any single event as marking the point where Gothic ceased to be the local style of north-eastern France and the regions round about, including parts of England, and became an international style (the first of its kind) this would have to be the fourth Lateran Council of 1215, which marked the climax of the pontificate of Innocent III. Innocent's reign (1198–1216) has always been taken as the high-water mark in the fortunes of the medieval Papacy. During those years the Church approached more closely than at any other time in its history to the reformers' ideal of a totally emancipated, supranational organisation, with the Pope himself recognised by most, if not all, of the secular rulers of Christendom as their feudal overlord. To the prelates who met together at Rome in 1215 the occasion must have seemed one that justified a great deal of exultation, and if there was any discussion of church architecture it is likely to have been in terms of victory monuments.

Whatever may have happened at the fourth Lateran Council, in the years which followed the diffusion of Gothic began to assume the form of something like a systematic campaign. Gothic had already reached England in 1174, when the choir of Canterbury was rebuilt after a fire. Here its presence is to be explained by the close connections that prevailed all through the 12th century between Canterbury and the ecclesiastical polity of northern France. In Spain something that perhaps deserves to be called Gothic is to be found in the cathedral of Cuenca (after 1183), where there are decided connections with the proto-Gothic of Burgundy. But generally, where symptoms of Gothic occur elsewhere in these two countries at the end of the 12th century, it is due directly or indirectly to the enterprise of the local Cistercians. St Bernard's Order was not actively committed to the promotion of Gothic as a style, but the austerity of its simpler forms provided a useful foil to the more exuberant kinds of Romanesque, which were particularly prevalent in the western extremities of Europe. It is significant that in Germany and Italy in the 12th century the part played by the Cistercians in introducing Gothic was far less conspicuous. There the native forms of Romanesque were usually innocuous enough to require no active measures to escape their insidious influence.

The spread of Gothic in the early 13th century was conducted in different ways at different levels. At the top, so to

57

56

58

speak, where dynastic or ecclesiastical prestige was involved, and only the best would do, we find more or less straight imports from France. This is what happened at Burgos (1222) and Toledo (1227) in Spain. The English, already having their own kind of Gothic, and therefore not needing to import anyone else's, proceeded on their own insular way. During the first half of the 13th century England was perhaps more isolated from the Continent than at any other time since the Norman Conquest, and it is therefore not surprising that the Gothic which evolved there should have been, to say the least, eccentric. Some of the eccentricities, however, particularly the asymmetical vaults of Lincoln, were to suggest possibilities of waywardness that were eagerly followed up by late Gothic Germans (but not until the 14th century). The Germans themselves were much more cautious. At Maulbronn and Ebrach the Cistercians at last gave some sort of belated lead, but it was not really until Cologne was started in 1248, and the nave of Strasbourg two years later, that they plunged wholeheartedly into the task of mastering the new style. Nothing is more remarkable than the difference between the German response on the one hand to Gothic architecture and on the other to Gothic sculpture. The possibilities of the latter they seem to have grasped instinctively. The former they had to learn, slowly and even laboriously. In fairness, however, it must be admitted that when they had passed through their long apprenticeship they emerged as masters equal to the French. And thanks to historical circumstances over which they had no control, the Germans had far more opportunity to display their talents during the later Middle Ages than did the French, with the result that the period 1350–1500 is apt to appear in the history books of medieval art as an age dominated by the Germans.

In the south of Europe, that is from Aragón to Italy, the overwhelming impression is that Gothic was imposed from above, that it was accepted reluctantly and grasped only superficially. To a very considerable extent it was promoted by the new orders of friars, Innocent III's special international agencies for ensuring the 'togetherness' of Church and people. This meant that right from the start there was a tendency for Gothic churches to be bare and barn-like and, apart from one or two easily identifiable intruders among the later cathedrals in the area, southern Gothic retained this character. The consequences of this were deceptively far-reaching, as we shall see in due course. Just how perfunctory the southern response to Gothic could be is apparent in out of the way churches like the Cistercian S. Nicola at Agrigento in Sicily, where there are pointed arches and ribbed vaults, but nothing else to remind a northern Frenchman of home.

It may seem perverse to consider these peripheral forms of Gothic before the central masterpieces. But it is as well to be reminded of the tremendous difference in performance between the home product and the foreign copy. In a comparatively small area of northern France, and over a period of perhaps no more than one man's lifetime,

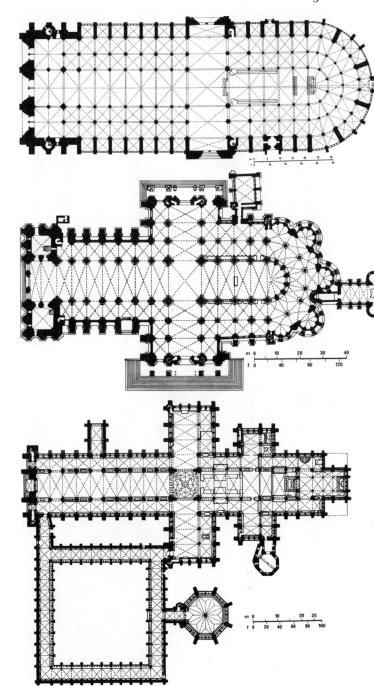

a series of cathedrals were built that successively perfected an image worthy of the arrogance, the power and the sublimity of Pope Innocent's conception of the Catholic Church. If he bestowed the favour of his approval on the style of these monuments, his instinct was unerring. And even if he did not, the higher clergy of the Church drew the appropriate conclusion for themselves.

CHARTRES

From a French Gothic point of view, the fifty years between 1190 and 1240 were the most auspicious of the whole Middle Ages. At Chartres (1194) and at Bourges (before 1195) in France, two great designs were worked out, which in their respective ways utterly transformed the whole scale of church building in that country. It was not just a question of enlarging the size of existing members. On the contrary both involved the radical rethinking of accepted formulas, and both achieved spectacular effects that had not been seen before in the West. At Chartres everything was sacrified to the presentation of two vast iconographical programmes—of sculpture in the portals, and of glass in the windows. The architect of Chartres must have been one of the most self-effacing men of genius ever to have graced his profession. It was his task to prepare a framework in which other men's talents would be displayed; and the fact that it is still the statues and the windows that people go to see at Chartres is a back-handed token of his success. One is apt to forget the liberties that he took and the risks he ran by attempting the unprecedented. For the sake of the windows he removed the traditional galleries of 12th-century cathedrals, he enlarged the arcades and he heightened the clearstorey. Above all, to secure the fragile box of glass that reared itself far above the roofs of the aisles, he resorted to the relatively new device of flying buttresses, which he piled up around the church like a permanent scaffolding of stone. Compared with the brilliance of colour in the windows and the narrative interest of their subject-matter, there is little in the actual stonework to catch one's eye. And it is the same outside. No one pauses for long to examine the buttresses when the portals are to be admired. This architecture is just superb structural engineering.

As an image of the Church Triumphant, Chartres is perhaps the most ambitious (and providentially still complete) thing of its kind. Nowhere else are the great themes of Christian doctrine and the Christian view of history presented in such a universal and, at the same time, such a particular way. It is the building that above all others seems to convey the mood of the Lateran gathering. From this point of view, we may perhaps be allowed to single out for special mention the confrontation across the central doorway of the north transept of *St Peter*, decked out in the splendid robes of a 13th-century Pope, and *Melchizedek*, the priest-king of the Old Testament, who was here, typologically, St Peter's forerunner. It was an identification much favoured by Pope Innocent, and the images at Chartres must surely have been intended to refer to him.

68. **Plan of Notre Dame, Paris.** c. 1163.
69. **Plan of Chartres cathedral.** 1194.
70. **Plan of Salisbury cathedral.** 1220. Notre Dame, whose choir was consecrated in 1163, has one of the simplest cathedral plans devised during the experimental period of the 12th century in northern France. The absence of projecting transepts or chapels must be explained by the desires of the architects, rather than by liturgical needs; it was found necessary to add chapels soon afterwards. Compared with the simplicity of Notre Dame, Chartres goes to the opposite extreme with a very prominent transept and an uneven ring of chapels, the plan of the latter partly conditioned by the chapels of the 11th-century crypt beneath. This type of east end, though usually with regular chapels, became standard in French High Gothic churches. English 13th-century cathedrals such as Salisbury generally did not adopt the French *chevet*, but preferred square east ends with parallel projecting chapels. The double transept was also a popular feature. Instead of the great western portals of French cathedrals, the English preferred lateral porches.

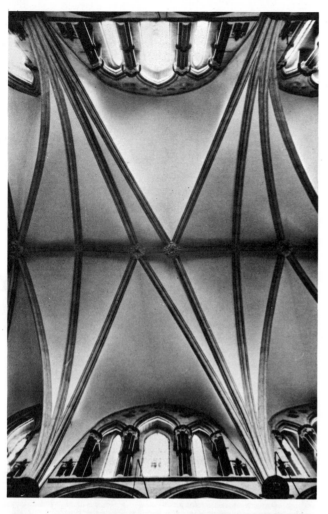

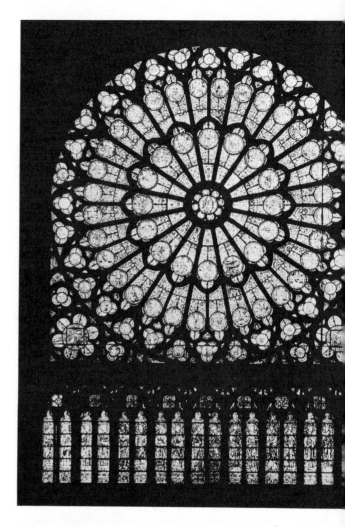

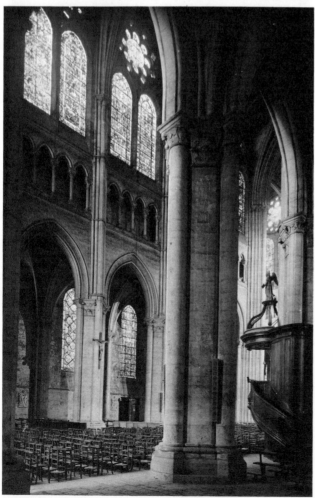

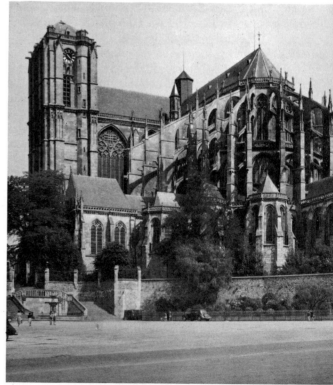

74 (above). **East end of Le Mans cathedral.** Begun 1218.
Note the immense height of the clearstorey of this building,
whose vaults are supported by a complex series of flying
buttresses. Compare the transparency of this Gothic *chevet*
with the solid masses of a Romanesque east end such as
Conques (figure 32).

71 (opposite, left). **Vault of St Hugh's choir, Lincoln cathedral.** Begun 1192. The new Gothic works at Lincoln incorporated many ideas from the slightly earlier choir at Canterbury; this vault, however, is a new departure. English Gothic took up the ridge rib, and the principle of multiple ribs diverging from a single point, but not the asymmetry of this arrangement, which remains unique.

72 (opposite, right). **North transept rose window** of Notre Dame, Paris. Mid-13th century. In the 13th century the clearstorey of Notre Dame was heightened and rose windows added to the transepts, to bring this early Gothic cathedral into line with the latest ideas of 'Rayonnant' architecture—the name derives from the centrifugal radiating tracery patterns found in rose windows such as this.

73 (opposite, below left). **Nave of Chartres cathedral.** 1194. The elevation of Chartres, with its tall arcade, narrow triforium and immense clearstorey (compare Laon, figure 61) became the standard type for the French High Gothic cathedral. At Chartres the windows are still either lancets, or openings grouped together as in the clearstorey to form 'plate tracery'. Compare the more delicate effect of bar tracery, invented slightly later (figure 77).

BOURGES AND LE MANS

Bourges is a more complex building than Chartres, and conversely, although there is some magnificent glass and some interesting sculpture there, it is the architecture that commands our deepest attention. There is no transept at Bourges and, perhaps because of the spatial unity that this ensures, it is the one great vaulted hall of its kind that invites comparison across the centuries with those of Imperial Rome. Certainly the arrangement of its nave and four aisles in echelon calls to mind one of the most distinctive features of old St Peter's and S. Paolo fuori le Mura in Rome, or for that matter Romanesque Cluny which was itself inspired from that quarter. In its own more subtle way, this allusion conveys much the same meaning as the *St Peter* and *Melchizedek* at Chartres. We are invited to think of Bourges as a reiteration in the Church's new style of its venerable Early Christian archetypes. But in other ways Bourges broke new ground. Like Chartres, it also has no gallery, only here all the gain has been concentrated in the arcades, with the result that these are quite prodigious. Moreover, the columns on which they are carried do not stop short at their capitals. Instead, they seem to push on upwards through the walls until they meet the ribs of the vaults. The effect of this is to make the residual bits of wall above the arcades seem no more than screens, stretched from one pillar to the next. There are no structural reasons why they should not be dispensed with. And in the choir of Le Mans (started 1218), which was one of the progeny of Bourges, this next logical step was taken. The impression at Le Mans is quite staggering. A huge arcade is surmounted by nothing more substantial than a row of great clearstorey win-

dows. There is hardly any masonry to be seen in the entire elevation, and in spite of its great size the whole design has the kind of delicacy that would be more appropriate in a reliquary casket. It is small wonder that, outside, this reliquary of masonry is clasped by the most extensive array of flying buttresses in the whole of France. Whatever one thinks of the masonry at Chartres, here structure reaches the level of the most consummate art. *74*

REIMS

One of the more amazing things about the Gothic cathedrals of northern France that were built in the fifty years or so after Chartres and Bourges is the way in which each of them contrived to preserve its own individuality. No two are alike, even though they were all devoted to a single end and shared a common repertory of skills and experience. At Reims (started 1211), apart from the sculpture to which we shall return, the great innovation was bar tracery. This began as a device for breaking up the growing apertures of lancet windows by inserting thin patterns of cut stone into what were in effect holes too large for the ordinary lead and iron armatures that held the glass. Very soon, however, the link between tracery and windows ceased to be exclusive, and it became a kind of abstract ornament that could be applied almost universally—to walls, over voids or simply left free-standing. *77 81*

The implications for the future of this new development at Reims were to prove almost incalculable. If any single invention permits us to distinguish earlier from later Gothic architecture, this was it. It is hardly a coincidence that the anonymity which shrouds the great structural engineers of the Chartres-Bourges era should suddenly have dispersed when we turn to Reims. We know the names of all the master-masons who worked at Reims, and the same is true of Amiens, Westminster and Cologne. It is as though masons suddenly acquired a new kind of reputation that made them memorable and, while this may have had something to do with wider changes in the social habits of the 13th century, it also surely reflects a change in the professional status of the masons themselves.

Essentially tracery was a kind of ornament, and it was a kind of ornament that the masons themselves could produce. In the process of specialisation which went on all through the 12th century, anyone with an outstanding talent for cutting stone tended to be channelled into the field of pure sculpture. This consisted of giving relief to two-dimensional drawings and, as we have seen, the sculptors tended either to get these directly from metalworkers or manuscript illuminators, or else they learnt how to make them for themselves from the same sources as the metalworkers and manuscript illuminators. The result of this was that a man of genius like the designer of Chartres had hardly anything to do with the decoration of his cathedral. With the invention of tracery, however, the masons began to make a spectacular come-back. Whether or not the decline in the sheer amount of sculpture that we find *62,63,65*

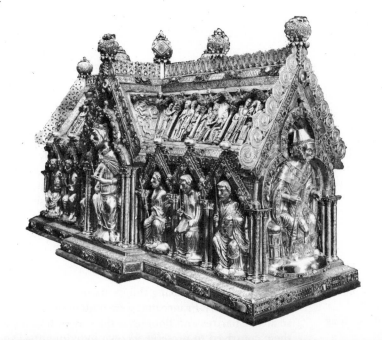

75. **Charlemagne shrine.** Early 13th century. Silver-gilt, copper-gilt, enamel, filigree, precious stones. 80¼ × 37 × 22½ in. (204 × 94 × 57 cm.). Cathedral Treasury, Aachen. Although architectural detail is used on this shrine—the ends are gabled, and the figures set under arcades— it has a far more tomb-like appearance than do the later Gothic shrines. The reliefs on the cover show scenes from the life of Charlemagne (see plate 46).

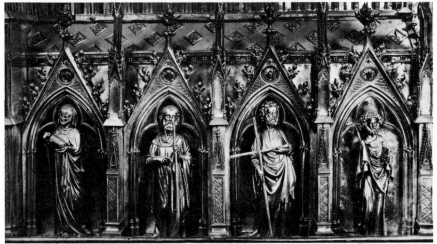

76. **Shrine of St Gertrude** (detail). After 1272. 70¾ × 21¼ × 31½ in. (180 × 54 × 80 cm.). Formerly in the convent church of St Gertrude, Nivelles (destroyed 1940). Compared with the Charlemagne shrine (figure 75) this reliquary with its rose windows, pinnacles and niches is nothing less than a church in miniature. Although, paradoxically, it still has reliefs on the roof, it looks forward to the architectural fantasies of such 14th-century reliquaries as the Three Towers shrine at Aachen (plate 66).

in later Gothic cathedrals is to be explained in this way (tracery was much cheaper than sculpture), there is little doubt that tracery was one of the factors involved in the fundamental change that took place in the painting of stained glass during the second half of the 13th century. Instead of the deep-toned glass that we find at Chartres or Bourges, this became perceptibly lighter, and instead of being fired into the glass much of the colour was simply painted on the surface. In both these ways stained glass became a far more delicate art, less like enamelling, and much more like translucent painting. and in the process the tracery in which it was set itself became far more visible.

But the repercussions extended further. Like space frames, arches and mouldings, tracery designs were basically a question of applied geometry. But a new factor now entered the situation. This was what might be called architectural drawing. No doubt there had been drawing of a kind from the time ashlar had to be cut to precise profiles. What was special about Gothic tracery drawing was its often extreme elaboration, which called for an order of skill with rulers and compasses quite unknown before, and the fact that to be useful at all it had to be done to scale. This idea of scale is of crucial importance. It at once establishes the possibility of kinship between very large and

very small forms; and from this there opens up the prospect of an entire field of application for the new kind of drawing, outside the limits of architecture properly so-called. This is precisely what happened. Apropos of Romanesque drawing, it was suggested that its firm lines betrayed the dominant influence of metalwork. In the 13th century the whole question of dependence and interrelation among the arts was given a fresh twist by the arrival on the scene of this new kind of drawing. First and foremost we can see its effect on metalwork itself. If we compare one of the late Romanesque reliquaries, like that of St Elizabeth at Marburg in Germany (c. 1236), with, first, the shrine of St Taurin at Evreux in France (c. 1250) and then that of St Gertrude at Nivelles in Belgium (after 1272), the process of transformation unfolds before our eyes. The first, in spite of its 'transepts' and gables, is still basically conceived as a sarcophagus. The last is, to all intents and purposes, a miniature Gothic church. But if shrines became churches, churches also became shrines, and in the formal equation of church and reliquary, already foreshadowed in Romanesque times, we have a clue to most, and the best, of the monumental and decorative art in northern Europe between 1250 and the Reformation.

(Continued on page 401)

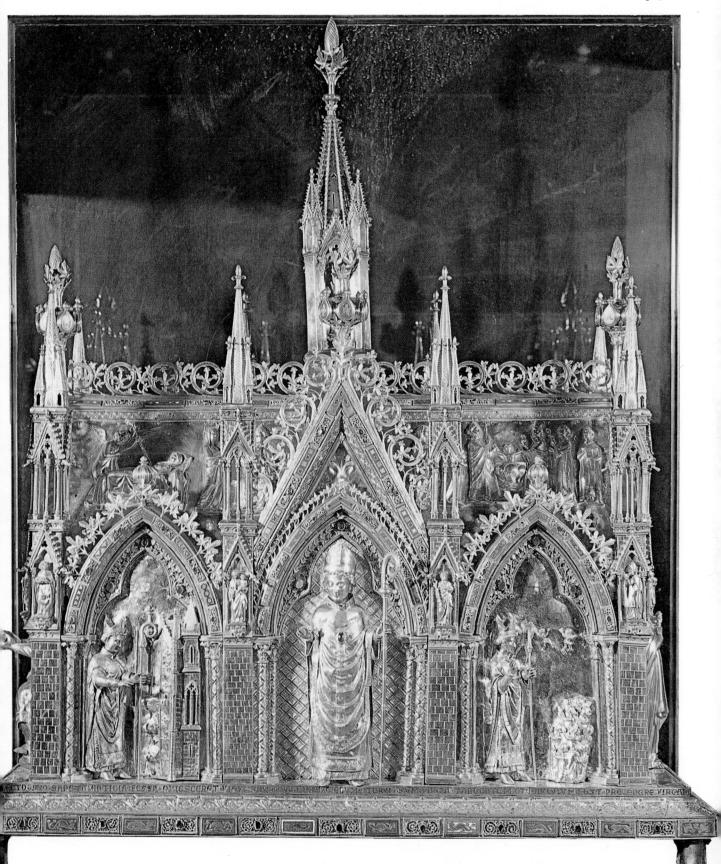

65. **Shrine of St Taurin.** 1240–53. Silver and gilded copper with enamel plaques. h. 28 in. (70 cm.). Church of St Taurin, Evreux, Normandy. This reliquary illustrates the crucial transition in the design of this class of object that occurred in the middle of the 13th century, i.e. from something basically conceived as a tomb to something modelled on a church or chapel. Hence the significance of the architectural detail.

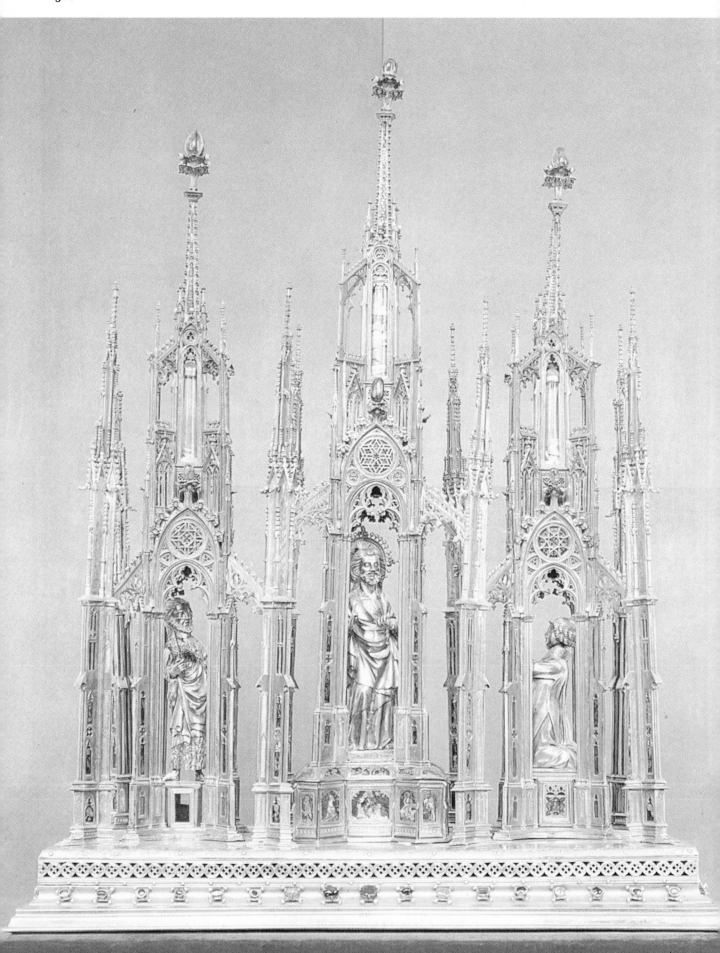

66 (opposite). **Three Towers reliquary.**
c. 1370. Silver gilt with enamel plaques.
37 × 29 in. (94 × 74 cm.). Cathedral
Treasury, Aachen. The insubstantial
beauty of this reliquary, when compared
with the shrine of St Taurin at Evreux
(plate 65) or the Shrine of St Gertrude,
Nivelles (figure 76), shows on a small scale
how far architectural concepts had moved
from the more solid forms of the 13th
century. Far more care is lavished on the
framework than on the figures themselves.

67 (right). **Detail of the niche-work in
the Lady Chapel, Ely cathedral.**
c. 1310. The niche-work of Ely Lady
Chapel is among the most refined
examples of small-scale, decorative
carving of the English Decorated period
(*c.* 1250–1350). The arches are
characterised by what are called 'nodding
ogees', i.e. they not only undulate but are
broken forward to form canopies.

68. **Detail from the choir stalls,
Chester cathedral.** *c.* 1380. Wood. The
intricate carving of these choir stalls is
typical of the late medieval obsession with
elaborate architectural decoration. It can
be compared not only with such such small-
scale objects as the Three Towers shrine
(plate 66), but also with the great
cathedral spires (see figure 85).

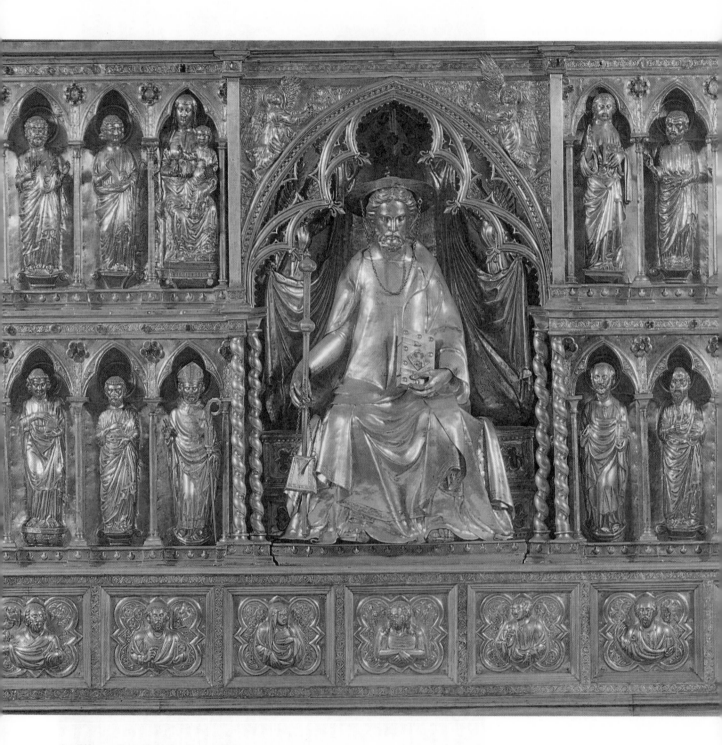

69. **Silver altar** (detail). Begun 1287,
completed *c.* 1396. Overall height over
7 ft. (215 cm.). Cathedral, Pistoia. The
fact that the current European
preoccupation with niche-work extended
also to Italy can be seen in this altar, which,
although ordered in 1287 to house a relic
of St James the Great, was much added to
in the 14th century. The figure of Christ
shown here dates from about 1353 and is
the work of Giulio Pisano. The smaller
figures are earlier.

70. **The Sufferings of Job.** Jamb sculpture on the Virgin Porch, Notre Dame, Paris. *c.* 1220. This is an example on a small scale from the 'classical' period of early Gothic sculpture. Compare the style of this naturalistic group of figures with the monumental column figures of Reims and Chartres (figures 52, 63).

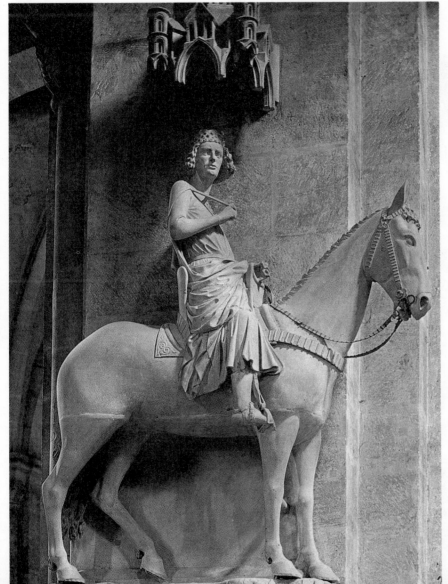

71. **The Bamberg Rider.** *c.* 1236. Nearly life-size. Bamberg cathedral. The statue was probably intended to stand over a doorway. The identity of the Rider has never been established. Various kings of Germany associated with Bamberg have been suggested, including Frederick II. Whoever he is, the rider embodies contemporary German ideals of knightly virtue.

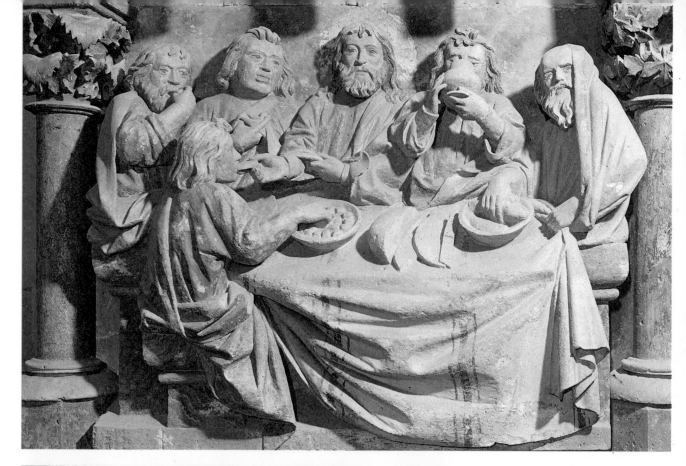

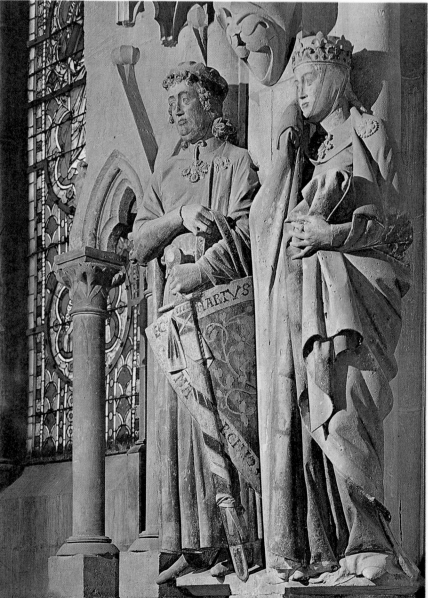

72 (above). **Master of Naumburg.** *The Last Supper* After 1249, h. *c.* 36 in. (91 cm.). West choir screen, Naumburg cathedral. One of the scenes of the Passion. Observe the great attention given to purely ephemeral gestures. All six figures are doing something that would be different a moment later or a moment before. It is this that makes the Naumburg screen one of the dramatic masterpieces of Gothic sculpture.

73 (left). **Master of Naumburg.** *Ekkehard and Uta.* After 1249. Life-size. West choir, Naumburg cathedral. One of the pair of figures representing the founders of the cathedral and their wives. Ekkehard was Margrave of Meissen (1032–46). Uta was a Polish princess. As retrospective portraits they may be modelled on 13th-century contemporaries.

74 (opposite). **Gabelcrucifix, or Pestkreuz.** 1304. Wood. Over life-size. Church of St Maria im Kapitol, Cologne. In this extraordinarily horrid statue of Christ on the Cross, his sufferings have been deliberately exaggerated, and his body distorted to make it into a caricature, designed to evoke both terror and pity. This was to become a characteristic feature of one strand of later Gothic art in Germany.

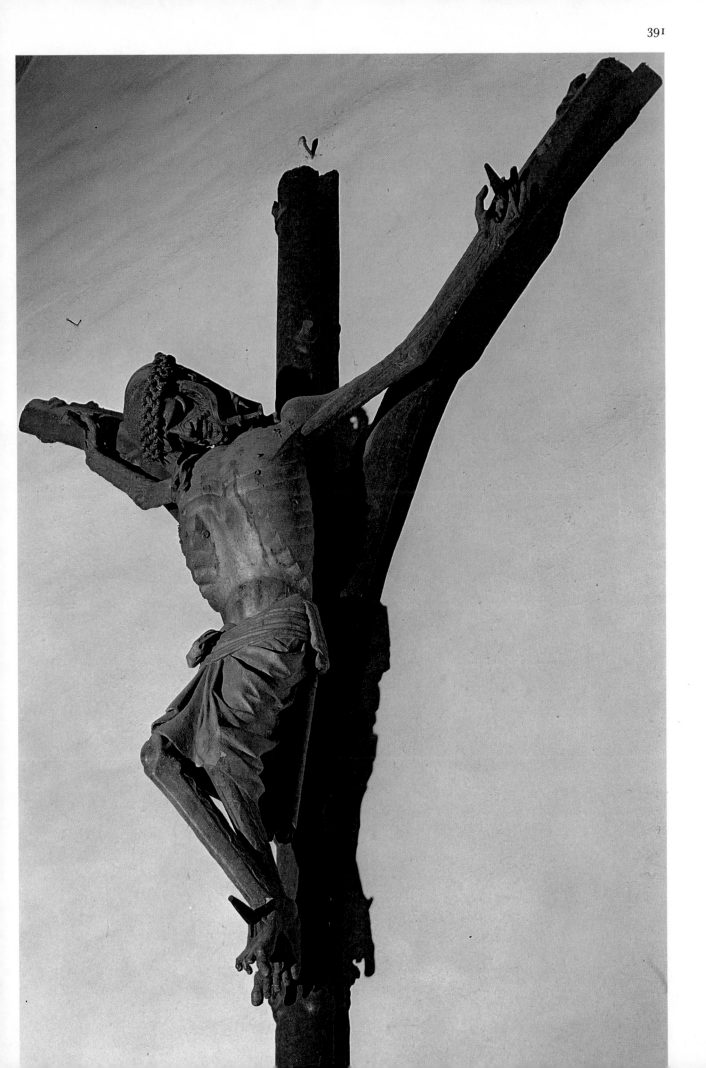

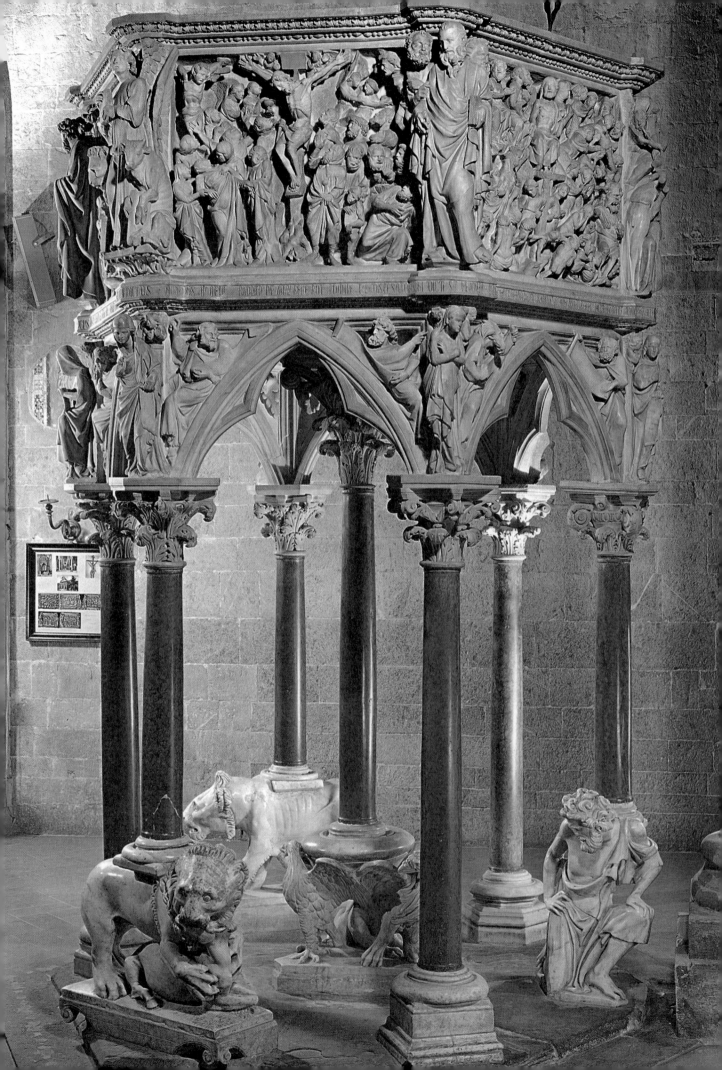

75 (opposite). **Giovanni Pisano.** *Pulpit.* Completed 1301. S. Andrea, Pistoia. The inscription on the pulpit praises Giovanni as being 'blessed with higher skill' than his father Nicola Pisano, and the emotionalism which fills his figures, with their swaying Gothic forms, is the antithesis of Nicola's monumental classicism (compare figures 96, 98).

76 (right). **Virgin and Child.** 1339. Silver gilt, h. 27¼ in. (69 cm.). Louvre, Paris. This figure of the Virgin, presented by Jeanne d'Evreux, wife of Charles le Bel of France, to the abbey of St Denis reflects the increasing sophistication demanded by royal patrons. The rich effect of the statuette is enhanced by the enamelled scenes from the life of Christ round the base.

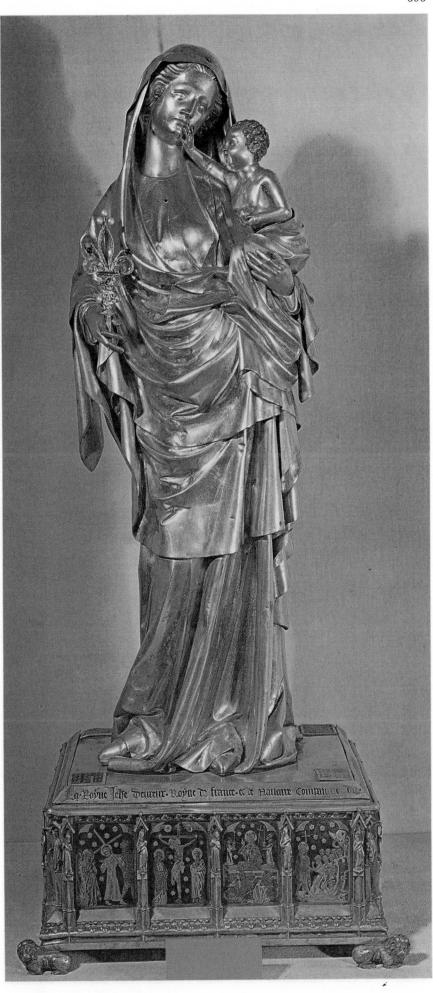

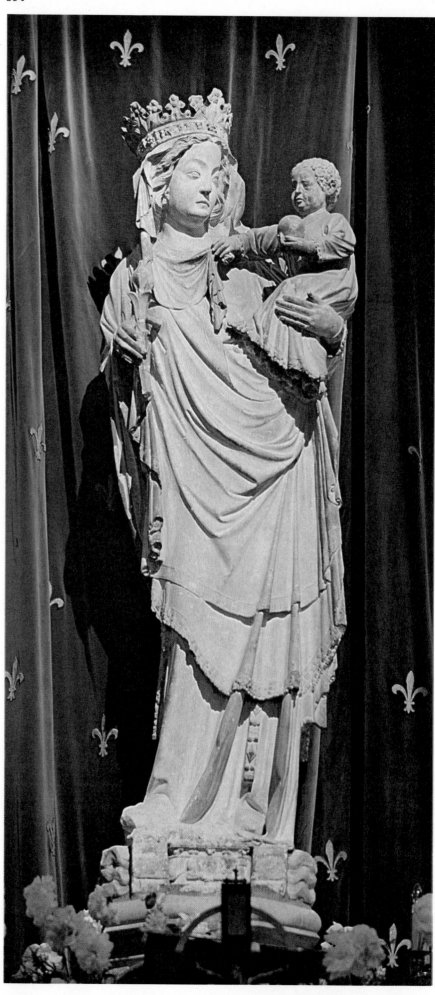

77. **Virgin and Child.** First half of the 14th century. Notre Dame, Paris. The composition of the *Virgin and Child*, very popular in Gothic art, was repeated so often that inevitably many of the works appear stereotyped. This *Virgin* from Notre Dame, when compared with the silver *Virgin* of Jeanne d'Evreux (plate 76), seems, in spite of her elegance, stiff and unoriginal.

78 (opposite). **A page from the Maciejowski Old Testament** (MS. 638 f. 3r). c. 1250. 15½ × 11¾ in. (39 x 30 cm.). Pierpoint Morgan Library, New York. This manuscript, illuminated in Paris, was presented to Shah Abbas the Great of Persia by a papal mission in 1608, and at his request the Latin descriptions were translated into Persian. The extremely lively scenes illustrate episodes in the Old Testament, from the Creation to the life of David. The ones on this page show *The Drunkenness of Noah, the Building of the Tower of Babel, The Sacrifice of Isaac,* and *The Leading of the Children of Israel into Captivity.*

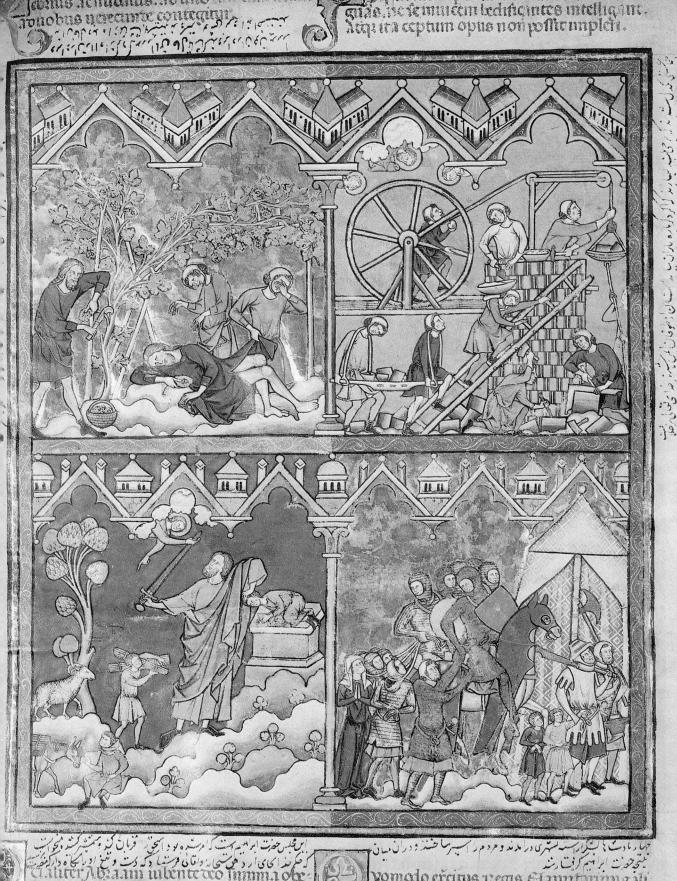

 النص العربي في الهامش الأيمن

...ebrius ac induratus. ab uno filiorum ...
...onobus ...ecunte contegitur ...

Quomodo sapiam humanam confundit lin-
guas. ne se mutuem hedificantes intelligant.
Atqui ita ceptum opus non possit impleri.

Qualiter Abraam iubente deo summa obe-
diencia sacrificare filium suum unicum no-
lens iam eleuato gladio ut feriret. ab angelo
retrahitur. et aries pter spem oblatus sacrifi-
cio destinatur.

Quomodo exercitus Regis Elamitarum cali-
orum trium regum victo rege gomorre cu
aliis quatuor regibus. captiuos ducunt. zint
alios Loth nepotem habrahe.

النص العربي والفارسي في الهوامش

טקסט עברי

79. St Peter. Detail from the Westminster Retable. Late 13th century. Westminster abbey. This retable, though much damaged, is one of the finest examples of English painting at this date, combining an Italianate modelling of the draperies with the slender elegance of the French and English court styles. There is no attempt, however, to create an illusion of space, and the background is conventional diaperwork.

80. **The Crucifixion.** From the Psalter of Robert de Lisle (MS. Arundel 83 part II, f. 132r). Before 1339. 13¾ × 9 in. (35 × 23 cm.). British Library, London. The East Anglian school of illumination, to which this manuscript belongs, is remarkable for its riotous border decoration, but this page shows a dignity and restraint more usually associated with large-scale painting. The plastic modelling of the draperies adds depth to a composition in which even the architectural motifs are merely part of the overall decorative design.

81 (opposite). **Jean Pucelle.** *The Annunciation* From the Book of Hours of Jeanne de Savoie (f. 13r). Second quarter of the 14th century. 7 × 5 in. (18 × 13 cm.). Musée Jacquemart-André, Paris. The influence of Jean Pucelle was such that motifs from his works are still to be found in books produced some fifty years after his death. His elegant, swaying

figures and charming marginal grotesques became, in the hands of his workshop, somewhat stereotyped, but his first-hand knowledge of Italian painting gave a new impulse to French illumination.

82 (above). **Master Consolus.** *A Miracle of St Benedict.* Second half of the 13th century. Fresco. Lower church,

monastery of Sacro Speco, Subiaco. The solid stocky figures of this fresco provide a sharp contrast to the attenuated forms beloved of northern Gothic artists (see plates 79 and 80). The rocky cave in which the saint sits gives a three-dimensional quality to the painting, although the little trees are a conventional stylisation.

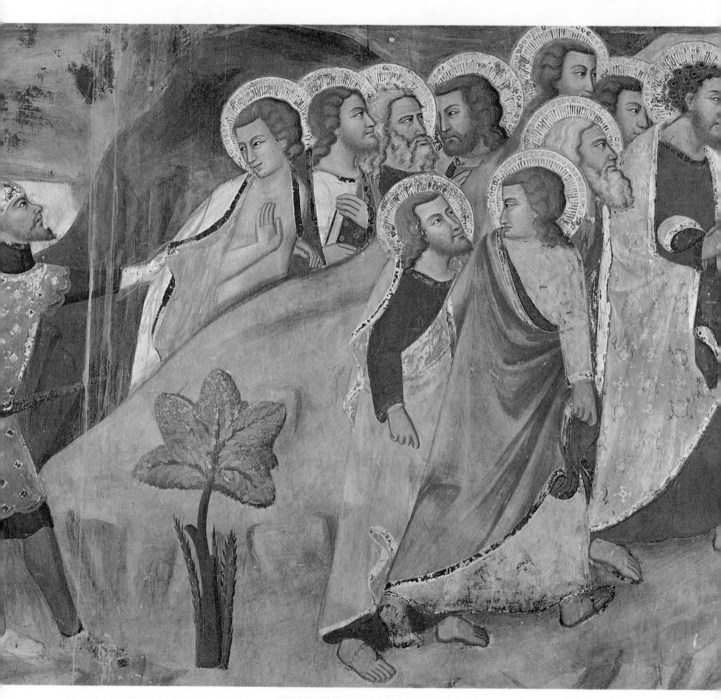

83. **The Betrayal of Christ** (detail). Third quarter of the 14th century. Wall-painting. Lower church, monastery of Sacro Speco, Subiaco. This detail from the Passion shows the apostles fleeing from the scene of the betrayal of Christ. Although Sienese origins are traceable in the facial types, the heavy figures have none of the refinement of the Sienese school (see plate 87).

77. **Nave of the abbey church of St Denis.** Second quarter of the 13th century. Suger's works at the east and west ends of St Denis (see figures 54, 55) are now linked by a 13th-century 'Rayonnant' nave and transepts. Wall surfaces are reduced to a minimum by the enormous expanse of the bar tracery clearstorey windows, and even the outer wall of the triforium is glazed (compare plates 60,61).

THE SAINTE CHAPELLE

Unquestionably the finest and most celebrated of all the church-reliquaries was the Sainte Chapelle in Paris. This was built in the royal palace to house a fragment of the Crown of Thorns, which was bought by Louis IX (St Louis) from the impecunious Latin Emperor at Constantinople in 1239. The relic arrived in 1241, and the chapel was ready by 1248. It consisted of upper and lower chambers, reminiscent of the palace chapel at Aachen. but the upper chapel is what really matters. It is a veritable glass-house, and in fact resembles in so many details the cathedral of Amiens that we are entitled to regard it as the work of someone from that town, where the choir was at that very moment in the course of construction. There is, therefore, some specific ground for thinking of the chapel as the clearstorey of a cathedral choir, transposed and set up as a free-standing structure. But the converse is also true. We are entitled to conclude that the upper parts of a cathedral choir were themselves conceived as a kind of chapel destined to contain a reliquary. This has already been suggested in the case of Le Mans, but it is perhaps even more obvious at Amiens and Cologne. External and, better still, aerial views of these cathedrals from the east, bring out with great clarity an abrupt change of style between the relatively austere chapels of the lower half of the building and the clearstorey of the upper, in which all the decorative enrichments are concentrated. It is known that when Cologne cathedral was rebuilt in 1248, the explicit purpose was to provide a more worthy setting for Nicholas of Verdun's shrine of the Three Kings, and the fact that Amiens was selected as its principal model closes a neat ring of connections between these three buildings. Together they provide the two basic prototypes for the smart churches of the future—the reliquary chapel, and a new, tracery-decorated version of the High Gothic cathedral. The style they have in common is usually called Rayonnant. 65 77

Although Rayonnant developed naturally out of the invention of tracery and although in many respects it was no more than a refinement of what had been achieved in the High Gothic cathedrals, nevertheless it coincided with one of the great divides in medieval history. Precise lines of demarcation are deceptive and difficult to draw here. But it is true to say that after the middle of the 13th century there are symptoms of a pervading mood of disillusionment, and that by the end of the century the high hopes and self-confidence which had sustained the buoyancy of the previous two hundred years had all but evaporated. The generation that grew to manhood in Europe after the death

78. **Choir of Gloucester cathedral,** looking east. *c.* 1337. In the 14th century the Romanesque arcades and galleries of Gloucester choir were concealed by a screen of tracery, and a vast window was inserted in the east wall. The Perpendicular style, of which this is one of the earliest examples, derives its name from the predominating vertical tracery bars—a radical change from the flowing curves of Decorated tracery (figures 79, 80).

79. **Window in the Octagon of Ely cathedral.** 1322–42. 80 (opposite, left). **Nave windows of Exeter cathedral.** Mid-14th century. The windows in the elaborate octagonal crossing of Ely, which replaced the Norman tower after its collapse in 1322, have the flowing tracery typical of English

of St Louis (1270) subscribed to few of the ideals which had dazzled their grandparents or even their parents. With the fall of Acre in 1291 the Crusade was virtually acknowledged to be a lost cause. The pretensions if not the myth of the medieval Empire had been destroyed by the Papacy in its fight to the death with the Hohenstaufen, and in contriving to survive, the Papacy itself had pawned away its spiritual prestige. After the humiliation of Boniface VIII at Anagni in 1303, no one, not even the Popes themselves, took seriously their claim to exercise universal authority. Even the heroic effort of St Thomas to demonstrate that the operations of the rational intellect were entirely compatible with the dogmas of the Christian faith seems to have convinced his immediate successors far less than remote posterity. An age of exuberance slowly dissolved into one of scepticism and retrenchment, and with the extinction of familiar terms of reference there was inevitably a certain amount of confusion as to the right way to turn next. By and large the instinct of the 14th century was to demand new sources of authority less fallible than reason or tradition. These were sought in many directions—in the Bible itself, in the unquestionable immediacy of mystical experience, in the *de facto* power of secular governments and, not least, by a few poets and scholars in Italy, from the records of the accomplishments of classical antiquity.

So far as patronage was concerned, the main long-term effect of these changes was that the laity took the place of the church as its principal source. The lead here was taken by the French royal family. That most Christian king, St Louis, made it his business to serve the Faith in ways that

he considered appropriate to his station, that is by lavishing on holy relics the expensive luxuries that he denied himself and his court. Other members of his family did likewise, though their motives became progressively less unworldly. Rayonnant was very much the French court style. The name is derived from the characteristic tracery pattern of the rose windows that are frequently found in French churches from about 1240 onwards, and these, wherever they occur, are sure pointers to the influence of Paris. As the king's power spread more and more effectively across the length and breadth of France, so we can trace Rayonnant architecture following in its wake—into Normandy, the Loire valley, the south and the south-west. Imperceptibly from being a royal style it became a national, and even an international, style. If it was the Church's policy to promote the advance of Gothic to the limits of Christendom, this wish was fulfilled in the 14th century, though perhaps not in the way that Pope Innocent had desired. For it was on the prestige of France rather than of the Church that Rayonnant was carried across the Channel to England, across the Pyrenees to Spain and across the Rhine into Germany.

GOTHIC IN ENGLAND

The fortunes of Rayonnant Gothic in England were very much at the mercy of entrenched insular prejudices. In a sense the whole architectural history of England between 1250 and 1350 can be seen as a running battle between protagonists of the alien style, whose headquarters was the court in London, and the guardians of the native tradition,

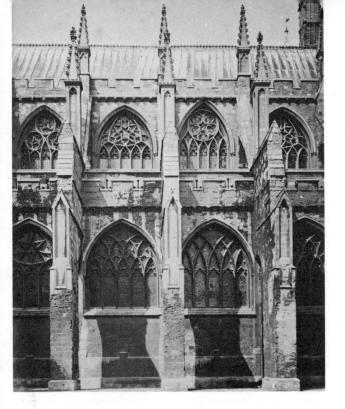

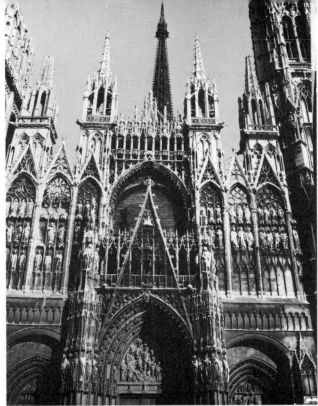

architecture of the Decorated period, particularly in northern England. The nave windows of Exeter illustrate the diversity of intricate tracery patterns found in this style, which continued side by side in the 14th century with the new Perpendicular tracery (see figure 78).

81. **West façade of Rouen cathedral.** First half of the 15th century. Although the tracery patterns found on the elaborate Gothic façade of Rouen cathedral can be compared with those developed earlier in England (figures 79, 80) the use of transparent screenwork to cover a whole façade is typical of French Flamboyant architecture.

whose strength was mainly in the west country. Not one of the great royal buildings of this period, Westminster Abbey (1245), St Stephen's Chapel in the palace of Westminster (1290), or the choir of what is now the cathedral of Gloucester (1336), can be truly described as a Rayonnant building in the French sense. Yet all three abounded with French ideas, and in the end there emerged in England a late Gothic style, Perpendicular, which was wholly based on the use of tracery panels. Without the influence of France it would be impossible to account for this radical metamorphosis of English Gothic. But with characteristic perverseness Perpendicular was to be in its way every bit as insular as the so-called Early English Gothic of the previous age. It has no counterpart on the European mainland. The only part of England that did contribute something to the stock of late Gothic ideas on the Continent was the north. Here the main centre was York, where the nave of the cathedral was rebuilt after 1291. In its own way York, like London, responded to what was happening abroad, although in this case it was perhaps the Low Countries and the Rhineland rather than France which provided the inspiration. But what distinguished the Gothic of northern England in the first half of the 14th century was its tracery. Right from the start English tracery designers showed tremendous inventiveness and, so far as we can tell, they were the first to explore the possibilities of reversing curves, at least in stone. (The sinuous line of the reversed curve would seem more appropriate to a tensile and resilient material like metal rather than stone, and it may well be that the idea was borrowed from metalwork. In that case it

may have originated in the Low Countries, and constitute yet another symptom of interaction between the two arts.) In the great west window of York minster, surely the loveliest thing of its kind in the whole range of Gothic windows, and even more unambiguously in the blind tracery behind the reredos at Beverley, these reversed curves form themselves into characteristic flame-like shapes, which are perhaps better known by the French term '*flamboyant*'. There can be little doubt that there is some connection between these English patterns and the features from which late Gothic in France takes its name. But how the idea was transmitted from England to France is something of a mystery. It is often said that the English invasion of France in the Hundred Years War had something to do with it—as though English soldiers travelled with tracery patterns in their knapsacks. What is perhaps more likely is that the English idea was taken up first in the Low Countries (where it may even have developed on its own) and that it passed from there to France, along with all the other Flemish forms which left their mark on French art at the end of the 14th century.

79

81

Be that as it may, the other English contribution, namely patterned vaulting, came from roughly the same part of the world, i.e. the dioceses of York and Lincoln. The asymmetrical vaults of St Hugh's choir at Lincoln were designed as early as 1200, and the star-patterned vaults of the aisles of the nave there (*c.* 1230) after an interval of more than two generations suddenly appear to have caught the attention of masons working for the Cistercians and the Teutonic Knights in improbably outlandish parts of the world like

71

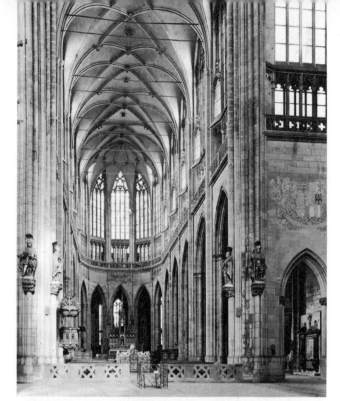

82. **Choir of St Vitus cathedral, Prague.** Choir completed 1385. The French architect called in by Charles IV to rebuild Prague cathedral, Matthew of Arras, died in 1352, and his place was taken in 1353 by a German, Peter Parler. He designed the net vaults of the choir, which, unifying as they do the entire vault surface in a continuous pattern, are of great importance to later German decorated vaults.

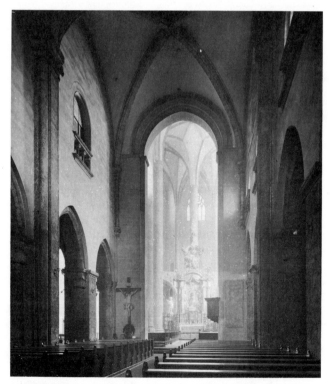

83. **Franciscan church, Salzburg.** Nave consecrated 1221, choir begun 1408. Hans von Burghausen (or Stethaimer), the architect of the choir, worked on a number of churches in eastern Bavaria and Austria at the end of the 14th century and beginning of the 15th. All are characterised by their great height and complex vaults. This choir at Salzburg is perhaps the most spectacular, thanks to the deliberate contast between choir and nave.

Pomerania and East Prussia. Just why this should have happened is very hard to say. Nevertheless the event was to be of some importance, for the ideas in question filtered southward through Silesia and reached Prague, the capital of Bohemia, in the 1350s, at the very moment when the cathedral of Prague was being built by a German mason called Peter Parler. There are some indications that Parler knew what was happening in England on his own account. Perhaps after the Hundred Years War broke out German masons, who had formerly spent their *Wanderjahre* learning how the French did things, turned to England instead. But however it happened there came together at Prague two different currents of development, one ultimately from France, the other from England. And from their mixing, under the aegis of the royal patronage of Bohemia, at that time by far the most important in the German world, there emerged the characteristic late Gothic style of Germany.

GOTHIC IN GERMANY

During the 13th century Germany encountered Gothic in two forms—as Rayonnant direct from France, and in the much more primitive version that was favoured by the mendicant orders. As Rayonnant was both expensive and difficult, it was attempted only on special occasions, of which Cologne and the Strasbourg nave provided the most outstanding instances. The very size of these undertakings made them a kind of training ground, where German masons slowly mastered both the methods of Gothic construction and the techniques of tracery design. This early prestige remained with them right through the Middle Ages, and Strasbourg was actually accorded formal preeminence over all the masonic lodges in Germany. The friars' churches, though far less impressive as architecture, were important for another reason. The religious condition of Germany in the 13th century offered scope for the friars second only to Italy and Languedoc. And the scale on which they built their churches in Germany was only equalled or surpassed in Italy. The international character of their organisations was responsible for bringing into Germany types of church that were perhaps more at home in the south rather than in the north of Europe, and this may be one of the reasons why the kind of building known as the 'hall church' found favour there in Gothic times. Structurally, the antecedents of the hall church were the single-storeyed Romanesque abbeys of south-west France, Catalonia and perhaps northern Italy. Their defining characteristic was the absence of a clearstorey, and in the Gothic halls this result was achieved by making the aisles as high as the nave. It would not do, however, to stress unduly the friars' predilection for this kind of church. It is perhaps true that for preaching purposes high aisles and broad arcades were more suitable than their opposites, and it is certainly true that some of their more ambitious buildings in the 13th century conformed to the hall church formula. But their patronage of the type was never exclusive, and in any case the prevalence of halls among

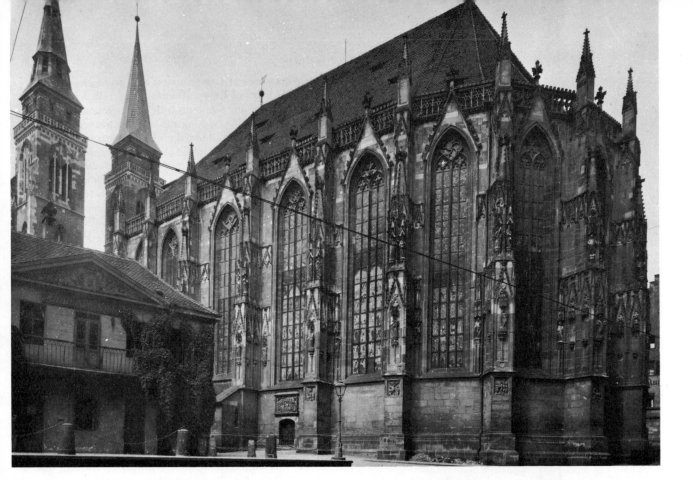

84. **Choir of St Sebaldus, Nürnberg.** 1361–72. The
parish church of St Sebaldus was built in the 13th century,
but the choir was rebuilt (possibly by one of the Parler family)
in the 14th in a manner more suited to house the remains of
its patron saint. The choir is a combination of hall church
and chapel, with an ambulatory around the shrine.

late Gothic churches in Germany requires something
more by way of explanation than the friars can provide.

One way of describing a hall church is to say that it
combines some of the characteristics of a church with a
nave and two aisles, i.e. a cathedral, with some of the char-
acteristics of a chapel. It is in effect a chapel with two rows
of columns inside. During the 14th century we can trace the
development of German thought along these lines until the
hall church emerges as a third alternative. In 1355, when
a new choir was built at Aachen to house the shrine of
Charlemagne, who was treated as a saint in his own church,
it took the form of an attenuated Sainte Chapelle, and it
may be regarded as the German equivalent of the choir of
Gloucester which was also intended to honour a would-be
royal saint. But long before that time, the tall windows
running from floor to vault which are an infallible symp-
tom that Gothic architects were thinking in terms of chap-
els, whether the Sainte Chapelle or not, had appeared in
the apses of a number of churches, mostly below cathedral
rank, while the rest of the building was handled in the
usual way, i.e. as a basilica. Most of these hybrids are now
to be found in the lower Rhineland and the Low Countries,
but it may be that the idea spread north and east from the
Paris region. In a sense, the hall church was the result of
extending this process of conversion to the rest of the build-
ing. Just as it is possible to think of the Sainte Chapelle as
an isolated cathedral clearstorey, so it is possible to see the
influence of the high windows of Cologne cathedral in the
Wiesenkirche at Soest, which was built in 1331 by a mason
who was laid off when the choir of Cologne was finished in

1322. Perhaps the Wiesenkirche is not the best example
whereby to illustrate the chapel-like propensities of hall
churches. But in something like the choir of St Sebaldus at
Nürnberg (1361), these are quite unmistakable. Outside it 84
is an enlarged Sainte Chapelle, while inside it is a hall, with
the shrine of St Sebaldus himself still there to underline the
symbolic function of the whole building. Moreover, if we
turn to the choir of the Franciscan church at Salzburg 83
which, although it belongs to the first decade of the 15th
century, really forms an integral part of this development,
we shall see just how seriously the master-mason, Hans von
Burghausen, set about the task of making us conscious of the
spatial unity of his hall. Although there are columns, they
do not form bays; and if we compare his vault with that of
the Wiesenkirche, we observe that the latter is conceived as
a series of discrete compartments, whereas the former has
an all-over pattern as though it were an encrusted ceiling.
There is perhaps no more fitting monument than the choir
at Salzburg at which to break off these remarks on late Ger-
man Gothic architecture. Designed deliberately as a foil to
the dark and low 13th-century nave by which it is ap-
proached, its soaring space and brilliant light can still evoke
vestiges of the piety and fervour that converged on the altar
in its midst. It may well be that what we have here is no
longer a victory monument of the Church Triumphant, as
at Chartres. But perhaps there is something more than
poetry in those German eulogies which see in this and sim-
ilar buildings a vision permeated by the higher spirituality
of the later Middle Ages.

But before we leave Gothic architecture altogether, there

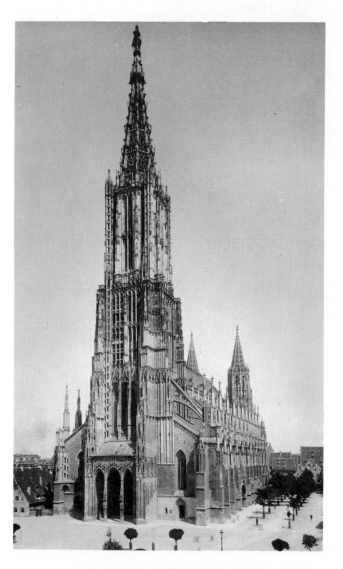

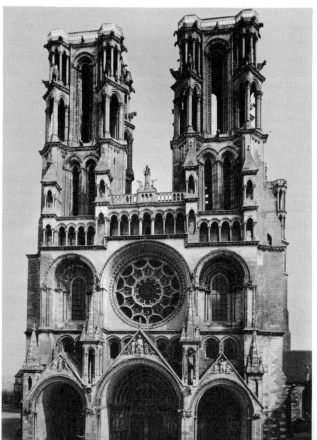

85. **West tower of Ulm minster.** 15th and 19th centuries.
86. **West front of Laon cathedral.** Late 12th century. Laon (see also figure 61) was built with towers not only at the west end, but also at the crossing and over the transepts. This fashion for a large number of towers (compare figure 28) gave way in the High Gothic period to a preference for two west towers alone. In the later Middle Ages often all attention was focused on a single enormous tower of elaborate design, such as this example at Ulm, the upper parts of which were only completed (in accordance with the medieval architect's drawings) in the 19th century. Contrast these two examples of Gothic design with the Romanesque towers of Cluny and La Charité sur Loire (figures 27, 28).

are two more of its many aspects to which allusion, however brief, must be made. One of these is the part played by towers and spires in the external effects of the great churches of the north. Up to a point it is true to say that all the really interesting things about later Gothic are concerned with surface decoration of one kind or another. Even vaults, which began as structural devices *par excellence* ended up as overhead surface patterns, different in detail from window tracery perhaps, but not serving any essentially different aesthetic purpose. Indeed, the fan vaults of English Perpendicular were to all intents and purposes tracery applied to the surface of the vault. When structural variations were adopted they were nearly always simplifications of the High Gothic system. The one exception to this rule was the great church tower, which was generally intended to carry a spire as well, although it did not always receive one. The idea of the great tower was inherited from Romanesque architecture, and no doubt to begin with they performed the same functions in a Gothic as in a Romanesque church, i.e. at the west end to carry bells and to provide useful rooms for storage, and over the crossing to serve as lanterns (though this was not always the case). They were of course also intended to make imposing façades, and to provide, when present, suitably climactic effects at the centre of the building. But Gothic towers seem to have gradually shed their practical aspects in favour of symbolic ones. The crucial moment was probably reached when the architect of Laon decided to build his towers open. No doubt there were good practical reasons for doing this. For one thing, the superstructure could be made a good deal lighter, and all sorts of complications at the corners could be made much more effective than in a solid tower. But the principal effect of the change was to substitute a gigantic free-standing ciborium for what had hitherto been a box, and this allowed the tower to acquire something of the iconographical significance of the individual compartments of the building below. It is clear from the remarks by Villard d' Honnecourt on the subject that the towers of Laon made a great stir, and the methods used there to effect the transition from a square to an octagonal section continued in use right down to the end of the Middle Ages. Until the time when the façade of Strasbourg was designed (*c.* 1277), towers and spires tended to become more and more delicate, so that in the end they seemed more like the fantasies of metalworkers than structures of solid stone. It is a great pity that the Strasbourg towers

87. **Nave of Barcelona cathedral.** Begun 1298. The huge
arcades resting on lofty piers—a feature of both Barcelona
cathedral and the slightly later church of Sta Maria del Mar
in the same town (plate 62)—are reminiscent of the design
of Bourges (plate 59) but the dim interior is typical of the
Gothic of southern Europe (compare figure 67).

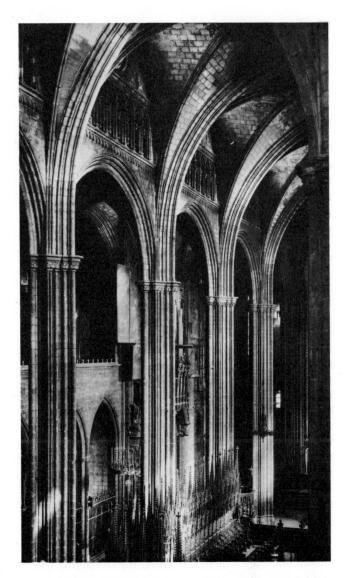

were never built on the lines laid down in the famous draw-
ing, but we can get some idea of what they might have
been like from the lantern and open-work spire at Frei-
burg, further up the Rhine (started *c.* 1300). Shortly after-
wards, however, in the façade designed for Cologne cathe-
dral (*c.* 1330), everything was enlarged to a gigantic scale.
Spires over five hundred feet high were planned, and to
ensure their stability many more stages, and therefore sec-
tions and set-backs, were required. Towers of this magni-
tude called for engineering skills of perhaps an even higher
order than those demonstrated for us by the vaults of the
13th-century cathedrals. In Germany they became some-
thing of a masonic *tour de force*, and as prestige symbols
their value was no doubt overwhelming. Of the many that
were designed, however, only two were actually com-
pleted during the Middle Ages—the great monolithic
finger on the west front of Strasbourg (which replaced the
ealier design), and the south tower at Vienna. But their
counterparts exist in every country of northern Europe.

It is necessary to resist the temptation to regard these
towers merely as vulgar prodigies. In the multitude of
gables by which they are surrounded at all levels, the idea
of the niche is never very far away, and each of the finials
that terminate the residual masonry at the set-backs is in a
sense a miniature tower and spire in itself. The spire of
Strasbourg is made up of tier upon tier of open traceried
compartments, in fact a veritable multitude of tiny ciboria.
No statues inhabit these abodes, but this is perhaps no more
than the recognition of inexpediency. On the Tour de
Beurre at Rouen, which is one of the best French examples,
clusters of statues may be seen high up and far away from
the eye of any human beholder, each under his own gable—
the saints keeping their eternal watch. And this, basically,
is the purpose that all the niches and gables were meant to
serve. In the last resort the tower itself was a gigantic reli-
quary, the last and in some ways the greatest of the medi-
eval variations on this theme.

This brings us back once more to the recurrent question
of interaction among the Gothic arts. In the cathedral
treasury at Aachen are two magnificent reliquaries, each in
the form of three towers. They date from the middle of the
14th century and, scale, material and technique apart, it is
clear that there is a fundamental identity of form between
them and, say, the towers and spires of the Strasbourg
drawing. The largest and the smallest categories of Gothic
art meet in their preoccupation with the symbolism of the
niche. The formula could be applied in many ways. King
Edward II of England at Gloucester (d. 1327) and Pope
John XXII at Avignon (d. 1334) both lie under their own,
stone, versions of the Three Towers shrine. Gabled can-
opies of wood could be placed side by side to form choir-
stalls, or enlarged in splendid isolation to make a bishop's
throne, so that in yet another way during the performance
of the holy office the clergy could feel themselves at one

with the company of Heaven. In stained glass and in illu-
minated manuscripts ornamental architecture of the same
kind serves precisely the same purpose, and it was almost
certainly with the intention of evoking an illusion of this
sacred space under canopies that the first tentative steps
were taken in the north toward the mastery of perspective.

The versatility and often the sheer banality of so much of
this Gothic niche-work is apt to deflect the attention of
amateurs toward the exceptional masterpieces, which
qualify as art to us. But for any historical estimate this was
what Gothic art was really about—the evocation of the
sacred. By far the most effective way of doing this was by
drawing lines of demarcation between the sacred and the
profane, i.e. by setting space apart, or devoting it, in the
old classical sense of the word. This has always been archi-
tecture's special function, and there is nothing remarkable
in Gothic acknowledgment of the fact. But the scope of the
idea was something that the Middle Ages had to explore for
themselves, and behind the tortuous proliferation of
Gothic detail may be detected the strong flavour of a very
peculiar yet not wholly preposterous religiosity.

GOTHIC IN SOUTHERN EUROPE

It is against the background of this all-pervading aspect of
northern Gothic that we ought finally to turn once more to

the south. For there the prickly paraphernalia of Gothic tracery and niche-work is for the most part conspicuous by its absence. When we do come across it, as at Milan (1386) and the later Gothic cathedrals of Spain (e.g. 15th-century Seville) we may be certain that masons from Germany, the Low Countries or France have been travelling far from home. But at Albi (1282) the predominant impression of the masonry is that of the bleak Dominican church at Toulouse, and perhaps it was even closer to the lost Franciscan church there which was even more severe. In Aragón the same austerity was combined with a still more ambitious type of structure. The 14th-century cathedral of Palma de Mallorca, and Sta Maria del Mar at Barcelona, perhaps the most spectacular Gothic building in the western Mediterranean, confront us with distinct allusions to the programme of Bourges. Here if anywhere the great Gothic tradition of structural engineering was carried beyond the achievements of 13th-century France. The ultimate triumph of Gothic vaulting, the projection of a span of more than seventy feet across the nave of Gerona, was reserved for Catalonia. And it is perhaps worth remembering that the debate of the Gerona masons as to whether they should attempt this prodigious feat took place at almost exactly the same time as another debate at Florence, where Brunelleschi tried to persuade the masons of the cathedral that it was possible to build the projected dome bequeathed to them by their predecessors. In conception if not in execution, that dome was a Gothic work, and Florence cathedral (started 1296) belongs to a group of Italian churches which, though on the whole less enterprising than their Aragonese counterparts, reflect much the same general approach to Gothic. Sta Maria Novella at Florence (nave 1278) is perhaps the most satisfying of these, but Milan cathedral (before it received the benefits of northern cooperation) and S. Petronio, Bologna (started 1390), are its most grandiose representatives.

There is certainly no lack of competence in these southern Gothic buildings, and if the forms of northern decoration are missing this must ultimately be a question of southern taste. But it also follows that the role of the masons in the general economy of the arts was very different in the south. By the 14th century Gothic had come to mean two quite distinct things, which can be summarised under the headings of engineering and design. In the north both were practised by the same people, whereas in the south the masons did the engineering and the decoration was left to someone else, usually painters. The fact that in Italy the exponents and guardians of the traditions of 'disegno' were not primarily architects was certainly responsible in part for the eccentric development of all the arts there in the 14th and 15th centuries. For one thing, the masons, because they had no vocabulary of architectural ornament of their own, were wide open to Brunelleschi's classicism when it came. And in fact all the really interesting things in late Florentine Gothic are concerned with the search for just such a vocabulary. But the most important thing of all

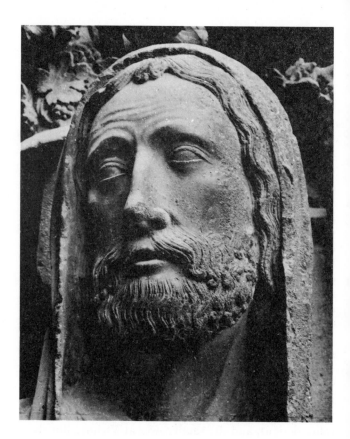

was the undue prominence that painting assumed in Italy. The invention of linear perspective might almost be said to have arisen from the efforts of painters to do what in the north would have been left to the niche-workers. The creation of the illusion of space was first and foremost a question of creating an illusion of architecture. But before we consider the significance of Gothic painting it is necessary to say something about the figure arts, and first and foremost this means sculpture.

GOTHIC SCULPTURE

If we go right back to St Denis, we come face to face with a preliminary paradox that the sculpture of the first Gothic buildings can only really be called Romanesque. New beginnings in architecture do not necessarily mean new beginnings in sculpture and, so far as we can tell, the transformation of the figure arts started in a region notorious for its loyalty to Romanesque architecture. Furthermore it would be quite wrong to postulate some pre-ordained course of parallel development for the two arts. By the 1170s the new architecture and the new figure sculpture met up with one another, probably in Champagne, and from then on they proceeded to develop in close proximity to one another for about a hundred years. But to speak of Gothic sculpture before about 1230 requires a good deal of qualification.

The great discovery made by the sculptors of the High Gothic cathedrals was that the special relationship between God and man could be expressed in terms of man alone, and that neither the divinity of God nor the experience of God required any drastic transfiguration of the human form. Henceforth both God and the saints could be depicted without conspicuous stylistic deformation, and for the first time since classical antiquity the way was open for a kind of art that was both humanist and representa-

88 (opposite). **St John the Baptist.**
c. 1215. South doorway on the west front
of Reims cathedral. The rebuilding of
Reims cathedral began in 1211, and
from the beginning an extensive
sculptural programme was planned.
Some of the earliest figures are the
forerunners of Christ of whom *St John the
Baptist* is one. Stylistically they can be
linked with the north transept sculptures
of Chartres.

89. **The Blessed in Heaven.** 1230s.
Tympanum of the Christ Porch in the
north transept of Reims cathedral. The
serentiy of these figures is typical of the
idealised view of mankind which
characterises so much of early 13th-
century French sculpture. While the
Germans aimed at representing man's
emotional reaction to a situation, the
French in such sculptures as these
achieved a heroic quality of a totally
different nature.

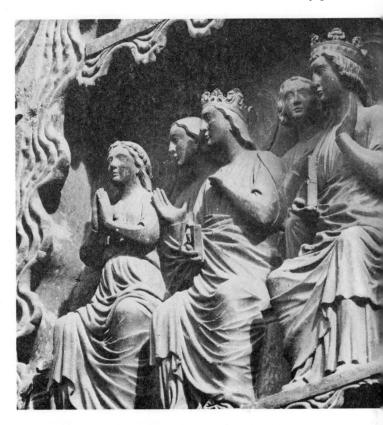

tional. It is not surprising, therefore, that in emancipating themselves from the tyranny of attitudes which had prevailed since Early Christian times, Gothic sculptors should have called upon classical forms, or what they took to be classical forms, to play a catalytic role. They did so in several stages. It was brilliantly demonstrated recently that in the north portal of the west front of Notre Dame, Paris, the style of the column figures was more than superficially affected by 10th-century Byzantine ideas, perhaps an indirect consequence of the flood of portable Byzantine works of art that reached the West after the sack of the city by the Crusaders of 1204. But more or less at the same time, i.e. about 1220, the first group of sculptors working at Reims took the even more decisive step of using actual Roman statues as their models. In view of what happened in Paris, it is unlikely that the Master of the Antique Figures at Reims expressly wished his *Virgin of the Visitation* to look like a Roman matron. Instead we ought perhaps to see both sets of statues as attempts to find suitable formulas for free-standing figures, by men who were not yet clear in their own minds as to what they wanted and did not want their images to be. To us, knowing that in another two hundred years sculptors would once more turn to the antique for their inspiration, the early works at Reims are liable to seem unduly significant. That they were perhaps the most accomplished statues of their generation cannot be denied. But the most important thing about them is that in spite of their quality they were not copied (except at Bamberg). The second school of Reims sculptors evolved an entirely new style of drapery which owed nothing to its predecessors, apart from a certain sense of monumentality, and perhaps the method of building up figures from simple geometrical abstractions. In the abrupt end which befell this brief Gothic experiment with classical sculpture it is possible to recognise once more the censorship of the

Church. At the moment when the Inquisition was setting up its tribunals, it is hardly likely that classical forms should seem anything other than pagan. But in any case the prohibition, if it amounted to such, cannot be said to have frustrated the natural growth of Gothic sculpture.

While it is clear that the imitation human being was in some sense the goal at which sculptors were aiming, it would be wrong to regard this quest as an exact replica of that which led the Greeks from archaic to classical forms. For the Greeks the human ideal could be expressed only in terms of physical perfection. For the men of the Middle Ages, however, with their acute sense of the antithesis between body and soul, humanism was first and foremost concerned with the attributes of personality. All virtue belonged to the soul, and the vitality of the soul was expressed through the emotions. In so far as it sought to render these things in movement, gesture and facial expression, Gothic sculpture was much closer to its Hellenistic than to its classical antecedents. But in practice it received very little help from any examples. The sculptors were on their own, and the novelty of their enterprise, especially in its early stages, revealed itself in both understatement and overemphasis.

Essentially the problems resolved themselves into two quite distinct categories. On the one hand were those connected with the rendering of things like beauty, grace, nobility or wisdom—the ideal aspects of personality—while on the other were less edifying characteristics and the more extreme forms of emotion. At the risk of committing a gross oversimplification, it is expedient to deal with these separately, and to discuss the former as though they were exclusively French, and the latter as though they were predominantly German. It may be said at once that neither of these generalisations is true, but the accidents of survival to some extent excuse this cavalier treatment. They also justify taking the German achievements first.

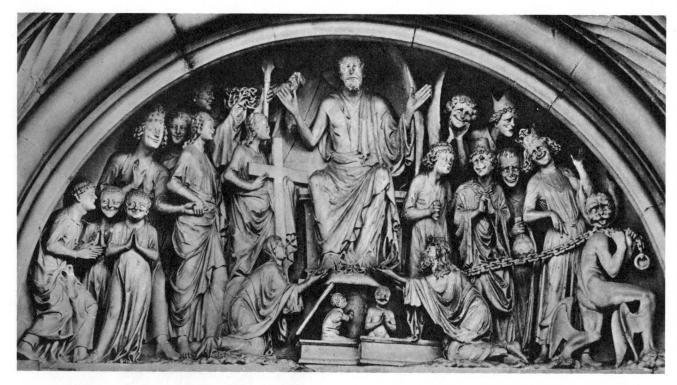

90. **The Last Judgment.** Second quarter of the 13th century. North portal *(Fürstenportal)* of Bamberg cathedral. Instead of presenting a catalogue of possible torments the sculptor of this tympanum set out to portray the emotional reaction of those condemned to everlasting damnation. Ludicrous as the result may seem in this case, the attempt to enhance a dramatic situation through its emotional content is of great importance to German sculpture.

92 (opposite). **The Death of the Virgin.** Second quarter of the 13th century. South transept portal, Strasbourg cathedral. Although both in facial types and drapery styles these figures from one of the tympana show affinities with contemporary French sculpture, the dramatic presentation of the scene is characteristically German.

91. **South transept portal of Strasbourg cathedral.** Second quarter of the 13th century. The Gothic figures set on either side of this Romanesque portal represent the *Church* and the *Synagogue.* Although each has her traditional attributes, the postures of the two figures are themselves expressive of triumph and defeat. The trumeau figure represents Solomon.

Between about 1230 and 1260 three programmes of sculpture were carried out in Germany of surprising virtuosity. They were at the cathedrals of Bamberg, Strasbourg and Naumburg. Although the Master of Naumburg was active after the reception of Rayonnant architecture on the Rhineland, all three are associated with buildings whose Gothic is either nonexistent or of an extremely tentative kind, which makes the High Gothic connections of the sculptors themselves even more remarkable. Before these campaigns there was comparatively little monumental sculpture to be seen in Germany, and what there was seems to have emanated from Italy rather than France. The dramatic shift of German interest from the south to what was happening beyond the Rhine after the battle of Bouvines in 1214, and after the virtual withdrawal of Imperial patronage, is symptomatic of the new political and cultural orientations of 13th-century Europe. It might have been expected that this decline in the political fortunes of Germany would have entailed a general atrophy of her spiritual life. On the contrary, in certain fields, precisely the opposite happened. A generation before, German poetry had suddenly burst into life, and it is perhaps legitimate to acknowledge bonds of sympathy between the poets and the sculptors, even though their statues were not meant to illustrate literature. Why should we not think of Wolfram's *Parsifal* when we look at the Bamber *Rider*?

BAMBERG

The impact of French sculpture on Germany can perhaps best be seen at Bamberg. Already before the exponents of

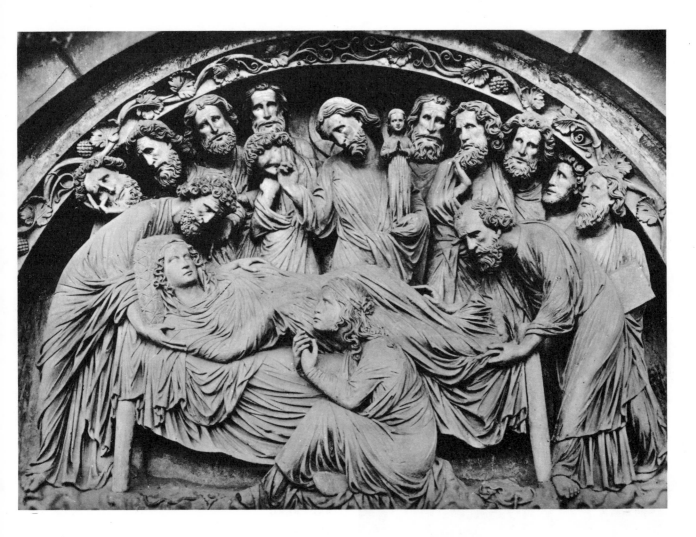

the new style arrived, a screen around the eastern choir was being carved in a late Romanesque style of tremendous vigour, seemingly derived from contemporary Bavarian manuscripts, as one might have expected in a region without established traditions of monumental sculpture. The French influences came from Reims, but they seem to have been infused by the vitality of the local school in more ways than one. although they are connected, the freedom and energy of the Bamberg drapery folds make the efforts of the Master of the Antique Figures at Reims seem pedantic by comparison. This vigour is a token of a quite different artistic purpose. In nearly all the great ensembles of French cathedral sculpture the overriding purpose is didactic. The figures are there to represent nothing more than themselves in the concourse of the heavenly host. Often they can be identified only by their attributes. But the Bamberg Master on his infinitely smaller scale is concerned with something more, which might be called the emotional participation of his characters. From this point of view he is at his most interesting, even if he is not entirely successful, when he tries to cope with a dramatic scene like the *Last Judgment*. On the whole, French *Last Judgments* tend to be phlegmatic affairs, which only come to life, so to speak, in the horrible torments of the damned. At Bamberg we are offered not scenes of damnation but what are meant to be contrasted psychological studies of the saved and the damned. The contrast is admittedly not very effective. If the little souls on their way to the eternal delights of Abraham's bosom look suitably smug, those about to suffer seem in positive transports of hilarity. The attempt to con-

vey anguish has misfired. But the important thing is that it should have been attempted at all.

STRASBOURG

At Strasbourg, hardly any later than Bamberg (*c.* 1235), nothing whatever has misfired. On the south transept of the cathedral are two portals, each with a carved tympanum, one devoted to the death of the Virgin, the other to her coronation. The *Coronation* scene is handled in a perfunctory way in a style which, though reminiscent of Chartres, could equally well have been derived from the famous *Hortus Deliciarum*, a manuscript closely connected with Nicholas of Verdun, and at that time kept at the monastery of Mont Ste Odile, near Strasbourg. On the other hand, the *Death of the Virgin* is so shot through with sentimentality that it would seem almost more at home in the 19th century than in the 13th. The traditional Byzantine formula, where Christ himself comes to carry the Virgin's soul to heaven, has been turned into a purely human death-bed scene in which the Son pays his last respects to his mother, and the row of apostles in the background provide an array of expressions of muted grief. Even the malignant Jew in the foreground has been rendered in an equivocal way so as not to strike a discordant note. One may not approve of this kind of art today, but it shows a remarkable command of the technique of arousing emotion by representing it which, after all, has been one of the principal methods of Western art from that time almost to our own.

When we turn to the statues of the *Church* and the *Synagogue* which stand on either side of the Strasbourg portals,

93. **Synagogue.** Second quarter of the 13th century. South transept porch, Strasbourg cathedral. The anatomical distortions of this figure, which are exaggerated by the clinging draperies, convey, as the impassive face does not, a sense of defeat. The eloquent twist of the body, and the head averted from her trimphant rival, the *Church*, are echoed in the multiple breaks in the spear she carries.

the possibilities of sculpture seem to have been explored a stage further. The contrast between these two symbols was a specialised form of a dichotomy on which Romanesque theologians had meditated endlessly—that between old and new, prophets and apostles, nature and grace, and so on. The *Church* is a beautiful young woman with cross and chalice, looking boldly across the portal at her superseded rival. The *Synagogue* is also a beautiful young woman—at least from the front. Her head is downcast and turned against the twist of her body, so that one senses a certain tension in her acquiescence. but if we actually look at her from the side, that is as the *Church* sees her, everything changes. It is from this angle that the broken spear really looks broken, the downcast head is on a broken neck, and the lovely body turns out to have an ugly sag in the abdomen. Like Kundry in *Parsifal* this image has two personalities, one beautiful and one repulsive; the beautiful one is a snare of worldliness, while the ugly one is the truth as God sees it. Is this reading too much into a Gothic statue? If it were an isolated case, it would be as well to be sceptical. But at Naumburg the beholder is brought into an even more specific relationship with a statue, or rather with a group of statues.

NAUMBERG

The west choir of the cathedral of Naumburg seems to have been built, either just before or just after 1249, as a kind of memorial chapel ostensibly intended to honour early benefactors of the cathedral. This choir or chapel is closed off from the rest of the church by a screen which is carved with reliefs of the Passion. It was customary in medieval churches to raise over the screen dividing choir and nave a rood cross, i.e. a crucifixion, with Mary and St John in attendance. A few Romanesque examples have survived in Germany, and there are several famous painted instances from Italy. The imagery that surrounded the rood cross was particularly complex, and in 13th-century Germany it was often presented in a lavish and literal way. The Naumburg instance is only the best preserved. Here the rood has been brought down and placed in the doorway of the screen, so that the doors are set under the arms of the cross. Anyone entering the chapel has therefore to pass immediately under the outstretched arms of Christ. The idea that Christ was the door to everlasting life may be found in many French cathedrals, but usually in the form of the *Beau Dieu* of Chartres which, if nothing else, is infinitely less theatrical. The *Christ* at Naumburg is deliberately pathetic. The crown of thorns hurts. The body twists with pain. He is a human being, dying. The Romanesque roods completely ignored this aspect of the crucifixion. They present the death of Christ as a triumph. Sometimes, as in the Ottonian Gero cross at Cologne, one senses the heroic cost, but pathos is always absent. The Naumburg *Christ* is the first known to us in which it becomes the predominant aspect. By comparison with the extravagant variations on the theme which followed and

which did not reach their culmination until Grünewald's Isenheim altarpiece in the 16th century, it is modest and passive, and all the more moving. We cannot escape this Christ. On either side of the doorway are the lamenting figures of Mary and St John who point to him in their grief, which in this case cannot be mistaken for anything else. But Mary goes further. She is not wrapped up in her grief. She lays one hand on her breast, points to Christ with the other and addresses you, the beholder. You are brought dramatically into the situation.

The whole thing is in fact a little Passion play. And the scenes in relief above are stills from the same drama. Whether they were in fact inspired by some primitive Oberammergau, they achieve an unprecedented realism. The sculptor delights in capturing the most ephemeral gestures—drinking from a cup at the Last Supper, or even pouring the water for Pilate to wash his hands. The figures move with a solemn prescience as though they know they have to reveal their characters in their faces. We recognise the forbearance of Christ, the malignance of the High Priest and the weakness of Pilate. Although these scenes had been carved on many previous occasions, this was perhaps the first time that the figures were set out in depth, in a way reminiscent of later pictures.

Inside the choir, somewhat to our surprise, we encounter realism of quite another sort. It is clear that the sculptor was acutely sensitive to the tragedy of the Passion, and he may well have been the kind of artist who expressed his piety through his art. But this does not prepare us for the assortment of secular characters who await us. Moreover, the discovery that they are all historical personalities adds to the surprie. As they all lived and died long before the statues were made, there is no possibility that they were literal portraits. But they could have been modelled on actual contemporaries, and they inevitably call to mind characters from contemporary literature. With the possible exception of a lively Frenchman masquerading as St Joseph at Reims, these are the first medieval statues about which we may risk remarks on the subject of national character. Germans say that they are unmistakably German, and few would disagree, at least about some of them.

It is not necessary to actually like the Master of Naumburg's work to realise his importance. In his quest for realism at all costs he was obviously a fanatic, but in finding ways to achieve his purpose he broke new ground. For this man art was not primarily a question of making the invisible visible, or simply of making statues. It was making people. The dangers to which this point of view could lead he managed to avoid, either because he was an innovator, or because he lived and worked in an aristocratic world. But we can trace his influence through a succession of later German sculptors who, perhaps to suit the taste of burgher patrons, turned his expressiveness into caricature. On the one hand there are horrible things like the Pestkreuz at St Maria im Kapitol at Cologne, which is a veritable anticipation of Grünewald, on the other the mannered and slightly

94. **Gero Crucifix.** Third quarter of the 10th century. h. 74 in. (188 cm.). Wood with traces of pigmentation. Cologne cathedral. Compare this stern Ottonian interpretation of the Crucifixion (see also plate 15) with the Gothic sculpture at Naumburg (figure 95).

95. **The Naumburg Master.** *The Crucifixion.* After 1249. Rood screen, Naumburg cathedral. The expressive figures of the Virgin and St John in this Crucifixion group convey their emotions with a dignity and restraint which is far more realistic than the exaggerated contortions of the Bamberg damned (figure 90).

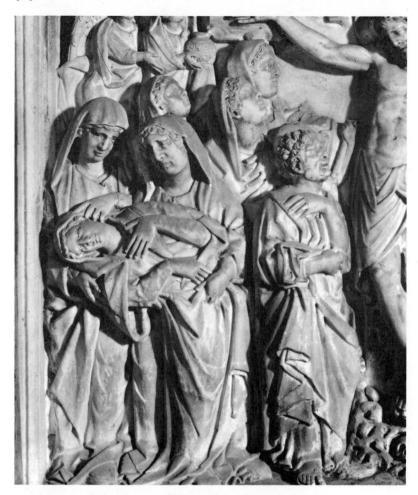

96 (left). **Nicola Pisano.** *The Crucifixion* (detail). 1260. Detail of pulpit in Pisa Baptistery.

98 (opposite). **Giovanni Pisano.** *The Crucifixion* (detail). 1301. Detail of pulpit in S. Andrea, Pistoia. The striking difference in style between these works by two members of the same family can only be explained by the influence on Giovanni Pisano of northern Gothic sculpture. Although the placing of the figures in both details is almost identical, the stiff poses and classically-inspired heads of Nicola's group have a formality which, in Giovanni's work, has been replaced by a feeling for movement and expression more compatible with the art of the Master of Naumburg (see figure 95). (See also plate 75.)

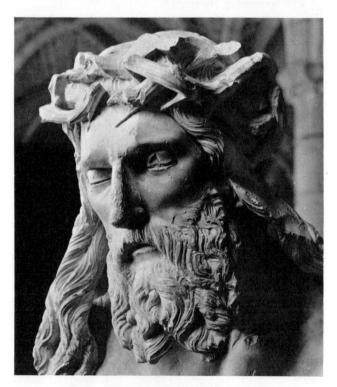

97. **Claus Sluter.** *Head of Christ.* 1395–9. Stone. h. 24 in. (61 cm.). Musée Archéologique, Dijon. This fragment of the *Crucified Christ* comes from the Calvary which originally surmounted Sluter's Well of Moses, executed for the Chartreuse de Champmol at Dijon between 1395 and 1406. this sculpture, though mutilated, is still an impressive portrayal of patient suffering.

frivolous statues in the west portals at Strasbourg. It needed an artist endowed with very great depth of feeling and acute sense of character to control this legacy, and so far as the north of Europe was concerned there was apparently no one of the requisite calibre before Sluter at the end of the 14th century. It is doubtful whether Sluter actually knew any of the Master of Naumburg's work, although it is conceivable that he may have seen some at Mainz. But either knowingly or unknowingly, when Sluter cut right across the fashionable delicate style of his day in favour of monumental figures, highly charged with emotion, he was taking up where the Master of Naumburg left off. The head and torso of *Christ* from Sluter's Calvary at Dijon (1395) is the first to bear comparison with the Naumburg *Christ*, while the *Virgin and Child* from the portal of the Chartreuse at Dijon remind us, if not of the Naumburg *Virgin* herself, then of the essays on that theme by the Italian, Giovanni Pisano.

THE PISANO FAMILY

If anyone can be said to have inherited the outlook of the Master of Naumburg, the best claimant in the generation that followed was this most gifted member of a whole dynasty of sculptors. Giovanni's father, Nicola, appeared at Pisa in the middle years of the 13th century, where he completed a pulpit for the Baptistery in 1260. It is often said that he came from the south of Italy, where Emperor Frederick II (1198–1250) had been promoting his own private renaissance for political ends. Frederick's activities constituted the one blatant instance of outright 'pagan'

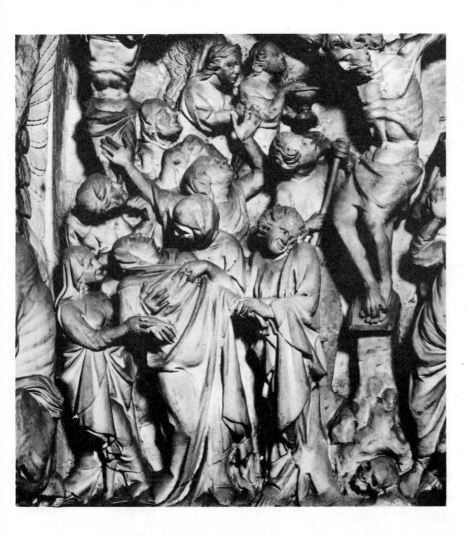

classicism in the Middle Ages. At Capua in 1233, on a monumental gateway guarding the approaches to the River Volturno on the road from papal Rome, whose lower section was composed of superbly rusticated masonry, were several statues and busts in niches representing the Emperor and his officers of state accompanied by allegorical figures whose purpose certainly fell under the heading of propaganda. Togas, fillets and ideal facial features, together with a quite unmedieval sense of anatomical proportions, set these statues apart even from the classicising works at Reims. Not unnaturally they have been hailed as harbingers of the later Italian Renaissance. Yet in their own time, with the possible exception of Nicola Pisano, they were curiously without influence, and like everything else about him Frederick's use of classical art forms is shrouded in ambiguity. One suspects that it was nothing more than a convenient instrument of ideological warfare. Certainly for the rooms of his castles, e.g. Castel del Monte (c. 1240), he was prepared to use the prevailing Gothic fashion of his time. Even here, however, it was perversely characteristic of the man to use Gothic for domestic rather than ecclesiastical purposes.

The rusticated masonry of Capua and Castel del Monte reminds us of one other much neglected aspect of medieval classicism, namely its influence on military architecture. When the Crusaders built their castles, e.g. Krak des Chevaliers in Syria, on the principle of two concentric walls each furnished with projecting towers, they were following the example of the 5th-century land walls at Constantinople. No doubt the state of warfare in the 12th and

13th centuries offered highly practical excuses for such imitations. But the castles and fortified defences which the Savoyard, Master James of St George, built for Edward I of England in north Wales about 1280 must have borne an equally remarkable likeness to other late Roman defence works.

But, to return to Italy and the Pisani, the only classical models that come readily to mind when we are confronted by Nicola Pisano's pulpit are Etruscan tombs and a sarcophagus known to have been in the Campo Santo at Pisa in his time. So the southern hypothesis is not particularly strong. The Pisa pulpit more or less coincides with the high-water mark of Imperial fortunes in central Italy, i.e. the victory of Montaperti in 1260. And with the triumph of the papal agent, the Frenchman Charles of Anjou, over the Hohenstaufen in 1265 it soon evaporated. The three successors of the Pisa pulpit, made for the cathedral of Siena (1265), S. Andrea at Pistoia (finished 1301) and the cathedral at Pisa (finished 1310), have a much more pronounced northern Gothic flavour. It is often said that Giovanni, who was responsible for much of the second and all the last two pulpits, learnt his Gothic in France. It may well be that he went to France, but if he did so he almost certainly went via the Rhineland, and the religious hysteria that seems to animate his later work is much more likely to have been imbibed in Germany than in France. Even so, it is not necessary to attribute all his violence and agitation to northern sources. If he ever saw something like a 3rd-century AD battle sarcophagus (now in the Ludovisi collection of the Terme Museum at Rome) this could well

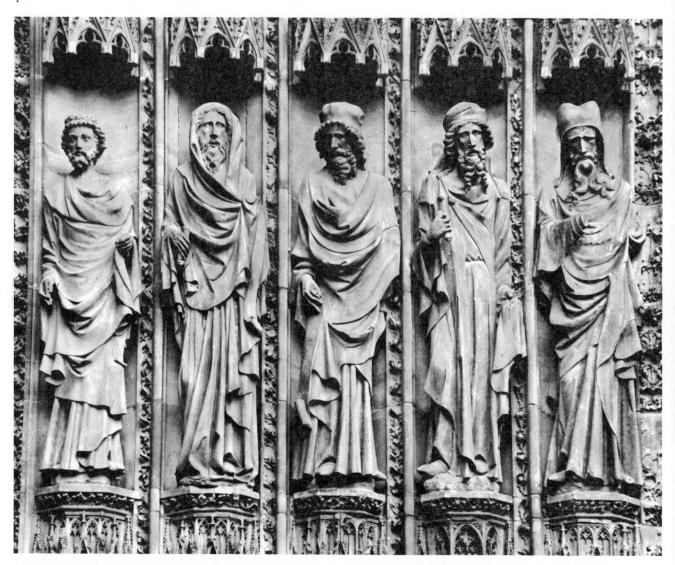

99. **Prophets.** Last quarter of the 13th century. Central portal on the west front of Strasbourg cathedral. The draperies of these figures, which give little indication of the body beneath, and the elaborate treatment of hair and beards are symptomatic of a swing in interest away from the heroic forms of early 13th-century sculpture and towards that absorption with decorative detail which marks so much 14th-century work.

have accounted for more than just the formal lay-out of his panels. Other members of the Pisano family, less emotional than Giovanni, did, however, derive from France a more congenial kind of Gothic. The first set of bronze doors, which Andrea Pisano made for the Baptistery at Florence (1330), brings us face to face with the more suave and elegant Gothic figure style whose ultimate home was Paris.

In discussing this German Gothic sculpture, and works that share its fundamental outlook, the vocabulary of human experience comes naturally to mind. The function of drapery in these statues is subordinate to, and in fact shows off, their psychological content. Nevertheless a Gothic statue was very seldom thought of as a body over which draperies happened to have been placed, as classical Greek statues were. For most Gothic sculptors drapery was the body. Just how essential clothes were becomes painfully obvious when they were removed altogether, which is what happened to the embarrassed but celebrated *Adam and Eve* at Bamberg—the first monumental nudes in medieval art. As examples of anatomy they are woefully inadequate, however effective as reminders of original sin. When

we turn to the other main category of Gothic figures, however, where there was no ulterior purpose for the drapery to serve, we find that the patterns tended to become ends in themselves. Actually no very hard and fast line of demarcation can be drawn between the two groups in this respect. The same conventions could obviously occur on both sides of the line.

The first essential was for monumental figures to emancipate themselves from the influence of the columns out of which they had, so to speak, emerged. We find symptoms of this in the transept and portals at Chartres, where the figures begin to loosen and turn towards one another. At Reims by 1220 the process was complete. A decided swaying movement can be detected in some figures of the classical group, and this even operates in the orthogonal dimension as well (i.e. from back to front) although here one suspects that questions of balance and stability were involved, rather than aesthetic effects. How these figures

(Continued on page 433)

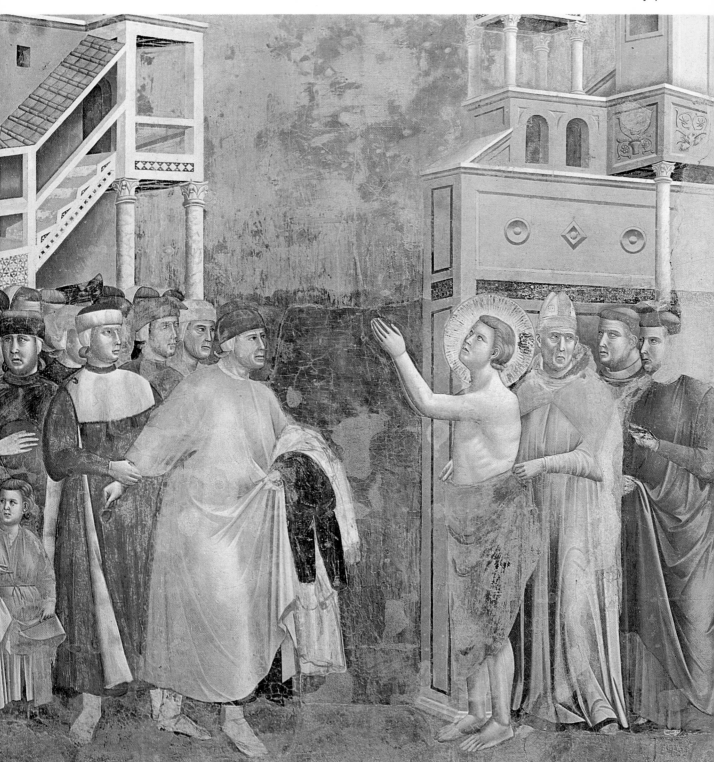

84. **School of Giotto.** *St Francis renouncing his Inheritance.* c. 1300. Upper church, S. Francesco, Assisi. The drama of this episode in St Francis's life is heightened by the sharp demarcation between the two groups (see p. 437) and the arrested movement of the figure stepping towards the saint. The buildings are seen as three-dimensional objects, and the bodies of the figures are clearly defined under their draperies.

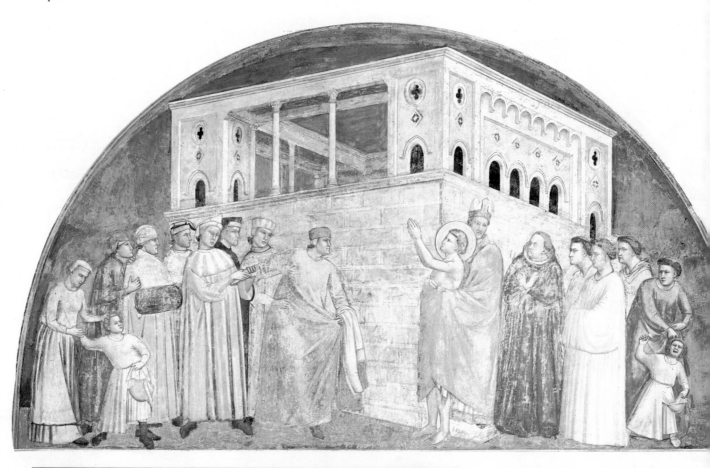

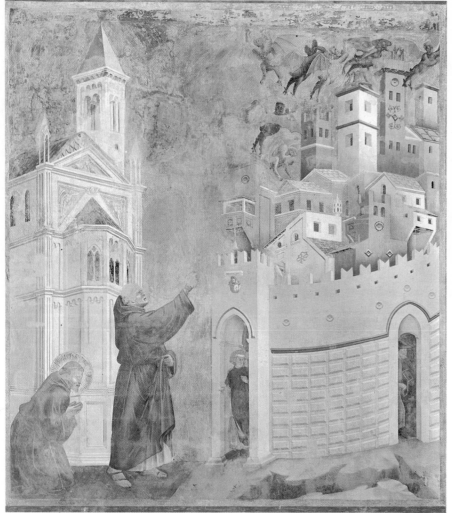

85. **Giotto.** *St Francis renouncing his Inheritance.* 1320s. Fresco. Bardi chapel, Sta Croce, Florence.

86. **School of Giotto.** *St Francis driving out the Devils from Arezzo.* c. 1300. Upper church, S. Francesco, Assisi. The very obvious symbolic division of the Assisi frescoes (see plates 86 and 84) has in the later Bardi chapel fresco (plate 85) been rejected in favour of a more subtle composition. The single massive building underlines the emotional conflict of the two groups, and draws the spectator into the centre of the drama. In the Assisi fresco of the casting out of devils the eye is led from one side to the other through the up-flung arm of St Francis.

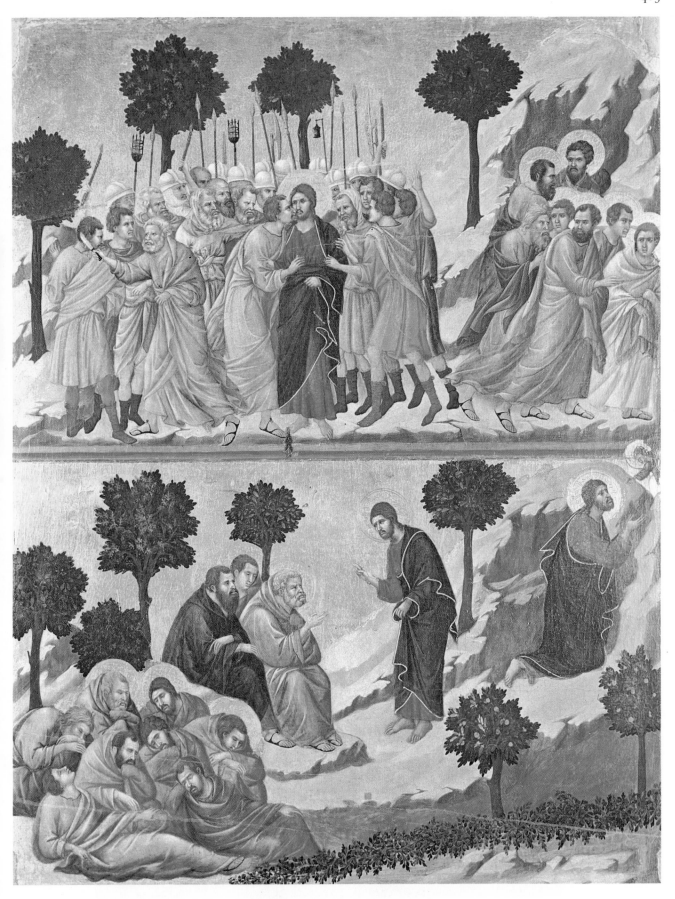

87. **Duccio.** *The Agony in the Garden,* and *The Betrayal of Judas.* Panel from the *Maestà.* 1308–11. Museo del'Opera del Duomo, Siena. When the *Maestà,* to which this panel belongs, was completed in 1311, it was carried to Siena cathedral in a triumphal procession. The soft folds of the drapery display Duccio's interest in achieving a decorative effect, very different from Giotto's starker monumentality. (See also plate 88.)

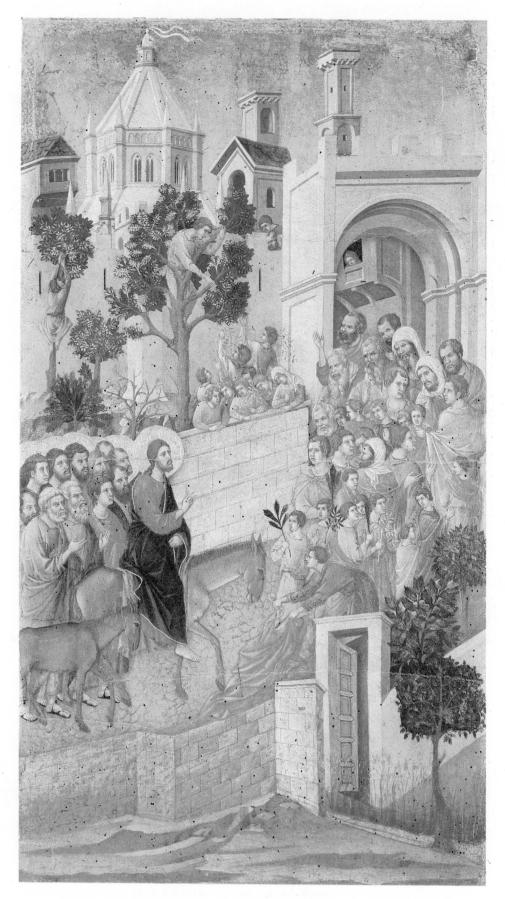

88. **Duccio.** *The Entry into Jerusalem.*
Panel from the *Maestà.* 1308–11. Museo
del'Opera del Duomo, Siena. The
composition of this panel conveys a strong
sense of recession. The spectator is led in
through the little gate, to converge with
the crowd spilling out from the town
behind, without a break between fore-
ground and background.

89, 90. **North Italian school.** *Pentecost* (f. 448v), and *Measuring the Heavenly Jerusalem* (f. 473r). From the Bible of Clement VII (MS. 47672). Mid 14th century. 14 × 9½ in. (36 × 24 cm.). British Library, London. In the Pentecost scene the artist has tried to convey a feeling of depth by seating the apostles and Virgin in a box-like room. This kind of spatial experimenting led ultimately to the mastery of perspective in the 15th century. The scene from the Revelation of St John the Divine shows the angel with the golden reed measuring the heavenly Jerusalem. Whereas Duccio's earthly Jerusalem (plate 88) is recognisably an Italian town, this city is a shrine in which the medieval love of precious materials could indulge itself in a literal illustration of St John's description.

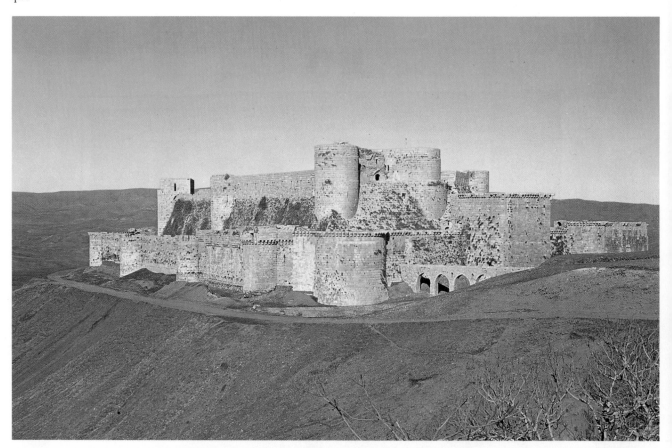

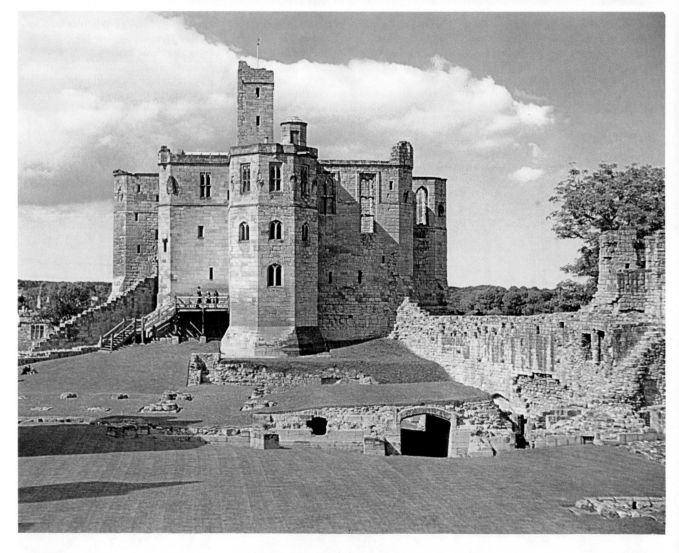

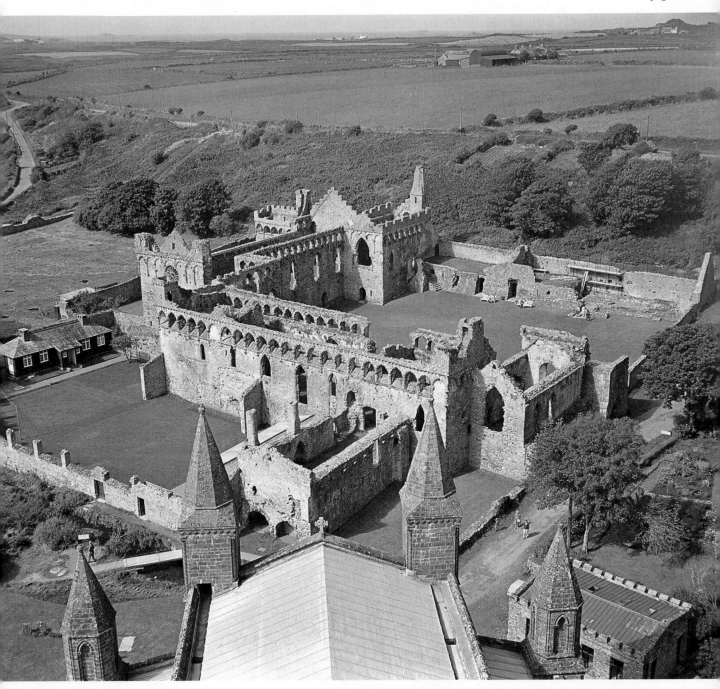

91 (opposite, above). **Krak des Chevaliers,** Syria. Late 12th century. This Crusader castle, built by the Hospitallers to guard the coastal parts of the Holy Land, on a scale unparalleled by contemporary fortifications in western Europe, includes the revolutionary feature of a double curtain wall. It withstood numerous Muslim sieges until it fell through treachery in 1271.

92 (opposite, below). **Warkworth castle,** Northumberland. 15th century. The keep of Warkworth was rebuilt by the Percy family in the early 15th century. With its symmetrical exterior and complex interior plan, it is not merely a defensive building, but displays the concern for elaborate and comfortable living conditions which increasingly characterises late medieval secular architecture.

93 (above). **Bishop's palace, St Davids.** 13th and 14th centuries. The enormous scale of this Bishop's palace reflects the size and importance of the domestic buildings of medieval ecclesiastical institutions, of which now so often only the churches remain intact. In the later Middle Ages Bishops were frequently criticised for spending too much on their own comfort.

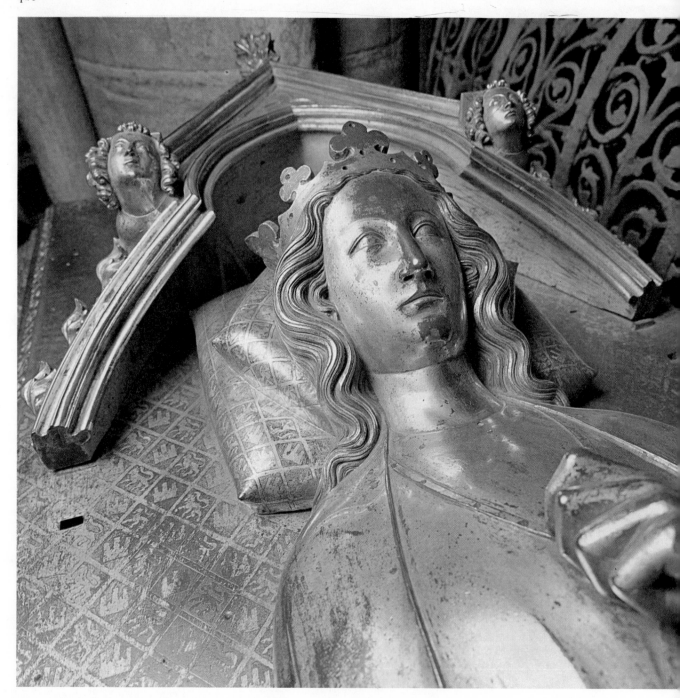

94 (previous pages). **Jean Bondol.**
Apocalypse Tapestry. Begun 1377. h.
169¼ in. (430 cm.). Musée des
Tapisseries, Angers. This scene, of the
woman crowned with the sun, forms part
of a set of tapestries ordered by Louis I of
Anjou for the hall of his castle. Jean
Bondol, who executed the cartoons, was
court painter to Charles V, and even in
the medium of tapestry his quality as an
illuminator is apparent.

95 (above). **William Torel.** *Queen
Eleanor.* 1291–2. Bronze. Approximately
life-size. Westminster abbey. Soon after
the death of Eleanor of Castile in 1290,
Edward I, inspired by the royal tombs at
St Denis, commissioned three bronze
effigies from the goldsmith William Torel
—two of Eleanor herself, and one of
Henry III. In this idealised figure of the
queen there is no attempt at portraiture.

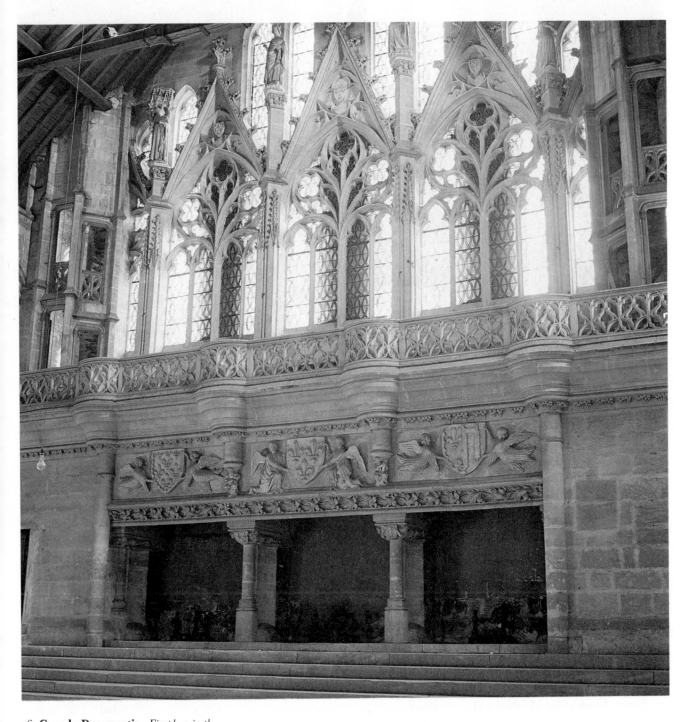

96. **Guy de Dammartin.** *Fireplace in the palace of the Counts of Poitou*, Poitiers. 1384–6. This magnificent triple fireplace with its balustraded gallery was ordered by John, Duke of Berry, one of the wealthiest courtiers and connoisseurs of his time. Between the traceried gables are set figures, not of the saints, but of John of Berry himself, his brother Charles V and their wives.

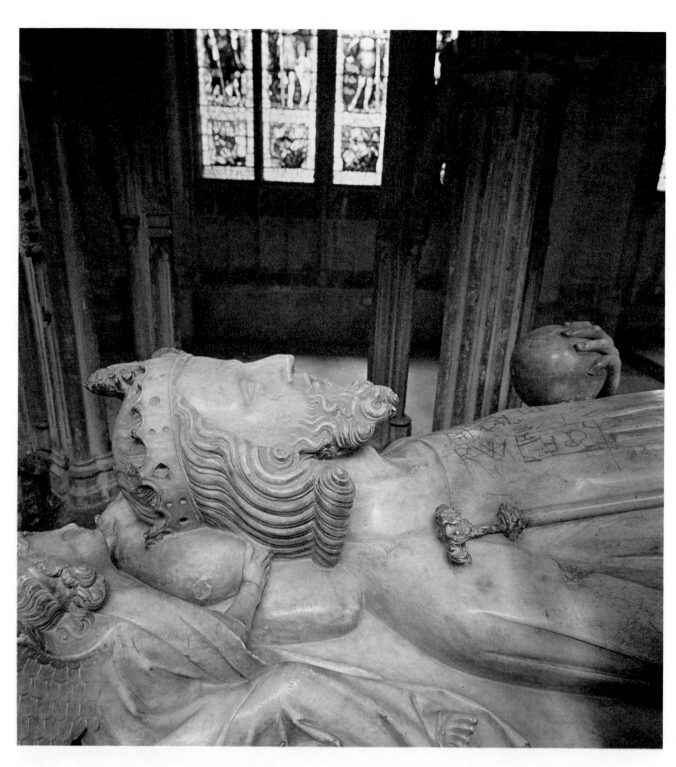

97 (above). **Tomb effigy of Edward II.**
Early 1330s. Alabaster. Approximately
life-size. Gloucester cathedral. Edward II
was murdered in 1327 and the
splendour of his tomb at Gloucester may
well have been part of the attempt to
surround his besmirched reputation with
the odour of sanctity. The softness of the
alabaster enhances this extremely

romantic image of the king, and the
technical quality of the carving suggests
London workmanship.

98 (opposite). Attributed to **Arnolfo di
Cambio.** *Charles of Anjou. c.* 1277.
Marble. Over life-size. Capitoline
Museum, Rome. This figure, which
commemorates Charles's senatorship of

Rome, is assumed to have stood on the
Capitol. It shows the classical elements, so
marked in the work of Nicola Pisano, in
whose workshop Arnolfo di Cambio was
trained. These still persisted in Italian
Gothic sculpture, side by side with
Giovanni Pisano's developments towards a
style more closely allied with northern
Gothic (see plate 75, figures 96, 98).

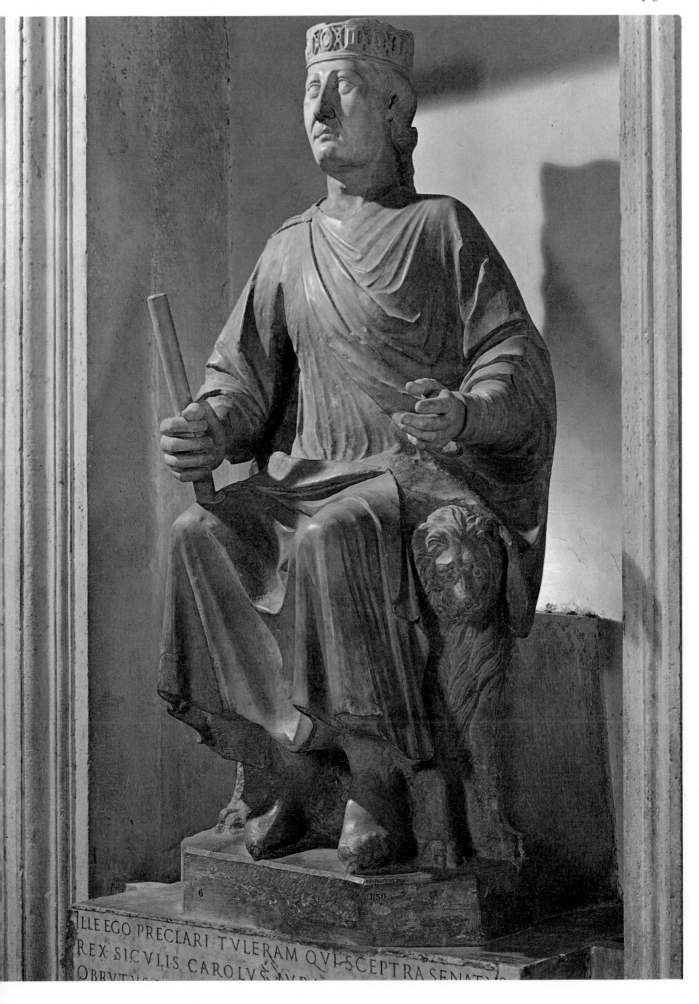

ILLE EGO PRECLARI TVLERAM QVI SCEPTRA SENATVS
REX SICVLIS CAROLVS NV...
OBRVTVS...

99. **Bonino da Campione.** *Monument to Cansignorio della Scala*. 1370–4. Sagrato di Sta Maria Antica, Verona. This is the most elaborate of the three Scaliger monuments in Verona. As in the two earlier ones the tomb effigy is placed under a canopy surmounted by an equestrian monument. The architecture here, however, plays a far more important part than in the monument to Can Grande della Scala whose mounted figure (figure 106) dominates his tomb.

plane mortelle love that

100. **Battle scene.** From the Story of Alexander (B.L. Royal MS. 20 B xx, f. 16r).). British Library, London. The artist's enthusiasm for gory detail, found in this scene from a French manuscript of the popular story of Alexander, can be paralleled in many contemporary descriptions in secular literature; but it must also reflect something of the brutal if colourful nature of medieval warfare.

101. **Tomb effigy of Edward III.** *c.* 1377–80. Gilt copper. Approximately life-size. Westminster abbey. If this figure of Edward III is compared with the earlier effigy of Eleanor of Castile (plate 95) it is obvious that idealisation has given way to realism. In spite of the stylisation of hair and beard an attempt at portraiture, possibly based on a death mask, has been made.

100. **Schnitzaltar.** c. 1330. Wood. St Maria, Oberwesel.
In this, one of the earliest surviving Schnitzaltars (carved
wooden altars), the doll-like figures are treated as separate
units set into the architectural whole—in much the same
way as the figures on a church façade (see figure 99).

were actually composed is given away by Villard d' Hon-
necourt in his sketchbook. In what are little more than
doodles, he shows outlines drawn around abstract geo-
metrical figures like squares, triangles and pentagons. It
is unlikely that either he or any sculptor of his time got far
beyond the stage of thinking of bodies as anything more
than outlines of this kind. The rest was simply a question
of filling in the drapery. A statue deliberately planned to be
seen from two views like the Strasbourg *Synagogue* was quite
exceptional. But although it suggests that an outline was
drawn on the side as well as on the front of the block even
this stopped short of being a fully rounded statue in the
Greek sense. It is more like two high reliefs placed at right
angles to one another and then very skilfully merged to-
gether. In fact monumental Gothic statues never quite
seem to escape the residual characteristics of relief. Apart
from the method of their composition, this has something
to do with their being placed against walls or in niches and
tabernacles, and though we can often move slightly to left

102 (opposite). **Jean II.** c. 1360. 35¾ × 16 in. (91 × 41 cm.).
Louvre, Paris. This is the earliest surviving French panel
painting, and its vivid characterisation of the king—who died a
prisoner of the English—shows that as in tomb sculpture the
tendency to idealise the features of royal patrons was giving way
to an unflattering realism. The stark profile view possibly
derives from antique coins.

or right for an oblique view, there is always a point beyond
which we are not meant to go.

The first great display of monumental statues in niches
is to be seen at Wells in England (c. 1220–40). On the whole
the English were not impressed by French cathedral por-
tals, to judge from the rigorous exclusion of statues from the
diminutive doorways at Wells, on the characteristically
snobbish grounds that they did not show proper respect
for the niceties of class distinction in the spiritual hierarchy.
By the 14th century, for instance at the cathedrals of Stras-
bourg or Bordeaux, we find the Germans and French agree-
ing with them, at least to the extent of providing proper
niches in their portals to protect the saints from profane
contagion. At Wells the niches were attached to buttresses,
and for the most part they impose a single viewpoint on the
statues. In spite of its buttresses, however, the Wells façade
is basically a screen, and by the 14th century it was recog-
nised in Germany that the proper place for this feature was
behind the high altar. An early 'Schnitzaltar' of this type is
at Oberwesel on the Rhine (c. 1330) where each figure or *100*
pair of figures is treated like a relief set under its own can-
opy of Rayonnant tracery. One climax of the subsequent
development is to be found in Spanish retables around
1500. But already a century before, in Jacques de Baerze's *102*
altar for the Duke of Burgundy at Dijon (1391), the idea
was given a new twist when the sculpture was so to speak
detached from the tracery and organised into little pic-
torial scenes on the Naumburg pattern. The whole altar **72**

was in fact nothing but a sacred toy theatre. Once this new orientation was established, the way was open for the truly fantastic altarpieces of late 15th-century Germany, in which have been rightly recognised the consummation of all Gothic tendencies to concentrate the arts of architecture, sculpture and painting into a medieval *Gesamtkunstwerk*.

63 But, to return to actual figure sculpture, once the rippling undulations of the classical drapery style had been rejected at Reims, the problem was to achieve something like the same effect by other means. In spite of its casual naturalism, what makes classical drapery interesting is its subtle exploitation of balance, contrast, tension and climax, and none of this was lost on the sculptors of the next generation. They became expert at mixing patterns informally so that one sequence of folds cut across another, or the left half was the antithesis of the right half, or the top mirrored

76 the bottom. They made their figures bend and twist, so that the movement created lines of tension (without ever actually evoking the underlying anatomy). They used clasps and free hands to gather up bundles of cloth at points of special emphasis. A favourite device was to play off nests

99 of broad chevron folds against dramatic vertical shadows or cascades of frills. The place where all these possibilities were first explored was once again Reims, and this was the basis of the special reputation of that cathedral in the Gothic world. The ramifications of the various Reims styles are to be traced all over Europe, into Spain, England and Germany, as well as throughout France. Two of the most famous variations on these themes are the *Vierge Dorée* at Amiens, and the *St Elizabeth* at Bamberg.

COURTLY ELEGANCE IN PARIS

Whereas it is by and large true to say that the dramatic aspects of these early and mid 13th-century statues were developed and exaggerated in Germany, in France they gradually succumbed to the cult of elegance for its own sake. To serve the French court there grew up in Paris a whole range of what must almost be called luxury arts. Apart from occasional tapestries like the set at Angers, our knowledge of these is to be had chiefly from illuminated manuscripts, ivories and small statuettes in other materials, the latter now almost invariably deprived of the miniature architecture in which they were originally set. The purpose of these objects was to furnish the private chapels of their aristocratic owners. Every castle, and ultimately every large house as well, had its own chapel. These now began to vie with churches in the splendour of their equipment. And with the growing influence of French fashions abroad, small-scale and therefore portable works of French art often found their way into the remoter corners of Europe. Established courts like those of England and Spain, Princes of the Church like the Archbishop of Cologne, and relative newcomers like the 14th-century despots of the northern Italian cities (in particular the Visconti of Milan) all to some extent emulated the court of France.

Though the *Virgin* on the south transept of Notre Dame in Paris was made only a few years after the one at Amiens,

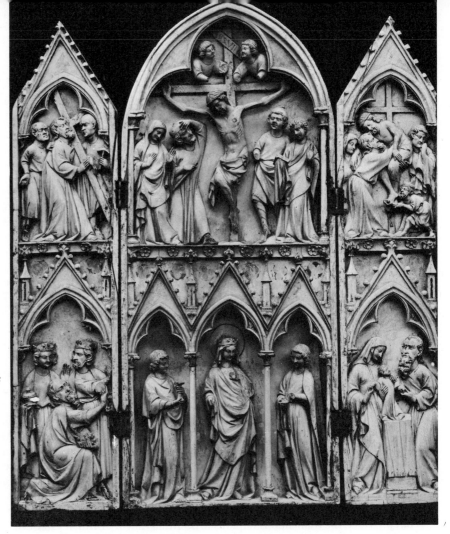

101 (opposite, left). **St Elizabeth.**
c. 1235. Bamberg cathedral. The cascades and deep-cut folds of the draperies, with their echoes of Reims (see figure 63), provide a startling contrast to the brutal realism of the saint's face, a study in stern old age. The dramatic perception which played so large a part in German Gothic sculpture lends to this figure a power lacking in the Reims *St Elizabeth*.

102 (opposite, right). **Jacques de Baerze.** *Schnitzaltar* (detail). 1391. Wood. Dijon Museum. Instead of the isolated figures of the Oberwesel altar (figure 100), three scenes—the Adoration, the Crucifixion, and the Entombment—are here presented as though in a theatre.

103. **Triptych** from the church of S. Sulpice. Mid-14th century. Ivory. 12½ × 11¼ in. (32 × 28 cm.). Musée de Cluny, Paris. The 14th century in France saw the production of a vast number of small-scale works in ivory. Many of them, although technically of a very high quality like the one shown here, display little more than a concern with sophisticated elegance. Even the gestures of grief in the Passion scenes are formalised.

she has a better figure, is much more aristocratic, but at the same time far less of a personality. Moreover, well bred Parisian *Virgins* were evidently not expected to give way to the kinds of emotion that were permissible in remote provincial backwaters like Naumburg. Their vacuous, pretty faces are invariably untroubled by intimations of sorrow. Elegance was essentially a matter of bearing, and to the sinuous curves of Reims Paris added its own graceful backward-bending movement. This was particularly effective in statues of the *Virgin and Child*. But we may observe that the dominant effect was as much frivolity as tenderness. When we compare them with Giovanni Pisano's infinitely more serious versions of this favourite Gothic theme, we find that he went out of his way almost deliberately to destroy the impression of elegance by thrusting the heads of mother and Child towards one another, as though they were deformed by the force of the feeling that drew them together.

At its best, however, this Parisian style achieved standards of nobility that were in their way unequalled. The silver-gilt statuette of the Virgin which was made for Jeanne d'Evreux before 1339 is more than just fastidious. She may be taken to represent in their best form the courtly ideals of 14th-century society, and the fact that she is gilded reminds us that this was still an age in which precious materials and fine, gleaming finishes were appreciated as much as form. It is unlikely that Paris entirely displaced the Low Countries as the traditional headquarters of these particular skills, but so long as the French court remained

in residence there, i.e. until the crisis of the Hundred Years War, there was a constant drift of the best craftsmen in that direction. Just how much virtuosity they were called upon to lavish on the production of extravagant toys, thinly disguised as reliquaries, has now to be judged from isolated survivors like the 'Goldenes Rossel' at Altötting in Bavaria.

GOTHIC PAINTING

In its love of jewellery and bright colours, the Gothic age did not differ fundamentally from the Romanesque. Nearly all statues were painted, and so at least were selected parts of buildings. This brings us finally to the art of painting and its place in the hierarchy of the Gothic arts. To put it last once more is still perhaps no great injustice. For in Gothic eyes, as previously, the main purpose of paint was to colour surfaces, and surfaces that did not lend themselves to other forms of decoration, such as stonework and books. But even walls were covered with tapestries whenever possible, and the surest way to make a book sumptuous was to fill it with gold leaf. Any primacy which painting may have enjoyed among the arts by default of competition, up to Romanesque times, was certainly not retained by it during the Gothic centuries.

When painters painted images, they were concerned with them first and foremost as outlines, i.e. as two-dimensional shapes, and any subsequent interest in modelling or space was almost certainly subordinate—the by-product of gesture and situation. After the revival of sculpture on a large scale in the 12th century, painters no

79

doubt found themselves called upon to provide the finishing touches to the works of their colleagues, and then, by an extension made easy through their common interest in outline drawings, to supply alternatives for statues or reliefs. It is not a simple matter to compare the relative charges made by painters and sculptors throughout the Middle Ages but, all things being equal, a picture should have been less expensive than a statue. So when we encounter a painting of something that could have been done in relief or in the round, it is likely to have been a cheap substitute—however excellent its artistic merits may seem to us. A painted wooden cross, or retable or altar-frontal

10, 69 would have been made of gold and bejewelled if possible. From this point of view, painting may be said to have become a copying art, once the others were established. Even in the field of manuscript illumination, where there was an established tradition and the problems were peculiar to the trade, there is growing evidence from the 13th century onwards that the artists who were engaged in this kind of work fell more and more completely under the spell of styles and fashions which originated outside the world of books. From then on, illuminators would seem to have been professionals, closely in touch with other artists.

What provided the tremendous impetus to painting that we can observe all over Europe in the 13th century was the

84, 85, 86 foundation of a large number of friars' churches, and the rebuilding or refurnishing of an even larger number of other churches—not just cathedrals and abbeys, but right down to the level of parish churches. And it was for the less well endowed of these that painting was called upon to perform its more ambitious tasks. Special enterprises, like

79, 95, 101 the Sainte Chapelle in Paris or Westminster abbey in England, could command the resources of all the arts, and there was little inducement for painting to attempt what the others could do in more spectacular media.

Medieval painting only really started to break new ground when its own traditions were so to speak cross-fertilised with the other arts, i.e. when it tried to do what was perhaps more appropriate for sculpture and even architecture. For reasons already given, this happened

88 more extensively in Italy than elsewhere. Up to the 13th century, when Italy was in need of artistic inspiration, she was accustomed either to draw on her own considerable resources and traditions, or else to call upon the eastern Mediterranean, where Byzantium was still the artistic and cultural capital of the world. But after 1200 all this was changed. The sack of Constantinople in 1204, the growing integration of Catholic Christendom, and even to some

84, 85 extent the personality and fame of St Francis of Assisi, all indirectly helped to reorientate Italy away from the Mediterranean, and toward transalpine Europe. For the first time in her history, Italy became susceptible during

98 the 13th century to artistic influences from the north. The first form which these took was of course Gothic architecture. This was already making its mark by 1220. Sculpture came much later in the century, but by the time Giovanni

Pisano produced his statues for the façade of Siena cathedral (*c.* 1284), it had at least one brilliant exponent. The reaction of painting to the north was, however, much more complex. For one thing the native traditions were strongly entrenched; and secondly, it was not through northern painting that the relevant influences were brought to bear on the Italians. What happened in Italy during the hundred years between 1250 and the Black Death was not the reception of a new style so much as the formation of an entirely new view as to what the art of painting was for, and what it could do. These changes were so profound that, during the period in question here, the artists can scarcely have been conscious of the implications of what they were doing, which was nothing less than to repudiate the presuppositions underlying almost the whole previous history of painting in so far as it was concerned with symbolic outlines and surfaces. The outlook towards which they gradually worked their way was the theory of illusionistic or representational painting: the business of the painter was in some sense to recreate visions of reality, and here reality was not that world beyond the senses into which it had hitherto been claimed or assumed artistic imagination had the power to penetrate. It was nothing but the world of ordinary sense-perception. Subject to this immense curtailment of its scope, painting could henceforth set about the reinterpretation of its traditional Christian themes—until in the end they were no more than prodigious human events performed by heroes. No doubt to the vulgar laity this constituted an enormous improvement, like the cinema over Greek tragedy. But one can sympathise with those conservative theologians who shook their heads and regarded it all as the beginning of the end.

In committing itself to the imitation of reality, Italian painting, whether it knew it or not, was following in the footsteps of the Master of Naumburg. but there was all the difference in the world between a sculptor trying to do this, and a painter—at least in the 13th century. It is therefore not surprising that the whole process took a great deal longer than one man's working lifetime. The laws of illusion proved singularly elusive. In fact during the Gothic period, only three achievements call for comment. They may be referred to as: (1) the integration of figures with the architectural or landscape backgrounds of the scenes that they enact; (2) the introduction of emotional attitudes; and (3) the construction of three-dimensional buildings, more particularly interiors. It is obvious that the first and the last of these could be, and they did in fact become, interconnected.

GIOTTO

In both Romanesque and Byzantine painting, architecture and landscapes are present as the subject requires, not because all events must take place in some physical context. And when they occur, they do so as symbols rather than as representations. These attitudes lingered long in Gothic painting as well. But during the 13th century,

104. **Ambrogio Lorenzetti.** *Good Government in the country* (detail). 1337–9. Palazzo Pubblico, Siena. The subject of these frescoes decorating the old centre of civic authority in Siena is, appropriately, the effects of good and bad government in town and country. The prosperous countryside in the background of this detail is part of a panoramic view into which the foreground figures move, without any break in continuity.

buildings and mountains begin to perform a new function. We can see this already well developed in the famous cycle of frescoes devoted to the life of St Francis in his church at Assisi, which are traditionally the work of Giotto, and were made just before 1300. In these pictures the figures are clearly regarded as being on some sort of stage, and the primary purpose of the various backgrounds is to cut off the superfluous space behind the actors. This is already very different from the golden empyrean which is the normal ambiance of Byzantine saints. But at Assisi the backgrounds do something more. They actually participate in the dramas that take place before them as marks of stress, rather like the music in a Wagnerian music-drama. Thus when St Francis repudiates his patrimony, the two groups of figures, those whom he is leaving and those whom he is about to join, are so to speak identified and accentuated by the buildings behind them, and the void in between is nothing less than the unbridgeable gulf across which St Francis cannot return. Again, in the scene where the saint expels the devils from Arezzo, he and his colleagues are placed before the cathedral, while the town on the right slopes away so that its roofs continue the movement of St Francis' arm—which is in effect the direction of the miraculous power and the line of flight of the discomfited devils. Precisely the same method of composition is to be found in the documented Giottos of the Arena chapel at Padua (1304–6). Thus in the scene of the *Deposition of Christ* the hillside at the back sweeps down to converge with the mourners lamenting over the dead body. It perhaps reaches its climax in another cycle by Giotto on the

theme of St Francis, this time in the Bardi chapel in Sta Croce at Florence (1320s). Here the renunciation scene is placed at the top of the wall of the chapel in a semicircular lunette. For practical reasons there is now only one building, and it is set obliquely, so that its apex fits comfortably into the curve of the frame, and its edge cleaves the stage into two separate triangular areas, in which the groups are placed. Dramatically the purpose is realised even more effectively than at Assisi.

It may seem perverse to single out this aspect of Giotto's art above all others, but it is the one that most clearly reveals his approach to picture making. The basic problem was to create a stage. The rest follows from this—the modelling that turns images into personalities, and the carefully graduated emotions that define their respective parts. To call this art Gothic, as it is now becoming fashionable to do, shows insight into the sympathies which sustained the revolutionary side of Giotto's achievement. But he was never quite Gothic in the German sense, and those for whom his gravity and grandeur used to make him the true founder of the Renaissance in Italian art were not perhaps far wrong.

The other great contemporary Italian school of painting had its headquarters at Siena. Politically, Ghibelline Siena was the inveterate enemy of Guelf Florence, and the same allegiance determined her attitude to Papal Rome. Until 1305, when the Pope withdrew to Avignon, Rome itself had been the home of another important group of painters —of whom Cavallini is the best known. Rome was the one medieval city where extensive displays of Early Christian

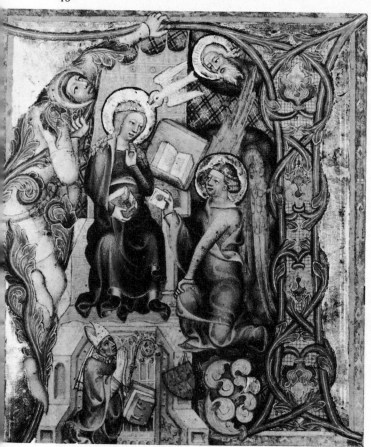

105. **The Annunciation.** Illuminated initial from manuscript (Clm. 6, f. 4v). Third quarter of the 14th century. Cathedral library, Prague. The cult of connoisseurship, which developed during the 14th century, led to the increasingly lavish decoration of private devotional books. Although this reached its climax in the magnificent collection of the Duke of Berry, it was not confined to France alone, as can be seen from the quality of this missal made for a Bohemian bishop.

mosaics and painting could be seen, and during the 13th century many of these were restored, replaced or emulated. This experience seems to have been the determining factor in shaping the Roman school, and to some extent its cause was taken up by Florence when the flow of patronage dried up in Rome. The artistic affiliations of Siena seem to have oscillated from one side to the other of the Rome-Florence programme. In the days after the Hohenstaufen (i.e. Ghibelline) victory at Montaperti in 1260, when one might have imagined that Siena would 'go classical', she seems in fact to have remained stubbornly loyal to what Vasari calls the '*maniera greca*', which was in effect a last link between Italy and Byzantium. On the other hand, by the first quarter of the 14th century Siena was already beginning to respond far more wholeheartedly than Florence to specific details of northern Gothic. With the establishment of a French dynasty at Naples in 1265, one would have imagined that Naples would have played a decisive part in spreading Gothic throughout Italy. But though Naples had the patronage, she does not appear to have produced artists of any considerable merit, and it was therefore Florentines like Giotto, or Sienese like Simone Martini, who figured most prominently in 14th-century Neapolitan art history. If Duccio, a slightly older con-

temporary of Giotto, is chiefly famous as an exponent of the former trend, he was nevertheless susceptible, especially in the smaller and more obviously pictorial panels of his great altarpiece, the *Maestà* for Siena cathedral (1308–11), to the varied episodes of the Gospel story. The presentation may be less dramatic than Giotto's but there is more incident, a far more vivid sense of colour and, perhaps most important of all, a sense of continuity between the foreground and the landscapes behind.

The high-water mark of Parisian Gothic influence on Italian painting is to be found in the work of another Sienese, Simone Martini. A generation younger than Duccio, he in fact ended up at the papal court at Avignon where he died in 1344. It was perhaps through Simone more than anyone else that Italian Gothic began to exercise a reciprocal influence on its French sources. This may be observed most clearly in the field of manuscript illumination. In the works of the illuminator Master Honoré who was active in Paris at the end of the 13th century and the beginning of the 14th, the figures are still set in architectural frames or against patterned backgrounds, and in spite of their modelling and the placing of one figure behind the other the effect is still very much akin to sculptured relief. A generation later, in works principally associated with the workshop of Jean Pucelle, while the figure style undergoes no drastic change, the architecture in or before which the figures are set begins to display properties that are decidedly three-dimensional, and the details of some of the buildings can only be explained in terms of Siena. During the second half of the 14th century French illuminators became progressively more interested in landscape backgrounds, and this also implies Sienese influence. The great innovator here was undoubtedly Ambrogio Lorenzetti. So far as we can tell it was Lorenzetti who took the decisive step, in his fresco of the effects of *Good Government in the Country* for the town hall at Siena (1337–9), of making a panoramic landscape the subject of the painting. Even more than in its twin devoted to *Good Government in the Town*, this picture betrays a recognition of the essential unity of foreground and background, and from this point onwards the way was open for the development of unrestricted three-dimensional illusions. Lorenzetti was also the first man to apply this outlook to the architectural interior. In his *Presentation in the Temple* (1342) we encounter the first convincing architectural vista in European painting, based on something that approximates to the perspective constructions of the 15th century.

In his capacity to evoke an impression of space on two-dimensional surfaces, Ambrogio Lorenzetti brought European painting within sight of the Renaissance. It would, however, be a mistake to speak of him as a Renaissance artist even to the same extent as Giotto, if only because (landscapes apart) his ideas on the subject of what use to make of his new space remained fundamentally Gothic. As yet no one wished to evoke new and imaginary worlds, and it was only some two generations after the Black Death that Lorenzetti's discoveries were developed.

MAN AND THE RENAISSANCE

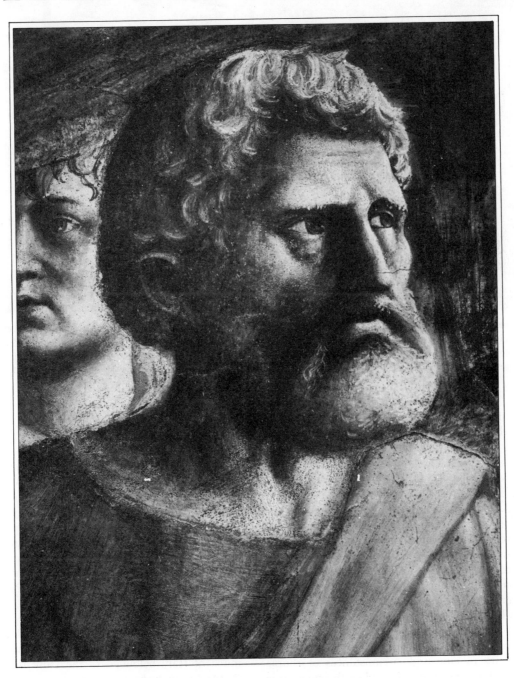

Towards a New Style

The numbers in the margins refer to the illustrations to Man and the Renaissance: heavy type for colour plates, italics for black and white illustrations.

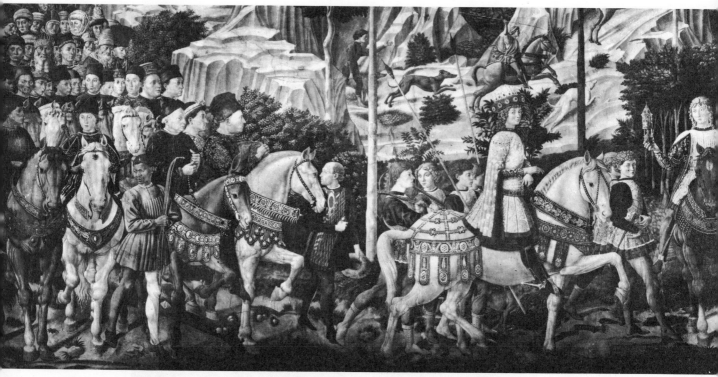

1. **Benozzo Gozzoli.** *The Journey of the Magi.* 1459. Fresco. Chapel, Palazzo Medici-Riccardi, Florence. In spite of its ostensible religious subject, this work probably gives a fair idea of a 15th-century state procession, with members of the local court taking part. Evidence of 'conspicuous expenditure' on clothes and horse-trappings is abundant, for the 'state' of a medieval or Renaissance prince was demonstrated visibly by the number and quality of his attendants.

Since the decline of the Roman Empire, the inhabitants of Italy have had to suffer many foreigners, either as members of marauding armies, or as pilgrims and 'tourists' avaricious for treasures which Italy possessed and the northern nations did not. Moreover, Italians have always stressed the differences which separated them from 'barbarians beyond the Alps'. This feeling is clearly apparent in the writing of Petrarch and Dante; in 1366 Petrarch for instance, referred to the Alps as 'the soaring mountains set against the fury of the barbarians.'

It is the paradox of her history during the Middle Ages and Renaissance that Italy presents an extraordinarily flourishing commercial situation against a chaotic political background. Probably both commercial wealth and political divisions were responsible for the development of the 'civilisation of the Renaissance in Italy', but conditions varied from city to city, and circumstances of course changed throughout the period covered by this book. It is impossible to tell exactly to what extent the production of art depended on the great wealth at Italian patrons' disposal, and how much it was stimulated by political and social rivalries.

Certainly Italy throughout the present period was rich beyond comparison with the North, for Italian merchants were closest to the eastern sources of luxury goods such as spices and silks which were so eagerly sought after by the rest of Europe. It is true that the discovery of fresh sea-routes to the East in the 15th century gradually changed the traditional pattern of trade, while the discovery of America and the flow of American gold and silver to the Spanish kingdom in turn affected the Italian economy; but the full consequences of these discoveries were not felt until the 17th century. From the 14th to the 16th centuries Italians remained the bankers of Europe *par excellence*, and dominated the luxury trade and commerce of the continent through a concentration of rich and flourishing towns—Genoa, Milan, Venice in the north; Mantua and Ferrara; Bologna and the towns of the Via Emilia; Florence, Pisa, Siena; and Perugia, the towns of the Papal States and Rome itself.

The causes of Italian political disunity are beyond the scope of this book, but the root of the trouble was undoubtedly the lack of any effective unifying authority. Nominally much of Italy belonged to the Holy Roman Emperors (successors to the Frankish Charlemagne for whom the title was revived in Rome in the year 800), but as Germans these emperors had never succeeded in effectively governing the whole peninsula, and in any case their claims to political domination were frequently resisted by the popes who undermined attempts at imperial organisation of Italy. In the early 14th century the great Italian poet Dante attributed most of the disorders of his native land to her political disunity in his treatise *On Monarchy*. In the middle of the century the Luxembourg emperor Charles IV (crowned

emperor 1355) recognised that even in northern Italy his own officials (such as the Visconti in Milan) only waited to increase their personal power and usurp what imperial rights were left.

Yet, in spite of hostility to foreign domination, Italians were never able to unite in repelling the outsiders as they crossed the Alpine passes; internal political divisions proliferated, and seem to have been increased by commercial rivalry. But during the 15th century Italy had some respite from foreign invasion, since the French kings had long been occupied in constant wars with the English, while the power of the German emperors—even in their own lands—was being constantly weakened by their own subjects. The historian can see that the invasion of Italy by the French king Charles VIII in 1494, and the German Sack of Rome in 1527, show the resumption of an earlier pattern of Italian history brought about by the consolidation of the French monarchy under Louis XI, and the rise of the house of Habsburg under the Emperor Maximilian (1493–1519); but to contemporary Italians these events were an enormous shock following the absence of serious threat from northern Europe during the earlier part of the 15th century. In retrospect this century seemed a 'Golden Age' mirrored by the artistic achievements to be described in this book.

Internally the first half of the 15th century saw the gradual crystallisation of the five great powers of Italy: Milan, Venice, Florence, Naples and the Papal States whose rulers drew within their orbits the rulers of lesser cities, or replaced them. A characteristic of this period is that the Italian princes developed what ultimately became the modern machinery of diplomacy based on a strong and—in many ways—civilised dislike for large-scale wars. Wherever possible they used highly trained mercenaries led by such men as Francesco Sforza and Bartolommeo Colleoni (commemorated by Verrocchio), and their reliance on such armies was accompanied by the development of diplomacy through the system of resident agents and representatives whose aims included the reduction in scope of any war and the erection of elaborate systems of alliances. These developments are perhaps summed up in a conversation recorded by the Florentine Machiavelli to whom the French cardinal de Rohan remarked that the Italians did not understand war, whereupon Machiavelli replied that the French did not understand politics (*The Prince*, chapter III).

The concentration of wealth and the competing centres of political power led also to an exceptional concentration of different artistic centres (in striking contrast to conditions north of the Alps) and, throughout the period, the possession of power and wealth was invariably accompanied by ostentatious display, at its most ephemeral in court festivities, processions and pageants, but often lastingly commemorated in public and family palaces, *mausolea*, and in all the decorative fittings executed for prince-citizens like the bankers Cosimo and Lorenzo de' Medici. Almost invariably great rulers in Italy were also great patrons.

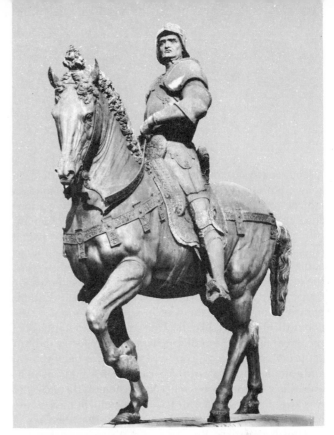

2. **Andrea del Verrocchio.** *Equestrian statue of Bartolommeo Colleoni.* 1481–8. Bronze. Venice. Bartolommeo Colleoni came from a Bergamasque family and commanded the forces of the Venetian republic between 1455 and his death in 1475. Leaving a large part of his private fortune to the republic, he also stipulated that they should erect a public monument to him. The result was the figure begun by Andrea del Verrocchio.

3. **Sandro Botticelli.** *Giuliano de' Medici.* c. 1475. Paint on panel. 21¼ × 14¼ in. (54 × 36 cm.). Staatliche Museen, Berlin. Five years younger than his famous brother, Lorenzo the Magnificent, Giuliano was murdered in the cathedral of Florence during the Pazzi conspiracy (1478). Like his brother, he was a patron of letters and the arts.

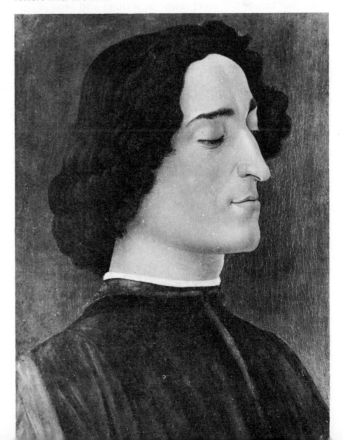

The renaissance of interest and enthusiasm for the language, philosophy and literature of antiquity began as a largely academic movement in the 14th century; various cities such as Florence then became centres of the 'humanistic' philosophy which scholars evolved from their pagan classical sources; eventually the humanists and their ideas had a considerable effect on the visual arts. In particular, the study of antique texts like Plutarch's *Lives* seems to have transformed the way in which men regarded their contemporaries—or at least the way in which historians wrote about them. A work like the *Lives* stresses the character of the 'great man', and undoubtedly helped to foster the cult of the individual in 15th-century Italy, so that biographical and autobiographical writing became increasingly fashionable. The Florentine bookseller Vespasiano di Bisticci, who was acquainted with a wide variety of eminent men, wrote his own *Lives*, and it is surely significant that the lives of two northern artists, Roger van der Weyden and Jan van Eyck, were first written by an Italian scholar, Bartolommeo Fazio, between 1453 and 1457. Machiavelli's *Prince* was written as an invocation to the inept Lorenzo II de' Medici to become a 'great man' and rid Italy of the 'festering sore' of barbarian invaders. The task undertaken by Vasari in his *Lives* (1550 and, enlarged, 1568) shows this cult of the individual being applied to the careers of painters, as well as to men of illustrious political houses; and there is no doubt that the emphasis on the importance of the individual, the influence of his actions and personal foibles, gives Italian history a human dimension which no other contemporary society possesses. To some extent, on the other hand, the acceptance by writers and men of importance of an individual for his personal achievements (and not solely for his investiture with office, or because of his hereditary importance) probably provided Italian artists with a more liberal background than their northern counterparts.

The devotion of scholars to the recovery of classical writings and the imitation of classical language and style also paved the way for any revival of antique art: and, because this was an academic movement, it acquired a prestige which it would otherwise not have had and, moreover, gained a widespread currency since the scholars were the most articulate members of society. The exact process by which practising sculptors, painters and masons became conscious of this classical literary revival cannot now be traced; but it was certainly assisted by the additional visual stimulus in the plentiful classical monuments which survived in their country. It is certainly significant that in the early 15th century artists such as Brunelleschi went to Rome to study and to ponder on the classical ruins there.

At this point, it might be tempting to interpret the course of Italian 15th-century artistic development in a way similar to that of literature and letters; and to postulate a similar 'Renaissance' associated with attempts to recover a shattered but not entirely vanished heritage from the antique world of Greece and Rome. The situation, however, was far more complicated. Indeed, it is possible that the concept of 'Renaissance' is a hindrance to understanding since it associates the production of art with a somewhat artificial scheme of progress in which the worth of any work is measured by the extent to which it looks 'classical' or 'antique'. This attitude gives whole tracts of art history the appearance of stagnation, particularly north of the Alps, and destroys the idea of continuity in Italian art itself by discounting those elements which bind the art to its immediate past. Such an idea also gives a false impression of the artists concerned as being merely painstaking archaeologists rather than creative individuals.

To avoid distortions of this nature the opening chapter of this book is concerned with 'change' rather than 'Renaissance'. The theme of change is, of course, generally common to all art at all times. But in Europe (1400) there occurred one of those rare moments of community of artistic expression between Italy and the North which gave subsequent changes something of the nature of a common point of departure, summed up by the expression 'International Gothic art'. Taking this style as a starting point, it will be easier to compare Italian to other European art, and to understand more clearly the character of what is normally called the art of the early Renaissance.

THE INTERNATIONAL STYLE

This phrase was never intended to imply that art produced north and south of the Alps looked identical. Common features, however, can certainly be found in works produced for the most important artistic centres of the time which justify its use. In art produced for the courts of Paris, Prague and Milan (three of the most important centres of patronage) the general Gothic figure style of the 14th century persisted. This meant that figures were elegant, sometimes rather mannered, portrayed without passion and that drapery was decorative. Moreover, this figure style was associated with a narrative style which was frequently anecdotal and discursive; and works of art often contained a lavish display of fashionable costume and rich ornament and a wealth of incidental detail such as animals and flowers wherever the artist could find space to include these.

There can be little doubt that the introduction of such detail and the general decorative effect for which artists strove corresponded with their patrons' tastes. But the striking quality of work produced in this style must also always have depended on the enthusiasm and interest of the patrons involved and, in this respect, the artists of both Bohemia and France were particularly fortunate. In Bohemia the emperors Charles IV (1346–1378) and Wenzel IV (1378–1419) were both ardent patrons of the arts; while in France, the French royal family included such well-known connoisseurs as Charles V (1364–1380) and his brothers Philip the Bold, Duke of Burgundy (died 1404) and John, Duke of Berry (died 1416).

There were differences in the appearance of art produced in northern Europe. The pictorial style current in Prague

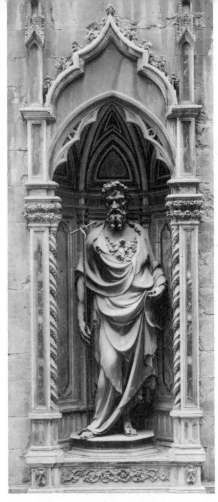

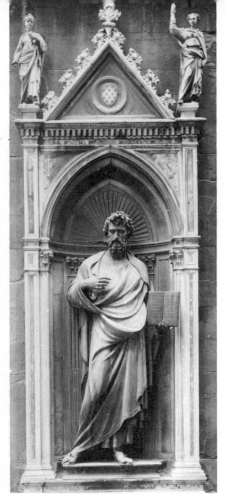

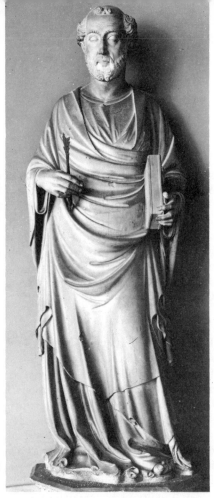

4. **Lorenzo Ghiberti.** *St John the Baptist.* 1414. Bronze. h. of figure 8 ft (244 cm.). Or S. Michele, Florence. Executed for the Arte dei Mercanti. This was Ghiberti's first important surviving commission to be completed. By Italian standards (compare figure 11) this is an unusually graceful figure much influenced by the International Gothic style (compare figure 18).

5. **Lorenzo Ghiberti.** *St Matthew.* 1419–22. Bronze. h. of figure *c.* 8 ft 6 in. (259 cm.). Or S. Michele, Florence. Executed for the Arte del Cambio. The prevailing interest in antique motifs has gone half way towards transforming the style of figure 4. Head and gesture are antique, although drapery and stance are still graceful. The architecture is strangely hybrid.

6. **Nicolo di Piero Lamberti (il Pela).** *St Luke. c.* 1400. Marble. Museo Nazionale, Florence. Formerly on Or S. Michele. Executed for the Arte dei Giudici e Notai. Nicolo was not an outstanding master but his *St Luke* shows well the style perpetuated in Florence since the early 14th century (compare Andrea Pisano)—a stolid figure covered by many small neat drapery folds.

had a gently modelled appearance from which it has acquired the name 'the soft style'. It became popular ultimately in much of what is now modern Germany, from Hamburg in the north to Swabia in the south, and along the Rhine where the city of Cologne formed an important centre. The 'soft style' is still to be seen in the work of Stefan Lochner of Cologne during the 1440s. The rather heavy rounded Bohemian style never made very serious headway in Paris, for the surviving panel paintings and manuscripts suggest that the French royal family as a rule favoured a more refined and elegant technique. The Dukes of Milan appear to have favoured both styles although the history of Milanese court art is by no means clear.

The spread of this stylistic fashion southwards into Italy was slow and complicated but there are unmistakable signs of its presence and popularity in Florence between 1390 and 1425. In Florence, the painter Lorenzo Monaco was a gifted exponent of it by the end of his life (*c.* 1370–*c.* 1425); and Gentile da Fabriano brought the style, with all its richness and delicacy, with him when he came south to Florence (*c.* 1421). It may be observed that Gentile was a true court artist who had worked in the ducal palace at

Venice and was to go on to work for the papal court in Rome (*c.* 1427).

Another admirer of these characteristics was the Florentine sculptor Lorenzo Ghiberti. In fact, no other Florentine sculptor of the period imitated with such incisive elegance this late Gothic style from the North. At the start of his career (1401) he was confronted by the famous competition for the commission of a pair of bronze doors for the Florentine baptistery. Ghiberti gained the commission after submitting a bronze relief on the subject of the *Sacrifice of Isaac*. His relief and one other by the Florentine Brunelleschi are all that remain from the competition but they show that these two competitors were working in totally different styles; and of the two, it is surely significant that the Florentine judges preferred the Gothic elegance of Ghiberti's work. For, whereas Brunelleschi emphasised above all the drama and tragedy of this Old Testament scene, Ghiberti paid more attention to its surface finish. His torso of Isaac is a beautiful piece of modelling and his Abraham is clothed in a delicate ripple of folds. The qualities found in Ghiberti's relief were developed by him in his first pair of bronze doors. The figure style is also to be

2

seen in his first great bronze statue for Or S. Michele—the
St John the Baptist of 1414. Ghiberti's position, however, is
far more ambiguous than that of the painters who worked
in this late Gothic style; and although his figure style re-
mained essentially the same throughout his long career (he
died in 1455), his sculpture on occasions reveals the char-
acteristics of the more forceful and expressive style which
superseded the decorative elegance of the 'International
Gothic'.

ARTISTIC CHANGE IN TUSCANY

It is apparent that many artists in Tuscany were not satis-
fied with this late Gothic style. Indeed, as early as 1401
Brunelleschi's trial relief provides evidence of a revolt
against these decorative conventions. The attention given
by Brunelleschi to the modelling of the torso of Isaac is so
summary as to provide a strong contrast to Ghiberti's
work. Isaac's body is distorted and great emphasis is laid
on Abraham's dramatic gesture as he is about to sacrifice
his child. Other sculptors followed his lead, notably
Donatello and Nanni di Banco in Florence, and the rather
isolated figure of Jacopo della Quercia in Siena; and all
successfully produced individual solutions to their common
problem of exploring some form of artistic expression which
avoided the elegant superficiality of much of the work of
their contemporaries and immediate predecessors.

To what sources did these men turn in their search for an
art which was more serious and visually more dramatic?
Since no artist at this date recorded his intentions or im-
pressions, it is only possible to answer this question from a
consideration of the sculptors' actual work. It here be-
comes apparent that one important influence was not a
classical source at all but the work of an earlier Tuscan
sculptor, Giovanni Pisano, perhaps the most dramatic and
passionate sculptor of the entire early Gothic period. Ad-
mittedly Giovanni Pisano never actually worked in Flo-
rence, but he left two major monuments nearby, the façade
sculpture on Siena cathedral and the pulpit of S. Andrea
at Pistoia. Here at hand were violent dramatic gestures,
deeply cut expressive drapery and, indeed, that impa-
tience with surface texture as an end in itself, which are so
apparent in the Brunelleschi relief by comparison with
Ghiberti's work.

It seems probable, therefore, that sculptors deliberately
turned back to art of the not-so-distant past in search of
qualities which they could not find in the work of their
masters or contemporaries. A similar process may be found
in Florentine painting at a slightly later date when
Masaccio ignored current stylistic tendencies and produced
work whose gravity and indeed austerity can only have
come from a very penetrating appraisal of the art of Giotto.
Thus it seems to have been the work of medieval rather
than classical artists which at first stimulated Tuscan
sculptors and painters to rebel against the accepted artistic
conventions of the late 14th century.

Nevertheless, the development of art in Italy has always

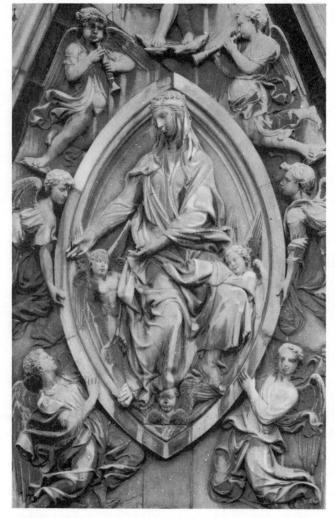

7. **Nanni di Banco.** *Virgin of the Assumption.* 1414–21. Marble.
On the Porta della Mandorla, Duomo, Florence. Nanni di
Banco was a remarkable experimenter, changing to this excited,
vigorous style from the absolute impassiveness of the *Quattro
Santi Coronati* figures. His work, so unlike that of Ghiberti,
shows again the immense stylistic upheaval of the early
15th century in Florence.

been complicated by the visible remains of the classical
world. Not unnaturally, sculptors were particularly affect-
ed by these remains since architecture and sculpture sur-
vived in comparatively large quantities whereas the paint-
ing had virtually all perished. Thus throughout the Middle
Ages, Italian sculptors continued to imitate classical dec-
orative motifs and showed a general preference for relief
sculpture—a typically classical form. Indeed, the first great
Tuscan Gothic sculptor, Nicola Pisano, was already draw-
ing heavily from antiquity in the 13th century, so that in
the early 15th century, during the first stylistic upheaval
since that period, it comes as no surprise to find sculptors
once more turning to antique art in search of inspiration.

But in Italy in 1400 this change coincided with the liter-
ary and humanistic movement already mentioned. The
Florentines, building on foundations laid in the 14th cen-
tury by Petrarch, came positively to identify themselves
with the republicanism of ancient Rome in their military
struggle against the presumed tyranny of the Visconti
Dukes of Milan. Politics and scholarship were actually
linked in the persons of two successive and remarkable
chancellors of Florence, Coluccio Salutati (chancellor

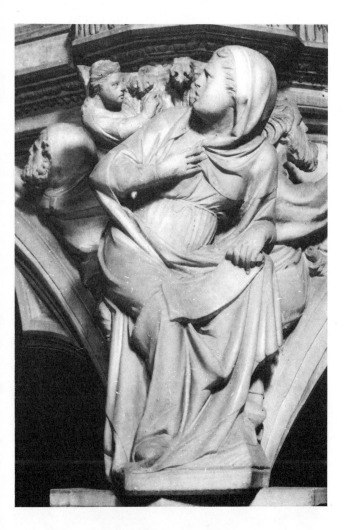

8. **Giovanni Pisano.** *A Sybil.* 1297–1301. Marble. h. 24½ in. (62 cm.). On the pulpit, S. Andrea, Pistoia. Giovanni Pisano evolved one of the most dramatic interpretations of Gothic style. His figures were full of expression and movement, of a type to be found in work by Jacopo della Quercia (see figure 9).

9. **Jacopo della Quercia.** *Figure representing a Virtue.* 1414–19. Marble. Fragment from the Fonte Gaia, now in the Palazzo Pubblico, Siena. Jacopo used figures such as this to animate the architecture of the huge fountain called the Fonte Gaia. Characteristic of this animating movement is the extreme turn of the figure whereby the head points in one direction and the knees another.

1375–1406) and Leonardo Bruni (chancellor 1411–1444).

It is difficult to know what importance this literary movement had for those Florentines who were not scholars. The finer points of the new academic teaching must have been beyond the grasp of all but a small minority. There is, however, plenty of evidence to suggest that the emulation of antiquity was, at the very least, a fashionable attitude which was within the reach of everyone. A man might not be very clear about republican virtues or the teaching of Cicero; but the identification of Florence as the heir of ancient Rome in the cause of liberty could be as much a matter of the heart as of the head.

From this, however, it follows that it is much harder to estimate the significance which this 'classical revival' had for working artists. Certainly during the first twenty years of the century many seem increasingly to have used ideas which are recognisably classical in origin. Two instances occur: in the trial reliefs already described Brunelleschi used the classical statue of the *Spinario*, the boy taking a thorn from his foot, as the basis for one of his lower figures; but Brunelleschi's version is swathed with Gothic drapery in such a way as to transform the original model of a naked

boy. Ghiberti's figure of Isaac is also based on an antique model. The artist here showed a remarkable sensitivity to the nuances of classical flesh modelling and it is thus curious that the more 'Gothic' artist had a far greater *rapport* with his classical original.

Although these provide instances of detailed borrowing from antique art, the reliefs could hardly be described as antique in appearance. However, there were also a number of far more remarkable essays in a classical style, particularly in the niche figures on the church of Or S. Michele. In the statues of the *Quattro Santi Coronati* the sculptor, Nanni di Banco, emulated a Roman style in some of the drapery, and some of the heads are based on classical busts of a type similar to those representing Caracalla. Yet the whole group still has only a superficially antique appearance, for the drapery style is not consistent in its classicism and the whole group is contained in a niche that is solidly and ornately Gothic. Moreover, along the base is a relief scene carved in an unremarkable traditional manner.

It is clear from Nanni di Banco's development that he was not concerned with what might by called an organised classical revival. Both he and Donatello were eclectics in

the best sense of the word, choosing from and experimenting with what they saw around them, and antique models were far from being their chief or unique source of inspiration. Ghiberti's work also shows a similar eclecticism and a very interesting example occurs in his statue of St Matthew on Or S. Michele. This figure shows that Ghiberti too had been affected by the expressive qualities which other sculptors had already seen in antique figures and his sculpture momentarily acquired a rhetorical feeling which on the whole is alien to his style. The hybrid nature of the whole conception, however, is clear. The triangular pediment of the niche, the fluted pilasters, the eloquent gesture and the modelling of the head derive from antique models. But the crockets climbing up the pediment, the pointed arch, the sway of St Matthew's figure and the sweep of drapery clearly recall how close to the surface Ghiberti's Gothic antecedents are.

The direct imitation of antiquity proceeded so erratically that it cannot be supposed that the artists themselves saw the recovery of antiquity as a species of mission to which they were bound. But scholars, already heavily saturated with an admiration of antiquity, were very soon prepared to explain the artistic revolution which they had witnessed in terms of the recovery—or renaissance—of an art that had been lost since the decline of the Roman Empire. The idea of a 'renaissance' in art achieved its universal acceptance precisely because it was the explanation placed on events by the existing *litterati*, the scholars and historians. Ultimately the main historian chiefly responsible for this interpretation was probably Giorgio Vasari, a painter with a humanist education, whose great work *The Lives of the Most Excellent Italian Architects, Painters and Sculptors* appeared in the mid-16th century. Long before this time, however, the legend of the 'Renaissance of classical antiquity' had been born.

It had comparatively innocent beginnings, in that early 15th-century humanists found it complimentary to compare the greatness that they knew from experience with the greatness that they knew only from literary tradition. In this fashion the 15th-century renown even of Gentile da Fabriano was compared with the ancient renown of Greek artists such as Apelles, Parrhasius and Zeuxis. There was, however, perilously small distinction between this comparison of the *renown* of the ancients and moderns and a comparison of the *achievements* of the two civilisations. From there it was a small step to suggesting that the achievements of the present were rendered possible by a recovery of those of the past, and that the past was 'reborn' in the present.

This chain of reasoning was encouraged by 15th-century developments in Italian historiography where the idea of a 'middle age' of destruction or stagnation was now postulated. It was this historiographical framework that Ghiberti adopted when he came, late in life (*c.* 1450), to write three *Commentarii* in which he attempted the highly personal task of placing his own achievements in an his-

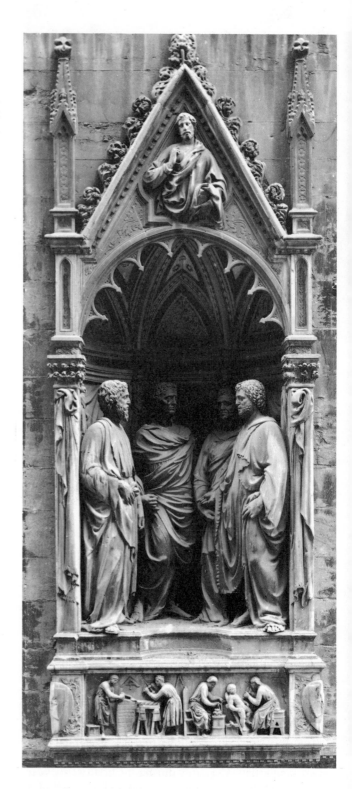

10. **Nanni di Banco.** *The Quattro Santi Coronati. c.* 1415. Marble. Or S. Michele, Florence. Perhaps the only obvious stylistic link between this niche and figure 7 lies in the figure of the blessing Christ in the gable. Although the niche is in general character similar to that of figure 4, the evidence of interest in antique art is very strong in the heads which are based on different antique types. Executed for the Arte dei Fabbri.

11. **Donatello.** *St Louis.* c. 1423. Gilt bronze. h. 104¾ in. (266 cm.). Here seen in its original niche on Or S. Michele, Florence. Now in Museo dell'Opera di S. Croce, Florence. Executed for the Guelphs. The weighty folds of the drapery betray a style completely different from that of Ghiberti. No less striking is the architecture of the niche, far more faithful to the art of antiquity than the niche of *St Matthew* which immediately preceded it (figure 5).

torical setting. Art history fell into three main divisions. Ghiberti first dealt with antique art in large sections of text lifted directly from Vitruvius and Pliny; there followed a very short section on the 'middle age' followed in turn by the 'revival' of art *c.* 1300. This revival, of course, culminates in Ghiberti's own life and work. But Ghiberti's historical standpoint, even in imitating contemporary practice, provides a further warning against a too rigid conception of a 'Renaissance' in Italian art *c.* 1400. The revival described by Ghiberti was one of art as a whole *c.* 1300. What interested him was the age of Giotto and the development of Gothic art out of the previous Italo-Byzantine style, a development to which he attached his own career. Although himself an interested collector of antique sculpture, the literal recovery of an antique style is never mentioned as a legitimate or significant factor in Tuscan developments. Again, for artists themselves, classical antiquity was only one of a number of sources or aids to change; at this stage the 'Renaissance' did not have for them the status of an artistic programme or manifesto.

The impression is strengthened therefore that developments in Florentine art *c.* 1400–25 represent, not an attempt to recover antiquity, but a reinterpretation of a number of existing elements which included the visible remains from the High Gothic period *c.* 1300 as well as the classical past. The result was a new style at once powerful, dramatic and rich in variation. Brunelleschi's trial relief pointed in this direction; but the most violent expression of this change is to be found in the work of Donatello. This is easily seen in the series of standing figures, devised for the campanile of Florence cathedral and for the church of Or S. Michele. They include an evangelist, *St Mark*; a warrior saint, *St George*; an episcopal saint, *St Louis of* 11 *Toulouse*; and a group of prophets. Each in its own way is a work of vivid imagination. Even the figure of *St Louis*, traditionally a mild figure, is swathed in a heavy majestic cope which lends the mild face a considerable gravity. The standing prophets in the niches on the campanile show 12 how Donatello could re-think a traditional task of the sculptor and imbue his statues with contrasted drapery and varying emotional states.

Like his great predecessor Giovanni Pisano, Donatello instilled dramatic force and vigour into almost every commission. He took up the motif of the naked *putto*, reintro- 14 duced earlier from antiquity by Jacopo della Quercia as a decorative idea, but produced in two pulpit balustrades a mob of running and jostling *putti* totally without precedent. His treatment of a commission for some bronze doors in the 13 Old Sacristy of S. Lorenzo (Florence) was equally characteristic. Asked for doors whose panels should contain pairs of prophets and apostles, he produced an individual scheme for each panel so that the figures either salute each other, argue, or almost pointedly seem to ignore each other.

It is not difficult to appreciate that dramatic changes occurred in Donatello's sculpture. The positive aspect of

12. **Donatello.** *Lo Zuccone.* 1427–36. Marble. h. 76¾ in.
(195 cm.). Museo dell'Opera del Duomo, Florence. Formerly
on the campanile. Heavy tumbling drapery and strong facial
characterisation are to be found in Donatello's statues for the
Florentine campanile. The dramatic use of drapery is again
reminiscent of Giovanni Pisano.

change in architecture can also be seen in the work of
Donatello's friend Brunelleschi from *c.* 1420. Brunelleschi,
like Donatello, had been trained as a goldsmith, but he was
probably ten years older than the sculptor. For some
reason architecture attracted him, and he became both an
engineer and a designer of buildings, perhaps under the
inspiration of a visit to Rome some time during the first two
decades of the century. Brunelleschi's first great achieve-
ment was the dome built over the crossing of Florence
cathedral—an engineering feat which involved the archi-
tect in the invention of an ingenious system of scaffolding
and in a complicated method of brick construction. The
latter was certainly in part derived from a study of Roman
ruins. The appearance of the dome, however, is certainly
not classical: it is supported on ribs and for technical
reasons has a distinctive, elongated shape unlike any dome
surviving from the antique world.

Brunelleschi also studied the details of classical mon-
uments and it is generally assumed that he passed on to
Donatello the knowledge acquired from these investiga-
tions for, from about 1420, a number of comparatively
correct features drawn from antique architecture appear in
the sculptor's work. Perhaps the most striking instance of
this is the niche designed for the figure of *St Louis* on the
Or S. Michele. It takes little effort to realise the great differ-
ence between this and Ghiberti's niche for his *St Matthew.*
The only explanation is that somebody (probably Brunel-
leschi) had been looking very closely at antique niches
with the eye of an archaeologically minded draughtsman.

Nevertheless, in terms of classicism there is in Brunel-
leschi's architecture a hiatus between the engineering
aspect, the aspect of its detailed decoration and the overall
planning and impression. The dome of Florence cathedral,
as a mass of engineering, is conceived on a scale comparable
to the vast ruins in Rome. The detail of Brunelleschi's
buildings is probably more 'classical' than anything since
the end of the Roman Empire. But his style is as personal
as that of Donatello and Masaccio and, like theirs, must be
derived from a complex of sources which includes Tuscan
work from the not-so-distant past. For instance, it has fre-
quently been remarked that the extensive use of coloured
marble and the light round-headed arcades which are par-
ticular features of Brunelleschi's style are also a constant
feature of Tuscan Romanesque architecture of the 12th
century (see S. Miniato al Monte, Florence).

Brunelleschi would certainly have admired the Roman-
esque architecture of Florence. The exact age of these
buildings was not known with any certainty and the bap-
tistery, for instance, was widely thought to have been a
Roman temple. Even if he thought that these buildings
were late antique, however, Brunelleschi was still exercis-
ing a deliberate choice in their favour: for Early Christian
basilicas existed in Rome and it is clear that he rejected

(Continued on page 465)

1. **The Limbourg Brothers.** *The City of Rome.* c. 1415. Painting on vellum. Page 11½ × 8¼ in. (29 × 21 cm.). From the *Très Riches Heures du Duc de Berry.* Musée Condé, Chantilly. Rome of the Middle Ages, city of marvels and travellers' tales. This is not strictly a northerner's account since, although the Limbourg brothers were Flemish, they seem here to have copied an Italian model. But, from what-ever source, the Rome of the sightseer is here clearly in evidence. The Vatican city (bottom, left), the Pantheon (left, centre) and the equestrian statue of Constantine (top right), then outside the Lateran palace, are easily visible. The history of Renaissance art is in part concerned with the change of attitude towards the visible remains of antiquity.

2. **Lorenzo Ghiberti.** *The Sacrifice of Issac.* 1401. Bronze, parcel-gilt. 18 × 16 in. (46 × 41 cm.). Museo Nazionale, Florence. A trial relief submitted in the competition for the commission of a pair of bronze doors for the Florentine Baptistery. Comparison with the Brunelleschi relief below will establish through the common elements many of the detailed requirements of the competition. Ghiberti's composition is probably more subtle than that of Brunelleschi but the real difference lies in the emotional tone. Ghiberti's relief is remarkable for its refinement and delicacy, the dramatic elements being kept carefully in control.

3. **Filippo Brunelleschi.** *The Sacrifice of Isaac.* 1401. Bronze, parcel-gilt. 18 × 16 in. (46 × 41 cm.). Museo Nazionale, Florence. Produced in circumstances similar to Ghiberti's relief (above). By contrast, Brunelleschi paid very little attention to the beauty of the individual parts of the composition; compare, for instance, the two versions of the torso of Isaac. Brunelleschi produced a dramatic effect almost totally absent from Ghiberti's relief which permeates not merely the distorted figure of Isaac but also the deep folds of Abraham's cloak.

4. **Masaccio.** *St Peter healing the Sick by the Fall of his Shadow.* 1427. Fresco. 90½ × 63¾ in. (230 × 162 cm.). Brancacci Chapel, Sta Maria del Carmine, Florence. During his short life, much of Masaccio's most important work was done for the church of the Carmine. This scene reminds one how little he owed to the decorative and graceful work of many of his contemporaries. It is, however, equally far from the dramatic violence of Brunelleschi or Donatello, and much of Masaccio's ability to convey a situation through the telling glance or gesture seems to be derived from a new appreciation of Giotto.

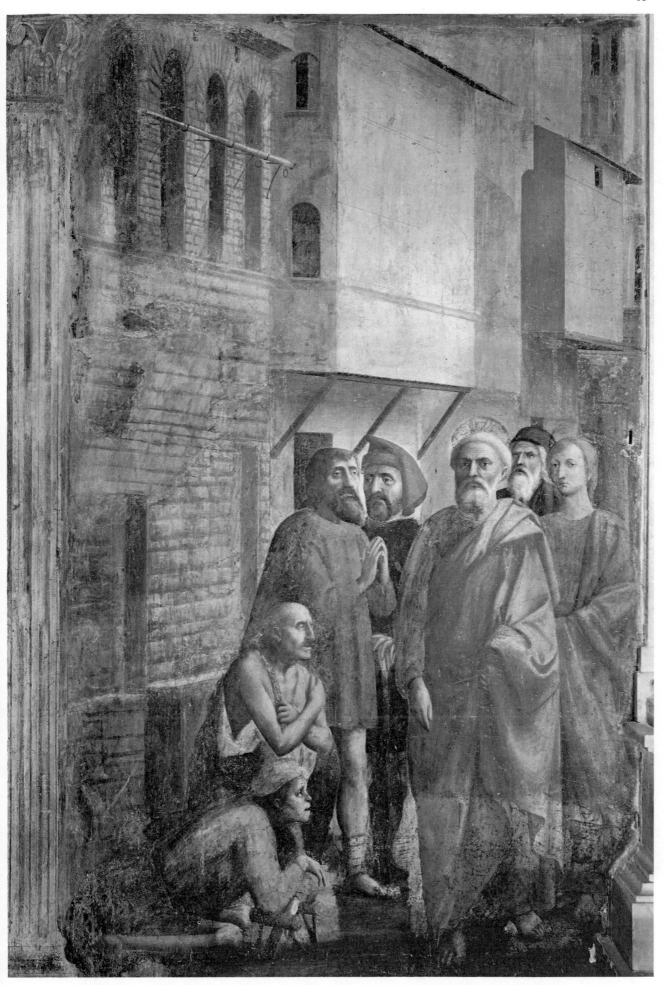

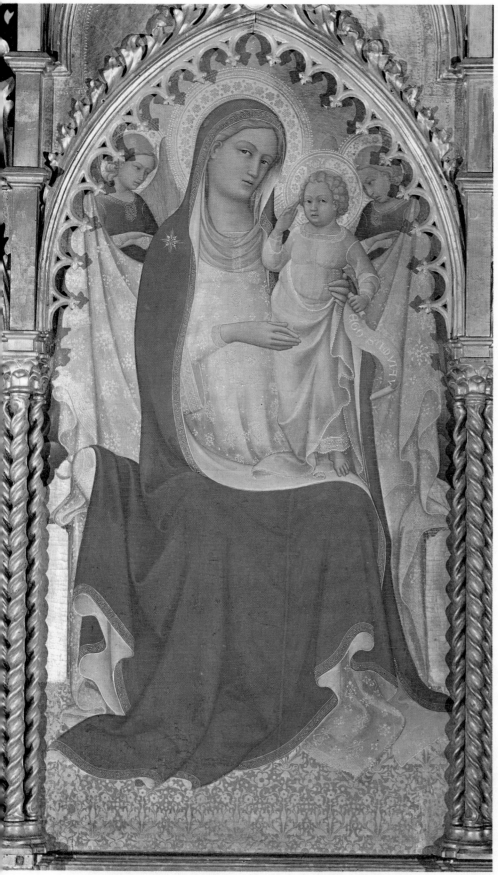

5. **Lorenzo Monaco.** *Madonna and Child.*
c. 1410. Tempera on wood. Centre panel
of the Monte Oliveto altarpiece. Palazzo
Davanzati, Florence. One of the most
accomplished Florentine artists up to his
death in *c.* 1425–6; a friend and
associate of Ghiberti. The decorative
effect of this panel is self-evident. The
artist has, without making the figures
physically improbable, arranged the folds
of drapery in a series of loops and curls
which can be appreciated as a continuous
pattern. Depth and volume are minimised
to this end, and the figures are given a
conscious grace and elegance.

6. **Masaccio.** *Virgin and Child with Angels.*
1426. Tempera on wood. 53¼ × 28¾ in.
(135.5 × 73 cm.). National Gallery,
London. Central panel of a large
polyptych executed for Sta Maria del
Carmine, Pisa. An imposing ensemble
with no pretension to grace or elegance.
Space and volume are emphasised where
possible in order to heighten the sub-
jective impression of physical presence.
Notable is the treatment of haloes which
now appear as foreshortened discs.

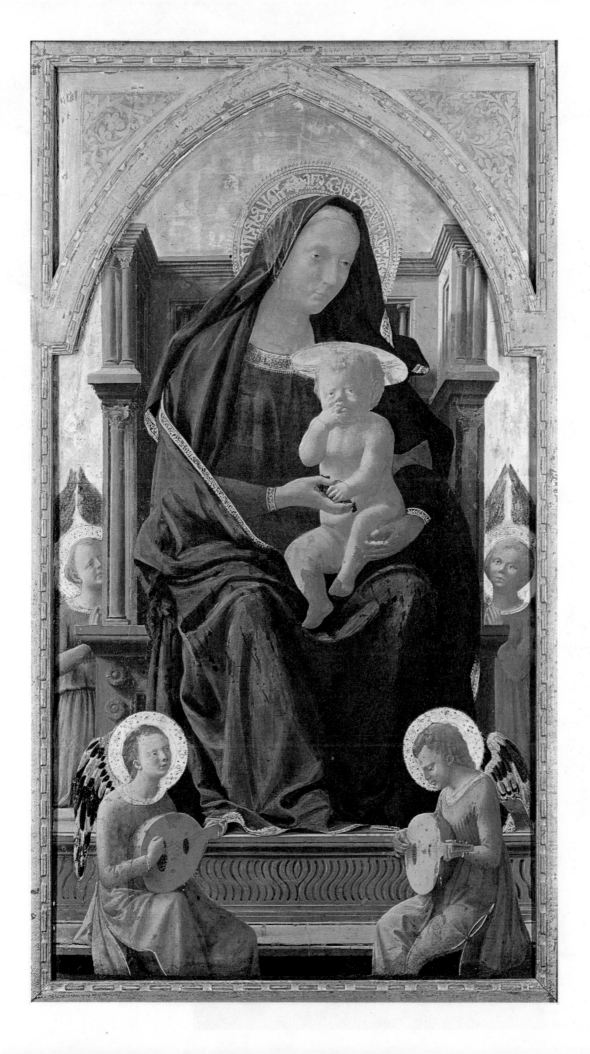

7. **Filippo Brunelleschi.** *The Old Sacristy, S. Lorenzo,* Florence. 1418–28. The use of coloured marble for decorative ends had long been a feature of Florentine architecture. In spite of the precise archaeological derivation of most of the detail, the Old Sacristy represents a brilliant rethinking of this tradition. The treatment of wall surfaces was still characteristically two-dimensional, and the heavy projecting pediments and columns of the twin entrances were probably additions of Donatello, whose doors they frame. Verrocchio's Medici tomb (left) with its arch was completed in 1472.

8. **Filippo Brunelleschi.** *S. Spirito,* Florence. The Nave looking east. Begun *c.* 1436. Although very similar to the earlier church of S. Lorenzo, S. Spirito contains several important changes. The general proportions of the component parts of the building were significantly altered. Furthermore the rectangular lines of the older church were modified by the addition of a string of apsidal chapels which encircle the church. In this way the architect moulded the internal contours of the church into something more interesting and more complicated.

THE PICTORIAL RELIEF IN THE
EARLY 15TH CENTURY

9. **Donatello.** *Herod's Feast and the Execution of St John the Baptist.* 1427. Gilt bronze. 23½ × 24 in. (60 × 61 cm.). Relief from the font, Siena Baptistery.
10. **Lorenzo Ghiberti.** *The Story of Jacob and Esau. c.* 1435. Gilt bronze. 31 × 31 in. (79 × 79 cm.). *Porta del Paradiso,* Florence Baptistery. The device of linear perspective benefited sculptors as well as painters and the result was a revived interest in the pictorial relief in which a space deeper than the actual depth of the carving was indicated illusionistically. Like the painters, the sculptors were enabled to control with greater ease the relative sizes of architecture and figures, as these examples in sharply contrasted styles show.

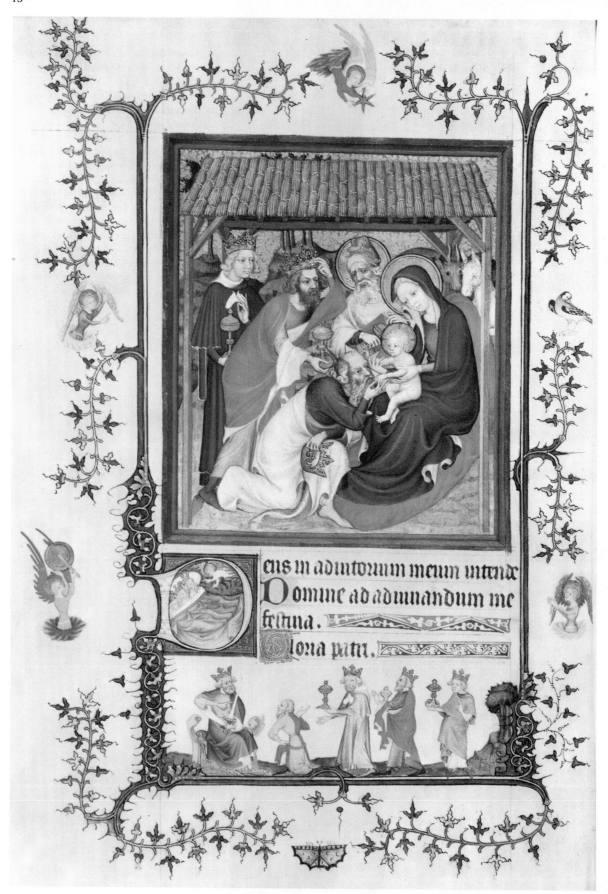

11. **The Circle of the Master of the Parement de Narbonne.** *The Adoration of the Magi. c. 1380. From the Très Belles Heures du Duc de Berry.* Painting on vellum. $11\frac{1}{2} \times 8\frac{1}{4}$ in. (29 × 21 cm.). Bibliothèque Nationale, Paris. This scene, from a sumptuous late 14th-century Book of Hours, is in style uncharacteristic of French book illumination, particularly in the large, serious, heavily modelled heads of the figures (compare the following illustrations). This feature derives from Italy, but other more enduring aspects of Italian influence are visible, particularly in the construction and control of pictorial space.

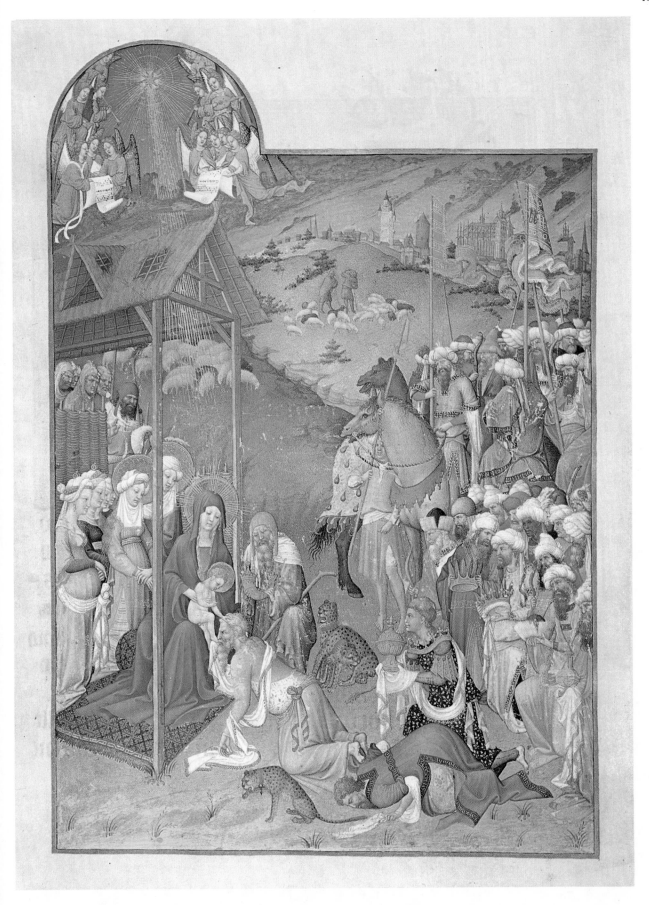

12. **The Limbourg Brothers.** *The Adoration of the Magi. c.* 1415. From the *Très Riches Heures du Duc de Berry.* Painting on vellum. Page 11½ × 8¼ in. (29 × 21 cm.). Musée Condé, Chantilly.

An extravagant full-page spread of fascinating detail. The modelling of the facial features is scarcely emphasised and figures have a grace and elegance lacking in plate 11. Yet in order to amass so much detail the artists had to know how to construct the space of a landscape, and this understanding came from Italy.

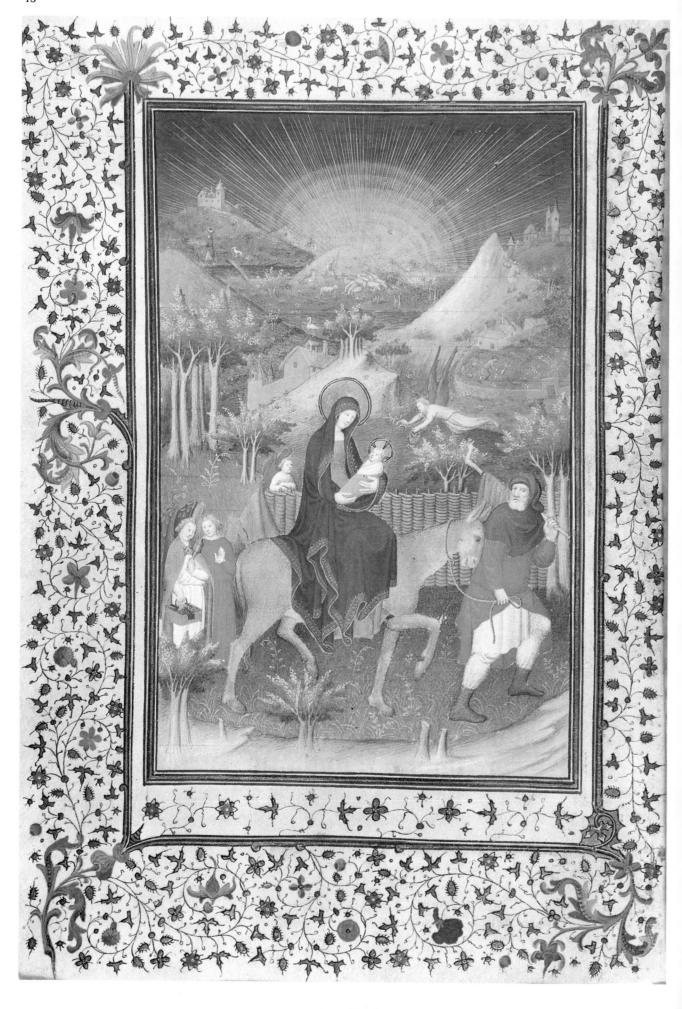

13. **The Master of the Hours of the Maréchal de Boucicaut.** *The Flight into Egypt. c.* 1405–10. From the *Hours of the Maréchal de Boucicaut.* Painting on vellum. Page 10¾ × 7½ in. (27.5 × 19 cm.). Musée Jacquemart-André, Paris. This Book of Hours is striking, among other things, for its landscape settings. In their European context they are remarkable since the artist has departed so far from the conventional treatment of rock-formations and attempted also to indicate an atmospheric haze in the far distance.

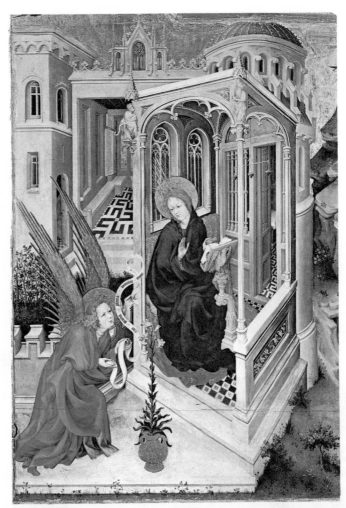

14. **Melchior Broederlam.** *The Annunciation.* After 1392. Wing from an altarpiece executed for Philip the Bold, Duke of Burgundy, originally in the Chartreuse de Champmol, Dijon. Painting on wood. 63¾ × 51¼ in. (162 × 130 cm.). Dijon Museum. The scene takes place in a palace, replete with symbolism but also containing elaborate decoration, a smart tiled floor and a pretty garden. To the right are the traditional rock-formations used to indicate landscape (compare plate 13). This ambitious spatial construction is a further instance of the influence of Italian example but the restraint and delicacy of the figures are typical of French taste.

15. **Robert Campin.** *The Annunciation. c.* 1425. Centre panel of the Mérode triptych. Painting on wood. 25½ × 25½ in. (64.5 ×64.5 cm.). Cloisters Collection, Metropolitan Museum of Art, New York. Painted for the Inghelbrecht family of Malines, Belgium, this interpretation of the theme is remarkable for the setting in which it takes place. There is, again, much implied symbolism in the detail, but the completeness of the interior setting and the unpretentious *milieu* are new features in Flemish panel-painting. The full rounded faces stand in contrast to those of Broederlam, and are reminiscent of the style of plate 11. Also clearly visible here is the new angular drapery convention which made its appearance *c.* 1420.

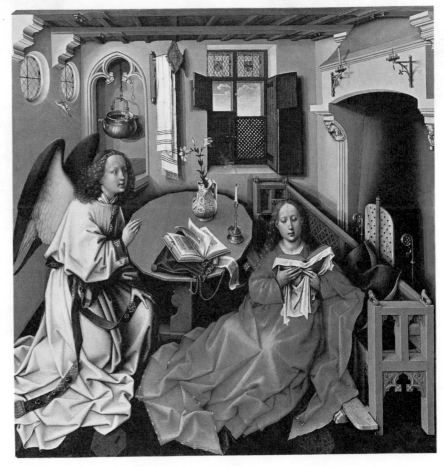

THE PORTRAYAL OF EMOTION,
OLD AND NEW STYLE

16. *Pietà. c.* 1400. Painting on panel.
Diameter 25¼ in. (64 cm.). Louvre, Paris.
Like plate 14, this was executed for
Philip, Duke of Burgundy and has been
attributed to Jean Malouel, court artist
and probably the uncle of the Limbourg
brothers (see plates 1 and 12). It is a
sensitive and moving composition,
depending very little on facial expression
to achieve the impression of tragedy and
grief. This reticence seems to have been a
general characteristic of French court
taste.

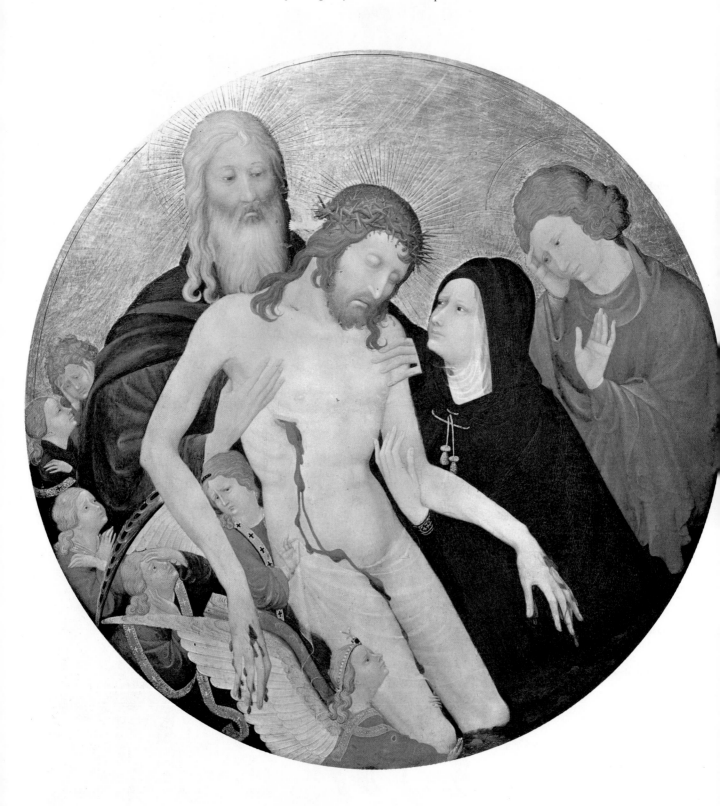

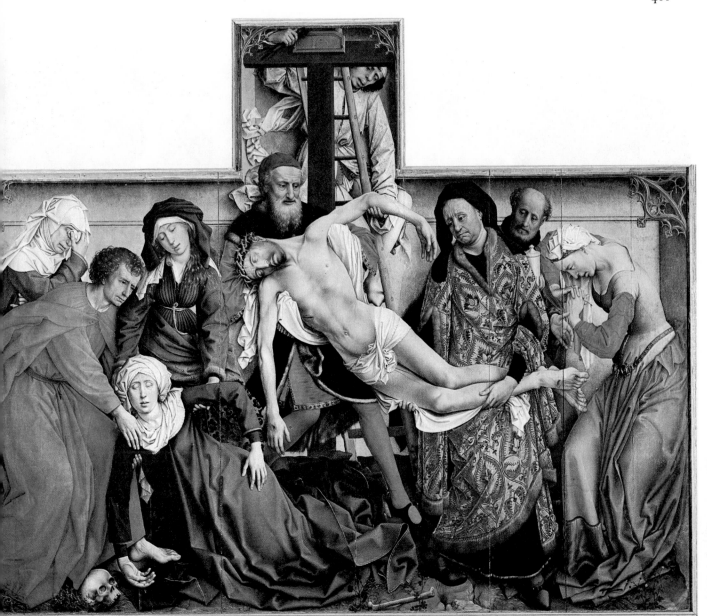

17. **Roger van der Weyden.** *The Descent from the Cross. c.* 1435. Painting on panel. 78¾ × 104¼ in. (200 × 265 cm.). Prado, Madrid. Painted for the chapel of the Guild of Archers, Louvain. The desire of the painter to involve the spectator directly in the tragedy of the occasion is clear and contrasts strongly with plate 16. Facial expression is important and gestures and actions are more dramatic, the figures being placed as if on a stage.

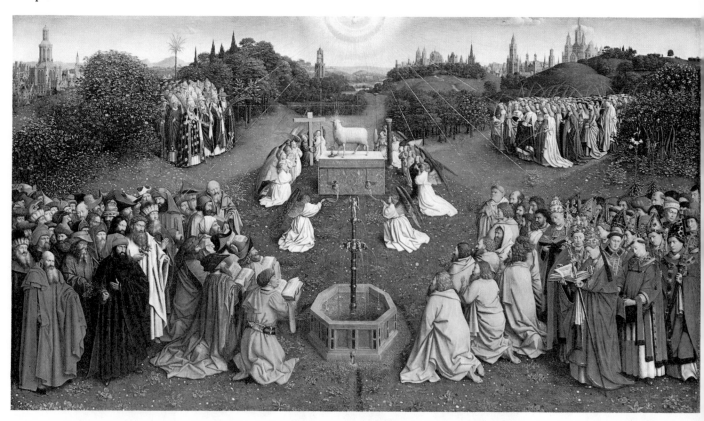

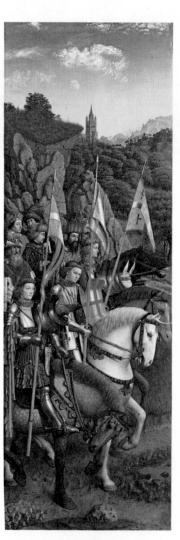

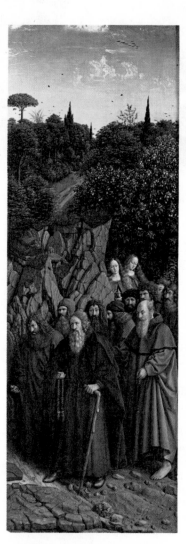

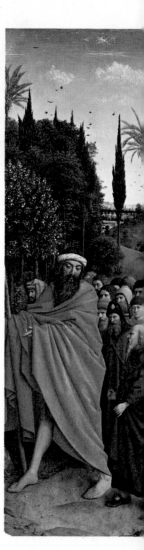

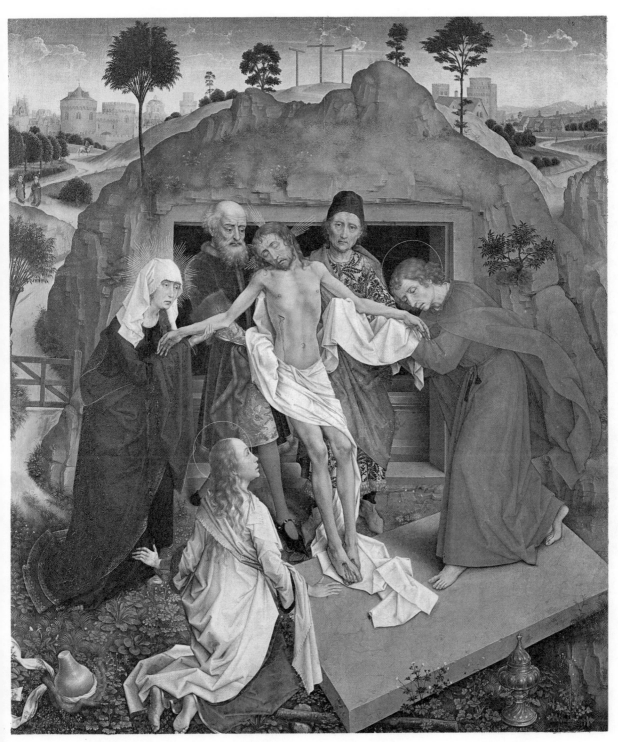

18 (opposite). **Hubert** and **Jan van Eyck.**
The Ghent altarpiece (lower scenes, front
face). Completed 1432. Painting on panel.
Dimensions of *The Adoration of the Lamb*
(above) 4ft 5¾ in. × 7ft 11½ in.
(136.5 × 242 cm.). Panels below, each
4 ft 10 in. × 1ft 8¼ in. (147 × 51 cm.).
St Bavon, Ghent. The nature of Hubert's
contribution has never been unanimously
agreed. These five panels (the largest is
actually set in the centre of the four
narrower ones) illustrate the enlarged
scale of the painter's conception of settings.
Like a great wall-painting, this landscape
may be read continously from one side
to the other.

19. **Roger van der Weyden.** *The
Entombment. c.* 1450. Painting on panel.
14 × 17¾ in. (35.5 × 45 cm.). Louvre,
Paris. In comparison with plate 17 it is
clear that the more extrovert aspects of
grief have been quietly laid on one side.
Only the symbolism of grief is retained in
the attitude of the kneeling Magdalen.
This gesture and the scheme as a whole
were probably noted by Roger during a
visit to Italy in 1450 (the basis of the
composition seems to be a work of Fra
Angelico) but the style of their restate-
ment is totally northern. This makes an
interesting contrast to later attitudes in
the North to Italian art.

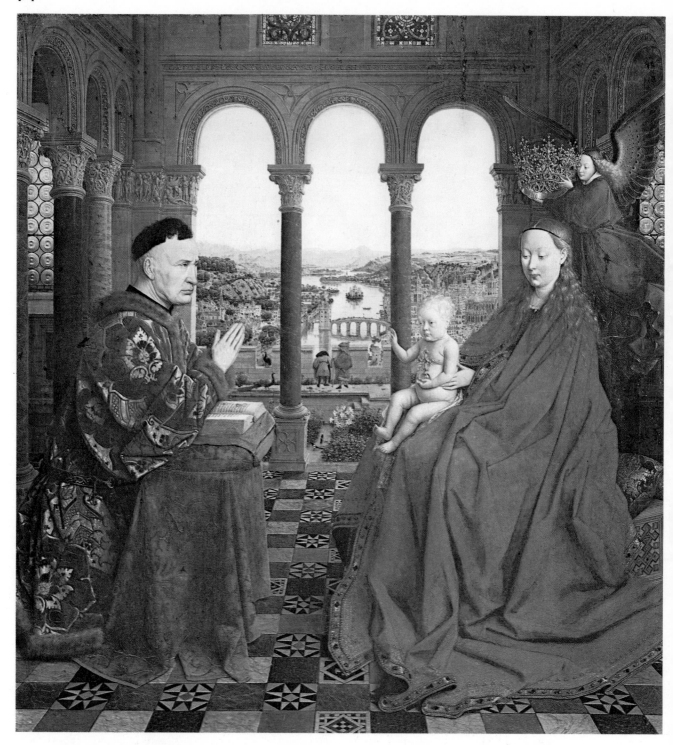

20. **Jan van Eyck.** *The Madonna with the Chancellor Rolin. c.* 1435. Painting on panel. 26 × 24½ in. (66 × 62 cm.). Louvre, Paris. The cardinal Rolin was chancellor of the duke of Burgundy and the splendour of the setting of this votive painting reflects his social standing. (Compare plate 15, where the kneeling donor appears on a side panel, not included here). This is one of Jan van Eyck's most brilliant works, displaying his gift for portraiture and his astounding technique as a painter of detail and texture.

them as models for his main churches since they had one particular decorative feature which Brunelleschi ignored. They made extensive use of fresco cycles on the walls. This decorative fashion had spread to Tuscany. A certain amount of mosaic decoration appears in the baptistery of Florence; and frescoes were added to the aisle walls of S. Miniato. But the main decorative effect in those churches came overwhelmingly from the application of a marble incrustation to the walls.

Brunelleschi's turn towards this style of architecture is one of the more remarkable features of Florentine art at this time. To have imitated old St Peter's, Rome, with its great fresco cycles running along the walls above the main nave colonnade would have been perfectly permissible and genuinely 'antique'. Painters existed who could well have executed the paintings. Yet Brunelleschi deliberately planned buildings which excluded painted frescoes from their decorative scheme and, like the earlier Florentine churches, relied for their decorative effect on the handling of coloured marble. The reason can now only be guessed; but it is likely that these Tuscan buildings would have seemed to him more genuinely 'architect's churches' in which the architect was in complete charge from the start, planning and foreseeing every aspect of the completed effect. For this reason, the curious fact emerges that almost none of the great achievements of the 15th-century fresco painters in Florence was executed in a 15th-century building because the architectural fashion revived by Brunelleschi made no provision for this kind of decoration.

Brunelleschi certainly chose this style precisely because the entire completed effect of any architectural project mattered a great deal to him. In particular the mathematical relationship of one part of a church to another part, both in plan and in elevation, was worked out with great care; and in underlining shape and proportion the plain grey-green *pietra serena* of Florence undoubtedly plays a vital role. All Brunelleschi's buildings display an intricate system of interrelated proportions.

Brunelleschi's architectural style did not change very much. He experimented, however, in a number of different types of building—for instance, the loggia of the *Innocenti* or the two churches of S. Lorenzo and S. Spirito. Very important for the future were the more compact buildings such as the Old Sacristy (of S. Lorenzo) or the Pazzi chapel (of S. Croce). There was, however, one subtle and interesting development in Brunelleschi's feeling for the sculptural qualities of architecture. Much of his work is constructed of flat wall-surfaces articulated by *pietra serena* pilasters or ornament (the church of S. Lorenzo is an example). During the 1430s he appears to have discovered that the walls could, as it were, assume a shape of their own, and that an architect, in modelling the walls into convex or concave shapes, was also fashioning the interior space into something more complex and exciting. This change can be followed in S. Spirito or in the unfinished church of Sta Maria degli Angeli. It may be connected with a further

13. **Donatello.** *Bronze door* in the Old Sacristy, S. Lorenzo, Florence. Between 1434 and 1443. Bronze. 92½ × 43 in. (235 × 109 cm.). The problem of what to do with repeated pairs of figures was solved here in a most dramatic way. The summary nature of the dividing ornamental bands focusses attention on the action contained in the rectangles.

14. **Donatello.** *Cantoria.* 1433–8. Marble with polychrome mosiac inlay. Overall size 137 × 224½ in. (348 × 570 cm.). Museo dell'Opera del Duomo, Florence. Using an antique idea already revived by Jacopo della Quercia, Donatello enriched the balustrade of the gallery with this unruly mob of dancing *putti* who move as on a stage set behind the proscenium framework of the columns.

15. **Filippo Brunelleschi.** *The dome of Florence cathedral* from the south-east. Built *c.* 1420–36. Lantern designed 1436 but only built after 1446. The dome, of unusual shape, dominates the surrounding city and it is still possible to get a 15th-century impression of the gigantic nature of Brunelleschi's achievement. Much of the upper part is of concealed brick to lighten the structure.

journey to Rome which there is some reason to suppose that Brunelleschi took with Donatello in 1433. Certainly the plan of Sta Maria degli Angeli is very close to that of the Roman temple of Minerva Medica. Brunelleschi may therefore have become aware of the fact that much Roman imperial building makes its effect through the complicated shapes of the walls as well as through the surface adornment.

The mathematics or geometry which Brunelleschi required in calculating his architectural effects also led him by paths now obscure to pioneer a carefully calculated system of perspective construction—that is, to devise a system for the representing of three-dimensional shapes on a flat surface by the use of geometrical constructions on the part of the painter. Only descriptions survive of his practical demonstrations of the new technique for calculating the recession of space on a flat surface; the codification of the method was made by the scholar Leone Battista Alberti in his treatise on painting of 1435. Sculptors were also interested in these problems and, about 1420, the pictorial relief was revived as a medium of art. Medieval relief sculpture as a rule had pretended to no greater depth than the actual depth of the stone carving; but now sculptors began to treat the area of the stone surface after the manner of a picture, modelling the figures against a complete and receding background which was generally indicated in a low, delicate relief. In carving of this type it was possible to give the new technique of perspective construction full play, as can be seen in the work of both Donatello and Ghiberti.

During these years Masaccio made his debut as a painter, being inscribed in the guild of the *Medici e Speziali* in January 1422. Born in 1401, Masaccio was far younger than either Brunelleschi or Donatello. The problem of his training as an artist has never been completely settled but he collaborated frequently with another artist from the same Florentine parish, Masolino. Since Masolino was the elder by almost twenty years his work might be expected to have

had some effect on the young artist; yet curiously Masaccio's painting (with its economy, austerity and solidity) owes little, if anything, to Masolino's late Gothic style. Masaccio must somehow have acquired a distaste for the current decorative tendencies in painting, and this distaste must have led him to study the work of Giotto and also that of sculptors, past and present. Little exact imitation can be found in Masaccio's fragmentary surviving painting; but there is no other explanation for the extreme plasticity of his figures, otherwise extremely uncharacteristic of his period. His work must also have owed something to Brunelleschi, for Masaccio undoubtedly knew of the general developments taking place in the study of perspective as can be seen from his huge fresco of *The Trinity* in Sta Maria Novella. Again from this fresco it can be seen that he must have been thoroughly acquainted with the elements of antique architecture.

In 1428 Masaccio went to Rome where he died within a few months. Two commissions from among his surviving works should be mentioned. The first was a polyptych, an altarpiece painted for the church of the Carmine in Pisa in 1426; the fragments of this are now dispersed throughout a number of different galleries, and the central figures —*A Virgin and Child with Angels*—are in the National Gallery, London. In this it will be noticed that part of the solidity of Masaccio's figures comes from the painter's awareness of the part played by light and shadow in defining volume. The presence of the Virgin is also rendered more imposing by the device of a low viewpoint, while a number of supplementary features tend to stress both this viewpoint and the solidity of the figures. These include the projecting fingerboard of the lute played by the right-hand angel, but the most important is the halo of the Christ Child, painted not as the customary flat circle but as a solid, three-dimensional disc. The frescoes which he painted in the Brancacci chapel of the Florentine Carmine church also contain these qualities. As might be expected, the general tone of the narrative is one of majestic gravity; the frescoes are sombre in expression, although an atmosphere of emotional tension is created by the hysterical pathos of Eve and the hopeless gesture of Adam as they are driven out of Eden.

All the known works of Masaccio represent the uncompromising style of a young man. Like most uncompromising works, his painting has a certain lack of appeal, for Masaccio was certainly not interested in conveying either charm or conventional beauty to the beholder. It is a matter of speculation whether, and in what directions, his style might have mellowed, had he lived.

At this period the phrase 'Italian Renaissance' is highly misleading if applied to the visual arts. As has already been suggested this is partly because artists were not yet themselves obsessed with the idea of a 'rebirth' of the greatness of classical antique art in their own works. But it should also be noticed that the artistic changes here described were in any case almost entirely restricted at first to Florence.

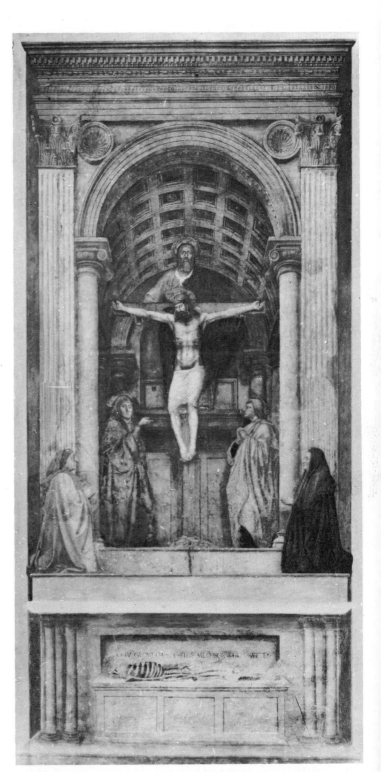

16. **Masaccio.** *The Trinity.* 1426–7. Fresco. 192½ × 124¾ in. (489 × 317 cm.). Sta Maria Novella, Florence. This fresco was painted as a funeral monument with those commemorated appearing as donors kneeling above an altar table. The gravity of the figures is matched by the enormous classical architectural setting which creates the impression of real physical presence in a way probably never before achieved by a painter.

For much of the first half of the 15th century the other important Italian centres of patronage—Venice, Verona, Ferrara or Milan for instance—continued to demand works which were essentially similar to those produced at the end of the 14th century. At this stage Florentine artistic change did not greatly affect the development of the visual arts in the rest of Italy.

ARTISTIC CHANGE IN FRANCE AND BOHEMIA

As in Tuscany major artists in the North were faced by the problem of developing, or breaking away from, the decorative conventions of the 'International Gothic' style. But, perhaps on account of disturbed political events, there was no continuity of development similar to that which is apparent in Florentine art. For in Prague conditions of court patronage became very unsettled following the deposition of the Emperor Wenzel in 1400 and, although Wenzel re-established himself and reigned as king in Bohemia until 1419, from 1400 onwards Prague became steadily less important as an artistic centre. In France the death of Charles VI in 1422 and the subsequent dynastic claims of the English king to the French crown led once more to war, and this temporarily eclipsed the artistic ascendancy of Paris. This lack of stability and continuity is tantalising for the historian of art because certain stylistic changes had already occurred in both these centres.

In Bohemia these changes took the form of an extraordinarily involved and mannered drapery and figure style which is difficult to describe, although easily recognisable (the *Madonna* of St Vitus, and the Krumlov *Madonna*, *c*. 1400). It appears to have been evolved shortly before 1400 and is to be found in the work of both painters and sculptors. In France, on the other hand, this style was confined to sculpture and is chiefly associated with the work of Claus Sluter, the *imagier* of the Duke of Burgundy.

Little is known about Sluter's origins, and some of his work is disputed, but changes similar to those found in the Bohemian figures can be observed in the *Virgin* (almost certainly from Sluter's hand) and in the portal figures at the entrance to the chapel of the Chartreuse de Champmol near Dijon. Here again the sculptor has breathed a new life into the conventions of the previous years, working the drapery into a fantastic cascade of folds but—and it is an important reservation—instilling his figures with a vigour and dramatic force without parallel in Bohemia. Sluter's individuality and originality has never been disputed and finds its most positive expression in the battered remains of a Calvary group, the so-called *Puits de Moïse*, which stands in the middle of the cloister of what was formerly the same Chartreuse. Now the base alone of this Calvary group survives intact: around its polygonal form stand figures of prophets, each swathed in voluminous drapery, the face of each utterly individual. Like much medieval sculpture these figures were once carefully painted, and they must have been a striking sight when newly completed. Collectively, however, they form a

17. *Madonna and Child. c.* 1400. Paint on panel. The whole 35 × 30¼ in. (89 × 77 cm.). National Gallery, Prague. From the cathedral of St Vitus. Painting and sculpted frame illustrate the extremely elaborate drapery style of the late 14th century, favoured at the Bohemian court.

18. *Madonna and Child. c.* 1400. Limestone, painted. h. 44 in. (112 cm.). National Gallery, Prague. Originally from Cesky Krumlov. Like figure 17, the drapery is elaborately decorative, and in the full-length figure the mannered somewhat wayward grace of the style becomes more obvious.

19. **Claus Sluter.** *Madonna and Child. c.* 1390. Marble. Chapel, Chartreuse de Champmol, Dijon. The elaboration of the drapery makes an interesting contrast to the Krumlov *Madonna* (figure 18). The style is far more vigorous and dramatic and there is an element of psychological involvement between the Mother and the Child which was beyond the intentions of the Bohemian master.

group of impressive gravity in contrast with the hysterical angels above their heads.

It is natural to look for a painter of the same dramatic force as Sluter. Work of a comparable kind certainly exists, but in looking for it, a curious duality in French court art emerges, a duality not unlike that presented by the contrasted styles of Donatello and Ghiberti in Florence. Long tradition appears to have established a taste for elegance and refinement at the French court and a dislike of art which demanded emotional involvement on the part of the spectator. The patronage of Sluter is thus unexpected and, in the absence of surviving evidence, it is impossible to reconstruct the circumstances in which his work caught the fancy of the Burgundian duke. The origins of the equivalent style in painting are clearer and they seem to lie in Italy. An admiration of Italian art may therefore have recommended the style to the French king. For it was Charles V who appears as a donor in one of the chief monuments of the style, an altar frontal of *c.* 1375 known as the *Parement de Narbonne*. Perhaps the most noticeable feature in this painting is the size of the heads of the figures and the expressions conveyed by the deep-set, mournful, eyes. This expressive quality, like some of the compositions, probably stems from Italian painting and, although more at home on a large scale, also had a limited popularity in the medium of manuscript painting. It also appears in one of the few surviving altar panels from the Chartreuse at Dijon, painted probably *c.* 1416 and representing, among other episodes, the martyrdom of St Denis and his companions. Through the manipulation of the facial expressions of the executioner and onlookers, the painter succeeded in conveying something of the horror and shock of the martyrdom. This is one aspect of French court painting *c.* 1400 and led, by devious means, to the emotional expressiveness of Roger van der Weyden. 21 11 22

In general, however, in paintings executed for the French court such extremes seem to have been avoided. Especially in the field of manuscript illumination the most accomplished artists concentrated on the portrayal of detail and on the settings of their scenes without any appeal to the emotions. These artists apparently had an infinite capacity for taking pains over their work, and were given ample opportunities for doing so, since a large work—such as an historiated Bible—might occupy two, or even more, painters for perhaps two or three years. The innovations which are introduced into these manuscripts can generally be traced back to 14th-century Italian painting; in particular the illuminators gradually came to imitate the Italian artists' control of space, which made it possible to incorporate their observation of detail into a convincing whole.

In one field these painters even went beyond any Italian precedent. This was in their observation of landscape and phenomena of nature. Although the exact development of this change is a mystery, it can be seen that in the last decade of the 14th century a royal painter like Melchior Broederlam was still content to use conventional trees and 14

rocks similar to those of earlier Sienese painting. Other artists had already slightly modified these conventions, but no previous development explains the landscape of an artist still only known from his main work, the so-called **13** Boucicaut Master (he produced a Book of Hours for the Maréchal de Boucicaut). During the years 1405–10 this artist rejected the rocky hills of Sienese art in favour of a landscape seen as a gentle, undulating recession glimpsed across a lake. The patterned gold background, usual up to this date, was replaced by a sky whose colour modulations seem to be related to the idea of a misty haze rising off the surface of the lake.

This aspect of the change in style—the more realistic treatment of descriptive detail—did not automatically imply a revolution in taste. It was not necessary to enliven the figures or make the faces expressive after the manner of **21** the *Parement de Narbonne*; it seems that most Parisian illuminators ignored this style, and certainly the figures of the Boucicaut Master have all the remoteness and fastidious elegance of the Parisian tradition. Of all the court artists of this period, however, the most famous are probably the **12** three brothers Limbourg, who worked for the Dukes of Burgundy and Berry and they represent a high point in the manuscript illumination not only of this period but of all time.

ARTISTIC CHANGE IN THE NETHERLANDS

It was at this point, *c.* 1415, that the Parisian court tradition was broken; the immediate signs of the break are to be seen in the fact that the centre of artistic interest shifts from manuscripts and a few panel paintings executed for the French royal family to an ever increasing number of panel paintings painted for far less exalted patrons in the Netherlands. A bourgeois clientele with a taste for panel painting seems to have emerged in circumstances which are extremely obscure. The history of Netherlandish art during the 14th century, as far as can be judged from the surviving works, was undistinguished. The country was divided into a number of separate counties such as Brabant and Artois; and since each had its own comital court, it is to be assumed that the international standards of Paris would, via these local courts, have filtered through to the bourgeoisie of the towns. Indeed, a court artist, such as **14** Melchior Broederlam also had a shop in the town of Ypres, and by these means townsmen were able to aspire to 'court art'. Some sort of civic background is probably essential in order to explain the emergence of two outstanding Flemish painters Jan van Eyck and Robert Campin for neither appears to have begun his career under the immediate influence of Parisian art. Jan van Eyck, although he joined the court of the Duke of Burgundy later in life (*c.* 1425, at which period Philip of Burgundy moved his capital to Flanders), is first mentioned in the service of the Prince **15** Bishop of Liège. Robert Campin was a master at Tournai who never had any documented professional connections

20. **Claus Sluter.** *Base of Calvary group, so-called Puits de Moïse (Well of Moses).* 1395–1406. Chartreuse de Champmol, Dijon. Much of the prevailing interest in realistic detail was present in these figures but now very little of the original gaudy paintwork survives. It was coupled, however, with a distinctive and probably revolutionary drapery style; the figures themselves were set in differing attitudes—never graceful and sometimes awkward.

with any princely court. There must have been a link between their world and that of the Boucicaut Master, but it is not possible now to trace it with any degree of assurance.

In passing, a stylistic change should be noticed as one of the characteristics which marks a difference in paintings executed between 1415 and 1425, for during these years a change occurred in the treatment of drapery. Whereas the Parisian painters produced a drapery style which is refined, elegant and in which the material falls in gentle, delicate folds, this was already changing in the earliest surviving work of Robert Campin (*c.* 1420). It was replaced by a style which was more angular and in which the folds take abrupt unexpected turns and form flat zigzag patterns. The style is far more weighty and the influence of sculpture on painting at this point is possible. Ultimately this convention spread across northern Europe and was imported back into sculpture.

It is easiest to pass to this new style in painting by means of the work of Jan van Eyck who at least began life as a court artist, although that court was a provincial one. Although his later work for the Duke of Burgundy has now all been lost, a votive panel painted for the duke's chancellor, Nicolas Rolin, survives and represents the highest level of court art at that time. It is instructive to compare it with an earlier product of the same class such as the Wilton diptych in the National Gallery, London. In both works the outward trappings of material wealth are recorded with meticulous detail and infinite care. But the chancellor Rolin kneels in a marble palace which opens out on to a delectable roof garden. Beyond lies a town, painted with a miniaturist's love of detail. This painting shows that Jan

21. *Parement de Narbonne* (detail). *c.* 1373–8. Paint on silk. Whole 30¾ × 112½ in. (73 × 286 cm.). Louvre, Paris. Said to have come from Narbonne, this silk altar-hanging was certainly produced originally in Paris for the royal family. The unknown master was strongly influenced by Italian art for his compositions, and, although the figures are graceful, their faces portray a feeling and passion not to be found earlier in the 14th century.

22. **Henri Bellechose.** *Crucifixion with the Martyrdom of St Denis* (detail). 1416. Paint on canvas (transferred from panel). Whole 63½ × 82½ in. (161 × 210 cm.). Louvre, Paris. The new taste for heavily characterised faces made little impression in Paris but some echo of it appears here in a painting executed for the Chartreuse de Champmol. Many of these types are extremely Italianate (14th century). The style by some obscure path reappears in the work of Robert Campin.

van Eyck owed a great deal to the extraordinary achievements of the Parisian miniaturists before him; but his grasp of pictorial structure would equally be unthinkable without a deep understanding of that aspect of Italian art. It was a combination of these two elements that produced a style whose crystal clarity has never been equalled before or since.

The settings of Flemish paintings became with surprising suddenness far more ambitious. This would, however, appear to develop naturally out of the aspirations of earlier manuscript painters. It frequently seems, for instance, as though the Limbourg brothers were trying to adapt to manuscript illumination schemes probably derived from large-scale wall decoration; panel painters at a later date more appropriately also began to think in these inflated terms. Thus a gigantic polyptych, such as the Ghent altarpiece, is gigantic not only in actual size but also in the conception of the scenes. The lower landscape is made to stretch across five panels in a manner reminiscent not of previous panel painting, but of fresco decoration, for instance in the Campo Santo at Pisa.

Jan van Eyck lived much of his life at Bruges. Robert Campin lived at Tournai and it was from his workshop that another great Flemish artist emerged—Roger van der Weyden. Of the two aspects of French court art already described, Robert Campin appears to be closer to that represented by the *Parement de Narbonne* and the painting of the *Martyrdom of St Denis*. Unlike Jan van Eyck, he concerned himself with human emotion and Roger van der Weyden did likewise. Roger's handling of emotion is, however, considerably more sophisticated; and it is indeed remarkable that he was able to handle emotions such as grief with such reticence that it avoids appearing grotesque.

Roger van der Weyden lived until 1464, and in the course of this long working life his style varied considerably. The importance, for instance, of Italian ideas fluctuated, particularly around 1450 when Roger probably journeyed to Rome. He avoided the detailed brilliance of Jan van Eyck, but developed a range of expressiveness which was considerably greater. It is for this reason that he forms an acceptable complement to van Eyck and the pair are usually regarded as joint founders of what is rather misleadingly called the 'Flemish Renaissance'.

CONCLUSION

These observations help to place in perspective the events in Tuscany. The work of Donatello and Masaccio was not an isolated phenomenon but part of a wider reaction against the 14th-century style which had international implications. The sources used by the great Tuscan artists were not exclusively classical; and, even though scholars' enthusiasm was restricted to the revival of the forms and language of classical literature, the processes of artistic creation did not run along such narrow lines. Artists were caught up in a far more complicated process and their immediate purpose was not the archaeological reconstruction of an antique style.

It is necessary to make these points in order to bring out the peculiar quality of the following phase of Italian art. For at this stage, perhaps for the first time in European history, scholarship really did join hands with artistic creation, with decisive and far-reaching effects.

The Triumph of Antiquity

The title of this chapter is suggested by a phenomenon which became widespread in Italian art during the second half of the 15th century. Artists began to look at the appearance of antique art as a whole and not mainly as an agglomeration of striking or stimulating detail. This development is important since, through a more painstaking attempt to imitate classical art, Italians, artists and patrons alike, were educated to a more sensitive appreciation of classical art; without this, the extremely sophisticated classicism of the High Renaissance would hardly have been possible.

The artistic environment in which this took place did not basically differ greatly from that of the 14th century or indeed from that of the 16th century. Art was always a trade demanding apprenticeship: the young artist, sculptor or painter, spent a number of years in the workshop of an established master, learning the techniques of art and graduating by degrees from the preparation of pigments and cleaning up the workshop to taking part in the workshop commissions. His career was not more likely to be interrupted by external events than the lives of other citizens. Political disaster might induce an artist like Leonardo to flee from Milan (the fall of Ludovico il Moro, 1499) or Michelangelo to flee from Florence (the fall of the Medici, 1494), but most artists like most citizens trimmed their sails to the prevailing winds and continued as best they could. Occasionally external events seem to have affected a painter's whole style; it is recorded that Botticelli was deeply affected by the preaching of the Dominican friar Savonarola, who inveighed against the sins of the Florentines at the time of Charles VIII's invasion of Italy and the expulsion of the Medici from Florence. The painter's acceptance of Savonarola's puritanical doctrines probably acccounts for the deep solemnity of his later works, such as the *Pietà* at Munich. But other artists seem to have been entirely unaffected by the most adverse circumstances: for instance, Benvenuto Cellini continued to produce his elegant and decorative works in spite of months spent in the dungeons of the papal prison (1539).

Nevertheless the political and social background to these artistic developments was hardly a settled one. Equilibrium of a sort existed *c.* 1460–90 and it has already been mentioned that to those living in the 16th century this period had the appearance of a kind of Golden Age. Yet, although a few of the smaller princes such as the Gonzaga managed successfully to retain the allegiance of their subjects and the control over their estates, none of the major ruling dynasties survived the entire 15th century. The Medici family under masterly guidance of Cosimo the Elder (d. 1464) maintained its ascendancy over Florence for a time. But all Cosimo's successors were beset with political and financial problems. The famous political *coup* known as the Pazzi conspiracy (1478) came dangerously close to success and Lorenzo the Magnificent only escaped assassination by a hair's breadth. Moreover, in an age of economic recession, his political recovery could not save the finances

23. **Donato Bramante.** *Scene set in antique ruins.* 1481. Engraving. Bramante was the first architect to think of antique architecture in terms of the colossal scale of extant Roman remains. Even in this early engraving, with its erratic archaeological research and its patently 15th-century figures, the gigantic size of Bramante's conception is already striking.

of the Medici bank. By 1494, when his son Piero was driven from Florence, the bank was perilously near ruin.

Other major dynasties suffered from a similar instability. The Papacy was, of course, by its very nature unstable, and the hazards of election certainly affected the development of art in Rome. Milan also suffered a change of dynasty in 1447, when the male line of the Visconti family died out and the condottiere Francesco Sforza seized power (1450). The Sforza family was not itself united and its most magnificent ruler, Ludovico il Moro, was actually for much of his 'rule' regent for an incompetent nephew, Gian Galeazzo: on the death of this nephew in 1494, Ludovico usurped to himself the position that should have gone to an infant son.

It was observed at the beginning that an intense political life is one of the characteristic features of Italy at this period. In the 15th century the political prospect is like a kaleidoscope with frequent rearrangements of alliances to meet changed circumstances. As readers of Machiavelli

know, within and without the state no ruler could afford to relax his political vigilance. But the importance of politics for art lies in the nature of the patrons which are brought to the fore. Sometimes particular effects can be demonstrated. The change of dynasty in Milan inaugurated a period of artistic patronage which was more catholic in outlook than that of the Visconti. The Sforza family, particularly the famous Ludovico il Moro, introduced into Milan outsiders like Bramante and Leonardo. Usually the effects are far more difficult to trace; and this must be borne in mind in following the developments which now have to be considered.

FLORENTINE ART AFTER 1430

At the beginning, the development outlined above does not seem to have been a Florentine movement. This is surprising because Florence continued to be a leading centre of humanistic studies and scholarship. She possessed a thriving university with provision for the study of Greek and Latin; and around the family of the Medici, the effective rulers of Florence from *c.* 1430 until 1494, there grew up a circle of scholars and friends known as the 'Platonic Academy', naturally enough devoted to the study of the works of Plato and his followers. This did not, however, exercise an immediate transforming effect on local artists to the extent of compelling them to copy literally whatever antique models they could gain access to. These artists had more than enough to occupy them in assimilating artistic developments of the first thirty years of the century; and what makes Florentine art of the 15th century so vital and interesting is that it was largely stimulated by this living style, and not by the dead hand of classical antiquity. These developments must now be examined.

The influence of Brunelleschi was ubiquitous in Florentine church design during the 15th century. Such churches as were built, like the Badia at Fiesole, or the churches by Giuliano da Sangallo (for instance, Sta Maria degli Carceri at Prato) continued to make their visual impression through large plain rectilinear surfaces articulated by bands of *pietra serena*. Of a development of the more complex spatial aspects of Brunelleschi's late style there is little sign.

In one aspect of architecture, however, the precedent of Brunelleschi's work provided little help. This was in the problem of façade design, for Brunelleschi never built either a secular or ecclesiastical façade (except the little loggia of the Pazzi chapel), although he must have had plans for both his churches of S. Lorenzo and S. Spirito. Indeed, no complete 15th-century Florentine church façade exists. In order to see how architects approached this problem, one has to turn to the façade of Sta Maria Novella—an unsatisfactory procedure, for, like many medieval buildings, this façade incorporates buildings from different dates. Much of the lower part, up to the main cornice, is 14th-century; the main doorway, the side

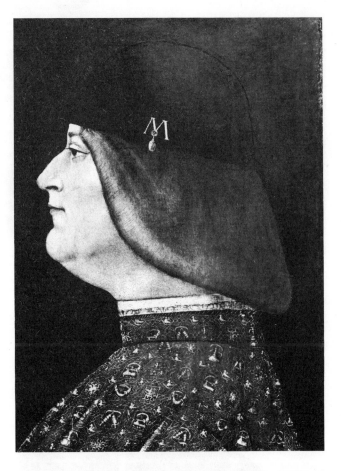

24. Ascribed to **Giovanni Boltraffio**. *Ludovico Sforza (il Moro)* (detail). 1495. Paint on panel. Trivulzio Collection, Milan. Ludovico was one of the most ostentatious of 15th-century princes. The splendour of his court was remarkable, as were the artists whom he patronised. It was he who invited the assistance of Charles VIII of France, precipitating a new series of foreign invasions into Italy which resulted, amongst many calamities, in his own downfall. He died a close prisoner, in the dungeons of Loches castle.

columns, the cornice and upper part were added by the scholar-architect Leone Battista Alberti in the years following 1456. The result is disjointed because in its proportions Alberti's coloured marble decoration does not harmonise with the earlier scheme. However, in spite of this, the combination of central pediment and boldly used volutes over the side aisles was a striking innovation which was to be very influential in the future.

Alberti also produced one secular façade—that of the Rucellai palace in Florence. Here, certain traditional features were retained—for instance, the mildly rusticated stonework and the round-headed two-light windows. On this scheme were imposed three rows of pilasters, each representing a different classical order. To the modern sightseer, the result may seem flat, unantique and academic; but, distant as this façade may be from the Colosseum in Rome, the fact remains that this was the first time

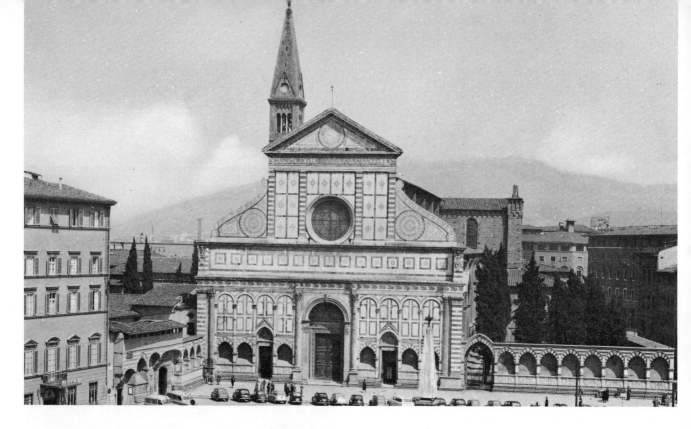

25. *The façade of Sta Maria Novella*, Florence. Partly 14th-century with additions by Alberti. *c.* 1456–70. Much of the lowest tier of marble arcading is 14th-century, Alberti adding the centre door the Corinthian columns and the upper parts. Although a

system of proportional relationships binds these additions together, the façade lacks cohesion because the verticals in the upper part do not correspond to those of the lower. The heavy side volutes were, however, an important innovation.

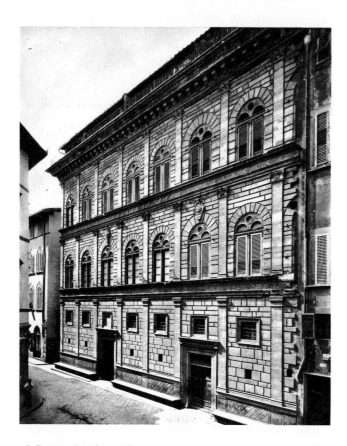

26. **Leone Battista Alberti.** *Palazzo Rucellai*, Florence. *c.* 1436. This palace is notable for its system of pilasters, tier above tier, each tier bearing a different order of capital. The flatness of the relief is partially balanced by the heavy cornice, but although revolutionary in its concept the design as such was little imitated by Florentines in the 15th century.

since the decay of Rome that any architect had attempted to reproduce the classical effect of superimposed orders of architecture. Historically, therefore, the Rucellai palace stands out as a supremely important monument in the development of Western architecture.

If the Florentines had been bent on a course of strict classical revival at this time, the Rucellai palace would surely have been immediately copied by architects for their patrons. But no 15th-century Florentine attempted to develop Alberti's scheme, perhaps because of its somewhat academic perfection. Far more popular—because far closer to the Florentine tradition—was a building, almost contemporary in date, by a different architect, Michelozzo. This palace of the Medici family relies for its effect on two features—firstly, the gradations in the degree of rustication in the stonework. There was obvious scope for development in this idea, which must have commended it to architects. Secondly, the Medici palace has an enormous heavy projecting cornice along the top. This feature derived from the Rucellai palace but, emphasised by its isolation, it makes the Medici palace distinctively different from its predecessors. The cornice replaced the projecting roof found on older palaces, the purpose of which was to provide some shade for the windows from the overhead sun. Although not contructed according to strict classical rules, it is classical in detail, and succeeds in lending the whole façade an authentic air of ponderous 'antiquity'. A number of variants of the Medici palace façade appeared during the remaining part of the century of which the Palazzo Strozzi is certainly the most gigantic.

Turning from architecture to painting and sculpture, the historical picture becomes more confused. Painters of course had to evaluate not merely the achievements of

Masaccio but also those of Donatello; and ultimately they had to come to terms with the new scientific theory of perspective construction. This process can be demonstrated in the work of Domenico Veneziano, one of the most able painters of the generation following Masaccio. The Sta Lucia altarpiece which he painted *c.* 1440 tackles and solves many of the main artistic problems posed during the previous twenty years. The traditional form for an altarpiece, a series of separated panels joined together in an elaborate frame, was abandoned during this period in favour of the form found here. The Virgin has been united with her attendant saints who form a group around her —a scheme known as a *sacra conversazione*. Here then is one innovation accepted by Domenico, although in the triple arch across the upper border of the picture he preserved a suggestion of the older form of altarpiece.

But the full subtlety of the Sta Lucia altarpiece lies in the balance struck between the spatial construction of the painting and its surface pattern. In an age in which artists were very concerned to produce an appearance of 'realism', and when a convenient geometrical system for indicating space had just been perfected, it was especially hard to strike this balance. Domenico successfully provided his figures with an accurately delimited space in which to exist; but at several points he placed complicating or ambiguous features which momentarily confuse the spectator's comprehension of this space. The Virgin, for instance, appears to sit in a niche which is certainly some distance behind her. The upper edge of the triple arcade is juxtaposed to the frame of the picture, although it certainly occupies the middle ground of the spatial construction. The longer one looks at this altarpiece, the more ingenious the artist's creation appears. The painting satisfies the demands of reality; but by confusing the eye in this way the painter forces the spectator to 'read' the composition in the first instance as a decorative pattern.

Domenico's style owes a considerable amount to the great Florentine artists. The heavy characterisation of the male faces and the deep folds of drapery are derived from a study of the work of Donatello and Masaccio and obviously differ from the earlier tradition of, for instance, Gentile da Fabriano. Nevertheless, Domenico's painting does not demonstrate an awareness of all Masaccio's achievements. In particular the use made by Masaccio of light and shadow in modelling his figures and compositions was not developed by Domenico, for in the work of the later painter light flickers from surface to surface and in the process of definition line plays an important part. These effects can be observed in the work of other painters, for instance, of Castagno who was a little younger than Domenico. The desire of these artists to indicate weight and volume was accompanied by an unwillingness to reduce the overall brillance of colour by adopting the heavy shadows of Masaccio.

In this general development the case of Uccello is instructive. He was considerably older than either Domen-

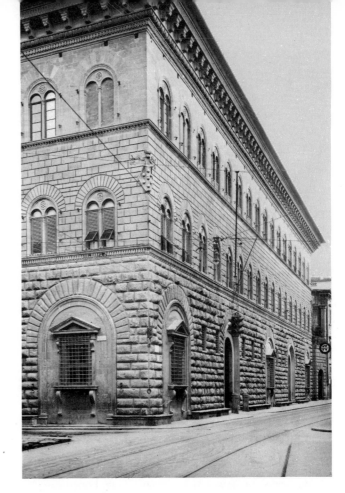

27. **Michelozzo.** *Palazzo Medici-Riccardi*, Florence. *c.* 1444–64. The visual impact of this palace is probably greater than that of figure 26 on account of the greater variation in surface texture. It should be noted that the palace was much enlarged in the 17th century particularly on the side of the Via Largo (right, here). The ground floor was originally open to the street but the openings were walled up in the 16th century, the inserted windows being designed by Michelangelo.

ico or Castagno—older even than Masaccio. He began his training in the workshop of Ghiberti and his earliest known work in the Chiostro Verde of Sta Maria Novella has something of the elegance and detailed portrayal of the International Gothic style. During the succeeding years, however, he became passionately interested in the contemporary discoveries in art. Four heads which he painted round a clockface in Florence cathedral have something of Masaccio's method of modelling in light and shadow, and many of his works demonstrate almost an obsession with the intricacies of perspective construction. But in his later years these interests were modified; and a late work such as the *Night Hunt* (Ashmolean Museum, Oxford) is full of gay colour and elegant little figures.

In spite of the influence of Donatello and Masaccio, a constant undercurrent of restraint and refinement ran through Florentine art which it is perhaps too easy to forget. Donatello seems to have reacted violently against it in his last years (*c.* 1453–66) for he produced a number of works of devastating emotional force and highly unorthodox finish. In a figure such as the *Magdalen* (Florence baptistery) the extraordinary surface quality plays an essential part in conveying an impression of extreme

28. **Masaccio.** *The Tribute Money* (detail). 1427. Fresco. Brancacci chapel, Sta Maria del Carmine, Florence. This detail gives a good impression of Masaccio's technique of modelling faces in light and shadow and his somewhat sombre colouring.

29. **Andrea del Castagno.** *Pippo Spano* (detail). *c.* 1451. Fresco transferred to canvas. Castagno Museum, S. Appolonia, Florence. Part of the decoration of the Villa Volta, Legnaia, and more immediately attractive than the style of Masaccio. Shadow is not used to the same extent and the whole head is crisply linear.

asceticism; but in 15th-century Florence Donatello's aims must have been scarcely comprehensible and still less palatable.

An alternative style always existed. Ghiberti himself lived until 1455 and his bronzework must have been a permanent reminder of the positive qualities attached to grace and technical refinement. It is not difficult in these circumstances to understand the success of Luca della Robbia's development of glazed polychrome terracotta as an artistic medium. Luca's own tasteful and elegant canon of art, as expressed in his Cantoria reliefs (Opera del Duomo, Florence, *c.* 1431–8) may well be contrasted with the unruly vigour of Donatello's *putti*.

Three sculptors, all born *c.* 1430, carried this sculptural tradition to new peaks of excellence. Their names were Antonio Rossellino, Desiderio da Settignano, and Andrea del Verrocchio, and all three were miraculously accomplished craftsmen. The influence of Donatello should not be underestimated, though. These sculptors were constantly employing ideas originating in Donatello's work, but generally emptied of any dramatic or emotional content. The use of low relief is an example. Again, Donatello had continually deployed his figures as if on a stage, half independent of their setting. Donatello's sculpture also exhibited extremes of human types which led to the intriguing decorative idea of the use of contrasted human types.

Of these three sculptors Desiderio's work probably has the most sensitive surface finish. Both he and Antonio Rossellino developed the conception of the sepulchral monument as a stage on which sculpted figures act out parts. The Rossellino monument to the Cardinal Prince of Portugal (S. Miniato al Monte, Florence) confronts the spectator with a miniature stage complete with proscenium arch and marble curtains. A heavy marble sarcophagus is revealed on which two *putti* and two angels balance in momentarily arrested motion.

Verrocchio, on the other hand, had the most fertile invention. His output, almost entirely in bronze, presents a stream of concentrated and varied invention. Much of the inspiration of his work derives from Donatello and, indeed, seems to have been executed in conscious competition with him. For, like Donatello, he produced a figure of *David*, a dancing *putto* and an equestrian monument. The group of the *Doubting Thomas* was designed for a niche that had held Donatello's figure of *St Louis*; and the scheme of the *Doubting Thomas* group was probably inspired by Donatello's Cavalcanti altar of the Annunciation (St Maria

30. **Desiderio da Settignano.** *Angel* (detail). *c.* 1450–1. Marble.
Part of the altar of the Sacrament, S. Lorenzo, Florence.
A major work by one of the most accomplished craftsmen of the
15th century. Few artists have ever equalled the sensitivity
with which Desiderio finished the surface of his marble
sculpture.

Novella). But, in keeping with the general stylistic ten-
dencies of the period, the group is deprived of all emotional
feeling, and the spectator is instead immediately assailed
by the sheer beauty of the cascades of drapery, and the
technical finish of the bronzework.

In painting, too, an alternative style existed. Alongside
the sculpture of Ghiberti and Luca della Robbia should be
placed the painting of Lorenzo Monaco, Masolino, Gentile
da Fabriano and Fra Angelico. It is true that much in
painting was fundamentally altered by the events of the
1420s. Obvious things changed. Houses and palaces were
painted as if built in a Brunelleschian manner. The heads
of Masaccio and Donatello provided a new vocabulary of
facial types, so that the narrow-eyed faces of the previous
century dropped out of use. Figures were placed more
carefully with relation to one another; and architecture
was related more carefully to the size of the figures it was
meant to contain. Yet it was possible to incorporate all
these new features into a work without resorting to shock or
drama. This is the essence of the art of the extremely
accomplished painter-friar, Fra Angelico. He was probably
about the same age as Masaccio, but his work is always
colourful, pleasing and reticent. His background detail was
always carefully observed and, like Gentile da Fabriano,

Fra Angelico had a *penchant* for flowers, strange costumes
and rich vestments. But, compared with Gentile, the
structure of his scenes and figures is more logical and
stable, and it is in this respect that the influence of Masaccio
can be most easily perceived.

An impressive synthesis of contemporary styles was
evolved by the painter Filippo Lippi, whose work forms a
good introduction to the painting of the second half of the
century. He was born probably *c.* 1406, being closer in age
to Fra Angelico than Castagno or Domenico Veneziano.
He entered the Order of Carmelites (in whose church
stands Masaccio's Brancacci chapel) and to begin with
his figures possessed a heaviness and volume derived from
Masaccio. But already by 1437 this early tendency was
being overlaid by a liking for descriptive detail. A com-
parison of his Barbadori altarpiece (1437–8) with Domen-
ico Veneziano's near-contemporary Sta Lucia altarpiece
reveals clearly the direction in which Filippo Lippi was
moving. Individually his figures are reasonably solid, and
the space in which they stand is defined both behind and in
front; yet the whole balance between structure and decora-
tion, so carefully maintained by Domenico, is weighted
heavily in favour of decoration by Filippo. His painting
lacks the superb clarity of Domenico Veneziano, but is at
the same time more human and less like an intellectual
exercise.

Filippo Lippi's work never has the coldness or austerity
of younger artists such as Castagno or Domenico Vene-
ziano; yet it is more demonstrative than that of Fra
Angelico. And while it has much of Fra Angelico's delicacy,
it can be playful and humorous too. These features emerge
in the frescoes painted by Filippo Lippi for the cathedral
of Prato and in numerous paintings of the *Madonna and
Child*. The *Madonna* pictures are often humorous and
the Christ Child is given an extremely unidealised ap-
pearance, without having the impassively sour expres-
sion of the Child in Masaccio's London *Madonna*. The
frescoes contain a considerable array of different human
types and the appropriate scenes contain a well controlled
emotional content. Yet any emotion is balanced both by
the pleasing surroundings and by the delicacy and grace
of the figures.

Painting of this order and quality inevitably exercised a
considerable influence. Fra Filippo's pictures of the
Virgin, for instance, dictated the fashion for the next half-
century and affected sculptors as well as painters. There is
no doubt that his style of narrative fresco also attracted
attention with its judicious balance between dramatic
action and decoration. On succeeding painters, however,
the work of Domenico Veneziano and Castagno must also
have exercised some influence. Unfortunately so much has
been destroyed that this influence is difficult to define. Yet
in the work of a painter such as Domenico Ghirlandaio, the
figures are far more tightly painted than those of Fra
Filippo; moreover, the ambitious spaces that he encloses
are more carefully and convincingly worked out—all of

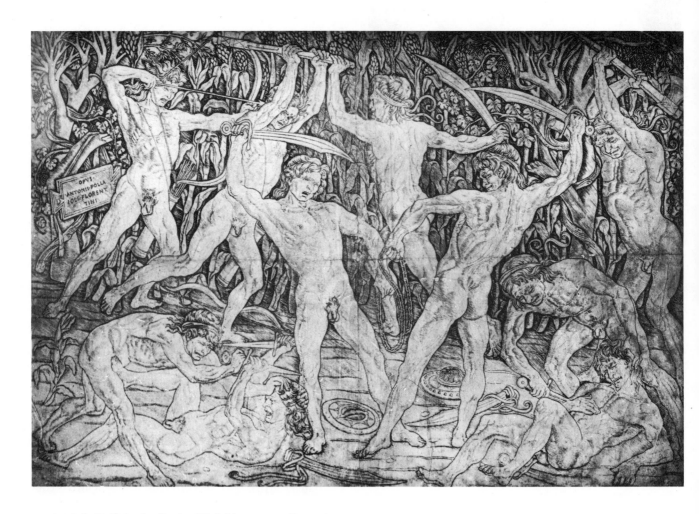

31. **Antonio Pollaiuolo.** *Battle of Nude Men. c.* 1470. Engraving.
Experimental studies like figure 32 were used to perfect
compositions such as that of this engraving or of the *Martyrdom
of St Sebastian* (plate 30). The tradition was handed on to
Signorelli (figure 46) and ultimately was further transformed
by Michelangelo.

which suggests that in planning and technique the style of
22 the master of the Sta Lucia altarpiece continued to have a
marked importance.

Domenico Ghirlandaio was the most eminent fresco
painter working in Florence between *c.* 1470 and 1490. He
painted two extensive cycles, both commissioned by
leading Florentine families, in the churches of Sta Trinità
and Sta Maria Novella. In both, emphasis was noticeably
placed on setting and incidental detail. Recognisable
portrait figures of members of the two families were in-
troduced into the narrative scenes; recognisable views of
Florence were incorporated into the background. All this
strongly recalls the court art of the years *c.* 1400. There is
a considerable increase in the amount of classical detail
included in his work, if comparison is made with the work
of earlier painters—a feature to which reference will be
made later; there is also clear evidence in his painting of
contact with Flemish art. In 1480, for the church of
Ognissanti, he painted a fresco of *St Jerome in his Study*

which is certainly derived from a painting by van Eyck.
Ghirlandaio's landscape backgrounds and domestic in-
teriors also betray the influence of Flemish painting—an
influence which is already discernible in Florence before
this date. The very 'humanisation' of Filippo Lippi's
Madonnas recalls the development already followed by
Robert Campin. Flemish religious paintings and portraits
were certainly prized by private collectors and connoisseurs
but a few major works were also on public view, such as the
Portinari altarpiece of Hugh van der Goes which was set up
in the church of S. Egidio *c.* 1480.

Sandro Botticelli was almost exactly contemporary with
Domenico Ghirlandaio. Although he was primarily a panel
painter (whereas Ghirlandaio's most important public
works were frescoes), the two artists inevitably have many
points in common. Two *Adoration* paintings will show a
similar taste for colour and costume and antique ruins.
There is, too, a similar treatment of landscape in the new
style learnt from Flanders. But Botticelli's painting has a

32. **Antonio Pollaiuolo.** *Hercules. c.* 1460. Pen and brown ink. 9¼ × 6½ in. (23.5 × 16.5 cm.). British Museum, London. The beginning of a revolution in the technique and use of drawing. A rapid pen sketch is here used to capture one aspect of a human figure in motion; sketches such as this formed the basis of a new artistic understanding of the human figure.

33. **Leonardo da Vinci.** *Studies for the Adoration of the Magi. c.* 1480. Pen and ink. 10½ × 7 in. (27 × 17.4 cm.). Wallraf-Richartz Museum, Cologne. One of the earliest beneficiaries of the experiments of Antonio Pollaiuolo was the young Leonardo. In his hands, drawing became a major tool of exploration of the human figure, architecture, botany, biology and many other subjects.

far more strongly marked linear clarity. His figures have clear meticulously drawn outlines, the internal areas being filled out by delicate modelling. His work in general has a serious, melancholy quality reminiscent of some of Domenico Veneziano's paintings, the feeling sometimes being emphasised by the troubled attitudes of his figures and by the twisting, curving line of his drawing. An artist who inherited this tendency was Filippino Lippi, the illegitimate son of Filippo Lippi, who worked in Botticelli's workshop after the death of Fra Filippo. Filippino's painting is at times barely to be distinguished from that of Botticelli, but he pushed the nervous linear quality of the style to its limits. He conceived his art on a small scale so that even in large frescoes architecture and compositions are broken up by a multitude of small details.

The linear character of painting at this time is very remarkable. At its extremes some works almost seem to have the appearance of a coloured engraving; and this may indeed be connected with the fact that many Florentine painters, including Ghirlandaio and Botticelli, began their careers in the workshops of goldsmiths. Perugino, Leonardo da Vinci and Lorenzo di Credi, all primarily painters, all worked in the shop of the goldsmith Andrea del Verrocchio. This tendency on the part of painters to begin their careers as goldsmiths cannot have been accidental and was almost certainly connected with the training in competent draughtsmanship which was increasingly becoming an essential part of the artist's equipment. Drawing now became increasingly important in the preparation and planning of works presumably because, in the search for 'realism', the preparatory stages themselves became crucial to the success of the finished article. In the execution of large works such as frescoes it now became common to make use of cartoons.

Countless drawings, of course, exist which date from before this period; but the development in Florence was towards a new kind of drawing. A comparison of a drapery study by Pisanello and a drapery study by Leonardo da

480

34. **Isaia da Pisa.** *Virgin with SS. Peter and Paul.* Perhaps *c.* 1440. Marble. Crypt of St Peter's, Rome. Little is known about Isaia da Pisa but the drapery style of these figures is certainly derived from some antique original. The somewhat pedestrian nature of the carving is, however, typical of much work produced in 15th-century Rome.

for one of Leonardo's early works, the Scopeto *Adoration of the Magi*, a large number of preliminary studies exist, couched in a comparable linear style.

The spasmodic appearance of antique ruins in the paintings of Ghirlandaio and Botticelli has already been mentioned; and the triumphal arch in Pollaiuolo's *Martyrdom of St Sebastian* will not have escaped notice. These slightly nostalgic fantasies of classical remains are symptomatic of a new development in the attitude of artists and patrons to antique art. Granted the persistent academic enthusiasm for classical literature, already mentioned, it is perhaps surprising that Florentine artists were not more concerned with the exact resurrection of antique style. Very little 'archaeological art' was, it seems, produced; and a sculptor such as Donatello clearly saw antique art as a source of ideas, to be used with extreme freedom and inventiveness. Little by little, however, artists did begin to explore more literally the appearance of antique remains and the means by which they made their own peculiar aesthetic impact. There is little evidence to show how artists came to feel impelled to make these deliberate attempts to recreate antiquity and the appearance of the classical world; for even in Italy at this period almost no artists adequately recorded their intentions. Yet, although this may appear to be a somewhat pedantic aspect of art history, it cannot be ignored. It has already been pointed out that it was through the artist's painstaking imitation of classical art that artists and patrons came to appreciate more completely the qualities inherent in it. Without these attempts to imitate and to emulate, the extremely sophisticated understanding of antique art during the 16th century would hardly have been possible.

It might be expected that Rome would play an important part in this development; but Rome was not an important centre of art during the 15th century. The city was visited fleetingly by a series of important outside artists including Masaccio, Masolino, Gentile da Fabriano, Pisanello, Brunelleschi, Donatello, Alberti, Fra Angelico, Piero della Francesca and others. But the situation in Rome was confused and the ability of the indigenous artists severely limited. There was indeed an obscure artist living in Rome called Isaia da Pisa who made an interesting attempt to imitate antique sculpture; but in general

(Continued on page 497)

Vinci will show that their purpose is fundamentally different. The study of Pisanello will probably do no more than record the surface pattern and detail; but the studies of Leonardo concentrate on the underlying structure rather than the surface adornment. In the Leonardo study drawing has become a vehicle for exploration and experiment; and it is this aspect of the *use* of drawing which for a long time remained unique to Florence.

Antonio Pollaiuolo is representative of this development and was in fact one of the leading Florentine artists of the period. A sculptor, a goldsmith and a painter, his output, *32* although small, contains a precious series of drawings executed in a sensitive linear technique. This was easily manipulated and enabled him with very little trouble to experiment in recording the human figure in a wide variety of poses. Two works survive, each in its own way a *tour de force*, which show the results of these experiments. *31* One is an engraving, a *Battle of Nude Men*, which has an additional interest in that it shows how close is this linear draughtsmanship to the craft of the goldsmith. The second *30* is a painting, the *Martyrdom of St Sebastian*, the most remarkable aspect of which is the way the painter has used the theme to demonstrate his acquired skill in manipulating the human body. Here the art of drawing must have played a large part.

Antonio Pollaiuolo passed on this graphic skill to one artist in particular—Leonardo da Vinci. Although Leonardo never worked under Pollaiuolo, his style of drawing *33* and his attitude to its purpose are so similar to Pollaiuolo's that some sort of relationship must have existed; already

21 (opposite). **Leone Battista Alberti.** *Self-portrait.* 1430s. h. 8 in. (20 cm.). Bronze. Samuel H. Kress Collection, National Gallery of Art, Washington. The importance of academic scholarship in creating conditions favourable to the revival of an antique style in art is certain. Alberti was an important figure in this process since, although a scholar and a gentleman, he deigned to participate directly in artistic creation and designed some of the earliest buildings in a consciously revivalistic manner. His own self-portrait therefore opens this section.

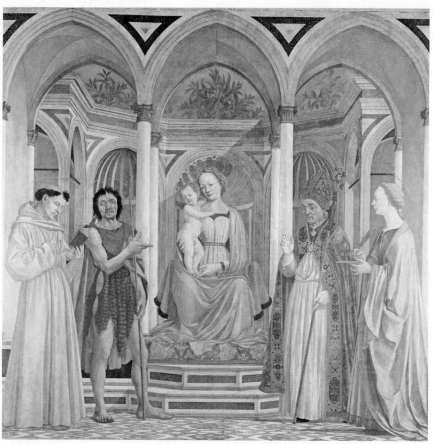

22. **Domenico Veneziano.** *The Virgin and Child with SS. Francis, John the Baptist, Zenobius and Lucy. c.* 1440. Tempera on panel. 82¼ × 84 in. (208 × 213 cm.). Uffizi, Florence. In spite of the example of Alberti and the presence of other eminent humanist scholars, the development of Florentine 15th-century art was seldom guided primarily by a desire to imitate the antique. The painters, grappling with the new scientific methods of perspective construction and the conflicting styles of art current *c.* 1420–30, had other things to think about. This altarpiece painted for the church of Sta Lucia dei Magnoli, Florence, judiciously balances space against pattern and contains in the triple arcade an ingenious reminiscence of the now outmoded form of the polyptych.

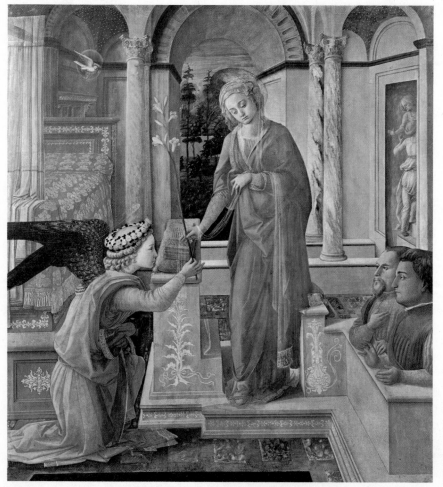

23. **Fra Filippo Lippi.** *Annunciation with Donors. c.* 1455. Tempera on panel. 60¼ × 56¼ in. (153 × 143 cm.). Palazzo Venezia, Rome. The work of a near-contemporary of Domenico Veneziano. Once again, the triple arcade provides a reminiscence of the old-style polyptych, one compartment corresponding to each of the main figurative constituents of the compositions. It will be apparent how much more detail is included here, the result being a curious combination of marble palace and domestic interior.

24. **Antonio** and **Bernardo Rossellino.** *Tomb of the Cardinal-Prince of Portugal.* 1460–6. S. Miniato al Monte, Florence. Perhaps the most elaborate of surviving 15th-century Florentine tombs, forming one side of a funerary chapel. Much of the detail, such as that of the sarcophagus, is ostentatiously classical. Yet the total effect has something of the atmosphere of a carnival float, emphasised by the marble curtains as if drawn back for a theatrical production. The carving is of extremely high quality, and the superb finish, coupled with the complete lack of emotional profundity, make this monument typical of its period.

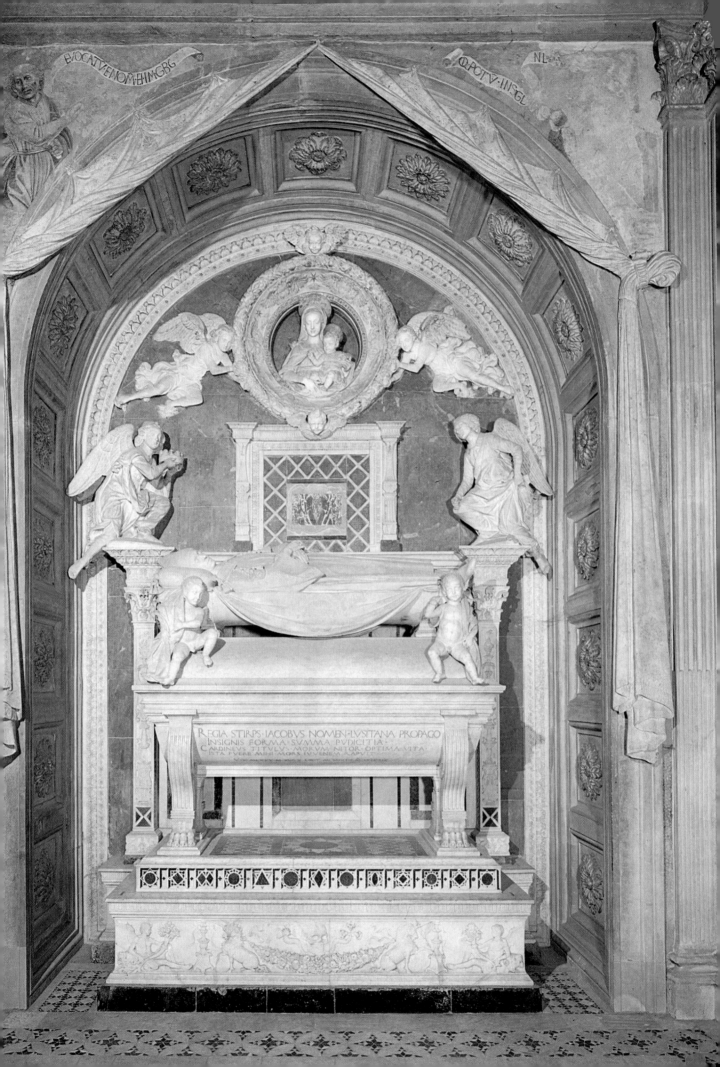

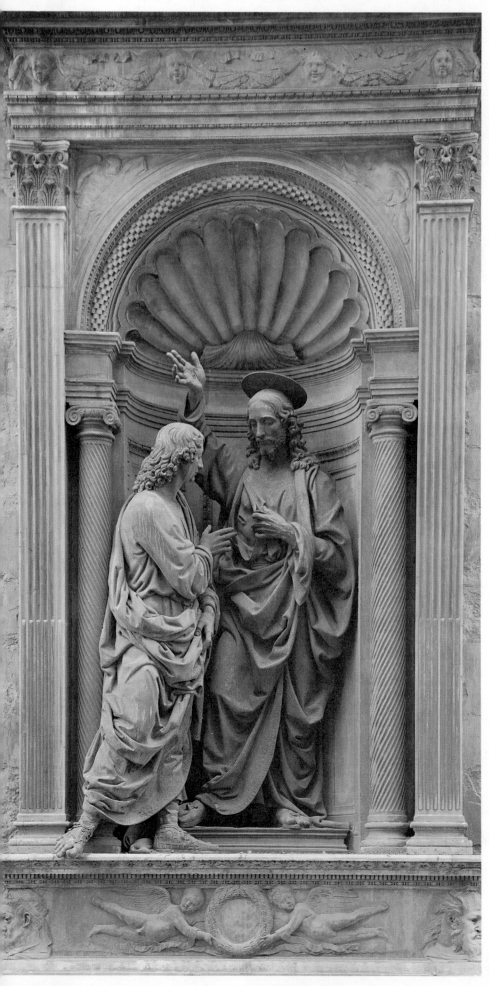

25. **Andrea del Verrocchio.** *Christ and the Doubting Thomas.* 1465–83. Bronze. Or S. Michele, Florence. A further example of Florentine sculpture in the third quarter of the 15th century. Verrocchio was a goldsmith by training and every detail of these figures was treated with loving care whether or not it would actually be seen by the spectator. The faces are almost expressionless and the artist, abandoning any attempt to create dramatic interest, lavished all his attention on the lines of the drapery and the detailed treatment of hair and hands. The niche was constructed *c.* 1423 for a figure of St Louis by Donatello.

FLORENTINE FRESCO-PAINTING
AFTER MASACCIO

26. **Fra Angelico.** *Scenes from the Life of St Stephen.* 1447–9. Fresco. Chapel of Nicholas V, Vatican. At the height of his fame Fra Angelico was called to Rome to help in the renovations taking place in the Vatican palace. His style by this date had achieved a curious independence of other Florentine artists. Following perhaps Masaccio, he pruned the detail of his narrative scenes down to the bare essentials. But they are not generally constructed according to Albertian perspective, and the backgrounds and impassive solid figure style seen here probably owe more to Giotto and his immediate followers.

27. **Fra Filippo Lippi.** *The Funeral of St Stephen.* 1452–64. Fresco. Prato cathedral, near Florence. An interesting contrast to Fra Angelico. The church is constructed according to the accepted ideas on perspective, and the whole composition probably owes much to an influential fresco by Masaccio (now destroyed) showing the consecration of the Florentine church of the Carmine. This included flanking groups of spectators, containing (as here) portraits of contemporaries.

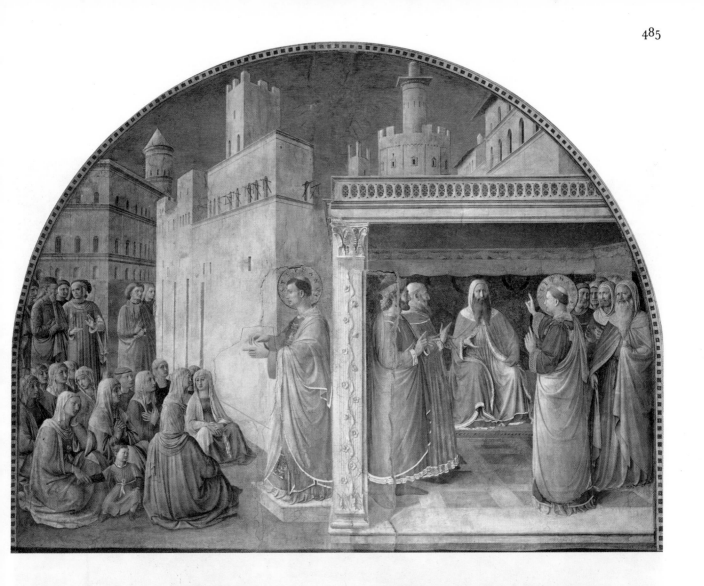

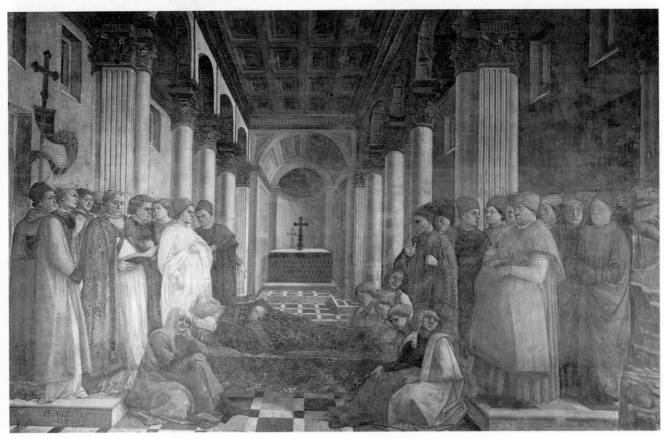

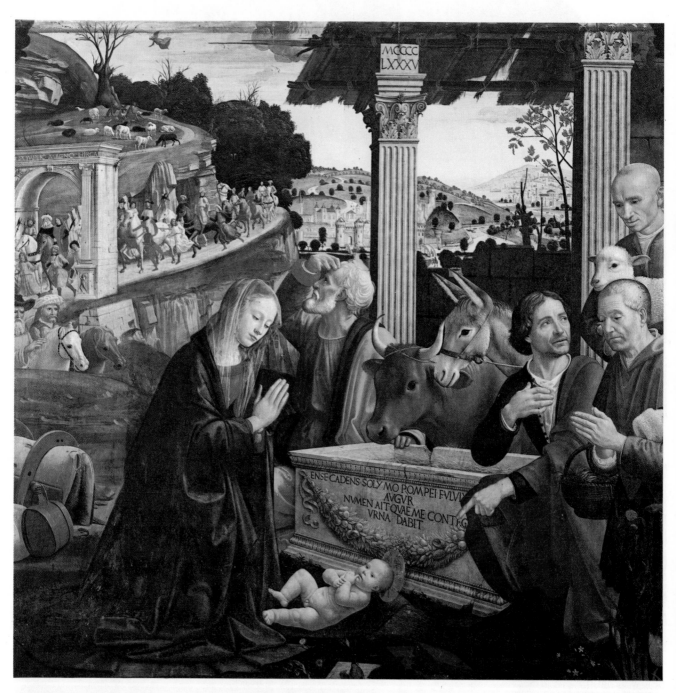

28. **Domenico Ghirlandaio.** *Adoration
of the Shepherds.* 1485. Tempera on panel.
65¾ × 65¾ in. (167 × 167 cm.).
S. Trinità, Florence. The altarpiece of the
Sassetti chapel, the walls of which were
also frescoed by Ghirlandaio. The
deliberate introduction of classical
objects is obvious, including a sarcophagus
with its beautifully painted inscription.
However these isolated objects are only
part of a very varied setting. The journey
of the Magi (left) is, in feeling, very
similar to the painting of the Limbourg
brothers (plate 12); the background
landscape owes a great deal to Flemish
painting and, indeed, the shepherds
(right) seem to be based on one of the
striking features of the Portinari altar-
piece of Hugo van der Goes (which had
lately arrived in Florence).

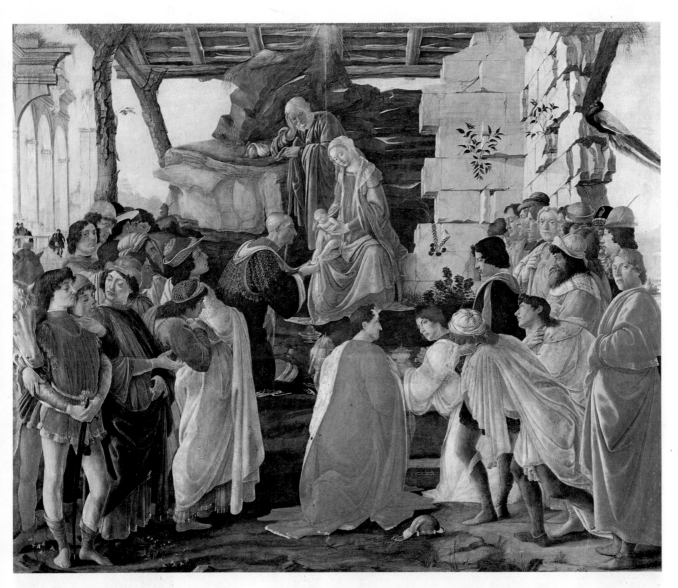

29. **Sandro Botticelli.** *Adoration of the
Magi. c.* 1475. Tempera on panel.
43¾ × 52¾ in. (111 × 134 cm.). Uffizi,
Florence. Ruins, as a symbol at the
Nativity, represent the crumbling away
of the Synagogue and the Old Dispen-
sation. Here they have been made
deliberately classical and given an
emotive twist through the suggestive
power of weeds and creepers. Nostalgia
for the antique was often a powerful
element in 15th-century Florentine
painting, and Botticelli indeed attempted
to provide a classical garb for such
humanist subjects as *The Birth of Venus* or
The Calumny of Apelles. Here, however, the
participants are in contemporary dress,
many of them being recognisable as
members of the Medici family.

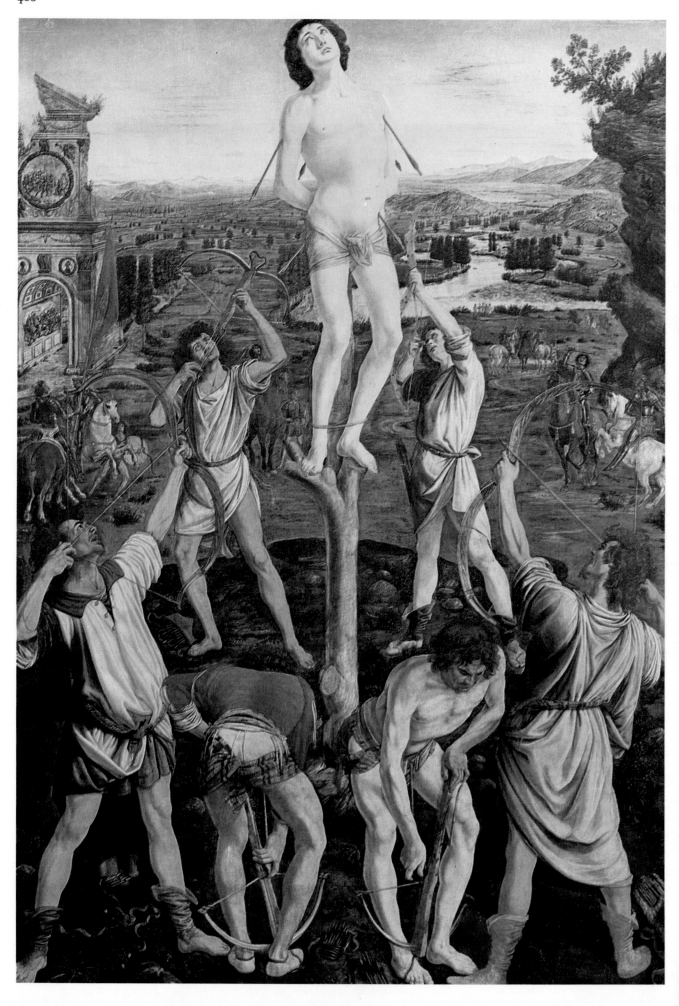

30. **Antonio** and **Piero Pollaiuolo.** *The Martyrdom of St Sebastian.* 1475. Tempera on panel. 114¾ × 79¾ in. (291.5 × 202.5 cm.). National Gallery, London. The comparatively meek figure of the saint is perhaps by Piero. Antonio's excellence as a figure painter, one of his major contributions to Florentine art, is clearly visible in the archers, whose figures seem to be a deliberate demonstration of this skill, but the beauty of his landscape is also inescapable.

31. **Leone Battista Alberti.** *S. Francesco*, Rimini. Generally called, on account of the dynastic purpose of its transformation, the *Tempio Malatesta*, the encasement of this medieval church in a classical skin was begun by Alberti *c.* 1450, but never finished. The impressive features of this exterior are its austerity and the depth of its relief.

32. **Pietro da Milano.** *Triumphal Arch* at the main entrance of the Castello Nuovo, Naples. 1452–66. Designed in honour of King Alphonso of Aragon, this entrance is classical in intention. Little is known about the master-mason, Pietro da Milano, but if he was the designer he had imaginatively grasped two of the ingredients of classical ruins—size and relief. Decorative restraint and proportion eluded him, yet this arch forms an interesting parallel to the work of Alberti.

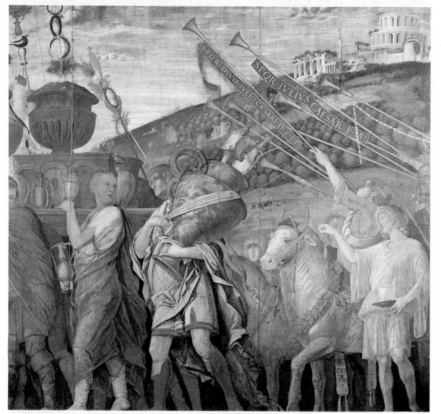

33. **Andrea Mantegna.** *Parnassus.*
1496–7. Painting on canvas.
63 × 75½ in. (160 × 192 cm.). Louvre,
Paris. One of the mythological works
intended by Isabella d'Este, wife of
Francesco Gonzaga, for her private
apartments. Mantegna accepted the
subject-matter and devised a form of
figure style and dress appropriate to it.
At this time contemporary costume
ceased to be acceptable for scenes derived
from classical sources.

34. **Andrea Mantegna.** *The Triumph of
Caesar* (section four: *The Vase Bearer*). *c.* 1490.
Painting on canvas. 107 × 112 in.
(271 × 284 cm.). Royal Collection,
Hampton Court. A part of his grandest
surviving work and a vivid evocation of
antique splendour and festivity.
Mantegna's sources have yet to be worked
out in detail, but this sustained fidelity
to the classical past would not have
been possible had not Mantegna been
also part-scholar and part-archaeologist.

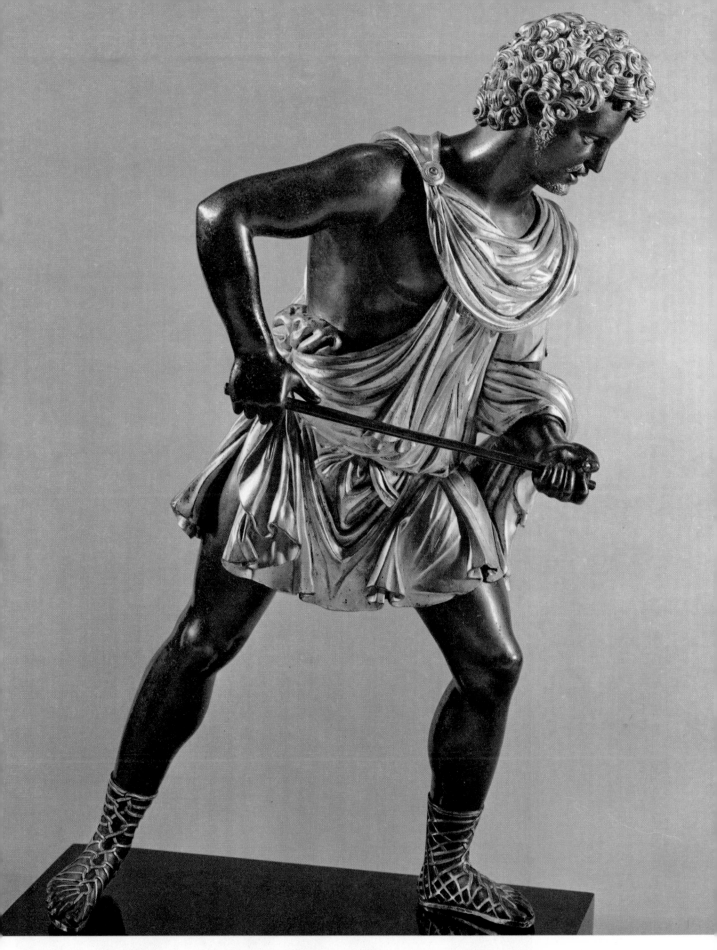

35. **Piero Bonacolsi (Antico).**
Meleager. c. 1510. Bronze, parcel-gilt.
h. 12 in. (31 cm.). Victoria and Albert
Museum, London. Known generally by
the name Antico, this artist's main

occupation is also indicated by it. He
worked for the Mantuan court on the
restoration of ancient bronzes and the
fabrication of new ones in an antique
style. At both producer and consumer

levels, a new intensity of connoisseurship
over the real appearance of antique
figurative art now emerged.

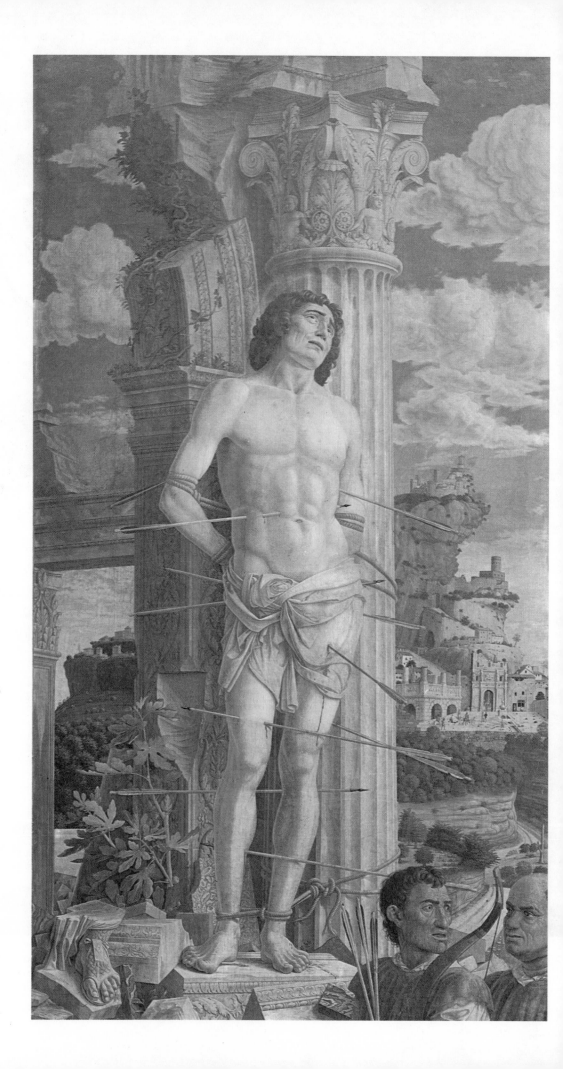

ST SEBASTIAN—MANTUAN AND
FLORENTINE PAINTING AROUND 1470

36. **Andrea Mantegna.** *St Sebastian.*
c. 1470. Tempera on canvas. 101¼ × 56 in.
(257 × 142 cm.). Louvre, Paris. This
painting displays an ardent nostalgia for
the antique past. Mantegna's figures also
have a firm sculptural appearance which
suggests a prolonged and detailed study of
classical statuary. Note here the upturned
eyes with their suggestion of classical
pathos, and the strength which the
architecture lends to the figure.

37. **Sandro Botticelli.** *St Sebastian.* 1474.
Tempera on panel. 78 × 34 in.
(198 × 86 cm.). State Museums, Berlin-
Dahlem. Despite the presence of humanist
scholars, Florentine artists were not at
this time orientated towards antiquity.
St Sebastian is shown here as a graceful
youth. Behind is a landscape with a town
of slightly Flemish appearance. The saint
is tied to a tree, not a column. Yet the
simplicity of this painting is one of its main
attractions. In addition, like much
Florentine art of the time, it is emotionally
uncomplicated and demands little of the
spectator beyond enjoyment and
admiration.

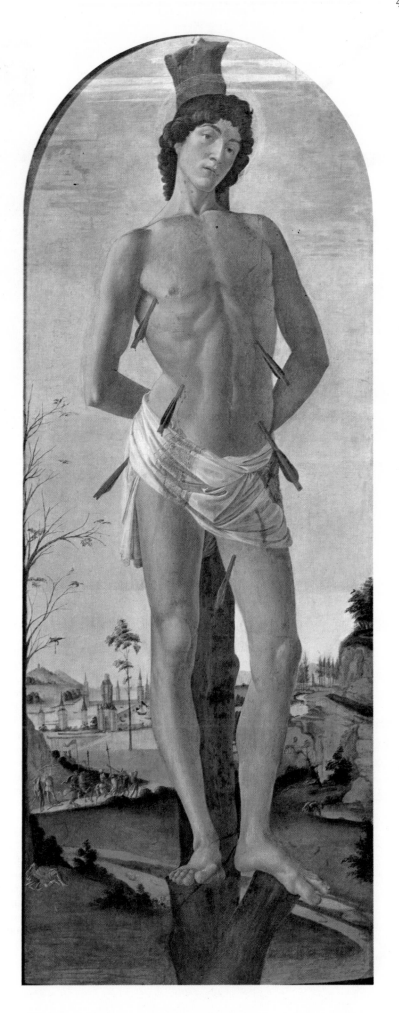

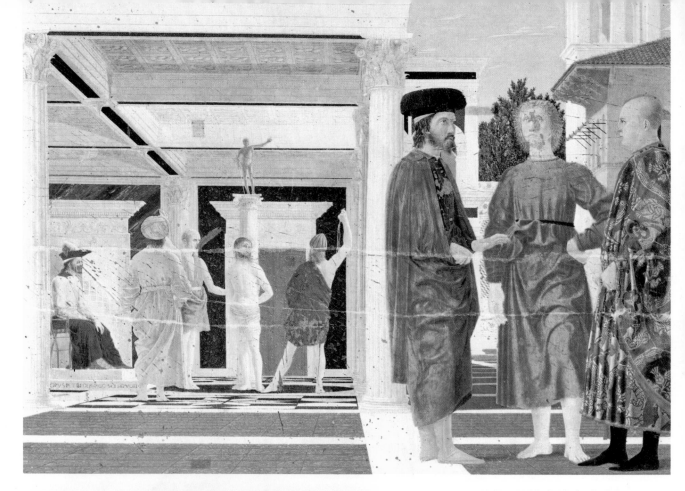

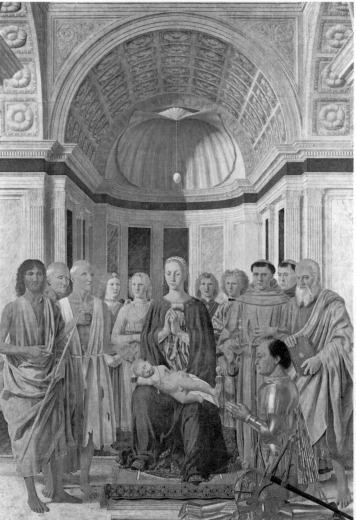

CLASSICAL REVIVAL IN URBINO AND MILAN.

38. **Piero della Francesca.** *The Flagellation of Christ.*
c. 1455. Tempera on panel. 23¼ × 32 in. (59 × 81.5 cm.).
Ducal Palace, Urbino. The precise meaning of this
work and the significance of the three right-hand figures
have not yet been satisfactorily settled. Piero's interest
in antiquity was probably fostered by his acquaintance
with Alberti, and from this source is derived the
beautifully considered architectural setting. The
fascination of mathematics and geometry are reflected
in the careful proportions and elaborate yet accurate
perspective.

39. **Piero della Francesca.** *Virgin and Saints with
Federigo da Montefeltro. c.* 1470. Tempera on panel.
97½ × 67 in. (248 × 170 cm.). Brera, Milan, Painted
towards the end of Piero's active career, this painting is
more developed than plate 38, notably in its treatment of
light. In the reconciliation of space with pattern, the
construction is comparable to plate 22 by Piero's teacher,
Domenico Veneziano. The conception of a group of
saints in a unified monumental architectural setting
probably appears here for the first time and was to have
important devlopments in Venice.

40. Attributed to **Vincenzo Foppa.** *Martyrdom of
St Sebastian. c.* 1485. Fresco. 68 × 105½ in. (173 × 268
cm.). Brera, Milan. Probably from a fresco scheme of
1485 formerly in Sta Maria in Brera. Foppa's career is
obscure but he seems to have been deeply influenced by
Mantegna and (less certainly) by Piero della Francesca.
The austere antique character of the architecture is
particularly striking here since Milanese taste generally
demanded something far more decorative.

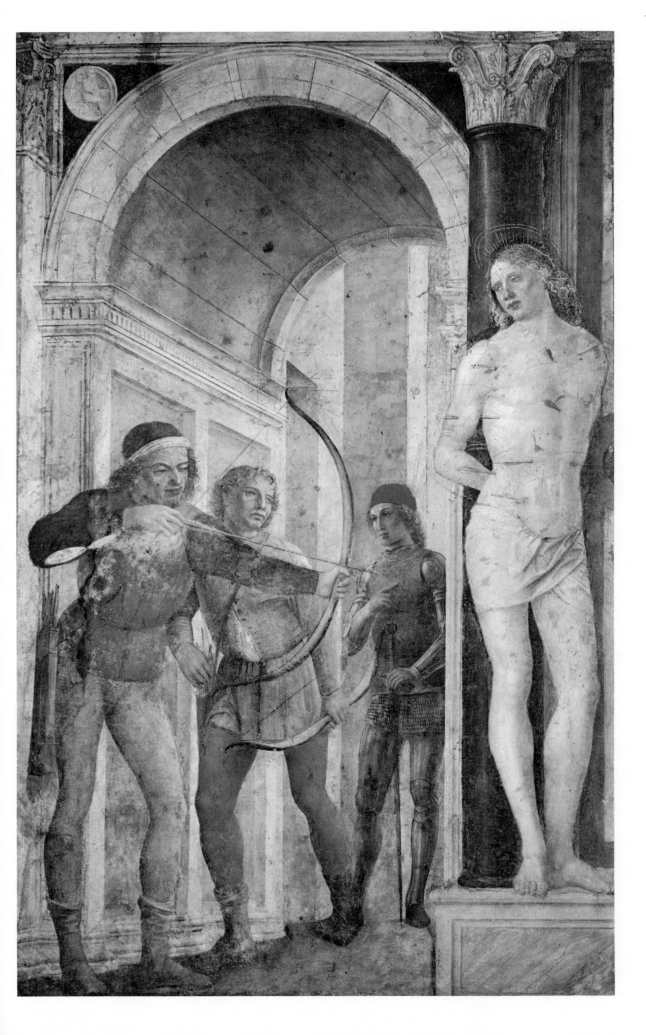

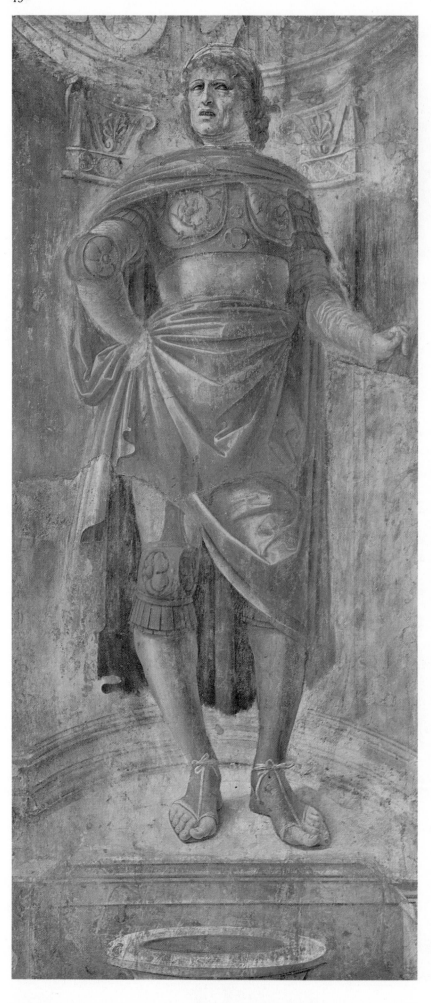

41. **Donato Bramante.** *Famous Hero.*
c. 1477. Fresco. 50 × 112¼ in.
(127 × 285 cm.). Brera, Milan. The idea
of a decorative scheme based on famous
heroes from the past is an old one. The
novelty of this cycle lay in the antique
subject-matter being set in antique
costume and an antique context. The
influence of Mantegna is very strong and
is certainly responsible for the attempt to
devise a convincing classical impression.

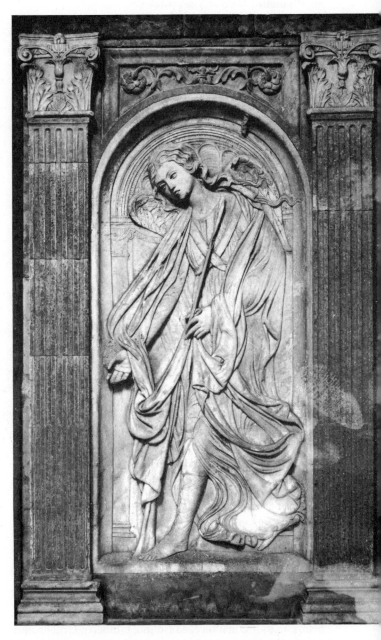

Roman artists were followers rather than pioneers, and most of the notable work done there during the 15th century was by Florentines or artists trained in Florence.

The creative vitality of Florentine art may have hindered any move towards a more literal attempt to recapture the style of antiquity; but elsewhere in Italy a number of artists appear to have adopted an archaeological idiom between 1440 and 1460, and this is one of the most significant trends of what is generally called the Renaissance.

ALBERTI AT RIMINI

One of the earliest monuments in this idiom was the work not of an artist by training but of the scholar-architect Leone Battista Alberti. This was the church of S. Francesco at Rimini which he remodelled as a classical mausoleum for the Malatesta, Lords of Rimini. The project, probably already planned by 1450, is far more convincingly 'antique' than any of Alberti's Florentine projects. This may probably be explained by the existence in Florence of intrusive local factors which complicated Alberti's task—for instance, the difficulty of dealing with the fortress-like walls of a Florentine palace, or the half-finished medieval façade of Sta Maria Novella. These problems did not exist at Rimini, for Alberti's task was to conceal completely the medieval church inside a splendid new classical architectural skin. As a result the architect had naturally a free hand and Alberti was able to create the impression of a truly antique *gravitas*—almost impossible in Florence with its strong tradition of surface decoration in coloured marble. It is true that this impression vanishes within the building where the sculptors Matteo dei Pasti and Agostino di Duccio were commissioned to decorate the now visible medieval church with sculptured reliefs. But even if the total effect is here less convincing the relief style of these sculptures is no less antique in intention than the architecture of Alberti. It is found slightly later on the façade of S. Bernardino, Perugia.

Another project similar in aesthetic intention was the triumphal arch executed at Naples as the main entrance to the Castello Nuovo (designed *c.* 1453). This is a far less meticulous work of scholarship than Alberti's façade at Rimini. It was probably designed by a Pietro da Milano (about whom very little is known) and the sources are as diverse as the standard of sculpture is variable. The sculpture is, in any case, only 'classical' by fits and starts and in the reliefs the figures are mostly shown in contemporary dress. But the bold outlines of the design are clear and the general antique intention makes an interesting parallel to the 'Tempio Malatesta', as Alberti's Rimini church came to be called.

PADUA

For the most remarkable developments in this archaeological idiom, it is necessary to turn north of the Apennines to Padua and to the work of Andrea Mantegna. His appearance is unexpected, for although Padua was an established centre of humanism Mantegna's stylistic antecedents

35. **Agostino di Duccio.** *Virtue. c.* 1457–62. Marble. Detail from façade of S. Bernardino, Perugia. The extreme lowness of the relief of these sculptures is similar to work inside the Tempio Malatesta, Rimini. The style is ultimately based on antique models.

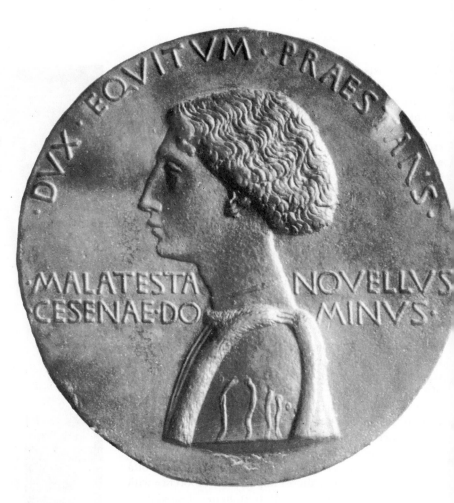

498

36. **Pisanello.** *Medal of Novello Malatesta, Lord of Cesena. c.* 1445. Diameter 3¼ in. (85 mm). Museo Nazionale, Florence. The practice of making commemorative portrait medals was revived in the 15th century and one of the most celebrated medallists was Pisanello. The gap between the antique idea and 15th-century practice is well illustrated here; for this medal is excellent in its clarity, but 15th-century in every detail of its appearance. The artist did not emulate the appearance of Roman imperial coins. Novello was a younger half-brother of Sigismondo who commissioned the Tempio Malatesta at Rimini.

were late Gothic. North Italian tastes seem to have been conservative, and in this area the style current *c.* 1400 survived with remarkable persistence up to the middle years of the century. The most influential painters had probably been Gentile da Fabriano and Pisanello, each of whom travelled widely in northern Italy and worked in a number of towns including Venice. Both the republic of Venice and the Visconti princes of Milan were well served by native artists, too: and in spite of the appearance of a number of Florentine artists in north Italy in the years before 1440 (for instance, Masolino, Ghiberti, Uccello and Filippo Lippi) their influence seems to have been negligible. Even though Donatello lived in Padua *c.* 1443–53 and produced three major works (the equestrian monument to Gattamelata, the high altar sculpture for the church of S. Antonio, and a crucifix for the same church) it was eventually the native Paduan artist, Mantegna, who decisively altered the course of art north of the Apennines.

Andrea Mantegna was brought up in the household of an artist and connoisseur of the antique, Squarcione. The ability of Squarcione as a creative artist is not clear, but the early influence of these surroundings was of the greatest importance since, from everything that he ever created, it is clear that Mantegna was as nearly in love with the ancient world as any artist could be. He certainly learnt much from the Florentines—probably, for instance, the technique of accurate perspective and foreshortening. He

derived from Donatello various compositional devices, but not the emotional figure style of Donatello's high altar in the church of S. Antonio. His figures demonstrate instead a style learnt not from Donatello, nor from the soft flowing conventions of the Gothic tradition, but from a direct appreciation of solid antique sculpture. It is in this way that the influence of Squarcione's collection of antiques can be understood, although Mantegna's archaeological zeal went far beyond his figure painting. In the frescoes which he painted in the church of the Eremitani at Padua the background is full of evidence of this interest in the classical past, for the detail includes triumphal arches and other classical remains, painted reliefs and friezes, and classical costume. Mantegna had not, it seems, at this date been to Rome where even in ruins classical remains survived in oppressive numbers. These 'stage props' must therefore have been culled from the less abundant remains in northern Italy, from the drawings of other artists or from objects assembled by collectors. The exact source is, for the most part, uncertain; but Mantegna's enthusiasm for the material shines out like a beacon.

MANTUA—MANTEGNA AND ALBERTI

In 1460 Mantegna entered the service of the Gonzaga, Lords of Mantua, and became their chief painter. In this position his importance and influence increased very considerably since he had the opportunity of devising a

number of large decorative schemes to which his genius was particularly suited. Two of these schemes fortunately survive. The first, the fresco decoration of the so-called *Camera degli Sposi* (a later name) in the Castello at Mantua, seems to resume Mantegna's achievements up to that date (1474). It has the monumental solidity of his early style and a firm grasp of illusionistic effect (probably derived from Florentine artists). There is a vault covered with antique detail but its rather sombre effect is modified by the famous *trompe l'oeil* oculus with its gallery of grinning girls. By the time of the second decorative scheme, the *Triumph of Caesar* (*c.* 1486–94), the early stiffness had entirely vanished. The painting no longer gives the impression of a collection of ideas, meticulously assembled, but of a real triumphal procession of living people who happen also to be Romans. The evocation of ancient Rome had never before been carried out with such success.

In the period immediately following the *Triumph of Caesar* Mantegna embarked on a further scheme of decoration, this time for Isabella d'Este, the wife of his master, the Marquess Gonzaga. His task was to paint a series of mythological scenes for the walls of one of Isabella's private rooms, called her *studiolo*. (Various other artists including Perugino and Giovanni Bellini were also asked to contribute paintings.) By this stage the somewhat forbidding remoteness of Mantegna's early style vanishes and his lately acquired freedom in figure painting resulted in some of the most graceful compositions of his career.

The patronage of the Gonzaga family at Mantua is of absorbing interest in the history of Renaissance art. The interaction between the artists and their patrons is unfortunately obscure; but the result of this interaction between the discerning collector and the sensitive artist was that the term 'Renaissance' ceased merely to be appropriate to a purely literary humanistic movement. By 1500 there existed a circle of scholars, patrons and artists with an astonishingly sensitive visual apprciation of the essential character of antique art.

One aspect of this complicated evolution is to be seen in the history of the paintings ordered for Isabella's *studiolo*. This type of commission was new and perhaps oppressively literary in its approach, for the subject matter of the paintings was laid down by Isabella, and represented an erudite assemblage of antique matter. Earlier in the century and elsewhere in Italy it would have been acceptable to clothe the characters taking part in a species of contemporary fancy dress. But now in Mantua new standards were required and Mantegna succeeded in making the antique subject matter look antique.

Another aspect of the same evolution is to be seen in the work of a remarkable bronze sculptor, Piero Bonacolsi, whose nickname 'Antico' gives an indication of the direction of his interests. He was employed by the Gonzaga family in making small bronze statuettes which then entered their collections and were appreciated alongside the genuine antiques.

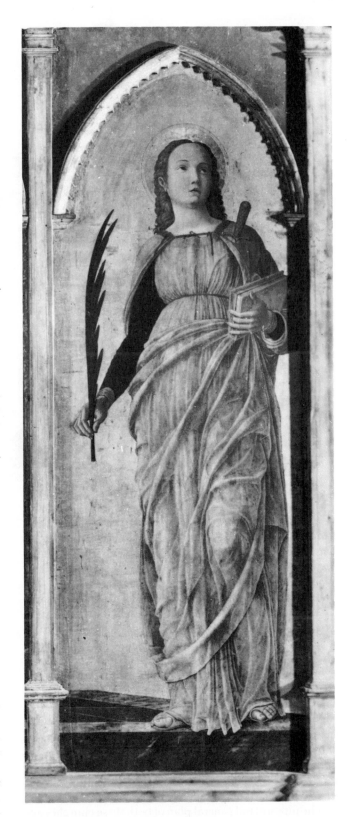

37. **Andrea Mantegna.** *St Justina* (detail from altarpiece of St Luke). 1453–4. Tempera on panel. Brera, Milan. Mantegna was about twenty-three when he painted the altarpiece and this detail illustrates the cold sculptural clarity of his early style.

38. **Leone Battista Alberti.** *Façade of S. Sebastiano*, Mantua. *c.* 1460. The façade was probably intended to be approached by a broad flight of steps and further vertical pilasters may have been envisaged. Even in its imperfect state, however, S. Sebastiano presents an impressive façade.

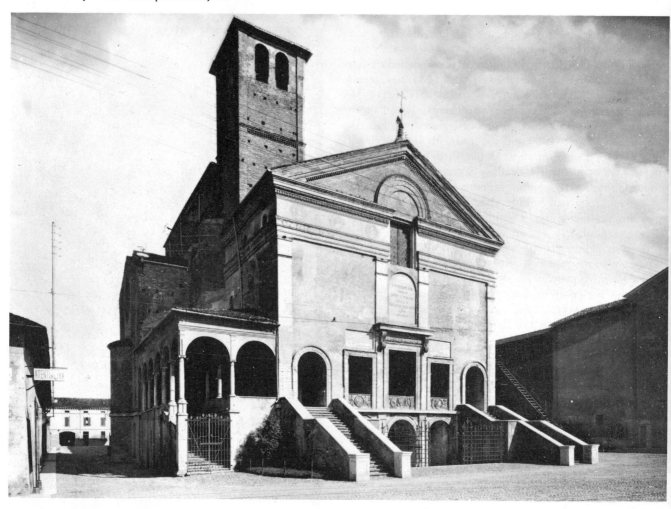

There is yet another aspect to this 'Mantuan Renaissance' since Mantegna's career overlapped with the late career of Alberti who, although he died in Rome, spent his last years in Mantua. It was at Mantua that Alberti planned and began his two most important buildings, the churches of S. Sebastiano (*c.* 1470) and S. Andrea (*c.* 1480). These churches are of the highest significance because at last Alberti was unhampered by existing buildings or local architectural prejudices. The more unusual of the two, S. Sebastiano, was never completed and suffers now from an erroneous restoration of the façade. But originally the front was intended to present a scheme of attached pilasters supporting the pediment and reached by a broad flight of steps which should have extended across the entire face. The façade of S. Andrea, on the other hand, returns to the idea of a triumphal arch. The treatment is very restrained, the main ornament being a ponderous coffered vault inside the porch which gives a suitable impression of gravity to the whole design.

The interior and general plan of both these churches are equally important. S. Sebastiano is built in the shape of a Greek cross—that is, its four arms are of equal length. This form of centralised plan increasingly obsessed Renaissance architects since they knew that its use had ample precedent in the churches and temples of the Byzantine and Roman world. Nevertheless it was to the Western tradition that Alberti returned for the plan of S. Andrea. This has a normal Latin cross plan with a nave that extends outwards appreciably further than either the transepts or the choir. The walls of the nave have an elevation whose elements are similar to those of the west façade, so that the interior and the exterior of the building are closely related. The nave has no upper windows (clerestory) so that the general effect is dark and ponderous, but this seems to have been intentional, for Alberti is known to have considered an awe-inspiring gloom to have been suitable for churches; and in this his architecture presents a striking contrast to Brunelleschi's churches with their brilliant clarity. Alberti poured the results of a life-time of enquiry into the nature of antique architecture into these two Mantuan churches; and he seems to have attempted to recreate something of the grandeur of ancient Rome, perhaps with greater deliberation than was ever true of Brunelleschi.

It is now possible to realise that archaeological demands were far less thorough-going in Florence. The treatment of the subject of St Sebastian, for instance, affords some interesting comparisons. Early in his career Mantegna produced a painting of the saint, naked, bound to a

39. Leone Battista Alberti. *Façade of S. Andrea*, Mantua. *c.* 1470. Alberti's greatest architectural undertaking. Like the Tempio Malatesta, the basis of the façade is an antique triumphal arch. But late in life Alberti learnt the value of relief and contrasted textures in architecture. Here the centre of the design is broken into by the heavily coffered archway.

40. Leone Battista Alberti. *Interior of S. Andrea*, Mantua. *c.* 1470. The church was never finished in Alberti's life and consequently much of the interior is of a later date. He certainly envisaged the heavy proportions and the coffered vault, with no window openings. His writings show that he favoured dim religious gloom in churches, unlike Brunelleschi (see plate 8).

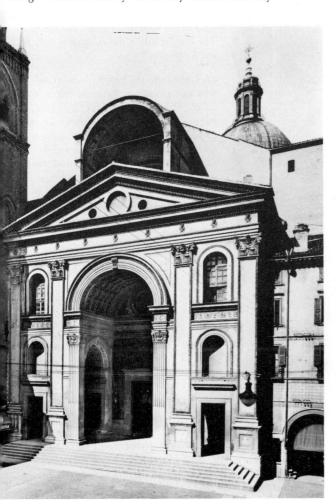

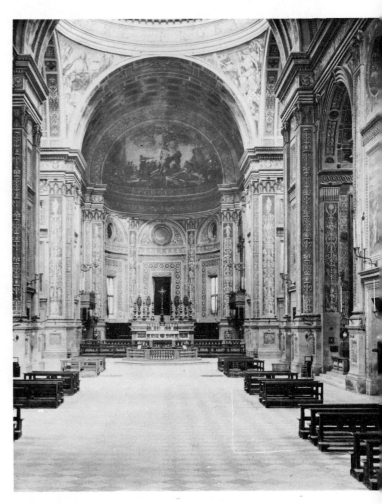

Corinthian column and surrounded by classical remains. The painting of St Sebastian naked was not an entirely new idea but at this date it was more common to shew him fully clothed (usually in contemporary garb) and holding an arrow as a symbol of his martyrdom. This shift of interest, which certainly sprang from a renewed interest in antique statuary, was quickly followed elsewhere; and at this point the representation of St Sebastian clothed virtually ceases. Thus in 1474 Botticelli painted a representation similar to Mantegna's. Botticelli however was intent on portraying a graceful idealised human body, and the torso of his saint does not have the sculptural appearance of Mantegna's whose imitation of classical pathos in the face of the figure is also missing. Finally, Botticelli's saint stands in front of a Flemish-style landscape. Neither figure, of course, is 'right' or 'wrong'; but it is Mantegna's painting that has the better claim to the title 'Renaissance', in the sense in which this word is usually understood.

PIERO DELLA FRANCESCA

Mantegna's early style may frequently seem to be reminiscent of the painting of Piero della Francesca. No evidence exists, however, which might determine whether Piero, who was his senior by about twenty years, might have been

able to influence him. Piero's own career began in Florence under Domenico Veneziano, and his painting seems always to have retained some of the impassive solidity associated with Domencio's style. Piero was a provincial artist in the sense that he spent much of his life in his home town of Borgo S. Sepolcro where he had considerable local standing. Nevertheless, he executed work for the three Italian courts of Ferrara, Rimini and Urbino, and also paid a visit to the papal court at Rome in 1460. At Rimini he executed fresco work in Alberti's Tempio Malatesta (1451) and *31* presumably at that date struck up an acquaintance with Alberti which was renewed later at the court of Urbino. Piero's interest in classical architecture is obvious from the fastidious detail of his architectural backgrounds. It seems **38** indeed possible that he gave advice in the design of parts of the ducal palace at Urbino. His interests, however, were not primarily archaeological but theoretical (the last years of his life were devoted to a treatise on perspective) and this interest emerges clearly in some of his later work. For instance, an altarpiece of the *Virgin and Saints* (now in the **39** Brera, Milan) has a spatial organisation which, although apparently of transparent simplicity, is of extreme complexity. In many ways this altarpiece is similar to the Sta Lucia altarpiece of Domenico Veneziano, for the

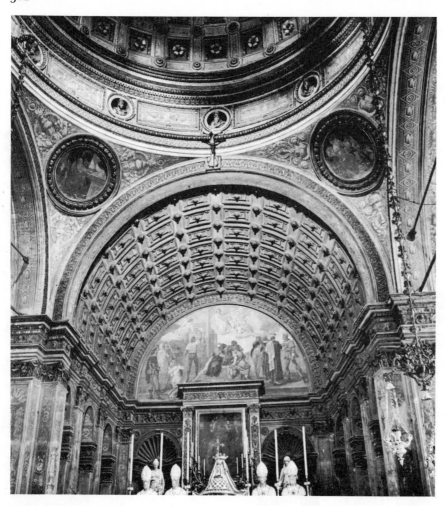

spatial construction is meticulously accurate; but care is taken in the compositional pattern to associate closely and ambiguously objects from various depths in the picture so that the surface composition dominates the painting. The Brera altarpiece has the appearance of a compact organisation of figures and architecture; and it takes a considerable effort of the intellect to work out that the Virgin is not sitting beneath the suspended egg but is a considerable distance in front of it.

Since he worked at Ferrara, Piero certainly influenced the local painters there. The work of Mantegna nevertheless seems to have had even greater influence. Mantegna's distinctive drapery style, his love of imposing architecture and his pronouncedly linear technique seem to have made a deep impression, particularly on Cosmè Tura, the most important court painter. In spite of the strength of this influence, Tura's work is hardly 'classical'. Archaeological truth meant very little to Tura and his Ferrarese patrons, and Tura's style developed into something triumphantly mannered and personal. The strange drapery patterns, the troubled faces of his figures, the startling colours and the fantastic forms given to his architectural features all betray the touch of a brilliant, exotic painter developing his art far beyond his prototypes.

MILAN—BRAMANTE

The influence of Mantegna and Mantuan art are also to be observed in Milan, but again the circumstances of the individual situation have to be considered. Unfortunately

nothing is simple about Milanese art. Ever since the end of the 14th century Milan and Pavia, the two chief cities of the Visconti dukes, had been great consumers of artistic works and had supported artists of many different nationalities. But before 1450 the 'classical revival' and the interests of what is called the Renaissance had hardly penetrated the duchy. Politically and culturally Milan was orientated as much to the north as to the south and indeed, since its Visconti rulers spent much of the first half of the 15th century at war with Florence, the city was automatically sealed off from one influence which might have transformed the work of local artists.

However, in the middle of the century a change of dynasty occurred, the Sforza succeeding the Visconti; and with this political change Florentine artists appeared on the scene. They included Michelozzo, sculptor and architect of the Medici family, and associate of Donatello; Antonio Averlino, called Filarete, sculptor and architect who had visited Rome, and who later in Milan compiled an architectural treatise; and finally (*c.* 1482) Leonardo da Vinci, the pupil of Andrea del Verrocchio. The appearance of these artists had widely varying stylistic effects. The older Milanese artists seem to have ignored them; the younger, particularly the painters, seem gradually to have succumbed, rather unhappily, to the new influences. One interesting example is the artist Foppa, who belonged to the same generation as Mantegna and Cosmè Tura. His early work is executed in the late Gothic tradition of Milan and his late painting (he survived until 1515–16) is in-

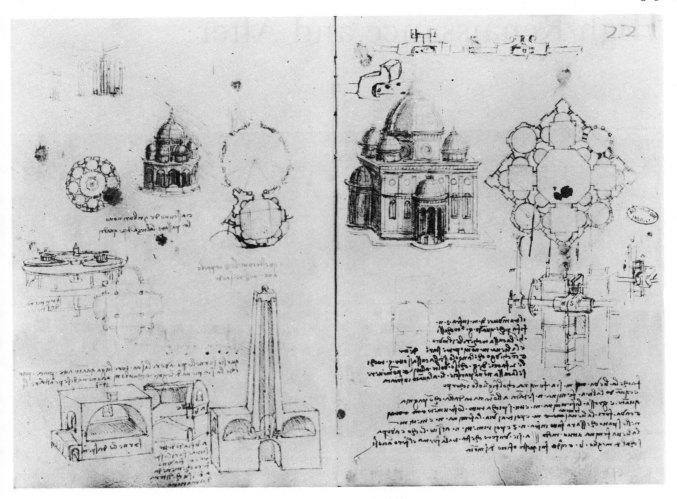

42

fluenced by the painting of Leonardo. But his 'middle style' does not reflect the work of any of these Florentines. A fragmentary fresco of *St Sebastian*, with its clear plastic figure style and its simple austere antique architecture, brings one back to the work of Mantegna or perhaps Piero. While it appears certain that neither Mantegna nor Piero ever visited Milan, they had a common and illustrious pupil in Bramante, who originated from Urbino and arrived at Milan *c.* 1477.

The influence of Mantegna on Bramante seems clear in two early works. One of these, a series of fragments from a scheme of fresco decoration, is clearly dependent on Mantegna for the linear style of painting and the rather laboured antique accoutrements of the figures. Bramante also evoked an extraordinarily romantic impression of antique grandeur in an engraving of 1481 of a half-ruined classical building, which shows Mantegna's influence even more clearly. Nevertheless, the architecture of this engraving is not, according to strict classical principles, very correct.

After this date Bramante's architecture did in fact rapidly acquire a more authentically antique character. His church of Sta Maria presso S. Satiro, Milan (*c.* 1483–6) seems to owe something to Alberti's church of S. Andrea at Mantua. Here Bramante had to build a church on a restricted site and resorted to creating the illusion of space where none existed. To achieve this, he used the device of an elaborate *trompe l'oeil* perspective in the chancel, obviously drawing on knowledge acquired from Alberti or Piero.

Bramante was also concerned in Milan with two small circular buildings—the church of S. Satiro itself and the sacristy to Sta Maria presso S. Satiro. It was mentioned earlier, in connection with Alberti, that centralised buildings had a peculiar fascination for architects at this period; and although elaborate intellectual justifications were put forward for the use of this type of plan, it seems likely that for professional architects it was the aesthetic problem involved that provided the overiding fascination. This problem had already been taken up by Brunelleschi and Alberti and discussed by Filarete in his treatise. It also fascinated Leonardo from whose hand a number of drawings of circular buildings survive from this period. All this interest must have served to stimulate Bramante, and this development reached its culmination in his design for the rebuilding of St Peter's, Rome, in the first decade of the next century.

But the peculiar artistic demands of Milanese taste meant that Bramante, like Michelozzo and Filarete, were each in turn compelled to cover their work in this city with an excessive incrustation of ornament. (This peculiarity of the wealthy citizens and their rulers is best exemplified in their own extraordinary cathedral). As long as Bramante remained in Milan, his fundamental appreciation of the character of antique architecture tended to be hidden by inessential ornament; and it is one of the stranger features of his career that on arrival in Rome (1499) his style underwent an abrupt change, as though suddenly purged of the excesses of his Milanese creations.

High Renaissance and After

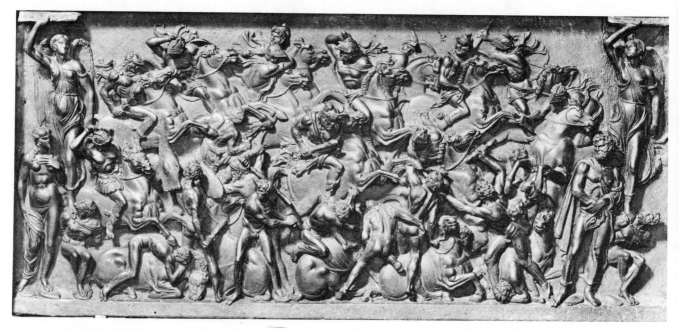

43. **Bertoldo.** *A Battle Scene. c.* 1485. Bronze. 17 × 39 in. (43 × 99 cm.). Museo Nazionale, Florence. For a short time Bertoldo was the master of the young Michelangelo and passed on to him some of his understanding of antique art. Here he recreated an antique relief of a battle scene. The mutilated original is still in Pisa and it seems that Bertoldo supplied from his imagination a large section in the centre which is missing there.

With the turn of the century, Italy once more became a prey to foreign invaders. At first, the country was a battleground between the French and Spaniards when Charles VIII of France invaded with the intention of conquering the Kingdom of Naples (then ruled by Spaniards). But by 1520 it became the scene of a far more serious struggle between Francis I of France and the Habsburg emperor Charles V when the French tried to hold on to their existing gains (particularly the duchy of Milan),and the emperor attempted to expel them from their influential position. Eventually the Habsburgs triumphed, and by the Peace of Cambrai (1529) Francis I renounced all his Italian claims, but during the struggle Italy had once more been continuously crossed by foreign armies, Rome had been sacked by mutinous German troops, while Florence had again briefly expelled the Medici family. Such was the unstable political background of the High Renaissance and the beginnings of what has been termed Mannerism in art.

The revival of Rome as a major centre of patronage is one of the most important aspects of the history of Italian art during the period 1450–1550. Politically the 15th-century popes were extremely weak. Nominally they were overlords of a large area in central Italy stretching from Bologna in the north to Terracina in the south. In practice, however, towns like Bologna, Rimini and Perugia were ruled by the local families and pursued independent policies. The city of Rome was perpetually prey to the disputes of families such as Orsini and Colonna. Not until the reign of Alexander VI (Rodrigo Borgia, 1492–1503) did any pope seriously undertake the problem of making a reality out of the far-reaching claims of the Papacy to political authority. Pope Alexander attempted to achieve these aims through the activity of his natural son Cesare Borgia, whose meteoric career in subduing the petty tyrants and *condottieri* of central Italy and the Romagna was the subject of classic analysis in Machiavelli's *Prince*. The Borgia plans fell into ruins through the unexpected death of Alexander, but the succeeding pope Julius II pursued similar aims in attempting to make the papal authority both respected and feared, even though as a della Rovere (from Savona, on the Italian Riviera) he was the personal enemy of the Borgias. The troubles of the papacy during the 14th century (first, the Avignonese 'exile' and then the Great Schism) had had disastrous consequences for the production of works of art in Rome. Recovery took a long time. For most of the 15th century the capital of Christianity, although frequently visited by the best artists, was inhabited by none. Roman art remained extraordinarily provincial, and it was not until the beginning of the 16th century during the political recovery of the Papacy that Rome became once more, as it had been in the 13th century, a permanent centre for the production of the highest quality art.

There are two possible explanations for this slow recovery. Firstly, there is no doubt that the prevailing system of patronage made it difficult to establish an artistic centre

where none already existed. Patrons were jealous of their *protégés* and guarded them carefully. They allowed artists under their patronage to travel, but only on condition that they returned; for instance Lodovico Gonzaga was prepared to send Andrea Mantegna to Rome, but the latter worked there for the pope on the basis of a temporary loan. It must be admitted, too, that the artists often tended to gravitate towards a single court or patron, much as a modern writer may gravitate towards a single publisher.

Secondly, Rome was governed by an institution (the Papacy) rather than a dynasty, and this fact made it more difficult for the city to be a settled centre of patronage. Of course, the succession to the Papacy was frequently influenced by dynastic considerations; but the artists' futures were often insecure in these circumstances, for the projects of one pope might well be abandoned by his successor.

This situation was remedied by a disturbance of the balance of power at the beginning of the 16th century. It happened that the election of Julius II (1503), one of the most militant and forceful popes ever to reign, coincided with a period of grave Florentine political instability and weakness. As the result of a revolution in 1494 the Medici had been expelled (with their supporters) and Florence became briefly and precariously a republic. The leaders of this republic were in no position to resist Pope Julius; and one of the results of this weakness was the departure of a series of artists of major calibre such as Michelangelo, Raphael, Andrea Sansovino and Jacopo Sansovino—all of whom went to Rome to work at the papal court.

By a further stroke of fortune Julius II was succeeded by two members of the Medici family, Leo X (1513–21) and Clement VII (1523–34). The Florentine artists did not therefore all disappear back to Florence since, although the Medici family was restored in Florence (1512), the head of the dynasty was ruler of Rome. These three popes were amongst the most avid patrons of the arts and under their leadership Italian art became centred on Rome in a manner hitherto without parallel. This 'golden age' lasted only until the Sack of Rome in 1527; but it is not fanciful to see in the works of art produced in Rome at this point in history an art which ultimately changed the face of Italy and Europe.

The art produced in Rome during the years up to *c.* 1520 is usually described as the High Renaissance; and while the label has a general convenience, it will be seen that any search for a 'High Renaissance style' has its own dangers. The great artists who worked in Rome during this period were strongly contrasted in temperament and personality (the major contrast was, of course, between Michelangelo and Raphael); and these personal contrasts and antagonisms found artistic expression in contrasted conceptions of painting, sculpture or architecture. It is fruitless for these reasons to search for a uniform High Renaissance style. What emerges is rather a series of new departures in art, each in turn capable of being developed and reinterpreted with great variety by different artists.

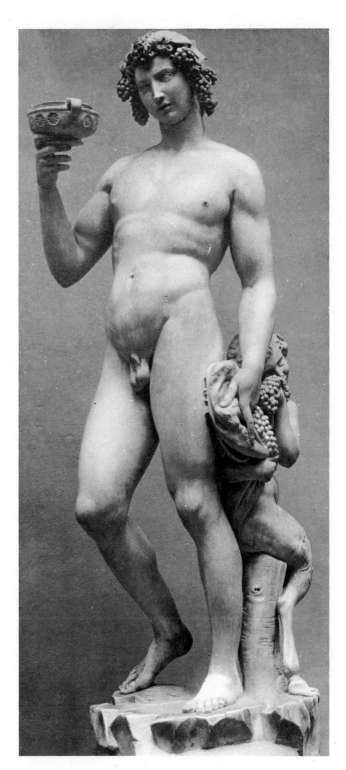

44. **Michelangelo.** *Bacchus. c.* 1447. Marble. h. 80 in. (203 cm.). Museo Nazionale, Florence. This figure was carved for Jacopo Galli and it was intended to stand in a garden amongst a collection of antique statuary. The piece is inspired by antiquity but given a personal and to some extent repulsive interpretation which makes it very different from, for instance, the type of classicism favoured by the Lombardi family in Venice (compare figure 88).

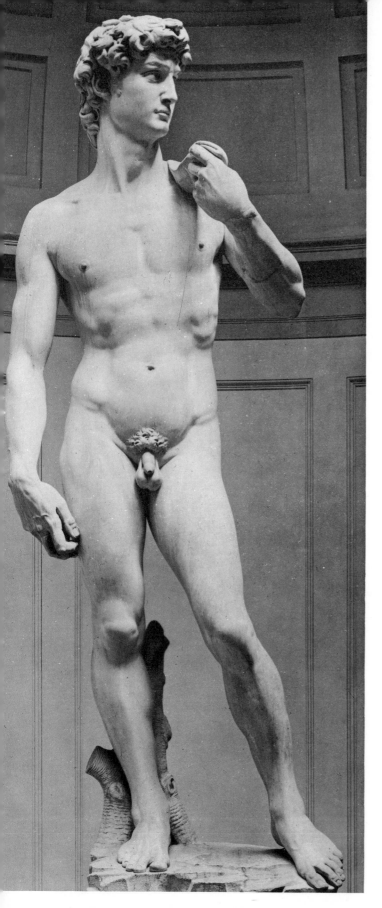

45. **Michelangelo.** *David.* 1501–4. Marble. h. 16ft 10½ in.
(514 cm). Accademia, Florence. This is one of the most
important statues in the history of the Renaissance. Here for the
first time a sculptor successfully emulated both the scale and
the physique of the colossal figures of antiquity. The *David* set
new standards of public statuary and, looking back from the
middle of the 16th century, the historian Vasari could
still give it his unstinted praise.

FLORENTINE ART AROUND 1500: MICHELANGELO AND LEONARDO

To understand the achievements of these giants of the
Renaissance it is necessary to trace their careers before their
arrival in Rome and, in particular, to analyse the develop-
ment of sculpture and painting in Florence *c.* 1500. During
the last decade of the 15th century Florentine sculptors
appear to have accepted the movement for classical re-
construction in its entirety. Thus Bertoldo, the sculptor of
the Medici, reworked the composition of an antique relief
as an artistic exercise, supplying from his imagination parts
missing in the original. At about the same time the young
Michelangelo carved a sleeping *putto* which was mistaken
by connoisseurs for an antique; and his execution of a
figure of *Bacchus* (now in the Bargello, Florence) shows the
extent to which not merely the subject-matter of classical
sculptors, but also the style were now taken over. This
figure of *Bacchus* has a special interest for the illustration of
the character of these developments in Florence; for the
model used by Michelangelo—probably a *Bacchus* of
Praxiteles—was certainly similar to the model underlying
the near-contemporary *Adam* of Tullio Lombardo in New
York. It is easy to see how each artist extracted and
emphasised completely different characteristics from his
model. Tullio emphasised the surface characteristics of
Praxiteles' work; but Michelangelo achieved a disturbing
flaccid quality in the surface of the flesh and also vigorously
reinterpreted the subject-matter itself, producing a figure
at once fascinating and repulsive.

Michelangelo's figure of *David* is however undoubtedly
the greatest sculptural monument to the 'classical revival'
in Florence. This represents the revival of an earlier
project (1462), and the marble block which Michelangelo
used had already been partially worked by an earlier
sculptor. The revival of the project is not surprising since
the image of David seems to have exercised a peculiar
fascination on the Florentines throughout the 15th century
as a symbol of freedom overcoming tyranny (Goliath).
Indeed in 1501 the Palazzo della Signoria of Florence
already possessed three representations of David (two by
Donatello, one by Verrocchio), and the creation of a
further figure, of giant stature and destined to stand in the
main square, carried with it overtones of political defiance
on the part of the new-born republic. But the statue which
emerged from Michelangelo's hands was more than this.
His gigantic naked male figure successfully challenged
comparison with the great naked antique statues of gods
and heroes. Thus it was possible for the historian Vasari,
looking back from the middle of the century, to say that the
David had 'stolen the thunder of all statues, whether
modern or ancient, Greek or Latin'.

The monumental figure style which characterises all
Michelangelo's work (sculpture or painting) can in part be
traced back to the use to which he put antique models and
to the 'triumph of antiquity' in Florence at this moment.

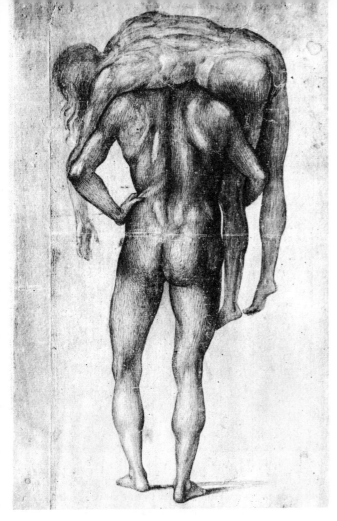

46. **Luca Signorelli.** *Study of Two Nude Figures. c.* 1503. Watercolour, heightened with white. 14 × 10 in. (35.5 × 25.5 cm.). Louvre, Paris. Executed during the period of the Orvieto frescoes, and, indeed, very similar to two figures visible in plate 43. Signorelli was an important precursor of Michelangelo in his interest in the nude form.

47. **Michelangelo.** *The Battle of Cascina* (study). 1504–5. Pen and brush with ink and heightened with white. 28½ × 11½ in. (42 × 29 cm.). British Museum, London. The care with which Michelangelo constructed the fresco of the *Battle of Cascina* is evident from its fragmentary remains in drawings and sketches. This study shows that Michelangelo, being a sculptor, brought to his drawings a far more sensitive appreciation of the surface qualities of the human torso than was ever possessed by predecessors such as Signorelli.

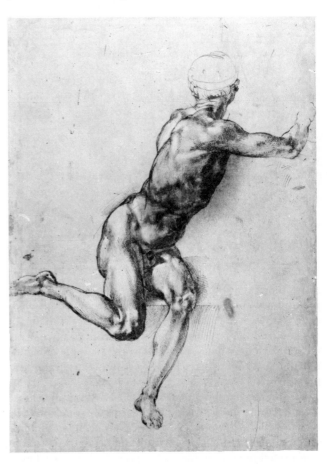

But to execute a single gigantic figure, like the *David*, was one thing: to imagine a world peopled entirely by gigantic monumental beings (as in the Sistine ceiling) was to imagine a new artistic world which could only be conquered by degrees. This development—or for that matter the achievements of Leonardo or Raphael—would not have been possible without the peculiar Florentine developments in the use and technique of drawing, which have already been mentioned in the previous chapter. The mastery of *disegno* came to have an overriding importance in the training of Florentine and Roman artists and sculptors, since *disegno* was regarded as the tool with which artistic ideas were stated and developed, and through which new ideas received experiment.

The importance of Antonio Pollaiuolo (with his influence on Leonardo da Vinci) has already been mentioned. Pollaiuolo had a further, perhaps unexpected follower in Luca Signorelli, an Umbrian artist from Cortona. This was unexpected because Signorelli had been a pupil of Piero della Francesca and, on the face of it, nothing could appear less likely to be successful than an attempt to mingle the heavy, majestic style of Piero with the decorative and vigorous style of Pollaiuolo. But the unexpected happened; and, although in the course of a long career

Signorelli produced a large amount of uninspiring provincial work, he also produced a handful of works of great intrinsic and historical significance.

In particular figure painting seems to gain a new dimension in the fresco cycle in the cathedral of Orvieto. The subject-matter of these frescoes, events leading up to the Last Judgment, was interpreted by Signorelli to allow him to display his ability to manipulate the human figure with the facility of Pollaiuolo and the gravity of Piero. But this singular achievement was not attained without a considerable amount of detailed experiment, the record of which lies in a series of masterly drawings. *Disegno*, once more, was used as a means of exploration.

The extent to which Michelangelo was influenced by Signorelli is difficult to determine, although he almost certainly saw the Orvieto frescoes which were completed between the execution of the *David* and his next great public work, the fresco of the *Battle of Cascina*. This fresco was to have been painted in the Great Hall of the Palazzo Vecchio in Florence, and it depicted a famous Florentine victory. As a battle picture it might have been expected to take its character from the tradition established in Florence by Uccello in such works as the *Battle of S. Romano* (now in the National Gallery, London). Michelangelo chose to

48. *The Battle of Cascina*. Grisaille on panel. 30 × 51½ in. (76 × 130 cm.). 16th-century copy after Michelangelo. Collection of the Earl of Leicester, Holkham Hall. The original (1504–5) was intended for the Palazzo Vecchio, Florence, and this copy represents the central group of the composition. It is interesting to compare it with Leonardo's pendant picture (figure 49) since the approach to the treatment of the subject-matter of a battle scene is so different. Michelangelo's interests were closer to those of Signorelli (plate 43).

49. *The Battle of Anghiari*. Free variant by Rubens after Leonardo da Vinci. *c.* 1615. Chalk with pen and gouache. Louvre, Paris. Original (1503–6) intended for the Palazzo Vecchio, Florence. This work, so very different from that of Michelangelo (figure 48), allowed Leonardo to explore further two sets of problems which had already fascinated him—that of conveying human emotion and that of capturing the movement of horses.

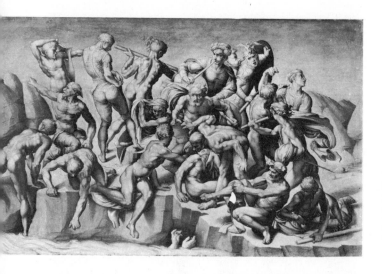

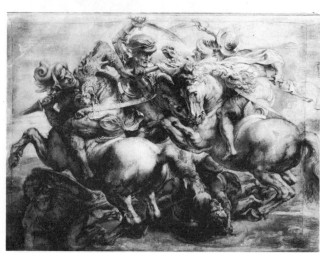

show, however, not the battle of Cascina itself but a preliminary episode in which the Florentine troops were caught unawares in a state indicated by the nickname of the composition *The Bathers*. It was at this point that his imagination may have been fired by the example of Signorelli, for he too interpreted his subject-matter to enable him to display his mastery of the human form.

This unconventional treatment of a battle subject must have been the more striking in that, on an adjacent wall, the council set to work Leonardo da Vinci on yet another battle subject, the *Battle of Anghiari*; and Leonardo certainly interpreted the task in the way expected—he showed men fighting—and used the subject-matter to enable him to display two features in which *he* excelled—the portrayal of human emotion and the portrayal of horses. Thus the projected frescoes for the Florentine council chamber presented the inhabitants of Florence with two sharply contrasted artistic experiences. The complicated movement and vivid ferocity of Leonardo's project would probably have made the most immediate impact. Yet no Florentine, looking back, would have been able to find any adequate 15th-century precedent for the precision, weight and monumentality of Michelangelo's nudes. At a single step the young artist progressed far beyond any possible precedents. Nobody before had drawn the human form with such impressive weight and body; equally, nobody had combined the sum of these forms into such a closely knit and balanced surface pattern.

Nevertheless, the importance of Leonardo da Vinci's return to Florence should not be underestimated. For about seventeen years this celebrated genius had been in the service of the Sforza dukes of Milan, for whom he had taken on a number of diverse tasks such as the painting of *The Last Supper* (Sta Maria delle Grazie), or the modelling of a gigantic equestrian monument to Francesco Sforza. The Florentine and Paduan antique revivals seem to have

passed him by; and this, combined with the fact that he belonged to a generation older than that of Michelangelo, probably accounts for his more traditional treatment of the battle theme in the council chamber. But during his absence Leonardo's attitude to light and colour in painting had changed out of all recognition, and his return projected a new style of painting into the artistic world of Florence. He now used delicate and sober colouring; his paintings possessed a sensitive tonal unity; and, by contrast with the brilliant definition of his early painting, the transitions from light to shadow were gently blurred in a technique later called *sfumato* (indicating that the individual degrees of these transitions had 'vanished'). At its most obvious this contrast of styles may be seen by setting the early Uffizi *Annunciation* alongside the Louvre *Virgin and Child with St Anne*.

This picture in the Louvre also demonstrates a further novel aspect of Leonardo's painting. His figure compositions, like this one, immediately attracted attention on account of their fascinating complexity. Soft, gentle and sinuous, this was a style opposed in most particulars to the world of *David* and the *Bathers* cartoon. Paintings of this Leonardesque type were intimate; they possessed delicacy, refinement and sensibility.

Leonardo's compositions seem to have exercised a fascination on the young Raphael who came to Florence at about this time (1504). Raphael had been trained under an eminent provincial master, Perugino, who, like Signorelli, had been a pupil of Piero della Francesca. Perugino's development had, however, been totally different. Having spent a short period working under Verrocchio, he developed an extremely graceful style which retains nothing of Piero's monumentality. On the other hand, Perugino derived from Piero an insight into the underlying geometry of space and proportion and (also probably from Piero) a more sensitive approach to colour. All these things he

handed on to his pupil Raphael; and it is not surprising therefore that to Raphael the paintings of Leonardo in their grace and colour must have seemed to explore anew those things in art that he already valued. Raphael certainly reworked and developed a number of Leonardesque schemes during these years; and he was among the first to attempt to emulate Leonardo's complex portrait style.

Shortly before going to Rome Raphael had also begun to experiment with the vigorous figure drawing of the Florentine tradition. This is to be seen in the *Deposition* painted in 1507 for a Perugian patroness, Atlanta Baglioni. This painting has a particular interest because a number of drawings survive which record the evolution of the composition from a static graceful Peruginesque arrangement of figures to the violent and strenuous action seen in the finished painting.

In these works is presented the genesis of those contrasts which mark the mature style of Raphael and Michelangelo in Rome. One general point deserves comment; taken collectively, the works which have been examined present a far greater range of human and emotional expression than is to be found in the previous decades of Florentine art. The generation which produced Andrea del Verrocchio had valued the decorative aspects of art without paying much attention to the emotional content of their subjects, or to the dramatic impact which a work might make on the spectator. The last fifteen years of the century saw a significant swing in Florentine taste. The late *Visitation* of Ghirlandaio is charged with emotional feeling which is not concealed by the superficially decorative character. The painting of Botticelli becomes increasingly troubled and serious in its emotional tone. The solemn character of Michelangelo's early sculpture (the Vatican *Pietà*, for example) is also remarkable; and this solemnity was shared by much of the sculpture of Andrea Sansovino. To these must also be added the subtle sweetness and sentiment of Leonardo's female figures, and the grotesque fury of his battling warriors, so that it can be seen that the rising generation of artists had a major task of assimilation before them. No artist could now easily avoid the problem of endowing any given work with an appropriate emotional tone or a unified dramatic force.

ROMAN ART FROM JULIUS II TO THE SACK OF THE CITY

It was at this point that Pope Julius II began summoning artists to serve him in Rome to further his ambitious schemes for the rebuilding and embellishment of the Vatican palace and basilica. These schemes find their most obvious expression in the architectural projects of Donato Bramante who, it will be remembered, had arrived in Rome in 1499 during the pontificate of Alexander VI (Borgia). Bramante was responsible for such widely differing projects as the Tempietto at S. Pietro in Montorio (1502), the Belvedere court in the Vatican, and the first plans for the complete rebuilding of St Peter's.

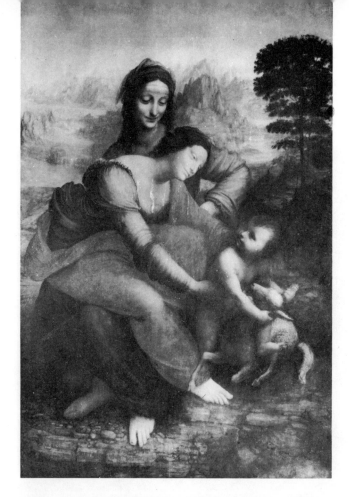

50. **Leonardo da Vinci.** *Virgin and Child with St Anne. c.* 1500–7. Paint on panel. 67 × 51 in. (170 × 129 cm.). Louvre, Paris. The origins of this composition date from Leonardo's stay in Milan although the work was chiefly painted in Florence. It has a sinuous complexity which fascinated contemporary artists but the painting is also a study of psychological relationships.

51. **Raphael.** *The Canigiani Sacra Famiglia. c.* 1507. Paint on panel. 51½ × 42 in. (131 × 107 cm.). Alte Pinakothek, Munich. Painted originally for the Florentine Domenico Canigiani. The landscape betrays Raphael's origins in the workshop of Perugino, but the composition presents an obvious instance of the way in which works by Leonardo (e.g. figure 50) inspired young artists to work on similarly compact and complicated figure compositions.

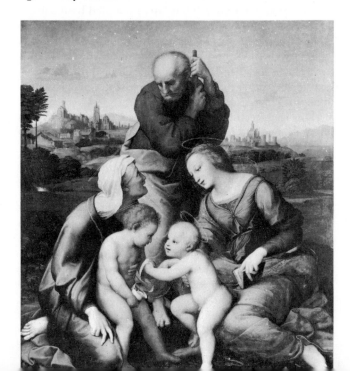

52. **Michelangelo.** *Pietà.* 1498. Marble. h. 69 in. (175 cm.). St Peter's, Rome. One of the few completed works of Michelangelo. It was commissioned by a French cardinal, Jean de Villiers de la Groslaye. The subject was unusual for

Italy and was treated by Michelangelo with deep solemnity. Here is a new attention to mood and feeling, found also in the work of other artists, and characteristic of a change of emphasis in Florentine art at this time.

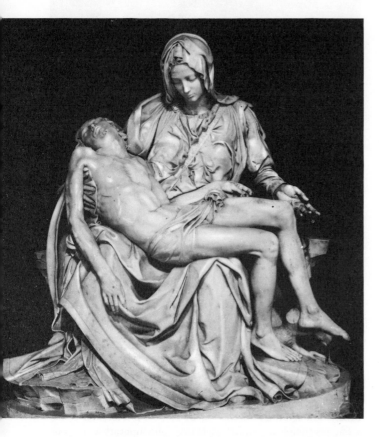

An examination of the architecture produced in Rome *c.* 1500–20 will illustrate the contrasted character of much 'High Renaissance' art—a problem that has already been mentioned. The genius of Bramante lay especially in the clarity of his buildings. He had a fine appreciation both of the scale of the antique remains around him and also of the three-dimensional qualities of the components of classical architecture. This, combined with a flair for archaeological reconstruction, emerges clearly in the exterior of a palace built probably for himself but later inhabited by Raphael, 54 and subsequently called the Casa di Raffaello. The positive plasticity of this façade can easily be judged when it is compared with Alberti's Rucellai palace which, by contrast, looks timid and academic. The Casa di Raffaello has extraordinary clarity and a kind of relentless logic which makes it perfect of its kind.

This architectural development was cut short by Bramante's death in 1514 but these few buildings gave architecture, in effect, a new starting point. Bramante's style was certainly criticised—among others by Raphael—on account of its austerity and comparative lack of adornment and decorative invention. These very criticisms, however, indicated a way in which the style might be developed. 55 Raphael himself designed one palace façade, the Palazzo dell'Aquila, in which the component parts of Bramante's design were rearranged and a rich band of stucco decoration was added. This gave the façade a sparkle and richness lacking in the Casa di Raffaello.

This same period also saw two fundamentally contrasted approaches to the use of sculpture on architecture. The

contrast is visible in a comparison of the statuesque figures of the Sistine ceiling and the niche figures designed by Raphael for his Chigi chapel in Sta Maria del Popolo. For Michelangelo it was sculpture that gave life and movement to an architectural surface. For Raphael it was merely an adjunct or embellishment to something which already possessed a character and harmony of its own.

It is perhaps the contrast represented by Raphael and Michelangelo which gives to the period of the High Renaissance not a unity but a diversity. The personal antipathy between them is well known. Raphael, by nature sociable and cultured, was able to train and hold a large number of talented pupils and assistants and for this reason his artistic legacy was very considerable, notwithstanding his premature death. Michelangelo, on the other hand, never had the patience to tolerate assistants for long; and, although he aided younger artists who sought his help, he was a much more withdrawn personality. These personal differences were accompanied by different forms of art. On the one hand, the sculptural weight of the figures on the Sistine ceiling may be contrasted to the grace and elegance of Raphael's frescoes in the Vatican *stanze* or in the Villa Farnesina. The deep seriousness and pervasive emotion of all Michelangelo's work are opposed to the more flexible variety of psychological approach in Raphael's; and, finally, the increasing effort needed by Michelangelo to complete any work is strongly contrasted with the apparently effortless completion of innumerable works by Raphael and his studio.

The dazzling fertility of Raphael's mind coupled with his extreme ability as an artist enabled him to master and to develop new ideas with surprising rapidity. One part of this development can be seen in the Vatican *stanze* where, from room to room, the artist progressed towards more ingenious spatial compositions and to more complex figure constructions—a development which accentuates the problem of distilling a 'High Renaissance style'. He and his pupils also devised secular decoration for private houses and villas, such as the Villa Farnesina (built originally for the banker Agostino Chigi who was one of Raphael's most important patrons) with its scenes of gods and goddesses, where a careful and pleasing balance was struck between the demands of reality and the demands of decoration. In another room in the same villa Baldassare Peruzzi, another artist from the circle of Bramante, painted a series of ingenious illusionistic frescoes combining rich colouring with the classical severity of Bramante's architectural style.

The whole decoration of the Villa Farnesina reflects the new 'court style' provided for an educated and critical clientèle. Like much court art, it was a 'connoisseur's style'; but, unlike most previous court art, the type of connoisseurship demanded an academic and literary bias such as had hardly been known before. This does not merely apply to the iconography of these works, although the humanistic content of this type of commission has already been noted in the paintings done for Isabella

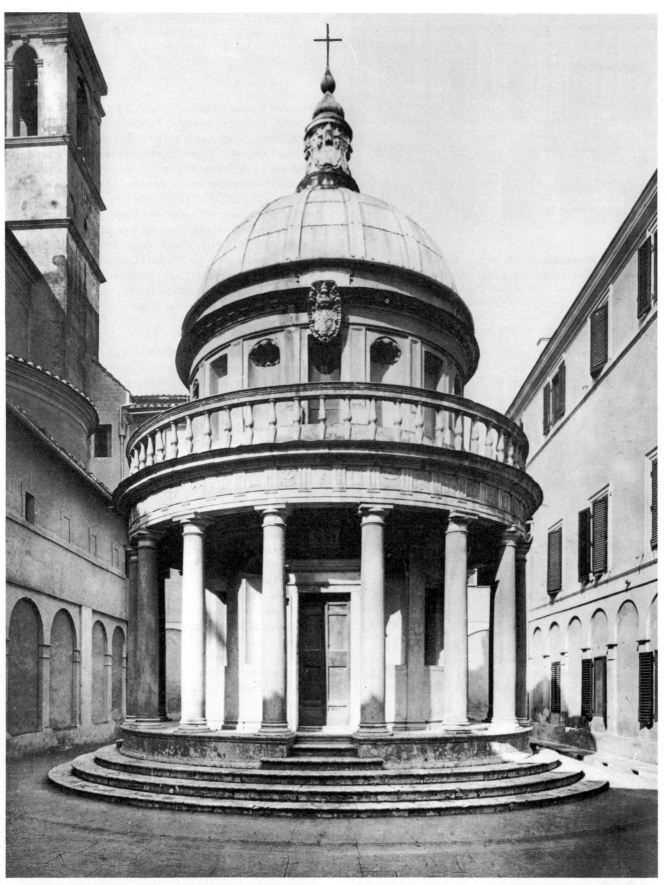

53. **Donato Bramante.** *The Tempietto* at S. Pietro in Montorio, Rome. 1502. This, one of Bramante's earliest Roman buildings, was little more than a large monument intended to mark the spot where St Peter was crucified. Both in its centralised plan and in the detail the building has antique prototypes, and it seems certain that the idea of the recreation of an antique building style was foremost in Bramante's mind. Nevertheless, in comparison with the buildings of Milan, the restraint and simplicity of the Tempietto are extremely remarkable. In the use of antique ideas, the Tempietto is an important landmark in the history of Renaissance architecture.

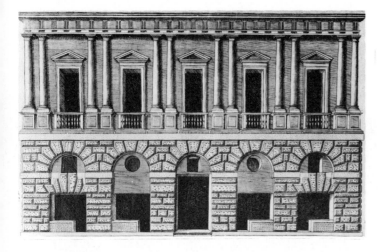

54. **Donato Bramante.** *Casa di Rafaello*, Rome. *c.* 1514.
Demolished. Engraving by A. Lafreri. An important building in
the history of palace architecture. The heavy columns
emphasised the importance of the first floor where the main
living apartments were situated. On the ground floor were
shops, an idea probably derived from Roman ruins.

55. **Raphael.** *Palazzo dell'Aquila*, Rome. Begun *c.* 1520 but
designed earlier. Demolished. Perhaps a considered contrast to
the Casa di Rafaello. Certainly the firm structural qualities
inherent in that design were abandoned for something far
more decorative.

d'Este's *studiolo*. The new style had visible archaeological
aspects not only in Bramante's architecture, but in many
features of the painting emanating from the circle of
Raphael. The 'painted tapestries' which span the vault of
the *Sala di Psyche* in the Villa Farnesina would have been
appreciated by the connoisseur as a recollection of the
awnings used by the Romans to cover open-air theatres;
the landscape style of Raphael's pupil Polidoro da Cara-
vaggio would have been recognised as a deliberate emula-
tion of antique painting. And the antique derivation of
much of the 'grotesque' decoration, so characteristic of this
period, would have been a source of informed comment
and pleased recognition.

In spite of Raphael's early death (in 1520) his style lived
on in the work of an extremely gifted group of followers
who were present in Rome during the early 1520s. They

included Giulio Romano (who left for Mantua in 1524),
Peruzzi, Pierino del Vaga, Polidoro da Caravaggio and
Parmigianino (who only arrived in 1523, some time after
Raphael's death). These artists were inspired by common
devotion to the cause of beauty, elegance and decorative
invention—whether in the extreme elongation of Parmi-
gianino's figures, the façade schemes of Polidoro, or the
palace decoration of Pierino del Vaga. All seemed set fair
for the development of this brilliant and civilised culture
when political fortune once more intervened. Imperial
troops descended on the Rome of Clement VII in 1527, the
Eternal City was sacked and plundered and the artistic life
initiated by Julius II and so carefully nurtured by the two
Medici popes was scattered to the four winds.

FLORENTINE ART: 1505–30

After the expulsion of the Medici in 1494 and the execution
of Savonarola in 1498 the city of Florence was continued as
a republic. The defiant political character of some of the
art produced for the republic has already been mentioned
notably Michelangelo's *David* and the two great battle
scenes in the Palazzo Vecchio. However, the strength of
the republic derived only from the weakness of the Medici;
its own weakness was that it depended upon support
from France, so that the defeat of France in Italy and the
general alliance between the Medici, the Spaniards and
Habsburgs led to the downfall of the republic in 1512
and again after a brief revival 1527–30. The Medici family
was restored with the blessing of the Emperor Charles V
who elevated the city to a duchy (1530). Eventually, the
Duchy of Florence was absorbed into a new state, the
Grand Duchy of Tuscany, in 1569.

During these early years of the century, Florentine art
had pursued a somewhat uneven course. The exodus of
important artists during the first decade impoverished the
artistic resources of the city and only in the field of painting
does a distinguished tradition of 'second-line' artists emerge
after the depredations committed by Julius II. If one can
imagine Michelangelo, Leonardo and Raphael as excep-
tional geniuses who lay outside the main stream of Floren-
tine painting, then it is apparent that there was still an
extremely competent local tradition of painting stretching
in unbroken sequence from Fra Bartolommeo and Alberti-
nelli through Andrea del Sarto to Rosso Fiorentino and
Jacopo Pontormo. Florentine painting did not therefore
collapse *c.* 1510. The story with sculpture and architecture
is very different. No local sculptor was able adequately to
continue the standard of excellence established by Michel-
angelo and Andrea and Jacopo Sansovino. During the
1520s, after Michelangelo had returned to his native city,
his chief competitors were Baccio Bandinelli and Francesco
da Sangallo, men of extremely uneven ability. The case
with architecture is similar. The most distinguished archi-
tecture of this period is Michelangelo's Medici chapel and
the library in the monastery of S. Lorenzo.

(Continued on page 529)

42. **Maerten van Heemskerck.** *View of the Roman Forum from the Capitol.* Signed and dated 1535. 8½ × 22 in. (21.5 × 55.5 cm.). State Museums, Berlin-Dahlem. Rome of the High Renaissance was still substantially that of the Limbourg brothers (compare plate 1). Crumbling ruins still mouldered away, half concealed by the accumulated debris and rubbish of a thousand years. The attitude to the ruins had, however, changed out of recognition. They were now symbols of a vanished greatness, to be treasured and admired, drawn and redrawn, studied and analysed.

43. (page 514 top). **Luca Signorelli**. *The Damned. c.* 1503–4. From the frescoes in the chapel of S. Brizio, Orvieto cathedral. These frescoes were praised by both Michelangelo and Vasari for the extraordinary variety achieved by the artist in the manipulation of the human body. Trained under Piero della Francesca and Antonio Pollaiuolo, Signorelli combined aspects of the work of each, achieving his results with the aid of a long series of experimental drawings (see figure 46).

44. (page 514 below). **Pietro Perugino**. *Christ's Charge to St Peter.* 1481. From the frescoes in the Sistine chapel, Vatican (see figure 61). With a background very similar to Signorelli, Perugino nevertheless produced a totally different art. He possessed an interest in spatial relationships derived from Piero della Francesca and a passing interest in antique remains. But above all his figure style is graceful in a manner unlike both Piero and Signorelli. The value set on grace was of great importance in the training of the young Raphael.

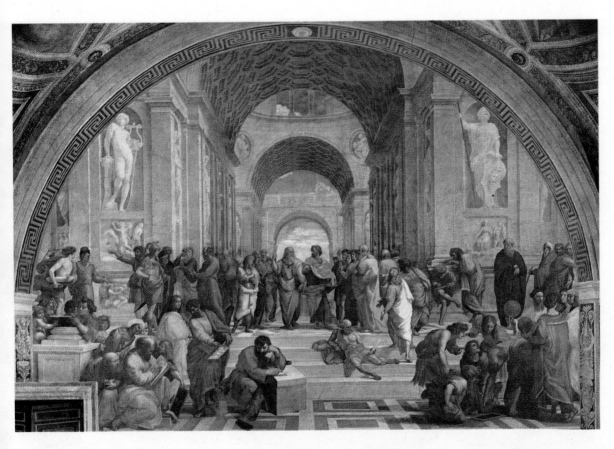

RAPHAEL AND THE VATICAN
STANZE

45. **Raphael Sanzio.** *The School of Athens.*
1508–11. l.c. 18 ft (584 cm.). Fresco from
the *Stanza della Segnatura,* Vatican. The
accumulated wisdom of the ancient world
is here personified in a vast concourse of

philosophers gathered round the persons
of Plato and Aristotle. Behind rises an
enormous antique structure based partly
on classical ruins and partly on ideas of
Raphael's protector, Bramante.

46. **Raphael**. *The Fire in the Borgo.*
1514–17. l. *c.* 15 ft (457 cm.). Fresco

from the *Stanza dell'Incendio*, Vatican. The
Peruginesque simplicity of the early
Stanza has been eliminated. The figure
style of Michelangelo has clearly made
its mark in the figures on the left; and in
its composition the scene, a miracle
from the time of Leo IV (847), is much
more complicated.

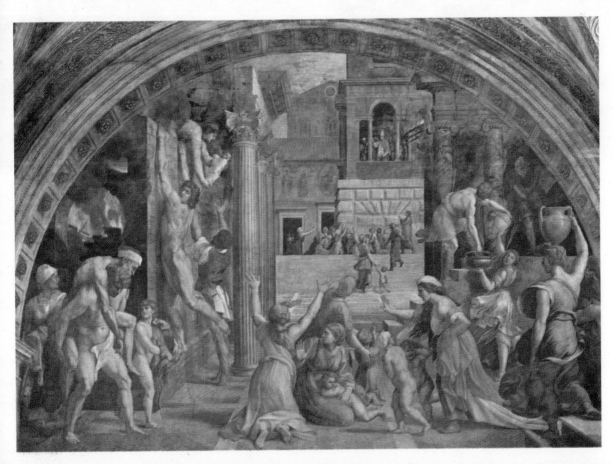

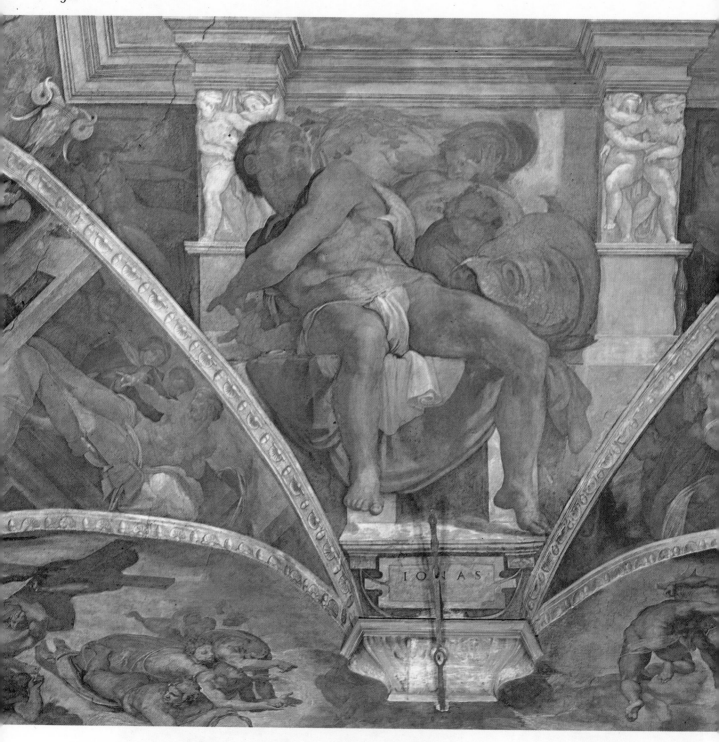

THE TWO POLES OF HIGH
RENAISSANCE FIGURE STYLE

47. **Michelangelo Buonarroti.** *Jonah.*
1511. Fresco at the western end of the
Sistine chapel, Vatican. Part of the later
work on the Sistine ceiling. The figure of
Jonah, looking up to the scenes of the
creation above, faces the spectator as he
enters the chapel and is probably the most
striking single figure on the ceiling.
Comparison with the work of Signorelli
will show how Michelangelo had in a
short space raised the art of figure painting
to a new plane.

48. **Raphael.** *The Triumph of Galatea.*
1511. 116¼ × 88½ in. (295 × 225 cm.).
Fresco from the Villa Farnesina, Rome.
The twisting attitude of Galatea is derived
from a lost work of Leonardo da Vinci and
is a reminder of the influence of Leonardo
on the young artist. The lithe grace of
Raphael's painting is here contrasted
with the ponderous grandeur of Michel-
angelo in order to demonstrate different
aspects of High Renaissance art in Rome
as a prelude to subsequent developments.

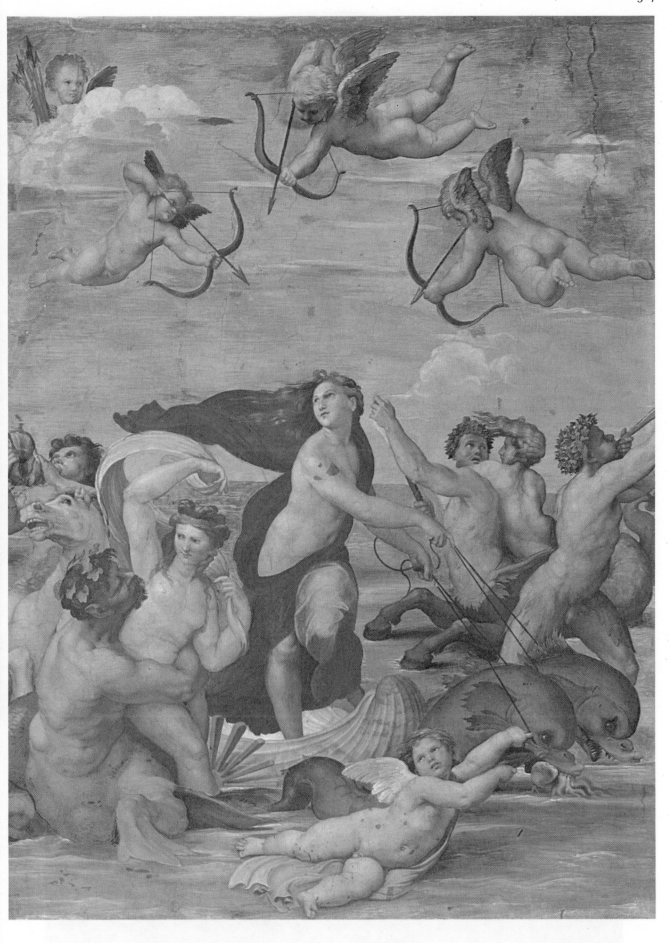

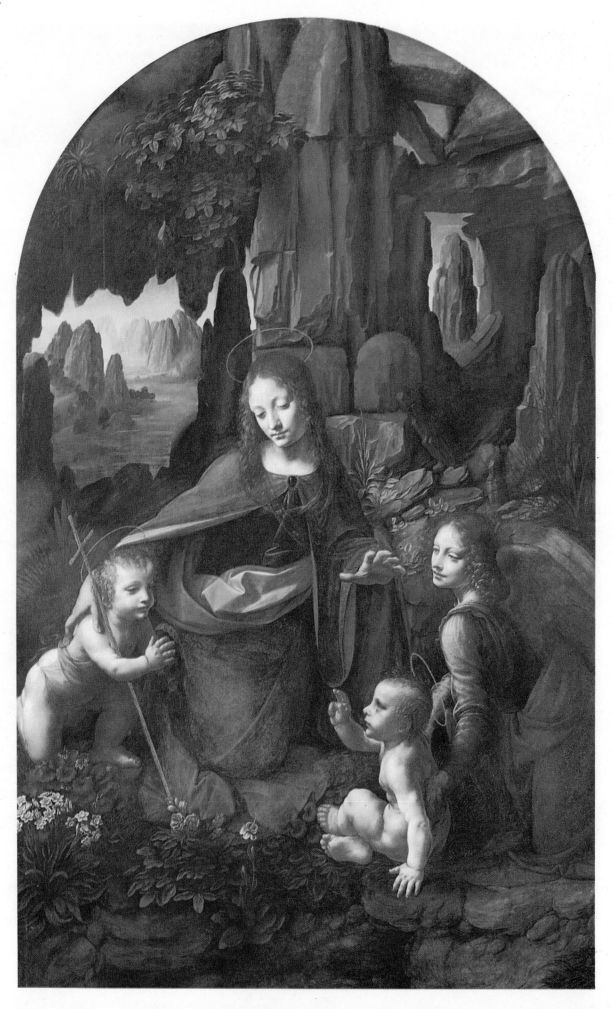

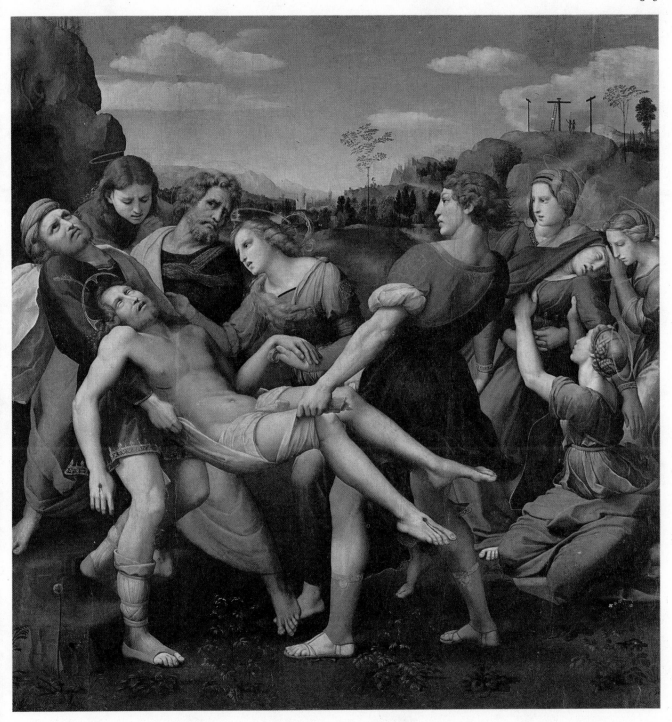

49. **Leonardo da Vinci.** *The Virgin of the Rocks*. Finished *c.* 1507. Paint on panel. 74½ × 47¼ in. (189.5 × 120 cm.). National Gallery, London. The history of this work is complicated by the existence of an earlier replica in the Louvre. Their relationship is still disputed but it seems likely that the London version was finished *c.* 1507–8 and therefore represents the last phase of Leonardo's painting style. The carefully modulated lighting, the gentle shadows, the sweeetness and grace of the figures are recognisable as traits which made a deep impression on the younger generation of artists.

50. **Raphael.** *The Deposition*. Signed and dated 1507. Paint on panel. 72½ × 69¼ in. (184 × 176 cm.). Borghese Gallery, Rome. Painted as a commemorative work for a Perugian family, it began life as a *Lamentation over the Dead Christ*. Subsequent changes in mood and content probably reflect the influence of the works of Michelangelo and Leonardo on the young artist. The picture certainly contrasts with the series of *Madonna* paintings from this period.

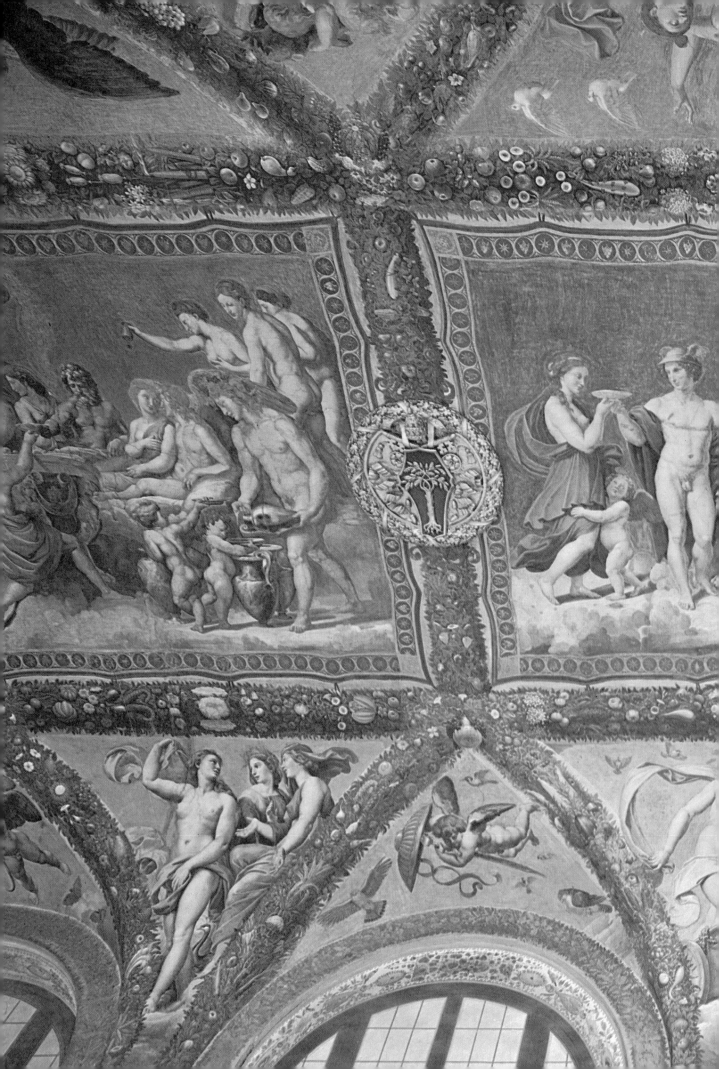

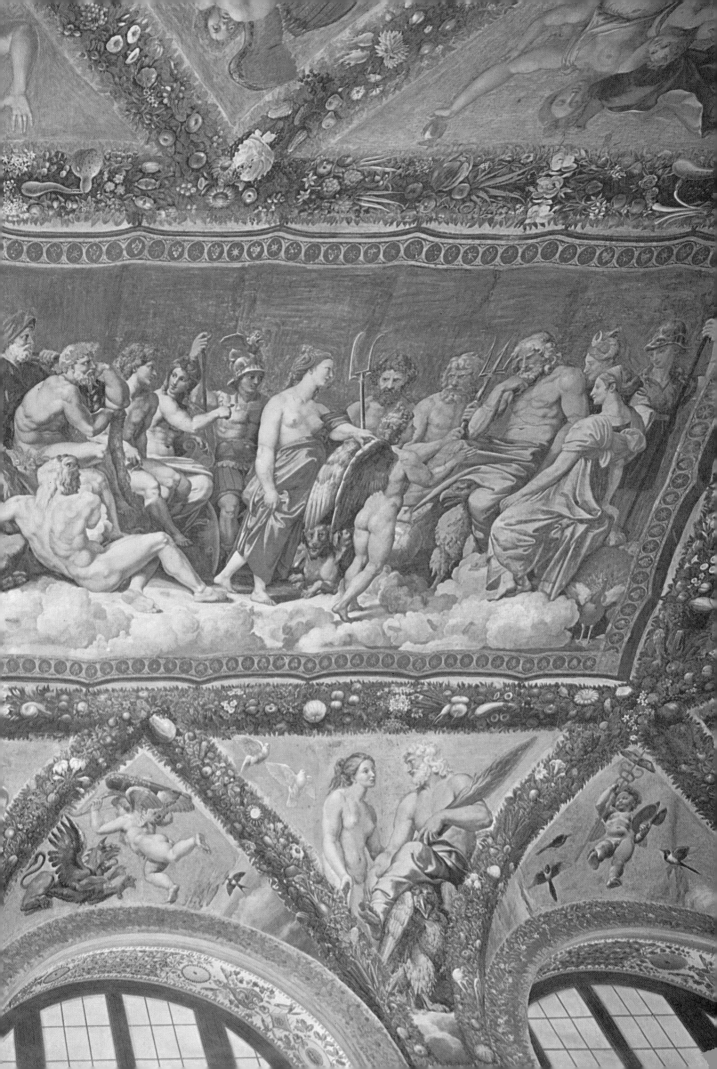

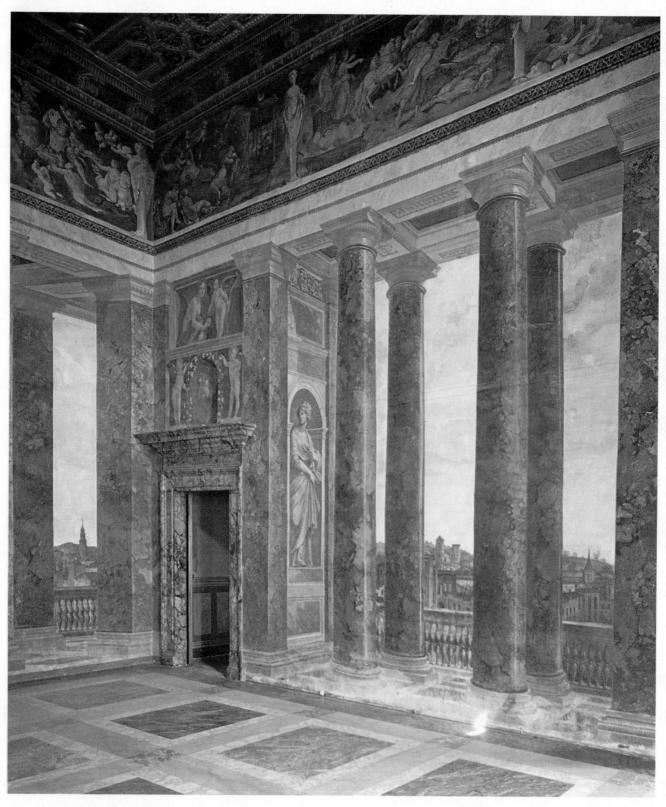

THE NEW COURT ART

51. (previous pages). **Raphael**. *Ceiling of the Loggia di Psyche*. 1517–18. Fresco. Villa Farnesina, Rome. The original builder of what became the Villa Farnesina was the papal banker, Agostino Chigi, one of Raphael's most important patrons. He employed a number of artists from the circle of

Raphael and Bramante, both here and in the family chapel in Sta Maria del Popolo, Rome. The *Loggia di Psyche* on the ground floor, originally open along one side, formed the entrance to the villa and is decorated with the story of Cupid and Psyche.

52. **Baldassare Peruzzi**. *Sala degli Prospettivi*. 1508–11. Fresco. Villa

Farnesina, Rome. Peruzzi was also an architect and was responsible for the general design of the building. The walls of this room on the first floor are painted to simulate a panoramic view of Rome seen through colonnades. Peruzzi is known to have designed stage scenery, and his mastery of this type of illusionism may be derived from this source.

THE HEIRS TO THE HIGH
RENAISSANCE

53. **Jacopo Pontormo**. *Vertumnus and
Pomona*. 1520–1. Frescoed lunette from the
Villa Medici, Poggio a Caiano. The
general atmosphere of this lunette with
its suggestion of foliage and the open air
may be compared to the *Loggia di Psyche*
(plate 51). The bright cheerful colours
and the contrasted figures were considered
suitable decoration for the informal sur-
roundings of a country retreat. The in-
fluence of Michelangelo is clearly felt in
some of the nude figures.

54. **Jacopo Pontormo**. *Pucci altarpiece*.
1518. 84¼ × 72¾ in. (214 × 185 cm.).
S. Michele Visdomini, Florence. The most
important master of Pontormo was
Andrea del Sarto from whom much of the
pictorial style of this altarpiece derives. It
makes a strong contrast to plate 53 for
here it is the influence of Leonardo which
underlies the whole work. The compli-
cated psychological relationships find for
instance a muted counterpart in the
London *Virgin of the Rocks* (plate 49). The
contrasted styles of High Renaissance
painters were already leading to con-
trasted developments among their
successors.

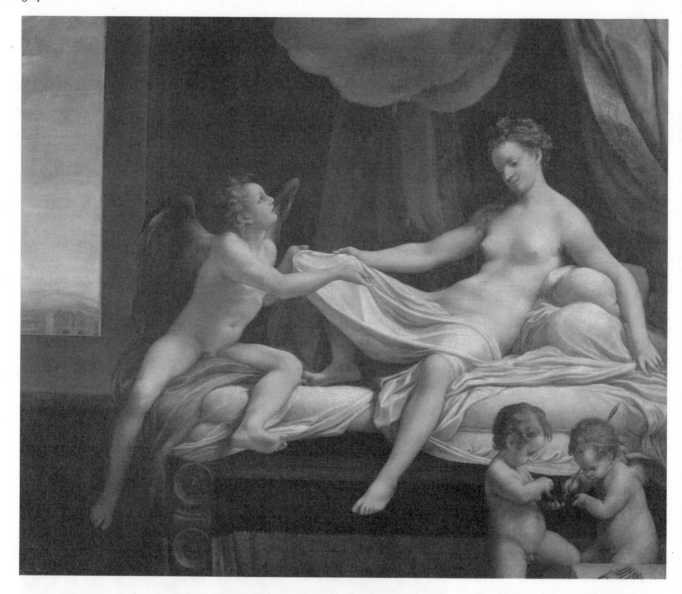

55. **Antonio Allegri (Correggio).**
Danae. 1531. Paint on canvas. 63½ × 76
in. (161 × 193 cm.). Borghese Gallery,
Rome. From obscure beginnings
Correggio became one of the foremost
mythological and allegorical painters of
northern Italy. The softness of his painting
and his extraordinary ability to capture
the nuances of human expression made
his work famous and much sought after.
This work was probably executed for
Federico Gonzaga, Duke of Mantua.

56. **Francesco Mazzola (Parmigia-
nino).** *La Madonna dal Collo Lungo. c.* 1535.
Oil on panel. 85 × 52 in. (216 × 132
cm.). Pitti Palace, Florence. Parmigianino
was a great admirer of the style of
Raphael, producing a delicate attenuated
version of Raphaelesque grace. Post-
Raphael painting frequently seems
contrived and artificial but these were
positive qualities which were admired at
the time. Hence the careful contrasts here
in size and type of figure and the juxta-
position of the rigid columns and the
curving form of the Madonna.

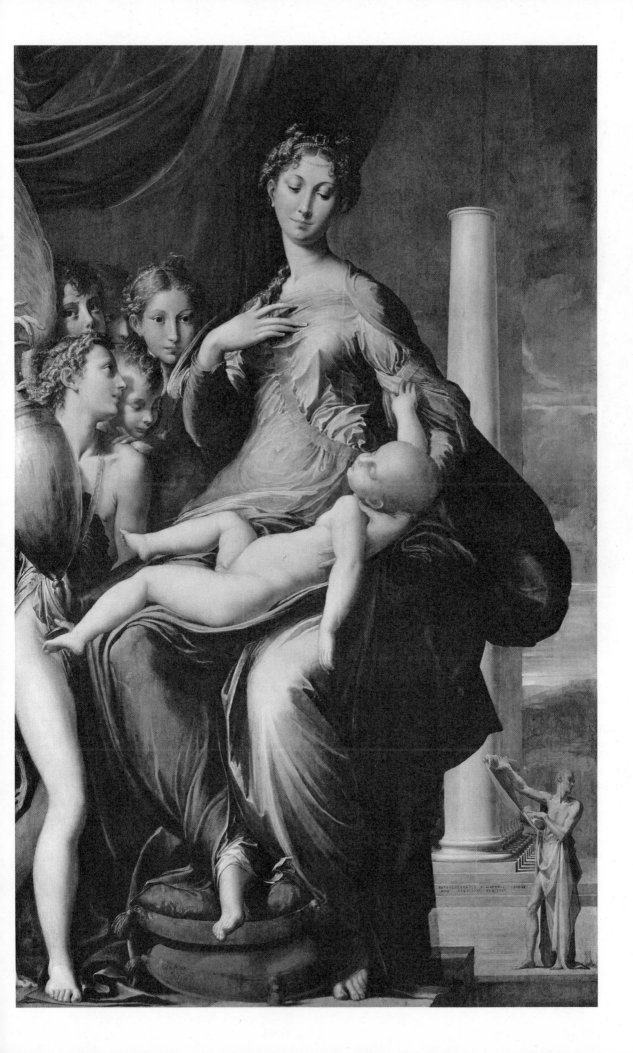

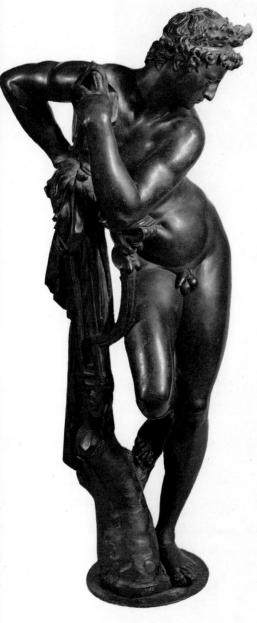

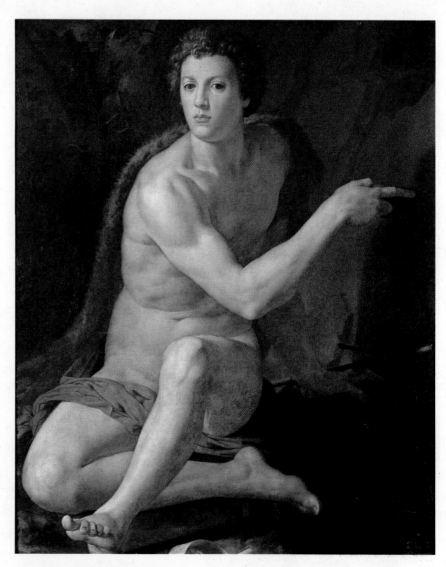

FLORENTINE ART UNDER THE
MEDICI DUKES

57. **Giovanni Bologna.** *Apollo.* 1573–5.
Bronze. h. 34½ in. (88 cm.). Palazzo
Vecchio, Florence. Part of the decoration
of the *Studiolo* of the Duke Francesco
de' Medici, the programme was devised
by the scholar Borghini (1570) and the
artistic supervisor was Giorgio Vasari. The
contribution of Giovanni Bologna presents
a fair sample of the general figure style
of the decoration and of the taste of the
16th-century Medici court.

58. **Agnolo Allori (Bronzino).** *St John the
Baptist.* Probably before 1553. Painting
on panel. 47¼ × 36 in. (120 × 92 cm.).
Borghese Gallery, Rome. Bronzino was
court painter to Cosimo, the first Grand
Duke of Tuscany, and produced an easily
recognisable brand of court art of a frozen
passionless elegance which was much to
the taste of Cosimo and his Spanish wife,
Eleanor of Toledo.

59. **Giovanni Bologna.** *Fountain of
Oceanus.* 1567–70. Boboli Gardens,
Florence. Fountains became popular
decorative undertakings during the
second half of the 16th century. They
demanded ingenious iconography as well
as supreme artistic skill in formal com-
position for their execution, and full
appreciation of them required a sustained
intellectual effort on the part of the
spectator. Here the great bowl represents
the ocean into which the gods of the three
rivers of the Nile, the Ganges and the
Euphrates pour their waters. They are
dominated by a standing figure of
Neptune.

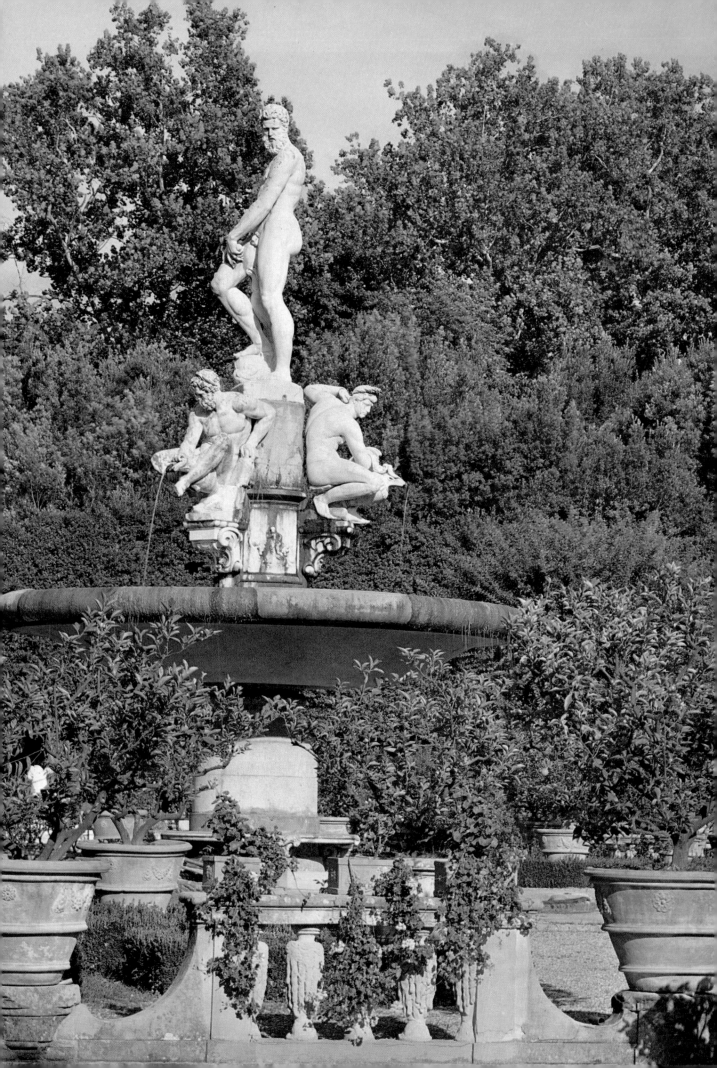

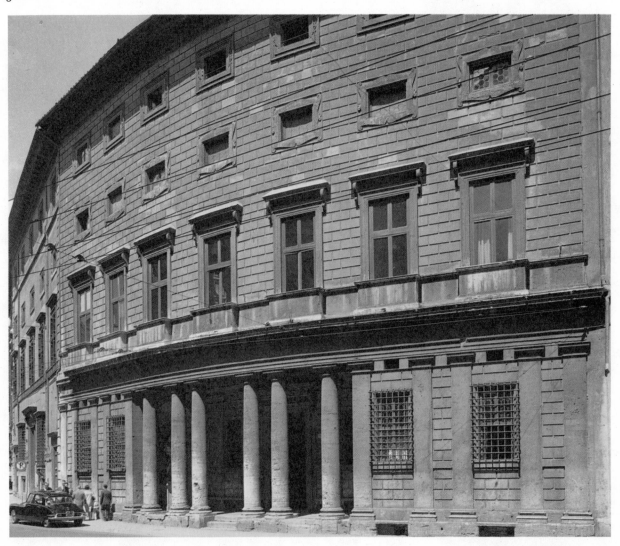

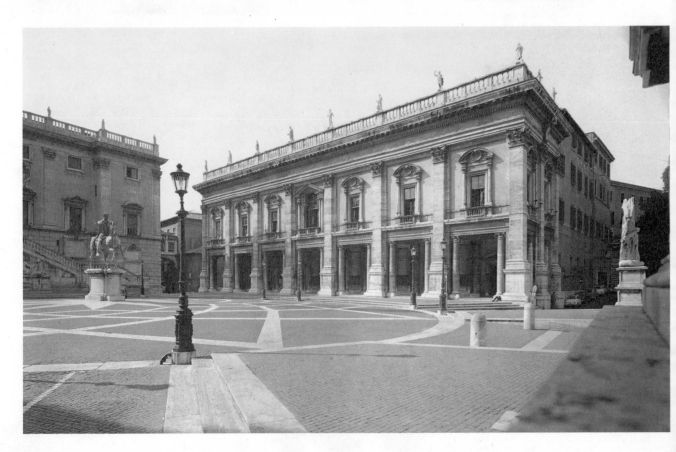

60. (opposite). **Baldassare Peruzzi.** *The Palazzo Massimi alle Colonne* was built during the 1530s to the designs of Peruzzi (see also plate 52). Although ingenious in its plan, the façade presents an essentially flat surface decorated with a variety of motifs in low relief.

61. (opposite). **Michelangelo.** *Palazzo dei Conservatori*, on the Capitol, Rome. Designed by Michelangelo in 1546 but not completed until 1568, after his death. The heavy plasticity of the individual parts forms an obvious contrast to the earlier façade of Peruzzi (plate 60). Michelangelo is in this respect closer to Bramante than to the intervening Roman architects.

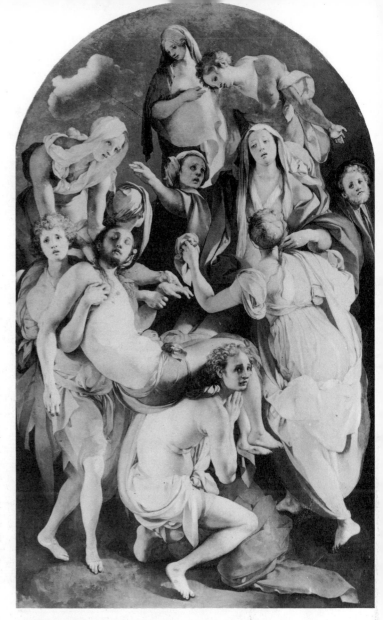

56. **Pontormo.** *Desent from the Cross.* 1526–8. Oil on wood. 123¼ × 75½ in. (313 × 192 cm.). S. Felicità, Florence. Painted for the Capponi chapel in S. Trinità. It is interesting that this should represent virtually the same subject-matter as Raphael's *Deposition* (plate 50) since comparison emphasises an almost obsessive interest in the human figure, developed mainly under the inspiration of Michelangelo. The careful construction of the chain of human elements is matched by the chain of human reaction which binds the figures to each other by glance and gesture, and also includes the spectator.

Andrea del Sarto was probably the most important painter in Florence during this period. He was only three years younger than Raphael, and his position in Florentine painting is comparable to Raphael's position at Rome. Sarto, too, had the talented pupils already mentioned, and other excellent artists such as Francesco Salviati also passed through his hands. Sarto was also deeply influenced by the work of Leonardo; and, like Raphael, he produced his own synthesis of the style of Leonardo and Michelangelo in so far as he was able to be acquainted with either. The artists Rosso and Pontormo, maturing in the years around 1515, are more complicated painters because their artistic experience was more complicated. The contrasts of style in evidence to a young artist of this time must have been both bewildering and stimulating. The very rich colouring of Sarto was set off against the cooler colours of Leonardo and the brightness of the surviving Quattrocento painters (Botticelli only died in 1510). It has already been suggested that the emotional mood of a painting became more important because of the wide variations visible in contemporary painting. There was the intense emotion of Botticelli's late *Pietàs*, the enigmatic glances of Leonardo's female figures, the distorted fury of his battle scene, the violence of Michelangelo's unfinished *St Matthew* or the urbane world of Raphael's *Madonnas*. Apart from all these stood the cartoon of *The Bathers*, presenting a new vocabulary of expression in the figurative arts.

The enormous range of the choice of style open to a young artist intent on experiment is clear, and it is probably this factor which gives the work of an artist such as Pontormo a seemingly erratic course. The variety of his style can be seen in two early works, close in date. The first is an altarpiece painted when Pontormo was 24 for the church of S. Michele Visdomini in 1518. It owes much in its composition to Pontormo's master, Sarto, but into the relief-like composition is worked an exaggerated study of psychological states which leans heavily on the example of Leonardo. In some respects it is too complicated; so much is happening that the spectator's attention would be dispersed if it were not for the rigid formal organisation of the work. This rigidity compensates for the painter's evident intention to extract every ounce of psychological involvement from each one of the actors present.

The decoration which Pontormo executed at the Medici villa at Poggio a Caiano (1521) stands in complete contrast. All the disturbing Leonardesque psychology and the mysterious *sfumato* were abandoned, for the reason that a different type of commission demanded a different style of painting. The work is no less carefully balanced, but the spatial organisation is of an entirely different character suggesting a real world inhabited by three-dimensional people. Unlike the mystery of the Visdomini altarpiece, the ideas are expressed with clarity, informality and humour. Yet another side to Pontormo's versatility is to be seen in the frescoes in the Certosa at Galuzzo (near Florence) with their attenuated figures, and evident borrowings from Dürer engravings. Yet this was the very time that Pontormo came once more under the influence of Michelangelo, being one of the few Florentine artists whom the great man found congenial to him after his return in 1516. Pontormo's career is therefore symptomatic of the state of affairs in Florence in which a talented painter could choose from a wide number of styles and forms of expression in order to suit a particular situation.

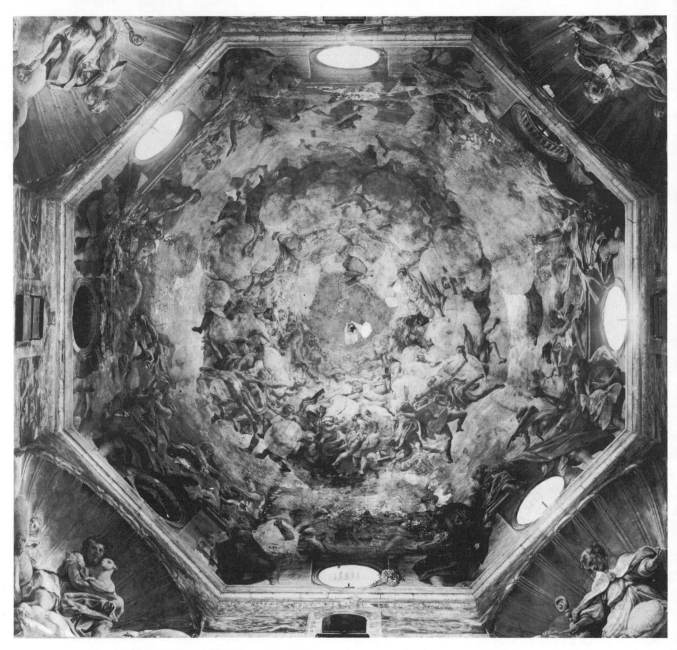

A variety of expression similar in kind and greater in extent is also to be found in the work of Rosso Fiorentino. He too began as a pupil of Andrea del Sarto but, on moving to Rome in 1523, he came directly into contact with the decorative tradition of Raphael's followers, an experience which exercised a refining influence on his style. This ultimately bore fruit in France at Fontainebleau, whither Rosso went in 1530 to serve Francis I (see p. 562).

PARMA AND MANTUA

Artistic developments outside Rome, Florence and Venice (see p. 569) have not the same continuity of interest, although the work of isolated painters in different centres has considerable importance. One such artist was Correggio who emerged from the competent but pedestrian background of the current court style around Milan, Mantua and Ferrara. He was born *c.* 1489 (being thus a little younger than Andrea del Sarto and Raphael). Up to *c.* 1520 his work although sensitive has a curiously provincial quality, containing a strange combination of elements derived from Mantegna, Raphael and Leonardo. After this date he seems, dramatically, to have acquired a new grasp of figure construction (perhaps in central Italy) and his ability as a

painter was transformed. In 1520 he began a decorative fresco scheme for the cupola of the church of S. Giovanni in Parma; and this was followed in 1526 by the decoration of the great dome of the cathedral of Parma itself. In both of these schemes he applied a newly acquired Michelangelesque figure style to the difficult problem in dome painting of devising a scheme both aesthetically satisfying and iconographically legible. In Parma cathedral he also managed to bring to the subject, *The Assumption of the Virgin*, an impression of the infinite space of Paradise, of excitement, jubilation and participation in the event portrayed. In this it has been said that he anticipated certain developments of baroque art; and the frescoes of the dome of Parma cathedral certainly constitute an important monument in the history of art and a highly individual creation of the Renaissance.

Correggio's painting on a smaller scale is hardly less remarkable, for the excited emotion of the Parma dome shows only one side of his art. Perhaps because his most immediate models did not include those Florentine masters of emotional involvement, Donatello and Michelangelo, he approached the problem of conveying emotion with a rare delicacy and sensibility. In his hands the individual's

58. **Francesco Xanto Avelli da Rovigo**. *The Triumph of Alcyone*. Signed and dated Urbino 1533. Maiolica dish. Diameter 19 in. (48 cm.). Wallace Collection, London. Italy was famous for its maiolica. The designs are interesting for in general they faithfully reflect contemporary taste, and this artist actually plundered the works of the great in order to supply most of the figures on this dish. They are drawn from engravings after such artists as Raphael, Rosso and Baccio Bandinelli.

57. **Correggio**. *Assumption of the Virgin*. 1526–30. Fresco inside the dome of the cathedral, Parma. Although the figures convey an impression of great excitement and perhaps unruly movement, this dome is most carefully planned so that the main action and the figure of the Virgin are to be clearly seen from the nave. By following the composition the spectator moves by degrees from the natural to the supernatural world, an idea commonly associated more with art of the baroque period.

possession of ecstasy, the expression of joy, desire and love are all treated with an unerring touch. He raised the portrayal of intimate emotional expression to a new level and in this once more his painting looks forward to the achievements of the next century.

In the years around 1530 the towns of Parma and Mantua once again assume a particular interest through the presence there of Parmigianino and Giulio Romano, both of whom had worked in Rome during the 'golden age' before the Sack. It was the painter Parmigianino who developed to its most extreme the languid grace of the Roman 'court style', a type of elegance which through various intermediaries became very popular at the French court. At Mantua the Duke Federigo Gonzaga had already before the Sack succeeded in attracting the services of Raphael's chief assistant who was employed in designing and decorating a new summer retreat on the outskirts of Mantua called the Palazzo del Tè (mainly *c*. 1526–34). This building was to be an informal place of rest and recreation, and it seems to have been ideal for the most extravagant artistic experiments in every medium, in a manner which might have been considered inappropriate in the more formal surroundings of a town palace. The influence both of the

architecture, with its contrasted textures in stonework, and of the decorative schemes for the interior was enormous on account of the immense variety of invention displayed there. It was from Mantua that the Bolognese Primaticcio went to the court of King Francis I; and thus the decorative style of Giulio Romano spread to France and came to have consequences of European significance.

ROMAN ART AFTER THE SACK

The terrible Sack of Rome, although it undoubtedly had profound consequences for the papacy, did not permanently disrupt the artistic patronage of the city. Michelangelo who had been in Florence since 1516 was called back to Rome in 1534 by Clement VII; but of the other Roman artists who had been scattered abroad in 1527 only Pierino del Vaga was to return (in 1538–9). Instead there appeared a brilliant group of younger artists, all born *c*. 1510 and many of them trained in Florence (the artistic relationships between Florence and Rome became from now on extremely close). Chief among these artists were Francesco Salviati, Jacopino del Conte and Giorgio Vasari who later compiled the famous series of artists' lives. The style of the first two is to be seen in a small oratory of S. Giovanni Decollato, the fresco decoration of which proceeded intermittently from *c*. 1535 onwards. This style exhibits what the 16th-century Italians called *maniera*. It is dependent on both Raphael and Michelangelo; but the superficial style of Raphael's history painting and the Sistine ceiling have been so far mastered that the effect is one of effortless grace and ease. From the connoisseur's point of view there is much to be admired in these works, both in the variety of pose and gesture, and in the differences in human type. The decorative conceits of the painted architectural framework are attractive and pleasing. But the painters' mastery of all the technical discoveries of the Renaissance triumphed at the expense of other concerns. These paintings are consciously clever and the artists are content to treat all subjects alike and with the same superficial emotion.

The painting of this group of artists presents the strongest possible contrast to the late work of Michelangelo who, between 1536 and 1541, was working on the great fresco of the *Last Judgment* in the Sistine chapel. The choice of subject-matter for this fresco was peculiar since it replaced a painting by Perugino of *The Assumption of the Virgin* in whose honour the chapel had been dedicated. Since the Sack of Rome had been widely regarded as a judgment from Heaven, it is certain that there was some association between those terrible events and the *Judgment* scene which Michelangelo was now called upon to paint. The artist gave the scene his own intensely felt interpretations. The total effect is not entirely pessimistic, but it is perhaps significant that Christ turns towards the damned, and that the mouth of Hell yawns immediately over the altar. As in Michelangelo's other figurative works the naked human body is the dominating factor, and the deep emotion of the artist is poured relentlessly into every part of the painting.

59. **Jacopino del Conte**. *The Preaching of St John the Baptist*. 1538. Fresco. S. Giovanni Decollato, Rome. A good example of Roman *maniera* after the Sack. The most obvious debt is to Michelangelo but the artist is able to manipulate a

Michelangelesque figure style to suit his own extremely complicated purposes. The general effect is further confused by the constant contrast of facial types, all of which were intended to add interest and excitement.

When first uncovered, the work was only dimly appreciated: the most common reaction seems to have been to ask whether so many naked figures were suitable for the private chapel of the pope. The problem of whether great works of art transcend the demands of prudery has a familiar ring in our own day; and it is interesting that for some years a battle raged between those who excused Michelangelo's figures on account of the grandeur of their conception, and those who merely saw indecency in the writhing naked forms of both sexes. Eventually the censors won, and the offending parts of the fresco were clothed with drapery.

Michelangelo's style of painting is as much susceptible of analysis as, say, the work of Jacopino del Conte. The Sistine chapel *Last Judgment* is an incredible piece of virtuoso painting displaying a limitless technique in the manipulation of the human form and physiognomy. But the technical mastery is put to the service of the subject and the work has profound feeling and religious conviction. It is of course difficult to define or estimate the degree of emotional content in a work of art, since this always involves a subjective judgment on the part of the spectator.

60. **Francesco Salviati**. *The Visitation*. 1538. Fresco. S. Giovanni Decollato, Rome. In contrast to Jacopino (figure 59), the inspiration of Salviati seems to have been the work of Raphael and his immediate followers (especially Parmigianino). Salviati's figures are appreciably more delicate than those of Jacopino and references to Raphael's tapestry designs appear in the setting.

But it is significant of this period that it was increasingly being asked whether religious art should not be more serious and appropriate in feeling than the decorative professionalism of the generation of Jacopino del Conte allowed. These feelings came to a head at the Council of Trent (1545–63) at which time the Church put forward some general recommendations on the subject of propriety and solemnity in ecclesiastical art. Gradually a reaction was setting in, and in Rome particularly some attempt was made *c.* 1580 under the leadership of the Jesuits to eradicate from religious art the almost pagan detachment of the *maniera*. However there can be no doubt that many patrons, particularly in the privacy of their own palaces, preferred the detachment of the *maniera*. This aspect of taste is particularly true of Florence in the middle of the century, where the Medici court artist, Bronzino, specialised in paintings of a frigid and passionless perfection.

The contrasts inherent in painting of the *maniera* are also to be found in sculpture. The decorative aspects of the work of Salviati and Vasari have their sculptural analogies and it is no accident, for instance, that this was an age of complicated sculptural monuments such as fountains. These large decorative ensembles were ideal ways of displaying technical virtuosity in the handling of stone or bronze. But the public monuments of Michelangelo and Raphael and his followers again presented to these sculptors a fundamental contrast between the languid grace and elegance, and the superhuman force and energy of their respective styles. By far the greatest and most significant synthesis of these is to be found in the work of Giovanni Bologna. It is remarkable that he was not even an Italian but a Fleming (his real name was Jean Boulogne) who came south *c.* 1554, and eventually settled in Florence. The manner in which he was able to master all facets of the Italian traditions of sculpture is astonishing. Yet he produced all the traditional types of commission from tiny bronzes to large fountains and funerary monuments; and his work conveys by turns, according to Italianate standards, the ideal, the sensuous, the elegant and the passionate. His sculpture, in effect, provides an essential link between the diverse styles of the earlier 16th century and the baroque period.

57

61. *The Sistine chapel*, Rome. Built by Sixtus IV. *c.* 1475–80. The earliest frescoes (on the side walls) were executed 1481–2 by a group of artists from Florence led by Perugino. The ceiling was decorated by Michelangelo 1508–11 and the painting on the altar-wall was added by him 1536–41. The chapel relies for its effect entirely on the simplicity of its proportions (it is a double cube) and on its painted decoration. Michelangelo's *Last Judgment* immediately draws the spectator into the world of the supernatural (compare figure 57), and it is noteworthy that this association is achieved in part by linking the composition directly to the long horizontal lines of the chapel architecture.

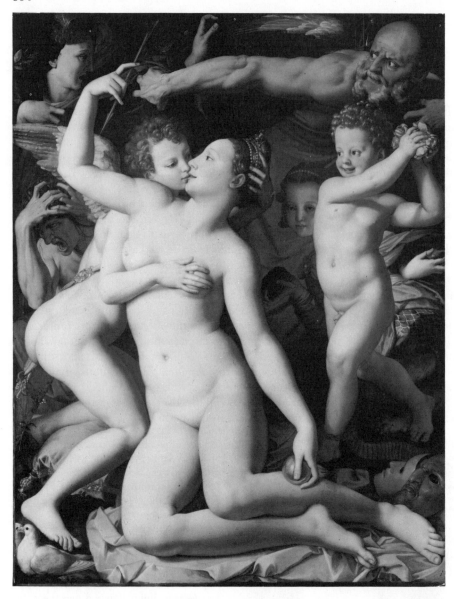

62. **Bronzino**. *Venus, Cupid, Folly and Time. c.* 1545. Paint on panel. 57½ × 45¾ in. (146 × 116 cm.). National Gallery, London. An excellent example of the style of court painting favoured by the Medici. It is brilliant in colouring and detailed technique but otherwise frigid.

Roman architecture after 1530 was again dominated by Michelangelo. Other competent architects existed such as Baldassare Peruzzi, or Antonio da Sangallo the Younger, but the work of neither had the rich plasticity nor such un-conventional classical usage as is found in Michelangelo's work. A comparison of two palace façades will emphasise this point and show how in architecture, too, there was a 60 curious duality of approach. The Palazzo Massimi alle Colonne was built after 1530 to Peruzzi's designs. It is an ingenious piece of architecture adapted to fit the curve of the street, and is given an all-over texture of surface rustication interspersed with decorative motifs in shallow relief. Like the Palazzo dell'Aquila, this work has the 16th-century quality of *maniera* and creates a very different 61 impression from the palaces built by Michelangelo and his followers on the Capitol. Although these were built at a considerably later date (after 1546) Michelangelo's ap-proach here to the use of classical features is similar to that found in the Medici chapel and library of S. Lorenzo which are very close in date to the Palazzo Massimi. Michel-angelo's approach to an exterior wall surface is far more sculptural, while the individual parts of the architecture are made to recede or to project much more emphatically. Michelangelo also showed a considerable freedom in his

use of classical ideas. Architecture for him was not a set of rules; and classical ideas were merely points of departure which the architect might dispose of or order as he thought fit.

Eventually an intermediate architectural style developed in which certain motifs were either taken over from Michelangelo, or twisted in a manner reminiscent of his style, and this development may be seen in the buildings of Vasari and Vignola. Architectural surfaces were given a limited degree of plasticity, but not enough to create the majestic and overawing impression of Michelangelo's uncompromising style. Michelangelo's plans to complete the central part of the basilica of St Peter's, the direction of which was handed over to him in 1547, bear out this opinion; and it is to be suspected that he was the only architect capable of thinking in architectural terms which were emphatic enough to match the scale of the building projected by his old rival Bramante.

MANNERISM

Two particular problems emerge from the study of art in 16th-century Italy. The first concerns the nature of Mannerism. The second concerns the improved status of artists and of the arts in general. The conception of

63. *Palazzo Farnese*, Rome. Begun *c.* 1513 by Antonio da Sangallo the Younger. Basically this façade is Florentine in type and would in normal circumstances have been remarkable chiefly for its size. Its building history was, however, protracted and after Sangallo's death (1540) Pope Paul III commissioned Michelangelo to complete it. His contribution included the design of the cornice and top storey, and also the large window over the main entrance. Here the centre is emphasised in an unusual way by omitting the pediment and recessing the window. Instead of the pediment, Michelangelo installed the large shield bearing the Farnese arms surrounded by a splendid cartouche.

'Mannerism' is almost inseparable from that of 'High Renaissance' art implying, as it does, a kind of Hegelian antithesis to a presupposed thesis of stylistic taste. The illusory nature of the artistic unity of the High Renaissance period has already been mentioned, and this in itself complicates any attempt to define mannerist features. Nevertheless much of the strongly individual art of the decades following *c.* 1520 has been seen as a deliberate reaction against artistic works which preceded it. Analyses of the nature and causes of this reaction vary. Sometimes it is attributed to the 'inner tension' of the artists or to the 'unstable complexion of [their] moral world'. Sometimes Mannerism is shown as a species of 'angry young man' movement, and sometimes as a way of life in which 'it was impossible to retain an everyday commonplace outlook on things and the surrounding world'. Mannerist tendencies are seen equally in the confident boasting of Cellini's autobiography or the morbid introspection of Pontormo's diary. At its widest and least useful Mannerism is equated with anything fanciful, extravagant, unexpected or odd.

The term from which the word derives has already been mentioned—*maniera*—which means 'style' and could imply 'stylishness' with associations of grace, refinement and facility. *Bella maniera* was first applied in this sense to the style of art produced by Raphael and his followers; the concept of *maniera* thus began life in considerably reduced circumstances, although later the concept was extended to include all those artists of the years following *c.* 1520. This means, however, that there was no conscious 'mannerist movement' in the 16th century in the sense of a Salon des Indépendants or a Pre-Raphaelite Brotherhood in the 19th century.

By common consent Mannerism is also used to describe the multiplicity of artistic means by which the extraordinary creations of the period 1500–20 were assimilated and developed during the subsequent years; and provided there is general agreement about the *type* of art covered, then this notion has a certain utility. However, since Mannerism is unfortunately fraught with the neurotic psychological overtones mentioned above, the use of the word can become a positive barrier to understanding works of art produced during the period except in a negative fashion. Mannerism will stand not for a style of art of great inventive richness, but for a contagious psychological condition of protest. This approach is not very stimulating, for continually to isolate 'anti-High Renaissance' tendencies is akin to describing 15th-century Florentine art in terms of 'anti-Gothic' tendencies. Thus earlier in this chapter an attempt was made to describe the work of Pontormo, one of the leading examples of a mannerist painter, in the positive terms of a maturing artist consciously varying his style, not in moments of crisis or instability, but to suit a particular commission.

ART HISTORY AND CRITICISM

Nevertheless, the personal instability of some mannerist artists rests on recorded fact. Some 16th-century artists were strange people with unusual and sometimes morbid interests. Pontormo by the age of 51 did become emotionally unstable and this is revealed in his diary (1555–6). According to the account of Vasari, Parmigianino gave up painting at the end of his short life and, 'bearded, long-haired and neglected', took to alchemy. However, these and other anecdotes, far from indicating a general *malaise* (there were plenty of contemporary artists who appear to have been quite normal) are part of a general change in the attitude to art and artists. The causes of this change go back to the literary humanism of the previous century and the evaluation of such treatises as those of Pliny and Vitruvius. The existence of these works lifted the visual arts into the realm of scholarship and gave them a prestige never enjoyed before. Scholars and other articulate members of society took an interest in them and were willing (in imitation of Pliny) to collect and record stories about the artists. This development reached a 16th-century climax in the *Lives* compiled by Vasari, the first serious essay in the history of Western art. In the 15th century Ghiberti, in imitation of antique precedent, had written three *Commentarii* which included memoirs of his own life;

64. *St Peter's*, Rome. On the death of Antonio da Sangallo, Michelangelo took over the direction of work on St Peter's (1547). At this date the central crossing arches had been erected so that the general scale of the building was determined but neither its final plan nor the shape of the dome. Michelangelo's design for the dome matched Bramante's original scale of building and is notable for the enormous weight of the projecting columns buttressing the drum and the heavy ribs on the dome itself. It was probably designed and partially built *c.* 1561–4 but the completion *c.* 1585–90 came long after Michelangelo's death.

and, since memoir-writing is a form of self-expression, it is not surprising that other artists took up the idea. Of all these, the most famous reminiscences are those of Cellini, vividly revealing, as they do, the character of the writer and the circumstances in which he lived.

Yet the existence of these literary effusions, while they shed light on the character of specific artists, does not provide grounds for supposing that the 16th-century artist as a creature was noticeably different from his 15th-century counterpart; and there is still room to doubt whether professional life for the majority of artists changed particularly in the 16th century. But one aspect of professional existence had materially altered, for new possibilities existed for advancement, and also a new type of recognition. The immense prestige enjoyed by Michelangelo opened up unprecedented possibilities for the aspiring artist. This prestige did not prevent Michelangelo being ordered by successive popes from project to project like a superior servant; but it did mean that his greatness was acknowledged as greatness during his lifetime by an increasing band of *litterati* and *cognoscenti* who were prepared to publicise their opinions. For considered art criticism was one of the most important developments of the 16th century; and, while this might be a questionable asset for the artist, it did open up the possibility of a new sort of fame. Moreover, if artists were willing to don the aspect of a courtier, then the example of Raphael was before them, who rose so high in the esteem of Leo X that it was rumoured (quite wrongly) that the pope had offered to make him a cardinal. Thus in these respects the 16th century was perhaps a century not so much of absolute change as of new horizons.

The Italian Renaissance and Art beyond the Alps

65. **Jean Goujon**. *Gallery supported by caryatids*. 1550–1. In the ground floor *Salle* of Lescot's wing in the Louvre, Paris. In the spread of classicising standards and taste outside Italy, the court of France played an especially important part. These figures form part of the interior decoration of the new wing of the Louvre, built after 1546.

The political history of the northern European states during this period is too complicated to be easily summarised, but it is necessary to notice the recovery of France under Louis XI (1461–83), the unexpected rise to power of the Habsburgs through a series of fortunate marriages, and finally the European struggle between the same Habsburgs and the French kings, a struggle which was fought out partly in Italy and partly in the North where it was brought to an end in 1558. At the same time the political situation was greatly complicated in the early 16th century by religious disorders in Germany and Switzerland; by serious revolts (on both the intellectual and political planes) against the ecclesiastical hierarchy, the authority of the pope and the temporal régimes which supported the papacy; and after 1517 by the swift spread of the 'protestant' doctrines of Luther and Calvin.

The interrelation between political events and the spread of classical learning and ideas is obscure. In 1500 Germany already possessed great scholars such as Reuchlin (1455–1522), who had studied in Italy; but the greatest figure in the 'rebirth' of classical thought and literature in northern Europe was undoubtedly the Dutch scholar Erasmus of Rotterdam (*c.* 1469–1536) whose printed editions of classical texts seeem to have made the writings of antique authors available to northerners. As in Italy the prestige attached to classical scholarship was gradually accompanied by a new reverence for classical works of art, and then for the 'classicising' art of contemporary Italy, but this was more halting, and less consistent, than in Italy.

Italian standards and Italian taste gradually came to be accepted as the dominating influence in European art. The crucial word here is 'dominating' for northerners had at no point in medieval history been insensitive to Italian artistic ideas. Indeed, the adaptation by northern artists of Italian ideas to local needs is a constant feature of medieval art. Yet, however important Italy may have been as a source of inspiration, the ideas were almost always converted into the local idiom and to any Italian might well have been unrecognisable as of Italian origin. The development now to be examined has its logical sequel in the 17th century and cannot be pursued here to its conclusion. Yet it requires only a short study of the early 17th century to see that by this date Italian influence in the arts at least superficially, had a destructive effect on local traditions, to an extent previously unknown. By contrasting the painting of Rubens with that of Gerard David, or the Whitehall Banqueting House of Charles I with the Hampton Court Banqueting Hall of Henry VIII, or late 16th-century German sculpture with the tradition of Stoss and Riemenschneider, it can be seen that northern art had been altered almost out of recognition. Italy, from being merely a fruitful but occasional hunting-ground for ideas, had come to have on artists and patrons alike an hypnotic effect of unprecedented strength.

Armed with this foreknowledge, it is perhaps tempting to approach art beyond the Alps with a sense of expectancy, waiting for these changes to take place. Yet such an attitude entails missing much that is rewarding in a century that

66. **Dirck Bouts**. *The Justice of the Emperor Otto: Ordeal by Fire.*
c. 1475. Paint on panel. 127½ × 71½ in. (324 × 182 cm.).
Musées Royaux des Beaux-Arts, Brussels. Bouts' grasp of spatial
effects in painting was remarkable, but his scenes tend to be
impassive and the action congealed. In this feature, he forms an
obvious contrast to his great predecessor Roger van der Weyden.

produced painters such as Hugo van der Goes, sculptors
like Gerhaert and Stoss, or such remarkable buildings as
the chapel of King's College at Cambridge. And while it is
impossible in a short space to do justice to these artists and
their works, an appreciation of *Italian* art is greatly en-
hanced by some knowledge of, the traditions which it
ultimately vanquished.

FLEMISH PAINTING IN THE LATER 15TH CENTURY

The achievements of Jan van Eyck and Roger van der
Weyden (see pp. 470–1) placed a considerable burden on
their successors. The full exploitation of the achievements
was beyond the scope of any single master, although a
number of lesser painters developed different aspects. Of
the immediate successors, Petrus Christus of Bruges, an
associate of Jan van Eyck, was the only painter to con-
centrate wholly and with some degree of success on con-
tinuing the tradition of minute observation and brilliant
detail established by the master. Dirck Bouts, a painter of
Louvain, made a positive contribution to Flemish art in his
carefully organised backgrounds and landscapes. He seems
purposely to have avoided the expressive emotion of
Roger's work, and the action of his paintings tends to
appear frozen and congealed into immobility. A remark-
able synthesis of all these painters is to be seen in the work
of Hans Memlinc who worked at Bruges and seems to have
drawn on the impassive style of Bouts, the compositional
harmony of Roger and also, in his brilliant flashes of
detailed observation, on the style of van Eyck.

But of all these Flemish painters in the second half of the
century only one master emerged who appears truly to
have stood out from this general development. This painter,
Hugo van der Goes, lived much of his life at Ghent although
some time before his death he entered a religious house
near Brussels. Since he was alleged, according to a con-
temporary account, to have become mentally unstable at
the end of his life (1481–2) there is strong inducement (as
with Pontormo, already mentioned) to romanticise his life
on this basis. But he appears to have been a successful
professional painter who, without holding court office,
nevertheless executed work for the ducal court of Burgundy.
The peculiar forcefulness of his paintings is easily ap-
preciated when they are set alongside those of his contem-
poraries. He was one of the very few Flemish 15th-century
artists whose paintings do not have a uniformly high view-
point. The heads of the main figures are, as a rule, painted
as if slightly above the head of the spectator who is there-
fore, subjectively, dominated by them. Apart from this
there are also changes of viewpoint, and juxtapositions of
figures and objects contrasted in scale, which give Hugo's
large work an uneasy and unsettled appearance. His
painting is generally intensely serious in expression.

There were two other painters of exceptional individu-
ality—and both from the northern counties; one was
Geertgen tot Sint Jans, of Haarlem in the county of
Holland, the other Hieronymus Bosch, of 's Hertogenbosch

67. **Hieronymus Bosch**. *The Temptation of St Anthony.*
c. 1500–10. Paint on panel. 51¾ × 46¾ in. (132 × 119 cm.).
Museu Nacional de Arte Antiga, Lisbon. The meaning of
Bosch's paintings is now obscure; perhaps it was forgotten
almost as soon as the painter had died. What can now be
admired are the great breadth of vision and technical skill.

68. *A Miracle of the Virgin. c.* 1480. Detail from the wall paintings
in the chapel of Eton College. The interest of these works lies
partly in the way they illustrate the spread of a Flemish style
outside Flanders. The painter's name is unknown but he seems
to have been acquainted with the art of Bruges and Louvain.

in the county of Brabant. By the standards of Bruges and
Brussels both would have been judged provincial. But the
paintings of each are very unusual and unexpected, and
any mention of their work here significantly enlarges an
appreciation of the range of northern painting.

About Geertgen very little is known, although a later
writer recorded that he died at the age of 28 in about 1490.
In this short life he displayed a remarkable feeling for land-
scape painting and produced one study in tonal effects
which seems to be entirely revolutionary. This is the
Nativity painting now in London in which the lighting is **71**
derived exclusively from sources within the picture, so that
the whole painting is worked out not in terms of colour but
of light and shadow.

The career of Hieronymus Bosch, like that of Geertgen, **67**
is obscure, and in spite of the fame of his paintings their
precise meaning is still elusive. It is not entirely certain for
whom these works were originally intended, although
later, in the 16th century, Bosch's work was much admired
by King Philip II of Spain. For this reason it seems un-
likely that the fantasies which flowed from his brush were
subversive or heretical (as is sometimes suggested), and
more likely that his paintings embroider, with a wealth of
detail drawn from obscure local lore, general 15th-century
moral themes such as the mortality of man. Certainly he
put the achievements of previous Flemish painters to a very
personal use but there is no doubt about the quality of his
painting. If the strange iconography of his work can tem-
porarily be disregarded, the extreme beauty and limitless
scale of his landscape painting is apparent.

THE SPREADING INFLUENCE OF
NETHERLANDISH PAINTING

Gradually, the general style of Flemish painting spread to
most areas in Europe north of the Alps. By 1475 it had a
transforming influence comparable to that of Italian art at
a later date, becoming a new species of 'international court
style' in the sense that few northern courts escaped its
influence. In England the most impressive surviving monu-
ment to the ubiquity of this style is the wall decorations **68**
devised in 1480 for the chapel of the royal foundation of
Eton College, which were probably painted by a Fleming.
The popularity of this type of painting is also clear in Spain
and Portugal, where a 'Flemish' style succeeded a pre-
dominantly 'Italianate' style of the 14th century.

The spread of this style in the area now covered by
modern Germany is more complicated, and in many ways
more interesting. One of the more problematical masters
was Lukas Moser. He may have worked in and around Ulm
and been a contemporary of Robert Campin, but his only
certain work is an altarpiece painted for Tiefenbronn **69**
(Württemberg). This altarpiece is dated 1431 and thus
antedates even the completion of the Ghent altarpiece by
Jan van Eyck. Moser approached his subject on a scale as
large as that of van Eyck. When the two wings of the altar-
piece are closed, so that Moser's painting is visible, it will

be seen that the whole exposed area is treated as a unity with landscape and architecture extending across from one panel to the next. Moser's painting includes a brilliant description of a stretch of water with light reflecting off it. But, although this use of light is reminiscent of the style of Jan van Eyck, it is not certain whether there were any links between the two painters. No German painter ever acquired the complete assurance and clarity of Jan van Eyck, but several artists attempted to imitate his use of light, so that during the 1430s and 1440s a series of painters appeared whose work has a hard, brittle appearance. Such a painter was Konrad Witz of Basle, almost exactly contemporary with Jan van Eyck. Another similar artist was Hans Multscher who worked both as a sculptor and a painter in and around Ulm. Further afield should be included the Master of the Aix *Annunciation*, a work datable 1442.

A more balanced assimilation of the Flemish style took place in the second half of the century based on a general synthesis of Roger van der Weyden and Dirck Bouts. This may be followed in the work of such artists as Schongauer at Colmar, Pleydenwurff at Nürnberg and a variety of anonymous artists in Cologne. Since artists such as Pleydenwurff often travelled (Pleydenwurff visited Prague and Breslau) this generation of artists both assimilated and spread this style.

MICHAEL PACHER

These painters appear to have derived their style in general from Flanders. Michael Pacher, a contemporary of Schongauer, was very different. Born *c.* 1435 in the Tyrol at Brunico, he was within a comparatively short distance of northern Italy and the Veneto. From Pacher's paintings it is generally inferred that he visited Padua at some date *c.* 1470. For, in his great altarpiece at St Wolfgang the definition of space became an overriding consideration for the artist; and his figure style acquired something of Mantegna's dry linear appearance. Whether Pacher also saw the work of Antonello da Messina at Venice (1475–6; see p. 572) is less certain, but his paintings certainly contain areas of brilliantly illuminated detail reminiscent of the Eyckian tradition to which Antonello belonged. Since Pacher was also a skilled sculptor, and would have habitually thought out his works in three-dimensional terms, his enthusiasm for Italianate perspective can be understood. It is true that his painting is un-Italianate in many other details. Buildings continue to be Gothic in style, and the drapery of his figures still has the crumpled folds of the Campin tradition.

In other respects, however, it is profoundly Italianate in intention with its crude foreshortening and harsh definition; and it begins to be doubtful whether Pacher was accomplishing yet another transformation of the Gothic style by means of elements drawn from Italian art or whether this was at last the beginning of the downward slope for the whole northern tradition.

69. **Lukas Moser**. *The Tiefenbronn altarpiece*. 1431. 118 × 78¾ in. (300 × 200 cm.). Parish church, Tiefenbronn. The outside of the wings of this altar, when closed, show scenes from the life of St Mary Magdalen. The way in which the panorama spreads across the wings is reminiscent of the contemporary Ghent altarpiece by the van Eyck brothers. Note the skill with which the surface of the water is painted.

GERMAN 15TH-CENTURY SCULPTURE

Both Hans Multscher and Michael Pacher were sculptors as well as painters. This serves as a reminder that any account of German 15th-century art must extend far beyond the art of painting, and indeed it must embrace masterpieces from every branch of the arts. Much of the most striking work was executed in the area of the Rhine and in the southern duchies, especially Swabia, Franconia and Bavaria—areas studded with rich and flourishing towns. None of these provincial centres, it is true, could rival the sheer concentration of the art of Florence. But in the same way that Borgo S. Sepolcro produced Piero della Francesca or Urbino Raphael and Bramante, so the German cities spasmodically produced a succession of gifted masters. Indeed, a town such as Ulm might easily have rivalled many Italian towns in the quality and diversity of the work produced within its walls.

The history of northern sculpture during the first half of the 15th century is very fragmentary. Although it might be expected to describe a course similar to painting, the subsequent destruction in the Netherlands has been so great that any thesis concerning the development and spread of a French or Burgundian court style cannot be proved because hardly any sculpture survives in the three former centres of Brussels, Bruges or Antwerp. The little that can be deduced of the contemporary taste at Prague

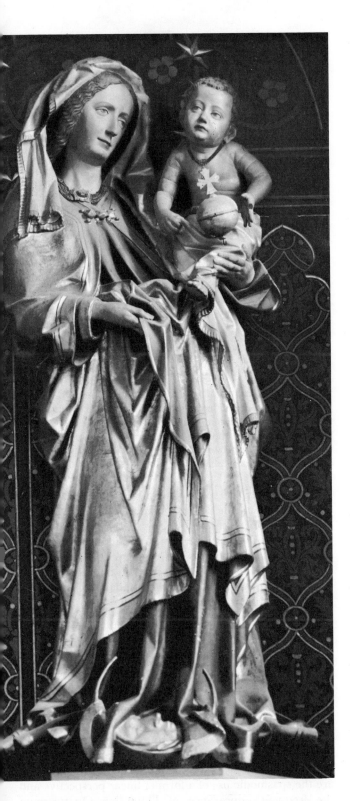

70. **Hans Multscher**. *Madonna and Child*. 1456–8. Frauenkirche, Vipiteno (Sterzing). The central figure from a large altarpiece. The soft flowing drapery patterns of the earlier part of the century have given way to something more angular, the so-called 'crumpled' style. This reached its most fantastic in the work of a man like Veit Stoss (see figure 73).

and Dijon *c.* 1400 shows that at about this time drapery was made both heavier and more exuberant in its patterns. Works in this style can be traced in Germany during the first half of the century at a town such as Nürnberg, although often it lacks the realistic detail and strong emotional expression of Sluter's sculpture. Exceptions existed like Hans Multscher, who has already been mentioned as a painter. His main activity took place in Swabia at Ulm; but in the Tyrol at Vipiteno (formerly Sterzing) there exist the pieces of a large carved altar executed by him in 1456–8. The central figure of the Madonna has an elongated face and serious expression which, though reminiscent of Sluter, may be derived from Flemish painting. Another important point to be noticed is the suggestion of a new drapery convention in the folds around the Virgin's hands and feet. There the decorative pattern becomes more angular and the appearance more crumpled. It is the 'crumpled style' of drapery, again already seen fully developed in Flemish painting, which gives German late medieval sculpture much of its individual character, and this leads directly on to the work of Nikolaus Gerhaert.

Gerhaert worked in Alsace for much of the period between 1463 and 1467 when, at the command of the Emperor Frederick III he moved to Vienna, dying at Wiener Neustadt in 1473. He is thought to have come from Leyden in Holland and, although nothing is known about his training, it is possible that he had travelled in both France and the Netherlands. His range covered sculpture of almost every type; and he had a command of naturalistic detail worthy of Jan van Eyck. Although much of his work is now in a fragmentary state, one feature emerges clearly; his style heralds the appearance in sculpture of a fully developed 'crumpled style' of drapery.

It was probably Gerhaert's work that fixed many of the characteristics of late 15th-century German sculpture. Already before Gerhaert's death, Michael Pacher had begun his masterpiece, the altarpiece at St Wolfgang (1471–81), an ensemble of overwhelming richness. It is worth observing, however, that the central carving of the *Coronation of the Virgin*, in spite of this richness of detail, is not confused. The strong decorative tendencies of the style are set off against an effective use of depth which breaks up the surface into a series of visually comprehensible units. Depth is also employed to give dramatic effects of light and shade; for instance, the two saints flanking the altarpiece emerge from the depths of the recesses in which they stand.

Three men may be mentioned to give an idea of the range and quality of the work produced by the generation of German sculptors succeeding Gerhaert and Pacher. Erasmus Grasser, who worked mainly in and around Munich (Bavaria), in 1480 produced a set of small figures for the decoration of the Rathaus there. Known as 'morris dancers', these figures are all set in elaborate and contrasted poses, and each has an individual physiognomy and expression. Veit Stoss, a contemporary Nürnberg sculptor, was probably a more impressive artist. His figures are

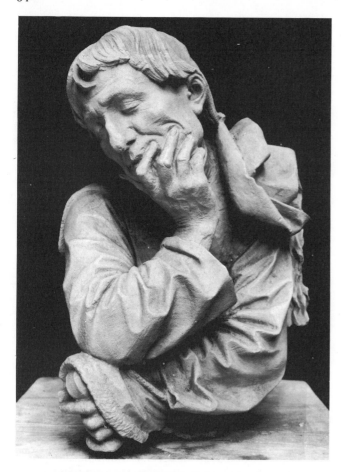

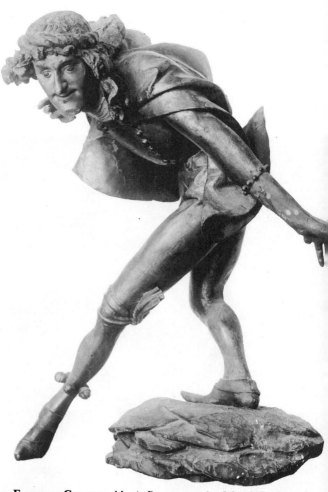

71. **Nikolaus Gerhaert**. *Portrait figure. c.* 1465. Sandstone. h. 28 in. (41 cm.). Private collection. Very little is known about Gerhaert although he seems to have been a brilliant sculptor. This half-length portrait of a man who is either blind or asleep is an example of the vivid realism of his style.

72. **Erasmus Grasser**. *Morris Dancer. c.* 1480. Wood. Rathaus, Munich. This sculpted figure is one of a set which forms part of the lateral decoration of the main council chamber. Each figure presents a contrasted pose and the set represents an interesting continuation of the sort of strong characterisation found in the earlier sculpture of Gerhaert.

remarkable for their vivid expressive faces and the extreme convolutions of the drapery, which appears at times to be taking on a life of its own. Of all late Gothic manifestations *73* of the 'crumpled style', the drapery of Veit Stoss is perhaps the most extreme and individual. The only contemporary of Stoss to appear now as a serious rival was a sculptor of Würzburg, Tilmann Riemenschneider. By comparison his sculpture is restrained in its emotive expression, and his drapery, while being elaborate, is not violently exaggerated. His faces, although expressive, are not violently over-emphasised. In any sculpted group restraint makes it easier for the spectator to understand what is going on. A Riemenschneider altarpiece, indeed, often has the appearance of a well managed stage set and a considerable amount of attention was devoted to the problem of making the drama comprehensible. As a piquant dramatic device, his surviving altarpieces are pierced in the rear wall with tiny windows to admit light from behind as well as from the front.

The strength and excellence of northern artistic traditions can now be grasped. Architecture in the late Gothic tradition of the North was at least as inventive and exciting as anything found in Italy, whether its culmination is taken to be the English Perpendicular style or the achievement of the masons in Germany. The architecture of Brunelleschi might well have seemed pedestrian to a traveller from

Nürnberg, and the spire of Strasbourg cathedral more spectacular than the dome of Florence cathedral. Would the interior of the chapel of King's College, Cambridge, have seemed less splendid than the interior of the papal chapel of Sixtus IV, the Sistine chapel? Differences of approach and taste were, indeed, as fundamental as the visual differences between Veit Stoss and the contemporary work of Andrea Sansovino.

SOME EARLY APPROACHES TO ITALIAN
RENAISSANCE ART

The assimilation of Italian Renaissance ideas in the North did not automatically mean complete submission to an alien style. At the French court the painter Jean Fouquet produced work which bears numerous traces of Italian influence. During a working life which extended from *c.* 1440 to 1481 he visited Rome and probably saw the work of Piero della Francesca and Fra Angelico. However, the two most obvious general Italianate features of his paintings are the spasmodic use of a form of linear perspective and the frequent appearance of Florentine Quattrocento architectural features. The striking volume and simplifications of his painting of heads and limbs is also reminiscent of Italy. A similar approach is to be found in work attached to the anonymous master of the altarpiece in the cathedral of Moulins (the Maître de Moulins); and indeed, in view of

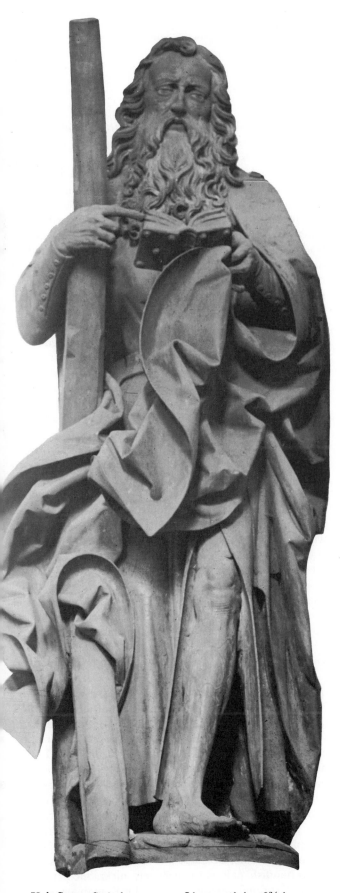

73. **Veit Stoss**. *St Andrew. c.* 1505. Limewood. h. 78¾ in. (200 cm.). St Sebaldus, Nürnberg. The work of Stoss stands out, in a period already full of brilliant and exciting sculpture. The drapery of his figures is perhaps excessively complicated, their faces excessively troubled, but they represent the ultimate development of many features inherent in Gerhaert's work.

the whole course of Italian influence in the North during the previous century, this development might be expected. Northern artists had frequently shown interest in the structure and compositional ideas of Italian painting, while the incorporation of Italian decorative details is also found before this date.

A sculptural work which shows a similar type of influence is the shrine of St Sebaldus at Nürnberg, executed by the Vischer family, mainly between 1508 and 1519. This contains a large amount of small decorative sculpture, some of it clearly deriving from Italian models. Considering the presence of Veit Stoss in Nürnberg at this time, the figure style of the Vischer family is surprising in its simplicity, for in its general appearance it is closer to the decorative sculpture of the earlier 15th century before the 'crumpled style' became pre-eminent. Whether the evident clarification of structure owes anything to Italy is not clear (Hermann Vischer visited Italy in 1515); but the total effect of the shrine is still recognisably northern.

Even the most blatantly characteristic subjects of Italian Renaissance painting could be translated into a northern idiom. The court painter Lukas Cranach who, apart from a brief stay at Vienna, worked most of his life at the Saxon court at Wittenberg, derived a number of ideas from Italian paintings which he must have seen. One of these was a subject familiar from Venetian art, the reclining naked female—a subject apparently popular with the Elector of Saxony. Few people, however, would dismiss Cranach as a feeble plagiarist. The basic idea was translated into his own terms and, in a very personal way, these recumbent nudes have a charm and appeal of their own although entirely unclassical in proportions and recognisably Germanic in their facial types.

THE APPEAL OF THE NEW STYLE FROM ITALY

Towards the end of the 15th century a crucial change gradually took place in the attitude of northerners to Italian art. Assimilation was no longer enough; exact mimesis and reproduction came increasingly to be expected. Italian art became the only fashionable art and compromise with the local tradition was no longer acceptable. The turning point seems to have been reached when it was considered necessary to import Italian artists into the North—a process which was already beginning during the 1490s, when the Florentine Andrea Sansovino visited Portugal at the request of its king. Early in the next century the royal tomb of Henry VII of England was executed by an Italian (Pietro Torrigiano), an event without parallel since the time of Henry III in the 13th century. But of all European courts, the French royal family were probably the most closely acquainted with Italian art since, in the course of the political upheavals of the late 15th and early 16th century, both Charles VIII and Louis XII invaded Italy. It is surely significant to find the funeral monument of Louis XII executed by two Italian brothers, Antonio and Giovanni Giusti (1515–31); whereas at about

74. **The Vischer Family**. *Shrine of St Sebaldus*. 1508–19.
Bronze. St Sebaldus, Nürnberg. This work, an interesting
contrast to the contemporary work of Stoss (also in Nürnberg),
was executed by Peter Vischer the Elder and his two sons Peter
and Hermann. In general outlines the monument is traditional
but the figures are remarkable for their simplicity (contrast Stoss)
and many of the ideas for detail were imported from Italy.

the same date, the Emperor Maximilian was still happy to
entrust the family mausoleum at Innsbruck to various
German artists (1508–33).

The growth of an Italian Renaissance style in the North
must naturally have been assisted by the fact that princely
patrons were impressed by it. But Italian art also had what
may be crudely called a 'selling-point' possessed by no
other European art—it was associated with a literary
tradition which provided not only rules enabling the lay-
man to judge beauty, but also a nascent vocabulary of art
criticism. Italy was already a land of art treatises and a
land in which educated people were prepared to take an
informed interest in the arts. The means existed towards the
end of distinguishing 'right' from 'wrong' in art, as if the
Italians had eaten fruit from a new Tree of Knowledge. As
the 16th century progressed this came increasingly to mean
that any form or work of art based on antique models was
'right', while the rest (which included most northern art
in any form of Gothic idiom) was wrong, although it must
be admitted that a judicious writer such as Vasari admired
the detailed technique of many northern artists.

An interesting story emphasising the apparent 'rightness'
of art derived from the antique was related by Benvenuto
Cellini in his autobiography. While he was serving the
French king the artist Primaticcio persuaded Francis I
to send him to Rome to obtain plaster casts of certain
major pieces of antique sculpture. 'He told the king that,
when his Majesty had once set eyes upon those marvellous
works, he would then, and not till then, be able to criticise
the arts of design, since everything which he had seen by us
moderns was far removed from the perfection of the
ancients.' This approach must have had a very marked
effect on patrons, collectors and connoisseurs. Persistent
propaganda of this nature would ultimately make those
who patronised art in the style of Veit Stoss feel decidedly
uncultivated. The seeds of the Grand Tour had been sown.

The will to imitate the Italian High Renaissance styles
quickly spread to artists themselves, particularly in the
Netherlands—with results which were far from happy. Jan
Gossaert, called Mabuse, a painter who was a little
younger than Cranach, nevertheless provides an interesting
case for comparison. He too was influenced by Italian
models, but having visited Italy in 1508 he experienced his
models at first hand. He certainly possessed the desire to
emulate the classical ideal; but the almost painful Flemish
realism, the painstaking technique and uncertain articula-
tion deprive his figures of charm (unlike the Cranach
nymph). The spectator is left with the impression of heavy
graceless ridicule. Gossaert was the first of a succession of
Netherlandish painters collectively nicknamed 'the Ro-
manists' through their enthusiasm for Roman art, ancient
and modern. This enthusiasm was certainly fostered by the
presence of Raphael's cartoons in Brussels *c.* 1516–19
where the Sistine chapel tapestries were being woven; it

(Continued on page 561)

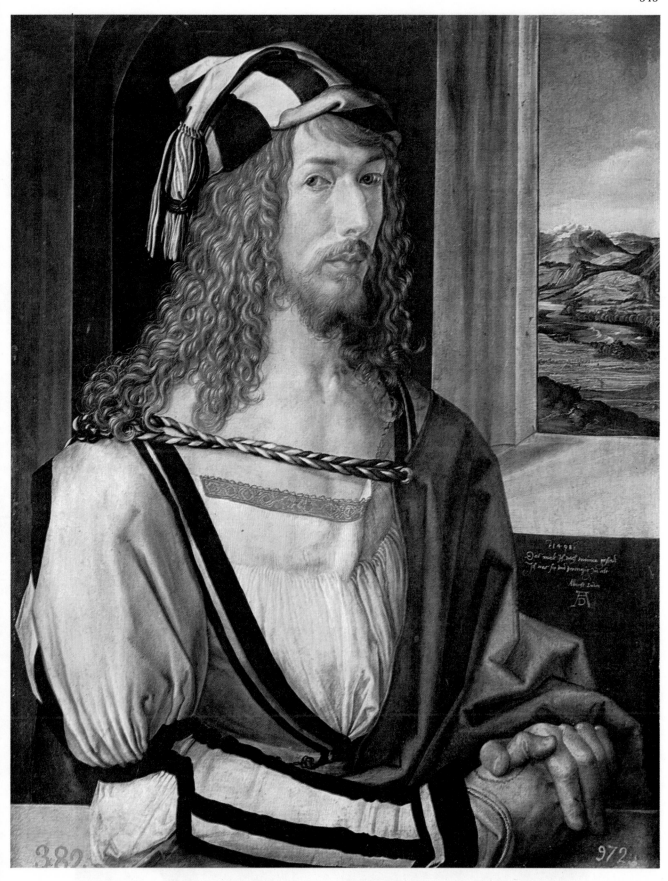

62. **Albrecht Dürer**. *Self-portrait*. 1498.
Painting on panel. 20½ × 16 in.
(52 × 41 cm.). Prado, Madrid. From

c. 1490 enthusiasm for the learning and
culture of Italy gathered momentum
north of the Alps. One of the earliest
northern artists to devote intense study to
Italian art was Albrecht Dürer. This
self-portrait, painted shortly after his first

visit to Venice, may therefore be regarded
as symbolising the beginning of the
process by which northern art came to be
completely penetrated by ideas and
standards from the south.

FLEMISH ART—BEFORE AND AFTER

63. **Hugo van der Goes**. *The Portinari altarpiece*(right wing). *c.* 1475. 99½ × 119½ in. (253 × 141 cm.). Uffizi, Florence. It is interesting that, in spite of all differences of taste and style, Flemish painting was prized by Italian business-men and collectors such as the Portinari family. Hugo van der Goes was one of the greatest late 15th-century Flemish artists still recognisably painting in the tradition of van Eyck and Roger van der Weyden.

64. **Bartholomäus Spranger**. *Hercules and Omphale*. 1575–80. Painting on panel. 9½ × 7½ in. (24 × 19 cm.). Kunsthisto-risches Museum, Vienna. Schooled in Antwerp among the Romanists, Spranger moved to Rome and thence to Vienna and Prague. In the course of his life he developed his own personal brand of Italianate painting which, whatever its merits, is far removed from the world of Hugo van der Goes. Such was the magnitude of the influence of Italian art on the North.

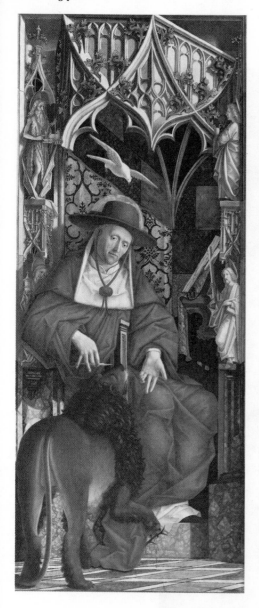

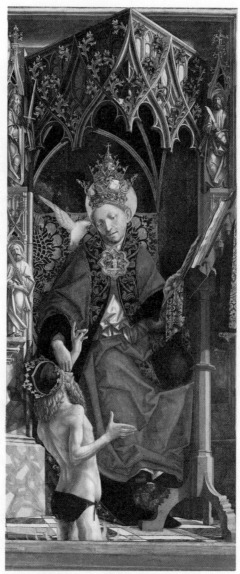

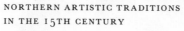

NORTHERN ARTISTIC TRADITIONS
IN THE 15TH CENTURY

65. **Michael Pacher**. *The Fathers of the
Church*. Part of an alterpiece from
Neustift (Tyrol). 1482–3. Paint on panel.
Each part *c*. 81 × 36 in. (206 × 91 cm.).
Alte Pinakothek, Munich. At some stage
in his career Michael Pacher experienced
the work of Mantegna and his followers.
Only this explains the emphasis on spatial
definition and the wiry clarity of his style.
In spite of this there is as yet no sign of any
wish to introduce antique motifs.

66. **Michael Pacher**. *The Coronation of
the Virgin*. 1471–81. Centre panel of the
altarpiece of St Wolfgang. Painting on
wood. 153½ × 124½ in. (390 × 316 cm.).
A superb example of a common type of
German altarpiece. Pacher was both
sculptor and painter which may explain
the three-dimensional emphasis of his
painted work. Notable here is the elabora-
tion of the tracery in the canopy, a typical
feature of late 15th-century sculpture and
architecture.

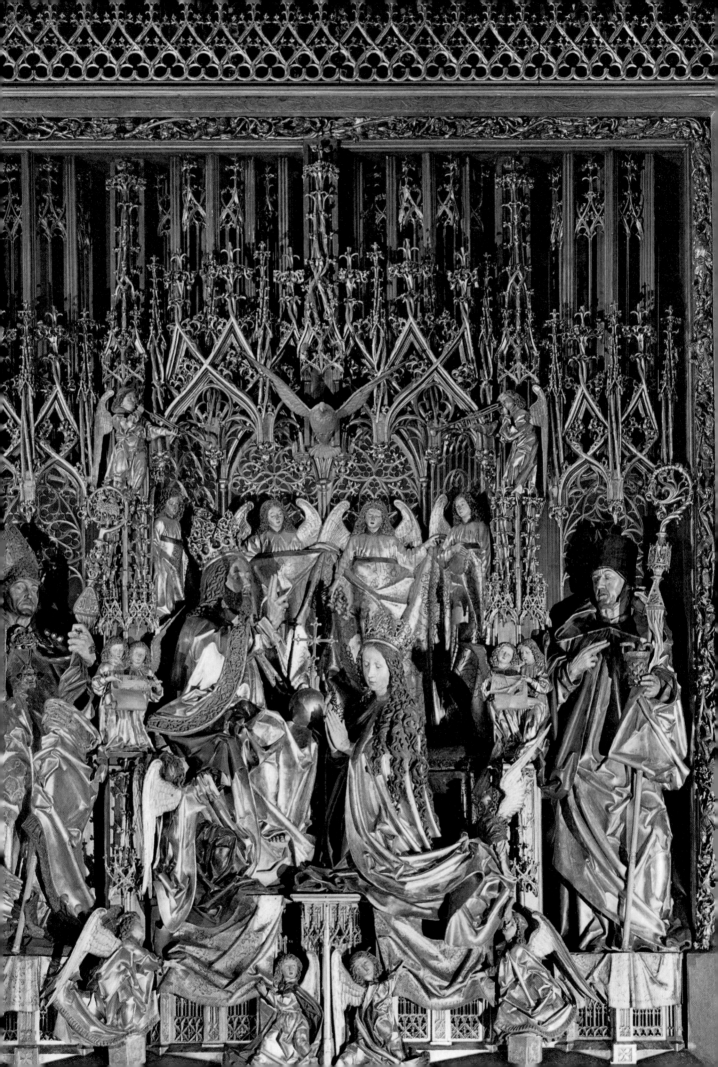

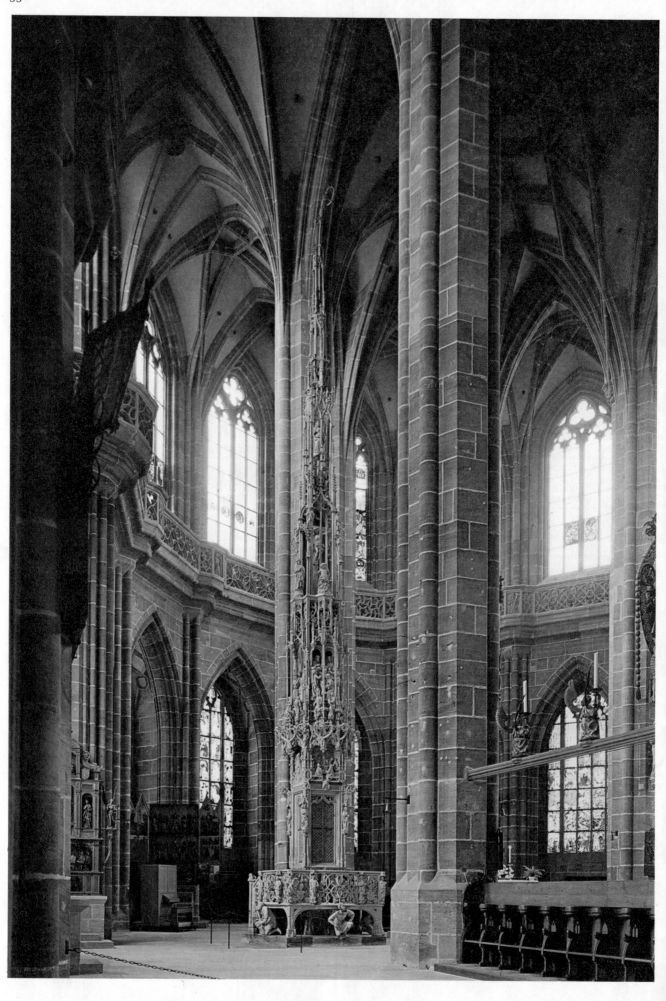

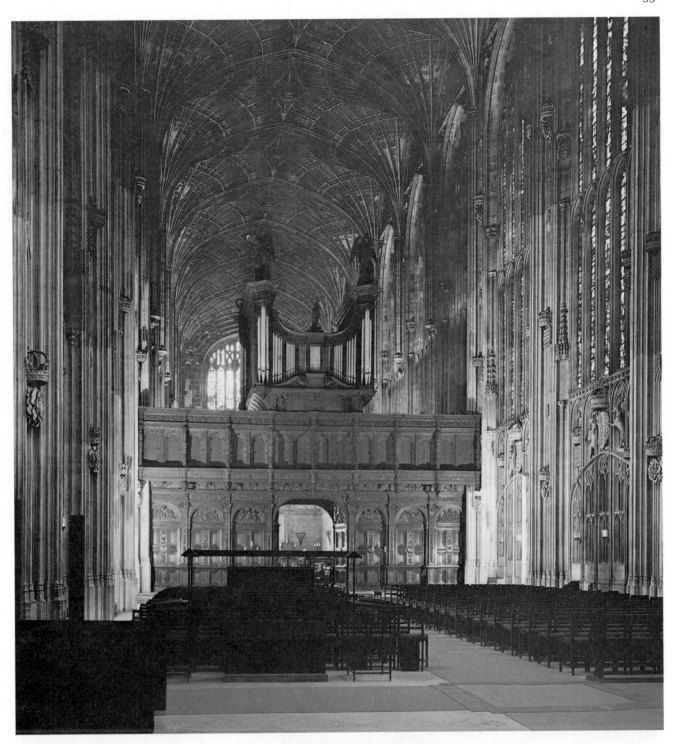

67. *St Lorenz*, Nürnberg. This church, designed and built *c.* 1493, is a 'Hall-church'—a common late Gothic type in which the aisles rise to the same height as the nave. Nürnberg possesses two great churches of this type. St Lorenz is furnished inside with an elaborate Sacrament Tabernacle (1493–6) by Adam Krafft, visible here. Its canopy work may be compared to that of the St Wolfgang altarpiece (plate 66). St Lorenz also possesses various works of Veit Stoss.

68. *The Chapel of King's College*, Cambridge. Planned in the 15th century, this chapel was built mainly between 1508 and 1515. Its construction therefore ran parallel to the earliest phase of the rebuilding of St Peter's, Rome. It is one of the most imposing monuments of English Perpendicular architecture and the sumptuous character of the interior underlines the fact that, although built for a collegiate community, it is in fact a royal foundation. The choir screen, added 1533–5, is one of the earliest studies in Italianate detail to survive in England.

69. **Jean Fouquet**. *The Visitation*. A page
from the *Hours of Etienne Chevalier*.
c. 1452–60. Painting on vellum. 6½ × 4¾
in. (16.5 × 12 cm.). Musée Condé,
Chantilly. The figure and drapery style
belong to the northern tradition but the
scenery is Italian—probably Florentine.
Notable is the light classical architecture
and the wall with cypress trees
beyond—both of which find many parallels
in Florentine work of the time. Fouquet has
also taken the trouble to imitate, accurately,
Albertian perspective.

70. **Lukas Cranach**. *Nymph. c.* 1530.
Painting on panel. 28¾ × 43 in. (73 × 109
cm.). Thyssen-Bornemisza Collection,
Switzerland. Cranach is famed as a
portraitist but he also produced for the
court of Saxony a numer of erotic
pictures based on Venetian prototypes of
Giorgione, Titian and Palma Vecchio.
The extent to which the painter depended
on his Italian examples is debatable. A
comparison with Titian (plate 92) would
suggest that the idea from the south has
been translated into triumphantly
German terms.

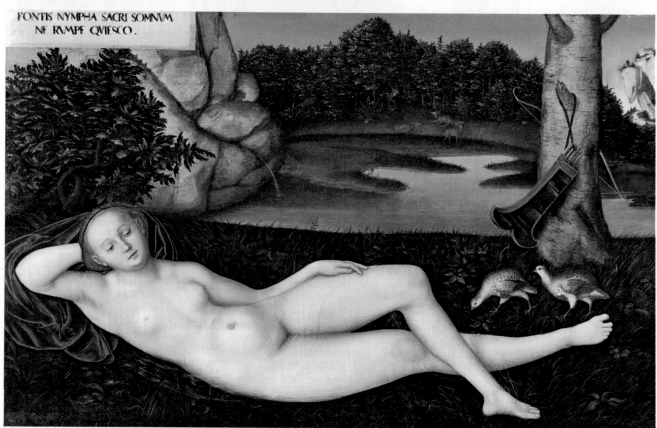

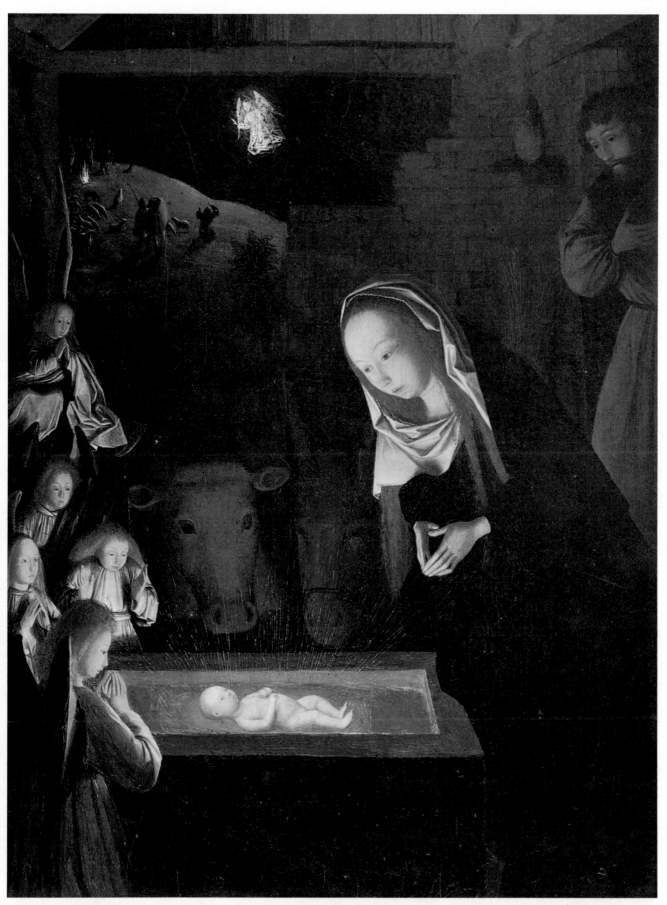

71. Attributed to **Geertgen tot Sint Jans**. *The Nativity*. c. 1490. Painting on panel. 13½ × 9¾ in. (34 × 25 cm.). National Gallery, London. The origins of this remarkable study in the use of light and shade are obscure. It remains unique in northern Europe during the 15th century and the nearest parallel is Piero della Francesca's *Dream of Constantine* at Arezzo (c. 1450s). Whatever the nature of the links between these two works, Geertgen's minute masterpiece must occupy a significant place in the history of painting.

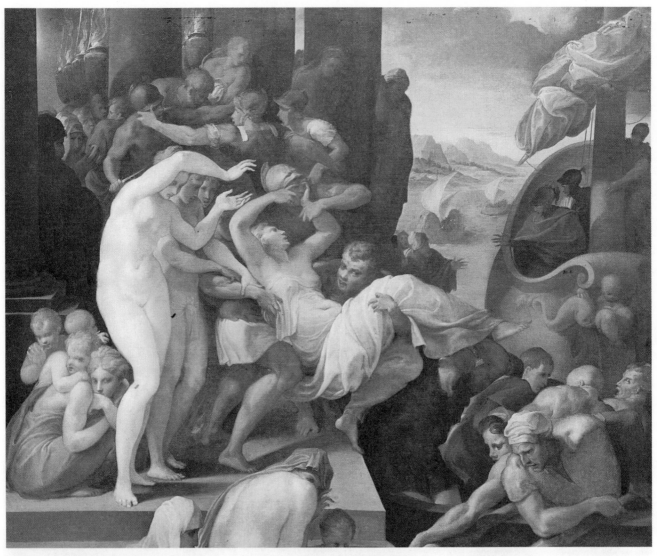

ITALIAN ARTISTS IN FRANCE

72. **Francesco Primaticcio**. *The Rape of Helen*. Probably 1540s. Painting on canvas. 61¼ × 74¼ in. (155.5 × 188.5 cm.). Bowes Museum, Barnard Castle. A good example of the type of painting practised by artists imported into France by Francis I. The style is ultimately Roman (it makes an interesting comparison with Salviati and Jacopino del Conte—see figures 60, 59) but learnt at second-hand through Giulio Romano and especially Parmigianino (see plate 56). It had great influence on local sculptors.

73. **Benvenuto Cellini**. *The Royal Salt*. Gold, enamel and precious stones. h. 10¼ in. (26 cm.). Kunsthistorisches Museum, Vienna. This famous saltcellar, completed in 1543 and destined for Francis I of France, was based on a model prepared in 1539 for Cardinal d'Este of Ferrara. Like the great fountains of the age, it is elaborate in form and iconography and represents the ocean (Neptune) and earth. The great elegance of the figures compares well with the style of Primaticcio.

556

74. (previous page). **Jan Gossaert (Mabuse).** *Neptune and Amphitrite. c.* 1516. Painting on panel. 74 × 48¾ in. (188 × 124 cm.). State Museums, Berlin-Dahlem. Early Flemish attempts to imitate Italian art at all closely often appear ludicrous to modern eyes. In spite of this, it is true that artists from Flanders remained among the most avid followers of the cult of Italy and the antique. To this passion we owe many works of minor significance such as the beautiful topographical sketches of the city of Rome by Heemskerck. From this area emerged, later in the century, important artists such as Spranger (plate 64) and Adriaen de Vries (plate 75).

75. **Adriaen de Vries**. *The Hercules Fountain*, Augsburg, 1602. Among the early works of de Vries are two large fountains executed for Augsburg. One of these, the Hercules fountain, is reminiscent

of another Hercules fountain, that of Giovanni Bologna at Bologna. Since de Vries learnt under Giovanni Bologna in Florence his sculptural style is understandably similar. Artists such as de Vries and monuments such as this fountain played an important part in propagating a truly Italianate style.

76. **Wenzel Jamnitzer.** *Spring.* Bronze. h. *c.* 28 in. (71 cm.). Kunsthistorisches Museum, Vienna. One of four allegorical figures forming part of a fountain executed for the imperial court. The work of Jamnitzer from *c.* 1545, like the later works of Spranger, marks the full acceptance of the Habsburg family of an Italianate style for their court commissions. The exact sources of Jamnitzer are obscure but his figures clearly belong to the same stylistic group as those of Parmigianino, Primaticcio and Cellini (see plates 56, 72 and 73).

77. **Pierre Lescot.** *Façade of the Louvre*,
Paris. *c.* 1546. Part of the new building of
the Louvre, begun *c.* 1546, this façade is
remarkable for its careful dignity and
restraint. Its virtues are not perhaps fully
apparent until comparisons are made
with other contemporary buildings such
as Somerset House, London (figure 81)
or the castle at Heidelberg (see below).
No building, however, could match the
unexpected grandeur and massive
classicism of the palace of Charles V at
Granada (see figure 83).

78. *The Ottheinrichsbau*, Heidelberg.
1556–9. Like many early essays in a new
style, there are many excesses and mis-
understandings here, and a *horror vacui*
reminiscent of certain phases of medieval
art. Comparison with the palace of
Charles V (figure 83) or the Escorial will
emphasise the riotous but rather thin
nature of the applied classical detail.

NORTHERN LANDSCAPE PAINTING

79. Albrecht Altdorfer. *Danube Landscape.* *c.* 1520. Painting on panel. 12 × 8¾ in. (30.5 × 22 cm.). Alte Pinakothek, Munich. Northern landscape painting often seems to be epitomised in the work of Breughel. He had, however, many predecessors including Geertgen tot Sint Jans, Patenir and Dürer all of whom,

in different ways, devoted particular attention to painting of the countryside. Albrecht Altdorfer, in a completely different part of Germany, was also a highly individual landscape artist, producing evocative studies of pine-clad hills and mountain lakes. Normally at this date a token figure subject was still attached to a painting, but here the landscape has taken complete control.

80. Pieter Breughel the Elder. *Landscape with Gallows.* Signed and dated 1568. Painting on panel. 18 × 20 in. (46 × 51 cm.). Hessisches Landesmuseum, Darmstadt. The subject-matter of Breughel's paintings is frequently enigmatic. Here the beauty of the landscape and the harmless games of the children seem deliberately contrasted with the gaunt shape of the empty gallows. In common with much of Breughel's work, the beauty of the scene probably holds also a simple moral message.

was also stimulated by frequent journeys to Italy. Thus Jan van Scorel of Utrecht travelled there in 1520–4, Scorel's pupil Maerten van Heemskerck in 1532 and Bernard van Orley of Brussels at some unknown date. At this point, therefore, a further number of 'un-Flemish' features appear in the painting of northern artists—heavy nude studies, striking foreshortening, conscientiously contrasted figure poses, and heavy, Bramantesque architectural detail.

DÜRER AND ITALY

The oppressive influence of Italy is also to be found in the career of a far greater artist than any of the 'Romanists'. That artist was Albrecht Dürer, a native of Nürnberg whose works therefore should be set alongside those of Veit Stoss and the Vischer family. Dürer was trained as a painter and engraver in the current post-Rogerian style *c.* 1486–9. He was indeed an admirer of the great engraver Martin Schongauer of Colmar who had in his turn been much influenced by the style of Roger van der Weyden. This early training left a permanent impression on Dürer's work although he assimilated many ideas from Italy. Dürer is indeed a good example of a great artist whose work remained triumphantly northern in character, in spite of the fact that he investigated the basis of Italian art more profoundly than any of his German contemporaries. Perhaps this was precisely because he was not willing to be merely a superficial imitator. Dürer visited Italy twice (1494–5 and 1505–7) and between these visits he became fascinated by the theories of art emanating from Italy. Perhaps during the first Italian journey he met the Venetian artist Jacopo de' Barbari who showed him two drawings of a man and a woman 'constructed by means of measurement', but who refused to divulge what these measurements were. Dürer seems to have thought for a short while that the Italians had discovered artistic secrets which would provide some sort of key to beauty. There followed an idealistic phase in Dürer's career which culminated in the *Adam and Eve* engraving of 1504. In this, apart from Eve's face, the general impression is extremely Italianate. Eventually Dürer's attitude to the theory of human proportion developed far beyond this simple search for a single ideal; but the striking feature is that he accepted the Italian idea that 'good art' has rules, and that these rules could be the subject of academic analysis to be reduced to textbook formulas.

81. (opposite). **Hans Holbein.** *Henry VIII.* 1542. Oil and tempera on wood. 86½ × 26¼ in. (219 × 66 cm.). George Howard Collection, Castle Howard, Yorkshire. One of Holbein's later and most magnificent court portraits. This type of portrait is a status picture, underlining the position of the sitter by the splendour of his clothing. It has much in common with Bronzino's court portraits of the Medici and with the work of imperial artists such as Jakob Seisenegger. Holbein's brilliant technique was well suited to this style of work but his most sensitive portraits were of sitters like the More family, with more sympathetic characters.

75. **Antonio** and **Giovanni Giusti.** *Tomb of Louis XII.* 1515–31. Marble. St Denis, Paris. Although the attribution of the total design of this monument is not entirely settled, the presence of Italian sculptors at the French court was symptomatic of a change of attitude in France towards the artistic taste of Italy. From now on Francis I tried systematically to propagate an authentic classical style in France and imported Italian artists for this purpose.

76. *Tomb of Maximilian I.* 1508–33. Bronze. Hofkirche, Innsbruck. Many different German sculptors took part in this project in which the dead man was shown surrounded by illustrious ancestors. The 'family genealogy' is an old motif in north European art, and in general this monument followed northern traditions (contrast figure 75).

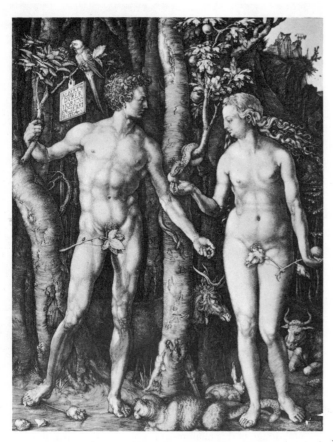

77. **Albrecht Dürer.** *Adam and Eve.* 1504. Engraving. 9¾ × 7½ in. (24 × 19 cm.). This probably represents Dürer at his most Italianate, although the detail of the background foliage and Eve's face to some extent counteract this impression. The derivation of Adam's figure is, however, unmistakable. Dürer was the first northern artist to try to master the theory of Italian art.

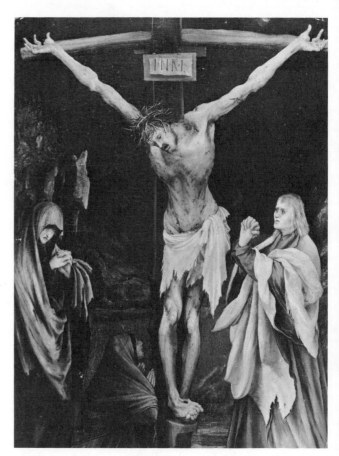

78. **Mathias Grünewald.** *Crucifixion. c.* 1524. Pinewood. 77 × 60 in. (195.5 × 152.5 cm.). Badische Kunsthalle, Karlsruhe. Grünewald's own brand of realism was unsparing in its intensity, and emerges particularly in his representations of Christ's Passion.

As a result he compiled *Four Books on Human Proportion* (published shortly after his death); and other works were projected but never written, such as a treatise on architecture. The tone of his writing is by turns humble and pedagogic, and underlying it all is the assumption that there is a 'right' and a 'wrong' in art which can be distinguished when the intellect comes to the aid of technical expertise.

This aspect of Dürer's Italianism is frequently emphasised both for its intrinsic interest and on account of its unexpected appearance in a non-Italian artist at this date. Dürer's reputation in his own time, however, rested on his skill as an artist, particularly as an engraver. It was widely recognised on both sides of the Alps that he had raised the art of engraving to a new level. But he was seen as one German artist among others; and shortly after his death his friend, the humanist Melanchthon, thought it not inappropriate to compare him directly to Cranach and Grünewald (1531). This may now seem surprising. Grünewald, a shadowy personality, painted in an extraordinary and vivid style. For instance, his unforgettable representations of the *Crucifixion* are horrific and unsparing in their savage detail, and it may seem difficult to imagine how the smallest acquaintance with his painting could fail to separate his style from that of Dürer. However it did not occur to Melanchthon to see them as opposites; he took the

grandeur of Dürer's style and opposed to it the grace of Cranach's, adding that Grünewald held a middle course between the two. This is interesting since it can only mean that in 1531 the idea of the unity of the German Gothic tradition was still a commonplace. In spite of Dürer's own personal interest in Italian ideas and Cranach's interpretation of Italian themes, Italianism and classicism were still of small importance in any critical assessment of style. Dürer and Cranach were first and foremost the heirs of a German tradition which they held in common with Grünewald.

FONTAINEBLEAU—THE DEVELOPMENT OF FRENCH RENAISSANCE ART

One by one the north European courts fell under the spell of antique art. It seems likely that in this process the increasing prestige enjoyed by classical scholarship and letters played a considerable part, but the influence of letters on the visual arts is often hard to trace. The most prominent centre in the general tendency to emulate Italian achievements in the arts was certainly France where the kings consistently extended their patronage to Italian artists throughout the first half of the century. The chief of these royal patrons was Francis I who began by patronising the unequal talents of the Giusti brothers and Leonardo da Vinci (1517). The series of artists should have included

78

79. *Francis I. c.* 1530. Oil on canvas. 39¾ × 29 in. (96 × 74 cm.). Louvre, Paris. Painted here by an unidentified artist, in the past thought to be Jean Clouet, Francis I was the first French king to patronise, determinedly and consistently, artists from Italy. The rebuilding of Fontainebleau was begun by him, and under his patronage the first phase of 'Fontainebleau Mannerism' developed.

80. **Primaticcio.** *Detail from the Chambre de la Duchesse d'Etampes,* Fontainebleau. *c.* 1541–5. Paint and stucco. This illustrates well some of the features of 'Fontainebleau Mannerism'. The figures are extremely attenuated and elegant, and the decoration is exuberant. Noteworthy are the huge plaster scrolls, known as 'strap-work', which here make their first major appearance in west European art.

Fra Bartolommeo who, however, declined an invitation, and Andrea del Sarto who accepted, but stayed less than a year (1518–19); and the architect and sculptor Jacopo Sansovino was also lost to the French court, because in the course of the journey he was persuaded to stay permanently in Venice (1529). Eventually the first important Italian artists who radically changed the appearance of French court art were Rosso Fiorentino, who arrived in 1530, and the Bolognese Primaticcio, who arrived from Mantua in 1532.

By this date Francis I was already enlarging and improving his hunting lodge at Fontainebleau and, as a result of the concentrated activity there during the next decades, the works of art executed for him are usually referred to collectively as being of the 'Fontainebleau school', the style being called 'Fontainebleau Mannerism'. The work required from Rosso and Primaticcio was mainly of a decorative character and, drawing from a joint experience of Mantua and Rome, they produced schemes of decoration in a fascinating and wholly individual style. Many of these still survive; their character is fantastic, elegant and extravagant. One feature which was apparently new and contributed to the richness of each room is the consistent combination of painting and moulded stucco work, which was treated for the first time in immense curling scrolls (generally called 'strapwork').

A later arrival at the French court was that flamboyant personality Benvenuto Cellini who paid a brief visit in **73** 1537, and then stayed permanently from 1540 to 1545. His style has much in common with that of Primaticcio who became his great rival at Fontainebleau. Cellini's two main surviving works from this period are the elaborate gold saltcellar (already begun in Rome in 1539) and the bronze lunette relief more generally known as the 'Nymph of Fontainebleau' (1543–4). In both, the figure style is attenuated as in the work of Primaticcio; and the saltcellar has an elaborate allegorical iconography which Cellini himself explains in his writings.

The presence of these Italian artists and others such as the architect Serlio (who arrived *c.* 1540–1) assisted the precocious development of a native classicising style. This can be appreciated by comparing the exterior of the Louvre palace as it was rebuilt *c.* 1546 with contemporary building at other northern courts. The Louvre façade was designed by a French scholar-architect Pierre Lescot and, with its **77** rather flat monotonous surface, is not perhaps very inspiring. Comparisons with Alberti's Rucellai palace spring **26** to mind. However two further palaces exist, which bring out the inherent restraint and discipline of Lescot's design and emphasise his great understanding of the Italian models which he used. One is the palace built in London at **81** about the same date by the Lord Protector of England,

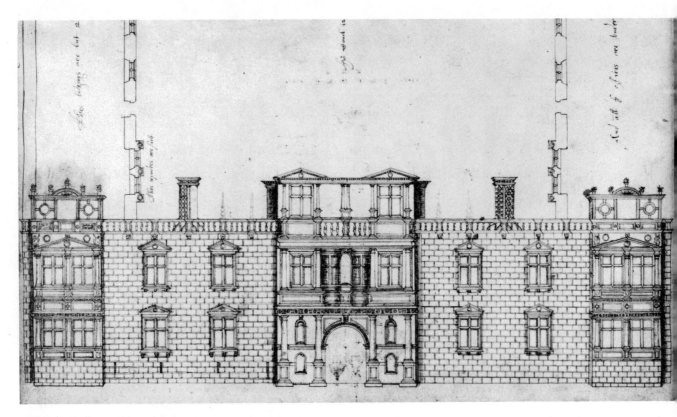

81. **John Thorpe.** *The Strand façade of Somerset House, London.*
Early 17th century. Drawing. 10¾ × 16¾ in. (27 × 43 cm.).
The Soane Museum, London. The palace was built 1547–52
and no longer exists. It presents the first attempt at a wholly
Italianate piece of building in England, although most of its
decorative ideas stemmed in the first place from France.

Somerset, which by comparison with the Louvre seems
weak and incoherent. The other is at Heidelberg where,
on the other hand, that part of the castle built (*c.* 1556–9)
by Prince Otto Heinrich, Count Palatine of the Rhine, is
overpoweringly ornate.

The Frenchman Philibert de l'Orme was a far greater
architect than the careful designer of the Louvre. He came
from a family of masons, and early in his life visited Italy,
including Rome (*c.* 1533), where he completed a first-hand
survey of classical remains. On his return he received em-
ployment from the French king on a wide range of projects;
but he also compiled a treatise on architecture which was
first published in 1567. As with the case of Dürer, the idea
of a treatise was Italian; but it is soon apparent (again as
with Dürer) that the writer was not merely a slavish imita-
tor of Italy. Both de l'Orme's writing and his building make
it plain that French artists were now developing an in-
dividual version of the classical style.

The Italianate background which produced these archi-
tects also produced two outstanding sculptors. The first,
Jean Goujon, collaborated with Lescot at the Louvre. His
range of expression was limited but during the middle
years of the century he developed a restrained and personal
brand of classicism, which is certainly not the work of a

hesitant northerner playing with something new and half
understood. The sculpture of Germain Pilon has greater
variety. By comparison with Goujon his figures are heavier
and his drapery more exuberant, but his work is neverthe-
less always elegant. It is clear that he had completely
mastered the grammar of Renaissance sculpture and that,
as with architecture, the French were on the way to
developing an individual sculptural style in the classical
idiom.

During the course of the 16th century it becomes in-
creasingly difficult to follow and explain the spread of
classical and Italianate ideas in Western art. The fantastic
decorative ideas developed at Fontainebleau were them-
selves widely copied, for Fontainebleau was more easily
accessible to many northern artists than Italy; and more-
over the ideas evolved by Rosso and Primaticcio received
wide publicity through the medium of engravings. This
phenomenon was not confined to France because ever since
the last years of the 15th century the publication of orna-
ment, figures and scenes in the form of engravings had
become increasingly popular both north and south of the
Alps. The idea of 'publication' followed in the wake of the
invention of printing and, as the 16th century proceeded, it
became increasingly common.

82. **Germain Pilon.** *The Risen Christ.* Begun *c.* 1583. St Paul-St Louis, Paris. Part of a sculptural complex intended for the Valois chapel, St Denis (chapel never completed). Although strongly influenced both by the Italians of Fontainebleau and by Michelangelo, he mastered the style to the extent of being able to use it for his own strongly personal and at times emotional purposes.

RENAISSANCE ART AND THE EMPIRE

The patronage of the imperial court during the 16th century ran a somewhat erratic course. The emperors never employed Italian artists with the single-mindedness of the French kings although, admittedly, they used Italian artists while in Italy itself, and Charles V had a great respect for the portraiture of Titian. But there seems to have been little desire for a strongly classicising form of art; and consequently Renaissance ideas arrived by circuitous routes. For instance, Wenzel Jamnitzer, the chief gold- **76** smith to the imperial court (from *c.* 1545), handled a figure style akin to those of Cellini and Primaticcio with elegance and assurance. A craftsman of Nürnberg, he apparently never travelled widely and he must have learnt his style at second hand from drawings and engravings.

The establishment of a living classical artistic tradition in Germany was the work not of visiting Italians nor of enthusiastic Germans, but of itinerant Netherlandish artists. Two great artists were working for the imperial court at the end of the 16th century. One of these, Bartholo- **64** mäus Spranger, came originally from Antwerp. By way of Paris and Lyon he travelled to Italy (1565–6) where he worked successively in Parma and Rome. Eventually, through the mediation of his fellow-Fleming, Giovanni Bologna, he went to Vienna (1575) to serve the Emperor Maximilian II and finally (1576) Rudolf II. Thus the court painter of Vienna and Prague in the last quarter of the century had experience of Parisian court art as well as the work of Correggio and Parmigianino, and of the entire gamut of Roman art from the Sistine ceiling and the *Stanze* up to his departure. From these sources he evolved a style which is characterised by the softness of its technique. It seems likely that his early experience of the work of Correggio and Parmigianino left a permanent impression.

Another Habsburg court artist was the sculptor Adriaen de Vries who came from The Hague. Like Spranger he moved to Italy early in his life and worked under Giovanni Bologna in Florence. After a period of years spent in Rome and Turin he moved to Augsburg (1596) and thence to the court of Rudolf II at Prague (1601). Already in Italy (1593) he had produced some small bronzes for the emperor which show a complete mastery of the style of Giovanni Bologna; and it was through the influence of work such as his two Augsburg fountains (*Mercury* and *Hercules*) that an in- **75** dependent classical sculpture style developed in Germany.

It is impossible here to follow all the significant developments of Renaissance art throughout Europe, but of the German princes the Electors of Bavaria deserve mention. The Elector Albert V, in direct imitation of Italian princes, built an Antiquarium (or Museum for his collections) in an elaborate Italianate style between 1569 and 1571. Later (1581–6) the Elector William V built the Grottenhof of the Munich Residenz and installed in its centre a fountain by another great Italianising sculptor from the Netherlands, Hubert Gerhard (1590). One of Gerhard's masterpieces, a figure of St Michael (1588), is on the façade of the Michaels-

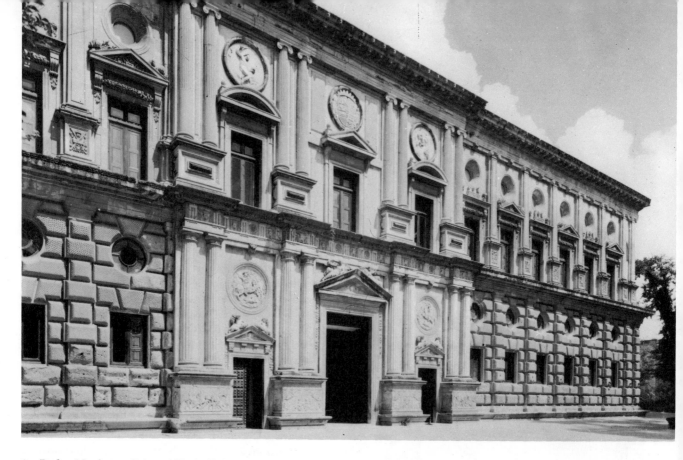

83. **Pedro Machuca**. *Palace of Charles V, Granada*. Probably built from 1539 onwards. Little is known about the architect but his façade has all the heaviness and monumentality of Bramante's architecture. Machuca may have used ideas publicised by the Italian architect Serlio but the massiveness with which they are used distinguishes this design from other contemporary Italianate palaces outside Italy (contrast figure 81 and plates 77 and 78).

kirche in Munich, and this church is itself one of the more important architectural monuments of German Renaissance art. Again it was designed by a Netherlandish architect working in a classical style, Friedrich Sustris. At this stage two general observations may be made. Firstly, the spectacle of these major works of art of the 'German' Renaissance executed by Netherlandish artists reminds one that, however pedestrian the art of the 'Romanists' may seem, the Netherlands remained one of the main European centres of enthusiasm for Italian art. Secondly, the uncertain beginnings of German Renaissance art and its late development meant that the first great classicising monuments by northern artists in Germany were heavily influenced by late 16th-century Italian art. And so, as in the case of Gerhard, when an Italianate classicising style was at long last wholly accepted in Germany, it was already almost baroque.

RENAISSANCE ART IN SPAIN

By the late 15th century Spanish sculpture and architecture had developed into a rich and fantastically ornamented Gothic style, and although Italianate motifs were increasingly introduced they naturally create a rather bizarre impression. Until the second half of the century art produced in Spain continued to have a strongly provincial flavour and with few exceptions there was no real understanding of the ideas underlying the Italian classical revival. As in Germany, this may in part be explained by the lack of a tradition of continous court patronage; but even when the Habsburg Spanish wealth was poured into artistic enterprises, there is no clear evidence of a consistent royal taste. Philip II collected the strange works of Bosch; but when El Greco came to Spain in 1577 the strangeness of *his* work failed to interest Philip. Philip had a large number of paintings by Titian; but to decorate the Escorial palace in 1585 he summoned three Roman painters reared in the style of Pierino del Vaga and Salviati. Of these three he developed a preference for an artist called Pellegrino Tibaldi.

The formality surrounding the Habsburg court is legendary and some echo of it might be expected in the art patronised there. This is perhaps visible in the work of Tibaldi and his companions. But if comparison is made with the work of contemporary Spanish sculptors, then it is much more obvious in those works commissioned from the Leoni family in Milan. Among other things, Leone Leoni and his son Pompeo executed two large bronze kneeling groups of the families of Charles V and Philip II for the mausolea in the Escorial.

It was presumably a fundamental dislike of the excited ornamental taste peculiar to Spanish art which led Charles V and Philip II to commission two palaces which succeed in being not only totally different from any other contemporary buildings in Spain but also extremely unusual in the context of European architecture.

The first of these is the palace built by Charles V at Granada. The architect was the Spaniard Pedro Machuca, of whom little is known, although the palace was built probably in the years following 1539. If this date is correct the palace was unique outside Italy; for not even Lescot at the Louvre had grasped so clearly the essential character of the Roman architecture of Bramante and his followers.

567

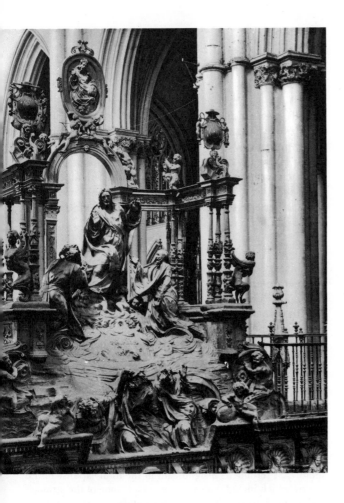

84. **Alonso Berruguete.** *The Transfiguration.* 1543–8. Toledo cathedral. Berruguete had visited Italy earlier in his career (*c.* 1508–17) and his style was much influenced by Italian forms, ideas and ornament. However, like many native Spanish sculptors, he developed an excited and agitated manner which had the effect of introducing a kind of baroque extravagance into his style.

really is because these gestures and movement combined with Italianate detail are things associated more readily with the 17th century than with the mid 16th.

PORTRAITS AND LANDSCAPES

The 16th century was not, on the whole, an outstanding century for north European painting. There were two creative poles, one represented by Cranach who absorbed Italian ideas into his own individual style and the other by Spranger who had mastered a truly Italianate style of his own; and much of the painting produced in France and the Netherlands fell uncomfortably betwen these two aspirations and became merely Italianate imitation. It is not surprising, therefore, that on the whole artists excelled in those forms of painting which were relatively unaffected by the revived classicism coming from the south. Two such forms were landscape painting and portraiture. Northern Europe continued to produce distinguished portrait painters in the 16th century, including Massys, Gossaert and Jean Clouet: but none of these excelled Hans Holbein, *79* the Swiss artist from Basle. Holbein was able to record with extraordinary ability the detailed appearance and texture of a sitter's costume in an age when, both in Italy and in the North, great importance was attached to such detail. But added to this he had the uncanny ability—common to all great portrait painters—of being able to respond to some aspect of his sitter's personality and then to fix this with some characteristic glance or expression. Thus Holbein's portraits have constant and subtle variations which **81** endow them with unusual interest and vitality.

Towards the end of the 15th century landscape came to be treated more deliberately as an independent subject for the artist. This is already apparent in the work of Geertgen and David, where the subject-matter of a painting was sometimes reduced to exiguous proportions. In the work of artists such as Joachim Patenir and Albrecht Altdorfer at *85,* **79** the beginning of the 16th century, a fantastic, imaginary countryside might now occupy the whole canvas where, in the 15th century, it would probably merely have been glimpsed through a window or behind a group of figures. The recording of landscape too now became more com-

Architectural motifs, which Lescot applied rather like a decorative skin, here assume a weight and plasticity appropriate to their function. The simplicity and directness of this style left no apparent trace on Spanish architecture; and its stylistic successor was again a royal palace, the Escorial. The planning, design and execution were again the work of Spaniards—Juan Bautista de Toledo and Juan de Herrera, and work began in 1562. The style again echoes Roman architecture but the scale of execution, the complexity of the plan and the general austerity of the style make it exceptional in Europe. Not even in Italy can satisfactory parallels be found. Here, therefore, between the solemn formality of court taste and the exceptional liveliness and emotion of traditional preference were the makings of a highly individual classical style of the 17th century.

Native Spanish painting and sculpture tended towards a more intense emotional expression than the tastes of the Habsburg monarchs allowed (it was probably this which Philip II found distasteful in the painting of El Greco). A species of 'proto-baroque' art is already visible by the middle of the century in the work of Alonso Berruguete. He had visited Italy, probably between 1508 and 1517, and on his return he rapidly evolved a personal style without exact parallels in contemporary Europe. The key to the understanding of this style seems to lie in the fact that he shed the trappings of Spanish Gothic art but expressed the same highly pitched emotion in the classicising dress of Italian art. Thus in the *Transfiguration* made for the high altar of Toledo cathedral (1543–8) the group has the superficial appearance of being much later in date than it

mon, as can be seen in the drawings of Dürer. The connections with Italy are not at all clear; for although northern artists certainly influenced the Italians, it is also true that the earliest surviving drawing of an actual landscape is the 1473 *Arno Valley* by Leonardo da Vinci. Many Italian painters were extremely sensitive to the beauties of the natural world and no survey of landscape painting could ignore the success of Venetian artists in making a landscape background convey a mood to support the subject-matter of the painting (see p. 572). But of all northern landscape artists of the 16th century the greatest was probably Pieter Breughel. His early style is close to the tradition of Bosch and an element of satire persists throughout his work. However his mature paintings show an unprecedented interest in the countryside and its inhabitants. Trained in Antwerp, he travelled to Italy in 1552–3 and penetrated as far as Sicily. During the course of this journey he certainly visited Rome, but he is distinguished by the fact that classical Italy apparently made no impression on him at all. His satirical pictures of the countryside and country life, so different from any contemporary work in Italy, are fre-

quently obscure in their precise meaning; but since these vivid evocations of the more earthy aspects of rustic life were appreciated and collected by members of the Spanish ruling hierarchy during Breughel's life-time, it is unlikely that their intention is ever subversive or heretical. Breughel, like Bosch, was probably producing personal meditations on such general subjects as the folly of mankind which he illustrated from his insight into rural life.

CONCLUSION

The history of Renaissance art in northern Europe of the 16th century must remain inconclusive for reasons already suggested. The spread of Italian ideas was uneven and in certain countries, notably England, extremely spasmodic and unpredictable and almost always through a foreign intermediary. For instance the first English architectural treatise of Italianate usage by John Shute (1563) was heavily influenced from Flanders. Nevertheless by 1580 the transforming influence of Italy was almost everywhere apparent and the story was completed in the following century.

85. **Joachim Patenir.** *Landscape with St Jerome.* 1515. Paint on panel. 29 × 35¾ in. (74 × 91 cm.). Prado, Madrid.
Patenir was one of the first painters to concentrate wholly on landscape painting—even to the extent of getting other artists occasionally to paint the figures of the subject-matter. Here the subject, St Jerome, is insignificant in the total expanse of the setting which includes a small town and some of the strange rock formations peculiar to Patenir's style.

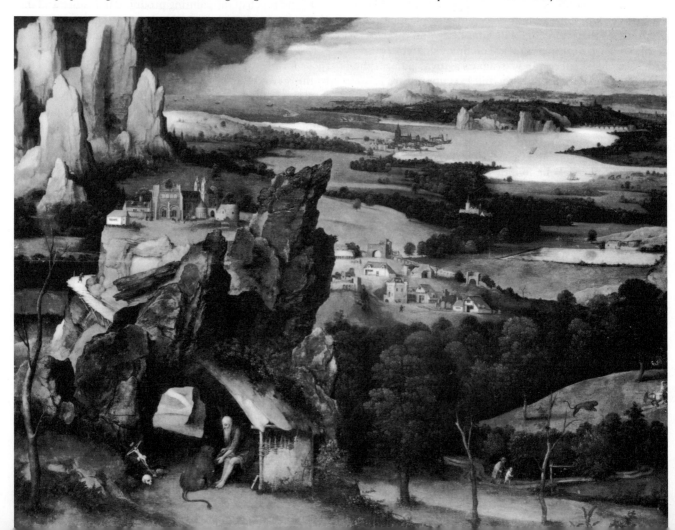

The Venetian Renaissance

The development of Renaissance art in the republic of Venice may be studied with a satisfactory sense of completeness. Apart from Florence, Venice was the only Italian city with a continuous history of first class artistic creation throughout the period under consideration. Elsewhere, as we have seen, individual cities and courts (occasionally) harboured artists of distinction and temporarily became centres for the diffusion of a particular style before lapsing back into provincial status (the court of Urbino in the 15th century is an example). The republic of Venice throughout this period managed to train or to attract a long succession of distinguished artists most of whom seem to have enjoyed life in Venice sufficiently to stay permanently.

The reasons for this are to be sought at two levels. First, Venice possessed an unusual political system combining rigidity with stability. By the late 15th century, the Doge was little more than a figure-head and the real power was held by a Council of Ten. Membership of the Council was elective, but the whole system was controlled by a small aristocratic oligarchy. Power was maintained by a devious but efficient system of informers and all threats to security from within were promptly and usually secretly dealt with.

This ruthless police system had its compensations. Since the touchstone of all things was state security, things which did not threaten the state tended to be permitted. There was, in fact, a permissive attitude in Venice to nonconformity hardly to be experienced elsewhere in Italy. Such an attitude was designed to foster trade relations and was indeed essential in a city where Germans from the North rubbed shoulders with Turks from the East. Venice possessed a free cosmopolitan atmosphere not to be found anywhere else.

The oligarchic government promoted continuity. Trade promoted wealth and diversity and these provided the second advantage for artists. Such a setting provided any artist with a rich visual experience and the possibility of large financial rewards. The state and the great religious confraternities or scuole were assiduous patrons of the arts, and although they replaced the major types of private patronage, private individuals still commissioned and bought large numbers of smaller religious works and altarpieces.

86. **Antonio Lombardo.** *A Miracle of St Anthony of Padua.* 1505. Marble. Detail of decoration of the Capella del Santo, S. Antonio, Padua. The Lombardi family of masons and sculptors were among the most perceptive of the classicising artists of the late 15th century. The style of this relief, both in the drapery and in the facial types, is perhaps more convincingly antique than any other piece of sculpture in this book, and it has a dignity and restraint typical of Venetian art at this period.

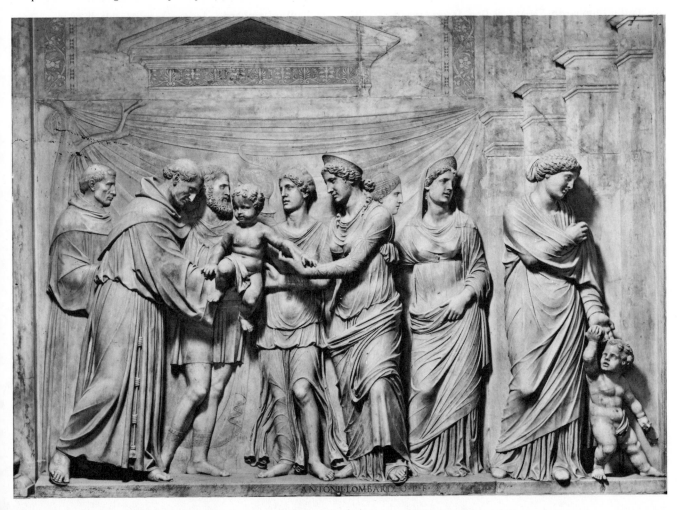

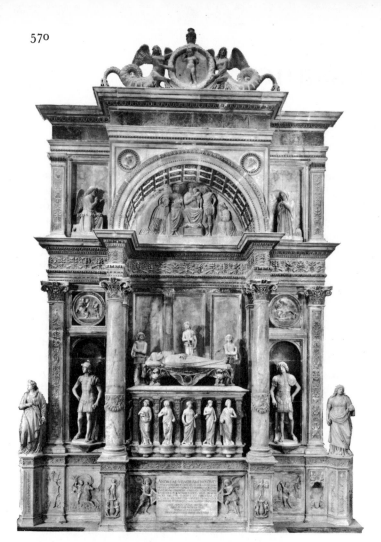

87. **Tullio Lombardo.** *Tomb of the Doge Andrea Vendramin.*
c. 1490. Marble. Formerly in Sta Maria dei Servi, later
transferred to SS. Giovanni e Paolo, Venice. This enormous
monument is really a triumphal arch adapted to serve another
purpose. The quality of the sculpture varies but the general
style is similar to figure 86. The best sculpture is of a very high
quality (see figure 88).

88. **Tullio Lombardo.** *Adam. c.* 1490. Marble. h. 76 in.
(193 cm.). Metropolitan Museum of Art, New York. Formerly
part of the tomb of the Doge Andrea Vendramin (figure 87).
One might suppose that Tullio Lombardo had had before his
eyes a genuine work of Praxiteles, so skilfully handled is the
surface of this marble body. It is a sad fact that the
corresponding figure of *Eve* has now vanished.

The tradition of Gothic art in Venice was a strong one
and, as in most centres of north Italy, it survived up to the
middle of the 15th century. It is seen in a monument such
as the *Porta della Carta* of the Doges' Palace (1438–42) or in
the paintings of Jacobello del Fiore and Antonio Vivarini
(c. 1420–50). As with many other Italian centres, the
transforming impetus came from Padua although the
degrees by which it was accepted were not the same in
painting and sculpture.

THE LOMBARDO FAMILY

In sculpture and architecture the chief agents of change
were a non-Venetian family of masons called the Lom-
bardi. The father, Pietro Lombardo, came originally from
Carona (northern Lombardy). He is known to have been
in Padua in 1464 and he probably settled in Venice during
this decade. Much of his work survives and, while it is clear
that he could not or would not purge Venetian monuments
and buildings of their ornate character, he did radically
revise the architectural detail and general form of the work
he undertook in response to an archaeological enthusiasm
which he must have developed at Padua. In his monument

to the Doge Pietro Mocenigo (died 1476) in SS. Giovanni
e Paolo he adopted a form of niched architecture based on
a triumphal arch; and, since Mocenigo had been a success-
ful general, he filled the niches with warriors which are
very similar to the Roman soldiers painted by Mantegna.
The most successful elements in the design are probably
the decorative details, and it is clear from these that
Pietro Lombardo had a highly sensitive appreciation of the
visual character of antique sculpture—an appreciation
hard to match before this date except in the Tempio
Malatesta at Rimini.

This appreciation was shared by Pietro's two sons An-
tonio and Tullio, and between them they were responsible
for a group of works whose very personal classicism sets
them in a class apart from contemporary developments in
the rest of Italy. One of these was the monument to the
Doge Andrea Vendramin (c. 1490, SS. Giovanni e Paolo).
Apart from its enormous size, it is designed on a larger
scale than its predecessors. The detail is less fussy, the in-
dividual parts are larger in relation to the whole, and the
design is developed in depth so that the central arch
projects well forward from the main body of the monument.

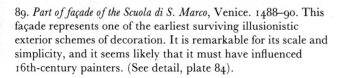

89. *Part of façade of the Scuola di S. Marco*, Venice. 1488–90. This façade represents one of the earliest surviving illusionistic exterior schemes of decoration. It is remarkable for its scale and simplicity, and it seems likely that it must have influenced 16th-century painters. (See detail, plate 84).

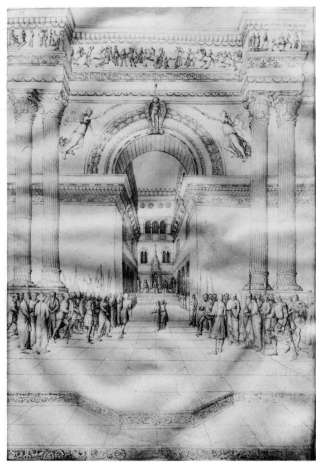

90. **Jacopo Bellini.** *Christ before Pilate. c.* 1455. Pen and ink. 17 × 11½ in. (43 × 29 cm.). Louvre, Paris. From one of Jacopo Bellini's drawing books. These drawings display a fascination for the new art of perspective. They also show a somewhat erratic and wayward taste for antique details. Both of these features probably reflect the influence of Jacopo's son-in-law, Mantegna.

All these changes represent a more mature appreciation of the grandeur of ancient Rome. In addition to all this, however, the sculpture intended for the monument shows at its best a masterly understanding of antique carving. The figure of *Adam* (now separated from its original destination) shows a most unexpected appreciation of the essential softness of Praxitelean sculpture and like Michelangelo's *Bacchus* it seems to be based on the *Bacchus* of Praxiteles (now known only through copies).

A second major work of the Lombardo family was the rebuilding of the Scuola di S. Marco (*c.* 1490). Here the unexpected innovation was in the lower part of the façade, which was treated like an enormous piece of illusionistic relief sculpture. The right-hand entrance is flanked by two scenes from the life of St Mark which take place in spacious receding loggias with heavily coffered ceilings. The figures, dressed in drapery of a classical type, are probably deliberately dwarfed by the massive piers of the colonnade, so that the scenes are played out in an atmosphere of austere grandeur.

A further monument on which the Lombardo family worked was the chapel of St Anthony in the church of

S. Antonio at Padua. Here it was intended to portray scenes from the life of St Anthony in narrative reliefs whose style and setting would have been similar to the reliefs on the Scuola di S. Marco. The Lombardo family only completed a few reliefs, however, the rest following piecemeal *86* as the 16th century progressed. But those which they executed show again their unerring instinct for conveying the measure and gravity of an antique work.

MANTEGNA AND VENETIAN ART

The influence of Mantegna as a source of this classicising style is clear. Mantegna's influence on Venetian painting was equally important, although the total effect was less complete. This influence is to be seen in two particular ways. First, his mastery of pictorial structure had a profound effect on both the lay-out of scenes and the paintings of figures and drapery. This is as easily seen in the early work of Giovanni Bellini as in the painting of Bartolommeo Vivarini. It is also to be seen in the drawings of Giovanni's father, Jacopo Bellini, which show a sudden *90* enthusiasm for enormous vistas and fantastic perspective constructions. Mantegna's influence also emerges in a

passing enthusiasm for archaeological detail. In Jacopo Bellini's drawings classical details and objects of a classical character appear alongside his compositional studies; and in the very early work of Giovanni Bellini antique monuments and arches occasionally intrude into the background in a manner reminiscent of Mantegna. These links are not surprising because Jacopo Bellini had agreed in 1453 to the marriage of his daughter to Mantegna, who thus became Giovanni Bellini's brother-in-law.

However, the brilliant style of Mantegna's painting did not overwhelm Venetian painters. Although Giovanni Bellini adopted many of the formal devices of Mantegna so that, for instance, his figures for a brief period take on the statuesque appearance of Mantegna's style, his feeling for colour was never dominated by his brother-in-law. Almost any comparison will always show that Bellini had a greater sensitivity for the overall colour harmony of a painting—a feature characteristic of Venetian painting.

ANTONELLO DA MESSINA

There was one outside artist who affected Venetian painters in the way that they used paint and colour—as opposed to the way that they looked at ruins or drew perspective. This **86** was the Sicilian painter Antonello da Messina. Although there are still numerous problems connected with his career, he seems to have been influenced by Flemish painting. His work also contains hints of the influence of Piero della Francesca but without conclusive connections. In 1475–6 he is known to have visited Venice, where he painted a great altarpiece for the church of S. Cassiano and worked on a number of portraits.

Antonello's painting lent impetus to two particular changes in Venetian art. Firstly, he speeded the development of oil as a painting medium in place of the traditional egg tempera; and in the wake of this transition to a more malleable medium came a completely new attitude to the use of light in the definition of form and detail. This new attitude to the control of light is so important that it **88, 89** deserves emphasis. A comparison of two Bellini *Madonnas* —perhaps fifteen years apart in date—will demonstrate the point. Both are superb paintings and show a skilful balance of colour, but in the earlier work the definition of the figures is largely achieved by a clear outline, whereas in the later one it is left very much to the play of light and shadow.

Once this discovery had been made, the way lay open to the incorporation of shadow tones into the colour scheme of the picture, and to the realisation that the whole range of any particular picture could be immeasurably enriched by the blending of light and dark tones in addition to the traditional blending of complementary colours. A spate of Antonellesque painting followed. The new understanding of shadow was used in the first instance to clarify structure by giving all lit surfaces a vivid intensity. This approach, applied to forms of architecture, schemes of landscape or details of costume, is typical not only of Giovanni Bellini at

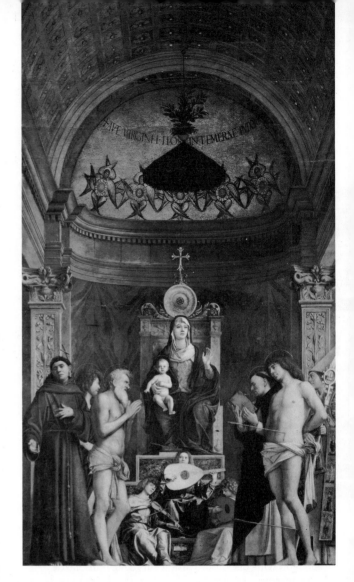

this period but also of the generation of Cima da Conegliano and Alvise Vivarini. This style of painting was still ardently admired by the young Lorenzo Lotto in the **8** opening years of the 16th century. Eventually the new discovery came to be used almost exclusively to enrich colour. The late paintings of Bellini are often remarkable not for the clarity of their structure, but for the depth of colour achieved by contrasting rich primary colours, lit by an intense light, with profound shadows.

LATE QUATTROCENTO VENETIAN PAINTING

Alongside these changes other developments occurred. During the years 1470–80 the Venetian *sacra conversazione* altarpiece took on the chief characteristics which it was to have for the next fifty years—a stately group of figures within a late 15th-century architectural setting. This convention was derived from Donatello's sculpture for the high altar of S. Antonio at Padua, but it was given a characteristic Venetian formality. One of the earliest examples is the S. Giobbe altarpiece of Giovanni Bellini **9** himself.

Throughout this period Venetian artists maintained an almost late Gothic sensitivity to the beauties of the natural world. One of the earliest works of Giovanni Bellini sets St Jerome with his lion in a magical landscape reminiscent **9** of the settings of early 15th-century artists such as Gentile da Fabriano. This feeling for landscape became a perma-

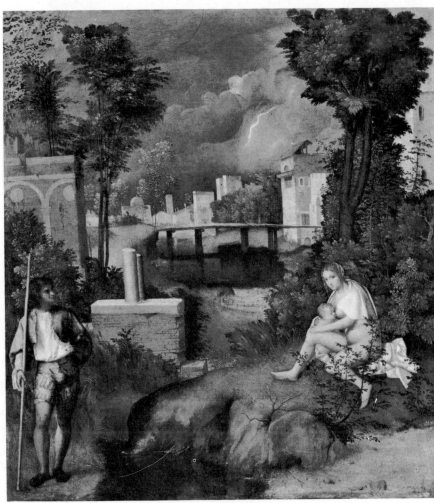

91. **Giovanni Bellini.** *The S. Giobbe altarpiece. c.* 1480. Paint on panel. 184¼ × 100½ in. (468 × 255 cm.). Accademia, Venice. The first great *sacra conversazione* of Venetian art to survive. The physical presence of the figures was originally emphasised by the wooden frame which was carved to correspond to the architectural setting of the painting. Their impressiveness is increased by the low viewpoint, by which means they seem to tower above the onlooker.

92. **Giorgione.** *La Tempesta. c.* 1503. Oil on canvas. 32¼ × 28¾ in. (82 × 73 cm.). Accademia, Venice. This is one of the few certain works by Giorgione and is one of the most famous early Renaissance landscapes. The subject of the work is uncertain and X-ray examination suggests that it may even have been changed in the course of painting. All that remains is a peculiarly evocative mood enhanced by the approaching storm in the background (compare plates 87 and 90).

nent feature of Venetian painting, and the landscape settings of Giovanni Bellini, Giorgione and Titian are famous. Yet those of less well known artists such as Lorenzo Lotto are no less striking—for instance, his painting of *St Jerome in the Wilderness*, a work almost contemporary with Giorgione's more famous *Tempesta*. The development of Venetian painting already mentioned had one particular effect on the Venetian representation of the countryside. Since the richest colouristic effects are to be found when the contrast between intense colour and shadow is at its greatest, Venetian painters came to favour the time of day most suited to these conditions. Thus, many scenes came to be set at those most evocative times, the hours around dawn and sunset, when intense sunlight is offset by deep shadows.

One further aspect of the Venetian tradition should be mentioned, namely the continued popularity enjoyed by a distinctive type of history painting or the painting of stories of both religious and secular subjects on a large scale. Elsewhere in Italy, large-scale interior paintings were generally executed in fresco, but in the course of the 15th century the Venetians discovered that paintings lasted longer in the sea air when painted on canvas. From *c.* 1480 onwards, therefore, it became customary to paint interior history paintings on huge areas of canvas mounted on a frame which was then installed in the required position. Throughout the later 15th and 16th centuries there was a constant demand by the republican government and the scuole for schemes

of decoration of this kind. The actual style of these paintings in the late 15th century had a certain amount in common with history paintings in Florence. Like a Ghirlandaio fresco, a late 15th-century Venetian history painting contains a great deal of incidental detail, portraits of important living people, and views of the home city. In Venice the style was based on the work of Jacopo Bellini, and of the surviving paintings the most remarkable are probably those of Carpaccio. He was no lover of dramatic action: even when the most violent events are depicted, movement takes place but in suspended animation; and the senses are roused not by terror or awe at what is happening, but by the pleasing colour and the painter's detailed observation of the scene laid out before the eyes.

THE FONDACO DEI TEDESCHI

The first major monument of Venetian 16th-century art was the external decoration of the lately rebuilt Fondaco of the German merchants in 1507–8 by Giorgione and Titian. Like all external frescoes in Venice the originals soon perished, and the walls of the building now preserve only the faintest traces of paintings which had an impact in Venice similar to Michelangelo's *Bathers* cartoon in Florence. The arrangement of the decoration and the subject-matter can now only be approximately reconstructed from descriptions and a few engravings made in the 18th century. But we know that part of the decoration consisted of

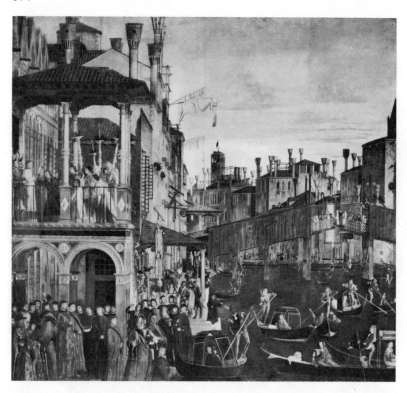

93. **Vittore Carpaccio.** *A Miracle of the True Cross.* 1494–5.
Oil on canvas. 143¾ × 153 in. (365 × 389 cm.). Accademia,
Venice. Carpaccio was one of the great Venetian history
painters on a grand scale. His style developed in the years around
1490 and emphasised the setting at the expense of the subject-
matter (compare Ghirlandaio in Florence, plate 28). These
settings are, however, superbly painted and present a vivid
picture of Venetian life at this period.

94. *Nude female figure.* 1507–8. Engraving after Giorgione. Part
of fresco decoration of the Fondaco dei Tedeschi, Venice. Very
little is now known about the details of the decoration, almost all
of which has vanished. The few fragments and literary
descriptions suggest that the scheme included painted nude
figures, seated and standing (as here), contained within an
illusionistic architectural setting.

monumental figures set either in niches or in some other
architectural context. It was probably this commission
more than anything else which turned Venetian painters'
minds to the problems connected with the painting of the
human figure. The painters of the Fondaco were in part
taking on the rôle of sculptors and, in its original state, the
influence of the soft, reticent classicism of the Lombardi
sculptors must have been apparent. The same dignity is to
be found a little later in the superb paintings of female nude
figures by Giorgione, Titian and Palma Vecchio.

The influence of the Lombardo family is to be seen
also in the tendency at this time towards 'relief painting'.
Whereas the narrative style of the Bellini family relied for
its effect on enormous vistas in which the human element
tended to be lost, the new generations of painters reduced
this great expanse of setting by increasing the relative
size of the figures and bringing them to the front of the pic-
ture space. The figures thus came to occupy the first atten-
tion of the onlooker. There are several instances of this in
the early work of Titian, but the most exciting and revolu-
tionary is certainly his enormous altarpiece of the *Assump-
tion of the Virgin* painted for the Frari church in Venice
(*c.* 1517). Perhaps basing his scheme on Mantegna's
fresco of the same subject in the Eremitani church at
Padua, Titian emphatically arranged his apostles in a gestic-
ulating mass across the panel, shutting out the background
completely. The whole success of the painting rests on the
actions and gestures of the figures which it contains.

With the *Assumption* the traditional decorum of Venetian
painting was rudely shattered by the unprecedented
excitement and vigour displayed. No satisfactory explana-
tion of this sudden eruption has ever been found, but the
Assumption is so alien to previous Venetian taste that Titian
had presumably been inspired by some knowledge of works
of art outside the city, perhaps of Roman origin.

CENTRAL ITALIAN ART AND VENICE: 1500–30

During this time the extraordinary flowering of art in
Rome had already begun. The fame of artistic events at the
papal court had already attracted away two promising
young artists, Sebastiano del Piombo and Lorenzo Lotto,
and, although no other notable Venetian artists travelled
south at this time, a knowledge of events increasingly
trickled north. The way in which developments outside
Venice impinged on Venetian artists is part of the story
that now has to be followed.

In architecture and sculpture the course of events is
comparatively clear. The splendid creations of the Lom-
bardi had not led to any spectacular developments either in
architecture or in sculpture; and in both fields an un-
distinguished situation was relieved by the arrival of Jacopo
Sansovino from Rome, after the Sack of 1527. It was he
who built the first wholly classical buildings in Venice
(including the library of S. Marco) and introduced the
sculptural style of Florence and Rome. Thence till his
death in 1570 his influence in these fields was paramount.

96. **Titian.** *St Sebastian. c.* 1520. Pen and ink with wash.
7 × 4½ in. (18 × 11.5 cm.). Städelsches Kunstinstitut, Frankfurt.
This study is connected with an altarpiece painted for a church
at Brescia. It is clearly based on the work of Michelangelo, and
in its Venetian context is a figure of unprecedented power and
vigour. It was not for another two decades, however, that Titian
attempted to develop this figure style.

97. *Façade of the Palazzo d'Anna*, Venice. *c.* 1535. Drawing after
Pordenone. 16¼ × 22 in. (41 × 56 cm.). Victoria and Albert
Museum, London. Pordenone was undoubtedly one of the most
talented and ingenious illusionistic painters of the first half of the
16th century. One of his most famous façade decorations was
that of the Palazzo d'Anna which fronted on the Grand Canal.
The figures which appear to leap and tumble into the canal and
the figure of a god flying in above are all typical products of
Pordenone's ingenious and inventive nature.

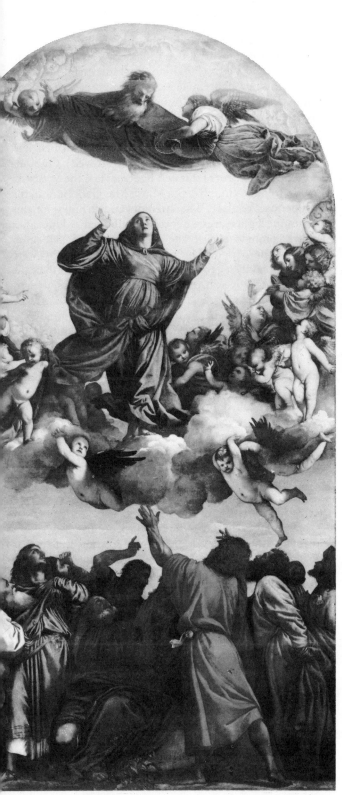

95. **Titian.** *Assumption of the Virgin.* 1516–18. Oil on panel.
27½ × 141¾ in. (690 × 360 cm.). Sta Maria Gloriosa dei Frari,
Venice. Titian may have been developing an idea first used by
Mantegna in the Eremitani chapel at Padua. In Venice the
vivid excitement of this work was without precedent and comes
as a considerable shock after the restraint of the
previous decades.

Jacopo Sansovino had been a friend of Bramante and Raphael. His figure style has great elegance and refinement, and it is perfectly understandable that it should have been acceptable to the Venetians. To begin with, at least, the work of Raphael and his followers exerted more influence than that of Michelangelo in the republic. The careful compositions and calculated delicacy of a painter such as Parmigianino presented a type of painting easily imposed on the reticent classicism of the first decade of the 16th century. Direct influence of Michelangelo's figure style is far harder to trace during the first forty years of the century and one particular instance illustrates well the type of problem involved. This is the figure of St Sebastian from Titian's altarpiece now in the church of SS. Nazaro e Celso at Brescia. This figure is deliberately plagiarised from the two slaves executed during the second decade of the 16th century by Michelangelo for the Julius monument (they are now in the Louvre); and it is to be presumed that the vivid muscularity, the twisted limbs and the general expressiveness fascinated the young Titian. But the resulting figure is almost monstrously overweighted for its position in the Brescia polyptych, and by its mass and movement disturbs the balance of the whole altarpiece. Although it is known that the figure of St Sebastian had great admirers when it was painted (1520), it is without parallel in Titian's career until the 1540s.

PORDENONE

There was, however, one Venetian artist who was also much impressed by Michelangelo's work and who made strenuous attempts to master and to use its vivid actuality. This artist, Pordenone, had obscure origins in Friuli. It seems probable that he had some direct experience of Roman art but, apart from a general taste for struggling muscular figures derived from Michelangelo, he also quite suddenly developed an extreme and shocking style of illusionism. His main work is only on a large scale in fresco; and from the surfaces of domes, flat walls and external façades Pordenone bombarded the spectator with masses of swirling, tumbling, bulky figures. A good example of this was a palace façade overlooking the Grand Canal. Like the Fondaco dei Tedeschi, this perished after a comparatively short existence, but is, fortunately, known through a drawing. Men and horses stumble out into the canal; a god flies in through an upper opening; the Roman hero Quintus Curtius, astride his charger, plunges outwards into the abyss. This façade was a very striking creation and it is not in the least surprising that Pordenone, if only by his shock tactics, acquired a reputation which, for a short time, rivalled that of Titian (Pordenone died in 1539).

THE PAINTING OF TITIAN FROM ABOUT 1540

During his lifetime Pordenone was an isolated figure, but immediately after his death essays in the assimilation of Michelangelo's style became more frequent. The leading

figure continued to be Titian but at this point (c. 1540–50) the scene was joined by two considerably younger men, Tintoretto and Veronese. Titian's first successful surviving essay in this new figure style was a scheme of ceiling decoration for the church of S. Spirito in Isola, Venice (1542–3, now in Sta Maria della Salute). He may have been coaxed towards this style by a successful precedent of Pordenone, an illusionistic ceiling in the Doges' Palace which had strikingly foreshortened figures (now destroyed). One outstanding monument of this new figure style is the *St John the Baptist* from the church of Sta Maria Maggiore (now in the Accademia, Venice). The strength and firmness of this statuesque figure are conveyed in subdued colouring, a feature common also to the ceiling paintings and other works of the period. The heaviness and plasticity were accompanied by a general reduction of the strength of the colouring, the overall tones tending to be dominated by blues, browns and greys.

This colouristic change in Titian's work was vitally important in the history of Venetian painting during the second half of the century; and it was accompanied by an equally important change in technique. Titian's working methods became broader and freer and the paint has greater fluidity. These changes have never been satisfactorily explained and perhaps they are best seen as the reaction of an ageing man (Titian was aged about 50) against a style which still had much in common with that of the early years of the century. Certainly at this point the vivid intense colouring common to Venetian artists, which with slight modifications had been in general usage since c. 1480, gives way to something more complex and frequently more sombre.

Since in its early stages the emphasis seems to have been on tone rather than colour, it is interesting that it was during these years that Titian painted his first known night scene (1548). The subject, the *Martyrdom of St Lawrence*, did not demand a night scene, but Titian used the subject as an essay in dark shadow, lit only by the flames of the fire, the surrounding torches and a beam of light from heaven. Thus all colouring was expunged from the scene, and the tonal unity of the work, based on the neutral colour of the shadow, is complete. For the next twenty years all Titian's works tended to have an individual tonal unity based on one or two particular colours. Within these limits the blending of complementary colours is often fantastically complicated but the final result is that every area of a picture has an equal strength. For example, forward areas and distant areas ceased to be differentiated in strength or type of colour.

The paintings in which this late style was developed included a number of mythological subjects, termed by Titian *poesie*, and commissioned by Philip II of Spain. The

(Continued on page 593)

82. **Jacopo Sansovino.** *The Library of S. Marco*, Venice. Begun 1537. This was the first large High Renaissance building in Venice, the façade being based on the external wall of a Roman theatre. Comparison with earlier buildings makes it easy to see how novel the classicism of Sansovino was when it first appeared in Venice.

83. **Vittore Carpaccio.** *View of the Doges' Palace and S. Marco.* Detail of the painting *The Lion of St Mark. c.* 1516. Paint on canvas. Doges' Palace, Venice. The façades of the chief palace in Venice date from *c.* 1309–1424. It is built in an ornate Gothic style and is partially faced in rose-coloured marble. The impression of colour was continued in the cathedral of S. Marco behind, where mosaics played a large part in the façade decoration. Against these the order and discipline of Sansovino's work (plate 82) appear very striking.

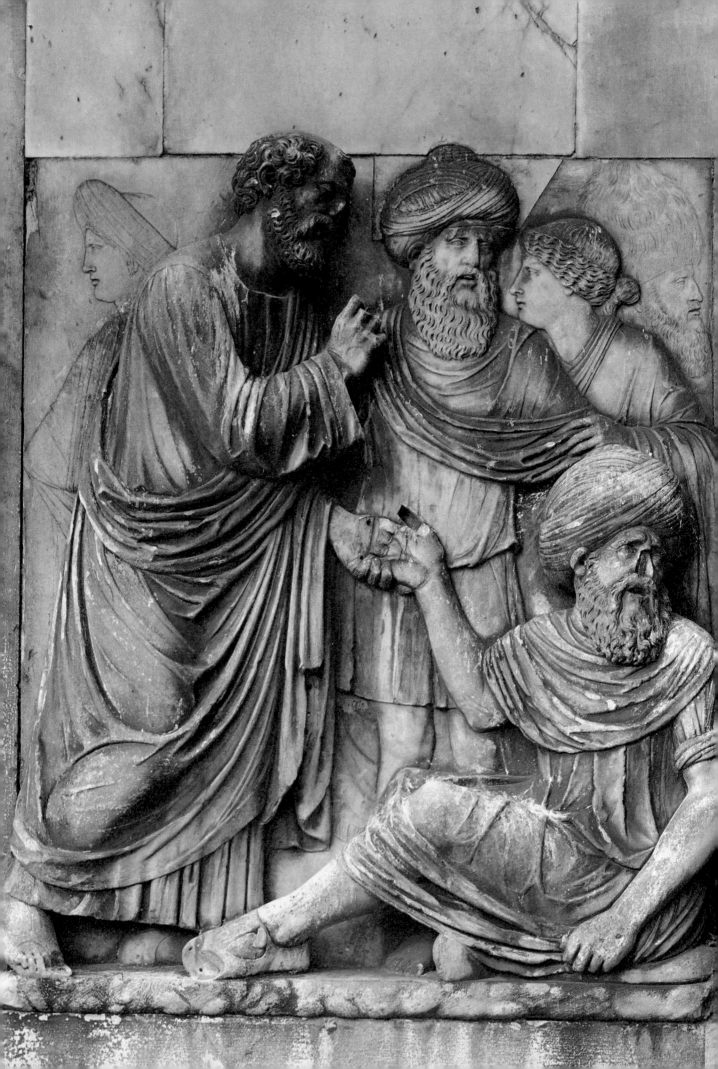

84. **The Lombardo workshop.** *A
Miracle of St Mark. c.* 1490. Detail from
the façade of the Scuola di S. Marco,
Venice. Perhaps by Tullio Lombardo
(see figure 87) these reliefs show a strange
combination of a classical drapery style
with oriental turbans. The drapery is
characteristic of the period; unexpected is
the total treatment of the wall surface with
its illusionistic space. The emptiness of this
space and the concentration on the events
of the narrative portrayed contrast
strongly with the normal approach of
contemporary painters (see figure 93).

85. **Jacopo Sansovino.** *Hermes.*
c. 1537–40. Bronze. h. 58½ in. (149 cm.).
Loggetta di S. Marco, Venice. Jacopo
Sansovino, the heir of Bramante as an
architect, was the heir of Raphael as a
figure sculptor. The four figures on the
Loggetta combine with the architecture
to form one of the most accomplished and
elegant compositions in Venice. Jacopo
Sansovino was the first High Renaissance
sculptor in Venice.

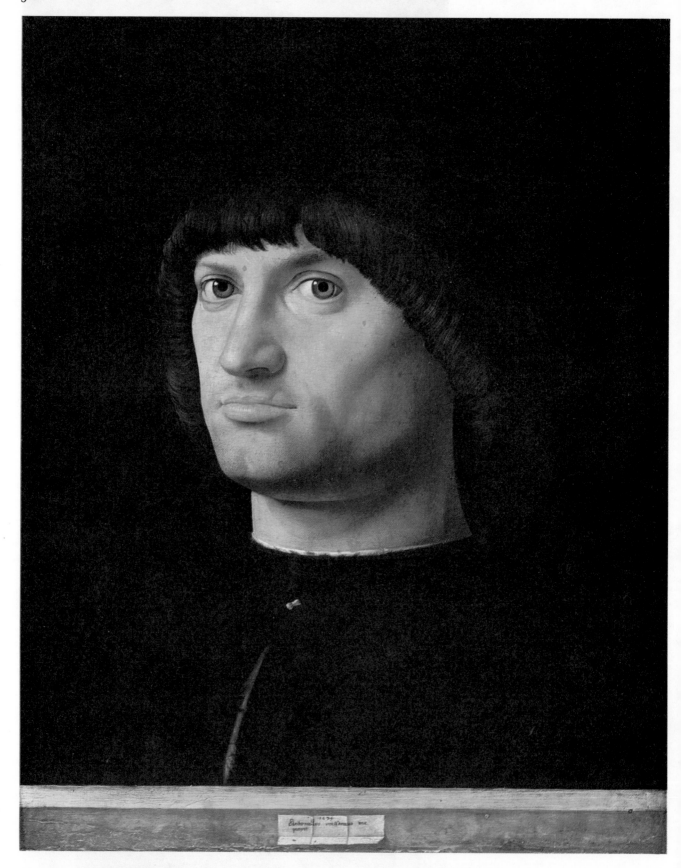

86. **Antonello da Messina.**
Il Condottiere. Dated 1475. Paint on panel.
13¾ × 11 in. (35 × 28 cm.). Louvre,
Paris. Antonello was one of the most
influential outsiders ever to visit Venice.
The effect of his work can be gauged from
plates 88 and 89. One of his most impor-
tant types of painting was the portrait,
where his use of light rather than line to
define form and detail is particularly
striking.

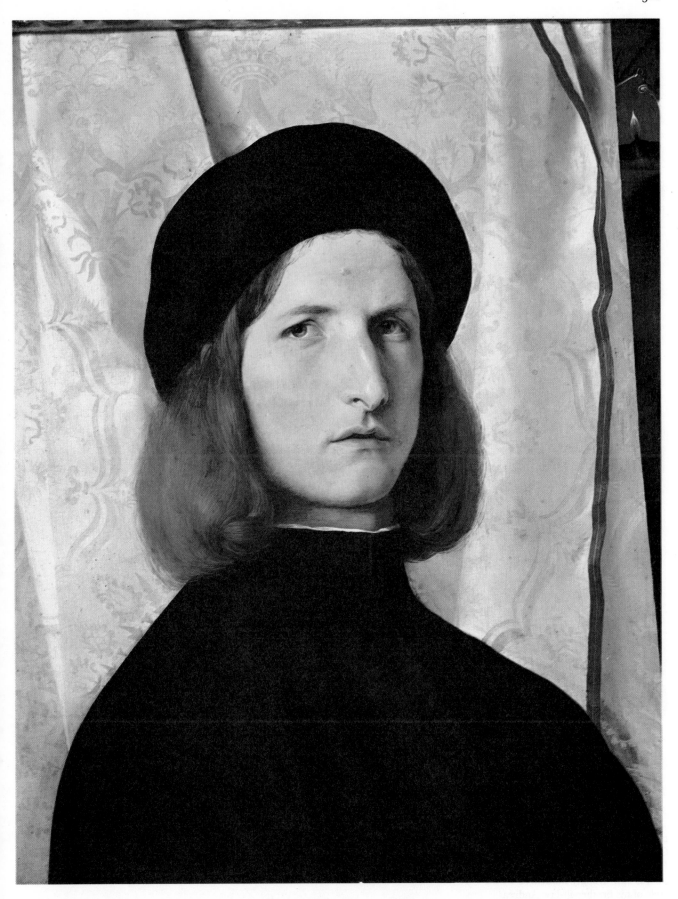

87. **Lorenzo Lotto.** *Portrait. c.* 1506–8. Paint on panel. 16½ × 14 in. (42.3 × 35.8 cm.). Kunsthistorisches Museum, Vienna. The effects of Antonello's style were still being felt in the early 16th century. Lotto, one of the most gifted of the young generation of Venetian artists, gave his portraits the brilliance and directness made popular by Antonello.

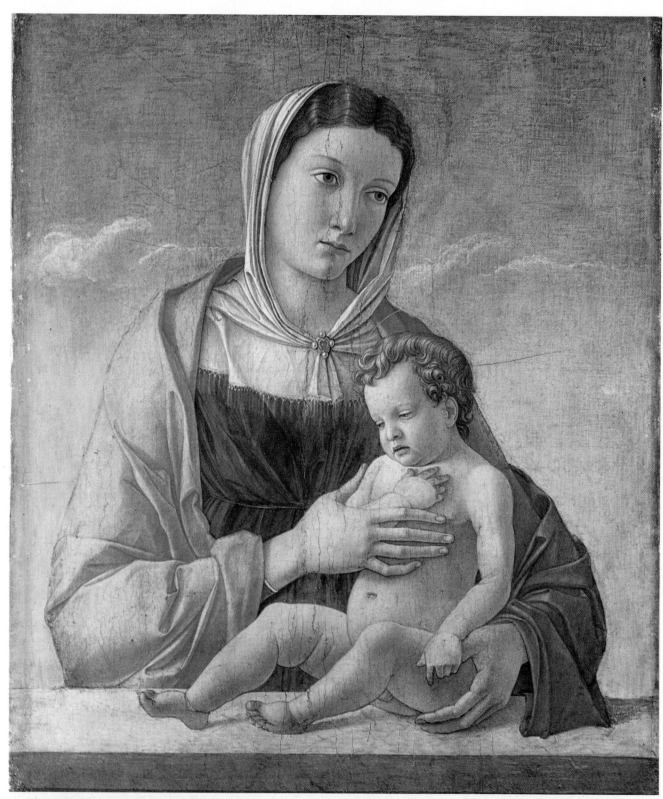

88. **Giovanni Bellini.** *Madonna and Child.*
c. 1465. Paint on panel, transferred to
canvas. 20½ × 17 in. (52 × 42.5. cm.).
Correr Museum, Venice. When Giovanni
Bellini painted this *Madonna and Child*
he was still strongly influenced by the
style of his brother-in-law Andrea
Mantegna. The painting of the Child, for
instance, is dry and linear and the folds
of the drapery are hard and clear. The
colouring is, however, gentle and the
blending of different shades of red
extremely delicate.

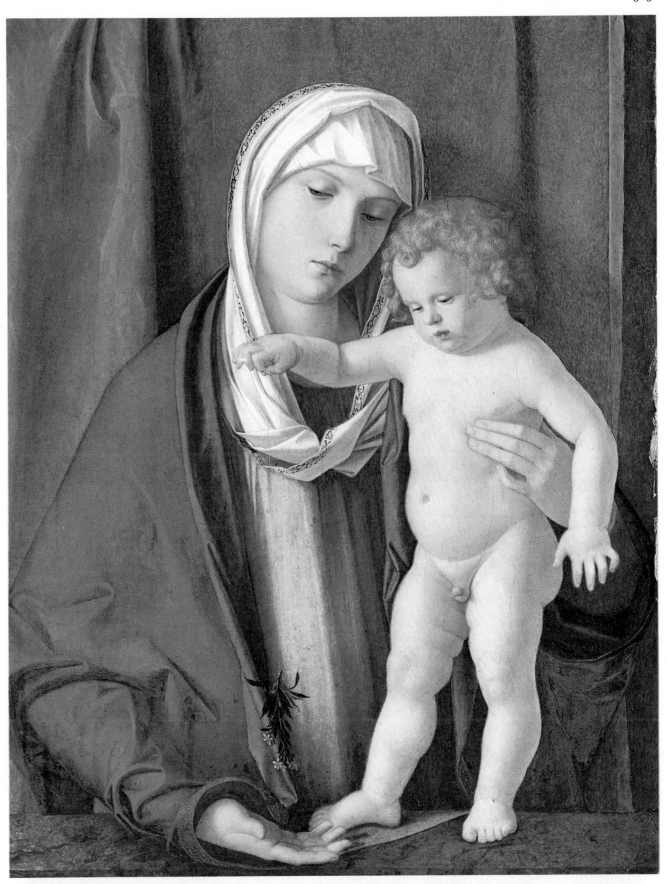

89. **Giovanni Bellini.** *Madonna and Child.*
c. 1480. Paint on panel. 25½ × 19 in.
(65 × 48 cm.). Burrell Collection,
Glasgow Art Gallery and Museum.
The change in style since the date

of plate 88 is most easily seen in the
treatment and use of light. It is noticeable
that the background is screened by a
curtain so that the light source can be
controlled. It is intresting that at about

the same time, similar experiments were
being made by the young Leonardo in
Florence. Here, in Venice, the impetus
seems to have come from Antonello da
Messina (see plate 86).

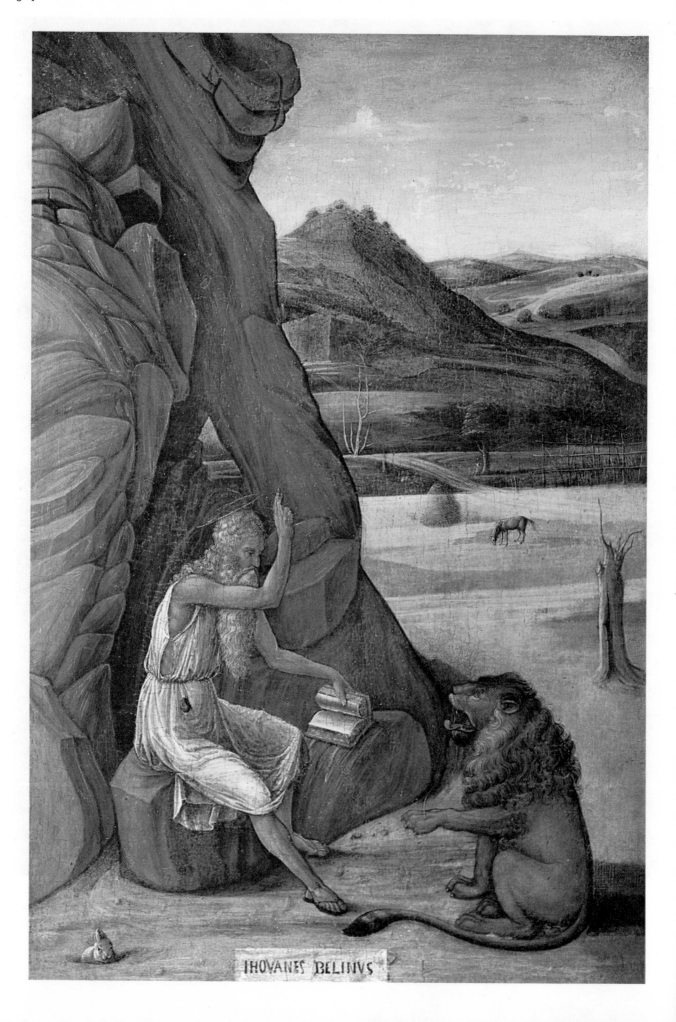

IHOVANES BELINVS

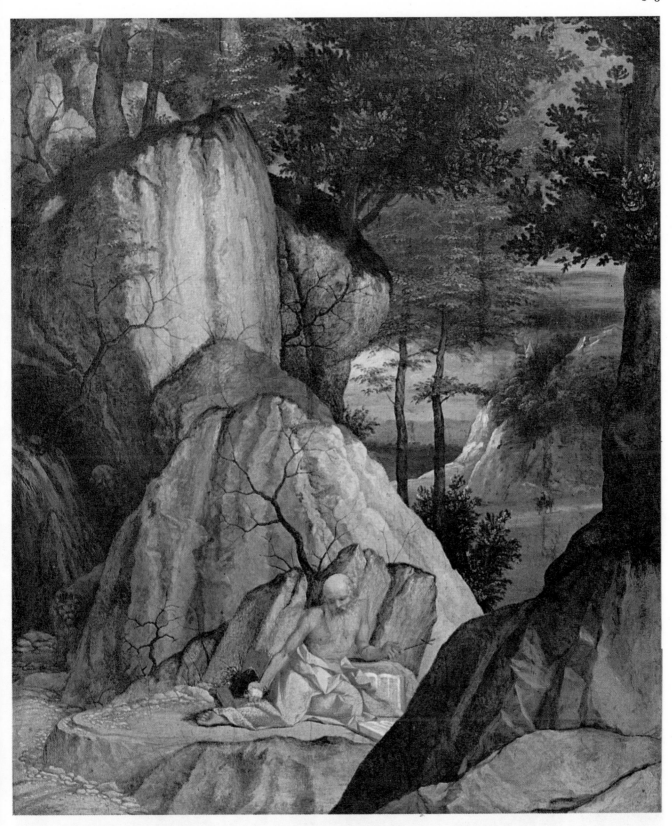

VENETIAN LANDSCAPE PAINTING

90. **Giovanni Bellini.** *St Jerome in the Wilderness. c.* 1460. Tempera on panel. 17¾ × 14 in. (45 × 35.5 cm.). Barber Institute of Fine Art, University of Birmingham. One of Giovanni Bellini's earliest undated works and closely related to the drawings of his father, Jacopo. The sensitivity of the landscape and the

radiance of its lighting and colouring are part of an older tradition which can be seen at work in the painting of Gentile da Fabriano.

91. **Lorenzo Lotto.** *St Jerome in the Wilderness. c.* 1506. Paint on panel. 18¾ × 15¾ in. (48 × 40 cm.). Louvre, Paris. The evocative character of Venetian landscape painting is famous (see also

plate 92) and was greatly enhanced by the new insight into the use of light derived from the work of Antonello. Giorgione's *Tempesta* (figure 92) is the most famous example of the early 16th century, but this small panel of Lotto is hardly less creative with its suggestion of barren solitude.

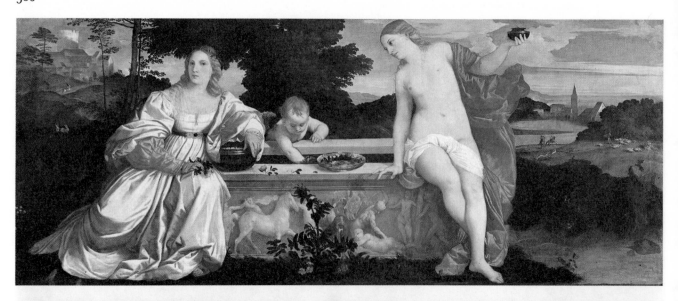

92. **Tiziano Vecelli (Titian).** *Sacred and Profane Love. c.* 1515. Paint on canvas. 46¾ × 111 in. (118 × 282 cm.). Borghese Gallery, Rome. Perhaps the most famous, although not the first female studies of the Venetian High Renaissance. The relief-like composition is notable, set against a remarkable romantic landscape.

93. **Jacopo Robusti (Tintoretto).** *The Finding of the Body of St Mark. c.* 1562. Paint on canvas. 159½ × 159½ in. (405.2 × 405.2 cm.). Brera, Milan. Originally in the Scuola di S. Marco, this belongs to the same class of painting as much of the work of Carpaccio. The concentration of dramatic interest which has taken place is clear. Note also Tintoretto's dramatic use of light.

94. **Paolo Caliari (Veronese).** *The Mystic Marriage of St Catherine. c.* 1560. 148½ × 95¼ in. (377 × 242 cm.). Accademia, Venice. One of Veronese's most sumptuous altarpieces, this painting is in sharp contrast to the work of Tintoretto. Veronese's love of bright colours, costume and beautiful architecture link him with the earlier tradition of Carpaccio and Gentile Bellini.

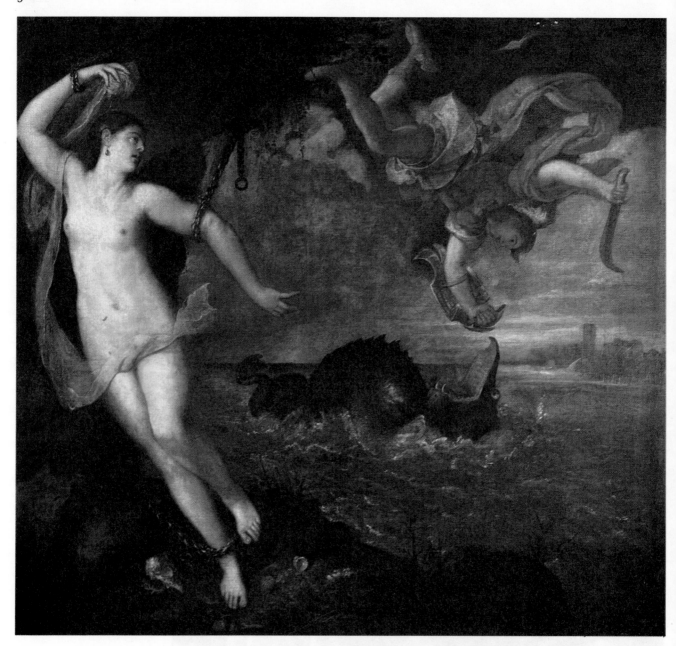

95. **Titian.** *Perseus and Andromeda. c.* 1560. Paint on canvas. 70½ × 77¾ in. (179 × 197.5 cm.). Wallace Collection, London. One of a group of works dispatched to Philip II of Spain. Comparison with plate 92 will show the intervening change in Titian's style. The painting is given a general colour tone which unites all parts of the work. The figure elements of the narrative became shapes within this colour construction.

96. **Tintoretto.** *The Ascension. c.* 1576–81. Paint on canvas. 211¾ × 128 in. (538 × 325 cm.). Scuola di S. Rocco, Venice. Part of Tintoretto's most famous undertaking (see figure 99), this makes an interesting comparison with the earlier work of Titian (plate 95). Both artists have a fully mastered figure style and both use figures as shapes to be disposed within a surface pattern with only a secondary regard for depth. Tintoretto's result is consciously extravagant and dramatic, with its extremes of brilliance and shadow and sudden changes of figure scale.

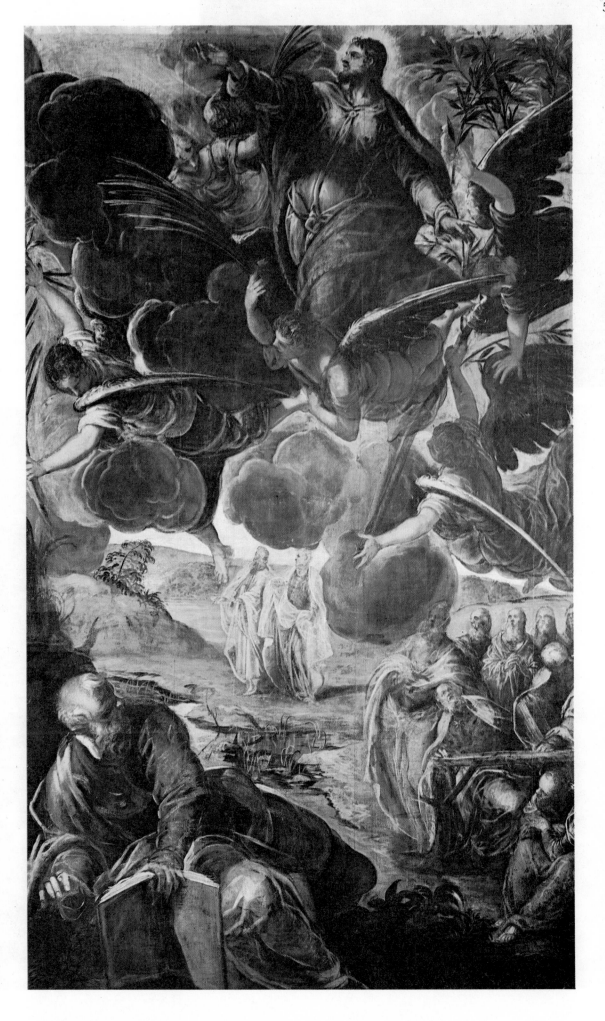

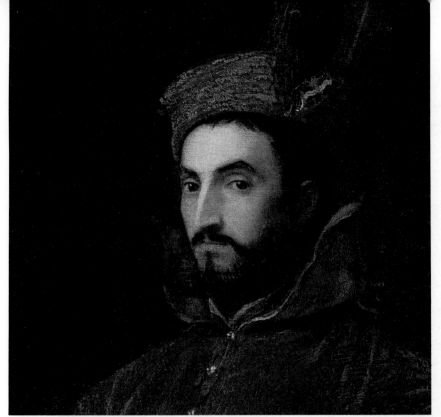

97. **Titian.** *Ippolito de' Medici* (detail). *c.* 1533. Paint on canvas. 54¼ × 41¾ in. (138 × 106 cm.). Pitti Palace, Florence. Part of one of the portraits from Titian's middle period. The costume, so important in this type of portrait, is said to be Hungarian, recording a military expedition of Ippolito. The image is proud, arrogant and withdrawn and must surely have been very flattering to the sitter.

98. **Lorenzo Lotto.** *Andrea Odoni.* Signed and dated 1527. Paint on canvas. 44¾ × 39¾ in. (114 × 101 cm.). Royal Collection, Hampton Court. Unlike the portraits of Titian, up to *c.* 1540, Lotto's are seldom reserved or withdrawn. Here the well known collector, Odoni, offers part of his collection to the spectator for inspection.

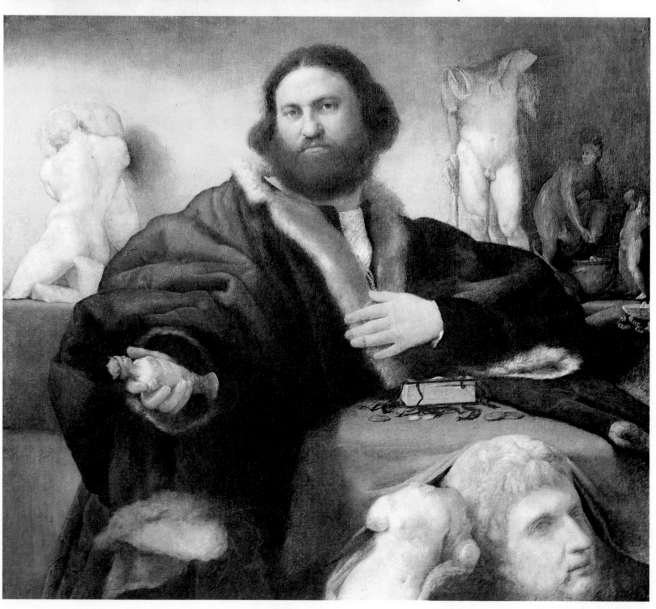

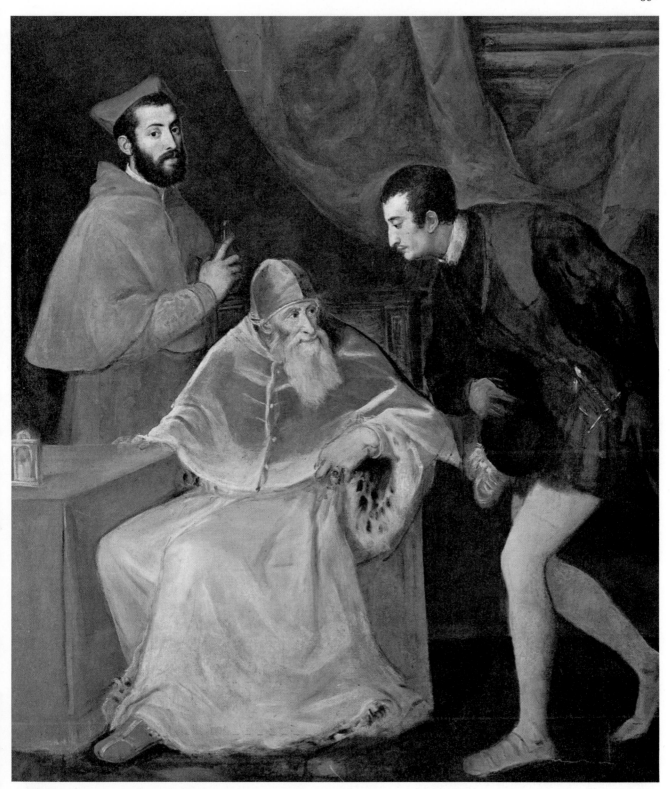

99. **Titian.** *Pope Paul III with his Nephews
Alessandro and Ottavio. c.* 1546. Paint on
canvas. 83 × 68¾ in. (200 × 127 cm.).
Galleria Nazionale di Capodimonte,
Naples. One of the most extraordinary
pieces of artistic licence in art history, in
which a senile pope turns towards an
obsequious nephew. Large areas of
drapery were never finished and it has
been conjectured that the Farnese family
objected to the work. This style of
portraiture is a long way from the flattery
accorded to Ippolito de Medici (see
plate 97).

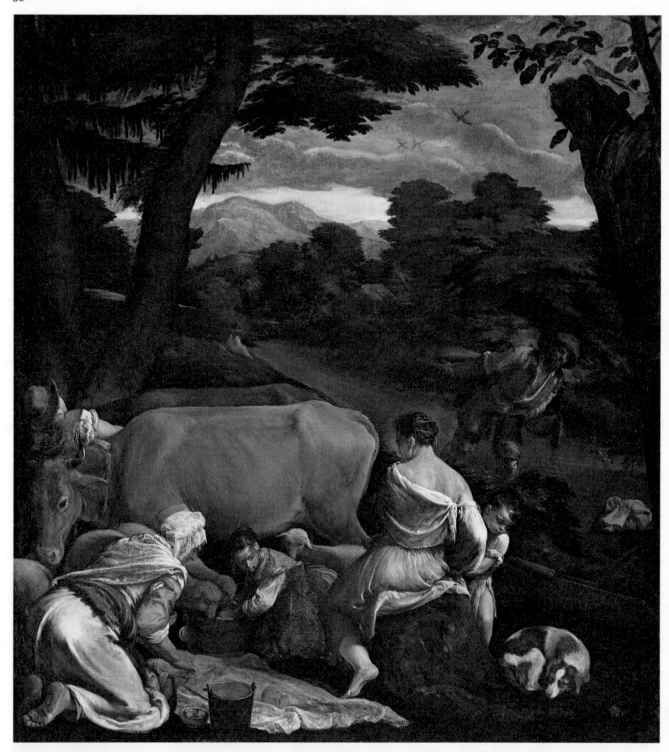

100. **Jacopo da Ponte (Bassano).**
Pastoral Scene. Paint on canvas. 54½ × 50¼
in. (138.5 × 127.5 cm.). Thyssen-Borne-
misza Collection, Switzerland. Jacopo
Bassano lived most of his life at Bassano.
His style was closely linked to the
metropolitan style of Venice, and his
characteristic works of pastoral subjects,
painted in dark tones with brilliant white
lights, date from the 1550s onwards.

series, now scattered among numerous collections, illustrates the full range of Titian's development between 1550 and 1560 and demonstrates in addition how he finally absorbed the contrasted figure styles of Michelangelo and Raphael's followers (particularly Parmigianino).

PORTRAITS

During the years in which these major changes were taking place in Titian's figure style and approach to colour, it is not surprising that other changes are apparent, particularly in his portraiture. Titian from his earliest years was a brilliant portraitist and his work quickly became fashionable among the Italian princes. A typical portrait of the 1530s, that of the cardinal Ippolito de' Medici in Hungarian costume, shows a proud self-assured aristocrat in richly coloured clothing—a picture of the cardinal as he undoubtedly would have liked to see himself. This attitude to his sitters Titian replaced during the 1540s by a more personal interpretation of the subject seated in front of him. The climax of this was the unfinished triple portrait of Pope Paul III and his two nephews. The seated pope is shown as a senile old man attended by two shifty and obsequious relatives. In general Titian's portraits of the 1540s are among his most powerful and penetrating creations. They include two contrasted studies of his friend Pietro Aretino and a number of other portraits painted in Rome and during his visits to the imperial court at Augsburg. Of all these the portrait with the most important influence was his equestrian study of Charles V; indeed centuries of subsequent equestrian portraiture have perhaps obscured the curiously personal character of this vision of the ageing emperor galloping in full armour through the totally deserted and utterly romantic landscape of the Veneto.

Lack of space has made it impossible to deal adequately with Italian portraiture. Its introduction at this stage does not mean that Venetian portraiture determined the course of portraiture in the remainder of Italy. Unquestionably the most influential portraitist during the first twenty years of the century was Raphael. Titian, who imitated Raphael prototypes in his portraits of Paul III and his Farnese nephews, was not alone in following Raphael's lead. Raphael set new standards for court portraiture and much of the subsequent development of portraiture in Italy followed indications already suggested by him. Alongside Titian there existed a considerable number of other Italian portrait painters, many of whom have already been mentioned in other contexts—Rosso Fiorentino, Pontormo, Parmigianino, Bronzino and Salviati among them. Indeed in Venice itself other talented portrait painters were also active; and although Titian alone had an international reputation the more intimate personal style of Lorenzo Lotto and Palma Vecchio is worth mentioning. A painter of inspired technique but unpredictable invention, Lorenzo Lotto achieved some of his greatest results in this type of work.

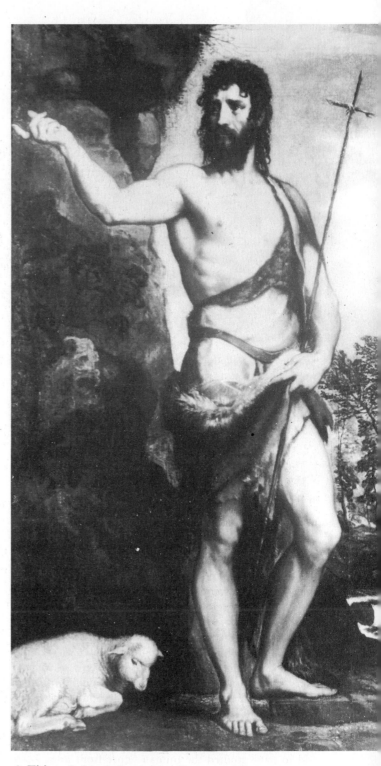

98. **Titian.** *St John the Baptist* (detail).*c.* 1542. Oil on canvas. 79 × 52¾ in. (201 × 134 cm.). Accademia, Venice. Formerly in Sta Maria Maggiore. Perhaps Titian's greatest essay in a Michelangelesque figure style. The calm gesture and noble proportions are extremely impressive. This work forms part of a general change in the Venetian painters' attitude towards figure painting and their general acceptance of many of the characteristics of central Italian art.

99. *The Upper Hall*, the Scuola di S. Rocco, Venice. The Scuola was built between 1517 and *c.* 1545. The painted decoration of the interior is entirely by Tintoretto who worked there spasmodically from 1564 up to 1587. The Upper Hall was decorated 1576–81. This Scuola is the only one to survive with its decorative schemes intact, illustrating the splendour and sumptuousness of Venetian public buildings. It is remarkable how well the flashing colour of Tintoretto's canvases blends with the heavy gilded woodwork of the ceiling.

TINTORETTO

In the whole field of Venetian painting the years around 1545 saw fundamental changes. In 1548 a newcomer made his first public appearance in a painting for the Scuola di S. Marco. His name was Jacopo Robusti, called Tintoretto; and the painting was of one of the miracles of St Mark, *The Miracle of the Slave.* From the outset Tintoretto committed himself to a dramatic and bold style in which his main intention was generally to force the spectator into some form of subjective emotional involvement. To this end all means were used including lighting and shadow, and an emphasis on the human figure unprecedented in Venetian art apart from the works of Titian of the 1540s, as we have seen. Tintoretto's earliest biographer, Ridolfi, writing in the next century, related both how he admired Michelangelo and how he was accustomed to experiment with lighting by using miniature stage sets inside boxes, in which the lighting could be controlled. Tintoretto was also said to have studied the human figure from unexpected angles by suspending small clay models in the air. Naturally the results of these experiments do not all suddenly appear in the same painting; but the theatrical nature of another work for the Scuola di S. Marco, *The Finding of the Body of St Mark*, must surely have resulted from such experiments.

Tintoretto had very little use for settings as objects of intrinsic interest, thus dividing himself from a recurrent feature of the Venetian pictorial tradition. Settings are the 'outer casings' designed to contain the drama within. Indeed throughout much of his greatest work, the decoration of the Scuola di S. Rocco, interest in the natural or architectural settings is extremely perfunctory. Space as a compositional device is almost eliminated, the constant tendency being to arrange the figures in a strong pattern across the surface of the canvas, regardless of their presumed depth in space. Titian had already gone some way towards this conception in his *poesie*, but on the whole Tintoretto's colouring—perhaps influenced by the dark tonality of some of Titian's work—has none of the gentleness of the *poesie*. Tintoretto's technique of contrasting areas of deep shadow with intense colour may have been designed for the physical setting in which his canvases were to be placed—a setting of dark wooden panelling relieved only by ornate carving and ponderous gilding. Certainly the deep shadows of Tintoretto's painting blend perfectly with this framework, while the coloured shapes take up the decorative rhythms of the gilded wood-carving. The work is divided between three rooms, and in the main room on the first floor Tintoretto's approach to space becomes most arbitrary. Thus he juxtaposes tiny distant figures and enormous foreground figures, a device which discourages any attempted spatial comprehension by the spectator.

100. *The main salon, Villa Barbaro*, Maser, near Castelfranco. Built by Palladio; decorated by Veronese *c.* 1559–60. Vernonese's feeling for beautiful architecture is well illustrated by the painted architecture of this cruciform room. Through the painted arches are seen fantastic painted landscapes so that within the house one is constantly reminded of the purpose of a villa as a country retreat.

101. **Jacopo Sansovino.** *Neptune.* 1554–67. Doges' Palace, Venice. The pair of figures of which this is one were among the earliest gigantic statues to be executed in Venice. To this extent Venice lagged behind Florence where the taste for colossal nude figures went back at least as far as the *David* of Michelangelo (see figure 45). Sansovino's touch is visible in the closely contained outlines and movement of the figure.

VERONESE

Tintoretto was, in a sense, a history painter first and a decorator second. There is little sensuous enjoyment to be felt in front of most of his painting because the subject-matter was so intensely felt and portrayed by the artist. The decorative quality of these S. Rocco paintings is of a highly specialised kind, as though Tintoretto had forced his intensely dramatic style into a decorative role. However, at the same time in Venice there lived another major artist whose work is so consciously decorative that dramatic action is either avoided or is so artificial as to be unbelievable. This artist was Paolo Veronese, who at the age of about twenty was already engaged in the decoration of villas and country houses. Regardless of the subject on which he was engaged, his work always remained that of a decorator at the highest level of genius. In almost every respect his painting differed from that of Tintoretto. He painted many large and brilliant altarpieces, a type of work to which Tintoretto was seldom attracted. He avoided scenes of emotional or dramatic content and will almost certainly be remembered for his series of 'supper scenes' (*The Last Supper, Christ in the House of the Pharisee* and others) in which a magnificent architectural setting is filled out with all the paraphernalia of a rich man's household —servants, friends, animals, guards and so on.

Unlike Tintoretto, Veronese dwelt lovingly on architec-tural detail. He often worked in collaboration with architects such as Michele Sanmicheli of Verona, or Andrea Palladio; and one of his greatest decorative schemes was the interior decoration of the Palladian Villa Barbaro at Maser (near Castelfranco). Here his appreciation of beautiful architecture was given full play because much of the decoration consists of a painted architectural scheme superimposed on the plain bare wall-surfaces of the rooms.

Veronese's emphasis on detail strongly recalls the history paintings of the Bellini and Carpaccio; although the figure style is totally different, the range of interests is similar enough to suspect that both artists catered for a permanent aspect of Venetian taste. There is a further affinity in colouring. Unlike the mellow tones of Carpaccio's work, Veronese's painting has a silvery appearance. But both laid great emphasis on colour itself in dress and costume as a decorative element; and for Veronese the deep shadows common in Tintoretto's style were not allowed to intrude and to destroy this festive and brilliant impression.

BASSANO

Of the many secondary painters belonging to this Venetian tradition, one of the most interesting is Jacopo da Ponte, who is generally known, after his home town, as Bassano. He lived a large part of his life there; but he was trained in

102. **Alessandro Vittoria.** *St Jerome*. Before 1568. Marble.
h. 75½ in. (192 cm.). Sta Maria Gloriosa dei Frari, Venice.
Part of an altar erected by the Zane family, of which large parts
have since been destroyed. The composition of this figure is
such that it can never have blended with any architecture but
must always have appeared as a violent actor on a stage.

Venice (*c*. 1530) in the workshop of a lesser artist Bonifazio
de' Pitati and during the course of a long life (he died in
1592) the series of major changes in his style always re-
flected artistic ideas current in Venice. Thus, a style
modelled on Bonifazio was succeeded *c*. 1540 by a stylistic
phase much influenced by Pordenone; and it was only after
this (during the 1550s) that he began to paint in his more
familiar manner with dark tones offset by brilliant white
highlights and flashes of radiant colour (certainly under
the influence of his contemporary, Tintoretto). What might
have been an undistinguished provincial career was re-
lieved by the production of a large number of paintings of
a particular kind—those scenes of rustic life linked loosely
to a Biblical subject, with which Bassano's name is now
generally associated. These detailed paintings of peasants,
animals, fruit, vegetables and other rustic objects, distantly
reminiscent of the contemporary work of Breughel, were
unusual and made Bassano famous in his own day. Already
by the 1560s they were becoming collector's pieces.

VITTORIA

The change which overtook Venetian painting during the
1540s also affected sculpture. The Venetians developed a
taste for colossal statuary and, following the commission of
a statue of *Neptune* for the Piazza S. Marco (*c*. 1544, lost),

the Venetian senate commissioned Jacopo Sansovino to
carve two great figures representing *Mars* and *Neptune* for
the Doges' Palace (1554). Standing on the main staircase
in the courtyard of the palace, these figures are very
impressive. They show that Sansovino still exercised the
closest control over his compositions, even on an heroic
scale and in a commission free of architectural restraint.
The figures have a closely contained silhouette, and it is
this compact nature and the frontality of their poses which
produces their dramatic impact on the spectator.

Jacopo Sansovino was accustomed to employ a large
number of assistants. Buildings such as the library of
S. Marco were intended to be decorated by quantities of
figure sculpture which Sansovino, as a matter of course,
left to his assistants. One such assistant was Alessandro
Vittoria, a sculptor from Trento who arrived in Venice in
1543 and was destined to become the most distinguished
sculptor working in Venice during the second half of the
century. To call him a pupil of Sansovino would be mis-
leading; they certainly quarrelled, and the young Vittoria,
about 40 years junior to Sansovino, found his true inspira-
tion in the work of Michelangelo. His style was opposed in
many ways to Sansovino's, and the sources of his inspiration
are to be sought in the sculpture of the Julius II monument
rather than the Loggetta or the Doges' Palace. In particular
the Michelangelo *Slaves* seem perpetually to have fascinated
Vittoria. These, it will be recalled, had been known to
Titian as early as 1520 while he was working on the Brescia
altarpiece; but there the *St Sebastian* had been an isolated
essay in a Michelangelesque style. Vittoria constantly
returned to the contrasted compositions of the two *Slaves*,
and these influenced the form which several of his most
notable works were to take. It is not therefore surprising
that his style of sculpture is very different from that of
Sansovino; sculpture for Vittoria was not something to be
contained within the main outlines of its architectural
setting. Instead, in a manner similar to Michelangelo's
intentions for the sculpture of the Julius II monument, his
statues move in front of the architecture with a vigour and
freedom, setting up rhythms which are frequently in
contrast to their setting.

16TH-CENTURY ARCHITECTURE IN THE VENETO

Jacopo Sansovino and the Veronese Michele Sanmicheli,
two of the most important 16th-century architects working
in the region controlled by Venice, came north after the
Sack of Rome in 1527. Both had spent many years there
and both were completely familiar with the architecture of
Bramante and his successors. In some sense the architecture
of both formed a commentary on that of Bramante for, like
Raphael, both showed in different ways how the austerity
of Bramante's work might be enriched and enlivened.
Amongst other work in Verona, Sanmicheli designed three
palaces, each of which is based on the design of the Casa di
Raffaello in Rome. But in each the architectural decora-
tion is significantly varied and augmented.

This increased surface richness is also to be found in the work of Sansovino. His most notable Venetian building, the library of S. Marco (begun 1537), is not based immediately on any building by Bramante; the tiers of arcading are closer to the Roman Theatre of Marcellus. But the amount of carved decoration is striking; and the carved swags of flowers and fruit along the upper frieze are reminiscent of the stucco decoration on Raphael's Palazzo dell'Aquila. Nevertheless, although Sansovino was an ingenious manipulator of classical architectural motifs and decorative ideas, his architecture retains an august three-dimensional gravity.

Of all later 16th-century Italian architects Andrea Palladio was probably the most influential. For in 1570 he published *I Quattro Libri dell' Architettura*, a work which is more scholarly and extensive than any other 16th-century Italian treatise on architecture; but besides Palladio's ideas they also contained his original work, for most of the buildings for which he was responsible are illustrated. In his youth he visited Rome in the company of a humanist called Trissino, and there in 1540–1 made a thorough study of the antique remains. However, most of his life was spent in Vicenza where much of his work is to be found. He also worked in Venice, and the church of S. Giorgio Maggiore, set on its island opposite the Doges' Palace, is probably his most familiar building.

Palladio drew upon a wide variety of sources. He admired the symmetry and order of Bramante's work but, after the manner of Bramante's successors, his work is carefully enlivened by a limited amount of sculptural decorations. As a whole his work was so judiciously balanced and consistent that it still appeals to architects.

Palladio's fame rests also on his splendid series of villas. The villa, as an architectural commission, was a comparatively recent arrival on the scene. The idea of the villa was certainly publicised by Alberti in the 15th century, but the actual building of villas depended on the realisation of patrons that it was now possible to have a country retreat which was not also a fortified castle. In the years around 1480 the Medici family built the famous villa at Poggio a Caiano which must have been among the earliest buildings of this type. Nevertheless there were different types of country retreat; some, like the Palazzo del Tè, were very close to the city; others, built at a considerable distance, were based on family farm property for the supply of provisions and necessities. Palladio constructed both, but the majority belong to the second, more rural, variety. Both Sansovino and Sanmicheli had designed villas; and it was from the Villa Soranza of Sanmicheli (1545–55, destroyed) that Palladio took one of his most characteristic ideas, that of building projecting wings stretching out from the main block. These wings were normally used to connect the main block with the outbuildings; but subjectively they seem to reach out and to embrace the countryside in which the building stands.

The formal satisfaction given by Palladio's villas derives chiefly from their symmetry. This is often aided by the placing of a classical portico with columns and pediment across the main front of the central block. Once, in the Villa Rotonda, Vicenza, the idea was repeated on all four sides of the house, giving an effect of complete symmetry and perfect balance. The classical portico perhaps gives his villas the appearance of timeless grandeur and elegance; it was certainly the feature most frequently exploited by the Palladian imitators of 18th-century England.

CONCLUSION

The 16th century was the century not merely of the Renaissance but also of the Reformation. Some mention has already been made of the Counter-Reformation and its effects on art. These effects were real in Italy, particularly in art associated with the Society of Jesus (founded 1540). It may be asked, therefore, whether the Reformation had comparable effects. But the nature of the various religious movements which made up the Reformation was such that its effects were totally different. The decrees of the Council of Trent which embody much of the essence of the Counter-Reformation were at least concerned with the reform of the content of ecclesiastical art rather than its destruction. But the reformed Churches of Luther and Calvin found themselves against so much of the very content of traditional religious art that they had no option but to destroy it. Thus many forms of art connected with religious observance —for instance, altarpieces, stained glass or carved images— ceased to be required altogether in those areas which in the 16th century came ecclesiastically to be controlled by a reformed Church. This, however, merely produced the negative result that artists had to make a living from those secular branches of their profession which were still permissible. It was still possible to paint portraits and genre paintings, to carve garden decorations and public monuments and to build palaces and town halls.

Some artists are known to have had reformist sympathies or to have been in touch with men of known reformist sympathies. This applies to many of the great northern painters *c.* 1525 and includes such men of widely differing styles as Dürer who, in spite of his appointment as court painter to the emperor, knew Luther and was also a friend of Erasmus, Holbein who lived much of his life at the Protestant court of England and also knew Erasmus, Cranach, court painter at the Protestant court of Saxony, and Grünewald who appears to have had Lutheran inclinations. Yet there seems little common ground between these artists to suggest 'Reformation characteristics'; and while the painting of Grünewald may seem to suggest psychological disturbance, there is nothing to prove that this disturbance can be interpreted directly as a 'sign of the times'.

Many writers have tried to summarise the character of the Renaissance world. In art, the changes may be seen as an abandonment of a Gothic style and a transition to one based on antique precedent. Many great changes can

103. **Michele Sanmicheli.** *Palazzo Bevilacqua*, Verona. *c.* 1530.
The design of this palace was based on Sanmicheli's recent
Roman experience, particularly the Casa di Rafaello
(see figure 54). Sanmicheli has, however, varied the ornament
considerably, adding embellishments to suit his own taste and
possibly that of a client who wished for a more sumptuous
appearance.

104. **Andrea Palladio.** *Villa Barbaro*, Maser, near Castelfranco.
c. 1550–60. This is perhaps Palladio's most serene and successful
country villa. The wings of the plan (which actually contain out-
houses) seem to stretch out to embrace the countryside. Inside
(see figure 100) one is continually reminded of the presence of the
countryside and of the open air through the fresco decorations of
Veronese.

be seen in other fields of human activity; indeed, if any
particular period of history merits the title 'transitional'
more than any other period, the 15th and 16th centuries
must have a high claim to consideration. The consolidation
of new nation states in France and England, the ultimate
feebleness of the Holy Roman Empire as an effective
political institution; the religious protest of Luther, the
growth of Protestantism and the disappearance of a
Universal Church; the geographical discoveries of the
Portuguese and Spaniards; the astronomical theories of
Copernicus and Galileo—all these fall within the years
1400–1600 and run parallel to the re-evaluation of the
culture of classical antiquity.

The main subject here has been the 'classical revival'. Of
this expression, the word 'revival' is worth emphasis since
this was a new element in Western art. In discussing the
impact of Italian art on the North, it was suggested that one
of the advantages of Italian art was that it had a specious
semblance of 'rightness' when compared with other styles.
This was almost entirely due to the fact that it was essentially
a revivalist style with an august body of literature and
monuments as a court of appeal to back it. Not all the genius
of Michelangelo, Raphael and Bramante can hide this
aspect of the Italian Renaissance. The spread of classicism
committed Europe to three hundred years of revivalism in
art from which it only began to emerge at the end of the
last century. Whether this was good or bad is obviously
immaterial; it happened, it was a new phenomenon, and it
emerged within the period covered by this section of this
book.

The years around 1400 had a certain convenience as a
beginning to this section since the pervasive International
Gothic style provided some sort of common point of
departure for European art. It would be extremely difficult
and indeed rash to attempt to present as tidy a picture of
art in 1575. No comparable state of affairs existed. For
whereas by 1630 most European countries had devised a
classicising idiom of their own which gave a semblance of
unity to European art comparable with that which it had
possessed in the 14th century, in the 16th century this was
still very far from being the case. It is at this point, there-
fore, that the reader must pass on to the 17th century.

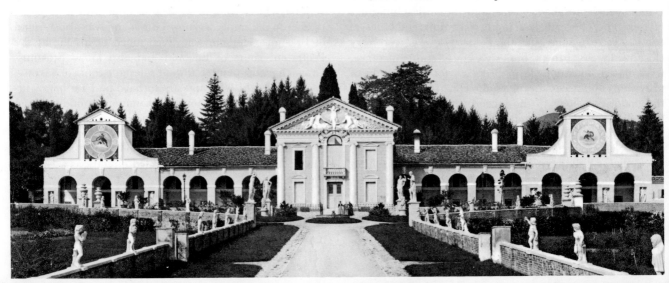

THE
AGE OF BAROQUE

Introduction

The numbers in the margins refer to the illustrations to The Age of Baroque: heavy type for colour plates, italics for black and white illustrations.

RENAISSANCE AND BAROQUE

The period known as the Baroque, which comprises broadly the 17th and 18th centuries in European art, was the intermediate phase between the Renaissance and the Modern Age. In a sense it was the Renaissance enacted over again. Viewed with hindsight it appears as a repetition with variations of what had preceded it, a renewal of creative activity on the same lines as before, a second revolution of the same wheel.

Like all phases of art, the Baroque went through a sequence of rise, climax and decline. But the resemblance to the Renaissance goes further than that. Baroque and Renaissance artists were faced with essentially the same kinds of task and worked largely for the same patrons: the court, the aristocracy and the Church. In this book we shall meet chiefly the same types of work of art as had characterised the Renaissance: in architecture, churches and palaces; in sculpture, life-size marble statues made for altars, tombs and public squares or gardens; in painting, idealised figure compositions representing subjects from the Bible, classical history and mythology.

Like the Renaissance, the Baroque was dominated by the work of great artists. The equivalents of Leonardo da Vinci, Michelangelo, Raphael, Titian and Dürer in the one period are Bernini, Poussin, Rubens, Rembrandt, Velasquez and Tiepolo in the other. More than this, both groups of artists shared many of the same basic aesthetic attitudes and looked back—the second partly through the eyes of the first—to the same source of inspiration: the Antique. Classical art, which meant chiefly the architecture and sculpture of ancient Rome (not Greece), is an almost constant factor in the background of the works of art to be discussed in this book. Its relationship to the Baroque is symbolised in the etching by Piranesi illustrated as figure 1.

Yet, as we watch the wheel turn and the sequence of styles come round again, we notice, as we should expect, important differences as well as similarities. In the first place, almost everything is pitched in a higher key, the tone is more florid and colourful, the textures are richer, there is more decoration, more light and shade, apparently less control. The lyrical refinement characteristic of Renaissance art is not often found; where there is restraint, it is apt to appear as severity. There is also sometimes deliberate striving after effect.

In the second place, the baroque period was accompanied by an expansion of art on all fronts, in its geographical limits, in its patrons and in its categories. It was not so much that the centre changed from any of these points of view (although Paris replaced Rome as the artistic capital of Europe almost half-way through the period) as that the fringes became more important. The spread of art can be seen in the rise or revival of national schools in France, Spain, Holland, England and Central Europe. These all contributed far more to the Baroque than they had to the

Renaissance, which had been dominated by Italian art, although the Baroque itself also had Italian origins. This upsurge of creativity north of the Alps reflected the growth of national states and a shift in economic power, which continued throughout the period, from the Mediterranean lands to the countries bordering the Atlantic, especially England and France. Moreover the Baroque was carried overseas by Catholic missionaries to Latin America and the Far East, while colonial settlement brought English architectural styles to the eastern seaboard of North America in the 18th century.

In patronage, the middle classes began to play an active though not yet a decisive part, except in Protestant Holland where there was no official court or aristocracy and no demand for paintings from the Church. But the clearest way in which art expanded was in the growth of the so-called 'lesser categories'. This is especially visible in painting. The lesser categories were portraiture, landscape, *genre* painting (the representation of subjects from everyday life) and still-life painting. For the first time, apart from portraiture, these now took a significant place alongside the traditionally superior categories of painting, whose subjects were drawn from the Bible, classical history and mythology. In architecture, town houses and town-planning assumed the same role; in sculpture this role was taken by portrait busts. In the 18th century, interior decoration and furniture entered the mainstream of stylistic developments for the first time, and one entirely new art was created during this period: porcelain.

The third basic change brought about by the Baroque lay in the increasing complexity of stylistic trends. It is true that the Renaissance was by no means a single, unified movement. It reached its climax in different places at different times, and its long, extremely varied final phase —Mannerism—in some ways marked a reaction against the period of its highest and most typical achievements. But the Renaissance was still far more homogeneous than the Baroque. In fact, the word 'Baroque' is not properly adequate to describe the art of the 17th and 18th centuries except in a very general sense. Although it was the dominant style, which coloured all others in varying degrees, in the strict sense it was only one style among several others which developed simultaneously, as must now be explained.

THE MEANING OF STYLISTIC TERMS AND THE THEME OF THIS BOOK

Nowadays 'Baroque' is used as a stylistic term (as distinct from a period label, as in the title of this book) to describe the art that first arose in Italy shortly before 1600, flourished there until the mid-18th century and spread particularly to Flanders, Germany, Central Europe (i.e. Austria, Bohemia and Poland), Spain, and the Spanish colonies overseas, although it also produced echoes of varying intensity in the art of all other European countries. Alongside the Baroque a classical movement grew up in

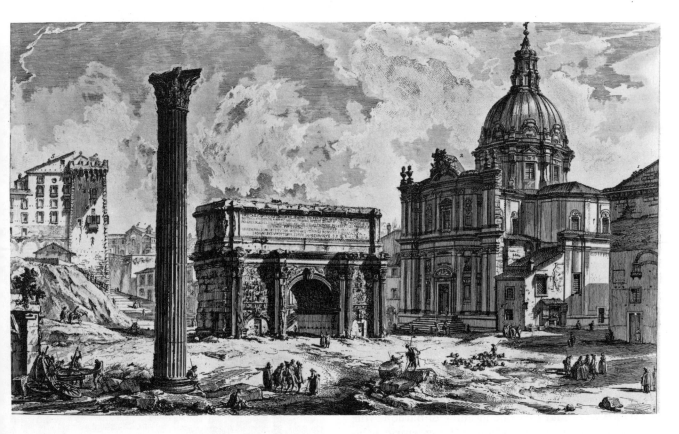

1. **Giovanni Battista Piranesi.** *The Arch of Septimius Severus with the Church of SS. Luca e Martina.* 1759? Etching. 14 × 22½ in. (35.5 × 57.5 cm.). This etching, from the series, *Le Vedute di Roma*, is reproduced here to underline the importance of Rome in this period and to symbolise the relationship of baroque art to the Antique. A 17th-century church—Pietro da Cortona's SS. Luca e Martina (1635–50)—faces classical ruins in the ancient Roman Forum. Rome was the artistic capital of Europe in the first three-quarters of the 17th century and again assumed a key role in the age of Neo-Classicism.

partial opposition to it, finding its particular home in France. There was also a third style, Realism, associated with such artists as Caravaggio and many Dutch painters.

All three styles continued, with modifications, into the 18th century. But the 18th century also saw the creation of a new style, the Rococo, whose relationship to the Baroque has some similarities with the relationship of Mannerism to the Renaissance; that is, it was partly an adaptation of the earlier style and partly a reaction against it. By the 1760s, classicism had merged into Neo-Classicism and had become the characteristic style of the age. This broke the dominance of the Baroque and created a link with the modern period.

It also broke the cycle which had begun just before 1600, so preventing the wheel from completing its revolution; that is to say, although both the baroque and rococo styles declined, the period ended on a rising not a falling note. In a sense this had also been true of Mannerism, for many of the developments typical of the Baroque had been conceived in the late 16th century. In the same way, Neo-Classicism was not only a backward-looking movement but also one that laid the foundations of modern attitudes to art.

The tracing of these stylistic movements, together with a discussion of their characteristics, forms the theme of this book. In general history, the period corresponds to the hey-day of the *ancien régime*, the power struggle between European states and such intellectual currents as the later stages of the Counter-Reformation, the Enlightenment, and the beginnings of modern science. Soon after the period opened the Thirty Years' War (1618–48) began; its end was marked by the outbreak of the French Revolution (1789).

Some explanation should perhaps be given as to why styles rather than national schools have been chosen as the units into which this book is divided. It might be said that such an approach makes artists appear to conform to trends which have only been defined in retrospect; moreover, there is a temptation to endow these trends with a will of their own (making the Baroque 'do' this, the Rococo 'do' the other), whereas in fact they have no existence apart from the works of art they describe. But the styles identified by modern art historians are related to issues which were actually felt by at least some artists at the time. Against a background of the Renaissance as well as classical antiquity, these artists were among the first in history able to exercise a conscious stylistic choice. The very number of

schools and masterpieces created by the Baroque militates against too factual an approach in so short a book as this. Furthermore the characteristics which cut across national frontiers and the boundaries between the arts are of exceptional interest in this period, making a deeper understanding of its artistic achievements possible than would have been the case with a straightforward chronological and geographical survey.

THE ORIGIN OF 'BAROQUE' AND 'ROCOCO'

Like most art-historical terms before the late 19th century, 'Baroque' and 'Rococo' were both introduced in retrospect and were first employed in a spirit of abuse. 'Baroque' seems to have been derived either from a Portuguese word, *barroco*, meaning an irregularly shaped pearl, or, as some historians assert, from an Italian term, *baroco*, a stumbling block in medieval scholastic logic. In either event, the word had acquired currency in a metaphorical sense in Italian and French by the 16th century, when it meant any contorted idea or tortuous, involved process of thought.

Its application to art did not begin until the second half of the 18th century, during the ascendancy of Neo-Classicism. It was then, and up to a point still is, defined in terms of its opposition to classical values. In 1771 the *Dictionnaire de Travaux* gave one meaning of Baroque (the other referred to its use as a synonym for eccentric or bizarre) as 'in painting, a picture or figure . . . in which the rules of proportion are not observed and everything is represented according to the artist's whim'. Sculptors and architects who offended against classical rules were even more severely attacked than painters. The Italian critic, Milizia, influenced by the great neo-classical theorist, Winckelmann, wrote in 1797: 'Baroque is the ultimate in the bizarre; it is the ridiculous carried to extremes. Borromini went delirious, but in the sacristy of St Peter's, Guarini, Pozzi and Marchione went Baroque.'

In the 19th century, the word continued to be used chiefly of certain aspects of Italian 17th-century architecture, although the hostility towards the style it referred to spread to the other arts and also to the art of other countries. It was not until the publication of Heinrich Wölfflin's *Renaissance und Barock* in 1888 that 'Baroque' was neutralised for art-historical purposes, although Wölfflin applied it to an earlier period—the hundred years from about 1530 to 1630—than is now usual. Even in Wölfflin's time it was only in Germany and only among scholars that baroque art was considered respectable; elsewhere it was still regarded as a debased continuation of the art of the Renaissance. In England and America popular prejudice against the Baroque continued almost until the second world war. Since then it has won general acceptance, partly owing to the contemporary readiness to consider any style on its merits, rather than judge it in advance by abstract aesthetic standards, and partly because of the appeal of the sheer energy, daring and inventiveness so typical of the Baroque to modern taste.

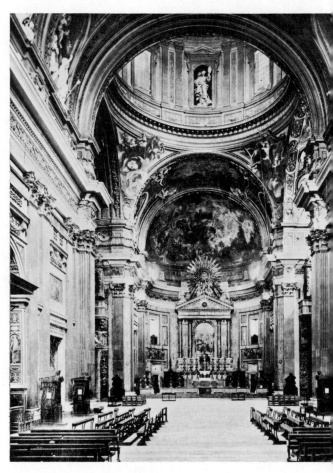

2. *The Interior of the Gesù, Rome.* Architecture by **Giacomo Vignola,** begun 1568. The baroque use of rich materials and ornate decoration as a means both of glorifying God and appealing to the worshipper's emotions is shown here in the mother church of the Jesuit Order in Rome. At first the interior was comparatively bare, and it only received its present form in the late 17th century. The frescoes in the apse, pendentives, dome and nave (fig. 29) were painted from 1672–83 by Gaulli.

The origin of 'Rococo' is rather the same. In its purest form the Rococo was a fanciful decorative system devised in France about 1700 for the treatment of interiors and ornamental objects generally, as an escape from the pompous, monumental style typified by Louis XIV's Versailles. In these fields—ornament and decoration— it reached its zenith in Paris in the 1730s, spread to other arts and other countries, particularly Germany, and was later associated retrospectively with the age of Louis XV. *Le style Louis XV*—inaccurately—or *le style Pompadour*— even less accurately—as it came to be known, was first called 'Rococo' by the early Romantic artist and pupil of David, Maurice Quaï, in 1796–97. The word was probably derived from *rocaille*, an adjective referring to the shells and bits of rock used in 16th-century decoration, and became current in Paris studios as a nickname for the style against which

3. **El Greco.** *The Immaculate Conception. c.* 1613. Oil on canvas. 128 × 65¾ in. (323 × 167 cm.). Museum of S. Vicente, Toledo. Although El Greco's style is usually placed under the heading of Mannerism, his late work is in many ways baroque in feeling. He was among the first artists to develop the continuous upward-soaring movement typical of the Baroque and to convey emotion by means of fluttering draperies and ecstatic expressions and gestures. The Immaculate Conception of the Virgin Mary was one of the devotional subjects brought into prominence by the Council of Trent.

4. **Peter Paul Rubens.** *Apotheosis of James I* (detail). 1629. Oil on panel. 37½ × 25 in. (95 × 63.1 cm.). Mrs Humphrey Brand, Glynde Place, Sussex. This was probably Rubens's first sketch for the ceiling of the Banqueting House, Whitehall, which was commissioned by Charles I in honour of his father and the Royal House of Stuart. The canvases were completed in Antwerp and set up in place in 1635. It shows the use of art as propaganda on behalf of a secular monarch, corresponding to the use of religious art for similar purposes in Catholic churches. Rubens's sketch, in shades of silver-grey and honey-yellow, is a superlative example of his brushwork.

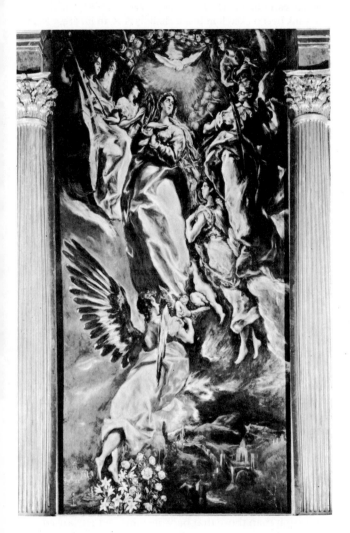

artists were by then in full revolt. In effect, what the Baroque was for Winckelmann and the Italian neo-classicists, the Rococo was for neo-classicists in France. The rehabilitation of French rococo painting, decoration and furniture began over a century ago, much earlier than the Baroque, but it is only quite recently that the Rococo has been critically assessed.

THE INFLUENCE OF RELIGIOUS AND PHILOSOPHICAL IDEAS

Very broadly, the 17th century was an age of authority, the 18th an age of scepticism. This should at once be qualified by pointing out that the spirit of scientific enquiry which eventually undermined authority first appeared very early in the 17th century, while the hierarchical social structure characteristic of the beginning of the

period persisted almost unchanged until the French Revolution. Nevertheless, the association of the first of these two centuries with hierarchy, precedence, degree and the maintenance of authority, and the second with liberty, scepticism, rationalism and the challenge to authority, generally holds good.

The 17th-century deference to authority can be seen, for example, in the doctrine of the divine right of kings, in the Church's claim to interpret all knowledge and experience in the light of its teaching, and in the way in which artists justified their theoretical principles by appealing to classical sources. None of these things was new but they all became more pronounced in this period. In secular affairs, power was concentrated more than ever in the hands of the ruler or his first minister: for example, Pope Urban VIII, Cardinal Richelieu, Philip IV of Spain, Louis XIV of

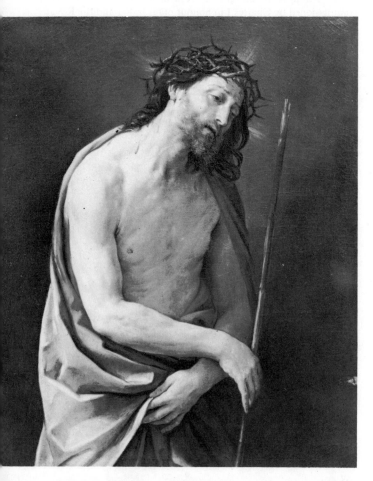

5. **Guido Reni.** *Ecce Homo. c.* 1640. Oil on canvas. 44½ × 37½ in. (113 × 95 cm.). Fitzwilliam Museum, Cambridge. Like El Greco's *Immaculate Conception* and Lebrun's head representing *Terror* (fig. 6), this is an example of the all-absorbing subject for 17th-century artists of emotional expression, which reflected the contemporary interest among theologians and philosophers in the psychology of the soul. When the treatment of emotion is as direct and charged with pathos as it is here it is apt to seem distasteful nowadays, but it is highly characteristic of baroque art and cannot be dismissed as insincere.

6. **Charles Lebrun.** *The Expression of Terror.* 1668? Pen and black ink over a sketch in black chalk. 7¾ × 10 in. (19.5 × 25.5 cm.). Louvre, Paris. The concern with expressing emotion originated in the Renaissance and was taken up in the 17th century by both classical and baroque artists. Lebrun, director of the French Academy of Painting and Sculpture, 1663–90, attempted to reduce the problem to rules, and this diagrammatic head, showing the way the facial muscles contract under the stress of terror, was one of a series drawn by him to illustrate his lecture on 'The Expression of the Passions'. The lecture, probably first given in 1668, was first printed in 1696, and was widely influential.

France, Colbert, Charles I of England, and Cromwell. In religion (taking the Catholic view), the tide of Protestantism was halted—in some places turned back—and the Catholic church felt a renewed sense of confidence in its mission, contrasting with its anxious, defensive stance in the previous century. The religious orders founded during the first phase of the Counter-Reformation also attained their greatest power and influence in this period. This was particularly true of the best organised and most militant among them, the Society of Jesus, founded in 1540.

The effects of the Reformation on the arts were largely negative, since religious paintings and sculpture were banned from Protestant churches, but the Counter-Reformation, through its doctrinal instrument, the Council of Trent (1545–63), had far-reaching consequences. The representation of heretical ideas and indecent or irrelevant matter was forbidden; pictures and statues of the Virgin Mary, the martyrs and saints, particularly in states of ecstasy or meditation, increased; and religious art was encouraged in churches provided it gave instruction in the Faith (in an almost medieval sense) and was conducive to piety.

From the last of these proposals it was a short step to the use of art as a means of propaganda—an idea that was also seized on by secular rulers for their own ends. Of its nature, propaganda is designed to reach the mind of an audience by appealing to its emotions, and there is a predictable relationship between the more emotional and rhetorical

—in general the more baroque—forms of art in the 17th century and the patronage of courts and the Catholic Church. On the whole, baroque art in the strict sense is associated more with Catholic than Protestant countries (see endpaper map), more with countries particularly loyal to the Pope (e.g. Spain) than those which, while still Catholic, followed a comparatively independent religious policy (e.g. France), and more with countries that remained feudal and rural in their political and social organisation than those that became more industrialised and 'advanced' (this is shown by the continuance of the Baroque in the 18th century in countries like Spain and Southern Germany, whereas France and England turned to the more refined and worldly styles of the Rococo and Neo-Classicism).

This is not to say that the Baroque was consciously evolved by Catholic, monarchical patrons as a deliberate instrument of policy or that it was an inevitable outcome of their societies; still less is it to suggest, as was once the fashion, that the Baroque was the invention of the Jesuits. In fact the Baroque, like most other styles, was invented by artists and found expression as beautifully and effectively in small, private works as in large, public ones, although the latter are its most typical manifestations. Moreover, the Church's attitude towards art, particularly the attitude of the religious orders, was still comparatively restrictive in the first half of the period, though as much perhaps for reasons of economy as from principle; the rich baroque

7. **Charles Nicolas Cochin the Younger.** *The Drawing School in the Academy.* 1763. Engraving by B. L. Prévost. 4 × 8 in. (10.2 × 20.4 cm.). Although dating from the second half of the 18th century, this engraving represents the curriculum introduced in the French Academy in the 1660s—a curriculum imitated with minor variations by academies all over Europe. The young students are seen copying the work of other masters, while the older ones are drawing from life and from casts after the Antique.

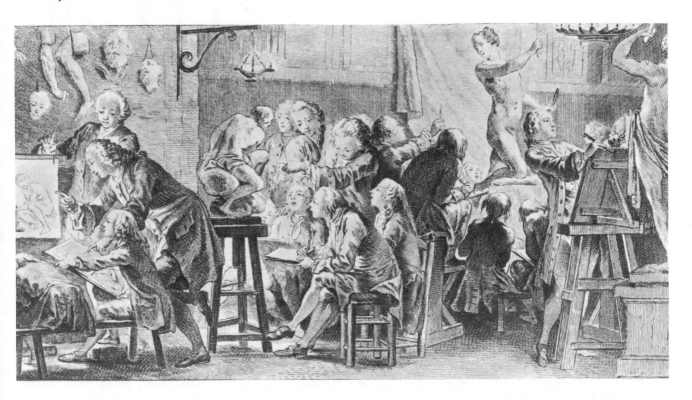

altars and decorations that fill Catholic churches today were only introduced in the second half of the 17th and in the 18th centuries.

Another point that needs clarification is the degree to which fluttering draperies and exaggerated facial expressions and gestures in baroque paintings and statues were intended to stir the worshipper into sharing the emotions of the person or persons represented. A test case of this is Bernini's statue of the *Ecstasy of St Teresa*, made for the Cornaro Chapel in Sta Maria della Vittoria, Rome, in 1645–48, the subject of which is the saint's vision of the love of God, which she experienced in the form of a flaming dart thrust into her by an angel. There is no doubt that this statue is a highly charged and sensational work, but Bernini was probably at least as much concerned with *representing* the emotion described by the saint as with *inducing* a corresponding emotion in the observer. In fact Catholic theologians, especially the Jesuits to whom Bernini was closely attached, discouraged too much indulgence in feeling during meditation or prayer, as being likely to lead to backsliding when the feeling had worn off. What contemporary theologians were very interest in, however, was the psychology of the soul. The state of mind of the saint, the martyr and Christ himself were minutely speculated upon and analysed. Concern with the analysis and vivid representation of emotion played a correspondingly important part in 17th-century aesthetic theory. In so far as the observer was intended to identify his own

emotions with the subject-matter, the explanation is likely to be found in aesthetic theory rather than theology. Some theoretical writers drew a parallel between the visual arts and rhetoric—the art of persuasion—and evolved a primitive doctrine of empathy, not new in the 17th century. What was new was the expression of it in art.

AESTHETIC DOCTRINES OF THE PERIOD

The 17th-century deference to authority found direct expression in the arts, first, in the constant quotation of classical sources in both practice and theory, and, second, in the doctrine of the hierarchy of categories, according to which large-scale figure paintings with subjects from the Bible, classical history and mythology were considered intrinsically more important than portraits, landscapes, *genre* scenes, and so on. It may also be said that a baroque church façade or figure composition was modelled on a hierarchical system, with a climax at or near the top and with each part related to the others in descending order of importance, the lesser always enclosed within the greater, down to the smallest details. Aesthetic theory revolved round these 'higher' categories, and it was not until the 18th century that writers began to go more deeply and intelligently into the aesthetic problems of portraiture, landscape and *genre* painting.

The central aesthetic doctrine of the period was the belief that painting and sculpture were modes of imitating ideal nature—ideal not actual nature, because it was held,

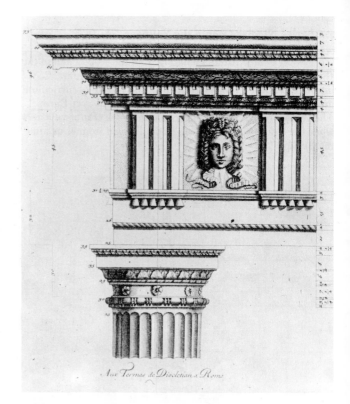

8. **Roland Fréart de Chambray.** *Plate from the 'Parallèle de l'architecture antique et la moderne'* (detail from the 2nd ed., 1689). 1st ed., Paris, 1650. 11 × 7¼ in. (28 × 18.4 cm.). Like the interest in expression, the systematic study of the five classical orders of architecture (Tuscan, Doric, Ionic, Corinthian and Composite) began in the Renaissance and was continued in the 17th and 18th centuries, especially in France. Fréart de Chambray was one of the first to advocate strict adherence to the rules laid down by the Roman writer, Vitruvius, and he used engravings after measured drawings from classical remains to support his arguments. The plate shown here illustrates the Doric Order from the Baths of Diocletian, Rome.

following Plato and Aristotle, that actual nature was always imperfect in some way. It was the business of the artist to discover and represent the perfect or ideal forms of things, his guide to the ideal being the sculpture of the ancient Greeks and Romans and, in modern times, the paintings of Raphael. Importance was also attached to decorum, that is, the principle that every form in a picture or piece of sculpture should be represented in a style appropriate to its subject-matter. The same was true in architecture. The correct classical 'order'—Tuscan, Doric, Ionic, Corinthian or Composite—had to be used for the appropriate type of building, and if more than one order was employed they had to be arranged above each other in the sequence sanctioned by classical precedent and justified by the ancient Roman writer on architecture, Vitruvius.

All these doctrines were expounded repeatedly in theoretical treatises, particularly in the second half of the century, often in association with academies. The most important academies were the Roman Academy of St Luke, founded in 1593, and the French *Académie royale de peinture et de sculpture*, founded in 1648 but not fully active until the 1660s. Academies were another means of enforcing authority in the arts, though they were also concerned with improving the status of the artist and in the 18th century with organising exhibitions. The most representative theoretical treatise was *The Idea of the Painter, Sculptor and Architect* by G. P. Bellori, published in Rome in 1672.

Academies and theoretical writings both contained a classical as opposed to a baroque bias, but the principal aesthetic doctrines, all of which originated in earlier periods and were only elaborated and codified in the 17th century, were subscribed to by baroque and classical artists alike. One of the few subjects of debate seems to have been the relative importance of form, which classical artists stressed, and colour, which was emphasised by artists of the Baroque. Otherwise the distinguishing features of the Baroque, such as the dynamic treatment of space, movement and

light and shade, fell outside the scope of theory. It is a curious but striking fact that the Baroque had no specific aesthetic programme of its own. This was even more true of the Rococo, which was a consciously anti-theoretical movement.

The debate over form and colour came to a head in the French Academy at the end of the 17th century, resulting in the victory of the 'colourists' and the substitution of Rubens for Raphael and Poussin as the hero of contemporary artists. But this did not mean the replacement of one orthodoxy by another; it meant, rather, the weakening of orthodoxy altogether. A more liberal attitude towards the imitation of antiquity was also adopted following the 'Quarrel of the Ancients and the Moderns'. In other words, the challenge to authority which was now beginning in philosophy was finding expression in the visual arts. The high seriousness which had informed 17th-century figure painting and sculpture went out in the first half of the 18th century, and was replaced by a frank delight in purely visual and decorative effects. The aesthetic qualities admired were 'variety', 'charm' and 'grace'. There was a new appreciation of the evocativeness of sketches and drawings, precisely because they were unfinished in the conventional sense. Works of art were now less often judged by reference to absolute rules and standards than by intuition.

But if scepticism and the general distrust of all dogmas and systems taken from sources outside sense experience found a perfect reflection in the Rococo, that other component of 18th-century thought—rationalism—led to a classical revival and eventually to Neo-Classicism. Neo-Classicism, in sharp contrast to the Rococo, was deeply inspired by theory. Perhaps it is the only movement in the history of art to have been brought into being by critics, philosophers and connoisseurs rather than artists. However, its style is so closely bound up with the ideas underlying it that it will be best to postpone any discussion of those ideas until the appropriate chapter.

The Baroque

THE APPEAL TO THE EMOTIONS

It will be best to begin this account of baroque art in the strict sense of the term with a point that has been touched on already in discussing religious propaganda and rhetoric, namely the way in which baroque art appeals to the mind through the emotions. Of course, all art appeals in varying proportions to both the emotions and the mind. But the Baroque makes use of emotional appeal as a means of reaching the mind in a special way. It goes out to meet the spectator's emotional susceptibilities; it is 'spectator-orientated' to a greater extent than any other style. Unlike the diffuse, tortuous style of some forms of Mannerism, it is visually easy to read.

To give an example, the design of baroque ceiling decorations is calculated, having regard to the shape, size and lighting of the room, to make it as convenient as possible for the spectator to view the ceiling from the position or positions he would naturally take up. This factor had scarcely been considered in the previous period, when ceilings were designed to be seen either from one viewpoint only or from a variety of conflicting viewpoints. Mannerist painters were also apt to treat the ceiling on either too large or too small a scale for the height of the room, filling low ceilings with very large forms and high ceilings with very small ones. The characteristic of baroque ceilings is that they are optically 'just right'.

To give another example, figures in easel and wall paintings tend to be concentrated in the foreground plane. Caravaggio, one of the revolutionary painters of the new age, had begun to do this even before 1600, although in many ways he was still a pre-baroque artist. In almost all his pictures the background is shut off by a wall of darkness, leaving only a shallow stage in front for the figures to move in. Mood, action and the physical reality of bodies are thus insistently pressed on our attention, involving us in the imagined world of the artist's creation. This device is repeatedly used, not only in Caravaggio's art but also —in fact slightly earlier—in that of Ludovico and Annibale Carracci, and later in the work of Guido Reni, Pietro da Cortona, Rubens, van Dyck, Rembrandt (though not consistently) and many others. The darkness lightens in these later examples and is characteristically varied with half-lights and reflected lights or is replaced altogether by a pale grey neutral background or a landscape and clear sky. But the figure or figures remain compellingly 'there' —alert, expressive and watchful. Sometimes they gaze at or gesture directly towards us, as if to penetrate the psychological barrier between their world and ours.

The psychological impact resulting from baroque effects of close-up can also, paradoxically, be produced by the opposite means—emphasis on the extension of space in depth. This was chiefly used in the high and late baroque periods (i.e. from the 1630s onwards) and is most characteristic of the last third of the 17th century. In painting it occurs particularly in illusionistic ceiling decorations, but the spatial depth of Claude's landscapes, which are scarcely baroque in any other sense, is another example. Architectural examples of this use of extended space are the staircase and the vista, both of which acquired a new importance in the baroque period. With paintings the spectator's feeling of being drawn into the space is naturally subjective, but with buildings it can and should be translated into action. Baroque buildings must, that is to say, be walked round and through and be studied, as it were, on the move if their true quality is to be realised. The problems of baroque space will be discussed in more detail later.

ILLUSIONISM

A further, related means of heightening the emotional appeal of a work of art was through the use of illusionism. Illusionism was far from being an invention of the baroque period, nor are all baroque works of art illusionistic, but it now became more common and more convincing than ever before. In one sense illusionism only represented the extension of an ambition that artists had first had in antiquity and revived in the early Renaissance—the ambition of complete realism. Vasari often praises a work for being so lifelike as almost to deceive the eye. Admittedly, by the High Renaissance mere optical deception was no longer considered enough, and the literal copying of nature, without selection or idealisation, was despised by 17th-century critics. Nevertheless, the vivid and convincing rendering of ideal nature was still regarded as one of the painter's and sculptor's primary tasks. Even in the 17th century the creation of a lifelike image out of the inanimate materials available to the artist contained an element of the miraculous, and the technical skill required to produce such an image was highly prized. 'It is an imitation made with lines and colours on a flat surface of everything under the sun' said (or rather quoted) Poussin, and this was still the basic definition of painting. It remained so for conservative critics until the 19th century.

However, there is a distinction to be made here between illusionism and realism. Realism meant the faithful rendering of the outward appearance of objects, whether such objects belonged to the actual world or were only present to the imagination; idealisation was therefore excluded. Illusionism, on the other hand, was not only consistent with idealisation and the imaginative representation of supernatural events and experiences, but was often combined with them.

Typical examples of illusionism are Bernini's *St Teresa*, Pozzo's ceiling of S. Ignazio in Rome and Egid Quirin Asam's *St George* altar in the monastery church at Weltenburg. None of these depict situations or events that could have been seen with the natural eye, yet they brilliantly project into visual terms what might have been seen by the eye of the imagination. They appear to be so convincing that 'they might almost be there'.

A further use of illusionism which these examples illustrate consisted in overcoming the limitations of materials; marble was made to look like hair or cloth, gilded

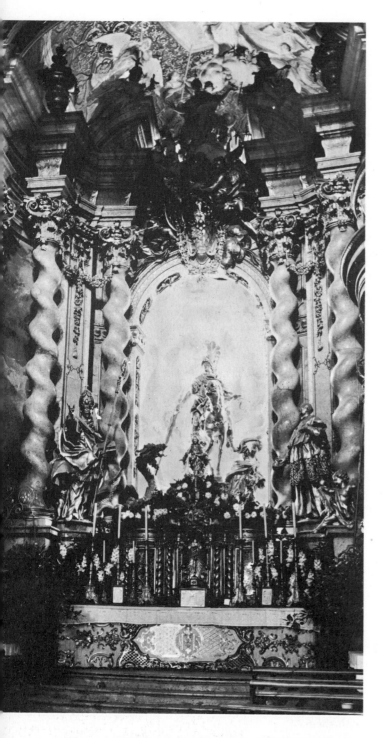

metal like rays of light, or a painted picture-frame like a real one. Nor was illusionism confined to painting and sculpture. In architecture the design of a building did not necessarily correspond to its structure, and façades and screen walls were freely used to mask an irregular or unpleasing feature behind them. The modern doctrine of functionalism, which was founded in the age of Neo-Classicism, had no place in the Baroque.

Without doubt the most versatile master of illusionism was Bernini. His command of it is as apparent in small things as in great. During his visit to Paris in 1665, when he executed the marble portrait bust of Louis XIV, Chantelou recorded his observation: 'Sometimes in order to imitate the model well it is necessary to introduce in a marble portrait something that is not found in the model.' This seems to be a paradox, but he explained it thus: 'in order to represent the darkness that some people have around the eye, it is necessary to deepen the marble in that place where it is dark in order to represent the effect of that colour and thus make up by skill, as it were, the imperfection of the art of sculpture, which is unable to give colour to objects.' Of an earlier work by Bernini, the *David* in the Borghese Gallery, the sculptor's biographer wrote: 'The magnificent head of this figure (in which he portrayed his own features), the vigorous down-drawn, knitted eyebrows, the fierce, fixed eyes, the upper lip biting the lower, marvellously express the righteous anger of the young Israelite taking aim with his sling at the forehead of the giant Philistine. The same resoluteness, spirit and strength are found in every part of the body, *which needs only movement to be alive*' (present writer's italics).

Another way in which illusionism enhanced the vividness of a work of art was through the use of devices designed to associate it with the real world of the spectator. In this sense the *David*, executed in 1623, was one of the first true baroque statues, for its whole stance and gaze suggest movement beyond the limits of the sculpture itself. Its focus is not within the work of art but outside it, in the spectator's space. The same effect can be seen, though not carried to such lengths, in Rembrandt's painting, the *Night Watch*, in which the leading figures appear to be marching out of the picture towards us. It occurs again in the type of equestrian portrait in which the horse and rider are shown head-on. This motive was actually invented by El Greco in the 1590s

(Continued on page 625)

9. **Egid Quirin Asam.** *High Altar with St George killing the Dragon.* 1721. Altar figures in gold and silver gilt stucco, the twisted columns in marble, the rest in wood and stucco, partly painted and gilt. Monastery Church, Weltenburg, Bavaria. Besides its spectacular illusionism (see text), this altar is characteristic of the Baroque in its use of richly coloured materials, heavy architectural forms and broken pediments and twisted columns. The church was built in 1716–18 by Egid Quirin's brother, Cosmas Damian Asam, who also designed the fresco of the *Immaculate Conception* painted on the back wall of the brightly lit space behind the altar.

1. **Gianlorenzo Bernini.** *The Ecstasy of St Teresa.* 1645–48. Marble. Life-size figures. Cornaro Chapel, Sta Maria della Vittoria, Rome. This is one of the touchstones of the Baroque, combining as it does sculpture, architecture and painting—or, at least, an effect analogous to painting—and projecting a powerful sense of illusion. Nature is brought into the work of art by the use of light from a concealed source, filtered through yellow glass, to re-inforce the symbolic light represented by metal rays. The artist's object is to create a convincing visual equivalent of St Teresa's own account of her mystical experience.

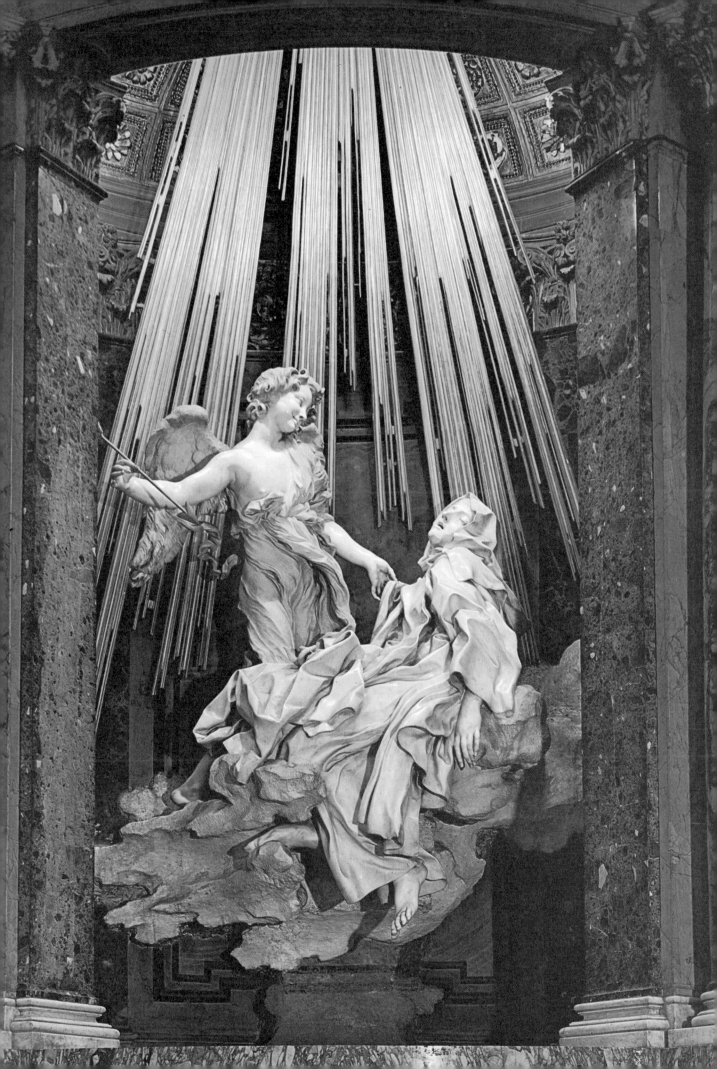

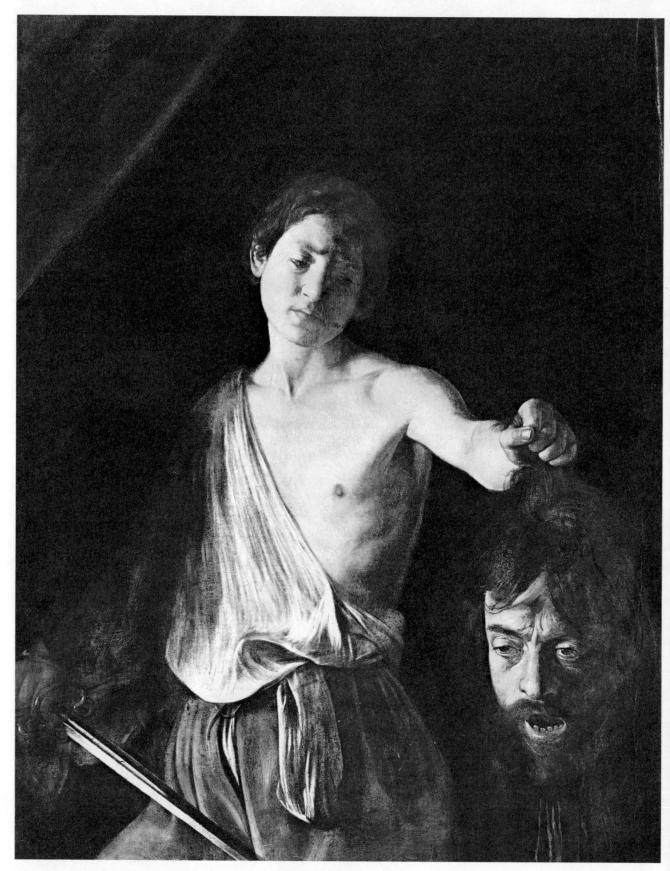

2. (above). **Michelangelo da Cara-vaggio.** *David with the Head of Goliath.* *c.* 1605. Oil on canvas. 49¼ × 39¾ in. (125 × 101 cm.). Borghese Gallery, Rome.
3. (opposite). **Guido Reni.** *St John the Baptist.* *c.*1640. Oil on canvas. 88½ × 63¾ in. (225 × 162 cm.). Dulwich College Picture Gallery, London,

reproduced by permission of the Governors of Dulwich College. These two interpretations of the young male nude from the Early Baroque period are both simplified in form and highly evocative in feeling. Caravaggio's *David* is harsh, tragic, and ambiguous in its implications.

The realistically painted surfaces, the darkness, the sword and the violence are the hallmarks of his art, and the head of *Goliath* is modelled on his own features. Reni's *St John*, by contrast, shows an idealised, unequivocally beautiful youth, sensuous without being sensual.

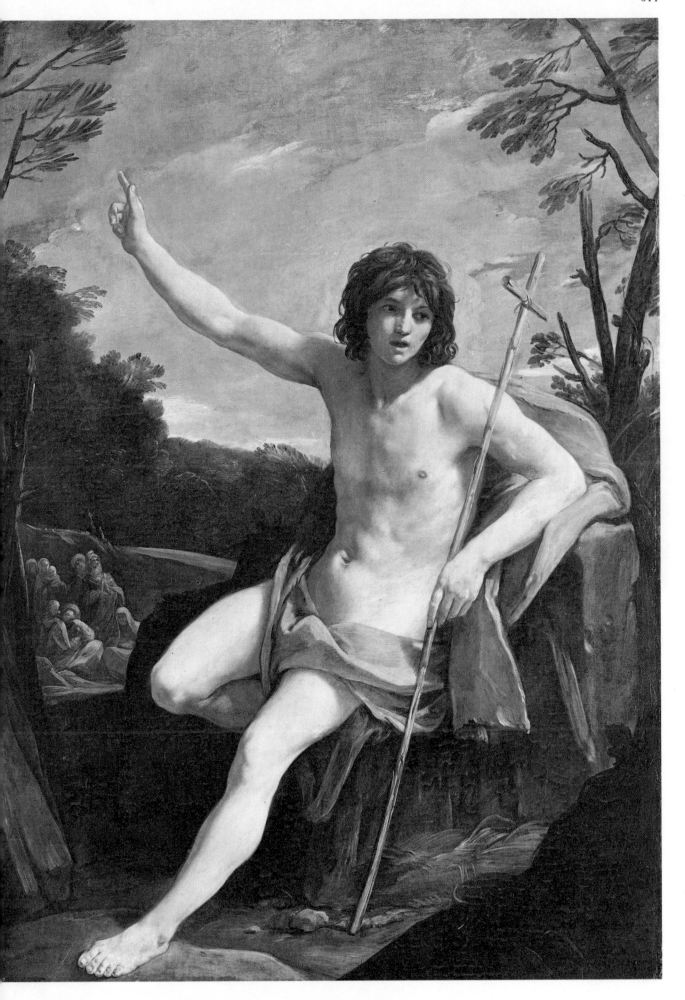

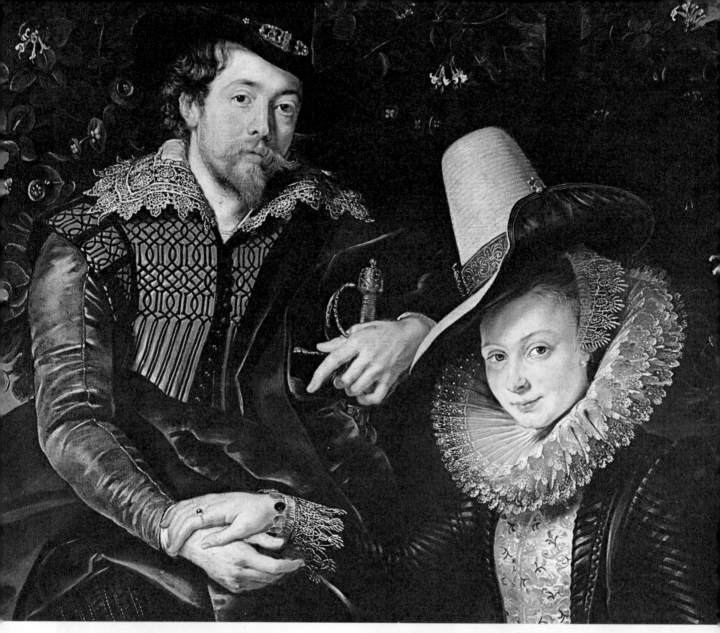

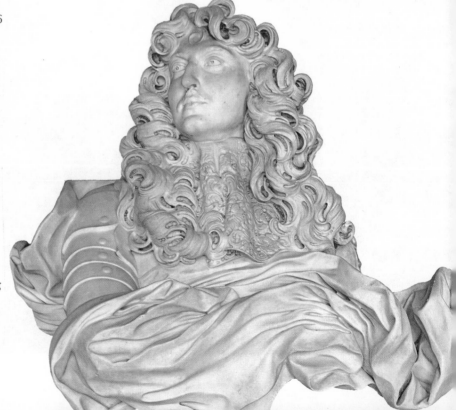

4. (above). **Peter Paul Rubens.** *Self-portrait with Isabella Brant* (detail). *c.* 1609. Oil on canvas. 70½ × 53½ in. (179 × 136 cm.). Alte Pinakothek, Munich. This portrait of the artist with his first wife was painted about the time of their marriage. with its Early Baroque vivacity, it radiates charm, affection and the success the artist had obtained from his long stay in Italy and with his new position as court painter in his native city, Antwerp.

5. (right). **Gianlorenzo Bernini.** *Portrait-bust of Louis XIV.* 1665. Marble. Life-size. Versailles. This is a portrait of the most powerful personality of the baroque period by that period's greatest sculptor. It was originally intended to stand on a gilt and blue enamel globe, resting on a marble cloth with emblems of victory and virtue in relief. The globe was to be inscribed *Picciola Base*, expressing the idea that the whole world was but a small base for this monarch to stand upon. However, the idealisation of the features in the sculpture itself conveys majesty clearly enough.

6. **Rembrandt van Rijn.** *Lady with a Fan.* 1641. Oil on canvas. 41½ × 33 in. (105 × 84 cm.). Reproduced by Gracious Permission of Her Majesty the Queen. The sitter's name was Agatha Bas; she married the Amsterdam merchant, Nicolaas Bambeeck, whose portrait is now in the Museum of Fine Arts, Brussels. They lived in the same street as Rembrandt. Agatha Bas was herself a burgomaster's daughter, and the discreet richness of her clothes and jewellery reflects the wealth and power of the Dutch merchant class in the heyday of its power. For all this, Rembrandt's brushwork, though exquisitely wrought, is subordinated to the expression of character, bringing before us a unique physical presence. This presence is insistent and disturbing, yet compellingly 'there'—an effect obtained with the aid of baroque illusionistic devices (the fan and the left thumb overlapping the window frame), though the portrait is otherwise quite un-baroque.

7. **Narciso Tomé.** *The Transparente.*
Completed 1732. Marble and other
materials. Toledo Cathedral, Spain. The
highly charged effects shown in the
previous illustration are here carried to
their ultimate and most dazzling con-
clusion. The altar is a setting for the
Blessed Sacrament, seen through a glass-
fronted receptacle (hence 'Transparente').
It is lit from above and behind the spec-

tator's head through a high window,
surrounded by sculptured figures of
Christ, prophets and saints, and let into
the Gothic vaulting of the ambulatory.
8. (above). **Peter Paul Rubens.** *The
Adoration of the Kings.* 1634. Oil on canvas.
129¼ × 97¼ in. (328 × 247 cm.). King's
College Chapel, Cambridge; reproduced
by courtesy of the Provost and Fellows.
Rubens's *Adoration of the Kings*, painted for

the Convent of the Dames Blanches at
Malines, exemplifies the power and
eloquence of the baroque altarpiece at
its most magnificent. The three great
figures of the Kings enact the offering up
of worldly authority to the Holy Child.
The artist's style, now past its most
aggressive phase, combines his usual
energy with a new note of tenderness and
composure.

9. (left). **Pietro da Cortona.** *The Rape of the Sabine Women* (detail). *c.* 1629. Oil on canvas. 108 × 166½ in. (275 × 423 cm.). Capitoline Gallery, Rome. Cortona's *Rape of the Sabine women* is one of the first secular examples of Roman High Baroque painting. Note the greater complexity of the forms compared with Caravaggio's or Guido Reni's and the introduction of a new quality of dynamic physical energy— appropriate to the subject, no doubt, but typical of Cortona's work. His figure style has a plastic richness comparable with Bernini's in sculpture.

10. (opposite). **Peter Paul Rubens.** *The Garden of Love* (detail). *c.* 1630. Oil on canvas. 50 × 68 in. (127 × 173 cm.). Waddesdon Manor, Bucks., National Trust. These are three figures from the right side of the first version of Rubens's *Garden of Love*; a later, more famous version is in the Prado. The subject is a *fête galante*, in which a number of elegantly dressed couples, accompanied by Cupids and watched over by a statue of Venus, are seen talking to each other and em- bracing on the terrace of a house. Such paintings by Rubens strongly influenced Watteau and were used, transformed from a baroque into a rococo idiom, as the basis of much French 18th-century painting (see plates 73 and 74).

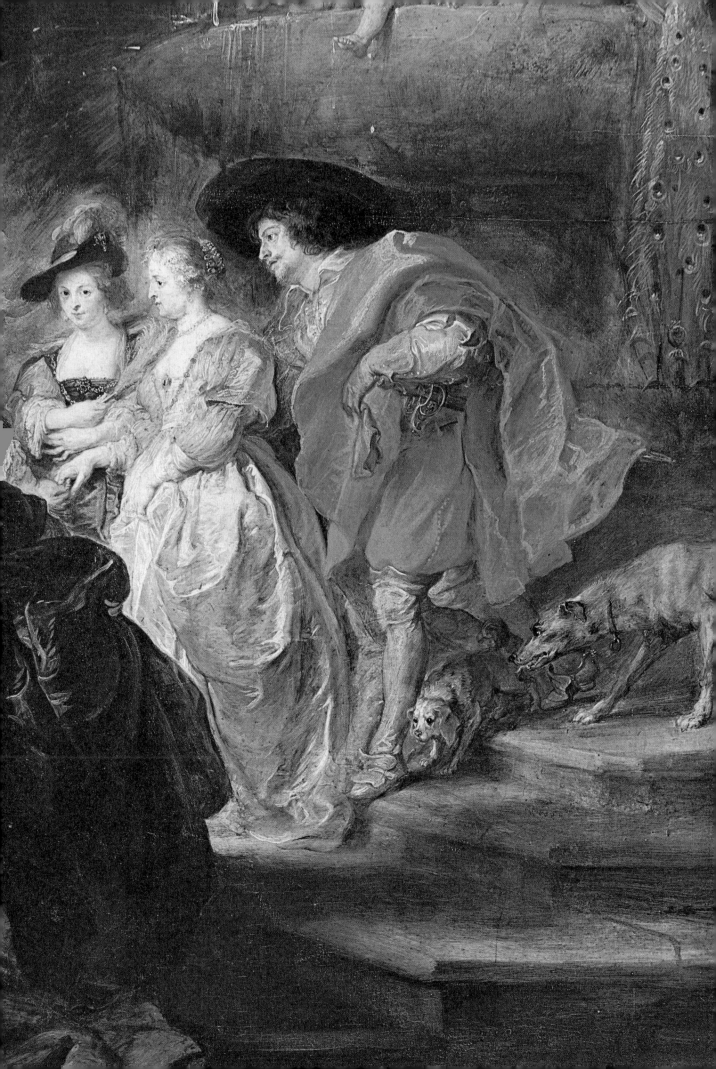

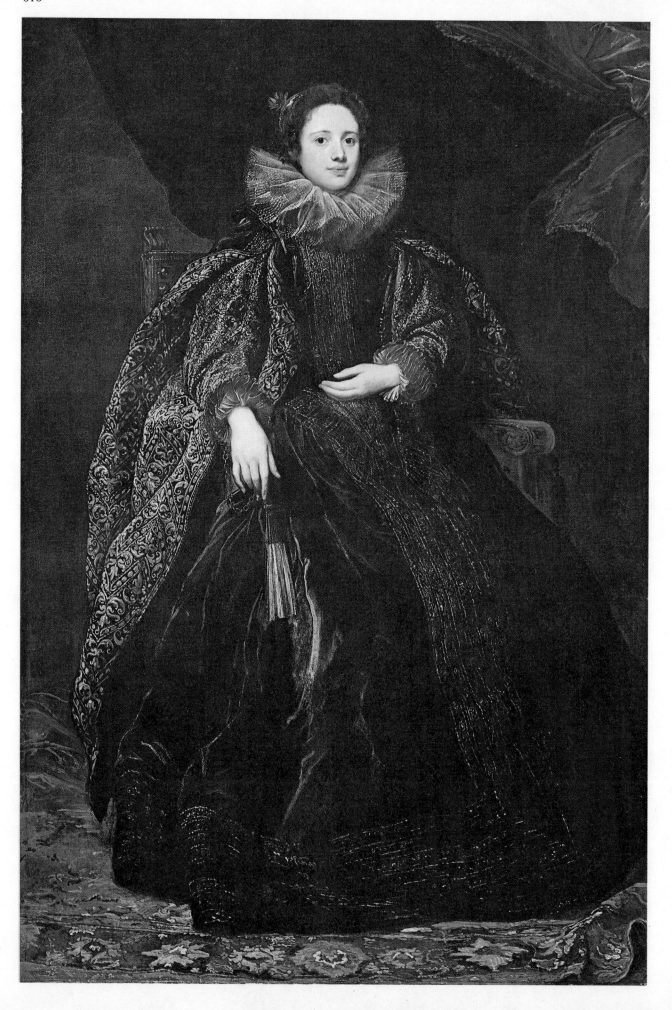

11. (opposite). **Anthony van Dyck.**
Marchesa Balbi. c. 1625. Oil on canvas. 72
× 48 in. (183 × 122 cm.). National Gallery
of Art, Washington (Andrew Mellon
Collection). Like other Northern artists
who aspired to possess an internationally
recognised style, Van Dyck spent several
years in Italy, both fulfilling important
commissions and studying the art of the
Renaissance, particularly the work of
Titian. Among the cities he visited was
Genoa, then a flourishing maritime power,
based on trade, not unlike Antwerp and
Amsterdam, but dominated by a more
conservative ruling class, which outshone
even Venice in its love of luxury. Van
Dyck's evocation of aristocratic elegance
and his rendering of heavy brocaded velvet
in this portait are alike breathtaking in their
effect.

12. (below). **Rembrandt van Rijn.**
Bathsheba. 1654. Oil on canvas. 56 × 56 in.
(142 × 142 cm.). Louvre, Paris. The courtly
magnificence shown opposite may be
contrasted with this painting by Rembrandt,
which is one of the noblest, most moving
and psychologically most realistic
treatments of sexual feeling in the history of
art. The whole composition, not just the
figure of Bathsheba herself, seems to com-
municate her mixed emotions of desire and
foreboding, as she holds King David's letter
of invitation limply in her hand. The nude
is one of the few examples in Rembrandt's
art in which he does not denigrate the
female body, hence it is perhaps not
coincidental that he modelled the pose on
an engraving after a classical relief.

13. *St Peter's, Rome.* Proto-, Early and High Baroque are here combined in the dome (by **Michelangelo,** 1547), façade (by **Madeina,** 1606) and colonnade (by **Bernini,** 1657) of St Peter's—the dates are those of the designs. The three parts link the ages. The first is summed up in the majesty and grace of the dome, a resolution in pure architectural terms of mass and soaring energy possible in quite this form only in the mid-16th century. The second is typified by the grandiose nave and façade added to the central

crossing of the Basilica for liturgical reasons, a step characteristic of the practical, early 17th-century phase of the Counter-Reformation. Representing the third age, the ceremonial repetition of the columns enclosing the oval piazza and symbolising the all-embracing arms of the Church are typical both of High Baroque spatial concepts and of the period's revived interest in symbolism.

14. **Jakob Prandtauer.** *The Monastery of Melk*, Lower Austria. Begun 1702. Standing on a high rock overlooking the Danube and fully exploiting the visual possibilities of its position, Melk is one of the most spectacular buildings of Central European Late Baroque. In feeling it contrasts markedly, and characteristically, with St Peter's. Symbolism, intellectual content and the use of a strict vocabulary of architectural form are subordinated to a single end, the creation of an overwhelming scenic effect.

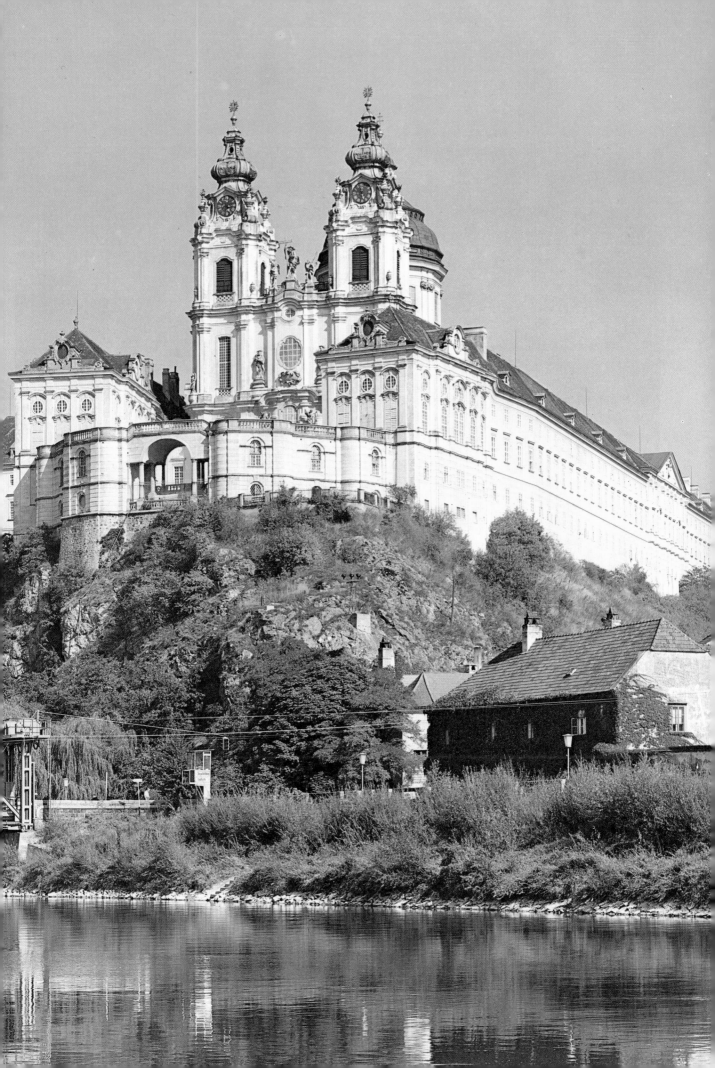

15. (above). **Peter Paul Rubens.** *The Tournament. c.* 1635–40. Oil on canvas. 28¾ × 42½ in. (73 × 108 cm.). Louvre, Paris. This is an example of the 17th-century realistic landscape of the Netherlands, given a baroque vitality of style and a mysterious, romantic mood. The dexterity of the brushwork is such that forms are sometimes indicated by the merest touches of paint on the surface, yet everything is vivid, everything is firmly in place. The work lies mid-way between a sketch and a finished picture—a new pictorial type invented by Rubens.

16. (right). *Salon de Vénus*, Versailles. *c.* 1671 onwards. This room, decorated for Louis XIV under the direction of Lebrun, is one of six arranged *en suite* forming the *Grand appartement de reception due Roi*; they are the earliest in the Château that survive. The iconography of the rooms is based on the planets, the last room, containing the throne, being dedicated to the Sun-God, Apollo, with whom the King identified himself. The subject of the ceiling painting in the *Salon de Vénus* is the influence of love on kings. The statue in the niche of Louis XIV is by Jean Warin. The capitals and over-doors are in gilded copper, the walls in coloured marble. The room was originally furnished with inlaid tables and cabinets, stools covered with cut velvet or tapestry, and gilt-bronze candelabra. The original marble flooring and doors were replaced by the present wooden floor and doors in 1684.

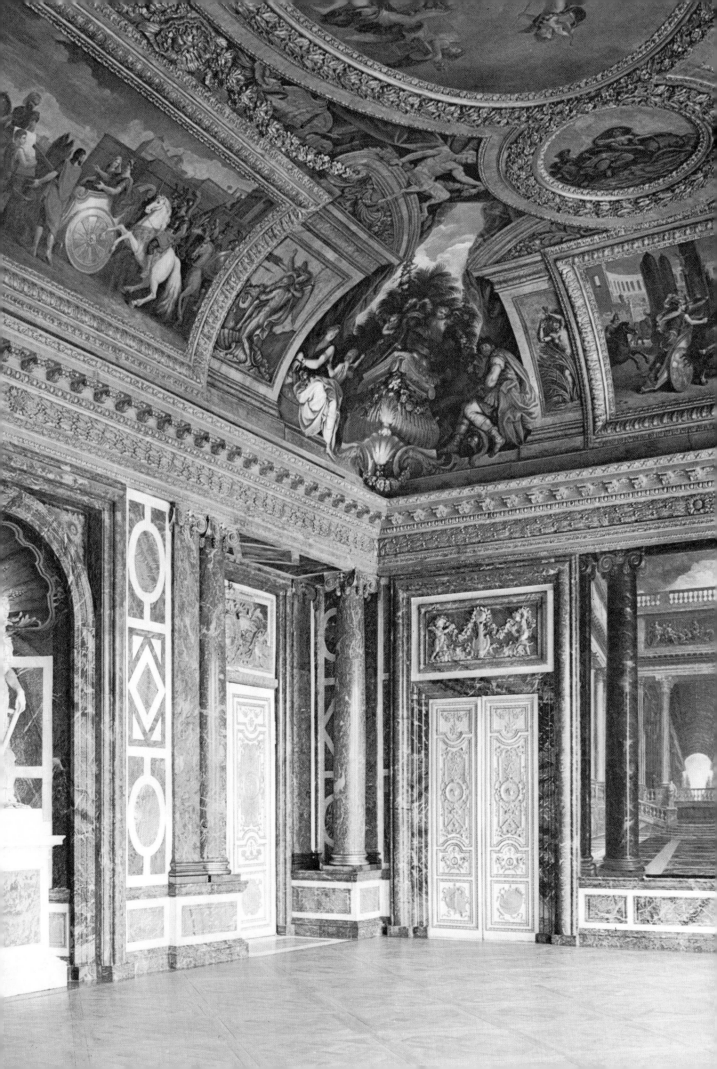

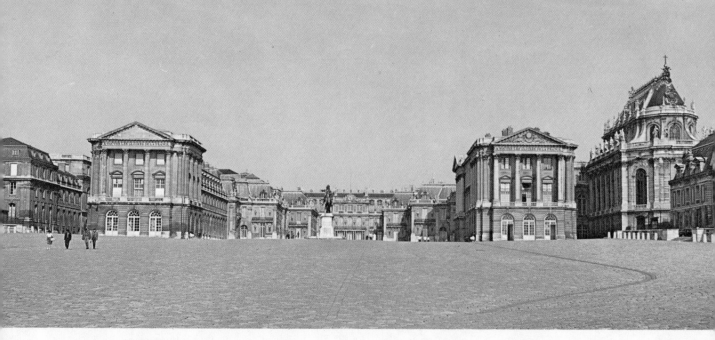

17. (above). **Louis Le Vau.** Château de Versailles: the Forecourt, *Cour royale* and *Cour de marbre.* Begun 1669. Although neither greatly distinguished as architecture nor fully baroque in style, Versailles —with its vast scale, magnificent interiors and gardens and, above all, its associations with the court of Louis XIV—is in many ways the key secular building of the period covered by this book. The Château on this, the town side, extends forward from a central block, the wings of which form first the *Cour de marbre* (originally built 1624 but altered by le Vau), then, second, opening out of the first, the wider *Cour royale* and finally the forecourt. The tall building on the right is the chapel added by J-H Mansart in 1689 to 1703—the most fully baroque part of the Château.

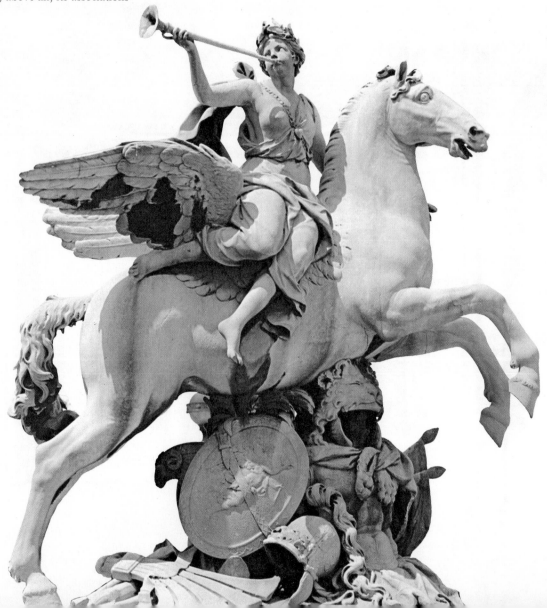

in a picture of *St Martin dividing his Cloak*, although, unlike a baroque artist, El Greco still held the forward movement in check. It was taken up by Rubens in his portrait of the Duke of Lerma (1603), when it was given its first, experimental baroque form. Suaver, more accomplished interpretations of the motive occur in Rubens's later work and it received its final, fully baroque rendering in equestrian portraits of Charles I by van Dyck. But illusionistic devices could also be used effectively in a much more restrained way, as in Rembrandt's *Lady with a Fan*. Here they are confined to the painting of the thumb of the right hand and the fan itself, which appear to overlap a false window-surround just inside the picture frame. Yet these touches are significant, however slight they may seem. Together with the 'close-up' placing of the figure and the intense gaze in the eyes, they remind us once more of the baroque emphasis on the quality of physical presence, an emphasis which is somehow made all the more telling in this instance by the very lack of baroque drama or movement. Rembrandt's sinister, watching figure seems almost bodily to have entered our world.

Of course, this impression is literally 'an illusion', and the question arises, how far is baroque illusionism intended to go? Illusionism is not *trompe l'oeil*, although *trompe l'oeil*—the actual tricking of the eye into assuming that a painted object is real—is no doubt illusionism in a specialised form. For practical reasons *trompe l'oeil* is usually confined to still-life objects, whether treated as part of a picture or on a surface on which such objects might be expected to appear; the deception would hardly work with figures or landscape. Essentially, illusionism is intended to astound and to move, not to deceive. The expected response to it is similar to the way an audience responds to a play in the theatre. As members of the audience we know that the drama we are watching is not real, but we react to it emotionally almost as if it were real. From one point of view we remain conscious that what we are witnessing is art, yet in another sense we willingly suspend disbelief and allow ourselves to become involved in the situation. It is the same with illusionism in the visual arts; indeed all representational art has this power to 'take us out of ourselves'

in some degree, but illusionistic art is more consciously calculated to do it. St Teresa's mystical experience is vividly re-enacted in Bernini's statue before our eyes; Charles I in van Dyck's portrait rides out through a triumphal arch *11* towards us (in its original setting in the now destroyed long gallery at St James's Palace this portrait probably filled the whole of one end wall down to the floor, thus intensifying the illusion which is now partly lost); in S. Ignazio we look upwards and see the roof of the church apparently open to the sky, its walls continued by an architectural construction painted in steep perspective, and hundreds of figures soaring upwards as far as the eye can see. *32*

In each case we are moved to astonishment at the performance—a reaction that was certainly part of the artist's intention. The popular view of the Baroque is right in this

10. **Gianlorenzo Bernini.** *David slaying Goliath.* 1623. Marble. Life-size. Galleria Borghese, Rome. This is one of several marble statues made by the young Bernini for his chief patron in his early years, Cardinal Scipione Borghese, nephew of Pope Paul V. It illustrates the baroque principle of creating a focus beyond the limits of the work of art (the presence of Goliath is implied, not made actual in another sculpture across the room). The face is also a striking study in expression, for which Bernini is said to have used his own features studied in a mirror. The pose is adapted from the classical *Borghese Warrior.*

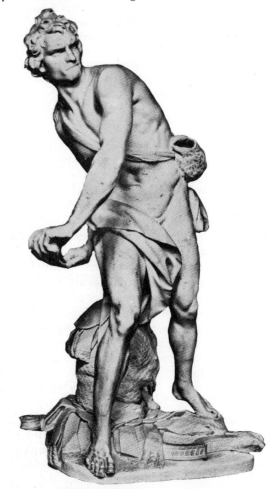

18. (left). **Antoine Coysevox.** *Fame.* 1700–02. Marble. Jardin des Tuileries, Paris. This allegorical equestrian statue is one of a pair, the other representing *Mercury*, made by Coysevox for the gardens of the château of Marly, a pleasure retreat built for Louis XIV near Versailles, since destroyed. The statue is a particularly fine example of the garden sculpture ordered in immense quantities for fountains, grottoes and other ornamental purposes in the park of Versailles. The turn of the figure's head and the trophy beneath the horse recall Bernini's statue of Louis XIV, but the forms of the horse itself have been regularized and given an almost relief-like profile. This modification of baroque energy and *élan* in accordance with classical principles of style is typical of late 17th-century French art.

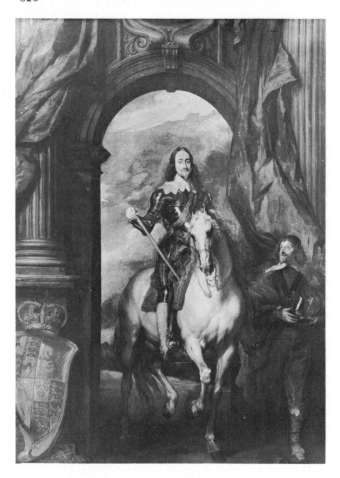

11. **Anthony van Dyck.** *Charles I with the Equerry, M. de St Anthoine.* 1633. Oil on canvas 145 × 106 in. (368 × 269 cm.). Buckingham Palace (reproduced by Gracious Permission of Her Majesty the Queen). This equestrian portrait shows baroque illusionism and the mingling of the imagined and actual worlds in terms of painting. Charles I was one of the great collectors and patrons of the age, and van Dyck's portraits of him are among the 17th-century's most famous images.

respect: that surprise and spectacle play an important part in its total effect. And this part increased with time. By the early 18th century sheer spectacle had become the chief *raison d'être* of many works of art, for example Bavarian churches and palaces. Effects that had been evocative in the first half of the 17th century now became astounding. At the same time the element of make-believe in illusionism increased, although the actual use of illusionism in painting declined after 1700 except in ceiling decorations. Tiepolo's **89** ceilings are the supreme example. They are illusionistic on account of the fact that flying figures seen from below are represented in the sky but there is no longer any pretence that they are actually there. The whole thing has become an immensely sophisticated and exquisite conceit, as formal and self-conscious as Mozartian opera—and as dazzlingly beautiful.

THE FUSION OF THE ARTS

Just as the distinction tends to get blurred in baroque art between art and life, so there is often a blurring of the distinctions between the various arts. The arts were also apt to exchange roles, or rather each moved in the direction

of painting. Architecture became more sculptural, sculpture more pictorial and painting itself more strictly concerned with visual appearances; that is, by a greater stress on light, shade and colour rather than form and outline, painting was made to reproduce more faithfully what the eye sees as distinct from what it knows to be there.

Underlying all this and connected with the devices of illusionism and close-up discussed so far, was the tendency in baroque art to deny the importance of the frame. Compositionally, the interest was concentrated in the central area, thus detracting attention from the edges. In this connection the fullest advantage was taken of the way altarpieces were lit by candles from below so that highlights and prominent relief were emphasised while the shadows merged into the surrounding architecture.

In tombs, altars and decorative *ensembles* the three arts of painting, sculpture and architecture were increasingly combined. It is true that there are Renaissance precedents for this (e.g. the Chigi Chapel by Raphael in Sta Maria del Popolo in Rome), but such precedents are rare, whereas in the high and late baroque periods (less so in the early baroque) the amalgamation of the arts became the rule rather than the exception whenever it was appropriate.

In this respect, as in so many others, Bernini was the most original and creative mind. He had been a painter and stage designer when young as well as a sculptor and architect, and his experience in all four arts was fused in his imagination. Admittedly his early works scarcely show much inter-connection between the arts. His first sculptures are pure sculpture, his one early building (the church of Sta Bibiana) is pure architecture, and he did not begin to introduce pictorial effects into architecture or sculpture until he had given up pure painting. But in his mature works the fusion of the arts is complete. Sometimes sculpture, sometimes architecture predominates, but his buildings always include sculptural features (S. Andrea al Quirinale) and his sculptures often have an architectural setting or base (the Tomb of Alexander VII). Occasionally, as in the *Baldacchino* in St Peter's (conceived by Bernini though perhaps designed in detail by Borromini), it is impossible to decide to which category the work belongs. In every case the two arts are fully integrated, so that each is, as it were, a continuation of the other.

The contributions of painting and stage design to the result are found partly in the introduction of pictorial and theatrical elements, so that the work has something of the 'look' of a picture or a spectacle on the stage, and partly in the use of coloured materials: dark-brown and gilt bronze, and plum-red, brown, green and yellow-ochre in addition to white marble.

The two works which show these characteristics most clearly are the *St Teresa* and the *Cathedra Petri* in St Peter's. The first is framed like a picture with marble columns at each side and a curved pediment above, while sculptured figures in niches let into the chapel walls sit and discuss the miraculous event portrayed on the altar, like spectators in

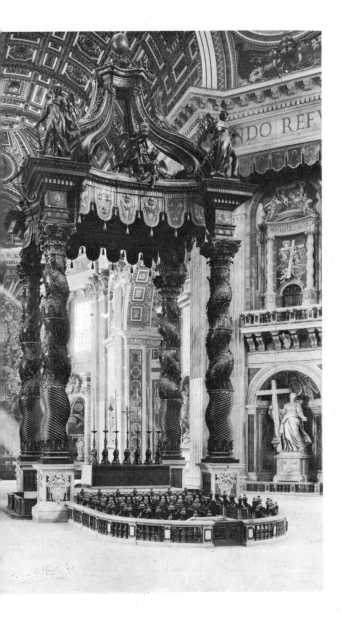

12. **Gianlorenzo Bernini and Francesco Borromini.** *The Baldacchino in St Peter's, Rome.* 1624–33. Bronze, partly gilt. 93 ft. high (28.5 m.). On account of its curving shapes, twisted columns and ornate splendour, this majestic canopy over the tomb of St Peter has been called the first manifesto of Roman high baroque art. It is an architectural work treated in sculptural terms; note the illusionism in the way the bronze is used for the cloth hangings at cornice level. The Baldacchino stands directly beneath the dome of the Basilica. The *Cathedra Petri* (fig. 13) can be seen in the background on the left. The twisted columns echo the late classical columns supposed to have come from the Temple of Jerusalem, which were built into the Old St Peter's and of which two can be seen flanking the niche at the top right.

13. **Gianlorenzo Bernini.** *The Cathedra Petro.* 1657–66. Marble, bronze (partly gilt), coloured glass and gilt stucco. St Peter's, Rome. The *Cathedra Petri* is so-called because its centre-piece encloses the ancient wooden chair believed to have been the throne of St Peter. The four great bronze figures supporting the chair are the Greek and Latin Fathers of the Church: from left to right, SS. Ambrose, Athanasius, Chrysostom and Augustine. The back of the chair is decorated with a relief of the scene 'Feed My Sheep'; the papal keys and tiara and, above them, the Dove of the Holy Ghost, in the centre of the window, are further important features of the scheme.

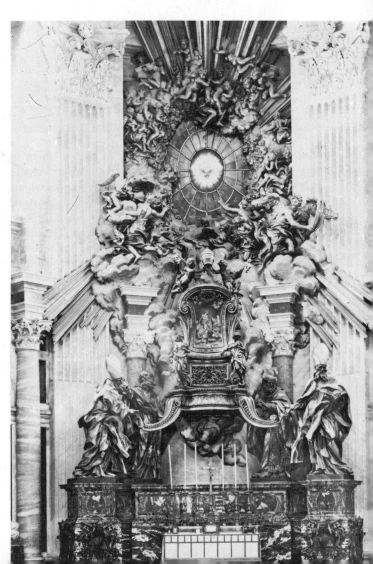

theatre-boxes. The validity of this comparison has recently been disputed, on the ground that the altar frame projects so far into space that the figures cannot see the saint; this is true but is not apparent to the real observer standing in the chapel. It has also been objected that most of the sculptured figures are not watching the 'stage', but this would probably have been typical of 17th-century theatre audiences. The second work, the *Cathedra Petri*, has the whole west end of St Peter's for its stage (unlike most cathedrals and churches, St Peter's is orientated towards the west) and has no frame, but spills out irregularly over the two great pilasters, which belong to Michelangelo's architecture, at either side of the round window in the centre.

Nor is this all, for Bernini did not only make use of more than one art for these works; he also harnessed nature to his ends. In both cases light, filtered through yellow glass and continued illusionistically by means of gilt metal rays, is made part of the work of art. In the *St Teresa* it comes from a concealed source above the altar; in the *Cathedra Petri* it streams through the central window, which contains an image of the Holy Dove in leaded outline and is the focal point of the design. Surrounding this window are figures of

15. **Jean Baptiste Tuby** (after a design by **Lebrun**). *The Fountain of Apollo*. 1668–70. Lead. Engraving by Chastillon, 1683. Versailles Gardens. This fountain is the centre-piece of a pool linking the end of the *tapis vert* with the head of the *grand canal* and is one of the most spectacular pieces of garden sculpture at Versailles. The surfaces of the figures and horses were originally covered with gilt bronze. Fountains were an integral part of the conception of Versailles from the start and much ingenuity and money were expended on organising the water supply.

14. **Gianlorenzo Bernini.** *The Four Rivers Fountain.* 1648–51. Stone (travertine), the figures in marble. Engraving by G. B. Falda. Piazza Navona, Rome. The obelisk is a restored classical remain which was found in the Campagna and which Pope Innocent X ordered to be erected in the centre of the square which contained his family palace. The fountain was designed by Bernini, although the base and figures were executed by assistants. The four personified rivers are the Nile, Danube, Ganges and Plate. The church of Sta Agnese (pl. 84) is just outside the picture to the left. The Piazza Navona is the largest and most famous baroque square in Rome.

angels in gilt stucco floating on clouds. Below them is suspended the magnificent bronze throne containing the relic—the ancient wooden chair of St Peter—from which the *Cathedra* gets its name. On the lowest level, supporting the throne with miraculous ease, are four colossal bronze figures representing the Fathers of the Church. The effect created by this astounding work, seen framed between the giant twisted columns of the Baldacchino in the late afternoon when the setting sun comes into line behind the window, is one of the supreme visual triumphs of baroque art.

As an alternative to natural light as part of a work of art there was also water. It goes without saying that the fountain as a form of decorative art was not a baroque invention, but fountains now became larger, freer in design and more illusionistic in treatment. The conceit inherent in the idea of a fountain—that of a fictitious figure immersed in a real element and performing the real act of spouting water—was exploited in ever more ingenious ways. Mythological and allegorical figures, sea-horses, cherubs, dolphins, etc., associated with water, lent themselves naturally to the purpose. In one instance, Bernini's *Neptune*, which actually stood above, rather than formed part of, a fountain, the figure is jabbing at the water with

his trident, illustrating a passage from Virgil's *Aeneid* describing Neptune calming the waves.

But this narrative treatment, though characteristic of Bernini's artistic personality, was unusual. More often the fountain was a purely decorative feature, the symbolism of which was not intended to be interpreted too precisely or taken very seriously. The best known fountains used in this way are those in the gardens at Versailles, where their function is to bridge the gap between the contrived, man-made splendour of the château and the informal beauty of nature. Although in one sense the fountain is a minor art form, from another point of view it can be regarded as the *ne plus ultra* of the Baroque, on account of its fusion of the two arts of sculpture and architecture with each other and of nature with both. Of Bernini's *Four Rivers* fountain in the Piazza Navona one may fairly ask—is it sculpture? is it architecture? is it nature?—and get no clear answer.

Following Bernini's example, the use of two or more arts in combination, with or without the addition of natural light, was taken up by countless baroque artists in Italy, Austria, Southern Germany and Spain (less so in Northern Europe and France). Gaulli's illusionistic ceiling of the Gesù, the composition and outline of which directly echo the *Cathedra Petri*, has a feigned not a natural source of light

and most of its figures are painted, but the painted surface
spreads across the frame on to the coffered vault of the
church and some of the figures towards the edge are treated
partly in painting and partly in high-relief stucco. From
the ground one can hardly tell where the painting ends and
the real stucco and architecture begin.

As to the later use of natural light, the best known
example is probably the *Transparente* in Toledo Cathedral
by Narciso Tomé, which is even more spectacular than the
Cathedra though less subtle in design. Here the source of
light is not within the *Transparente* itself (and is not visible
in the part of the work shown in plate 7) but above and
facing it across the open space of the Gothic ambulatory of
the cathedral. The light, that is to say, comes from a
window let into the vault opposite the altar and is only seen
if the spectator turns and looks over his shoulder. But the
vault itself is filled with sculptured figures of prophets and
saints in the same style as those on the *Transparente*; they
thus form part of the same work of art. The asymmetrical
relationship of the two parts, with one on a different level
from the other, together with the upward three-dimen-
sional movement of the composition, are typical of the late
Baroque.

Also typical of the late baroque phase is the way in which
pure spectacle in the use of these devices tends to outweigh
all other considerations. This is especially true of German
baroque art. In Egid Quirin Asam's *St George* altar at
Weltenburg the statue of the horse and rider are seen head-
on against a picture painted on the back wall, which is
some distance behind the altar itself. The space between is
flooded with light, which throws the statue into startling
silhouette and gives it a flickering, flame-like outline while
leaving its internal forms mysterious and dark. The result
is frankly theatrical, much more so than was the case with
Bernini's *St Teresa* or *Cathedra Petri*, in which methods bor-
rowed from the theatre were used not as ends in themselves
but in order to put across a serious message with the maxi-
mum effect. It is important to realise that there are degrees
of theatricality in baroque art. Bernini's ingenious but con-
trolled use of stage effects belongs at one extreme; at the
other there is the mid-18th-century Frauenkirche at Dres-
den, which is designed like a theatre throughout, with the
seats arranged in a semi-circle round the altar space, and
galleries all round, as they would be in an auditorium.

By this time theatre design had itself become a highly
sophisticated art in its own right. From Bologna a whole
family of artists, the Bibiena, gained international reputa-
tions by their stage designs alone, and the architect, Juvarra,
who produced his greatest buildings in north Italy, also
worked in this field. More than one factor drew the theatre
and baroque art together. There was the love of display
which was common to both; there were the opportunities
for controlled lighting effects, illusionism and trick per-
spective; the theatre, like the pulpit, was the natural home
of rhetoric. Finally, the theatre was a 'total art' in a way
that visual art could never be, as it involved real figures

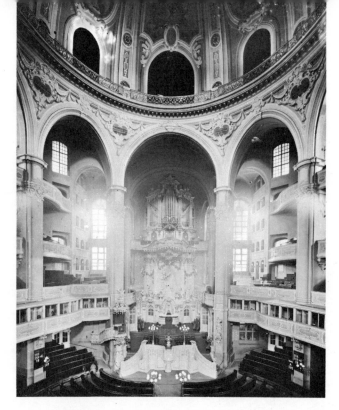

16. **Georg Bähr.** *The Interior of the Frauenkirche, Dresden*
(destroyed in the Second World War). Begun 1726. Although
built and always used as a Protestant church, the Frauenkirche
in Dresden was structurally as baroque as the Catholic
churches of Bavaria, particularly in its analogies with the
theatre. The spaces leading off the central space and seen
through the arches can be compared to the stage design by
Bibiena, fig. 17. The very beautiful organ case at the back of the
'stage' stands in for the altar. Both the placing of this organ and
the multiplication of subordinate spaces and singing galleries
reflect the growing importance of church music in Germany in
the age of Bach.

17. **Giuseppe Galli Bibiena.** *Design for a Stage Set.* Engraving,
by J. A. Pfeffel, from the series, *Architettura e Prospettive*, Augsburg,
1740. 12 × 20 in. (30.5 × 50.7 cm.). Stage design was in a sense
the logical end to which baroque art tended, since its virtual
freedom from material and structural limitations made possible
the realisation of effects, particularly of illusionism and
perspective, that Bernini or Borromini could never have created
in marble or stone. Although based on Bologna, the various
members of the Bibiena family worked as much for Austrian and
German as for Italian courts, designing settings for operas and
shows connected with betrothals, weddings and other
celebrations.

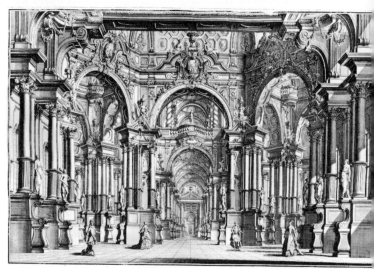

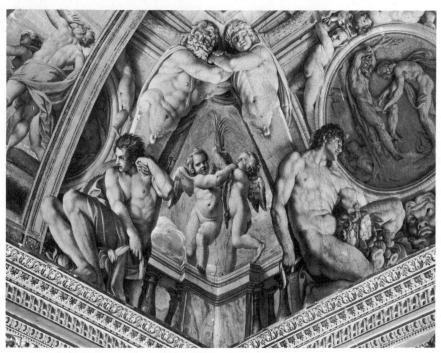

18. **Annibale Carracci.** *The Farnese Ceiling* (detail of corner). 1597–*c.* 1600. Fresco. Palazzo Farnese, Rome. The Farnese Ceiling, painted on the flattened barrel vault of the main, 66 ft long, gallery of the palace for its then owner, Cardinal Odoardo Farnese, was the first great painted ceiling of the baroque period. Its subject was the loves of the Gods in Antiquity—an unusual choice for a Prince of the Church, although such a subject was just then becoming possible in the more liberal atmosphere that set in around 1600. The pictorial arrangement is based on a painted architectural framework open to the sky at the corners; on this framework are painted imitation stone figures (herms), imitation bronze medallions, imitation pictures (at left of this detail) and 'real' nude figures kneeling or seated on the actual cornice of the room. The ceiling is thus illusionistic in detail, if not as a whole, as well as being highly decorative.

19. **Annibale Carracci.** *Study for One of the Nudes in the Farnese Ceiling.* 1597–98. Black chalk with white heightening. 16¼ × 16⅛ in. (41.3 × 41 cm.). Louvre, Paris. Annibale Caracci is thought to have made over 600 drawings in preparation for the Farnese Ceiling, ranging from rough sketches of whole compositions to handsome studies for individual figures, of which this is an example. In thus preparing the work in great detail he revived the practice of Raphael and Michelangelo, which had been in abeyance during the Mannerist period, and handed this practice on to his successors.

(actors) and speech in addition to costumes and scenery. Extending its range still further, the theatre branched out during this period into opera—potentially the 'total artwork' *par excellence*. The first opera was actually performed in the late 16th century—a fact which is sometimes overlooked by those who claim that the invention of opera was 'a product of the Baroque'. Nevertheless, opera was an art which only spread from its original home, Italy, to the rest of Europe in the 17th century and only became fully developed during that period. It could fairly be said that opera and baroque art evolved at more or less the same time and speed and, in some important respects, in similar ways.

THE SPLENDOUR OF BAROQUE ART

No account of the Baroque would be worthwhile that did not include some discussion of its qualities of sheer visual splendour. Baroque artists appealed to the spectator not only through the use of illusionistic devices, methods borrowed from the theatre and eloquent gestures and expressions, but also by providing enchantment for the eye. Except for the outsides of buildings, which were in natural stone, marble or brick, they used rich colours in all the

arts: coloured marbles and coloured or gilt carved wood in interiors, and saturated colours in paintings. Rooms in palaces were filled with expensive furnishings and tapestries; even church interiors became increasingly ornate.

Some of this visual magnificence was achieved merely by accumulating the maximum quantity of material. This was especially the case with Spanish architecture and decorative art (though not with painting), whereas the design itself is often uninventive. But in Italy, France and Germany, the ornamental quality of art is not something added afterwards but an integral part of the conception. The design, whether in the style of the figures in painting and sculpture, or in the treatment of columns, capitals, windows, etc., in architecture, has an element of sensuous beauty which attracts in itself. This is perhaps most obvious in Austrian and German churches and palaces of the 18th century, but it can also be seen in a restrained way in the first masterpiece of early baroque ceiling decoration, Annibale Carracci's ceiling in the Palazzo Farnese, begun in 1597.

If one compares this ceiling with corresponding Renaissance works, from which it was ultimately derived, the main difference lies precisely in its bias towards decoration.

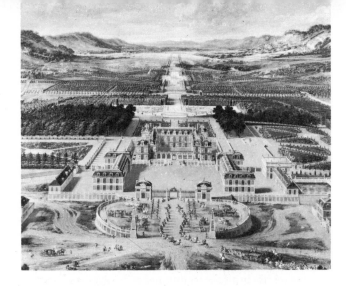

The austerity of Michelangelo's *Sistine Ceiling* is replaced by a new lightness of conception and touch and a greater use of decorative accessories. Painted shells, masks, swags of fruit and other ornaments cover the feigned architectural framework. Just how deeply this emphasis on sensuous visual beauty goes can be seen by comparing Annibale Carracci's drawings with Michelangelo's. The latter are hard, austere and sculptural. The former show a conception of the body that is altogether more sensuous; the figures are more fluid in outline and seem literally to breathe a sense of physical well-being.

The same qualities lie at the heart of Rubens's style both as a draughtsman and painter. His feeling for sensuous beauty is not merely superficial; it does not lie only in the saturated colours he uses, the opalescent brilliance of his flesh, or the luminous shadows and expensive dress materials which he liked painting. It is an essential quality of his whole art—a sort of energising centre nourished by the physical powers of the body—of which these outward manifestations are only the sign. He transmitted the outward manifestation, though less the vital centre, to his successor van Dyck. In van Dyck's portraits the self-conscious cultivation of luxury and the arts of personal adornment assumes the status of a way of life.

One form of the love of splendour in architecture can be seen in the treatment and placing of buildings in such a way that they gain the best advantage from a superlative site; examples are the monastery of Melk overlooking the Danube, and the church of Sta Maria della Salute, Venice, which guards the entrance to the Grand Canal and 'composes' the view from whichever direction one looks at it. The conscious creation of a style to exploit these natural advantages was a special feature of north Italian, Austrian and south German architects of the late baroque period (although Sta Maria della Salute is mid-17th-century).

Another manifestation of the same attitude was the taste for magnificence on a very grand scale, independently of the site. By no means all the greatest or even the most dazzling works of baroque art are large; there is a jewel-like richness even in quite small buildings like Borromini's church of S. Carlo alle Quattro Fontane and also, of course, in works of the applied arts; jugs, table ornaments, candle-sticks, doorknobs, etc. Nevertheless, grandeur for its own sake is obviously a characteristic to which the Baroque tends. St Peter's, Rome, in its present, baroque form is one of the largest buildings in the world, although it should be remembered that Michelangelo's contribution to it was already on a colossal scale. In painting, Rubens prided himself on his ability to undertake vast decorative projects; the forms in his larger pictures are the embodiments of majesty and power; and his handling in these pictures has an incomparable breadth and sweep.

In secular art the taste for grandeur was given a new impetus by the creation of Versailles, where everything was done in the most spectacular way possible. In its finished form, for which Jules-Hardouin Mansart was re-

20. **Pierre Patel the Elder.** *View of the Château of Versailles* (detail). 1668. Oil on canvas. 45¼ × 63½ in. (115 × 161 cm.). Musée de Versailles. Begun in 1624 by the architect, Le Roy, as a small country residence for Louis XIII, Versailles was transformed, first through the enlargements begun by Le Vau in 1669 and secondly through the still vaster additions undertaken by J.-H. Mansart from 1678 onwards, into the grandest palace in Europe. Patel's painting shows the Château as it was completed for Louis XIII, although the ranges either side of the forecourt (now the *Cour Royale*) may have been added by Le Vau when he first started working there for Louis XIV in the early 1660s.

21. *Plan of the Château of Versailles*

PLAN OF FIRST FLOOR APARTMENTS

A–G Grand Appartement de Reception du Roi

E Salon de Vénus

H–J Grand Appartement du Roi

H Cabinet du Conseil

I Chambre du Roi

J Salon de L'oeil-de-boeuf

K–V Petit Appartement

L Cabinet de la Pendule

W courtyard

LE ROY 1624

LE VAU from 1669

MANSART from 1678

GABRIEL from c. 1765

19th Century

17 sponsible, the Château is nearly 600 yards long. Inside and outside, teams of craftsmen were employed under the overall supervision of Lebrun to make the Château the most magnificent palace in Europe, which it undoubtedly remains. Not that the architecture as such is particularly baroque, apart from the chapel; if anything, it is classical in form and disposition. But its cumulative effect—a conscious exercise in all the techniques of display—is certainly baroque in feeling. This is partly a result of the scale and massiveness of the architecture, but it also derives from the

40 baroque treatment of the accessories and furnishings. This contrast between outside and inside, and between the major arts of painting, sculpture and architecture on the one hand, and the minor arts of furniture, silverware, textiles, etc., on the other, is often seen in classical contexts.

Returning to painting, a word should now be said about brushwork. For a variety of reasons it is no accident that the pictorial approach of baroque painters was derived more from Venetian than Florentine or Roman Renaissance art. In the 16th century it was above all in Venetian painting that the qualities of sensuous beauty and splendour associated with the Baroque were found. A crucial moment in the history of the birth of Baroque occurred in 1598 with the transference from Ferrara to Rome of a group of mythological paintings by Titian. These paintings were studied by almost every artist working in Rome from the time of their arrival there until the 1630s; among those who copied them were Rubens and Poussin.

In the 17th century itself, Venetian painters contributed little to the Baroque, but the influence of 16th-century Venetian art on baroque painting, not only in Rome but elsewhere in Italy, and still more in Flanders and Spain (Rubens had studied in Venice and Rome, Velasquez had seen many Venetian paintings in Madrid), was immense. Without doubt the most important forerunner of the Baroque in painting was Titian. Titian's art had the power and the mastery of colour, light and shade that baroque painters adopted.

The free, expressive brushwork of Venetian painters was no less influential. A broad, lively and beautiful handling of paint is one of the most widespread characteristics of 17th-century art. There were no rules for this and each artist developed his own individual style. For instance,

3 there was the fluent, dynamic handling of Rubens, in which the brushstrokes seem to record every movement of the

23 artist's powerful mind. There was Velasquez's dryer, less personal stroke which gives an impressionistic texture to the surfaces of his canvases and an independent beauty to colour which is unique in the 17th century. There was

64 Frans Hals's method, which is superficially similar to Velasquez's, but more vigorous and cruder.

22 Finally there was Rembrandt, whose brushwork is the most expressive and varied of all. Rembrandt's handling is sometimes far from attractive in the ordinary sense. Sometimes it is harsh and expressionistic; sometimes its beauty lies in its representational subtlety; but sometimes it has a

22. **Rembrandt van Rijn.** *Portrait of Jan Six* (detail). 1654. Oil on canvas. 44 × 40 in. (112 × 102 cm.). Jan Six Collection, Amsterdam. This example of Rembrandt's brushwork dates from the later part of his career, when he had ceased to model forms by tracing their outlines and had turned instead to using irregular patches and smudges of paint to fix the positions of forms and to indicate the direction of their lines of force. No brushwork in European art is more subtle and expressive than this.

23. **Diego Velasquez.** *Portrait of a Lady with a Fan* (detail). *c.* 1635. Oil on canvas. 36½ × 27 in. (92.8 × 68.5 cm.). Wallace Collection, London. Velasquez's brushwork is more elegant and regular than Rembrandt's, but both artists used basically the same principle—that of expressing colour, form, atmosphere and tone by means of the brushstrokes alone. This means that the brushwork is not just something added to a previously drawn and shaded design but is an integral part of the conception.

richness of texture that is as glowing and sumptuous as that of any 17th-century painter. These four artists are no doubt conspicuous as masters of the brush, but the feeling for paint as a medium and the optical approach to form, stressing colour, light and shade rather than outline, affected all artists of the period in varying degrees. Even though classical theory condemned this characteristic and criticised the appeal to the senses as morally wrong, those artists who were most sympathetic to classicism unconsciously found themselves using richer colours and freer brush-stokes than their Renaissance predecessors.

BAROQUE DRAMA AND THE USE OF LIGHT AND SHADE

On the one hand, drama in baroque art is connected with the psychological and theatrical devices already described; on the other, it is a function of the effects of movement to be discussed shortly. In fact like most characteristics of baroque art, its qualities of drama merge into those on either side of it and would hardly need to be treated separately except for their associations with another quality —violence—and the treatment of light and shade. Most baroque paintings have dark backgrounds; their colours are rich and glowing rather than bright; the light in them tends to be concentrated on forms in or around the centre of the composition. The same applies to architecture, in that churches especially tend to be unevenly lit. Windows are high and often small, and most of the daylight comes through a lantern in the dome. The result is an evocative, sometimes dramatic chiaroscuro effect similar to that in paintings. The light may be quite strong in some parts but deep pools of shadow are left in the recesses, in doorways, under arches, behind pillars, etc. To this fitful natural light and shadow must be added the evocative light of candles. It was only in the 18th century that churches became light and airy once more.

The first painter to use strong contrasts of light and shade, and to introduce a special emphasis on violence in art, was Caravaggio. He made the two mutually supporting. In his work the large areas of almost black shadow not only close off the background, but heighten the drama inherent in the subject-matter; even where there is no actual violence the darkness creates a mood of foreboding and tragedy. It is a mood similar to that evoked by Webster's lines in the *Duchess of Malfi*: 'Oh this gloomy world, / In what a shadow, or deepe pit of darknesse / Doth (womanish, and fearefull) mankind live!'

Caravaggio's direct influence was brief, though intense, and was confined to his immediate followers, many of them foreign-born, who worked in Rome. But the indirect consequences of his work for European art were far reaching and incalculable; Velasquez in Madrid and Georges de la Tour in Lorraine probably produced the finest and most sensitive of all paintings in the Caravaggesque style, although neither of them may ever have seen an original work by Caravaggio. In a wider sense Caravaggio's innova-

tions spread even further and percolated into still-life and *genre* painting.

On the other hand, the pervasive current of violence and darkness in 17th-century painting was certainly not due to him alone; there were other methods of creating strong contrasts of light and shade. Like brushwork and colour, those methods were derived from 16th-century Venetian painters—to some extent from Titian but still more perhaps from Tintoretto. The Venetian treatment of light and shade, which was more luminous and atmospheric than Caravaggio's, is clearly seen in the work of Bolognese painters like Guercino. It also occurs, applied in a more **20** decorative sense, in the paintings of Rubens and van **8, 11** Dyck. Neapolitan painters used a Caravaggesque type of chiaroscuro softened slightly by free baroque brushwork and varied by half-lights (Ribera, Cavallino). **24**

However, the greatest master of chiaroscuro was, once **70, 6, 12,** again, Rembrandt. He may have owed something in- **19, 65** directly to Caravaggio and something to the Venetians. Although he never left Holland he made himself aware— partly by attending auction sales, partly by studying the work of his lesser but more cosmopolitan Dutch contemporaries—of the whole heritage of European painting since the Renaissance. But the final result was his own. Like Caravaggio he tended to concentrate the light on the forms in the centre of the composition and to leave the background in darkness. But whereas Caravaggio's darkness is space-denying, Rembrandt's is space-creating. Varied by half-lights and reflected lights and also sometimes by light from more than one source, it is intensely luminous. Its effect is spiritual and poetic rather than dramatic.

But Rembrandt, too, sometimes painted scenes of violence, especially in the relatively early period of his career following his move to Amsterdam in 1631. Occasionally there is more than a hint of sadism in these works. The *Night Watch*, too, is a painting of great dramatic power, **19** though the drama lies in the method of presentation rather than the subject: light glows in the centre of the scene, drums beat, banners are unfurled and the members of Captain Frans Banning Cocq's militia company march out on parade in a swirl of movement. Drama and splendour are here combined.

To Catholic painters, scenes of martyrdom gave further **24, 25** opportunities for the representation of violence. Such scenes were nearly always shown in semi-darkness, which intensified the horror—in fact it was often the chief means of expressing it. The overt dwelling on the physical effects of torture—bloated bodies, torn limbs and streaming blood, which are common in German Renaissance art—is less a feature of baroque martyrdoms than one might expect. This was because the paintings had a religious purpose corresponding to the doctrines of the Counter-Reformation. The martyrs were represented as heroes, not as the limp, broken, helpless victims they would have been in fact. Physical agony was softened by spiritual exaltation in their expressions.

24. **Jusepe de Ribera.** *St Sebastian tended by St Irene.* 1628. Oil on canvas. 61½ × 74 in. (156 × 188 cm.). Hermitage, Leningrad. The surface realism and strong tone contrasts characteristic of Caravaggio are here combined with baroque plasticity and breadth of handling. This 'baroque' interpretation of Caravaggio may be compared with the classical interpretation seen in Georges de la Tour's rendering of the same subject (fig. 51). A certain voluptuousness was traditional in the treatment of St Sebastian's martyrdom but the dwelling on the spiritual exaltation rather than the physical agony was typical of the 17th century. In fact, the episode in which the saint was nursed back to life by St Irene and her attendants was more often painted in this period than the scene of his 'execution' by archers.

25. **Salvator Rosa.** *Landscape with the Crucifixion of Polycrates. c.* 1665. Oil on canvas. 29 × 39 in. (73.5 × 99 cm.). Art Institute of Chicago. A taste for the macabre, which was endemic in Neapolitan painting, already appears in Ribera's work and was brought to an extreme by Salvator Rosa. This can be seen both in his figures and his landscapes, which, after Rubens's, are the most baroque in 17th-century painting. The strong tone contrasts, jagged rocks and shattered trees are typical. Polycrates was the ruler of the island of Samos and a patron of poets and artists. He was lured to the mainland by Oroetes, the lord of Sardis, and there crucified in 522 BC. The subject is very rare in art.

It would be wrong to condemn this approach as insincere or self-indulgent, as if it were merely a dishonest attempt to make death by martyrdom seem attractive. Apart from the religious purposes involved, the painters were concerned with exploring states of mind. Nor was the agony of the martyr the only state of mind to be represented. In baroque religious art we find ecstasy, adoration, sorrow, triumph, wonder, contemplation and many other moods, as well as hatred and pain. One of the most eloquent representations of emotion in the art of the period is also the subtlest and most restrained—Rembrandt's *Bathsheba*.

BAROQUE MOVEMENT

The characteristics typical of the baroque treatment of movement, which are as important for architecture and sculpture as they are for painting, hardly appeared before the 1620s. The chief problem for baroque artists before that date was to substitute coherence and correct proportions for the anarchy prevailing under Mannerism. The burden of solving this problem was mainly carried by Italian artists of the generation of Caravaggio, Annibale Carracci and Maderna. In most other countries late 16th-century styles persisted until the second quarter of the 17th century.

The first painter to develop the techniques of true baroque movement was Rubens, who had lived in Italy from 1600–1608 and was thoroughly familiar with the whole of 16th-century and contemporary Italian art. His great discovery, which he made a few years after returning to Antwerp in December, 1608, was the principle of building his compositions round a dynamic spiral line. This line is a line of force which attracts all forms to it. It is essentially three-dimensional, starting at the bottom in the foreground of the composition, either at the centre or to one side and soaring upwards and inwards in a spiral or zig-zagging diagonal. Its great and novel consequence is that it gives an unprecedented vitality to the whole picture, which is now conceived in dynamic not static terms. Moreover, it is purposeful movement which leads up to a climax; it is quite different from the scattered hither-and-thither move-

ment of Mannerist art, which has great vitality but leads nowhere.

Nor does Rubens's three-dimensional line apply only to the composition; it has its counterpart in every figure and every detail of the picture. Figures surge, twist and turn, and draperies flow not in an altogether natural way, but not in a contorted way either, so that once the eye accepts the artificial principle on which the painting is conceived —and it does this quite easily—the movement appears logical and convincing. It is a movement which is reflected not only in the poses of figures but also in their modelling and the contours of their limbs. It is as apparent in oil sketches and drawings as it is in finished pictures; in fact, it is seen at its purest in the sketches, where a figure in bold foreshortening and of the utmost complexity may be clearly indicated with no more than half-a-dozen fluent strokes with a fine brush.

Rubens was also the creator of another characteristic of baroque movement: the tendency for forms to blend and merge into one another. In a full baroque painting the eye is given only a few points of rest. Apart from these points the forms are not distinct from one another as they are to a large extent in Renaissance art; rather, each one leads into the next. The relationship of forms is like the sequential arrangement of images in Milton's poetry. One can hardly dwell on each in isolation, but must take them as part of a continually moving whole.

It was not until the 1620s that Italian artists reached an equivalent stage. The innovator here was Bernini in a series of sculptures mostly done for Cardinal Scipione Borghese (the *Apollo and Daphne*, the *David* and the *Neptune*). As one might expect from an Italian artist and a sculptor, the forms are more solid and compact than is the case with Rubens's paintings, but the principle of movement is similar. There is the same thread of energy running right through the figures and the same power of conceiving it in three dimensions. The result is once more essentially dynamic, not static, and the forms flow organically into one another. It is the same in later, more complex works like the *Cathedra Petri*, in which the various parts of the composition merge into one another. The climax of Bernini's method can be seen in one of his last works, the *Angel with the Superscription*. From a formal point of view there is scarcely any distinction between the treatment of the drapery and that of the figure. The whole sculpture is animated by a refined, sophisticated, almost feverish vitality, which runs down into small details like the chiselling of the hair and the fingertips.

It was from such works as this that Austrian and German 18th-century sculpture was evolved. But by then the movements had become quicker, suaver and more graceful; less energy was released as the forms became lighter in weight. Bodies were made thinner, and heads, now smaller than before, were turned at a sharper angle to the shoulders—in paintings they were often turned away from the spectator and their faces were lost in shadow. Figures seem all

26. **Peter Paul Rubens.** *The Conversion of St Paul. c.* 1616. Oil on panel. 37½ × 47½ in. (95.2 × 120.7 cm.). Count Antoine Seilern, London. Starting from the point where Leonardo da Vinci and Titian had left off, Rubens transformed the traditional pictorial theme of struggling horses and riders into the earliest manifestation of high baroque painting in Europe. The composition is based on a series of contrasting curves held together by a powerful 'S' which spirals upwards and inwards from the bottom left. Note also the violent foreshortenings typical of the Baroque.

27. **Peter Paul Rubens.** *Landscape with the Shipwreck of Aeneas.* 1624. Oil on canvas. 23½ × 38½ in. (60 × 98 cm.). National Museum, Berlin-Dahlem. Rubens was the greatest master of baroque landscape in the first half of the 17th century. Natural forms—trees, rocks, streams, paths and so on— are subjected to the same twisting dynamic movements and contrasting light and shade patterns as are human beings in his figure compositions.

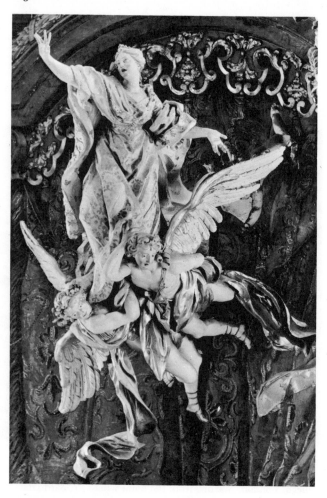

28. **Egid Quirin Asam.** *The Assumption of the Virgin* (detail).
1718–22. Painted stucco. Life-size figures. Monastery church,
Rohr, Bavaria. Baroque principles of modelling underlie this
group by Asam, but the tortured energy of Bernini or Puget has
been replaced by an air of theatrical ease; the Virgin gestures
and opens her mouth like an opera singer and is seen to have
attained her position not by her own efforts but with the help of
some supernatural agency. The outline of the group no longer
follows the contours of the human body but is defined by limbs,
wings and fluttering draperies. From this 'late baroque' point it
was a short step to the Rococo.

29. **Giovanni Battista Gaulli.** *The Adoration of the Name of
Jesus.* 1674–79. Fresco. Ceiling of the Nave of the Gesù, Rome.
This fresco represents the transition from the 'high' to the 'late'
Baroque in Roman ceiling decoration. Compared with fig. 30,
the whole ceiling is treated as a single unit of space, without any
architectural framework, and the painted figures are made to
spread out onto the coffered vault of the church itself; the
illusion is that of a roof opened to the sky to reveal a vision of the
heavenly host in adoration of the Holy Name, while damned
souls tumble into the darkness below. Both the figure style and
the irregular outlines of the composition echo the *Cathedra Petri*
(fig. 13). See fig. 2 for a view of the interior of the church.

limbs. Legs and arms often trace lines so complicated that
the spectator can hardly work out how the figures are
posed. Movement in the spaces between forms was also
indicated with a new subtlety. The Virgin and the Angel in
22 Günther's sculptured group of the *Annunciation* are as in-
tricately related to each other by their movements as two
figures in a dance, although they never touch. The wider
gaps left between figures in late baroque ceilings also
allowed new scope for implied movement across open
89 spaces. Tiepolo, seizing on the possibilities of this, exploited
it with consummate ease and grace.

Movement in Italian mid-17th-century baroque ceiling
paintings seems heavy by comparison with Tiepolo's soar-
ing flight; it is like an irresistible force whose characteristic
is power rather than speed. It also stops short of the treat-

ment of details, which are handled almost as if they were
static forms. In Guercino's *Aurora,* where baroque move-
ment is fully manifest in Italian painting for the first time,
Dawn in her chariot charges across the sky, scattering
flowers and expelling the fleeing figure of Night. It is
not so much the horses, which appear to have stopped in
mid-flight, as the subsidiary forms—the clouds, the flowers
and the figure of Night—which bring the composition to
life.

A more dynamic treatment of form can be seen in the
next great Roman ceiling painting, Pietro da Cortona's
Triumph of Divine Providence in the Palazzo Barberini. Here
the figures surge across the surface in a vast, almost im-
penetrable mass moving in different directions and some-
times getting in each other's way, so densely are they

30. **Pietro da Cortona.** *The Triumph of Divine Providence.*
1633–39. Fresco. Palazzo Barberini, Rome. This vast and
complex fresco, painted on the ceiling of the *Gran Salone* in the
family palace of the reigning pope, Urban VIII, inaugurated a
new phase in Roman baroque ceiling decoration. The painted
architectural framework and many of the decorative details at
the corners were adapted from the Farnese Ceiling (fig. 18), but
a new dynamic surges through the composition, the spaces are
more open and all the forms are shown in writhing movement
which focuses on a single figure, the personification of Divine
Providence. In detail, the meaning of the work is highly
complicated but its central theme, implied rather than stated, is
the presentation of Urban VIII as the agent of Providence.
The fresco is thus a specimen of propaganda on behalf of 'divine
right' comparable to the almost contemporary Whitehall Ceiling.

31. **Pierre Puget.** *Herm figure from the Doorway of the Town Hall,
Toulon.* 1656. Marble. Life-size. Puget was the only
17th-century French sculptor whose work was almost purely
baroque; all the others were classical to a greater or lesser degree.
This figure shows the characteristics of baroque modelling:
heavy plasticity, deep cutting of the muscles and draperies, and
a complex three-dimensional structure. Although the same
principles had already been seen in Bernini's work, Puget's style
was mainly derived from Pietro da Cortona and his treatment of
emotion recalls Michelangelo. A 'herm' (from the classical god
Hermes) is the technical name for a statue representing the
upper part of the body which ends in a pedestal or plinth out of
which the body appears to spring; such figures were often used
beside doorways to support a balcony, as here.

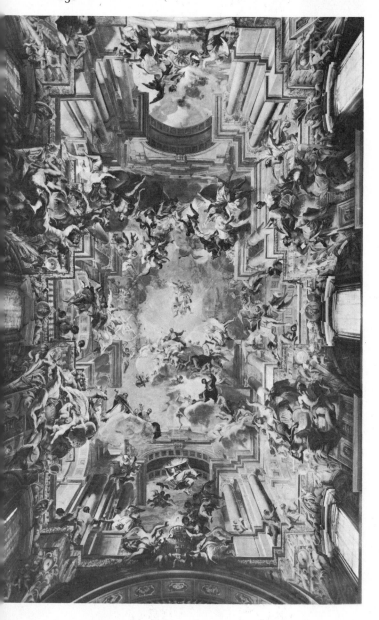

33. **Simon Vouet.** *The Adoration of the Kings* (detail). *c.* 1635–38. Engraving by M. Dorigny, 1640. This is part of a lost ceiling fresco painted by Vouet in the Hôtel Séguier in Paris after his return from Italy in 1627. The decorative style he brought with him was compounded of elements drawn from Roman baroque painting and the art of Veronese. This combination was new to French art and was highly effective for its purpose, although Vouet modified it in keeping with the general trend of the time towards classicism and in deference to classical French taste.

32 (left). **Padre Andrea Pozzo.** *Allegory of the Missionary Work of the Jesuits.* 1691–94. Fresco. Ceiling of the Nave of S. Ignazio, Rome. This late baroque ceiling shows the use of a complex scheme of feigned architecture painted in perspective to create the illusion of recession; the resulting space is much deeper than in the earlier ceiling by Pietro da Cortona (fig. 30). Perspective architecture had been out of fashion in Rome since the beginning of the century, as it had (and has) the disadvantage of only looking right from one spot, immediately below the vanishing point; if the spectator moves away from this spot the illusion 'literally' collapses. But the ceiling was admired on account of the technical skill displayed in it and the method was often copied in Germany and Central Europe, where Pozzo himself settled (in Vienna) in 1702.

packed. Problems of three-dimensional modelling in steep foreshortening have now been mastered with almost as much skill as Rubens could show at this date, although the figures are grouped much less subtly than in the Whitehall Ceiling, which Rubens painted almost at the same time.

Following Cortona, the next stage in Italy was Gaulli's ceiling of the Gesù, in which movement upwards is counterbalanced by the downward movement of the rebel angels tumbling out of the sky. In all these examples it will be noticed how the whole surface is involved. The same is true of easel paintings and altarpieces. The movement of background accessories and the free play of light and shade are integral to the design and contribute to its total effect. One can see this, for example, in Murillo's several variations on the theme of the *Immaculate Conception*, in which the Virgin is borne upwards on billowing clouds and cherubs crowd round her like moths round a lighted candle.

Baroque movement was first introduced into French painting in the late 1620s by Vouet, who had spent the previous dozen years in Italy, just at the time when the new techniques were being developed there. But French taste was instinctively more classical than that found elsewhere, and Vouet began to restrain his baroque exuberance soon after settling in France. It was only at the very end of the 17th century, when artists rediscovered Rubens, that the High Baroque era in painting was much appreciated in France.

As might be expected, all this had its counterpart in architecture, in the use of curving façades, ingeniously constructed domes, dramatically lit staircases, etc. Baroque buildings of all kinds also tend to be higher in relation to their width than 16th-century buildings, which gives them an effect of upward soaring movement. The great precedent for this in 16th-century architecture was the dome of St Peter's, designed by Michelangelo and built shortly after his death. Its slighly pointed curve gives life and energy to the heavy mass, so that this dome became the almost too perfect model for baroque architects. Movement is also expressed in the handling of architectural detail, as in the way in which the vocabulary of classical forms is broken up and different parts of a building are made to flow into one another.

34. Francesco Borromini. *Central First Floor Window of the Collegio di Propaganda Fide, Rome.* 1662. Engraving from G. G. de Rossi, *Architettura Civile,* 1692. This engraving dissects a baroque window design. The regular forms and straight-line arrangement of a classical window are 'bent' as far as they will go. The columns stand on a concave curve; the entablature projects forward in the centre in a convex curve, then cuts back to project again at the outer edges at 45 degrees. (The same scheme, writ large, recurs in the façade of S. Carlino, fig. 36.). The triangular pediment is reduced in size and separated from the entablature by a curving form. Such breaches of the classical rules of architecture were strongly condemned by the theorist, Bellori, but it should be noted how calculated they are—they are not merely wayward fantasies.

35. Mathias Braun. *Entrance of the Palais Thun-Hohenstein, Prague. c.* 1720. The architecture of this doorway shows the distortions of classical patterns and formulae discussed under fig. 34, translated into the bolder, heavier forms of the Central European Baroque. The powerful modelling of the sculptured eagles (by Braun, the leading Bohemian sculptor of the period) may be compared with the figures on the staircase of the Prinz Eugen Stadtpalais in Vienna (fig. 44). The palace was designed by Giovanni Santini.

BAROQUE SPACE

True baroque space, like true baroque movement, was only developed in the 1620s—in architecture, despite some earlier experiments, hardly before the 1630s. Until then painters were preoccupied with normalising space after the arbitrary, irrational distortions characteristic of the later 16th century, and architects with creating practical, hall-like structures in which large numbers of people could assemble. From the point of view of design, buildings were conceived mainly in terms of elevation. Façades, interior walls and arcades in churches were treated in larger, more harmoniously related units and were more richly modelled than before; but structurally their function was to shut off or, in an interior, enclose or sub-divide, space rather than mould, suggest or trap it, as was to be the case after 1630.

The first steps towards a new conception of space in architecture were taken in northern Italy. As early as the mid-16th century, Genoese architects had begun to discover the possibilities of the steeply-rising ground behind the main street on which the most fashionable palaces were built and they constructed staircases of unparalleled in-

genuity at that date, although these were hardly yet Baroque. More significant for the future were the first tentative experiments in the inter-relationship of interior spaces made by the Milanese architect, Ricchino. Ricchino also has the distinction of creating what was probably the earliest façade with a concave curve, that of the Palazzo Elvetico, Milan, which he designed in 1627.

The next stage, which had incalculable consequences for architecture, actually occurred in sculpture. As so often before, Bernini was the originator. His early statues dating from around 1620 are posed in such a manner that they not only produce a powerful psychological and illusionistic effect, but also reach out into space in a visual sense. Air 10 circulates between and around their limbs so that the space, as well as the solid marble, becomes part of the work of art. There is a similar conquest of space and interrelationship of solid and void in the *Baldacchino* in St Peter's. 12

In pure architecture the projection of forms into space was given both convex and concave forms; convex in the exquisite semi-circular portico attached to the façade of Sta Maria della Pace by Pietro da Cortona (the same

36. **Francesco Borromino.** *Façade of S. Carlo alle Quattro Fontane, Rome.* 1665–82. As the date indicates, this façade was only begun long after the rest of the church was finished, but the same architectural principles, expressed by contrasting convex and concave curves, were employed throughout. Note the 45-degree angle of the corner tower, typical of Borromini's contribution to baroque architecture. As the church authorities aptly and approvingly commented: 'Everything is arranged in such a manner that one part supplements the other and the spectator is stimulated to let his eye wander about ceaselessly.'

37. **Francesco Borromini.** *Plan of S. Carlo alle Quattro Fontane ('S. Carlino'), Rome.* 1638–41. From the engraving by J. Sandrart (reversed to show the plan in the same sense as the church). The design of this little church was evolved through a sequence of stages, each based on variations of the possible relationship between circles and two equilateral triangles with a common side. This geometrical approach marked a radical break from the arithmetical approach, based on multiples and sub-divisions of a single unit or module, which was used by Renaissance and classical architects. (Interior illustrated pl. 80).

motive was taken up by Wren and Gibbs in England); concave in the use of façades curving outwards at the ends, especially where the latter are emphasised by towers as in Sta Agnese in Piazza Navona. Towers with open-work upper-storeys of very ingenious design are the most striking examples of the baroque trapping of space. As in Bernini's early sculptures, air and light flow freely around and between the forms—an effect heightened by the contrast of strong light and deep shadow created in Italy by the sunshine. In fact the imaginative use of light and shadow plays as important a part in baroque architecture as it does in baroque painting. Steeples in northern Europe were the equivalent of towers in the south. The steeples in Gibbs's London churches, even more than those of Wren, soar upwards like the painted architecture in illusionistic ceiling decorations, conquering the sky.

A final, untypical, but unsurpassed example, is the relationship of solid and void in Bernini's Colonnade of St Peter's. Although the columns and entablature of this are purely architectural in form, they have a dynamic, sculptural function, powerfully intensified by the sweeping oval curve of the Piazza. Once again space circulates freely between the solid forms; the Colonnade makes a dramatic, definite boundary to the Piazza, yet it is a boundary which is visually and physically penetrated with ease.

Turning to the treatment of interior space, the first important example is Borromini's little church of S. Carlo alle Quattro Fontane (called S. Carlino). The plan of this church is basically oval, a form not invented by baroque architects but much used by them and handled with unprecedented inventiveness. Borromini, like Guarini after him, was fascinated by geometry. His method at S. Carlino was to evolve the basic oval of the ground plan by means of intersecting circles produced with a ruler and compasses. He then 'bent' the four quadrants of the oval inwards. The undulating, alternately concave and convex curve which resulted formed the line of the main cornice of the church. At one end of the long axis he placed the entrance, at the other the high altar; side altars filled the concave spaces at each end of the short axis. Above the cornice he used semi-circular arches to bring the design back to a simple oval which forms the base of the beautiful coffered dome.

The total effect is thus created by purely architectural means; unlike Bernini, Borromini was only an architect, not a sculptor as well. His architectural forms are of an extreme and daring inventiveness, not only in their interrelationships but also in themselves. They have sharp, cutting edges and, like this architect's plans, are evolved by geometrical means. Nevertheless, the spatial effect of the interior of S. Carlino has analogies with sculpture. The forms, though distinct in themselves, seem to flow into one another and to project and recede in a sculptural way. Visually Borromini's use of geometry is quite unlike that of Renaissance architects. If one stands in a Renaissance building the mathematical basis of the design is so clear

(Continued on page 657)

19. **Rembrandt van Rijn.** *The Night Watch.* 1642. Oil on canvas. 152½ × 197½ in. (387 × 502 cm.). Rijksmuseum, Amsterdam. In fact, this represents a parade of the militia company of Captain Frans Banning Cocq and is a daylight scene, not a 'night' watch; but *The Night Watch* is the traditional title (acquired in the 19th century when the picture was covered with brown varnish), which it would be absurd to discard for the sake of strict accuracy. The civic group-portrait was the main type of public commission open to 17th-century Dutch artists. The finely dressed dramatically lit figures, with drums beating and banner unfurled, are formed into a pattern of baroque complexity, their leaders 'walking out' of the picture towards the spectator.

20. (following pages). **Guercino.** *Aurora* (detail). 1621–23. Fresco. Casino Ludovisi, Rome. This fresco, painted for the nephew of Pope Gregory XV on a coved ceiling in the principal room of the Casino Ludovisi, represents the transition in style from the Early to the High Baroque in Rome. The relatively clear outlines and simplified forms are typical of the former phase, while the dynamic movement, dark colours and strong tone contrasts (never before seen in a fresco) belong to the latter. Aurora (the Dawn) in her chariot charges across the sky scattering flowers. Outside the details shown here are to be seen her lover, Tithonus, whom she has just left, and the fleeing figure of Night, whom she chases away.

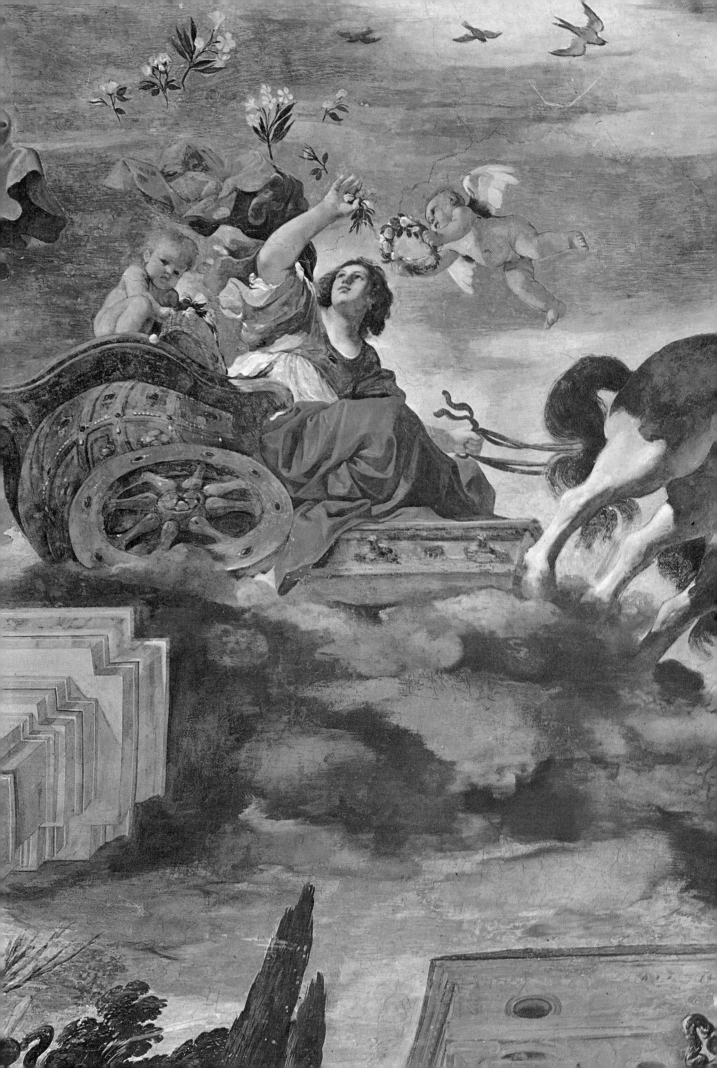

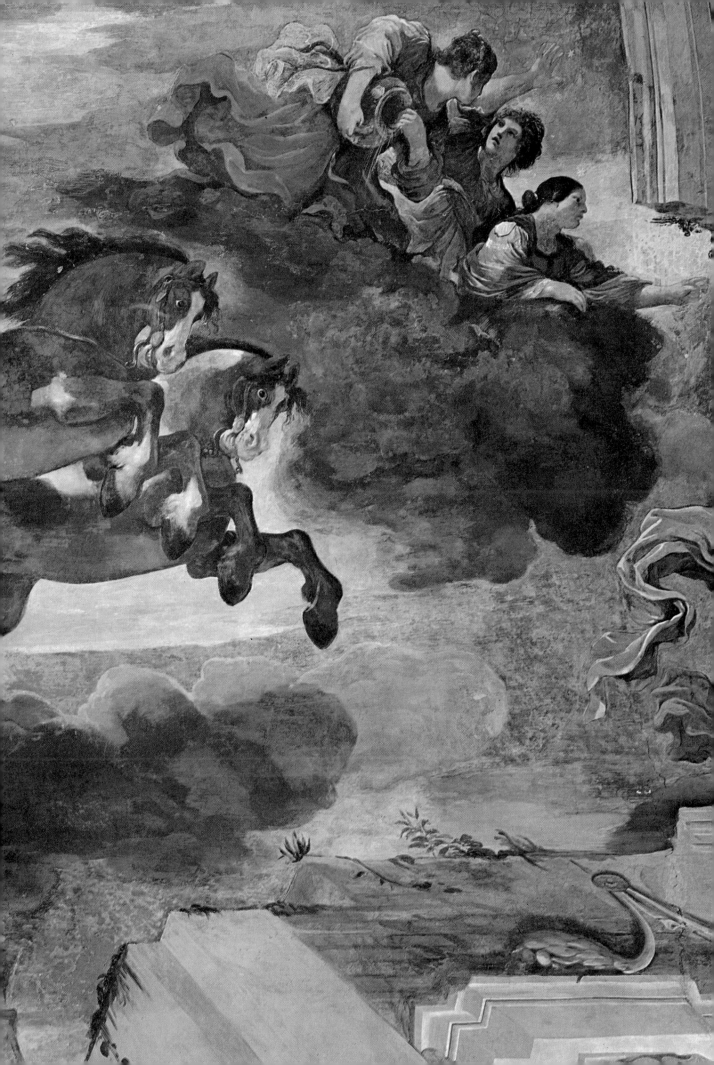

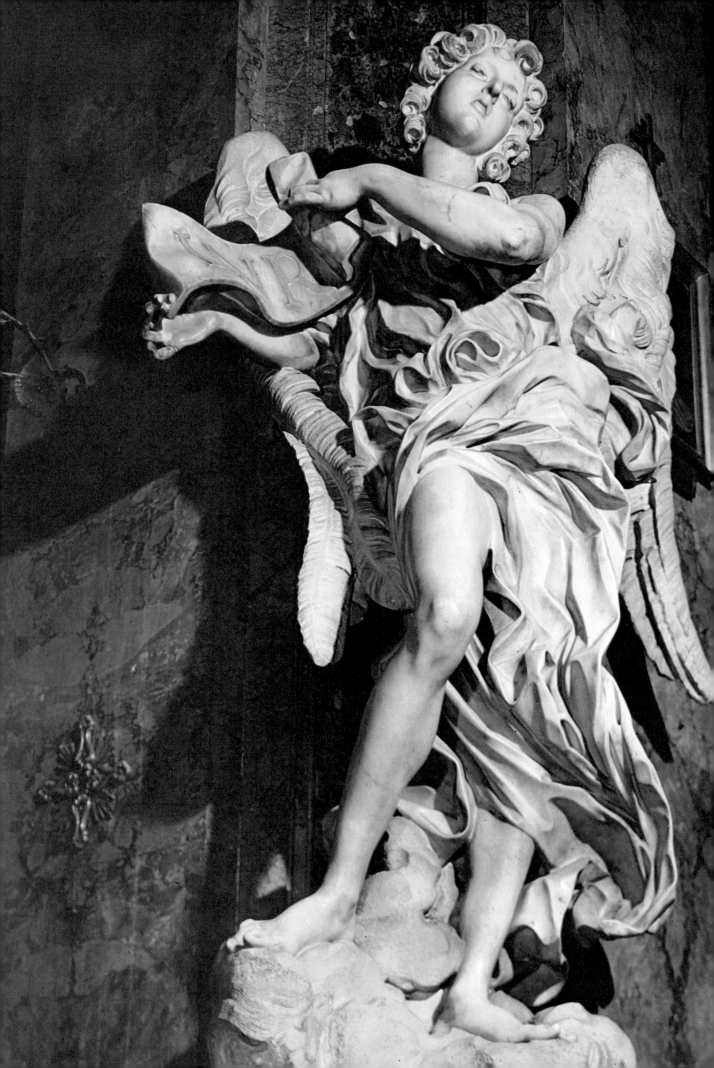

21. (left). **Gianlorenzo Bernini.** *The Angel with the Superscription.* 1668. Marble. Over life-size. S. Andrea delle Fratte, Rome. Originally designed as part of a series of angels holding the instruments of Christ's Passion made for the Ponte Sant'Angelo, this figure and one other were kept indoors on the Pope's orders, replicas being substituted on the bridge to save them from weathering. In style it shows an even more extreme form of Baroque than the angel in *The Ecstasy of Sta Teresa* (plate 1). Initially, the pose was derived from a classical statue, but in developing the design, Bernini took it far from classical concepts of style. The virtuosity of the cutting, irregularity of the outlines and the near-affectation of the expression and movements of the hands were a starting point for much 18th-century German sculpture, as can be seen from the illustrations on this page.

22. **Ignaz Günther.** *Virgin of the Annunciation* (detail). 1764. Carved and painted wood. 63 in. high (160 cm.). Weyarn, Upper Bavaria. The group of the Virgin and Angel of the Annunciation, of which this figure is a detail, was made for the Brotherhood of the Rose-garland at Weyarn to be carried in their processions. Seen as a whole, it is a composition of immense decorative sophistication, the turning poses of the figures interlocking with and answering each other, yet not touching, like the parts of a Bach fugue. The style is attenuated, refined, almost Gothic in its elongations, yet emotionally unrestrained and rococo. In feeling the analogy with Bustelli (plate 85) is close. Yet Günther, the supreme exponent of German rococo sculpture, lived in Munich the humble life of an ordinary master-craftsman.

23. **Christian Jorhan the Elder.** *St Nicholas* (detail). *c.* 1760–67. Carved and painted wood. Altenerding, Bavaria. 18th-century Bavarian sculpture offers a unique combination of sophisticated style and popular feeling. Jorhan is typical of the dozens of sculptors who produced work in this vein. He was influenced by Günther but never became so extreme.

24. (right). **François Mansart,** completed by Jacques Lemercier. *The Val-de-Grâce*, Paris. Begun 1645.

25. (below). **Francesco Borromini,** modified by Carlo Rainaldi and others. *Sta Agnese* in Piazza Navona, Rome. Begun 1653.

These two church exteriors show a comparison and contrast between Roman and Parisian mid-17th-century architecture. The building histories of both churches are complicated. The Val-de-Grâce (right) shows obvious dependence on earlier Italian models (plate 38), but the lower storey (by Mansart), with its massive projecting portico, is more severe and classical than if the church had been Italian. The dome also has an un-Italian solidity and compactness. Sta Agnese (below), commissioned by Pope Innocent X, is typical of the Roman High Baroque. The pierced towers of complex design at either end of the curved façade were an important and influential innovation. The effect, which depends on the tension set up between convex and concave curves and on the space 'trapped' between the towers and the dome, is brilliantly dynamic.

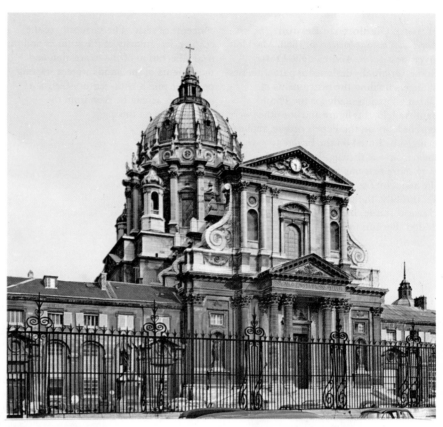

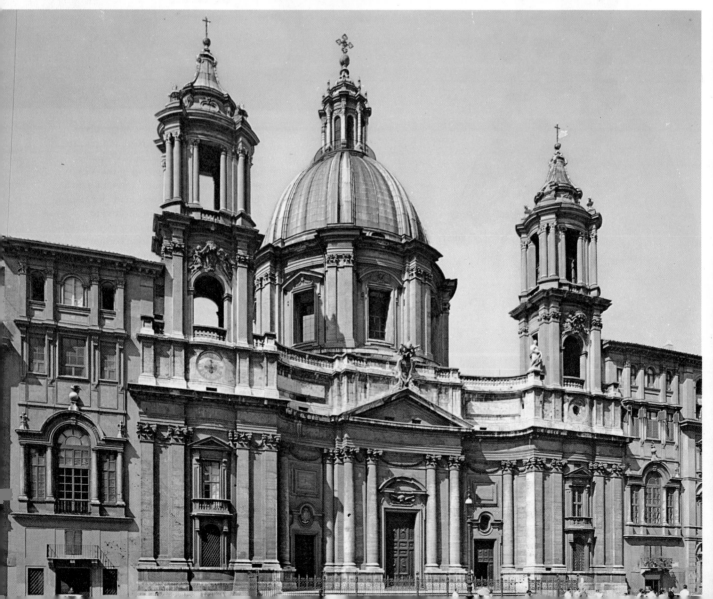

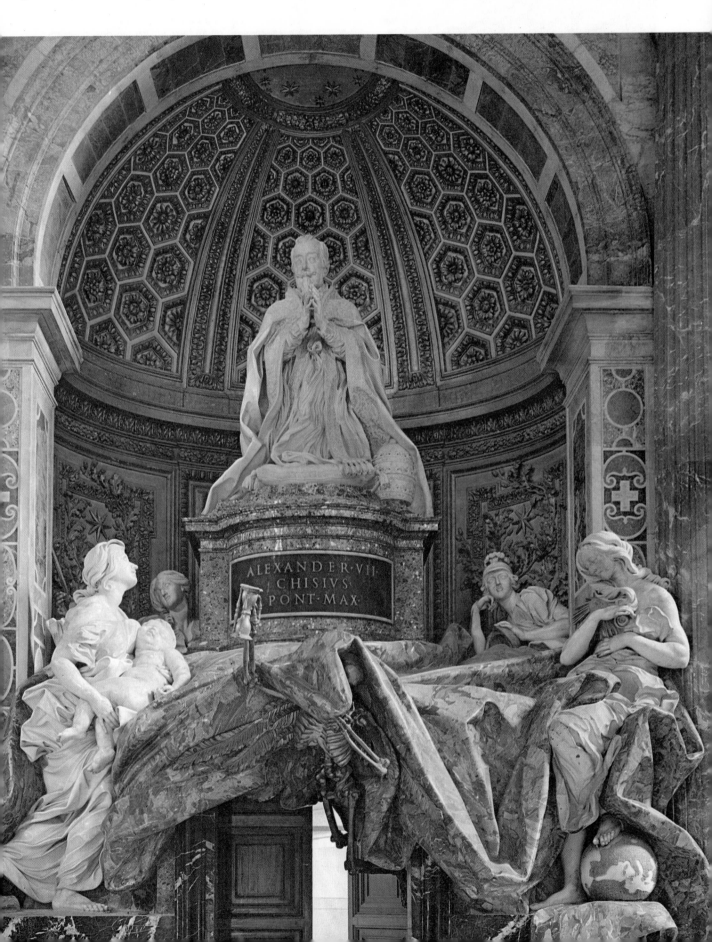

26. **Gianlorenzo Bernini.** *Tomb of Pope Alexander VII.* 1671–78. White and coloured marble. St Peter's, Rome. The Pope kneels calmly in prayer, allegorical figures wreathed in swirling draperies adore or mourn him, while Death, in the macabre figure of a skeleton with an hour-glass, emerges from the entrance of the tomb to summon him to eternity. As in the Cornaro Chapel (plate 1), the partly narrative, partly symbolic conception underlying the work is made vivid and actual by Bernini's inventive genius, backed up by immense illusionistic skill and the use of richly coloured marbles.

27. (left). **Francesco Borromini.**
S. Carlo alle Quattro Fontane, Rome.
1638–41. This little church, of which one
side altar and about a third of the interior
space are shown here, has been described
as one of the 'incunabula' of the Roman
High Baroque. Borromini based the plan
on an intricate geometrical diagram,
evolved through several stages, to which
he finally gave the form of an oval with
undulating sides (the two columns on the
right of the illustration mark the inward
projection of the curve). The dim light
and the height of the church in relation to
its small floor area give one the feeling of
standing in a shrine or grotto. The purity
of the architectural elements, unobscured
by sculptural decoration, is typical of
Borromini.

28. **Johann Michael Feichtmayr.**
Putto. c. 1760. Stucco. Abbey Church,
Ottobeuren, Bavaria. This bewitching
putto, perched on a curl of painted stucco
on the edge of an altar-frame, belongs to
the St John the Baptist altar attached to
the north-east pier of the crossing (on the
left facing the choir in plate 86).
The religious statues in the church are
more serious than they look from a
distance, but they are surrounded by
decorative stucco-work of the utmost
fancy, ending in pure uninhibited play
at the extremities of each group. Feicht-
mayr worked at Ottobeuren from 1756
to 1764.

29. (opposite). **Bartolomé Murillo.** *The
Immaculate Conception. c.* 1660. Oil on
canvas. 81 × 56¾ in. (206 × 144 cm.).
Prado, Madrid. Although this work, at one
time in the Escorial, does not sum up all
possible kinds of 17th-century religious
feeling, let alone of baroque pictorial style,
its theme and manner of presentation can
both be considered representative. First, it
exemplified the cult of the Blessed Virgin
(specifically, her innocence of Original
Sin); second, it is emotional in treatment;
third, its composition consists of a shifting,
irregular pattern of light, shade and colour
to which all elements of the picture
contribute and which merge into one
another.

30. (left). **Mattia Preti.** *Modello for the Plague Fresco.* 1656. Oil on canvas. 50¾ × 30¼ in. (129 × 77 cm.). Galleria Nazionale di Capodimonte, Naples. This is a finished oil study for one of a series of frescoes (now destroyed) painted by Preti to be displayed over the gates of Naples in commemoration of the plague which struck the city in 1656. Saints intercede with the Madonna on behalf of the victims seen below, while an angel with a flaming sword and a scourge is sent to drive out the infection. Stylistically, the painting exemplifies the Neapolitan High Baroque: daring, broadly treated, heavily shadowed and with a streak of the morbid in its emotional content.

31. (opposite). **Giambattista Tiepolo.** *The Trinity appearing to St Clement (?).* *c.* 1730–35. Oil on canvas. 27¼ × 21¾ in. (69 × 55 cm.). Reproduced by courtesy of the Trustees of the National Gallery, London. The greater airiness, brilliance of colour and virtuosity of handling displayed in this painting contrast with the relatively crude brushwork and raw emotions shown in the work opposite. Tiepolo's picture was painted as a preparatory study for an altarpiece in the Chapel of the Nuns of Nôtre Dame at Nymphenburg, now in the Munich Gallery, but it is so highly finished that it might almost be a smaller, alternative version of the final work.

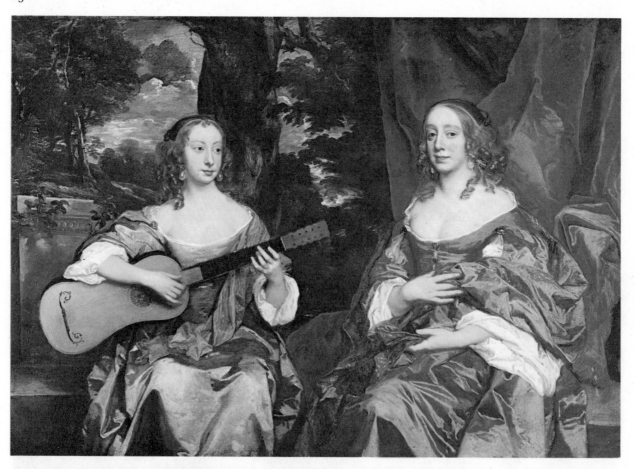

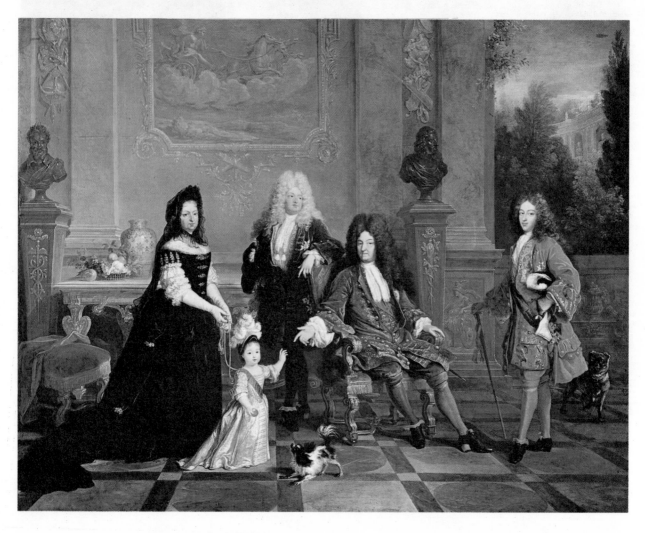

32. (opposite, above). **Peter Lely.** *Two Ladies of the Lake Family. c.* 1660. Oil on canvas. 50 × 70¼ in. (127 × 178 cm.). Reproduced by courtesy of the Trustees of the Tate Gallery, London. An example of baroque portraiture in its English form: the style recalls van Dyck, but the inter-

pretation is less refined. The composition has a decorative fullness and breadth characteristic of this phase of the Baroque.

33. (opposite, below). **Nicolas de Largillière.** *Louis XIV and his Heirs. c.* 1710–15. Oil on canvas. 50 × 63 in.

(127 × 160 cm.). Reproduced by permission of the Trustees of the Wallace Collection, London. Despite the stiffness of the poses, the scale and the grouping give this work a degree of intimacy previously unknown in court portraiture. The next stage after this was the 'Conversation Piece'.

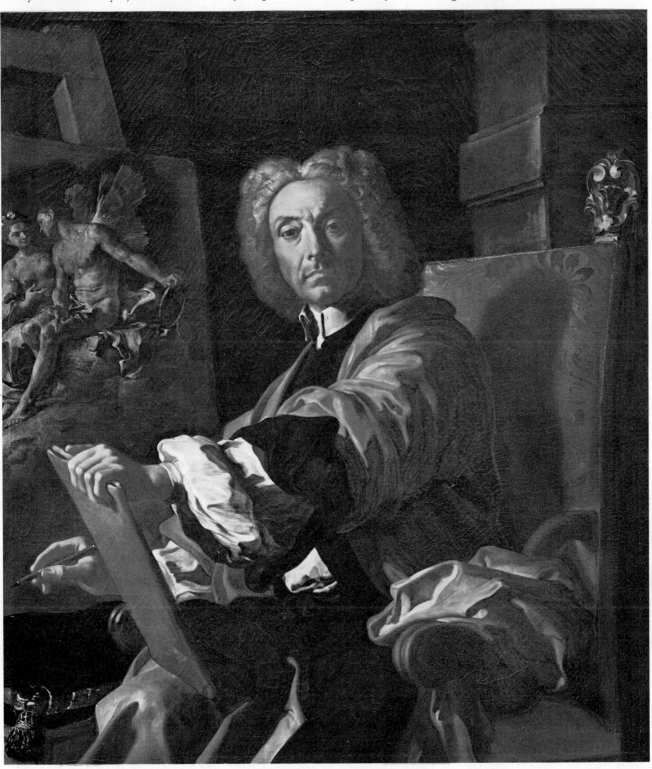

34. (above). **Francesco Solimena.** *Self-portrait. c.* 1715. Oil on canvas. 50½ × 44 in. (128 × 112 cm.). Uffizi, Florence. This is an example of Late Baroque portraiture at its most flamboyant. It shows the leader of the Neapolitan School consciously presenting himself as a

'Prince of Painters'. Few other portraits of the period make use of so many of the techniques of subject painting: compositional inventiveness, bold diagonals and shadow cutting across and into the forms.

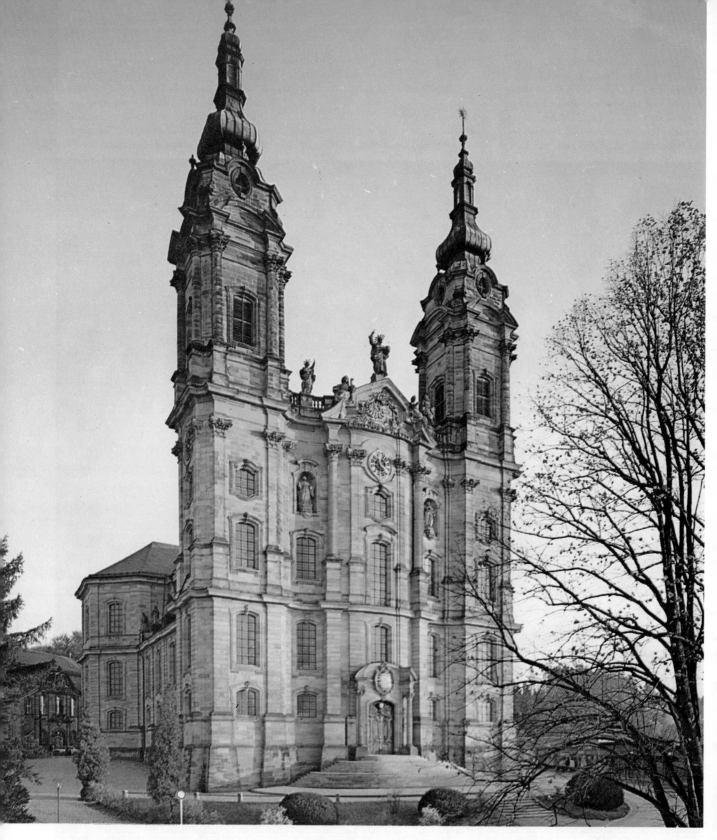

35. (above). **Balthasar Neumann.** *Vierzehnheiligen*, Northern Bavaria. 1744–72. The plan and interior of Vierzehnheiligen ('Church of the Fourteen Saints'), by south Germany's greatest baroque architect, Balthasar Neumann, is of unparalleled ingenuity and complexity—a series of inter-penetrating ovals and circles with no clear division between them and no dome over the intersection of the nave, transept and choir. The façade, of Gothic height and narrowness, and Borrominesque derivation in its architectural style, consists of two soaring towers flanking a curved front.

36. (right). **José Peña** and **Fernando de Casas.** *West Front of the Cathedral of Santiago de Compostela*, Galicia, Spain. 1667–1750. The baroque rebuilding of the exterior of the great romanesque cathedral of Santiago de Compostela, containing the shrine of the Apostle St James, was begun in 1650. Of the part seen here, the inner flight of steps leading up to the west door dates from 1606, the south tower, by Peña, from 1667–70 and the north tower (which repeats the south) and central section of the façade, which is by de Casas, from 1738–50. Architecturally, the most exciting part is the south tower, with its powerful silhouette and groups of five alternating square pilasters and half-columns, with unusual capitals on the storey below the belfry. The façade is typical of Spanish baroque architecture, a flat surface encrusted with a riot of fanciful decoration.

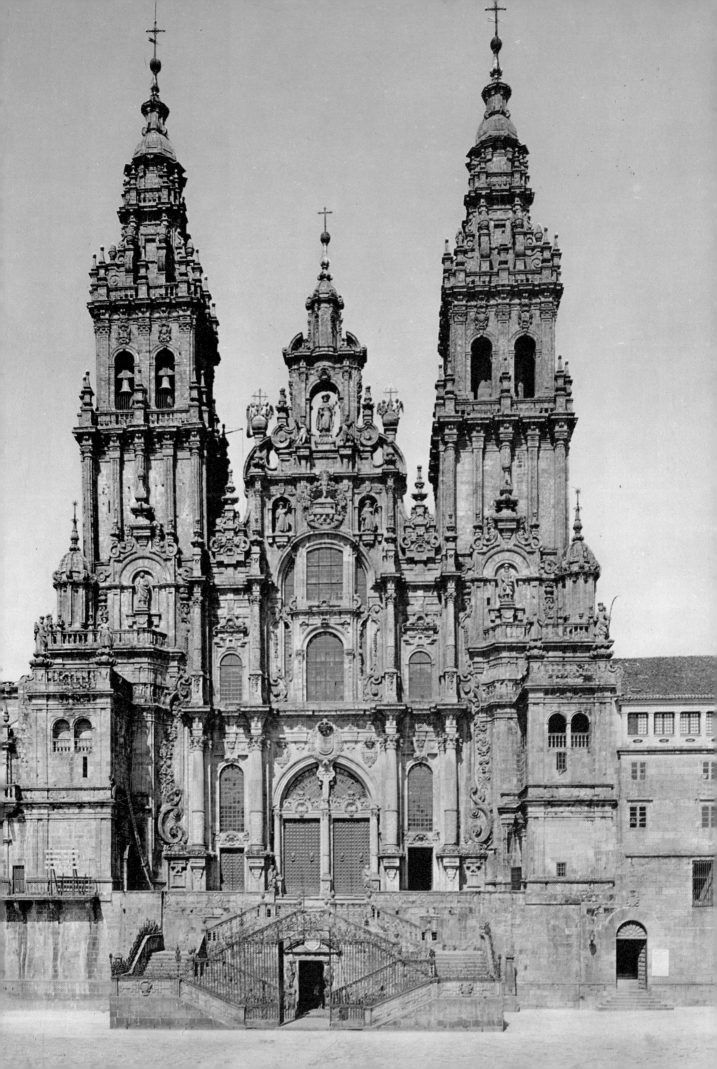

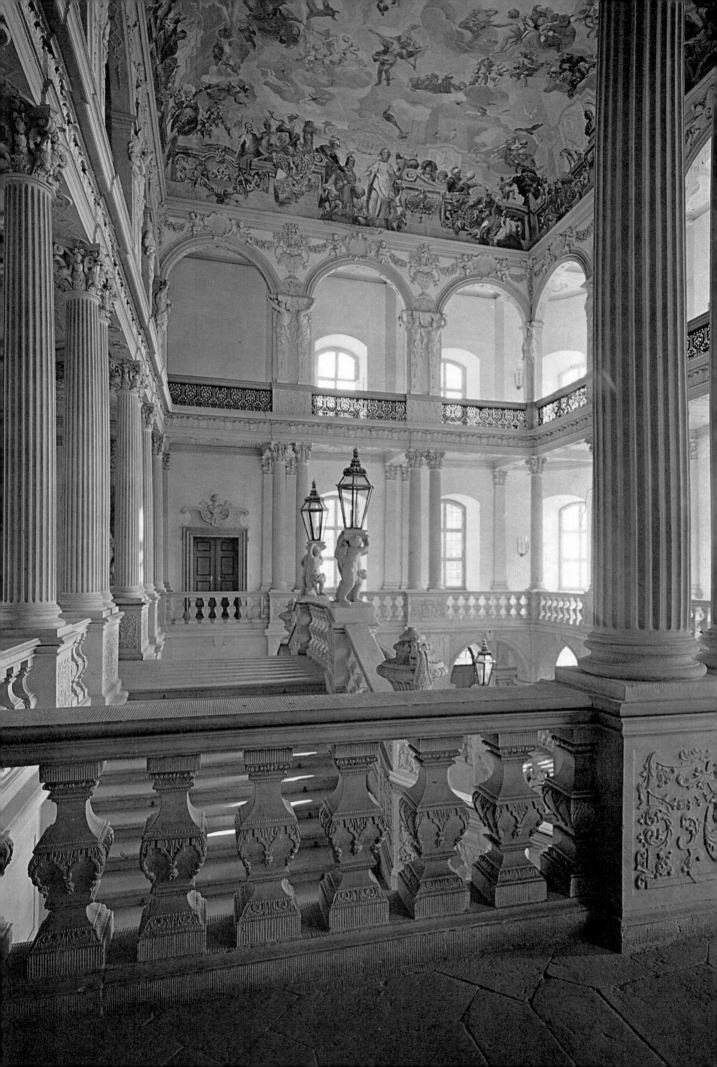

that one can measure the distance of each part of the building from the eye. Borromini's approach produces the opposite of spatial clarity. Standing in S. Carlino one is never quite sure how far away its boundaries lie. The undulating curve of the wall and the cornice produces an effect of uncertainty. One is aware of the space as being loosely, elastically contained, not rigidly bounded.

The undulating curve of the interior is repeated in the façade designed much later. Here the lower and the upper storeys are contrasted with one another. The lower storey consists of an alternating concave-convex-concave curve, with the entrance door in the convex part. The rhythm of the upper storey runs concave-concave-concave, with a little convex structure projecting from the central concave surface. Further vitality and movement are given by the addition of sculptured figures and an irregular balastrade at the top. The same qualities are to be seen in the façades and interiors of the third great architect of the Roman High Baroque, who was also the painter of the Barberini Ceiling—Pietro da Cortona. Cortona, however, used closely coupled or overlapping pilasters of varying thicknesses to carry the eye smoothly from one part to another, not the irregular forms of Borromini.

The spatial elasticity of the interior of S. Carlino accounts for the parallel with Bernini's architecture, which is otherwise based on more traditional principles. Bernini, too, designed a small oval church, S. Andrea al Quirinale, in which ground plan, cornice and dome follow a continuous, not an undulating curve. But since this curve is itself a non-geometrical form, it creates a similar uncertainty in the definition of the boundary, which is further enhanced by the unusual placing of the chapels either side of the long axis. The same oval curve is used again in the Colonnade of St Peter's. As Bernini described it himself, this Colonnade was designed to symbolise the embracing arms of the Church. Grandeur, power and magnificence are combined with a sensation of almost physical welcome. The effect is the reverse of forbidding—not least because of the warm apricot-coloured stone, slightly rough and pitted in texture, of which the Colonnade, like most Roman buildings, is constructed.

For the next stage in the baroque treatment of space in

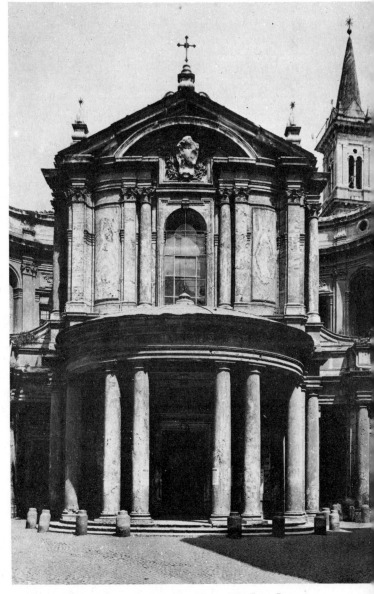

38. **Pietro da Cortona.** *Façade of Sta Maria della Pace, Rome.* 1656–57. Like Borromini, Cortona used contrasting curves and created deep spaces under arches and porticos to exploit the contrast between cast shadow and the strong Roman sunlight, but he kept the units of his design comparatively distinct and was less capricious in his handling of detail. The result is a more elegant and composed façade than that of S. Carlino. The curved wings do not correspond to the shape of the 15th-century church behind them but conceal an irregular agglomeration of buildings and narrow streets.

37. (left). **Lukas von Hildebrandt** and **Johann Dientzenhofer.** *The Staircase,* Schloss Pommersfelden, Bavaria. 1714–19. Because by its nature it compels movement in three dimensions, the staircase as an architectural feature lent itself to baroque treatment, particularly to the use of contrasting intensities of light on its various levels. At Pommersfelden the staircase is the most prominent feature of the palace. The design was provided by Hildebrandt, its execution being entrusted to the resident architect, Johann Dientzenhofer.

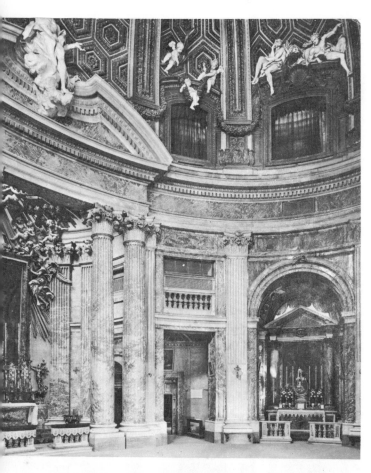

39. **Gianlorenzo Bernini.** *Interior of S. Andrea al Quirinale, Rome.*
1658–70. Bernini used a regular oval plan for this church and
treated the architectural forms with classical correctness, apart
from the cutting back of the pediment over the high altar to take
the statue of St Andrew being assumed into heaven. But,
although the design has an unsurpassed dignity, comparable to
that of the Colonnade of St Peter's (pl. 4) on a much smaller
scale, it is as baroque as the interior of S. Carlino (pl. 80), on
account of its flexibly treated space. Sculpturally and
colouristically it is much richer than S. Carlino.

40. **Guarino Guarini.** *Interior of the Dome of the Chapel of the Holy
Shroud, Turin.* 1667–90. The unusual design of the coffering in
the pendentives and the geometrical pattern of the ribs in the
dome show that Guarini's architecture was derived from
Borromini's rather than Bernini's or Pietro da Cortona's. The
ribs themselves are transverse, not longitudinal (contrast fig. 39,
with longitudinal ribs), and are obtained from the intersection of
alternating, diminishing hexagons with the curved surface of the
dome. The cross-section of the dome is in the form of a pointed
curve, not a hemisphere, producing an almost Gothic effect of
upward movement. Small segmental windows are inserted
beneath each rib and the whole culminates in a star-shaped 'rose
window' at the base of the lantern.

architecture one must return to northern Italy. Here, in
Turin, Guarino Guarini, who had visited Rome, created a
small group of very important buildings which are even
more remarkable than Borromini's in design. Guarini went
further than any other Italian architect in abandoning the
principles of classicism. In the domes of the Chapel of the
Holy Shroud and the Church of S. Lorenzo he created
structures of almost Gothic complexity. Instead of the
dome being a closed hemispherical surface, as was the case
in all previous Italian churches, it becomes in Guarini's
hands an open lattice-work structure with ribs crossing the
curve like cords, not converging on the centre. The result is
the ultimate expression of the baroque conception of space
in Italy: here are continuity and elasticity of space, dynamic
movement and a glimpse towards the infinite.

Guarini and Borromini were the main sources for
Austrian and South German architects. In south Germany
the centrally-planned church was less favoured than the

more traditional Latin cross plan with a choir, transept and
long nave. But ovals were often still the basis of the design,
flowing into one another, for example at Vierzehnheiligen
by Neumann, in a way that dazzles and astounds. Even
more than in Borromini's churches the exact position of the
spatial boundary, or rather boundaries, is unclear. Walk-
ing about this church, one cannot read its design with the
eye. It only appears as a series of fluid interrelated spaces
which are barely divided from one another. Curve follows
curve both in the walls and in the vaults and these curves
are constantly changing as one views them from different
angles. Although the details are less fine than in earlier
Italian architecture, the spatial effects of South German
churches are unparallelled in European art.

Other and in some ways still more dramatic opportuni-
ties for the treatment of space in baroque terms were
provided by the staircase, since a staircase necessarily in-
volves movement in three dimensions. Admittedly, the

41. **Guarino Guarini.** *Exterior of the same Dome.* The interlocking
stepped effect of the transverse ribs seen from the outside reflects
the complicated structure within. The pagoda-like lantern is
also very unusual. The drum is pierced by six large round-headed
windows. It is typical of Guarini that there is no continuous
cornice separating the drum from the dome but an undulating
line, an idea hinted at, though never precisely carried out,
by Borromini.

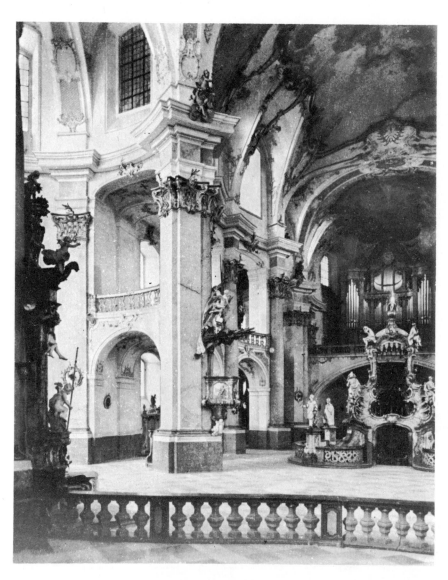

42. **Balthasar Neumann.** *Interior of the Church of the Vierzehnheiligen, Northern Bavaria.* 1743–72. The plan of this church is basically a traditional Latin Cross with a nave, transepts and choir, but there is no dome over the crossing and the interior articulation springs from three longitudinal ovals cut by two transverse ovals. The view reproduced here is taken from behind the chancel rail in the choir oval, looking towards the altar of the Fourteen Saints in the central oval, with the south transept, circular in plan, on the left. The interpenetration of spaces and the manipulation of light which results is the epitome of German baroque architecture. The colouring, some of the detail and the altar tend in style towards the Rococo.

aesthetic limitations as well as possibilites of this feature are determined by its function, for it can never be other than a means of getting from one place to another. But by the late 17th century, the staircase was certainly treated as an end in itself, and in some 18th-century German palaces it is the most prominent feature of the building, with a part of the palace all to itself. (Significantly, there is a word for this in German—*Treppenhaus*, 'stair-house'—which has no exact equivalent in other languages.)

Structurally two basic types of open staircase had already been developed in the 16th century, to begin with in Spain —first, that consisting of four short flights turning through 360 degrees round a square well; second, the type which begins with a single flight up the centre, then divides at the half-landing, returning in two flights to meet at the main landing. The baroque contribution was two-fold: first, to enlarge the ornamental features of the staircase by means of sculptured balustrades and architectural, sculptural or painted decorations on the walls and ceiling; second, to exploit the contrasts in light and shade on the various levels.

The first examples to show the latter are 17th-century Italian staircases (notably the Scala Regia by Bernini in the Vatican), although staircases in Italy were not given particular consideration in the design of the building as a whole and were often fitted into awkward corners. This comparative neglect of the actual siting of the staircase is also often found in French staircases, even at Versailles where the *Escalier des Ambassadeurs* (destroyed in the 18th century) was remarkable chiefly for its grandeur and the magnificence of its decoration, not for its position or the complexity of its design. The full exploitation of the lighting possibilities of the staircase was a development of the late Baroque, for instance the staircase by Fischer von Erlach in the town palace of Prinz Eugen in Vienna. In this example, the visitor comes in through a relatively low, dark vestibule, then ascends the staircase to reach a light open area above. The balustrades are thick and massive with sculptured figures attached to them. In German (as distinct from Austrian) palaces the effect reaches extremes of lightness and spaciousness. The various levels of the stairs themselves are treated more intricately than before with 'quarter landings' on straight flights producing a sort of undulation. Still more attention is given to the space above the stairs. Pommersfelden has galleries in this space; Würzburg has one of the greatest ceiling paintings of the 18th century, Tiepolo's *Olympus with the Four Quarters of the Globe*; Bruchsal, structurally the most ingenious, has an oval plan.

Although other possibilities for the staircase were developed by considering it from the outside of the building, the most characteristic baroque feature of the treat-

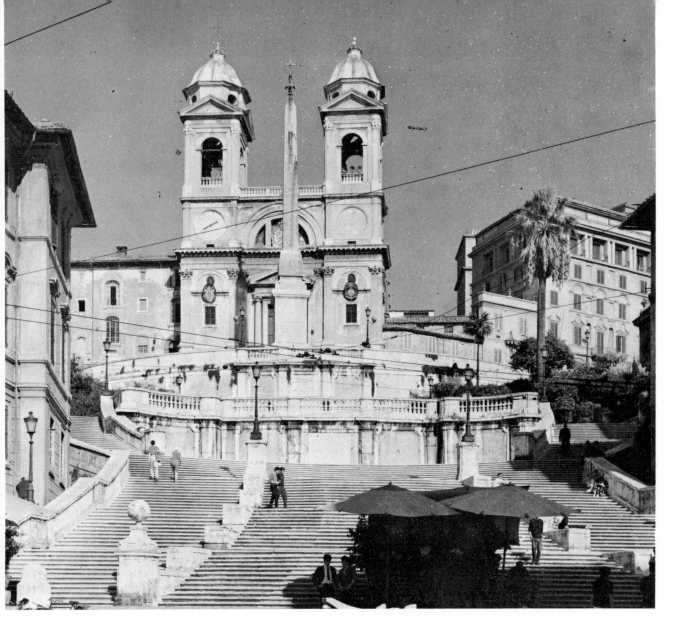

43. **Francesco de Sanctis.** *The Spanish Steps, Rome.* 1723–25.
The contrasting curves of the stairs and balustrades seen in plan produce a sensation of constant variety and surprise (qualities almost of the Rococo) as one walks up. It is as if the architecture had taken charge, controlling one's movements in ways that are hard to resist or understand yet are gentle enough to be delightful rather than disturbing. The church at the top is the SS. Trinità de' Monti, built in the 16th century, with a façade by Maderna.

ment of outdoor space was the vista. This, too, was a development of the late 17th and early 18th centuries and was associated with the grandiose palace layouts of that period. Earlier one finds more limited town planning schemes, such as the Piazza del Popolo in Rome with its three streets radiating into the city, the centre one of which is framed by two small centrally planned churches by Rainaldi. But really this is not so much a vista as a series of contrasting narrow and open spaces designed to surprise.

Surprise was also the principle of the greatest Roman example in the 17th century, Bernini's approach to St Peter's. This started at the Ponte S. Angelo, with its sculptured figures of angels holding the Instruments of the Passion, and led across the river to the ancient Castel S. Angelo surmounted by an angel with a flaming sword; then the visitor turned left through narrow streets until he reached the Colonnade. Stepping between the columns he was confronted by the immense oval space of the Piazza—a dramatic change from darkness and meanness to magnificence and light. Across the Piazza the space narrowed again for the final stage up the steps to the façade of St Peter's itself. Then once again the visitor had to go through a fairly dark and narrow entrance but, inside, the surprise was repeated again and a new spiritual magnificence was added to the secular splendour left behind. The climax of all this was the Cathedra Petri at the west end of the Basilica. Paradoxically,

44. **Johann Bernhard Fischer von Erlach.** *Staircase of the Prinz Eugen Stadtpalais, Vienna.* 1694–8, 1708–11. Next to the stage set, the staircase gave baroque architects more scope for ingenuity than almost anything else. That of the Prinz Eugen Stadtpalais is structurally quite simple, but the transition from the dark ground floor to the well-lit upper floor—a transition dramatised by the thick-set sculpted figures and the massive, very personal architectural detail—is typical of the Central European Baroque.

the greatest vista in baroque Rome is in an interior.

In many ways the outdoor vista, conceived as an avenue with a culminating feature at the end, was more characteristic of northern Europe than the south. Versailles, with its great alleys between the trees and punctuated by lakes and fountains, is the supreme example. It is this which explains one of the otherwise surprising aspects of baroque garden design, namely that it is based on strict symmetry and straight lines, rather than dynamic movement and curves. Vistas are also found in England at this time, for example at Greenwich, where Wren's naval hospital is divided in two, as it were, to reveal a view of the Queen's House across an open space at the far end.

As might be expected, the most striking effects of space in painting occur in ceiling decorations. Perspective architecture was a common method of creating space in these, especially at the beginning and end of the 17th century. (In the middle of the century it went out of fashion.) The first problem for baroque painters was to learn how to treat the ceiling as a single unit of space rather than as a series of separate compartments—a process which took a long time, although one can see the trend towards unification beginning with Annibale Carracci's ceiling in the Palazzo Farnese, Guercino's *Aurora* in the Casino Ludovisi marks a further stage in this process, since it has only three compart-

ments, two of which flow into each other by the breaking of the architecture between them.

The management of the whole surface as a single space was first achieved in domes, reviving a method invented in the Renaissance by Correggio. In Pietro da Cortona's ceilings in the Palazzo Pitti, Florence, dating from the 1640s, it was transferred on a small scale to the ceilings of rooms. Finally, from the 1670s onwards it became a commonplace of the treatment of large vaults (the Gesù, S. Ingnazio, etc.). From this time onwards, too, the space of the ceiling was increasingly merged with the real space of the room. The painted decoration no longer stops at a solid unbroken cornice, but spills over into the real architecture, which itself becomes more and more fanciful. In 18th-century ceilings the three-dimensional stucco forms, continuing the real architecture, reach up into the ceiling in irregular curving shapes and then recede again like waves on the seashore.

There was a further problem which ceiling painters only solved gradually, namely the extension of the space in depth. The perspective architecture used at the beginning of the 17th century produced this extension automatically, but in the following phase, when painters were employing a looser framework (for example, Guercino in the *Aurora*), the painted space hardly reaches far above the real surface of the ceiling. It was not until the 1660s that the roof was taken off, as it were, and space was extended to infinity. In the late 17th and early 18th centuries effects of unparalleled splendour were achieved by this means. Countless numbers of figures soar upwards, receding as far as the eye can see like stars in the sky.

CONCLUSION

The Baroque is not easy to sum up. It is a centripetal not a centrifugal style, by which one means that all its characteristics are compatible with one another and can be combined in the same work. Such works represent the Baroque in its most typical forms. They are the touchstones, the works by which the Baroque can be recognised and against which others can be tested for the degree to which they approach it. As has been seen, Baroque is very much a style of 'more' or 'less'. A further aspect of this is that not all characteristics need be present at once, yet they all interlock. Illusionism, emotional and psychological appeal, splendour, movement, space, are interrelated qualities; in a sense they are all functions of each other.

This does not mean that the Baroque was not also capable of wide varieties of expression. When examined in detail, Bernini, Borromini, Guercino, Neumann, Rubens, Pietro da Cortona and Tiepolo are seen to be very different from one another; in the Baroque, as in other periods, great masters and major national schools retained their own individuality. But this problem has been deliberately neglected in this chapter, partly because to have treated artists as individual personalities would have made it much more difficult to isolate the characteristics of the Baroque as a style.

Seventeenth-century Classicism

THE CONTRAST BETWEEN CLASSICISM AND THE BAROQUE

Seventeenth-century classicism was opposed to the Baroque in many ways, but the two styles shared a preoccupation with ideal form, an emphasis on eloquence of expression and gesture, and the same basic architectural vocabulary. Moreover, classical artists absorbed something of the baroque qualities of luminosity, saturated colour and psychological realism. Sometimes baroque influence went further, as in Sacchi's paintings, Algardi's sculpture and Lebrun's decorative work at Versailles, resulting in the compromise between the two styles known as Baroque-classicism. But over such matters as the appeal to the senses, the fusion of the arts and the treatment of space and movement, there was in principle a marked difference of approach, and this difference became more marked with time.

Almost from the beginning, classicism had the character of a resistance movement against the Baroque. This is not to say that it was simply retrospective; on the contrary, 17th-century classicism was creative, not narrowly imitative or reactionary. Nevertheless, classical artists were more wholehearted in their respect for tradition than their baroque contemporaries. They tried to make their finished works conform to principles derived from ancient and High Renaissance art; they did not merely use prototypes from those sources as raw material to be freely transformed into new designs. Raphael, held in respect by all 17th-century artists (except perhaps Caravaggio), was admired by the classicists barely this side of idolatry. The ideals of the classicists regarding form and composition were clarity, harmony and balance. If they were architects, they believed in preserving the correct use of the orders; if painters, they regarded colour as an adjunct to form, not as equal or superior to it. Beginning with Poussin, if not earlier, they held that art should appeal more to the mind than the senses.

45. **Annibale Carracci.** *The Choice of Hercules.* 1595–97. Oil on canvas. 65¾ × 93¼ in. (167 × 237 cm.). Galleria Nazionale di Capodimonte, Naples. This picture, also known as the *Judgement of Hercules* or *Hercules at the Crossroads*, was originally the centre piece of the frescoed ceiling of the Camerino in the Palazzo Farnese, which Annibale Carracci painted before starting on the ceiling of the Gallery (fig. 18). Its subject is Hercules in the act of deciding between Virtue (left) and Vice, and the picture is thus an allegory of man's power of moral choice. The lucid harmonious solution to the compositional problem laid the foundations of 17th-century classicism in painting.

46. **Andrea Sacchi.** *Allegory of Divine Wisdom.* 1629–*c.* 1633. Fresco. Palazzo Barberini, Rome. This fresco, painted in a room about half the size of the Gran Salone (fig. 30) and on a much lower ceiling, was a conscious attempt by Sacchi to keep to the classical rules of clarity, simplicity and order in the face of the rising tide of the high Baroque. Cortona's *Triumph of Divine Providence*, painted in the immediately following years, was a high baroque 'answer' to it, and the contrast in methods of approach was debated in the Academy of St Luke.

CLASSICISM IN PAINTING

Few artists other than Poussin quite succeeded in living up to the classical ideals in practice, nor were the differences in attitude between the two sides felt immediately even in theory. The spirit underlying Annibale Carracci's *Choice of Hercules*, painted soon after that artist's move from Bologna to Rome in 1595, was one of eager response to the discovery of the Antique and of Michelangelo's and Raphael's frescoes, but there was no question of its being an anti-baroque manifesto. Even before he left Bologna, Annibale's style had begun to change in a classical direction. When in the following years he painted the Farnese Ceiling, he created a masterpiece that at once revived the traditions of Roman High Renaissance fresco painting and laid the foundations of both the classical and baroque trends in 17th-century art. In this influential work there is a perfect fusion of its various constituent elements and no sense of conflict between them. The sources of the ceiling include motives from Michelangelo, Raphael, Titian and the Antique; its style combines something of the clarity and firmness of outline characteristic of classicism with a deco-rative richness and exuberance suggestive of the Baroque. Maderna's façade of Sta Susanna combines classical and baroque qualities in architecture in the same way.

However, among the next generation of painters working in Rome, especially the Carracci pupils, there was a perceptible classical reaction. The classical implications of the Farnese Ceiling were followed up and its baroque ones ignored. By the early 1620s a contrast between the two styles was becoming apparent. It is possible that Guercino, who had come to Rome in 1621 with one of the most advanced baroque styles in Italy, was advised by his patron's learned secretary, Monsignor Agucchi, to change to a more classical manner, and acted on the advice, although he never became a fully classical artist. In the same years Guido Reni was cultivating another quality on which classical artists and theorists laid stress—ideal beauty. Although Reni's paintings are baroque in sentiment and handling, they exhibit a classical emphasis on the perfect human body which with Reni was almost an obsession.

In 1629 Andrea Sacchi began a ceiling in the Barberini

Palace, the *Allegory of Divine Wisdom*, that likewise had certain baroque features but was composed, unillusionistically and with relatively few figures, on classical lines. Almost immediately it was 'answered' by another, larger ceiling in the same palace, the *Triumph of Divine Providence* by Pietro da Cortona—the first great masterpiece of Roman high baroque painting—which has already been discussed.

Despite Cortona's resounding triumpth for the Baroque in the 1630s it began to seem in the next decade as if classicism was gaining ground. Compositions became clearer, figures were more spaced out and were reduced in number and foreshortenings were tamed. Even the most baroque artists, including Bernini, succumbed to these tendencies to some extent. Nor was the change of mood confined only to Italian artists or to artists who belonged in the broadest sense to the classical tradition; it was felt throughout all European art. In Rome a small group of painters, of whom the best known was Sassoferrato, went back to the 15th century for inspiration, producing a sort of Pre-Raphaelitism looking like that of the German Nazarenes of the early 19th century. Elsewhere in Italy the Baroque was less drastically modified. Outside Italy a new calm, simplicity and order permeated the works of such otherwise unclassical painters as Velasquez and Rembrandt at this time. Dutch landscape, *genre* and still-life painting were similarly affected although they were quite unconnected with classicism in the formal sense. A spirit of *recueillement* set in; it was as if painters all over Europe had paused for thought.

The greatest representative of this phase was Nicolas Poussin. Poussin made classicism into a serious, expressive and deeply moving pictorial language as perhaps never before or since; to find anything comparable to his art one has to go back to the Parthenon Frieze, which he never knew. By temperament he was an admirer of the Venetians and his early works glow with colour and a poignant sensual charm, but he gradually purified his style of these attractions in the interests of clarity and intellectual precision. By 1642 he could write: 'My nature leads me to seek out and cherish things that are well ordered, shunning confusion which is as contrary and menacing to me as dark shadows are to the light of day.' At the same time he was making careful studies after ancient statues and bas-reliefs, and, when he came to compose his paintings, would sometimes approximate the final version of a form more closely to the classical original than it had been in the first sketch.

Poussin's saturation in the moral attitudes and visible remains of the ancient world gave a mood of austere gravity to his mature and late works. He took great care to arrange his figures in such a way that every gesture and expression would tell. Nothing was allowed to be either superfluous or unclear. Standing in front of such a work as the *Sacrament of Confirmation*, we are the witnesses of some high, solemn ceremony (our role is very definitely that of observers rather than participants). All movement in the picture is restrained, gestures are restricted to lines parallel to the surface and space is plotted with mathematical exactness.

47. **Nicolas Poussin.** *Studies after the Antique. c.* 1645–50. Pen and brown wash. 12½ × 8¼ in. (32 × 21 cm.). Musée de Valenciennes. Ancient Greek and Roman sculpture was naturally of great interest to Poussin (though perhaps no more so than to Rubens) and he made many drawings after it, particularly after sculptured reliefs. He used the knowledge so gained not only for details and accessories but also—and here he differed from Rubens and other baroque artists—as a guide to the finished appearance of his paintings as a whole

There is no blending of forms and no extravagance of emotion, as there would be in baroque art. Everything is governed by the intelligence and appeals to the intelligence for its appreciation. Yet for all the deliberation of Poussin's art, for all his reputedly conscious attempt to suppress feeling, his paintings are hardly ever cold or lifeless. Classicism in the hands of a great artist does not mean emotional sterility but an emotional tension—a tension developed between the imaginative force of the informing idea and the strict discipline of the means used to control and express it.

IDEAL LANDSCAPE PAINTING

Another type of classical painting which flourished in Rome at this time was ideal landscape, of which Poussin himself was one of the greatest masters. The sources of ideal landscape can be traced back to the Renaissance but the founder of the tradition in its 17th-century form was Annibale Carracci. Many of its practitioners were foreign-

48. **Gaspard Dughet,** also called **Gaspard Poussin.** *Classical Landscape. c.* 1650–70. Engraving by Châtelain, 1741. Gaspard Dughet was the third great classical landscape painter working in Rome in the 17th century, ranking next after Nicolas Poussin (who married his sister) and Claude Lorrain. His work chiefly shows the influence of his brother-in-law but his treatment of nature is less severely mathematical and he occasionally introduces a pastoral note or lighting effect reminiscent of Claude. All the conventions of classical landscape are set out in this engraving in almost 'text-book' fashion.

49. **Claude Lorrain.** *Study of Trees. c.* 1640. Brown wash and black chalk on pale ochre-tinted paper. 9⅞ × 7⅛ in. (25 × 18.2 cm.). British Museum, London. It was by making studies from nature such as this that Claude acquired the knowledge of tree forms, atmosphere and light that he used in his paintings. The early *Landscape with a Goatherd* (pl. 44) is only slightly more idealised than this drawing and is similar to it in feeling. But the drawing itself is already simplified and idealised to some extent and is a form of visual poetry, not a literal record, and is a work of art in its own right.

ers, of whom Poussin and Claude Lorrain were French, Poussin's brother-in-law, Gaspard Dughet, was half-French and Adam Elsheimer was German. (Although the latter was not strictly an ideal landscape painter in the classical sense he belonged to the tradition by association.)

The essence of ideal landscape painting lay in the conjunction of two things: drawing from nature in the country-side round Rome (the Campagna), and the use of a certain set of pictorial conventions. These conventions might be applied in a variety of ways and with greater or lesser degrees of elaboration but, reduced to their simplest, they would produce a landscape composed as follows. The foreground would consist of a more or less flat plain, often with a stream running through it. To one side and generally rising the whole height of the picture there would be a tree or group of trees with spreading foliage, seen partly in shadow and silhouetted against the sky. On or towards the other side and set further back in space there would be a second group of smaller trees, balancing the first, often near some rising ground surmounted by a classical building. The distance would consist of further flat ground, possibly with a winding river, and, on the horizon, a faint line of hills or a view of the sea. Two other essential ingredients were figures, often drawn from some story in the Bible or classical mythology, and an all-pervading light. This light was in many ways the key feature of the system. Elsheimer

was the first to discover the poetic possibilities of light enveloping the whole of a landscape composition, but it was Claude who treated it with a subtlety unparalleled in his time and not surpassed in representational accuracy until the days of Impressionism.

All the natural features of ideal landscape, including the light, were inspired by the Roman countryside, and many of the drawings made by artists from nature—especially the drawings of Claude—are of great beauty in their own right. Nevertheless, the end which the artists had in mind in their paintings was not to represent nature as they saw it, but to treat it in an idealised way. They transformed the Campagna into a region of enchantment and delight, conceiving it in imagination as it might have been in a remote Golden Age. As in Poussin's figure paintings, the elements of the landscape were carefully selected and related to each other according to principles of clarity and order.

Despite the consistency of the conventions employed, ideal landscape was neither a monotonous nor stereotyped form of art. It was capable of almost infinitely varied nuances of interpretation and several major differences of emphasis. Poussin, as might be expected, stressed logic and clarity, preferring strong sunlight and sharp outlines and applying to the confusion of external nature the same principles of mathematical order which he introduced into his figure compositions. Claude, on the other hand, chose

50. **Claude Lorrain.** *Study for 'Landscape with the Nymph Egeria'.*
1663. Pen, shades of brown and grey-brown wash and white
body-colour. 7 × 9½ in. (17.8 × 24 cm.). English Private
Collection. This drawing is a study for a painting, the central
part of which is reproduced on pl. 45. Such highly finished
drawings were as typical of Claude's later years as the nature
studies were of his earlier, although he produced examples of
both types of drawing throughout his life. This drawing is like a
painting in all but medium.

a softer light, often the light of morning or evening rather
than midday, and created a more idyllic mood. Sometimes
he actually represented the sun in his paintings using it as
the source of light for the first time in the history of art. If
the sun is not visible, the light still emanates from an area
of the sky just above the horizon, filling the whole composi-
tion with its radiance and linking foreground and back-
ground in a continuous spatial unity.

Whether this discovery of the poetry of light is a specifi-
cally classical characteristic is an open question; in some of
Claude's early harbour scenes the light has a splendour and
theatrical intensity that are more typical of the Baroque.
But pervasive, poetic light is generally associated with
moods of serenity and calm. In Italy such moods always
occur in landscapes that are also classical in form; in Hol-
land in the 1640s and 1650s they occur in landscapes that
are classical only in spirit but, in keeping with the climate,
a subdued, misty light plays almost as central a part in the
landscapes of van Goyen or Cuyp as it does in those of
Claude.

Although Poussin and Claude spent their working lives
in Rome, they were typically French artists, in that it was
in France rather than Italy or any other country that clas-
sicism found its most constant expression. After Poussin's
death in 1665, the Baroque was once more in the ascendant
in Italy and such artists as attempted to resist it in the name

of classicism were pulled further than before in a baroque
direction. It was as if the whole conflict had shifted its
ground and was taking place more on baroque terms. It
was not until the mid-18th century that classical ideals
were revived in Italian painting and even then the revival
was largely confined to Rome. In the liveliest centre of
Italian painting at that time, Venice, classicism was hardly
felt at all except perhaps as a quietening of style in the last
works of Tiepolo. Nor did classicism find much echo in any
of the arts in Spain, Germany and Central Europe until the
advent of Neo-Classicism in the last quarter of the 18th
century.

The classical bias of French painting was naturally due
in part to Poussin's influence, but it can also be found
before that influence became effective (in the early 1640s),
at least as an attitude of mind if not yet as a desire to imitate
classical antiquity. The French Caravaggesque painter
Georges de la Tour, who worked in the small town of Luné-
ville in Lorraine, differed from Caravaggio himself in
precisely this way. He used all the Caravaggesque devices
of close-up, surface realism and strong tone contrasts but
assembled his compositions with a new economy and re-
straint. Even in harrowing scenes such as the *St Sebastian*
tended by St Irene there is no movement, no violence and very
little blood; there is only the motionless body of the saint
on the ground, a single arrow and the silent figures of
St Irene and her serving women coming to tend him. An-
other instance of the way the inherently classical tendency
of French taste could influence an unclassical type of art
can be seen in the work of the *genre* painter, Louis le Nain.
The baroque decorative artist, Simon Vouet, also began to
modify his style in a classical direction after his arrival in
Paris from Rome in 1627, although he might have done
this in any case in conformity with the general trend of
European art.

From 1640–42 Poussin himself stayed in Paris, having
been summoned there by the King to decorate the long
gallery of the Louvre. The visit itself was a failure and
Poussin returned to Rome in disgust but his influence was
implanted in Paris to become a permanent feature of
French art. Under that influence, which was reinforced by
that of Lebrun who had been his pupil in Rome, the French
Academy evolved the theoretical doctrines which fixed the
rules of classicism for the next hundred years.

CLASSICISM IN SCULPTURE

In view of the eagerness with which ancient sculpture
had been studied ever since the Renaissance, one might
expect there to have been as strong a classical current in
17th-century sculpture as there was in painting. In fact this
was not so and it is difficult to find a reason for it other than
the accident that no classical sculptor was born who was
anywhere near talented enough to challenge the supremacy
of Bernini. Until the middle of the century there were few
good sculptors in France and, by European standards,
none at all in England or Holland. In Flanders, apart from

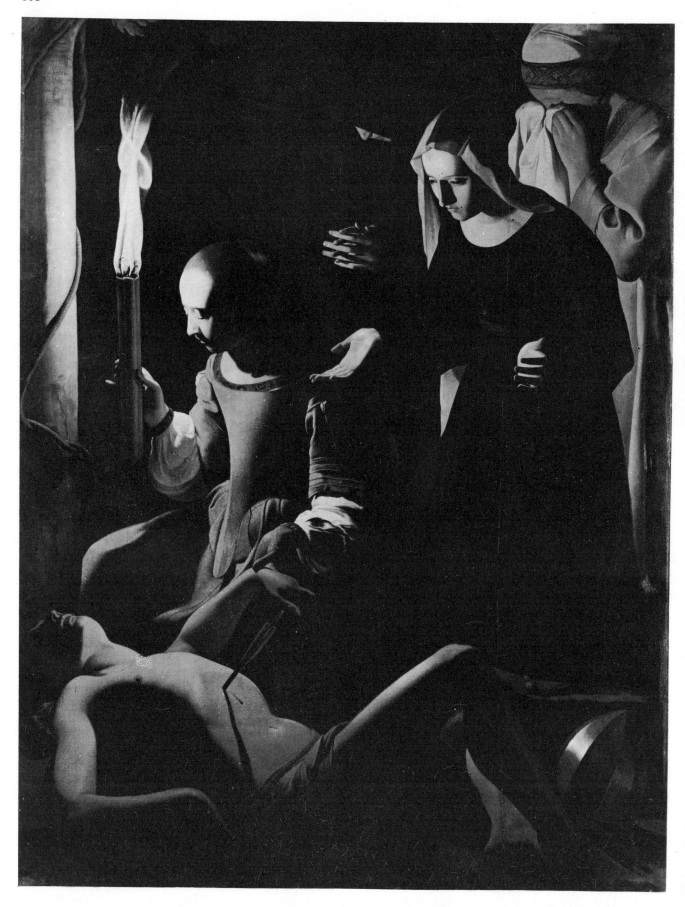

51. **Georges de la Tour.** *St Sebastian tended by St Irene. c.* 1650. Oil on canvas. 63 × 50¾ in. (160 × 129 cm.). National Museum, Berlin-Dahlem. This classical interpretation of Caravaggio should be compared with Ribera's baroque interpretation shown in fig. 24. The caption to that work also contains a note on the subject-matter. The characteristic of Georges de la Tour's last period, to which this painting belongs, is an extreme simplification of form, to the point where the figures seem almost as if made of carved wood.

Duquesnoy, who spent most of his career in Rome, the most important sculptor was Rubens, although his designs for work in this medium were mostly carried out by assistants. In Spain there were two main types of sculpture, neither of which was classical: first, decorative sculpture used in conjunction with architecture and of no great interest in itself; second, carved and coloured wooden sculpture, which will be discussed under the heading of realism in the next chapter.

The two important sculptors working in Rome who achieved real individuality and showed this in at least some classical ways were Duquesnoy, who was Flemish by birth, and Algardi. Duquesnoy was a friend of Poussin and his statue of Sta Susanna in Sta Maria di Loreto was conceived on consciously classical lines. The figure stands clear in a niche with one leg taking most of the weight and the other leg trailing in the manner of the Antique. The folds of the drapery fall naturally according to the laws of gravity and are not agitated by the emotion of the figure as they would be in a statue by Bernini. One hand points across the body to the altar; the head turned in the other direction looks towards the congregation (or rather, this was the original arrangement—the figure now stands on the wrong side of

52. **François Duquesnoy.** *Sta Susanna. c.* 1626–33. Marble. Life-size. Sta Maria di Loreto, Rome. This is to Bernini's sculpture as Sacchi's paintings are to Pietro da Cortona's (figs. 46, 30). The figure is at present placed on the wrong side of the church; it originally stood so that the saint pointed in the direction of the altar and looked towards the congregation, thus creating a baroque relationship between the real world, the world of art and the world of spirit. Otherwise the statue shows all the marks of a consciously considered classicism.

53. **Alessandro Algardi.** *Portrait Bust of Cardinal Domenico Ginnasi. c.* 1630–40. Marble. Life-size. Galleria Borghese, Rome. The restrained treatment of the drapery and clean silhouette of this bust invite comparison and contrast with the dynamic, aggressively baroque bust of Louis XIV by Bernini (pl. 5). At the same time, the face is more expressive and realistic than that of Duquesnoy's Sta Susanna, giving Algardi a place mid-way between his two great contemporaries in the baroque-classical spectrum.

54. **François Girardon.** *The Grotto of Thetis.* 1666–73. Marble. Life-size figures. Engraving by J. Edelinck, 1678. This rather disagreeable engraving shows the original arrangement and setting of the group which now stands, partly altered, in a naturalistic grotto made in the 18th century in the gardens at Versailles. Girardon clearly conceived the work as a three-dimensional picture or as a sculpture in very high relief, giving it a style and composition that proclaimed its debt to Poussin. The subject is Apollo tended by Nymphs in the Grotto of Thetis after his work (of driving the chariot of the sun across the sky) was completed at the end of the day.

the church). The features and hair are modelled according to classical conventions, the eyeballs are unmarked and the expression is one of thoughtful tenderness. The only baroque characteristic is the pronounced curve of the figure outwards into the space of the church—a characteristic only visible from the side.

In his subsequent work Duquesnoy was more strongly affected by baroque influences. Algardi could not avoid these either and he had in addition a baroque feeling for the plasticity of form and surface. His carving of a head is in some ways even more subtle than Bernini's, though it is more restrained. From a naturalistic point of view he could create the illusion of hair, eyes, ears and lined and wrinkled skin, all in white marble, with incredible skill. Like Duquesnoy he held feeling and movement in check in most of his works and kept the outlines of his figures clear.

Sculpture was less important in France than either painting or architecture and, with one or two striking exceptions, was chiefly used in a decorative context. In contrast to Italy, classicism is the rule, baroque the exception—an exception which, however, tended gradually to modify the rule towards the end of the period. Most French sculptors spent a period of training in Italy, where they studied the Antique as well as contemporary Italian art. What they carefully avoided was the influence of Bernini, who was less important for French sculpture than was Poussin, even though the latter was a painter. Moreover there was often an association between French sculptors and contemporary architects and painters: Sarrazin worked with Vouet and Mansart, and Girardon and Coysevox were part of the team that created Versailles.

Sculptors at Versailles were employed both inside the Château and for making decorative statuary and fountains for the gardens. The general atmosphere of Versailles and the context in which all this sculpture was seen—not framed in isolation, but combined with other arts and with nature —inevitably gave it a certain baroque flavour. Indeed the sculpture is among the chief sources of the decorative splendour of Versailles. Its function is to attract, impress and charm the eye. Yet in detail the work of Girardon at any rate—Coysevox's rather less so—was classical in style. The former's masterpiece, the *Grotto of Thetis*, is directly reminiscent of Poussin in composition and seems to show the artist almost deliberately resisting the baroque possibili-

55. **Antoine Coysevox.** *Tomb of Cardinal Mazarin.* 1689–93. Marble and bronze. Life-size figures. Louvre, Paris. This tomb may be compared with Bernini's of Pope Alexander VII (pl. 26). But whereas the Italian master used all the available baroque devices of illusionism, rhetoric and a rich and varied colour scheme, Coysevox built up his composition into an almost symmetrical pyramid, keeping to the most economical means of expression and confining his materials to white marble and dark bronze.

ties of the commission he was given. An engraving made before the setting was altered shows that Girardon isolated the figure group as far as possible from the niche containing it, whereas a baroque sculptor would have interrelated the two. The figures themselves are treated as separate units with clear spaces between them; their gestures and expressions are restrained and their movements kept parallel to the surface. The same restraint, parallelism and detachment can be seen in Coysevox's tomb of Cardinal Mazarin (1689–93). The sculptural and architectural components of the monument are kept sharply distinct from one another with the three separate allegorical figures on one level and the effigy of the Cardinal, accompanied by only a single *putto* with a *fasces*, on the other.

Coysevox was instinctively a more baroque sculptor than Girardon but he too moderated the natural exuberance of his style according to the classical dictates of economy and restraint. Even though his equestrian statue of *Fame*, made originally for the gardens of Louis XIV's Château at Marly, has a certain baroque panache and is superbly decorative, it has none of the rippling three-dimensional movement of a horse and rider by Bernini. The same quali-

ties can be seen in Coysevox's portrait busts, a field in which he was one of the finest masters of the 17th century. In place of Bernini's dynamic twist of the head in the *Louis XIV*, 5 which makes it seem as if the figure had just turned imperiously to speak or look at something, Coysevox uses only a slight contrast between the line of the body and that of the head. The expression is pensive, the drapery merely a formal suggestion of a classical robe and the silhouette of the bust simple and regular.

CLASSICISM IN ARCHITECTURE

There seems to have been little interest in classical architectural theory in Rome before the last quarter of the 17th century. Perhaps partly for this reason, and partly once more because of the accident of birth, the classical current in the Italian architecture of the period was even weaker than that in sculpture. The high baroque architects, Bernini, Borromini, Pietro da Cortona and Guarini, had no classical contemporaries who would deserve mention in so short a book as this. At the beginning of the century, Maderna's work showed an unselfconscious blend of clas- 38 sical and early baroque elements that corresponded

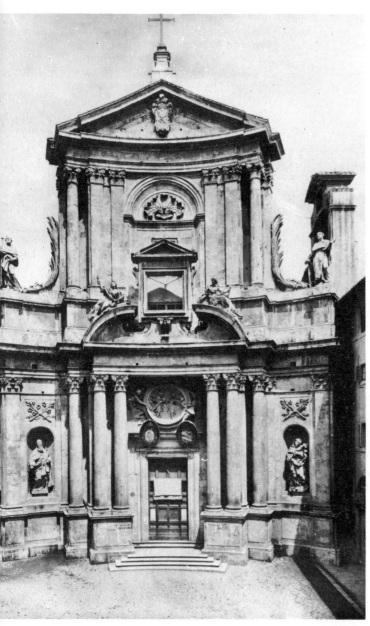

56. **Carlo Fontana.** *Façade of S. Marcello al Corso, Rome.*
1682–83. Fontana was the leading architect in Rome in the last
twenty years of the 17th century, after the deaths of Bernini,
Borromini and Pietro da Cortona. Though partly echoing
Cortona's façade of Sta Maria della Pace (fig. 38), S. Marcello
marks a return to the dignified restraint of Maderna's
Sta Susanna of 1597–1603 (pl. 38). Its architect was skilful,
suave and industrious rather than great; among his north
European admirers and pupils were Hildebrandt, Pöppelmann
and Gibbs.

broadly to Annibale Carracci's style in painting. It was
only in the 1680s that the classical current became strong
enough to create an anti-baroque reaction, and even that
very partial. Perhaps Bellori's attacks on Borromini in the
Idea (1672) encouraged the new trend, by recalling Italian
architects to their classical and Renaissance heritage. On
the other hand, the Roman atmosphere of the time was so
saturated with baroque feeling that this could not be
escaped either. The chief exponent of the resulting 'ba-
roque-classical' compromise was Carlo Fontana, whose
façade of S. Marcello combines a more or less classically
correct use of the orders with a baroque context. The
concave curve of the façade and the continuous upward
movement joining the lower and upper storeys are baroque;
yet the façade has no contrasting convex curve and the
various formal units—columns, pilasters, pediments and
so on—are handled in such a way as to be easily read.

The fullest and most perfect realisation of classicism in
architecture, even more than in painting and sculpture,
occurred in France. The classical movement there began as
early as the second decade of the century with the work of
the first great French architect of the period, Salomon de
Brosse. De Brosse's innovations were, first, as strict as possi-
ble a regard for symmetry, so that the sides as well as the
back and front of a free-standing building could be read as
a balanced unit and, second, conception of the whole
building in terms of mass rather than surface ornament.

The second of these innovations was to be particularly
important to the leading French architect of the next
generation, François Mansart. All Mansart's buildings are
conceived three-dimensionally and depend for their effect
on the exact relationship of the various parts. This harm-
ony of parts is the essence of classical architecture. In the
Orléans Wing at Blois, the regularly repeated windows
and restrained pilaster order on all three storeys articulate
an exterior divided into four main parts, i.e. a *corps-de-
logis* (body of the building), a central frontispiece slightly
raised on the upper storey, and two short projecting wings.
Even the traditional French pitched roof, modified by
Mansart into the hipped form which bears his name, is
made part of the scheme by the adjustment of its propor-
tions to the strictly classical frontage below. Sharp edges
and angles impart precision to the design. There is no

(Continued on page 689)

38. **Carlo Maderna.** *Sta Susanna*, Rome. 1597–1603. The
church of Sta Susanna, Maderna's first important work and his
greatest artistic success, typifies Roman Early Baroque
architecture. Although the general arrangement recalls
Vignola's design for the Gesù, the width of the façade has been
reduced in relation to its height, the various architectural
elements (pilasters, half-columns, niches, volutes, etc.) have been
made to fill more of the wall space and the design as a whole has
been treated in high relief. There is also a new concentration
on the centre of the façade rather than its edges.

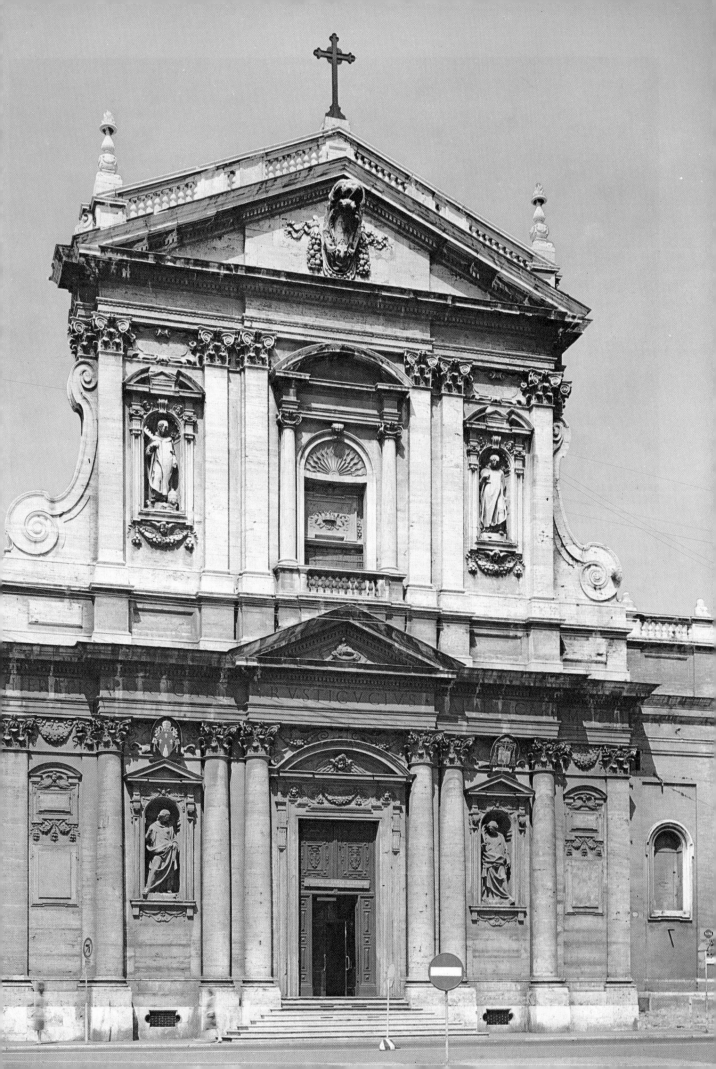

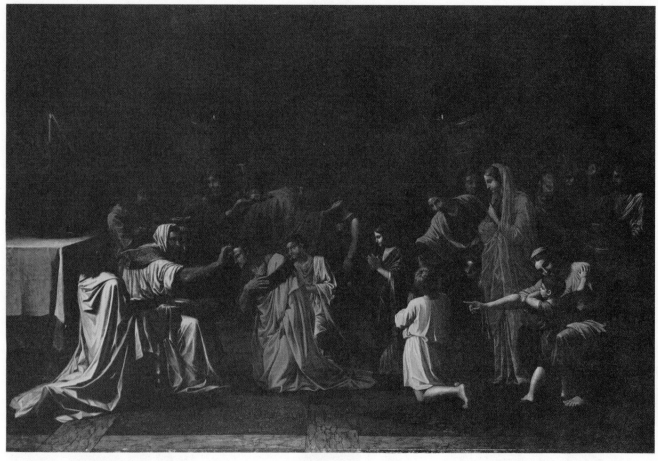

39. (above). **Nicolas Poussin.** *Con-firmation.* 1645. Oil on canvas. 46 × 70 in. (117 × 178 cm.). Collection: the Duke of Sutherland, Mertoun; on loan to the National Gallery of Scotland, Edinburgh. From Poussin's second series of *Seven Sacraments*, painted for Fréart de Chantelou, this is 17th-century classicism at its purest and best. The quality it shares with the Baroque of Bernini, Rubens or Rembrandt is its high seriousness; stylistically it could hardly be more different. With Poussin, the intellectual discipline which he imposed on the free play of imagination resulted in its own special kind of beauty.

40. *Table. c.* 1680. Carved and gilt wood. Hotel Lauzun, Paris. This massive, ornately designed side-table is typical of French furniture of the reign of Louis XIV; it would have fitted well with the early interiors at Versailles (see plate 16), where the furnishings, conceived as part of a unified decorative ensemble, were more unrestrainedly baroque than the architecture. The volutes, acanthus leaves and garlands are treated naturalistically, in keeping with the taste of the period for illusionism.

41. (opposite). **Nicolas Poussin.** *Diana and Endymion* (detail). *c.* 1631. Oil on canvas. 47½ × 66 in. (121 × 168 cm.). Detroit Institute of Arts. This is an early, comparatively baroque work by the greatest master of 17th-century French classicism. The fluid brushwork, the sense of movement and the glowing colours are qualities reminiscent of Titian, whose work Poussin was able to study in Rome at this time. The subject also recalls the type of poetic picture which Titian made famous. Endymion was a youth renowned for his beauty and his perpetual sleep. As he slept, his beauty warmed the cold heart of the moon goddess, Diana, who came down to him and embraced him. At this moment the dawn breaks, a transition symbolised in the picture by the appearance of Apollo's chariot in the sky. The refinement of the poses and the purity of the outlines show something of the strict classicism Poussin was to develop a few years later.

42. (opposite, above). **Annibale Carracci.**
The Flight into Egypt. c. 1603. Oil on canvas.
48 × 90½ in. (122 × 230 cm.). Galleria
Doria-Pamphili, Rome.
43. (opposite, below). **Adam Elsheimer.**
The Flight into Egypt. 1609. Oil on copper.
12½ × 16¼ in. (31 × 14.5 cm.). Alte
Pinacothek, Munich.

44. (above). **Claude Lorrain.** *Landscape
with a Goatherd.* 1637. Oil on canvas. 20¼
× 16¼ in. (51.5 × 41.3 cm.). Reproduced
by courtesy of the Trustees of the National
Gallery, London. These three works
illustrate early stages in the development
of ideal landscape painting in Rome.
Elsheimer's picture is the most intensely

poetic and Northern, Annibale Carracci's
the most stately and Italian. Claude's
shows a synthesis of the other two, combined
with a new sensitivity to nature and light.

678

45. (above). **Claude Lorrain.** *Landscape with the Nymph Egeria* (detail). 1669. Oil on canvas. 61 × 78½ in. (155 × 199 cm.). Galleria Nazionale di Capodimonte, Naples. The picture was painted for Prince Lorenzo Onofrio Colonna and included in Claude's record of his compositions, the *Liber Veritatis*, as No. 175. The scenery is loosely based on that of Lake Nemi, near Rome. The painting shows the extremes of subtlety and poetry which Claude's style reached towards the end of his life. The softness of the light, the strangely elongated figures

and the delicacy of the transitions in both the colours and the tones embody a mood and style that are more ideal than in the *Landscape with a Goatherd* (plate 44).

46. (opposite). **Nicolas Poussin.** *The Burial of Phocion* (detail). 1648. Oil on canvas. 46 × 70 in. (114 × 175 cm.). Collection: the Earl of Plymouth, Oakleigh Park, Ludlow. Painted for a Parisian merchant named Cérisier, this work, with its pair, the *Gathering of Phocion's Ashes*, refers to the story of an

Athenian statesman who was condemned to death, and his ashes ordered to be scattered outside the town, for his refusal to abandon an unpopular policy under pressure from the mob. The style contrasts with that of Claude's *Landscape with Egeria*; the sunlight is stronger, the forms are more sharply defined and regularly drawn, and nature is, as it were, given the lucidity and order of a mathematical proposition. It should not be forgotten, however, that the painting has the beauty of mathematics as well as its impersonality.

47. (above). **Albrecht Cuyp.** *Cattle and Figures. c.* 1660. Oil on panel. 15 × 20 in. (38 × 51 cm.). Reproduced by courtesy of the Trustees of the National Gallery, London. Cuyp was chiefly a landscape painter but animals often appear in his pictures, forming compositions which, though naturalistic in detail, show a classical stillness and sense of design.

48. (left). **Louis Le Nain.** *The Farm Waggon.* 1641. Oil on canvas. 22 × 28½ in. (56 × 72 cm.). Louvre, Paris. Scenes of low life are rarer in French 17th-century painting than in Dutch, though they occur quite frequently in French graphic art. Louis Le Nain was the most sensitive painter in France of this type of theme. He treats the peasants who were his subjects with great sympathy, even dignity, but is completely reserved, detached and objective about them. They seem to stare back at the spectator with an air of Stoic contemplation.

49. (opposite). **Philippe de Champaigne.** *Omer Talon.* 1649. Oil on canvas. 88½ × 63⅝ in. (224 × 162 cm.). National Gallery of Art, Washington. (Samuel H. Kress Collection). Although the setting and pose recall Rubens, the baroque qualities of style are here firmly controlled by the principles of French classicism: clear light, clear colours, sharp outlines and severe restraint in both gesture and expression.

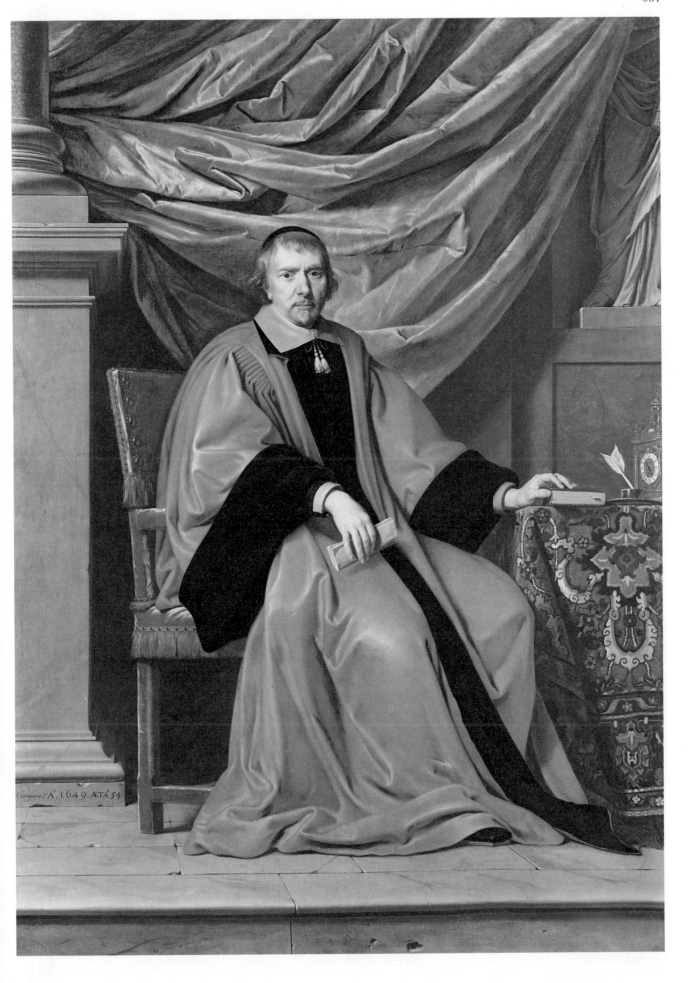

Cornouaille FA. 1649. ÆTA.54.

50. (above). **Louis Le Vau, Claude Perrault** and **Charles Lebrun.** *The East Front of the Louvre*, Paris. 1667–70. This severe, lucid façade, designed by three French architects, was chosen by Louis XIV for the east front of the Louvre after plans by Bernini had been rejected. Although the scale, the interplay of light and shade created by the free-standing colonnade and the variety of rhythm due to the coupling of the columns are baroque, the design is otherwise more strictly classical than that of any earlier French building.

51. (below). **Ange-Jacques Gabriel.** *Ministry of Marine*, Paris. Designed 1753, built 1757/8–68. The Ministry of Marine is one of a pair of buildings fronting the Place de la Concorde. Gabriel's basic plan, with its vista between the buildings leading to a projected domed Madeleine (never built in that form) was baroque. However, the design of the Ministry of Marine itself recalls the east front of the Louvre, while its greater richness, use of sculptural ornament and open arcades on the ground floor give it an 18th-century festive air.

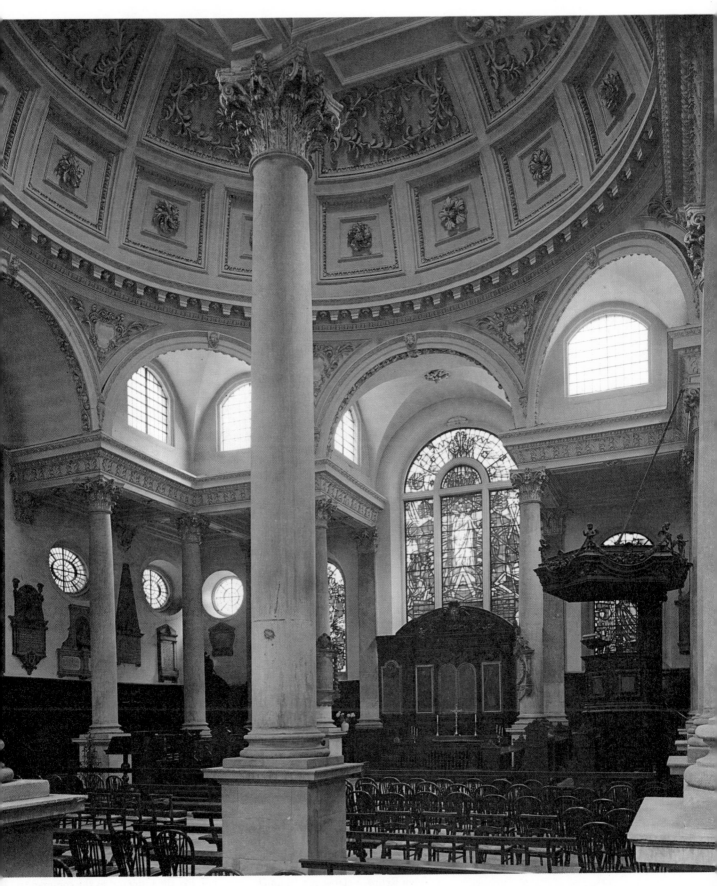

52. **Sir Christopher Wren.** *St Stephen's, Walbrook*, London. 1672–79. This church, one of the finest of the fifty-one built by Wren in the City of London after the Great Fire of 1666, was damaged in the last war and not all the original gilding and carved woodwork was replaced in the restoration. Apart from its spatial complexity (a domed central space combined with a cross-in-square plan), the design has little in common with Catholic churches of the period. The effect is restrained, intimate and dignified, but to these somewhat pedestrian qualities the classically- coffered dome and unbroken ring of the cornice add a note of almost Renaissance serenity.

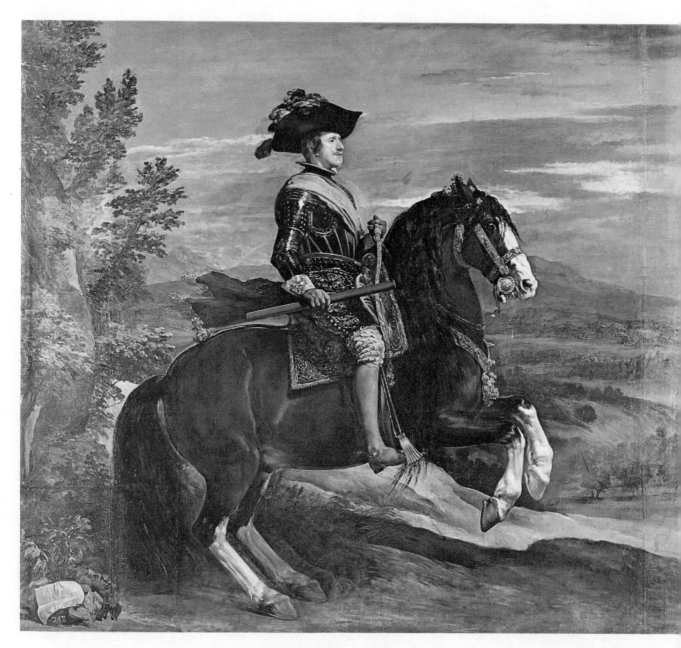

53. **Diego Velasquez.** *Philip IV of Spain.* 1634–35. Oil on canvas. 118½ × 124 in. (301 × 314 cm.). Prado, Madrid. Painted for the Hall of the Realms in the Palace of Buen Retiro, Velasquez's *Philip IV* belongs to a tradition of equestrian portraiture going back to Titian's portrait of the king's great-grandfather, the *Emperor Charles V,* (already in the Spanish Royal Collection), inviting a comparison not only between the two pictures but also, as contemporaries would have understood, between the two monarchs. Philip is presented as the more spirited figure, riding alone across open country, not, like the Emperor, as the commander of troops in battle. The artist has created this unforgettable image of Absolute Monarchy—stiff, unyielding and remote—without trappings, by pictorial means alone.

54. **Diego Velasquez.** *The Infanta Margarita in Blue.* 1659. Oil on canvas. 50 × 42 in. (127 × 107 cm.). Kunsthistorisches Museum, Vienna. The Infanta was the daughter of Philip IV by his second wife, Mariana of Austria. In contrast to Van Dyck, who painted a complete image of aristocracy in his portrait of *Marchesa Balbi* (plate 11), Velasquez shows a subtle awareness of the distinction between the sitter and her exalted role; the six-year old Princess stands anxiously in her stiff dress putting on an appearance of regal authority rather than embodying the reality of it. Velasquez was also a major innovator in the handling of colour and atmosphere, blending the two together in a way not seen again until the time of Impressionism.

55. (below). **Sanchez Cotán.** *Quince, Cabbage, Melon and Cucumber. c.* 1602. Oil on canvas. 25¾ × 32 in. (65.5 × 81 cm.) From the Permanent Collection of the Fine Arts Society of San Diego, California. Painted at the very beginning of the century in Toledo, Spain, this is a picture of hallucinated, almost surrealist, intensity, apparently planned on a basis of pure geometry; the curve on which the pieces of fruit lie has been shown to be a parabola. The interest in still-life detail, especially the careful, item-by-item depiction of detached objects, is typical throughout Europe at the time, but no other artist could have arranged the objects to form such an unusual design or treated them in such an animistic way.

56. (opposite, above). **Floris van Dyck.** *Still Life.* 1613. Oil on canvas. 19½ × 30½ in. (49.5 × 77 cm.). Frans Hals Museum, Haarlem. This painting is similar to the previous one in that the objects as such are treated in meticulous detail, but their arrangement is more commonplace. The composition is also more crowded and domesticated; it is, as it were, a brightly-coloured inventory of food and household goods rather than a consciously thought-out design.

57. (opposite). **Willem Claesz Heda.** *Still Life with Goblet and Fish.* 1629. Oil on panel. 18 × 27¼ in. (46 × 69 cm.). Mauritshuis, The Hague. This picture shows still-life objects treated by the method used in Van Goyen's *View of Emmerich* (plate 61); that is, as in a 'tone painting'. The forms are carefully selected and self-consciously posed, colour is subdued and the design is balanced in terms of horizontals and verticals.

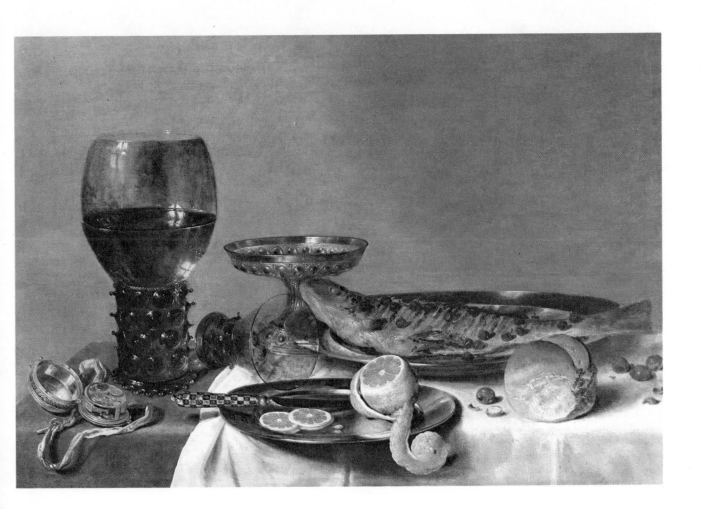

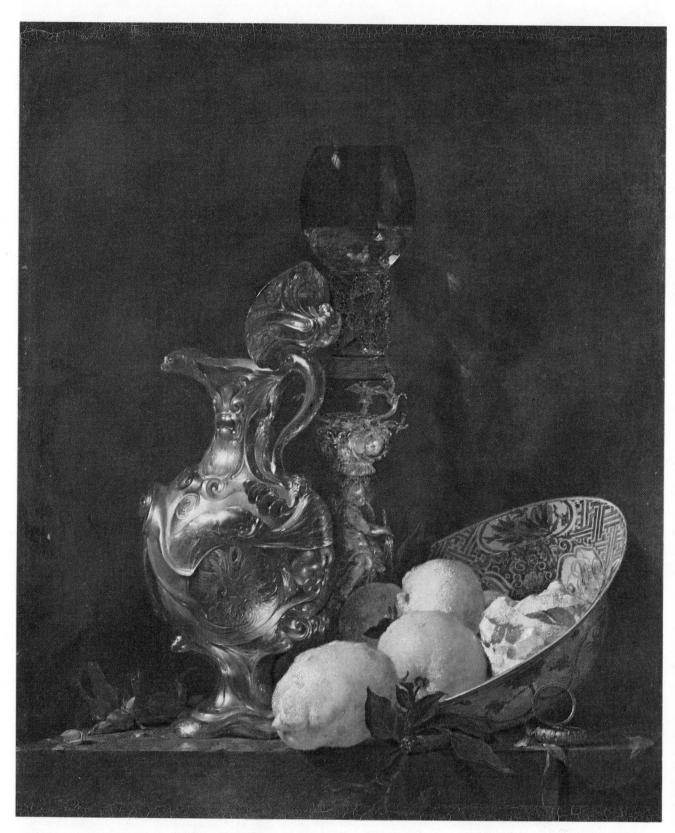

58. **Willem Kalf.** *Still Life with Jug and Fruit. c.* 1660. Oil on canvas. 28¼ × 24½ in. (72 × 62 cm.). Rijksmuseum, Amsterdam. This picture shows a change in Dutch still-life painting parallel with the change in landscapes during the same period (see plates 62, 63). The splendid baroque silver jug (a handsome example of 17th-century Dutch silverware) was clearly painted with as much pride in the craftsmanship which went into the object as self-congratulation on the pictorial skill lavished on its representation. The ripe lemons spilling out of the Cornucopia-like Delft bowl also show the exuberance of the Baroque, as does the build-up of the composition.

sensation of movement as there would be in a baroque building; instead, there are one or two graceful added touches—the ornamental motives in the two upper storeys of the frontispiece and the curved colonnades in the angles on the ground floor—which enliven what might otherwise be a forbiddingly severe front. At no point do these touches obscure the structure of the building, which is lucid, monumental and scrupulously finished in detail.

Mansart's classical style has rightly been considered as the near-equivalent of Poussin's classicism in painting, although the two men probably never met and the former spent his whole life in France. The object of Mansart's architecture is not surprise but visual and intellectual satisfaction. The placing of each motive and the scale and proportions of each part are extremely inventive yet, once having been invented, seem not only right but inevitable. As in Poussin's paintings, everything is done according to

reason. In the same way the quality of the style depends on the tension set up between the imaginative power of the initial idea and the strictness of its means of expression.

The turning point for French architecture came with Bernini's visit to Paris in 1665 to discuss the design for the east front of the Louvre. This was a moment of truth for European art. It heralded the transfer of the artistic leadership of the western world from Rome to Paris. The greatest living architect and sculptor was invited by the King who was now Europe's most powerful ruler, to fulfil the most important civil commission of the day. Yet Bernini's plans were rejected, like those of the other Italian architects invited to submit. His arrogance irritated the French and he returned to Rome in a huff leaving only the portrait bust of the King as a tangible memorial of his visit. **22**

The King's minister, Colbert, felt that French artists were now capable of standing on their own feet; the actual,

57. **Inigo Jones.** *The Queen's House, Greenwich.* 1616–18, 1630–35. This chaste and initimate house, built as an adjunct to the rambling Tudor palace which then lay between it and the River Thames, was the first English building designed in the classical style. It was originally two rectangular blocks joined by a bridge which spanned a public road running through Greenwich Park. The sides were filled in by Jones's pupil, John Webb, in the early 1660s. The colonnades either side were added in the 19th century, following the line of the former road.

58. **François Mansart.** *The Orléans Wing of the Château of Blois.* Designed 1635. The wing added by Mansart to the Château of Blois for Louis XIII's brother, Gaston d'Orléans, is elegantly precise in detail yet monumental in its total effect. Its ordered harmony epitomises the spirit of 17th-century French classical architecture.

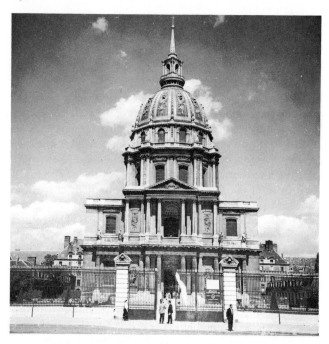

59. **Jules-Hardouin Mansart.** *The Church of the Invalides, Paris.*
1680–91. S. Marcello, the Invalides and St Paul's Cathedral
represent three different types of Baroque-Classicism current in
the late 17th century. The baroque element in the Invalides
probably sprang as much from a desire for magnificence and
grandeur of scale as from any wilful defiance of classical rules.
Of the three buildings, the Invalides undoubtedly carries the
most authority with its superb open site and the vista leading
up to it from across the Seine.

60. **Christopher Wren.** *St Paul's Cathedral, London.* 1675–1711.
(Modern drawing to show a view of the Cathedral now
obscured by buildings.) The contrast between the classical dome
and the baroque west towers of St Paul's is almost gauche, yet the
total effect is pleasing and the dome itself is one of the noblest in
Northern Europe, while the quality of the detail in the west
towers has been revealed by the recent cleaning.

extremely classical east front of the Louvre was designed by
Le Vau and Claude Perrault in collaboration; and when it
came to finding an architect for the first re-building of
Versailles for Louis XIV in 1668, there was no question of
appointing anyone but a Frenchman. Le Vau's project
was grand, effective and classically organised in terms of
simple masses with a straight skyline broken only by statues.

Not only the statues, however, but the whole spirit
animating Versailles, which was principally intended as a
sumptuous setting for the Court, implied a leaning to-
wards the Baroque and, from the 1670s onwards, baroque
grandeur and pomp applied to basically classical archi-
tectural forms began to predominate in France. The
leading architect of this phase was Jules-Hardouin Man-
sart, the great-nephew of François, who began to give Ver-
sailles its present, overwhelming form in 1678 and created
the baroque-classical church of the Invalides from 1680–91.
The latter stands in an open setting at the back of the wide,
comparatively low buildings of the hospital. With its rich
decoration, tall lantern and needle-like spike at the top, the
dome of the Invalides stands out in baroque splendour
when seen, as it can be, from almost any point in Paris.

The other country with a significant though less deep-
rooted classical tradition in architecture was England. To
begin with, England was artistically so backward that the
handful of buildings put up in the first half of the century
in the Italian Renaissance style, designed by Inigo Jones,
shone out like good classical deeds in an otherwise naughty
late medieval world. Yet, by a curious combination of
chance and retrospectively-felt influence, the Queen's
House at Greenwich, begun by Jones in 1618, became in
the broadest sense the model for practically all English

domestic architecture for the next two hundred years. It is
almost a reproduction of a Palladian villa, but not quite.
Its proportions are longer and lower and it is at once more
reticent and more picturesque in feeling (the latter quality
is admittedly as much due to the setting as to the building
itself). Compared with Mansart's Orléans Wing at Blois, it
is simple almost to the point of insignificance, and is con-
ceived in terms of line and surface rather than mass. Despite
its plan, it is not visually a cubic building but a series of four
separate façades.

From about 1660–1715, however, a new tendency was
superimposed on this type of Renaissance classicism. The
demand in England, as all over Europe, was for grander
and more official-looking buildings, including churches.
The dominant architect of this phase was Sir Christopher
Wren, who not only rebuilt St Paul's Cathedral and fifty-
one City Churches after the Great Fire of London of 1666,
but also worked on several great public buildings (Chelsea
and Greenwich Hospitals, Hampton Court, etc.) and the
Universities of Oxford and Cambridge. He knew more of
contemporary European architecture than Jones, had
better opportunities and was a more inventive planner. In
the City Churches he applied classical principles and
motives to a basically Dutch, box-like type of church design
with great ingenuity and variety. His project for St Paul's
began as a Greek-cross (equal-armed) structure with a
dome and portico in the Renaissance manner, was then
adapted for practical and liturgical reasons to incorporate
a nave, and finally assumed a semi-baroque form. The jux-
taposition of the plain but massive classical dome with the
baroque west towers is inconsistent but effective. A harsher,
more idiosyncratic type of English Baroque can be seen in
the buildings of Wren's pupil, Hawksmoor, and on a
colossal scale, in Blenheim Palace by Vanbrugh. At Blen-
heim, huge wings joined by colonnades open out one after
another from the central *corps-de-logis*, striding over the
Oxfordshire countryside with the military genius and ar-
rogance of the owner, who never lived to see it complete—
the great Duke of Marlborough. It is Versailles in a colder,
more practical and more Augustan climate.

Realism

61. **Gregorio Fernandez.** *Pietà.* 1617. Painted wood. Museo Provincial, Valladolid. Spanish polychrome sculpture had its roots in popular religious art and was only touched in passing by the great stylistic movements emanating from Italy and Flanders in the Renaissance and 17th century. Its appeal lay in its surface realism and direct emotional intensity, although Fernandez here shows an acquaintance with current fashionable styles in the gesture and expression of the Virgin.

THE RELATIONSHIP BETWEEN REALISM AND IMITATION

Realism has been a recurring theme in European art from late classical times almost down to the present. But when realism has been found to be as constricting as a previous, anti-naturalistic style had seemed artificial and distorted, then artists have again moved away from realism and towards fantasy, thus beginning the cycle over again.

It goes without saying that whenever realism has appeared it has taken its precise character from the style of the period in which it found itself. Indeed 'realism' has not always been the term used; sometimes 'naturalism' or —with relation to late Roman portrait sculpture—'verism' have been used instead. In the 17th century there were three main kinds of realism: the first associated with Spanish polychrome sculpture (i.e. sculpture in carved and painted wood); the second with Caravaggism in the broadest sense; and the third with Dutch painting.

With all three kinds the emphasis has lain on the exact and careful rendering of surface appearances. Thus realism is a term of narrower scope than imitation, which in 17th-century theory referred at least as much, if not more, to the truthful representation of *human* nature. It was no doubt chiefly in this sense that Poussin meant it when he described painting as 'an imitation by means of lines and colours on a flat surface of everything under the sun.' This all-embracing definition reflected the long classical tradition, going back to Aristotle, according to which all forms of art, even dancing, were modes of imitation. In that sense art was the enactment in formal terms of almost any human act, story or emotion. Realism, on the other hand, comprises less than this. It does not even necessarily imply the logical reconstruction of spatial relationships and proportions. Neither the first type of realism to be discussed—Spanish polychrome sculpture—nor even to some extent the second— Caravaggism—was entirely logical in this respect.

SPANISH POLYCHROME SCULPTURE

Spanish carved and coloured wooden sculpture was religious in subject-matter and in the 17th century was basically a popular art. Its motivating spirit was the fervid, superstitious piety of the Counter-Reformation in Spain (virtually no female nudes or mythological subjects occur in Spanish 17th-century art). Glass eyes, eyelashes of real hair, wigs, and even costumes of real fabric were widely used. The statues so made were destined for altars or to be carried in groups through the streets (as they are still in some places) during religious festivals. In the first half of the century, however, there were at least two sculptors, Gregorio Fernandez in Valladolid and Juan Montáñez in Seville, who extracted from this crude *genre* an art of extraordinary expressiveness and poignancy.

The statues they created for monasteries and local parish churches embodied an intensity of emotion, expressed in terms that were somehow both Gothic and baroque at once, not seen elsewhere in European art at this time. To the popular mind these statues represented Christ, his Mother and the saints in states of anguish or meditation as real, familiar, recognisable figures. As works of art, they are quite without the formal sophistication or idealisation typical of Italian and Flemish religious painting and sculpture of the period. They contain no references to the Antique and only slight traces of the conventions of pose and movement handed down from the Renaissance. The articulation of their bodies is not always correct and it is sometimes hard to see how the figures would stand on their feet.

Their appeal lies in two things: first, the directness with which the emotions are expressed, a directness which seems wholly unpremeditated and to be the result of intuitive sympathy with the feelings of the people for whom the statues were intended; second, the very great beauty of their execution. The sharpness and explicitness of the

carving is almost medieval in character although the forms themselves have a roundness and fluidity which betray their true period.

The colouring is intense, variegated and to modern eyes often overdone. Bright pinks, greens, blues, browns and flesh tints are applied to the highly polished wood which gives the figures a gaudy look (admittedly the colour is often the result of later over-painting). Only the sincerity of the emotion staves off sentimentality. It sometimes does not even do that; these statues are, after all, the ancestors of the saccharine plaster figures sold in churches and religious bookshops today.

The next time that carved and coloured wooden sculpture flourished was in Bavaria in the 18th century. Bavarian 18th-century sculpture has all the swaying refinement of the late Baroque and Rococo, a refinement carried to the edge of decadence by the greatest Bavarian sculptor of the period, Ignaz Günther, although his work, too, was designed for a popular audience.

CARAVAGGISM

Caravaggio has already been mentioned in this book from the point of view of the dramatic and emotional qualities of his art. However, he was regarded in the 17th century—first with approval, later with mounting hostility —as a realist. 'Everything in art is trifling that is not taken from life' was a favourite saying of his, according to contemporaries. But how far were Caravaggio's paintings realistic and to what extent were they done from life?

His early works show an extremely exact rendering, based on careful attention to textures and local colours, of objects he could have set up in his studio—arrangements of fruit and flowers, flasks of wine, furniture, clothes, swords and so on. He is even known to have owned a pair of bird's wings, which a fellow artist borrowed on one occasion. All these things appear in his paintings, especially in the early ones which are quite brightly coloured. It seems reasonable to assume that such pictures were painted in the way Caravaggio said they were, that is, with loving care and with at least the costumes and still-life objects in front of him.

However, the representation of figures from the life would have been more difficult, even when a model or models could be made to pose in the studio, and it would have been completely impossible to paint figures in violent action in this way. In fact, as 17th-century critics noticed, uncertainty in the treatment of figures in movement was one of Caravaggio's weaknesses. He could concentrate, as he did, on violent subject-matter involving outflung limbs and contorted faces, and could create a convincing image of *action* by this means; but this did not solve the problem of movement, which required an ability to relate figures in space to each other and depended on learning an acquired system of pictorial conventions. Since these conventions were despised by Caravaggio, his figures appear curiously still, almost frozen, despite their emphatic action. They also

62. **Michelangelo da Caravaggio.** *Rest on the Flight into Egypt.* *c.* 1596. Oil on canvas. 51 × 63 in. (130 × 160 cm.). Galleria Doria-Pamphili, Rome. This is an example of Caravaggio's early style, antedating the characteristic 'dark' manner he developed in his middle years, as a result of which he decisively altered the face of European art. His early paintings are executed in strong, clear colours almost without shadows and with loving attention to surface detail; see especially the wings of the angel. The pose of the angel, however, is still Mannerist.

63. **Francisco de Zurbaran.** *The Martyrdom of St Serapion.* 1628. Oil on canvas. 47½ × 40¾ in. (120.5 × 103.5 cm.). Wadsworth Atheneum, Hartford, Conn. This very remarkable work was painted for the Mercedarian Monastery at Seville, to hang in the room where the bodies of the monks were placed before burial. St Serapion was an English bishop martyred in North Africa in 1240. As a work of art, the picture combines the mood and lighting of Caravaggio with the tactile qualities of Spanish polychrome sculpture.

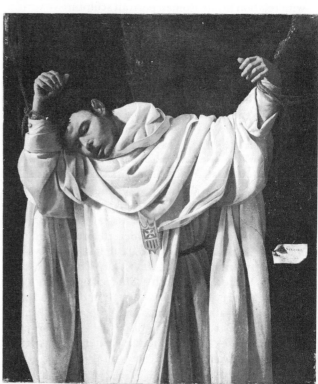

have virtually no realistic setting, only a wall of darkness which comes down behind them. Judged as a realist, what Caravaggio gives with one hand—truth of surface detail—he takes away with the other—failure to put the details together so as to form a convincing whole.

What he excels in is truth to the physical and psychological facts of a situation. Even in his late works, from which picturesque costumes and still-life are almost absent, there is an insistence on incidental details—the lacing of a garment, the grain in a piece of wood, or the sharp edge of a sword-blade—which is all the more telling on account of the economy with which it is used. Indeed such details, which correspond to the way the eye notices small things in moments of crisis, are an aspect of Caravaggio's psychological realism which is at least as important as his exact but limited depiction of appearances.

But he was a realist above all in his choice of cast. A Magdalene or a St Catharine by Caravaggio is an ordinary Roman girl dressed in (almost) contemporary clothes and only recognisable as a saint by her attributes. More important still, Caravaggio abandoned the tradition, which had prevailed throughout the whole of Italian art in the previous two centuries, of representing sacred figures as heroes. At the risk of putting too modern a gloss on his work, one could almost say that Caravaggio was the inventor of the anti-hero in religious art. His Bible episodes take place in dark corners, his Christs and Saints are dressed in drab clothes and are often half-obscured by shadow. They are not larger or purer than life but, on the contrary, tough working men who would hardly stand out in a crowd. Ordinary people press round them in defiance of the Counter-Reformation doctrine that lay people could only approach God through the intermediary of the clergy. Moreover Caravaggio sometimes shows both saints and peasants with dirty feet.

Realism of this sort was held to be disrespectful to religion with the result that Caravaggio's altarpieces were regularly rejected by the church authorities who had ordered them. This was despite the fact that he received repeated commissions from churches as well as from aristocratic persons with *avant-garde* tastes. It was also despite the fact that, as we can now see, he was one of the great religious artists of the 17th century.

Caravaggio's influence lasted longest in the Spanish colony of Naples and in Spain. In Naples, his style was turned into a tough, dramatic, heavily-charged loaded manner, suggestive of prisons and dark caverns, that can be called Caravaggesque-Baroque, the artist chiefly responsible for this being the Spanish painter, Ribera, who spent most of his working life in the city.

Caravaggio had himself visited Naples leaving several pictures there, two or three of which may have been sent on to Spain. If so, it is possible that Zurbaran and Velasquez may have seen them, for without copies, at least, of paintings by Caravaggio it is difficult to explain the early styles of these two artists. Neither, however, was indebted to Caravaggism alone. At the very beginning of the century the *genre* painter, Juan Sanchez Cotán, had produced a number of remarkable still-life pictures in a highly realistic style which had affinities with, but was quite independent of Caravaggism. Moreover, the Spanish tradition of carved wooden sculpture was at least as important as Caravaggism for Zurbaran and Velasquez. The former's *Martyrdom of St Serapion* is a fascinating combination of Caravaggesque and local Spanish realism. The motionless figure is silhouetted in livid colours against a neutral dark background and its surfaces are treated in extremely sharp focus so that it almost gives an illusion of being a carved statue; you feel that if you were to tap it with a finger-nail it would sound like wood. At the same time the monumentality and simplicity of the forms, the face with its shadowed eyes, and the harsh raking light, recall Caravaggio. It is a startling, inelegant, yet deeply moving image that could only be found in Spanish art.

Velasquez's earliest works are even more deeply rooted in the tradition of Spanish wooden sculpture, yet he began quite quickly to evolve a broader, more sensuous style. He produced some pictures which are Caravaggesque in subject-matter as well as treatment, but right from the beginning the marks of his personal genius can be seen. This genius has two main aspects. The first might almost be called a human rather than an artistic one, since it has to do with his reaction to people. After his appointment as court painter at Madrid in 1625, he spent most of his life producing portraits, mainly of the Royal family, both separately or in groups. As far as is known, Velasquez never complained of his lot or criticised his patrons. He was a court artist no less than van Dyck, yet the results in terms of style and treatment were very different. Velasquez was evidently a secretive and withdrawn man and his sitters as he depicts them are equally uncommunicative. The pomp, trappings and grandeur of majesty are all there, as is the stiffness of Spanish etiquette, yet one always feels that the royal persons are acting out their roles and are not quite grand enough for the part. Their expressions are veiled and suspicious; the little princesses, in the marvellous series of portraits which Velasquez painted of them towards the end of his life, try to assert their dignity, but are too genuinely child-like to succeed. More than any other great artist of the period Velasquez concentrates the expression in the eyes and mouth; the rest of the face and the hands and body are mute. Again and again there are hints of some personal longing, of a desire for some genuine emotion to escape the formal conventions of dress and bearing, but Velasquez never for a moment lets us know what this emotion is. Even his clowns and dwarfs leer and grimace, not spontaneously, but in a way dictated by their deformed physique and the role expected of them at court.

The famous *Las Meninas*, painted by Velasquez towards the end of his life, seems to sum up his position. The painter stands proudly beside the canvas yet is scarcely on the same social level as the maid-servants and dwarfs, let alone the

55

63

53, 54

64

64. **Diego Velasquez.** *Las Meninas (The Maids of Honour).* 1656. Oil on canvas. 125 × 108½ in. (318 × 276 cm.). Prado, Madrid. *Las Meninas* has the air of being one of the great puzzle pictures of the 17th century. A sitting for a portrait is in progress which has been interrupted: the Princess, who is the subject of the portrait (possibly with her maids, since it is a large canvas), turns with her attendants to face the King and Queen, who appear in the doorway and whose figures are reflected in the mirror. Such an intimate glimpse of royalty is very rare, yet the mood is highly formal and various ambiguities are set up in the relationship between the observer and the observed.

65. **Jan Vermeer.** *The Artist in his Studio.* *c.* 1665–70. Oil on canvas. 51 × 43¼ in. (130 × 110 cm.). Kunsthistorisches Museum, Vienna. This is another view 'behind the scenes' of 17th-century art, and it, too, withholds as much as it reveals. Vermeer is showing how he painted a 'Vermeer', i.e. bit by bit, since the head on the canvas is nearly complete while the rest of the surface is still blank. Yet he gives no clue as to the personality of the artist, or even whether the artist is meant to be himself.

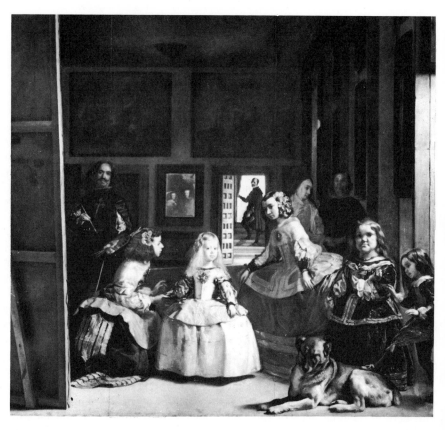

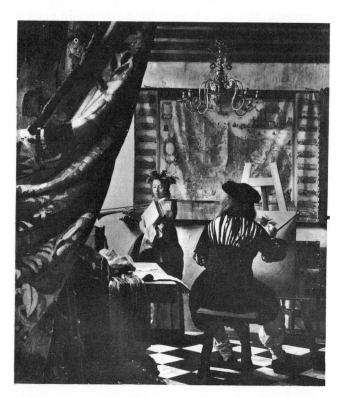

princess. His place, rather, is with the nun and the priest, and his figure is overshadowed by the vast canvas which we see from the back on the left of the picture. There is visual as well as psychological ambiguity in this composition, which results in a highly original variation on the normal baroque relationship between the work of art and the spectator. Framed in a mirror on the back wall are the images of the king and queen who are standing in the position of the real spectator of the picture. In imagination the spectator has become the two royal figures before whom their daughter and members of the household, including the painter, are standing. For a royal portrait of the period it is a uniquely intimate scene. Psychologically, few 17th-century paintings show a more 'baroque' relationship between the imagined and the real world, yet the painting is not baroque in any other sense.

Las Meninas is unusual in another way, too, for it is a fascinating representation of a painter at work. Not that Velasquez reveals anything of his methods; on the contrary it is typical of him that he should conceal them. But the very use of the mirror and the choice of subject—that of another picture being painted—shows a new self-consciousness concerning the act of painting. This is the other aspect of the genius of Velasquez, for one feels that no other

66. **Jan van Goyen.** *Landscape.* 1626. Oil on panel. 12½ × 21 ¾ in. (31.7 × 55.2 cm.). Messrs Alfred Brod, London (1961). This painting illustrates the first phase in the development of realism in Dutch landscape. The elementary problems of proportion and coherence have been solved, but the treatment of light and shade is still schematic, the details are all painted according to the same rather stiff formula, and there is little suggestion of atmosphere.

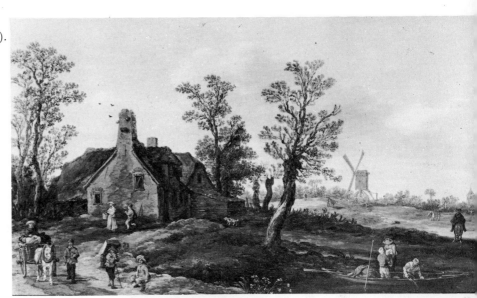

17th-century artist was so original in his use of paint. For him paint only partly served illusionistic purposes; it was applied less to reveal and define forms, than slightly to veil them, and hence to attract attention to itself as paint. Examining the treatment of a richly brocaded dress, we feel that the shimmering brilliance of the surface is not just that of the dress itself, but of the paint apart from the dress. The brush-strokes are, as it were, a substitute for embroidered leaves and flowers, not an exact visual equivalent of them. Moreover Velasquez goes further than any other 17th-century painter except Rembrandt in subordinating the contours of forms to the patches of tone and colour which make up the picture surface even though his figures are often silhouetted in contrasting tones against a neutral-grey background.

To what extent can this be described as a realistic style? Despite its origins in Caravaggism it is clearly very different in its mature form from the style of Caravaggio himself. On the one hand, it is less illusionistic in the treatment of surface detail; on the other, it is optically truer in the treatment of the whole. From a psychological point of view it is much less dramatic, yet precisely because of its calmness and perhaps even its ambiguity, it is closer to everyday experience. Velasquez's style is not so much 'more' or 'less' realistic than Caravaggio's as realism of a different kind —a kind that was admired and taken up again in the second half of the 19th century.

DUTCH PAINTING

Dutch painting—the third type of realism—presents a simpler problem than the art of Velasquez. It embodied a realism of content in a new sense and presented for the first time a comprehensive visual record of the way of life of a whole people. Its accuracy may be less literal than is sometimes supposed, but at any rate it represents the picture that Dutchmen of the period wanted to see of themselves and their country. Almost all possible forms of *genre* paint-

67. **Pieter de Hooch.** *Courtyard of a Dutch House.* 1658. Oil on panel. 28¾ × 24½ in. (73 × 62 cm.). National Gallery, London. De Hooch was a more explicit painter than Vermeer. His brick-by-brick treatment of the surfaces of everyday objects epitomises the 'photographic' tendencies in Dutch Realism.

68. **Adriaen Brouwer.** *A Boor Asleep. c.* 1632–38. Oil on panel.
14 × 10½ in. (35.8 × 27 cm.). Wallace Collection, London.
Brouwer was a Flemish artist who spent the first half of his short
working life in Holland and the second half in Flanders, where
this picture was probably painted. He was the greatest master of
peasant *genre* in either country and was the true successor to
Pieter Bruegel. Humour, insight, irony and the familiarity that
breeds respect, allied to marvellous technical skill, are combined
in this study of a young peasant asleep.

ing in the widest sense of the word were practised; that is,
paintings that depict an environment. The Dutch country-
side with its canals, dunes, farm-houses and windmills
constituted the subject-matter of landscape painting. The
Dutch coast provided the material for marine painting.
People from almost all classes, in farms, taverns, guard-
rooms and ordinary domestic houses, figure in *genre* paint-
ing. The produce and imports of Holland—flowers, fruit,
fish, game, cheese, carpets, glassware, and silverware—
made up the various kinds of still-life painting. Finally,
Dutch artists represented church interiors, streets and—in
some ways most important of all—people, for there was an
unprecedented demand for portraiture.

Leaving Rembrandt aside for the moment, the end to-
wards which Dutch painting moved can be most con-
veniently called photographic realism. Each picture rep-
resents a section of the visible world. The plain, objective
treatment is consistent throughout, each part of the com-
position being painted with the same care under natural
conditions of light. The consequence of this was that the
colours, tones, proportions, and spatial intervals had all to
be studied from nature and carefully related to each other.

On the other hand, the methods of achieving this result
were not discovered all at once and even the most realistic
Dutch paintings depend on artifice. As one follows the
history of 17th-century Dutch painting one can observe
stylistic conventions succeeding one another, coming into
fashion and going out again, and all the time becoming
more flexible and less obtrusive. The first thing to achieve
was pictorial clarity. The easiest problem to solve in
realistic painting is fidelity to surface detail, so that the
earliest still-life pictures, for instance, show the separate
objects with brilliant and literal accuracy, but without
much relationship between them. The first landscapes,
continuing to reflect the methods used in the previous
century, show a marked contrast between the minuteness
with which leaves and branches are rendered and the
artificiality of the composition.

The trend towards a new kind of realism began in the
decade 1610 to 1620, a decade dominated in portraiture by
Frans Hals. In contrast to the conventions of earlier peri-
ods, space in landscapes and *genre* scenes was reduced and
the viewpoint brought down to eye-level. Paintings of all
kinds also now began to contain fewer figures and objects
than before. In the 1620s, with artists such as van Goyen
(landscape), Porcellis (marine painting), Brouwer (*genre*),
Heda (still-life), colours were subdued and compositions
unified by subtle relationships of tone. By these means it
became possible to extend space further into depth and
by the 1640s landscapes had acquired an openness and
atmospheric calm that form a parallel with the ideal land-
scapes of Claude painted in Rome at the same time.

The degree of realism achieved at this stage was exact
but limited, since colours were subordinated to tone and
forms to atmosphere. The final stage in the progress of
realism was reached in the third quarter of the 17th century
—the 'Golden Age' of Dutch painting. This was a period
studded with well-known names: Ruisdael, Cuyp, Ver-
meer, de Hooch, Steen, Terborch, Van de Velde, and
Kalf. All forms of painting had a new solidity and breadth.
The lessons regarding tone, atmosphere and space learned
in the previous phase were now supplemented by mastery
of colour and form—qualities that had hardly been seen
before except in portraiture and religious paintings.

Along with an almost unprecedented representational
accuracy in the rendering of the visible world went imag-
inative qualities that saved these paintings from being
dull. Ruisdael's landscapes with their great trees, rocks and
heavy clouds sometimes have an almost baroque grandeur.
Cuyp favoured a warm golden light in contrast to the grey
atmosphere preferred by other Dutch painters and more

typical of the local climate. Van de Velde exploited the decorative possibilities of 17th-century ships by silhouetting their sails and masts against the sky and dwelling on their ornamental hulls with loving care. Portraiture, other than Rembrandt's (about which one can hardly generalise), was marked by a new exuberance, reflecting both the skill of painters and the self-confidence of sitters; with Hals, it became a field for the brilliant display of brushwork. The domestic interiors of de Hooch are characterised by subtle effects of perspective. Still-life painters, who had previously dwelt on the minimum of precisely painted, telling details, now delighted in the sensuous qualities of objects; a still life by Kalf is almost as much a manifestation of the art of display as a baroque altar.

However, it was Vermeer who was the most imaginative of this group of artists even though his imagination was controlled by that most un-baroque quality, extreme reticence. For Vermeer a figure in an interior surrounded by a few carefully chosen objects—a chair, a musical instrument, a map on the wall—was almost as much an opportunity for the painting of optical values as a king or princess was for Velasquez.

Vermeer's *Artist in his Studio* makes an interesting comparison with *Las Meninas* of Velasquez. Both are pictures which reveal the painter's self-consciousness about his art and its problems. Vermeer typically has his back to the spectator; his world is less ambiguously observed than Velasquez's, but is more enclosed. It is a world of still figures who scarcely communicate with each other and hardly ever touch. The beginnings of the picture on the easel in the *Artist in his Studio* would suggest that Vermeer painted his own pictures stroke by stroke, yet they have complete atmospheric and tonal unity. Like Velasquez, Vermeer never outlines forms, but paints them in relationships of tone. When examined closely, these tones can be seen to be very slightly simplified, suggesting that light and shade had an importance for the artist independent of their representational function, in the same way that paint had an independent importance for Velasquez. It is not an accident that both painters were admired by the Impressionists; indeed Vermeer, who was forgotten after his death, was not rediscovered until their time.

Finally Rembrandt, who is of all artists the most difficult to fit into any of the stylistic trends of the 17th century. The key words that come to mind when thinking of Rembrandt's art are spirituality and truth. His spirituality is very much that of the 17th century and his emphasis on emotional expression is characteristic of the Baroque, but with Rembrandt expression is not always evident on the face. Many of his figures are withdrawn and contemplative and what they contemplate is not outside themselves but within. This reflects a contrast between Catholicism and Protestantism rather than between Baroque and non-Baroque. What Rembrandt does is to show the isolation of the individual, but in a religious and metaphysical context. It is the complete honesty with which he represents the human situation

69. **Willem van de Velde the Younger.** *A Dutch Man-of-War Saluting.* 1707. Oil on canvas. 65¾ × 91 in. (167.7 × 230.5 cm.). Wallace Collection, London. The ability to combine minute accuracy in the rendering of detail with faultless control of atmosphere and space was the ultimate achievement of Dutch realism. Van de Velde was also adept at making the most of the decorative beauty of sailing ships.

70. **Rembrandt van Rijn.** *The Three Crosses.* 1653. Etching (3rd state). 15¼ × 17¾ in. (38.7 × 45 cm.). This masterly etching by Rembrandt is hardly realistic in the visual sense. In its emotional power and dramatic use of light and shade it is closer to the Baroque. Yet it is without baroque idealisation or heroics and is governed by absolute fidelity to psychological and spiritual truth. In the 4th state of the etching, possibly executed some years later, Rembrandt radically altered the design, making it even more expressionistic.

71. **Jean-Baptiste Greuze.** *The Village Betrothal.* 1761. Oil on canvas. 36¼ × 46½ in. (92 × 118 cm.). Louvre, Paris. This picture was exhibited at the *Salon* of 1761, where it was greeted with rapturous enthusiasm by a public eager to pore over the details of its subject-matter. Bourgeois life began to acquire self-consciousness in the mid-18th century and to find its chroniclers in novelists and periodical essay writers. Greuze was its painter, and his work is important not only for its own sake but also for its revelation of a new anecdotal attitude to art.

that constitutes the chief sense in which he may be called a realistic artist. Even on a lower level the accuracy with which he shows the effects of atmosphere on forms and textures is unsurpassed: if one carefully observes the head and right hand of the *Old Man Seated*, one can see how the form is fully modelled; yet it is not so much the actual surface of the form which is depicted as the light and atmosphere through which that surface is seen.

27

Nevertheless, this observed external realism is only part of the inner spiritual realism with which Rembrandt depicts the predicament of man, and—no less important—woman. The *Bathsheba* is at once a baroque, a classical and a realistic picture and, at the same time, more than all three. It is baroque in the luminosity of its modelling and chiaroscuro and in the hint of deep golden brocades in the background; classical on account of the dependence of the pose on an engraving after an ancient Roman relief; realistic in the rendering of flesh and texture and, still more, in its honest presentation of the complex psychological facts of Bathsheba's emotional dilemma as she contemplates King David's invitation. It is more than all three in that it sums up Rembrandt's concern for humanity.

12

REALISM IN 18TH-CENTURY PAINTING

Realism in 18th-century painting consisted chiefly in depicting bourgeois activity in a moral light. It was thus as much a matter of content and attitude as of observation and style. Its antecedents lay in 17th-century Dutch *genre* painting, which now became popular, especially in France, but it was more self-conscious than its sources and showed signs of claiming a new status in the hierarchy of categories. Theoretical argument was deployed on its behalf, Hogarth acting as his own publicist and Greuze finding a champion in Diderot, who also admired the 'honesty' of Chardin.

A further characteristic shared by these three artists was

an interest in story-telling. Unlike Vermeer's or de Hooch's domestic scenes, Chardin's imply the moment before and after the one represented; looking at his pictures we feel that in a few minutes the house of cards will fall down, the meal before which grace is being said will be eaten, the child so lovingly dressed by the nurse will go out for a walk. With Hogarth and Greuze this preoccupation with narrative became explicit.

Borrowing his method and his cast of characters from contemporary fiction and the stage, Hogarth developed a new type of picture-story, of which he was both author and painter, illustrating what he called 'modern moral subjects'. Six or more episodes would be assembled, showing a rake's or harlot's 'progress' or the consequences of marrying for snobbery or money. In each case the *donnée* of the situation is some character defect or act of folly which leads inevitably to a disastrous end. Along the way there is much coarse humour, an indefatigable attention to detail and more than a touch of melodrama, but genuine feeling underlies the satirical approach.

Greuze, who owed something to Hogarth, was just as didactic in his intentions but far more solemn. Belonging to the second half of the 18th century rather than the first, he was affected by the sentimentality of his age. Encouraged by Diderot, he also attempted to inculcate morality by the direct method—that is, by showing virtue itself in action—not by the indirect weapon of ridicule employed by Hogarth. In a period which was beginning to concern itself with problems of education and social relationships and which laid a new stress on the importance of the family, the success of such paintings as *The Village Betrothal*, *The Dutiful Son* and *The Dying Grandfather* was assured. Here was painting which the *Salon*-going public could pore over and discuss.

Considering Chardin, Hogarth and Greuze as painters, Chardin was incomparably the finest of the three. He possessed a sensitivity to texture and atmosphere, shown particularly in his still lifes, which lay mid-way between that of the Dutch painters and the Impressionists, while the figures in his narrative compositions are touched with Watteauesque reticence and grace. Hogarth, too, conceived his 'line of beauty' as a rococo S-curve, but the gestures and attitudes of his figures are sometimes stilted and his chiaroscuro and brushwork are late baroque. In his insistence on nature rather than works of art as the proper standard of excellence for the painter, and in his discussion of problems of representation, he was more advanced in his theory than he was in practice. As a painter Greuze was skilful rather than sympathetic, at least to modern taste. To convey his message he often depended on the vocabulary of expressions and gestures proper to history painting. By what has sometimes been unfairly regarded as poetic justice but probably reflected no more than a hardening of attitudes in the Academy, in 1769 he submitted a conventional history picture, but was still only accepted as a *genre* painter.

The Rococo

INTRODUCTION

The Rococo is the most attractive artistic movement between the Renaissance and Impressionism, yet partly for that reason it is the hardest to write about. Its charm is a *cliché* of modern criticism; its qualities are all on the side of fantasy, wit, sensibility and smiling ease. Unlike the baroque and neo-classical movements that came before and after it, it is amoral and intuitive, not didactic and intellectual. It requires no elaborate background of historical or theoretical knowledge to be enjoyed. Its essential object is to please.

A century ago the brothers Edmond and Jules de Goncourt evoked the flavour of French rococo painting in words which are hard to improve on but over-rate sentiment at the expense of style. For instance: 'Watteau renewed the quality of grace. It is no longer the grace of antiquity that we meet with in his art:... The grace of Watteau is grace itself. It is that indefinable touch that bestows upon women a charm, a coquetry, a beauty that is beyond mere physical beauty. It is that subtle thing that seems to be the smile of a contour, the soul of a form, the spiritual physiognomy of matter.' Or again: 'Voluptuousness is the essence of Boucher's ideal; the spirit of his art is compact of it. And even in his treatment of the conventional nudities of mythology, what a light and skilful hand is his! how fresh his imagination even when its theme is indecent! and how harmonious his gift of composition, naturally adapted, it might seem, to the arrangement of lovely bodies upon clouds rounded like the necks of swans!' These two artists have worn the labels hung on them by the Goncourts ever since; and who shall say that those labels are entirely wrong?

What needs to be re-emphasised, however, is the technical brilliance of these artists—in other words, the 18th century's discovery of style. A sense of style, even stylishness, is the distinctive quality of rococo art. It is a quality that shows itself in the mastery of a particular rhythmical movement, the irregular S-curve, cultivated for its own sake and handled with seemingly effortless ease. We are made aware all the time of a consciousness of artistry, a revelling in the beauty of the performance, a delight in 'the thing well done'. It was an attitude eminently characteristic of an age which brought the conduct of human relationships to the level of an art. It belonged with those new arts of the 18th century, arts which have to do with communication between two or at most a small group of people: conversation, letter writing, chamber music, dancing, manners, seduction. Thus the Rococo was neither a public art, like the Baroque, nor a solitary art, like Impressionism, but an art of polite society.

Although lacking a theory, the Rococo had a stylistic momentum of its own, making it almost impossible for artists who used its conventions to be wholly bad; the worst vices of rococo art spring from want of feeling rather than want of skill—at times it could be heartless. On the other hand, the same conventions, superbly adapted to

72. **Claude Audran.** *Ceiling Design* (detail). *c.* 1709. Watercolour and gold. 8 × 13½ in. (20.1 × 34.3 cm.). National Museum, Stockholm. This design for part of a ceiling decoration is similar to those produced by Audran for the Château de la Ménagerie (see text). The motives are adapted from arabesques (a traditional type of intricate pattern using a mixture of abstract forms interwoven with figures, animals and plants), but everything has been made lighter, freer and more playful. Such designs were an important source of the Rococo.

modest talents, put the very highest levels of imaginative achievement almost equally out of reach. Of the painters and sculptors of the period, perhaps only Watteau and Tiepolo can be compared with the greatest of their predecessors and successors—and Tiepolo was at least partly a late baroque rather than a rococo artist.

FRENCH ROCOCO DECORATION

It was in royal buildings dating from around 1700 near Versailles that the first examples of the new style of decoration were produced, and within two years it began to appear in certain rooms at Versailles itself. An important impulse behind this was the desire to escape from the stiffly formal atmosphere of the state apartments created at Versailles in the 1670s by Lebrun. As early as 1679 the first royal retreat, the Château de Marly (like so many other buildings of the period, since destroyed) was projected; for the next hundred years the search for ever more informal

73. *Salon of the Hôtel de Bourvallais (Place Vendôme), Paris. c.* 1717.
This is a typical French rococo interior of the Regency period
(1715–23). The hallmarks of this phase are the large mirrors
with curved tops, paintings over the doors, and repeated wall
panels decorated with stylised leaf motives at top and bottom
and elaborate medallions in the centre (the door panels are
similarly decorated). Notice also the S-curve of the fireplace
opening and the open-work cornice. As yet there is no break
with symmetry and the various units are still bordered with
straight lines. The colour scheme is white and gold. The architect
in charge was Robert de Cotte but the design of this room,
showing the influence of Pierre Lepautre, may be due to one of
his assistants.

settings continued, reflected in the construction of the
Grand Trianon, the *Petit Trianon* and the Belvedere, and
culminating just before the Revolution in the creation of
the English garden and the artificial rustic village in the
grounds of the *Petit Trianon* for Marie Antoinette.

A moment of significance for the genesis of the Rococo,
embodying an attractive personal touch, occurred in 1699.
In that year Jules-Hardouin Mansart, the chief architect at
Versailles and the newly appointed Surveyor of the Royal
Works, submitted a scheme for the decoration of one of the
rooms in the small Château de la Ménagerie, which had
recently been rebuilt for the thirteen-year old Duchess of
Burgundy, fiancée of the eldest grandson of Louis XIV. The
scheme provided for a ceiling painted with figures of
classical goddesses. The king, however, objected to these.
'It seems to me,' he wrote, 'that something ought to be
changed as the subjects are too serious; a youthful note
ought to appear in whatever is done. You will bring me

some drawings when you come, or at least some sketches.
There must be an air of childhood everywhere.' The
drawings, which survive though the Château does not,
were by Claude Audran, who later became the master of
Watteau. They show that the ceiling was covered with a
pattern of arabesques, more wayward than any previous
examples and revealing an almost calligraphic touch. The
motives consisted of loops and tendrils of acanthus leaves,
garlands of flowers, ribbons, arrows, stylised rustic bowers,
all spun out like filigree work, with hunting dogs, birds and
figures of young girls perched among the tendrils and
branches. The king was well pleased with the decorations,
which he called 'magnificent' and 'charming'. It should be
emphasised that the Rococo was welcomed by everyone
from Louis XIV downwards, eagerly and at once. It was
not until the 1740s that hostile criticism of it began.

Painted arabesques, derived ultimately from ancient
Roman 'grotesques' (so-called because they were found in

87

grottoes) and brought to a new pitch of refined elaboration in France under Lebrun, were a major source of rococo decorative motives. But the crucial step was the application of these motives to the carved frames of mirrors and wall panels. Here again the key date is 1699. The location was the redecorated king's apartment at Marly and the artist a draughtsman on the staff of the Office of Works, Pierre Lepautre. Hitherto the standard type of French interior decoration had consisted of wood or, less commonly, marble panelling divided into sections of rectangular or some other strictly geometrical shape. Above the panelling was a heavily moulded cornice and above that a high coved ceiling painted with allegorical figure subjects. Chimney-pieces were relatively high and the spaces above them usually filled with paintings or relief sculpture. Lepautre's innovations at Marly were, first, to modify the corners of the mirror-heads and panels by introducing leaf forms and curved scrolls in the shape of a C, both derived from arabesques; second, to alter the proportions of the mouldings so as to create a new effect of slenderness and grace. In the centre of the ceiling of the king's bedroom he placed a large rosette, leaving the rest of the ceiling blank—another idea which was to be widely imitated.

From this time onwards, mirrors—at first round-headed, later more elaborately curved at the top—became the standard feature above chimney-pieces. Chimney-pieces themselves were now reduced in height and their openings soon began to assume the characteristic S-curve of the Rococo. Architectural forms, where used (which was seldom), became increasingly attenuated. At the same time, doors and walls were raised and cornices pushed up into the ceiling so as to reduce the coving to a mere rounding of the angle with the wall. Later, mirrors were introduced not only above chimney-pieces but also on the other walls of the room apart from the window wall. Windows themselves, round- or oval-headed like the mirrors, were raised almost to the height of the cornice and were often continued down to the floor (hence the term 'french window'). Walls were flat, without projecting chimney-breasts or pilasters. Ceilings were left unpainted or were treated only with arabesques, while paintings with figure or animal subjects were confined to the spaces over the doors. The typical colour scheme was gold for the relief mouldings and ivory white for the walls. Sometimes the walls were left as natural wood, but positive colours were hardly ever used in France during the rococo period.

The rococo interior thus consisted essentially of a series of tall, slender, self-contained units placed side by side—mirrors, windows and doors alternating with decorative wall panels in carved wood. The technical term for such panels is *boiseries*. It was in the design of these that the rococo decorator (known as the *sculpteur*) showed his inventive skill. The corners of the frames were rounded and turned in, and the resulting C-shaped scrolls were made to issue in sprays of leaves pointing towards the centre of the panel. Mirror-heads were given increasingly complex curves with scrolls

74. **Antoine Watteau.** *Drawing of a Shell. c.* 1710–15. Red and black chalk. 11⅝ × 7⅜ in. (29.6 × 18.6 cm.). F. Lugt Collection, Institut Néerlandais, Paris. This drawing was probably made for documentary reasons, but the shell illustrated here may be taken as almost a microcosm of the Rococo. Many of the characteristic features of the style are shown—the irregular S-curve, the fronds and spikes, the asymmetry, the sensation of growth and the fascination with the natural world and with the exotic. Shell motives often occur in German rococo decoration, though not so much in French.

75. **Juste-Aurèle Meissonnier.** *Design for a Soup Tureen. c.* 1735. Engraving from the *Livre d'Ornemens.* 7¼ × 10¼ in. (18.5 × 26 cm.). The intricate forms of this fantastic soup tureen, which would have been executed in silver, echo the natural forms of the shell drawn by Watteau. There is also a resemblance in spirit. Meissonnier's work is representative of the *genre pittoresque*, a phase of the Rococo characterised by a love of asymmetry and keen interest in the world of marine and plant life as a source of decorative motives.

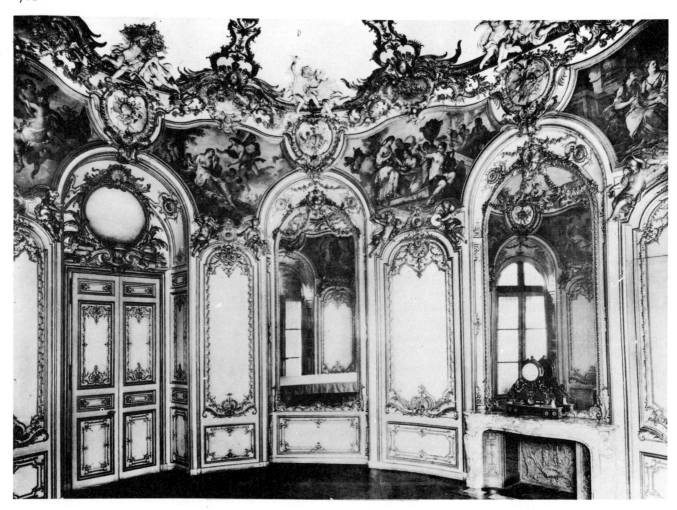

76. **Germain Boffrand.** *Salon de la Princesse, Hôtel de Soubise, Paris. c.* 1735–40. This exquisite oval room is the *pièce de résistance* of the suite added by Boffrand to the order of the Prince de Soubise soon after the latter's marriage in 1732 to the 19-year old Marie-Sophie de Courcillon. The exterior architecture is of classic simplicity but the interior embodies the perfection of French Rococo. The ceiling of the room is pale blue, the walls are white and the mouldings are treated with gold leaf. Windows occupy four of the five arched spaces out of view of the camera in this illustration.

meeting back-to-back in the middle and further scrolls masking the transitions from the curved to the vertical parts of the frame. The centres of panels were decorated either with rosettes incorporating the same combination of scrolls and acanthus leaves, or with trophies, that is, assortments of instruments illustrating a particular theme or activity—music, geometry, astronomy, hunting, the visual arts, and so. Although many of these decorative forms and motives used by the Rococo were of classical or Italian baroque origin, they were now employed in a new spirit and with a total rejection of the Antique. In contrast to the Baroque, where the forms sprang out of the mass, the Rococo relied upon a delicate surface play. Relief was everywhere kept low.

In 1701, two years after its first appearance at Marly and the Château de la Ménagerie, the new style was tentatively introduced at Versailles itself. This was in the apartments on the first floor facing the *Cour de Marbre*, which were remodelled at this time to form the *Salon de l'Oeil de Boeuf*, the *Chambre du Roi* and the *Cabinet du Conseil*. Again the executive designer was Pierre Lepautre, and for the next ten or twelve years the Royal Works, of which he and the *sculpteur*, François-Antoine Vassé, were the leading spirits,

continued to be the main source of new ideas in rococo decoration. After 1715, however, when Louis XIV died and was succeeded by his five-year old great-grandson, Louis XV, the situation changed. The Regent, the Duc d'Orléans, transferred the hub of French society from Versailles to Paris. Private buildings—the Palais Royal (then owned by the Regent himself), the Hôtel de Toulouse, the Hôtel d'Assy, the Hôtel de Bourvallais, the Château de Chantilly and others—now became the settings in which the most advanced rococo decorations were executed.

It was during this period—the Regency, which lasted until 1723—that the stylistic features described above first became fully developed. The sophisticated, urban society which fostered them was that for which Watteau painted; its leading designer, in succession to Lepautre, was the Italian-trained Gilles-Marie Oppenord, whose father was Dutch though he himself was born in Paris. There was now a still greater use of curves, including contrasting curves, especially for the tops of doors and for the frames of the pictures above them. These frames took on an undulating, S-shaped outline, with palm branches for the mouldings. Shell motives were also sometimes introduced, although they never had the importance in French decoration that

21

77. **Jean Courtonne.** *Hôtel de Matignon, rue de Varennes, Paris.*
1722–23. French exterior architecture during the rococo period
was characterised by reticence and simplicity, although touches
of relief sculpture and channelled wall surfaces generally enliven
the façade. The 45-degree edge of the projecting centre-piece

seen here is also typical. The lack of monumentality is striking by
comparison with Blois by François Mansart (fig. 58), although
the tall windows fitted almost flush with the façade and the
short wings projecting at each end are elements in common.

they had in Germany. Altogether there was a new fluency
and ease, with more interlacing than before and an oc-
casional touch, reflecting Oppenord's Italian training, of
baroque plasticity. Painted arabesques sometimes included
monkeys (from which the term *singeries* derives) and
Chinese figures. *Chinoiserie*, that typically 18th-century
flirtation with the exotic which accorded so well with the
Rococo, also became popular in England. Indeed in
England, where it invaded furniture design as well as
interior decoration, *chinoiserie* was one of the chief forms in
which the Rococo became acceptable (another was mock
Gothic).

On the Regent's death in 1723 the young king moved the
court back to Versailles, but the major initiatives in rococo
design were still taken in Paris, The late 1720s and 1730s
were characterised by the development of a new phase of
the style, the *genre pittoresque*, of which the principal feature
was asymmetry. The designer credited with the introduc-
tion of this was the ornamentalist, Juste-Aurèle Meisson-
nier, who was born in Turin of Provençal parents; his
opposite number as an interior decorator was the *sculpteur*,
Nicolas Pineau. In was Meissonnier, according to Cochin
in his attack on the Rococo in 1754, who 'invented the

contrast of ornaments, that is to say, he abolished sym-
metry', but he did this mainly in designs for craft objects in
silver, such as candlesticks, jugs, clocks, monstrances and
table ornaments. Engravings after his work were published *75*
from the late 1720s onwards (this was a common practice
with rococo designers) and became widely influential in
Germany. They show an astonishing assortment of freely
curving, semi-organic forms, flowing, twisting and waving
almost like water plants, or like the tropical shell illustrated
on page 701 in a drawing attributed to Watteau. *74*

Similar forms were used for the design of tables, chairs,
chimney-pieces, fire-dogs and clocks. It was an age in
which many new types of furniture were produced, each
decorated with marquetry or Chinese lacquer-work and
ormolu mounts (gold-leaf on bronze) often created by
famous craftsmen and designers—Cressent, Gaudreux,
Oeben, Caffieri and so on. The simple categories of table,
chair and cupboard used in previous periods were now
sub-divided into specialised types determined by their
purpose: writing tables, gaming tables, boudoir tables,
console tables, *secrétaires*, *bureaux* (both of these being types **36**
of desk), armchairs, upright chairs, sofas, settees, ward-
robes, *commodes* (chests-of-drawers), bookcases, cabinets

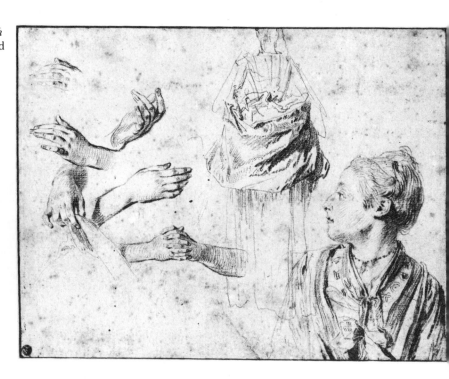

78. **Antoine Watteau.** *Sheet of Studies with two Figures and Hands. c.* 1715–20. Red and black chalk. 6½ × 8⅞ in. (16.5 × 22.5 cm.). British Museum, London. Appreciation of sketches for their own sake was a characteristic of 18th-century aesthetics and it is fitting that Watteau was one of the two greatest draughtsmen of the period (the other being Tiepolo). His drawings have all the delicacy and sensitivity of his paintings, but with an added charm due to their lack of finish. Despite their piecemeal character, the various studies of which the sheets are composed always belong together harmoniously on the page.

display cases and countless others, each with its own technical name. They reflected the new search for privacy and convenience, which occurred in society at this time.

By 1740 the climax of the Rococo had been reached in France, although the reaction against it scarcely began before the 1760s. One work belonging to this final phase must, however, be mentioned. This, perhaps the finest surviving rococo room in all France, was the oval *Salon de* **76** *la Princesse* in the Hôtel de Soubise, a late work by Germain Boffrand, designed about 1735. Eight arch-topped spaces, either mirrors, windows or doors, are arranged symmetrically round the room with panels between their vertical sides and paintings by Natoire illustrating the story of Cupid and Psyche in the spaces above the panels. Above the whole scheme, already on the cove of the ceiling, runs a waving cornice which dips down to meet the tops of the arches and rises over the paintings to send out open bands of scroll-work which converge on a rosette in the centre of the ceiling. The room is more positively feminine than the **36** private apartments at Versailles, as was appropriate for the young princess for whom it was created. From here it was a short step artistically to the still more ravishing and **84** more flamboyant Hall of Mirrors by Cuvilliés at the Amalienburg, completed a few years later.

The unusual oval shape of the *Salon de la Princesse* is a reminder that the Rococo in France was essentially a style of surface decoration and not of three-dimensional architecture. Almost all the rooms so far mentioned in this chapter are similar in shape and proportion to those of the late 17th century, that is, nearly square in plan with the height about two-thirds of the length and width. The only important structural innovation was sometimes to round off the corners. Being a style without spatial qualities, it was not well adapted to the treatment of exteriors or churches.

Classical orders were sparingly used or omitted altogether and windows often had no pediments. The height of the house was reduced compared with the Baroque, with the main rooms often situated on the ground floor. The main form of exterior decoration was a light horizontal channelling of the walls and some judiciously placed relief sculpture. A new type of building, the 'retreat' or *maison de plaisance* in the park of a great palace, was also characteristic, and not only at Versailles. Examples range from the enchanting *Pavillon Français* in the grounds of the Trianon (c. 1750, by Gabriel), through the Amalienburg, to the comparatively large residence of Sans-Souci, built for Frederick the Great of Prussia by Knobelsdorff in 1745–51. All these are single-storey buildings with ground plans including projecting elements, either curved or jutting out in square forms at 45 degrees to the entrance front. In England they have their counterparts in Chinese, Indian and Gothic follies and sham ruins, though the latter were meant only to be looked at, not lived in, and were rococo only in spirit, not form. Similarly, the early 18th-century English landscape gardens of Pope and Kent, with their winding paths and streams, so different from the straight formal alleys of contemporary French gardens, may also be counted as manifestations of the Rococo, even though they surrounded houses of classical design.

FRENCH ROCOCO PAINTING

The development of French rococo decoration was due to a succession of comparatively minor figures, but French rococo painting was created by a single artist of genius, Antoine Watteau. Watteau's apprenticeship to the arabesque painter, Claude Audran, has already been mentioned; he was also linked with another painter of arabesques, Claude Gillot, who, in addition, was noted for his

(Continued on page 721)

59. **Jan Vermeer.** *A Lady and Gentleman at the Virginals. c.* 1660. Oil on canvas. 28½ × 24½ in. (72 × 62 cm.). Reproduced by Gracious Permission of her Majesty the Queen, Buckingham Palace.
Vermeer's still, silent, contemplative art represents a sort of classicism without the influence of classical antiquity. He was the great master of Dutch bourgeois genre painting. Ladies and gentlemen, separately or together, occupy his carefully furnished interiors, talking, reading or writing letters, drinking, pouring milk or, as here, playing music. The instrument is a virginals, an earlier version of the harpsichord, its lid inscribed *Musica Letitiae Comes Medicina Dolor* [*um*] (Music is the companion of joy, the balm of sorrows). The painting also exemplifies Vermeer's controlled rendering of daylight and, on the back wall, his fondness for a geometrical pattern of rectangles.

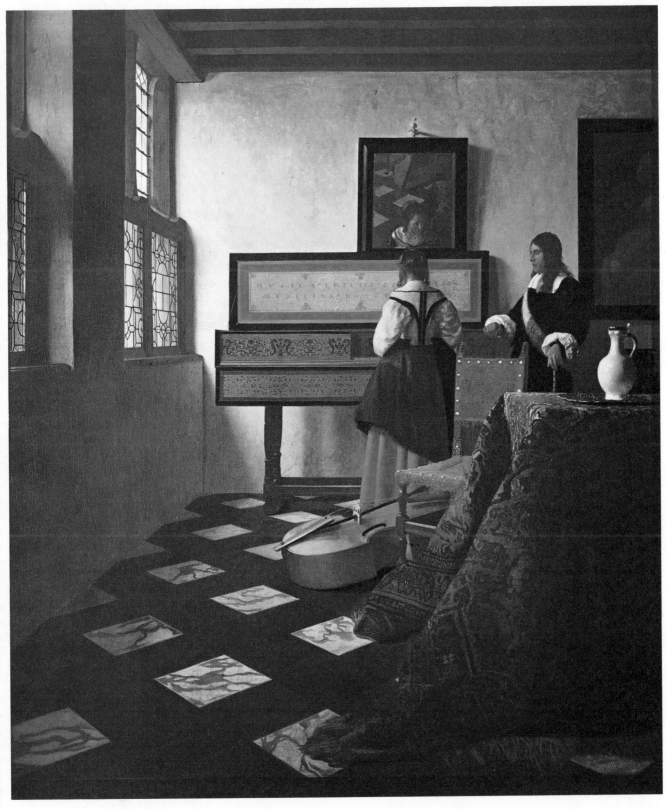

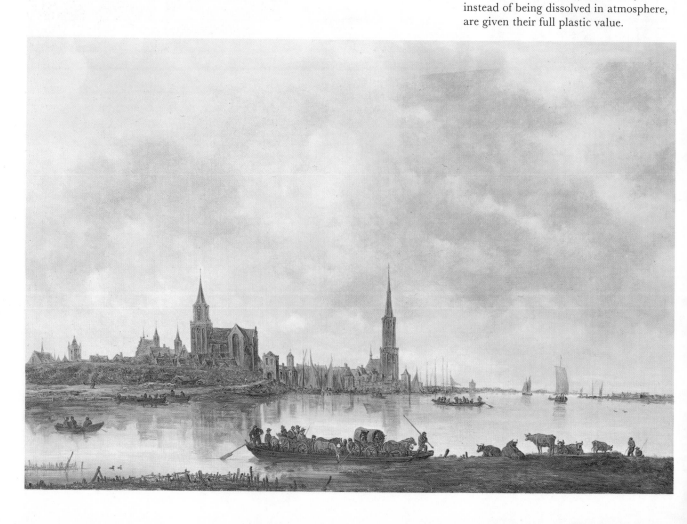

60. (left). **Julius Porcellis.** *Seascape.*
c. 1640. Oil on panel. 13 in. (33.5 cm.),
diameter. Museum Boymans van
Beuningen, Rotterdam.
61. (below). **Jan van Goyen.** *View of
Emmerich.* 1645. Oil on canvas. 26 × 37½
in. (66 × 95 cm.). Cleveland Museum of
Art, Ohio, (John L. Severance Collection).
62. (opposite, above). **Philips Koninck.**
View in Holland. c. 1670. Oil on canvas.
52¼ × 63⅛ in. (133 × 161 cm.). National
Gallery, London.
63. (opposite, below). **Jacob Ruisdael.**
Wooded Landscape. c. 1660. Oil on canvas.
41½ × 58½ in. (103 × 148 cm.). Worceste
College, Oxford.

These four paintings represent various
types of 17th-century Dutch marine and
landscape painting. All are more realistic
than the landscapes illustrated as plates
42–48 and all represent Holland; they
may be described as prose, whereas the
others, inspired by the scenery of the
Roman Campagna, embody poetry of one
kind or another. But they are not artless,
nor are they free from pictorial conven-
tions. The first two belong to the phase
known as 'tone painting', of roughly the
second quarter of the century; the colours
are restricted, compositions are simple
and the picture space is chiefly taken up
with sea and sky. The other two paintings
belong to a later stage. They are more
colourful and dramatic, and forms,
instead of being dissolved in atmosphere,
are given their full plastic value.

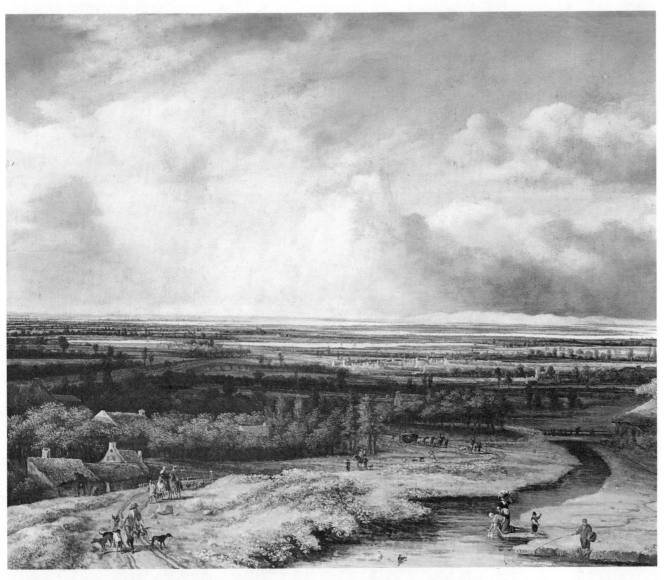

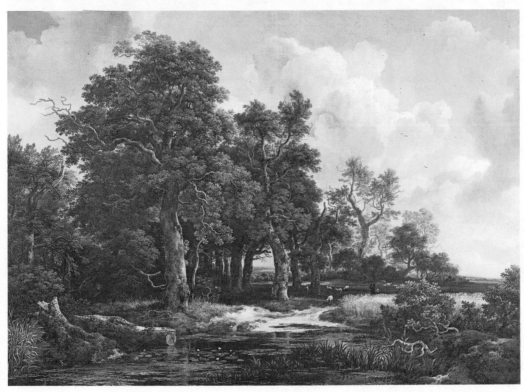

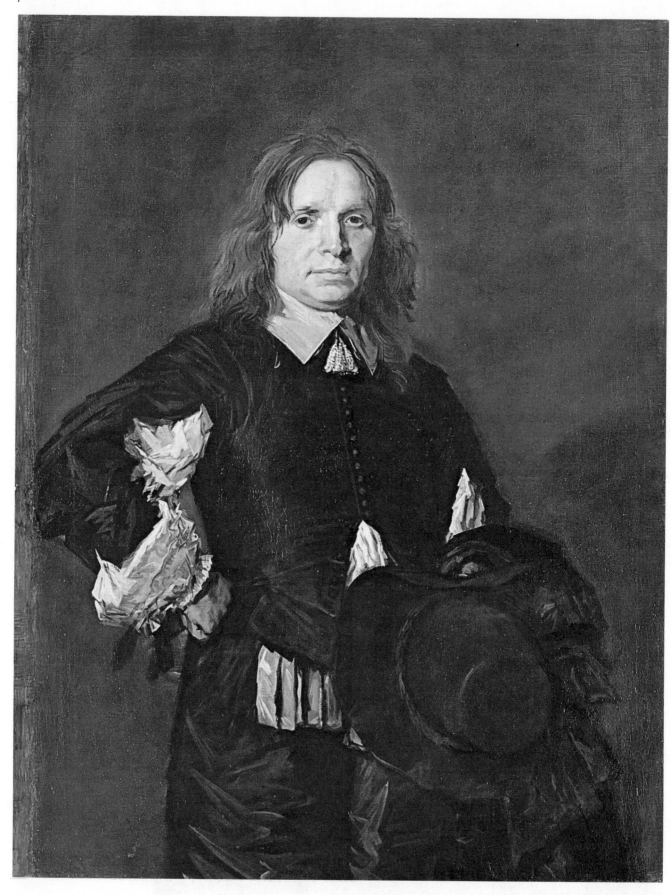

64. **Frans Hals.** *Portrait of a Man.*
c. 1650–52. Oil on canvas. 42 × 33 in.
(106.5 × 84 cm.). Metropolitan Museum
of Art, New York. (Gift of Henry C.
Marquand, 1890).

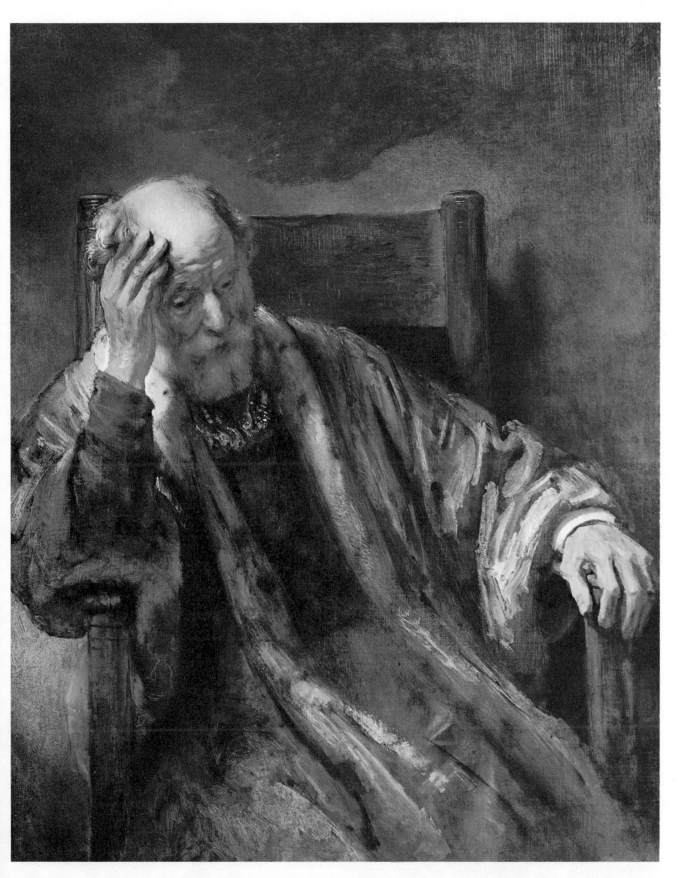

65. Rembrandt van Rijn. *An Old Man Seated.* 1652. Oil on canvas. 43 × 34 in. (111 × 88 cm.). Reproduced by courtesy of the Trustees of the National Gallery, London. The contrasting strengths of the two greatest Dutch masters of portraiture are clearly seen in these two examples. Hals exhibits a robust, straight-forward approach, showing the sitter as he would wish to appear in society. The vitality of the portrait is conveyed as much by the artist's brushwork as by the sitter's expression. Rembrandt, on the other hand, concentrates on the introspective possibilities of portraiture. The model is assimilated to the artist's idea of him, so that the picture ceases to be a portrait of an individual and becomes a study of contemplation. The open brushwork—softened by glazes at the top left, allowed to remain raw and unfinished at the bottom right—is typical of Rembrandt's later years.

66. (right). **Jean-Baptiste Chardin.** *The Morning Toilet. c.* 1740. Oil on canvas. 19¼ × 15¼ in. (49 × 39 cm.). National-museum, Stockholm. From the ingredients of childhood aping adulthood, and adult-hood wishing to mirror itself in childhood, Chardin has managed to produce a remarkably unsentimental picture, relying on a simple, pyramidal composi-tion, symmetrical and balanced in spite of the casual lopping of the furniture at the edges, and allowing himself only the coffee-pot in the foreground to demon-strate his astounding facility with still life. Chardin undoubtedly knew the work of some of the Dutch 17th-century genre painters (though not Vermeer), but his art has a purely pictorial and aesthetic beauty, independent not so much of subject-matter as of illusionism, to which theirs still clings.

67. (below). **J.-C. Duplessis.** *Inkstand. c.* 1770. Apple-green and white Sèvres porcelain, with gilding. 7 in. long. (17.8 cm.). Reproduced by permission of the Trustees of the Wallace Collection, London. The style of this piece seems to be a little old-fashioned for 1770, since the more flamboyant Louis XVI style had already superseded the rich but simpler fashion associated with the reign of Louis XV, whose portrait is on the cameo and who presented the inkstand to his daughter-in-law, Marie Antoinette. The painted Cupid decorations by Falot indicate that this is a marriage gift, and the terrestrial and celestial globes flanking the crown of France may be intended as a rather fanciful political emblem.

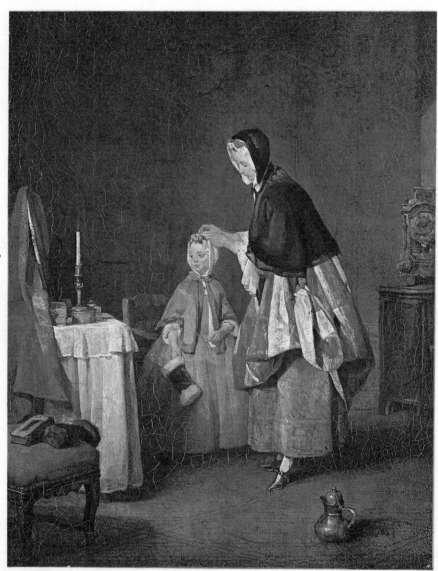

68. (above). **Jan Steen.** *The World Upside-Down. c.* 1663. Oil on canvas. 41¼ × 57 in. (105 × 145 cm.). Kunsthistorisches Museum, Vienna. The canvas is inscribed *In Weelde Siet Toe* (When you lead the sweet life, be prudent). This use of a tag or proverb is typical of Steen, who was Holland's greatest painter of popular life. But while he intended a warning, there is no doubt that he enjoyed depicting scenes of which he ostensibly disapproved.

69. (right). **William Hogarth.** *The Countess's Dressing-Room. c.* 1743. Oil on canvas. 27¾ × 35¾ in. (70.5 × 91 cm.). Reproduced by courtesy of the Trustees of the National Gallery, London. This is the fourth scene from Hogarth's most famous series of 'Modern Moral Subjects', the *Marriage à la Mode*. The style is realistic, though the stilted poses and artificial movements suggest the contrived realism of the theatre; but Hogarth's intention is didactic and satirical, not documentary, and the whole series is an attack on immorality in high life and on the follies of marrying for money.

70. (above). **Versailles.** *Cabinet de la Pendule.* 1738. The *Cabinet de la Pendule* forms part of the 'Petits appartements' created in the 1730s by Louis XV in the north wing of Versailles facing the *Cour de marbre.* These rooms were deliberately planned to be lighter, pleasanter and more intimate than the 'Grands appartements' made for Louis XIV (plate 16) and are typical of French Rococo. The chimney-piece and furniture are of the period but the end of the room, originally oval, was squared off in 1760.

71, 72. **Joseph Willems** (?) *A Shepherdess* (71). 12⅛ in. high (30.8 cm.). *An Actor in Turkish Costume* (72). 12¾ in. high (32.4 cm.). *c.* 1760–65. Chelsea porcelain. Victoria and Albert Museum, London. Meissen, the most important European centre of porcelain manufacture in the first half of the 18th century, prompted the growth of porcelain factories in England. Chelsea, the earliest of them, was apparently founded soon after 1745, its master-modeller being the Fleming, Joseph Willems. Willems's style is an elaborate interpretation of Rococo, loaded with picturesque detail. Shepherds and shepherdesses were the stock themes of the late 50s and 60s.

73. **Jean-Honoré Fragonard.** *Blind Man's Buff. c.* 1775. Oil on canvas. 84 × 77½ in. (213 × 197 cm.). National Gallery of Art, Washington. (Samuel H. Kress Collection). At one time in the collection of Fragonard's chief patron, the dilettante Abbé de Saint-Non, this painting belongs to the tradition of Watteau's *Le Bal* (plate 74) and ultimately of Rubens's *Garden of Love* (plate 10). However, the subject is more anecdotal and the treatment more decorative. The light atmosphere, picturesque setting (based on the gardens of the Villa d'Este at Tivoli) and easy, relaxed, composition, so diaphanous that a puff of wind might blow it away, are typical of French Rococo landscape painting.

74. (above). **Antoine Watteau.** *Les
Plaisirs du Bal.* 1719. Oil on canvas.
19¾ × 24 in. (50 × 61 cm.). Dulwich
College Picture Gallery, London; repro-
duced by permission of the Governors of
Dulwich College. This record of the
pleasures of a highly civilised country life
was taken as a historical document by
Hazlitt, who saw Louis XIV as the
leading dancer, but, as with all Watteau's
work, the setting and the vaguely
16th-century costumes put the picture
into the realm of arcadian fantasy. For
Watteau, as for Cocteau in 'Beauty and
the Beast', the statuary is a living and
participating element in the setting, and
the landscape, taking up and tidying
elements in Watteau's most influential
forerunner, Rubens, never threatens to be
more than an agreeable background to
the fête.

76. **François Boucher.** *Cupid a Captive.*
1754. Oil on canvas. 64½ × 32⅝ in.
(164 × 83 cm.). Reproduced by permis-
sion of the Trustees of the Wallace
Collection, London. This panel, which
shows Cupid held captive by the Three
Graces, was painted, with three others, as
a decoration for the boudoir of Boucher's
friend and protectress, Madame de
Pompadour. It was through the influence
of Louis XV's most celebrated mistress
that Boucher became First Painter to the
King in 1765, and his weightless and
pretty treatment of traditional classical
subjects is one aspect of the *style Pompadour*.
The fleshier aspects of Ruben's vigour
have become the rhetoric of titillation, and
only in the immense *Rising* and *Setting
Suns*, also in the Wallace Collection, does
Boucher come close to Ruben's grandeur.
Here he creates a decorative, asymmetrical
soufflé of forms very similar in feeling to a
figure group in porcelain of the period,
or to a silver table ornament by Meisso-
nier.

75. (left). **René Dubois.** *The Tilsit Table. c.*
1760–70. Oak, lacquered in green and gold
vernis Martin and partly gilt, with chased
and gilt-bronze mounts; the top inlaid with
green Moroccan leather. Height, 30; width
56½; depth 28¾ in. (76 × 143.5 × 73
cm.). Reproduced by permission of the
Trustees of the Wallace Collection,
London. This table seems to have been
made for Louis XV, who gave or sold it to
the Empress Catherine II of Russia. It takes
its name from the supposed fact that the
Franco-Russian Treaty of Tilsit (1807) was
signed at it, its then owner, Prince
Kourakin, being the Russian Ambassador
to the French Imperial Court. The intricate
raised ornaments and elaborate caryatids
on the legs (once attributed to the sculptor,
Etienne Falconet), give this piece a rich and
rather sombre quality, for all its elegance,
though the lacquer has darkened. The
rectangular top and straight legs below the
caryatids represent the beginnings of a
classical reaction against the Rococo.

78. (opposite). **Godfrey Kneller.** *Matthew Prior.* 1700. Oil on canvas. 54½ × 40⅛ in. (138 × 102 cm.). Reproduced by courtesy of the Master and Fellows of Trinity College, Cambridge. As a work of art this was perhaps an inspired accident, un-typical of Kneller and not quite sustained by the technical skill necessary to carry it off (contrast the previous example). Nevertheless, it is one of the most original portraits of its time. Together with certain portrait-busts by Coysevox, it brings into focus the 'new man' of the 18th century: the intellectual—rationalist in spirit, sceptical, urbane and cosmopolitan.

77. (below). **Maurice Quentin de la Tour.** *Self-portrait. c.* 1750–60. Pastel. 25¼ × 21 in. (64 × 53 cm.). Musée de Picardie, Amiens. A more developed example of the same species is shown here; La Tour presents himself as a man of the world rather than as an artist. The pose of the figure is now extremely simple, even casual; vitality is given by the flickering pastel strokes which concentrate attention on the lace at the wrists and throat, on the wig and, above all, on the mocking eyes and mouth.

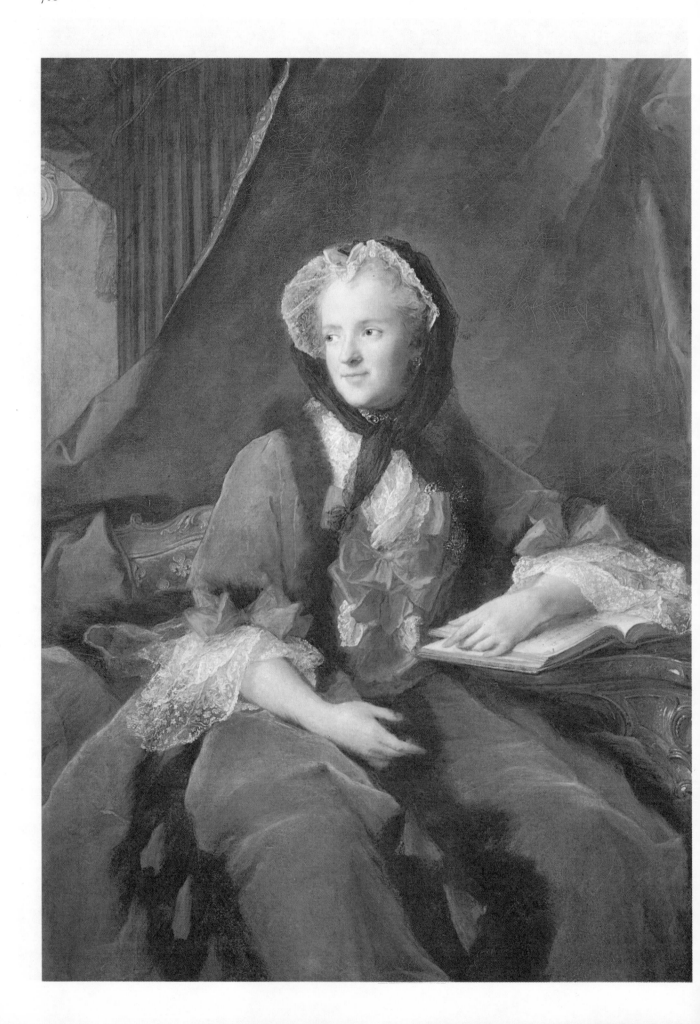

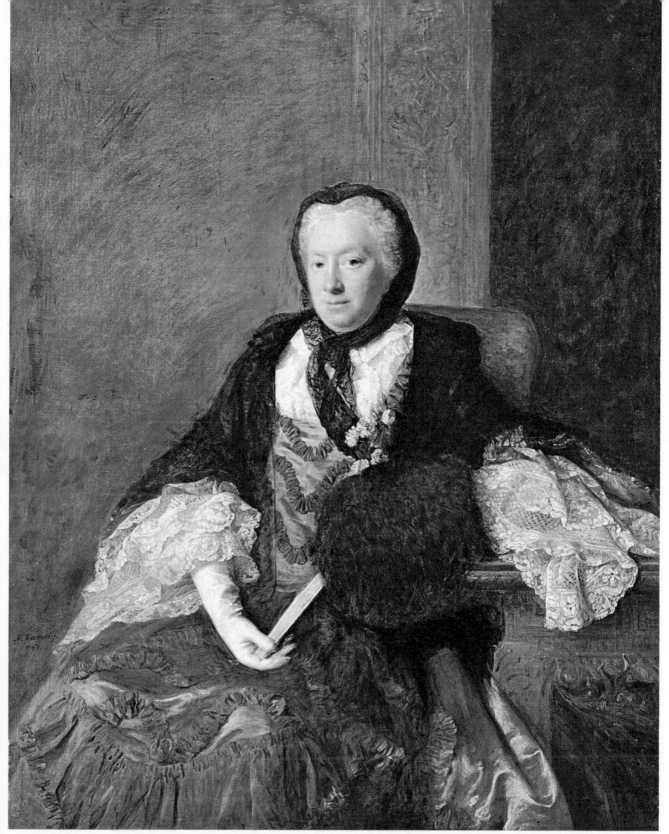

79. (opposite). **Jean-Marc Nattier.**
Queen Marie Leczinska. 1748. Oil on canvas.
53¼ × 38½ in. (135 × 98 cm.). Versailles.
This lively picture is far from being a state
portrait in the conventional Late Baroque
sense. Louis XV's queen is seen in her
town dress and reading the Bible, like any
Scots lady among Allan Ramsay's
clientele. But her wayward glance is less
staid than it would be if she were Scottish
and, discreetly in the background, she is
seen to be sitting on a couch embroidered
with the Royal Lily of France.

80. (above). **Allan Ramsay.** *Mary Atkins
(Mrs Martin).* 1761. Oil on canvas.
50 × 40 in. (127 × 102 cm.). Birmingham
City Art Gallery. Mary Atkins, the sister
of Rear-Admiral Samuel Atkins, married
Admiral William Martin in 1726.
Ramsay's smoothness and daintiness, quite
unlike the robustness of Reynolds or the
bravura of Gainsborough, reflects the
Italian background of his art. But there is
something French in his brushwork and
colour, here reflected in a silvery tonality
that recalls Nattier, as does the rather

nonchalant, almost homely, flavour of the
portrait, which in Britain is hardly
paralleled until Raeburn, another Scot.

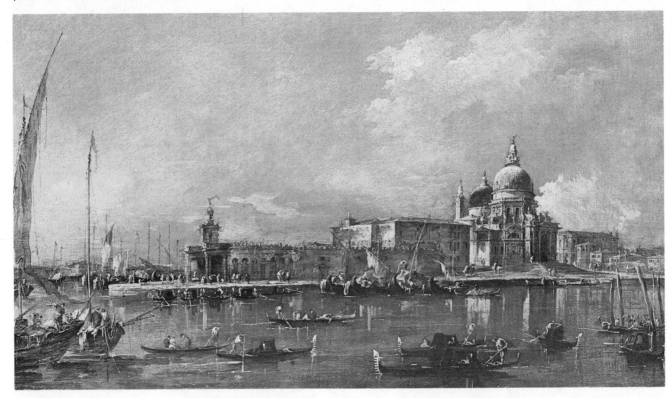

81. (above). **Francesco Guardi.** *View of Venice with the Salute and the Dogana. c.* 1780. Oil on canvas. 13⅜ × 20⅛ in. (34 × 51 cm.). Reproduced by permission of the Trustees of the Wallace Collection, London.

82. (below). **Antonio Canale (Canaletto).** *Venice: the 'Bucintoro' returning to the Molo. c.* 1728–30. Oil on canvas. 30¼ × 49½ in. (77 × 126 cm.). Reproduced by Gracious Permission of Her Majesty the Queen, Windsor Castle.

Canaletto and Guardi were the successive masters of view painting in 18th-century Venice. Of the two, Canaletto is the more factual and precise, exposing all forms—buildings, bridges, boats, water, people—to the same clear, even light. Guardi is the more evocative and fanciful. In his paintings light tends to be uneven and to flicker capriciously over the surface. Both pictures illustrated here, taken from points of view almost opposite each other, show famous buildings in Venice: Guardi (above), the Customs House, and the sumptuous baroque church of Sta Maria della Salute. Canaletto (below), the Campanile, St Mark's Library, the Piazzetta (with a glimpse of St Mark's Cathedral) and the Doge's Palace.

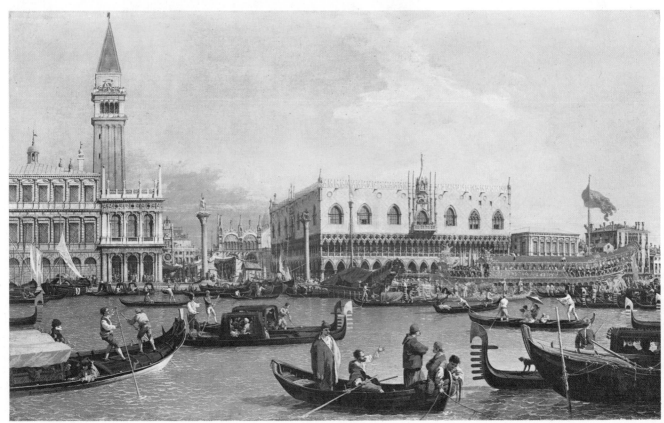

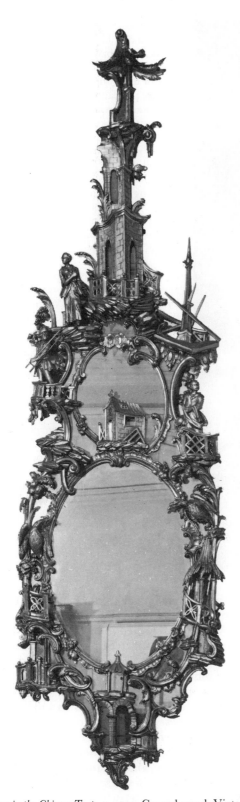

79. *Mirror in the Chinese Taste. c.* 1740. Carved wood, Victoria and Albert Museum, London. This mirror, probably by an anonymous English craftsman, illustrates the fairly common fusion of rococo scroll-work and asymmetry with motives taken from Chinese art. The preference for natural over artificial or abstract forms is also typical of the period.

pictures of the Italian actors of the *commedia dell'Arte*. Both these *genres* were important for Watteau. Like the arabesques of the interior decorators, his own work is intimate, curvilinear and graceful. Like them he also avoided the Antique except as a source of romantic, playful allusion. While he was growing up at Valenciennes (which until a few years before his birth was still part of Flanders), the disputes between the Ancients and the Moderns, the *Poussinistes* and the *Rubénistes*, the formalists and the colourists, were being decided in favour of the latter in each case, and by the time he arrived in Paris in 1702 Rubens had begun to displace Poussin as the hero of French painters. Watteau himself studied the great series of paintings which Rubens executed in 1621–25 for Marie de Médicis in the Luxembourg Palace, of which Audran was curator. His own style was in many ways a translation of Rubens's into 10 modern, lyrical terms, with the pomp and grandeur left out. But Watteau is not just Rubens on a small scale, nor is his work all grace and deportment and fashionable couples holding hands or dancing on a terrace or in a park. On the contrary, his art is intensely personal and rooted in reality, both the reality of visible nature and the psychological reality of human emotions and desires, independent of their religious and mythological sanctions.

Watteau's drawings are the records of his studies from 78 life. As a man he was restless and difficult and died relatively young of tuberculosis, condemned perhaps to be a spectator of, rather than a participant in the life he observed so sharply. He transformed that life into poetic terms without depending on baroque heroics. One feels that the transformation was conscious, even partly ironic. Herein lies the importance to Watteau of his interest in the theatre. His paintings seem to represent life changed into art in just the same way that life is changed into art on the stage, although his work is never stagey. (Hogarth made a similar use of the theatre, but with different results—results which *are* often stagey.) Significantly, Watteau's figures scarcely ever look at the spectator; they are joined in pairs and are absorbed in each other (but not self-absorbed like Velasquez's or Vermeer's). And when they turn to face us they reveal themselves as actors taking their bow, actors in the traditional roles of the Italian comedy: Pantaloon the merchant, Isabella and Orazio the star-crossed lovers, Harlequin the sprightly servant, Mezzetin the musician and, finally, Pierrot or Gilles, the dull-witted innocent whom Watteau raises almost to the status of a hero, perhaps the only hero in his art. The actual paint, which is handled with magical dexterity, further detaches the figures from everyday reality, making them untouchable and remote. Permeating everything is a sense of anticipation, of waiting on the event, of feelings never to be translated into action. There is another comment of the Goncourts', which beautifully sums up Watteau's attitude. Writing of the picture which is perhaps the masterpiece of rococo painting, the *Embarquement pour l'Ile de Cythère* (so-called, although this scene has been shown to represent a return from the island),

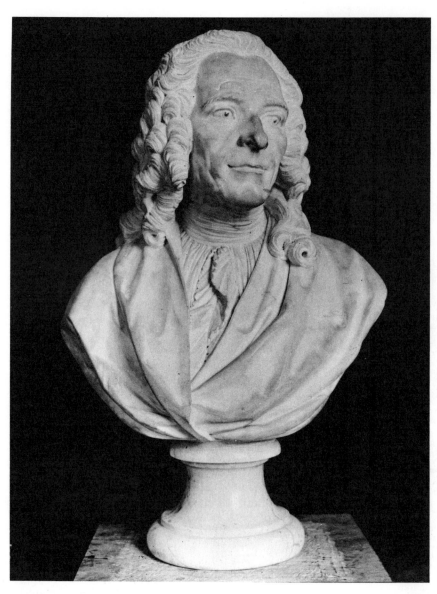

80. **Jean-Baptiste Lemoyne.** *Portrait Bust of Voltaire.* 1745. Marble. Life-size. Château de Chaalis (Oise). The weight of classical and baroque tradition was greater in sculpture than in painting or interior decoration, yet French mid-18th-century portrait busts have simple outlines and an air of relaxed civility that link them with painting. Lemoyne's bust of Voltaire has the sensuousness and surface vitality of the Baroque without its turmoil, though it is too bland to be a good characterisation. Voltaire was the presiding genius of the 18th century as Louis XIV was of the 17th, and the contrast in personalities is matched by the contrast beween the two busts (this and pl. 5).

81. **Matheas Daniel Pöppelmann.** *Pavilion of the Zwinger, Dresden* (badly damaged in the Second World War but since restored). 1709–19. The Zwinger was an ensemble of buildings, pavilions and screen-walls surrounding a court; it was laid out by Augustus the Strong, King of Saxony, as an open-air pleasure palace for court balls, plays and other entertainments. The king's art collection and library were also to be housed there. What was built, though extensive enough, was only a small part of his intention. The type and sculptural character of the forms are strictly speaking baroque but the gaiety and lack of pomposity animating the scheme give it a rococo flavour.

they say: 'It is love, but it is poetic love, love which dreams and which thinks, modern love with its longings and its garland of melancholy.'.

Watteau died in 1721, leaving only weak successors to the *genre* he had invented, the *fête galante*. Perhaps his truest 66 heirs were, on the one hand, Chardin, whose work has been mentioned in another context, and, on the other, Gains- 97 borough, who may never have seen any of his paintings but who certainly knew his work through engravings and through the medium of drawings by French artists living in 76 London. But Watteau was also a starting point for Boucher, the most successful painter of the mid-century and the favourite artist of Madame de Pompadour. Like Watteau, Boucher profited from the dethronement of the ancient gods which had been effected at the beginning of the century, but he continued to use them as protagonists of his pictures, not merely as benevolent statues half-hiding in the background, as Watteau had done. With Boucher the cloud of Olympus became the pillows and sheets of an 18th-century bed, and Venus and Diana were made into sex symbols of greater accessibility than ever before. The world of Venus in Boucher's imagination, with its sea-nymphs and shells, its coral, reeds, water and foam, was the perfect accompaniment to rococo schemes of decoration. The waves and gambolling nudes have the same sinuous outlines, while the cool blue of the sea, the white of the glistening spray, the applegreen of leaves and the pink and white of the bodies produce a typically rococo colour harmony. These same colours were also to be used in Sèvres porcelain, and Boucher's flesh-tints have a porcelain-like lustre. As a manipulator of compositions he attenuates the Baroque in ways that will now be familiar: the bodies group and intertwine themselves in a loose, asymmetrical yet continuous association, like the decorative motives in a rococo trophy, leaving a free irregular space around them. The *Cupid a Captive* illustrated here even has the tall vertical proportions of a rococo panel.

Boucher's even airier successor was Fragonard, who

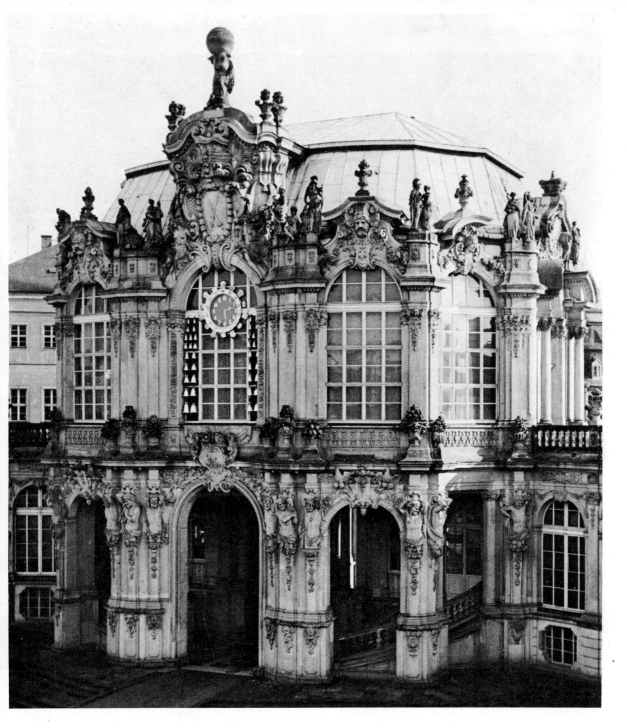

continued the rococo style in painting up to the Revolution, untouched by the neo-classical movement though sensitive to some early romantic tendencies. He belonged to the phase of *sensibilité* which swept across Europe, originally from England, in the second half of the 18th century. The titles of some of his pictures will indicate his characteristic vein: *The Stolen Kiss, Cupid stealing a Nightgown, The Souvenir*. He also loved games and picturesque anecdote. But together with Hubert Robert he rediscovered the Italian landscape for French art and treated it in a way that recalls Watteau rather than Boucher. Trees of soft, silvery green fountain up against the sky while boys and girls play in an Italianate garden below. This is rococo landscape painting at its prettiest and most assured.

On a more realistic level, the 18th century discovered the concept of individual personality (as distinct from temperament or character) and hence was a great age of portraiture. Symbolic attributes, baroque trappings and psychological complexities were abandoned and in their absence the individual was made to appear, alert and at ease, in his or her social aspect. There is no question of abandoning social status, but the sitter is now, as it were, prepared to converse with his social equals. Occupations—reading or embroidery—are sometimes admitted but they can easily be dropped if a visitor calls. Dress is simple and everyday, not that of the court; poses are relaxed and expressions animated. Nattier, Tocqué, Perronneau and Quentin de la Tour were the representative French portrait painters of the age, while Jean-Baptiste Lemoyne the Younger was the typical sculptor. In England their nearest equivalent was the Scottish painter Allan Ramsay. Perronneau and La Tour worked in a new, typically rococo medium: pastel (actually first used at the very beginning of the century). Pastel naturally lacks the density and luminosity of oil paint and would have been useless if the prevailing style had demanded the dark shadows of the Baroque. But the Rococo required instead that the artist concentrate on lightness of effect and use soft pale colours.

77, 79

80

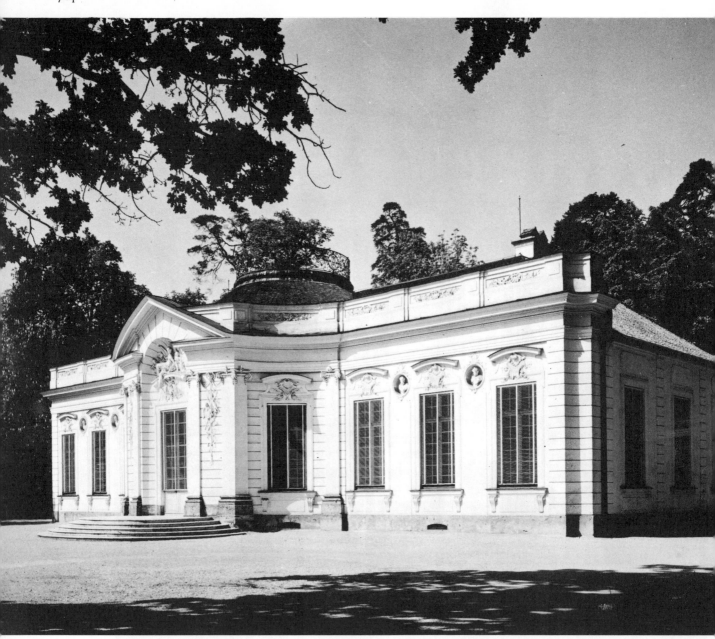

82. **François Cuvilliés.** *The Amalienburg, Schloss Nymphenburg, Munich.* 1734–39. The exterior of the Amalienburg suggests French elegance and simplicity, yet the rudimentary curved pediments over the windows would have been too whimsical for French taste, even at this period. The key word for the building is 'charm'. The famous Hall of Mirrors (pl. 13) is in the centre, behind the projecting block. The Amalienburg was built for the Electress Maria Amalia, wife of the Elector Karl Albrecht of Bavaria.

THE ROCOCO IN GERMANY

The close-knit society of Paris and the French court produced a relatively homogeneous kind of art, at least in interior decoration. In the German-speaking lands (Germany itself, Austria and Bohemia) the situation was different. There the numerous kingdoms, principalities and bishoprics, spread over a wide area, made for great variety, and there were also other factors in operation to complicate the position. In the first place, many works were the product of a single organising brain, as was usual in France, but of a team, which might well consist of artists of two or three different nationalities. The patron, too, would often take a hand in the design, which must sometimes have disconcerted the artists. Moreover, a 'baroque' situation still obtained in many respects. That is to say, there was still a demand for prestige buildings on a colossal scale. Churches remained as important as palaces, the money for both often coming from the same source; and the baroque fusion of the arts, involving not only painting, sculpture and architecture but also, even more than in Italy or France, woodwork and stucco decoration, was of great significance. In fact, no French or Italian 17th-century work is quite so complete an example of the *Gesamtkunstwerk* ('total artwork') in the baroque sense as the interiors of Vierzehnheiligen or Ottobeuren or the *Kaisersaal* at Wurzburg, all of which date from the mid-18th century. Unlike the churches of Bernini and Borromini, which were not designed to be painted, almost all those by German and Central European

architects had painted ceilings—an idea derived from the late 17th-century decoration of Italian churches such as the Gesù and S. Ignazio. Indeed, 18th-century painting in Germany and Central Europe had little importance except in these decorative settings.

At the same time, the Baroque in these countries was not bound to the same intellectual traditions as it was in Italy and France, and was thus freer to develop in a rococo direction. 18th-century German interiors, whether religious or secular, became increasingly spacious and light. By a natural process of evolution the powerful, dynamic curves of the Baroque were able to assume the quicker, more playful and more sinuous rhythms of the Rococo, and rococo colour harmonies—white with pink, blue or green and relatively little gold—were adopted. Similarly, a baroque pulpit or altar-frame could grow rococo curls at its edges, while a pure rococo altar, with all that that implies of asymmetry, fantasy and caprice, could naturally form the climax of that architecturally most baroque of churches, the Vierzehnheiligen. It is not uncommon or surprising, either, to find rococo furnishings and stucco work in a baroque setting, as at Ottobeuren, or baroque decorative forms being used in a rococo spirit, as on the exterior of the Upper Belvedere in Vienna. An even better example of this is the Dresden Zwinger, which had no practical function whatever but was solely a place for entertainment and courtly display—the most expensive permanent playground in the world, until its virtual destruction in the last war. Still late baroque in form and dating from quite early in the century (1709–19), the architecture is hardly more than a skeleton on which to hang decoration that takes it close to the Rococo.

The tendency for decorative considerations to outweigh structural clarity can also be seen in the churches of the Asam Brothers in Bavaria, where the normal balance between the arts is tilted in favour of the sculpture, painting and ornament at the expense of the architecture, although here the spirit remains wholly baroque. Similarly in sculpture: Egid Quirin Asam's *Assumption* at Rohr acts as a link between the full Baroque of Bernini and the near-Rococo of Günther, which was itself a stage on the way to the pure Rococo of Nymphenburg porcelain. In this sequence one sees how the deeply serious, agonised ecstasy of Bernini is transformed first into the airborne, theatrical rhetoric of Asam, then into the plangent, affected yet personal grace of Günther, and finally into the pure icing-sugar sweetness of Bustelli, the designer of the Nymphenburg figures. At no point is there a definite break; there is evolution—in fact the spiritual and emotional distance travelled is enormous—but no revolution in style.

Sometimes, however, the movement of German Baroque towards the Rococo was combined with French influences, when it produced what in one sense was a mixed Franco-German style but which from another point of view was an extension of the French Rococo taken to extremes undreamt of in France itself. This development occurred in two main centres, Bavaria and Prussia, both of which were ruled by strongly Francophile princes. It was Bavaria that discovered the French Rococo first. As early as 1706 the Elector Max Emanuel, who had taken Louis XIV's side in the War of the Spanish Succession (and spent ten years in exile in Paris for his pains), sent the young Joseph Effner to Paris to be trained first as a garden designer and then, probably under Boffrand, as an architect. When patron and architect returned to Bavaria in 1715 they resumed the building of the palaces of Nymphenburg and Schleissheim (both begun earlier by previous architects), using the French manner and incorporating some restrained rococo motives in the interiors. More remarkable, however, were the results which followed from the replacement of Effner by Cuvilliés on the succession of Karl Albrecht to the Electorship in 1726. François de Cuvilliés, who was a dwarf, had been discovered by Max Emanuel in Flanders and sent to Paris to study from 1720–24, where his arrival coincided with the first full flowering of the French Rococo under the Regency. It was this style, not modified or tamed but developed in new and exciting ways, which he brought back to Bavaria, using it first in the *Reiche Zimmer* ('rich rooms') of the Munich Residenz, begun in 1729, then in the Amalienburg (1734–39) and finally in the Residenz Theatre (1751–53).

The hunting lodge and *maison de plaisance* of the Amalienburg, in the grounds of Schloss Nymphenburg, is Cuvilliés' masterpiece and by general consent one of the supreme examples of rococo architecture and decoration in Europe. Its centrepiece is a circular room, the Hall of Mirrors, about forty feet in diameter and with a domed ceiling. Adjoining this on either side are a bedroom and a gunroom which, with a kitchen and other service rooms, complete the building. Seen from the outside the wall of the central room projects in an undulating curve, while at the back the façade recedes concavely with further, tighter convex and concave curves either side of the door. The corners of the building are also cut out with concave curves. The decoration of the exterior is very simple. Graceful Ionic pilasters adorn the central features at front and back (otherwise the wall surfaces are partly channelled); simple 'bows'—the traces of pediments—are drawn like eyebrows over the windows on the main front, with sculptured heads in circular recesses between them; and the whole is finished off with a balustrade. Carefully placed rococo ornaments in relief sculpture complete the effect. It is all very lucid, elegant and almost entirely French.

Inside, however, Cuvilliés let his imagination take wing. The Hall of Mirrors is close enough in its general arrangement to the oval *Salon* in the Hôtel de Soubise to make one wonder whether they can have been designed independently of one another (though which came first is another question), but the differences are as striking as the similarities. Briefly, what Cuvilliés does is to take French rococo motives, adapted mainly from the *genre pittoresque*, and treat them with German plasticity and lack of inhibition. There

82, **84**

76

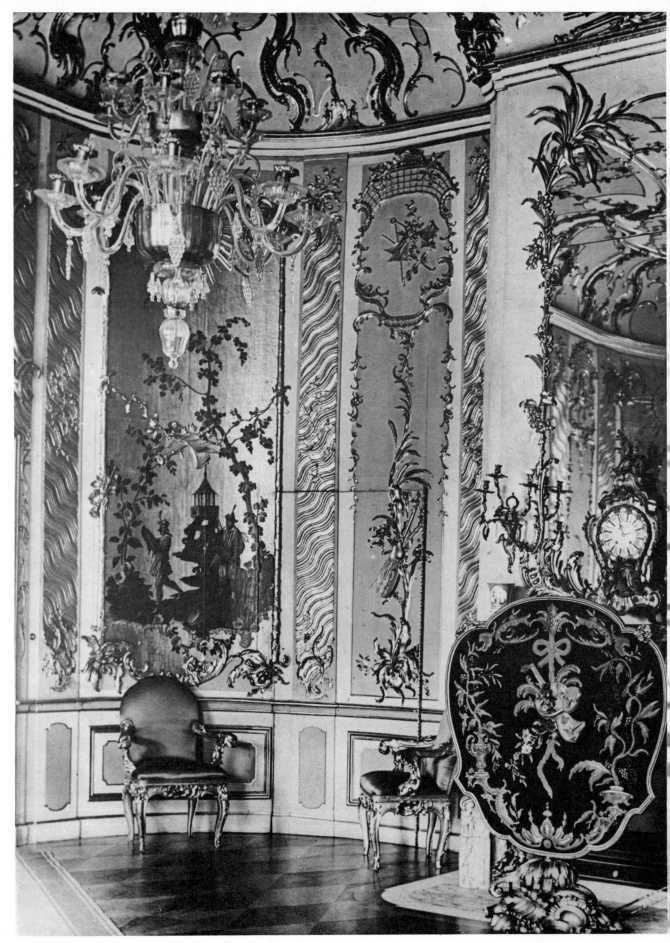

83. **Georg Wenceslaus von Knobelsdorff.** *The Music Room, Potsdam, Stadtpalais* (destroyed in the Second World War). 1745–51. Frederick the Great's passion for the French Rococo was almost as great as, if less enduring than, that of Max Emanuel of Bavaria. In the Music Room at Potsdam the compositional patterns of the *genre pittoresque* are combined with Chinese influence to produce an effect that is at once supremely graceful and romantically mysterious. Its pervasive flowing lines differentiate it from English *chinoiserie*, which was more self-consciously eccentric.

are no wall panels but a continuous sequence of oval-topped mirrors alternating, not quite symmetrically, with windows and doors. The bevelled edges of the panes of mirrorglass echo the glazing bars of the windows in a squared pattern which, enchanced by the reflections, creates an effect of all-round outdoor light. Everywhere the decorative forms are slightly heavier and a good deal more naturalistic than they would be in a French interior. Shells, lions' feet, flags, musical instruments, cornucopiae, plants and flowers make up the surrounds of the mirrors. As in the *Salon de la Princesse* an undulating cornice occupies the coving where the ceiling begins, but above this, instead of open bands of scroll-work leading to the centre, there is a fantastic display of luxuriant forms such as one might find in an overgrown garden—urns, baskets, *putti*, plants of all kinds, animals and birds, some of which fly off onto the ceiling. Cuvilliés maintains the rococo principle of keeping his ornament on the surface rather than making it grow out of the structure beneath, but when one looks at a room such as this one realises how clear, disciplined and restrained true French rococo decoration is by comparison. In the Amalienburg there are the qualities of both wit and elegance, but also a luxuriance, a readiness to go to extremes, that could only be found in Germany. Cuvilliés' decoration piles up in a firework display of ornament, all executed in silvered stucco on a pale blue ground. Beside it the equally personal and scarcely less beautiful decorations carried out a decade later by Knobelsdorff for Frederick the Great of Prussia look thin. In the interiors of Charlottenburg, the Potsdam *Stadtpalais* (partly destroyed in the last war) and Sans-Souci, there is a finer, lighter, more whimsical touch and still more asymmetry than in Cuvilliés work—qualities which at Charlottenburg and Potsdam contrast with the classical architecture of the exteriors. The music room at Potsdam shows Chinese influence; at Sans-Souci there were *singeries*.

Like Cuvilliés, Knobelsdorff had been trained in Paris and his interpretation of the Rococo is basically courtly and French, though adapted to German circumstances. The opposite combination—a native German Rococo tinged with French influences—is found in the work of the painter and plasterer, Johann Baptiste Zimmermann, who worked mainly in churches. After beginning his career as an assistant to Cuvilliés at the Munich Residenz and the Amalienburg, he went on to collaborate with his brother, the architect Dominikus Zimmermann. The typical Bavarian church interior of the mid-18th century—light, airy and resplendent with gay colours—was essentially their joint creation. These churches, of which the best known is Die Wies (1745–54), were commissioned by local parishes and monasteries rather than courts and were spatially simpler than those of the Baroque. The architecture often seems cut on the curve like a gigantic piece of fretwork, which then becomes a surface for relief stucco and painting. At Wies, which is actually built of wood, the contours of the windows and arches are scrolled, the capitals are invaded by orna-

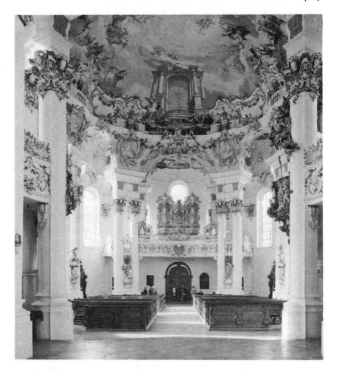

84. **Dominikus and Johann Baptiste Zimmermann.** *Pilgrimage Church of Die Wies, Bavaria.* 1745–54. Architecture by Dominikus, stucco and painting by Johann Baptiste. Although the latter had worked under Cuvilliés at Munich and had thus absorbed French influences, a church like Die Wies can fairly be called German Rococo, that is, a local adaptation of the late Baroque. Scrolls are everywhere—on the arches, the window surrounds, the capitals, the organ-case and, above all, the stucco *cartouches* (shields) round the pictures in the pendentives. Apart from their characteristic S-curves, these *cartouches* sprout into the fronds and spikes of a rococo shell (see fig. 74) and have the typical asymmetry of the *genre pittoresque*.

ment and rococo S-curves roam freely over the spandrels and vault, either as shell-like cartouches or as frames for the paintings. The colours are pink and green combined with gold and bluish white in the ornament, deeper blue and red in the columns of the choir and a dominant pale blue in the ceiling fresco.

The other important Bavarian church architect of the period was Johann Michael Fischer, who completed Otto-86 beuren (in which Dominikus Zimmermann had also been involved) during the 1750s. The confused building history of this church did not allow for much architectural sophistication but it became the arena for some of the most dazzling rococo ornament in any German church. The stucco decoration and furnishings—altars, pulpits, statues, capi-28 tals, picture frames and cartouches—are pinned to the wall surfaces like some vast collection of tropical butterflies. In the cartouches the rococo shell, with its irregular S-curves, asymmetry and growths of spikes and tendrils, found its ultimate decorative expression. The designer of all this was another specialist in stuccowork, even more important and brilliant than Johann Zimmermann—Johann Michael Feichtmayer.

PORCELAIN

Before leaving the subject of German Rococo, a word should be said about porcelain, whose manufacture in the mid-

18th century replaced that of tapestries as the prestige activity of courts. Until the early 18th century, 'hard-paste' porcelain, possessing the thinness and lustre of a shell and the hardness of steel, had been a prized Chinese import, the methods of its production a mystery in the West. But in 1709–10 the secret was discovered in Dresden and the famous factory of Meissen was set up under the patronage of the king of Saxony, Augustus the Strong. For the next forty years German factories dominated European production, but by the late 1740s rivals had sprung up in Austria, France, Italy and England, often for 'soft-paste' rather than 'hard-paste' ware; in the second half of the century the greatest centre was at Sèvres, near Paris. Unlike their Continental counterparts, the English factories at Chelsea, Bow, Derby, etc., were established by commercial enterprise, not by royal patronage. In the earliest examples at Meissen only 'useful' objects were made—plates, cups, saucers, jugs and bowls—in imitation of their Chinese originals, but soon figures began to appear as well. Sometimes these were designed by specialists such as Kändler and Bustelli, sometimes by artists who were primarily marble sculptors, like Falconet. Bustelli's Nymphenburg figures are in some ways the quintessence of the European Rococo, fusing all its expressions into a single miniature art. Stylistically their origin is not French but Italian, transmitted through the sculpture of Ignaz Günther, and their subject-matter is often taken, like Watteau's, from the characters of the Italian Comedy. In feeling they show the wit, grace and aristocratic elegance of the French Rococo.

THE ROCOCO IN ITALY

Owing to the Church's dominance over secular princes, the long classical traditions of Italian art and the overwhelming prestige of the great monuments of the past, which acted like a conscience in the minds of contemporary artists, the Rococo had little chance to develop in Italy, especially in Rome. Nor was it much helped by French influences, which tended if anything to reinforce the classical rather than the rococo trend. Yet, as in Germany, the Baroque—and even classicism—could sometimes mutate in a rococo direction or be combined with rococo elements. This was more likely to happen at a distance from Rome. Thus the late baroque churches of Juvarra and Vittone in Piedmont are painted in pale, varied, near-rococo colours, while the closest approximation to the Rococo in Italian sculpture was found at the opposite end of the Peninsular, in the work of the Sicilian sculptor, Serpotta. One may also include here the picturesque coloured figures made in Naples for Christmas cribs, which have something of the same origins and popular flavour as German polychrome sculpture. But rococo elements are not lacking even in Rome itself. The Spanish Steps are designed on a basis of lilting rococo curves, while the massive figure of Neptune on the Fontana di Trevi stands on a fluted scallop shell, and many anonymous 18th-century palaces have elegant rococo window frames connecting the different storeys

rather than elements of a classical order. In a house at Portici near Naples an entire room was decorated in the early 1750s with pure rococo ornamentation carried out in porcelain. Rococo rhythms and motives are also common in 18th-century Italian furniture design.

But it was, of course, in Venetian painting that the Italian Rococo found its greatest exponents. Venetian painting, which had sunk into near-oblivion in the 17th century, owed its 18th-century revival in the first place to the rediscovery of its own Renaissance past. Appropriately, its favourite artist from that past was Veronese. Tiepolo's style originally grew from a fusion of Italian late baroque influences and the figure types, colours and pageantry of Veronese. An early work by Tiepolo such as *The Trinity appearing to St Clement* has the rich colour, steep foreshortenings and powerful diagonals of the late Baroque, though the gain in lightness and decorative brilliance over the high Baroque of a 17th-century artist like Mattia Preti can be measured by comparing this painting with plate 44. When he reached Würzburg in 1750 to paint the ceilings of the staircase and the *Kaisersaal*, Tiepolo was the master of the most accomplished decorative style in Europe. Was that style rococo in the true sense? Hardly. Innocent of the naturalistic ornaments that made up the repertoire of Boucher's French Rococo, it kept more closely to the Italian tradition of dependence on the human figure. What is more, one feels that Tiepolo still sufficiently believed in the poetic and psychological truths of the classical allegories he was depicting—sufficiently, that is to say, for him not to need to sidestep them, as Watteau did, or, like Boucher and Fragonard, retain them only as a cover for erotic titillation. The old gods were still a living force and, in the Christian sense, Tiepolo was a great religious artist.

In terms of style Tiepolo used larger rhythms and broader brushstrokes than his French contemporaries and was still loyal to the traditions of the grand manner. But the admission that the greatest painter of the 18th century was technically behind the times need not worry us any more than the fact that the greatest musician of the period, Johann Sebastian Bach, was also out of date. The achievement of the *Kaisersaal* ceiling is breathtaking in its splendour and beauty. No other artist could have unified such a space with such consummate ease and grace; the sweeping, plangent curves that link the various groups appear to be simple and casual yet actually are subtle in the extreme. He also adopted one technical device that was different from that used by 17th-century baroque ceiling painters; instead of making all forms converge on a single vanishing point, he used several vanishing points, which made the space more fluid but which at the same time were not noticed as an anachronism because of the lack of architecture and the large areas of open sky. Like Neumann's architecture and Bossi's stucco decoration at the Würzburg, to which the ceiling forms a climax, this is late baroque form used in a rococo spirit, for pure enchantment and delight.

85. **Francisco de Goya.** *The Parasol.* 1777. Oil on canvas.
41 × 60 in. (104 × 152 cm.). Prado, Madrid. This is one of the
first series of designs for tapestries which Goya produced for the
palace of El Pardo, Madrid, and with which he first made his
reputation. The subject, the composition and the romantic,
ironic charm recalling porcelain figures by Bustelli, are all in the
spirit of Rococo. Yet a certain detachment in the artist's attitude
to his subject-matter and a sketchy simplicity in his handling of
paint hint at the great revolutionary painter he was to become.

If 18th-century Venice lacked the repertoire of ornament
of the French Rococo, it had its own equivalent—the
caprice. 'Caprice' painting meant the assembling of imagi-
nary ruins, statues, tombs, etc., together with monks,
bandits and other characters then considered picturesque,
in a fantastic setting. At the beginning of the century
Sebastiano and Marco Ricci produced a number of these
caprices in a late baroque style, mainly for English con-
sumption. The master of the pure rococo caprice—Fran-
cesco Guardi—belonged to the second half of the period.
In his views of Venice he gave the city a dream-like grace
very different from the bright, coloured-postcard sharpness
of Canaletto, even though Venice, paradoxically, is one of
the few western European cities with no rococo architecture
of its own.

In 1762 Tiepolo left Venice on his last journey abroad, to
Madrid, where he died in 1770. His stay there partly co-
incided with that of Winckelmann's favourite painter, the
neo-classicist Anton Raphael Mengs, whose followers
executed the dreary canvases that replaced the great altar-
pieces designed by Tiepolo for the monastery of Aranjuez
but taken down in the 1770s because their style was no
longer fashionable. At the same time a young Spanish
artist, Goya, was preparing to give the Rococo a last breath
of life in the tapestry cartoons he painted in the 1780s. The
conjunction of these three artists, Tiepolo, Mengs and
Goya—the first the master of the late Baroque and Rococo,
the second the official representative of Neo-Classicism, the
third the future genius of the Romantic Movement—in
Madrid in the 1760s marked as crucial a turning point in
the history of European art as Bernini's visit to Paris a
hundred years before.

Neo-Classicism

A capsule history of art would state that the second half of the 18th century witnessed the rejection of the Baroque and Rococo and their replacement by a new style—Neo-Classicism—that depended on strict imitation of ancient Greek models. However, this is so simplified as to be almost worthless; it not only misrepresents Neo-Classicism itself but also omits the Gothic Revival, Picturesque Movement and beginnings of Romanticism. Yet it remains true that Neo-Classicism is best defined in terms of its relationship to ancient art. It was a movement which embraced a new, more comprehensive and scholarly attitude to Antiquity than before, and which disregarded both the Middle Ages and the classicism of the Renaissance and the 17th century. This return to first principles is perhaps the central feature of Neo-Classicism. It implied that modern art was not just the latest manifestation of a long, continuous tradition but the outcome of a dialogue exclusively between the present and the distant past.

At least, this was the theory; in practice it took some time to realise and was perhaps never fully realised very often, least of all in painting. Other factors introduced further complications into the style, and it constantly overlapped and faded into the Romantic movement that grew up alongside it. Yet its ideal was to create a modern idiom based solely on research into, and reflection upon, the principles of ancient art. This is more fundamental than the question whether Greek or Roman art was the main source. Looking at the problem in this light also reveals that the attitude to Antiquity was less uncritical than is sometimes supposed.

EARLIER 18TH-CENTURY CLASSICAL REVIVALS I: ENGLISH PALLADIANISM

An interest in the recent as well as the remote past is what distinguishes the classical revivals of different countries in the first half of the 18th century. In many respects these revivals were a continuation of the classical reactions of the 17th century. Their principles were the same: rejection of baroque (and where relevant rococo) extravagance and caprice, use of the 'best' models and a conscientious regard for rules. The first to occur in the 18th century began in England about 1715. This movement, usually called Palladianism, was almost wholly confined to exterior architecture, although it had some parallels in sculpture.

It opened typically with a manifesto, the first volume of a book, *Vitruvius Britannicus*, containing 100 engravings of 16th- and 17th-century buildings in Britain, chosen and edited by the Scottish-born architect, Colin Campbell. At the psychological climax of the book Campbell inserted illustrations of a house designed by himself, Wanstead in Essex, which was then nearing completion (it has since been destroyed). The implication was clear: although the earlier achievements of English architects were worthy of commemoration, the style of the future was to be that of Wanstead, with its clean lines, avoidance of baroque orna-

ment and visual drama, and straight façade dominated by a classically correct hexastyle (six-columned) portico. The words 'Vitruvius' and 'Britannicus' in the title of the book were both significant: the first recalled the first-century BC Roman writer whose *De Architectura* enshrined the rules of classical architecture; the second expressed the idea, widely held in England at the time, that the English were the successors of the Romans.

The 17th-century English architect regarded by Campbell as the closest follower of Vitruvius, and hence the best model from the recent past, was Inigo Jones; Wren, Vanbrugh and Hawksmoor were too baroque. Behind Jones lay Palladio, who gave the new movement its name. A new English translation of Palladio's *Quattro Libri dell'Architettura* also began to appear in 1715. The line, Vitruvius-Palladio-Inigo Jones, was to dominate English architecture, particularly country house architecture, for the next forty years.

Among subscribers to *Vitruvius Britannicus* was the young 3rd Earl of Burlington, who had just returned from the Grand Tour, already with a passion for architecture. In 1719 he re-visited Italy to study Palladio. While there he acquired a large collection of Palladio's drawings and later bought and financed the publication of drawings by Jones. He also invited William Kent, then studying in Rome to be a painter, to return to England to complete the decoration of Burlington House in London (now, much altered, the home of the Royal Academy). As a painter Kent was a failure but he became, in close association with Burlington, one of the principal architects of the English Palladian movement; he was also its leading interior decorator, furniture designer and landscape gardener. As such he was one of the first artists to take complete charge of the interior decoration and furnishing of a house.

Burlington himself was a considerable architect, and his own house at Chiswick, begun in 1725, illustrates the qualities of English Palladianism. Its model was a type of villa created by Palladio in north Italy, with a portico on the main front, rooms arranged round a central octagon, and the whole, except for the portico, fitted into a square. Its elevation is a freer interpretation of Palladio than its plan but this in itself is characteristic. The qualities it exemplifies are: clarity, compactness and restraint; a liking for severe rectangular outlines, sharp angles and undecorated corners; an absence of columns or pilasters attached to the walls; insistence on plain lintels or unbroken triangular pediments over windows and doors; domination of the whole design by a classically proportioned and correctly detailed portico; finally, strict symmetry and harmonious grouping of the separate parts.

At Chiswick only the stairs, decorated with urns and rounded, sculptural balusters, relieve the austerity of the exterior with a touch of baroque movement. Yet this plain type of exterior architecture was often combined with a richly baroque treatment of the interior and an informal 'rococo' garden. This relationship between the exterior

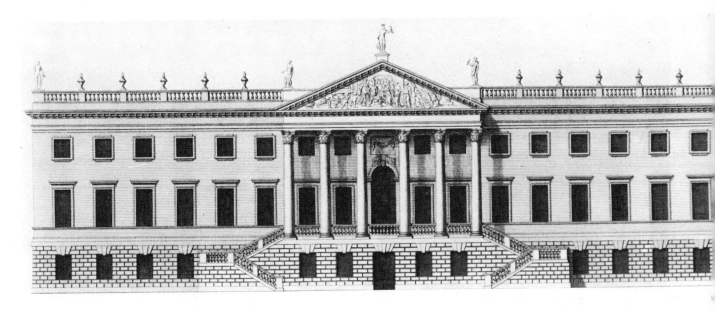

86. **Colin Campbell.** *Design for Wanstead House, Essex.* Plate from *Vitruvius Britannicus*, Vol. 1 London, 1715. 9¾ × 14¾ in. (24.7 × 37.5 cm.). This is a plate from the book of engravings by the Scottish architect, Colin Campbell, which inaugurated the Palladian movement in English architecture. Wanstead, designed by Campbell himself and then in process of building, illustrates the style he advocated: lucid, regular, restrained in ornament, and correct according to the classical rules laid down by Vitruvius and followed (in his view) most faithfully in later times by Palladio and Inigo Jones. The house was demolished in the early 19th century.

design of the house and its setting was the exact opposite to that found (say) at Versailles, where a visually sumptuous architecture was accompanied by dead straight avenues of trees and rigidly geometrical *parterres*. Yet the solution at Chiswick was the more rational from the 18th-century point of view. To the generation of Burlington, Kent and Pope, who theorised about gardens as well as designing them, reason and nature were almost synonymous terms.

In their view the rational style for a building was necessarily the classical one, since a building is man-made, and it was self-evident that the controlled, classical approach to architecture was more in accordance with reason than the undisciplined baroque. In the 'natural' sphere of garden design, however, it was appropriate to apply as little control as possible, since nature was inherently reasonable and should therefore be left alone. Besides, the attractions of an unclipped and unstraightened-out garden were beginning to be felt. Although art was used, the object was to simulate a natural effect.

By his example and influence, which was political and social as well as artistic, Burlington established a near-dictatorship of taste in England until his death in 1753. Among contemporary architects James Gibbs, who had been trained in Rome under Carlo Fontana, was almost alone in having a strong enough artistic personality to withstand Burlington's influence—though even he modified the eloquent late baroque style he had learnt in Rome in a classical direction. St Martin's-in-the-Fields, designed by Gibbs in the 1720s, shows the successful results of this process. With its stately portico, massive yet restrained treatment of the side walls and magnificent steeple rising directly above the roof, St Martin's is generally agreed to be one of the handsomest churches in the classical style in London. In many ways it represented the fulfilment of ideas conceived but never fully realised in Wren's City Churches. It also has the unusual distinction for a London church of being decorated inside with late baroque stucco ornament executed by Italian craftsmen. In the second half of the century it had a wide influence in North America.

EARLIER 18TH-CENTURY CLASSICAL REVIVALS II: FRANCE AND ITALY

No equivalent movement on the Continent exactly coincided with the beginnings of English Palladianism, although the theoretical writings of Cordemoy, which cut deeper than any of the rather superficial ideas of the Burlington circle, were published in Paris as early as 1706. The French architect who corresponds most nearly to Kent in the 1730s (Kent's masterpiece, Holkham Hall, was started in 1734), was Ange-Jacques Gabriel. Gabriel's career began in the 1730s at Versailles and Fontainebleau and he succeeded his father as chief architect to the king in 1742, but his most important works date from the 1750s. Stylistically he is very different from Kent as he depended on different sources; the parallel between them lay in their revival of classicism through its interpretations in the recent past. What Palladio and Jones were to Kent,

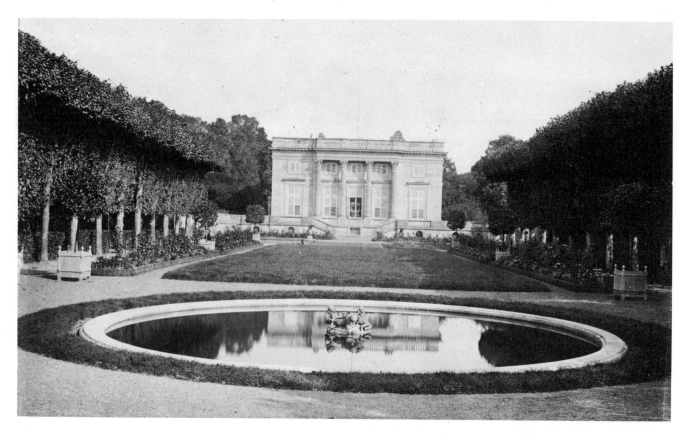

87. **Ange-Jacques Gabriel.** *The Petit Trianon, Versailles.*
1762–68. Begun for Louis XV's mistress, Madame de
Pompadour and finished for her successor, Madame du Barry,
this small retreat on the Versailles estate is a French parallel to
English Palladianism. It is square in plan with undecorated
corners, correct classical detail and simple proportions. Curves
and 45-degree angles are avoided throughout. Although its
designer, Gabriel, mainly used Italian Renaissance and
17th-century French classical sources, the building also has a
slight 'English' look, owing to its proportions and straight
balustrade.

François Mansart—a distant forbear—was to Gabriel;
significantly, neither Mansart nor Gabriel visited Italy.

In works like the Ecole Militaire (original project 1750)
and the Place de la Concorde (formerly Place Louis XV,
designed 1753), Gabriel sought to bring back the nobility
and grandeur which had been largely missing from French
architecture during the rococo period. The planning of the
Concorde, with its grandiose space and bold vistas leading
into and out of the square, represented a conscious return
to the age of Louis XIV although lack of money prevented
the project from being finished as Gabriel intended.

51
50 The Ministry of Marine and its companion building
which face the square echo the East Front of the Louvre,
only in richer, slightly more ornate form. Open arcades on
the ground floor, sculptured trophies on the skyline and
reliefs in the pediments at either end of the façades give
these buildings a festive air. Yet Gabriel has broken none
of the classical rules; everything is correctly proportioned;
symmetry, order and clarity are preserved. In the realm
of public buildings, this was a realisation of one of the key-
notes in French thinking about the arts in the 1750s—the
desire to return to 'the good taste of the previous century'.

In Rome during these years there was also a return to a
grander, more considered classicism than that of the late
Baroque-Classicism of the beginning of the century. 5
Curved façades and broken pediments were abolished and
sculptural ornament was reduced to a minimum. The
source of inspiration was the early 17th-century Baroque-
Classicism of Maderna, whose façade of St Peter's was the 1
model for that of St John Lateran, designed in the 1730s.

Developments in sculpture were less consistent and, at
least up to the mid-century, more closely linked to the
Baroque. But in England it is possible to find parallels with
Palladianism in the portrait-busts and tombs of the
Flemish-born sculptor, Michael Rysbrack, whose sources 8
were the Antique and the 17th-century sculptors, Duques-
noy and Coysevox. In France the struggle for classicism was
waged from 1732 onwards by Bouchardon, who returned
in that year from a long stay in Rome; the style he evolved
was a blend of the Antique and Girardon, with occasional
influences from the Renaissance.

There was also an attempt to revive history painting in
these years. In England it was Hogarth, rather surprisingly
and in a sense *faute-de-mieux*, who took up this task in prac-

88. **John Michael Rysbrack.** *Study for the Monument to Sir Isaac Newton in Westminster Abbey. c.* 1731. Terracotta. 13¾ in. high. (34.8 cm.). Victoria and Albert Museum, London. This is a model for the principal figure on the tomb of Newton which was designed by the Flemish-born sculptor, Rysbrack, in collaboration with William Kent. The vigour of the execution and the strongly marked surface reveal Rysbrack's baroque inheritance, but the figure is composed on classical lines and has been given a noble Roman head and a grave authoritative expression. This is one of the finest pieces of sculpture produced in England in the 18th century.

tice (it did not lack supporters in theory). In France the role of impresario was assumed by Mme de Pompadour's brother, the Marquis de Marigny, who became Surveyor of the Royal Works on his return from Italy in 1751. In Rome, Pompeo Batoni, who is better known for his portraits, returned in his history paintings to the style of the 17th-century Bolognese classicists, Annibale Carracci and Domenichino. The Renaissance painter who was adopted as the ideal and patron saint of this movement was Raphael, whose reputation had been set above that of all others by the critic, Bellori, in the late 17th century. In France there was also a renewed interest in Raphael's great 17th-century successor, Poussin.

THE TURNING POINT OF THE 1750S

The position around 1750 may therefore be summed up as follows. In England, France and Rome—less so in other parts of Italy and hardly at all elsewhere in Europe as yet—there was growing hostility towards the Baroque and, where relevant, the Rococo. The Baroque was coming to be seen as extravagant, tortuous and unruly, the Rococo as degenerate and frivolous as well, since it was associated with a degenerate society. Attacks on the Baroque began in England in the years after 1715; those on the Rococo started in France in the 1740s, culminating in Cochin's articles in the *Mercure de France* in 1754. The style proposed as a replacement of the Baroque and Rococo was a sober, rational classicism. The Antique was to be the main source of this, but 17th-century classicism was admired and was often the direct model.

Developments on these lines occurred chiefly in architecture, but they also affected interior decoration, sculpture, and to a smaller extent, painting. Nor did the link with the 17th century end in practice with the 1750s. On the contrary, painters especially remained dependent on its aid, though they would not always have admitted it, and the career of Jacques-Louis David, who at first owed as much to Poussin as to the Antique, shows how different it was to achieve a 'pure' neo-classical style. The lack of extant examples of ancient Greek and Roman painting compared with the many works of sculpture and architecture available contributed to this situation.

Nevertheless, a number of other things happened in the 1750s which led to a radically new phase of the revival, and

with these it is fair to say that Neo-Classicism began. Almost without exception they were not works of art but publications—reminders that Neo-Classicism was at heart an intellectual and philosophical movement, fostered by new ideas which only later, partially and not always successfully found expression in practice. In architecture the neo-classical period was *par excellence* an age of unrealised and unrealisable projects, though these might also be attributed to its romantic tendencies.

The key publications of the 'fifties included the first volumes of the Comte de Caylus's *Recueil d'antiquités* (1752) and of the official record of the archaeological discoveries at Herculaneum, *Le Antichità di Ercolana* (1755); Piranesi's *Le Antichità Romane* (1756); Robert Wood's *Ruins of Palmyra* (1753); Laugier's *Essai sur l'architecture* (1753) and Winckelmann's *Reflections on the Imitation of Greek Works of Art in Painting and Sculpture* (1755). Also in the 1750s the Englishmen, James Stuart and Nicholas Revett, visited Greece, although the first volume of their great work, *The Antiquities of Athens*, did not appear until 1762 and was forestalled on the Continent by J. D. Le Roy's less well produced *Les Ruines des plus beaux monuments de la Grèce* (1758).

The significance of all this new archaeological information is that for the first time it seriously extended the range of men's knowledge of the ancient world beyond that of the well-trodden ground of classical Rome. Now other periods and regions came into view: classical Greece, territories settled by the Romans overseas, ancient Egyptian civilisation, and pre-Roman civilisation in Italy itself. The character of this information and the wealth of new theoretical ideas generated at the same time are best considered under three main heads: one, the revival of Rome as a creative centre of the arts; two, the passion for Greece; three, the formulation of a new theory of expressive architecture.

THE REVIVAL OF ROME

It goes without saying that Rome had never ceased to be a centre of the arts since the High Renaissance. However, the decline in patronage which began before 1700 meant that few great works of art were produced during the first half of the 18th century and the number of famous Roman artists was very small. Even De Sanctis, the architect of the Spanish Steps, is scarcely remembered except by specialists. The Academy of St Luke and the Roman branch of the French Academy went into suspended animation. Few great foreign artists studied in Rome, preferring Paris or North Italy instead. Meanwhile students at the French Academy were notorious for neglecting the Antique. The keenest visitors were English, including connoisseurs, Grand Tourists and writers as well as artists; among them, as we have seen, were Burlington, Kent and Gibbs.

Yet it was during these years that Rome was being prepared for her new role as the great museum of Europe. Every day more pieces of classical sculpture were unearthed and added to those already familiar since the Renaissance. The Popes eagerly supported this activity.

89. **James 'Athenian' Stuart.** *The Monument of Lysicrates, Athens*. Plate from *'The Antiquities of Athens'*, Vol. 1, London, 1762. 16¾ × 10½ in. (42.5 × 26.5 cm.). This engraving is taken from one of the key publications of Neo-Classicism. The discovery of ancient Greek architecture was a decisive factor in the movement, although its influence hardly became apparent in contemporary architecture until the 1790s. The refined style of this engraving is almost as significant as its subject-matter.

The Vatican collections were supreme, and in 1734 Clement XII opened Europe's first public museum of antiquities in the Palazzo dei Conservatori on the Capitol. Its main stock was naturally still Hellenistic, Greco-Roman and Roman work, and Roman copies of Greek originals, not authentic Greek work of what is now called the classical period (6th, 5th and 4th centuries BC). The significance of this for Neo-Classicism will shortly become clear.

The casual and nostalgic attitude to ancient Roman architecture of the first half of the 18th century is well summed up in the view paintings of Pannini. These represent the ruins themselves accurately enough but show them from picturesque angles and often in imaginary relationships to each other. What Pannini offered his patrons were theatrically handsome souvenirs, not records of hard archaeological fact. Something very different was created by Giovanni Battista Piranesi, who was an architect by training and used the sharp, clear media of etching and engraving, not oil paint. But Piranesi was not merely a dry copyist; quite the reverse. His treatment of Roman ruins was highly subjective and dramatic and in some ways misleading. Using a low viewpoint, bold diagonals and strong tone contrasts, he surrounded his buildings with wiry foliage and small, bizarre figures reminiscent of Salvator Rosa or Sebastiano Ricci, and threw them in startling silhouette against the sky. The extravagance of Piranesi's imagination, revealed even more clearly in his etchings of fantastic prisons than in his views of ancient ruins, was far from the neo-classic ideal.

Yet his many publications, dating from the late 1740s to the 1770s, were more comprehensive than any produced before. In some he made useful contributions to research and, despite his play with scale, using small figures to exaggerate the size of buildings, he never tampered with the archaeological correctness of his views. More important, his

90. **Giovanni Battista Piranesi.** *View of the Temple of the Sibyl at Tivoli. c.* 1755–60. Etching. 16¾ × 25⅛ in. (42.5 × 63.8 cm.). Piranesi's bold dramatic style lies at the opposite extreme from Stuart's delicate linear precision, yet both men—one the advocate of Greek, the other of Roman architecture—were scrupulous archaeologists and both were equally important figures in the neo-classical movement. Piranesi's copious etchings, which invested Roman remains with a new glamour and excitement, were especially popular in England.

91. **William Chambers.** *Somerset House, London.* Begun 1776. This illustration shows the central feature of the east side of the main court. Somerset House is a grave, noble, learned and competently planned building, rather than an inspired one. Its sources are found in Roman, Italian Renaissance and French 17th-and 18th-century architecture, but not in Greek, to which Chambers, as an academic and a traditionalist, was strongly opposed. He was, on the other hand, an admirer of Piranesi, and there is some similarity in feeling between his handling of classical forms and Piranesi's etchings. His role in English architecture was comparable to that of Reynolds in painting.

presentation of classical architecture coloured the attitude of his own and succeeding generations towards ancient Rome. Rome had threatened to become merely irrelevant or boring; now it was exciting again. Piranesi's personal contacts and his audience were wide, particularly among Englishmen. He was a friend of Robert Adam, an ally of Chambers, an inspirer of Soane and (in France) an important influence on the first true neo-classical building, the Panthéon in Paris, designed in 1755–56 by Soufflot.

The hankering after imaginative grandeur, sometimes turning to megalomania, which pervaded the 'romantic' wing of Neo-Classicism, started with Piranesi. To put it another way, it was partly due to him that a neo-classical building could be both forbiddingly severe and romantically evocative at once. The result was something quite different from the rhetoric of the Baroque; it was a quality residing in the massively hewn blocks of masonry themselves, in the sheer, cliff-like columns and walls and in the cavernous spaces under porticoes and vaults—a quality that was eloquent not of some human or divine message but of the internal drama of stone.

This contribution by Piranesi was more important than his spirited but ill-founded defence, conducted in the early 1760s, of the innate superiority of ancient Roman architecture as compared with Greek. Perhaps his principal role here was to keep the lines of demarcation between the two styles clear. The consequences of this can best be seen in England, where Piranesi's influence was stronger than anywhere else except Italy. Both Sir William Chambers and Robert Adam, who dominated English architecture from the late 1750s to the 1780s, took Piranesi's side against the partisans of Greece.

In fact Chambers, whose chief work was Somerset House in London, was in some ways still a Palladian, harking back to Kent and Inigo Jones as well as to ancient Rome. Adam was a much more original architect, more picturesque and less 'correct', but he too used only Roman sources—or what he though were Roman sources. In fact there was a confusion here. In the controversy on behalf of the two opposing styles the chief argument in favour of the Greek was that Greek architecture existed first and that Roman architecture was derived from it—a point that the partisans of Rome could hardly contradict. The latter counterattacked, however, by claiming that both Greek and Roman architecture depended on Etruscan, which grew up on Italian soil and ante-dated both.

Little was known of Etruscan civilisation and nothing of its architecture but this was not considered an objection; it was enough to establish its theoretical *priority*. In 18th-century arguments that side would win which could show that its chosen style went back the furthest in time, reaching out to the dawn of civilisation and the very origins of man. This fascination with the primitive occurs, in a different context, in the architectural theories of Laugier, which will be discussed later.

Meanwhile, despite its irrelevance to the main problem,

92. **Jacques Soufflot.** *The Interior of the Panthéon, Paris.* Designed 1755–56. Originally built as the Church of Ste Geneviève, the Panthéon was secularised during the Revolution and made into a mausoleum for France's national heroes. It is planned on a Greek cross with equal arms, apart from an extention for the portico at the entrance, and has a dome over the crossing. Its austere grandeur echoes Piranesi's interpretation of Roman ruins, while its interior construction, using columns rather than arcaded walls or tiers, reflects the functionalist theories of the Abbé Laugier (see text). It is generally regarded as the first true neo-classical building.

the search for Etruscan works of art went on. Soon enough, in the course of excavations in south Italy and Sicily, some 'Etruscan' vases were found. These vases were in fact Greek but their Greek origin was not realised until later. They were eagerly sought after, notably by Sir William Hamilton, the British ambassador at Naples, who presented his collection to the British Museum in 1772. Josiah Wedgwood seized on them as the inspiration for his pottery, which he began to manufacture in the early 1760s at Burslem in Staffordshire, afterwards moving to a new site near Stoke-on-Trent which he called Etruria.

Finally, Robert Adam incorporated motives from these 'Etruscan' vases in his interior decorations. He combined them with figures, borders and slender, abstract architectural forms taken from the mural paintings found at Herculaneum, and also added motives from classical grotesques, to form a composite but highly original style. Yet, so great was the prestige of 'Etruscan' art, that he called the style

(Continued on page 753)

83. **Sebastian and Marco Ricci.** *Monument to the Duke of Devonshire.* 1725. Oil on canvas. 85¾ × 64½ in. (218 × 164 cm.). Barber Institute of Fine Arts, Birmingham University. This painting is one of about two dozen similar works by various artists commissioned as a commercial venture by an Irishman, Owen McSwinney, living in Venice. The subjects were allegorical tombs surrounded by ruins and treated in a fanciful and flattering late baroque manner, in honour of various prominent Englishmen, recently deceased.

84. (above). **François Cuvilliés.** *Hall of Mirrors*, The Amalienburg, Schloss Nymphenburg, Munich. 1734–39. The *Maison de Plaisance* of the Amalienburg was built by Cuvilliés for the Bavarian Elector, Karl Albrecht, as a counterpart to a pseudo-Gothic 'hermitage' in his palace park. The stucco is by J. B. Zimmermann, the carving by J. Dietrich. The pavilion is one of the earliest and most perfect examples of German Rococo, although its Flemish-born architect was trained in France and its exterior fulfilled French architectural theories of the period. The reduction of a hall of mirrors *à la Versailles* to the scale of a pleasure pavilion is matched by the light and sculptural forms of the decoration and is wholly in the spirit of Rococo.

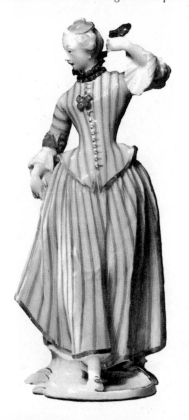

85. **Franz Anton Bustelli.** *Columbine.* c. 1760. Nymphenburg porcelain. 7¾ in. high (19.7 cm.). Victoria and Albert Museum, London. This is one of a series of sixteen figures from the Italian *Commedia dell' Arte* designed by Franz Anton Bustelli, master-modeller at the Nymphenburg porcelain factory (until 1760 at Neudeck, a suburb of Munich) from 1754 until his death in 1764. Bustelli's new rococo style, all pointed elegance, uninhibited emotion and wit, made Nymphenburg, under the patronage of the Elector of Bavaria, into one of the two or three leading porcelain works in Germany after the decline of Meissen. The vivacity of the pose, with its underlying wistfulness of mood, is a perfect embodiment of the *Commedia dell' Arte* spirit—the subversive charm of impoverished Italy brought to the formal, prosperous north, that charm which delighted artists and musicians from Watteau to Mozart.

86. (opposite). **Simpert Krämer, Johann Michael Fischer** and others. *Abbey Church*, Ottobeuren, Bavaria. 1737–67. Like many Bavarian 18th-century churches, Ottobeuren is by several different designers. The somewhat conventional plan, with a nave, choir and transepts meeting in a crossing under a dome, is basically Krämer's. His work was then modified by Fischer, who took over in 1748 and was responsible for the majestic, light-filled interior, in which the spaces, articulated by regularly grouped columns and a heavy cornice, flow into one another in a typically late baroque manner. With the decoration, however, the idiom changes again, for, pinned to the wall surfaces of the church, is some of the most dazzling rococo sculptured ornament to be found anywhere. This ornament—playful, inventive and brilliant in white, gold and other colours—was supervised and partly executed by J. M. Feichtmayr.(see plate 28).

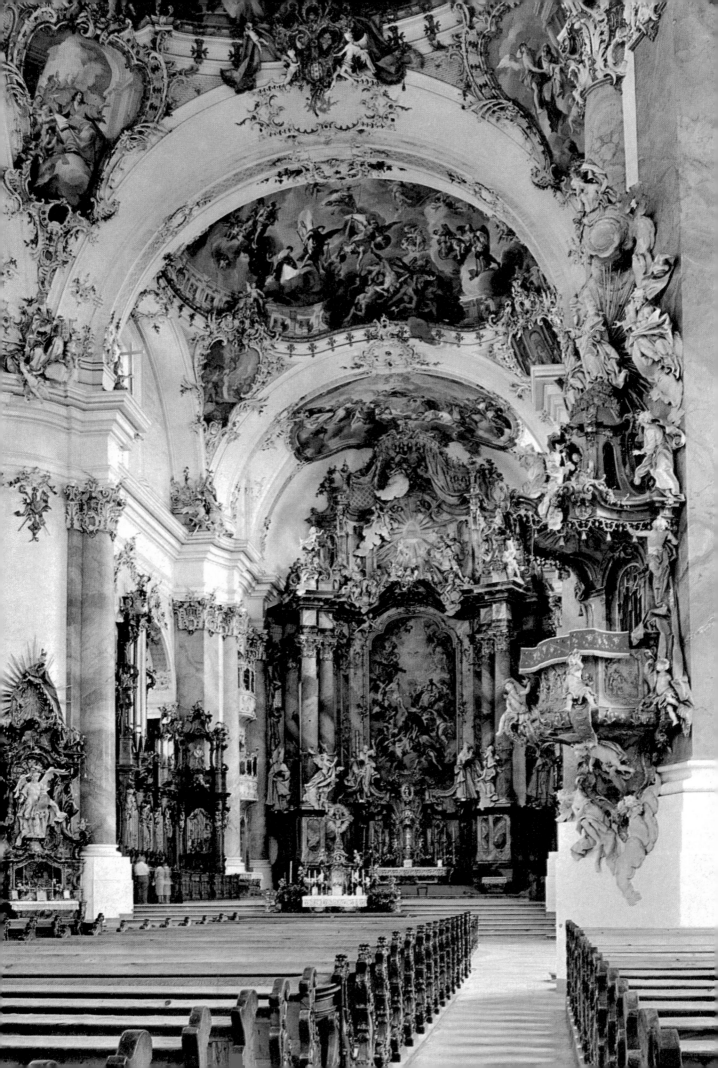

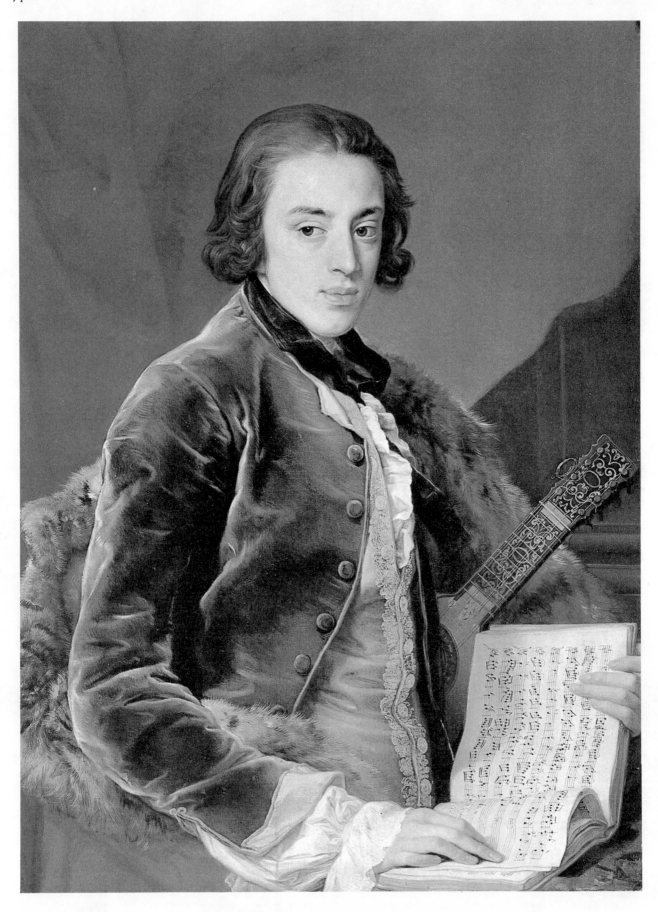

87. **Pompeo Batoni.** *John, Marquis of Monthermer. c.* 1760. Oil on canvas. 38¼ × 26¼ in. (97 × 67 cm.). Collection: the Duke of Buccleuch and Queensberry, K. T., Boughton House, Rutland. This portrait, presumably painted in Rome, was earlier attributed to Batoni's chief rival for the English Grand-Touring clientele, Anton Raphael Mengs; but it is suaver and more intimately graceful than the men in Meng's pictures. It combines a sharply characterised, unmistakably English face with a decorative liveliness in the composition only possible in a Continental portrait.

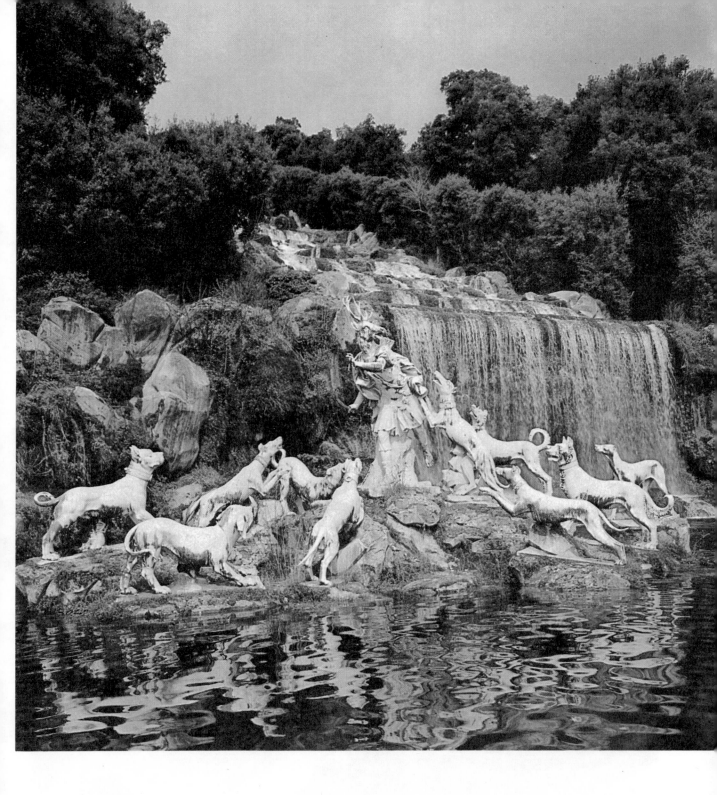

88. **Luigi Vanvitelli.** *The Great Cascade*, Caserta, near Naples. *c.* 1770. Figures in white marble. The palace of Caserta, the 'swan-song' of the Italian Baroque, was built by Vanvitelli for the Bourbon King of Naples, Charles III. In its scale and impressiveness, its gardens, fountains and cascades—though not in its plan or style—it emulates Versailles. The elegant pseudo-classical figures at the bottom of the Great Cascade, representing *Diana and Actaeon*, disport themselves on the rocks as if taking part in a masque or *tableau-vivant*. The group has no architectural setting, and the baroque union of art with nature here merges into the Picturesque.

89. (following pages). **Giambattista Tiepolo.** *Apollo conducting Beatrice of Burgundy to Frederick Barbarossa.* 1751–52. Fresco. Ceiling of the *Kaisersaal*, Residenz, Würzburg. At the height of his career, Tiepolo was called to Würzburg to decorate the dining-room of the Prince-Bishop, Karl Philipp von Greiffenklau; the room itself, an eight-sided rococo *salon* with multi-coloured marble columns and elaborate stucco-work, was designed by Balthasar Neumann. Tiepolo's il-lusionistic ceilings are the culmination of a great tradition; but although, as in the case of his baroque predecessors (see plate 20), the theme—the 12th-century episode of the Betrothal of Beatrice of Burgundy to the Emperor Frederick Barbarossa—is grave, Tiepolo's treatment is all lightness and rococo. The actors are in 16th-century fancy-dress *à la Veronese*; there is occasionally a playful element of genre, and disembodied *putti* flit in and out of Antonio Bossi's glittering stucco arabesques which frame the ceiling. It is painting not for instruction, but for decoration and charm.

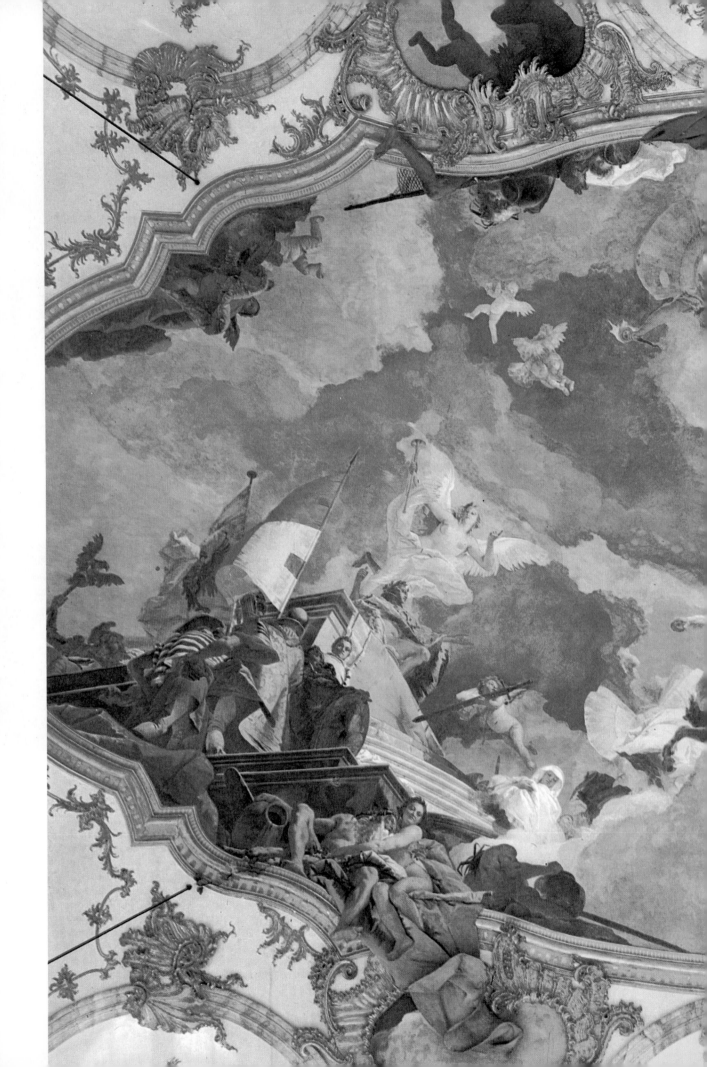

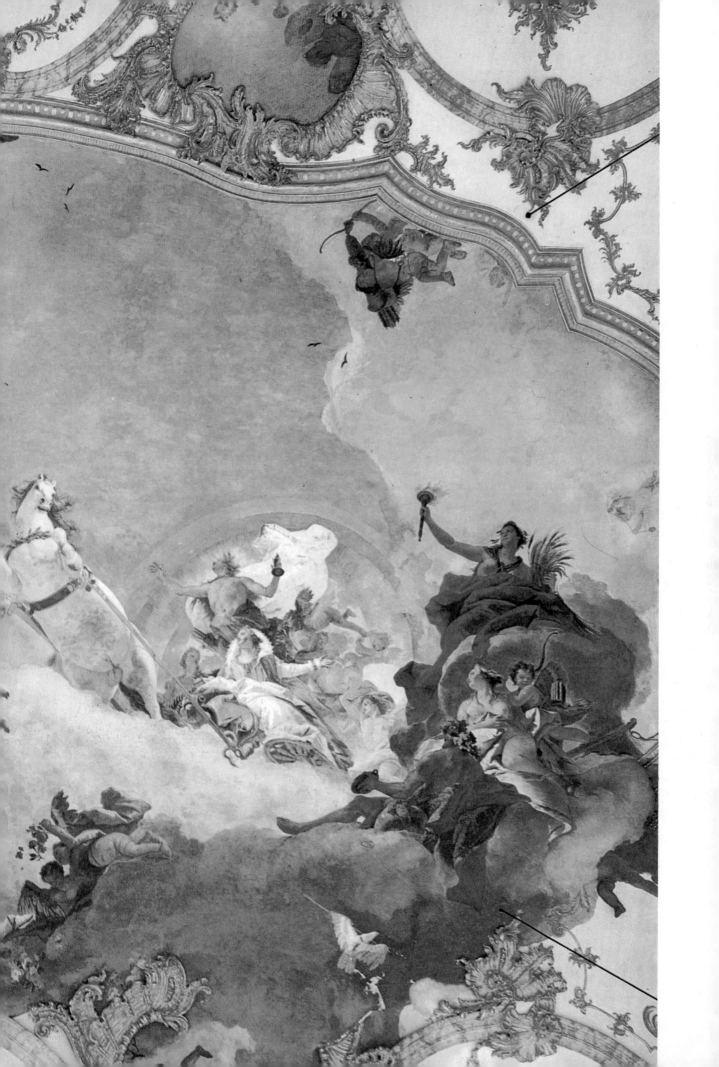

90. (opposite, above). **Lukas von Hildebrandt.** *The Upper Belvedere*, Vienna. 1721–24. There is a hint of Versailles in this baroque summer palace, built for Prince Eugene of Savoy. (No great patron of the period, least of all one who had helped to defeat Louis XIV, could overlook such an example). But the architecture is more playful and festive. Hildebrandt is noted for his use of colour and variegated skylines. The arrangement of 'Upper' and 'Lower' Belvedere, with a long, stepped garden in between, echoes the 16th-century Belvedere in the Vatican.

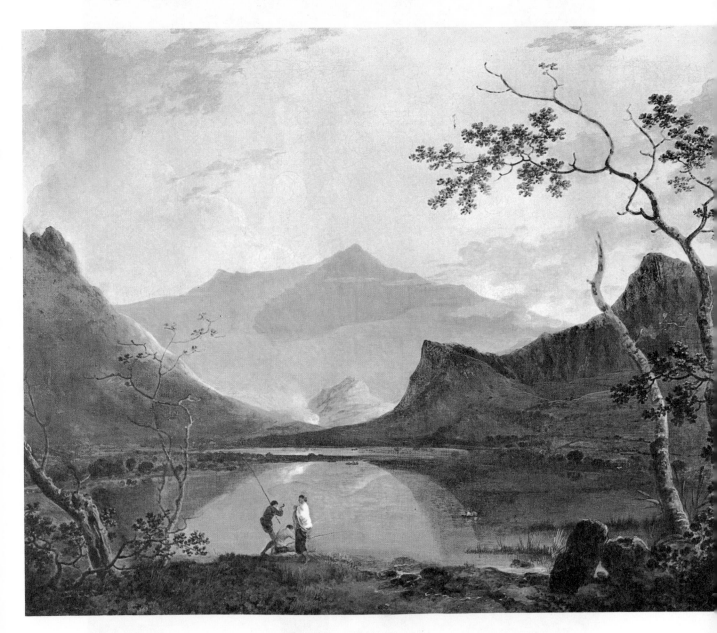

91. (opposite, below). **Lord Burlington.** *Chiswick House*, London. *c.* 1725. This shows the English type of the Palladian summer villa, built by and for Lord Burlington, arbiter of taste in England in the second quarter of the 18th century: unostentatious, comparatively small, architecturally 'correct', picturesque only in its setting—in short, a reaction against everything that Versailles (and, nearer at home, Blenheim) stood for. The design recalls the villas built by Palladio in the Veneto in the 16th century, but modified in the light of Burlington's knowledge of Palladio's own reconstructions of ancient Roman buildings.

92. (above). **Richard Wilson.** *Snowdon seen from across Llyn Nantll.* 1776 (?). Oil on canvas. 39½ × 50 in. (100 × 127 cm.). Walker Art Gallery, Liverpool. Classical in its construction and rococo in its principal outlines, this landscape is one of the first mountainous landscapes of the 18th century and one of the first oil paintings to show a view in Wales. The sensitive rendering of light and atmosphere owes something to both Claude and Cuyp, but Wilson adds a new, pre-romantic note of reverie. As Ruskin put it: 'I believe that with the name of Richard Wilson, the history of sincere landscape art, founded on a meditative love of nature, begins for England.'

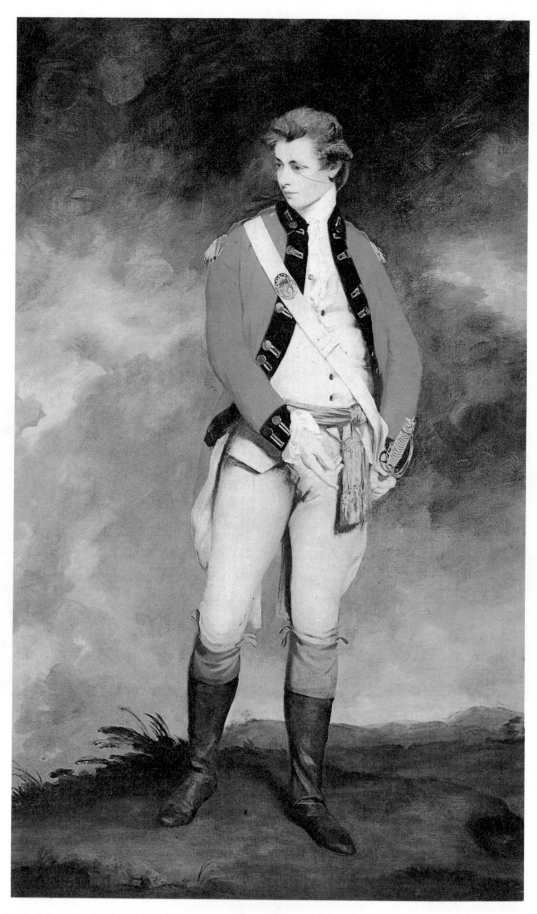

93. **Joshua Reynolds.** *Colonel John Hayes St Leger* (detail). Oil on canvas 93 × 58 in. (236 × 146 cm.). Waddesdon Manor, Bucks., National Trust. Colonel St Leger was aide-de-camp to the Prince of Wales.

94. (opposite). **James Gibbs.** *St-Martin's in-the-Fields*, London. 1721–26. This view shows the church as it was originally seen before the construction of Trafalgar Square, i.e. along a narrow street parallel with the portico. The integration of the steeple with the church so that is appears to rise through the roof behind the portico was a daring innovation, which became widely influential in North America later.

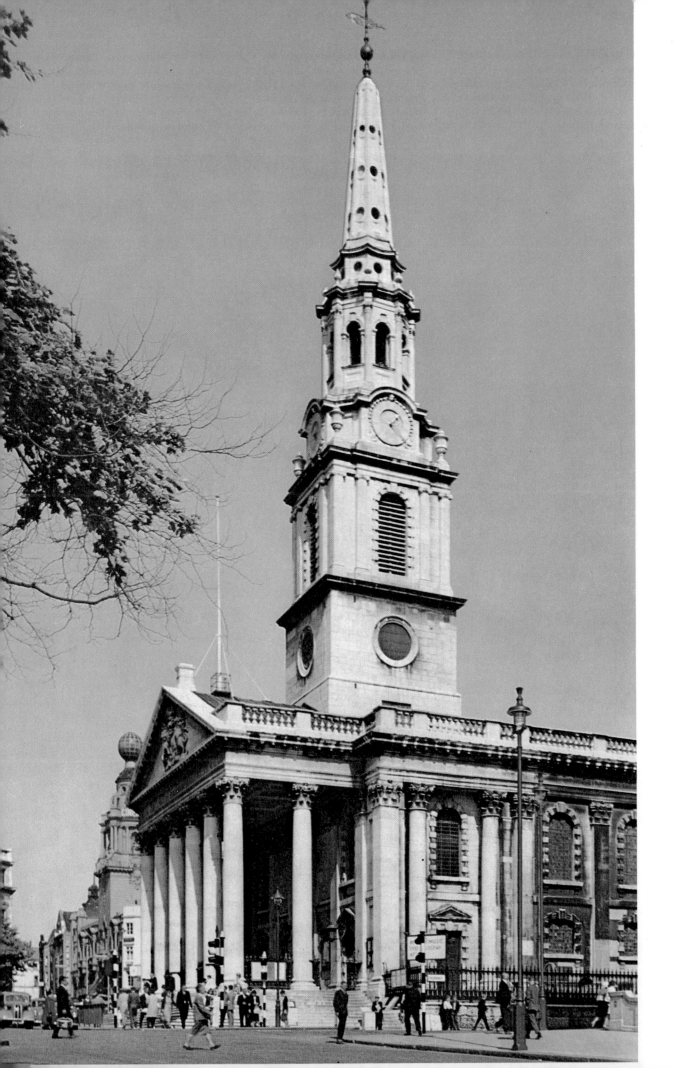

95. **Robert Adam.** *The Etruscan Room,* Osterley Park, Middlesex, *c.* 1775. The archaeological spirit behind this design was stimulated by the discovery of Greek vases (then thought to be Etruscan) in southern Italy.

96. **Thomas Gainsborough.** *Mrs R. B. Sheridan, c.* 1783. Oil on canvas. 85 × 58¾ in. (216 × 149 cm.). National Gallery of Art, Washington (Andrew Melton Collection). This portrait shows the wife of the dramatist, slightly windswept and *deshabillée,* in a landscape, in the painter's

most poetic manner. The breeze has brought a becoming blush to her cheeks, harmonizing with her dress, while the 'all over' handwriting of the brushstrokes produces an atmosphere truly, if artificially, pastoral.

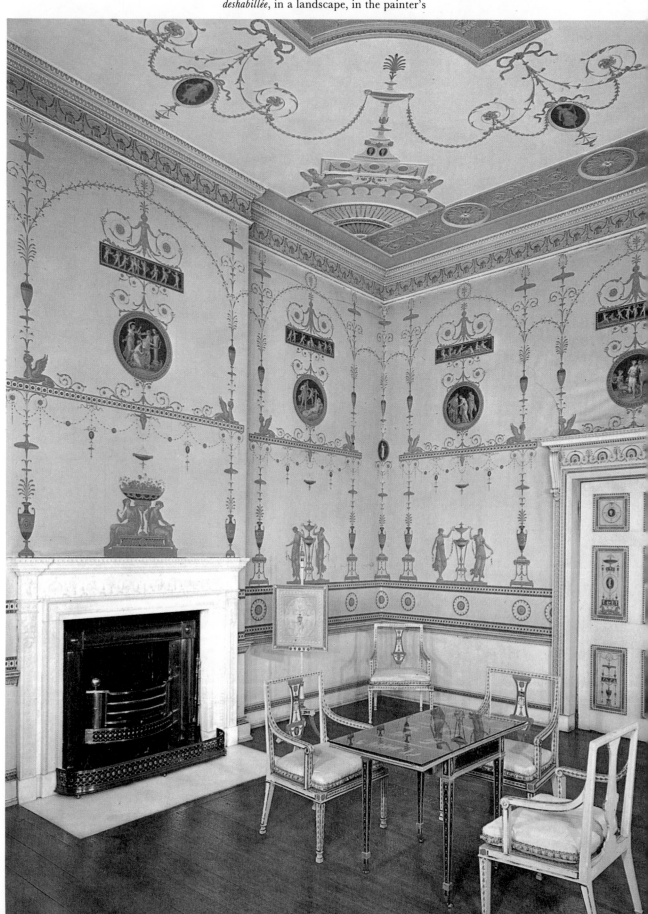

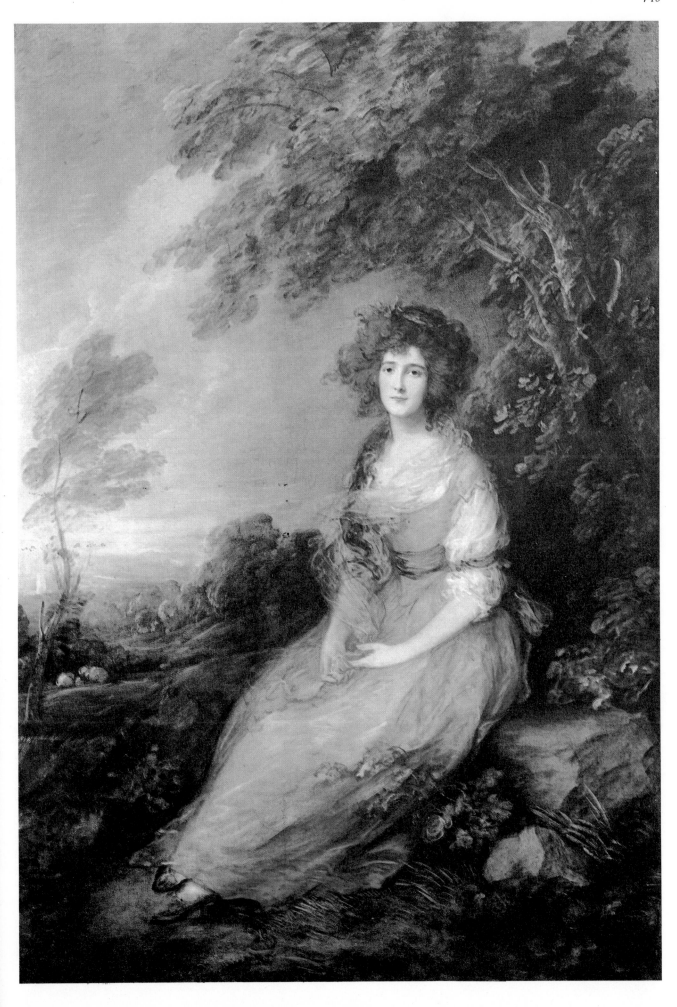

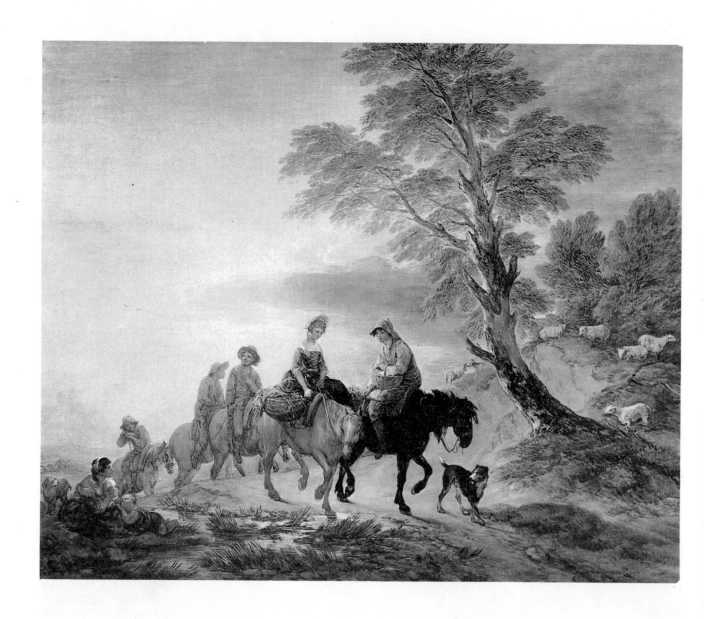

97. **Thomas Gainsborough.** *Going to Market. c.* 1769. Oil on canvas. 48 × 58 in. (122 × 147 cm.). Reproduced by courtesy of the Royal Holloway College Council, Englefield Green, Surrey. With its asymmetrical composition and cursive, elegant lines, this is one of the most rococo of Gainsborough's landscapes. The mood is considerably less artificial than that of *Blind Man's Buff* and a moist, silvery haze, suggestive of the English climate, pervades the scene. The gentle rhythms of the composition recall Gray's *Elegy*: 'Along the cool sequestered vale of life They kept the noiseless tenor of their way.'

98. (opposite, above). **George Stubbs.** *Horses in a Landscape. c.* 1760–70. Oil on canvas. 39 × 74 in. (99 × 188 cm.). Ascott House, Wing, Bucks., National Trust. The air of static calm, and clear, sharp outlines of the horses are qualities similar to those found in Wilson's *View of Snowdon*. But Stubbs, the finest of all English painters of horses, was a more objective artist than Wilson. The frieze of horses seen against the simple, unfocussed landscape has a neo-classical simplicity comparable to the figures on a Wedgwood vase.

99. (opposite, below). **Benjamin West.** *The Death of Wolfe.* 1770. Oil on canvas. 59½ × 84 in. (151 × 213 cm.). National Gallery of Canada, Ottawa. This picture, representing General Wolfe's death during the capture of Quebec in 1759, is generally taken to be the first history painting in modern dress. Such was no doubt its ultimate significance and it was certainly popular when it was exhibited at the Royal Academy in 1771, but West's original intention may rather have been to raise the traditional modern-dress battle-piece, hitherto considered a rather low genre, to the level of history painting. He composed the picture on classical lines, with borrowings from the Old Masters and by reconstructing of the scene not 'as it was' but 'as it ought to have been'.

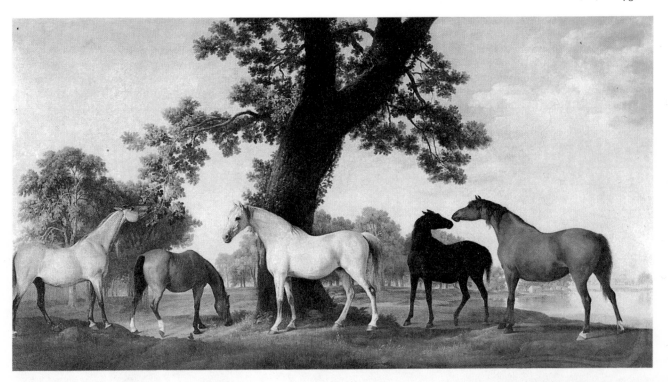

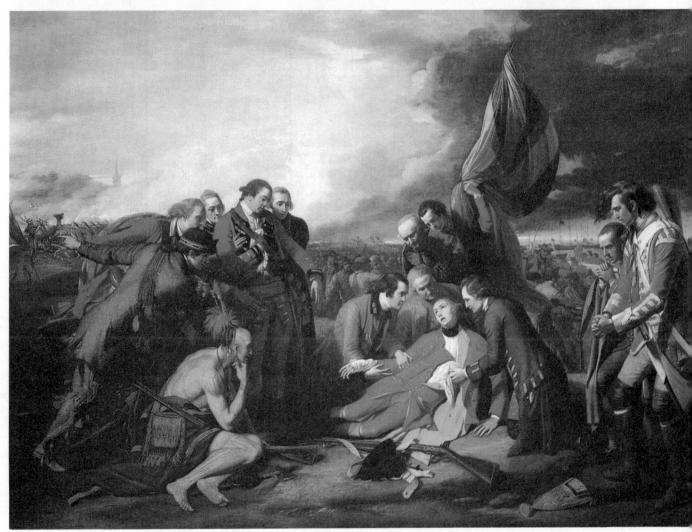

752

100. **Richard Mique.** *The Temple of Love* in the Gardens of the Petit Trianon, Versailles. 1778. White marble. The picturesque 'Jardin anglais' laid out for Queen Marie-Antoinette in the grounds of the Petit Trianon was the final attempt by the French Royal Family to realise a century-long dream—the dream of escaping from the stultifying formality of Louis XIV's Versailles. The garden, with its winding paths, streams and lakes, contained —besides the Temple of Love—a grotto, a 'Belvedere' and a complete artificial village in rustic style (the 'hameau'), planned by the landscape painter, Hubert Robert, and executed by Mique. The Temple of Love itself, standing on a small island and glimpsed through trees, is reminiscent, like its English prototypes, of the buildings in Claude Lorrain's landscapes (plate 45).

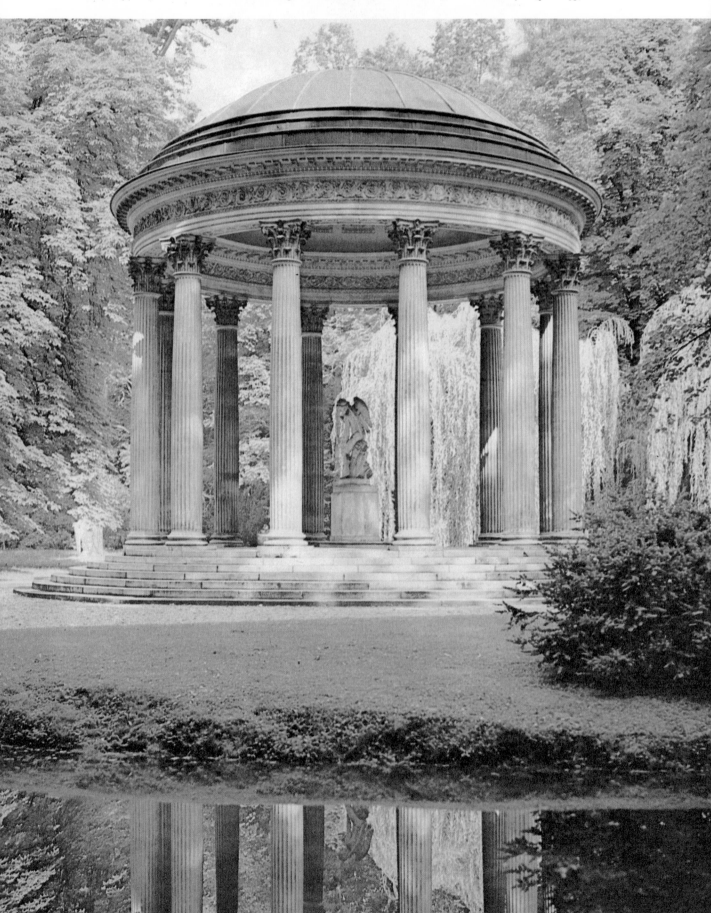

by this name, and few Adam houses dating from the 1770s or later are without an Etruscan Room. By a curious irony one of the comparatively few cases of actual Greek influence on 18th-century art was thought to derive from something else.

Chambers, Adams and Soufflot (the architect of the Panthéon) all studied in Rome in the 1750s. They were the representatives of a new trend, whereby a visit to Rome became the rule rather than the exception for foreign artists. Other Englishmen there at some point during this decade included the painters, Joshua Reynolds, Richard Wilson and Gavin Hamilton (who stayed the rest of his life), and the sculptor, Joseph Wilton. Among French painters were Hubert Robert and Fragonard; Joseph Marie Vien, the teacher of David, had already arrived in Rome in the 1740s and returned to Paris in 1750. One important German painter was also present, Anton Raphael Mengs, who was another permanent resident except for periodic visits to Madrid. Almost the only important north European artist of this or the next generation who never visited Italy was Thomas Gainsborough.

However, not all those on this list became neo-classicists, as the inclusion of Hubert Robert and Fragonard makes clear. Wilson primarily discovered Claude Lorrain; Reynolds studied Raphael, Michelangelo, and, in Venice, Titian, besides the Antique. Both these English artists show the continuation of the approach to classicism through its Renaissance and 17th-century interpretations. What they achieved by this was a classic elegance and gravity, combined in Reynold's case with a baroque chiaroscuro derived from Rembrandt and with the colour and breadth of handling of Titian.

In his *Discourses* Reynolds was if anything *opposed* to Neo-classicism except in sculpture; his approach was still basically that of Bellori and the 17th-century French academicians. Other painters who shared the same tendency were the American, Benjamin West, and Greuze, who paid a belated visit to Rome in 1768. Except for the modern dress on which its fame depends, West's *Death of Wolfe* was a pure exercise in traditional academic history painting, with poses taken from Poussin and Van Dyck and expressions from Lebrun.

Greuze used the same method in his *genre* pictures. Despite the everyday subject-matter, the figures obey the classical rules, putting the correct, revealing expressions on their faces, making emphatic gestures with their hands, moving their limbs parallel to the picture plane and grouping themselves so as to underline the narrative quality of the picture.

In fact it was not until a slightly later generation (which included West)—which reached Rome in the 1760s—that the development of a tentative neo-classical style in painting and sculpture became possible. The leaders of this group were Gavin Hamilton and Mengs from the previous generation, who were in Rome already. Besides West, who used the new style for his pictures of classical subjects, the group included the painters, Angelica Kauffmann and James Barry, and the sculptors, Joseph Nollekens, Houdon and Clodion. Of these only the sculptors were artists of the first rank; the painters were interesting rather than good. However, by this stage a new factor had arisen—Winckelmann's panegyric on behalf of ancient Greek sculpture.

THE PASSION FOR ANCIENT GREECE

The supremacy of Greek art over that of all other nations and periods had been admitted by various artists and critics long before Winckelmann's time. Among the earliest to do so was Nicolas Poussin, but at that time it was still a question of speculation as almost nothing was known of Greek art at first hand, (curiously, little attention was paid to the one major work of Greek architecture available to them, the great Doric temple at Paestum, south of Naples). A further impulse to the doctrine of Greek superiority was given by the English philosopher, Shaftesbury, in the early 18th century. It was no doubt his influence that prompted Stuart and Revett to visit Athens. Once they and others had made the journey in the 1750s, the seperate character of Greek as distinct from Roman architecture became plain and the battle on behalf of the two styles was joined.

Winckelmann, who had also read Shaftesbury, tackled the problem in the more difficult field of sculpture. His contribution was twofold. First, he asserted the supremacy of Greek art over all later art with a new clarity and force. The opening sentence of the *Reflections* reads: 'Good taste, which is spreading more and more throughout the world, was first formed under Greek skies.' His second point, because it was newer, was even more decisive, though it was at the same time subtly confusing for reasons that will be seen in a moment. What Winckelmann claimed to do was to define the special characteristics of Greek sculpture. Here there are two key passages. The first reads: 'The outstanding, universal characteristic of Greek works is thus a noble simplicity and calm grandeur in action and expression. As the bottom of the sea lies calm beneath a foaming surface, so the statues of the Greeks express nobility and restraint even in suffering.' The second passage paid tribute to 'the precision of contour, that characteristic distinction of the Ancients.' Interwoven with these brief but telling sentences was a restatement of the old academic doctrines concerning decorum, idealisation, obedience to the rules, and so on, taken from Bellori. It need hardly be added that the whole book was violently hostile to the Baroque.

Not the least remarkable thing about the *Reflections* is that they were written not in Rome, still less in Athens, but in Dresden, where there were only minor examples of classical sculpture and weak copies of the famous masterpieces in Italian collections to be seen. It was not until after the book was published that Winckelmann moved to Rome, to become librarian to the great collector, Cardinal Albani, and in 1763 Keeper of Antiquities at the Vatican. Yet even in Dresden he was able to see beneath the surface

93. **Etienne Falconet.** *Baigneuse.* c. 1760–80. Marble. 15 in. high. (38 cm.). National Trust, Waddesdon Manor, Bucks. For much of his life Falconet was Director of Sculpture at the Sèvres porcelain manufactory, and his statues and figurines have the polished lustre and rococo sweetness combined with classically simple outlines characteristic of Sèvres. Falconet maintained that the warmth and softness of the human body were better rendered by his own contemporaries than by the Ancients.

of the feeble objects in front of him, to grasp something of the essence of classical Greek sculpture that lay within. 'Noble simplicity', 'calm grandeur', 'precision of contour' —reading these phrases nowadays one is apt to think automatically of the Parthenon frieze. But the sculptures from the Parthenon did not become well known to the west until the 19th century, and Winckelmann's descriptions were meant to apply to later, Hellenistic, works like the Laocoön, the Apollo Belvedere and the Medici Venus.

When he got to Rome he wrote a series of appreciations of these works which bore out his original theories. Herein lay both the strength and the weakness of Winckelmann's influence. On the one hand he provided a novel, arresting interpretation of long-familiar masterpieces of classical sculpture which was comparable in its freshness and visionary enthusiasm to Piranesi's re-interpretation of ancient Roman architecture. On the other hand, his claim to distinguish between authentic Greek art and its later derivatives was undermined by the scarcity of actual Greek works of the classical period. (It was perhaps typical of him that he never visited Greece).

On the lowest level he simply encouraged a confusion of terms; people came to regard as 'Greek' what they had previously called 'antique'. In France, especially, many of the forms hailed as *à la grecque* were still Roman in origin, even though they were treated in a 'calmer', 'simpler' and more 'precise' way than before. In sculpture the result of Winckelmann's writings was to induce a glacial, polished look, with all individuality eliminated from the surface and a characterless stiffness of pose. The unGreek but typically mid-18th century warmth of sentiment which he unconsciously introduced into his descriptions also had surprising consequences. By an unexpected paradox it became possible to combine 'Greek' smoothness and precision of outline with rococo eroticism, most noticeably in female nudes: hence the 'pure' yet seductive girls in paintings by Vien with titles like *Greek Lady at the Bath*, and the coy nymphs and bacchantes of Falconet and Clodion.

In short, smoothness of form and clarity of outline became the distinctive qualities of neo-classical painting and sculpture, and fidelity to Greek or Hellenistic models was of secondary importance. A clear illustration of this is the 'demonstration piece' of the neo-classical movement in painting, Mengs's *Parnassus*, which was executed in 1761 for a ceiling in the Villa Albani, with Winckelmann's approval. Although it is a ceiling picture it is not treated illusionistically but as if it were to be hung on a wall. The principles on which it is painted are Winckelmann's but the 'imitation of the Ancients' which he urged as 'the only way for us to attain greatness' is played down. The background space is shallow, the movements are restrained and kept parallel to the surface, all the contours are distinct, not overlapping, and the composition is spread out like a classical frieze. But the sources used for the figures include not only the Apollo Belvedere and ancient Roman paintings from Herculaneum but also pictures by Raphael and Poussin. In fact the whole painting is more reminiscent of Raphael than anything else. The same reliance on a frieze-like composition and a mixture of sources is found in the first clumsy neo-classical history paintings of the 1760s by Hamilton and West. These pictures constituted a *genre* and a style that only reached maturity with David's masterpiece, the *Oath of the Horatii*, in 1784.

A more immediately successful application of the doctrine of linear precision can be seen in such things as engravings, interior decorations, works of small-scale decorative sculpture and objects of art. Some typical examples are Wedgewood vases, the early relief sculptures of Flaxman (who designed for Wedgwood) and the beautiful friezes of horses in paintings by Stubbs, though the latter are without direct neo-classical associations. More beautiful still are the supremely graceful interiors of Robert Adam, where the quality of linear precision is combined with an ornate, 'all-over' treatment of the surface reminiscent of the Rococo. The decorative motives used in these interiors —Greek frets, Roman acanthus scrolls, anthemion and guilloche borders, sphinxes, griffons, rams' heads, masks,

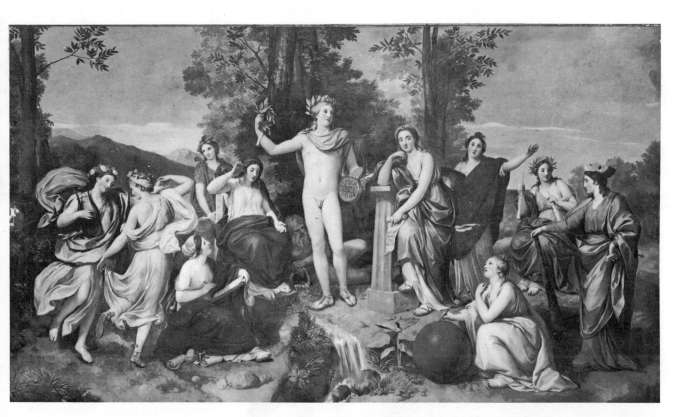

94. **Anton Raphael Mengs.** *Parnassus with Apollo and the Muses.*
1761. Fresco. Villa Albani, Rome. Mengs's *Parnassus* is the most
celebrated painting of the first phase of Neo-Classicism,
although it is not the earliest and is not purely neo-classic. Its
sources include the works of Poussin and Raphael as well as the
Antique. The central figure, adapted from the *Apollo Belvedere*, is

perhaps the closest approximation in painting to Winckelmann's
definition of the central qualities of classical Greek sculpture:
'noble simplicity and calm grandeur' and 'precision of contour'.
Although the fresco is painted on a ceiling it is treated as a
wall picture and is completely unillusionistic.

putti, medallions, urns, candelabra, tripods and rosettes—
were drawn from a mixture of classical sources 'transfused',
as Adam himself put it, 'with novelty and variety'. The
exquisitely drawn and engraved designs for decorations of
this type are among the most satisfying products of this
phase of Neo-Classicism. Together with the needle-sharp
engravings of Stuart's *Athens*, they mark the opposite ex-
treme of the style from the colossal, Piranesi-inspired
architecture of buildings like the Panthéon or old Newgate
Prison or the wilder projects of Ledoux.

In France the resistance to the Rococo was more doctri-
naire than in other parts of Europe and the neo-classical
forms which replaced it were heavier and more severely
rectangular. But even here the reaction was not unqualified
or truly Greek. Two different areas can be distinguished.
In work produced for the court there was some compromise
with the Rococo and a return to the style of Louis XIV.
Essentially, 'Louis Seize' furniture and decoration de-
pended on the substitution of symmetry, straight lines and
simple, mainly abstract ornament for the freely roving
curves and naturalistic sprays of the Rococo, as in the

tables and cabinets of the *ébéniste*, René Dubois. Similarly, 75
the little round temple in the gardens of the Petit Trianon
by the typical 'Louis Seize' architect and successor to
Gabriel, Richard Mique, is Engish in form and Roman in 100
detail and Greek only in the elegance and precision of its
treatment.

In Paris, however, there were more serious attempts to
be Greek, or at least classical in more than a conventional,
decorative sense. As early as 1756–57 the *amateur*, Lalive de
Jully, ordered new furniture for his apartment which, ac-
cording to Cochin, writing in the 1760s, started a fashion
for 'garlands looped like well-ropes, clocks in the form of
vases, and beautiful inventions which were imitated by all
the ignorant and flooded Paris with bits and pieces *à la
grecque*.' The furniture that survives shows that it was hardly 98
Greek in the strict sense (as Lalive acknowledged) but it
was extremely massive and severe, with hard edges,
rectangular forms, ornaments of lions' heads and feet and
borders of key and wave pattern design. Going further, one
may guess that the 'bits and pieces *à la grecque*' which
flooded Paris, influencing not only decoration and furni-

95. **Robert Adam.** *The Sculpture Gallery, Newby Hall, Yorks. c.* 1767–1780. This gallery consists of three rooms built and decorated throughout by Robert Adam to display the sculpture belonging to the owner of the house, William Weddell. The collecting of Antiques was an important feature of the neo-classical period, when English Grand Tourists were the principal buyers. Such collections were not merely curiosities but the inspiration of a way of life. Adam's sculpture gallery at Newby, which is sharp and elegant in detail and beautifully lucid in form, is one of the finest interiors of its date in Europe.

96. **Robert Adam.** *Design for a Ceiling at 7, Queen Street, Edinburgh.* 1770. Pen and watercolour. 18¾ × 18¾ in. (47.5 × 47.5 cm.). Royal Institute of British Architects, London. This design incorporates many of the decorative motives constantly used by Adam; cameos, fans, ribbons, vases, palmettes, acanthus leaves, honeysuckle flowers, and guilloche and indent-pattern borders. It is also a good example of the refined technical precision typical of neo-classical decorative designs.

ture but gold and silver objects, jewellery, textiles and even hairstyles, were culled from such sources as the Hercula-neum publications and Caylus's *Recueil d'antiquités*—when they were not simply made up. A characteristic invention of the period was a multi-purpose article of furniture, based on a classical tripod, known as an *Athénienne*. Neo-classical design at this stage was Egyptian, 'Etruscan' and Roman as well as Greek.

We are thus forced to conclude that, despite the enthusiasm for all things Greek, the actual knowledge of Greek art at this period was still limited and confused and the number of works executed in a purely Greek style correspondingly small. In English architecture the main field in which pure Greek design appeared was the garden pavilion; an example is the small Doric temple in the grounds of Hagley Hall, near Birmingham, which was built by Stuart in 1758 and was the first of its kind in Europe. In France the short, stumpy Greek Doric or Tuscan column, rising straight out of the ground without a base, was used in large-scale buildings by architects like de Wailly and Peyre (in the Théâtre de l'Odéon, Paris, 1779–82), Chalgrin, Brongniart and Ledoux. But French architects were influenced by other considerations than Greek revivalism, as must now be explained. The true Greek revival in architecture, which swept across Europe and the United States in the early 19th century, did not begin until the 1790s.

THE CREATION OF 'EXPRESSIVE' ARCHITECTURE

The idea that the design of a building should express its function existed before and has continued to exist since the neo-classical period. But until the 18th century it was not so much the forms themselves as the ways they were used that were expressive. Thus the circular plan and simple mathematical proportions of the ideal Renaissance church symbolised the perfection of God; the dynamic rhythms, contrasting curves and upward soaring movement of the baroque church façade conveyed the power and glory of Catholicism. But in both cases the actual forms used, columns, cornices, pediments and so on—the vocabulary of classical architecture—were irrelevant to the expressive purpose; the same effect might have been gained with forms of quite different, non-classical design. Admittedly there was a belief that each of the orders had its emotional character or 'personality'; it was agreed that the Doric was masculine and the Corinthian feminine, with the Ionic in between. But directly the argument entered into details, confusion and contradiction set in. By the mid-17th century it was questioned whether the so-called characteristics of the orders were really inherent and therefore absolutely true, or whether they were simply established by custom. Certainly by the 18th century the fact that Vitruvius had laid down the general lines of approach was no longer considered a sufficient explanation.

The scepticism towards authority implied in this was the

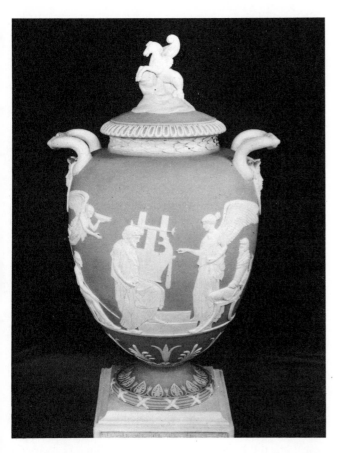

97. **Josiah Wedgwood.** *Vase with the Apotheosis of Homer. c.* 1789.
Blue and white jasper-ware. 13 in. high. (33 cm.). Nottingham
City Art Gallery. This shows the type of elegant vase, adapted
from Greek (then thought to be Etruscan) originals, made by
Wedgwood at his factory called 'Etruria' near Hanley, in
Staffordshire. Jasper-ware was invented about 1774–5.
The graceful lines and the forms of the decoration are akin to
Robert Adam's interiors. The very pure outlines of the figurative
relief, designed by the sculptor, John Flaxman, and the
Homeric subject-matter, are also typical of Neo-Classicism.

98. **Louis Joseph le Lorrain.** *Filing Cabinet. c.* 1756–57.
Oak veneered with ebony, with decorative motives in gilt
bronze. 63½ × 42½ in. (161 × 108 cm.). Musée Condé,
Chantilly. This cabinet formed part of a suite of furniture made
for the Parisian *amateur*, Ange-Laurent de Lalive de Jully,
who was clearly the inspirer of the design. Completely different
in style from rococo furniture, it was called *à la grecque*, although
the owner himself realised that it was not Greek in the true sense.
Its main features are its heavy, square-edged forms, straight
lines and abstract classical ornament. The looped garlands at
the top were nick-named well-ropes (*cordes de puits*).

starting point of the new, revolutionary theories of Corde-
moy (1706) and the Venetian teacher, Lodoli, which to-
gether were summed up and developed further by Laugier
in his *Essai sur l'architecture* of 1753. Not that these archi-
tectural philosphers wanted to discard the expressionist
approach to architecture and see its forms governed purely
by aesthetics. On the contrary, what they had in mind was
the rejection of the aesthetic approach; the orders were no
longer to be used ornamentally or as wall decoration, but
solely in accordance with their function. The most radical
definition of this function was given by Laugier.

Laugier based his argument on Vitruvius's contention,
previously accepted merely as a historical curiosity, that the
Doric order was originally developed from the uprights and
cross-beams of wooden temples. He then went further and
deduced that the wooden temple must have been derived
from a still earlier construction, the primitive hut. Like the
appeal to 'Etruscan' sources in the debate between the
supporters of Greek and Roman architecture, this was an-
other example of that fascination with origins that marked

the 18th century. It was equally an example of the fascina-
tion with nature as the ultimate authority. The primitive
hut preceded all other forms of construction and can only
have been evolved from a natural source. It was also
necessarily functional and therefore rational.

Modern architecture, argued Laugier, should similarly
return to first principles. It too should be rational and
functional. And just as the primitive hut, as Laugier
visualised it (he was the first to do so) would have consisted
only of upright posts, cross-beams and a pitched roof, so the
ideal modern building should consist entirely of the same
basic forms—columns, cross-beams and a roof. This was
the final challenge to Vitruvius's authority and to the
whole later development of classical architecture. What
Cordemoy had already called 'architecture in relief'
—pilasters, half-columns, ornamental pediments, attic
storeys and so on—all those forms previously used to articu-
late a wall surface—should go. Laugier even disagreed with
Vitruvius about the proportions and number of the orders;
he saw no reason why these should be sacrosanct.

Laugier's influence was profound and was greater than appears at first sight, for it is obvious that few modern versions of the primitive hut were required. His contribution was to assert that the forms of a building should proclaim its function and, although he passionately believed that the only proper form of upright was the column not the wall, he opened the way to the use of forms of any shape, arrangement or size. Visual beauty was to arise only from simple geometrical shapes and to be subordinate to character and expression. From this followed the tough, 'brutalist' quality of some neo-classical architecture, especially in France.

One of the first buildings to reflect Laugier's influence was the Panthéon by Soufflot, although, as we have seen, it also owed something to Piranesi and Roman architecture and depended on a 17th-century source—Wren's St Paul's Cathedral—for its dome. Originally the design would have been closer to Laugier's ideal for Soufflot wanted to make the outside 'more window than wall' but for structural reasons the windows had to be filled in. Inside he did succeed in supporting the roof, including the dome, entirely on columns, not piers (it is worth noting that he was also an admirer of Gothic construction). The detail throughout is of extraordinary, chilling beauty—very restrained, diamond-hard and austerely inventive, especially at the back. Needless to say it includes no ornamental or figurative sculpture. Appropriately, the building was praised by Laugier as 'the first example of a perfect architecture'.

Probably the most important building to show Laugier's influence in England before the time of Sir John Soane was Dance's Newgate Prison, (designed in 1769 and demolished in 1906); Laugier's functionalism was there combined with the melodrama of Piranesi to produce a building of consciously frightening power. In France the chief exponent of this approach was Claude-Nicolas Ledoux. Ledoux was the type of the 18th-century philosophical architect, as Laugier was the century's typical architectural philosopher. He summed up the rationalist tendencies of the age and, carrying them to their logical conclusion, undermined all its traditional methods. His favourite forms were the pyramid, the cylinder and the cube, and he sometimes dispensed entirely with classical motives.

Many of his works were purely theoretical and only existed in engraved form in a treatise published towards the end of his life, in 1804. They included a project for an ideal city, which looked forward to the secular, functional Utopias of the 20th century rather than backward to the symbolic Cities of God of the Renaissance. It was also typical of Ledoux's modern brand of functionalism to devise appropriate houses not merely for different classes of people but for people of different professions, activities and states of life; they included the House for the Writer, the House for the Broker, the Shelter for the Rural Guards, the House for Four Families, etc.. Moreover, although his buildings were formally composed of related units of solid geometry, without ornament of any kind, they were not abstract. On the contrary, their design was consciously expressive of their purpose, often in a quasi-symbolic rather than a practical sense.

The toll-houses or *barrières* erected between 1784 and 1789 on the outskirts of Paris exemplify this. Their purpose was the collection of a newly imposed tax on grain brought into the city from the countryside. Looking at, for example, the Barrière de St Martin, it is hard to avoid the feeling that Ledoux enjoyed his task. Although he was a revolutionary architect and dabbled in ideas about public morals and law which have a Rousseauesque flavour, he was an authoritarian in politics and, until the Revolution, a loyal servant of the government (he later became an admirer of Napoleon). His toll-houses were surely larger than necessary for practical purposes, and their massive, square-edged and brutal forms must have had an intentionally demoralising effect on the unfortunate peasants who had to pay taxes at them. It is not surprising that some were torn down by the mob during the Revolution or that their architect narrowly escaped the guillotine.

Despite Ledoux's conservative position in politics compared with that of Jacques-Louis David, there were interesting parallels between them in temperament and artistic personality. Both were to some extent *philosophes*, yet both were animated as much by passion as by reason. In treating the *Oath of the Horatii* as a pre-Revolutionary manifesto, David chose a subject whose implications were as eloquent of the subjection of the individual to the good of the state as were Ledoux's toll-houses. In *The Lictors bringing back to Brutus the Bodies of his Sons*, exhibited a few weeks after the start of the Revolution, this theme became explicit. Brutus who had condemned his sons to death for treachery, stoically turned his back on their bodies when they were brought back from execution.

But apart from these considerations of subject-matter, there is a Ledoux-like toughness and austerity in David's early style which sharply differentiates his interpretation of Neo-Classicism from the effete reworking of the Antique recommended by Winckelmann. In feeling and style his art looked back in many ways to Poussin; he used the same relationship of figures to space, the same method of modelling forms by light and shade and the same type of compositional arrangement. No other artist but Poussin created the same tension between the severity of the forms and the depth of emotion they contain. Yet there was also a new quality, for David's paintings expressed a modern, personal kind of heroism that was to be identified forty years later as Romantic by Stendhal.

THE
MODERN WORLD

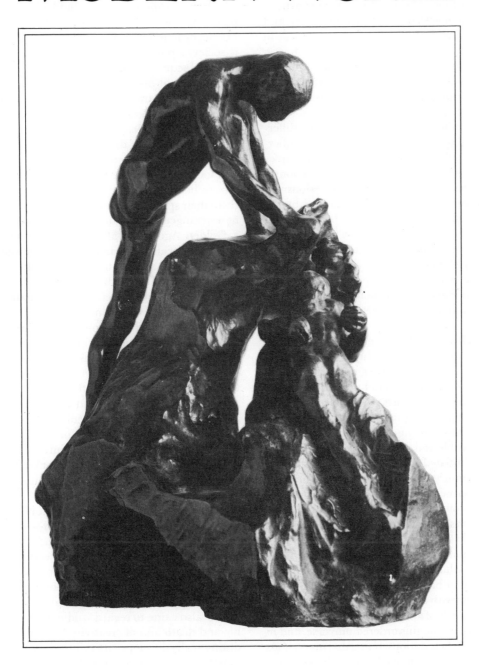

Introduction

It is precisely our uncertainty which brings us a good deal closer to reality than was possible in former periods which had faith in the absolute. KARL MANNHEIM

Today we are in a position to survey a vast field of artistic creation. We are familiar with the art of distant periods and people and know a great deal about the circumstances in which widely divergent kinds of art were produced. Though we have our predilections, we are accustomed to the notion of different kinds of beauty and different forms of significance and feel no need for a universally accepted hierarchy of art forms and styles.

In the eighteenth century the situation was quite different. Though artists in the western world might take liberties with the principles they had inherited, these principles were still upheld and defended. Rococo painting obviously represented some deviation from the high seriousness exemplified in the work of Raphael and preached by the academies ever since the sixteenth century, but it did not challenge this idealism. Not that there were no arguments about the relative greatness of modern and ancient artists, or about the primacy of colour over drawing or of drawing over colour (represented in France as a posthumous rivalry between Rubens and Poussin), but such dissensions took place within one small area, as it now seems to us, of the field of art.

Taking the period from the High Renaissance to Tiepolo as a whole, it is clear that the most highly regarded artists were those who stood at the centre of art, embodying those values upon which art was believed to be founded. Today we honour more readily those artists who are seen to stand on the periphery of art, seeking to extend its realm. This reversal has come about during the last century and a half; it was made possible and necessary by revolutionary processes that were initiated in the eighteenth century.

To speak of that century as an age of reason is curiously wide of the mark. It opened as an age of reasonableness and became an age of revolution. The world as described by Descartes and Newton seemed to offer man a definable and secure place. All would be well if man lived in harmony with this essentially harmonious universe—a beneficent God-ordained system into which man would fit if he practised a kind of spiritual etiquette based on moderation. But having settled his relationship with his Maker, man now turned to himself. 'The proper study of mankind is man,' wrote Pope, the greatest poet to celebrate this ordered universe, and in so writing he struck at its foundations. Using that marvellous reason, which had achieved so much for preceding generations, eighteenth-century men probed into man himself. Being able to take for granted the physical and theological pattern left to them, they examined man for the first time independently of any supernatural factors: man as man. At once it was seen that reason plays a minor role in man's life. He has emotions, sensations, instincts that determine his actions and reactions; even when reason is put to work, irrational factors will decide what it is to work on. Pascal's precocious recognition that 'the heart has its reasons of

which reason knows nothing' suddenly became a commonplace. And when man turned to the society that shaped his life, he found it ill-designed to meet his needs. Yet what is society's purpose?

Jean-Jacques Rousseau (1712–78) asked most of the questions that his age wanted asked and provided many answers. He examined civilised society and found it to be a kind of straitjacket that hampered man's natural growth. But society was clearly created by men, for their mutual benefit in some far distant past. If some were placed in positions of power, this must have been by general agreement and for the good of all. So it follows that if rulers failed to govern beneficially, the implicit contract which had given them their special position could be considered broken and new arrangements made. Accepting the ancient dream of a Golden Age when all men lived in perfect harmony, Rousseau dreamt of a primitive society devoid of the artificial accretions that seemed to stifle his world. For the first time in the history of civilisation man wondered what he might have lost in achieving social order and material advantages. And as he turned away from civilisation and looked longingly towards what had been thought of as barbarism, so also he turned away from cities and formal gardens towards nature.

Nature came to be seen as the regenerative, corrective influence it has been for us ever since. For the first time man felt the exhilarating drama offered by great mountains and the hints of cosmic vastness and timelessness given by deserts and empty oceans. It is difficult to us today to imagine a world in which people took no interest in wild nature, but it has to be emphasised that to European culture the high and slightly guilty regard we have for landscape and for the rustic and the seafaring life is something quite recent. Nor do the occasional exceptions in earlier times disprove this—one thinks of Petrarch's ascent of Mont Ventoux in 1336 and of Breughel's Alpine sketches of 1554. The writers of the later eighteenth century and the painters of the nineteenth educated the western world into a sensibility towards the appearance and the processes of nature. And this last aspect is perhaps the more important: it was not only the appearance of nature that now appealed to man, but he also came to regard wild nature as the exemplar of life and death and of creativity. At the same time science dramatically developed its ability to explain these processes in nature and in man himself.

Developments of this kind, accompanying the demolition of old social structures, the industrial revolution's assault on old ways of life and the loosening hold of religious faith on the minds of many, have given us a sense of vulnerability and of individual isolation as well as a new need for self-reliance. Modern man is expected not so much to learn the rules of religion and society and to abide by them, as to 'find himself' and to be 'true to himself'. The onus is inescapable and considerable, and it is small wonder if, in all forms of

human creativity, the kind of beauty that results from arranging beautiful objects to convey a harmonious idea has generally been replaced by more challenging and discordant forms of signification.

Revolutions in attitudes and values, unlike political revolutions, proceed mostly below the surface of man's actions. Obviously the nineteenth and twentieth century world is full of elements, even apart from the constancies of human existence, inherited from the eighteenth. This cultural retentiveness is what makes history like a woollen thread and not a string of sausages, varying in quality and degree from country to country, from town to country, between social classes. A survey like this one must highlight those new elements that establish themselves sufficiently firmly to become part of the complex thread, and it is the beginning of each significant fibre that is likely to receive the most attention. The reader is therefore warned against seeing as a succession of inspired leaps those gestures of rebellion and reconstruction that may scarcely have been noticeable within the matted complexities of the contemporary situation. Certainly the nineteenth century holds a special place in history for offering the widest chasms between progressives and reactionaries, rich and poor, enlightened and philistine. Any revolution separates clearly those who wish to preserve what they can of the past from those who want to replace the past with something new. In the nineteenth century this confrontation happened at many levels of existence: radicalism and conservatism divided the worlds of religion, politics, science, and education as much as the world of the arts. The vehemence of the struggle was quite unprecedented.

The eighteenth century, then, prepared the ground for these battles and largely determined the causes over which they should be fought. In the arts it had been a strange period. The seventeenth century, the age of Baroque, had been full of creative actions on a bold scale. Splendid buildings were erected in Europe's capitals, especially churches and palaces, but including also the handsome merchant houses of Amsterdam. There was an impressive series of outstanding artists from several countries— Bernini, Poussin, Rubens, Rembrandt, Velasquez, and behind them crowds of other fine painters, sculptors and architects that in a less star-spangled age might have achieved greater prominence. The arts had worked together harmoniously to create monuments to the glory of God and of kings and princes: the palace of the sun-king Louis XIV at Versailles is a fitting climax to the age. The eighteenth century was not without its extravagant princes trying to emulate Versailles (especially in Germany where, in other respects too, the Baroque had a late flowering), but the art of that age is characterised by delicacy where the Baroque was robust, domesticity where the Baroque was palatial, privacy where the Baroque was public. The virtues of

eighteenth-century art are those of restraint and refinement, and this restraint applies also to art's subject-matter and emotional content. The novel, the essay and the shorter poem are its literary forms while the seventeenth century had produced great epic poems and real tragedies. The scale of creativity had changed. Although the academies continued to yield pride of place to history painting (paintings of subjects from ancient mythology and history, from the Bible and very occasionally from modern literature), it was the minor art of portraiture that flourished particularly. When eighteenth-century artists attempted the great themes to which they were encouraged to aspire, they diminished them, as Boucher, for all the charm of his art, diminished the gods and goddesses that lounge about his elegant canvases. The seventeenth century had been heroic in its actions; so too in less obvious ways the nineteenth century was to be heroic. In the seventeenth century this heroism had the almost invariable support of great patronage; in the nineteenth, heroic actions were to be performed increasingly without benefit of patronage or encouragement.

The eighteenth century left much in confusion, not least the arts. The habit of preaching one kind of art and producing another weakened the principles upon which art had been founded. But the century saw also processes beginning that would be much more destructive: the growth of historicism, of archaeology and of interest in non-European civilisations. The Greco-Roman paintings discovered at Pompeii and Herculaneum, the detailed study and recording, for the first time, of classical Greek architecture in Athens and elsewhere, and of Roman architecture in outlying centres such as Palmyra and Baalbeck, the investigation of medieval remains as part of the study of national pasts—these were some of the most important aspects. They led inevitably to the dethronement of imperial Rome and sixteenth-century Italy as the only true authorities in art. Greek architecture had qualities which the Roman had not, imperial Roman architecture of Augustus's time was shown to be only one stage in the development of Roman design, countries such as Britain, France and Germany could point to exceptional artistic achievements completed before the Renaissance spread its veneer of Mediterranean classicism, and the arts of Egypt, India and the Far East offered exotic delights as well as serious instruction. Where there had been one composite model for high art, there now were many. It is remarkable how quickly writers on art and sometimes artists found it necessary to discover moral reasons rather than aesthetic ones for attaching themselves to one style of art or another.

One aspect of this intensified interest in the past and awakening appreciation of other cultures was the development of art history. Before the second half of the eighteenth century the art of the past was studied in direct proportion

to its significance as a guide to the present. Vasari in the sixteenth century had written biographies of the most important artists of his country, from Giotto to Michelangelo, to show how in Michelangelo Italy had produced an artist at least equal to the greatest in antiquity. Of antiquity itself he knew relatively little; of the Dark Ages that came between his time and antiquity he did not care to know much. Imperial Rome was the only past that mattered. From the 1760s on this simply focussed view has to be discarded. The German scholar, Winckelmann, made the first systematic study of Greek art and showed how different phases in its development brought forth different qualities comparable to those discernible in the different phases of Renaissance art. This implied what others at about the same time had stated firmly—that criteria must vary according to the period of art to which they are applied. Other scholars made studies of Byzantine painting, found opposed virtues in Sienese and Florentine painting, and came to see qualities in the 'primitive' phase of Italian art (particularly in the art of Fra Angelico), that were not to be found in the more grandiose art of Raphael. This acceptance of the relativity of styles brought with it the separation of aesthetic quality from the idiom, and to some extent from the subject-matter of any particular work of art.

The nineteenth-century artist was freed of all obligations but that of being a genius. In his essay on Gothic architecture, inspired by the sight of Strasbourg Cathedral (1772), Goethe states that 'whether it proceeds from savage rudeness, or from refined feeling, art is complete and vital. It is the art of the characteristic, the only true art. The genius must look neither at models nor rules, must not profit by the wings of others, but by his own'. And Baudelaire warned (1859): 'Everything that is not sublime is useless and criminal'. The freedom thus given to the artist is matched only by the burden placed on him. And on us too there is placed a burden, to search into the world of the artist which never before has had so many mansions, but the rewards are infinite.

The numbers in the margins refer to the illustrations of The Modern World: heavy type for colour plates, italics for black and white illustrations.

The First Half of the Nineteenth Century

DAVID, WEST AND THE CLASSICAL TRADITION

In 1785, the *Salon*, the official annual Paris art exhibition, was dominated by a picture at once recognised as revolutionary: *The Oath of the Horatii*, by Jacques Louis David (1748–1825). A critic called it 'the most beautiful picture of the century'. Yet it is a curiously bare work, charmless in colour and austere in design—scarcely the kind of picture one would have thought likely to please the fashionable world of eighteenth-century France. In fact, it met a demand that had been growing during the preceding twenty or thirty years for an art that refuted the grace and frivolity of the Rococo and aimed at high standards of didactic seriousness and aesthetic severity. Others, such as Greuze and David's teacher Vien, had set off in this direction but here was a work that fully satisfied both standards. Its subject is that moment when the brothers swear to fight to the death to save their city from the attacking tyrant, and David has staged it with the strictest economy and clarity. The three young men are fused into one silhouette, balanced on the right by the looser group of women and children. All the figures and the action occupy one plane within the bare and box-like space of the picture's architecture. The result is great psychological concentration on the event. Stylistically, this picture derives from Roman reliefs and the paintings of Poussin, although David goes much further in constructing his composition on almost blatantly geometrical lines. Behind the impressiveness of the subject stands the condition of France. France was on the eve of revolution; and here was a picture celebrating the moral vigour of republican Rome.

In subsequent pictures David returned again and again to themes that were drawn from ancient history to illuminate the condition of France. His style became more elaborate and he used the latest archaeological discoveries to produce an effect of historical accuracy. The ladies of Paris began to imitate the clothes and coiffures of the women in his pictures; French furniture makers drew on his pictures and on his sources. David became politically as well as culturally powerful, and acted as artistic dictator until the fall of Robespierre, when he was imprisoned for some months. It was then that he conceived the theme for a picture to celebrate peace and love: *The Sabine Women* (1796–9), showing these ill-gotten women boldly imposing peace between their captor-husbands and their fathers and former husbands. The picture transcended political factions and was greatly admired. David himself saw it as a great advance from the primitive solidity of the *Horatii*, and as Greek where the earlier picture had been essentially Roman. He modelled the main figures on the Hellenistic sculptures that General Bonaparte was sending to France from Italy.

With works such as these David made Neo-Classicism a revolutionary style, taking it far beyond sixteenth- and seventeenth-century classicism in factual accuracy, severity of presentation and undisguised didacticism. 'The antique will not seduce me', he had said in 1774, when he set off for Rome; 'it lacks action and does not stir the emotions'. What he saw in Rome persuaded him to *choose* classicism, and his success led others to choose the style soon after. Stylistic questions apart, Neo-Classicism in David's hands also served to cleanse painting of a lavishness of design and colour that in the hands of all but the finest painters had become cloying. As France's leading painter he had a large number of select students, and he taught them with a liberality of taste that was quite unusual in Neo-Classical circles.

The American painter Benjamin West (1738–1820) spent the years 1760–3 in Rome, undergoing much the same experiences that made David into a firm classicist. In 1763 West settled in London and in 1771 was appointed History painter to King George III. 'History' (meaning narrative, from the Italian *istoria*) was the term for art dealing with noble themes from classical authors or religious texts in a dignified, instructive manner. David's paintings are outstanding examples of the tradition going back to the Renaissance and classical antiquity. This kind of art was agreed to be the most important and honourable, as well as the most taxing. It was partly in order to encourage the growth of a national British school of History painting that the Royal Academy had been formed in London.

Yet his most famous painting, *The Death of General Wolfe* (1770) challenged and in effect undermined the tradition to which it contributed. In 1759 Wolfe had defeated the French defenders of Quebec City by means of a night attack. He thus secured French Canada for the British, but he was mortally wounded and died during the battle. West turned accounts of the event into a narrative painting of modest size yet unmistakably of the History kind. People who saw it as he worked on it were amazed to see its hero and bystanders in modern dress, not the nudity or vaguely classical robes usual in History painting: if West was to attempt to give History status to a recent event, he should do all he could to avoid datable details lest his work, tied to a particular moment, should soon lose its moral and artistic point. But when he had finished, 'Mr West has conquered', said the admiring Reynolds, overcoming his earlier doubts.

Ba 99

INGRES

David's most successful pupils were Antoine Jean Gros, whose dramatic pictures of Napoleon campaigning have much of the Baroque's fulsomness while his teaching was much more strictly classical than David's, and Jean Auguste Dominique Ingres (1780–1867), who upheld the dignity and the primacy of Neo-Classicism in France during the first half of the nineteenth century while working in a highly idiosyncratic style shot through with Romantic fantasy. In him are uniquely combined the two main traditions of

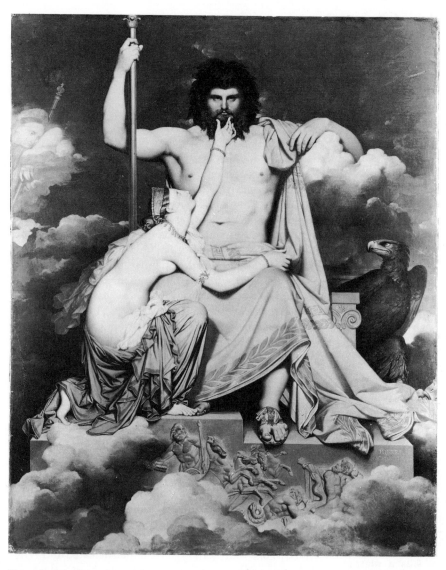

French painting, that of Poussin and that of Rubens, with Poussin representing rationalism, design and an appeal to the educated mind, and Rubens emotionalism, colour and an appeal to the senses. Consciously he was dominated by classical standards. His devotion to the ancients was absolute: 'Regarding the marvels of the ancients, doubt itself is a reproach'. He taught that all the expressive power of painting resided in the drawing. Drawing 'is the foundation, it is everything. A thing well enough drawn is always well enough painted'. He accepted the high academic rating of History painting, and, while it was necessary for him to paint portraits (and they include some of his finest work), landscape was to him at best a backdrop. He advised a visiting German landscape painter: 'Study Pheidias, Raphael and Beethoven, and you will be the greatest landscape painter in the world'. Colour was to him 'the animal part of art', a dangerous element that could interfere with 'the profound study that the great purity of form demands'. Purity of form demands purity of outline. Ingres's drawing abandons the meticulously detailed modelling of academic drawing since Raphael in favour of an outline that will suggest the roundness of the object. The Greeks were thought to have placed a similar emphasis on outline, and the published engravings of discoveries at Pompeii and

Herculaneum may have encouraged this notion. But Ingres's line went beyond the normal drawing of Neo-Classicism in its ability to present a highly refined form and yet transmit his sensual awareness of the subject.

Partly because of this, his work was at first dismissed as barbaric. Ingres did in fact find himself attracted by what he described as 'the formless beginnings of certain arts' which 'sometimes contain, fundamentally, more perfection than the perfected art'. He was the first primitivist in European painting, studying Giotto and early Florentine painting as well as unclassical aspects of ancient art as found in some Greek vase painting.

His *Jupiter and Thetis* (1811) illustrates the dualism of his art. At first sight it is a boldly Neo-Classical work, clearly organised on one plane and with the concentration of action that David's example encouraged. But to convey the emotional situation described by Homer, the clinging and beseeching Thetis and Zeus obdurate, he has recourse to an extreme degree of exaggeration and abstraction, opposing a soft, curling structureless form to an almost symmetrical monolith. In due course, however, Ingres established himself as the defender of classical standards with paintings in which his idiosyncrasies were subdued; he had a tremendously successful career and honours were heaped on him.

He ruled despotically over a large number of students, forbidding them absolutely to look at pictures by Rubens, and attempted to rid French art of all the tendencies associated with Romanticism. In his own work it continued, however, to be his hypersensitivity to line and the powerful sensuality expressing itself through that line, that made his work so much superior to most Neo-Classicism and most Romanticism. His work ranged brilliantly from exquisitely composed portraits to sensuous paintings of nude women as *Odalisques*, their erotic content sharpened by exotic seasoning, and from limp and defenceless maidens chained to rocks for semi-Gothic Rogers to rescue, to *The Apotheosis of Homer*, intended to decorate a ceiling and representing an apotheosis of classicism, with portraits of the heroes of the French classical tradition. One of his last works was *The Turkish Bath* (1863), an anthology of his life-long studies of the female form, assembled as though to prove his command of abstract design.

Ingres, by placing himself at the head of French classicism and attacking all aspects of Romanticism, labelled himself a reactionary. Yet he has given much to modern art and in many respects comes closer to later developments than most of his liberal contemporaries. Not only did Degas, Picasso and others look to him as a master draughtsman, but his reiterated emphasis on drawing combined with his sense of perfect form was abstract in intention. Classical idealism aims at the representation of the perfect object; Ingres's idealism aimed at the perfect work of art. For its sake he allowed himself extremes of distortion of forms and of space, and this not for the sake of any impersonal absolute but for the sake of the expressive power of each picture. His work varies widely. Even his bigotry had something modern about it: no painter had more moral view of art and of the rightness of his own work. And he was the first painter to voice his sense of the frivolousness of easel painting, that 'invention of periods of decadence'—a view frequently expressed since his time.

DELACROIX

As leader of classicism, Ingres found himself confronted by the younger painter, Eugène Delacroix (1798–1863), as the unwilling champion of Romanticism and modernity. Ingres consciously held classical values while he undermined them in his art; Delacroix resisted being called Romantic and saw himself as part of the classical tradition. His view of that tradition was a personal one. He greatly admired Poussin and indeed wrote about him. But his opinions changed, for having admired Raphael as the greatest of all painters (Ingres would have agreed with him), he replaced him in turn with Rubens, Titian and Rembrandt. The 'ancients' were his ideal of excellence, but 'Titian and the Flemish painters have the spirit of the Antique', and 'Rubens is more Homeric than some of the ancients'. At every stage of his work the classical and the romantic conflict and collaborate. Baudelaire said that 'Delacroix was passionately in love with passion, but coldly determined to express passion as clearly as possible', and at once we recognise that this synthesis of passion and control is the basis of all the greatest art. But as a Romantic Delacroix placed special value on excitement, warmth, richness, spontaneity and fantasy even while he insisted on the need for knowledge and skill.

As a young man, Delacroix had greatly admired the work of Théodore Géricault (1791–1824). From him he got his passion for English painting and English literature (particularly Byron and Scott), and his first major work, *Dante and Virgil crossing the Styx* (1822), owes a good deal to Géricault. But Delacroix found his friend's work lacking in unity. To him unity meant a deep concordance of subject, meaning and manner, and the integration of the elements of the picture into one dynamic gesture. He was, in short, a Baroque painter, bringing to largely secular subjects the celebratory enthusiasm which the Baroque reserved for gods and kings. Medieval history and legends, Nordic myths, Renaissance and modern fiction, contemporary events and scenes—Delacroix ranged widely over the subject-matter that the age of Romanticism opened to art. His first masterpiece, *The Massacre of Scio* (1824), symbolically represents the dominant political topic of his time, the Greeks' struggle for independence, and he returned to the theme in *Greece expiring on the ruins of Missolonghi* (1827). The 1830 revolution even led him to produce his one treatment of contemporary Parisian life, though this too was in symbolical terms—*Liberty on the Barricades*. More characteristic of him, though, is subject-matter of a more melancholy kind, reflecting more directly his own personality and solitude. We may imagine him in character somewhere between Hamlet and Faust, both of them very much in his mind and frequently in his art. Perhaps *The Death of Sardanapalus* (1828) reveals him most fully. Its subject comes, like many others, from English literature, from Byron's tragedy of 1821, dedicated to Goethe. The Oriental king is soon to die. He reclines on his funeral pyre, while the objects that gladdened his life are destroyed before his eyes: jewels and precious jugs and bowls, his horses and his women. His slaves do his bidding and the scene is one of great violence, but the king is unmoved, even by the almost sexual abandon of the girls (sisters, surely, of Ingres's houris). For all the agitation it is a quiet picture. In spite of the near-chaos of the cornucopian composition, attention focusses on the heavy, immobile and spiritually detached figure of Sardanapalus. Neither he nor the others are drawn with much accuracy—he looks very much like a Henry Moore sculpture—and if we examine a preparatory drawing for the picture, we can see at once that anatomical accuracy was no part of Delacroix's programme, but rather expressive pose and movement, to which in the painting he added colour and chiaroscuro. The picture is full of musical qualities, with passages that communicate their emotional content long before they are recognised for what they represent, with shapes that stand out like melodies to reappear elsewhere in developed form, and with groupings within the total composition that seem almost like symphonic movements. Delacroix had a passionate love for

2. **Eugène Delacroix.** *Studies for the Death of Sardanapalus. c.* 1827. Pen and wash. 8 × 12¼ in. (20.5 × 31.4 cm.). Louvre, Paris. As these studies show, Delacroix was more intent on finding dramatic and affecting figures and relationships than naturalistic accuracy.

music, which seemed to him the finest of the arts for its direct appeal to the emotions, and he often spoke of musical qualities in painting. He wrote: 'There is an impression produced by a given arrangement of colour, light, shade, etc.. This is what might be called the music of a picture'. One of the basic themes of nineteenth-century painting is the growing value attached to this pictorial music, and the conflict between this and the representational aspect of painting.

Among these musical qualities in painting, colour is of prime importance. In this respect particularly, Delacroix prepared the ground for many a subsequent painter. He learned much from Veronese, Rubens, Titian and Rembrandt. His contemporary, Constable, taught him how to keep an area of colour alive by breaking it up into small touches of differing shades and tones of that colour. From observation he learned the colour content of shadows and the mutually invigorating effect produced by complementary colours in juxtaposition. He appears to have known of Chevreul's lectures about colour contrasts through a friend's notes. His visit to North Africa in 1832 greatly developed his awareness of colour, and in subsequent paintings, especially in the great murals he did for a chapel in Sainte-Sulpice (1857–60) and elsewhere, he used complementaries to animate his colour harmonies. His comments on colour are noted in his *Journal* (first published 1893–5) but were available long before that through the writings of assistants and theorists; they were of great seminal importance later, especially to the Post-Impressionists.

Neither Ingres nor Delacroix had followers of great significance. Théodore Chassériau had the distinction of drawing on both masters without diminishing what they stood for. Others popularised the exotic side of their work, building careers on scenes of North Africa and Near Eastern life that were vaguely thought of as Oriental. But most of their successors turned out work whose banality facilitated public acclaim. It is against the spongy bulwarks of their established art that a handful of impatient artists were to lead their attacks. Only in the field of landscape painting did other French painters help to lay the foundations for what was to follow in the second half of the century and to this subject we shall return.

Outside France, Neo-Classical painting flourished but

briefly, while Neo-Classical sculpture and architecture endured. Nor did any other country produce grandiose Romantic painting comparable with Delacroix's. Apart from landscape painters, who, from the 1790s onwards came in every spiritual size, the most significant painters were strange individual figures that seemed to exist outside the art of their age.

GOYA

The Spaniard, Goya, for instance, may seem to have been as public a painter as anybody, for he was principal painter to Charles IV of Spain. Yet the greater part of his work, and certainly his greatest work, was profoundly personal in character—so much so that one is astonished at the recognition with which his abilities met. Francisco de Goya y Lucientes (1746–1828), David's close contemporary, began his career in a world of faltering Rococo and a decaying court. Neo-Classicism was the revolutionary alternative to Rococo, a public and impersonal art of reconstruction. But Goya chose not to offer visions of a nobler world but to record the sickness of his own, and to this purpose developed a graphic and a painting style that derived from Tiepolo, Velasquez and Rembrandt.

He was the first but not the last painter to use his art to mirror the evils of his time, and his time provided him with exceptional evils. It brought to a decadent Spain war, insurrection and reprisals of a savagery quite abnormal until our own century. Fate gave Goya not only genius but also brought him repeated sickness and total deafness from the age of forty-six. Visual communication alone linked the troubled man to the horrors of the outside world. The first fruit of his particular relationship to the world around was the set of etchings, *Los Caprichos*, begun about 1796 and offered for sale in 1799. Here was something quite different from the social commentary of caricaturists who lampooned the protagonists of society and politics for the entertainment of society. Goya's satire is rooted in compassion, is unpartisan, and ultimately expresses an optimistic sense of misery resulting more from institutional forces than from individuals. A well-known plate of the *Caprichos* is that inscribed *El sueño de la razón produce monstruos*. The artist sits, sleeping, while dreadful images crowd about his head: 'The dream of reason brings forth monsters'. The world of

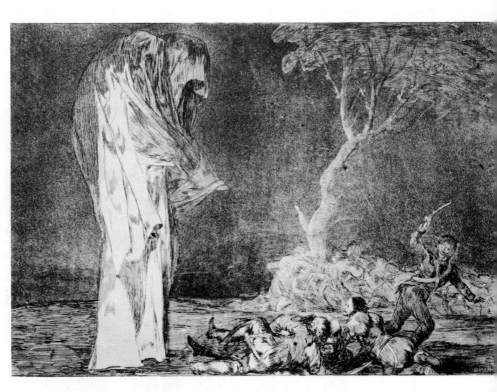

3. **Francisco de Goya.** *Disparate de Miedo* (The *Disparate* of Fear). Etching No. 2 of the *Disparates* or *Proverbios*. Date unknown—this etching appeared in posthumous proofs, 1854–63. 9¾ × 13¾ in. (24.5 × 35 cm.). British Museum, London. Goya not only commented on the condition of his world: he gave visual expression to timeless anxieties that had not before been allowed to form art's content.

Romanticism was aware of man's mental activity below the conscious level of its creative power, and some people toyed with subconscious imagery as an alternative to Gothick contrivance. In Goya's case one feels he would rather not have dreamt. It is a painful world he inhabits, in which recognisable subjects mingle with figures out of witchcraft and ancient symbols of evil. A drawing for the same plate has the inscription, 'A universal language, drawn and etched by Francisco de Goya in the year 1797'; his intensely personal vision, he implied, is the common property of us all, and he was right. He recorded the collapse of eighteenth-century stability in terms that apply to all periods of social disintegration.

Between 1808 and 1815 Goya worked on his second series of etchings, the *Disasters of War* (not published in full until 1863). Here he was dealing with specific events, which he condensed into often quite simple subjects and presented with great dramatic force. Behind these etchings lay the Spanish tradition of the barely sufficient statement: the naked stage, direct communication across the footlights, the complete lack of sentimentality. His large painting, *The Execution of the Rebels on 3 May, 1808* (1814), is related to the series and shows the same bareness and concision. The figures are grouped with almost diagrammatic clarity, the landscape setting has a primitive bleakness and merely provides an arena for the action, and the faceless soldiers, blind agents of impersonal power, act as one force against their bunch of prisoners. There is a surprising lack of colour. The dominating grey-greens and ochres suggest the colours of Analytical Cubism, just as the picture as a whole sends one, in search of descendants, via Manet to Picasso's *Guernica*. Goya is clearly in the Baroque tradition, yet the clarity of this design is such that one can compare it with David's in *The Oath of the Horatii*. Not only do Neo-Classicism and Romantic Baroque meet as equals in this picture, but they join hands with the primitive Renaissance art of Giotto

as Goya jettisons all the skills of painting trees and landscape and individualised human beings.

The anti-naturalistic and fantastic element in Goya's art that frequently showed in his previous work, dominates his next series of etchings, the *Disparates* (Curiosities) or *Los Proverbios*, etched between 1815 and 1820. These, like the paintings he did on the walls of his house during the same years, are all images of profound anxiety. Such work could not produce immediate followers. Indeed, one is tempted to see Goya as the end of a development and a national school. But the *Caprichos* were known in France and England (Delacroix, for example, made drawings after the whole set), and from the 1860s onwards Goya has been recognised as part of our artistic inheritance in that fundamental, inalienable way shared perhaps only by Michelangelo and Rembrandt. All his work radiates his humanity. He was the first great artist to have treated contemporary horrors as his material. In a very un-Baroque and modern way he chose subjects without heroes, in which the protagonists are the anonymous multitude and nothing is achieved but a secular and pointless martyrdom. He was the first and greatest painter of the absurd.

BLAKE

In England portraiture still received the lion's share of artists' and patrons' attention. Gainsborough and Reynolds had brought to it exceptional talents, and had promulgated a new kind of portrait, informal even when presenting princes, that had considerable influence on the Continent. But Reynolds condemned the low ambitions of artists content with portrait painting and worked for a situation in which painters and sculptors could emulate the great Italians and devote themselves to treating important historical and religious themes in a classical manner. His pleas had some effect. A small number of influential but not very agreeable British artists (and Americans in Britain)

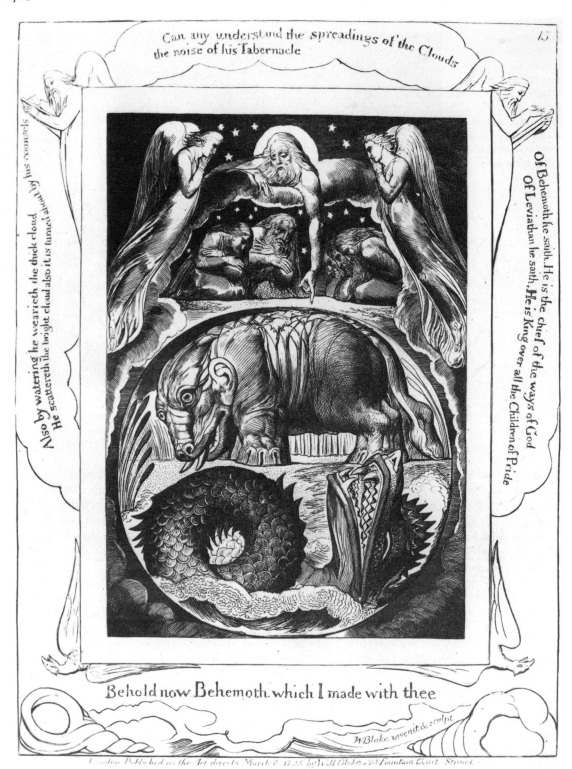

Behold now Behemoth which I made with thee

Can any understand the spreadings of the Clouds the noise of his Tabernacle

Also by watering he wearieth the thick cloud He scattereth the bright cloud also it is turned about by his counsels

Of Behemoth he saith. He is the chief of the ways of God Of Leviathan he saith, He is King over all the Children of Pride

W Blake invenit & sculpt

London Published as the Act directs March 8 1825 by Will Blake N.t Fountain Court Strand

contributed to the development of international Neo-Classicism.

Britain's major nineteenth-century painters did not fit *4, 7* Reynolds' prescription. William Blake (1757–1827) detested everything Reynolds stood for. He wanted passion, imagination, the rejection of everything that smacks of moderation and good breeding. 'The road of excess', he wrote, 'leads to the palace of wisdom'. In his poetry and his art, often in combination, he presented a view of the world in which man, through his mental and physical powers and desires, is directly linked to the supernatural. ' "What," it will be Question'd, "When the Sun rises, do you not see a round disk of fire somewhat like a Guinea?" O no, no, I see

4. **William Blake**. *Behemoth and Leviathan, illustration no. 15 to Book of Job*, 1825. Engraving, 7 7/8 × 6in. (20.1 × 15.1cm), Tate Gallery, London. For Blake art imitated nature only in order to make his visions visible to others. Blake saw Job as representing those who followed religious observances without regard for its spirit, and his illustrations carry a polemical charge as well as serving the Biblical text.

1, 2. **Jacques Louis David**. *The Oath of the Horatii* (above). 1784. Oil on canvas. 130 × 168 in. (330 × 427 cm.). Louvre, Paris. *The Sabine Women* (below), 1799. Oil on canvas. 152 × 245 in. (386 × 520 cm.). Louvre, Paris. Two stages in David's Neo-Classicism are represented here: masculine severity in the earlier work succeeded by greater elegance and elaboration in the later.

(Continued on page 785)

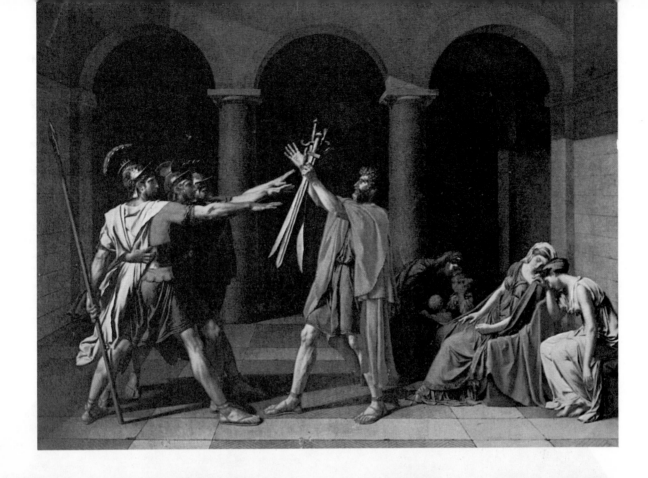

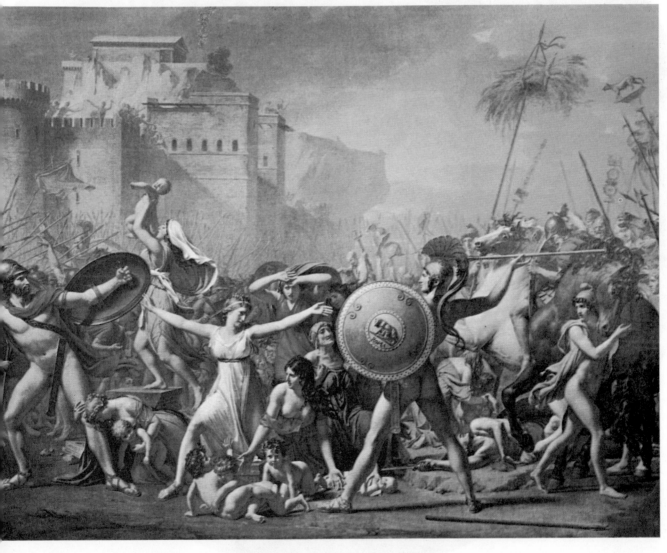

3. **Jean Auguste Dominique Ingres.**
The Turkish Bath. 1863. Oil on canvas.
42½ in (108 cm.) diameter. Louvre,
Paris. Although Ingres considered himself
the champion of the new classicism, his
work often incorporates elements of fantasy
and of Baroque design which suggests that
Neo-Classicism must be regarded as one
facet of Romanticism. Typical of his time
is Ingres's fascinated interest in the Near
East; exceptional for his time, the
expressiveness of his design and the sub-
servience to it of natural appearances.

4. (opposite). **Théodore Géricault.**
Horse Frightened by Thunder and Lightning.
1820–21. Oil on canvas. 19¼ × 25¾ in.
(49 × 60 cm.). Reproduced by courtesy of
the Trustees of the National Gallery,
London. Painting and horses were the twin
passions of Géricault's life and he
combined them on several occasions. But
the horse had a special significance for
Romantic art generally as a pure and noble
beast of exceptional sensitivity, with exotic
associations.

5. (opposite below). **Eugène Delacroix.**
The Death of Sardanapalus 1827. Oil on
canvas. 145 × 195 in. (395 × 495 cm.).
Louvre, Paris. One of the largest and most
complex of Delacroix's easel paintings,
Sardanapalus is also one of the most turbulent
embodying the half-guilty regard for Near-
Eastern barbaric pleasures of his time.
Delacroix has filled his picture with
incident and with dynamic forms and
colours, yet every part is anchored to the
compelling stillness of the king, whose
formal weight resolves the restless jig-saw
puzzle of bodies and objects just as the white
of his robe appears to subsume all
the other colours of the painting.

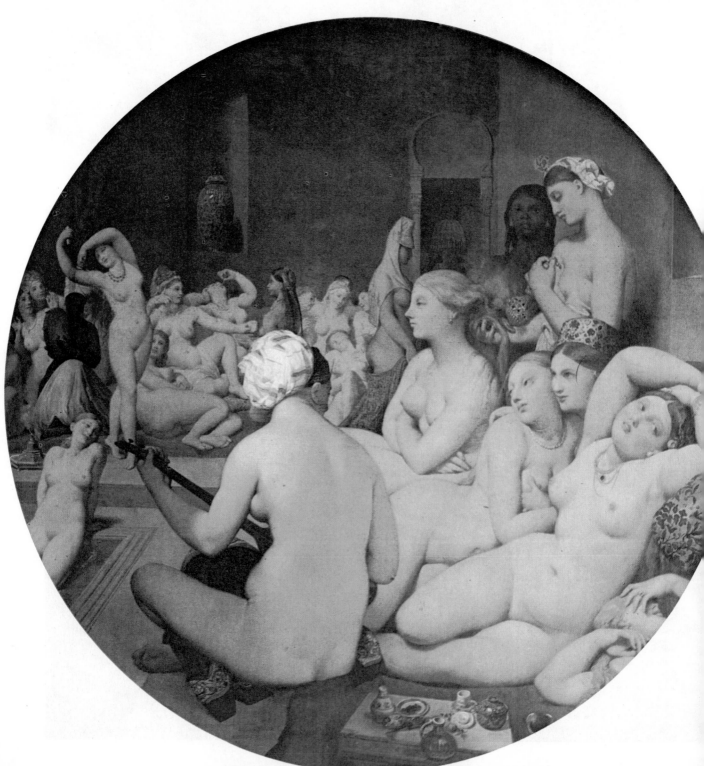

6. Francisco de Goya y Lucientes.
The Execution of the Rebels on 3rd May, 1808.
1814. Oil on canvas. 104½ × 135½ in.
(266 × 345 cm.). Prado, Madrid. The
coincidence of Goya and the Napoleonic
wars in Spain produced a new kind of
painting: on the scale of a History painting,
but using a contemporary subject without
heroes to celebrate. Here there are no
names, no glorification, but a bare,
powerful statement of man's pointless
inhumanity. The whole picture is directed
towards this statement—little colour,
composition and artificial light
concentrating attention on the action, the
executioners abstracted for the sake of
concision and expression. It is thus a distant
forerunner of the bare stage of modern
drama.

7. William Blake. *The Simoniac Pope.*
c. 1825–27. Watercolour. 14½ × 20½ in.
(37 × 52 cm.). Reproduced by courtesy
of the Trustees of the Tate Gallery,
London. One of an unfinished set of
Dante illustrations done in the last years of
Blake's life. His visionary art is seen here at
its most clarified—the many sources on
which he drew having been integrated
within a personal style that has little
connection with the art of Blake's time.

HELL
Canto 19

8. **John Constable.** *Barges on the Stour, with Dedham Church. c.* 1811. Oil on paper laid on canvas. 10¼ × 12¼ in. (26 × 31 cm.). Victoria and Albert Museum, London. (Henry Vaughan Bequest). It is customary nowadays to insist on the vigour and freshness of Constable's exhibition pieces, the larger paintings for which studies such as this oil sketch were done. They lack, however, the fluency of his small sketches, the immediacy of notation and the truth to natural appearances that combine to give the impression of absolute spontaneity and disguise the wealth of artistic skill and scientific knowledge that went into them. Constable's view of the natural world has become so integral a part of ours that it requires an act of will to remember that the reality of his pictures is not nature's reality but art's. 'It is the business of a painter', he wrote in 1824, 'not to contend with nature . . . but to make something out of nothing, in attempting which, he must almost of necessity become poetical.'

9, 10. **Joseph Mallord William Turner.**
Norham Castle. c. 1840–45, (above) and
Snowstorm—Steamboat off a Harbour's Mouth.
1841–42, (below). Both oil on canvas. 36
× 48 in. (91.5 × 122 cm.). Reproduced by
courtesy of the Trustees of the Tate Gallery,
London. In his late work, Turner's interest
in the dramatic situations offered by
history and fiction (so dear to his age) shifted
to the dramatic situations often provided
by nature. Light is the dominant visible
element in land and seascape, and it
becomes a major part of Turner's concern,
so that he seems to offer a link between
Claude in the seventeenth century, and the
French Impressionists later in the
nineteenth. But he also sought pictorial
form and structure through which to
express the energy, the drama or the
sweetness of nature, her serenity or her
turbulence, and this he had to invent and
to assess in terms of its correspondence
with his emotional, as well as visual
experience. In this respect he stands beside
Cézanne in uncovering issues that still
challenge the modern artist.

11. **Gustave Courbet.** *The Studio.* 1855. Oil on canvas. 142 × 235½ in. (361 × 598 cm.). Louvre, Paris. With his country background and his attachment to the realities of the visible world, Courbet saw himself as the champion of Realism (his own term). His themes were from the real world, richly and potently conveyed in paint. Here, however, he combines a realistic manner with a synthetic subject. This statement about the world around him and his own place in it is expressed in dramatised and partly symbolical terms. The section on the right includes portraits of some of his friends: on the extreme right the poet and art critic, Baudelaire.

12. (left). **Théodore Rousseau.** *The Plain of Montmartre. c.* 1835. Oil on panel. 92¾ × 139¾ in. (235 × 355 cm.). Louvre, Paris. In the 1830s, Rousseau came to be recognised as the champion of anti-academic landscape painting among that liberal-minded part of Paris's art public that also admired Delacroix. This, and his disregard of the classical qualities through which, according to academic opinion, landscape could be raised to the level of art, meant repeated rejection by the jury of the *Salon.* His work became more tranquil in the 1840s and subsequently received some recognition, which turned to fame and popularity in the 70s—by which time the Impressionists were bearing the brunt of conventional disapproval. Rousseau owed much to Claude and to the Dutch school of the seventeenth century, but he was instinctively drawn to open-air painting of landscape, and English painters, particularly Constable, had an important effect on him. In his work of the 1830s Rousseau adds to such influences an emotional quality that is Byronic rather than (as in the case of Constable) Wordsworthian.

13. **Jean François Millet.** *The Wood-sawyers c.* 1850–52. Oil on canvas. 22½ × 32 in. (57 × 81 cm.). Victoria and Albert Museum, London. (Ionides Bequest). Millet, after ten years in Paris, abandoned city life for a rustic environment and painted pictures in which the life of peasants is given symbolical status. He was much influenced by earlier Dutch painters. Van Gogh greatly admired his work, and painted several versions of some of Millet's compositions.

14. **Jean Baptiste Camille Corot.** *Ville d'Avray. c.* 1835–38. Oil on canvas. 11 × 16 in. (28 × 40 cm.). Louvre, Paris. Dutch influence and the open-air painting of landscape were transformed in the art of Corot by his deep sense of classical structure. Thus he can be seen as a milestone on the road from Poussin, in the seventeenth century, to Cézanne, just as his regard for the transient sense impressions offered by the constantly changing face of nature makes him a forerunner of the Impressionists. The moderate fame he achieved during his lifetime was largely on account of the more 'finished' and anecdotal studio compositions he sent to the *Salon. Ville d'Avray* is one of his small outdoor paintings, an outstanding example of his ability to reconcile freshness of vision with a composition which is almost geometric in structure.

15. **Caspar David Friedrich.** *The Cross and the Cathedral in the Mountains. c.* 1811. Oil on canvas. 17¾ × 15 in. (45 × 38 cm.). Kunstmuseum, Düsseldorf. A North German with an essentially mystical conception of nature, Friedrich painted melancholy portraits of particular stretches of landscape as well as visionary scenes in which landscape is combined with symbolical matter. In this small picture the visionary is to the fore, although the rocks and branches of the lower portion reveal his close study of natural appearances. The hieratic symmetry of the Crucifix, the church and the trees gives a supernatural quality to the scene which is rendered disquieting by the complete absence of man—as though Divinity had deposited that integrated artifact on the irregular surface of the earth.

16. **Peter von Cornelius.** *Joseph Revealing Himself to his Brothers.* 1816. Fresco painting. 93 × 114¼ in. (236 × 290 cm.). Nationalgalerie, East Berlin. In drawing unashamedly on Central Italian painting of around 1500, the Nazarenes challenged the long-established right of artists to base themselves on the art of Raphael and his successors, and drew attention to the virtues of a more two-dimensional, more brightly coloured and less grandiloquent art. Cornelius was the most intelligent and self-critical of the group. This fresco is one of a series he painted for the Prussian Consul-General in Rome.

17. **Auguste Rodin.** *Head of Grief.* Before 1882. Bronze. 9¼ in. high. (23.5 cm.). Musée Rodin, Paris. The expression of extreme anguish in this work is comparable, through the history of art, to such sculptures as the Hellenistic *Laocoon* and the dying Christs and martyrs, achieved through a mixture of realism and expressionism.

19. (right). **Adolf Friedrich von Menzel.** *The Artist's Sister with a Candle.* 1847. Oil on canvas. 18 × 12½ in. (46 × 32 cm.). Bayerische Staatsgemäldesammlungen, Munich. Menzel was admired for his historical scenes celebrating with cinematic verve the eighteenth-century Court of Frederick the Great. But he also painted a series of very personal pictures (mostly in the 1840s) that reveal his extraordinary gifts as an observer of light and atmosphere in simple domestic scenes.

18. **William Holman Hunt.** *The Hireling Shepherd.* 1851. Oil on canvas. 30 × 42½ in. (76 × 103 cm.). Reproduced by courtesy of the City Art Gallery, Manchester. Moralising content combined with an essentially moral sense of truth to appearances, makes the work of the Pre-Raphaelites at once characteristic of mid-Victorian bourgeois values, yet revolutionary in the brightness of tones and colours and the democratic evenness of attention given to all parts of the canvas.

20. **Edouard Manet.** *Olympia.* 1863. Oil on
canvas. 51¼ × 74¾ in. (130 × 190 cm.).
Musée de l'Impressionnisme, Paris.
One of the most controversial paintings
in the history of art, *Olympia* was still a
matter for violent disagreement when it was
accepted by the Louvre in 1907. Manet
was clearly linking himself to the long
tradition of the femal nude in art,
particularly in Venetian painting, but it
seemed to his contemporaries that he was
mocking that tradition by denying its erotic
function. He arranged his subject so that
its three-dimensionality was minimal, and
gave the flowers and the draperies an
attractiveness he did not allow the girl's
head and body. However, she is painted in
not so very different a way from Ingres's
subtly under-modelled nudes.

21. **Kitagawa Utamaro.** *Child Upsetting a
Goldfish Bowl.* 1755–1806. Wood-block
print on paper. 15¼ × 9⅞ in. (38.75 × 25
cm.). Department of Oriental Antiquities,
British Museum, London. Japanese prints
exerted a great influence on the painters
in Paris in the 1860s who were turning
away from the elaborate three-dimen-
sionality achieved by perspective and tonal
modelling. These prints offered pictorial
harmony and rhythms of an entirely
unnaturalistic kind.

5. **Alexandre Cabanel**. *The Birth of Venus*, 1863. Oil on canvas. 31½ × 53 in (80 × 135 cm.). Philadelphia, Pennsylvania Academy of the Fine Arts. The public that condemned Manet's *Olympia* unreservedly admired this skilled but wholly platitudinous treatment of an ancient theme. Its attractions are obvious, and are left undisturbed by anything new in the way of idea or method. The picture unambiguously belongs to the tradition of Raphael's *Triumph of Galatea*. To us it may seem to devalue that tradition by spending it so mindlessly, but then to Cabanel and his contemporaries Manet seemed to be ruining painting by refusing to ally himself to it.

an Innumerable company of the Heavenly host crying, "Holy, Holy is the Lord God Almighty".' He took pictorial ideas from a wide range of sources—from contemporaries, from Greek and medieval art, from Italian Mannerism, and above all from Michelangelo—and he used a variety of often original techniques, but the chief thing that separated him from all his contemporaries was his almost exclusive concern with the world of the spirit at a time when art rarely dealt with anything beyond the physical horizon. His poetry and his art are entirely visionary; sometimes he claimed to be working on the instructions of supernatural agents. What he searched for aesthetically was clarity and vigour, and at times a fluency of design that later make him seem a forerunner of Art Nouveau. Line was his chief means of expression; colour was secondary. Chiaroscuro and academic modelling he rejected as destructive of clarity. Because of this, it would be tempting to hail him as a precursor of Impressionism but of course he did not concern himself with light any more than with other aspects of naturalism. All his pictures embody complex literary ideas, often his own, and it must be remembered that he should be seen as an illustrator rather than a painter in the usual sense, working in a field where conventional pressure was lighter, even if the seriousness and originality of his art made him one of the greatest figures of his time.

THE RISE OF LANDSCAPE PAINTING

The most important achievement of British art in the first half of the nineteenth century certainly lay in landscape painting. Indeed, the dramatic rise of landscape painting generally in this period was the most significant event in nineteenth-century European art. It is not surprising that the era in which the effects of the industrial revolution became visible, in which towns grew and darkened as peasants were turned into the proletariat, should also have seen a new and compensating love of landscape. But the deep sense of landscape as divinity revealed, already expressed in James Thomson's widely translated poem. *The Seasons* (1726) and spread, as we have seen, by Rousseau and others, was an essential part of the new appreciation of wild nature. The resistance to landscape painting was considerable. Academic theory saw little value in it, and next to none when pictures represented particular stretches of country void of classical associations. For artists exploring

this new field, a sense of moral significance was a necessary support—their only historical support came from the Dutch school of the seventeenth century, and none at all from the generally admired masters of the Renaissance. The opposition must have realised that landscape painting, if it was accepted as serious art, would make a breach in the academic concept of art as a language addressed principally to the mind. A landscape by Constable needs to be read in a different way from David's *Oath of the Horatii*. The latter presumes a knowledge of ancient history, the ability to recognise the story's relevance to his time, and a willingness to accept one moment of the story as standing for the whole; its full appreciation requires some knowledge of classical design. Constable's landscape demands a response not from the intellect but from the affections; the most common human experience of nature will go a long way towards meeting his demands, though a familiarity with the country-side and a devotion to it similar to his own would help one further. That this kind of art should have become, during the later part of the century, the pace-maker of European painting suggests, first, a shift of interest from an art with a specific content to an art of generalised and indefinable meaning, and, second, a profound change of attitude in the beholder. The landscape painting demanded of the spectator that he project himself into it. Far from involving a dehumanisation of art through the demotion, or even the dismissal, of man as the visible subject, it opened the doors of appreciation to a far wider body of spectators and implied a descent of art from its pedestal of privilege and scholarship.

LANDSCAPE PAINTING IN BRITAIN:
CONSTABLE AND TURNER

In the first half of the nineteenth century it was certainly England that played the leading role in this development. The nature poetry of Wordsworth coincided in time with the emergence of the new landscape painting. Blake himself gave it some impetus through his primitive little woodcuts illustrating *The Pastorals of Virgil* (published 1821); indeed, his immediate influence is more apparent in landscapists such as Samuel Palmer than in figure painting. More immediately relevant is the pioneering work of Richard Wilson and Thomas Gainsborough who in the eighteenth century attempted to find English paraphrases for, respectively, the Roman scenes of Claude and the Dutch portrait-

landscapes of Ruisdael and Hobbema. These and other precursors of English Romantic landscape painting, helped to educate some part of the public towards a taste for landscape and eased the Academy's acceptance of such work. Constable and Turner never had to face the rigorous displeasure that landscape painters in France encountered.

One is tempted to contrast Constable and Turner as the country boy who gave his life to expressing an innocent attachment to the environment of his youth, and the town boy who discovered nature as a strange and partly inimical force. Certainly John Constable (1776–1837), who never ceased to feel a special relationship to his native Suffolk, and in his choice of subjects from other counties seldom stirred from scenes of comparable peace and simplicity, came as near as we can imagine feasible to recording normal, rather than exceptional appearances. That he should have had the firmness of purpose to persevere with this at a time when the representation of landscape was still beset by weighty conventions of composition, colour, tone and subject, give him the character of a rebel. This does not mean that he did not evolve conventions of his own and borrow from earlier landscape painters (particularly the Dutch and Rubens), especially in producing the six-foot canvases that he considered his most important works. Behind them lie pencil and oil sketches whose extraordinary degree of naturalism was the result of years of painstaking observation of nature under varying conditions of season and weather. In his time the science we know as meteorology was being born, and he himself considered landscape painting 'a branch of natural philosophy', that is, physics, but of greater underlying importance was his sense that moral feeling should be the content of his art. Constable was an instinctively religious man. 'Everything seems full of blossom of some kind, and at every step I take, and on whatever object I turn my eyes, that sublime expression of the Scriptures: ' "I am the resurrection and the life", seems as if uttered near me.'

While Constable's art is essentially English—not merely for the subjects he chose, but equally for the Wordsworthian sentiments—Turner's is European or even global. He began by testing himself against all kinds of predecessors: Wilson, the Dutch marine painters and landscapists (including Rembrandt), Canaletto and Guardi, Poussin and Claude, Gainsborough and the Norwich watercolourists. In his own watercolours he was more detached, more personal; one senses an Oriental delicacy and understatement that may have been inspired by Chinese art. Then he specialised. The character in any work that enables us to recognise its author is a product of specialisation, and a focussing of interest to the exclusion of other possibilities. Turner—and this characteristic is remarkably modern—specialised to the point where his art became incomprehensive to his contemporaries. Quite early on heads were shaken. Benjamin West, President of the Royal Academy, said in 1805 that Turner's works were 'tending to imbecility'; Hazlitt in 1816 quoted an anonymous wit as saying that they were 'pictures of nothing and very like'. Later even Turner's admirers had to agree that his art had gone astray.

J. M. W. Turner (1775–1851), the precocious son of a London barber, was more blatantly a Romantic painter than Constable. From his early days he knew the value of simple, self-contained motifs, but there was in him a drive to the elemental and the heroic that led him into more rhetorical subject-matter. *The Battle of the Nile*, selected *Plagues of Egypt*, *The army of the Medes destroyed in the desert by a whirlwind*, *The Deluge*, *The Destruction of Sodom*—such subjects offered him opportunities for Wagnerian presentations in which dramatic narrative was partnered by equally dramatic staging. Later the staging was to dominate. When in Yorkshire Turner experienced a particularly fine thunderstorm, he jotted down notes of its forms and colours on the back of a letter and told his companion, 'Hawkey; in two years you will see this again, and call it *Hannibal crossing the Alps*'. And so it was (1812). Between 1830 and his death, he painted pictures whose shared subject is the energy of nature, or rather the vortices of brushstroke and the colour and weight of paint in which such a theme can be communicated. They look essentially visionary, and in a way they are. At an advanced age Turner had himself lashed to the mast of boat in a storm, and then he painted a picture 'to show what such a scene was like': *Snow Storm—steamboat off a harbour's mouth* (1842), but one hesitates to accept the picture as a bare record, just as one hesitates to accept Turner's action as mere fact-finding. What Turner sought was a visible equivalent for a complex of sensations that were not exclusively visual, and this equivalent, to be a picture, had to have an imposed coherence. Small wonder that his contemporaries did not know what to make of such work: it looks beyond Impressionism to Expressionism and to Futurism.

This technical freedom was the product of innate brilliance (Turner was made a full member of the Royal Academy in 1802, at the age of twenty-seven), years of experimentation and study, and ultimately the rejection of skills he no longer needed. Long before Cézanne, Turner brought watercolour methods into his handling of oils, and was attacked for it. He studied colour, in Goethe's theory and in his own and the old masters' practice, with a thoroughness that even Delacroix could not match; colour and what the Futurists in 1910 were to call *linee-forze* (strictly 'line forces') became the visible constituents of his art. If this makes him sound like an abstract artist, no matter; Turner appears to have been the first painter to have had a picture hung upside down and to have said it looked better that way.

LANDSCAPE PAINTING ELSEWHERE

Constable and Turner were certainly the outstanding landscape painters of their age, but the rise of landscape was a European phenomenon. In France the Barbizon School produced paintings with something of Constable's closeness to nature and poetic feeling. Théodore Rousseau (1812–1867) was particularly affected by the example of England. He and Jean François Millet (1814–1875) lived almost continuously in the village of Barbizon on the edge of the Forest of Fontainebleau, painting the land and the

6. **Thomas Cole**. *In the Catskills*, 1837. Oil on canvas 39 × 63 in. (99 × 160 cm.). Metropolitan Museum of Art, New York (Gift in the memory of Jonathan Sturges by his children, 1895). For American landscape to become viable as art, painters first had to submit it to the traditional methods of landscape painting. Cole valued the wildness of the American landscape, and echoes Salvator Rosa in his dramatic scenes.

rustic life around them. Others spent periods working with them, like Charles François Daubigny (1817–1878), probably the first artist to complete his paintings out of doors. Attractive and comforting as these painters' works appear to us now, it is difficult to understand why French officialdom should have so denigrated and feared them. But the French had no tradition of naturalism and suspected the Barbizon painters, with their untrimmed beards, of being political revolutionaries as well as underminers of classical values. Even J. B. C. Corot (1796–1875), who was willing to turn his luminous landscape sketches into relatively conventional classical landscapes for exhibition at the *Salon*, had difficulty in having his work accepted. His smaller, more personal, pictures combine simple organisation with a justness of tone that is almost the equal of Constable's (some of whose works he had seen and admired).

'All nature here is new to art', wrote the American painter Thomas Cole (1801–1848) about his native land. Yet his career shows how difficult it was for a painter ambitious to give his work artistic value not to see through the eyes of the classical tradition, and that for a landscape painter meant the tradition of Claude and Salvator Rosa. In fact, Cole was admired in America for transcending the specific local character of the scenes he painted, giving them a more universal meaning and a place in art. For a direct treatment of landscape to convince people as art, it needed to acquire moral meaning. Particularly important was the association of the love of nature with human simplicity and decency. 'The lover of nature', wrote Emerson in 1836, 'is he whose inward and outward senses are still truly adjusted to each other; who has retained the spirit of infancy even into the era of manhood'. Moreover, the American West beckoned as a wilderness untouched by man, an Eden, a land where might be found the Golden Age of which the ancients had written, where human beings and nature would be at one, living in peace and without sin. It also promised escape from a society and an urban world which Rousseau in the eighteenth century and others since had castigated as the enemy of moral and physical vigour. It is this kind of vision we find so warmly expressed in Erastus Salisbury Field's painting *The Garden of Eden*. George Caleb Bingham's *Fur Traders Descending the Missouri* (1844) is an outstanding work combining observation of a river and people Bingham (1811–1879) knew well from childhood up with a clarity he had learned from Poussin.

COURBET AND DAUMIER

Realism of one kind or another, however, became the dominant mode of French painting in the middle years. Much of this was of the laboured story-telling kind that long continued to enjoy the unwearying and uninformed support of the middle classes and were painted by men who, were they living today, might be producing second-rate films.

Gustave Courbet (1819–1877) earned the hatred of the art public of his time with a realism that went beyond the bounds of good manners. His anti-intellectualism and anti-clericalism, his unsentimental view of such a privileged subject as the female figure, his passion for the physical presence and his belief that anything other than that was an evasion of truth, made him the most attacked artist of his time. His finest works tend to be his landscapes but his range was wide and included still-life, nudes, a monumental portrayal of a *Burial at Ornans* (1850)—a scene of peasant life presented with the grandiloquence David brought to Napoleon's crowning of his wife—and a number of large pictures celebrating the greatness and humanity of Courbet. *The Studio* (1855) synthesises his interests. On one side of the large picture there are peasants, poachers and beggars; on the other side a few of his friends. In the middle, between an admiring child and a nude model whose presence in the crowded studio was an affront to decency, sits the painter himself, finishing a landscape with a few fine, operatic gestures.

11

Honoré Daumier (1808–1879) was a realist of another kind. A glazier's son, he grew up in Paris. He learned the craft of lithography and in 1831 began to work for the journal *La Caricature*. In 1832 he was imprisoned for one of his political cartoons, but returned to work after six months in gaol. In 1834 *La Caricature* was suppressed; from then on Daumier worked for *Charivari*. More or less untrained, he had turned himself into one of the great draughtsmen of western art. To his extraordinary fluency and power of drawing he joined a deep sense of social injustice and a personal understanding of urban poverty and pretensions. His political attacks could not have been so bitter had not his kinship with the masses been so close. His lithographs were admired by well-known artists, such as Corot and Delacroix. The novelist, Balzac, who also worked for *Charivari*, said of him: 'This boy has something of Michelangelo under his skin'.

6

GERMAN ROMANTIC PAINTING

Germany, too, in the first decades of the century produced notable landscape painters. These owed more to the traditions of Baroque landscape and to late eighteenth-century pioneers such as J. P. Hackert and J. C. Brand than to British or French example which contributed more in the middle and later years of the century. The most original figure among them was Caspar David Friedrich (1774–1840). He was born on the Baltic coast and studied at the Copenhagen Academy, but he lived most of his life in Dresden painting landscapes in which his intimacy with all parts of Germany provided him with the means to express strong Romantic sensations of cosmic anguish. He exploited the thrilling forms of Gothic ruins and Alpine peaks. He employed great vistas of open land and seascape and placed in them minute and solitary figures. After Friedrich's death his work was quickly forgotten. Its Nordic qualities appealed less to his successors than the Romantic realism of the Barbizon School. One of his friends was Philipp Otto Runge

15

(1777–1810), remembered outside Germany more for his treatise on colour, published in 1810, than for his elaborate paintings in which a detailed and factual manner, sometimes uplifted by his almost religious valuation of light, is combined with mystical content. At a less intense level, similar qualities can be found in the work of the Nazarenes, a group of artists that was formed in Vienna and moved to Rome in 1809. They devoted themselves to the propagation of painting in the manner of the *quattrocento* Italians with elements introduced from German art of the age of Dürer. They wanted to find in Christian art a simplicity and energy that the Neo-Classicist had found in paganism. Their most important contribution to the art of the century was the attention they paid to mural painting.

THE BRITISH PRE-RAPHAELITE BROTHERHOOD

In Britain, the revolutionary atmosphere of the middle of the century threw up a group of painters whose aims were in some respects similar to those of the Nazarenes. The Pre-Raphaelite Brotherhood was formed in 1848 by three painters, William Holman Hunt (1827–1910), John Everett Millais (1829–1896) and Dante Gabriel Rossetti (1828–1882), in protest against the polite untruths of academic painting. They demanded an art full of meaning, presented with absolute accuracy. Their works were much ridiculed when they began, and they have frequently been ridiculed since, but their passionate attachment to detailed appearance, including its colour, their use of white grounds and very pure paints to capture and hold this colour, their insistence on clear narrative through clear design—these aspects of their work made them not only revolutionary within the British art world of their time but also influential during the rise of Art Nouveau.

The Pre-Raphaelites, too, were realists of a kind, and realism seems to have been a common denominator of European art once the more subjective phases of Romanticism had passed their climax. Any continuing commitment to realism, however, soon confronts the painter with insuperable difficulties. In developing a convincing pictorial language to express the three-dimensional and mobile world in which he lives, the realist painter has to decide which kind of falsification best fits his purpose. Constable had dealt brilliantly with aspects of reality particularly far removed from the reality of paints and canvas, especially with regard to light and intimations of growth and change. He and others had proved the value of a non-academic technique as a means to vitality. Today we find the small oil sketches of Constable, Corot and others more naturalistic than their large, exhibitable works, but in their own time it was the other way round. Sketchy techniques were systematised around 1870 by the Impressionists into a new style of painting and ultimately led to idioms far removed from naturalism. The establishment of loose configurations of brushstrokes as a legible and serious means of painting and as an alternative, to say the least, to the laboured finish admired in the academies, is one of the major achievements of early nineteenth-century painting.

What, one wonders, would have happened to painting if archaeological search had thrown up as vast a quantity of classical painting as it did of sculpture and architecture? The pressure of antiquity on sculpture, through these discoveries, through the writings of such men as Winckelmann, and for lack of any thriving sculptural tradition, was enough to take almost all life out of the art. The Italian, Antonio Canova (1757–1822), was the leading Neo-Classical sculptor in Europe. An able, likeable person as well as a strict upholder of classical ideals, Canova with his assistants was responsible for a great quantity of what Hildebrandt later described as 'petrified human bodies'. Countless others followed his example, pre-eminently the Dane, Bertel Thorwaldsen. It is no exaggeration to say that, in a century when the other arts worked from constantly altering premises, the Neo-Classical sculptors appointed themselves guardians of the Greco-Roman tradition, not to say of European civilisation. Their successors continued to hold this pose for the rest of the century. This does not mean that all these sculptors were inept or unprincipled. The opposite would be truer: many of the men who gave their lives to creating variations on classical prototypes were paragons of sincerity and diligence. Some of them, indeed, were men with more than a touch of genius, like the Englishman, John Flaxman (1755–1826), the friend of Blake, whose sculpture has a freedom unknown in Continental Neo-Classicism, and whose long series of cool line illustrations to Homer, Hesiod, Dante and others, shaped the international taste of his time.

The only sign of any liberalising activity within the sculpture of this period comes from the few sculptors who tried to oppose a relative realism to the idealism of the classicists. While this meant some loosening of classical conventions, it could not at this time mean much more than a move towards the Baroque. Even this degree of deviation

7. **Antonio Canova.** *Stuart Monument.* 1819. Marble sculpture in St Peter's, Rome. Skilled, efficient and likeable, Canova triumphantly rode the wave of Neo-Classicism and by his success played a great part in burdening his successors with the weight of the classical tradition.

8. **John Flaxman.** *Orestes Pursued by the Furies.* From *compositions from the Tragedies of Aeschylus* designed by John Flaxman, engraved by Thomas Piroli. 1793. 12 × 7 in. (30.5 × 17.8 cm.). Reproduced from 'Flaxman's Classical Outlines', 1874. A fine Neo-Classical sculptor with an unexpected penchant for Gothic art, Flaxman was most important in his time for his line illustrations, which were studied all over Europe and guided painters and sculptors towards a feeling for the incisive quality of classical forms.

9. **François Rude.** *Departure of Volunteers.* 1836. Stone. On the east façade of the Arc de Triomphe, Paris. Like Delacroix, and possibly under his influence, Rude opposed Baroque richness and complexity to the Neo-Classicism of his time.

10. **Antoine-Louis Barye.** *Jaguar Devouring a Crocodile. c.* 1850–55. Bronze. 3¼ × 9½ in. (8 × 24 cm.). Ny Carlsberg Glypothek, Copenhagen. Barye's vigorous sculptures of animals were not acceptable to the Salon, which upheld the Greek tradition of idealised human beauty.

11. **Honoré Daumier.** *Jacques Lefèbre. 'L'esprit fin et tranchant.'* 1830–2. Coloured clay. 8. in. high (20 cm.). Musée des Beaux-Arts, Marseilles. Daumier made his satirical busts of French parliamentarians as models for his political caricatures. It is possible that the soft medium of clay helped him to achieve that expressive exaggeration of selected features that is the essence of caricature.

was more or less limited to France, where Delacroix could offer support and example. François Rude (1784–1855) made his relief on the Arc de l'Etoile a few years after Delacroix painted his *Liberty on the Barricades*. Antoine Louis Barye (1796–1875) long studied the forms and movements of animals in the Paris *Jardins des Plantes*, but his animal sculptures, for all their basis in observation, are shot through with a Baroque and Romantic sense of action and energy that takes very similar forms in the paintings of Rubens and Delacroix. To inject this energy into sculpture is a considerable achievement. Undoubtedly Barye's concentration on animal subjects gave him a freedom he could hardly have exercised in figure sculpture; at the same time it should be noted that work of this kind meant repeated exclusion from the *Salon*.

In this situation the sculpture of Daumier comes as a complete surprise, particularly the small busts of politicians he made in the 1830s. They were his means of finding that exaggerated yet unmistakable version of his subjects that is the essence of caricature. He had no sculptural training or ambitions; he was free from the limitations of a professional sculptor working for a public and in a tradition. Yet these busts too can be seen as part of a tradition: they belong both to the history of caricature and to the involvement of art in the eighteenth-century pseudoscience of physiognomy, as in the heads sculpted by the German, Messerschmidt, around 1780.

The weight of classicism apart, there may be other reasons why sculpture at this period is so inferior to painting. Literature was undoubtedly the dominant art form of the age. Although pioneering artists looked to music as their ideal, the arts in general were deeply involved with literature and were judged largely for their literary qualities. Here sculpture is certainly at a disadvantage; it is not a medium suited to narrative. Even so succinct a situation as that presented in *The Oath of the Horatii* could scarcely be treated as statuary. Yet musical qualities were even more out of reach of an art long concerned almost exclusively with the human body. Moreover, for the preceding four centuries sculpture had been losing the primacy it held in ancient and medieval times to painting, and painting had taken over many of sculpture's special functions and characteristics. Sculpture did not attract the greatest talents, and if it did attract a great deal of public patronage, this was often misguided enough to do more harm than good. Even fewer people could appreciate the merits of sculpture than those of painting, and this continues to be true in our own century. The totally unreal world of painting appears to be more open to the kind of dialogue between work and spectator that leads to appreciation than is the physically real yet spiritually unreal world of sculpture. The cost of making sculpture, and especially of making it exhibitable, as for example by casting it in bronze, is far greater than that of painting pictures, so that the rebellious sculptor is likely to

find himself unable to work at all. The successful sculptor of the nineteenth century, on the other hand, much bespoken for his monuments of generals and civic worthies, his portrait busts and his elaborate tomb sculptures, was likely to gather a team of assistants around him and to arm himself for all the mechanical devices that his century could devise for turning a clay sketch into a large marble or bronze.

ARCHITECTURE: THE MULTIPLICITY OF STYLES

Much of this applies also to the period's architecture. Here it was not merely the weight of classicism that counted, but rather the bewildering variety of architectural languages that archaeologists and travellers found and described. Architecture had its 'museum without walls' long before painting and sculpture. Each proffered style had its burden of associations and it was these that endeared it to the literary-minded public. In other words, the nineteenth-century patron commissioned buildings on the same partly playful principles as the eighteenth-century aristocrat who required Gothic ruins, Greek temples and Japanese bridges to ornament his grounds. The eighteenth-century patron knew a great deal about classical architecture and often

12. **Etienne-Louis Boullée.** *Newton Cenotaph.* 1784. Projects of this kind, produced in large quantity during the years of the French Revolution, express the age's hopes of a heroic new world as well as the designer's inclination to bold and affecting forms. The Russian Revolution, too, evoked projects of a semivisionary kind.

provided his own designs. The nineteenth-century merchant or industrialist knew that Gothic architecture spoke of faith and a national past, that Greek architecture suggested a heroic democracy, that Florentine Renaissance architecture celebrated the power of commerce, while more exotic styles (as in the paintings of Ingres, Delacroix and many others) hinted at exotic delights as well as the more calculable values of empire.

NEO-CLASSICAL ARCHITECTURE

This multiplicity of styles presented the designer with opportunities and problems that were unprecedented. The bolder architect at first seized the freedom implied in this multiplicity, so that within the realm of Neo-Classicism we find both the pedantic purveyor of archaeologically accurate replicas of ancient architecture and the inventive designer using the old idiom to subjective and Romantic ends. On paper this could be done with especial virtuosity. The French Revolution threw up a generation of designers for whom classical design, with occasional elements from the Middle Ages, was a starting point for marvellously fanciful inventions. Ledoux and Boullée were the greatest of them. Etienne Louis Boullée headed his writings on architecture with the motto *Ed io anche son Pittore* ('I too am a painter'), demanding

for himself a painter's freedom. His grandiose design for a Newton Cenotaph (1784), a cross between the ancient Mausoleum at Halicarnassus and the Roman Pantheon, suggests a planetarium on a fantastic scale and thus refers to Newton's investigations. Its form is nakedly geometrical, but Boullée's drawing wraps his building in awesome light and shade. Such a design can hardly have been intended for execution. On a more realistic scale, however, the English architect, Sir John Soane (1753–1837), was equally bold. His work for the Bank of England is only one example from a career studded with works of great originality and refinement. The offices he built for the Bank are top-lit, which suited his feeling for dramatic lighting and allowed him to apply his sensitivity for geometrical forms and smooth surfaces to the problem of vaulting. Fundamentally classical in idiom, these offices suggest also the floating domes of Byzantine architecture; their severity is more in accord with Winckelmann's assessment of the Greek spirit than with ancient buildings. Yet there exists a watercolour by Soane showing one of the offices as a ruin in a deserted landscape, in some distant age, with plants sprouting from cracks in masonry. That so apparently cool and intellectual an architect as Soane should dream of his work in terms of the passing of civilisations under the timeless eye of nature,

14. **Sir John Soane.** *Bank of England, the 5% Office, London,* from 1788. Watercolour (by one of Soane's draughtsmen, *c.* 1819). 38 × 28 in. (96.5 × 71 cm.). Sir John Soane's Museum, London. Soane brought to the classical tradition a rare sensitivity to the poetic qualities of architectural form, nurtured by his interest in non-classical, as well as classical, phases of design. Neo-Classicism was not for him an occasion for subservience to particular Greek or Roman models but rather an invitation to find a personal and modern equivalent for the strength and simplicity he surmised in the ancients.

13. (left), **Karl Friedrich von Schinkel.** *Altes Museum, Berlin.* 1823–5. Not only is Schinkel's Museum an outstanding example of Neo-Classical design; as a museum it is a building of a new kind, symbolical of the historicism of nineteenth-century European culture.

illuminates the Romantic strain within Neo-Classicism: the Neo-Classicist was aware of the classical past as something distant, destroyed and awesome, and felt for it not the admiring kinship the Renaissance felt for a time when beauty and reason had been brought into unison, but rather the nostalgia a man may feel for his birthplace and a European may feel for the cradle of his civilisation. In more or less overt forms such feelings are expressed in Neo-Classicism everywhere. Comparable in creativeness with Soane was the Berlin architect, Karl Friedrich von Schinkel *13* (1781–1841), first a designer of stage sets and then Prussian State architect. The clarity of his personal classicism lends his buildings an air of exceptional rationality, and there are times when the bareness and near-functionalism of his designs link them to buildings designed a hundred years later, but his logic and his strength is one of visual effectiveness rather than abstract principle—which he could at times apply equally well to buildings in the Gothic style.

PICTURESQUE DESIGN

Visual effectiveness as a criterion for architectural design is a more revolutionary concept than it may seem. It was always one part of a designer's intentions but during the Renaissance it had come to be bound up with generally agreed conventions of rightness whose observance gave intellectual satisfaction as much as optical pleasure. During the Baroque period there was a greater appeal to the sensations, and it is no surprise to find Baroque architecture,

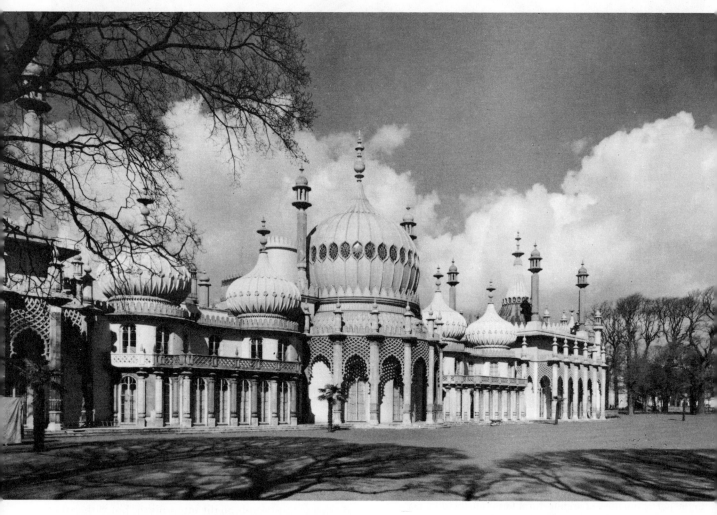

15. **John Nash.** *Royal Pavilion, Brighton.* Rebuilt and elaborated, 1815. The Prince Regent's pleasure palace by the sea is an extreme instance of the early nineteenth century's consciousness of style as an optional ornament. Here a fundamentally classical building is draped in a fancy dress of Indian origin.

so much attacked in the eighteenth century, so much admired in the nineteenth. The theoretical bases that had linked beauty to laws—such as the theory of proportions—were destroyed in the eighteenth century.

By 1800, the appreciation of architecture rested on the twin functions of association and sensual effect. Not being a figurative art, architecture had the advantage of sculpture: it could approach the condition of music through its qualities of size, mass, space, colour, texture, etc. English design, as well as English thought, played a leading part in this development. In the English landscape garden the eighteenth century had evolved an art form dominated by these two functions, and in the 1760s and 1770s it was widely imitated on the Continent. The principle of what became known as the picturesque had already been transferred from gardens to architecture in Horace Walpole's house, Strawberry Hill (begun 1748), and by 1800 it was affecting

town planning. In his development of Marylebone Park (later Regent's Park) and of Regent Street in London (1811 and after), the architect, John Nash (1752–1835), was guided entirely by visual effectiveness, swinging Regent Street in a dramatic curve, hingeing two unaligned streets on the circular portico of a church, and dropping buildings like classical back-drops around the landscaped park. Much the same sense of presentation informed his earlier work on the Royal Pavilion in Brighton (from 1815 on), a basically Georgian building which Nash transformed into a pleasure palace compounded of Indian, Gothic and Chinese elements. This kind of architecture, though not necessarily at Nash's level of fantasy or the Prince Regent's level of expenditure, flourished throughout the century to wrap its patrons in a variety of unreal environments that compensated for their despoliation of the real world.

THE SEPARATE WORLD OF ENGINEERING

The men who commissioned Gothic castles, Tuscan villas and Greek town houses also, directly or indirectly, brought unprecedented squalor into town life. The most significant invention of the nineteenth century is the slum. It was presumably his aversion from the world in which he made

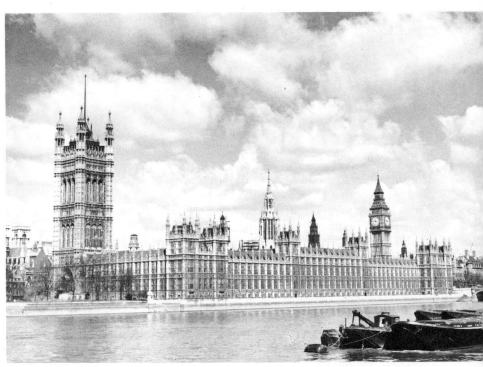

16. **Sir Charles Barry** and **A. W. N. Pugin.**
Houses of Parliament, London. Designed 1836;
built 1840–65. The re-building of the British
Houses of Parliament was an occasion for
debate on the question of an appropriate
style. A more or less Tudor style was chosen
on the grounds of national pride for a kind
of building that had hitherto been linked to
Greek democracy via Neo-Classicism.

his money that caused the industrialist to draw such a firm line between his economic and his cultural life. The engineering structures that figure so magnificently on the credit side of the industrial balance sheet of this time have no influence on the genteel and protected realm of architecture. The great technical inventions of men like Brunel and Telford were of little interest to professional architects intent on recreating the achievements of other ages and civilisations.

STYLES AND MORALITY

The tone of architecture gradually became more earnest. Some designers and critics began to question the propriety of stylistic permissiveness and demanded greater accuracy, more understanding of the basic principles of each style, and even some serious consideration of the meaning and the proper use of a style. Stylistic choice became a matter of morals; association was removed from the level of romance to that of historical fact. The English architect, A. W. N. Pugin (1812–1852), equated Gothic with Christian architecture. He made it his business to understand Gothic design thoroughly, and his love of it led him to love the world that had produced it. In 1835 he was received into the Roman Catholic Church and about the same time he began his great work of converting the Christian world to the use of the true Gothic style. He stressed the rationality of Gothic design. 'The severity of Christian architecture requires a reasonable purpose for the introduction of the smallest detail'. He insisted on a kind of honesty which had not been spoken of before and which has become one of the clichés of modern architecture: 'the external and internal appearance of an edifice should be illustrative of, and in accordance with, the purpose for which it is designed Every building that is treated naturally, without disguise or concealment, cannot fail to look well.' Pugin's buildings brought new strength and clarity to Gothic design. Apart from his writings he is best known for his collaboration with Charles Barry on the London Houses of Parliament: Barry got the commission

and made the general plan, while Pugin drew all the details, from mouldings and finials to ink wells and umbrella stands. John Ruskin (1819–1900), the great critic of art and society whose writings reached a vast public, supported Pugin's moralistic view of Gothic architecture and greatly elaborated his view of the connections between architecture and society. In *The Seven Lamps of Architecture* (1849) and *The Stones of Venice* (1851 and 1853) he made demands on the integrity of patrons and architects that were timely and effective; he also made statements that illustrate some of the flaws of even advanced Victorian artistic thought, as when he placed exclusive significance on the ornamentation of buildings, arguing that 'the only admiration worth having attached itself *wholly* to the meaning of the sculpture and colour on the building. . . . What we call architecture is only the association of these in noble masses, or the placing of them in fit places. All architecture other than this is, in fact, mere *building*.' Ruskin's influence showed itself in countless Gothic buildings in the English Decorated and Italian styles he favoured. Whereas Pugin's ideas had found realisation principally in church architecture, Ruskin found himself the father of Gothic museums, railway stations and sewage plants. A more happily fruitful aspect of his writing was his insistence on 'the loving and religious labour' that produced the vitality and infinite variety of Gothic architecture.

After the climax of Neo-Classicism in the first quarter of the century, the spreading and moral transformation of the Gothic Revival dominates architectural history. These are only two aspects, however, of a complex of interrelated developments. Italian Renaissance architecture was brought into service to provide a semi-classical idiom more relaxed in feeling and more genial in its associations. National pride expressed itself in the revival of local early Renaissance styles, as also in a selective use of local variations of Gothic and Romanesque. The choice of style generally continued to vary from the comprehensive to the extravagant, as when a flax mill in Leeds, Yorkshire, was designed and built in the manner of the Egyptian temples at Philae.

The Second Half of the Nineteenth Century

The example of Edouard Manet (1832–83) illustrates well the paradoxes that beset the realist painter. A man with a profound admiration for a considerable range of old masters and willing to base whole pictures on theirs, he is also an extreme case of a painter who looks at the world with such care that he comes to develop an idiom that appears highly artificial to people who have looked less carefully. He is represented in this book by the painting *Olympia* (1863) which he himself considered his masterpiece. It is in the tradition of reclining nudes that goes back to Giogione's *Venus*. One could account for much of it by describing it as a synthesis of elements from Giorgione, Titian, Goya, Ingres and one Jean Jalabert, who in 1842 had had great success with a picture of a nude woman attended by a negress. Yet *Olympia* was denounced with unimaginable fury when it was shown in the Salon in 1865. It was called obscene because it did not titillate the senses with hints of complaisant flesh. It was called ugly because it lacked all ingratiating modulations. It is in fact a hard painting. The frontally lit body is an almost flat shape of cream paint contrasting with the cold white of the sheet and the heavier cream of the shawl, and these are set against the dark tones of the negress, cat and background, so that one tends to see the picture as an opposition of roughly equal areas of light and dark. This works against the traditional concept of modelling and pictorial space; the public took as an affront the sharp confrontation that Manet created. That the nude has remarkable solidity of form is due to the magnificent drawing and the justness of what little modelling there is: she is a painted descendant of Ingres's drawings, though an ungrateful daughter. The flatness of Manet's painting had various origins. He had studied the work of Frans Hals, of Velasquez and Goya—all of them brilliant users of blacks. He was also impressed by the flat colours and designs of the cheap Japanese prints that were beginning to attract attention in France at this time. But he was guided principally by observation, noting the two-dimensional appearance of things under certain conditions and the way the eye cannot hold in focus more than a small area of a scene.

The execrations hurled at this picture established a new 'low' in painter-public relations. 1865, we may say, marks the final consolidation of the great schism between the serious artist and his public which was a product of Romanticism and yet denies Romanticism's view of the artist as soothsayer. For Manet, who greatly desired official recognition and respectability, it was a depressing experience, but it had the effect of limelighting him as a revolutionary. The result was that a group of younger artists formed around him and looked to him as their hero.

These were the Impressionists, principally Monet, Renoir, Pissarro and Sisley. Allowing for differences in temperament, it was the aim of these painters to represent the optical character of landscape and other subjects, to the exclusion of other aspects of reality. Monet is reported to have said that he wished he had been born blind and had subsequently gained sight, so that he could have begun to paint without knowing what the objects before him were. He wanted to concern himself only with turning the rays of coloured light that struck his retina into marks of paint on the canvas. To have attitudes to the objects from which these rays come, to know about them more than the eye sees, makes this process impossible. But even if he could achieve the objectivity he wanted, there was still the problem of how to capture these fugitive optical impressions. Monet evolved what was in effect a revolutionary technique: that of covering a white canvas with juxtaposed brushstrokes of unmixed paints. The whiteness of the canvas adds to the brilliance of the colours, and these are clouded neither by mixing on the palette nor by mingling on the canvas. The Impressionists added a liking for light tones and an almost canonical aversion from black, bringing to their work a brightness that at the time seemed unbearable.

The corollaries of this kind of painting are very important, even though the painters themselves may not have been aware of them. The brushwork gave their pictures an all-over texture, as well as an all-over brightness, which led to a new kind of pictorial unity—or at least a re-establishment of the pictorial unity that had existed in medieval and early Renaissance painting until the development of chiaroscuro. The rejection of the tonal articulation of a painting was supported by their frequent use of subjects lacking a marked compositional structure. The emphasis on the brushstroke as representing light rays inhibited it from delineating forms, so that even this articulation was reduced and contemporaries found it difficult to discern the subjects of Impressionist paintings. In the name of realism the Impressionists had thus created an idiom that had to be learned before it could be read. The spectator had to trust his eyes and ignore his expectations more completely than ever before. A firm line was drawn between the perceptual character of this visual art and the conceptual character of intellectual processes. But Impressionist painting also has spiritual implications, for all their eagerness to deal only in optical facts. The subjects they chose, the egalitarian way in which they painted these facts, the dominant role they awarded to light and colour as the medium revealing these facts, gave their work a quality of optimism and faith that recalls the moral overtones of Constable and the Barbizon painters (from whom they learnt much), and which is particularly striking when compared with the moralising implicit in many paintings by their contemporaries.

MONET, RENOIR, SISLEY AND PISSARRO

Of course there were differences between the paintings and personalities of the Impressionists—evidence, if evidence

were wanted, that full objectivity is not to be achieved. Claude Monet (1840–1926) was the most ruthless of them —the first painter to reject the art of the museums in its entirety. He attempted a most extreme concentration on the objective recording of transient optical facts in his series of paintings of Rouen Cathedral and of haystacks (the undifferentiating regard he had for these subjects is typical). Between 1900 and the year of his death, Monet worked on a series of large and small paintings of his water-garden at Giverny, painting again and again the same water-lilies hovering on the water, the movements of plants below its surface and the hanging fronds of willows reflected in it. His intentions were still fundamentally the same, though his very large canvases (some measuring as much as 6½ × 18½ feet), painted to hang in groups, envelop the spectator in a way that the smaller pictures by earlier nature painters could not. Moreover, as he painted the same appearances repeatedly, his brush went its own way more and more until the pictures turned into a free and wonderfully lyrical evocation of the scene rather than a record of it.

Monet had evolved the characteristic technique of Impressionist painting, and his colleagues worked in ways close to his before finding a more personal style. Auguste Renoir (1841–1919) used the same motifs as Monet during the early years of the movement and much the same technique, but even then the feathery softness of his touch is easily distinguished from Monet's firmer placing of the paint. By inclination Renoir was really a figure painter, celebrating the beauty of women and the sweetness of friendship. He loved the old masters; it is in the museums, he said, that one learns to paint. He visited Italy several times. Under Italian influence he returned to a clearer delineation of forms and even adopted classical subject-matter. For a man who had passed through Impressionism this involved finding a way of uniting monumental figures with landscape, and in some of his latest paintings of broadly brushed-in nudes in heavy but generalised landscape settings, Renoir achieved this without the prettiness that weakens so much of his earlier work. Alfred Sisley (1839–99) on the whole remained closest to Impressionism proper. His are the lightest paintings, the least problematic. Camille Pissarro (1830–1903), a latecomer to painting, was the oldest of the group. His work always retained a solidity of form and construction that was not Impressionist. This, together with his warm personality, made him an ideal intermediary between the Impressionists and other painters. The most socialist among a generally left-inclined generation of artists, he liked to introduce working peasants into his landscapes, without however becoming obviously polemical.

DEGAS

The Impressionists exhibited together for the first time in 1874. By the time of the eighth and last Impressionist exhibition of 1886, most of the artists we have mentioned had ceased to participate. A number of diverse painters had gathered around them. Several of them were artists of

little significance; others are important but did not adopt Impressionist principles. Edgar Degas (1834–1917), for example, although habitually included in accounts of Impressionism, was a profoundly classical artist with little interest in landscape and no desire to give primacy to light. An artistic descendant of Ingres, he attached major importance to drawing and made himself one of the great draughtsmen of all time. His subject was bodily movement, or rather the interaction between the forms and tensions in a moving figure and the picture area. Here he was strongly influenced both by Japanese prints and by photography which gave him and his contemporaries a taste for random compositions. Light was one of the factors he could employ, and some of his earlier paintings have an air of indoor Impressionism about them, but on the whole he used light more to define movement than to transmit colour phenomena. There is also in his art a strong element of commentary. While there is little in it that could be called literary, it is expressive of his attitude to society. There was rarely an art more ruthlessly devoid of sentiment and fantasy. Degas has been accused of misogyny. Certainly if we turn from Renoir's soft-bodied nymphets to Degas's average women caught in extreme poses, we move from **26** pleasure-objects to images devoid of erotic promise, and from indulged sensuality to an extraordinarily relentless insistence on fact. Compared with Degas, Courbet, the self-styled Realist, is a sentimentalist. It is significant of Degas that his kindest works, those in which one feels an attachment to particular people as much as to art, are those representing prostitutes awaiting clients, celebrating Madame's **17** birthday, and so on. Perhaps this corner of society was the one where reality and custom met. This is not to say that Degas made it his business to work realistically in the normal sense. 'Drawing', he said, 'is not what one sees, but what others have to be made to see'; 'drawing is not form, it is the way form is seen'. For him art was a purely artificial and sophisticated means of tricking the spectator into thinking that reality lies before him. But there is also another element in Degas's art, of which he was less aware, hinted at in these successive but contradictory words: 'The artist does not draw what he sees, but what he must make others see. Only when he no longer knows what he is doing does a painter do good things'. Not only cunning, then, but also unconscious creation. Here is a partial explanation of Degas's almost obsessive use and re-use of a small range of subject-matter: as he recreated the same pictorial situation again and again, his conscious control could lessen and a deep vein of poetry open up, expressing itself through great colour harmonies that have little to do with convincing representation and nothing at all to do with Impressionist light.

POST-IMPRESSIONISM: SEURAT

Also among the non-Impressionists who contributed to Impressionist exhibitions was Georges Seurat (1859–91). He studied books on colour, optics and the effective properties of the elements of painting. In 1885 he met Pissarro, who was impressed by Seurat's scientific interests and intro-

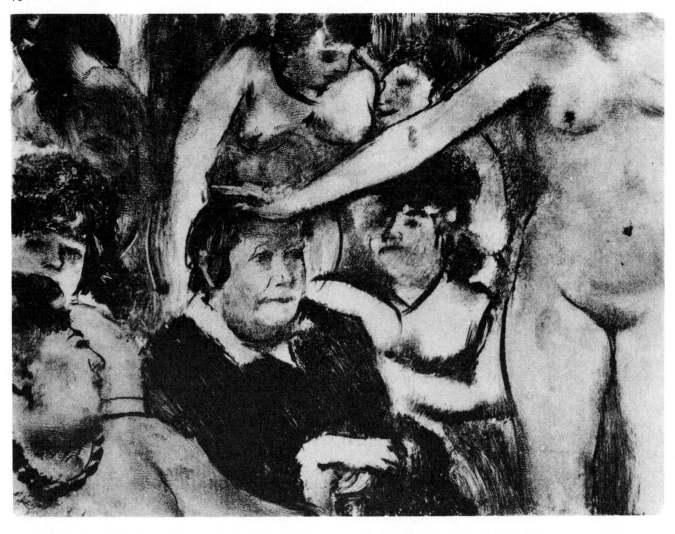

17. **Edgar Degas.** *The Madame's Name-Day.* 1879. Monotype. 4¾ × 6¼ in. (12 × 16 cm.). Private collection, Paris, ex. collection of Librairie Auguste Blaizot, Paris. Degas's graphic work joins keen observation and an extraordinary power of retention to a rare level of formal and compositional sophistication.

duced him to Impressionism. Seurat evolved a scientifically controlled version of Impressionism. Where the Impressionists had chosen paints that would resemble the colours before them, Seurat analysed each colour phenomenon into its constituent colours and set these down side by side, in dots of primary and secondary colour, to fuse in the eye by a process called optical mixture and offer a particularly vivid representation of the original colour complex. This method of painting came to be known as Divisionism, and the group that formed round Seurat (principally Signac, Cross and Luce) came to be known as the Neo-Impressionists. But Seurat was also concerned with form. He had learned that certain kinds of form, certain directions of line, carried a particular kind of expression, and he saw it as his duty to control the formal content of his paintings as closely as the colour content. To the 1886 Impressionist exhibition he contributed what he considered his *magnum opus*, the large picture entitled *Sunday Afternoon on the Island of the Grande*

Jatte. He had made a long series of studies on this island in the Seine; he had drawn and sketched in oils the figures for the picture, both out of doors and in the studio. The execution of the painting itself was a relatively mechanical process, though a very laborious one, that he could carry out day and night in his studio. It is a painting full of the monumentality that Impressionism lacked. The compositional left-right movement, stressing the picture's space, is counteracted by the figures which are grouped on clearly differentiated planes and mostly face to the left. Colours are contrasted; straight lines act against curves. There is a sufficient sense of space, but the picture has the strength of a mural.

Seurat died at the age of thirty-two. His later works show that he was developing the formal side of his work considerably and experimenting with more complex composition and more piquant shapes. One is tempted to speculate where this might have led. His influence was very great. His closest friend, Signac, wrote about divisionism. He and the other Neo-Impressionists did not share Seurat's great interest in formal values, and their divisionism became more and more personal and less analytical. Thus a way of painting founded in a scientific study of reality supported a tendency to a free and anti-naturalistic use of colour that became one of the foundations of modern painting. Outside Paris, Seurat's influence was first felt in Belgium where an avant-garde group calling itself *Le Groupe des Vingt*, formed in 1883, showed his work repeatedly and organised a Seurat

retrospective exhibition in 1892. Divisionism reappears as a decisive influence in Fauvism and in Italian Futurism. In a more profound way Seurat's insistence on analysis and control is echoed in the work of Mondrian and Kandinsky.

MONUMENTAL PAINTING: PUVIS DE CHAVANNES

Seurat was not alone in looking for a monumental mode of painting to replace the informal art of Impressionism. In French literature there was a comparable shift from realism towards a more subjective and imaginative mode of writing. The dominant literary movement of the 1880s was symbolism (Mallarmé, Rimbaud, Verlaine, etc.), which combined artificial imagery with an unprecedented exploitation of the emotive power of words and the sensory value of sounds. It was easy for those who succeeded Impressionism to overlook its poetic and moral content and to condemn it as materialism. In Cézanne's often quoted statement, 'Monet was only an eye, but, *mon Dieu*, what an eye!', the first half is as important as the second.

One of the artists much admired by Seurat and his friends, and by Cézanne, Gauguin, van Gogh and their contemporaries was Puvis de Chavannes (1824–1898), a traditionalist painter who tried to combine elements of Ingres and Delacroix with the clear construction of Poussin and the directness of Italian early Renaissance murals. He never learnt the fresco technique but adapted its qualities for the oil-on-canvas murals he busily produced for public buildings in France and in the United States (Boston Public Library) between the late 1860s and his death. Apart from reminding painters of the limitations of easel painting, his murals stressed the value of flat, rhythmic design, restrained colour in light tones and a calm and constructive spirit.

GAUGUIN

Gauguin, for example, learned much from him. Paul Gauguin (1848–1903), the stockbroker and amateur painter who threw up his profitable career and his family for the sake of painting, and escaped first from Paris and then from Europe in search of a more spiritually vital environment, has become a legendary figure of modern art. His primitivism is of especial importance. Gauguin rejected, or attempted to reject, Europe's whole artistic tradition in favour of the freely expressive modes of primitive peoples. In Brittany he was influenced by the simple art of the peasants and by the flat and linear style of a much younger painter, Emile Bernard (1868–1945). A group of painters formed round him and helped to propagate his demand for an art of dream and ecstasy, and of strong and simple shapes and colours originating in the mind and not in nature: 'Work freely and madly and you will make progress. Above all, don't labour over your picture. A great emotion can be translated immediately: dream over it and look for the simplest form.' His rapture at the beauty of Tahiti ('Fabulous colours everywhere; air like fire, but pure and tranquil in its silence') led him to produce some of his finest works, rich in emotive form and colour, yet contained within a clear pictorial structure.

VAN GOGH

Vincent van Gogh (1853–90), too, has been diminished by 30 legend: never was there a painter who was less of an inspired idiot, more of an expert. He trained himself thoroughly on the works of others; his education was wide, and the letters he wrote form the greatest literary monument left by any painter. True, he was a passionate man, but for mankind and not for himself. His efforts to serve others had been rejected and he turned to painting about 1880 as the only means left to him. His hypersensitivity to the world around him applied also to his work: to the materials of his art, the paints and brushes, the inks and reed pens, and to the pictorial elements he made his own, colour and form uniting in his linear application of dense paint. He knew colour more thoroughly and valued it more highly than any painter before him, prophesying the great role that colour would play in the art of the future, but everything he did had its justification not in abstract knowledge but in his own thin-skinned experience. In Paris (February 1886 to February 1888) he listened to the Impressionists and adopted something of their technique, but his full flowering came in the short period he spent in the south of France. From February 1888 until his death in July 1890, in Arles, in the hospital at Saint-Rémy, and (back in the north of France) at 18 Auvers—during twenty-nine months, interrupted by illness—he produced the great series of works that are *the* van Goghs. Light and colour were to him a form of divine revelation, and he knew that by setting certain colours against each other he could achieve an almost supernatural sonority. By heightening colour while simplifying and broadly characterising forms, he could achieve a transcendent expressiveness without losing contact with the objects he was painting. While other artists moved away from specific subject-matter towards more abstracted themes, van Gogh insisted on the uniqueness of everything he painted. His legacy is not merely a new intensity of colour, but also an intensity of expression, made all the greater by his firmly controlled manner of working and his humility before the face of nature.

CÉZANNE

Cézanne is at first sight the one Post-Impressionist who remained attached to Impressionism. Pissarro's influence in the early 1870s was of great formative importance for him, but we shall see that his art aimed at and achieved qualities of which the Impressionists knew nothing. Paul Cézanne (1839–1906) studied painting in Paris but spent most of his life in and around his native town of Aix-en-Provence, painting in a seclusion and a visual environment that were very congenial to him. His early paintings are partly vehemently expressionistic visions of feasts and orgies, rich in colour and movement and owing much to Delacroix, and sometimes equally vehement but much more controlled studies of resting people and objects that owe something to Courbet and Manet. His Impressionist paintings of 1872–4, when he was working with Pissarro, have a solidity that exceeds even Pissarro's. Cézanne never

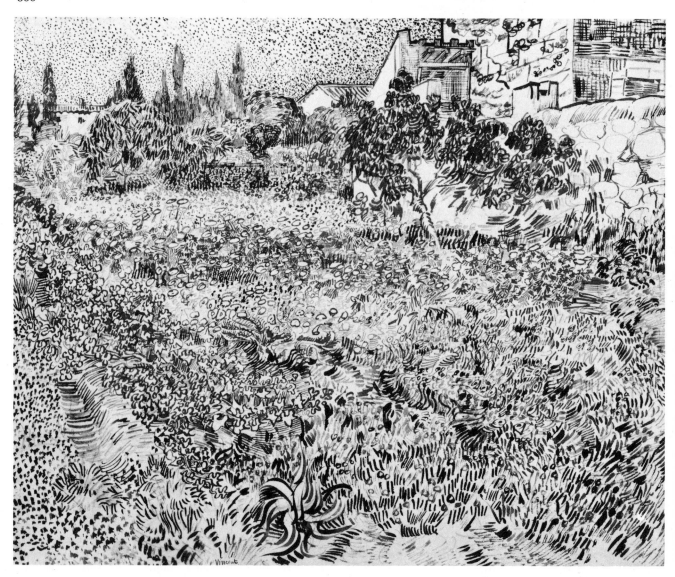

18. **Vincent Van Gogh.** *Garden.* July, 1888. Pen and ink on paper. 19½ × 24 in. (49.5 × 61 cm.). Oskar Reinhart collection, "Am Römerholz" Winterthur, Switzerland. Van Gogh's elaborate technique provided him with a wide range of marks of differing quality with which to build up his drawings. Note the strong sense of light, yet the absence of all shading.

33

adopted the Impressionists' interest in light and colour as the visible form of nature. He adapted their technique, placing brushstrokes side by side on his canvases, and their example led him to paint landscape. But whereas they were concerned with the constantly changing face of nature and their way of painting was evolved to cope with this instability, Cézanne dealt with a much more complex theme: the stability of things as well as their instability, their conceptual as well as optical value, their reality as well as the reality of the paint on his canvas.

There are many recorded statements by Cézanne, and it is characteristic of him that some of them seem to contradict others. The most revealing explanation he gave of his work was the one recorded by Bernard: 'I have my motif. (He joins his hands.) A motif, you see, is this. (He draws his hands apart, fingers spread out, and brings them together again, slowly; then joins them, presses them together and contracts them, making them interlace.) There you have it; that is what one must attain.' In other words: the integration

on the canvas of many-sided reality, nothing escaping. The process was slow and intuitive, involving much observation and then the deliberate establishment of certain cardinal points on the canvas as footholds in a region to be conquered. 'To paint is not merely to copy the object; it is to seize a harmony between numerous relationships'. He sought the tensions between objects as well as their physical presence as part of the pictorial tension of forms on the canvas. Portraits he found troublesome, not only because sitters could hardly manage the immobility he demanded, but also because of the complex psychological relationships that he had to command as well as everything else.

As time went on Cézanne's art became ever more gentle and tentative. His figure subjects culminated in the *Grande Baignade* of his last years, but generally speaking his work became less monumental and more totally integrated. Like Turner, he adapted watercolour methods for his oil painting, leaving gaps between the thin washes of increasingly economical colour. Yet, fragmentary and insubstantial as his later paintings often look, they embody the subject's reality, the painter's experience of the subject and his regard for the picture as a two-dimensional object bearing upon it touches of colour.

(Continued on page 817)

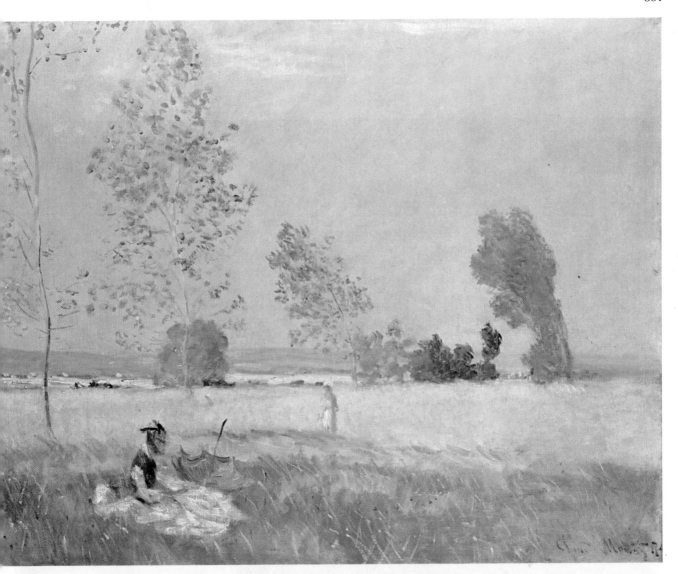

22, 23. **Claude Monet.** *Summer.* 1874
(above). Oil on canvas. 22½ × 31½ in.
(57 × 80.5 cm.). Nationalgalerie, Berlin-
Dahlem. **Alfred Sisley.** *Barge during the
Flood.* 1876 (right). Oil on canvas. 19¾ ×
24 in. (50 × 61 cm.). Musée de
l'Impressionnisme, Paris. Impressionism
can be seen as a kind of watershed between
traditional and modern painting. The
Impressionists' intention was to capture
the visual qualities of a scene. They
developed a pictorial shorthand that
increased the speed of painting, gave much
greater luminosity to their pictures, and
was sufficiently open not to contradict the
transience of nature's appearance. Thus
they attempted a more absolute realism
than that of the past and showed that
academic techniques could only deal with
a very limited naturalism. But
Impressionism too is a limited and an
artificial language, since it involves
exclusive attention to the optical values of
a scene at the expense of the observer's
conceptual knowledge of the world and his
emotional relationship to it.

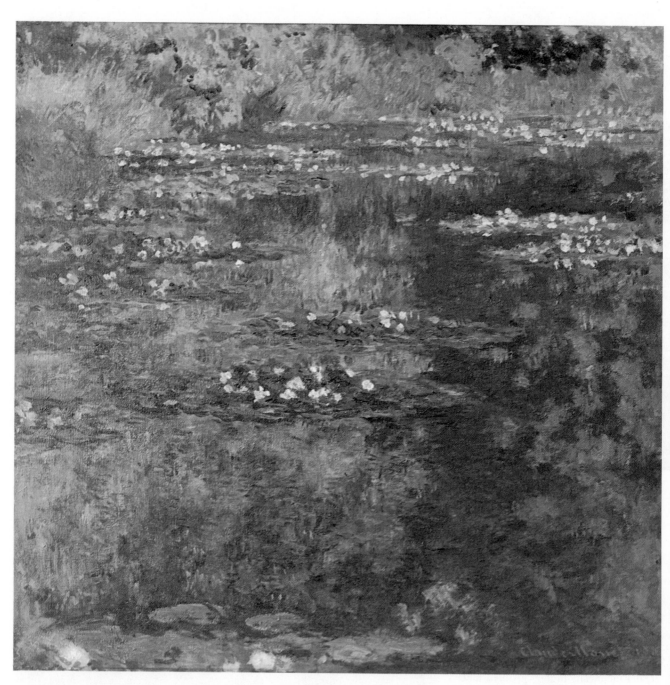

24. **Claude Monet.** *Water-lilies*
(Nymphéas). 1904. Oil on canvas.
35½ × 36¼ in. (90 × 92 cm.). Musée de
l'Impressionnisme, Paris. During the last
twenty years of his life, Monet repeatedly
painted the water garden he had himself
created at Giverny, near Paris. In his
pictures of this subject, often very large, his
Impressionist technique softens and
broadens, and, as he approaches the pool
with its water-lilies more and more closely,
the pictures lose all controlling structure
apart from that offered by the forms and
colours of his brushstrokes, until they
become scarcely legible as representations
of a place and take on an independent
existence as painted surfaces that are rich
in colour offering strangely ambiguous
sensations of space.

25. **Pierre Auguste Renoir.** *Nude in the
Sunlight. c.* 1875–6. Oil on canvas.
31½ × 25½ in. (80 × 61 cm.). Musée de
l'Impressionnisme, Paris. More than the
other Impressionists, Renoir concerned
himself with the human figure and thus
joined Impressionism to the long tradition
of art celebrating physical beauty.

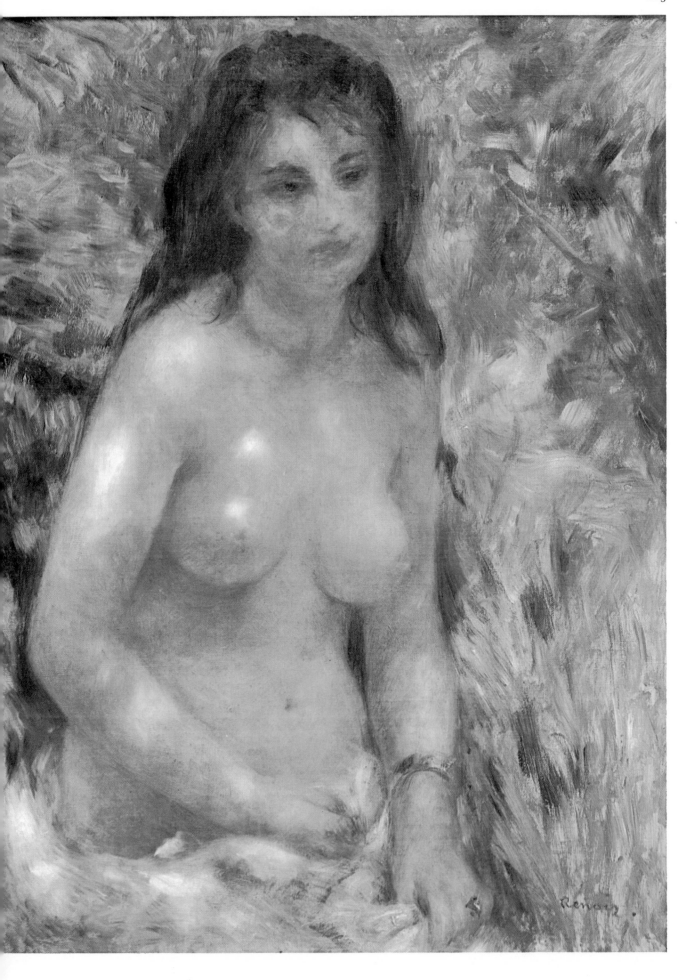

27. (opposite above). **Pierre Puvis de Chavannes.** *The Sacred Grove.* 1883–4. Oil mural. 180 × 418 in. (458 × 1062 cm.). Musée des Beaux-Arts, Lyon. Painted in pale colours to suggest the appearance of fresco painting, the paleness of Puvis' murals also contributes to their calmness, clarity and two-dimensional coherence. After the Baroque tendencies of Romantic painting, the work of Puvis drew attention to the values of clear design and pictorial economy.

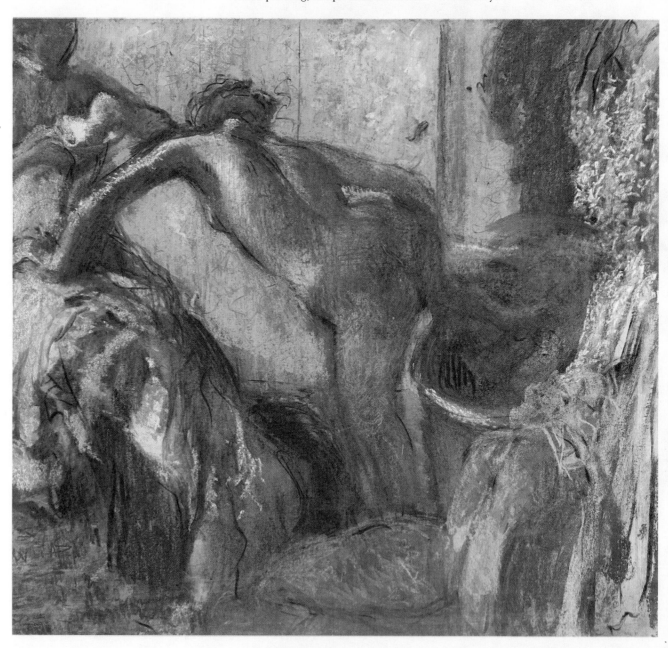

26. **Edgard Degas.** *After the Bath (La Sortie de Bain).* c. 1895–8. Pastel. 30 × 32½ in. (76 × 82.5 cm.). Phillips Collection, Washington. Degas is often grouped with the Impressionists, but his aims were much more complex. Although concerned in general with optical impressions in terms both of light and colour, he was particularly interested in the quality of movement in the human body and the structural relationship between the movement and tensions of the figure in relation to the picture as a whole.

28. **Georges Seurat.** *Sunday Afternoon on the Island of the Grande Jatte.* 1885–6. Oil on canvas. 81 × 120¾ in. (205.5 × 305.5 cm.). Courtesy of the Art Institute of Chicago, Helen Birch Bartlett Memorial Collection. One of the greatest monuments of nineteenth-century painting, this picture marks the meeting point of the naturalism of much of the art of that century, and the structural and psychological focus of much of its scientific research. Seurat was twenty-six when he began this painting which represents the fullest realisation of his ideas at that time. At the time of his death, his work seemed to be taking a new direction.

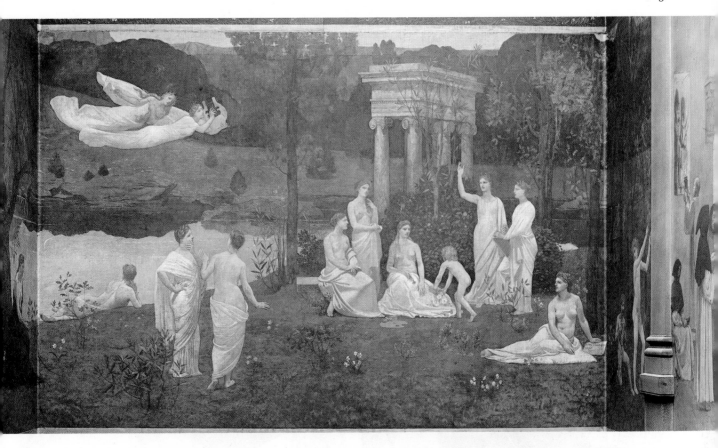

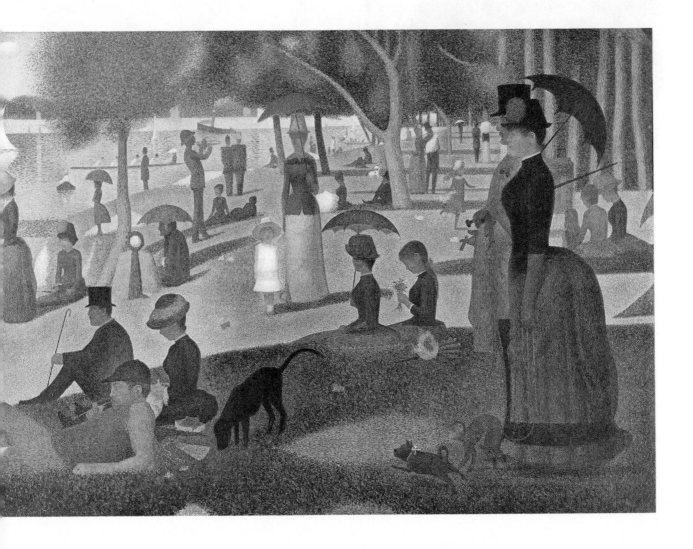

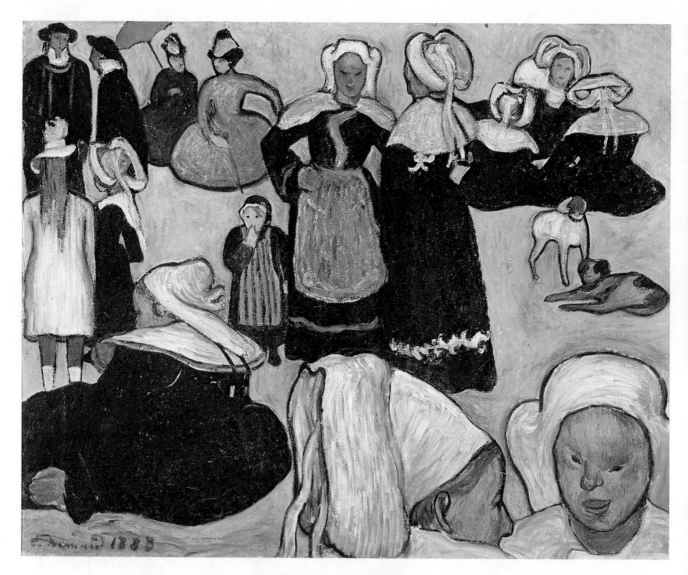

29. **Emile Bernard.** *Breton Women in the Meadow (Bretonnes dans la Prairie)*. 1888. Oil on canvas. 29⅛ × 36¼ in. (74 × 92 cm.). Collection: Maurice-Denis, Saint-Germain-en-Laye. Bernard's fame has been obscured by that of Gauguin. Bernard had painted this picture before Gauguin met him in Brittany, and it led Gauguin to strengthen his colours, simplify his colour areas and use firmly painted outlines—that is, to suppress the Impressionist elements in his work. Subsequently Bernard's stylised art became one of the sources of Art Nouveau; compare this illustration with van de Velde's embroidery, plate 32.

30. **Vincent van Gogh.** *Self-portrait with Bandaged Ear.* 1889. Oil on canvas. 23½ × 19¼ in. (60 × 49 cm.). Courtauld Institute Gallery, London. Painted in January, 1889, about three weeks after his attack on Gauguin and subsequent self-mutilation, this work demonstrates both the control and the power of van Gogh's art. The form and direction of the brushstrokes recreate the structure of the subject painted, and at the same time weld the picture into a tightly constructed whole.

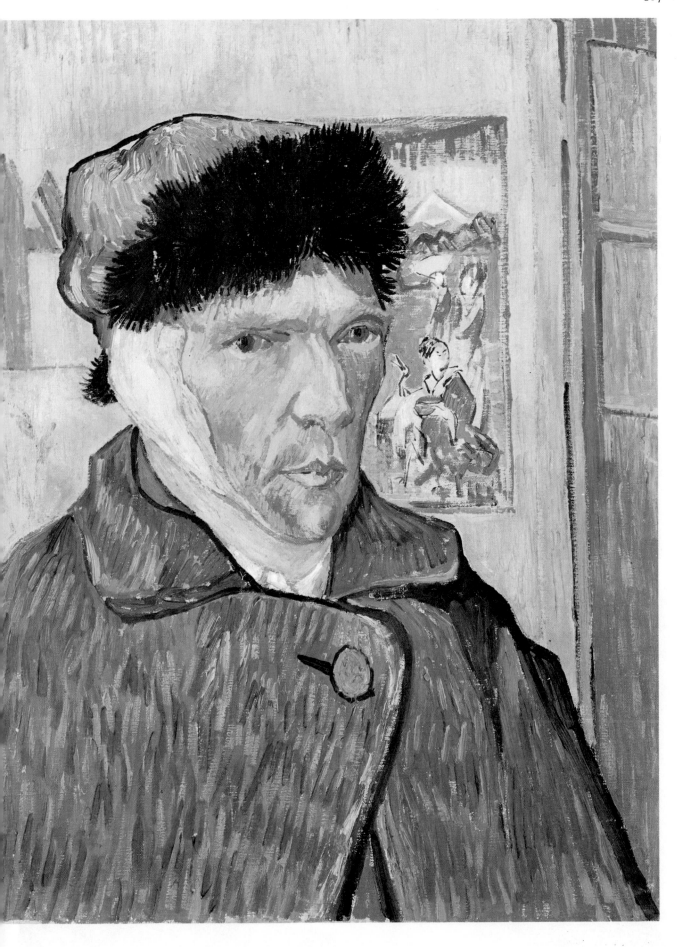

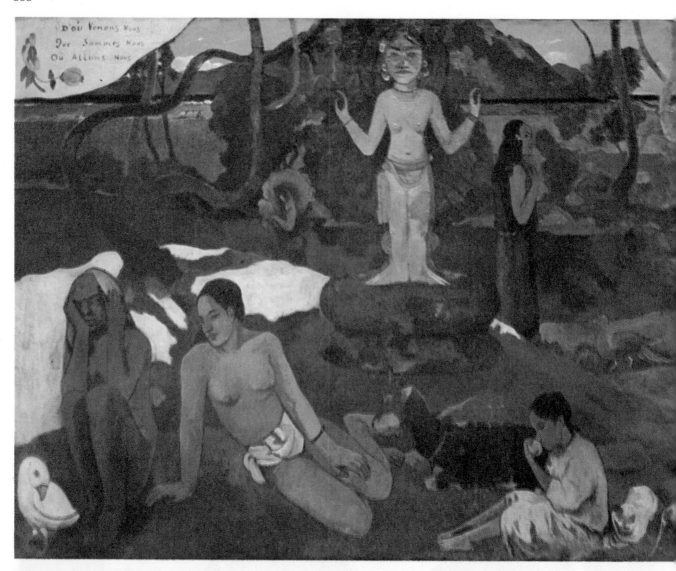

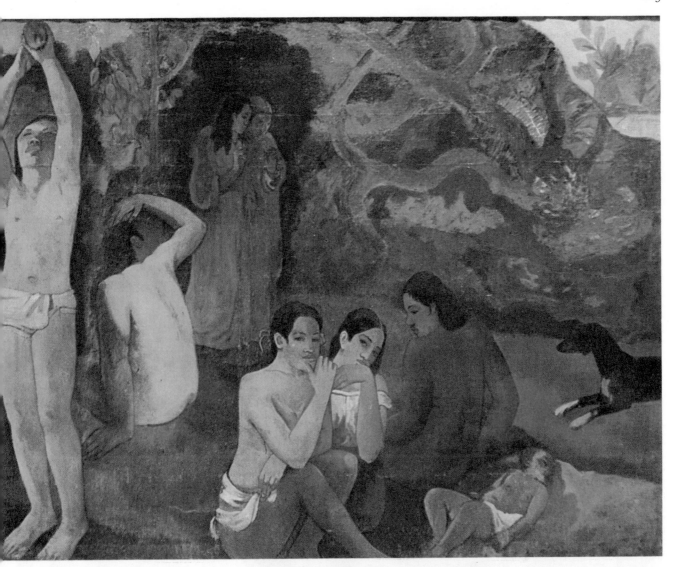

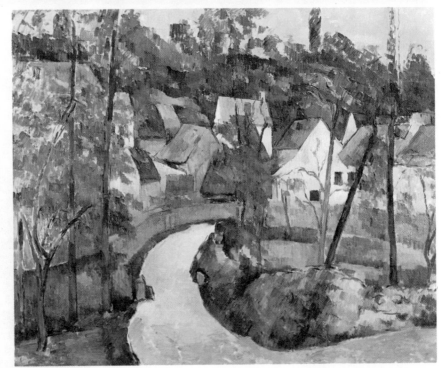

31. **Paul Gauguin.** *Where Do We Come From? What Are We? Where Are We Going?* 1897. 54¾ × 147½ in. (139 × 374.5 cm.). Courtesy Museum of Fine Arts, Boston. 'I believe not only that this canvas surpasses in value all my previous ones, but that I shall never make a better or a similar one. I have put into it before dying all my energy, a passion so painful in terrible circumstances, and a vision so clear, needing no corrections, that the hastiness disappears and life surges up.'

32. **Henri van de Velde.** *Engelswachen.* 1891. Tapestry. 55 × 91¾ in. (139.5 × 233 cm.). Kunstgewerbe Museum, Zürich. One of the first Art Nouveau painters to abandon fine art, Van de Velde became a leading architect, designer and theorist.

33. **Paul Cézanne.** *The Turning Road. (La Route Tournante).* 1879–82. Oil on canvas. 23½ × 28¾ in. (60 × 73 cm.). Courtesy Museum of Fine Arts, Boston. Impressionism led Cézanne to paint landscapes in the open air, but he strove to integrate forms and light and construct his pictures with the solidity of the old masters.

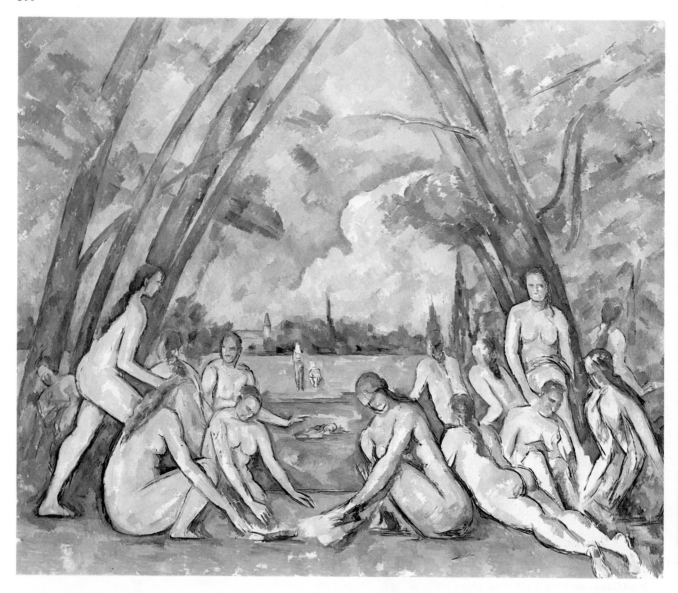

34. **Paul Cézanne.** *Bathers (La Grande
Baignade).* 1898–1905. Oil on canvas.
82 × 98¼ in. (208 × 249.5 cm.).
Philadelphia Museum of Art. (Wistach
Collection). The largest of Cézanne's series
of bathers, this picture represents his most
ambitious attempt to submit the human
figure to the kind of reconstruction he
imposed on landscape and still-life subjects,
and to distort it to fit his structural and
expressive purpose without diminishing its
presence or dignity.

35. **Odilon Redon.** *Cyclops. c.* 1898. Oil on
panel. 25¼ × 20 in. (64 × 50.8 cm.).
Rijksmuseum Kröller-Müller, Otterlo.
The development of Symbolist poetry
coincided with a tendency towards fantastic
art which found its finest expression in the
lithographs and pictures of Redon, who
thus stands out as a forerunner of
Surrealism.

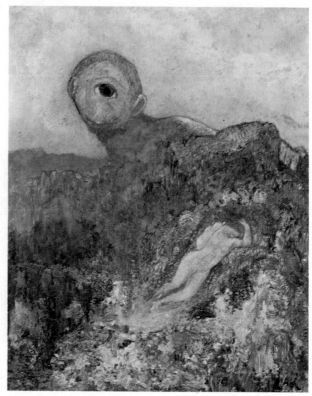

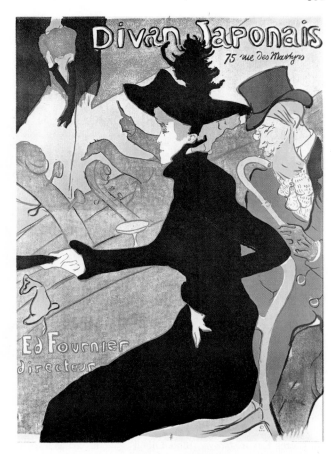

36. **Henri Marie Raymond de Toulouse-Lautrec.** *Divan Japonais.* 1892. Poster. Lithograph. 31 × 23½ in. (60 × 80 cm.). Musée Toulouse-Lautrec, Albi. Through his lithographs, for use as posters etc., Toulouse-Lautrec brought painting and commercial art into a particularly close relationship which continued through the Art Nouveau period. Since then the interchange has been more spasmodic.

37. **Pierre Bonnard.** *Le Café. c.* 1914. Oil on canvas. 28¾ × 41⅞ in. (73 × 106.5 cm.). Reproduced by courtesy of the Trustees of the Tate Gallery, London. In his contributions to the long history of paintings of domestic scenes, Bonnard achieves a transformation of the physical world into an independent pictorial world of colour and tone that is comparable to that of Monet in his late works.

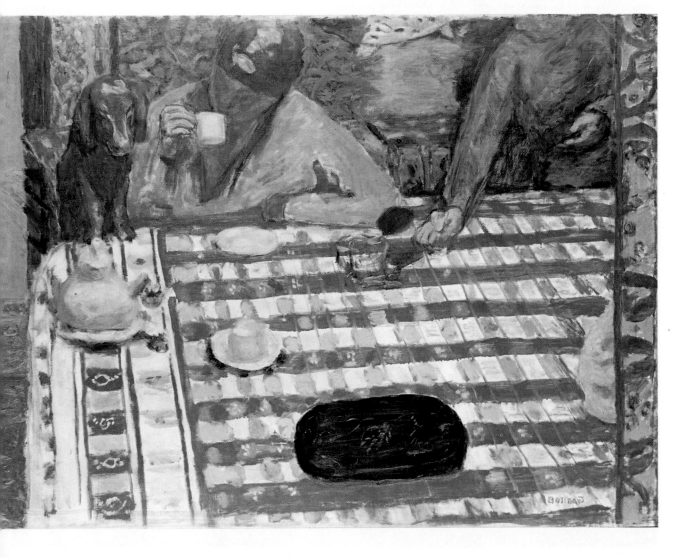

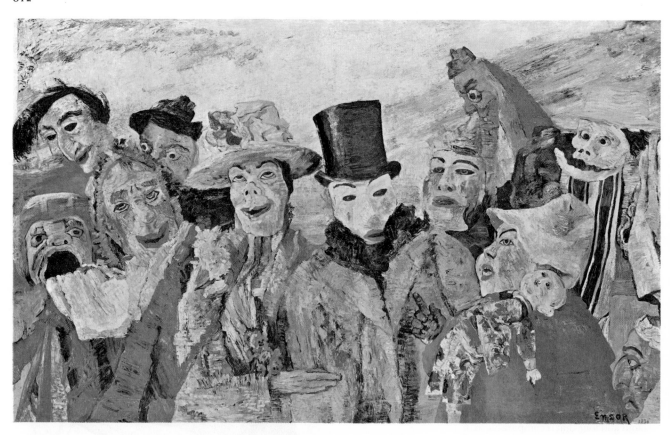

38. **James Ensor.** *Intrigue.* 1890. Oil on canvas. 35½ × 59 in. (90 × 150 cm.). Musée Royal des Beaux-Arts, Antwerp. Having had some success with beautifully painted domestic and outdoor scenes, Ensor rejected agreeable subject-matter and pleasant techniques and colours to use his art as a weapon to criticise the world about him, particularly its hypocrisy.

39. **Edvard Munch.** *Jealousy.* 1896 or 1897. Oil on canvas. 26½ × 39⅜ in. (67 × 100 cm.). Billedgalleri, Bergen. Reproduced by courtesy of the Munch Museet, Oslo. This work relates to specific events in Munch's own life, and is typical of his adaptation of a more or less Art Nouveau idiom for intensely subjective and expressive purposes.

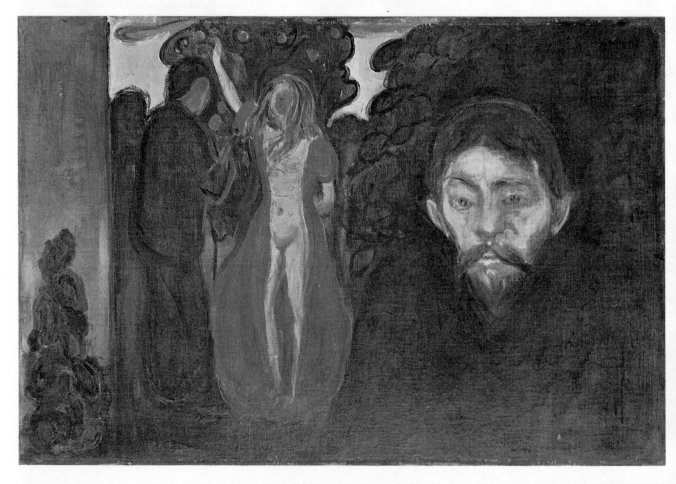

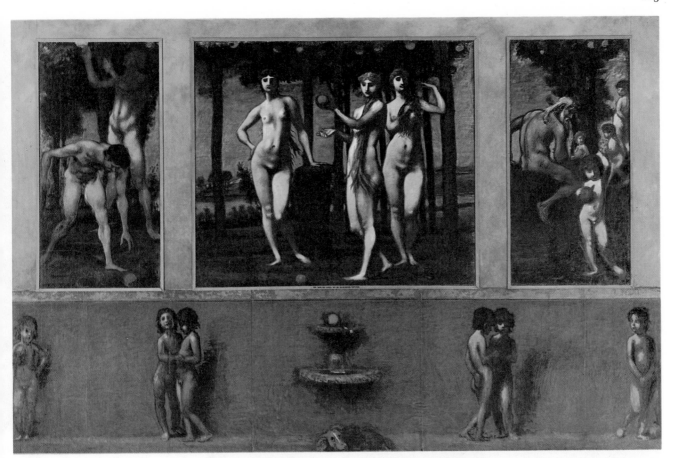

40. **Hans von Marées.** *The Hesperides II.*
1884–5. Tempera on panel. 134 × 190 in.
(340 × 482 cm.). Bayerische Staats-
gemäldesammlungen, Munich. While the
Post-Impressionists were challenging
naturalism in the name of organisation and
expression, the German painter Marées
sought monumentality and cohesion
through simplified classicism, a firm
structure, and a harmonious interrelation
of idealised forms and a few colours.

41. **Max Liebermann.** *The Cobbler's
Workshop.* 1881. Oil on canvas. 25 × 31½
in. (64 × 80 cm.). Nationalgalerie, East
Berlin. Impressionism was denounced in
Prussia as an art of rebellion and its
influence led to a schism in the Berlin
Artists' Society in 1892. Liebermann was
recognised as the leader of German
Impressionism but he adopted only some
aspects of it, and joined them to the kind
of realism he had seen in Dutch seventeenth-
century painting.

814

42. **James McNeill Whistler.** *Arrangement in Grey, (self-portrait).* 1871–3. Oil on canvas. 29½ × 21 in. (75 × 53.5 cm.). Institute of Arts, Detroit. In Paris Whistler was affected by Manet and Japanese art. From 1859 in London, his work displays a self-justifying aesthetic delicacy that borders at times on vapidity but has an extraordinarily fine sense of composition and tonal values.

43. **William Morris.** *Daisy wallpaper.* 1862. Wood-block on paper. 27 × 21 in. (68.5 × 53.5 cm.). Victoria and Albert Museum, London. Morris's emphasis on flat design in applied arts is closely contemporary with Manet's rejection of three-dimensional effects in painting.

44. **Gustav Klimt.** *The Kiss.* 1908 or 1911. Oil on canvas. 71 × 71 in. (180 × 180 cm.). Österreichische Galerie, Vienna. The greatest of Art Nouveau painters, Klimt (1862–1918) made bold use of large contrasting areas of colours and pattern to produce almost barbaric splendour.

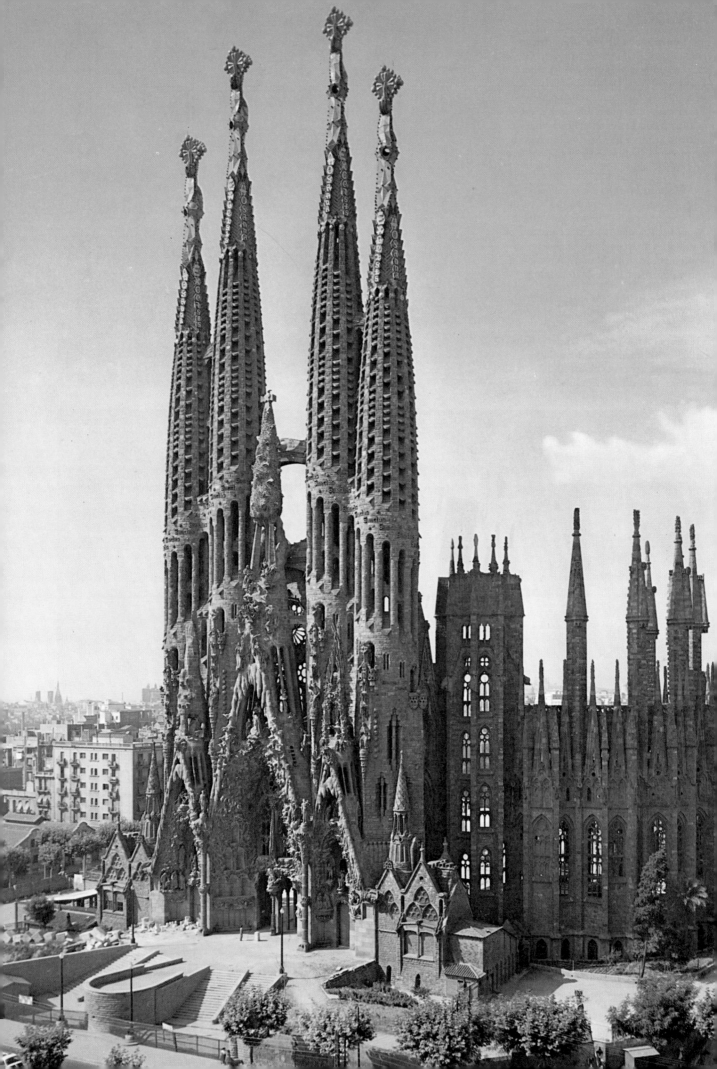

Cézanne's importance lies in his position as the meeting point of disparate traditions. Cubism and Fauvism owe much to him and countless painters have regarded him as their 'master *par excellence*' (as Klee wrote). Behind him lies the painterly tradition of Veronese, Rubens, Watteau, Delacroix, and the French classical tradition of Poussin, Chardin and Ingres. He is linked to Seurat in his concern for a clear structure on the picture plane, and to van Gogh by his regard for the value of objects and the need to 'realise' them. He spoke of 'realising his little sensation' and meant constructing a convincing pictorial image containing the character of his motif and yet preserving the reality of the painting itself as an object made of paints and canvas. Like an Impressionist he underlines the unity of things, but in terms of relationships, not under a blanket of light. And when he flattened pictorial space, stressing the surface of his picture with his mosaic-like touches of paint, adjusting the forms of three-dimensional objects to bring them to the surface, and rejecting (with the help of the Provençal climate) the possibility of atmospheric veils distancing the horizon, he was not applying a pre-conception or a dogma: he was observing, with a patience and an objectivity that are quite unequalled. Perhaps we can see, in this patience and this objectivity, his earlier turbulence harnessed to a clearer creative purpose. No longer is his passion seen in explosive subjects or their dramatic presentation; now it comes between the brushstrokes, in the act of looking, in the long process of weighing up and selecting. Cézanne did not beget a movement, yet he knew he was the progenitor of a new art and almost all painting since his day has owed something to him. His recognition that 'art is a harmony parallel to nature' is the foundation of many subsequent developments.

OTHER POST-IMPRESSIONISTS

Cézanne, Gauguin, Seurat and van Gogh are usually grouped together as the Post-Impressionists, but they share not so much a style as a negative attitude towards Impressionism. Associated with these giants, there were also relatively minor figures who made important contributions. The Nabi group based itself principally on the ideas of Gauguin and Bernard, and developed particularly their use of flat coloured shapes into decorative idioms that influenced the Art Nouveau movement. One of them, Maurice Denis, published in 1890 the challenging statement that became a rallying cry: 'Remember that a picture, before being a battle horse, a nude woman or some anecdote, is essentially a flat surface covered with colours assembled in a certain order'. Two of them, Edouard Vuillard (1868–1940) and Pierre Bonnard (1867–1947) started from such a decorative style

45. **Antonio Gaudí.** *Church of the Holy Family, Barcelona.* Gothic in its general silhouette, Art Nouveau in its tendency to curves and elaborate ornamentation rather than straight lines, and profoundly original in its structural basis, Gaudi's church, even in its incomplete state, is a monumental milestone on architecture's road from historicism to a new expressiveness and functionalism.

and added to it elements from Impressionism in paintings of domestic scenes. 'The painter's instrument is his armchair', said Vuillard, and they found in their homes complexes of light and dark, of linear structure and colour patterns of extraordinary visual interest. After 1900 Bonnard came to use more intense colours for pictures full of optical incident. To his interiors he added a series of resplendent land- 37 scapes, firmly constructed but wonderfully rich and fluid. Odilon Redon (1840–1916) was the painter most directly 35 associated with symbolism. 'Everything takes form,' he said, 'when we meekly submit to the uprush of the unconscious', stating with precision a view that has become the programme of many later painters. His close study of nature, of colour, and of the techniques of painting and lithography, enabled him to present his fantasies with great technical and imaginative freedom.

BELGIAN AND GERMAN PAINTING

Outside France, too, there were painters struggling away from the emphasis on natural appearances that dominated so much nineteenth-century painting. The Belgian, James Ensor (1860–1949), one of the *Groupe des Vingt*, turned away 38 from the sensitive recording of the world around him and used his work to criticise that world. He rejected not only naturalism but also traditional standards of fine painting, adopting a cartoonish manner that led even his friends of *Les Vingt* to exclude him from their exhibitions. The Norwegian, Edvard Munch (1863–1944), who studied partly in Paris and then spent some years in Berlin, used his art to express (and thus in part surmount) profound personal disturbances that made his streets echo with fear, filled landscape with death and turned woman into a vampire. Both Ensor 39 and Munch were to exercise much influence on the central European movements labelled Expressionism, both as painters and as graphic artists.

In Germany academic naturalism had joined with literary sentimentalism to rot the moral fibres of painting. Among the handful of painters fighting to lift their art to a higher level through style and seriousness, the most impressive was Hans von Marées (1837–87). He spent most 40 of his life in Italy, adopting the classical ideal of a Golden Age in order to concern himself first and foremost with pictorial organisation. He was the only German painter of the century to comprehend the constructive power of colour, and with his broad colour chords and clear linear structures, composed large paintings that have a real sense of the monumental. His country lacked an artistic past on which to establish new standards (until the Expressionists managed to strike roots into the age of Dürer) and it took little interest in Marées's abstraction. To this day he is little regarded outside Germany, perhaps the most underrated painter of his century.

IMPRESSIONISM OUTSIDE FRANCE

The general effect of Impressionism in Europe was an involvement with realistic tendencies, lending them a greater freshness of colour and technique. In Germany

painters like Max Liebermann (1847–1935), Corinth and Slevogt, worked on the basis of a brusque naturalism in which elements of Barbizon painting, Manet, Courbet and Impressionism mingled. James Abbott McNeill Whistler (1834–1903), American born, Paris trained, but working principally in London, came close to Impressionism in some of his less abstract works. But Manet, Spanish painting and Japanese prints were at least equally important to him, and his ideal was an entirely artificial art that owed little to observation. He said, 'As music is the poetry of sound, so painting is the poetry of sight, and the subject-matter has nothing to do with the harmony of sound or of colour', and he stressed the importance of our, so to speak, listening to his paintings by giving them titles that refer to music, *Nocturne, Symphony, Harmony*. He was a fine colourist, but it was in the tonal construction of his paintings that he was at his best, and he should be remembered as the last great manager of tone. Real Impressionism was less well received in Britain than might have been expected. English taste in landscape painting still inclined to the picturesque. The public, at last accustomed to Constable and the earlier works of Turner, on the whole found Impressionism too aggressive in colour and too wild in technique. The word, 'Impressionist', was attached to some English painters but their version of the style, as in the case of Philip Wilson Steer, was dominated by the English landscape tradition or, as in the case of Walter Richard Sickert (1860–1942), owed more to marginal figures like Degas than to the movement itself. Nevertheless the broken touch of Impressionism, its fresh colouring and adherence to everyday subject-matter entered deeply into European art consciousness; the very way in which we look at our environment has been altered by what was once generally agreed to be the work of incompetent anarchists.

The art of Winslow Homer shows how close to French Impressionism painters could come without debt to France. Homer (1836–1910) did in fact spend some months in Paris, and he is known to have had a high regard for the colour treatise of Chevreul, used also by French painters, but the source of his art is close, passionate observation. This he practised without colour through illustrations done for *Harper's* over many years, but to this experience he added a Constable-like association of visual truth with moral completeness. Henry James said he was 'a genuine painter: that is, to see, and to reproduce what he sees, is his only care', and went on to complain of his total lack of imagination. Other Americans, less burdened by a classical education than James, responded gladly to what they saw as American subjects treated with American directness.

ART NOUVEAU

Yet even as the ripples of French influence spread this new naturalism, a broad movement swept across Europe, owing much to Post-Impressionism but ranging widely over the fine and applied arts and architecture. Known as Art Nouveau in France and Britain and as *Jugendstil* in Germany, it represented the first new international style since the

19 **Jan Toorop.** *Girl with Swans (Dolce)*. c. 1896. Coloured lithograph. 9¼ × 7¾ in. (23.5 × 19.5 cm.). Rijksprenten-Kabinet, Amsterdam. The patterns of flowers and parallel lines, and the exaggerated quality of sub-Pre-Raphaelite languidness, make this print an extreme but by no means unique example of international Art Nouveau design.

Middle Ages, owing nothing to historicism. It was not principally a style of painting, although it derived some of its characteristics from aspects of Post-Impressionism and helped to spread these into the painting of other countries, but in its varying manifestations it placed great emphasis on the power of lines and colours irrespective of subject-matter and showed how such elements could control the character of a whole environment. A short-lived movement, it was one of the forces that pushed painting towards abstraction. Its immediate effect was to link the several centres where Art Nouveau flourished—notably Paris, Munich, Brussels, Vienna, Glasgow and Moscow—and to encourage pure artists to apply their sensibilities to design. During the height of Art Nouveau, roughly 1895–1905, a great number of painters turned from studio to workshop activities, like, for example, the Belgian, Henry van de Velde (1863–1957), who began as a Neo-Impressionist painter, then designed furniture and interiors, then worked as architect, and is perhaps most important for his work as teacher in Germany (Weimar) and Belgium (Brussels and Ghent). Generally speaking, Art Nouveau had the effect of encouraging artists to trust in their own inventiveness and to ally themselves less to recognised styles. Art Nouveau and Post-Impressionism form the platform on which twentieth-century painters were to build.

LATER NINETEENTH-CENTURY SCULPTURE: RODIN AND OTHERS

The history of sculpture in the second half of the century is brighter than that of the first: in Rodin, France produced a sculptor of outstanding quality and importance. But he

20. **Winslow Homer**, *The Gulf Stream*. 1899. Oil on canvas. 28 × 49 in (71 × 124 cm.). The Metropolitan Museum of Art, New York. Wolfe Fund. A realist with a growing taste for pictorial drama, Homer used observed fact as a basis for meaningful images. The composition is firmly classical, giving the image epic permanence.

21. **John Haberle**, *Time and Eternity*. c. 1890. Oil on canvas. 14 × 10 in. (35 × 25 cm.). The New Britain Museum of American Art. Haberle (1856–1933), of New Haven, Connecticut, represents a school of detailed naturalism that flourished in the USA in the last quarter of the nineteenth century. Often the theme concerns death and judgement.

stood alone. Around him the art of sculpture reached unprecedented depths, while hero-worship and rampant nationalism combined to guarantee demand. The few sculptors we need recall were almost exclusively French.

Jean-Baptiste Carpeaux (1827–75) can be seen as a follower of Rude, extending the latter's Baroque Romanticism into a lighter and at times more realistic vein that could be called Rococo Romanticism. A comparison of Carpeaux's relief *The Dance* (1869) on the Paris Opéra with Rude's relief on the Arc de Triomphe shows the greater *9* delicacy of Carpeaux's work, though it is doubtful whether this recommends it as sculpture for an architectural setting.

Sculpture played a similar role for Degas as it had *22* for Daumier. He made wax studies of dancers, bathers and horses, as alternatives to sketches done on paper, his aim being to seize the character of a pose and its involvement with the surrounding space.

Rodin alone achieved a really significant relationship *23, 24,* **17** with the past and the future. Auguste Rodin (1840–1917) was not naturally a revolutionary. He sought and gained public approbation and there were streaks in him of the sentimentalism that falsifies so much nineteenth-century art. He was more vehemently for the past than other sculptors but did not limit his enthusiasm to the classical tradition, taking a passionate interest in Gothic art and seeing Michelangelo as 'the culmination of all Gothic thought'. All his work was concerned with the human figure. He had the original idea (inspired by classical remains) of making truncated figures, limbless and/or headless torsos

which were thought in his day to reveal a streak of sadism (as perhaps they do), but have the important effect of lifting sculpture out of the range of normal subject-matter into a sphere where its abstract qualities of line, mass and tension dominate the responses it evokes. Rodin, who admired and encouraged Degas as a sculptor, went far beyond him in his search for the unposed pose. Degas was fascinated by the ritual gestures of women at their toilet, by the conventional movements of ballet dancers on stage and their almost as conventional movements off it, and he accepted gladly any deviations from his selected norms. Rodin planned for deviations. His models moved around him and he captured in swift line-and-wash sketches those momentary disposi-tions that seemed to him expressive. Thus, like Michelan-gelo, he found in artistically unprecedented movements a whole world of expressive form that seemed to him fundamentally at one with nature at large: 'A woman, a mountain or a horse are formed according to the same principles'. He was an expressionist before Expressionism. His means were often those of exaggeration, and he received into art figures and themes that were generally considered ugly and therefore unsuitable: 'in art only those things that are characterless are ugly'.

The range of Rodin's work is in itself impressive: from marbles laboriously worked by assistants to swift clay sketches, from incomplete torsos to the encyclopedic project (left unfinished but productive of many separate sculptures) of the *Gate of Hell*. The open surfaces of his bronzes suggest vivid sensations of life and mobility. In particular the surfaces of his smallest and improvised works, exhibited mostly after 1900, liberated sculptors from the strait-jacket of 'finish'. There was much opposition to his work in his day, but his influence was such that he alone can be thought of as the father of modern sculpture.

His exclusive attachment to the human body, however, limited his effectiveness in history. A great part of modern sculpture is concerned with other kinds of form and with questions of form unrelated to anthropometry. Here Rodin did offer one important precept: 'sculpture is the art of the hole and the lump', which could be taken as the underlying theme of much subsequent work, but he had little to say about sculpture as structure. Here lies the importance of Marées's friend, the sculptor, Adolf von Hildebrand (1847–1921), who insisted that sculpture is a visual art that must be organised to present itself clearly to sight. The sculptor's problem, he said, was that of 'unifying forms into relief effects'. 'So long as the chief effect of any plastic figure is its reality as a solid, it is imperfect as a work of art'. His own work is marked by impassivity and clarity, and by a simplification of forms that has been rendered commonplace by the host of his followers. Did Hildebrand sense the dichotomy of reality and unreality we mentioned earlier, and seek to reduce it? Historically his most important work is the treatise, *The Problem of Form* (1893), one of the few books ever written to question the functions of sculpture. Its influence reached not only sculptors but artists and writers on art generally.

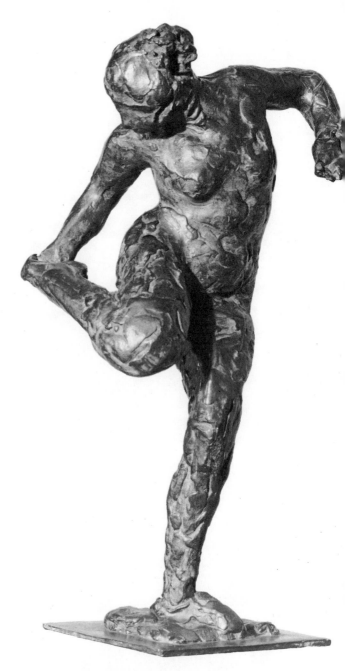

22. **Edgard Degas.** *Dancer Looking at the Sole of her Right Foot.* 1910–11. Bronze, 18¾ in. high (47.5 cm.). Reproduced by courtesy of the Trustees of the Tate Gallery, London. Clay was to Degas an ideal means for studying and capturing the character of a momentary pose.

The Italian sculptor, Medardo Rosso (1858–1928), in a different way also stressed the non-physical character of sculpture. Under the influence of the Impressionists, he modelled small sculptures affecting all the transience and indistinctness of form and the chance positions that they used in their pictures. To a long term view this seems an evasion of rather than a solution to the problems of sculpture, but historically Rosso played the interesting role of forming a bridge between Impressionism and the Futurists of his own country. He demonstrated in sculpture what has since become a stock theme of modern art aesthetics: 'We should accustom ourselves to seeing in movement the clearest and the simplest thing there is, since rest is merely the most extreme limit of the deceleration of movement, perhaps only an ideal limit that is never realised in nature,' as Bergson had put it in 1901).

23, 24. **Auguste Rodin.** *St John the Baptist preaching*. 1878.
Bronze. 79 × 21¾ × 38¾ in. (200 × 55 × 98 cm.). Musée
Rodin, Paris. *Polyphemus*. 1888. Bronze. 9¾ × 5½ × 6¼ in.
(25 × 14 × 16 cm.). Musée Rodin, Paris. Rodin sought powerful
expression rather than beauty. To achieve this he moved far
from naturalism and even further from ideal standards of beauty.
Often he gave his figures poses involving extreme physical
tension in order to express spiritual states, and he broke up his
sculptures' surfaces to enliven and dramatise the form.

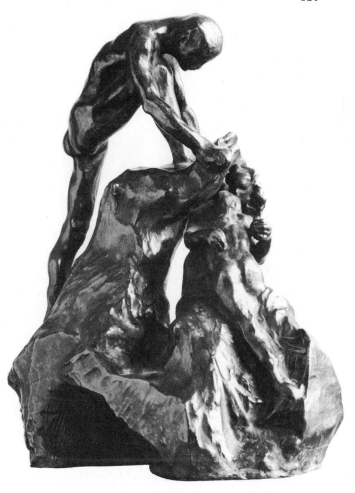

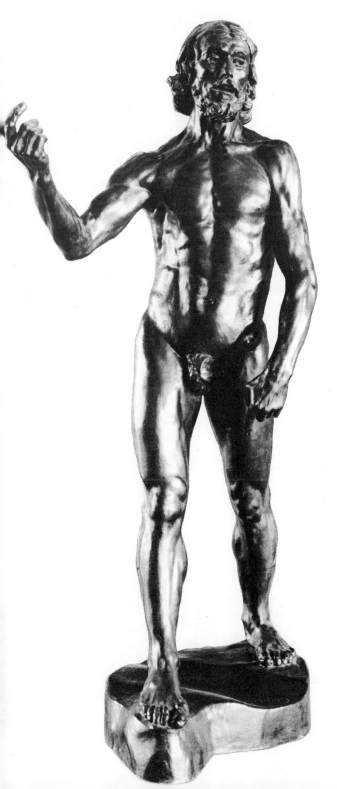

LATER NINETEENTH-CENTURY ARCHITECTURE

The bad architecture of the latter half of the nineteenth
century is more dismal than that of the former, when there
were still traditions of taste to guide designer and patron,
but the good architecture is more adventurous than anything
since Soane and Schinkel. Historicism was far from dead but
there was a growing desire among architects to stop treating
architecture as an art of imitation. The two outstanding
developments of this period were the impact of cast iron and
steel and the search for a kind of architectural primitivism
not unlike that which we have noticed in painting. In both
respects America took on a very important role.

It was a failure on the part of professional architects to
meet a specific architectural problem that led to the crea-
tion of one of the most revolutionary buildings of the cen-
tury. When the building committee for London's Great
Exhibition of 1851 had finished its designs, it was clear that
insufficient time remained for its erection. The solution
came from the Duke of Devonshire's head gardener,
Joseph Paxton (1803–65), who designed what became 25
known as the Crystal Palace on the basis of ideas he
had already applied to the design of glass and cast-iron
greenhouses. Erected in nine months out of mass-produced
and standard ingredients that could be taken down as easily
as set up, the vast Crystal Palace offered new experiences
in architectural light and space as a convincing demonstra-
tion of the utility of new materials and industrial techniques.
The exhibition inside it demonstrated at once the wonders
of international manufacture and the depths to which design
had sunk at the time.

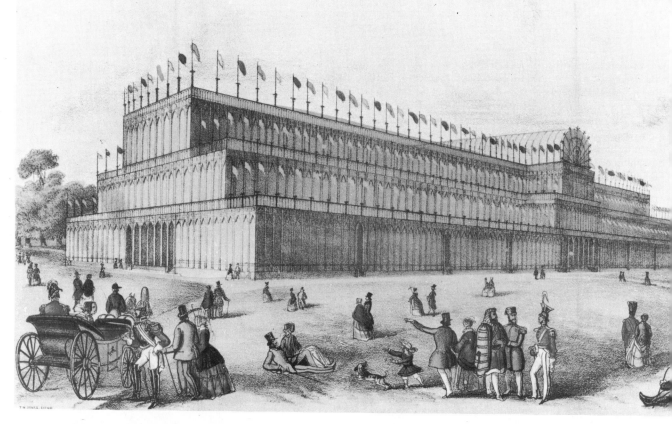

25 (above). **Sir Joseph Paxton.** *Crystal Palace, London.* 1850–51
A totally successful invasion of the field of architecture by the forces
of engineering and manufacture, this exhibition building was
honoured by later generations as a unique forerunner of the
technological architecture of the twentieth century.

26. **Lewis Cubitt.** *King's Cross Station, London.* 1851–52. Cubitt's
station shows considerable structural boldness but is
outstanding for the undisguised demonstration of its basic
structure on the front of the building, where another architect
would have preferred to veil the engineering structure of the
platform sheds with a façade of white-collared classical or Gothic
architecture.

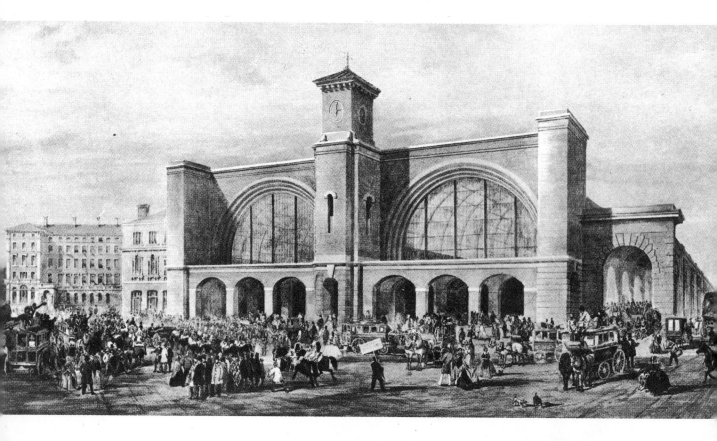

Henri Labrouste. *Reading Room, Bibliothèque Nationale, Paris.*
1862–8. Whilst Labrouste still found it necessary to pay homage
to tradition in his ornament, the fine lines of his metal and
terracotta vaults on their slender columns give his Reading Room
a new lightness and space.

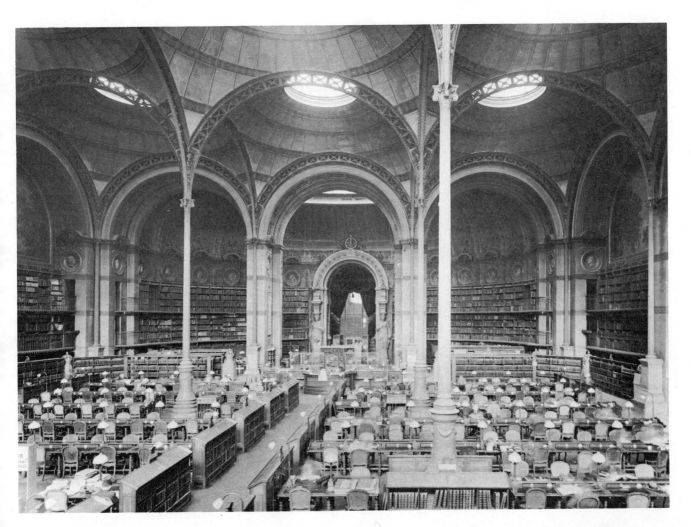

This system was also used to carry the two glass vaults
over a cast-iron substructure at King's Cross Station,
London (designed by Lewis Cubitt in 1850; and built
1851–2). The station has a special place in history because
of the way in which these vaults (that is, the utilitarian
engineering structure) are boldly displayed at the main front
of the station where it was normal to have recourse to
historical rhetoric. In Paris, where the discreet use of cast
iron to strengthen masonry has a long history, the Reading
Room of the Bibliothèque Nationale (by Henri Labrouste,
1801–75; built 1862–8) is an outstanding example of an
interior dominated by a very thinly disguised cast-iron
structure of great elegance. The process invented by Bes-
semer in 1855, facilitating the large-scale production of
steel, offered new possibilities for the use of metal in build-
ing. Gustave Eiffel's (1832–1923) tower, built for the Paris
Exhibition of 1889 and nearly a thousand feet high, cele-
brates the fact. Until the erection of the Empire State
Building in New York in the early 1930s, the Eiffel Tower
remained the tallest structure in the world. For the same
exhibition the engineer, Contamin (1840–93), erected the
Palais des Machines, a masterpiece of engineering.

It is the American steel-framed skyscraper, however, that
marks the true conjunction of architecture and engineering
and the moment when architects begin to accept engineering
structures as part of the forces they command. From about
1890 onwards, skyscrapers arose in Chicago and New York
in quick succession. Louis Sullivan (1856–1924) was the
most thoughtful and inventive architect to contribute to this
development. The dictum he propagated, that 'form follows
function', is neither unprecedented nor a sufficient explana-
tion of his work, which was as much concerned with new
ideas in abstract ornamentation (linking Sullivan to the Art
Nouveau movement) and with self-justifying formal effects
as with the logic of structure and function. One of his finest
office blocks is the Guaranty Building in Buffalo, New York

28. **Gustave Eiffel.** *Viaduct over the Truyère at Garabit.* 1880–4.
The creator of the Eiffel Tower in 1887–9 had previously had
two major opportunities to test the potential of the lattice-beam
he had developed: in a bridge over the Douro near Oporto,
Portugal, and in this soaring structure in the French Massif
Central.

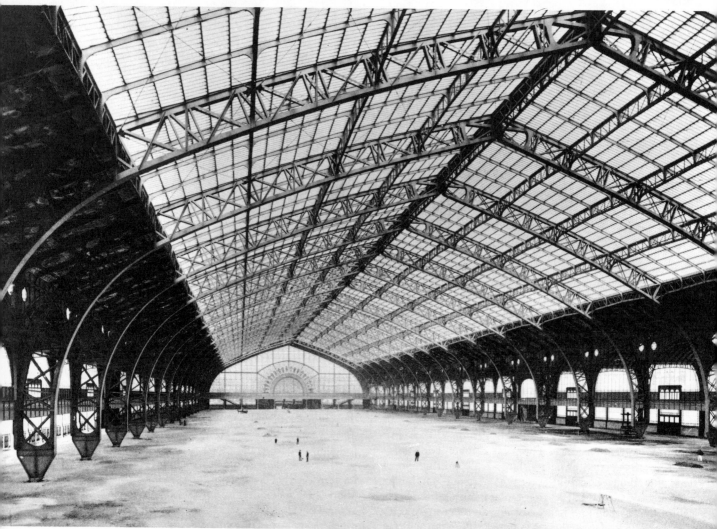

29, 31 (left and right). **Louis Sullivan.**
Guaranty Building, Buffalo, New York,
and *exterior detail* (left). 1894–5. Sullivan's
office buildings show his feeling both for
structure as a source of architectural
expression and for localised
ornamentation of a delicate and complex
kind.

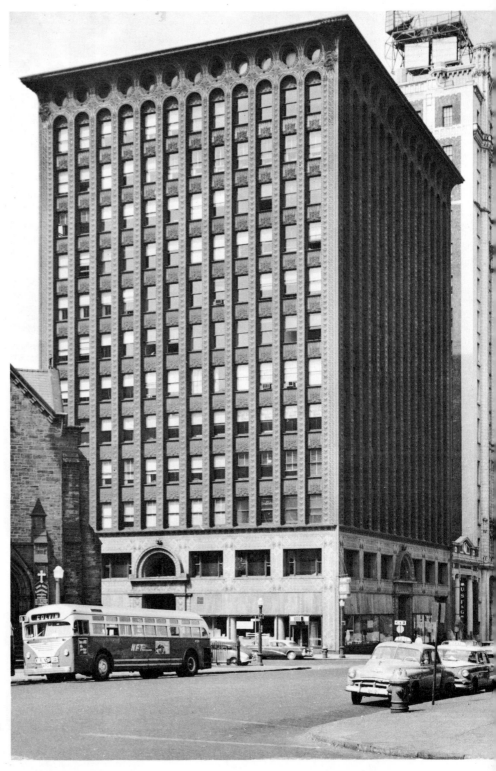

30 (left). Engineers: **Contamin, Pierre &
Charton.** Associated Architect, **Dutert.**
*Palais des Machines, Paris International
Exhibition.* 1889. Steel and glass. Span 375
ft., length 1,400 ft. (114.3 m. × 426.7 m.).
A heroic demonstration of the functional
potential of steel and glass engineering, this
exhibition hall helped also to develop a
new sense of formal beauty.

(1894–5). Here the cage-like structure is dramatically
expressed on the exterior, even hinting in the openness of the
ground floor at the later convention of raising buildings on
piers or *pilotis.* The upper storeys rejoice in the verticality
of the structure instead of countermanding it. The cornice-
like projection at the top and the ornamental terracotta
cladding represent the other side of Sullivan's interests.

THE REJECTION OF HISTORICISM

The freedom from historical styles shown by Sullivan's
work—the freedom, that is, for architects to form each
building according to its needs and his time's inclinations—
was successfully reasserted during the later decades of the
century. It was not the work of one architect and manifested
itself in different ways, but it always involved the rejection
of the heavy historical styles that flourished in the middle
of the century and an almost total aversion from the
associative evaluation of past styles for the sake of more
purely aesthetic responses. Historicism itself contributed by
drawing attention to periods of architecture when effects of
massing, of texture or bareness, of void set against solid, etc.,
dominated over conventional ornament. The simpler forms
of medieval architecture, and particularly of Romanesque
buildings, were important here, and contributions came
also from the traditions of peasant building, farms, cottages
and barns, and generally from local traditions that had

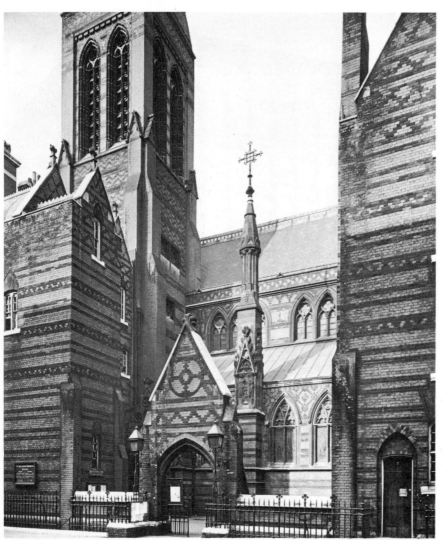

32 (left). **William Butterfield.** *All Saints' Church, Margaret Street, London.* 1849–59. Butterfield is an outstanding example of those few mid-century architects who were able to bring to Gothic design an inventiveness comparable to that with which Soane and a few others handled the classical idiom earlier.

34 (right). **Philip Webb.** *The Red House, Bexley Heath, Kent.* 1859–60. This house, which was built for William Morris, is an early example of the almost styleless primitivism that could result from a personal and more or less functional use of traditional idioms.

33 (below). **Richard Norman Shaw.** *Leyswood, Groombridge, Sussex.* 1868–9. Pen drawing. 22½ × 33½ in. (57 × 85 cm.). The Drawing Collection, Royal Institute of British Architects, London. To Shaw and to other architects of his generation, a personal and functional use of pre-Renaissance design traditions appeared to offer a way out of the historicism that had vitiated so much nineteenth-century architecture.

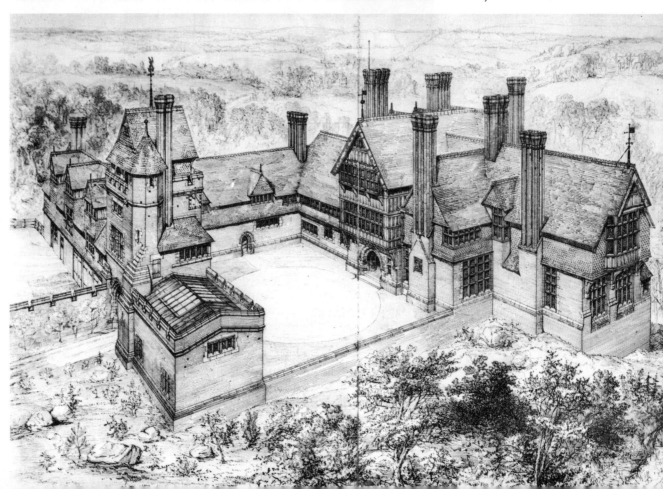

arisen without benefit of white-collared professionalism. Thus architecture was affected by the same search for the primitive basis of design that we observed in the work of the Pre-Raphaelites and that of Gauguin and his friends, and this search becomes even more characteristic of developments after 1900.

Here again Britain played a leading role. Butterfield's very personal use of Gothic forms in the 1840s and 1850s appears to have emboldened others. From about 1860, a number of British architects designed buildings in which historical elements play only a minor part. Richard Norman Shaw (1831–1912) used various late-medieval and Renaissance styles but handled them in an original and picturesque way. His buildings are curiously timeless and have a relaxed quality that contrasts absolutely with the gesturing of so much Victorian design. His career suggests that there was a considerable demand for his informal buildings. Philip Webb (1831–1915), a more sensitive but less famous architect, produced a masterpiece of organic architecture in his Red House. It looks as though it had been evolved rather than designed. Some of its forms hint at Gothic architecture, and steep tiled roofs and fine brickwork indicate the North, while its timeless quality is even more marked than in Shaw's work. Also Webb's feeling for materials and craftsmanship is greatly superior to Shaw's.

MORRIS

Red House was built for William Morris (1834–96), perhaps the greatest regenerative force in art and design of his time. Morris had studied architecture and had then turned to painting under the influence of Rossetti. In disgust at the aesthetic and technical quality of the furnishings available to him when Red House was being built, he decided to use things produced by his friends and by himself. Out

of this grew the firm of Morris, Marshall, Faulkner and Company, through which he hoped to reform design and influence the whole world of labour. He was inspired by Pugin and Ruskin, and by his passionate and practical regard for the Middle Ages as an age when over-specialisation had not yet deprived man of joy in his work. His own artistic talent lay in two-dimensional design, particularly in the repeating designs needed for wallpapers and fabrics. These are often outstanding, though not quite as revolutionary as has sometimes been thought. His designs were in fact widely appreciated, partly because he was already well-known as a Romantic poet, but it was not Morris's purpose to provide Victorian gentlefolk with pretty walls. He was a critic of society. He took up Ruskin's theme, that capitalism had turned work into labour, and developed it in writings that began in 1877 and were soon read in Europe and America. Wholesome work had been turned into mindless drudgery, he argued, when the process of making one thing had been split into separate actions. In matters of applied art, not only did no one person have the satisfaction of making a complete thing, but the act of conceiving and designing it was left to yet another person who could be totally unaware of the special problems involved in carrying out his design. The development of the machine had sectionalised and impersonalised the manufacturing process even further. The enemy was blind commercialism, and socialism the antidote.

Although Morris studied the processes involved in producing the things he designed, he could not reintegrate design and manufacture. What he did manage to establish, and his Arts and Crafts Movement propagate, was a new regard for crafts and for craftsmen and the need to relate design to function and material. He partly bridged, that is, the division between the fine artist and the craftsman that

35. **Frank Lloyd Wright.** *Ward Willits House, Illinois.* 1902.
In his 'Prairie Houses', of which this is one, Wright grouped the
rooms around a chimney-stack core, allowing space to flow from
one to the next and extending the house outwards by means of
porches. The functional simplicity of these houses attracted a
great deal of attention in Europe after 1910.

the Renaissance had struggled to achieve, and he partly
freed the decorative arts from their subservience to the
canons of fine art. In 1880 he wrote: 'Have nothing in your
houses that you do not know to be useful, or believe to be
beautiful', and he and his friends worked towards making
adherence to this principle possible. Later, in 1891, Morris
started the Kelmscott Press to bring the same standard into
printing and illustration. His failure was that of the society
in which he lived: all his work only served to make the rich
more comfortable. 'I do not want art for a few, any more than
education for a few, or freedom for a few. No, rather than
art should live this poor thin life among a few exceptional
men, . . . I would that the world should indeed sweep away
all art for awhile.'

THE UNITED STATES

The revitalisation of picturesque design seen in the work of
Webb, Shaw and their successors, was echoed in America,
particularly in the activity of Henry Hobson Richardson
(1838–86). Richardson's strong and masculine work

provided the basis also for Sullivan's innovations in the field
of commercial architecture, and it is out of the Richardson-
Sullivan sphere that there emerged one of the founders of
modern architecture, Frank Lloyd Wright (1869–1959). In
the 1890s and early 1900s, Wright built a series of private
houses in Illinois in which primitivistic tendencies are fused
with revolutionary ideas in domestic planning. An early
admirer of Japanese architecture, Wright brought into
Middle West houses some of its proportions and its clear but
informal relationships, and combined them with traditional
elements in American housing as well as his own ideal of the
articulated but undivided interior space. Wright was a
pioneer also of reinforced concrete architecture in the United
States, at the same time as Auguste Perret and others in
Europe, but it was especially his domestic work that became
influential in Europe from 1910, when the first of a series of
volumes illustrating his work was published in Germany.

ART NOUVEAU DESIGN

The architectural side of the Art Nouveau movement
drew strength from picturesque primitivism and from the
increasing use of metal in buildings. The last time that
architecture, painting, sculpture and the applied arts had
worked together in one spirit had been in the Neo-Classical
period. Now for a time this unity was re-established, and
there has continued to be much fruitful interchange be-
tween the arts. As a principally linear style, Art Nouveau
invited the use of metal for interiors (as in the work of
Victor Horta, 1861–1947) and exteriors (as in the Paris

36. **Victor Horta.** *Maison Horta, Brussels, Dining-room.* 1895.
Architectural Art Nouveau appears to have sprung fully armed
from the head of this Belgian architect in 1892. This interior shows
his use of flowing vegetable lines for furniture and furnishings
within a relatively geometrically structured room.

37, 38. **Charles Rennie Mackintosh.** *Glasgow Art School.* *Exterior* (1898–1909) and *interior of Library* (1907–9). While he is thought of as one of the finest designers in the Art Nouveau movement, Mackintosh's talents ranged wider than that style would suggest. The front of his School reveals his attachment to asymmetrical masses of masonry, stressed by the linear hardness of metal: the later Library shows him placing lines and planes in space with a clarity that heralds the rise of the *De Stijl* movement ten years later.

Métro stations designed around 1900 by Hector Guimard, (1867–1942).

The art that scarcely benefitted at all from the new style was sculpture, tied as it was to the representation of the human figure. But in the hands of some architects, the Art Nouveau period brought to a grand climax the partly sculptural art of massing, and generally encouraged a departure from the straight lines and right angles that are normally considered the bases of architectural design. The Spanish architect, Antonio Gaudí (1852–1926), is an extreme example of a man who took to its conclusion his age's desire to work outside the old stylistic limits, turning Art Nouveau into a subjective and almost expressionistic idiom and giving his buildings the character of a hand-moulded or vegetable form. Begun in 1884 and still fragmen- **45** tary, but built mostly in the 1890s, his Church of the Holy Family in Barcelona is a masterly yet free exercise in the

Gothic vein in which Art Nouveau and the primitive building forms that Gaudí had seen in Africa are brought together in a structure that is in itself a masterpiece of rule-of-thumb and craftsman's wiles. He was a man instinctively close to the spirit of the medieval master masons; he worked for his people and for the greater glory of God. In Glasgow, something of a similar spirit was driving Charles Rennie Mackintosh (1869–1928) into designing buildings and furniture that are as personal, as original as Gaudí's, and, largely for historical reasons, more influential on European developments. His Glasgow School of Art (1898 and 1907) wavers excitingly between simplicity or functionalism (careful use of good materials, large and plain windows to light the studios, the clear expression of structural elements inside the main shell) and an element of fantasy that smacks both of early nineteenth-century Romanticism and the morbidity of *fin de siècle* art and literature, expressed in over-weighty masses of masonry, exaggerated structural gestures, and ironwork not so much wrought as over-wrought. It is a building that stands between the picturesque tradition revived by Shaw and Webb, the functionalism associated with European architecture of the 1920s and 1930s, and the urge towards constructional legibility particularly associated with the *De Stijl* movement. In his own time Mackintosh's work, especially his furniture and interior designs, was of considerable influence in other Art Nouveau centres, particularly in Munich and Vienna.

The Twentieth Century: 1900–1920

The first decades of this century witnessed an extraordinarily rapid series of movements in art and architecture, running parallel to dramatic developments in literature and music, in science and technology, and the whole political and social structure of the world. It was as though the great artists of the nineteenth century had prised open the floodgates and now a vast and varied sea of artistic creativity and inventiveness was let loose over mankind. Nineteenth-century painters had questioned the representational function of painting as well as conventions governing perspectival space, the modelling of figures set in that space, and even the need to approximate to the normal appearance of things. Now painters asserted the greatest possible freedom, not only departing much further from normal appearances of form and colour but rejecting the long tradition by which pictures were supposed to be based on the visible world. At times they even abandoned the usual materials of painting, blurring the ancient demarcation between painting and sculpture. The sculptors of the later nineteenth century had weakened the hold of classicism and realism; now their successors were to challenge the concept of sculpture as the art of the tangible and the solid related to the world of objects in which we live, and investigated instead the interaction of planes and lines within the space in which they are set, or invented forms which, even if they may embody some references to the visible world, are primarily independent of it and self-sufficient. In architecture, now that the way had been found out of the labyrinth of historicism, and some attempt made to bring architecture and engineering together, new conceptions of design and building could be realised with great rapidity.

Each new movement brought with it its host of imitators and camp followers; each revolution produced its own academicism. The greatest masters are always too big to be contained in the movements with which they are associated, while to others the rebellious concepts that initiate a movement gradually become leaden conventions. The whole story of twentieth-century art is one of magnificent leaps forward and extraordinary regressions, of remarkable clear-sightedness on the part of a few protagonists and of misapprehension and thus devaluation on the part of many, of brilliant achievements and empty gestures, of profound originality and overflowing bandwagons. But, chaotic though it is, it is a story of unremitting vitality.

FAUVISM

The first of these movements to come before the public was Fauvism. Henri Matisse (1869–1954) and a group of friends that included Derain, Vlaminck and Rouault, contributed a roomful of pictures to a Paris exhibition in 1905 to find themselves labelled 'wild beasts' (*fauves*) and their work described as 'the barbaric and naive splotches of a child playing with his box of colours'. Assertive and unnatural colour was certainly a characteristic of Fauvism, rooted in the lyrical Divisionism of Signac and Cross, in Gauguin's decorative use of flat areas of unrepresentational colour, and in the vehement application of paint associated with van Gogh. Matisse was by far the greatest artist in the group. Aggressiveness was never part of his programme, though the paintings he did around 1905 include the most violent of his career. While some of his friends saw in the free use of form and colour a way of self-dramatisation, Matisse fused colour and form to convey his optical and emotional responses to his subject and constructed his paintings out of hard-won units of colour-form. 'What I dream of', he wrote in *Notes of a painter* (1908), 'is an art of balance, of purity and serenity'. Not a facilely agreeable art but one in which the outer and inner worlds are fused into a harmonious pictorial organisation. Between the outer world of objects and events, and the inner world of the artist's experience of these, he could see no conflict: his sensations belonged to both. To set down these sensations in an accurate and communicative way required the most delicate of adjustments: 'I want to reach that state of condensation of sensations which constitutes a picture'. Behind this lay not merely the subjectivism of Gauguin but also, significantly, the constructive spirit of Cézanne, as well as the long tradition of elegant painting in France: from the School of Fontainebleau, via Watteau, Boucher and Fragonard, to Renoir. Matisse devoted his art to such themes as beautiful women, interiors and flowers. The roughness that in about 1905 indicates a vein of rebelliousness (against Signac as well as against academic art) soon disappeared from his work. Already in 1907 he had reached a point of balance: 46 fluent lines that are pictorially so right that they seem more realistic than academic, colours that are often sharp and strange but are brought into unity—all of it energetic and taut but giving an impression of peace.

CUBISM

By this time, however, interest among Matisse's younger contemporaries was already moving away from Fauvism to an apparently more objective mode of painting. The death of Cézanne in 1906, followed by a retrospective exhibition in 1907, had drawn attention to his achievement as the creator of a new relationship between the picture and the objective world. The young Spaniard, Pablo Picasso (1881–1973), had spent his youth in Barcelona where he and his friends looked to Art Nouveau as the gateway to a new, free and expressive art. After several visits to Paris, Picasso settled there in 1904. In his so-called Blue Period and Rose Period paintings (about 1901–5), he had evolved a personal idiom, largely traditional in character, capable of conveying melancholic and lyrical themes. Then, under the influence of Cézanne and of ancient Iberian carvings, Picasso turned to more fundamental problems of representation, abandoning a style that had begun to bring financial rewards. In the large and unfinished picture *Les Demoiselles d'Avignon* he 49 demonstrated a new interest in monumentally constructed art. Large female nudes occupy a shallow pictorial space closed by draperies. The swinging lines of the draperies and their sharp edges are echoed in the figures which only distantly relate to the normal forms of women and are almost devoid of modelling. The heads of the three women on the left have a primitiveness of form that relates to Iberian sculpture; those on the right are derived from African negro

39. **Pablo Picasso.** *Mademoiselle Léonie*. 1910. Etching.
Collection, The Museum of Modern Art, New York. Purchase.
As Cubism became less concerned with sculptural mass and
more with indicating the spatial context of objects, linear structure
played a more and more decisive role. This can be seen in the
paintings of 1910–11, but in a graphic work like this the formal
devices invented by Picasso and Braque for this culmination of
Analytical Cubism are shown most clearly.

masks, long available in ethnological museums but only now
being recognised for their artistic power. Georges Braque
(1882–1963), a house-painter's son who had worked for a
while with the Fauves, saw the *Demoiselles* in Picasso's studio
in 1907. During the next four years he and Picasso worked
closely together, evolving the dramatically new style known
as Cubism. At first, in reaction against Fauvism, they
ignored questions of colour and concentrated their research
on form. What they sought was one element of Cézanne's
intention: a way of capturing the three-dimensionality of
things without destroying the two-dimensionality of the
picture. Cézanne had approached this partly through
colour. Picasso and Braque, after using the simplified solids
they saw in African carvings and to which Cézanne had
pointed in his famous dictum, 'Treat nature according to
the cylinder, the sphere, the cone', with the result that some
of their pictures were emphatically sculptural (quite unlike

Cézanne's), found a new solution by breaking up the object
before them into planes of simple form assembled in a
shallow pictorial space. The climax of their work in this,
the so-called 'Analytical Cubist' phase, came in 1911, by
which time Picasso and Braque had made their new idiom
complete and in which year they produced some outstand-
ingly beautiful demonstrations of it. In the same year a group
of artists including Gleizes, Metzinger, Delaunay, Picabia,
and Marcoussis, who may be described as second-string
Cubists, exhibited together and thus brought Cubism before
the public.

Although at the time it seemed that Cubism had finally
removed all subjective elements from art and made the work
of its practitioners indistinguishable (which had been said
of Impressionism a generation earlier), the work of the
Cubists varies greatly in character and significance. Some
general points can be made. Analytical Cubism introduced
and justified an artistic process that was at once destructive
and recreative. The Cubists took a limited range of objects
and destroyed their individual integrity: parts of a body
mingle with parts of a table and parts of a bottle and a glass
on that table. They abandoned the tradition of the single
viewpoint, using several views of an object much as the
Egyptians had drawn their figures to include conflicting but
characteristic views, and thus they introduced an element
of time or movement into their compositions, re-
emphasising the non-representational function of painting.
The result is barely recognisable seventy years later. In so
far as we do recognise the constituent objects, this is due to
occasional hints in detail and to the reconstructive assembly
of the parts in an arrangement that at times corresponds to
the model as seen from various angles and that always aims
at a pictorially coherent composition. The compositional
arrangement in Analytical Cubism is normally quite tradi-
tional, focussing on the centre of the canvas and diminishing
to the corners (a device that goes back at least to Leonardo
da Vinci); at times they used an oval format to escape the
problem of the empty corners. In terms of pictorial space,
or composition in depth, they were profoundly original.
Having followed the example of the Post-Impressionists in
reducing the space that seems to exist behind the canvas, the
Cubists at times appeared to project some of their facets
forward to penetrate the real space in front of the canvas.
Coming after Fauvism, Cubism at the time appeared a harsh
and disciplined manner of painting. Today it is clear that
its basis was subjective and sensational.

(Continued on page 849)

46. **Henri Matisse.** *Le Luxe II*. 1907–8. Casein. 82½ × 54¾ in.
(209.5 × 139 cm.). Royal Museum of Fine Arts, Copenhagen.
(Rump Collection). This is perhaps the earliest painting in which
Matisse's sensitivity to line as a constructive and decorative
element, and his unique control of broad colours are fully realised.
It is probably no coincidence that Matisse and Picasso should
have been working at lifesize figure subjects at much the same
time. They may have been aware of each other's activities: they
were certainly aware of the late figure paintings left by Cézanne
(see plates 34 and 49). *Le Luxe II* is the second of two very similar
paintings and is a marvellously refined version of the earlier work.

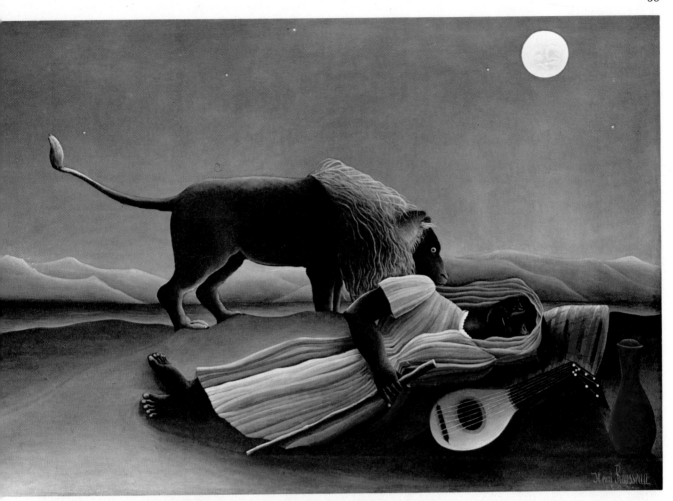

47. Georges Rouault. *The Old King.*
1936. Oil on canvas. 30¼ × 21¼ in.
(77 × 54 cm.). The Museum of Arts,
Carnegie Institute, Pittsburgh. Once one of
the most violently attacked of modern
painters, Rouault (1871–1958) was one of
the very few modern artists to use his art
as a vehicle for religious expression. His
paintings, with their glowing colours and
strong linear divisions, recall the stained
glass he handled as a young apprentice;
they are built up in many layers of paint and
often suggest the hieratic severity of a
Byzantine icon.

48. Henri Rousseau. *The Sleeping Gypsy.*
1897. Oil on canvas. 51 × 79 in. (129.5 ×
200.5 cm.). Collection, The Museum of
Modern Art, New York. Gift of Mrs Simon
Guggenheim). Most famous of the
'primitive' painters recognised by modern
art history, and the first to be honoured by
avant-garde artists, Rousseau confronts us
with the question: how naive was he? Was
his rejection of the academic traditions of
illusionistic realism (against which his more
obviously self-conscious contemporaries
were struggling with less success) totally
instinctive? He had the highest regard for
academic skills; at the same time he appears
to have been aware of his naivety as
something worth preserving. *The Sleeping
Gypsy* is one of his most elegant works. Its
hypnotic and visionary character makes it
an outstanding predecessor to Surrealism.
The guitar and vase, in their subtle
distortion and direct presentation, point
towards the first Cubist still lifes of Picasso.

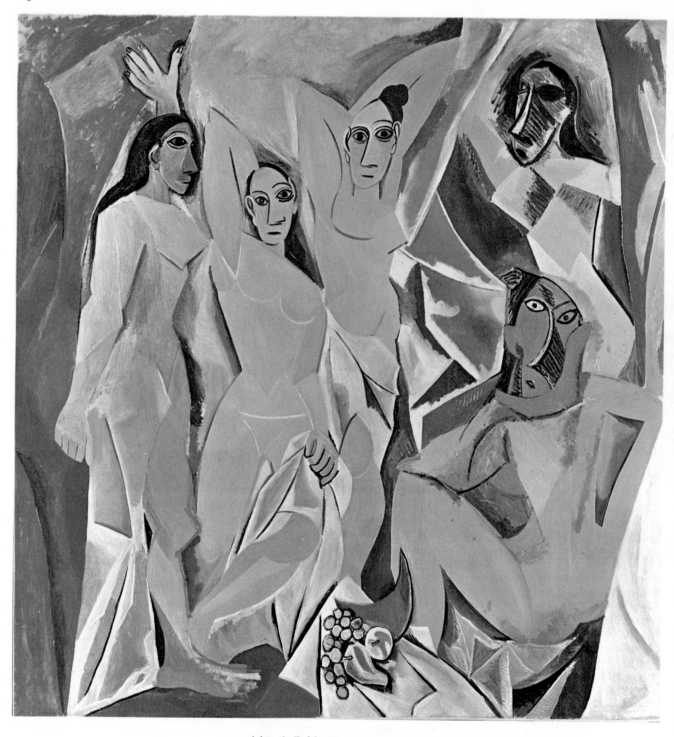

49. (above). **Pablo Picasso.** *Demoiselles
d'Avignon.* 1907. Oil on canvas. 96 × 92 in.
(244 × 233.5 cm.). Collection, The
Museum of Modern Art, New York.
(Acquired through the Lillie P. Bliss
Bequest). This large figure composition
clearly marks a turning point in Picasso's
career, inspired partly by Cézanne's late
figure paintings. His original intention was
to paint a scene of sailors and prostitutes,
but all action and symbolical meaning
disappeared as Picasso concerned himself
more and more with problems of
construction and expression. Out of this
concern, Cubism was born. The two heads
on the right were painted last and show
Picasso's interest in African masks.

50. (opposite). **Georges Braque.** *The
Portuguese.* 1911. Oil on canvas. 41¾ × 32
in. (116 × 81 cm.). Kunstmuseum, Basle.
A particularly fine example of Analytical
Cubism, showing the characteristic effect
of open relief in this kind of painting and
its tendency towards monochrome—
although Braque, in what is perhaps a
peculiarly French manner, includes very
delicately varied hues in his narrow colour
range as well as very pleasing brushwork.
The introduction of lettering in various
places adds to the spatial ambiguity of the
picture while also stressing the relatively
illusory quality of everything but the
lettering.

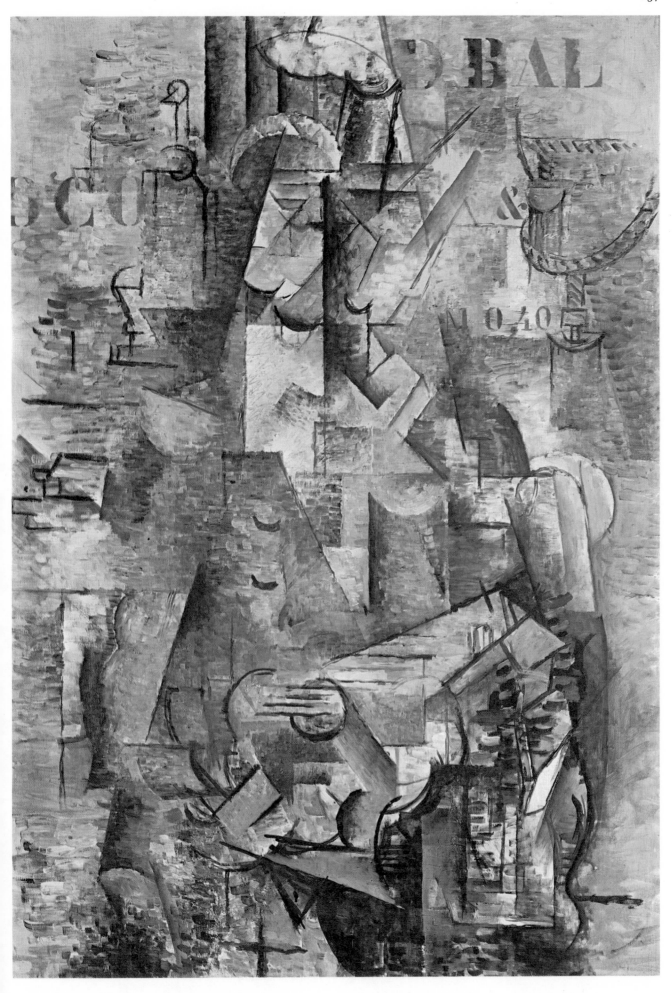

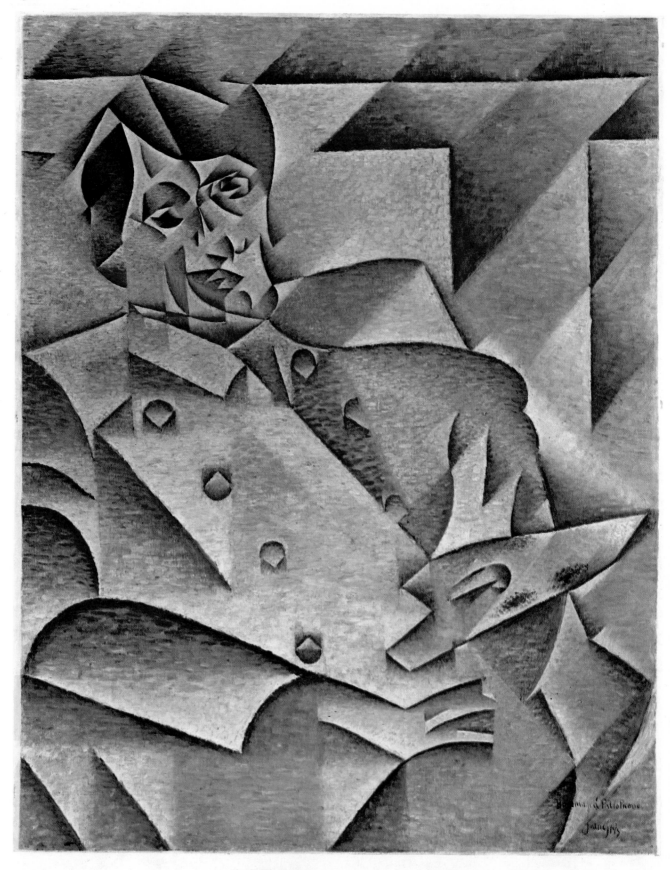

51. **Juan Gris.** *Portrait of Picasso.* 1912. Oil on canvas. 29¼ × 36¾ in. (74 × 93.5 cm.). Courtesy of the Art Institute, Chicago. (Gift of Leigh B. Block). Gris's Cubism was always more cerebral than that of Picasso and Braque. In this early painting he used an arbitrary but fixed pattern of contradictory light and shadow to unfold and to co-ordinate aspects of the subject. As a method this derives from Analytical Cubism, but Gris avoids some of the shortcomings of that style through his attachment to the kind of tightly controlled articulation of the whole picture area that is found in the work of Seurat.

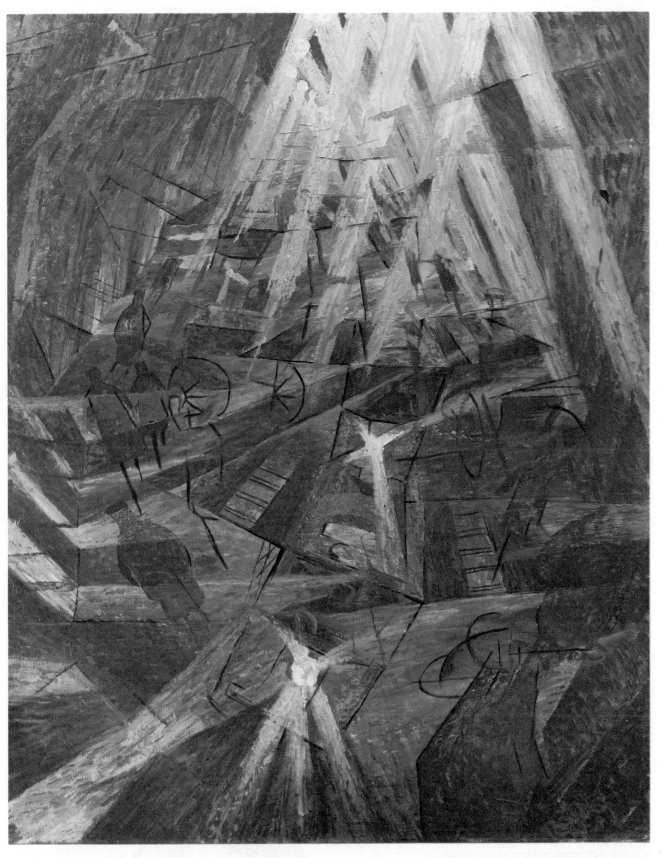

52. **Umberto Boccioni.** *Forces of a Street.*
1911. Oil on canvas. 31½ × 39 in. (100 ×
180 cm.). Collection: Dr Hänggi, Basle.
Boccioni's painting and sculpture, during
his short period of Futurist activity, varies
considerably as he tries to achieve the
synthesis of physical and metaphysical
elements demanded by the movement's
programme. Here he fuses aspects of
Cubism with Impressionism to convey the
optical and emotional experience offered by
a city thoroughfare at night. This painting
was included in the Futurist exhibition
which opened in Paris on February 5th,
1912, and subsequently toured Europe.

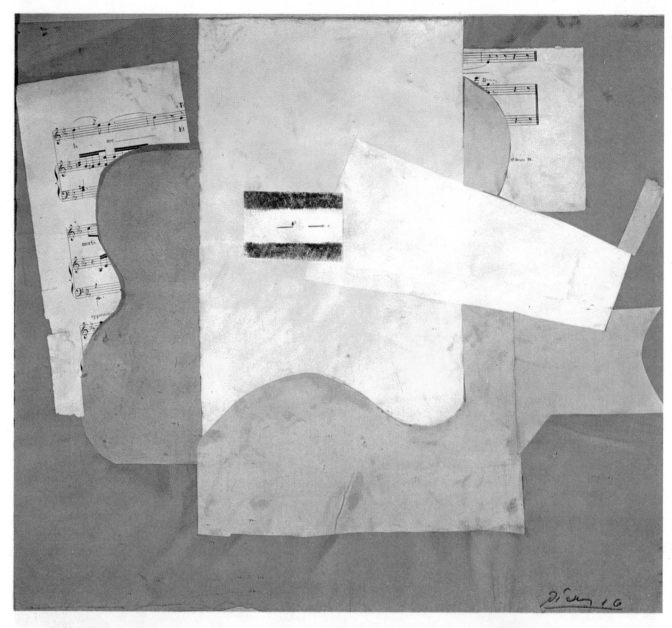

53, 54. **Pablo Picasso.** *Sheet of Music and Guitar.* 1912–13, (above). Gummed paper with pastel. 25½ × 23 in. (65 × 58 cm.). Collection. Georges Salles, Paris. *Mandolin.* 1914, (right). Wood construction. 23½ in. (60 cm.) high. Artist's collection. In his Synthetic Cubist work Picasso abandoned the painterly and illusionist aspects of Analytical Cubism and treated the canvas or board on which he was working as a support on which to construct images. Often he used pieces of paper and other materials that involved some degree of projection from this support, and a logical extension of this was the constructed relief. Picasso produced a series of such reliefs in 1913–14 and these inspired the development of Constructivist sculpture in Russia.

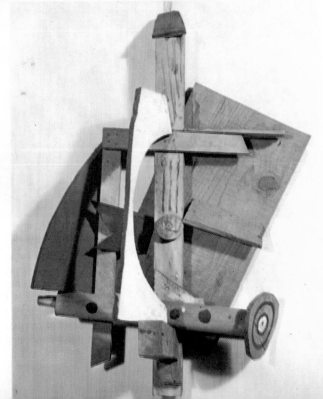

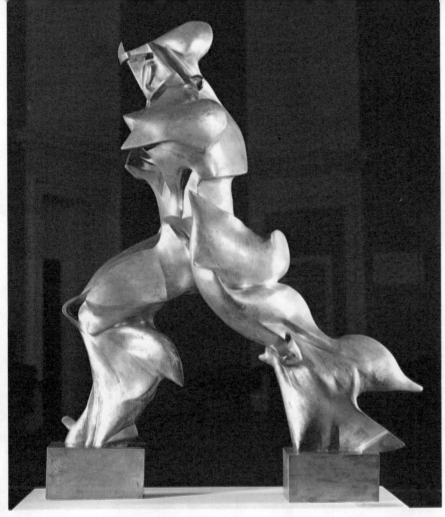

55. **Umberto Boccioni.** *Muscular Dynamism* or *Unique forms of Continuity in Space.* 1913. Polished bronze. 43½ in. high. (110.5 cm.). Museum of Modern Art, Milan. In this study of a figure in motion, Boccioni turned away from the photographic records of movements that fascinated some of his friends, (particularly Ballà), to find a formal means of giving sensations of movement. The result is oddly similar to the effects of the fluttering draperies of Baroque sculpture, and particularly to that Hellenistic figure, the *Victory of Samothrace*, specifically denigrated in Marinetti's first Futurist Manifesto of 1909 in favour of the new beauty of a racing car.

56. **Robert Delaunay.** *Circular Forms.* 1912. Oil on canvas. 50⅞ × 50⅞ in. (129.2 × 129.2 cm.). The Solomon R. Guggenheim Museum, New York. Delaunay's concentration on the expressive power of interacting colours remains one of the most influential acts of 20th-century art. Though not absolutely unique (Kandinsky in Germany, Kupka in France, Ballà in Italy were moving in much the same direction about the same time), Delaunay's abstract colour compositions today look the least dated and have been the most fruitful. Here painting approaches most nearly to the condition of music.

57. Marc Chagall. *Self-portrait with Seven Fingers.* 1911. Oil on canvas. 42 × 50½ in. (107 × 128 cm.). Stedelijk Museum, Amsterdam. (Collection: Regnault). Marc Chagall was born in Vitebsk, Russia, in 1889. He spent 1910–14 in Paris, returned to Russia for the years 1914–22. Since then he has lived almost continuously in France. During his first years in Paris he became acquainted with the Cubists and was influenced by their disruptive transformation of visual appearances. But his art is characterised by a lyrical expressionism in which the painter reveals his experiences and dreams, and in which his Russian-Jewish origin is represented through its vigorous folklore culture and its rich vein of poetry. This picture shows both the influence of Cubism and the all-pervading element of fantasy peculiar to Chagall.

58. Fernand Léger. *The Acrobats.* 1918. Oil on canvas. 38 × 46 in. (97 × 117 cm.). Kunstmuseum, Basle. As a socialist, Léger evolved out of Synthetic Cubism a language of painting that would, he hoped, bring art into the world of the proletariat's labour and leisure. Strong and clearly defined forms, suggesting machinery, are presented in energetic colours that bring a note of gaiety and optimism to a world more usually associated with smoke and grease. So Léger does not represent the miseries of the working class, but uses his art to celebrate the world of labour as virile and vigorous.

59. (opposite above).
Ernst Ludwig Kirchner. *Reclining Nude with Fan.* 1908. Oil on cloth. 25¼ × 36¼ in. (64 × 92 cm.). Kunsthalle, Bremen. Kirchner was the most gifted of the *Brücke* painters. By bringing technical

brashness and a personal note of emotion into his representation of unexceptional subjects, he hoped to give new life to an art that seemed to him suffocated by academic values and enfeebled by stylistic in-breeding.

60. **Oskar Kokoschka.** *Still-life with Sheep and Hyacinth.* 1909. Oil on canvas. 34¼ × 45 in. (87 × 114 cm.). Öster-reichische Galerie, Vienna. Oskar Kokoschka (born 1886) was of Czech and Austrian parentage and grew up in Vienna, where, as a young man, he became known as a particularly vehement and revolutionary painter and playwright. Viennese painting had sunk to a low level during the nineteenth century and had then blossomed luxuriantly in the Art Nouveau years around 1900. Kokoschka was one of those who rejected the artificiality of Art Nouveau and placed great emphasis on the closeness of art to everyday life, its tensions and conflicts as well as its beauty.

61. **Wassily Kandinsky.** *Light Picture.* 1913. Oil on canvas. 30¾ × 39½ in. (78 × 100 cm.). The Solomon R. Guggenheim Museum, New York. This is one of Kandinsky's earliest completely abstract oil paintings, and probably one of the most entirely spontaneous. Kandinsky's Abstract Expressionism offered a fundamentally new means of presenting emotions and sensations in pictorial form, short-cutting the process, illustrated by Kirchner and Kokoschka, of transmitting them through recognisable subject-matter.

Kandinsky showed that the picture can function as a surface on which the artist expresses himself directly through physical gestures, recorded by means of the brushes and paints that are an extension of himself.

62. (above). **Stuart Davis**, *Lucky Strike*.
1921. Oil on canvas. 33¼ × 18 in. (85
× 45.5 cm.). Collection, the Museum of
Modern Art, New York. (Gift of the
American Tobacco Company Inc.). The
Cubists and Futurists had stuck bits of
'rubbish' into their pictures, including in
one instance an empty cigarette-papers
packet. To monumentalise a packet of
cigarettes by itself is another matter,
evidence of Davis's willingness to let his
environment invade his art.

63. **Kasimir Malevich.** *Black Trapezium
and Red Square*. 1915. Oil on canvas. 39¾
× 24½ in. (101.5 × 62 cm.). Stedelijk
Museum, Amsterdam. Malevich was the
first painter to explore the optical and
communicative properties of simple
shapes, beginning with the black square
and then going on to more complicated
relationships.

64. (opposite). **Marcel Duchamp.** *The
Large Glass or Bride Stripped Bare by her
Bachelors Even.* 1915–23. Oil and lead wire
on glass (in two parts). 109¼ × 69 in.
(277.5 × 175.5 cm.). Philadelphia Museum
of Art. (Louise & Walter Arensberg
Collection). One of the great milestones of
modern art, and in many respects the most
radical and revolutionary work of its
generation.

65. **Constantin Brancusi.** *The Fish.*
1930. Grey marble (fish). Stone (base).
21 × 71 in. (53.5 × 180.5 cm.), (fish).
28½ in. (72.5 cm.), (base). Collection, The
Museum of Modern Art, New York.
(Acquired through the Lillie B. Bliss
Bequest). Like Michelangelo, Brancusi
felt that carving was concerned with finding
the ideal form within the stone. In rejecting
the Renaissance and 19th-century
concentration on the figure, he sought an
original independent image that the
material and the instinctive direction of
the artist would allow to emerge.

66. **Diego de Rivera**. *The market place at
Tenochtitlán*. 1942. Fresco. The
establishment of a socialist government
in Mexico led to the harnessing of art as
part of the country's propaganda effort,
first of all directed to the Mexicans
themselves. Murals in schools and other
public buildings taught the evils of
dictatorship and the rewards of
democratic life and work. The idiom of
this art is both naturalistic and
symbolical, with folk art elements
reminiscent of Giotto.

FUTURISM

Meanwhile, a related movement had come into existence in Italy and was about to erupt on the Paris art scene. The poet Marinetti had gathered around himself a group of young artists to propagate and demonstrate the heady joys of Futurism. This meant an enthusiastic acceptance of the modern technological world: machines, mechanical sounds, speed, the destruction of everything old. 'We will sing of the stirring of great crowds—workers, pleasure-seekers, rioters—and the confused sea of colour and sound as revolution sweeps through a modern metropolis. We will sing the midnight fervour of arsenals and shipyards blazing with electric moons; insatiable stations swallowing the smoking serpents of their trains, factories hung from the clouds by the twisted threads of their smoke . . .' (from Marinetti's *Futurist Manifesto*, published in *Le Figaro*, Paris, on February 20, 1909). The chief value of this new romanticism was that it related to the present, to physical and spiritual experiences that could be shared by everyone who travelled on a tram or merely opened his window on the bustle of a modern city. The aggressiveness of Futurism was a product partly of youth and partly of the great weight of the classical tradition that pressed on the shoulders of any Italian attempting to drag his country out of the artistic slough into which it had sunk since the days of Tiepolo. The *Manifesto of the Futurist Painters* (February 11, 1910) asserted their rejection of the entire past and their support for originality and audacity. The *Technical Manifesto of Futurist Painting* (April 11, 1910) went some way towards defining how these attitudes were to affect their work. Above all, they were to accept the reality of movement as opposed to the artificial or unusual condition of stillness, and, a corollary of this, the interaction and mutual interpenetration of the things around us in our experience. 'Painters have always shown us things and persons in front of us. We shall place the spectator at the centre of the picture'.

To realise these conceptions in art was not so easy as to list them. For all their bravado they knew they must look to Paris for guidance as well as for a platform from which to address the world of art. This guidance they found first in Divisionism and then in Cubism. As techniques, both are suited to indicating the mutual interpenetration of things, and Cubism, by its references to objects as seen from differing viewpoints, could imply both the movement of the object and that of the painter or spectator. But for more compelling images of movement and speed the Futurists turned to the camera. From photographers' studies they learned how movement could be indicated by repetition and by abstracted lines (akin to those 'shock waves' we know from photographs of models in windtunnels) that could suggest movement and also the response to that movement of the object's environment.

The most important artists in the movement were Boccioni, Severini, Carrà and Balla. Umberto Boccioni (1882–1916) was certainly the most creative amongst them, and his picture *Forces of a Street* (1911) is one of the most complete and successful demonstrations of their ideas.

Reference has been made already to the complex of sensations woven by Turner into his late paintings. The same words could be used of this Futurist painting. Turner was concerned with timeless and more or less universal experiences known to anyone alive to the forces of nature; the Futurists deal with urban society at the beginning of this century and to some extent even with the particular social and urban conditions obtaining in Northern Italy at this time. Stylistically they contributed little to painting, but their insistence on the dynamism of life as a basis for art permanently affected modern aesthetics. We shall refer in due course to Futurism's part in the development of sculpture and architecture. The movement's immediate success was considerable. In February 1912, they had their first group exhibition in Paris, and from Paris the exhibition (and some of the artists) went on to London, Berlin, Brussels, Hamburg, Amsterdam, The Hague, Munich, Vienna, Budapest, Breslau, Frankfurt, Wiesbaden, Zürich and Dresden. Publications and lectures spread their ideas even further afield.

SYNTHETIC CUBISM

The immediate consequence of the Futurist exhibition in Paris appears to have been that of giving renewed impetus to Cubism. Delaunay and the other second-string Cubists were encouraged by the Italians' example in their move away from the almost monochromatic and pseudo-scientific character of Analytical Cubism. Picasso and Braque, who were not impressed by the noisy upstarts from Milan, moved during 1912 from the Analytical phase of Cubism into what is known as the Synthetic phase— a change which involved a substantially different attitude to reality and to the materials of art as well as a surprisingly ironical view of art as such. While Analytical Cubism was concerned with a process of destroying the object and reconstructing it as a pictorial composition in what appears to be a shallow pictorial space, Synthetic Cubism usually involved the construction of objects (with paint or other materials) on the canvas. Early in 1912 Picasso used a piece of oil cloth in a picture and so initiated collage; in September Braque stuck on his canvas pieces of wallpaper printed to resemble wood. These acts refuted the tradition of skilful paint-handling which had contributed greatly to the beauty of many Analytical Cubist works; they also, by bringing bits of the real world into the artificial world of the picture, indicated a kind of double-take on the issue of what is fact and what is fiction, and this could become a triple-take, as when Braque began to paint sections of pictures to look like pieces of wallpaper. Soon other materials (matchboxes, corrugated cardboard), technical devices (decorator's comb, normally used for wood graining), and textures both physical (sand in paint) and optical (dotted and striped areas) were brought into Synthetic Cubism, and with all these came a new interest in colour. The new works of Braque and Picasso often seem to have been assembled on the canvas rather than painted, and to project forward from the canvas even when no extraneous materials are used. From the use

of materials and textures that normally have specific contexts or meanings there resulted a double function that has remained of great importance in modern art (and in advertising design, etc.): pictures could be planned as abstract organisations, often of quite large units, and yet at the same time the shape and/or the particular character of the collage materials (or imitation collage) could be used to indicate specific subject-matter. By 1913 Picasso was producing reliefs based on these ideas, as well as paintings.

In 1911 Picasso and Braque had been joined by the Spaniard, Juan Gris (1887–1927). More intellectual and analytical than they, Gris became the theoretician of Synthetic Cubism, the writer who could link Cubism to contemporary developments in science, as well as the painter of some exceptionally clearly organised pictures. His work is normally based on a firm geometrical structure which Gris gradually particularised to indicate certain objects; he said he did not wish spectators to read their own interpretations into his pictures. Robert Delaunay (1885–1941) meanwhile moved from a series of pictures which he called *Windows*, almost completely abstracted and richly coloured works in which hints of townscape come through a soft chequered pattern that may have been suggested by lace curtains but can also be seen as a regularised version of Divisionism, into completely abstract paintings, which he called *Disks* (begun late 1912), in which colour, arranged in segmental shapes, produces a rhythmic surging and swaying. Delaunay was the first to give full reign to the optical and emotive power of colour.

56

EXPRESSIONISM IN GERMANY

Although Delaunay's work was hailed by the poet-critic Apollinaire and was shown in Paris, it made a far greater impression in Germany. There the early years of the century had seen the eruption of one of the movements and individual activities that are assembled under the broad term, Expressionism. In Dresden in 1905 a handful of young men, whose studies had been principally architectural, formed themselves into a revolutionary group of painters. They called themselves *Die Brücke* (The Bridge) to indicate their desire to form a link between all revolutionary tendencies in art. They did not, that is, propose particular theories or styles other than those associated with anti-academicism. In some respects the character of their work comes close to that of the Fauves, without, it seems, their having had much knowledge of the French group: their colours are vehement, their brushwork is often brusque, and their design shows affinities with primitive art. But while a lot of Fauve painting aimed at ultimately decorative qualities of harmony and rhythm, and thus can be seen as an extension of Gauguin's achievement, Expressionism in general and the *Brücke* painters especially aimed at intense and particular communication. Whereas Fauvism, for all its apparent wildness, can be seen as essentially a part of the French tradition of fine painting, Expressionism represents a resurgence of Nordic anguish and pessimism, sharpened by the disturbed condition of German society at the time, and linked to the bitter and emotional art of such earlier

Northerners as Munch and Ensor, to some aspects of German early Romanticism, and to German art of the time of the Reformation, before classicism had imposed its veneer of dignity. From the art of Grünewald and his contemporaries the *Brücke* painters learnt the value of figural distortion, and to this they joined an intensification of the brushwork until it took on gestural qualities. One of the group's most successful ventures was the revitalisation of graphic art. Helped by the example of Munch and Gauguin, but inspired mainly by their predecessors of about 1500, they produced a great deal of graphic art of considerable power and originality, and generally encouraged the German public to take a more serious interest in graphic work than had been the case in other countries. Around 1910, the *Brücke* artists moved to Berlin. In 1913, recognising their growing diversity, they dissolved the group.

· By that time another group had been formed in Munich. Its protagonist was the Russian, Wassily Kandinsky (1866–1944), who had arrived in the Bavarian capital to study art at the age of thirty. He was deeply affected by the current Art Nouveau movement which he fused with Russian folklore elements, and then, influenced by Fauvism and by the folk art of southern Bavaria, turned to a free and sonorous style of landscape painting. During the next seven or eight years he developed a kind of free abstraction, now known as Abstract Expressionism, allowing references to his favourite themes (landscape, horsemen, etc.) to show among more or less abstract configurations, sometimes working impetuously and sometimes building up larger and more considered compositions on the basis of a series of sketches. In 1912 he published a book *Concerning the spiritual in art* in which he argued for the inner world of man as the

40. **Karl Schmidt-Rottluff.** *Road to Emmaus.* 1918. Woodcut. 15½ × 19½ in. (39 × 50 cm.). Philadelphia Museum of Art. The artists of *Die Brücke* brought new vigour to the long tradition of German graphic art, under the influence both of Munch and Gauguin and of primitive art.

41. **Paul Klee.** *Drawing with the Fermata.*
1918. Ink on paper. 6¼ × 9½ in.
(16 × 24.5 cm.). Klee Foundation, Berne.
Klee moved freely between figuration and
abstraction. In many pictures and drawings
he reveals a special interest in the aesthetic
and communicative function of signs and
symbols. It is possible that (as this example
may be taken to suggest) his musicianship
may have inspired this interest.

true source of artistic creation, and for 'inner necessity' as
art's driving force and subject. In the same year, he and his
friend, Franz Marc (1880–1916), produced a volume of
essays by various writers with illustrations of old and new
art called *Der Blaue Reiter* (The Blue Rider), which was the
name also of a group that they and their friends had started
in 1911. Like *Die Brücke*, *Der Blaue Reiter* proposed no specific
dogma or style, but whereas the Dresden group consisted
of a handful of young Germans making a protest that was
as much social as artistic against the world around them,
the Munich group, international in its membership and
affiliations, looked only for new and more richly expressive
languages of art. Theirs was a more meditative and construc-
tive expressionism, an attempt to move art away from the
world of fact into the world of the spirit, and, partly owing
to Kandinsky's own inclinations, they recognised colour as
their most powerful weapon.

The artist who, while only loosely connected with *Der
Blaue Reiter*, continued to work in its spirit and develop some
of its ideas, was Paul Klee (1879–1940). Ever since he
started to study art in Munich in 1898, Klee had been
searching for the essential art of painting. In his drawing
he early achieved complete individuality and control—a
control as much of the spirit as of the hand—but for more
than a decade he worked his way towards an equal command
of painting. Colour, he knew, was the basic issue, and he
worked incessantly to acquire an instinctive knowledge of
colour, comparable to the pianist's knowledge of the sounds
he can produce through his keyboard. He made continual
technical and aesthetic experiments, and studied the work
of other artists, especially Cézanne. In 1914, he visited North
Africa where, more profoundly even than Delacroix about
eighty years earlier, he was deeply stirred by the colour and
calm exoticism of the environment, and found himself at last
a colourist and thus a painter. From that time on Klee drew
and painted with incredible fluency and inventiveness. For
him art was something that emerged almost accidentally
out of an interaction of the artist's intellect and subconscious
with the technical means and skills at his command. 'Let
everything grow' is the root principle of all his thought: out
of the recognition of the potentialities of the simplest motifs,
sparingly used, can come works that are filled with the
human spirit and echo nature's creative processes.

REVOLUTIONARY PAINTING IN RUSSIA

Kandinsky, returning to Moscow in 1914, found there
an art world as well as a political world bubbling with
revolution. For some years Moscow had kept itself closely
informed on what was going on in Western Europe. The
educated Muscovite probably knew more about the Euro-
pean avant-garde than his equal in Paris. Fauvism, Cubism
and Futurism were known about almost as soon as they
happened, and contact between Moscow and German art
centres (especially Munich) was particularly close.

Out of a number of avant-garde actions that of Kasimir
Malevich (1878–1935) was the most decisive and has
become almost legendary. 'When in 1913', he wrote later,
'in a desperate attempt to rid art of the ballast of objectivity,
I took refuge in the form of the square, and exhibited a
picture that represented nothing more than a black square
on a white field, the critics—and with them society—sighed,
"All that we loved has been lost. We are in a desert. Before
us stands a black square on a white ground" But the
desert is filled with the spirit of non-objective feeling, which
penetrates everything.' In 1913–14, under the influence of
Paris, Malevich developed a personal fusion of Synthetic
Cubism with Futurism, but this he rejected in favour of
something less arbitrary (he did not actually exhibit his
black square until 1915, but a backdrop he designed in 1913
came close to it). One is tempted to see the Russian tradition
of the icon behind his elevation of a basic geometrical form
to art status, but what struck his contemporaries was the
heroically austere gesture of excluding all ingratiating
factors, of subject-matter, brushwork, perspective and even
colour, from his picture. It was easily the most ruthless
gesture any artist had made. At the same time, it was also
one of the most constructive. It focussed attention on the
optical and affective properties of a black square on a white
ground, that is, on the particular expression of a square of
a certain size and blackness in a particular relationship with
a larger white square (to be exact, only a white margin: here
we meet one aspect of the figure-field ambiguities discussed
by Gestalt psychologists and exploited by many later
painters). This made possible a revaluation of the most
fundamental and apparently most simple ingredients of art
and has led to some of the strongest works of our century.

Malevich soon went on to more complex assemblies of form and colour. After the Revolution of 1917, he and his friends were given positions of power in Russian art and education. Kandinsky, for example, was for a time in charge of an Institute of Artistic Culture which, he hoped, would systematically investigate the properties of the grammar of art. Malevich's movement, which he called Suprematism ('By Suprematism I mean the primacy of pure sensation in the visual arts'), attracted many followers for a time and was closely related to a sculptural movement that later became known as Constructivism. But dissensions between the artists and later the rejection by the Soviet government of any art that did not obviously serve industry and propaganda, put an end to progressive art in Russia.

HOLLAND: DE STIJL

In Holland, however, a similar movement had come into being. During the war years, Piet Mondrian (1872–1944), earlier a hypersensitive painter of landscape, had developed 67 Analytical Cubism into a personal idiom of great beauty, and had then gradually simplified that idiom until he was painting seascapes consisting of nothing but neat vertical and horizontal strokes of black paint on white. In 1917 he and Theo van Doesburg (1883–1931) formed the *De Stijl* (the style) group and published a magazine of the same name. Under Mondrian's aesthetic leadership, the group propagated an art of dynamic balance in which a few basic elements—vertical and horizontal black bands and rectangular areas of primary colours, white or grey—would be composed without reference to the visible world. Theirs was to be an art of pure spiritual beauty that would offer examples of harmony and stability formed of contrasts to a world suffering from individualism and conflict. In the 1920s the internal development and external influence of *De Stijl* were to be of great importance.

ART ATTACKS ART: DADA

Characteristic of the war years and of the period immediately following the war were those to whom the bloodshed and misery of the age seemed to confirm the bankruptcy of western civilisation and who made it their business to advertise this bankruptcy by mocking the culture on which the West had prided itself. Like Rousseau they denied the sanity of reason, but whereas Rousseau had pointed to man's dreams of beauty and his sensibility before nature as sources of regeneration, they opposed unreason to reason and anti-art to art. Such men were to be found throughout Europe and also in the United States. In Switzerland, a neutral oasis in a sea of violence, an international group came together and propagated such ideas. In 1916, a handful of émigrés met in Zürich and founded the Cabaret Voltaire—Germans, a Rumanian, a Hungarian, and Jean (or Hans) Arp who, having been born in Alsace-Lorraine (in 1887), was of variable nationality. There they wrote poetry, made objects, and presented wild cabaret performances, all to satirise art and literature. They called themselves 'Dada', the most significantly meaningless name they could find, yet one that

is the beginning of all speech. Paradoxically, they proved only that anti-art cannot be. Their literary nonsense had a liberating effect on writing, breaking through limitations of syntax and normal discourse; in art, their exploitation of accidental effect and alogical relationships revealed possibilities only vaguely glimpsed before and which many have been willing to explore and use since. The French artist, Marcel Duchamp (1887–1968), who had been one of the fringe Cubists in 1911–12, and who from 1915 onwards lived almost continuously in the United States, was certainly the finest embodiment of Dada ideas although he was never a member of the group. One of the most inventive forces in modern art, he was also one of the least productive. In a long life he created only a small body of work, practically every one is a masterpiece. The greatest of them is the so-called *Large Glass* on which he worked for eight years 6 (1915–23), the summation and apotheosis of his work and thought up to that time. It was laboriously painted and otherwise deposited on two sheets of glass which were accidentally broken in 1926; characteristically, Duchamp accepted the cracks, which now are seen as an integral part of the design, as a sympathetic contribution from fate.

The Dada vein in modern art, it should be noted, is unique. The Renaissance produced works of a minor kind, like Arcimboldo's vegetable heads, which were considered entertaining and skilful, and in the world of caricature there are things that could be thought of as mocking art. But it is characteristic of our century alone that much of the art produced in it should directly and indirectly question the function and the value of art. For while Dada raised these questions publicly, they were implicit in most avant-garde developments of these decades, and the works in which they are raised often stand far outside what had been thought of as the realm of art.

DEVELOPMENTS IN SCULPTURE

In 1900, for all the achievements of Rodin and Rosso, sculpture was still a very circumscribed field. The most important sculpture produced during the first two decades of this century represents both extensions of the freedom won by them—one thinks of Matisse's free handling of clay and the human form—and the rejection of their tradition in order to explore new fields. Once the value of African carvings and of primitive sculpture generally had been realised by the painters, the sculptors, too, found themselves confronted by alternative and unexplored traditions, and a great deal of the work of this period reveals the firm organisation and simplified forms of primitive prototypes. But among the African pieces admired at this time there were also constructed (as opposed to carved) works, and these, in combination with the example set by two-dimensional and low-relief Synthetic Cubism, may have contributed to the emergence of a completely new kind of sculpture that is assembled out of separate pieces of material, rather than modelled or carved. This kind of sculpture was already hinted at in the disintegration of objects into an open relationship of planar facets shown

in Analytical Cubism, and one may with some justice relate interests of this kind to the contemporary redefinitions of matter and time-space proposed by men on the frontiers of science. Within sculpture itself a very important contribution was that of Boccioni, who on April 11, 1912, published a *Technical Manifesto of Futurist Sculpture*, that demanded and described radically new kinds of sculpture as well as rejecting the old. He wanted sculpture of energy, of space, of relationships, that would be made of all sorts of materials, and could be mechanically mobile.

The fuller realisation of some of these ideas was achieved in Russia. Vladimir Tatlin (1885–1953), who visited Picasso in 1913, returned home to begin a series of constructed sculptures made of whatever materials came to hand. During the war years other artists, like the brothers Antoine Pevsner (1886–1962) and Naum Gabo (born 1890) joined what became known as the 'Constructivist' movement. In 1920 their *Realistic Manifesto* insisted that 'Space and time are the two elements which exclusively fill real life', and they went on to develop personal and poetic modes of Constructivism.

Marcel Duchamp meanwhile confronted the world with two apparently off-hand works of lasting significance. In 1913 he fastened a bicycle wheel to a stool and presented it as the first mobile sculpture. In 1914 he elected a French galvanised metal bottle-rack to become a work of art, and subsequently presented other such 'ready-mades'. Synthetic Cubism had shown that art could be made of found objects; Duchamp asserted that found objects could be art, implying that anything is art if the artist wills it so and that art resides not in the making of the art work but in the designation 'art'. Arp brought into sculpture the Dada concept of chance as a creative force, making reliefs in which the disposition of the forms was based on unplanned relationships and unexpected hints of meaning.

BRANCUSI AND OTHER SCULPTORS

At the other end of the artistic spectrum stood a sculptor, remote from movements and manifestos, in whose work both the vigour and the refinement of modern art find their fullest expression. Constantin Brancusi (1876–1957) came to Paris from his native Rumania in 1904, was deeply affected by the example of Rodin and Rosso, and then turned from both to find his own way. He developed two very different styles. On the one hand, he carved and modelled exquisitely refined forms that embody absolutes of perfection while at the same time confronting us as physically provocative and magnetic presences. These were far removed from the fleshy charms of so much traditional sculpture (to which Brancusi referred as 'beefsteak'), but they were not total abstractions either, and they hold a unique balance between the world of the senses and the world of the ideal. On the other hand, he produced a series of rough, tough sculptures, carved from old pieces of wood, in which suggestions from the African carvings he found being admired in Paris mingled with an innate primitivism linked to his peasant origins. These powerful and dramatic works complement

42. **George Grosz**. *The Great Coalition*. 1922–23. Brush, pen and ink. 17 × 14.5 in. (44 × 37 cm.). Grosz, a foundation member of the German Communist Party in 1919, used his great skills as draughtsman and his experience of a thorough academic training to produce drawings and prints showing the life of rich and poor in a period of economic chaos.

his more meditative productions like the gargoyles of Gothic cathedrals that thrust themselves over the heads of the smiling saints below. Brancusi evolved his mature idioms at the time when Picasso and Braque were creating Analytical Cubism, opposing to their disruptive treatment of reality works of transcendant beauty that were more akin in spirit to the finest achievements of Matisse. He said: 'Do not look for strange formulas or mysteries. I offer you pure joy'. And added: 'Look at my sculptures until you manage to see them.'

More directly linked to developments in Cubism and Futurism were such sculptors as Laurens and Lipchitz, and the Russian-born Parisian, Alexander Archipenko (1887–1964), who made the fruitful discovery that a hole in a sculpture could have an aesthetic function comparable to that of a projection. Duchamp's brother, Raymond Duchamp-Villon (1876–1918), produced in his *Horse* (1914) one of the most powerful sculptural expressions of animal and mechanical energy in that period. The Belgian Georges Vantongerloo (1886–1965), accidentally exiled in Holland during the war, joined the *De Stijl* group and carved or constructed works in which the group's programmatic rectangular relationships are brought into physical space. Expressionist sculpture in Germany looked to primitive and pre-Renaissance art forms for inspiration but adhered to the human figure and rarely went far beyond some limited degree of distortion.

43. **Amedeo Modigliani**: *Portrait of a Girl*. 1917. Oil on canvas. 31¾ × 23½ in. (81 × 60 cm.). Tate Gallery, London. The elegance and sheer attractiveness of Modigliani's nudes and portraits is the product of the most sophisticated linear organisation. Modigliani particularly admired the work of Brancusi.

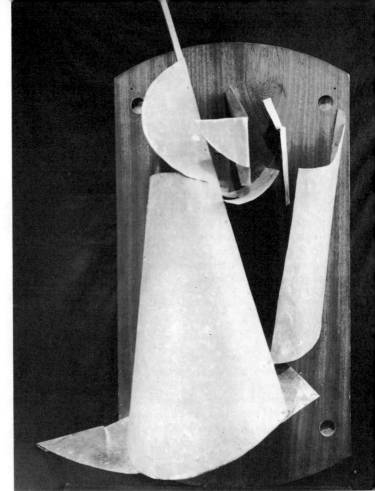

44. **Max Beckmann**. (below). *Carnival*, 1920. Oil on canvas. 73½ × 38 in. (186.5 × 96.5 cm.). Tate Gallery, London. The figures are dressed up for a Carnival; the association should be with fun and relaxation. Instead Beckmann implies deep malaise and the likelihood of disaster.

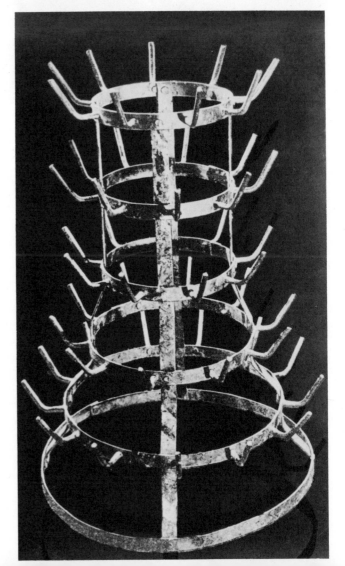

45 (above right). **Vladimir Tatlin.** *Relief*. 1917. Wood, zinc sprayed on iron. 39½ × 25¼ in. (100 × 64 cm.). Tretyakov Gallery, Moscow.

46. (right). **Marcel Duchamp.** *Bottlerack*. 1914. Galvanised iron, ready-made. 23¼ × 14½ in. at its base (59 × 37 cm.). Original lost; replica, Man Ray, Paris. One logical extension of introducing 'real' materials into art, such as a sheet of newspaper to represent a newspaper, can be that of omitting the art (in the sense of something created by the artist) altogether and enrolling an existing object as art.

47. **Jacques Duchamp-Villon.** *The Horse.*
1914. Bronze. 40 in. high (101.5 cm.).
Collection, The Museum of Modern Art,
New York (Van Gogh Purchase Fund).
One of the most forceful of early Cubo-
Futurist sculptures, Duchamp-Villon's
Horse shows the abstracted forms and that
sense of pounding energy proposed by these
movements while referring ambiguously to
animal and engine forms.

48. **Alexander Archipenko.** *Seated Figure*
1916. Terracotta. 21¾ in. (55 cm.).
Kunstmuseum, Düsseldorf. Archipenko
learnt from Cubism the juxtaposing of
positive and negative forms and generally
gave his sculptures forms of an inorganic
and mechanistic kind.

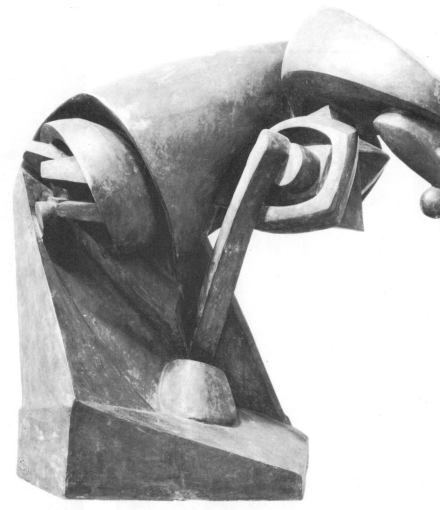

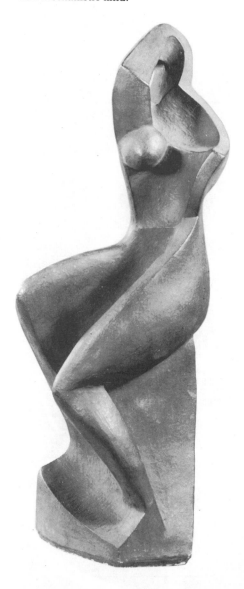

MODERNISM IN AMERICA

Up-to-date international avant-garde art arrived in
America with a bang. The Armory show—strictly the
'International Exhibition of Modern Art'—was vast,
attracted a lot of comment and a surprising number of
purchases, and was shown in New York during 17 February
– 15 March 1939 and then in Chicago and Boston. It was
primarily an American show (about 1200 items) but it was
the foreign works (about 400) that caused the stir: here were
Symbolists and Post-Impressionists in plenty, and
Fauves and, especially, Cubists. The exhibition made two
points: first, that there was what one of the organisers called
a 'new spirit in art' for America to be made aware of, and
second, that American artists need not—in a few instances,
already did not—fear to accept it and work within it.

The organisers of the show represented a national and an
international interest. some of them were members of what
was known as the Ash Can School, painters working in a
manner derived from Manet to portray the ordinary world
about them. Others were associated with the photographer
Alfred Stieglitz and the little gallery he ran at 291 Fifth
Avenue, New York, known as 291. Here could be seen the
best and the latest work from Paris. Around Stieglitz had
formed a small but very busy group of artists intent on
developing an American response. Among them was Max

49. **Georges Vantongerloo.** *Rapport des Volumes.* 1919. Stone. 4¾ × 4¾ × 7 in. (12 × 12 × 18 cm.). Marlborough Fine Art, London. Vantongerloo's first *De Stijl* sculptures investigate the formal relationship of void to mass within a precise volume—here a 12-centimetre cube, in other cases a sphere.

50 (above left). **Wilhelm Lehmbruck**
(1881–1919). *Kneeling Woman*. 1911. Cast
stone. 69½ in. high (176.5 cm.). Collection,
The Museum of Modern Art, New York
(Gift of Abby Aldrich Rockefeller). The
best known of German Expressionist
sculptors, Lehmbruck brings Gothic grace
and slimness to a kind of sculpture that
marks the last flickering of the classical
tradition.

52. **Auguste Perret.** *Musée des Travaux
Publics*. Begun 1937. Reinforced concrete.
Perret used the versatile new material,
reinforced concrete, to extend the long
French tradition of sophisticated
classicism. In some of his buildings he
achieved an elegance of design and
technical refinement comparable only to
French work of the eighteenth century.

51 (left). **Karl Schmidt-Rottluff.** *Head.* 1917. Wood. 13½ in. high (34.5 cm.). Reproduced by courtesy of the Trustees of the Tate Gallery, London. Most of the *Brücke* painters produced occasional sculptures. This head is one of a series done by Schmidt-Rottluff under the influence of African sculpture.

53 (below). **Le Corbusier.** *Dom-Ino House constructional system.* 1914–15. In this diagram, the young Le Corbusier demonstrated the structural skeleton of a reinforced concrete house; internal divisions and external cladding could be varied and variable since they play no structural role.

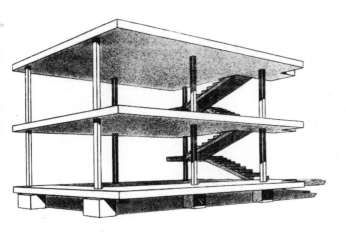

Weber (1881–1961), who had spent the years 1905–8 in Paris and understood Cubism thoroughly enough to make inventive use of it. Also John Marin (1870–1953) who was in Paris and western Europe during 1905–9 and again 1910–11. By instinct a lyrical painter with a deep feeling for nature, Marin was helped by Fauvism, Cubism and Futurism to give bold, untrammelled expression to his sense of the life of cities as a natural human habitat. The younger painter Man Ray (1890–1977) became known to Stieglitz who introduced him to Duchamp. Together they formed a group known as New York Dada (borrowing the term from the Zurich group). Its most impressive relic is a painting by Man Ray, *The Rope Dancer Accompanies Herself with Her Shadows.* Duchamp's influence upon it is clear, yet is quite unlike anything to be seen in Europe. In 1921 Man Ray went to Paris, and remained there as one of the leading figures in the Paris Dada and surrealist worlds.

NEW IDEAS IN ARCHITECTURE

Much of the radical work done by architects between 1900 and 1920 aimed at finding a comprehensive form embodying the constructional possibilities offered by glass, metal and concrete. Some architects, like the Frenchman, Auguste Perret (1874–1954), demonstrated the suitability

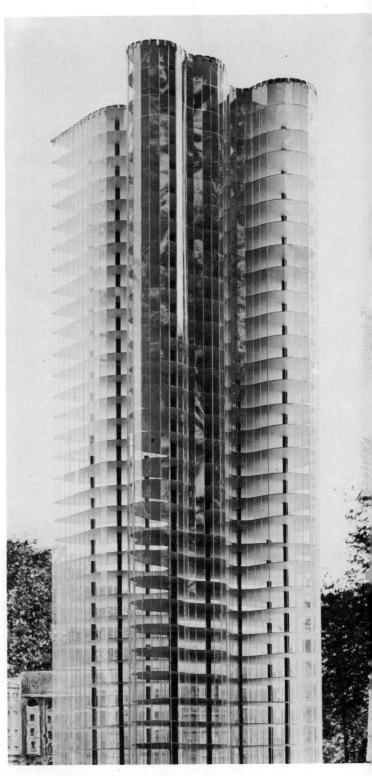

54. **Ludwig Mies van der Rohe.** *Project for Glass Skyscraper.* 1920. A forerunner of the rectangular glass towers of his later years, this early work by Mies shows him exploiting the angularity, transparency and reflecting function of glass architecture with almost Expressionist warmth.

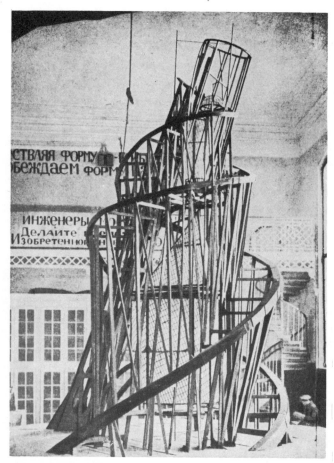

55. **Vladimir Tatlin.** *Monument to the Third International.* 1919–20. Wood, iron and glass. Remnants of this maquette are stored in the Russian Museum, Leningrad. Tatlin's project for a vast monument, new both as architecture and as sculpture, is an extreme example of the radicalism and optimism that together swept through the Russian art and design world during the years of the Revolution.

56. **Hans Poelzig** (1869–1936). *Chemical Factory, Luban.* 1911–12. A work or remarkable primitivism that recalls some of the visionary designs produced in France during the last years of the eighteenth century.

of reinforced concrete for post-and-lintel buildings of a fundamentally classical character. Le Corbusier (Charles-Edouard Jeanneret 1887–1965) in his early work combined an instinctive classicism with a realistic and functional view of human needs and structural opportunities. His *Dom-Ino* project for reinforced concrete housing demonstrated a logical use of concrete and implied maximum flexibility for internal divisions and external cladding. The German architect, Ludwig Mies van der Rohe (1886–1969), whose career opened with a number of refined designs in a Neo-Classical idiom, made projects for glass-clad sky-scrapers in 1919–20 that combined functional severity with an almost Expressionist regard for effects of transparency and reflection. In the same years the Russian Constructivist, Tatlin, projected a vast glass-and-iron tower that would be a *Monument to the Third International* and would at the same time contain buildings with facilities for conferences and lectures, broadcasting, administrative functions, etc., housed in a glass cylinder, a glass cone and a glass cube, all revolving at different speeds, the whole to be more than twice the height of the Eiffel Tower. Among the most impressive works to be executed in these decades were two German buildings that take little note of new materials and techniques but show the personal note already found in the adventurous work of leading designers of the later nineteenth century. Hans Poelzig (1869–1936) in his Chemical Factory at Luban (1911) created a remarkably severe and primitive building that is at once functional and expressive in the dramatic way favoured by architects of the French Revolutionary period. More expressionist in the modern sense is the *Einstein Tower* (1919–21), by Erich Mendelsohn (1887–1953), which looks as though it had been moulded by hand and was in fact designed to be built of poured concrete but had to be executed in bricks covered with cement. Like Tatlin's project, the Einstein Tower is both a monument and a functional building, containing laboratories and an observatory.

A combination of cool rationalism in planning with an expressive use of form was proposed by the Futurist Antonio Sant'Elia (1888–1916). The *Manifesto of Futurist Architecture*, published on July 11, 1914, over his signature though not actually formulated by him, defines the problem of the modern architect: 'to raise the new-built structure on a sane plan, gleaning every benefit of science and technology, settling nobly every demand of our habits and our spirits, rejecting all that is heavy, grotesque and unsympathetic to us (tradition, style, aesthetics, proportion), establishing new forms, new lines, new reasons for existence, solely out of the special conditions of modern living, and its projection as aesthetic value in our sensibilities.' It appears that what our modern sensibilities demand is very much a style, non-historical and more akin to the forms of bridges and liners than of conventional buildings, but his projects show this style functioning within original and far-sighted conceptions of modern city planning. His clusters of buildings connected by multi-level roads suggest the fulfilment, on a vast scale, of Boccioni's dreams of modern sculpture.

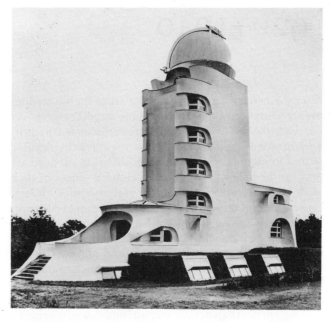

57. **Erich Mendelsohn.** *Einstein Tower, Potsdam, near Berlin.* Designed 1919, completed 1921. Intended for construction in concrete (but actually executed in cement-covered brick), the Einstein Tower appears hand-formed rather than built—a sculptural monument at the same time as a utilitarian structure.

58. **Antonio Sant'Elia.** *La Città Nuova Project.* 1912–14. Ink on paper. 20¾ × 20½ in. (53 × 52 cm.). Museo Civico, Como. Architecture could have achieved dramatic modernism that Futurism dreamt of. Sant'Elia's projects, none of which was ever realised, were exhibited in 1914 and offered a realistic solution to the problem of integrating the technological world with the traditions of urban life.

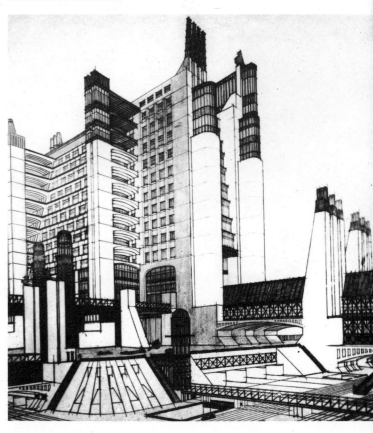

1920–1940

After the heroism of 1900–1920 the art of the succeeding twenty years seems quiet and in some respects regressive. Certainly the first world war left Europe exhausted in spirit. Several artists who had shared in avant-garde activities now retired to more or less academic positions to produce art that can be hollowly traditional behind a veneer of slick modernism. Picasso's work in the early twenties, though constantly shot through with his ebullience and brilliance, is Neo-Classical at heart. Matisse continued to fashion works of high sophistication and his activity seemed to be unaffected by changes in the political and cultural climate. Similarly Bonnard, living in the south of France, untouched by the clamorous world, painted joyous visions of landscape, or interiors or figures, working mostly from memory and striking a perfect balance between an Impressionistic regard for colour and soft pictorial textures and his strong sense of pictorial organisation. The heroes of painting between 1920 and 1940 were, on the whole, the protagonists of the earlier period, now working in less lime-lit positions.

Some of the movements that had sprung up before 1920 continued to play important roles. The *De Stijl* group, for example, grew in membership and reputation through the propaganda efforts of van Doesburg, who also tried to bring the group's ideals into architecture through collaborative projects undertaken with the young architect, Cornelius van Eesteren. Mondrian, now living in Paris, continued to work in the idiom he had created without even momentarily departing from it. In 1925, he resigned from *De Stijl* because van Doesburg wanted to change the idiom he was using from one based on vertical-horizontal relationships to one based on diagonals which he called Elementarism and for which he claimed greater dynamic force. This apparently minor change in fact struck at the roots of Mondrian's work. The vertical and horizontal co-ordinates of his art were to him the timeless principles of all man's constructive work and symbolically the most meaningful marks.

During the twenties van Doesburg was in fact making allegiances in various directions. Under his usual (adopted) name he spoke for the *De Stijl* group and also involved himself in the Suprematist and Constructivist movements that took root in Germany in the early twenties after having been displaced from Russia. One of the most active Russians to emigrate to Germany was El Lissitsky (1890–1947). Lissitsky and van Doesburg joined forces in Germany,

59. **Theo van Doesburg.** *Aubette Restaurant-Cinema, Strasbourg.* 1926–8. In decorating one of the rooms in a reconstructed eighteenth-century house, van Doesburg applied to ceiling and walls his newly invented version of Neo-Plasticism, Elementarism. His coloured rectangles, set at 45 degrees to walls and ceiling, create a dynamic ensemble. Other rooms were decorated by Arp and his wife, Sophie Täuber-Arp.

organised exhibitions together and published joint manifestos. Under another name, I. K. Bonset, van Doesburg was active in the Dada movement, particularly in Germany and Holland. His partner in a series of lecture evenings was Kurt Schwitters (1887–1948), a fine nonsense poet and the composer of a long symphony of basic oral sounds, who made pictures out of all the flotsam and jetsam of civilisation and in his house in Hanover gradually built up an environmental assemblage of rubbish that spread through three storeys.

SURREALISM

In Paris, Dada was transformed into Surrealism. Some of the Zürich Dadaists moved to Paris around 1920, and found there a literary Surrealist movement exploring the possibilities of spontaneous writing and considering the implications of the new theories of psychoanalysis for artistic activity. Under the leadership of the poet, André Breton, a Surrealist movement embracing literature, painting and sculpture was organised. Breton defined the meaning of Surrealism in a manifesto published in 1924, and in 1925 there was the first exhibition of Surrealist art. Surrealism spread widely during the next fifteen years and was one of the forces from which the new American painting of the post-1945 period emerged. The theory of Surrealism in art is briefly as follows: that in our dreams and in those moments when our imaginations overwhelm our intellects, associations and images rise into our consciousness that are much more relevant to our real existence than the conventional subject-matter traditionally used in the arts. Some of this had been recognised before in the field of literary creation. German writers around 1800 often spoke of poetry arising from man's unconscious. Drugs were used by writers like Baudelaire and de Quincey to facilitate access to the unconscious. The Surrealists saw a particularly significant forerunner in the pseudonymous Comte de Lautréamont (1847–70) who, in a melodramatic epic entitled *Les Chants de Maldoror*, provided the apologists of Surrealism with a stock of quotations: 'as beautiful as the chance encounter of a sewing-machine with an umbrella on an operating table'. The thrill of semi-recognition that such images evoke was certainly one of the aims of Surrealist painters. Men like Max Ernst (1891–1976) and Salvador Dali (born 1904) saw painting as a means of recording with hypnotic accuracy such anti-rational inventions, and they created complex pictorial metaphors of uncertain and thus unlimited meaning. Ernst also explored the use of automatic and 'found' techniques, like taking rubbings from floorboards (one is reminded of Leonardo's words about finding images in marks on old walls) and dribbling paint on to a canvas. The most important painter to emerge through Surrealism is the Spaniard, Joan Miró, (1893–1983), who developed a very free and personal language of painting, often involving colour-washed canvases on to which he put childlike images of people and things. Miró visited the United States for the first time in 1947 but was one of the most important Europeans influencing developments already under way there.

PICASSO AND SOCIAL COMMENT

Picasso, as alive to events around him as to the wide world of art past and art distant, was affected by Surrealism without accepting the limitations it implied. In the later twenties his work showed stylistic elements derived from Surrealism and also, more significantly, sounded a note of stridency characteristic of the movement but not of him. Out of a fusion of Cubist and Futurist elements and Surrealist feeling, and under the impetus of political events that affected him closely, Picasso produced in 1937 one of the masterpieces of European art in *Guernica*, a large picture 60 rather like a powerful altarpiece, commemorating the bombing of a Spanish village and pointing to the agonies that man inflicts on man. Those who commissioned the work were disappointed that Picasso had not chosen a more realistic idiom that the man in the street would understand, but *Guernica* remains a meaningful work while more realistic attempts at political and social commentary have almost always faded as quickly as the journalism they emulate. Although many have tried, few artists have succeeded in finding a viable compromise between the aesthetic demands of modern art and their need to communicate with a wide, average public. Even the best of them, like the Belgian painter, Constant Permeke (1886–1952), failed to reach a 76 wider public than that normally offered by the galleries. Instead, the man in the street's enthusiasm goes to the titillating charms and elaborate academic technique of Dali's 'hand-painted dream photographs'. Even in Mexico, where a group of bold and energetic painters worked with the support of the government to develop an indigenous art, real contact with the populace could not be achieved. From the 1920s on, Rivera, Orozco, Siqueiros and others presented themes of national concern in great murals where motifs derived from the Mexican Revolution and the pre-Columbian history of Mexico were mixed into an essentially European idiom. 66

GERMAN PAINTERS

In Germany, politically and financially bankrupt after the war, many artists felt bound to bring their work into the service of social progress. George Grosz (1893–1959) used elements from Futurism and Expressionism and particularly from the graphic work of Klee, to make sharp protests at the rottenness of the world around him. Others remained detached from these aspects of life, or saw their function in confronting social disorder with ordered and harmonious art. Klee worked quietly and unceasingly, drawings, prints, paintings and occasional sculpture coming from his hand in quantitative and stylistic profusion. There seemed to be no limit to his inventiveness. Just as Schwitters used any bits of rubbish that came his way, so Klee made his art out of any linear motifs, colours, techniques and media that presented themselves. His work in the twenties ranges 75 from rich figurative fantasies of patent complexity to the apparently childishly simple chequerboards of colour. It was his habit to work on several pictures at one time and these were often of very different kinds. What all his work shares is a sense of preciousness, as though Klee said to

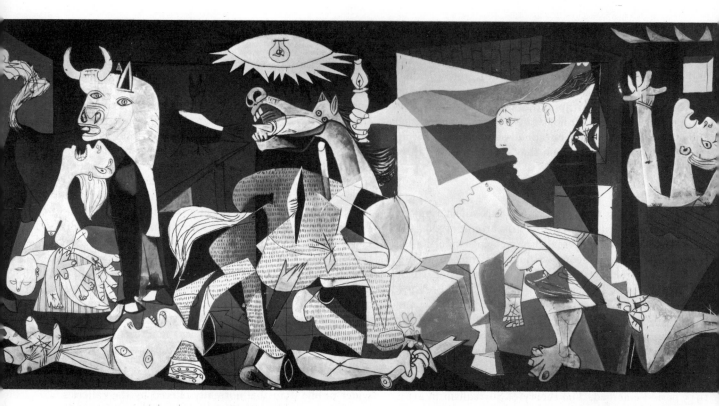

60. **Pablo Picasso.** *Guernica.* 1937. Oil on canvas. 11 ft. 6 in. × 25 ft. 8 in. (3.5 × 7.8 m.). Prado, Madrid. Commissioned to commemorate the destruction of a Spanish village by German bombers, Picasso created a monumental and almost monochrome composition expressing terror and destruction in generalised and almost religious terms.

himself that any mark or material would do but that once it was made or used it had to be respected and justified. In a lecture he gave in 1924 he described the artist's function as the humble one of transmitting inner and outer experiences into works of art just as the trunk of a tree draws up the sap from its roots and transmits it to its crown of foliage—'and the beauty of the crown is not his own; it has merely passed through him.' From 1921 until 1930 Klee taught at the *Bauhaus*, a design school opened in 1919 and directed by the architect Gropius until 1928. The school changed its character considerably, but Klee, concerned as teacher principally with lectures investigating the elements of art and with guiding the work of the weaving department, was affected neither by the Bauhaus's initial Expressionism nor by its subsequent dogmatic attachment to so-called basic shapes and colours.

Another teacher at the Bauhaus, which attracted to itself several outstanding artists but did not concern itself for long with the fine arts, was Kandinsky who returned to Germany from Moscow in 1921 and joined the school staff in the following year. In Russia Kandinsky's style had changed from the Abstract Expressionism of the previous years to a clear-cut, highly organised and sophisticated idiom distantly related to Malevich's. For some years he had investigated the specific qualities of particular colours and forms, and through his new work he intended not only to express his sensations, but also control their impact on the beholder. These investigations provided the basis for his theory lectures at the Bauhaus, some of which were published in 1926 as *Point and Line to Plane*. It has become a key text in the teaching of modern art.

(Continued on page 881)

67. **Piet Mondrian.** *Composition with Red, Yellow and Blue.* 1930. Oil. 19 × 19 in. (48 × 48 cm.). Collection: Alfred Roth, Zürich. Between 1920 and 1940, Mondrian worked ceaselessly on a series of paintings all employing the same limited language of forms and colours which he called Neo-Plasticism, and which for him represented the whole range of visual experiences condensed into an infinitely variable formula of relationships. Extreme as his discipline may seem, it was reached logically and gradually, from the warmly realistic Dutch landscapes via his outstandingly beautiful and subtle Cubist compositions. Nihilistic as it may seem, to Mondrian it meant inclusiveness rather than a negation, universality rather than an attachment to specific experiences.

Against the discords and accents of daily life he erected objects of controlled expression within which tensions and oppositions could be harmoniously contained.

68. **Kurt Schwitters.** *Hair-navel picture (Merz picture 21B).* 1920. Oil on board with painted relief of wood, cloth, earthenware and hair. 35¾ × 28½ in. (91 × 72.5 cm.). Lords Gallery, London. Schwitters' poetic use of urban debris gives his pictures a satirical and nihilistic note. But they are also affirmative, in that the various qualities of the ingredients he gathers are made to contribute to an essentially harmonious whole. He gave to all his works (pictures, poems, sculptures and constructions) the general title *Merz*, meaningless but suggestive. This picture is inscribed *'Merz ist nicht Dada'*—Merz is not Dada.

69. (left). **Max Ernst.** *Celebes*. 1921. Oil on canvas. 49¼ × 42 in. (125 × 107 cm.). Tate Gallery, London. One of a group of paintings done by Ernst in Cologne during 1921–2, in which fantastic images are presented in an intentionally uningratiating manner. It was bought by the French poet, Paul Eluard, and in 1922 Ernst himself moved to Paris where his work provided the basis for the art side of the Surrealist movement then forming.

70. **Joan Miró.** *The Carnival of Harlequin.* 1924–5. Oil on canvas. 26 × 36½ in. (66 × 93 cm.). Albright-Knox Art Gallery, Buffalo, New York. Using the traditional theme of domestic interiors (to which he returned in 1928 under the influence of Dutch seventeenth-century painting), Miró here presents one of his most Surrealist visions, at once humorous and sinister.

868

71. **Giorgio de Chirico**: *The Enigma of Time*. Collection Paré, Milan. The art of de Chirico forms a bridge between the Symbolism of Puvis de Chavannes and Gauguin (pls. 27 and 31) and Surrealism. Both movements were much concerned with suggesting ideas and feelings lying on the edge of reality. De Chirico's urban spaces, almost deserted yet heavy with omen, subvert classical settings to move with sensations of nostalgia and perhaps fear, partly through their vertiginous spaces and mad perspectives, partly through strong light and unexplained shadows. The manner of painting is emphatically literal and without grace.

72. **Salvador Dali**. *The Birth of Liquid Desires*. 1932. Oil on canvas. 37½ × 44 in. (95 × 112 cm.). Solomon R. Guggenheim Museum, New York. Dali's vision of a world of large objects inhabited by little men and women intent on their egotistical pursuits derives from the religious paintings of Bosch. Into them he fed a post-Romantic taste for eroticism heightened by corruption and danger. In this coldly sunlit picture the dominant object is both violin and body, and disintegrates before our eyes; space echoes hollowly, nightmarishly, as monstrous lovers grasp each other. Dali was one of the leading Surrealists in the early 30s, but his reactionary social attitudes and his self-glorifying behaviour soon led to his expulsion from the movement.

73. **René Magritte.** *Threatening Weather.* 1928. Oil on canvas. 21¼ × 28¾ in. (54 × 73 cm.). Collection: Roland Penrose, London. With the dead-pan technique of a primitive, the Belgian Surrealist, Magritte, presented conceptual clashes that mock both the world of reason and the world of visual communication.

74. **Wassily Kandinsky.** *Black and Violet.* 1923. Oil on canvas. 30¾ × 39½ in. (78 × 100 cm.). Collection: Hans and Walter Bechtler, Zürich. In his paintings of the 1920s, Kandinsky looked for a more controlled means of expression than is found in his earlier abstract work, basing his new experiments on his own research and that of other artists and psychologists into the affective properties of shapes and colours.

75. **Paul Klee.** *Senecio.* 1922. Oil on linen. 16 × 15 in. (40.5 × 38 cm.). Kunstmuseum, Basle. A particularly fine example of Klee's painting at a time when his work was especially varied and experimental. Although its free-hand geometry suggests the formal tendencies of Cubism, *Senecio* is without its spacial preoccupation, and owes more to the refined colour relationships associated with Matisse. In many respects, the art of Klee synthesises characteristics that had hitherto been assumed to be irreconcilable.

76. **Constant Permeke.** *The Betrothed
(Les Fiancés).* 1923. Oil. 59½ × 51¼ in.
(151 × 130 cm.). Musée d'Art Moderne,
Brussels. Of those painters who have tried
to involve their art directly in the social
struggles of our century, the Belgian,
Permeke, is one of the most convincing and
successful. The vigorous simplicity of his
forms, learnt from Cubism, is supported
by a subdued range of colours that, for all
their expressive earthiness, are often of
remarkable subtlety.

77. **Henry Moore.** *Recumbent Figure.* 1938. Green Hornton Stone. 54 in. (137 cm.), high. Reproduced by Courtesy of the Trustees of the Tate Gallery, London. In 1948, Henry Moore was awarded the International Sculpture prize at the Venice Biennale in recognition of his eminence in the world of modern sculpture. That this recognition should be achieved by a British sculptor is remarkable enough: the history of sculpture in Britain had been far from glorious for several centuries. That it should be achieved by a coal-miner's son from Yorkshire makes it even more remarkable. Yet in some ways this also illuminates the event. Moore was not a fundamentally revolutionary sculptor in the way that Picasso, Brancusi and Gabo were. His role is that of the synthetist. He had clearly been influenced by Brancusi and Arp. He also learnt much from archaic Greek and from Aztec sculpture. He took up the theme of 'truth to materials' and turned what could have been a functionalist dogma into the basis of a vital relationship between artist and matter. Most important, he brought to these influences and ideas a strong and undisguised vein of common human emotion, and it is perhaps his successful communication of such emotion through sculpture which is modern without being aggressive, and which manages to be at once classical and subjective, that gives him his wide and enthusiastic public today and assures his place in modern art history. The timeless theme of woman—lover, earth-goddess and giver of life—dominates all Moore's work, is accessible to all, and relates directly to just those organic forms of nature which Moore found in the structure of his carved materials.

78. **Ben Nicholson.** *Lilac and Goblet: June 16th, 1947.* Oil on board, 11¾ × 16 in. (30 × 40.5 cm.). Gallery Beyeler, Basle. Nicholson's fine compositions of colour areas and partly independent linear structures belong both to the world of abstract art, and to the long traditions of landscape and still-life painting. He was the first British painter to assimilate modern developments on the Continent and to evolve a personal (and perhaps recognisably national) idiom from them. He was also one of the first painters anywhere to ignore the barriers between abstract and representational art that had been thrown up between the wars.

79. (opposite, below). **Paul Nash.** *Landscape from a Dream.* 1938. Oil on canvas. 26½ × 40 in. (67.5 × 101.5 cm.). Reproduced by courtesy of the Trustees of the Tate Gallery, London, and the Paul Nash Trust. Painted a year after the large Surrealist Exhibition in London, this picture shows how Nash (and other British painters at this time) fused Surrealist elements of symbolism and conceptual multiplicity with an essentially Romantic vision of landscape. Nash wrote in 1937: 'To contemplate the personal beauty of stone and leaf, bark and shell, and to exalt them to be the principals of imaginary happenings, became a new interest'.

80. (below). **Piet Mondrian.** *Victory Boogie-Woogie.* 1943–4. Oil on canvas. 50 × 50 in. (127 × 127 cm.). Collection: Mr and Mrs Burton Tremaine, Meridan, Connecticut. In New York, where Mondrian spent the last four years of his life, a new excitement began to show in his work, giving it an almost Baroque character as against his strictly Neo-Plasticist series (plate 67). The brashness and pace of the city deeply affected the elderly and solitary man who, by extending his idiom very slightly, was able to bring a sense of rhythmical action into his last pictures, of which this, left unfinished at his death, is the most vigorous.

81. **Man Ray**, *The rope-dancer accompanies herself with her shadows*, 1916. Oil on canvas. 52 × 73⅜ in. (132.1 × 186.4 cm.). Museum of Modern Art, New York. The title has a Duchampian ring, and the basic character of this large painting, of dramatic shapes and lines given an only partly sensible meaning in retrospect (as opposed to starting with the idea of representing a figure on a tightrope) is likely to have Duchamp behind it.

82. **Edward Hopper**. *New York Movie*. 1939. Oil on canvas. 32 × 40 in. (81 × 101 cm.). Museum of Modern Art, New York. Hopper's objective, apparently impersonal manner, and his snapshot view of his subjects, cannot disguise a very personal note of melancholy and loneliness. We look at his paintings, uncertain whether he is praising or criticising what he shows us; the note of disenchantment, combined with his interest in how things actually look, that makes them different from other painters of the American scene.

83. **Thomas Hart Benton**. *City Activities with Dance Hall*. 1930. Mural for the New School of Social Research, New York. Benton took a rather simple view of the modern world, expressing some warmth for the agricultural world and the American South and West and disdaining modern city life and its entertainments. Everything tended to be mocked at least a little in his work.

84. **Andrew Wyeth**. *John Olson's Funeral*. Tempera. 21½ × 29½ in. (55 × 75 cm.). New Britain Museum of American Art. The world Wyeth describes in such detail is not unlike that we find also in Winslow Homer's ¡pictures (fig. 20). But what in Homer is presented with a pleasurable sense of discovery, in Wyeth comes out of the past, as nostalgia and with a sense of loss. It is perhaps this that gives his work its appeal to so broad a public: it looks like magazine illustrations developed, with much skill and effort, into paintings without a supporting story.

85. (above). **Gerrit Thomas Rietveld.**
Schroeder House, Utrecht. 1924.
86. (right). *Red-Blue Chair*, 1917. Stedelijk
Museum, Amsterdam. Rietveld's famous
chair is a remarkable early application of
the Neo-Plasticist idiom to three-
dimensional design. Note the use of primary
colours, and also the black horizontal and
vertical frame whose members do not
penetrate each other but retain their
integrity. In the same way the I-beams on
the exterior of the Schroeder House rise
against (rather than into) the balconies
which they support. Here too primary
colours and rectangular relationships
underlie the entire design, inside and out.
The physical austerity of the chair is
compensated for by the lively colour. The
house, for all its apparent severity, has an
air of relaxation and ease. Rietveld's Neo-
Plasticist designs go far towards justifying
Mondrian's dream of an environment
whose refined harmony would make all 'fine
art' redundant.

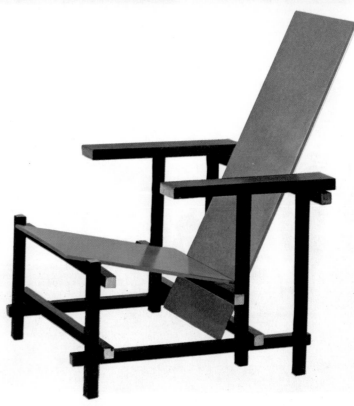

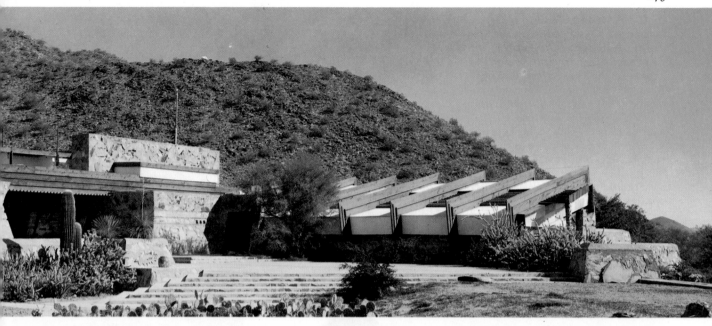

87. **Frank Lloyd Wright.** *Taliesin West,* near Phoenix, Arizona: the office and home of the architect. Wright's architecture fuses personal with tradition qualities in a unique way. Taliesin West suggest primitive indigenous building conventions while also embodying its designer's original conception of planning and construction.

88. (below). **Le Corbusier.** *Still-life with Many Objects.* 1923. Oil on canvas. 44¾ × 57½ in. (114.5 × 146 cm.). On loan to the Musée d'Art Moderne, Paris. (Artist's Collection). The Purist art of Le Corbusier and Ozenfant represented an attempt to cleanse Cubism of its romantic and subjective elements its ambiguities and illusionism. Here everyday objects are knitted together to form a clear and harmonious structure that can easily be understood.

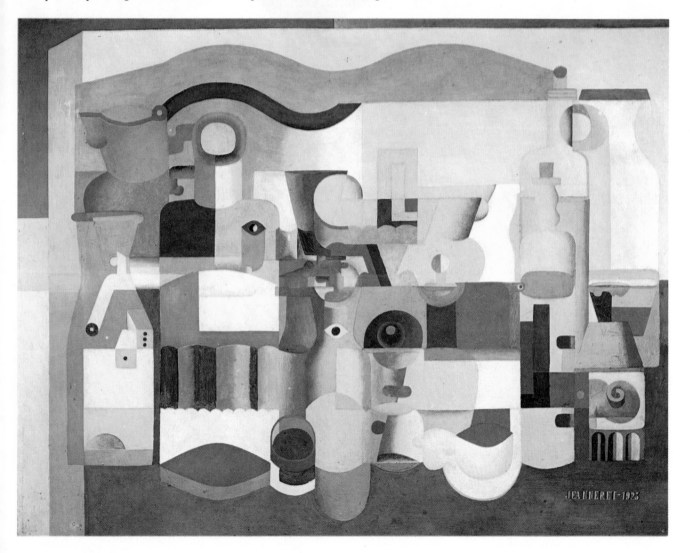

89. **Henri Matisse.** *The Snail*
(*L'Escargot*). 1953. Gouache on cut and
pasted paper. 112¾ × 113 in. (287 × 288
cm.). Reproduced by courtesy of the
Trustees of the Tate Gallery, London.
During his last years Matisse produced a
number of large and small works composed
of pieces of coloured paper in which he
anticipated many of the qualities of what
subsequently became known as Hard-Edge
painting. This is one of the large works in
this series, in which the roughly spiral
arrangement of the hand-coloured pieces
of paper suggested the title. Others lack
even this distant reference to actual objects.

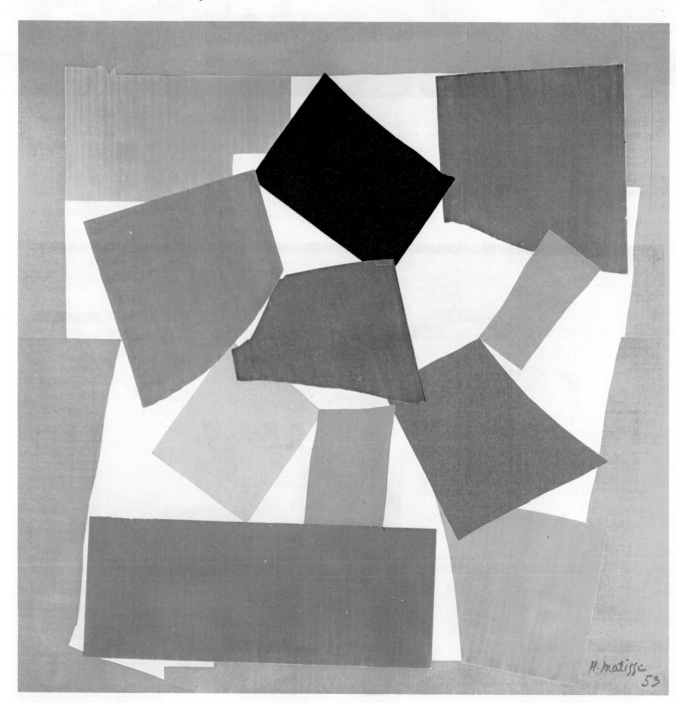

THE TWENTIES IN AMERICA

One consequence of the Armory Show was the unmistakable growth of interest in Modernism. Reports and debates in papers and magazines was paralleled by purposeful collecting, public and private. The two often came together, as when a private collection became a public museum, or when private individuals interested in art acted also as trustees of public institutions. Institutions such as the Museum of Modern Art and the Solomon R. Guggenheim Museum have been more than outstanding repositories of twentieth-century western art: through their exhibitions, their selective acquisitions, and at times their publications, they have shaped the understanding and thus also the further course of modern art.

An outstanding example of an artist with a positive view of European trends and yet with a markedly American idiom is that of Stuart Davis (1894–1964). Cubism influenced him profoundly; what he made of it was thoroughly Yankee. His straight, almost naive painting of a cigarette packet marks him out as a brilliant precursor of Pop art. In other paintings he found a lively and persuasive way of capturing the American scene through bright colours and energetic forms that suggest hoardings and jazz. A similar attempt, but by different, more naturalistic and delicate means is found in the work of artists often called Precisionist (there was no Precisionist group). Their subjects tended to be taken from the city environment, sometimes from industrial buildings and engines found elsewhere. They owed a little to Cubism, sometimes more to photography.

Other artists were eager to comment directly on the world they represented and on their relationship to it. In Edward Hopper (1882–1967) this comment is tacit but unmistakable. He said in 1927 that he hoped for 'the crystallisation of the art of America into something native and distinct', but it was his own apprehension of the world his art wrestled with, not a pointedly national idiom. It is only as we stay with his apparently so straightforward descriptive paintings that their burden of hopelessness settles on us. They are images of disillusionment where others painted superficial charms, and they are not images of nastiness where others took the dramatic and easier option of painting slums and decrepitude. His painting is soft-focus: we enter his world with our guard down. Peter Blume (born 1906) used a much more emphatic style. In his paintings unreality of an almost Surrealist sort is used to bring reality home to us and to protest against it.

TOTALITARIANISM IN RUSSIA, GERMANY AND ITALY

In Russia, Lenin's economic reforms, and the change of political climate they symbolise, led to a complete change of attitude towards avant-garde art. After 1921, some of the important artists of the revolutionary period left Russia; Similarly in Germany the accession to power of the National Socialists was soon followed by their attempt to eradicate modern art. Many artists emigrated. Those avant-garde artists who remained were forbidden to work. Works of art were removed from museums, galleries and private collections, to be sold abroad or destroyed. Adventurous directors of public galleries were dismissed. It was art's duty to glorify Hitler, the Third Reich and the Aryan race; anything else was denounced as a Jewish or Bolshevist attempt to undermine German virtue, or as the product of sick minds and charlatans. Several exhibitions of 'degenerate' art were organised, the biggest of which took place in Munich in 1937 and included work by more than a hundred artists going back as far as Liebermann.

Fascism in Italy was less concerned with culture—Mussolini himself took no interest in it—and such patronage as it exercised it gave to academic art. But even before Fascism became powerful, Italian artists themselves retired from the front-line positions taken up by the Futurists. Not only did they take a renewed interest in the art of the past (Carrà wrote a well known book on Giotto, published in 1924), but many of them renounced their own earlier radicalism.

DEVELOPMENTS IN BRITAIN

Far from destroying modern art, totalitarian measures helped to propagate it in other places. Great Britain and America benefited particularly from emigrating artists. In Great Britain, the influx of foreigners coincided with the emergence of the first English painter of international significance since Turner. Ben Nicholson (1894–1982) knew Paris and Cubism, and in the early thirties began to use the conventions of Synthetic Cubism as the basis for elegantly constructed and delicately painted still lifes. In **78** 1934 and 1935, he visited Mondrian and was deeply impressed by the tranquillity of his art and personality. Between 1934 and 1939, Nicholson carved a series of white-painted reliefs that, without in any way imitating Mondrian's work, have something of his intuitive approach to order. From 1938 to 1940, Mondrian lived in London, an encouraging presence for the pioneers of abstraction in England. The thirties saw also the emergence of Henry Moore and Barbara Hepworth as outstanding sculptors, and the tentative re-entry of Britain into the field of modern architecture. The most powerful movement in British art in the thirties, however, was Surrealism. A British Surrealist group organised an international exhibition of Surrealism in 1936, and *The London Bulletin* was published as a Surrealist magazine of art and literature. Herbert Read emerged as a champion of Surrealism and of modern art generally. The appeal of Surrealism in Britain is to be explained partly in terms of the strong literary element that easily dominated its aesthetic content, and partly in terms of the movement as an essentially Romantic mode of vision to which the countrymen of William Blake could easily respond. Before 1936, some painters, like Paul Nash (1889–1946), had al- **79** ready brought aspects of Romantic British landscape painting into metaphorical expression that was close in spirit to Surrealism. After 1939, when the war isolated Britain and dispersed her avant-garde groups, several painters (outstanding among them Graham Sutherland) worked independently in styles that moved between Romanticism and Surrealism.

61. **Ben Shahn**. *The Passion of Sacco and Vanzetti*, 1931–2. Tempera on cavas 84½ × 48 in; (214 × 122 cm.). Whitney Museum of American Art, New York. Shahn produced a series of 23 paintings commemorating the story of two men charged with murder and robbery but prosecuted because of their communist and anarchist views. After worldwide efforts to have the charges dropped Sacco and Vanzetti, arrested in 1920, died in the electric chair in 1927.

THE 1930S

On the whole, the 1930s were a dark decade for modern art. With large areas of Europe closed to living art by totalitarianism, and with the often academic works of Surrealism exerting a powerful appeal over a confused world, it must have seemed that the aesthetically more creative forms of modern art had lost the day. With the closing down of Russia, Paris became more than ever the centre of modern art. The more literary forms of painting and superficially modernised forms of academicism dominated the scene. Mondrian worked in Paris from 1918 until 1938,

but few people took any interest in his work and he did not have a single exhibition during those twenty years. The more worldly-wise Kandinsky, who worked in Paris from 1933 until his death in 1944, made rather more impact, and an international group met there to discuss abstract art, but they found little interest or encouragement and it is remarkable how few of its members were French.

Klee left Germany in 1933 and spent the remaining years of his life in Switzerland. From 1935 on he became increasingly ill, but his work flourished. His productivity if anything increased, his paintings tended to become larger, and for the first time much of his work cohered stylistically. In many of the paintings of 1935–40, heavy painted lines act with and against colour patches, making a new alliance between his powers as draughtsman and as colourist. But at the same time he continued to explore quite different kinds of pictorial imagery and the last year of his life, one of the most productive of his career, saw him attempting new things that at times seem to foretell the post-war adventures of much younger artists.

SCULPTURE IN THE 1920S AND 1930S

In the sculpture of these decades the most creative work was, as we found with painting, the achievement of a surprisingly small number of individuals, often working in seclusion. No great movements comparable to Cubism, Futurism and Constructivism arose to confront sculptors with new plastic concepts. Constructivism, condemned in Russia, flowered in the hands of the brothers Gabo and Pevsner. Gabo left Russia in 1921. The next twelve years he divided between Paris and Berlin, he then came to England in 1933 and went on to the United States in 1946. Pevsner settled in Paris in 1923 after two years in Berlin, and worked there until his death in 1962. In the work of both, Constructivism becomes detached from the aesthetic of Cubism and finds its own logic. Both started from massless reliefs and figures using thin sheets of material resembling the painted planes of Analytical Cubism and exhibiting something of that style's compositional simplicity. Pevsner, who had been a painter, moved from this into a remarkably austere style and method that owed much to his interest in mathematics. Using straight linear elements (wire or rod), he constructed works of sculpture that still have the compositional directness and thus monumentality of Cubism. Gabo's work has tended to be more obviously personal and meditative; paradoxically, it was he who had studied engineering. In the first years of the 1920s, he made a series of models for monuments and buildings that may represent an attempt to justify experimental art to the Russian authorities but may also be seen as counterparts to the glass skyscraper projects of Mies van der Rohe and Mendelsohn's Einstein Tower. Subsequently he moved away from such projects to self-sufficient works in a variety of materials, trying to realise complex relationships with forms that are themselves surprisingly simple and using materials that offered the maximum of insubstantiality. The development of plastics came to his aid, and it is in a long series of constructions based on this

62. **Naum Gabo.** *Linear Construction, No. 2.* 1949. Perspex and nylon thread. 36 in. (91 cm.). Stedelijk Museum, Amsterdam. Gabo's exploitation of plastic materials brought into Constructive art a quality of lyricism that cannot have been envisaged when the movement first expounded its principles but which is in no way contradictory to them.

63. **Laszlo Moholy-Nagy.** *Light-Space Modulator.* 1922–30. Movable construction, steel, wood and plastic. 59½ × 27 × 27 in. (151 × 68.5 × 68.5 cm.). Busch-Reisinger Museum, Harvard University. Space and movement has been one of the most persistent themes in modern art. In his mobile constructions Moholy-Nagy gave physical reality to the space, movement and light implied in his paintings and photograms.

64. **Alexander Calder.** *Red Toenail, Blue L.* 1962. Metal construction. 36 × 150 in. (91.5 × 381 cm.). Grosvenor Gallery, London. The mobiles of Calder are poetic and often gay interpretations of natural movement in terms of abstract forms and colours.

65. **Pablo Picasso.** *Head.* 1931. Wrought iron. 39½ in. high (100 cm.). Collection: the Artist. The freely expressionistic constructed sculptures of Picasso are the progenitors of countless welded-metal sculptures produced all over the world, and themselves are indebted to African constructed masks.

versatile material that his career finds its climax. Here sculpture, without ceasing to be apprehensive as a physical object, achieves an extraordinary fluency and lyricism—light and space are brought into expressive play.

Among the growing number of artists of many nationalities who attached themselves to Constructivism, Moholy-Nagy and Calder were particularly inventive and influential. Laszlo Moholy-Nagy (1895–1946), who was born in Hungary, developed a form of Constructivism that embodied his personal vision of a technologically transformed world of clear forms and shining surfaces. He was as interested in film and photography, in typography and industrial design, as in pure art, and during 1923–8 he helped to transform the Bauhaus into the industrially centred institution that became famous. His coolly romantic constructions of shining metals, often with moving parts to be seen under dramatic lighting, are the fullest expression of his enthusiastic spirit. From 1935 until 1937, Moholy-Nagy worked in London. Then he settled in Chicago and started there the *New Bauhaus* and so developed and propagated ideas that he had also set out in two deeply influential books, *The New Vision*, published by the Bauhaus in 1929 (an English edition appeared in 1947), and *Vision in Motion*, published in Chicago in 1947.

If light is the common denominator of Moholy-Nagy's pursuits, movement is the principal concern of the American, Alexander Calder (born 1898). Calder's parents were artists, but his own early interests lay in tools and in engineering. Working in Europe, he made himself a reputation for wire sculptures, then invented a series of motorised and hand-propelled sculptures with moving parts, and in 1931 began to produce mobiles in which finely balanced members are set in motion by air currents or by the touch of a hand. Their formal ingredients are abstract but they often hint in their general forms at trees, waterplants, and so on. Although technically they are constructions, they do not share the aesthetic qualities normally sought by Constructivism and suggest a spiritual kinship with Surrealism rather than any other movement.

PICASSO, ARP, BRANCUSI

A different kind of constructed sculpture, markedly expressionist in character, was initiated by Picasso in 1930 when he began to fashion three-dimensional objects out of odd pieces of scrap metal. As a creative process this was more akin to the rubbish pictures of Schwitters and to Picasso's own wood and cardboard reliefs of 1913–4 than to Constructivism with its accent on clear and abstract forms and modern materials. But the scrap yards, too, are part of the world, and Picasso's inventive handling of this material has been one of the most fruitful contributions to modern sculpture. At about the same time he produced a series of 'stick statuettes', usually between fifteen and twenty inches in height, which he made from long strips and sticks of wood and then had cast in bronze. Here expressionist distortion meets the Constructivist ideal of a massless sculpture inserted into space.

66, 67. **Jean Arp.** *Birds in an Aquarium. c.* 1920. Painted wood relief. 9⅞ × 8 in. (25 × 20.5 cm.). Collection, The Museum of Modern Art, New York. (Purchase). *Human Concretion.* 1949 (original 1935). Cast stone (original, plaster). 19½ in. high (49.5 cm.). Collection, the Museum of Modern Art, New York. (Gift of the Advisory Committee). Arp's optimistic sense of life and of the human warmth of rounded and nestling forms, penetrates his entire production.

Arp's work developed considerably during the 1920s and 30s. He gave less time to two-dimensional and relief work than during the Dada years, and was encouraged by Surrealism to exploit ambiguities of form and meaning in sculpture that took on a more and more biomorphic character. Using various materials interchangeably, Arp modelled forms that suggested a great variety of objects and experiences while always asserting life and physical well-being. Like Klee, he believed in the essential naturalness of art—'art is a fruit that grows in man, like a fruit on a plant, or a child in its mother's womb'—and his personal inclinations allowed him to develop his art into forms 66, 67 buoyant with life.

Undoubtedly the greatest sculptor at work during these decades was Brancusi, who continued to carve his tough and primitive-looking wood sculpture, and to model and carve his deceptively simple refined forms. At times he 65 would produce a carved marble sculpture and also a modelled and cast version, in which case he would adapt the original form in various scarcely noticeable ways to make it more suited to its new character. Often he used highly polished bronze for the cast version, himself polishing the metal with almost obsessive persistence. As a result, the form of the original, often rounded and expressive of mass and weight, seems to become immaterial as its surface reflects everything around it. During this time Brancusi's reputation spread widely, especially to the United States where he had the first of a series of important exhibitions in 1926. It was on that occasion that the American Customs refused to allow the normal duty-free entry for works of art to his *Bird in Space*. There followed a lawsuit to establish that what the officials took to be a piece of machine metal of industrial origin and function could be, and in this instance, was, a work of art. Eminent witnesses were called on both sides, and ultimately judgement was given in Brancusi's favour.

BRITISH SCULPTURE

It was partly under the influence of Brancusi that Britain, until then a land without sculpture of more than local interest, entered the international arena. With the emergence of Henry Moore (born 1898), England could boast a sculptor abreast of the Continental avant-garde and at the same time profoundly original. Moore can be seen as a synthesiser of various trends. From Brancusi he learnt the value of allowing the material to command the character of the work; Surrealism and Arp revealed to him the multiplicity of meanings found in familiar forms; certain technical devices he developed from the examples of Archipenko and Gabo. Michelangelo was a root influence on him, as well as archaic Greek sculpture and the carvings of pre-Columbian Mexico. Moore himself brought an instinctive response to the physical world and to its qualities of scale, texture and mass, and echoed them in sculptures that were often variations on the timeless theme of the reclining 77 female figure. In these he fused into miraculous unity suggestions received from the human image, from landscape

68. **Oskar Schlemmer** (1888–1943). *Abstract Figure, Sculpture in the Round*. 1921. Nickelled bronze. 48⅛ in. high (107 cm.). Marlborough Fine Art Gallery, London. In his paintings, sculpture and ballets, Schlemmer tried to fuse the ancient tradition of idealised human form with his time's consciousness of mechanistic materials and shapes.

forms and from the structure of the material itself. Brancusi once said: 'Your hand thinks and follows the thoughts of the material', and Moore has spoken similarly about the creative process as a kind of dialogue between the artist and the wood or stone under his hand. Barbara Hepworth (1903–75) also appeared in the thirties as an important new sculptor. While her work is more totally abstract than Moore's, it is more immediately human and intimate than his. He tended towards the dramatic and the monumental; she created forms that respond to deeply personal needs.

THE THIRTIES IN AMERICA

After the Wall Street crash, with Europe divided into aggressively totalitarian states and others uncertain whether to smile upon the dictators or denounce them,

69 (left). **Constantin Brancusi.** *Torso of a Young Man.* 1925. Polished bronze on limestone, wood base. 60 in high (152.5 cm.). Collection, Joseph Hirshhorn, New York. At first sight a sculpture of mechanistic severity, this torso soon reveals an extraordinary sensuousness of form and surface that is then stressed and complemented by the character of Brancusi's base.

70 (above). **Constantin Brancusi.** *King of Kings—The Spirit of Buddha.* 1937. Wood. 118¼ in. high (300 cm.). The Solomon R. Guggenheim Museum, New York. In this carving, for which Brancusi selected an old and weathered piece of oak, the Roumanian peasant in him comes to the fore.

71. **J. J. P. Oud.** *Workmen's Houses, Hook of Holland.* 1927–7. After adhering to the Neo-Plasticist idiom of the *De Stijl* movement, Oud here introduced into his masterpiece a few curved elements, making for a greater fluency of form. These terraces are the first outstanding example of low-cost housing of high quality design.

72. **Le Corbusier.** *'Plan Voisin' town-planning project, Paris.* 1922–30. Le Corbusier conceived the high-rise building as a vertical street or neighbourhood, situated in a beautiful and healthy park environment and well separated from traffic arteries.

American art tended to become more pronouncedly self-concerned. There was a conscious attempt to develop what is called a 'grass-roots culture' in preference to a cosmopolitan one, to promote rustic themes as against urban ones. The Regionalism that ensued was without stylistic priorities. Generally the effect of this art was to reassure, to suggest long-term stabilities to a world shaken by economic setbacks. In this context Thomas Hart Benton (1889–1975) stood out for his loud and muscular paintings, on the edge of caricature when they celebrated rural life and over the edge when he attended to the immoralities and narrowness of the cities. He had been part of the Stieglitz circle, but turned against what he decided was 'an intellectually diseased lot' by the end of the 1920s. His rumbustious idiom is seen at his best in some of the murals he painted in the 30s. His forthrightness—of mind as well as pictorial manner—stimulated later American painters even when their work was quite different in kind from his.

The 30s were also noted for a number of artists who, partly influenced by the Mexican muralists and by such Europeans as George Grosz, used their art for political statements and protests. It is difficult for such art to be sufficiently explicit in the information it presents and the commentary it offers to rise above the level of pictorial journalism. Ben Shahn (1898–1969) was an outstanding graphic artist and painter who used his art to campaign against injustice and social exploitation, in murals and small paintings. To do this he turned away from his earlier interest in Modernism. In order to deliver their message to the viewer he had to make his images easily legible, vehicles for unambiguous statements rather than general expressions of disquiet.

But the 1930s saw also the gathering of anti-realist forces in American art, partly thanks to the crisis in Europe. Arshile Gorky (1905–48) had arrived in the USA at the age of fifteen. He was excited by the art of Stuart Davis and, through his example, by that of Picasso and Léger. The intensely personal abstract he developed, a form of abstract Surrealism, was to stimulate others. Hans Hofmann (1880–1966) arrived in the USA at the age of fifty after wide experience of art in Europe and many years of running his own art school in Munich. A powerful teacher, he brought **90** into American art an understanding of colour as a structural as well as an expressive element, and this was to be of importance for the painting that developed in the 1940s and '50s. Josef Albers (1888–1976) arrived from the Bauhaus in 1933, another very influential painter and teacher of painting. Laszlo Moholy-Nagy, also from the Bauhaus, arrived in 1937 after a period in London. Mondrian arrived in New York in 1940 after two years in London.

ARCHITECTURE IN THE 1920S AND 1930S

In architecture the twenties and thirties mark a climax and a triumph. As patronage began to lose its fears of modernism, new architecture began to arise in many countries and in some quantity, presenting a remarkable unity of appearance. The precepts and projects of *De Stijl* and Suprematism, and the stylistic inclinations of two or three outstanding architects—notably Le Corbusier, Walter Gropius and Mies van der Rohe—fused to form what has become known as the International Style

73. **Le Corbusier.** *Villa Savoie, Poissy-sur-Seine.* 1929–31. An instinctive classicist, Le Corbusier gave a clear and carefully proportioned external form to his villa, while shaping its interior with a freedom that rested on his separation of the carrying function of columns from the dividing function of walls.

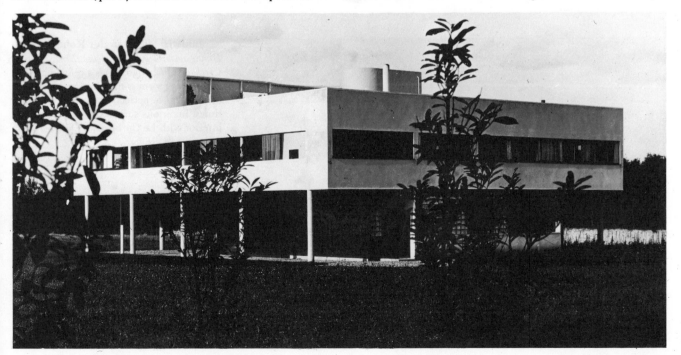

74. **Ludwig Mies van der Rohe.**
Dining-room. Tugendhat House, Brno, Czechoslovakia. 1930. Mies's refined economy of form is matched by his attachment to perfectly beautiful and, at times, luxurious surfaces. Compare this interior with Le Corbusier's *Dom-Ino* diagram, figure 53.

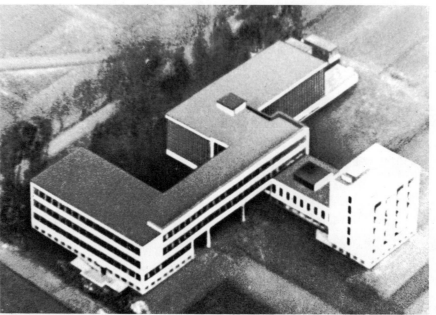

75. **Walter Gropius.** *Bauhaus building, Dessau, seen from the air.* 1925–8. The most famous building of the 1920s, Gropius's Bauhaus synthesises avant-garde architectural ideas from all over Europe. The decoration and furnishing of the interior was undertaken by the Bauhaus workshops.

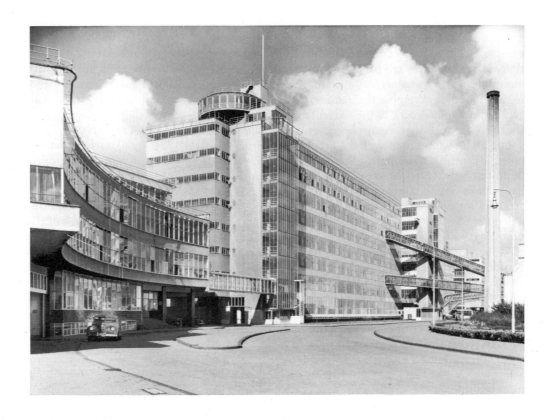

The one full embodiment of *De Stijl* principles in architecture is the Schroeder House in Utrecht (1923–24), designed by Gerrit Rietveld (1888–1964). Preserving the identity of each plane and stanchion, Rietveld juxtaposed the elements of his building with great delicacy and emphasised their independence by the use of contrasting colours. Another architect associated for a time with the *De Stijl* movement was J. J. P. Oud (1890–1963), the designer of a colony of workmen's houses in the Hook of Holland (1926). In one of his essays published by the Bauhaus in the same year Oud spoke of 'the need for number and measure, for cleanliness and order, for standardisation and repetition, for perfection and high finish; the properties of the organs of modern living, such as technique, transport and hygiene in the sphere of social conditions, massproduction methods among economic circumstances'. These words express some of the concerns shared by the leading architects of this period, and they show that although functionalism (that is, exclusive attention to material considerations as the source of architectural form) was often used to justify their designs, they were conscious also of aesthetic needs. This is as clear from Rietveld's hovering playing-card rectangles as from the almost endless horizontals and unbroken concrete surfaces of Oud's housing.

LE CORBUSIER

It is above all clear from the work of Le Corbusier, the great propagandist of functionalism ('the house is a machine for living in'), who, in his first book *Towards a New Architecture* (1923), pointed enthusiastically to the design and serial manufacture of aeroplanes, liners and cars as model

76. **J. A. Brinkmann, L. C. van der Vlugt** and **Mart Stam.** *Van Nelle Tobacco Factory, Rotterdam.* 1927-30. One of the most go-ahead buildings of the 1920s, this factory remains an outstanding example of functional design even while it embodies some of the stylistic predilections of its time.

77. **I. A. Golossef.** *Zoueff Club, Moscow.* 1927. An example of the bold architecture produced in Russia during the 1920s.

892

expressions of the modern age, and to Greek temples as comparable instances of unfettered modernism in their

88 time. His rationalism and his classicism are at bottom inseparable, which is another way of saying that Le Corbusier is an outstanding example of the tradition of French classical architecture, going back to the sixteenth century. During the 1920s, Le Corbusier began to be recognised as the leading young architect in Europe, partly through his writing and polemical projects and partly through the relatively few buildings he was allowed to realise. The projects included

72 plans for the rebuilding of part of Paris with enormous skyscrapers set into parkland—the first demonstration of a new kind of urban planning that has since been put into practice on a much more modest scale in many places. In 1927, he won first prize in a competition for the League of Nations Palace to be built in Geneva and, although his design was not used for the Palace, it has been an important prototype for the planning of building complexes of this type. The private houses he built at Garches (1927) and

74 at Poissy (1929–31) combine the basic ideas he had expressed in his *Dom-Ino* diagram of 1914 with his belief in traditional systems of proportion and in the basic geometric solids which, like Plato, he considered of their essence the most beautiful forms. Thus, in his search for a new order he returned to principles and values which we saw being discarded at the beginning of the previous century.

ARCHITECTURE IN GERMANY

In Germany, Mies van der Rohe showed himself to be an exceptionally sophisticated and thoughtful exponent of the International Style, particularly in the German Pavilion he designed for the international exhibition in Barcelona

74 (1929) and the Tugendhat House in Brno, Czechoslovakia

(1930). He ennobled the style by his use of fine materials (chromium-plated steel columns, marble, onyx, ebony) and by the unique delicacy of his detailing; austerity and clarity of form was accompanied by the organic lavishness of selected surfaces. Historically the most important monument of the period was, however, the new Bauhaus Building in Dessau (1925–6), designed by Walter Gropius (1883–1969): an informal composition of rectangular units with clean white concrete surfaces and large unbroken areas of glass covering the workshop block. The lettering on the outside of the building and the furnishings inside were designed by the staff and students of the school, so that the whole offered a magnificent demonstration of modern design. In 1929, Gropius was given an opportunity, in the Siemensstadt flats commissioned by an electrical company for its employees, to involve himself more deeply in the social issues which, he has always insisted, are the foundations of architectural design. The long 'slab' blocks he erected there have continued to be the most frequently used alternative to the 'point' blocks proposed on a vast scale by Le Corbusier.

'MACHINE AESTHETIC' AND THE INTERNATIONAL STYLE

Thus the development of geometrical abstraction, so brilliantly initiated in Holland and Russia, became the aesthetic basis of the international avant-garde in architecture at a time when it faltered in painting. While Mondrian's work was almost ignored and Malevich had to abandon his pioneer position, architects paid homage to the new language they had demonstrated. But on the whole this tribute was unconscious. The clear forms and logical appearance of *De Stijl* and Suprematist art fitted the twenties' vision of the new technological world so closely

78. **Robert Maillart** (1872–1940). *Schwandbach Bridge, near Schwarz-Canton, Berne.* 1933. Curved concrete slabs. Through technical expertise and inventiveness, an engineer like the Swiss, Maillart, is able to find new forms of construction that at times influence architectural design.

79. **Buckminster Fuller.** *Geodesic Dome for the Union Tank Car Company maintenance and repair facility at Baton Rouge, Louisiana.* October, 1958. Steel and plastic. 384 ft. span, 128 ft. high (117 × 39 m.). Architects have as yet taken little notice of the potentialities offered by new materials and new techniques, of which Fuller's multi-purpose domes are relatively simple examples. They come in all sizes and materials: this one, in spite of its size (its volume is 23 times that of the dome of St Peter's in Rome), is very light and cheap to erect.

that designers forgot that it was essentially a style they were handling, a set of conventions and not an ineluctable law. the general term 'machine aesthetic', invented by van Doesburg in 1921, was used for this set of conventions although they owed little to the forms and functions of machines. Adherence to these conventions tended to become a moral issue among modernists. At the Bauhaus, for example, where they were taught as the basis of all design, students were accused of aesthetic treason if they departed from them, although, as is obvious to us, there is no real reason why chairs and lamps and chess-sets should be designed on the basis of right-angles, spheres, primary colours, and so on. The International Style, for all its virtues as a harmonious and unifying idiom, gave the designer the dangerous illusion of working in close alliance with modern technology, when in fact it isolated him from the realities of technology almost as completely as the Neo-Classical designer of around 1800 was isolated from the industrial revolution of his time.

The United States, too, came under the spell of the so-called machine aesthetic, especially once Bauhaus teachers and ex-students began to arrive there. But the United States also had two major opponents of it. Frank Lloyd Wright had spoken of 'the Machine Age' as early as 1901 but he saw the machine as something that had to be dominated by individual genius. Gropius preached team-work; Wright the duty of subjective expression. And although some of his earlier work had heralded the International Style, after 1920 it was often marked by violently *93* idiosyncratic mannerism and the adoption of exotic influences such as that of pre-Columbian Mexican temple architecture. One of the most powerful monuments to Wright's originality and megalomania is Taliesin West in *87* Arizona, begun in 1938. This complex of buildings, school, design office, living quarters all in one, is made of great bulwarks of 'desert concrete' (concrete poured round locally found rocks) and a light superstructure of angled timber beams and canvas. It has been suggested that, consciously or unconsciously, Wright had conceived these buildings to make an impressive ruin for a future age, and we recall Soane's romantic vision of his own building as a victim of time. The other opponent of the International Style, and for quite different reasons than Wright's, was Buckminster Fuller (1895–1984), who would seem to have been the only man of that period to have faced the realities of functional design. He saw that new techniques and new social conditions invited a radical reconsideration of the bases of design. His Dymaxion House project of 1927 consisted of a hexagonal ring of plastic dwelling units hanging round an aluminium core of services. It is a project that still stands totally apart from the world of architecture as we know it and it remains one of a very small number of attempts to link mass-produced housing to the opportunities offered by technology and not to the old habits of building industries. Fuller's geodesic domes, which can be built in any size and *79* of almost any material—aluminium, plastic, cardboard for example—have been used in a very limited way. Fuller's example is a standing reproach to the men who shape our houses and towns and to those who commission them.

Since 1940

The decades have witnessed an unforeseeable expansion in the life and activities of modern art. Modernism, it could be said, has triumphed almost everywhere: the art of the twentieth century has overcome the resistance offered by traditionalists. An international communication system spreads up-to-the-minute news of the current doings of famous artists and of the new art made, in many different ways, by artists not yet famous. Art magazines, the arts pages of newspaper and general magazines, television programmes, all report to a wide public. Within the art world information moves even more quickly. Art dealers and museum curators travel and send exhibitions touring around the world. Exhibition catalogues have become primary sources of scholarly data and promotional exhortation. Critics have become more essentially part of the pioneering and promotional process, telling us that the time has come to admire this or that development, looking for art work that fits their assessment of what should come next, forming movements out of a handful of individuals by finding a catchy name for them, seeming at times to command and direct the artists' work to fit their theoretical projections of what art should concern itself with next. Artists themselves have increasingly tended to combine or even fuse their art work with critical and theoretical productions, at times with great intelligence and tactical skill. Never has art been produced and exhibited in such quantities and such variety. Never have so many words been spilled over it.

All this has its positive and its negative side. The usual cries are heard: this or that new art goes too far, insults public taste or intelligence, does not deserve the name of art. Going too far is indeed one of the characteristics, methods even, of contemporary art: taking an idea to its logical conclusion, or demonstrating one's position vis-à-vis the rest of art by extreme and unmistakable means. Artists have shown not only great inventiveness but also amazing managerial talents in planning impossible projects and carrying them out in the face of vast practical, financial, even legal difficulties. Just one example, for the moment: Christo's notorious orange curtain, slung across a wide stretch of Colorado. It was an amazing sight, but that is as nothing compared with the campaign of money-raising, permission-begging, and collaboration-seeking that this Bulgarian-born sculptor (born 1935) saw through in order to impose his will on land-owners, guardians of the law, preservationists and others. Which was the work of art, the curtain itself or the act of overcoming all those difficulties? Drawing that great plane of colour across the landscape was an astonishing painterly act, but what preceded it was more significant as a programme of peaceful persuasion. What remains from the event is the artist's handsome drawings of it, photographs of it, accounts of it and of the long campaign at various levels of seriousness in the media, and a documentary film of it compiled out of footage shot at various stages of the long process. The curtain itself has gone, and perhaps it does not matter. An artist has achieved an event of Napoleonic scale by peaceful means.

Is it art? There is still no answer to satisfy the disbeliever, but if it is not art what is it? Would the problem disappear

80. **Anthony Christo**. *Valley Curtain*. 1971–2. Pencil on paper. Tate Gallery, London. One of a series of drawings done by Christo as a record and celebration of his epic project of hanging an orange curtain across a valley in Colorado. Such drawings helped Christo to finance this and similar works.

if we had more words for activities and objects of this kind? The umbrella called 'art' has certainly had to open very wide to accommodate the variety of contradictory things recent decades have brought under it, but it is rather a plurality of things than a plurality of categories. Categories divide and encourage mental inertia; plurality of things within one category demands as well as exhibits mobility, like that complex of experiences we call life.

Taking a broad view of the last four decades we note areas of flowering that can be related back to pioneering work done around the time of the first world war, and areas of radical re-examination. The revolutions we associate with the heroic years of Modernism at the start of the century would seem not to have been enough: further revolutions are announced every few years, and they are associated with complaints that Modernism did not go far enough, was merely a pretence, was too self-regarding and too little concerned with the social roles of art. The expression 'Post-Modernism' has been introduced to signal this rejection of what the world was beginning to accept as a great period of invention and re-orientation. It is of course true that some of the claims made for Modernism, often by journalists and critics and sometimes by the artists themselves, were excessive. It is also true that much Modernism was in-

turned, more concerned with the language and the means of art than with the betterment of the world. Yet the beginnings of today's radicalism can be found within Modernism, including the demands for an art acting socially and politically. It is not Modernism itself that is being pushed aside, one feels, so much as the superficial and platitudinous readings of Modernism that obstruct a truer understanding. And, of course, its success: if Matisses, Kandinskys and Picassos are such hot financial properties now, then perhaps their art was not challenging enough. The truth is that it was challenging in some ways and not in others; it was not the artists themselves who offered it to the world as total originality or total dissidence.

ABSTRACT EXPRESSIONISM

The years immediately after the second world war saw a rediscovery of Abstract Expressionism. Kandinsky's semi-abstract and abstract work of the years 1911-14 provided a major impetus, as did Klee's small-scale but often dramatic, gestural pictures and some of the abstract paintings of Surrealists such as Miró. But it also was, or seemed to be at the time, a response to the horrors made so familiar by the war: the destruction of cities and of individuals, the barbarity of concentration camps and of mass annihilation by means of atomic explosion, found expression in paintings that spoke of violence and wounds. French, Italian and German painters were the leaders in this movement; there was an early response from a group that called itself Cobra by combining the beginnings of Copenhagen, Brussels and Amsterdam to indicate the origin of its members; British and Spanish painters responded in various ways. What had been an imperative art of protest for some became a style, or rather a whole range of styles unified only by being more or less abstract and expressionist in its free, often vehement handling of paint and colour. Elegance and the pleasures of pictorial dramatics soon dominated over the messages that had been claimed as the impulse to this kind of painting. What was gained was a reconsideration of the communicative power of abstract art, after years in which this vein of Modernism had almost petered out; with this also came renewed attention to the constructive and expressive power of colour, form, texture, gesture and scale as such. Another consequence was a marked internationalism that was positively refreshing after the nationalism of much 1930s and war-time art.

THE NEW AMERICAN PAINTING

This applied also in the United States, where the 1930s had seen a firm swing to regionalism as well as nationalism and a general turning away from the thrills of Modernism. America's economic problems may have had something to do with this; America's post-1945 role of world power had a lot to do with the strength of the wave of innovative painting that came to dominate the western art world in the 1950s. The USA's great opponent was the USSR where art is seen as part of the state's face to the world, and this meant largely rather dull, simplistic art representing the Russian people's

vigour and conviviality. American officialdom saw in American Abstract Expressionism the opposite to that: individualistic, vivid, energetic, and thus an apt image for the leaders of the 'free world'. The second half of the 1950s saw large exhibitions of modern American art, especially Abstract Expressionist art, moving between the USA and Europe with the support of Washington.

The New Painting, as it came to be called, had not, however, been given a warm welcome when it first surfaced around 1948. Jackson Pollock (1912–1956), Willem de Kooning (born 1904) and their associates had for some years run the gauntlet of harsh criticism before their work found its surprisingly sudden acceptance at the start of the 1950s. Today it is difficult for us to understand how their work could seem so appalling. Just as in the case of Van Gogh and Gauguin, people mistook painting methods of a new sort for violence and ugliness.

Pollock became known for large paintings in which tracks of poured and dribbled paint combined to form an abstract image that was no more and no less than a record of the painter's movements. The canvas itself had become a surface **91** on which the painter performed his act of painting; the lines and pools of paint are the vestiges of his action—Action Painting became a term for this kind of Abstract Expressionism. A statement of Pollock's, first published in 1947, was often reprinted and became something like a talisman to the rising generation of painters in America and Europe: 'When I am in my painting, I'm not aware of what I'm doing. It is only after a sort of "get acquainted" period that I see what I have been about. I have no fears about making changes, destroying the image, etc., because the painting has a life of its own, I try to let it come through. It is only when I lose contact with the painting that the result is a mess. Otherwise there is pure harmony, an easy give and take, and the painting comes out well.' Note the not-knowing, the willingness to destroy what is done as much as to work with it in a relaxed, open-ended way, in something like a meditative but also very physical engagement with the materials and the process of painting. Kandinsky, Klee, Miró and others brought a similar attitude to some of their work, and Pollock was as interested in these artists as in the temporary dribbled sand paintings made by American Indians. But Pollock's image, the bejeaned figure moving around his canvas on the floor, working out of instinct on the scale of a man's reach, seeking a kind of immersion in the act and a fluency that would be one with fluidity of his medium, had extraordinary influence throughout the western world—even on people who were not artists and on artists who had no desire to produce work like Pollock's.

De Kooning's way was different, although this was not at first so apparent as it is today. He too seemed to be producing large paintings of great splashes and dribbles of painting. **92** It was clear that he used brushes, that his marks were mostly made by firm gestures with the brush and the dribbles of painting were by-products of the sheer quantity of paint on his brushes. But his effects were not so different; if anything, his paintings looked even rougher than Pollock's. We can

now see that de Kooning was always more concerned with making and confronting an image than was Pollock. He worked on a vertical canvas, a surface with a top and a bottom, and several of his abstract paintings of the late 1940s have revealed themselves as compilations of fragmented anatomy. His erotic attachment to the female body became blatant in a series of *Woman* paintings he embarked on in 1950 and first exhibited in 1953, shocking those who associated the New Painting with pure abstract-ness. There is of course no reason why a painter should force himself to exclude all references to the visible world. To do so leads to clichés that are inimical to personal expression, to an act of painting akin to making a signature rather than to ever-new adventures. Pollock too let images back into his work in the 1950s, but de Kooning, one feels, had never wanted to do without them, blatant or latent. His great, slightly appalling images of women, archetypal creatures that are also pre-echoes of the forceful, sexually and politically challenging women of today, belong to the tradition of Rubens as much as to our century—and one recalls that de Kooning had been born in Holland and had studied art in Belgium before emigrating to the USA at the age of 22.

Other painters were drawn into Abstract Expressionism by the excitement and the quality of Pollock's and de Kooning's work. Each one had the task of working without apparent constraints whilst retaining something of a brand image that separated his work from another's. An art associated with wildness proved itself capable of remarkable refinement and variety, in terms of the marks made and the materials used. To this day a roomful of good Abstract Expressionist paintings is an exhilarating environment, even if familiarity has reduced the sense of risk which loomed so large in the 1950s. And if there was astonishing variety within the movement there was also something of a reaction within it, against the emphasis on spontaneity and instinctual action.

By 1950 two Abstract Expressionists had concentrated their activity to something that seemed dangerously minimal. Barnett Newman (1905–70) and Mark Rothko (1903–70) aimed at something beyond personal drama. Newman in 1948 spoke of 'an art that would suggest the mysterious sublime rather than the beautiful', a modern art that would lift mankind into a realm of experience larger than life, a religious or quasi-religious experience. The word 'sublime' is significant: it recalls Romanticism. Both painters achieved such an art by abstract means alone and by the suggestion these could afford. Newman's large flat surfaces of colour, interrupted in their expanse by the vertical **95** caesuras he called his 'zips', offered sensations of cosmic space and cosmic events. Rothko's weightless veils of reticent but glowing colour confront us like apparitions, moments of revelation from the spiritual world. Rothko said, in 1958, that 'all art deals with intimations of mortality'; his own takes us to the frontiers of our world and lets us glimpse something of the world beyond—a mystical experience known to many from particular moments in music but rarely **96** spoken of in connection with art. The size of these paintings announces their importance and carries with it the risk of

emptiness, like a sermon full of high rhetoric but offering only platitudinous thoughts. Their size and the necessity to let each one be seen wholly and without distraction makes them difficult to exhibit, and both painters gave a good deal of thought to this problem. What is unquestionable is the enduring effectiveness of their high-flying art, in spite of the world's increasingly agnostic attitude to questions of heaven and hell.

Critics long continued to comment on Abstract Expressionism in terms of headstrong ventures into the unknown, extremist acts performed without thought of the outcome and its implications, yet it must be clear that this art too had its skills and its controls. In Rothko and Newman these are blatant, and so are they in the work of younger men such as Morris Louis (1912–62) and Kenneth Noland (born 1924). Louis specialised in letting thinned paint soak into unprimed, absorbent canvas, fixing his loose canvas in such a way that gravity would take his colours in the direction he wished them to run. The recipe is simple enough but even Louis's adroit handling of it and his inventive use of scale and, above all, interval cannot quite explain the awe that his best paintings produce in the viewer. Noland has tended to work with geometrical forms that divide his canvases into harmonious colour areas. The Expressionist element in this art is reduced to next to nothing. Noland's surfaces and colours are of great refinement: we are back with the beautiful rather than the sublime, and with a concentration on painting as a matter of arranging colours on a flat surface. They are calm works, and intelligent rather than moving. Their minimalism—flat bands of colour wholly occupying the surface of the picture, without any additional element of accent or gesture—was matched or even trumped in the paintings done by a younger painter in 1960. Frank Stella (born 1936) that year produced a series of monochrome paintings in which the shape of the canvas and the composition of stripes were insistently identical (the stripes even echoing the width of the wood stretcher bars to which the

(Continued on page 913)

81 (opposite). **Frank Stella**. *Zambesi*. 1967. Lithograph. 15 × 22 in. (38 × 56 cm). Lawrence Rubin, New York. With these paintings, at a time when Abstract Expressionism was the great avant-garde event, Stella seemed to silence painting and to turn attention away from stirring emotional effects to question about what a painting is or should be.

90 (right). **Hans Hofmann**. *Still Life – Yellow Table on Green*. 1936. Oil on board. 60 × 44½ in. (152 × 113 cm.). André Emmerich, New York. Hofmann was an impressive painter of abstract pictures, but it was his teaching that was his gift to American art.

91 (below). **Jackson Pollock**. *Number 1*. 1948. Oil on canvas. 68 × 104 in. (172.5 × 264 cm.). Collection, The Museum of Modern Art, New York. (Purchase). The web of lines with occasional patches of paint is markedly linear in effect: we see a luminous thicket of coloured threads, which we follow and half want to unravel. To some extent, we re-enact what the painter did, following the movements of his arm over the large surface.

92. **Willem de Kooning**. *Woman 1.*
1950–52. Oil on canvas. 59 × 43 in. (150
× 110 cm.). The Museum of Modern Art,
New York. People were shocked when
these big, unlovely female figures surfaced
in de Kooning's Abstract Expressionism,
but in fact they had never been entirely
absent (he subsequently painted also some
larger compositions on landscape themes).
De Kooning's emphatic painterliness
contrasts with the graphic character of
Pollock's best paintings: de Kooning is
very much a man of thick paint and loaded
brushes. What is less apparent is the care,
the slow development and the many
corrections that went into such paintings.

93. **Jean Dubuffet**. *Metaphysic*. 1950. Oil on canvas. 44¾ × 35¼ in. (113.5 × 89.5 cm.). Collection: Mr & Mrs Arnold H. Maremont, Winnetka, Illinois. Dubuffet painted as a young man, then gave his time to running a wine business, and in the 1940s returned to painting. He is fascinated by grafiti, child art and the art of the insane. The results are both serious and humorous, ghastly and lively; their sheer attractiveness proves once again art's capacity for digesting the rawest of materials.

94 (right). **Josef Albers**. *Study for Homage to the Square: See*, 1961. Oil on canvas. 24 in. (61 cm.), square. Collection: the Artist. Albers' long series of paintings based on one design and sharing the title 'Homage to the Square' is a particularly convincing example of the spirit of research in modern painting. In this series, more exclusively than in his earlier work, he is concerned with the power and qualities of colour. By inventing for himself a repeatable design he can concentrate his and our attention on colour, and the particular design he has chosen, with its spatial overtones suggestive alternatively of recession or projection, involve him in controlling the spatial implications of his colour relationships. Thus a painting that at first sight seems no more than a handsome colour chord may reveal itself as a colour progression in space.

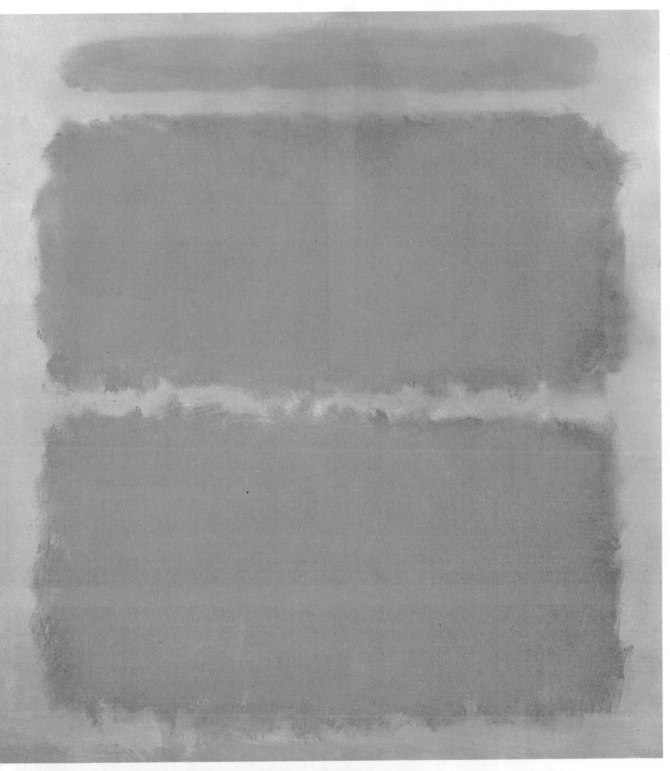

95 (opposite below). **Barnett Newman**.
The Third. 1862. Oil on canvas. 101 ×
121 in. (256 × 307 cm.). Private
collection. Large, flat colour surfaces,
made to seem even larger by Newman's
'zips', confront us as solemn, quasi-
religious statements. They suggest cosmic
space and events, or the interaction of
space with mankind (represented by the
'zips'). Compare this painting with
Giacometti's sculpture (fig. 88): the five
thin figures in an urban place seem to
inhabit the same awesome space that
Newman suggests in his paintings.

96 (above). **Mark Rothko**. *Mauve and
Orange*. 1961. Oil on canvas. 69¼ × 63
in. (176 × 160 cm.). Marlborough Fine
Art, London. The meditative, mystical
character of Rothko's paintings makes a
sharp contrast with the busy, energetic
work of Pollock. Yet, once that has been
noted, it is worth also noting the
similarities: the surface itself as a more or
less passive, spatial field, and the marks
appearing to float in front of that field.
We sense Rothko's soft rectangular
clouds as not unlike thickets: dense
though weightless, where Pollock's are
more teased out and wiry.

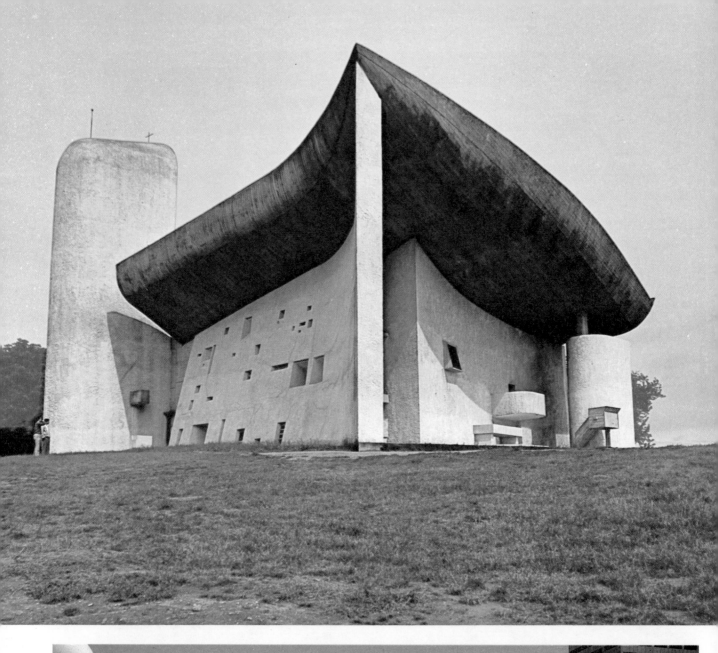

97 (opposite above). **Le Corbusier**. *Notre Dame du Haut, Ronchamp*. 1955. The primitive, handmade quality of this church, contrasting with Le Corbusier's own pre-war idiom with its references to ship design and other aspects of modern technology, gave it strong moral force as well as influence. Nor form or surface was predetermined; the architect even designed the coloured glass set into the thick, rustic south wall. Earlier Le Corbusier had linked his modernism to the classical forms of Greek architecture; here he appeared to be looking further back, to more basic ways of finding and making shelters. He called it 'totally free architecture'.

98 (opposite below). **Kallmann McKinnell & Knowles**. *Boston City Hall*. 1964. This very large and impressive building is conceived as a large structure into which cells with different functions are slotted. The form is influenced by Le Corbusier, the principle by Tatlin. The result is a building that avoids the oppressive blankness of much public architecture. It has a monumental function and character, but it is also visibly a building in which work of several sorts is to be done.

99 (above). **Georges Mathieu**. *Is*. 1964. Oil on canvas. 38 × 77 in. (165 × 195.5 cm.). Ginpel Fils Gallery, London. The act of painting is for Mathieu an elegant, exhibitionist performance: a limited range of gestures and signals and a few colours, executed swiftly and sometimes in public – in galleries but also in a store window in Tokyo. The paintings that result resemble each other like signatures.

100 (below). **Victor Pasmore**. *Transparent Polychromatic Construction in White, Black and Indian Red*. Painted wood and plastic. 32 × 35 × 18 in. (81 × 89 × 46 cm.). Collection: the Artist. One of the leading figures in Britain's effective entry into the world of modern art since the second world war, Pasmore insisted on the inevitability of three-dimensional constructive art as a logical outcome of the demonstrations of Mondrian and other classical abstractionists between the wars.

101. **Lucio Fontana**. *Gold of Venice*. 1961.
Oil on canvas. 59 × 59 in. (150 × 150
cm.). McRoberts and Tunnard Gallery,
London. Fontana emphasized the spatial
effect of cutting through a canvas,
bringing the space behind the canvas
into the picture. The cut is also
emphatically an act, its violence
contrasting with the luxurious character
of the golden surface, and the dark gash
with the luminous membrane.

102 (above). **Jasper Johns**. *Three Flags*. 1958. Encaustic on three superimposed canvases. 31 × 45½ × 5 in. (79 × 115.5 × 12.5 cm.). Burton Tremaine Collection. Painting a flag is the opposite to painting an abstract picture, especially an abstract painting intended to convey strong personal feeling. A painting of a flag is a painting of a flag . . . yet a flag is an abstract image, a conventional symbol with a specific function. Is a painting of an abstract symbol representational or abstract? And what happens if you change the colours of the original or combine two or more of them? Does that imply comments about the flag, or about the nature of representational painting? Like a Cubist painting, Johns's teases our understanding of pictures, forcing us to reconsider habits that have helped us to 'enjoy art'.

103 (right). **Robert Rauschenberg**. *Bed*. 1955. Oil on bedclothes. 74 × 31 in. (188 × 79 cm.) Leo Castelli, Gallery, New York. The sordid associations of this destroyed bed shocked, and were intended to shock, a public attuned to the heroic mode of Abstract Expressionism. Some of this sordidness lingers still, but it is clear also that time erodes this effect. We begin to see the splashed paint as colour, and the whole work as a dialogue between the formality of the quilt and the dynamic freedom of the act of painting.

104 (right). **David Hockney**. *A Bigger Splash*. 1968. Acrylic on canvas. 96 × 96 in. (244 × 244 cm.). The Marquess of Dufferin and Ava. Hockney's keen eye and quizzical taste for pictorial devices show up particularly well in this painting. On the face of it it portrays a scene, a moment, in the California he loves. So it does, but less directly than one assumes. The house he had seen and drawn. The water was copied from a photograph in a technical book on swimming pools, but he had to find a paint equivalent for it, by trial and error. The stillness, the intense and timeless blue, set off the frozen action of the splash – so compellingly that we do not ask about the diver. Setting the painted area in a margin of unpainted canvas asserts the painted-ness of it all.

105 (below). **Morris Louis**. *Alpha Phi*. 1961. Oil on canvas. 102 × 180¾ in. (259 × 459 cm.). Tate Gallery, London. Thinned acrylic paint is absorbed by the soft cotton cloth to become part of the surface rather than to lie on it. Louis learned to control the way the paint was absorbed and also the directions and forms in which gravity would draw it over and into the cloth. The result is dramatic and lyrical: radiant colours and large spaces. We confront it like one of nature's marvels—and almost forget the artist's role.

106 (right). **Kenneth Noland**. *New Light*. 1963. Plastic paint. 68 × 68 in. (173 × 173 cm.). Ulster Museum, Belfast. 107 (below). **Anthony Caro**. *The Month of May*. 1963. Printed aluminium and steel 9′ 2″ high (2.8 m.). Kasmin Limited, London. The American painter and the British sculptor (who are friends and admire each other's work) appear to work in much the same basic way: one on a flat surface, the other in our space, without a base to give his sculpture a separate stage. Both arrange colour-forms that do not intend to convey particular meaning. But Noland's paintings (of the 1960s) are symmetrical and have the character of heraldry; Caro's are never symmetrical and achieve a great range of expression: in this case light and cheerful, with a sense of upward movement or growth.

108 (above). **Andy Warhol**. *Green Coca Cola Bottles*. 1962. Acrylic on canvas (silkwoven). 57 × 83 in. (145 × 211 cm.). Whitney Museum of American Art, New York. Repetition both celebrates and devalues. The silkscreening process used by Warhol is itself a repetitive one. How large a gap do we habitually make between the image offered by a work of art and the real-life thing to which it refers? Often we look at art as though each work contained the artist: we meet Renoir, Van Gogh, Picasso, etc.

109 (right). **Andy Warhol.** *Race riot*. 1964. Silkscreen. Private collection. Repeating images is emphatic: *this* happens, again and again. We accept the violence as just part of life. It also, especially because Warhol enlarges newsprint photos, reminds us that they are everywhere: every morning they flood the breakfast table. How is it we can live with them? But repeating also questions the reality of what is shown: one begins to wonder whether there is a fact behind all these mass-multiplied pictures. Is there a real person behind his repeated images of Marilyn Monroe or Jackie Kennedy?

110. **Richard Hamilton**. *Just what is it that makes today's homes so different, so appealing?* 1956. Collage. 10¼ × 9¾ in. (27 × 25 cm.). This interior is not fundamentally unlike a traditional domestic interior, except that everything in it is lifted from the commercial and romantic platitudes of the day: out of the imagery of the mass media, not of 'high' art. The term Pop art was invented to identify this turn to contemporary commonplace source material. Hamilton went on to make paintings out of analyses of modern non-art taste (e.g. car design) and the associations that give it life, working with great sophistication and wit.

111 (left). **Roy Lichtenstein**. *Drowning girl*. 1963. Oil and magna on canvas. 68 × 68 in. (173 × 173 cm.). In reproduction Lichtensteins look like the comic strips from which they are derived. The actual paintings surprise us with their elegance and strength, as well as their size. Their very ordinary themes take on weight and significance, becoming monumental and exemplary, not unlike the History paintings of the classical tradition.

112 (right). **Yves Klein**. *Ant 7*. 1962. Oil on canvas. 40 × 29 in. (102 × 73 cm.). Gallerie Karl Flinders, Paris. Today one's first response to Klein's use of the woman as living paintbrush is perhaps a feminist one: women's nakedness exploited in the name of art. At the time people worried more about whether art was being exploited. They could see the logic of taking a direct impression of the bodies but is it art? The resulting images are vestigial, like Pollock's paint tracks, but offer none of the pleasures associated with the nude in art. Like Manet, almost a century earlier, Klein was challenging the art world at its most sensitive point.

113 (below). **Robert Smithson**. *Spiral jetty*. 1970. Stone and water. Great Salt Lake, Utah, USA. This is one of the best-known earthworks, and is very memorable. It is also very beautiful, partly because of the colour of the salt water. The form Smithson imposed, by means of loaders and trucks, is both geometrical and organic. Smithson felt that the entire landscape was dominated by circular motions and forms; like a Romantic poet he saw it in terms of cosmic forces. He had the finished work filmed from a helicopter, noting characteristically that 'helicopter' comes from the Greek word for spiral, *helix*.

114 (left). **Richard Smith**. *Gift wrap*. 1963. Mixed media. 50 × 208 × 33 in. (127 × 528 × 84 cm.). An exceptionally subtle manager of colour and paint, Smith took the more sophisticated end of advertising – notably cigarette advertisements – as his source material. He uses this not unlike a landscape painter uses nature: he transcribes but also transforms and personalises what he sees.

115 (above). **Philip Guston**. *Wharf*.
1976. Oil on canvas. 80 × 116 in. (203
× 295 cm.). After years as an admired
Abstract Expressionist, Guston returned
to unambiguously representational art.
Moreoever this art is uncouth and
aggressive to a degree pre-echoed only in
some of his earliest works of around
1930. It is filled with bitterness at the
cruelty and degradation man inflicts on
man, but it is also vigorous, a counter-
attack as much as an indictment.

116 (right). **Kenneth Martin**. *Chance and
Order 10 (monastral blue)*. 1972. Oil on
canvas 36 × 36 in. (91.4 × 91.4 cm.).
Tate Gallery, London. Constructive art
has proved a rich vein in modern art, but
one rarely trumpeted by exhibitions and
publications. Martin has made many
sculptures as well as paintings, based on
numerical sequences hit upon by chance
and deriving from these an order arrived
at by following a few self-imposed rules.
The positions and lengths of his single
lines and bundles of lines in this painting
are arrived at by such a game or system.

canvas is fixed), so that we hesitate to say which generated which. By 1964 Stella's stripe paintings had become much more elaborate in their shapes but still showed the same identity of inner division and total shape. He said of them in that year that they were based on the fact 'that only what is seen there is there . . . All I want anyone to get out of my paintings and all I even get out of them is the fact that you can see the whole idea without any confusion. What you see is what you see.' One could just about imagine a Pollock or a Rothko making such a statement, but only in theory: their paintings do explain themselves very clearly if we examine them, but the aim was entirely different, to stimulate a response way beyond the facts of paint on canvas. Noland and Stella, their artistic descendants, reject all such appeals. Note Stella's insistence on 'fact' and 'idea'. The idea is there, fully spelled out in each work. We do not look beyond the painting itself. Cool art challenged the dramatic rhetoric of Abstract Expressionism.

ACTION AND REACTION

We must pause a moment to note this reaction. It characterises artistic development in recent decades. The national and international success of the New Painting had been quite astonishing. Painters first, then also critics and soon a very wide public had come to admire this insistently personal and adventurous art, those amazingly large paintings that seemed to accuse all other art of timidity. For the first time, American painting (mostly the painting of New York) led the world, and the image it conveyed could well be read in historically American terms: strong individuals venturing as pioneers into a vast new continent, pressing on, self-reliant, away from European ways and values. It was, and remains, an art of extremes . . . and at the same time, in order to establish itself in the world through exhibitions and sales to private and public collections, it had to go on: go on being made, becoming if possible a little more extreme, pioneering a little further. Put like that, the task was clearly an impossible one; it is still astonishing with what energy it was attempted.

Nonetheless, in a world of quick and full information, a younger artist was bound to ask himself whether he wanted to attempt to out-Pollock Pollock, or out-Rothko Rothko; or whether, however much he admired them, he would not have to go in some totally other direction. That required a major decision—an act of invention strong enough to be visible in the context of the established heroes' fame. It required too, the interest of critics, dealers and exhibition makers, so that the invention can be charted on the map of the art world. In the process, the new venture had to be shown to be newer than the New. That almost inevitably meant presenting it as the enemy of what had been offered before. Whatever view Noland and Stella took of Pollock and the rest, their art implied a questioning of all that performance, that reliance on intuition.

Hardly has the world begun to respond to a new artistic experience, when it is asked to cope with a new one, countering, perhaps mocking, the last. Critics associated with the newest warn us off yesterday's in terms which echo the dieticians' leap-frogging warnings about carcinogens, cholesterol and so forth. With an appearance of logic it is shown to be what had to come, the corrective answer without which art would have died of untruth.

Perhaps it is so, to some extent at least. Repetition leads to staleness and then rottenness—bad in art as in food. Yet the one thing the twentieth century has learnt is that good art does not stale, and that successive inventions or movements do not cancel out what went before. Cézanne does not replace Michelangelo; Cubism does not replace Cézanne; Surrealism does not really controvert Cubism though it wants to. Each newcomer modulates our understanding of his predecessor but this need not be a destructive change (Cubism, for instance, shows us how much there is in Cézanne that Cubism cannot take notice of). For all the warlike talk, art does not destroy art, but adds.

NEO-DADA AND POP ART

De Kooning's women had shocked a world that had begun to immerse itself in the visionary realms of Abstract Expressionism. But at least it was still Expressionism of a sort, an art of deep emotionalism (de Kooning later said that he was amazed no one thought them funny). But what could this public make of Robert Rauschenberg's *Bed* and Jasper Johns' flags of 1955? It may seem odd to find them mentioned here together: one nice (handsome quilt) and nasty (paint smeared and dribbled over part of it, suggesting heaven knows what dreadful goings-on), an assemblage lifted straight out of ordinary life; the other a rather finely made painting of a familiar object of a distinctly honourable sort; one an image of violence, domestic violence at that; the other a nationalistic symbol that normally called for homage, but here painted straight, without apparent comment. In a way both works are very real, especially after all that abstraction. One is left in some doubt as to their message, but in no doubt that there is nothing sublime about it.

In 1956 a collage made as poster image for a London exhibition called 'This is Tomorrow' disconcerted the art public in a similar way. It was not, or not merely, that Richard Hamilton's *Just what is it that makes today's homes so different, so appealing?* is so unpleasant as well as so accurate an image, so thorough a summary of the values of modern western society. It is also, shockingly, art: a mid-twentieth-century equivalent to the de Hoochs and Vermeers we all admire so much for their account of domesticity in another age. Much the same care went into this composition, into the selecting and placing of the significant figures and other objects. Abstract Expressionism, though often represented as expressing intense individualism and protesting against all authority, suddenly looked escapist. Rauschenberg and Hamilton seemed to say that there was no room now for an art of spiritual adventures, and Johns was possibly even mocking the national emblem. Or, if he was not, was he saying that the flag was an object like any other, at least as fit for making a painting of as anything else, and perhaps no more so? He went on to paint targets, numbers, a variety of

things united only in their commonplaceness. He painted them with much skill and refinement, but he left the world wondering whether he was mocking the things he was painting, mocking painting by exercising his art on such banalities, or mocking the art public. Whatever else they were doing, these three artists were forcing us to ask what art is, what it is for.

In 1956 also the French artist Yves Klein (born 1928) embarked on a series of monochrome paintings, and painted objects, done in a glowing blue he subsequently patented as 'Klein International blue'. In 1960 he directed an event at a Paris gallery that involved three naked women daubing themselves with blue paint and imprinting their forms on vertical and horizontal canvases, while an orchestra of 20 musicians performed Klein's 'Monotonal Symphony'. He went on to do other newsworthy things, recording his and others' work on the edge, or just beyond the edge, of the territory we call art. This kind of activity still goes on, sometimes more prominent in the art balance of the time, sometimes less, and it certainly derives some impulse from Duchamp and the activities of the Dada groups of the first world war period. Mostly it offers little by way of visual satisfaction; its prime concern is with cultural, moral and political issues. That 1960 performance of Klein's had him using living women as brushes: the nude is a time-honoured subject and form of art, for reasons that might not always be entirely honourable—well, then, here are some more nudes, direct from the female body to the canvas. He was exploiting women and the whole convention of desirability. He was also exploiting the musicians, making them play the most boring composition possible. Was he entertaining or boring his invited audience, the upper crust of the Paris art world? Was he perhaps demonstrating the habitual exploitation of women? Was he demonstrating also the exploitation of the revolutionary artist as the licensed fool within the capitalist system?

The Pop artists of the early 1960s—in Britain and America first, and then also in other countries—appeared at first sight to be celebrating the marvels of consumerism, of mass production and its glamorised promotional image in advertising. So much skill and money went into magazine ads and hoardings that it is not surprising that artists should respond to this visual data as a new idealised world not unlike that of the old Classical tradition. On occasion Pop paintings can look very much like Neo-Classicism.

But Pop art was so named in reference to its use of modern commercial, not Neo-Classical, sources and that was certainly what was initially striking about it. Warhol's soup can imitated and perhaps celebrated the world of the supermarket, Lichtenstein's monumentalized frames from comic strips the world of low-brow fiction, Richard Smith's *Gift Wrap* the world of lavish cigarette advertising. Many complained that art had sunk to identifying itself with ephemeral, money-making trash; others thought this was kid's stuff devoid of artistic weight but an apt companion to the pop music that had suddenly become big international business. But artists could answer that commercial art is the product of talented professionals as well as of money, and

the pop culture of the 1960s was indeed a lively and compelling environment. Better that, they said, than the old-fashioned art of studio soul-searching and studio risk. Moreover, especially in Britain, the sudden public success of Pop art released artistic leanings that Modernism had repressed. Not only did Pop bring back figurative painting of a lively sort; it also lent itself to narrative and humour, and nowhere more tellingly than in the paintings and prints of David Hockney, the young man from Bradford who rapidly achieved something like international stardom through the quality and good humour of his art and his personality.

It pays never to underestimate the intelligence and the seriousness of artists. Hockney turned out to be the finest draughtsman for decades, and devoted his art, from the mid-1960s, to recording the world in which he moved—often that of urban California—as a pictorial comedy of manners. Warhol seemed to making a similar use of his art when he produced multi-image silkscreened paintings derived from photographs of Marilyn Monroe, Elvis Presley and other superstars of the day; but he could use the same methods also for rubbing his admirers' noses in the ubiquity of automobile crashes, of the electric chair, of Jackie Kennedy after the assassination of the president. Lichtenstein often picked on sentimental moments in the comic strips he raided for his art, and these became powerfully affecting as he enlarged and refined them, and put them before us as general situations lifted out of their more or less banal fictions. The art associated with fun and glamour could carry a powerful punch.

Above all, it reopened all sorts of questions about what art could do, to whom it should appeal, what kind of messages it could carry and what responses it could command. Abstract Expressionism suddenly looked rather self-indulgent, an art turned away from the realities of the modern world. The new generation proved willing to venture out of the studio and to engage in activities that brought it closer to the public at large and reduced painting's status as the primary art form. They presented Happenings—semi-impromptu theatrical events, usually anti-rational and absurd—made films, involved themselves in the legitimate theatre (Rauschenberg worked with Merce Cunningham's dance group; Hockney has become the most sought-after designer for opera). Artists and their activities have rarely been more public, less remote. Yet their attitudes to the world have remained ambiguous. Oldenburg's vast hamburgers, ironing boards, hard and soft fans and wash-basins, for example: they are certainly amazing and amusing objects to encounter in the polished halls of art, but can we be certain whether they are made in honour of the objects they portray or in mockery of our dependence on them?

MINIMALISM

Pop art and the concentrated, logical, silent art of painters such as Noland and Stella were both counters to Abstract Expressionism. By the mid-1960s the latter tendency had become an international movement. It was labelled Minimalism in recognition of its reductionist appearance, its

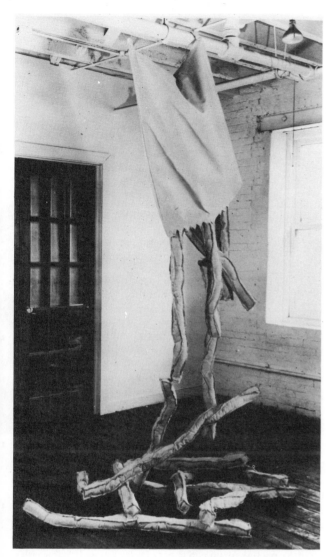

82 (above left). **Claes Oldenburg**. *Falling Shoestring Potatoes.* Painted canvas, Kapok. 108 in. high (274 cm.). Sidney Janis Gallery, New York. Much Pop art used images of American teen-age culture and is charged with nostalgia for it. Confronting Oldenburg's vast hamburgers, ice cream cones and other delicacies, we do not know whether they are monumentalised in praise or to bring out their monstrosity.

83 (above). **Donald Judd**. Untitled. 1969. Galvanised iron. 26 × 22½ × 4 in. (67.5 × 57 × 10 cm.). Scale, surface, interval: factors to which we tend to pay little conscious attention become dominant in Minimalist art, as they had in the reductionist abstract painting of Malevich and Mondrian (pls. 63 and 67).

exclusion of anything but the barest formal statement. Minimalism included painting but was most impressive, and most noticed, in the form of sculpture. This is partly because, as Donald Judd said in 1963, painting 'lacks the specificity and power of actual materials, actual colour and actual space'. Painting, even at its most factual and least illusionistic, still remains one step away from reality. To put it simplistically: art on the walls is safe, however bold or even nasty it gets; art on the floor is in our territory, in our way; we bark our minds on it if not our shins.

Anthony Caro, at the beginning of the 1960s, had proved the viability of a sculpture assembled from large elements of steel, with or without a coat of colour, a kind of sculpture that looked as impromptu as a Happening, had the perman-ence of metal construction, and in his hands proved capable of a wide range of communication, from the grave to the lyrical. But the work of Judd (born 1928) (to use him as an outstanding example of a tendency involving many artists in America and Europe) is more trenchant, as well as more limited. Judd is a very acute commentator on art. In a review of a Caro exhibition, in 1965, he said that he felt the work was good but undecided, undefined: 'Caro's interests should be stated more clearly', he ended. Whether or not this will do as a general comment on Caro, it says a lot about what Judd wanted to achieve. He is against multiplicity; he wants the intense interest generated by one form or one idea. He is not concerned about moving us or lifting us onto a visionary plane: 'a work needs only to be interesting'.

Judd and others certainly proved the interest inherent in the most succinct forms. They proved, in effect, the maximal impact of minimal elements. On occasion their work could be intensely dramatic, especially through repetition and through sheer size. They proved how disturbing, in a work that appears wholly self-evident, the slightest uncertainty can become. If, for example, the work is a cube of steel, so large or raised up so that you cannot see the top, how can you tell whether it has a top at all? Suddenly that becomes a major issue. The sheer monumentality of much Minimal art provokes associations with ancient cultures (one thinks both of pyramids and of that rectangular slab that performed as a basic God-image in Stanley Kubrick's film *2001* (1968). Judd himself pointed to Malevich as the essential precursor, as the first artist for whom 'form, color, surface, anything, existed as itself'. Judd ignored the mystical element within Malevich's endeavour; generally the Minimalists ignored, though they benefited from, the suggestive power of their monumental works.

Other artists recognised the rhetoric operating here and sought to minimalise that too. One way, following Duchamp's example, was to limit the artist's creative involvement in the work. Duchamp notoriously bought a bottlerack in a Paris store, signed it, and exhibited it as art. Fifty-three years later Carl Andre (born 1928) arranged a sculpture in a Los Angeles gallery that consisted of (I estimate) 1200 concrete slabs. The slabs formed a rectangular panel on the floor; from this panel Andre

46

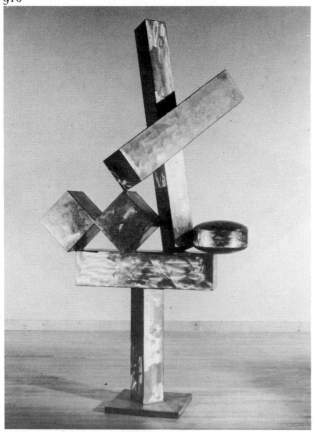

84 (above). **David Smith**. *Cubi XIX*. 1964. Stainless steel. 113 × 61½ × 41¼ in. (287 × 156 × 105 cm.). Tate Gallery, London. Smith (1906–65) was the most admired American sculptor of the post-1940 period and is sometimes associated with the Abstract Expressionism of his generation. His work has a quality of optimism, of enjoyment, that distinguishes it. Some of his earlier work, in bronze, had the character of wrought iron and tended to be linear. The *Cubi* series is in bright steel, ground to catch the light; this makes it look almost weightless and loosely assembled. Abstract though they are, the *Cubi* sculptures suggest objects on a table; perhaps it is this combination of abstract, hovering form with a memory of a benign pictorial formula that makes them so attractive.

85 (above right). **Carl Andre**. *144 pieces of magnesium*. 1969. 12 × 12 ft. (3.68 × 3.66 m.). Dwan Gallery. Andre mostly composes ready-made, anonymous elements. The material may or may not interest us as such. The arrangement is likely to be clear, calculated, undramatic. Even Noland's suave compositions look dramatic and rhetorical in comparison. Yet Andre's pieces tend to transform the spaces for which they are made, for all their reticence, and some of them are transformable according to where they are situated.

85 removed 30 slabs eight times, each time leaving a rectangular opening of the same area but a different proportion (1 × 30, 2 × 15, 3 × 10 and so on). This was determined by the size of the gallery, and part of the impact of the work related to its being a sort of floor (are we allowed to walk on it?). Andre has gone on to extend this principle of arranging ready-made modular things, steel squares, bricks, blocks of wood, also bales of hay as an ephemeral sculpture which returned to normal service as hay after the event. A public looking for artistic gestures of some sort is put out by this; anyone could do it, they say. Of course anyone could copy it, but the idea is original, and this idea takes us to the very roots of art, to the bases of mankind's way with the world, constructing significance out of the bits and pieces nature offers and inventing that most fundamentally human product, order.

Some of Sol LeWitt's work (born 1928) takes the form of information or instructions by means of which anyone can make a LeWitt work. A typical LeWitt is an arrangement of lines on a flat surface: a sheet of paper, a wall, a few rules, not unlike those for knitting or for playing a game, will serve as the recipe for a linear construction. These rules need not include rules about scale of material; in any case they do not require the artist's hand or presence, nor more than average care from the executant. People ask, is this art? It is not the *Mona Lisa*, to be sure, nor a Romantic drama in the manner of Delacroix. The distance from David's *Oath of the Horatii*, though, is less than one might think at first. LeWitt's work is (to use Judd's emphasis) interesting, and satisfying both visually and intellectually. It is not emotional yet it implies important things: that a work of art need not be unique or superior to what we can do; that workmanlike performance linked to intelligence can be as true a basis for art as a fevered display of paint manipulation; that art can be anywhere, in many places, done in many materials, outside the lavish culture reservations to which we are accustomed. Moreover, in its calm, ordered procedures it is both modern (echoing Klee's explicit insistence on the work of art as an image of the process that engendered it) and Classical.

CONCEPTUAL ART

LeWitt called his art conceptual in 1970 and the term has become the label for a great variety of art works done about that time and since. It is not an attractive term and has perhaps made the art seem more difficult and remote than it is. Cool it certainly is, on the surface at least. The Conceptual artist wants, says LeWitt, 'to make his work mentally interesting to the spectator, and therefore usually

he would want it to become emotionally dry'. If anything is to move the spectator it should be the idea behind the work, the concept, not its appearance. The idea's the thing, so much so that some artists would even contend that making the work is not always necessary. It follows that the form the work takes—its physical character—is not what we should judge it by, least of all its attractiveness.

It is this that makes Conceptual art seem remote. We, art consumers, art lovers, expect some effort on the part of the work of art to woo us, with charm or with the artist's emotional expression. Goya's etching is not in any obvious sense beautiful but it is finely wrought and it is charged with feeling. Delacroix's drawing is full of verve if short on correctness; the painting it served is a compendium of magnetic sights. We drink it all in through our eyes—and hardly stop to consider what it is all about. In short, we have become habituated to associating art with visual stimulation and with emotional response rather than with ideas and thought. In this we are the children of Romanticism: Renaissance and post-Renaissance artists would not have thanked us for dwelling so much on the looks of their work and so little on what it was created to convey. Duchamp tried to combat this habit, offering us little by way of visual sustenance. The Conceptual artists are his descendants in this respect, except that in most instances their intentions and imagery are far easier of access, if only we are willing give a few moments' attention to their ideas.

One more general point before we turn to specific examples. The late 1960s and 1970s saw artists becoming much more critical of art institutions than they had ever been. Modern art had become big business. Tycoons became glamorous through forming avant-garde collections; museums of modern art became more and more eager to be ahead of the game, to embrace each rising star as his light began to show and to feature each new trend as an important development. Some artists did very well out of this financially, but success, especially early success, can be a straightjacket. An artist famed for doing one kind of thing can find it wellnigh impossible to think of doing another. Meanwhile, with varying degrees of sensibility and sense, he sees his work shown around and reproduced, analysed and explained, sold and resold, and generally taken away from him physically and psychologically. He easily feels alienated from his own production—though, compared with almost every other sort of worker in the modern world, he is very closely identified with his work. In addition, he is surrounded by other artists, often his friends, who have little or no success while he has so much: the star system elevates one artist at the expense of many. And the many see endless attention, and vast amounts of money, being devoted to smarter galleries, glossier magazines, more elaborate art education programmes, and so on—even, in some countries, tax inducements for the rich to use some of the money they would otherwise yield to the tax collector in order to shine as art patrons—while many cannot exist as artists. Moreover, artists reaching maturity in the late 1960s were likely to find the path to any sort of success blocked by other artists only a few years older than themselves and not likely to give way. It is not difficult to understand why many of them, by means of Conceptual art, set out to circumnavigate the gallery system, in some instances even to attack it head on through their art. Even Judd's sober statement, that art need only be interesting, could seem too complaisant to artists who felt that the time had come to challenge not only what artists do but the entire world that appeared to be exploiting them as it also exploited many others.

The end of the 1960s saw, in western Europe and in the USA, a sudden radicalisation of intellectual life. Artists, writers, creative persons of all sorts, students, even school-children turned suddenly against the easy expansiveness of the 60s, the heady consumerism and the Vietnam war as though they were identical, even against hippiedom and all detachment from the realities of national and international politics. Where was progress towards racial and economic equality at home? What about the desperate needs of the Third World? Equality for women? While the galleries looked with pride on their holdings of affecting pictorial dramas and fine, cool, interesting pictorial and sculptural arrangements, much new art became directly and indirectly political to an unusual degree. At first this had to happen outside the galleries and the known art institutions. The very tradition of a work of art as an object to be bought, sold and owned was challenged and traduced.

Some examples out of many (it was the unexpected swarming of these works that was part of the excitement):

1965: in Düsseldorf (at the Galerie Schmela) Joseph Beuys (born 1921) gave a three-hour performance *How to explain pictures to a dead hare*. He carried the dead animal around the exhibition and sat and talked to it silently, telling it 'what cannot be said to his fellow man'. A later performance included a board inscribed 'The silence of Marcel Duchamp is overrated'. Art, he implied, should be heard, not seen.

1966: John Latham, part-time teacher at a wellknown London art college, borrowed from the college library a much-used book by the most magisterial of New York art critics (associated especially with Abstract Expressionism and its cool offspring such as Noland), Clement Greenberg's *Art and Culture*. People invited to Latham's house were asked to chew a page each from the book and to spit what remained into a flask. This stuff was processed by acid and fermentation. When the book was recalled by the librarian, Latham distilled the liquor and bottled it, and offered it to the library staff as the book. A day later he received a letter from the college to say his teaching would no longer be needed. (A small black case, containing the liquor and documentation on its history, is now in the collection of the Museum of Modern Art in New York.) This year also saw, among other works considered Conceptual, a number of 'earthworks' by artists on both sides of the Atlantic, large and small, self-evidently temporary or fairly enduring, rearrangements of the earth's surface. Some involved power machinery or explosives; others merely footprints or moving some pebbles or twigs by hand. In many instances, photographs would serve to record the work; these tended to

become saleable items by means of which the artists financed their ventures.

1967: Richard Long performed a cycling piece in eight English counties. Long (born 1945) has since become famous for his walks in remote places, with or without delicate earthworks made to signal his presence (and recorded in fine photographs), and for sculptures in galleries consisting of arrangements of stones or twigs brought in from the countryside. The photographs and the compositions he builds for exhibition tend to be poetic, lyrical even. Long's work produces an unusual tension between the attractions of a work as an object and as the mere representative of an idea.

1968: Walter de Maria executed a number of 'works in the desert', conceived earlier. They included, as one work, a square marked in California, a line in the Sahara and a line, at right angles to the preceding, in India. 'Three continents are needed for this image, which can be photographed in one day by a satellite': the image, obtained by combining the photographs, is a cross in a square. On September 22, in Frankfurt, Timm Ulrichs claimed a total eclipse of the sun as an art work. In November, the N. E. Thing Co. in Vancouver exhibited photographs and associated certificates, distinguishing between Aesthetically Claimed Things (ACT) and Aesthetically Rejected Things (ART); the former included all manner of sights, from a glacier to a pile of logs, the latter works of art.

86. **Walter de Maria**. *Pier and Ocean – Mile Long drawing (photographic detail)*. 1968. An idea of a grandiose but in most respects useless sort, executed far from anywhere with care and difficulty, and then recorded. Ambitious constructive gestures of this kind appear to take one back to the roots of art, associated with coming to terms with the universe and placating forces dangerous to man.

This is probably enough to suggest something of the range of activities covered by the label Conceptual art. The negative point is quite clear: these works deny the roles of taste, skill and myth; they break the convention that art is what certain people make for certain others to acquire and enjoy. Yet it is also clear that these artists want to exert pressure on conventional art production. Their products or by-products are saleable and collectable; certain galleries came into being almost at once to specialise in their work and thus to help them carry on working. Museums were soon adding examples to their stock, to be offered to posterity for examination and debate. Thus in some measure the art world embraced and consumed the work created to break it open, coping with the irritant as an oyster copes with a grain of sand. Indeed the art world changed in the process, not merely by accepting an enlarged concept of what art can be. It became, above all, more conscious of the artist as a generating force, and an intelligent, potentially troublesome one at that. Many a dignified art institution, opening its programme to include Conceptual art, found itself having to bend in order not to retreat in the face of the difficulties conceptual artists made for them. In one case, an exhibition of the work of Hans Haacke (born 1936), planned for the Guggenheim Museum in New York (a gallery highly regarded for its collection and exhibitions of modern and contemporary art), was cancelled at the last moment and the curator responsible for organising the show fired. Haacke had intended to display information about New York real estate dealings, and also to ask visitors to the exhibition to fill in a questionnaire putting ten questions about their social background and ten about their views on a number of economic and political issues. The Museum obviously expected to lose much of its support, especially the interest of wealthy trustees, if it allowed its space to be used for politically radical issues to be raised on its walls in the name of art. One sympathises with the director, yet of course it is disturbing to find that a western museum can suddenly censor an exhibition and thus act like its opposite number in a totalitarian state. The artist made his point by having the exhibition cancelled even more effectively than if the exhibition had taken place. Haacke managed a similar crisis in 1974 when he was asked to contribute to an international exhibition in the Wallraf-Richartz Museum in Cologne. He proposed to display a work from the museum's collection, a little Manet still-life of asparagus, and surround it with the 'social and economic position' of the persons who had owned the painting from the time it left Manet to the time it was bought for the museum. This would have brought out two delicate matters; the familiar one of the gap between what the artist received when he sold the painting and the money made by others out of the picture since, and the less obvious point of the extent to which cultural benefactors in the modern world tend to be very deeply involved in the world of Mammon. In this particular case it was implied that the chairman of the Friends of the museum, which had bought the Manet for the museum, had had an amazingly successful business career in Nazi Germany. Many people at the

87. **Barry Flanagan**. *No. 5, '71*. 1971. Felt and sticks. 24 × 102
× 102 in. (61 × 260 × 260 cm.). Tate Gallery, London.
Minimalism, with its monumental associations bred a reaction
against formality and permanence. Flanagan's temporary-
looking works, assembled out of sticks and strips of cloth, look like
the property of nomads rather than the memorials of a stable and
stagnant society.

museum thought very highly of Haacke's projected work,
but the director cancelled the invitation to show it. On the
day scheduled for the press view of that international show,
Haacke's project was realised in a smaller Cologne gallery,
with a full-size reproduction standing in for the museum's
Manet. Again, the media did their best to add to officialdom's
embarrassment. In 1975 Haacke exhibited, in New York,
six statements made by businessmen and others to support
the cause of business sponsorship of the arts. These state-
ments were made monumental: Haacke had them engraved
in magnesium plates, mounted on aluminium, like
commemorative plaques on buildings and monuments.
Here are two typical ones: 'EXXON's support of the arts
serves as a social lubricant. And if business is to continue
in big cities, it needs a more lubricated environment. Robert
Kingsley' (Manager of Urban Affairs for the EXXON
Corporation). 'The excellence of the American product in
the arts has won worldwide recognition. The arts have the
rare capacity to help heal divisions among our people and
to vault some of the barriers that divide the world. Richard
M. Nixon' (from an address to Congress during his years as
President of the United States). We are used to the artist as
a bohemian, living rough but with some enjoyment on the
fringes of society; we are used to him as a kind of priest,
offering a variety of visions of another world; we are used to
him as an entertainer, the licensed fool who may risk satire
but can expect to be beaten. We shall have to get used to the
artist who, recognising both the strength and the falseness
of the position modern society affords him as long as he

behaves himself, uses that position to make society see
precisely where its own tolerance ceases.

There is no way of summarising the methods and
materials employed by Conceptual artists; we have noted
some of them: performances, exhibitions of visual objects
(including documents), publications, earthworks (which
are plainly a form of large-scale sculpture). Others have
been: verbal definitions, numerical permutations, photog-
raphs, video tapes, television presentations, films, postal
works achieved by sending material through the mails. The
ingenuity that goes into these things seems endless. In every
case the aim is not to represent the world, but to change it.

RECENT FIGURATIVE ART

The start of the 1980s brought with it a return to figuration
in painting and sculpture. That, at least, is what a number
of critics announced, and the news brought comfort to those
who still saw in abstract art some sort of inhumanity. What
happened is that critics switched their attention from
Minimalism and Conceptual art to figurative work. To
make their manipulation of the art scene look like a historical
shift, they pretended that figuration had died or at least gone
deep underground during two decades of abstract rule.

Figurative art—and particularly the painting of figure
subjects—had in fact thrived and had a fair amount of
attention during the 1960s and 70s, even if we exclude the
sort that might be considered Pop. This remains true if we
exclude the great masters of Modernism still active during
those decades such as Picasso, who was splendidly
productive until his death in 1973. The immediate post-war
years had seen a significant growth in figure sculpture, a
sculpture reflecting the horrors of war and the oppressing
anxieties of a war at peace but locked into warlike confronta-
tions by mutual threats of total destruction. Alberto
Giacometti (1901–66) had become part of the Surrealist
movement in Paris with works that were symbolical and at
times abstract. During the war he turned to modelling

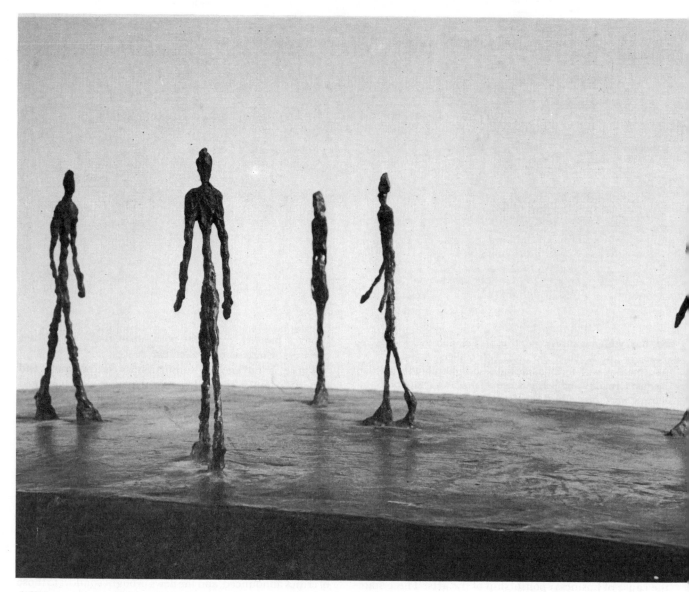

delicate, attenuated figures that, singly or grouped in space, were redolent of alienation and the fragility of mind and body. More powerful, possibly less poignant, expressions of desolation, private and public, were to be found in the work of Francis Bacon (born 1910), which rose to international fame after his large retrospective exhibition at the Tate Gallery, London, in 1962. Interviewed by the critic David Sylvester, Bacon said that his art was 'concerned with my kind of psyche, it's concerned with my kind of—I'm putting it in a very pleasant way—exhilarated despair'. Putting things in a very pleasant way is one of Bacon's great strengths as painter: no-one handles oil paint more deftly than he, in flat, velvety areas as well as in succulent sweeps of thick paint. He is also a master of pictorial stage craft, placing his figures and events in awesomely constricted or, worse, endlessly hollow situations. The visual pleasure and drama he prepares heightens the dreadfulness of his vision of humanity as the victim of internal and external forces of destruction. The combination is that proferred by Classical tragedy. Jean Dubuffet's (born 1901) insistently vulgar

vision makes a cheering contrast: we may be offended or amused, disgusted or aesthetically delighted by his studio versions of slum and lavatorial mural scratchings, but they do not disturb us. They are on the side of life, sex, survival; they are archetypal art, linking us back to prehistoric cave painting and Venus figures. The age-old attempt to use art to make human images, as convincing and alive as possible given the limited means of art—the age-old battle of trying to push those means towards ever more specific visual truth—has continued also, in all countries, usually without much interest shown by critics and their public.

But those decades saw also a development within figurative painting that has proved of great significance. It links with Bacon's work, and also with Pop art and Conceptual art: the return to figurative painting as a vehicle for narration and polemics. This too had never disappeared from the world's art (it is found in David's *Oath of the Horatii*) but it had been damaged for most purposes by the use to which it was put by the totalitarian states of Europe. It is interesting that one of the prime movers in this development

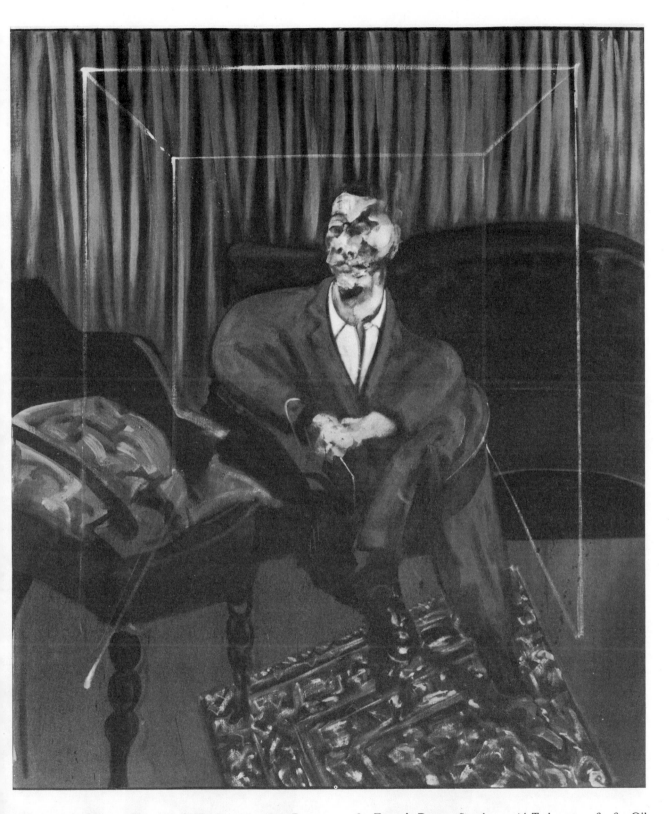

88 (opposite). **Alberto Giacometti**. *The Square*. 1948–9. Bronze, 24¾ × 17¼ × 8¼ in. (63 × 44 × 21 cm.). Offentliche Kunstsammlung. Basel (Emanuel Hoffman Collection). Giacometti's thin humanoids are usually said to express deep anxieties, personal and about mankind at large. Their form in fact arose from Giacometti's way of working in front of the model, pressing clay on to a vertical rod whilst attending to its character.

89. **Francis Bacon**. *Seated man with Turkey rug*. 1960–61. Oil on canvas. Tate Gallery, London. One of the most powerful and influential of post-war painters, Bacon remains unique for the dramatic vehemence of his art. The images are brilliantly staged, but their power comes also from the way he pivots them between horror and deliciousness, destruction and desire. He confronts us with terrible sights we half know already.

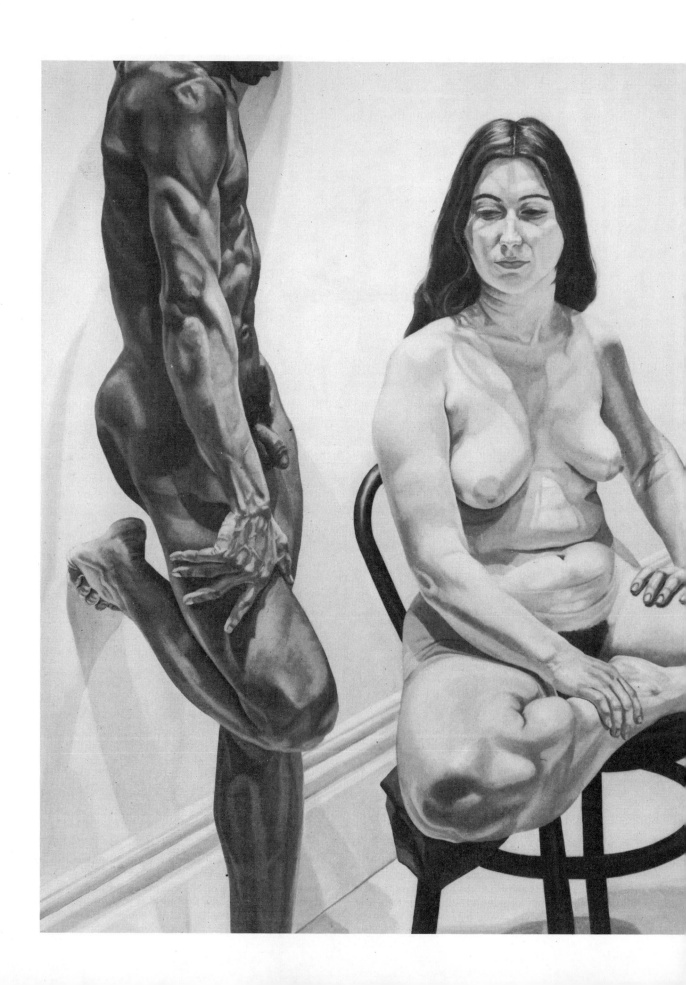

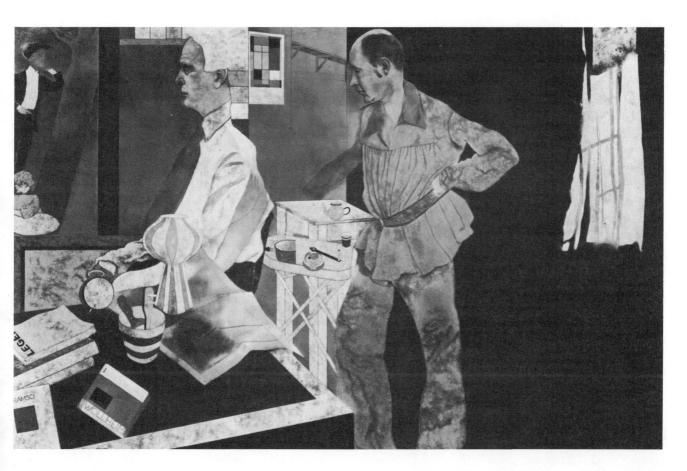

90 (opposite). **Philip Pearstein**. *Standing male and seated female models*. 1969. Oil on canvas. 74 × 62 in. (188 × 157.5 cm.). Professor and Mrs Gilbert Carpenter, Greensboro, North Carolina.

91 (above). **R. B. Kitaj**. *From London (James Joll and John Golding)*. 1975–76. Oil on canvas. 60 × 76 in. (152.5 × 243 cm.). Marlborough Fine Art, London Kitaj became known in the early 1960s as one of the Pop painters: he too used mass media source material, such as images from books and newspapers. But from the first he stood out for the learnedness and complexity of his methods, and his themes often relate to political history and philosophy. His most impressive paintings are poetical narratives, suggestive rather than direct, with the stylistic treatment as well as what is shown carrying much of the meaning.

associated his work blatantly with the history of European socialism as though to guard against contamination. The painter R. B. Kitaj (born 1932) was associated when he first began with the British wave of Pop art but he soon proved himself to be an essentially learned man who used his art as a meditative commentary on political and social themes. His work entices the mind as well as the eye, yet stops short of satisfying either. As in the work of many a modern poet, from Pound and Eliot on, we are held by the music of what is offered without being quite able to catch the words, the meaning. Many modern artists have stressed the role of process as an active element in the work. In Kitaj and certain other artists who have emerged more recently, the process of reading, assimilating, taking possession of what the work

presents has become a major factor. Philip Guston (1913–80) refers us to Leonardo da Vinci's statement that art is a thing of the mind. In 1970 he shocked the New York art world with a one-man show consisting of uncouth, more or less mocking, figurative paintings. Guston had been one of the most admired Abstract Expressionists; now, at the age of 57 he had suddenly, it seemed, turned his back on all sorts of pictorial poetry in order to offend his public. In fact he **115** had returned to what had made him a painter, the urge to make telling images of his personal obsessions and his understanding of the contemporary world. And that understanding was dominated by a kind of amazement at humanity's insistent cruelty and fear.

On the whole, recent figuration is cooler than Guston's, less appalled, more ironic. Having opened with a reformatory display of painting, which required the public of 1785 to go without the pleasures it had learned to associate with the art—pleasures of colour, movement, enticing bodies, lush staging—this account of modern art ends with Tony Cragg's *Britain seen from the North* (1981). We see the sculptor **92** in silhouette, and the island known as the United Kingdom. It is not in its normal position, as we know it from our maps; it is seen from another angle, or perhaps it is resting, tired. We cannot be certain whether Cragg (born 1949 in Liverpool, in the North of England) is making a political point and, if so, it is that one or perhaps something about the country having become a multi-coloured society, or even that 'this other Eden, demi-paradise. . . This precious stone

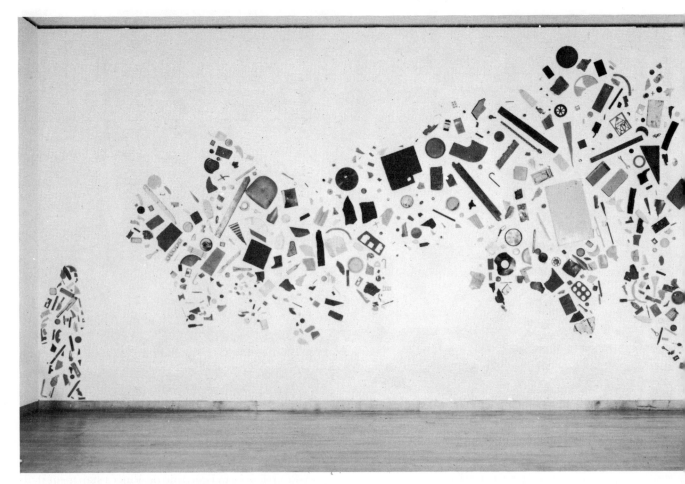

92. **Tony Cragg**. *Britain seen from the North*. 1981. Plastic. Tate Gallery, London. Modern art tends to be classified according to the methods employed, so that Cragg is known as the sculptor who works with rubbish collected where he is and rearranged to make an image. So he starts with the idea of recycling and giving significance to what we discard carelessly. Making order and finding significance has always been mankind's primary task; today this process has additional ecological point.

set in the silver sea' appears to be made of rubbish. Much of Cragg's work is made from rubbish collected and sorted by him. This work is made of bits of discarded plastic. In a sense, he is taking the Synthetic Cubist idea of using non-art materials to an extreme; he is also apparently doing the opposite, showing us that a traditional sort of drawing can be achieved by these means, as if those bits of plastic were no different from touches of paint. In most respects they are not. Like Kitaj, like Dubuffet, Cragg emphasises the artist's age-old role of image maker; at the same time his method embodies a message about art as a recycling activity, ever new but always also rooted in inalienable human concerns and processes.

ARCHITECTURE

The post-war years saw great programmes of reconstruction, especially of housing. They also saw some of the finest achievements of the International Style, but not as part of that reconstruction. The International Style, developed as architectural idiom associated with expectations of social progress, in fact with socialism, became the hallmark of successful capitalism. Its implications of functional directness were cleverly combined with signals of wealth. Mies van der Rohe was able, in the USA, to realise ideals he had worked towards before the war. One outstanding example is the Seagram office building on New York's Park Avenue, designed in collaboration with Philip Johnson. It is perhaps the most elegant piece of large-scale Minimalism, an immaculate form, exquisitely detailed, emphatically symmetrical, and lush on account of its tinted glass and highgrade internal surfaces. Across Park Avenue stands another splendid office building, Lever House, by Skidmore, Owings and Merrill (chief designer Gordon Bunshaft). It is in the Mies idiom, but detailed differently. The vertical slab is supported by columns set back from the sides, so that its pattern of glass and mullions is extra delicate, not having to accommodate itself to the structural elements. And the slab hovers above a horizontal structure providing a courtyard at street level and a roof terrace above. Here asymmetry rules, the vertical slab being mounted very much off-centre and at right-angles to the road. These two buildings have given birth to countless offspring around the world, only a few of them of comparable quality. Like the

Classicism of antiquity and the Renaissance, this modern Classicism is easy to imitate, even to make into a routine, yet leaves a lot of scope for skill and sophistication. The post-war years saw also the most brilliant advocate of the International Style abandoning it. ˙Le Corbusier's pilgrimage chapel at Ronchamp is another sort of architecture altogether, a hand-moulded building quite devoid of the machine implications of the Villa Savoie; if the villa hinted at the engineering of a modern liner, the chapel speaks of an old sailing-boat. The rationality of the one is answered in the irrationality of the other, crisp elegance by rustic primitivism. Both are masterpieces. The character of Ronchamp is not easily read from photographs of it. It is the interior that matters most, with its sloping floor, cunning direct and indirect daylight, its easy yet irresistible emphasis on the altar end. The non-believing architect achieved another marvel with his monastery La Tourette, where all-over clarity (if not Classicism) of design is accompanied by a wealth of rhythmic variations and other surprises, more felt than seen. The houses he designed for Ahmadabad in India and for Neuilly-sur-Seine near Paris share an earthy, protective quality quite absent from Le Corbusier's pre-war design: they represent the house as a warm, safe, burrow, not a proud, even arrogant display of confidence. How deeply he was now concerned with the symbolical content of the forms he was using is perhaps best seen in his work for the new Indian city of Chandigarh, especially in the General Assembly building. Here Indian traditions are joined to western. The shading, rain-scooping roof is at once functional and the parasol of authority. The full-breadth portico recalls Schinkel, as does the main feature of the internal organisation, the circular assembly that rises through the roof in the form of a cooling-tower. Light falls onto the assembly through the top of this tower; fixed on its outer face are curved forms sketching the path of the sun. The modern here joins hands with the ancient, particular cultures with global meanings. Le Corbusier's work at Chandigarh also proved undisguised concrete to be material as capable of nobility as the Travertine marble of Rome.

Echoes of the nobility and the drama of Chandigarh are to be found in only slightly less ambitious buildings elsewhere, such as the City Hall designed for Boston (Mass.) by Kallmann, McKinnell and Knowles and Kenzo Tange's Yamanashi Press and Radio Centre at Kofu in Japan. Monumentality—the formal vividness, not necessarily always joined to great size, by which a designed object becomes a memorable symbol—had not been sought by pre-war Modernist architecture (though one might consider to what extent Gropius's Bauhaus building both seeks it and declines it). In quite different ways it is unmistakable in the Seagram Building and in the state buildings of Chandigarh, and these examples served as invitation to architects weary of the pretended austerity of functionalism to give their buildings expression and significance.

The worldwide expansion of modern architecture is implicit in all this, and with it the dissemination of steel and concrete design and building techniques. But western urban

73. **Ludwig Mies van der Rohe**. *Seagram Building, New York.* 1957. Set well back on its site, approached from Park Avenue past two symmetrical pools, the Seagram Building has a fine monolithic character, a Minimalist sculpture as much as an office block. The detailing is exquisite, implying a structural simplicity local regulations do not permit; the materials are refined and expensive.

methods do not always serve in other places, and turn into extravagance and rhetoric in areas better served by their own traditional ways. Monumentality bred a reaction, and there developed a call for more basic techniques, related to locality. Vernacular forms and methods have been studied with much care, and on occasion yielded to. It can be efficient, as well as apt, to let people build in mud and straw or timber and woven mats if that is what they know. In America too there has been a move away from ambitious architecture relying on big-business strategy to the tactics associable with the peasant, the nomad and even the tramp. Examples of this sort range from the houses of Bruce Goff, a rustic echo of Buckminster Fuller's industrial Dymaxion project, and the shelters built for themselves by settlers in the wild but warm lands of California and Arizona out of local junk. Why should buildings be permanent encumbrances on the earth and on the individual?

At the other extreme, recent years have seen attempts to reconceive architecture and planning in terms harmonising with global industrialisation and space exploitation. The business of architecture does seem old-fashioned and hand-to-mouth compared with the making of cars and aeroplanes, let alone space stations. Perhaps it is just as well, but it would also be un-human not to investigate the possibilities of living systems starting from the upper levels of modern technological know-how. The 'Plug-in-city' of Peter Cook (born 1936) of the group Archigram; is one such experiment. One of his colleagues, Warren Chalk, stated the group's aims very clearly: 'We are in pursuit of an idea, a new vernacular, something to stand *alongside* the space capsules, computers and throwaway packages of an atomic electronic age' (1970). The answer to such all-out radicalism has been a surprising wave of historicism: an abandoning of stylist modernism in favour of an architecture of quotations, direct and indirect. The results can be amusing and also dramatic, but they have the character of stage sets, to be struck after the applause has ceased.

One striking example of this is the extension designed for the Tate Gallery in London by James Stirling. Stirling (born 1926) made a name for himself as a an architect who used the forms and materials of funtionalism to dramatise college buildings, bringing associations and indeed spaces associated with large factories or glasshouses into the world of lecture theatres, libraries and student accommodation. This seemed an architecture without style, although Stirling's way with these things gave them a personal flavour. The Tate extension is designed to be an episodic experience, suggesting several additions by several hands, without unified character, let alone style. This leaves the Palladian Classicism of the old gallery unchallenged. But if architecture carries meaning, the new building must mean indecisiveness, a lack of character, moral as well as aesthetic. It is particularly interesting to note this at a time when museums and art galleries are having to change their image and their methods. Having been primarily places offering safe storage, for their precious holdings, and access to them to scholars and a smallish public of art lovers, they are now

outgoing, attention-grabbing places vying for visitors and offering a variety of entertainments in addition to their older functions. Technically art museums present problems that architects have largely failed to solve: surfaces and spaces on and in which to exhibit works of art, suitable lighting conditions, helpful circulation arrangements and services of various kinds, to cope with permanent collections, storage restoration work and a variety of exhibitions and associated events. Louis Kahn has designed what are perhaps the most perfect galleries of recent times, the Yale Art Gallery, New Haven, Connecticut (1951–3) and the Kimbell Museum, Forth Worth, Texas (1972)—in both cases relatively small institutions with limited programmes of activities, though with collections of outstanding quality. But another sort of solution was proposed and, amazingly, accepted by the authorities in the case of the Pompidou Centre in Paris, by Richard Rogers and Renzo Piano. this building, intended to house Paris's main modern art collection and exhibitions, a major art library, a centre of audio-visual research, as well as the usual functions of a museum and arts centre, seemed to turn its back on the whole idea of architecture—and shockingly so in Paris, a city rightly proud of its architectural traditions. The project, like the Eiffel Tower a hundred years earlier, evoked an out-cry. The completed building still has

95 (above). **Le Corbusier**. *General Assembly Building, Chandigarh, India*. 1951–65. In making his designs for the buildings at the centre of the new capital at Chandigarh, Le Corbusier had to consider many practical problems, including the extreme climate, as well as Nehru's call for a city which would be a symbol of India's new freedom.

94 (opposite). **Skidmore, Owings & Merrill**. Lever House, New York. 1952. Compositionally, setting a tower above a horizontal unit, Lever House has a very different character from the Seagram Building across Park Avenue, and its surface detailing is lighter, less insistently classical.

96 (below). **Richard Rogers and Renzo Piano**. *The Pompidou Centre, Paris*. 1976. The Pompidou Centre offends against Parisian classicism as well as against the solemnity traditionally associated with municipal museums. Instead it is a fun palace executed in the idiom of ships and temporary exhibition stands.

its enemies but is the delight of many. This must be due largely to its character as a building (as a place in which to see works of art it has definite limitations). Its associations are with fairgrounds and travel. With its structure of steel tubes and bracing rods it looks temporary, mobile even, no more exclusive than an airport building or a ferry to take you across the bay. People feel free to use it and enjoy it.

Looking back over two centuries of architecture and building, we can see a number of very fine buildings, first mostly in stone and brick, then mostly in steel and concrete (though brick remains the primary building material in the western world). It is surprising how little industrialisation of building there has been. This must be due mainly to the reluctance of builders to change their time-honoured methods, and to the designers' unwillingness to engage in the kind of research—unspectacular and not necessarily very rewarding—that would lead to the development, with industry, of viable new building systems. What prefabrication there has been, has been associated with temporary accommodation and with penny-pinching and unreliability, rather than with the liberating option of changing the building for current needs.

Perhaps successful and honourable prefabrication will come, as Peter Cook implies, with developments in space travel. This suggests a long wait, and high consumption of precious materials. Meanwhile there should be room for less 'high-tech' developments, using commonplace natural and man-made materials, from straw to glass fibres. Global needs, energy conservation, the value of replaceable raw materials such as metals, make this imperative. The history of architecture proves that the human imagination will engage positively with whatever materials are provided.

Epilogue

During the 190 years surveyed here, the character of art and of artists has changed dramatically. Our story began with a sweeping revolution, visible and latent, and this revolution would seem to have prompted an accelerating chain reaction that has transformed our cultural life. Perhaps the most radical change of all is that we should accept change as a normal condition. In the days of Neo-Classicism the belief in ideal beauty and harmony still implied a goal which, once achieved, would permit no further artistic search. Today there is no general goal, unless it be that of free individual expression, and while we are familiar with the grouping and regrouping of artists willing to share an aesthetic idiom or a view of society, we are conscious of the lack of an all-embracing faith or vision that will bring a degree of unison into artistic creation to replace the patricide and fratricide that we accept as a normal part of modern self-determination in art. Such a faith cannot be manufactured, nor will bewailing our lack of it bring it more swiftly.

Meanwhile let us count our blessings. Art is a necessary and normal means of human expression. Do what he will, even the most individualistic amongst us is unable to shed his membership of mankind, and all his work is determined by values and functions which he shares with the rest of us. If the art of our age lacks the consolidating keystone of faith, it is none the less based on common ground. The strangeness of much modern art would at once disappear if we remembered its inescapably human origin.

If our century has failed to evolve a common structure of aims and values, some of its achievements have strikingly informed our art. The dramatic advances of modern science and the increasingly mechanistic character of our daily environment have necessarily left their mark on the content and idiom of art. Many artists, whether educated in scientific matters or not, have felt and emphasised a sense of kinship with the researching scientist, and their work has revealed an instinctive awareness of the changing picture of the world constructed by physicists and biochemists. Similarly the hypotheses of modern psychology have found echoes in art, just as philosophical theories have provoked artistic responses on many sides. Without any special knowledge of Einstein's theories the Cubists gave form to new concepts of space and time associated with him. The enthusiastic acceptance of modern technology characteristic of Futurism was taken up and made poetic by continuing generations of Constructivists. If Surrealism's use of Freudian theory seems curiously limited, all expressive art has benefited from the greater and more sympathetic insight into human actions that psychology has handed even to the most ignorant amongst us. Abstract Expressionist art seemed at its appearance directly influenced by Existentialist thought; subsequently it has sometimes looked as though Existentialist ideas had actually been plucked from the blossoming tree of modern art. One of the most persisting specialities of modern art, a consciousness of space as something to be explored and exploited, is the property also of astronomers and schoolboys. Inner space is another important theme of exploration in modern art.

The place of art in our lives has changed drastically. From the church and the court, art has moved into the market place. Some of it is herded into public galleries, available to us all. Much of it, after a brief appearance on the stalls goes into private hands, but anyone living above subsistence level is in a position today to acquire the work of reputable artists in the form of drawings or prints. While there is little sign of a general interest in art, art itself has become less exclusive and has thus paralleled the marvellous social advances of our time.

The role and image of the artist himself has also changed, for we have witnessed a complete transformation of the avant-garde. Today, the artist is neither the mysterious soothsayer nor the spurned outsider crying in the wilderness. More and more he has taken on professional status. Having once devoted a good part of his efforts to surviving the disdain of the public, the avant-garde artist today has to guard his integrity against the dangers inherent in success and publicity. The academies stand in the shadows while the limelight shines on successive waves of new and often very young artists, most of whom occupy the stage only briefly. Thesis is followed by antithesis; for synthesis there is no time. The danger in this situation does not lie in the rapid obsolescence of modes of art that yesterday seemed vital—the true work of art will survive in spite of this—but in a new academy of rebelliousness. To be new is the conventionality of our time. Not only is it easier to be new than to be good; it is also easier to be thrilled by the new than by the good.

The individual spectator, like the individual artist, has to find his way through a kaleidoscopic jungle of modern art. In a confused and fragmented world he cannot expect to find a neat and predigested world of art. Any knowledge of the art of the past and particularly of the recent past will help him to develop a sense of direction, but ultimately there is no substitute for his own developed sensibility. There can be little doubt that when, in some future age, the art of our time is measured against the art of the past, it will be found remarkable not so much for its inherent rebelliousness and self-questioning as for its ceaseless investigation into the potency of its means. In figurative and non-figurative art we have witnessed an ever sharpening awareness of the value of colour, line, form, scale and size, space and movement, both in their purely sensory effectiveness and as vehicles of emotion, and this will be recognised as an enduring contribution.

It has always taken time for cultural developments to reach people at large and it may be questionable whether the general public will ever feel the love for art which must be the basis for real understanding of it. We are told that our culture is moving from a verbal period into one of visual communication, which means that the requirements of normal living will demand a refinement of our visual awareness. The art of the last hundred years will be recognised as the great pioneer activity towards this refinement, and thus as the necessary and profoundly beneficial pursuit that some of us know it to have been.

ACKNOWLEDGEMENTS

Introduction
P. Almasy, Neuilly-sur-Seine 6; Belgeaux-Zodiaque 17; Jean Bottin, Paris 16; British Museum, London 14, 15; Commissioners of Public Works in Ireland, Dublin 4; Paolo Graziosi, Florence 2; Hirmer Verlag, Munich 7, 8, 10, 13; Mas, Barcelona 1, 3; Staatliche Museen-Preussischer Kulturbesitz, Berlin 11; Staatliche Museen zu Berlin 9; Wim Swaan, New York 12; H. Roger-Viollet, Paris 5.
The Classical World
Colour Photographs Antiken-Sammlung, Staatliche Museen zu Berlin 71; Joachim Blauel 27, 43, 44; British Museum, London, 3, 45, 121; Photographie Giraudon, Paris 42, 116; Fritz Henle 38, 64, 70, 117; Hans Hinz, Allschwil, 1, 2, 10, 48, 58, 80, 81; Hirmer Verlag, Munich 4, 19, 77; Michael Holford, Loughton 122; A. F. Kersting, London 49, 113; Metropolitan Museum of Art, New York 24; Museum of Fine Arts, Boston, Massachusetts 29; Newnes Books 11, 12, 13, 14, 15, 16, 18, 20, 21, 22, 23, 25, 26, 28, 30, 31, 32, 33, 34, 35, 36, 37, 39, 40, 46, 51, 52, 53, 54, 55, 56, 57, 59, 60, 61, 62, 63, 65, 66, 68, 69, 72, 73, 74, 75, 76, 78, 79, 83, 84, 85, 87, 90, 91, 92, 93, 94, 100, 102, 104, 105, 106, 107, 108, 109, 110, 111, 112, 114, 118, 119, 120, 124, 125, 126, 128; Paul Popper, London 115; Presses Universitaires de France, Paris 41; Scala, Antella, 5, 6, 82, 86, 98, 99, 101; V. Serventy 50; Raymond V. Schoder, Chicago 127; Skira 67; Viewpoint Projects 123; H. Roger-Viollet, Paris 103; Visual Arts Library, London 17, 47; Joseph P. Ziolo, Paris – André Held 8, 88, 89, 95, 96, 97. *Black and White Photographs* Acropolis Museum, Athens 16; Alinari, Florence 13, 24, 29, 44, 48, 58, 60, 64, 65, 71, 75, 87, 88, 91, 92; Archaeological Survey of India, New Delhi 81; Bernisches Historishes Museum 80; Bildarchiv Foto Marburg 62; British Museum, London 22, 43, 52, 54, 56, 57, 59, 68, 70; J. Allan Cash Library, London 20, 26; R. Descharnes, Paris 12; Deutsches Archäologisches Institut, Athens 8, 11, 17; Deutsches Archäologisches Institut, Rome 73, 78, 86; Fototeca Unione Rome 85; Fox Photos, London 19; Hirmer Verlag, Munich 5, 18, 27, 30, 32, 49, 50, 55; E. Boudot Lamotte 10, 15; I. Schneider – Lengyel, Schwangau 14; Mansell Collection, London 2, 46; Middle East Airlines, London 84; Musei Vaticani 35, 42, 67, 69; Museo Arqueologico Nacional, Madrid 61; Museo Civico Archeologico, Bologna 25; National museet, Copenhagen 63; Newnes Books 1, 4, 6, 7, 9, 21, 23, 28, 33, 34, 36, 37, 38, 40, 47, 53, 72, 76, 79, 89, 90; Ny Carlsberg Glyptotek, Copenhagen 45, 61; Tony Schneiders 3; Skulpturensammlung, Staatliche Kunstsammlungen, Dresden 31; Viewpoint Projects 39, 41, 66, 77; Warburg Institute, London 74, 82, 83.
The Early Christian and Byzantine World
Colour photographs F. Anderegg, University of Michigan, Ann Arbor 1, 2; Carlo Bevilacqua, Milan 37; Bibliothèque Nationale, Paris 48, 49, 63, 64; Germanisches Nationalmuseum, Nuremberg 47; Ara Güler, Istanbul 53; Hirmer Verlag, Munich 36, 61, 70; A. F. Kersting, London 26, 67; F. A. Mella, Milan 18, 19; Middle East Archive, London 28; Newnes Books 6, 14, 20, 21, 39, 41, 42, 43, 44, 45, 46, 50, 51, 52, 55, 65, 67, 68, 69; Österreichische Nationalbibliothek, Vienna 60; Josephine Powell, Rome 58, 59; Scala, Antella 15, 16, 17, 22, 23, 24, 25, 29, 30, 31, 32, 33, 34, 35, 38, 40, 54, 62, 66; Enzo Sellerio, Palermo 56, 57; Joseph P. Ziolo, Paris – André Held 3, 4, 5, 7, 8, 9, 10, 11, 12, 13. *Black and white photographs* A. C. L., Brussels 41; Alinari, Florence 2, 14, 27, 57, 58; Belzeaux – Zodiaque 44, 45, 46a, 46b, 46c; Osvaldo Bohm, Venice 24, 36; British School at Rome 25; Ara Güler, Istanbul 38; Studio Haig, Amman 18; Atelier Niko Haus, Trier 53; Hirmer Verlag, Munich 11, 12, 13, 21, 55; Kungliga Biblioteket, Stockholm 54; E. Boudot-Lamotte 34, 51; J. Lassus 1, 3, 5, 19a, 29a, 29b, 32b; Bildarchiv Foto Marburg 20, 35, 43; Musée d'Art et d'Histoire, Fribourg 42; National Buildings Record London 47; Newnes Books 9, 10a, 22, 48, 49, 56a, 56b, 59; OFALAC 7; Pontificia Commissione di Archeologia Sacra, Rome 8; Princeton University, New Jersey, Department of Art and Archaeology 33; Jean Roubier, Paris 39; Edwin Smith 52; Stadtarchiv Aachen 50c; E. Stawski 28; Joseph P. Ziolo, Paris—André Held 10b.
The Medieval World
Colour photographs Nigel Atkins 56; Lala Aufsberg, Sonthofen 38; Banque de Paris & des Pays-Bas, Brussels 45; Bayerische Staatsbibliothek, Munich 14, 17; Bibliothèque Nationale, Paris 52; Bibliothèque Royale, Brussels 54; British Library, London 47, 80; British Museum, London 1; Courtauld Institute of Art, London 89, 90, 100; Photographie Giraudon, Paris 9, 12, 16, 26, 29, 34, 44, 53, 65, 76, 94, 102; Michael Holford, Loughton 22; A. F. Kersting, London 57, 64, 79, 91, 101; Mas, Barcelona 8, 60, 62; Hans G. Meile. Augsburg 32; Ann Munchow, Aachen 18, 66; Museo Civico dell' Età Cristiana, Brescia 4; National Gallery of Art, Washington D.C. 55; Newnes Books 2, 6, 11, 19, 21, 23, 28, 30, 31, 33, 35, 37, 40, 48, 49, 50, 51, 59, 61, 63, 67, 68, 69, 70, 74, 75, 77, 81, 82, 83, 87, 88, 95, 96, 97, 98, 99; Newnes Books, Francis-E. Niffle 41; Picturepoint, London 92; Pierpont Morgan Library, New York 78; Réalités, Paris 20, 27, 39; Rheinisches Landesmuseum, Boon 3; Scala, Antella 5, 7, 10, 24, 25, 36, 58, 71, 72, 73, 84, 85, 86; R. Schlegelmilch, Trier 13, 42, 46; Studio Jon, Fishguard 93; Verkehrsamt der Stadt Köln 43; Verkehrsamt der Stadt Köln – Chargesheimer, Cologne 15. *Black and white photographs* A.C.L., Brussels 14; Alinari, Florence 45, 98, 104; Archives Photographiques, Paris 40, 49; Lala Aufsberg, Sonthofen 91, 100; British Library, London 24; British Museum, London 7; Courtauld Institute of Art, London 1, 6, 10, 12, 15, 16, 20, 23, 31, 43, 44, 52, 60, 62, 74, 76, 79, 80, 82, 83, 86, 97, 102; Photographie Giraudon, Paris 5, 19, 39, 41, 46, 48, 103; A. F. Kersting, London 57, 66, 73, 78; Kunsthistorisch Instituut der Rijksuniversiteit, Utrecht 22; E. Boudot-Lamotte 55, 64; Bildarchiv Foto Marburg 2, 3, 4, 8, 18, 21, 25, 27, 34, 35, 42, 47, 53, 63, 75, 84, 90, 94, 95, 101; Mas, Barcelona 87; National Museum of Ireland, Dublin 11; Newnes Books 58, 67, 71, 77; Normans Kunstforlag, Oslo 9; Rapho, Paris 81; Photo Rex, Toulouse 50; Rheinisches Bildarchiv, Cologne 65; Jean Roubier, Paris 26, 30, 32, 36, 37, 56, 61, 72, 86, 88, 89; Roger-Viollet, Paris 28, 51, 85; Warburg Institute, London 17; Yan, Toulouse 93, 99.
Man and the Renaissance
Colour photographs Plates 34 and 98 are reproduced by gracious permission of Her Majesty the Queen.
A.C.L., Brussels 18; Emil Bauer, Nuremberg 67, 75; Bayerische Staatsgemäldesammlungen, Munich 80; Bibliothèque Nationale, Paris 11; Joachim Blauel 65, 79; Bowes Museum, Barnard Castle 72; A. C. Cooper, London 34, 98; Photographie Giraudon, Paris 1, 12, 14, 20, 69, 86; Glasgow Art Gallery and Museum 89; Lossen Photo, Heidelberg 78; Metropolitan Museum of Art, New York 15; National Gallery of Art, Washington D.C. 21; Newnes Books 5, 6, 7, 13, 17, 22, 23, 27, 30, 33, 35, 36, 42, 47, 48, 49, 51, 52, 55, 58, 62, 64, 66, 68, 70, 71, 73, 76, 77, 82, 83, 85, 87, 88, 90, 92, 95, 96; Photo Precision, St Albans 81; Scala, Antella 2, 3, 4, 8, 10, 19, 24, 25, 26, 28, 29, 31, 38, 39, 40, 41, 43, 44, 45, 46, 53, 54, 56, 57, 59, 60, 61, 63, 84, 93, 94, 97, 99, 100; Staatliche Museen Preussischer Kulturbesitz, Gemäldegalerie, Berlin 37, 74; Joseph P Ziolo, Paris 16. *Black and white photographs* A.C.L., Brussels 66; Alinari, Florence 1, 2, 4, 5, 6, 7, 8, 9, 10, 11, 12, 13, 14, 15, 24, 25, 26, 27, 28, 29, 30, 31, 34, 35, 36, 37, 38, 40, 43, 44, 45, 52, 53, 57, 61, 86, 87, 93, 95, 99, 101, 102, 103, 104; Archives Photographiques, Paris 79; Bavaria Verlag, Munich 76, 78; Bayerische Staatsgemäldesammlungen, Munich 51; British Museum, London 23, 32, 47; J. E. Bulloz, Paris 22; Courtauld Institute of Art, London 48, 81; Fotografia Industrial S.A., Barcelona 83; Gabinetto Fotografico Nazionale, Rome 59, 60; Gallerie dell' Accademia, Venice 91, 92; Photographie Giraudon, Paris 21, 46, 49, 50, 65, 75, 80, 82, 90; Hills & Saunders, Eton 68; E. Boudot – Lamotte 41; Bildarchiv Foto Marburg 3, 19, 20, 69, 71, 72, 73, 74; Mas, Barcelona 84, 85; Metropolitan Museum of Art, New York 88; Museu Nacional de Arte Antigua, Lisbon 67; Narodni Galerie, Prague 17, 18; National Gallery, London 62; Newnes Books 16, 42, 55, 56, 63, 64, 77, 89, 94, 100; Rheinisches Bildarchiv, Cologne 33; Oscar Savio, Rome 54; Scala, Antella 98; Städelsches Kunstinstitut, Frankfurt 96; Victoria and Albert Museum, London 97; Wallace Collection, London 58.
The Age of Baroque
Colour photographs Lala Aufsberg, Sonthofen 23, 28, 86; Emil Bauer, Nuremberg 22, 35, 37; Cleveland Museum of Art, Ohio 61; Dulwich College Picture Gallery, London 3, 74; Detroit Institute of Arts, Michigan 41; Photographie Giraudon, Paris 77; Leo Gundermann, Wurzburg 89; Frans Halsmuseum, Haarlem 56; A. F. Kersting, London 52, 91, 94, 95; Mas, Barcelona 16; Mauritshuis, The Hague 57; Metropolitan Museum of Art, New York 64; Erwin Meyer, Vienna 14; Museum Boymans-van Beuningen, Rotterdam 60; National Gallery of Art, Washington D.C. 11, 49, 73, 96; National Gallery of Canada, Ottawa 99; Nationalmuseum, Stockholm 66; Newnes Books 1, 4, 5, 7, 8, 9, 10, 12, 13, 15, 16, 17, 18, 21, 24, 25, 26, 27, 29, 30, 31, 32, 33, 38, 39, 40, 42, 43, 44, 45, 46, 47, 48, 51, 53, 54, 55, 62, 63, 65, 67, 68, 69, 70, 75, 78, 79, 80, 81, 83, 84, 87, 90, 92, 93, 97, 98, 100; Rijksmuseum, Amsterdam 19, 58; Scala, Antella 2, 20, 34; Edwin Smith 88; Victoria and Albert Museum, London 71, 72, 85; H. Roger-Viollet, Paris 50. *Black and white photographs* Author 4; Alinari, Florence 2, 10, 12, 13, 29, 32, 36, 38, 39, 41, 52, 53, 56, 62, 94, 100; Archives Photographiques, Paris 19, 31, 58, 77, 80; Art Institute of Chicago, Illinois 25; Bavaria Verlag, Munich 9, 44, 84; British Museum, London 49, 78; Messrs Alfred Brod,

London 66; City Museum and Art Gallery, Nottingham 97; Country Life 95; Courtauld Institute of Art, London, 5, 6, 7, 8, 14, 26, 34, 47, 48, 50, 70, 73, 75, 76, 86, 89, 90, 99; Department of the Environment 85; Gabinetto Fotografico Nazionale, Rome 18, 30, 46; Photographie Giraudon, Paris 55, 71, 87, 98; Dr. F. Hepner, Potsdam 83; Hermitage Museum, Leningrad 24; A. F. Kersting, London 43, 91; Kunsthistorisches Museum, Vienna 65; F. Lugt, The Hague 74; Bildarchiv Foto Marburg 16, 42; Mas, Barcelona 61; Musées Nationaux, Paris 20; Museo del Prado, Madrid 64, 85; National Gallery, London 67; Nationalmuseum, Stockholm 20; Newnes Books 1, 3, 15, 17, 33, 54, 82, 93; Presse Bild Poss, Regensburg 28; R.I.B.A., London 96; Rijksmuseum, Amsterdam 22; Edwin Smith 40; Staatliche Museen, Berlin-Dahlem, Gemäldegalie 27, 51; Victoria and Albert Museum, London 79, 88; Villani, Naples 45; H. Roger-Viollet, Paris 59; Wadsworth Atheneum, Hartford, Connecticut 63; Wallace Collection, London 23, 68, 69.
The Modern World
Colour photographs Albright-Knox Art Gallery, Buffalo, New York 70; Architectural Association, London, 98; Art Institute of Chicago, Illinois 28, 51; Bergen Billedgalleri 39; Galerie Beyeler, Basel 78; Hedrich Blessing, Chicago, Illinois 87; J. Camponasca, Lyons 27; Leo Castelli Gallery, New York 103, 111; CNDP 104; Courtauld Institute Gallery, London 30; Detroit Institute of Arts Michigan 42; Doeser Fotos, Laren 85; Edimedia 71, 83; André Emmerich Gallery, New York 90; Photographie Giraudon, Paris 57; Solomon R. Guggenheim Museum, New York 56, 61; Fernand Hazan, Éditeur, Paris 54; Lucien Hervé, Paris 97; Hans Hinz, Allschwil 50, 52, 75; Kasmin Gallery, London 107; Kunstgewerbemuseum, Zurich 32; Kunstmuseum, Basle 5; Lords Gallery, London 68; D McKee Inc., New York, 115; Marlborough Fine Art, London 96; Mas, Barcelona 6, 45; E. Meyer, Vienna 60; Musée Royal des Beaux-Arts, Antwerp 38; Musées Royaux des Beaux-Arts de Belgique, Brussels 76; Museum of Art, Carnegie Institute, Pittsburgh, Pennsylvania 47; Museum of Fine Arts, Boston, Massachusetts 31, 33; Museum of Modern Art, New York 48, 49, 62, 65; Nationalgalerie Dahlem ur Berlin 22; National-Galerie, East Berlin 16, 51; Newnes Books 1, 2, 3, 4, 5, 7, 8, 9, 10, 11, 12, 13, 14, 15, 17, 18, 19, 20, 21, 23, 24, 25, 26, 29, 36, 37, 40, 43, 44, 53, 59, 66, 72, 73, 74, 77, 79, 88, 89, 93, 94, 99, 100, 101, 102, 105; Philadelphia Museum of Art, Pennsylvania 34, 64; Rÿksmuseum Kröller-Müller, Otterlo 35; Professor Alfred Roth, Zurich 67; Royal Museum of Fine Arts, Copenhagen 26; Silvana Editoriale d'Arte, Milan 55; Stedelijk Museum, Amsterdam 63, 86; Tate Gallery, London 116; Mr and Mrs Burton Tremaine, Meridan, Connecticut 80; Ulster Museum, Belfast 106; Visual Arts Library 81, 82, 84, 92, 95, 109, 110, 112, 113, 114; Whitney Museum of American Art, New York 108 © ADAGP 1984 35, 50, 56, 57, 60, 64, 65, 68, 70, 73, 75, 81, 93, 94, 112 © DACS 1984 22, 24, 29, 37, 46, 47, 49, 51, 53, 54, 58, 61, 67, 69, 71, 72, 74, 79, 88, 89, 93, 94, 99, 100, 101, 102, 105. *Black and white photographs* Wayne Andrews, Detroit, Michigan 28, 31; T. and R. Annan, Glasgow 37, 38; The Architectural Press 94, 95, 96; Archives Photographiques, Paris 9; Bauhaus Archiv, Berlin 75; Bibliothèque Nationale, Paris 12; Max Bill, Zurich 78; British Museum, London, 3, 5; Busch-Reisinger Museum, Harvard University, Cambridge, Massachusetts 63; Chevojon, Paris 30, 52, 65; Chicago Architectural Photographing Co, Illinois 35; Dyckerhoff & Widmann, Munich 57; Fox Photos, London 16; French Government Tourist Office, London 28; Alexander Georges, Pomona, New York 93; Photographie Giraudon, Paris 1, 11; Camilla Gray 55, 77; Grosvenor Gallery, London 96; Solomon R. Guggenheim Museum, New York 70; Lucien Hervé, Paris 53, 72; Joseph H. Hirshhorn Collection, New York 69; Humbolt Universität, Berlin 13; A. F. Kersting, London 15, 32; Kunstmuseum Bern 41; E. Boudot-Lamotte 36; Landesbildstelle, Rheinland, Düsseldorf 48; Leco Photo Service, New York 79; Bildarchiv Foto Marburg 27; Marlborough Fine Art, London 49, 68; Il Milione, Milan 24; Musées Nationaux, Paris 2; Museo Civico, Como 58; Museum of Modern Art, New York 39, 47, 50, 54, 60, 66, 67, 71, 74; National Buildings Record, London 94, 95; Newnes Books 6, 17, 20, 21, 26, 61, 80, 81, 88, 89, 90, 91; Ny Carlsberg Glyptotek, Copenhagen 10; Philadelphia Museum of Art, Pennsylvania 40; R.I.B.A. London 33; Man Ray 46; Pskar Reinhart Collection 'Am Römerholz', Winterthur 18; Rijksprinten Kabinet, Amsterdam 19; Sir John Soane's Museum, London 14; Staatliche Museen zu Berlin 23; Stedelijk Museum, Amsterdam 62; Dr Franz Stoedtner, Dusseldorf 56; Tate Gallery, London, 4, 22, 43, 44, 51, 84, 87, 92; Tretyakov Gallery, Moscow 45; Madame Theo van Doesburg 59; E. M. van Ojen, The Hague 76; Visual Arts Library 21, 42, 82, 83, 85, 86; Josiah Wedgwood & Sons, Stoke on Trent 8. © ADAGP 1984 40, 41, 43, 46, 47, 51, 64, 66, 67, 69, 70; © DACS 39, 53, 60, 61, 65, 72, 84, 85; © SPADEM 1984 42, 44